University of St. Francis
709.45 H335i 3 ed.
Hartt, Frederick.
History of Italian Pagainan

HISTORY OF

ITALIAN RENAISSANCE ART

PAINTING · SCULPTURE · ARCHITECTURE

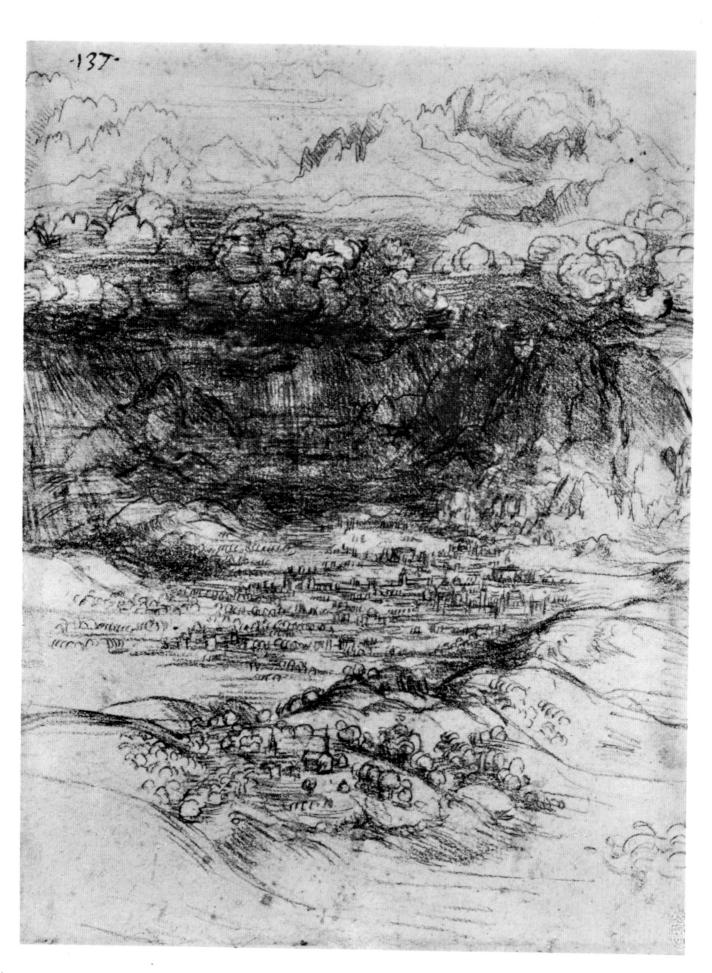

2005 2000 Elimilar, THEOUT

FREDERICK HARTT

Paul Goodloe McIntire Professor Emeritus of the History of Art, University of Virginia

HISTORY OF

ITALIAN RENAISSANCE ART

PAINTING · SCULPTURE · ARCHITECTURE

Third Edition

PRENTICE-HALL, INC., Englewood Cliffs, New Jersey and HARRY N. ABRAMS, INC., New York

LIBRARY
College of St. Francis
JOLIET, ILLINOIS

Project Director: Sheila Franklin Lieber

Editor: Ellyn Childs Allison

Designer: Dirk Luykx

Photo Research: Barbara Lyons

Frontispiece: Leonardo da Vinci. *Storm Breaking over a Valley.* c. 1500. For a discussion of this drawing, see page 432.

Third Edition 1987

Library of Congress Cataloging-in-Publication Data

Hartt, Frederick

History of Italian Renaissance art.

Bibliography: p. 677.

Includes index.

1. Art, Italian. 2. Art, Renaissance—Italy.

I. Title.

N6915.H37 1987 709'.45 87-968

ISBN 0-13-392093-3

Text copyright © 1987 Frederick Hartt Illustrations copyright © 1987 Harry N. Abrams, Inc.

Published in 1987 by Harry N. Abrams, Incorporated, New York All rights reserved. No part of the contents of this book may be reproduced without the written permission of the publisher

Times Mirror Books

Printed and bound in Japan

Contents

Preface 7

PART ONE

THE LATE MIDDLE AGES

- 1. Italy and Italian Art 11
- 2. Dugento Art in Tuscany and Rome 28
- 3. Florentine Art of the Early Trecento 62
 - 4. Sienese Art of the Early Trecento 91
- 5. Later Gothic Art in Tuscany and North Italy 122

PART TWO

THE QUATTROCENTO

- 133,154
- 6. The Beginnings of Renaissance Architecture 141
- 7. Gothic and Renaissance in Tuscan Sculpture 158
- 8. Gothic and Renaissance in Florentine Painting 178
- 9. The Heritage of Masaccio and the Second Renaissance Style 205

- 10. The Second Renaissance Style in Architecture and Sculpture 221
- 11. Absolute and Perfect Painting: The Second Renaissance Style 244
 - 12. Crisis and Crosscurrents 284
 - 13. Science, Poetry, and Prose 304
 - 14. The Renaissance in Central Italy 348
 - 15. Gothic and Renaissance in Venice and North Italy 378

PART THREE

THE CINQUECENTO

- 16. The High Renaissance in Florence 431
- 17. The High Renaissance in Rome 482
- 18. High Renaissance and Mannerism 538
- 19. High and Late Renaissance in Venice and on the Mainland 588
 - 20. Michelangelo and the Maniera 639

GLOSSARY 671

BIBLIOGRAPHY/BOOKS FOR FURTHER READING 677

INDEX 685

PHOTOGRAPH CREDITS 704

Preface

book, which first saw the light in 1969, will have reached voting age. With adulthood go new responsibilities. The forewords to the first and second editions staked out a claim for coverage within the scope of a single volume of the three interrelated arts of the Italian Renaissance—painting, sculpture, and architecture, known to the Italians themselves as the arts of design—according to the twin and partially subjective criteria of quality and art-historical importance. In this preface something needs to be said about both.

A famous critic once quipped in private correspondence, "Art is for the few and they should keep it secret." I doubt if he really meant this remark, but perhaps he was affected by the spectacle of art-saturated crowds tramping wearily through the endless galleries of great European museums without a glance at the masterpieces on the walls. But under favorable conditions public response is very different. Take, for example, Michelangelo's David (figs. 477, 478), which the visitor approaches from a distance, seeing it grow larger all the way, and then views in ample space, under close-to-ideal natural overhead illumination. No one who has ever witnessed the quiet crowds experiencing the physical and spiritual magnificence of the David can doubt the intensity and seriousness of their reaction. Any member of the crowd could easily give a list of the elements that go to form his personal sense of quality in this case. Any viewer who has never heard of Michelangelo, if such can be found in the Western world, and who entertains no objections to nudity, would probably furnish much the same list. One might object that any reasonably well carved fourteenfoot marble image of a nude athletic youth would attract a great deal of admiring attention. But two adequate, full-scale copies in marble are prominently displayed elsewhere in Florence, and nobody looks at them. The difference is quality, an entity that is elusive and in the last analysis indefinable, but nonetheless essential in the experience and evaluation of a work of art.

If statistics could be compiled as to the relative length of time spent by average viewers, as distinguished from specialists, in front of works of art in museums, I suspect that those objects attracting and holding visitors for the longest time would turn out to be those of highest quality, even taking account of such factors as novelty and

notoriety. From my own experience I might add that in one gallery of a major American museum one finds an array of French Impressionist paintings of the highest quality, and in the next an important series of competently painted works by those conservative academicians to whom Impressionism was anathema. I leave the reader to imagine which of the two galleries was full of delighted viewers. Again the mysterious spark of quality provides the explanation.

One might ask why the high quality of Impressionism that overwhelms today's viewers was anything but apparent to French critics and public at the time. The answer might be very helpful to readers of the first chapters of this book, which treat works of art whose style and content are unfamiliar to many. It takes a certain amount of time and experience before one can react warmly to any new image. The image of the David is not really new, even if we have not seen that particular work before. Admiration for strength, beauty, courage, and inspiration is universal, and requires no effort. If the reader is willing to forgive a touch of paternalism, I would like to appeal for the necessary mental effort to clear away the veils of unfamiliarity so that the quality of works of art not so immediately appealing may be given a chance to shine forth.

Works of art, like all human productions and like ourselves, are bound in time. Neither the *David* nor Impressionist paintings could have been created as we now see them at any other periods than those in which their creators lived. Their history, therefore, is a part of their very nature, if by history we mean their place in the development of art, and their relation to the circumstances under which they were produced. The history of works of art *after* creation is another story. It should not be essential to their appearance, but it too often is, in the case of damage or other alteration, and that also must be at least mentioned.

In determining historical importance, paternalism again sets in. The writer of a general text has to make difficult choices, and must often leave out works of high quality in favor of others somewhat less attractive in order to provide a reasonable account of historical situations and their development. The reader, then, is asked to trust the writer's judgment based on experience, and to recognize that sometimes these choices were painful.

In the forewords to earlier editions I have admitted to a personal slant in favor of Tuscany and especially Florence, which I would be willing to relinquish if it would be proved to me that the Renaissance originated anywhere else. I must also confess to greater excitement in contemplating the beginning of an important cycle than its end, and thus, according to some colleagues with later interests, have slighted the Cinquecento. In the second edition I included for the first time a number of important North Italian painters, sculptors, and architects, and in this one I have brought into the fold several more painters and sculptors, all from the Cinquecento and mostly from the North. In order to include these masters without increasing the size of the book unreasonably I have been obliged to eliminate two or three earlier and lesser artists as well as some important works, such as Giotto's frescoes in the Peruzzi Chapel, which are in such poor condition that they cannot be appreciated in small reproductions. In making my choices I have tried to leave some for other teachers, who in turn can choose according to their own individual judgments. My own undergraduate course was given in two semesters. Before embarking on this edition I made a survey of all courses on Italian Renaissance art given in American colleges and universities. To my surprise I found that slightly more than half (I have no means of translating these figures into actual student enrollments) compressed the subject into a single semester. No textbook can be devised to fit both one-semester and two-semester courses, and at the moment it is not possible to produce a streamlined version. I earnestly hope that students in the shorter courses will not lament the extra material, and instead will find this book of permanent value in their lives. That, after all, is the reason why they take such courses in the first place. For the general reader, whose rights are considered throughout, a more complete version is obviously of greater interest.

I have done my best to bring the book abreast of recent findings, although I do not guarantee bibliographical omniscience, and some new ideas and discoveries may have been shortchanged or overlooked. Teachers will be especially interested in knowing that the sections on Piero della Francesca, Botticelli, Leonardo, and Michelangelo have been massively revised and updated. Throughout the book I have attempted, where possible, to present the individual work of art in its context of contemporary history, to show how it fulfilled specific needs on the part of artist and patron, and to indicate how its meaning was intended to be conveyed. Sometimes the texts I quote may seem abstruse and remote from our own experience. That is not their fault. An iconologist (one who interprets the meaning of works of art through texts) often meets with the objection "But aren't you reading all this into the work of art?" If the iconologist has found the right texts, he has discovered only what was intended to be seen in the work of art, and

what the forgetfulness of centuries has caused to be read out of it. Visually the work of art is no less interesting if we do not know what it represents, just as the music of an opera sounds the same if, as is usually the case, we cannot understand the words. But how much more we enjoy an opera on television when the subtitles reveal to us the story behind all the sound! In the same way, knowledge of the meaning of a work of art can admit us into realms of experience in both the personality of the artist and the period to which he was speaking that would otherwise have been inaccessible, and thereby our enjoyment of the total work of art is greatly enriched. Such knowledge can even reveal previously unobserved qualities of form and color in the work of art. And it can tell us much about why the artist did certain things the way he did—and even, at times, give us a flash of insight into the forces that cause styles to change or disappear and new ones to take their place. In quite a number of instances I have presented tentatively ideas, labeled as such, that will eventually be more completely expounded elsewhere. Would it have been better to leave them out? Rightly or wrongly, I have always felt that I owed the student in my courses the benefit of my own thoughts even when not yet fully tested, and I saw no reason why I should not follow the same principle in this book.

In the foreword to the second edition I regretted the disappearance of the relative innocence of the first. Innocence, once lost, is not easily regained. Nonetheless, I have done my best, because in rereading every word I have become acutely aware that the book was getting too argumentative. Advanced students can always track down controversies that interest them by consulting the second edition.

Proper credit, nonetheless, has to be given for the conclusions of others, but since I could hardly go back to the beginnings of Renaissance scholarship in order to establish responsibility for every discovery or deduction, out of necessity I have established a cut-off date of 1970. Sometimes for personal reasons I have left a credit in the text, but the others are listed below. Those interested in pursuing a subject should turn to the Bibliography; books and articles not listed there can be found through the usual bibliographic indices. Here is a roughly chronological account of my chief indebtedness for new information.

Fresco technique: Millard Meiss and Leonetto Tintori; Ugo Procacci

Pietro Cavallini: Guglielmo Matthiae Pisa Baptistery pulpit: Eloise Angiola

Mary as the stairway to Heaven in Giotto and Michalangelo: Howard Hibbard

chelangelo: Howard Hibbard

Group receiving the model of the Arena Chapel in Giotto's *Last Judgment*: Ursula Schlegel

Assisi problem: Alistair Smart

Chronology of Taddeo Gaddi: Andrew Ladis

Guidoriccio da Fogliano as a post-sixteenth-century painting: Gordon Moran and Michael Mallory

Interpretation of Ambrogio Lorenzetti's *Good Government* frescoes: Uta Feldges-Henning

Relation between panels and frames: Creighton Gilbert

Dome of Florence Cathedral: Frank D. Prager and Giustina Scaglia; Howard Saalman

San Lorenzo and the Medici Palace: Isabelle Hyman

Brunelleschi in general: Eugenio Battisti

Portraits and patronage in the Brancacci Chapel: Peter Meller; Anthony J. Molho

Masaccio's Trinity: Charles Dempsey

Fra Angelico: Diane Cole Ahl

Architecture in Fra Angelico's Roman frescoes: Torgil Magnuson

Dates of the Chapel of Nicholas V: Creighton Gilbert

Palazzo Rucellai: Brenda Preyer

Sant'Andrea, Mantua: Eugene J. Johnson Alberti's optics: Samuel Y. Edgerton, Jr.

Domenico Veneziano's *Adoration of the Magi*: Hellmut Wohl

St. Paola and St. Eustochium in Andrea del Castagno's Vision of St. Jerome: Millard Meiss

Piero della Francesca: Eugenio Battisti; Creighton Gilbert

Piero della Francesca's *Flagellation*: Cecil Clough; H. Siebenhüner; Eugenio Battisti

Antonio del Pollaiuolo's Battle of the Ten Nudes: Colin Eisler

Astrolabe as instrument of *Prospectiva*: Samuel Y. Edgerton, Jr.

Botticelli's mythologies: Ernst Gombrich; Webster Smith; Ronald Lightbown; Mirella Levi d'Ancona; Charles Dempsey

Andrea Mantegna's Camera degli Sposi: Rodolfo Signorini

Andrea Mantegna's *Parnassus*: Phyllis Williams Lehmann

Lorenzo de' Medici's device: Eve Borsook

Sassetti Chapel: Eve Borsook

Bramante's St. Peter's: Luitpold Frommel

Raphael's St. Paul Preaching at Athens: John Shearman

Pontormo's Vertumnus and Pomona: Matthias Winner

Library of San Marco: Deborah Howard

Hell in Michelangelo's Last Judgment: Leo Steinberg

Palazzo Farnese: Luitpold Frommel

I am also indebted for suggestions—in lectures, unpublished material, correspondence, or personal com-

munications—to many scholars, notably:

Diane Cole Ahl: Giovanni Dominici's influence on St. Antonine of Florence

Paul Barolsky: Hill country in Fra Angelico's Visitation

Ludovico Borgo: Byzantine construction system in the face of Sassetta's St. Francis

George Brooks: Expression in Bronzino's portraits Walter Hanak: Old Slavonic characters in Luciano Laurana's Urbino city view

Richard Krautheimer: Alberti's architecture and theory, in general and in detail

Ralph Marcus: Hebrew inscriptions in Carpaccio's *Meditation on the Passion*

Joyce Plesters: Ultramarine and azurite

Marla Price: Christ Child in Giotto's Flight into Egypt

Virginia Chieffo Raguin: Humeral veil in Botticelli's Adoration of the Magi

If I have overlooked anyone I can only apologize.

Above and beyond all specific instances I am deeply grateful to the teachers who first trained me in the study of Italian art, especially Richard Offner, Walter Friedlaender, Erwin Panofsky, and above all Millard Meiss, who gave me my start in the Italian field more than half a century ago. Ugo Procacci, Leonetto Tintori, their colleagues and successors at the Gabinetto dei Restauri at the Uffizi, and Elizabeth Jones at the Fogg Art Museum have taught me what little I know about the all-important question of techniques and their relation to style. In addition to those scholars mentioned earlier, many colleagues have helped me with ideas and criticism, especially James S. Ackerman, Miles Chappell, the Reverend Gerald Fogarty, Sydney Freedberg, H. W. Janson, John Paoletti, Charles Seymour, and Jack Wasserman. Many readers have written to offer suggestions, all of which have been considered and, where necessary, acted upon and are here gratefully acknowledged. Finally, the example, the confidence, and the unfailing kindness of Bernard Berenson and Nicky Mariano, dear departed friends, have helped me beyond any possibility of expression.

The unforgettable Harry N. Abrams and Milton S. Fox, who commissioned this book in the first place, their successor Paul Gottlieb, who is personally responsible for the special character of this edition, editors May Lea Bandy, Patricia Egan, Margaret Kaplan, John P. O'Neill, Ellyn Allison, and Sheila Franklin coped with the innumerable problems of this book in stage after stage. Barbara Lyons hunted down scores of elusive photographs, and Dirk Luykx, with Jean Smolar, is responsible for the handsome design. The Bibliography has been revised by Alice W. Campbell. To all my warmest thanks.

F. H. Labor Day, 1986

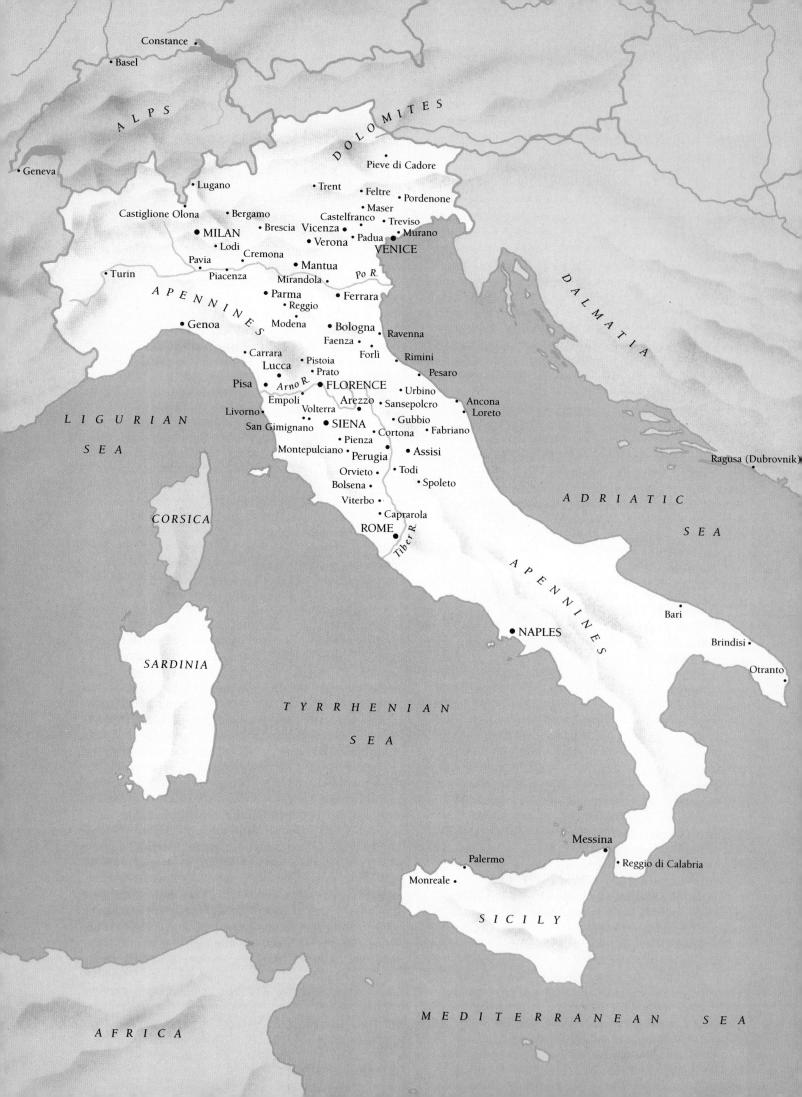

THE LATE MIDDLE AGES

Italy and Italian Art

he matrix of Italian art is Italy itself (fig. 1), a land whose physical beauty has attracted visitors from time immemorial. The variety of the Italian land-scape, even over short distances, transforms a country roughly the size of California into a subcontinent, harboring a seeming infinity of pictorial surprises. Alpine masses shining with snow in midsummer, fantastic Dolomitic crags, turquoise lakes reflecting sunlight onto precipices, wide plains of profound fertility, poplar-bordered rivers, sandy beaches, Apennine chains enclosing green valleys, vast pasture lands, glittering bays enclosed by mountains, volcanic islands, dark forests, eroded deserts, gentle hills—all these combine to make up the inexhaustible Italy that rewards and defeats a lifetime of explorations.

But not all the beauty of Italy was provided by nature. More than any other country in the Western world, Italy may be said to have been humanized. The country and its people have made their peace in an extraordinary way. Most towns, even some large cities, do not lie in the valleys as we think they should, but are perched on hilltops, sometimes at dizzying heights. The reason for such positions is not hard to discover, for most Italian towns were founded when defense was an essential. But the views from their ramparts offered for the inhabitants not only a military but also an intellectual command of surrounding nature. Even the hills that are not crowned with cities, villages, castles, or villas—and most of those that are—have been turned into stepped gardens, manmade terraces that hold, growing constantly and together, those essentials of Italian civilization-wheat, the olive, and the vine. Only here and there in Italy does one come across wild tracts whose rocks or sand have defied all attempts at cultivation. Everywhere cities can be seen from cities, towns from towns. Agriculture and forests are alike submitted to the ordering intelligence of man. On the Lombard plains the plots of woodland are marshaled in battalions; like perfect sentinels the disciplined cypresses guard the Tuscan hills. Three-hundred-yearold olive trees shimmer in gray and silver, winter and summer alike. The gardens are not flowerbeds but hedged and terraced evidences of human planning, patience, and skill. The Italian climate is less gentle than its reputation. Although the winters seldom match the severity of those in the United States or Northern Europe, neither can they offer brilliant days of blue skies and flashing snowfields. Even in South Italy and Sicily, winter is dark, wet, and interminable. Summer is hot, autumn rainy, and spring capricious. Yet in three millennia or so of constant and often stormy marriage with the land, the Italians have created a harmony between human life and the natural world not to be met with elsewhere. The forms of man's constructions and the spaces provided by geography seem to fit.

In the second half of the twentieth century the relentless forces of industrialization are draining the hill farms of their population. Thousands of stone farmhouses are now abandoned, among untended olive trees and weedy, crumbling terraces. The modern suburbs of the growing cities have marred, with endless blocks of apartment houses and factories, the beauty of many a valley and plain. The cancer of the modern motor highway, metastasizing throughout the peninsula, and inevitably accompanied by endless factories and warehouses, has devoured many a magical vista. A degree of automobile

smog has fouled the once-clear skies over Florence, Rome, and Naples. The façades of Roman churches and palaces are often blackened by exhaust fumes. But the basic concord of man and nature in Italy still survives. The country roads are still traveled, and the hill farms still worked, by pairs of colossal and surprisingly gentle long-horned oxen. The smoke still rises from the ancient towns on their hilltops. And views across the lines of cypresses and up the rocky ledges still reveal what might be the background of a fresco by Benozzo Gozzoli. The vast Umbrian spaces are still much as Perugino saw them. The rustling woods here and there in the Venetian plain still seem ready to disclose a nymph and a satyr from the paintings of Giovanni Bellini.

THE CITIES

It is the hard-won harmony between man and nature that makes not only the landscape of Italy but also the art of its people different from any other in the world. But this art in its entirety predates the rise of the national state. The Italian language uses the same word (paese) both for village and for country in the sense of nation. No wonder, because to the medieval Italian and to millions of Italian peasants and villagers today the boundaries of "country" do not extend beyond what can be seen from a hilltop village. A map of Italy in the Late Middle Ages or Early Renaissance would look like a mosaic, every piece representing a separate political entity sometimes hardly larger than the modern Italian village. These communes, which have often been compared to the city-states of ancient Greece, were all that was left of the Roman Empire, or let us say of the kingdoms and dukedoms founded in the disorders following the barbarian invasions and the ensuing breakup of ancient Roman society. During the Late Middle Ages, from the eleventh through the fourteenth century, these city-states were quite independent of one another. Each had set up its own peculiar polity, at least outside of the fairly monolithic South, the socalled Kingdom of the Two Sicilies, or Kingdom of Naples. Each ruled its surrounding area of farmland and villages from the central city. Each spoke a different sometimes a sharply individual—dialect, and not until the Renaissance did the modern Italian language begin to emerge, based on the Tuscan dialect. Although undermined by radio and television, most of these dialects are spoken (though not written) today.

At the outset of the Late Middle Ages, most of the city-states were republics, but in Lombardy many were ruled by their bishops. In general, they were merchant cities, and the republican governments were dominated by manufacturers, traders, and bankers. The republics were in a state of endemic if sporadic war with each other, even with visible neighbors (Florence with Fiesole, Assisi with Perugia). Fiercer even than the intercommunal wars were the civil eruptions, family against family, party against party. Under such conditions it was easy for

powerful individuals to undermine the independence of a city-state. Nobles in their castles, mercenary generals ostensibly hired to protect the republic, powerful merchants, all struggled to gain control of the prosperous towns, and the rate of their success in the fourteenth and fifteenth centuries measures that of the destruction of communal liberties. The most successful of all these superpolities was the papacy, which maintained varying degrees of control over a wide belt of Central Italian states.

Some of the republics were destined for greatness. Venice, at the top of the Adriatic, had by the thirteenth century extended an enormous colonial empire, largely in order to maintain its commercial ties with the East. Florence, in Tuscany, by the end of the thirteenth century was trading with Northern Europe and with the Orient, and had branches of its banking firms all over Europe, so much so that Pope Innocent III declared that there must be five elements, rather than four, because wherever Earth, Water, Fire, and Air were found in combination, one saw also Florentines. There were other important republics as well: Siena, Lucca, Pisa, Genoa-all separate, proud, independent states—and many much smaller. Each state, whether republic or despotism (duchy, marquisate, county, or merely signoria—lordship), tended to absorb its smaller neighbors, either by conquest or by purchase, so that by the end of the fifteenth century the peninsula was divided into a decreasing number of polities, each now dominating a con-

2. Plan of Florence. Crosshatched area, original Roman city; inner black line, 13th-century walls; outer black line, 14th-century walls and fortifications

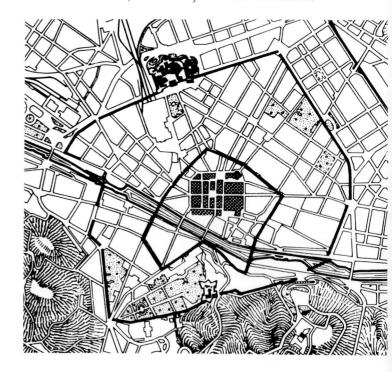

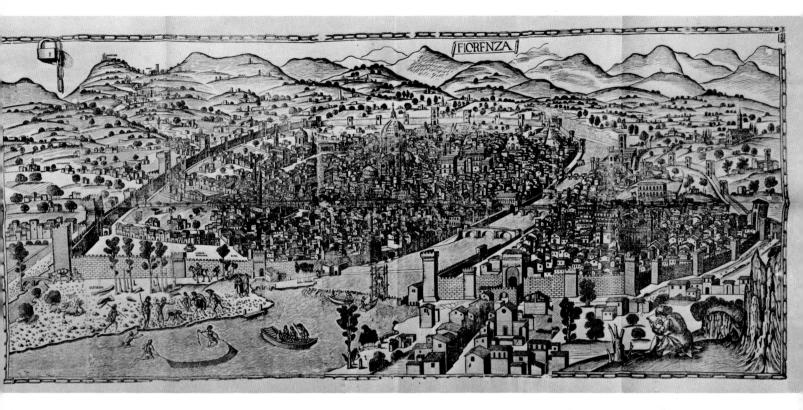

3. Florence as seen by an artist of the Quattrocento. Florentine wood engraving of c. 1480

siderable subject territory. Yet none were able to unite against the menace of the increasingly centralized monarchies of the rest of Europe, which, in the sixteenth century, were to submerge Italy almost entirely.

The most striking phenomenon of any one of these Italian city-states is a dense huddle of houses of almost uniform height-regulated by law-crowding up the slopes and toward the summits of the hills chosen for defense, often still surrounded by city walls with gates and towers. The jumbled planes of the tiled roofs are punctuated here and there by the loftier walls and towers of the churches and civic buildings. The town houses of the great noble and commercial families also generally culminated in towers, built to secure the fortunes, and even the lives, of their owners. Only in a few isolated towns are some of these house-towers preserved to their full height because, in the Late Renaissance, when the small republics had coalesced into a few larger princedoms, the owners were forced by decree to crop these means of defense.

In or near the center of every town is the piazza, the great square that is the focus of civic life. It is, above all, essential to understanding the civic nature of Italian art. Surrounded by a natural world that man is constantly trying to dominate, Italian art is based on communication between people in the square and its adjoining streets where the life of the community takes place. Wherever the great squares have not become parking lots, this is still true.

In even the earliest Italian paintings it is striking how immediately the circumstances of life, the people, and the architectural background of their existence are transported to the works of art. The visual field, the painting or the work of sculpture, under the guise of religious or historical narrative, presents a permanent image of the continuing reality of everyday life—the contact, conversation, conflict, between people that constitute the drama of the piazza.

In its ground plan Florence shows the nature of the expansion of the Italian city-state (fig. 2). A bird's-eye view shows the city in the fifteenth century, the largest in Europe, even if considerably reduced by the Black Death from the more than one hundred thousand inhabitants it had counted a century earlier, at a time when London and Paris were towns of twenty thousand or so apiece, and Bruges and Ghent, the trading cities of the North, did not surpass forty thousand. The colossal dome, whose construction we will presently follow, forms a focus for the city, which is surrounded by the circle of walls and then by the Tuscan hills (fig. 3). In the accompanying plan one can watch the metropolis grow. Roughly oriented from east to west in the ordinary manner of the ancient Roman town of the plains, the original square Roman city plan, slightly expanded on one side, is indicated by crosshatched lines. Within it, all the streets were straight and intersected by right angles. By the thirteenth century there were far more inhabitants in the suburbs clustering around the gates than remained inside the Roman walls, and a second circle of fortifications, much less regular, had to be built. In the fourteenth century a third circle of walls was constructed, which the city was destined never to fill during the Ren-

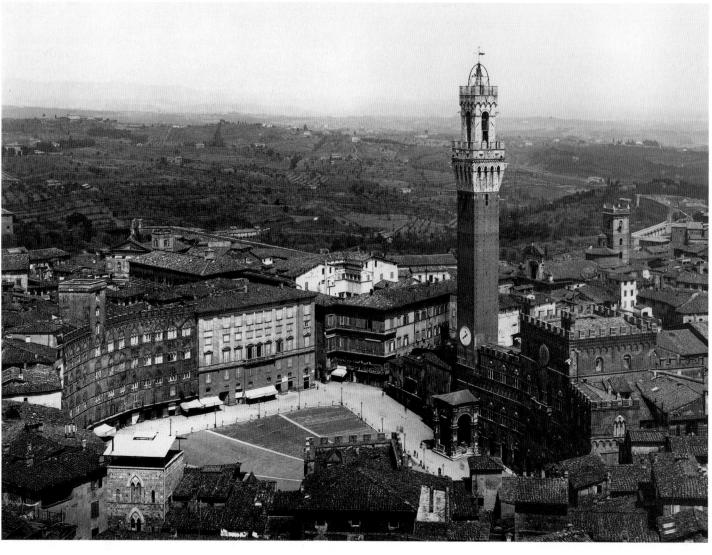

4. Aerial view of Siena from the west

5. Aerial view of Venice from the southeast

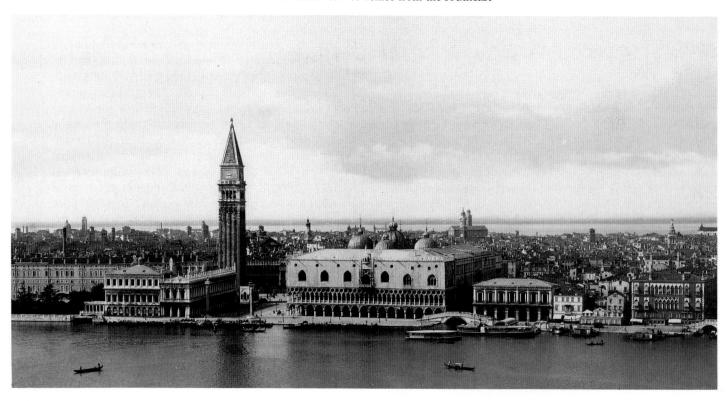

aissance. Their towered gates were often decorated with paintings and sculpture. Even today, when Florence has grown to half a million, a few large gardens remain inside the boulevards, which, except on the south bank, have largely replaced the walls. The narrow streets must have been overcrowded even during the Middle Ages and the Renaissance. They are flanked by stone buildings that present a forbidding appearance in their present, largely stripped state (or with, at most, tan stucco), but that were originally coated with gray, white, or even brightly colored stucco, if we can believe the representations in old paintings. The more splendid houses were often decorated with simulated architectural elements, ornament, and figures incised in the plaster, of which a few examples remain.

Siena (fig. 4) is some forty-five miles to the south over winding roads—in the Middle Ages probably a day's journey by post-horses. An intermittent commercial and political rival of Florence, Siena was eventually to succumb to her hated enemy in the middle of the sixteenth century. To a degree difficult for a foreigner to conceive, Siena is still the archetype of the resentful vanquished. It is a hill town, straggling in the shape of a Y along the crest of three hills, in the midst of a magnificent landscape. Instead of the foursquare intersections and powerful cubic masses of Florence, Siena presents us with a picture of constant climbs and descents, winding streets, and unexpected vistas. In comparison with the logic of Florentine architecture and planning, it appears illogical, spontaneous, roughly organized, and very beautiful.

The third city that will concern us chiefly, Venice, needs scarcely to be described, save to emphasize that its position, supported on wooden piles on hundreds of marshy islets in a sheltered lagoon along the Adriatic shore, rendered unnecessary either the city walls or the massive house construction of the mainland towns (fig. 5). The result was an architecture whose freedom and openness come as a release after the fortresslike character of so many other Italian cities.

THE ARTIST AND THE GUILDS

The typical Central and North Italian city-state of the Late Middle Ages was dominated by the guilds in every phase of its commercial and political life. Florence was a republic founded on commerce and ruled by an organization of guilds. These were independent associations of bankers and artisan-manufacturers. The guilds were self-perpetuating and self-regulating except insofar as they were forced to accept the domination of the Guelph party, the single political entity permitted in a democracy that, however restrictive by modern standards, was in advance of anything that had been conceived in Western Europe since the days of Pericles. In Florence the position of the guilds was symbolized by the niches reserved for each of the principal guilds in a curious building to which we will frequently return, the center of the food supply of the Republic in an era threatened constantly by famine—the combined grain exchange and shrine known as Orsanmichele (fig. 6). This was an enormous three-story structure in the center of the city, whose Gothic arches were, in those days, still open to the streets. Between the arches were the niches in which each guild had the civic responsibility to place a statue of its patron saint. The seven major guilds (Arti, as they were called) included the Arte di Calimala, the refiners of imported woolen cloth; the Arte della Lana, the wool merchants who manufactured their own cloth; the Arte dei Giudici e Notai, or judges and notaries; the Arte del Cambio, or bankers' and money changers' guild; the Arte della Seta, or silk weavers; the Arte dei Medici e Speziali, or doctors and pharmacists; and the Arte dei Vaiai e Pellicciai, or furriers. The painters, oddly enough, belonged to the guild of the doctors and pharmacists, to which they were admitted in 1314, perhaps—as is generally believed—because they ground their own colors as the pharmacists ground their own materials for medicines. In the 1340s the painters were classified as dependents of the physicians, perhaps because painters and doctors enjoyed the protection of the same patron saint, St. Luke, reputedly both artist and physician. And in 1378 the painters found themselves as an independent branch of the Medici e Speziali.

There was a constantly shifting number of intermediate and minor guilds. Among the former, and never admitted to the rank of the major guilds, was the Arte di Pietra e Legname, the guild of the workers in stone and wood. This comprised all sculptors who worked in either material. But if a sculptor was brought up as a worker in metals, such as bronze (and there was a completely different attitude on the part of the citizens toward this material and those who knew how to manipulate it), he made himself a member of a major guild, the Arte della

At the bottom of the social structure, outside the guilds, were the wool carders, on whose labors the fortunes of the city depended. Their situation in some ways was comparable to that of the slaves of ancient Athens, for although the Ciompi, as they were called, were permitted to leave their employment, their activities were severely circumscribed by law. These wretched creatures, constantly hovering on the brink of starvation, once did revolt, in the year 1378, and founded a guild of their own. Their participation in the government, and indeed their guild itself, was short-lived. The oligarchy resumed control, put down the Ciompi by mass slaughter and individual execution, and resumed complete control over the economy as well as the political fortunes of the Republic.

Through membership in one or more guilds, the artist's social position was established among the Mechanical Arts, not the Liberal Arts (grammar, logic, rhetoric, arithmetic, geometry, astronomy, and music), the only

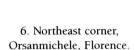

Rebuilt 1337

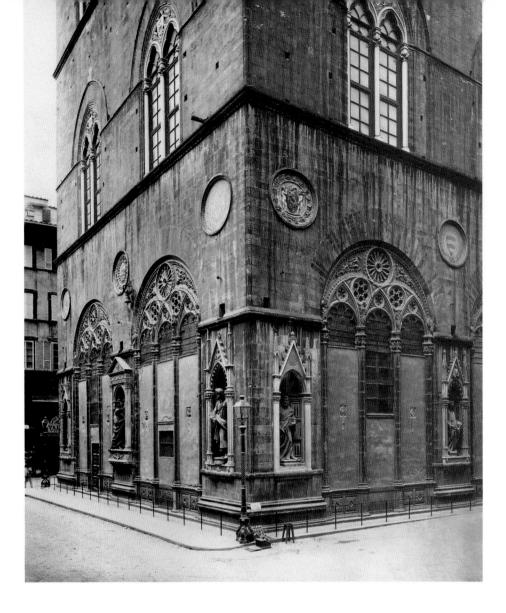

arts considered suitable for a gentleman either in antiquity or in medieval feudal societies. But in the Italian city-states classification among the Mechanical Arts represented a positive advantage to painters, sculptors, and architects. In 1334 the great painter Giotto (see pages 62, 79–80) is believed to have designed a set of reliefs for the campanile (bell tower) of the Cathedral of Florence, to be carved by the sculptor Andrea Pisano, that were intended to be seen and read by the working citizen in the street. The series begins with the Creation of Man (see fig. 84), skips the embarrassing episode of the Tree and its consequences, and goes on to show the first labors of Adam and Eve as if they had been a reward rather than a punishment. Next, going round the tower, all the early activities of mankind are shown, with the Mechanical Arts among them, including, of course, painting, sculpture, and architecture (see figs. 7, 16, 17).

Late in the fourteenth century the Florentine writer Filippo Villani devoted a chapter to the painters of his era, comparing them to those who practice the Liberal Arts. The Paduan humanist Pier Paolo Vergerio claimed (erroneously) in 1404 that painting was one of the four Liberal Arts taught to Greek boys. At the end of the fifteenth century, Leonardo da Vinci took up the struggle

in earnest (see page 434). The stakes were economic as well as social. The fifteenth-century artist, with some outstanding exceptions, was not well paid and often complained of poverty, but in the sixteenth century Michelangelo (who claimed noble ancestry), Raphael, Titian (who was actually ennobled), and many other artists attained wealth. The artist who could attach himself to the court of a prince occupied a position of great prosperity and had the corresponding power to enforce his style on others. By the late sixteenth century, academies, under princely patronage (see page 639), began to replace the long-moribund guilds.

The artist found himself an essential part of a closely knit society, for which he worked on commission. It would hardly have occurred to an artist of the thirteenth or fourteenth century to paint a picture or carve a statue for any other reason than to satisfy a patron. If he was a good artist, he would doubtless have had a substantial backlog of commissions all demanding execution. An artist did not enjoy a studio, as known to later traditions. The very word means "study" in Italian and came into use only in the seventeenth century when the artists joined and were dominated by academies. In the Late Middle Ages and throughout much of the Renaissance,

the artist worked in a bottega (shop). The word is also used figuratively, to signify the organized body of paid assistants and apprentices whose families paid for their instruction, all under the direction of the master, who himself had entered the system as an apprentice, at an age as early as eight. Women, until the late sixteenth century, were rigorously excluded from this often rough society, which increasingly required drawing from the male nude. Sometimes the bottega was really entered, like a shop, from the street. Minor artists might even exhibit finished work to the public in their shops. Artists as important as Masaccio, Ghiberti, Castagno, and Antonio del Pollaiuolo did not refuse commissions for jewelry, for painted wooden plates customarily given new mothers, for painted shields for tournaments or ceremonials, for processional banners, or for designs for embroidered vestments or other garments. And even the greatest artists were frequently employed in the design of triumphal arches, floats, and costumes for the splendid festivals that celebrated civic, religious, or private events. In his old age, in a period already dominated by the new academic conception of the artist as well as by the new autocracies, Michelangelo protested that he "was never a painter or a sculptor like those who keep shops."

For our purposes, the principal object made by a painter in a bottega was the movable picture, above all, the altarpiece. This is the work of art that stands as a religious image upon and at the back of the altar: it may concentrate in visual symbols the doctrine underlying the Mass, or depict the saint to whom a particular church or altar was dedicated, together with scenes from his life. Up to the thirteenth century or so, the exact date varying from place to place, the priest stood behind the altar, facing the congregation. (It is to this early form of the liturgy that the Church—both Catholic and Anglican, and doubtless others—has returned in our own day.) With the celebrant in such a position, there was room on the altar for nothing but the ritually required crucifix, missal, candles, and vessels of the Mass. Decoration and this could include images and narrative scenes was limited to the front of the altar and perhaps the sides and back. Sometimes the decoration was sculptured, in stone or even precious metals. Often it was painted on wooden panels, known as altar frontals.

In the thirteenth century the ritual was moved around to the front of the altar, so that the priest had his back to the congregation save for occasional moments when he turned to it for responses or readings. This change was a direct result of the growth of the city throughout Western Europe but especially in Italy, which placed wealthy burgher families in the position of donors to the new and often very large church buildings. The belief in the efficacy of the Mass as an instrument for salvation gave rise to chapels in which Mass could be said daily, sometimes many times a day, for the souls of departed members of these families. Such chapels ranged from mere altars along the inner walls of the side aisles to structures like little churches in themselves, but when they could be planned from the start, the family chapels were small rooms of standard size and architectural character, lining the side aisles and transepts. Sometimes chapter houses, for the meetings of an entire community of monks and nuns, and often sacristies, where the vessels, books, and vestments of the liturgy were kept, were endowed as family chapels and provided with altars. These family chapels outnumbered by about twenty or thirty to one the high altars at which Mass was said for an entire congregation, and in very few was there enough space for the priest to stand behind the altar. The new position of the priest left the altar-table open for large-scale religious images, and these developed with great rapidity in the thirteenth and fourteenth centuries. The crucifix, required for every altar, was the most immediate and logical theme. A crucifix stands on an altar in the fourteenthcentury fresco shown in colorplate 11. But the thirteenth century saw the growth of the veneration of the Virgin Mary, and quite early began to appear the images of the seated Madonna and Child, protectors of the Christian family, that play so large a part in Italian art, and are still

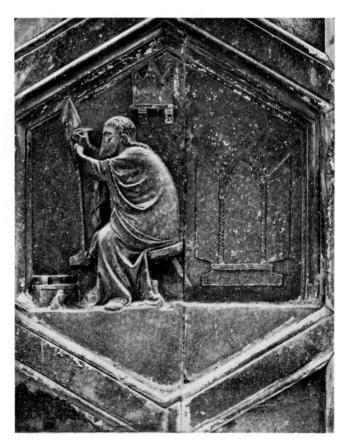

7. ANDREA PISANO (from designs by GIOTTO?). Art of Painting. Mid-14th century (c. 1334-before 1348). Marble. Lower row of reliefs, Campanile, Florence (see fig. 77)

to be found in Catholic homes everywhere. Moreover, the body of Christ is reborn on the altar in the Eucharist, and is offered to the communicant as Mary holds and offers her Son. If the chapel was large, the side walls, the space above the altarpiece, and even the vaulted ceiling offered themselves for painting in fresco of subjects often closely related to that of the altarpiece, and by the same artist. More than half of the paintings and sculptures treated in this book come from such family chapels, or indeed are still in place.

Large churches were generally divided by a massive wood or stone screen—treated as an important architectural element and sometimes containing its own small chapels—into a choir intended for the clergy, monks, or nuns for the celebration of the Divine Office (prayers and psalms sung seven times daily) and the nave, sometimes including the crossing of nave and transept, and often provided with its own altar, for the laity. This choir screen—called rood screen in England—was surmounted by religious images, usually crucifixes, sometimes of great size, often tilted forward so the faithful could see them more easily. (Colorplate 2 shows an example.) After the almost universal destruction of the choir screens in the sixteenth century, the crucifixes wound up elsewhere in the church, or eventually on museum walls.

Altarpieces, including tiny folding ones made to be set up in private homes as aids to devotions, were almost always composed of wooden panels. Sometimes two of these were joined together, in which case the work is called a diptych. More common, however, were the triptychs (three panels), and most frequent of all were polyptychs, whose construction in many panels within carefully designed architectural frames often suggests the façades of contemporary Gothic or Renaissance churches. An altarpiece on a high altar might have painted images and scenes on the back as well. Early in the fourteenth century began the custom of painting the predella, or pedestal of the altarpiece, with small narrative scenes, visible only at close range by the participants in the Mass—clergy and faithful—on their knees. And at about the same time the Gothic pinnacles, set between or even above the arches and their architectural gables, also began to provide fields for painting. The iconography of the altarpiece was determined by the clergy, or by the wealthy family who had ordered it, and even its shape could be subject to the patron's tastes. The altarpiece was often manufactured in all its elaborate details outside the painter's studio by a professional carpenter and woodcarver, who on occasion might also be a well-known architect, before the painter signed a contract to paint pictures on its surfaces and to gild its background. frame, and ornaments. Sometimes the painter was himself an architect as well, and would thus have provided the design no matter who carved and assembled the altarpiece. Sometimes the painter was confronted with a

ready-made and expensive altarpiece in little harmony with his own style. One of the Giotto-Pisano reliefs (fig. 7) shows the interior of a painter's bottega with one sizable blank triptych (a modern substitution for the damaged original) and two small framed panels on one of which he is earnestly at work.

THE PRACTICE OF PAINTING

The intricate procedures of the painter's craft (fig. 8), as practiced in Florence and North Italy, are described in elaborate detail by Cennino Cennini in *Il libro dell'arte* (*The Book of Art*; see Bibliography). Although he writes beautifully, and boasts that he studied with Agnolo Gaddi, the son and pupil of Taddeo Gaddi, an assistant of the great Giotto, there are no evidence and no paintings to back up this claim. The book was written in Padua, in North Italy, where Cennino had lived long enough

8. Tempera panel dissected to show five principal layers: *a.* poplar panel *b.* gesso, sometimes reinforced with linen *c.* underdrawing *d.* gold leaf *e.* underpainting *f.* final layers of tempera

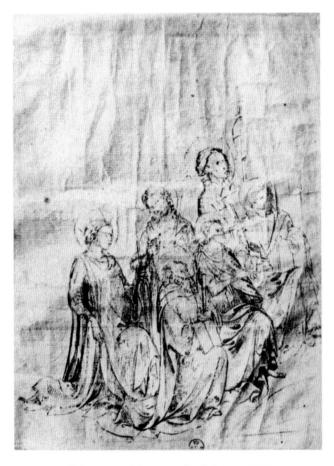

9. LORENZO MONACO. Six Saints. c. 1400. Quill pen on paper, 95/8 × 67/8". Uffizi Gallery, Florence

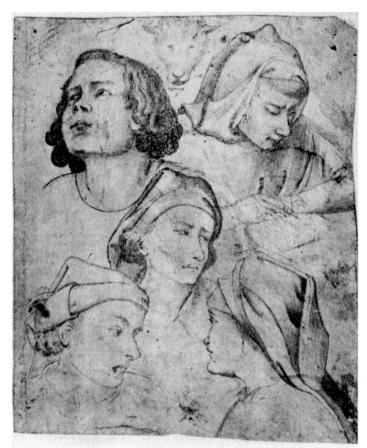

10. AGNOLO GADDI. *Five Heads*. c. 1380. Pen and wash on parchment, $7\frac{1}{4} \times 6\frac{1}{4}$ ". Castello Sforzesco, Milan

to write in the local dialect rather than in Tuscan. All we know for certain is that the art of painting as described by Cennino is how things were done in Cennino's own Paduan bottega. Nonetheless, we have no other technical treatise from this period (about 1400), and what Cennino says, although not necessarily relevant to earlier periods—and sometimes certainly mistaken—must be read very seriously.

Once joined and framed by the carpenter, the panels, of finely morticed and sanded poplar, linden, or willow wood, were specially treated by the painter after arrival in his shop. They were then spread with gesso, a mixture of finely ground plaster and animal glue. Sometimes the gesso was covered with a surface of linen soaked in gesso; then still more gesso was applied to the linen to form a sort of sandwich. When dry, the final gesso surface was very resistant and could be given a finish as smooth as ivory. Then came the procedure of drawing, whose exact role in the fourteenth and early fifteenth centuries is still a touchy point among scholars. Relatively few Italian drawings dating before the 1430s, compared with the vast number of later ones, are still preserved, and quite a number of those that do remain are apparently leaves from artists' pattern books, containing models for standard compositions, drawings of animals and birds, figures and heads, as well as numerous copies of famous works of art. Many, however, show all the signs of being sketches for actual compositions, and some can be securely identified as such, although only one, by Lorenzo Monaco (fig. 9), is for an altarpiece, one side of which is sketched out with light strokes of the quill pen. If these few drawings survive, there must originally have been many more.

Drawing is regarded as the foundation of all art by Cennino, who devotes twenty-eight of his brief chapters to the subject, advising the painter to draw daily on paper or on parchment or on panel (no such drawn panels survive) with pen, charcoal, or chalk and brush, from nature, from the paintings of the masters, or from his own imagination and teaching him all the technical procedures. A generation later the great architect and theorist Leonbattista Alberti (see Bibliography and pages 221–27), writing in Florence, speaks of "concepts" and "models" (doubtless sketches and detailed drawings) as customary preparations for painting and for storia (figure composition). In the mid-sixteenth century the painter, architect, and writer on art Giorgio Vasari (see Bibliography and pages 664-66), often called the first art historian, describes sketches as "a first sort of drawings that are made to find the poses and the first composition," dashed down in haste by the artist, from which he will later make drawings "in good form."

The importance of preparatory drawings may well have varied considerably from bottega to bottega, but the evidence suggests that the fourteenth-century painter could easily have drawn such standard images as Madonnas, saints, or crucifixes directly on the panel before painting. However, he must have sketched out, or even studied in detail, complex figure compositions in small scale, on paper or on parchment, to be kept next the painting as a guide in the early stages. Dust, paint drippings, and the wear and tear of the bottega (Cennino warns painters to cover all ornaments and gilding with a sheet while painting) would have rendered such sketches hardly worth preserving. This paragraph represents the author's hypothesis, but it seems preferable to the claim that suddenly in 1430 painters discovered the utility of the preliminary drawing, which architects and sculptors (often the selfsame individuals) had been employing systematically for more than a hundred years (see figs. 76, 156) and which painters were often required by contract to submit to their patrons for approval. Nor is there any other reasonable explanation for the surviving composition sketches, certain or probable. Other studies, involving the play of light on figures and groups (fig. 10), also survive and some of these may have been drawn for panels.

By the mid-fifteenth century a new technique, the spolvero (Italian for "dust off"), previously used only for occasional ornamental borders, generally rendered direct drawing on the pictorial surface obsolete. The spolvero was a full-scale drawing, on sheets of paper pasted together, rendered down to the last detail (for the figures at least) on the basis of preparatory studies. The outlines of the spolvero were transferred to the pictorial surface by "pouncing," or dusting. The surface was pricked with a sharp point and tapped with a sponge or bag loaded with charcoal dust, so that the outlines would appear as rows of little dots on the gesso. Sometimes these dots can still be made out. The preliminary composition sketch and other drawings were thus relegated to a safer stage of the work, resulting in their more frequent preservation, while the spolvero in turn was exposed to the dangers of the bottega (no spolvero remains intact). In the early sixteenth century even the pouncing was skipped. The spolvero was replaced by the cartoon (cartone or "cardboard"), a full-scale drawing made on sheets of very heavy paper glued together, whose outlines were transferred to the pictorial surface by means of a metal point, or stylus, pressing through the cartoon. Several cartoons and fragments of cartoons remain, but they are few compared to the thousands that must have been executed.

Cennino is explicit regarding underdrawing on panels, representing, however, only a single figure (he makes no mention of compositions). The underdrawing should be commenced with a piece of charcoal tied to a reed or a stick in order to gain a little distance from the panel and thus enjoy greater ease in composing. Shading

should be done by means of light strokes, as with the pen, and erasures should be made with a feather, so as to remove all but dim traces of the original strokes. The lines of the drawing are then reinforced throughout with a pointed brush, dipped in a wash of ink and water; the brush is made of hairs from the tail of a gray squirrel (the typical brush for work on panel). The panel is then swept free of charcoal with the feather, the painter shades in the drapery folds and some of the shadow on the face with a blunt squirrel brush loaded with the same wash, "and thus," Cennino tells him, "there will remain to you a drawing that will make everyone fall in love with your work."

In the thirteenth, fourteenth, and early fifteenth centuries, the backgrounds behind all figures and the haloes around the heads of saints were almost invariably gold leaf, applied in sheets over a red sizing to hold them to the gesso. In many altarpieces, the edges of the original sheets can still be made out, and as the gold leaf tends to wear off with rubbing, damaged gold backgrounds often display large areas of the underlying red. Gold, of course, was used because of its precious character. The value of gold was as high in the Middle Ages and Renaissance as it is today. But gold could be, and generally was, handled in such a way as to bring out its symbolic significance; for example, its great luminosity suggested the light of heaven. Gold haloes, and sometimes parts of the background, were at first tooled to make a pattern in relief, but later they were punched, after gilding.

When the gilding of the background was fairly solid, the painter could proceed with underpainting, usually in terra verde (green earth) for the flesh, but even the drapery was often outlined in this color. When the underpainting was completed, the artist would build up the actual painting in layer after layer of tempera—that is, ground colors mixed with yolk of egg as a vehicle, instead of with the oil of more recent tradition. Never, Cennino says, should this layer of tempera be dense enough to prevent the terra verde from showing through. Yolk of egg, as everyone knows, dries rapidly and becomes extremely hard. As a result, the painter could not easily correct what he had done. The strokes, applied with a sharply pointed brush usually made of gray squirrel hairs, had to be accurate, neat, and final, and although Cennino does not say so, the brushstrokes are generally parallel and seldom overlap, caressing in concentric curves each form of flesh or drapery. Cennino instructs the painter to keep three dishes at hand for each drapery color, the first full strength, the second mixed half-and-half with white, and the third an equal mixture of the first two, thus accounting for darks, lights, and intermediate tones. The highlights were brushed on last in white or near-white (sometimes yellow, or even gold pigment), and are inevitably the first to disappear in the rough cleaning to which almost all old pictures have been subjected in the past. Cennino also

11. FRA ANGELICO. *Madonna and Saints*. Before 1438 (probably 1436–37). Panel, transferred from original panel, 54×81¹/₄". Museo Diocesano, Cortona

instructs the painter how to use a different color for lights from that employed for darks if he wants to achieve an iridescent effect. The methods he describes, of course, made for a slow and craftsmanly approach to the art of painting in tempera. The Giotto-Pisano relief (see fig. 7) shows a painter at work on a small altarpiece, proceeding just as most modern painting students are told not to. A painter in the fourteenth century sat down to paint a panel and worked as closely as if it were a miniature.

Blue was a special problem. There were two excellent pigments available, both of which produced a brilliant clear blue—azurite from Germany (very expensive) and ultramarine, produced by grinding lapis lazuli from remote Afghanistan (as costly as gold, and sometimes more so). Both were customarily mixed with a little white. In the case of the Virgin's mantle, which had to be blue as she was Queen of Heaven, the white was usually omitted, probably out of respect. In consequence, in most early altarpieces the Virgin's mantle has unfortu-

nately turned dark grayish green on long exposure, through the action of the egg vehicle, and the viewer has to imagine the effect of the original beautiful blue. By the end of the Trecento, apparently, painters began to notice what had happened, and almost without exception in later paintings the Virgin's mantle is as blue as one could desire. A major surgical operation performed upon an altarpiece after damage in World War II affords us an unexpected opportunity to reconstruct the procedure of the artist. A Madonna and Saints by Fra Angelico (fig. 11), heavily damaged by mold, had to be transferred to a new panel; this is a difficult but not unusual procedure. After the mold and dirt are removed, the surface must be covered with sheets of cheesecloth dipped in plastic adhesive, which hardens sufficiently to retain the paint in perfect condition. The panels can then be detached from the frame, turned over, and the diseased wood and gesso either picked off or scraped away, leaving only the veil of pigment adhering to the hardened cheesecloth and adhesive.

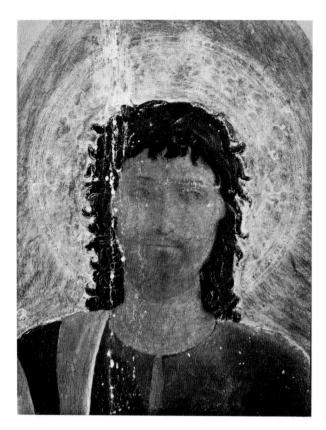

12. FRA ANGELICO. Head of St. John the Baptist, detail of *Madonna and Saints*.
Underpainting, seen from reverse side

At this stage the underpainting was revealed from the wrong side, as Fra Angelico himself never could have seen it (fig. 12). The soft *terra verde* used for underpainting the flesh was intact and also the broad areas of solid color under the drapery passages. Because all the diseased gesso was removed from the haloes in this instance, the patterns stand up in reverse in the photograph, which even shows Fra Angelico's delicate original strokes of underdrawing in brush still adhering to the underside of the film of tempera.

The fresh bright colors and flashing gold of the altarpieces were, of course, slightly toned down by the application of varnish; this practice was universal. Varnish has even been found on thirteenth-century panels beneath a complete layer of fourteenth-century repaint. All the colors were slowly obscured by candle smoke. It takes a considerable effort to restore mentally a darkened picture in a museum or a church to its original brilliance. We have, of course, some instances of old pictures that have suffered hardly at all: the most notable is probably a little Madonna and Child with Saints by Nardo di Cione (colorplate 1). Being a private altarpiece, this exquisite picture had the good fortune to remain closed for centuries, the surface preserved almost miraculously from dirt, fading or other discoloration, and rubbing or retouching of any sort. This may be the most perfectly preserved of all Italian fourteenth-century pictures, and it should be studied by visitors to the National

Gallery in Washington, D.C., as a standard against which to measure all other old pictures.

If the altarpiece forced the painter to work with meticulous care over months and years, he had a chance to express himself much more freely in another medium, that of fresco. According to Cennino Cennini, who seems to have described many of the standard procedures of Giotto and his followers, fresco (which in Italian means "fresh") was the most delightful technique of all, probably because the painter could work fast, pouring out his ideas with all the immediacy, vivacity, and intensity for which the Italians are universally known. A fresco today may appear detailed and exact when viewed from the floor, but seen close to, it reveals at once that it was executed at considerable speed. Most Italian fresco painters could manage an approximately life-sized figure in two days—one for the head and shoulders, the other for all the rest. Counting that an additional day had been spent on the section of background architecture or landscape above, a rule of thumb has been devised that arrives at the amount of time involved in painting a fresco by multiplying the number of foreground figures by three days. More exact methods are possible, as we shall presently see, but this simple system does correspond roughly to the usual state of affairs, at least among experienced fresco painters. Some skilled painters worked even faster.

In a fresco (fig. 13), the thirteenth- or fourteenth-century painter seems to have proceeded to paint directly on the wall without preparatory drawings on paper, beyond the same kind he would need for a painting on panel from nature or from imagination, or both. But if the sub-

13. Partially finished fresco at beginning of a day's work. Joints between previous days' work indicated in heavy lines. *a.* masonry wall *b. arriccio c.* painted *intonaco* of upper tier *d.* new *intonaco* ready for color *e.* previous day's work *f.* underdrawing in *sinopia*

14. Andrea del Castagno. *Crucifixion*. 1445–47. *Sinopia* drawing (portion). Cenacolo of Sant'Apollonia, Florence (see fig. 269)

ject was unusual, requiring completely new compositional inventions, and perhaps prior approval of the patron, much more detailed drawings may well have been made. The early painter drew on the wall rapidly, in much the same manner as he talked in the piazza. He stood on a scaffolding before a wall whose masonry had been covered with a rough coat of plaster called *arriccio* or *arricciato*. On this surface the painter could make, often with the aid of such devices as rules and chalk lines tied to nails, the principal divisions of the area he was going to paint. Then, with or without the aid of preliminary sketches, he drew rapidly, first with a brush dipped into a little pale and watery ocher, which would leave only faint marks.

Over the first ocher indications, the painter could then continue drawing the rough outlines of the figures lightly with a stick of charcoal, establishing the poses of the limbs, the principal masses of drapery, and so on. Then he would proceed to the third stage, the drawing in red earth called sinopia, after the name of the Greek city Sinope, in Asia Minor, from which the finest red-earth color was thought to have come. The red earth was mixed with water and made an excellent material in which to establish the smaller elements of musculature. features, even ornament, sometimes with the broad, free strokes of a coarse-bristle brush, sometimes with shorter strokes. In the process of detaching many threatened frescoes from the walls, by a method roughly similar to that used for transferring tempera paintings, many of these sinopie have been brought to light since World War II (fig. 14). Sometimes, in their freshness and freedom, the sinopia drawings are more attractive to modern eyes than are the more exact finished frescoes covering them, made to satisfy the taste of the times, which might well have been that of the artist also. Often the sinopia varies considerably from the fresco, either because the painter had changed his mind about the position of a limb or a piece of drapery, or in certain cases because the patron complained that a saint was wrongly dressed or placed. We even possess a letter in which Benozzo Gozzoli informed Piero de' Medici that he had just painted a cloud over an angel to which the patron had objected—presumably in the *sinopia*.

As the painter went on with the work, he (or his assistant) had to cover a section of sinopia each morning with a new piece of fresh, smooth plaster called intonaco, and thus had nothing but his memory (or some good working drawings) to guide him when he began to paint that area. Every day, therefore, the fresco consisted of a certain proportion of finished work, a certain proportion of sinopia, and one blank, challenging section of fresh intonaco that had to be painted before the end of that working day; thereafter, the intonaco became too dry to paint on. The colors in their water vehicle sank into the fresh intonaco, amalgamating with the water in the plaster and undergoing chemical changes on contact. Vasari showed that fresco colors when dry no longer look the same as when they were laid down on the wet plaster. The quality and luminosity of fresco coloring depend also on the exact stage of the drying process of the plaster on which the painter begins to work. He had not only to have acquired great experience, but also to watch with extreme care the humidity of the interior in which he worked. It goes without saying that he could not paint frescoes in cold weather in unheated interiors. Even if the water did not actually freeze, his fingers would not obey him.

Not all colors were water soluble, and some had therefore to be painted a secco, that is, on the dry plaster, from which they were, sooner or later, destined to peel off like any other wall paint. The joints between the days' work are usually visible and palpable, because the painter cleaned off with a knife whatever intonaco remained unused when the light failed, so that he would have a clean edge to start on next day. To keep the edge from crumbling, it was beveled. When new plaster was laid on, it inevitably left a soft and rounded edge adjoining the bevel. One can therefore often determine not only the limits of each day's work, but also the order in which they were done. Individual painters varied, not only as regards how much work they could do in a day, but also as to where they placed their joints. Sometimes the joints follow the contours of a head or figure, especially where the knife removed the plaster left unpainted at the end of a day, but more frequently the joints fall between two figures or two heads.

Naturally enough, the painter worked from the top down, not just to keep from dropping paint on completed sections, but also because the floorboards of the scaffolding had to be lowered every time the painter wanted to paint a lower level. The result is a tendency to compose in horizontal strips. The background landscape and architecture, sometimes including the haloes, were al-

most invariably painted before the heads of the foreground figures. Sometimes the painter started in the center and worked out, sometimes he worked from the sides toward the center. In neither case is it possible to determine which side came first, but if the painter worked from one side to the other, the sequence of days can be precisely established. At best it was piecemeal work, and this was a real drawback during the fifteenth century when all-over visual unity, including light and atmosphere, was considered the first essential of painting. The limits of the scaffolding prevented the painter from stepping back very far to get a view of the whole. Occasionally an impulsive painter went over the edge and was injured-Michelangelo, for instance, when he was painting the Last Judgment. Barna da Siena, according to Vasari, was killed in such a fall. Many of the older masters, particularly when faced with a hurried commission that had to be carried out with the aid of many assistants, did a great deal of secco painting over fresco underpainting. In the fifteenth century advanced painters carried out experiments, many of them ruinous, to discover a compromise between the demands of the new style and the limitations of the old method. But in any form of painting, throughout the Middle Ages and the Renaissance, both craftsmanship and long experience were required at every stage. Only at the point of the sketches and the sinopia, and again during the painting of faces, background details, and so on, was inspiration of much importance.

With the combined evidence of Cennino's testimony and the sinopie themselves, rediscovered in abundance, scholars have come to accept the notions that before the mid-fifteenth century the sinopia was universally employed and even that the painter could and did customarily work directly on the intonaco without preparatory drawings of any kind. In recent years, however, conservation work has shown that a number of fourteenthcentury fresco cycles, including both of those by Giotto in Santa Croce in Florence, had no preparatory drawings at all on the wall under the intonaco. (More recently, the frescoes by Nardo di Cione in Santa Maria Novella have shown only the roughest indication of shadows on the intonaco, insufficient to guide the artist.) It was physically impossible to carry out sinopie for huge frescoes, such as those shown in figures 107, 108, 121, 123 and colorplates 9, 16, 18, while running up and down the scaffolding because only a small portion of the wall could be seen from any level of the scaffolding, whose boards and beams effectively concealed any view of the whole from the floor. For such colossal paintings detailed and precise preparatory plans were indispensable. That Cennino does not mention them may indicate no more than that at the modest artistic level at which he places himself in Padua preparatory drawings were customarily skipped. In the opinion of the present writer, the deep interest in light shown by Giotto and his immediate fol-

15. MASO DI BANCO. Sts. Paul and Julian.c. 1340. Wash and white on tinted paper.The Louvre, Paris

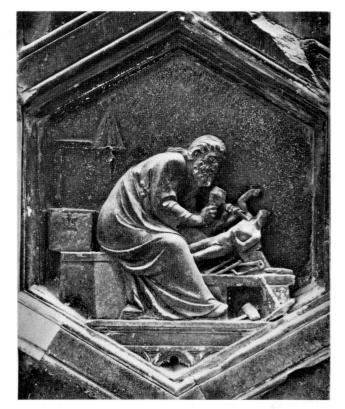

16. Andrea Pisano (from designs by Giotto?). *Art of Sculpture*. Mid-14th century (c. 1334–before 1348). Marble. Lower row of reliefs, Campanile, Florence (see fig. 77)

lowers would also have required preparatory studies on paper of the behavior of light on faces, drapery, and perhaps even backgrounds. A number of such drawings survive, especially the beautiful sheet attributed to Giotto's pupil Maso di Banco (fig. 15). Any preparatory drawings actually used in painting a fresco would have been exposed to even greater dangers on the scaffolding than those employed in the bottega. Small wonder that those preserved cannot be connected with known frescoes, at least in their present form.

The death knell of the *sinopia* was sounded by the *spolvero*, as in the case of panel painting, although there was a period, in the middle of the Quattrocento, when both were used in the same fresco. The *spolvero*—and later the cartoon—if necessary cut into sections, was brought onto the scaffolding and the outlines transferred by pouncing, or with a stylus in the case of the cartoon, as each section of *intonaco* went on the wall. The painter was then free to lay on his colors without having to remember a hidden section of *sinopia* under the *intonaco*, and with the *spolvero* or the cartoon always at hand to guide him. It is fascinating to note how often painters varied from the contours pounced or incised when they actually came to paint.

THE PRACTICE OF SCULPTURE

Giotto and Andrea Pisano also show us a sculptor (fig. 16) at work on a statue that is not standing vertically in its final position, but in the most convenient position for

carving—reclining at a diagonal. Even as late as the sixteenth century Michelangelo worked on some of his statues in this manner, which permitted the sculptor to approach every section easily without climbing and also gave every hammer blow the benefit of gravity. For the sculptor the block or slab of marble took the place of the painter's surface of gesso or intonaco. He, too, began by drawing. The outlines of the figure or figures were roughly sketched in charcoal on the surface of the block, from which the sculptor then began to liberate the work of art by carving away, first with a pointed, then with a toothed, chisel. The parallel marks left by the latter were removed with files and the surface polished with pumice and straw. The sculptor used drawing even more than did the painter. Before undertaking his statue in marble or any other material, he usually made a small model in clay, then sometimes a full-scale statue in clay, employing a device composed of adjustable iron rods jointed together and ending in points, so as to transfer first the basic, then the progressively finer, relationships of distance and proportion from the model to the finished work of art. The word "sculptor," incidentally, did not come into common use until the late fifteenth century. Older documents refer to even the most distinguished sculptors as tagliapietra (stonecutters).

Bronze was a luxury material, ten times as expensive as marble. The sculptor was generally but not always his own bronze founder, carrying out in person every stage of the difficult and dangerous operation. Around the original clay statue a plaster mold was so constructed that it could be removed in sections. These sections were taken off and coated inside with a thick layer of melted wax. Separately, a core of clay and shavings was built on a framework of iron so that the bronze statue could be hollow, for otherwise both weight and cost would be prohibitive. The shells of wax, removed from the plaster mold, were fixed to the core with wires to make a new statue of wax around the core. This wax statue was brushed with a paste made of fine ash mixed with water, and around it was made a mold of clay and shavings, which was supported by an iron framework pinned and jointed to that of the core. When the whole contrivance was heated, the wax ran out, leaving a space between core and outer mold to contain the melted bronze, which was conducted from a furnace through pipes. After the bronze had cooled, both core and mold could be easily chipped away, leaving a hollow statue whose thickness depended on the bronze founder's accuracy in measuring the core. In the Gothic period and the Early Renaissance, the rough surfaces of the bronze were carefully filed away by a process known as chasing, similar to an engraver's incising on a copper plate, or an armorer's incising designs on steel. Much fine detail was added to the statue by this laborious means. But later only the mold marks, bubbles, and other imperfections were removed, and the surface remained otherwise much as it had left the sculptor's hands in the original clay.

In the fourteenth and fifteenth centuries, much detail, and sometimes the entire statue or relief, was gilded. This was an elaborate process; details could be gilded by a means similar to that used for panels, but entire works had usually to be fire-gilt. This technique required the application of an alloy of gold and mercury. When heated, the mercury ran out, leaving the sculpture covered with a thin coating of gold. It is surprising to twentieth-century observers that statues, unless they were to be seen from the rear as well, were generally left with unfinished backs—in fact were scarcely more than reliefs deprived of their backgrounds.

THE PRACTICE OF ARCHITECTURE

Architecture, in the eyes of Italians during the Renaissance just as it is to some modern students, was the leading art of the period. New buildings went up everywhere, and old ones were remodeled. New city centers were constructed, and ideal cities—destined, alas, to remain dreams—at least reached the level of theoretical definition. It is in these structures and groups of structures that the most obvious reference was made to classical antiquity, in terms of classical proportions, revived Roman orders, arches, and decoration, not to speak of squares that recall Roman forums and direct imitations of Roman triumphal arches for the festivities of Renaissance sovereigns. Italian classicizing buildings were based on drawings, sometimes exactly measured but just

as often with highly personal embellishments on the part of the architect, of the buildings of ancient Rome, most of which were visible in far more nearly complete state during the Renaissance than they are today (see fig. 310).

Yet, in the long view, it is remarkable how little Italian architects understood, until the High Renaissance, of the fundamentals of Roman Imperial building, especially the system of vaulting that had been developed by the Romans to roof permanently, and still light adequately, vast interior spaces. In spite of the development of an influential new vaulting system in Lombardy in the late eleventh and early twelfth centuries, destined to remain without issue in Italy itself, Italian architecture of the Late Middle Ages and the Early Renaissance remained just what it had always been—an architecture of walls. In fact, the word used by all Renaissance architects, patrons, and theorists for "to build" was *murare* (literally, "to wall"), and in Italy a builder is still a *muratore*.

In comparison with the richly articulated architecture of masses and spaces developed during the Roman Empire, followed at Ravenna and, technically at least, surpassed in the Gothic cathedrals of France and other countries in Northern Europe, Italian buildings of the fourteenth and fifteenth centuries are strikingly simple and barren. They are vast spaces, or rather areas, enclosed by flat walls pierced at not necessarily regular intervals by doors and windows and, nine times out of ten, roofed by the same simple timber constructions used in Early Christian basilicas, and with at most a flat, wooden ceiling suspended from the timbers.

Even when he constructed a vault, the Italian architect was averse to the rich system of supports—the so-called exoskeleton—of a French Gothic church with all its flying buttresses and pinnacles. The massive masonry vaults of the cathedrals of Florence and Siena would collapse if it were not for their iron tie-rods (see fig. 126). The French visitor to Italy considers such a visible device a confession of incompetency, but his contempt is equaled by the Italian's revulsion from the complexity of the French system, which spoils, in his eyes, the simple beauty of the walls.

The builders of very large Italian churches often were far from sure, when they laid out the foundations of their structures, exactly how high the walls and columns were to go or how the interior spaces were to be vaulted. Calculation of spaces and forms was based on mathematical principles of sequence and proportion, rather than on the practical requirements of day-to-day living, to an extent that astonishes the twentieth-century observer indoctrinated with the ideals of functionalism. Elaborate drawings of architectural plans, elevations, perspectives, and details (see figs. 449, 502, 503, 566) survive in vast numbers and form one of the most striking categories of Renaissance artistic creation, especially when, as too often happened, the actual building was never built. Also,

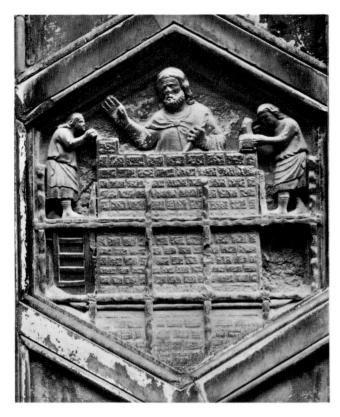

17. Andrea Pisano (from designs by Giotto?). Art of Architecture. Mid-14th century (c. 1334-before 1348). Marble. Lower row of reliefs, Campanile, Florence (see fig. 77)

architectural backgrounds, frequently unbuildable, provide a magnificent setting for the intense dramas of Italian Renaissance pictorial compositions. Sadly enough, most of the dreams of great Italian Renaissance architects for the rebuilding of Italian cities were prevented by circumstances—wars, personal quarrels, lack of funds—from becoming anything but dreams (see figs. 386, 436), but they have inspired actual projects of urban design ever since.

Although the work was carried out under the general direction of an architect, the key personality might well be that of the mason or builder, a member of the Arte di Pietra e Legname. Rarely did such a technician, however, rise to the status of designing architect in his own right. There was, in fact, no word for architect in the fourteenth century, only capomaestro (literally, "head-master"). Almost all the truly inventive architects discussed in this book began and continued as painters, sculptors, or, in the case of Michelangelo, both; came to architecture relatively late; and, great as their architectural achievements were, continued painting or sculpture as they had started. Often they were appointed capomaestro without either training or experience in building. The modern institution of an architectural office was unknown in the Renaissance, and the principal method of communication between architect and builder was a detailed wooden model, a number of which survive (see fig. 567). One major category of building, extremely important to the Italians of the Renaissance, military archi-

tecture, was given over to just such untrained men, who made themselves into expert engineers. Unfortunately, there is no room in this volume to discuss Renaissance fortifications, whose beauty, brilliance, and great practicality have attracted increasing notice.

Another relief from the Florence Campanile (fig. 17) shows the construction of a building with carefully rough-cut stones characteristic of Florentine houses and Florentine military architecture of the Late Middle Ages and Early Renaissance, the so-called rusticated masonry. The architect, holding a scroll that might be a plan or other calculations, is visibly directing the procedure; in a smaller scale, the masons are working on the scaffolding and laying the stones around its beams. As the wall rose, the masons moved these beams to a new level, leaving holes. These square holes are still visible today in Florentine medieval houses. The all-important wall, freestanding with a minimum of external buttressing (generally none at all), was the basis of all Italian architectural thinking until it was replaced by the elaborate radial organizations of spaces in the High Renaissance.

The concept of the flat wall plane dominates the arts of Italy to an extent inconceivable elsewhere. It is fascinating, for example, to note that the often rich and complex façade of an Italian church or a palace may seem to have little to do with the building behind it. Actually, this is not entirely true; the façade of a church, especially, sometimes tries to prepare the observer for the spaces and architectural motives of the interior. But the tissue of delicate elements that makes up the façade does no more, in general, than just turn the corner, and then stops short. The flat, untreated wall continues, abundantly visible from the sides of the building—as acceptable to Italian eyes as it is often startling to foreigners. For the façade is not considered an essential part of the building. It is rather a splendid ceremonial decoration for the piazza before it, rather like the huge shrines still erected in South Italian streets to celebrate the festival of an important saint. The façade sometimes does not have the same number of stories as the building behind it and often towers far above, so that its empty extent must be supported from behind by iron rods tied to the roof beams; sometimes it is embarrassingly lower than the bulk of the actual building. Too often, to the distress of everyone but Italians, the façade has never been built at all.

The wall is the beginning and the end of Italian architecture, and forms as well the broad field for fresco painting and the background for altarpieces and for sculpture. The wall is the plane from which perspective thinking starts, to create new, harmonious spaces in a world projected within and beyond its surface, which the observer is visually invited to step through. The wall is the screen on which the cinematograph of Italian civic life and Italian humanized landscape is printed, through the inexhaustible fertility of the Italian imagination.

2 Dugento Art in Tuscany and Rome

he first manifestations of an independent new style in painting and in sculpture seem to have taken place in Tuscany, a roughly elliptical region in west central Italy, embraced between the curve of the Apennines and the curve of the Tyrrhenian Sea. It is noteworthy that this region had become, shortly after the year 1000, the scene of important new political developments, and that it corresponds in general to the area inhabited in ancient times by the Etruscans, from whom the medieval Tuscans were in part descended. In the then-marshy valley traversed in part by the Arno, between the Apennine wall to the north and the central Tuscan hills, one by one the cities of Pisa, Lucca, Pistoia, Prato, and Florence constituted themselves free communes or republics, liberated from the domination of the counts of Tuscany after the death of the celebrated Countess Matilda in 1115, and owing a somewhat shadowy allegiance to either the emperor or, in the case of Florence, the pope. Somewhat later in the century Siena established an independent republic, free from the domination of its bishop and of neighboring feudal lords. These Tuscan city-states were the theater of the constant struggle for power between the merchant class and the old nobility, a struggle in which a high premium was placed on the value and initiative of the individual; they provided a rich market and a powerful incentive for the new art.

The word *Dugento* ("two hundred") is used in Italian to designate the thirteenth century (the 1200s), as *Trecento* is used for the fourteenth century, *Quattrocento* for the fifteenth, and *Cinquecento* for the sixteenth. The high quality and great richness of panel painting (the frescoes have largely disappeared) in the Dugento have come to be appreciated only in the last generation, prior to which the period was generally accepted as one of stagnation, under the influence of Byzantine art—the painting of the Eastern or Greek Empire, centering on Constantinople. According to Giorgio Vasari, Greek painters were called to Florence, and there Cimabue, whom Vasari considered the first of the truly Florentine painters, saw

18. *Christ Pantocrator*. 1148. Apse mosaic. Cathedral, Cefalù, Sicily

them at work and quickly surpassed their "rude" manner. Vasari knew little, of course, about the highly intellectual and refined painting of this later Byzantine civilization, but there is a germ of truth in his legend. Greek mosaicists were indeed called to the polyglot court of King Roger of Sicily in the twelfth century (fig. 18) and founded there a new school of Italo-Byzantine art. Byzantine influence anywhere in thirteenth-century Europe is all too easy to explain. In 1204 disaster befell the Byzantine Empire in the shape of conquest by the army of the Crusaders, who devastated the churches of Constantinople, as well as the Great Palace, a building of legendary magnificence, and scattered their artistic booty-painted icons, manuscripts, ivory carvings, enamels, fabrics with woven pictures—to almost every Western European country. Some objects probably deriving from the Sack of Constantinople are still visible in Italy today. Byzantine artistic ideas were imprinted on European imagination through the dazzling beauty of Byzantine style. Greek painters themselves, with little work to do in ruined Constantinople, were called to newly powerful Serbia (since 1919 a part of Yugoslavia) to work for the expansionist kings there, and doubtless they were also attracted by the wealth of Venice and the great Tuscan cities. They brought with them Byzantine style in the highly formalized and linear "Comnenian" phase (so called after the dynasty of Byzantine emperors that came to an end in 1204).

But for all their initial reliance on Greek models, on the Greek methods of dividing the anatomy into clearly demarcated but delicately shaded portions, and on the Greek way of rendering light on drapery by means of parallel striations of color or gold, even the earliest productions of Italo-Byzantine paintings show an energy and a tension that distinguish them at once from the more lethargic beauty of their Eastern models (fig. 19). It is not hard to realize that the mosaicists of the new school sometimes worked side by side with French sculptors straight from Chartres.

20. SCHOOL OF PISA. *Cross No. 15*. Late 12th century. Panel, 9'3" × 7'9¾". Pinacoteca, Pisa

PAINTING IN PISA

So little is left of Tuscan painting in the twelfth century that it is impossible to determine the main currents of its development, let alone the complex problem of its origins, but the earliest examples we know seem closer to the art of Romanesque Europe than to that of the Byzantine East. Rapidly, however, in the Dugento, probably as a result of the conquest of Constantinople, Byzantine influence becomes unmistakable. Pisa had been a rich and powerful seaport since Roman times, when it was the capital of the Province of Tuscany. In 1133, under Innocent II, Pisa was briefly the seat of the papacy, and St. Bernard called it a new Rome. The republic was in constant commercial competition and naval warfare with the rival ports of Genoa to the northwest and Amalfi south of Naples.

One of the earliest surviving Italian panel pictures is probably the anonymous and undated *Cross No. 15* in the Pinacoteca (painting gallery) at Pisa (fig. 20). This enormous work, probably for a choir screen, shows Christ spread out upon the Cross, but alive; scenes from the Passion and subsequent events are superimposed on either side of his body and at the ends of the bars of the Cross. The type of Cross with a living Christ—the *Christus triumphans* (Christ triumphant)—appears in a number of other examples. The purpose of these images, of

course, was not to show the agony of the Crucifixion as a specific incident, but rather to present a symbolic image of the sacrifice of Christ as a timeless doctrine and to dramatize for the worshiper the significance of the Mass. In the backgrounds the dominance of the architectural shapes with their many arches and slender columns, and the repeated vertical elements of the lateral scenes arranged in levels one above another, recall at once the Romanesque architecture of the Cathedral, Baptistery, and Leaning Tower of Pisa.

It was the necessity of viewing the painting from a certain distance that led the artist, doubtless, to consider very carefully not only the architectural structure of his total composition, but also the color arrangements that are evenly spaced and repeated to achieve an all-over harmony among a very few simple colors—blue, rose, white, tan, gold. Considering the potential drama of the subjects, the style is remarkably restrained. Clear, drawn contours outline every major element. The linear drapery style is closely related to that of contemporary Tuscan Romanesque sculpture. The artist had modeled the erect figure—whose arms seem stretched voluntarily against the Cross—with considerable delicacy, but as though it were carved in low relief. The wide-open eyes, in their curious squared lids, stare impassively outward. Against the elaborate architectural structures, within which we are supposed to imagine the stiff little figures to stand and move, the scenes from the Passion are treated as if they were incidents from a codified ritual. All in all, the style recalls the manuscript painting of the Romanesque period in Italy more than anything Byzantine.

Against this static and largely symbolic painting, another and even more beautiful example, Cross No. 20 in the Pinacoteca at Pisa (colorplate 2), sets forth an unexpected range of emotional values. The Christ is now shown dead, hanging lightly upon the Cross as if he were in reality opening out his arms to embrace all mankind. The type is that known as the *Christus patiens* (suffering Christ), destined to replace rapidly the Christus triumphans with a direct appeal to the personal feelings of the spectator. Again we do not know the date of the painting nor, strangely enough, considering the individuality of the style, the identity of the painter. It is at once evident that he was strongly influenced by Byzantine art. The pose of the body, with the hips curving to the figure's right, is common in Byzantine representations, such as the great mosaic at Daphni (see fig. 19) and examples in Serbia. Throughout the drawing of the anatomy and the drapery, the painter betrays his knowledge of Greek style. But even more important than the Byzantine elements in the painting, which never reach the point of imitation, is the intensity of feeling, resulting in a personal style of great lyric beauty and tragic power. By analogy with dated works in other Tuscan centers, it is possible to make a guess at a date around the year 1230 for this work. Very probably the great change in content

21. SCHOOL OF PISA. Deposition, Lamentation, and Entombment, details of *Cross No. 20* (see colorplate 2). c. 1230. Parchment on panel. Pinacoteca, Pisa

and in style between the two Pisan crosses is explained by the spread of the doctrine of St. Francis of Assisi (d. 1226), who preached and practiced a direct devotion to Christ himself, which culminated in 1224 in the saint's stigmatization with the wounds of Christ.

The new emotional content is evident throughout the painting: in the expression of sadness, rather than physical torment, on the countenance of the suffering Christ, and in the dramatic effectiveness of the small flanking scenes from the Passion, in which architectural backgrounds are now subordinated to direct human content. Everywhere the flow of line, in the hair and the delicately delineated features, in the long and slender fingers, and in the little flanking scenes silhouetted against the gold, reaches a pitch seldom achieved again in Italian art until

left: 22. Lamentation. c. 1164. Fresco. St. Pantaleimon, Nerezi, Yugoslavia

below: 23.
BERLINGHIERO
BERLINGHIERI. Cross.
Early 13th century.
Panel. Pinacoteca,
Lucca

Botticelli in the Quattrocento. In the Lamentation (fig. 21), long, delicate lines move downward with increasing rapidity through the angels' wings to Mary, who embraces her dead Son, whose body rests on her lap as in no scriptural account. This group was surely derived from Byzantine sources. The tenth-century theologian Simeon Metaphrastes was the first to describe Mary holding the dead Christ on her lap as in infancy, and as early as the twelfth century the scene was represented in Byzantine art. The passionately intense fresco at Nerezi in Macedonia (just south of Serbia, now in Yugoslavia), dated about 1164, shows this scene (fig. 22), another example of which may have migrated to Pisa. Cross No. 20 is one of the earliest of those tragic evocations of the relation between Mary and the dead Christ that, under the name of the Pietà (Italian for both "piety" and "pity") they were to acquire at least by the late years of the Trecento, is to form so important a subject for Italian artists of the Renaissance.

PAINTING IN LUCCA

Similar stages may be discerned in the painting of Lucca, a rival republic only about fifteen miles from Pisa; separated from the sea by the mass of the Monte San Giuliano, Lucca was able to carry on for centuries a splendid existence through its banking activities. A group of fine crosses of the *Christus triumphans* type culminates in an elegant example (fig. 23) by one of the earliest Italian artists known to us by name, Berlinghiero Berlinghieri, born in Milan, who founded a family of painters active in Lucca in the Dugento. In his signed *Cross* in the Pinacoteca at Lucca, Christ looks quietly out at the observer with wide-open eyes. The sides of the *Cross* are shorn of the narrative scenes customary in earlier examples, and are painted with many a reference to Byzantine style, particularly in the striated character of the drapery and

the separately modeled segments into which the body is divided. Small figures of Mary and John now appear under the arms of the Cross, like their larger counterparts in Byzantine art. The crossarms, as in many earlier examples, culminate in the symbols of the Four Evangelists.

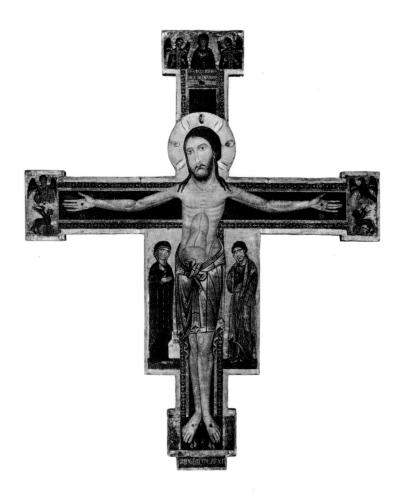

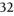

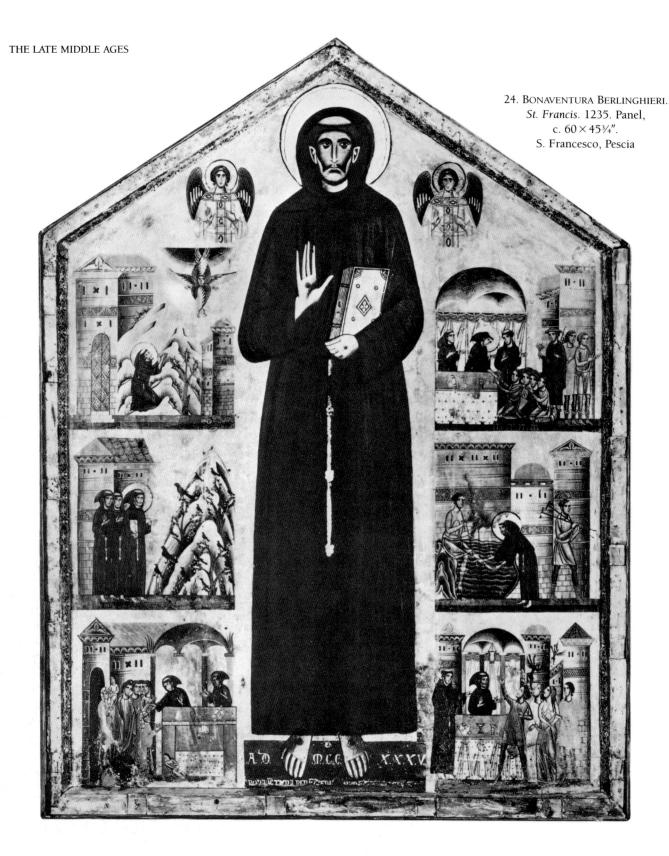

Berlinghiero's son, Bonaventura, was a painter of stronger character, judging from his signed *St. Francis* (fig. 24) in the Church of San Francesco at Pescia, a little town at the base of the Apennines about halfway between Lucca and Pistoia. The painting is dated strikingly early—1235—only nine years after the death of St. Francis himself, which makes it the earliest known image of the saint. If such a picture had been painted in

later times, we might be able to draw conclusions about the physical appearance of the subject, but there is no evidence that Tuscans in the Dugento attached importance to portrait likeness. At least, however, we can deduce from the extraordinary intensity of the face, with its emaciated cheeks and piercing gaze, a great deal about the meaning of St. Francis's message to his contemporaries. Bonaventura has shown us the ascetic St. Francis of

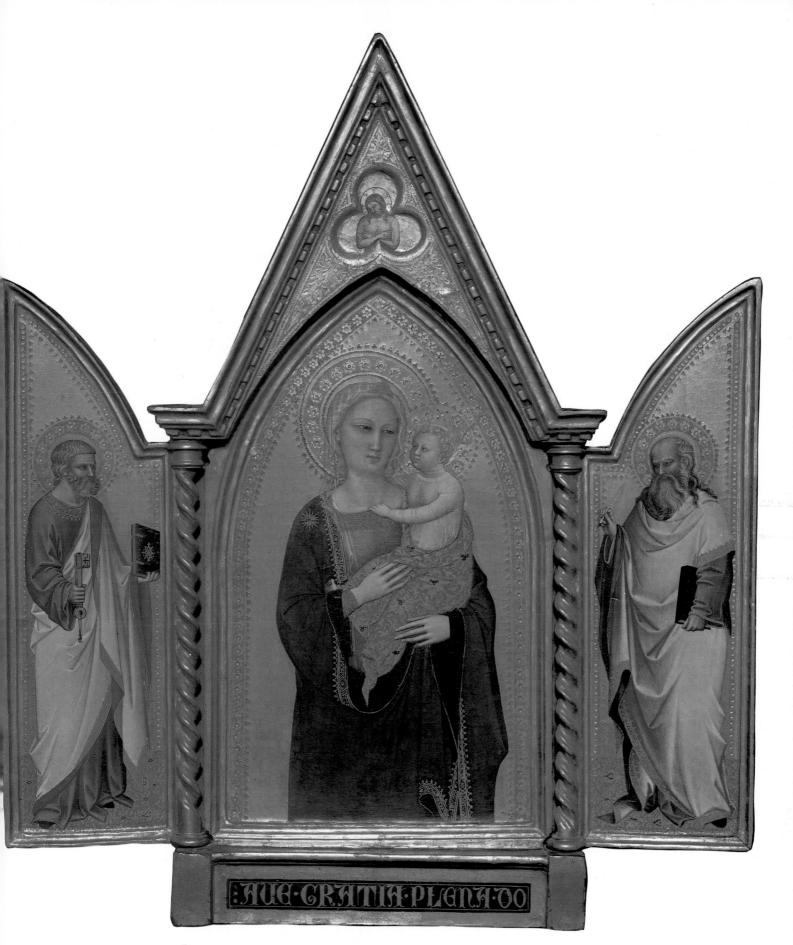

Colorplate 1. NARDO DI CIONE. *Madonna and Child with Saints*. Mid-14th century. Panel, 30" high. National Gallery of Art, Washington, D.C. (Kress Collection)

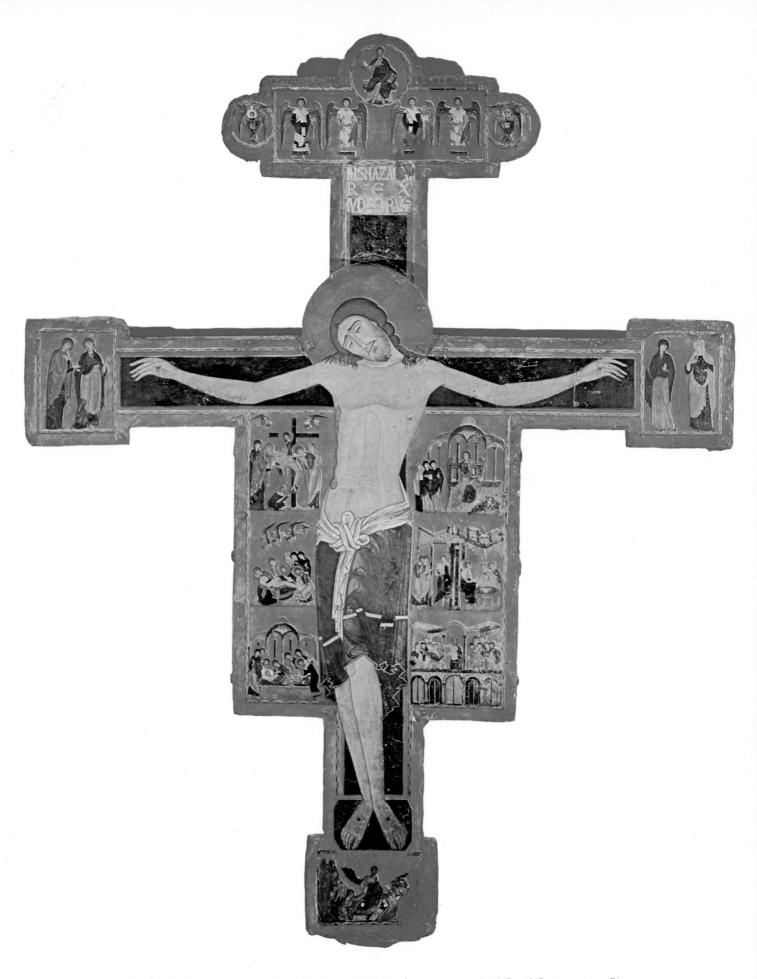

Colorplate 2. School of Pisa. Cross No. 20. c. 1230. Parchment on panel, $9'9'' \times 7'8''$. Pinacoteca, Pisa

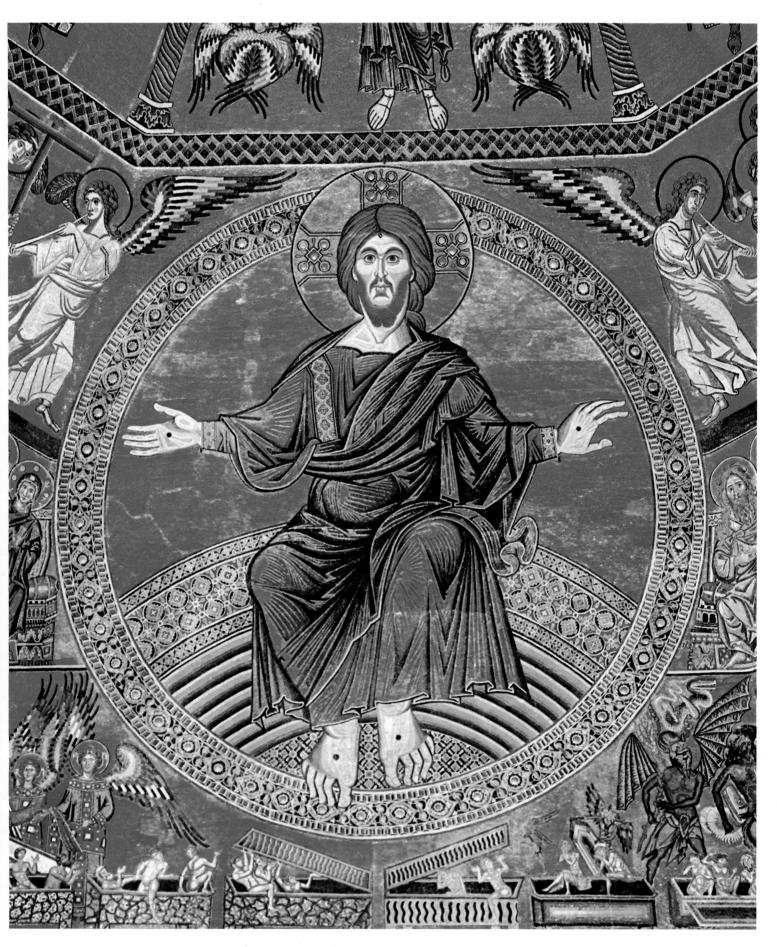

Colorplate 3. COPPO DI MARCOVALDO (attributed). Last Judgment (portion). Second half of 13th century. Mosaic. Baptistery, Florence

 $Colorplate~4.~CIMABUE.~\textit{Enthroned Madonna and Child.}~c.~1280.~Panel,~11'7''\times7'4''.~Uffizi~Gallery,~Florence~and~Child.~c.~1280.~Panel,~11'7''\times7'4''.~Uffizi~Gallery,~Florence~and~Child.~c.~1280.~Panel,~11'7''\times7'4''.~Uffizi~Gallery,~Florence~and~Child.~c.~1280.~Panel,~11'7''\times7'4''.~Uffizi~Gallery,~Florence~and~Child.~c.~1280.~Panel,~11'7''\times7'4''.~Uffizi~Gallery,~Florence~and~Child.~c.~1280.~Panel,~11'7''\times7'4''.~Uffizi~Gallery,~Florence~and~Child.~c.~1280.~Panel,~11'7''\times7'4''.~Uffizi~Gallery,~Florence~and~Child.~c.~1280.~Panel,~11'7''\times7'4''.~Uffizi~Gallery,~Florence~and~Child.~c.~1280.~Panel,~11'7''\times7'4''.~Uffizi~Gallery,~Florence~and~Child.~c.~1280.~Panel,~11'7''\times7'4''.~Uffizi~Gallery,~Florence~and~Child.~c.~1280.~Panel,~11'7''\times7'4''.~Uffizi~Gallery,~Tlorence~and~Child.~c.~1280.~Panel,~Tlorence~and~Child.~c.~$

Colorplate 5. PIETRO CAVALLINI. Last Judgment (portion). c. 1290. Fresco. Sta. Cecilia in Trastevere, Rome

right: Colorplate 6. NICOLA PISANO. Marble pulpit. 1260. Baptistery, Pisa

below: Colorplate 7. GIOVANNI PISANO. Lower half of façade. 1284–99. Cathedral, Siena

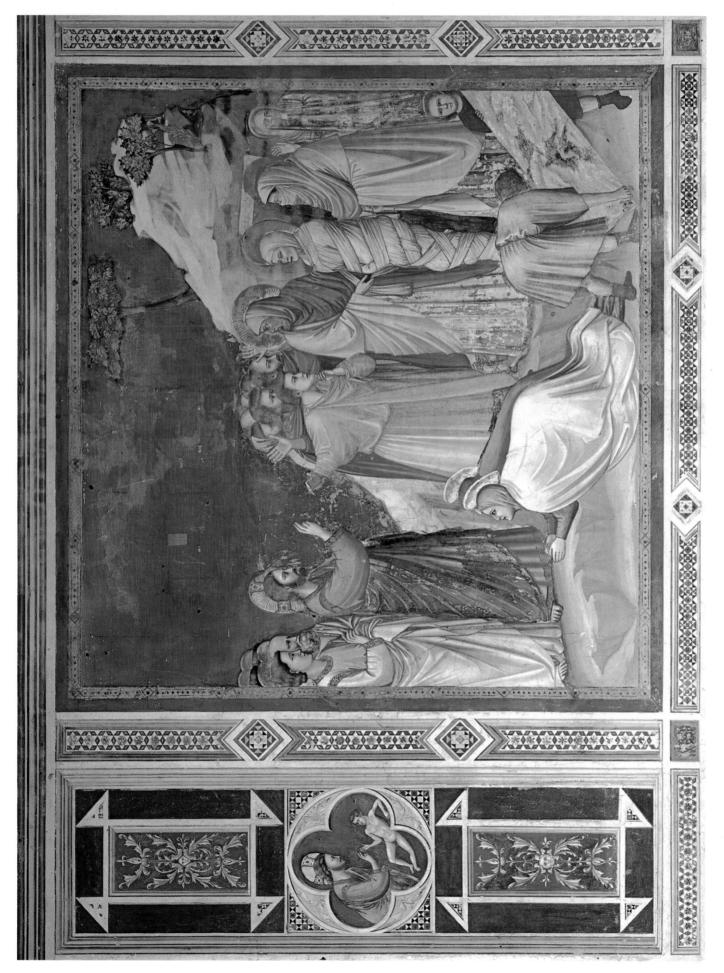

Colorplate 8. Giotto. Raising of Lazarus. After 1305. Fresco. Arena Chapel, Padua

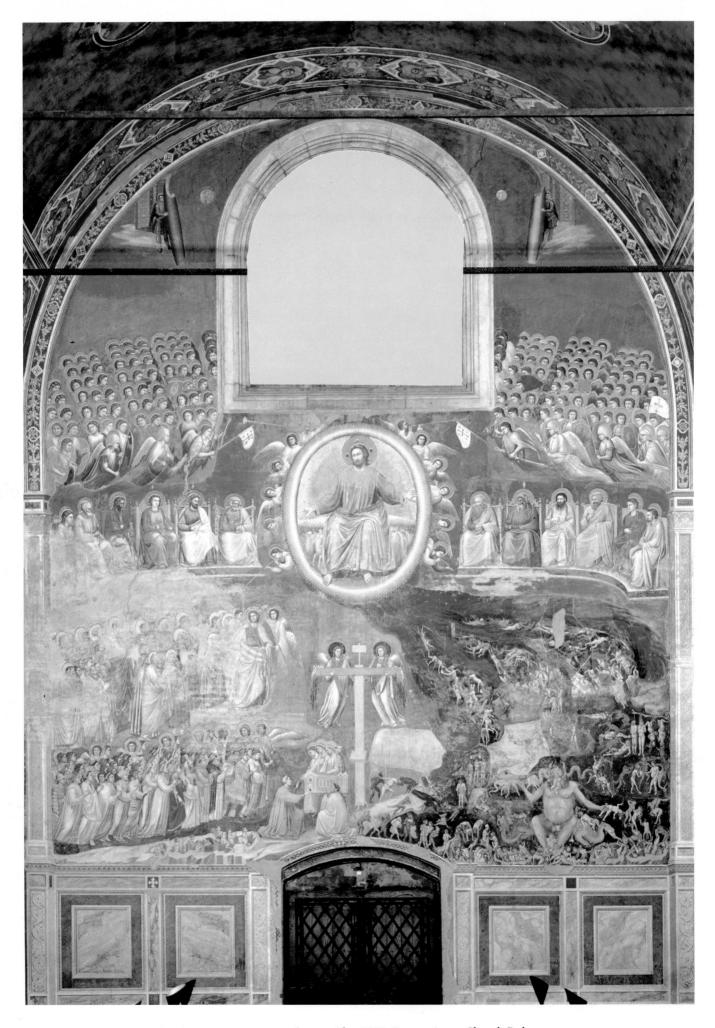

Colorplate 9. Giotto. Last Judgment. After 1305. Fresco. Arena Chapel, Padua

the private meditations and ecstatic prayers. The harsh power of the forms and the solemnity of the content come as a surprise if we know only the gentler representations of St. Francis and his life in the Trecento and Ouattrocento.

The shape of the picture, with its lateral scenes from the life of the saint, is partly determined by an analogy between this image and the traditional painted crosses. Its formulation, however, with a triangular top like the gable of a church or a shrine, was followed consistently in altarpieces representing the enthroned Madonna and Child until replaced in the mid-Trecento by the rich Gothic shapes imported from the art of France. The setting of two of the narrative scenes gave Bonaventura an opportunity for painting landscape backgrounds. Although these are strongly schematized according to models in Byzantine painting, in fact reduced to repeated, superimposed formulae to represent hills, there is something about the color and shapes that suggests a new feeling for nature accompanying the new interest in human emotional reactions. The Preaching to the Birds and the Stigmatization are very effective, both artistically and poetically. The architectural settings, however, were adopted almost without change from Byzantine models and show no relation to the Lucchese architecture of Bonaventura's day.

PAINTING IN FLORENCE

Until the Dugento, Pisa and Lucca were more populous and powerful than Florence, and Florentine painting seems to have got off to a slightly later start. But even the earliest examples show a directness, power, and plasticity denied to either of the two rival schools. The most impressive of the early works is a great Cross of the Christus triumphans type (fig. 25), whose affinities are all with works located in or around Florence. The Christ seems almost to be soaring; there is in fact no indication of the original wood of the Cross, which is dissolved into a background field of flat gold. The forms, more firmly modeled and strongly constructed than anything we have seen either in Pisa or in Lucca, culminate in a splendid head, whose round eyes gaze calmly outward. The nobility of the shapes contrasts with great delicacy in the rendering of such details as the dotted loincloth and in

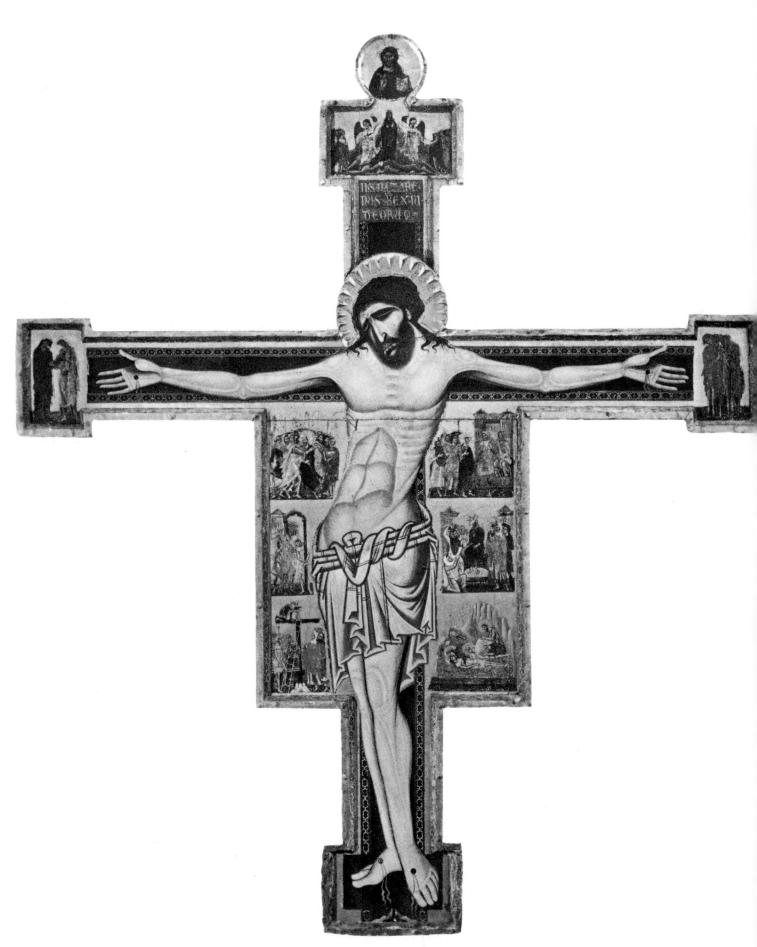

27. Coppo di Marcovaldo. *Crucifix*. Second half of 13th century. Panel, $9'7\%'' \times 8'11\%''$. Pinacoteca, San Gimignano

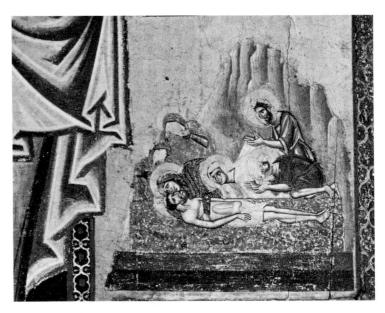

29. Lamentation, detail of fig. 27

the choice of colors, subdued and even a little dusty. The lateral narrative scenes make no effort to compete with the modeling of the central figure. Almost flat in their silhouetted shapes, they are, nonetheless, sharply alive, owing to the vivid contrast in linear directions and to the flashing glances of the eyes (fig. 26). As in Romanesque painting elsewhere in Europe, the heads in the small dramatic scenes are enlarged so that the effect of the facial expressions will not be lost. Byzantine canons of proportion, inherited from the Hellenic and Roman world, did not permit such violations. Whoever he may have been, this painter, like the master of *Cross No. 20* in Pisa, was a strong artistic personality; he is also the first of the great Florentine artists we are to encounter, the ancestor of a long and honorable line.

An equally gifted painter in a different emotional and stylistic vein was Coppo di Marcovaldo (active 1260s-70s), generally accepted as the author of the harrowing Crucifix (fig. 27) in the Pinacoteca at San Gimignano, which was then in Sienese territory. Even more deeply influenced by Byzantine style than was the painter of Cross No. 20, or the Berlinghieri family, Coppo turns the linearity, the compartmentalized figure, and the striated drapery construction to a purpose strongly opposed to the intentions of that lyrical master. In fact, he shows us a Christ whose sculptural body and face are convulsed and distorted with suffering, whose loincloth, powerfully rendered to show the depth of the waist, is broken into almost cubistic angles, all projected with a violence seldom if ever to be met with again in Italian art. We are reminded of Grünewald's harshness and terror-in the Isenheim altarpiece, painted two hundred and fifty years later—when we look at the rapidly moving, brightly illuminated shapes of the features (fig. 28). The closed eyes are treated as two fierce, dark, hooked slashes, the pale mouth quivers against the sweat-soaked locks of the beard, the hair writhes like snakes against the tormented body. Even the halo, carved into a separate raised disk and then broken by wedgelike indentations, is made to play its part in a total effect of the greatest expressive power. Coppo is known to have fought as a Florentine soldier in the Battle of Montaperti in 1260, when the Arbia River ran red with blood, and was taken prisoner by the Sienese after the defeat of the Florentine forces; it is sometimes suggested that the emotional content of the great Crucifix reflects Coppo's wartime experiences. As compared with the mournful beauty of the Lamentation in Cross No. 20 (see fig. 21), Coppo's scene has the immediacy of a television shot of street violence (fig. 29). The dead Christ lies rigid on the ground, his head held by his mother; the surrounding figures explode with emotion, and so does even the landscape with its drastic verticals. Parenthetically, it should be noted that the head of the Christ was painted over a layer of gold leaf, and some of the hair has crusted off, spoiling the effect of the long curves of Coppo's contours.

Among the other surviving works by Coppo di Marco-valdo is a *Madonna and Child* in the Church of the Servi in Orvieto (fig. 30). The subject itself forbade such expressionistic outbursts as we saw in the San Gimignano *Crucifix*, but Coppo's characteristic intensity of feeling is now merely transferred to the sphere of form and design. The Virgin is shown as she appears frequently in Byzantine representations, on a lyre-backed throne, crowned as Queen of Heaven and holding her divine Son upon her knee. The Child raises his right hand in blessing. Two angels, of a smaller scale than the Virgin and Child, are shown behind the throne. A glance at the head of the

30. COPPO DI MARCOVALDO. *Madonna and Child.* c. 1265. Panel, 7'9¾" × 4'5½". S. Martino ai Servi, Orvieto

Virgin, with its slightly receding chin, tremulous lips, and large, sad eyes, reveals an emotional content not explained either by the ordinary relationship of mother and child or by the ritual purpose of the image. Every Italian Madonna and Child contains, in one way or another, a reference to the adulthood of Christ, especially his Passion, death, and Resurrection. Frequently Italian Madonnas look mournful just when we would expect them to be happiest, endowed as they are with the ability to prophesy the tragic events to come.

As in the *Crucifix*, Coppo has divided the beautiful face into separate compartments by sharp, linear accents in the nose, lips, and eyes, and these divisions are strengthened by the modeling of the masses in light and dark. But here every shape is treated as an abstract form, severe and clear-cut like elements of architecture. Here, too, Coppo has sharpened the immediate impact of the

vision by wedge-shaped depressions in the halo, but they are smaller and more numerous than those in the San Gimignano *Crucifix*, creating a constant glitter of gold around the face. The energetic Christ Child, remarkably unchildlike in appearance, is already the Savior and Teacher, holding a scroll in his left hand.

The dramatic nature of Coppo's style is especially evident in the interplay of forces in the drapery, cut up in folds that are outlined and patched by gold striations. These are strikingly sharp and intense, and also irregular; in fact they tend to be organized in sunburst shapes that have little to do with the behavior of cloth. A portion of the crackling striations, seen alone, could almost be mistaken for a work of twentieth-century abstract painting, so strong an independent life do these forms lead. Few of Coppo's works can be securely dated, but the one picture that is inscribed and some documentary references indicate a relatively brief artistic activity, centering around the late 1250s, 1260s, and early 1270s.

The extensive cycle of mosaics filling the interior of the octagonal pyramid that vaults the Baptistery of Florence is the most important pictorial undertaking of the Dugento that remains in the Tuscan metropolis. On the west face of the pyramid is represented the Last Judgment (colorplate 3), persuasively attributed to Coppo di Marcovaldo. The commission for a monumental work of such prominence gives testimony to his importance in the cultural life of his native city. Far more, it provided ample opportunity for Coppo to display the extraordinary vigor of his imagination and the great power of his forms on an unprecedented scale. The central figure, more than twenty-five feet in height, is designed with an astonishing simplicity and clarity of statement; the anatomical masses are broken into relatively few segments, richly modeled in color. The whole is surrounded by broad and geometrically beautiful contours, in keeping with the characteristic sunburst shapes of the goldstriated drapery. The Lord is enthroned in a slightly ovoid glory whose border is adorned with clear-cut patterns of foliate ornament that show perfectly from the floor. Below the seat of his throne may be seen the seven blue arcs of the seven heavens. Gazing outward with the wide-eyed look familiar from the Christus triumphans, he stretches his right arm to beckon toward the blessed, his left to cast the damned into eternal fire. How far to carry the Coppo attribution into the surrounding angelic figures, many of them heavily restored, is problematic. But the athletic figures leaping from their tombs are convincing as Coppo's design, and even more so is the terrifying Hell scene, in which a few punishments and demons, clearly decipherable even from the floor of the Baptistery, do duty for the whole. Around Satan, writhing serpents and monstrous toads devour the damned, all rendered with the broad, clear zigzag shapes characteristic of Coppo's style. As always in his art, the intense expressive content is transformed into abstract shapes of

the greatest beauty. Coppo's mosaic of the enthroned Christ is the most awe-inspiring representation of divinity in Italian art until Michelangelo. Although his name was forgotten by tradition, not even to be mentioned in later sources, the sublimity of Coppo's vision remained to inspire, directly or indirectly, generations of Florentine artists.

PAINTING IN SIENA

During his stay in Siena, Coppo had considerable influence, especially on Guido da Siena (active c. 1260), the leading painter of the previously archaic Sienese School. Guido painted for the Church of San Domenico a huge *Enthroned Madonna* (fig. 31), now in the great hall of the Palazzo Pubblico. The face of the Madonna and the entire figure of the Child were cleaned off and repainted in

31. GUIDO DA SIENA (Madonna's face and Child probably by DUCCIO). *Enthroned Madonna*. Second half of 13th century. Panel, 9'4½"×6'4". Palazzo Pubblico, Siena

the early Trecento, probably by Duccio; the rest of the picture shows the adaptation to Sienese taste—more refined and even daintier than that of Florence, as will be seen later—of characteristic Italo-Byzantine motifs shorn of Coppo's tragic intensity of feeling. In other works, Guido appears to have been influenced still more strongly by the style of Bonaventura Berlinghieri. The Palazzo Pubblico Madonna has been the subject of a prolonged controversy dating back to the eighteenth century, because the painting bears an inscription declaring that Guido da Siena painted it in the "happy days" of 1221. This gave Sienese antiquarians ammunition in their battle to assert the cultural priority of Siena over the hated Florence. Although the inscription has been proved old and unaltered, most modern scholars are unable to date this accomplished painting alongside the crude efforts of the Sienese School in the early Dugento, about fifty years earlier than dated paintings that are almost identical with it in style. James Stubblebine has demonstrated that the inscription is lettered in a manner common in the early Trecento, and was added, for commemorative purposes, when the faces were repainted and Guido's exact dates had long been forgotten (see Bibliography)

CIMABUE

In most introductions to the history of art, Cenni di Pepi, better known by his uncomplimentary nickname of Cimabue (meaning "dehorner of oxen," or figuratively, "violent man"), appears as the earliest of Florentine and therefore of Italian painters (active c. 1272-1302); this is just where Vasari placed him, considering everything before Cimabue's time to be clumsy. In reality, Cimabue comes not at the beginning of a development but at its end. His altarpieces show him to be the last great, thoroughly Italo-Byzantine painter. Others carried Cimabue's style well into the Trecento, but they were minor masters who got no jobs in Florence itself; their activity was relegated to the villages, and soon ceased altogether. Cimabue sums up and refines an Italo-Byzantine tradition that had been going on for nearly a century in Tuscany, and elaborate and splendid though his creations are, he begins nothing essentially new.

The great Enthroned Madonna and Child in the Uffizi (colorplate 4), painted for the high altar of the Church of Santa Trinita in Florence, has always been attributed to Cimabue by Florentine tradition and is not now doubted, although no document connects it with the master, and we are not even sure of the date. Probably it was done a few years before Duccio's Rucellai Madonna of 1285 (see fig. 89). It is enormous, even larger than the Madonna by Guido—by far the most ambitious panel painting attempted by any Italian master up until that time. Inside the dark, narrow, and lofty church and seen properly by candlelight, it must have made an overwhelming impression. The enthroned Queen of Heaven

32. CIMABUE. Crucifixion. After 1279. Fresco. Upper Church of S. Francesco, Assisi

is here shown crownless, presenting her Child to the faithful, the throne held by eight angels, four on each side. In the arches below the throne, Old Testament prophets display scrolls containing their prophecies of the Virgin Birth. The throne is gigantic and fantastic. Cimabue has created a dream architecture that poses as many problems to the observer today as it probably did to the artist. Any attempt to figure out purposes and relationships is fruitless. Although every form can be traced back through Byzantine art to the best classical sources, the result is the antithesis of classical art. One is constantly aware of shifting shapes and floating forms, of figures that have no ground to stand on yet assume the duty of support, or of figures that suddenly appear from below as if in elevators that have stopped halfway up. Cimabue does not even seem to have made up his mind whether the curves beneath the throne are arches in elevation or niches in depth—or both.

The Child in this case is seated on the Virgin's left, holding his scroll and teaching, as he looks directly out toward the observer. This is a ceremonial subject depict-

ing a court ritual in which none of Coppo di Marcovaldo's emotional power could be tolerated. The gold striations of the drapery have proliferated to an astonishing degree. There are thousands of these tiny lines, and they weave a shifting, glittering network of shapes, moving back and forth from side to side, very like the bewildering effect of the multiple elements in the throne itself—as if the artist were trying to overwhelm the faithful with his image of regal majesty. The Virgin's heavenmantle was originally a brilliant blue, customary like the rose tone of her tunic. The coloristic effect when the painting was fresh must have been impressive, especially as the brilliant blue was brought into further relief by the flickering flame colors of the graduated tones in the feathers of the angels' wings.

Cimabue's drawing style is extremely nervous and delicate, very different from the raw power of Coppo's broad lines. The eye structure is characteristic, with the lower lid almost level, the upper lid shaped like a circumflex, and the sidelong glance contrasting with the downward tilt of the head.

Although Cimabue has a keen sense of modeling within certain definite limits, delicately shading all drapery save for the gold-striated garments of Christ and the Virgin, no form seems able to occupy space, no head is really round. He wishes to show everything he knows to exist, making both ears appear even in a three-quarters view of the face, as though no solid mass of the head intervened to hide one of them. The idea that the image of an object was received by the human eye as a reflection of light had, of course, occurred to no one. In his zeal to inform us, Cimabue gives us a kind of Mercator's projection of a global head on a flat surface. For all this descriptive naïveté, Cimabue's penetrating intelligence enables him to analyze and differentiate psychological types with considerable effect, as for example the distinction between the fresh, even a bit foppish, young angels and the weary, disillusioned prophets. His eye and hand delight in complicated shapes, long slender fingers, and the complex ornament derived from classical sources. Even when he gets to the gold background, he cannot stop inventing. The entire gold area, including the haloes that originally were supposed to represent a glow of light around sacred heads, is enriched with shifting patterns of incised lines.

Cimabue was also a monumental artist—very probably, he continued the Baptistery mosaics started by Coppo and others. His great abilities as a fresco painter can be only dimly suggested by photographic reproductions; especially badly preserved is his cycle of frescoes in the apse and transept of the Upper Church of San Francesco at Assisi. Even when one stands before the originals, little comes through in these ruined works beyond the movement of color and the unity of the frescoes with the walls they decorate and the spaces they dominate.

St. Francis, the Poverello ("little poor man") of Assisi, who married Lady Poverty and renounced all possessions whatsoever, is enshrined in one of the most magnificent buildings in Europe, a huge double church, one built above the other, erected over his tomb. Probably built with the collaboration of French and German architects, the Upper Church is almost completely lined with frescoes on walls and ceiling, and its window openings filled with stained glass, making it the most nearly complete surviving large-scale cycle of religious imagery in Italy before the Sistine Chapel. Cimabue's Crucifixion (fig. 32) is difficult to decipher because the whites were painted with white lead, which has oxidized and turned black with time. For this reason Cennino specifically warned painters against using white lead on walls. (Cimabue's fresco is often reproduced in a photographic negative.) Cimabue has conceived the Crucifixion as a universal catastrophe. Christ writhes on the Cross, his head bent in pain—perhaps already in death, although this is impossible to determine in the present state of the fresco. A great wind seems to have broken loose, as if produced by the earthquake recorded in the Gospels, sweeping the long folds of the loincloth off to one side. Angels hover in the air about the Cross, their drapery also blown by the wind, and hands reach upward from the vast crowd below toward the Crucified, from whose side pour blood and water (allusions to the sacraments of the Eucharist and Baptism) into a cup held by a flying angel. On our left appears Mary, the other Holy Women, and the Apostles; on our right are the Romans and the chief priests and elders, including the Roman centurion in the foreground who has recognized, through the earthquake, that Christ was the Son of God. Even from this wrecked fresco we can see that Cimabue was an artist of great dramatic capacity, endowed with an unprecedented ability to grasp and project the intensity of a moment of revelation. His entire stature we can glimpse only dimly through the barriers of time and change.

PAINTING IN ROME

While Cimabue was ruling the Florentine scene, a remarkable school of painters was working in Rome, where the practice of mural decoration in fresco and in mosaic had continued in an unbroken tradition ever since the great Early Christian works, although relatively few of the surviving medieval examples are of the highest quality. The late thirteenth century, however, saw a tremendous upsurge in pictorial achievement in Rome, continuing until 1305, when the seat of the papacy was removed from Rome to Avignon in southern France. A certain impetus may well have been given to Roman artists by exiled Greek masters from Constantinople, and there are documents recording the importation of mosaicists from Venice, doubtless either Greek or Greek-trained, by Pope Honorius III. The climax of Dugento monumental art in Rome is the colossal apse mosaic of Santa Maria Maggiore, signed by Jacopo Torriti, and executed during the pontificate of Nicholas IV (1285-94). The effect of the mosaic (fig. 33) is overwhelming. Christ and the Virgin, seated on a rose-colored cushion with their feet on sky-blue footstools, are robed in gold with blue shadows, against a deep-blue mandorla studded with gold stars and framed in skyblue with silver stars, which floats in the golden empyrean. As in certain earlier Roman medieval apse mosaics, the gold ground is crowded with curling blue acanthus scrolls, populated by ducks, doves, parrots, pheasants, cranes, and peacocks. The shell-niche at the crown of the apse moves through a startling succession of gold, skyblue, rose, and green. The mosaic is astonishing in the richness of the sources from which it derives. The subject of the Coronation of the Virgin is of French origin and had appeared in Gothic cathedral sculpture for more than a century. The relation of the linear style to that of Byzantine mosaic art is immediately apparent. And the acanthus scrolls are based on Late Classical originals, probably of the mid-fifth century. Strangest of all, the

33. JACOPO TORRITI. Coronation of the Virgin. c. 1294. Apse mosaic. Sta. Maria Maggiore, Rome

mosaic embodies actual fragments of a preexisting fifth-century mosaic, including a river god and a Roman sailing ship (barely visible below the angels at the left). Even more important than the triple origin of the ingredients of the composition, however, is the masterly ease with which they are harmonized with each other. The drapery motifs, for example, are at once Byzantine in their linearity, Gothic in their amplitude, and classical in their harmony. A new style is emerging in Rome, in which the three currents most active in the formation of the Italian Renaissance are already approaching fusion.

Several Roman painters including Torriti were active in the nave of the Upper Church of San Francesco at Assisi, probably after Cimabue had finished his work in the transept and choir. One of the most gifted of these was the Isaac Master, so called on account of two magnificent scenes from the story of Isaac and Jacob, which are the best preserved of the several works painted by this artist in the upper level of frescoes, above the famous series of the Life of St. Francis (fig. 34). The exquisite mosaic inlay of the frieze and base of the open architectural box that provides the setting reflects Roman architectural taste of the twelfth and thirteenth centuries. The flat ceiling with a diamond pattern in dark and light to indicate coffering, the gorgeous hangings of the bed, and the little colonnade at its base are conspicuous in Roman thirteenth-century art (see fig. 35). More important still, the majestic and beautifully modeled drapery curves, at once classical, Byzantine, and Gothic, strongly recall those of Torriti.

The scene is tense. In the adjoining fresco Jacob, abetted by Rebecca, has received the blessing of the blind Isaac by fraudulent means, presenting a gift of meat as venison. In this one, Esau, Isaac's favorite son, returns with the real gift, expecting the blessing; Isaac, realizing that he has been tricked, says to Esau, "Who art thou?" and "trembles very exceedingly" (Genesis 27:32-33). His right hand is raised, his left extended in confusion. Oddly enough, Esau, who should be looking at his father in dismay, gazes straight past him, while an unidentified young woman, holding a pitcher to her bosom (cf. fig. 35), looks on unmoved, and Jacob, now unfortunately almost destroyed, hustles off the scene at the extreme right. Stiff as the scene may be in poses and gestures, and imperfectly realized in certain details as well as in the flatness and weightlessness of the figures under their drapery, the painter was able to model faces and hands brilliantly and to indicate the play of light on architecture as had no earlier Italian master. The best one can say about a date is that the 1280s or early 1290s seem likely.

CAVALLINI

It is the new discovery of the meaning and function of light in the realization of form, although still carried out

in a manner that takes no account of the sources of light, that transfigures Roman mural art in the work of an authentic genius, known to posterity as Pietro Cavallini (really Pietro de' Cerroni, nicknamed Cavallino, or "little horse"), born sometime between 1240 and 1250, and active until about 1330. A notation by his son, Giovanni Cavallini, tells us that the painter lived to the age of a hundred and never covered his head, even in the worst days of winter. More to the point is the praise of the great Florentine sculptor Lorenzo Ghiberti, who knew not only the frescoes and mosaics by Cavallini that are still preserved, but also many others that have perished, including vast cycles in Old St. Peter's, San Paolo fuori le Mura, San Francesco, and San Crisogono, which rendered Cavallini's art accessible to countless thousands, perhaps millions, of pilgrims up to the late sixteenth century. Calling Cavallini a "most noble master," Ghiberti goes on to say of his work that it had "great relief," and of his mosaics that he had never seen such work done better.

The most important achievements by Cavallini still visible in Rome are the mosaics in the apse of Santa Maria in Trastevere (Trastevere: "across the Tiber") and the fragmentary frescoes in Santa Cecilia in Trastevere, both

34. ISAAC MASTER.

Isaac and Esau.
1280s or early 1290s.
Fresco, 10×10'.
Upper Church of
S. Francesco, Assisi

of which Ghiberti mentions, but neither of which can be securely dated beyond the probability they were done in the 1290s. Ghiberti discerned in Cavallini's frescoes in Old St. Peter's "a little of the ancient manner, that is, Greek." The circumstances of Cavallini's lost work in San Paolo fuori le Mura render this observation easily understandable. As Early Christian frescoes suffered from the passage of time, they were repainted again and again throughout the Middle Ages, and this was just the kind of job Cavallini was commissioned to do, keeping more or less to the same Late Classical compositions, but substituting his own ideas where little or nothing of the original was left. The classic quality of style he learned in the process is abundantly evident in the beautifully balanced composition of the Birth of the Virgin (fig. 35), which begins the series of the Life of the Virgin in Santa Maria in Trastevere, although the full quality of the work can only be appreciated in the color, whose soft radiance fills the entire apse with shifting and subtle variations of hue and value. The background, as we have seen, is a templelike structure, like a little stage set, related in its simple shapes to ancient Roman domestic architecture and shrines, while its inlaid ornament derives from Roman medieval sources. In contrast to earlier Byzantine representations of the scene, the two women setting a little table by the mother's couch in Cavallini's mosaic and the two midwives about to bathe the newborn Mary (a theme borrowed from representations of the Nativity of Christ; see page 52) carry their bread, wine, and water with the solemnity of a ritual rather than the pungency of an actual event. All the figures, standing, crouching, or reclining, are imbued with classic grace and simplicity, and though the gold striations persist as if ornamental in the mantle about St. Anne's legs, all the other

drapery masses recall Greek and Roman sculpture in the breadth of their forms and the ease with which the folds fall, in sharp contrast to the tension and complexity of drapery of Torriti or the Isaac Master. Most important of all, the splendid heads, tubular arms, and cylindrical bodies seem to owe their existence in space largely to the play of light.

This, of course, is a fundamental revolution in artistic vision, and it is quite clear that at this moment the change came about through intimate acquaintance with Early Christian models. An even sharper artistic transformation is visible in Cavallini's most important remaining work, a fragmentary fresco of the Last Judgment in Santa Cecilia in Trastevere (colorplate 5), which is all that is left of an extensive cycle once covering the entrance wall and nave walls of the church. The surviving strip of the majestic fresco is extremely difficult to see because it is bisected horizontally by the nuns' choir, and the nuns are in clausura. In the enthroned Christ and Apostles, whose rich coloristic harmonies are dominated by soft orange and green, and in the angels with wingfeathers in the usual graduated colors, there is a remarkable step beyond even the mosaics of Santa Maria, resulting in a wholly new sense of real rather than schematic volumes, surfaces, and textures in light. Cavallini's illumination still does not come from one identifiable source, but it plays richly on the drapery of the seated Apostles, and above all on the faces. Form seems to have roundness in depth wholly by the action of light, independent of linear drawing. The linear compartmentalization of the necks has been replaced by a beautiful columnar roundness, allowing the actual anatomical structure of the neck to be felt as never before in art since ancient times. Although the locks of hair are still formalized, the beards are strikingly naturalistic in texture, and the surfaces of the enveloping mantles have a soft and silky sheen, no doubt due in part to Cavallini's adoption of the Roman use of marble dust in his intonaco. The vivid naturalism of the seated Apostles, whose facial expressions betray deep and subtle states of feeling, owes little to antiquity, nothing to Tuscany, but much to a new stylistic current that made its appearance during the 1260s, almost simultaneously in portions of the Byzantinized world under the Palaeologan dynasty. It was noted by the author in 1969, after the first edition of this book had gone to press, and independently by others, that there is a striking relationship between Cavallini's style at Santa Cecilia and that of the frescoes that still, in damaged state, line the Church of the Trinity at Sopočani in Serbia, built in the early thirteenth century and decorated at the order of King Uroš I, probably between 1263 and 1268, by Greek painters in the new, luminary

Cavallini may have seen Palaeologan icons in Italy, but it is perfectly possible, considering the known migrations of artists in the Middle Ages and Renaissance, that the painter really went to Sopočani to absorb the new style in its full sweep, over entire walls. There were

36. Head of Christ, detail of Dormition of the Virgin. Probably 1263-68. Fresco. Church of the Trinity, Sopočani, Yugoslavia

rich and continuous relations between Serbia and Western Europe. Uroš himself had a French wife; his Venetian mother, Queen Anna Dandolo, daughter of a doge, was buried at Sopočani, which was built by Italian architects. The resemblance between such heads as the intensely compassionate Christ in the Dormition of the Virgin (fig. 36), by the finest of the Greek masters at Sopočani, and Cavallini's Apostles, in facial type, handling of beard and hair, expression, drapery masses, and above all form created by the movement of light, should not obscure the differences. The Sopočani painter is, for a Greek, surprisingly abrupt in his technique, and Cavallini has found it necessary to refine his brushwork and transitions of tone to a degree unknown since Pompeii and Herculaneum.

The innovations of Cavallini provided a strong incentive, perhaps even inspiration, for the younger and eventually greater Florentine master Giotto, who must have seen and studied Cavallini's work when he came to Rome. It is disappointing that, in spite of his longevity, Cavallini was not able to keep pace with the rapid changes in Italian style he had been instrumental in setting in motion. His later works, in Rome and in Naples, show only occasional flashes of the old fire.

SCULPTURE

While the Italo-Byzantine movement was reaching its height in Italian painting in the second half of the Dugento, Nicola d'Apulia, the sculptor known to us today as Nicola Pisano (active 1258–78) from his adopted city, the first of the great sculptural innovators, arrived in Pisa from South Italy. His startling classicism of motifs and style has often been attributed to a supposed connection with the classicizing culture of the court of Emperor Frederick II, who ruled in Nicola's native Apulia. Pisa, with its Roman history and pretensions, had a strong classical tradition of its own, and its ancient monuments had already been copied by Nicola's sculptural predecessors earlier in the century. His first known work, a rich marble pulpit for the Baptistery of the Cathedral of Pisa (colorplate 6), was completed in 1260 and signed with an inscription in which the artist proclaimed himself as the greatest sculptor of his day, in keeping with the selflaudatory inscriptions common in medieval Tuscany (Busketus, architect of the Cathedral of Pisa, had compared himself to Ulysses and to Daedalus).

The presence of a pulpit in a baptistery can be understood through the special importance of the baptistery in those Italian city-states where it was the only place to celebrate Baptism, the sacrament that brought the child into the Christian community. The baptistery, a separate building, thus had a civic as well as a religious importance. Sermons by Archbishop Federigo Visconti, who commissioned Nicola's pulpit, contain vivid symbolism of water as a vehicle for divine grace. Nicola's hexagonal pulpit, directly alongside the font, in fact looking down

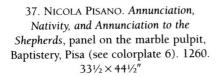

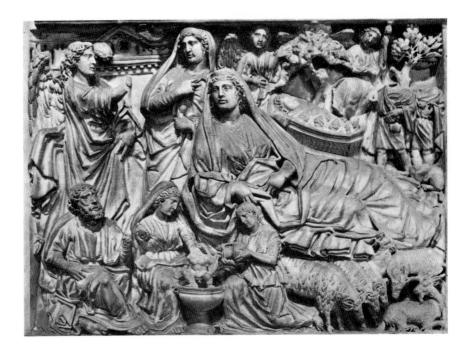

into it, is a magnificent construction of white marble from the quarries at nearby Carrara, with columns and colonnettes of polished granite or variegated red marble. The columns are of different length; every other one is short, supported on the back of a white marble lion, and the central column stands on a base enriched by seated sculptural figures. The pulpit shows the same juxtaposition of Northern European and Mediterranean elements we have noticed in contemporary Italo-Byzantine art (see pages 28-29). Although Nicola's study of original Roman Corinthian capitals (found in abundance in Pisa) has given to his a classical firmness and precision, his projecting acanthus leaves resemble the much freer naturalistic foliate ornament in French Gothic cathedrals, especially that at Reims, with which Nicola's ornament shows many other affinities: his six arches are just barely pointed in the Gothic manner, but they are enriched with the three lobes developed in the façade architecture of French cathedrals. The hexagonal parapet behind which the preacher stands provides fields for five splendid marble panels carved in high relief (the sixth being used for the opening from the staircase); the spandrels flanking the arches are filled with reliefs representing Old Testament prophets, and are separated by figures in high relief standing over the capitals. The whole structure, rich in detail yet compact, culminates in the white marble eagle that serves as the lectern, doubtless because the eagle symbolizes St. John, and his Gospel commences, "In the beginning was the Word, and the Word was with God and the Word was God."

Nicola was apparently required to compress a number of separate incidents into the same frame: in the initial scene one can make out first Mary's *Annunciation*, then the *Nativity*, then the *Annunciation to the Shepherds* (fig. 37). The Annunciation, of course, is one of the most important events in the Christian cycle, when the Angel

Gabriel brought to the Virgin Mary the tidings of her miraculous maternity. It was precisely when the Word struck her ear, according to theologians, that Mary conceived the human body of Christ. One of the reasons for dating Christmas on December 25 was the custom of celebrating the feast of the Annunciation on March 25, nine months previously, the first day of the Roman year. In fact, the new year began on March 25 throughout Tuscany, until the Gregorian calendar was adopted in the late sixteenth century. Florence, however, retained until 1750 its ancient custom of reckoning the new year from the feast of the Annunciation. In the Nativity Mary reclines upon a mattress before a suggestion of the cave that is used in Byzantine representations of this event, the same cave still shown to visitors in Bethlehem. At the bottom of the relief two midwives, their presence derived from a widely believed tradition preserved in an apocryphal gospel (but as Eloise Angiola points out, here doubtless connected with Baptism as well), are testing the temperature of the Child's first bath. At the lower left Joseph sits as a silent spectator. The shepherds, although damaged, can still be seen at the upper righthand corner; their sheep have already arrived on the scene at the lower right. These peripheral scenes act as a kind of frame for the enormous figure of the reclining Virgin, much as narrative scenes flank a Dugento Cross or a large-scale standing saint. Nicola clearly drew them all on the original marble slab, then cut in to the exact extent necessary to free heads, arms, and trees from the uniform background or from each other. No attempt was made to suggest distant space, so that the heads all arrive at the surface plane no matter how much the figures may overlap. Yet the crowded relief is responsive to the inner forces of the enclosing architecture, a feature impossible to observe in separate photographs but effective when facing the actual pulpit.

38. NICOLA PISANO. *Adoration of the Magi*, panel on the marble pulpit, Baptistery, Pisa (see colorplate 6). $33\frac{1}{2} \times 44\frac{1}{2}$ "

Not only the dense packing of the figures but, much more important, the rendering of their heads can be traced immediately to classical models, especially to figures on Roman sarcophagi, of which a number had remained in Pisa since antiquity, or been brought there in relatively recent times, and reutilized as Christian tombs. These provided Nicola with authoritative models. His Virgin has often been characterized as a Roman Juno, and indeed the straight nose, full lips, blank eyes, and hair waving back from a low forehead come directly from classical art. But for all these detailed and specific references to antiquity, and the figures' classical weight and dignity, the whole is strangely unclassical. The drapery breaks into sharp angles providing an all-over network reminiscent of the Italo-Byzantine forms in contemporary Dugento painting. The general compositional principles in the Baptistery pulpit reliefs are not far from those of Coppo di Marcovaldo and Cimabue. Classical and Gothic details alike are intrusions at this stage.

In the Adoration of the Magi (fig. 38), the seated Virgin is imitated, almost line for line and apparently with no sense of irreverence, from the seated Phaedra on a Roman sarcophagus, still in Pisa and in Nicola's day actually on the façade of the Cathedral, representing the legend of Hippolytus. The borrowing was first noticed, apparently, by Vasari. The Three Kings coming from the East to adore the Christ Child look very like Roman bearded figures, but again the drapery shows the staccato breaks of Italo-Byzantine style rather than the fluidity of even the mass-produced Roman sculpture available to Nicola. Most striking of all is the fine male figure, below the left-hand corner of the Adoration, now identified as Daniel (fig. 39), nude save for the cloak over his arm. He, in turn, was imitated from a figure on a Roman Hercules sarcophagus. In spite of the Christian horror of nudity,

naked figures do turn up in medieval art, especially in scenes of the Last Judgment; all are naked before God. In the Trecento, in fact, nude figures are more common than one might at first think. Andrea Pisano's sculptor (see fig. 16) is carving a male nude, and Cennino Cennini, though contemptuous of the female figure, describes the proportions and construction of the male nude in exhaustive detail. But this handsome *Daniel* is

39. NICOLA PISANO. *Daniel*, on the marble pulpit, Baptistery, Pisa (see colorplate 6). Height 22"

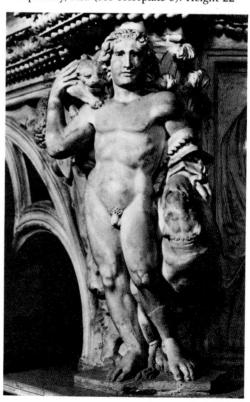

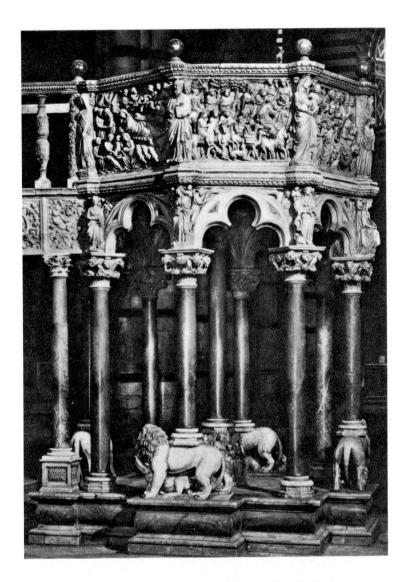

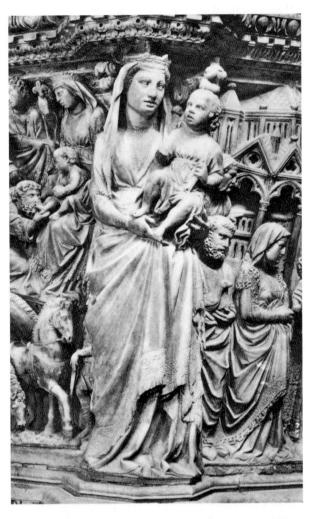

above left: 40. NICOLA PISANO. Marble pulpit. 1265-68. Cathedral, Siena

right: 41. NICOLA PISANO. Last Judgment (portion), panels on the marble pulpit, Cathedral, Siena. Each panel, 33½×38¼″

above right: 42. NICOLA PISANO. Madonna and Child, on the marble pulpit, Cathedral, Siena.
Height 33½"

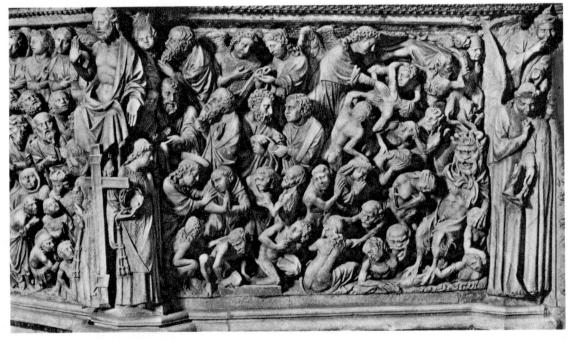

the first heroic nude in Italian art. The large head, of course, betrays the fact that Nicola is still a medieval artist, adapting the proportions to the relative sizes of the figures.

Five years after the completion of the Pisa pulpit, Nicola was called to Siena to execute an even more ambitious work for the Cathedral (fig. 40), octagonal and much more richly decorated. In this masterpiece Gothic and classical elements, more deeply understood than in the Pisa pulpit, blend effortlessly in a style of unprecedented serenity and dramatic resonance. From 1265 to 1268 Nicola worked on this immense undertaking with a group of pupils that included his son Giovanni and three other sculptors later to become well known and successful, including Arnolfo di Cambio. Doubtless these assistants were necessary in order to complete so elaborate a project in so short a time, but the general style of the work, and probably even the execution of most of the principal sculptural portions, shows the style of Nicola himself. The abrupt style of the Pisa Baptistery pulpit has given way to a broader and more unified movement of shapes and surfaces. Standing statues, rather than red marble colonnettes, separate the seven reliefs of the parapet, with the result that the flow of sculptured forms appears continuous. In all, nine columns of granite and porphyry support the pulpit; the four shorter ones rest on the backs of lions or lionesses who stand over animals they have struck down. Around the base of the central column sit the Liberal Arts, their number here augmented to eight. The pulpit was at one time dismantled, and all the statues are not now in their proper positions; furthermore not all the figures have been clearly identified. Nicola, like so many artists from the Middle Ages to the Baroque, must have had pattern books for stock scenes, and some of the events are here represented much as in the Pisa Baptistery pulpit. The most spectacular of the scenes is undoubtedly the Last Judgment (fig. 41), which comprises two relief panels and the intervening sculptural group of the enthroned Christ with attendant angels. The richness of the panoramic composition depends not only on the combination of various degrees of sculptural projection, but also upon the new and vivid conception of the muscular surface of the human figure, especially in the relief that shows the damned about to be dragged to Hell—figures whose freedom of pose and action gave inspiration to later artists, particularly the painter Duccio. All traces of Italo-Byzantine compartmentalization of form have been swept away by the movement of Nicola's surface. Drapery flows as easily as in the classical originals he admired, and the softness of the flesh portions and the grace of expression, particularly in the beautiful Madonna (fig. 42), whose bosom, for the first time in Italy, is clearly visible through her clothing, as in the statues of Reims Cathedral, point the way to some of the loveliest creations of the Florentine Quattrocento sculptors. The

question of French Gothic influence is still open, but Nicola's art is nonetheless a strongly individual creation, full of premonitions of the Renaissance, and forms a striking parallel to both the influences and the innovations of Cavallini in painting.

Nicola's gifted son, Giovanni Pisano, inherited the shop after the great master's death, at some time between 1278 and 1287. Giovanni (c. 1250-c. 1314) designed the lower half of the magnificent façade of Siena Cathedral (colorplate 7) and carried out some of its finest sculpture, before returning to the Arno Valley. In contrast to Nicola, Giovanni is determinedly Gothic, but it is a Gothic far removed from the courtly style as we know it in France; it is closer rather to the expressionistic Gothic of German sculpture. The powerful statues of prophets and saints on the façade of Siena Cathedral twist and turn to an extraordinary degree, as if to declare total in-

43. GIOVANNI PISANO. Mary, Sister of Moses. Marble. Museo dell'Opera del Duomo, Siena

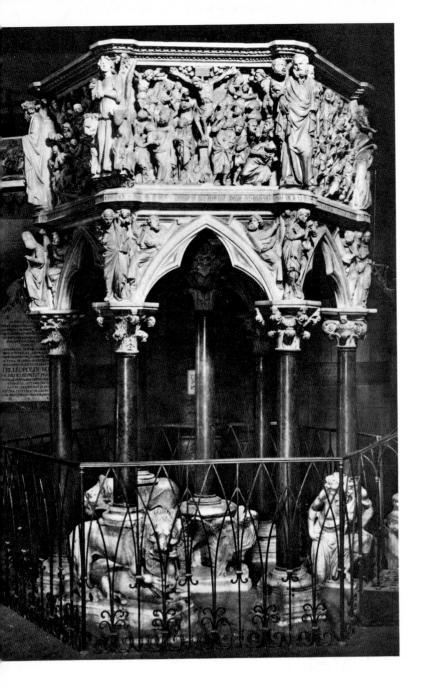

dependence from the confining rules of architecture, even though it was Giovanni himself who laid out the arches, gables, and pinnacles of the structure. The statues, of colossal size, recall the loftiest figures from the pinnacles of Reims Cathedral, carved only a few years earlier, in all respects except their intense activity, most strongly evident in the vivid figure of Mary, Sister of Moses (fig. 43). The most violent wrenches given to the figures—especially the neck projecting sharply from the torso and then twisted to one side—are to be explained, however, by a sensitivity to optical phenomena that was apparent even in the art of Nicola, whose sculptured reliefs were clearly designed to be seen from below, their shapes then responding to the movements of the arches. Giovanni was well aware that unsatisfactory effects would result if a sculptor did not take the visual angle into account when planning statues intended for a lofty position. He therefore brought the neck outward so that the face would not be hidden by the breast and knees of the figure, when seen from the piazza below. He also and this is common in Italian sculpture designed for such spots—reduced the figure and its features to their essentials, because at a distance fine detail would be lost and only the most powerful masses and movements could register on the eye. Today the originals have been taken down for safekeeping and have been replaced by copies on the cathedral façade. In their present setting in the Museo dell'Opera del Duomo, near or in some cases even below eye level from the entrance, the rationale for their extraordinary appearance has evaporated.

The self-laudatory inscription placed by Nicola on the Pisa Baptistery pulpit is exceeded in pretension by the inscription Giovanni carved on the magnificent pulpit he created between 1298 and 1301 for the narrow, dark Romanesque Church of Sant'Andrea in Pistoia (fig. 44),

above: 44. GIOVANNI PISANO. Marble pulpit. 1298–1301. Sant'Andrea, Pistoia

right: 45. NICOLA PISANO. Massacre of the Innocents, panel on the marble pulpit, Cathedral, Siena (see fig. 40). 33½×38¼″

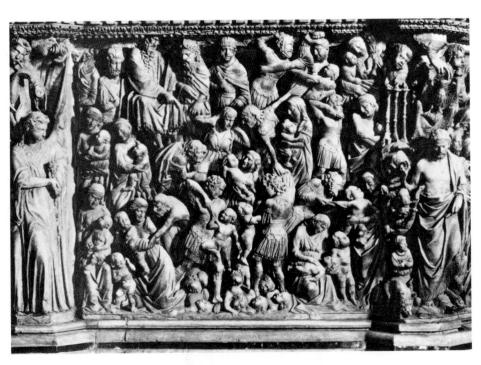

where modern illumination has only now permitted it to be fully appreciated. Nicola had claimed to be the greatest of living sculptors, and Giovanni states that he has surpassed Nicola, which in some respects is true—although he never approached the subtlety of his father's late style. Although hexagonal, the Pistoia pulpit gives a totally different impression from the Pisa Baptistery pulpit. The shapes of the cusped arches are now sharply pointed, the leaves of the capitals more strongly projecting. The classical elements, so important in Nicola's art, have been submerged by a rising tide of emotionalism. The reliefs seem almost to billow in and out, from the parapet to the angle sculptures and back again. The projections are much sharper, the undercuttings of heads, arms, and other projecting elements much deeper. The free, zigzag movement of the drapery has little in common with Nicola's carefully balanced folds. Even when the arrangement of figures and scenes appears to derive from Nicola's pattern book, the effect is one of deep hollows enclosed by fluid shapes in continuous motion.

A scene especially suited to the new possibilities of Giovanni's style is the Massacre of the Innocents, those children under the age of two who were slain at the command of King Herod, thus to destroy the infant Jesus he feared would replace him on the throne. Represented in a restrained way by Nicola, this scene becomes an orgy of sadism in Giovanni's relief (figs. 45, 46). On the upper right Herod is giving the order; the stage is filled with wailing mothers, screaming children, and soldiers holding up children and stabbing them with swords, while mothers below cradle their dead children and weep over them. Even the lesser figures—the prophets in the spandrels and the sibyls between the capitals and the parapet—share in the general agitation. The sibyls, Greek and Roman prophetesses who were believed to have

foretold the coming of Christ, will be seen again and again throughout Italian art, culminating in their grand representations by Michelangelo on the Sistine Ceiling. One strikingly dramatic figure, for example (fig. 47), inspired by an angel who has come to speak over her shoulder, is especially proto-Michelangelesque. Her excitement is communicated by the turn of her head, the

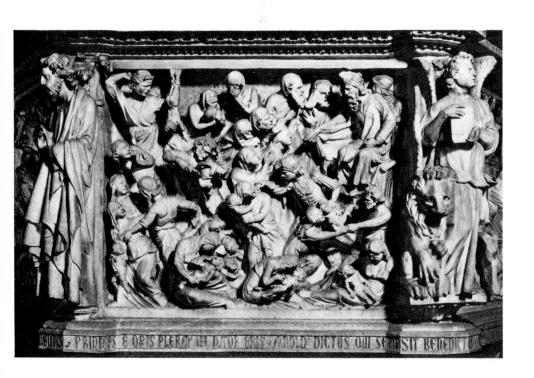

left: 46. GIOVANNI PISANO. Massacre of the Innocents, panel on the marble pulpit, Sant'Andrea. Pistoia. $33 \times 40\frac{1}{8}$ "

above: 47. GIOVANNI PISANO. Sibvl. on the marble pulpit, Sant'Andrea, Pistoia. Height 243/8"

far left: 48. GIOVANNI PISANO. Caryatid, on the marble pulpit, Sant'Andrea, Pistoia

left: 49. GIOVANNI PISANO. Madonna and Child, Arena Chapel, Padua. c. 1305–6. Marble

zigzag movement of the figure, and the constant flow and flicker of the drapery folds. But the wildest figure of all, strongly Germanic in its appearance, is the caryatid who has the unpleasant duty of upholding one of the columns on the nape of his neck (fig. 48), forcing severe contortions on the figure and a disturbing empathetic effect on the observer.

It is perhaps characteristic of the mélange of styles that coexisted in Dugento Tuscany that the Pistoia pulpit should be roughly contemporary with the last manifestations of the Italo-Byzantine style in painting. But we have seen that Cimabue was, at Assisi, capable of projecting emotional dramas on a large scale in fresco compositions. At this particular moment in Italian art, Gothic sculpture and Italo-Byzantine painting are allies. The last manifestations of Giovanni Pisano's art, however, really belong to the next chapter. The grand simplicity of his *Madonna and Child* on the altar of the Arena Chapel in Padua (fig. 49), her clear-cut profile so differ-

ent from the Romanizing profiles by Nicola, the broad sweep of the drapery masses enhancing the volume of the figure beneath them, the geniality and human directness of the expressions—all suggest a close familiarity with the art of Giotto, the great master whose frescoes fill almost the entire wall and ceiling surface of the same chapel. For the moment, at least, the harsh expressionism of the Pistoia pulpit is in abeyance, but this vein flows always just below the surface of Italian art and life, and under circumstances of stress will reappear again and again.

ARCHITECTURE

At this point we face a dilemma. It is logical enough to consider the great painters and sculptors of the Dugento and the Trecento as precursors of the Renaissance and, in their own right, as leaders of an artistic revival that is not directly comparable with the Gothic style that prevailed elsewhere in Europe. Despite their ties with the

left: 50. Nave and choir, Sta. Maria Novella, Florence. Begun 1279

below: 51. Plan of Sta. Maria Novella

Middle Ages, their work, as will be seen in later chapters, is inseparable from that of the Renaissance masters of the Quattrocento and Cinquecento. The same cannot be said of Dugento architecture—an Italian version of the Gothic without the organic complexity of French Gothic, to be sure, but Gothic nonetheless. Yet the figurative artists of the period worked within this architectural context; many of its basic preconceptions governed their frescoes, statues, and reliefs. In fact, they sometimes took part in the actual construction of Dugento buildings.

The great thirteenth-century religious movements, Dominican as well as Franciscan, required ecclesiastical buildings on an entirely new scale to accommodate their unprecedented congregations. The two finest Florentine churches of the period, Santa Maria Novella and Santa Croce, owe their existence to the preaching orders that still occupy them today. Santa Maria Novella (figs. 50, 51), founded by the Dominicans before 1246 but con-

structed from 1279 into the early Trecento, is perhaps the supreme example of the simplicity of plan, organization, and detail that characterizes Italian Gothic architecture as a whole. The church is also one of the noblest and most harmonious structures of the entire Middle Ages in any country. The plan is derived from that of the Cistercian Order founded earlier in France; in its monasteries throughout France, England, and Italy, a flat east end was substituted for the apse generally used in cathedral churches. But the relatively high side aisles, leaving little room for a clerestory and none for a triforium, are typically Italian. So is the contrast between the stone supports and arches, and the walls and vaulting surfaces covered with intonaco; these surfaces maintain a continuous membrane that encloses and harmonizes with the ascending and descending forms of the pointed arches, striped like the façade. Arches and vault ribs are flat, wall ribs are almost nonexistent, and compound piers are as simple as those of Romanesque buildings in

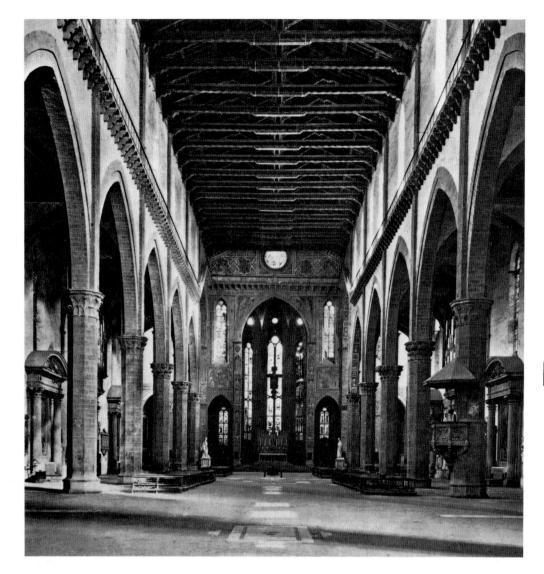

left: 52. ARNOLFO DI CAMBIO. Nave and choir, Sta. Croce, Florence. Begun 1294

below: 53. Plan of Sta. Croce

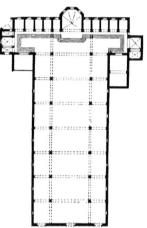

France. There is, moreover, no formal separation between the nave arcade and the wall above, pierced by simple oculi instead of the usual pointed Gothic windows. As a result there is nothing to interrupt the whole membrane, from whose dynamism emerges an unexpected and very beautiful feeling of calm and repose. This is in striking contrast to the energetic pictorial art and the rich sculpture of the period. However different the architectural forms of Santa Maria Novella may be from the later, classically derived elements of the Renaissance, the harmony of its lines and spaces renders it a fitting precursor of such Quattrocento masterpieces as San Lorenzo and Santo Spirito (see figs. 140, 141). At a moment when French architects had dissolved the wall entirely, converting whole churches into elaborate stone cages to enclose surfaces of colored glass, the unknown—possibly monastic—builders of Santa Maria Novella proclaimed the quintessentially Italian supremacy of the wall.

So did the architect of Santa Croce (figs. 52, 53), the great Franciscan church on the opposite side of the city, but in a very different way. In all probability this master was Arnolfo di Cambio, also very important as a sculptor, as a pupil and co-worker of Nicola Pisano, and as the first architect of the often-redesigned new Cathedral of Florence (see fig. 126). The construction of Santa Croce, founded in 1294, was continued well into the Trecento. The plan combines a timber-roofed nave of seven bays (immensely long for Italy), with a considerably lower, vaulted polygonal apse that is separated from the nave by a triumphal arch somewhat like those of the Early Christian basilicas in Rome but pointed, and pierced by two pointed windows. A choir screen, containing small chapels, whose position is still marked by the upward slope of the catwalk below the windows, separated the crossing from the nave. Octagonal columns replace the compound piers used in Santa Maria Novella, needless here since there is no vaulting. A catwalk carried on corbels separates the small clerestory from the nave arcade, and carries the eye straight down the nave, sharply up over the crossing, across and above the triumphal arch, and back up the nave again on the other side. While the church lacks the unearthly harmony of Santa Maria Novella, the loftiness and openness of its arches make it seem vast, almost endless. Its timber roof, instead of having the barnlike look so frequent in Italian preaching churches, is so richly treated that it contributes to the sense of mystery and grandeur. From the very start the

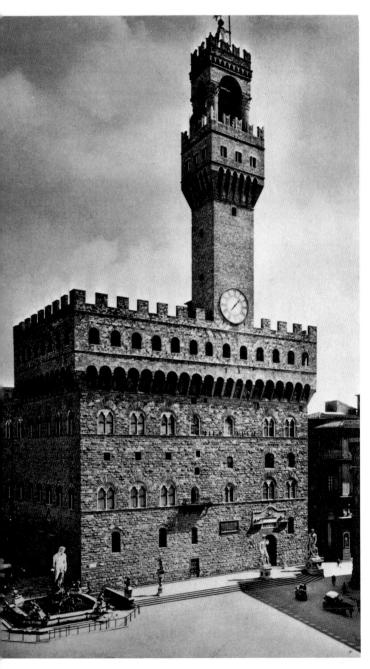

54. ARNOLFO DI CAMBIO (attributed). Palazzo Vecchio, Florence. 1299–1310

soaring wall surfaces were intended for painting, as were the windows for stained glass. In fact, the nave was still being built when Giotto and his most gifted followers, as we shall see in Chapter 3, were at work painting frescoes on the walls of four of the ten chapels (five flanking the apse on either side) along the rear wall of the transept, and in one of the two chapels terminating the transept. The Early Trecento painted decoration of the ceiling beams is still largely intact. The splendor of Santa Croce, of which this brightly painted roofing is an essential part, gives us some insight into how the Duomo of Florence (duomo is the Italian term for "cathedral") might have looked had Arnolfo's plan been followed.

In all the Italian city-states the building that housed the government competed in physical bulk and artistic magnificence with the principal churches, and Florence was no exception. Also attributed to Arnolfo, the Palazzo Vecchio (more accurately the Palazzo dei Priori, or Palace of the Priors, as the principal governing body was called) dominates a whole section of the city, and in popular imagination its tower is grouped with the dome of the Cathedral as a symbol of the city (fig. 54). In point of fact, the Palazzo Vecchio is not only the largest but also one of the last-built of the great Italian communal palaces of the Middle Ages. Many of these survive, and they form the finest body of medieval civic architecture known to us. The Palazzo Vecchio was erected in an astonishingly short space of time, only eleven years from the laying of its foundations in 1299 to the completion of the lofty bell tower in 1310. From the start the building was intended to complete a huge square produced by the destruction in 1258 of nearby houses of the traitorous Uberti family, who had fled Florence and later fought with the Sienese at the Battle of Montaperti. The building, of pietra forte (a tan-colored local stone), appears as a gigantic block, divided by stringcourses into a ground floor and two main stories, each of colossal proportions, crowned by a powerfully projecting arcade carried on corbels and culminating in machicolations. The tower, placed off-center apparently in order to make use of the foundations of earlier house towers, ends in a machicolated projecting story, and carries an open bell chamber supported on four columns.

The brutal power of the building mass is accentuated by the roughness of the blocks, rusticated, as in Roman military architecture. And the building seems even more impregnable by virtue of the relative delicacy of the mullioned windows with their trefoil arches, in imitation of French Gothic models. Its simplicity and force, its triumphant assertion of the nobility of man and his capacity to govern, were intended to symbolize the victory of civic harmony over the internal strife that tore the Republic apart in the last years of the Dugento. The building may also serve as a useful introduction to the artistic ideals of one of the greatest periods in Florentine art, the Trecento, and to the style of Giotto, its leading master.

Florentine Art of the Early Trecento

GIOTTO

iotto di Bondone (c. 1277–1337), born in the village of Colle di Vespignano in the valley called the Mugello, north of Florence, in an astonishingly short time revolutionized the art of Florence, of Tuscany, and in fact of most of Italy and eventually of the entire Western world. The first Italian master to achieve universal importance, Giotto is unquestionably one of the most powerful artists who ever lived. He was so recognized by his contemporaries. The Chronicle of Giovanni Villani, written a few years after Giotto's death, and before 1348, rates him among the great personalities of the day. Boccaccio (Decameron, VI, 5) claims that Giotto "brought back to light" the art of painting "that for many centuries had been buried under the errors of some who painted more to delight the eyes of the ignorant than to please the intellect of the wise." Dante, in a famous passage in the Divine Comedy, relates his encounter in Purgatory (XI, 94-96) with the miniaturist Oderisi da Gubbio, who bewails his own fall from popularity, comparing it with that of Cimabue, as an example of the transiency of worldly fame and fortune:

Cimabue believed that he held the field In painting, and now Giotto has the cry, So that the fame of the former is obscure.

Similar, according to Dante, was the success of the poet Guido Cavalcanti, inventor of the *dolce stil nuovo* (the "beautiful new style"), whose revolutionary use of the Tuscan language chased his competitors from the field. Dante's statements are literally true. Within a few years after the appearance of Giotto on the Florentine horizon, the style of Cimabue was banished to the villages, where it lingered only a decade or so. Immediately, most painters in Florence began to imitate the new style, which spread rapidly to other centers in Tuscany, including Siena, and then up and down the Adriatic coast, capturing one provincial school after another. Within a genera-

tion it met resistance only in Venice, strongly tied to the Greek East, and in Piedmont and Lombardy, deeply influenced by Northern Gothic. The basic conceptions of Giotto's art remained dominant, despite the personal variants of individual painters, into the Quattrocento; Renaissance artists and writers were emphatic in their insistence that Giotto was their true ancestor. Perhaps at no other moment in the entire history of painting has a single idea achieved so rapid, widespread, and well-nigh complete a change. In this respect only the French Gothic and Italian Renaissance styles in architecture can be compared to the effect of the Giottesque movement.

What was this new style? Cennino Cennini, who claimed to have been the pupil of Agnolo Gaddi (himself the son and pupil of Taddeo Gaddi, one of Giotto's closest followers), expressed the matter succinctly when he declared that Giotto had translated painting from Greek into Latin. Later Vasari was more voluble in his declaration that Giotto revived painting after it had languished in Italy since ancient times on account of the many wars that had overwhelmed the peninsula. Giotto, he said, abandoned the "rude manner" of the Greeks, and since he continued to "derive from Nature, he deserves to be called the pupil of Nature and no other." No one, not even in Cennini's time, was in a position to realize what Italian painting had gained from Byzantine examples and, perhaps, from actual Greek masters. To all commentators naturalness was equated with Latinity, which meant, of course, Roman culture in the larger sense-Italy and, as we shall see, France. The virtue of Giotto's style for his contemporaries and successors lay in its fidelity to the human, natural, Italian world they knew, as against the artificial manner imported from the Greek East. It is interesting, however, that not even Cennini speaks of Giotto drawing from posed models. But Villani seems to (XI, 12), referring to Giotto as "he who drew more every figure and action from nature," according to the precise significance one attaches to his word *trasse*, which can mean "drew" in two different senses. So pungent and convincing are Giotto's characterizations of human beings that we are almost compelled to presuppose such drawings.

The surviving work of all great Italian masters is a mere fraction of what they actually painted. But as we read Vasari's accounts of Giotto's work—even knowing that many of the paintings he mentions may really have been by other artists—we realize with especial sadness how little remains today of what Giotto must have produced in the course of a long and honored lifetime. He is reported to have worked throughout Tuscany, North Italy, and the Kingdom of Naples, including its capital, then ruled by a French dynasty. The great master was said even to have gone in person to France and there worked in Avignon, the new seat of the papacy after 1305, and elsewhere. French contacts are abundantly visible in Giotto's style, and commercial relations between Florence and all parts of Europe were so routine during the Trecento that we would be daring indeed to deny the possibility, even the ease, of a trip to France for so prosperous and universally desired a master. Whether or not Giotto really studied with Cimabue in Florence, as Vasari says he did, the older master can have played little part in the formation of the young artist's style as we now know it. The dominant influences must have been the sculpture of the Pisano family, the painting of Cavallini, French sculpture either in France itself or through small, imported works—and the rediscovery of nature.

During most of the Dugento, Florence and its territory had been the scene of bitter warfare between opposing factions: the Guelphs, who favored the pope, and the Ghibellines, who were attached to the Holy Roman Emperor. In reality, this was a class conflict, because the Ghibellines were the feudal nobility, and they and their supporters looked to the emperor to maintain them in their fiefs. The Guelphs, on the other hand, comprised the bulk of the city dwellers—artisans and merchants for the most part—who succeeded in establishing their guilds by the famous Ordinances of Justice in 1293; to all intents and purposes these ordinances disenfranchised the nobles unless, as many were eventually constrained to do, they were willing to adopt a trade and join a guild. An attempt of the nobles to regain power was put down in 1302, and hundreds of Ghibellines, including Dante, were exiled from the city. It is against this triumph of the energetic, prosperous commercial and artisan class, who equated their values with the highest ideals of the state, that one must understand the firm, quiet, eminently practical art of Giotto, with its emphasis on clarity, measure, balance, order, and on the carefully observed drama developing between human beings at close quarters.

THE ARENA CHAPEL. In this same period Padua, a great university city not far from Venice, had regained its republican independence and created a considerable state in the flat Venetian plain. A wealthy Paduan merchant, Enrico Scrovegni, acquired in 1300 the ruins of the ancient Roman arena in Padua as a site for his palace and chapel. He began building the chapel in 1303; in 1305 it was consecrated. A series of manuscript copies of the chapel's frescoes can be dated in 1306. From the very start, apparently, Scrovegni had the idea of asking Giotto, who according to one account was satis iuvenis ("fairly young") and who was then at work on a fresco series in the Franciscan Basilica of Sant'Antonio in Padua, to paint the interior of the chapel, probably in expiation of the sin of usury committed by Scrovegni's deceased father, Reginaldo. Undoubtedly, Giotto had assistants working with him, but he certainly planned the entire fresco cycle of the nave (those of the chancel are later) and painted all the principal figures and much of the rest with his own hand. The frescoes of the Arena Chapel form not only his greatest preserved achievement but also one of the most wonderful fresco cycles anywhere (fig. 55). They are astonishing in their completeness and state of preservation, despite the recent menace from industrial fumes. The chapel is small, intended for a congregation of the Scrovegni family and their retainers, and the frescoes themselves are smaller than they seem to be in reproductions; the figures are about half life-sized. The windows are on the south wall only and were kept small in order to provide as much wall space as possible for the frescoes; these climb the walls in three superimposed rows of scenes, like motion-picture strips. The scenes are enclosed in delicately ornamented frames that form a continuous structure of simulated architecture, apparently simple, but actually of great subtlety and complexity, surely designed by Giotto, and enclosing small scenes in French Gothic quatrefoil frames that act as commentaries on the larger ones. The vault is painted the same bright blue as the background color in all the frescoes—naturally enough, since vaults and domes were traditionally held to be symbolic of Heaven, and Italian documents show that the vault of an interior was often referred to as il cielo ("the sky"). This one is covered with gold stars, and bust portraits of Christ and the Four Evangelists, and the Virgin and four prophets, float in circular frames against the blue.

The chapel is dedicated to the Virgin of Charity. The wall surfaces are so divided that the Life of the Virgin and the Life of Christ are told on three levels, divided into six sections of narrative, in thirty-eight scenes. The incidents are so chosen as to lay special stress on the Life of the Virgin, as told in the Golden Legend by the thirteenthcentury Genoese bishop Jacobus de Varagine, and to omit from that of Christ many scenes in which the Virgin plays no role. Narration begins on the upper level, to the right of the chancel arch, with the events of the lives of Joachim and Anna, the Virgin's parents, on the righthand wall and the Life of the Virgin on the left, ending

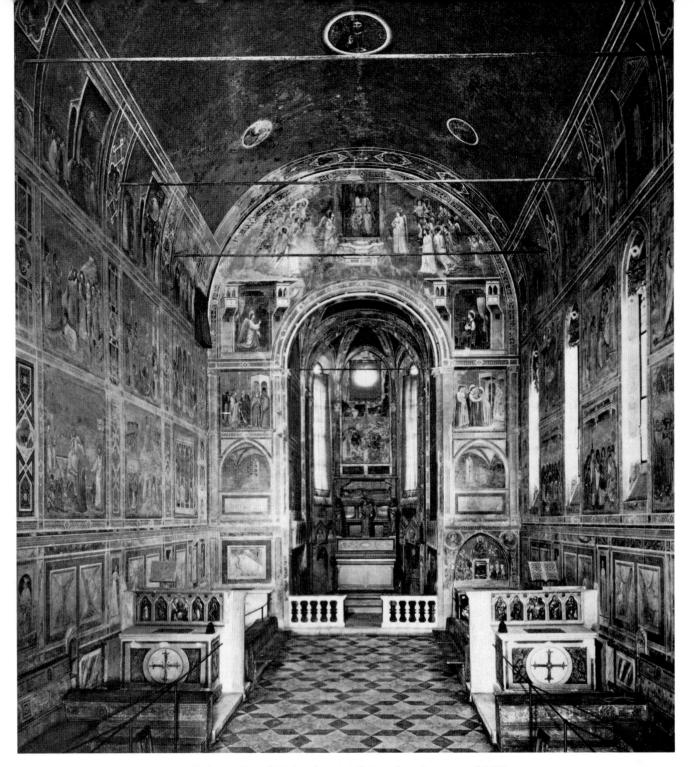

55. Arena Chapel, Padua. Interior, facing altar. Consecrated 1305

with the Annunciation on either side of the sanctuary and God the Father enthroned in the center over the chancel arch, sending the Archangel Gabriel on his mission. On the second level, the Infancy of Christ, on the right-hand wall, culminates in his adult mission, on the left. On the lowest tier, the Passion of Christ on the right is followed on the left by his Crucifixion and Resurrection. A dado below, painted to imitate veined marble, is relieved by small images in grisaille imitating sculptural reliefs, the Seven Virtues on the right and the Seven Deadly Sins on the left. The drama of human salvation comes to its climax in the Last Judgment, covering the

whole entrance wall (see colorplate 9). In a sense, the narration can be compared to that of the cinema, so exact is Giotto's sense of timing and so clear is his presentation of each dramatic incident. Unfortunately, in a book of this scope all of the scenes cannot be illustrated, and this cinematic sequence must be studied elsewhere.

The observer entering the chapel does not yet recognize the element of time, but he is at once aware that he has suddenly stepped into a world of order and balance. The Byzantine fabric of compartmentalized figures and gold-striated drapery has vanished. All is clear light, definite statement, strong form, firm ground, carefully

modulated ornament, simply defined masses, and beautiful glowing color, the colors of spring flowers. One is reminded of Ruskin's phrase, "the April freshness of Giotto."

In every scene, something in the dignity and balance of Giotto as a narrator makes one think of Sophocles, who "saw life steadily and saw it whole." Italian documents and sources contain no word for our "scene": scenes are invariably called storie ("stories"), and that is what they are throughout Italian art. Each storia is an incident from a continuous drama, and is based on a simple, human relationship of figures. We can follow the plot, generally accompanied in the Shakespearean sense by one or two subplots as well, in great or delicate, but never excessive, detail as we move through the series. In an incident from the Life of the Virgin, for example (fig. 56), Joachim, who will become her father but has here been expelled from the Temple on account of his childlessness, has taken refuge with the shepherds in the wilderness. This is the principal plot, and on the relationships among the figures the entire composition is founded. Joachim looks downward, overcome by humiliation. The shepherds accept him only with reluctance; one looks toward the other, attempting to gauge his response and judge whether it is safe to take in this outcast. The masses of the landscape are so deployed as to frame and accentuate this tense moment. Then comes the subplot; the sheep, symbols of the Christian flock (priests and ministers are still called pastors), pour out of their little sheepfold, and the dog, age-old symbol of fidelity in Christian art, leaps upward in joyful recognition of Joachim's sacred role.

The landscape, the most advanced known at that time, is powerfully projected, but deliberately restricted in scope. Cennini instructs his readers that, to paint a landscape, it is necessary only to set up some rocks in the studio to stand for mountains and a few branches for a forest. Yet Giotto's iceberglike, rocky backgrounds form an effective stage setting for his dramas, and in successive scenes that supposedly take place in the same spot he does not hesitate to rearrange the rocks a bit to bring out the inner meaning of the particular moment of action. The rocks enclose a distinct space that is limited, behind all the scenes, by the continuous heavenly blue background that should not be confused with real sky. It never contains clouds or other atmospheric phenomena, unless these are used to indicate the angels' celestial origin.

Within this shallow box of space, the figures stand forth in three dimensions like so many columns, the drapery masses simplified so as to bring out as convincingly as possible the cylindrical volumes of the figures, which show profile, one-quarter, and even back views instead of the customary three-quarter aspect of figures in Dugento painting. In delicate gradations, the light models faces, drapery, rocks, and trees, with a precision and delicacy far beyond the capabilities of Cavallini (not to speak of his Serbian models), establishing their existence in space. But—and this is of prime importance—no source is yet shown for the light. It is a uniform illu-

56. GIOTTO. Joachim Takes Refuge in the Wilderness. After 1305. Fresco. Arena Chapel, Padua

mination that bathes all scenes alike, regardless of the time of day, and this, of course, helps to maintain the unity of all the compositions within the space of the chapel. Giotto's light, having no source, casts no shadows and makes no reflections. With few exceptions, cast shadows do not appear in painting until the Quattrocento, yet we can hardly imagine that Trecento painters were unaware of shadows. In a famous passage in the *Inferno* one of the damned asked who Dante is, since he casts a shadow (and the dead do not). And there is a rich medieval literature on light and its behavior. But for some reason as yet unexplained, painters did not consider natural light effects to be suitable for representation. Giotto's realism is limited, like his space, by a set of conventions, but he often suggests a more distant space; some trees are shown cut off by the rocks, so that we read them as growing on the other side of the hill. And there is no limitation whatever to the depth and subtlety of his observation of the reactions of human beings.

The next scene is the *Vision of Anna* (fig. 57), back in Jerusalem, where she is visited by an angel who flies in through the window and announces to her that she will conceive and bear a child. Out on the back porch the servant, who is spinning, pays no attention. (This figure may be symbolic; Mary was destined to become a Temple virgin, engaged in spinning the wool for the veil of the Temple, rent at the Crucifixion, and the stairway symbolizes Mary's role as Stairway to Heaven.) The setting is a charming little construction—its classical pedi-

ment containing a medallion with a bust portrait uplifted by angels is imitated from a Roman sarcophagus—but it is not meant to indicate an actual building. Its jambs and entablature are enriched with ancient Roman carved acanthus scrolls, instead of Cavallini's mosaic inserts, and it is roofed with scales of marble rather than Italian roof tiles; probably this exterior also is symbolic, a shrine for the Immaculate Conception of Mary. Like the rocks in the landscape backgrounds, a few simple architectural elements symbolize a complex reality. The front wall is removed as in a stage setting so that we see the interior of the house, and Giotto has treated us to a view of a Trecento Florentine room with a bed and its curtains, a little chest for clothing, shelves, and various objects hanging on the wall. The cube of space is turned at a slight angle, so that we can see two sides at once. The head of the angel, seen from above, is foreshortened as a definite, powerful little volume in space. Vasari is eloquent on the subject of Giotto's foreshortenings, and he is probably right in claiming that Giotto was the first to be able to do them. Cennini tells us that the distant objects should always be represented darker than those in the foreground; this must have been another convention derived from Giotto, and it will be noted that the elegant frame of the architecture is more brightly lighted than the recesses of the interior, just as the foremost leaves on Giotto's trees are always lighter than those farther away (see fig. 56).

We next arrive at the famous Meeting at the Golden

57. GIOTTO. Vision of Anna. Arena Chapel, Padua

Gate (fig. 58). Meanwhile Joachim has also received a revelation from an angel and returns to Jerusalem to tell Anna, just as she rushes out to break the news to him. Their encounter, like the rest of the story described in the Golden Legend, occurs on a bridge outside the Golden Gate of Jerusalem. The small scale of the architecture as compared with the figures is explained by another Trecento convention, this time easy enough to understand. Architecture, especially Italian architecture, is relatively large; people are small. To apply the same scale to architecture and figures would result either in reducing the figures to a point where the story could be read only from close up, or in omitting all but the lower portions of the buildings. Giotto and his followers—in fact all artists, well into the Quattrocento-were content with a double scale that presented the story in all its force without mutilating the architecture.

In this case the architecture, in particular the beautiful shape of the arch embracing even the happy neighbors, reflects the emotions of the figures. Few scenes in art are more moving than this reunion of husband and wife. Anna puts one hand around Joachim's head, drawing his face toward hers for a long embrace. As always, Giotto's draftsmanship is broad and simple, leaving out details that might interrupt his message of sincere human feeling or the powerful clarity of his form. One subplot, of course, can be sensed in the reactions of the neighbors; another appears in the shepherd who accompanies Joachim and carries his belongings and who is partly cut

off by the frame, a convention to indicate that he has come from a distance.

Turning to the events directly connected with the Life of Christ, we find the *Annunciation* (figs. 59, 60), divided into two sections, in the spandrels flanking the sanctuary arch. The author underscores that this was the position designated for the Annunciation by a tradition going back to Byzantine art, because the prophet Ezekiel was shown a vision of the sanctuary of the Temple, whose gate was shut (Ezekiel 44:2–3):

... and no man shall enter in by it; because the Lord, the God of Israel, hath entered in by it, therefore it shall be shut.

It is for the prince; the prince, he shall sit in it to eat bread before the Lord; he shall enter by way of the porch of that gate and shall go out by the way of the same.

To Christian theologians the closed gate (*porta clausa*) of the sanctuary, which only the Lord both entered and left, stood for the virginity of Mary; the prince was Christ; the bread the Eucharist.

Giotto has represented the Annunciation, the moment of the Incarnation of Christ in human form, in a new and intimate way that is in keeping with his profound understanding not only of religion but also of the human heart. He has laid stress on the moment in which Mary accepts her immense responsibility: "Be it done to me according to thy will." In token of resignation she

58. GIOTTO. Meeting at the Golden Gate. Arena Chapel, Padua

59, 60. GIOTTO. Annunciation. Arena Chapel, Padua

crosses her hands upon her bosom and she kneels, as does the angel, as if enacting the widespread practice of genuflection on one or both knees, introduced in the eleventh century as an act of adoration of the Eucharist, but not required at Mass before 1502. On the noble figure of the Virgin, kneeling in absolute profile, beats a flood of light. This is actual light, not golden rays or masses of gold leaf (even though the haloes are still rendered as gold disks); it is painted with a soft orangeyellow pigment, in clustering rays. Yet there are no sources of natural light anywhere in Giotto's art. This is the light of Heaven. Light is identified mystically with the Second Person of the Trinity: "In him was life; and the life was the light of men.... That is the true Light which lighteth every man that cometh into the world." These words, repeated as a private devotion at the close of the Mass, eventually entered the liturgy.

The two little stages on which Giotto has placed the two participants of the Annunciation are derived, it has lately been shown, from constructions used in the dramatizations of the Annunciation that actually took place during the Trecento in Padua; these started at the Cathedral and culminated in performances in the Arena Chapel. But Giotto has filled his two spaces with the radiance of Divine Light, coming from the throne of God the Father in the arch above, as in the angel's pledge to Mary, in the Gospel. In his *Annunciation* we have emerged from a world where every scene is bathed in the same dispassionate light into a world of mysticism and revelation, unexpected for an artist so classical and self-possessed as

Giotto and prophetic of the great mystical paintings of the Late Renaissance and the Baroque, when light again plays the catalytic role. It is important for the deeper understanding of Giotto's style and personality to recognize that even he, the most reasonable of artists, found a point at which he was willing to break the rational order of his universe for a revelation, submerging clear shapes in a tide of shadow and light.

Before Giotto, Italian artists had always placed the Nativity in the cave required by Byzantine tradition (now less familiar to us than the stable, of European tradition). Although the cave still exists in Bethlehem—authentic or otherwise—the Gospel account gives no precise setting. Giotto, perhaps after his visit to France, adopted the shed usually depicted in Gothic art (fig. 61). He also eliminated the apocryphal account of the baby's bath. The midwives are still there, however; one is handing the Christ Child, already washed and wrapped, to Mary. The ox and ass, who almost invariably appear in Western Nativities, look on. They are a fulfillment of the prophecy of Isaiah: "The ox knoweth his owner, and the ass his master's crib: but Israel doth not know, my people doth not consider." Joseph is sleeping in the foreground. The Annunciation to the Shepherds is taking place around and above; rejoicing angels are scattered in a variety of positions against the blue, and one leans downward to give the tidings to two shepherds. One shepherd has turned his back to us—a simple device, yet it is impossible to overestimate what this implies for the painter's attitude toward space; he now can turn and move his figures in

61. Giotto. *Nativity*. Arena Chapel, Padua

62. Giotto. Flight into Egypt. Arena Chapel, Padua

any direction. Giotto's backs, moreover, are extremely expressive: the shepherd's astonishment is written in the set of his shoulders, the back of his head, the calves of his legs, even the hang of his garment.

In the *Flight into Egypt* (fig. 62), the family moves calmly and intrepidly off to the distant land, led by an angel who is visible only to the waist, disappearing in a trailing cloud. Mary, seen in complete profile, holds the Christ Child to her bosom. Both Giotto's intense humanity and his awareness of the meaning of time are illuminated by the fact that the previously almost bald Child has now grown dark hair. The pyramidal group is deliberately echoed in the structure of the background rocks. Giotto has again suggested movement in space by cutting off the last figures, to show that they have come from outside the frame. Giotto's animals are always delightful, and this patient donkey is one of his most convincing, a complete animal personality.

Turning to the mission of the adult Christ, the *Raising* of *Lazarus* (colorplate 8; fig. 63) is one of the most powerful scenes in the chapel. Christ, the clear-eyed, short-bearded Christ of French Gothic tradition, such as the majestic "*Beau Dieu*" from the central portal of Amiens Cathedral, whose very pose Giotto has adopted (fig. 64), rather than the Byzantine type favored by Coppo and

63. GIOTTO. Head of Christ, detail of Raising of Lazarus (see colorplate 8). Arena Chapel, Padua

64. Christ Treading on the Lion and the Basilisk ("Beau Dieu"). c. 1220. Central portal, Cathedral of Notre Dame, Amiens, France

Cimabue, stands silhouetted against the blue, calling Lazarus from the dead by a simple gesture of his right hand. The corpse in its grave clothes stands forth miraculously, in the pallor of death, while Lazarus's sisters, Mary and Martha, prostrate themselves before Christ in supplication. Giotto includes the traditional figures who cover their noses ("by this time he stinketh," John 11:39), yet in the context of his larger humanity such details never seem disturbing. Despite the considerable number of elements, the scene is clearly and simply composed, divided into blocks of figures by broad diagonals, verticals, and rhythmic curves. Again Giotto has exploited the back of the figure as an expressive device, in the massive workman at the right. The color is remarkably vivid in this scene and includes iridescent passages (the

bending workman is dressed in pale peagreen with rustcolored shadows), the formula for which is recorded in Cennini's handbook and persisted into Renaissance painting. An especially striking bit of coloristic freedom is seen in the veined marble of the tomb slab, forerunner of gorgeous effects that will turn up again and again in later Italian painting. Christ's blue garment was rendered in one of the pigments that, Cennini tells us, could not be painted in true fresco, and therefore had to be added a secco. As a result, much of it has peeled off, showing the brushstrokes of the underlying drawing. In a striking, but by no means unusual, balancing of New Testament events against those of the Old that were believed to have foreshadowed them, Giotto placed in the adjacent border a quatrefoil containing a little view of the Creation of Adam, very close to that carved later by Andrea Pisano, possibly from Giotto's designs, on the Campanile of the Cathedral of Florence (see fig. 84). Here the Triune God, whose cruciform halo marks him as having assumed the form of the Son, the Second Person of the Trinity, raises Adam from the dust, as Christ—obviously the same face—raises Lazarus.

We now turn to the story of the Passion; in the Betrayal (fig. 65) Giotto follows the general compositional arrangement of the scene in the Uffizi Cross (see fig. 26). The nucleus of the drama is the group of Christ and Judas. Even though his body almost disappears in the tidal wave of Judas's yellow cloak, which moves upward to embrace it, Christ stands as firmly as in the Raising of Lazarus, with the same calm gaze. Giotto has exploited the contrast between the classical profile of Christ and the bestial features of Judas, his lips pursed for the treacherous kiss, as a confrontation of absolute good and absolute evil. The contrast is especially striking since, in the preceding scene of the Last Supper, Judas had the same handsome, youthful face as many of the other Apostles. But the Gospel account (John 13:27; see page 262) tells us that the devil entered into Judas when he took the sop in wine. Giotto has increased the impact of the drama by inserting the noses and eyes of Roman soldiers, barely visible, between the confronted faces.

The unforgettable main group is flanked by two intense and sharply different subplots. Required by iconographic tradition to depict the episode of Peter cutting off the ear of Malchus, the High Priest's servant, Giotto has almost concealed it behind another of his great expressive backs, that of a hooded attendant at the left trying to restrain Peter. Especially telling is Giotto's exploration of the character and feelings of the High Priest himself at the right, entirely through his pose. He points

65. GIOTTO. Betrayal. Arena Chapel, Padua

66. GIOTTO. Crucifixion. Arena Chapel, Padua

toward the treacherous embrace in the center yet vacillates as he does so, as if unable to face the full wickedness of Judas's betrayal. His crooked finger begins to contract, and the masses of his garments break up into little shivering folds, deliberately contrasted with the sharp, forward lunge of Judas's cloak.

It will be noticed that the halo of Christ, modeled in plaster on the surface of the fresco, is shown in perspective. Some of the effect of the composition has become dissipated by the loss of the swords, halberds, and torches, which, painted *a secco*, have largely peeled off.

In some ways the Crucifixion (fig. 66) in the Arena Chapel is more impressive than any other in Italian art. Giotto has shown the Christus mortuus, not the Christ of the liturgical crosses of the late twelfth and early thirteenth centuries triumphant over death, nor the agonized victim in Italo-Byzantine representations. Here he is dead, quietly and absolutely. He hangs there; one is made to feel the actual weight of the body suspended from the arms. No one screams; there are few gestures. Mary stands under one crossarm and, in the most effective manner open to his temperament, Giotto has shown the result of her overwhelming grief. Mary collapses. That is enough. She has lost the columnar entity, the firmness, the grandeur with which Giotto endowed humanity. To his mind, perhaps, there could be no more terrible fate.

Mary is supported by St. John and one of the other Marys. Mary Magdalen, as she almost always does from now on, kneels before the Cross, her long golden hair unbound, gazing at the feet she once washed with her tears and dried with her hair. At the right, the Roman soldiers are disputing over Christ's seamless robe; one, dressed in a gilded cuirass, argues with a companion, who is about to cut the robe with a knife. Above are the grieving angels, their positions recalling their rejoicing counterparts in the Nativity; they soar against the blue, as in Cimabue's Crucifixion (see fig. 32), but their motion here follows in a beautiful arc the curve of the arms of the hanging figure. Some hold chalices to catch the blood from Christ's hands and side, others rend their garments or wring their hands. Directly above the Cross two angels fly straight toward the observer, so that their heads are foreshortened from above. Even this scene of deepest tragedy is presented with the same quiet firmness of composition—two blocks of figures, at once divided and united by the Cross-and the same fresh beauty of color we find throughout the cycle.

The justly famous *Lamentation* (fig. 67), like the *Betrayal*, follows a traditional Byzantine type, as at Nerezi (see fig. 22), common in the Dugento in Italy (see figs. 21, 29). The dead Christ is stretched across the lap of Mary, his head upheld by a mourning figure seen only from the back, while another holds up one of his hands;

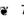

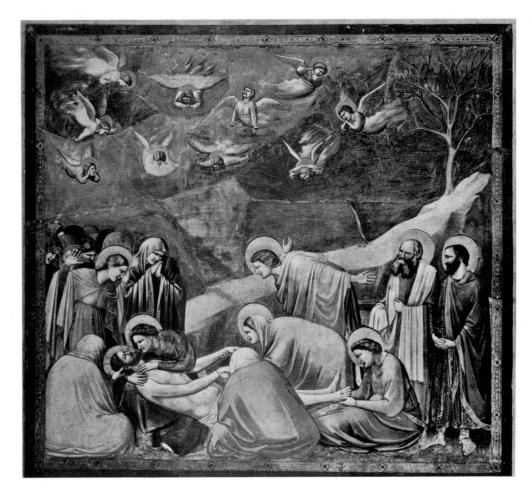

67. GIOTTO. Lamentation. Arena Chapel, Padua

Mary Magdalen gazes down at his feet cradled in her hands. John, the Beloved Disciple, stands with arms outstretched looking at the countenance of his Master, and the long line of the barren rock behind him moves down inexorably toward the mysterious interchange between Mary and Christ, she searching his face as if to elicit an answer from beyond the barrier that separates life and death. The angels here float in a discordant succession, twisting and turning first toward us, then away. But the drapery lines of all the main figures point sharply down, toward earth. Here and there some startling bits of Giotto's coloristic freedom are visible, especially the Apostle wringing his hands, whose gray-blue cloak has plumcolored shadows. At the upper right, summing up the tragic scene, stands a single withered tree. The author notes that this tree recalls Christ's words as he was led to Calvary, "If they do these things in a green tree, what shall be done in the dry?"; that is, If they do this while I am alive, what will they do after I am dead? This celebrated phrase was widely held to refer to the Tree of the Knowledge of Good and Evil, which withered after Adam and Eve ate the forbidden fruit. According to legend, especially the Legend of the True Cross later painted in more detail by Agnolo Gaddi and by Piero della Francesca, and the long poem called The Pilgrimage of Human Life by the fourteenth-century Cistercian monk Guillaume de Déguilleville, the wood of the Cross came from this tree. Its life was restored only through the Crucifixion of Christ, who was, mystically speaking, the fruit of the other tree that grew in the Garden of Eden, the Tree of Life. Thus, through the sacrifice of Christ, the Tree of Knowledge again brought forth life for mankind. Giotto was never sympathetic to elaborate theological symbolism, but in this case he seems to have utilized the well-known significance of the withered tree for an overwhelming dramatic effect.

The Last Judgment (colorplate 9) fills the entire entrance wall, save only for the inconvenient window around which Giotto deployed battalions of the heavenly host. On either side of the window solemn archangels roll away the heavens like a scroll (Isaiah 34:4; Revelation 6:14) to display the golden gates of Paradise. Rather than showing in detail the torments of Hell for which the Divine Comedy, begun by Dante at perhaps about the same time as the frescoes in the Arena Chapel, was to provide other painters with such an inexhaustible supply, Giotto selected only a few punishments and did not dwell on those. Millard Meiss has pointed out that, for Giotto, Hell is a place of disorder. To his temperament nothing could be more terrible than the dissolution of the structure of the Universe, which event seems to be taking place at the lower right. In the center, Christ, wearing the seamless robe, is enthroned as judge of all creation, on a rainbow throne. This, like the rainbow

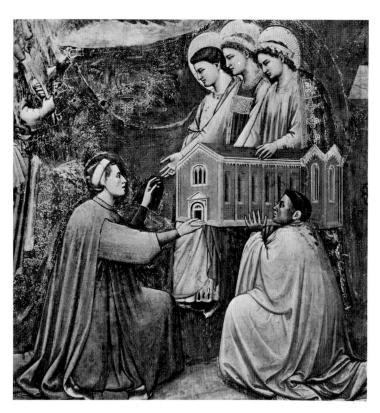

68. GIOTTO. Enrico Scrovegni Offering the Model of the Arena Chapel, detail of *Last Judgment* (see colorplate 9). Arena Chapel, Padua

glory around him, is made up of countless tiny, colored feathers, graduated in tone like those in the wings of Dugento angels, here recalling the many references in the Psalms to the Lord's wings and feathers. The seat is upheld by the beasts of the Four Evangelists, dimly seen in the blaze of light that emanates from the risen Lord. The glory is attended by angels on either side, and cohorts of angels float above. Whereas Coppo's terrifying Judge stares impassively, Giotto's compassionate Christ averts his face from the damned and in his humanity betrays what appears to be grief over their fate. To left and right, the Apostles are enthroned exactly as in Cavallini's fragmentary fresco (see colorplate 5), which Giotto must have known. Below, the dead rise from their graves and are welcomed into Heaven or consigned to Hell. Among the blessed can be seen the same soldier who saved the seamless robe! Four rivers of red and orange fire proceed from the throne of Christ to engulf the damned.

Directly over the door of the chapel, the Cross of Christ is upheld by angels, and directly below the Cross kneels Enrico Scrovegni himself, together with an Augustinian monk (fig. 68) upholding a clearly recognizable model of the Arena Chapel as his expiatory offering. (Considering the quality of the work he commissioned, it is to be hoped that Enrico's offering was accepted.) The portraits are among the earliest convincing examples of

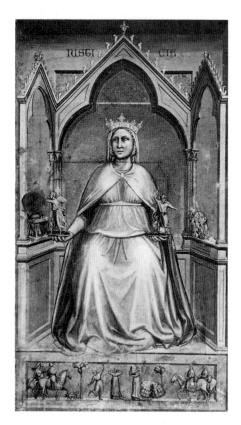

69, 70, 71. GIOTTO. Justice, Injustice, and Inconstancy. Arena Chapel, Padua

portraiture that we have, as distinguished from the stock effigies common in medieval art, which may or may not have resembled their subjects. One gets the feeling that Enrico Scrovegni must have looked like Giotto's portrait of him. The precise identity of the figures who accept the model has been a matter of controversy. The most persuasive arguments identify the left figure as St. John, the central one, holding out her hand toward Scrovegni, as St. Mary of Charity, to whom the chapel was dedicated. and the crowned woman on the right as St. Ursula, a royal princess (see page 417). Whoever they may be, they are beautiful figures, with their classical profiles, their calm, steadfast gaze, and their radiant flesh.

The Virtues and Vices on the lower sections of the walls recall the tradition so common in French Gothic portal sculpture. Enthroned Justice (fig. 69) is a regal figure before whom commerce, agriculture, and travel, the essential human activities of Italian corporate life, proceed undisturbed. Her counterpart, Injustice (fig. 70), is a robber baron (reminding us that Padua and Florence were both merchant republics organized against the nobility) who, from his castle gates surrounded by rocks and forests, presides over rapine and murder. Vices are proverbially more interesting than Virtues: in Giotto's fascinating series perhaps the most significant for his style is Inconstancy (fig. 71) on her precarious wheel, who tries so desperately to maintain the balance that to Giotto is the essential of existence.

THE OGNISSANTI MADONNA. Although not dated precisely, the great Enthroned Madonna (fig. 72), painted by Giotto for the high altar of the Church of Ognissanti (All Saints) and now in the Uffizi, is believed to have been done about 1310, not long after the completion of the Arena Chapel. The gabled shape is similar to that of Cimabue's Santa Trinita Enthroned Madonna and Child (see colorplate 4) and of a number of other Dugento altarpieces, beginning with Bonaventura Berlinghieri's St. Francis (see fig. 24), and may well have been ordered without Giotto's approval. Giotto has placed the Virgin on a beautiful Gothic throne, like that of Justice in the Arena Chapel—another instance of his interest in French inventions. This throne, with its pointed vault, delicate gable ornamented with crockets, and open arched wings, provides for the Madonna a cubic space that is utterly different from the elaborate Byzantine thrones of the Dugento. Her feet rest on a marble slab; access to the throne is provided by a marble step. Narrow panels are filled with delicate, controlled ornament painted to resemble inlaid geometrical shapes alternating with foliate motifs, in contrast with the free forms of the marble veining, surprisingly fluid and brilliant in color.

The Virgin gazes outward with the calm dignity we would expect of a Giotto representation. The Child looks slightly upward, his right hand lifted in the two-

72. GIOTTO. Enthroned Madonna (Ognissanti Madonna). 1310. Panel, 10'8" × 6'81/4". Uffizi Gallery, Florence

finger gesture of teaching, the scroll held lightly in his left, and his mouth open as if talking. Here, as in the frescoes, Giotto has completely abandoned anatomical compartmentalization. The massive shapes of the drapery and limbs have a clear-cut existence in depth, which no needless complexities are permitted to disturb. The robust Child is lightly but firmly held by his mother, whose fingertips press against his waist. Her right hand is truly sculptural in its apparent roundness, and the cylindrical shape of her neck is brought out by the clean, round neckline of the tunic. The Child's beautiful head is a definite block in space, completely hiding the right ear from our sight.

On each side of the throne three saints are grouped in a row behind three angels, grouped in a triangle, all of these figures smaller in scale than the Queen of Heaven. The two foremost angels, dressed in a beautiful, clear green, offer Mary a crown and a golden cylindrical box. They are in exact profile, as are the two kneeling, chant-

73. GIOTTO. St. Francis Undergoing the Test by Fire before the Sultan. Probably 1320s. Fresco. Bardi Chapel, Sta. Croce, Florence

ing angels before the throne who present crystal vases of lilies and roses, both symbols of the Virgin. The brilliant clarity of their profiles, strikingly similar to that of Giovanni Pisano's *Madonna* in the Arena Chapel (see fig. 49), and the glowing white of their tunics with shadows of soft lavender-gray make these among the most beautiful of all Giotto's figures. When compared with such complex visionary altarpieces of the later Dugento as Cimabue's *Enthroned Madonna*, Giotto's *Ognissanti Madonna* seems the quintessence of stability, harmony, and warm humanity.

THE BARDI AND PERUZZI CHAPELS. After the great fresco cycle in Padua and the equally fine Ognissanti Madonna panel, Giotto's style underwent a considerable change. Two fresco cycles remain in the chapels immediately to the right of the chancel in the Franciscan Church of Santa Croce in Florence, the chapels of the Bardi and the Peruzzi families, who derived their riches from the two greatest banking houses in Italy. The dates of the frescoes, painted when the other end of the church was still unfinished, are as controversial as the order in which the two chapels were painted. Both appear to date from the 1320s, a period of turmoil and difficulty, during which the hard-won popular government was sharply threatened from within and the territory of the Republic diminished by attacks from the Ghibelline forces of Pisa and Lucca, under the tyrant Castruccio Castracane. Under such circumstances, perhaps the heroic harmonies of the Arena Chapel could not be recaptured.

Both chapels were completely whitewashed in the eighteenth century; after the frescoes were made visible again in the nineteenth, they were so thoroughly repainted that any attempt to retrieve their original appearance seemed hopeless. Careful restoration has removed all or most of the repaint, to show a sharply different situation in each chapel. The Bardi Chapel, frescoed with scenes from the Life of St. Francis, reappeared in good condition, save for gaps left by earlier mutilations. But the Peruzzi Chapel is only a ghost of its former self; apparently it was painted in haste and largely a secco. In painting the Ognissanti Madonna, Giotto must have had some assistance, and certainly did in the frescoes at Padua and in the Bardi Chapel, not only in laying out the surface but also in the actual painting, especially of the background figures and less important details. But in the Peruzzi Chapel the quality of what is left indicates that Giotto made colored drawings that were then enlarged and possibly even painted in great part by his pupils. Conservation work by Leonetto Tintori in both chapels has shown conclusively that there were never any underdrawings on the wall, so preparatory drawings on paper or parchment are the only conceivable means of transferring the ideas from the mind of the painter to

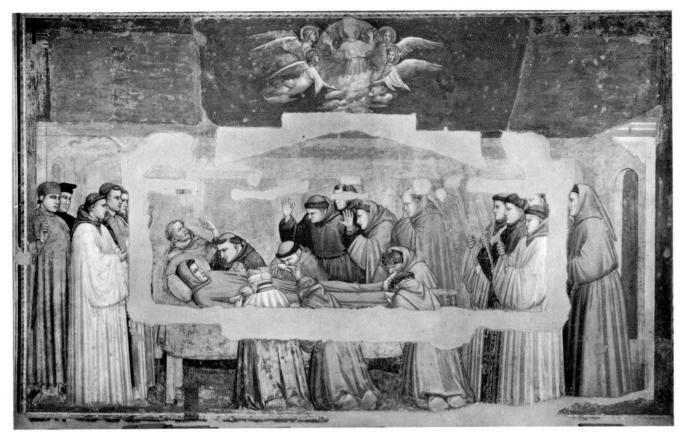

74. GIOTTO. Funeral of St. Francis (see also colorplate 10). Probably 1320s. Fresco. Bardi Chapel, Sta. Croce, Florence

the pictorial surface. At least one other fresco cycle and a considerable number of panel paintings, some of them very fine, betray the same collaboration between the overpopular master and the army of helpers necessary for the execution of all the commissions that he accepted in his later years.

In the Bardi Chapel the fresco representing St. Francis Undergoing the Test by Fire before the Sultan (fig. 73) shows some renunciation of the controlled dramatic intensity that made the Arena Chapel frescoes so powerful. A kind of stasis seems to have overcome Giotto in his late style; at first sight very little appears to be going on in these frescoes, all divided symmetrically as if they were altarpieces. A closer look, however, discloses that Giotto's essentially dramatic and human style has merely become subdued in his later years. In the center the sultan is seated grandly on his throne, his right arm crossing his body, his head turned slightly to the left. On the right St. Francis calmly prepares to undergo the test by fire from which, of course, he will emerge unharmed, to the great discomfiture of the Muslims who can be seen already creeping away on the left, their state of humiliation indicated not only in their faces but in the disarray of their drapery folds. The two slaves beside them are among the earliest representations of black persons known in Western art, and are sensitively understood not only in their rich coloring, set off by the luminous white and soft gray of their garments, but also in the careful analysis of their facial structure.

The Funeral of St. Francis (fig. 74) was mutilated to include a tomb, long since removed. Old photographs show the missing sections of the fresco replaced by some fanciful inventions of the nineteenth-century restorer. What now remains, if fragmentary, is at least entirely by Giotto's hand, and of the utmost beauty. The saint lies upon his simple bier before a wall; the other poverelli crowd weeping around him, kissing his hands and feet, gazing into his eyes, in a composition that subtly recalls the Lamentation in the Arena Chapel (see fig. 67). Priests and monks at the saint's head intone the Office of the Dead. Beside him, and with his back to the observer, kneels a richly dressed knight of Assisi, who, like a new St. Thomas, thrusts his hand into the wound in the saint's side. Above the little room, angels bear the released soul heavenward, attended by clouds. Again the composition is static, symmetrical, and carefully balanced, in contrast to the diagonal arrangements so common in the Arena Chapel. Yet a closer view shows that the drama still goes on, under the composed and quiet forms (colorplate 10). The beautiful face of the pale saint himself, his eyes mysteriously not quite closed, and those of the mourners—even the characteristic Giotto backs—betray an inner feeling too deep for overt expression. In this fresco the late style of Giotto reaches a

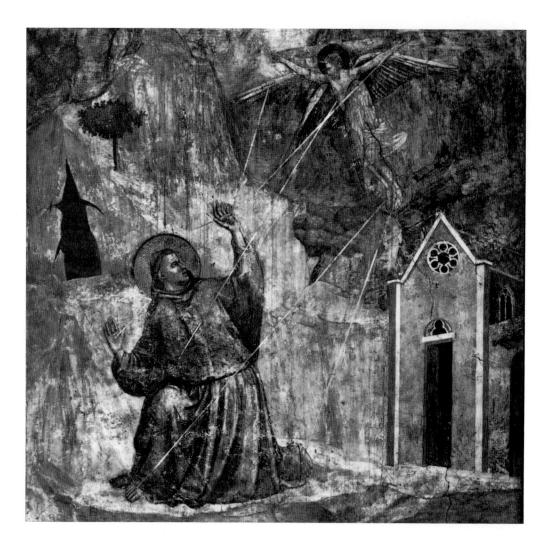

75. GIOTTO. Stigmatization of St. Francis. Probably 1320s. Fresco. Bardi Chapel, Sta. Croce, Florence

new stage of calm, purity, and breadth. Sometimes we are able to watch him at work; the head of the brother looking upward in wonder at the soul carried to Heaven was painted at great speed. The artist did not bother to erase his preliminary lines or to paint over the quick touches of the brush in which the cowl is indicated. The result is a head of astonishing freshness and freedom, the spontaneity of the brushwork reminding us of ancient Roman painting in Pompeii and Herculaneum, a style Giotto perhaps knew from other sources now lost to us.

The square space on the transept wall above the Bardi Chapel is filled by one of Giotto's mightiest compositions, the *Stigmatization of St. Francis* (fig. 75). This scene had been represented many times, ever since its first known depiction by Bonaventura Berlinghieri (see fig. 24, upper left-hand corner). Two altarpieces on the subject from Giotto's studio, but not his own hand, survive, as well as a famous fresco at San Francesco in Assisi. According to the *Legenda Maior*, the official life of St. Francis by St. Bonaventura (see page 87), two years before his death Francis was meditating on the lofty peak of La Verna in western Tuscany and asked a follower, iden-

tified by some as Brother Leo, to bring him the Gospels from the chapel altar and open them at random. Three times the leaves parted at the Passion. Then Francis knew he had been chosen to undergo the sufferings of Christ. He then became aware of a six-winged flaming seraph coming toward him through the heavens, and in the midst of the wings appeared a crucified Man. Christ's Crucifixion pierced St. Francis's soul "with a sword of compassionate grief," and when the vision disappeared, immediately the marks of the nails began to appear in his hands and feet, turning rapidly into the nails themselves, the heads on one side, the bent-down points on the other, and his right side was marked with a scar that often bled. A later life of St. Francis, the anonymous Fioretti (Little Flowers), speaks of a light that illuminated the surrounding mountains.

Berlinghieri does not show this light in any way, but other Dugento representations do, including the altarpiece of the Bardi Chapel, by an unknown Tuscan painter, as three stripes of gold descending toward the kneeling saint. But in the two works from Giotto's shop, and in this fresco, gold rays descend from the wounds of

Christ to the corresponding spots in St. Francis's hands, feet, and side, forming, as it were, a network of golden wires. Giotto does, however, follow older tradition (not that of the frescoes of the Life of St. Francis in Assisi, see page 80) by omitting Brother Leo, whose presence could only have detracted from the sublime theme of the fresco—man adopted by God, to both his suffering and his glory. In all earlier representations, St. Francis kneels before the vision, on one knee or on both; in this astounding work he seems to have been beaten to one knee on what Dante called the "raw rock" of La Verna by the sheer force of the apparition, falling away from it, saving himself from collapse by raising his right knee, yet turning toward the vision in combined surprise, pain, and loving acceptance. Never until Michelangelo was there to reappear in Italian art a colossal figure of such complexity or of so rich an interrelation of changing spiritual states and violent physical movement. The vision itself is beautifully drawn and painted, the flying wings each differently stretched, and the wing concealing Christ's body, according to St. Bonaventura's account, beautifully foreshortened.

The light described by the Fioretti radiates from the gentle Crucified, whose loincloth streams behind him against what was once a soft, blue cloud, now badly eroded. This same light, whose source, as in the Annunciation in Padua, is wholly spiritual, is the sole source of light in the picture, and almost dissolves the substance of the crag in an exquisite flow of changing color. A tree to the right bends as if with the storm of the apparition. On the left appears the mouth of a cave where the saint dwelled (other representations always show a cell), and on a ledge just below the summit of the peak perches the falcon who awakened St. Francis each morning. It has not vet been determined whether this scene, outside the chapel itself, was the first or the last to be painted. No matter, the image sums up triumphantly the meaning of St. Francis's existence, and situated as it is, it dominates the vast interior of Arnolfo's church.

The Design for the Campanile of Florence Cathedral. Giotto's mosaic for Old St. Peter's in Rome, *Christ Walking on the Waters*, known as the *Navicella* (*Little Ship*), survives in innumerable copies, but the original was so manhandled in its transfer to the new St. Peter's in the seventeenth century that it may itself be no more than a copy. Scholars are not agreed as to the extent of Giotto's participation in several panel paintings, the least convincing of which are those that bear his name most prominently (not "signatures" in the modern sense, but indications that the works were done in his bottega).

The principal surviving achievement of Giotto's last years is his brilliant design for the Campanile of the Cathedral of Florence (fig. 76). In January 1334 Giotto was appointed *capomaestro* of the Cathedral, whose façade and south wall, redesigned by Arnolfo, had reached the

level of the side-aisle roof, in an extraordinary document that extols Giotto's fame as a painter but mentions no architectural training or experience. The Campanile, the only portion of the Cathedral with which the aging master had anything to do, was mentioned again in April 1334. In January 1337 Giotto was dead. In the brief intervening period work proceeded at a rapid pace. A massive foundation was laid, and the first story constructed in exact correspondence with that of a huge, tinted drawing on parchment, now in the Museo dell'Opera del Duomo (cathedral museum) in Siena. The perfection of its execution would rule out a copy. In keeping with architectural practice today, the most likely explanation is that the design, involving much mechanical repetition of identical elements, was carried out by assistants from Giotto's sketches and calculations, and under his direction. We would be hardy indeed to detect his hand in any part of it, but it is his creation nonetheless, in the same sense as is the decorative framework of the Arena Chapel.

The design commences in the tradition of a common Tuscan campanile type, whose windows multiply as its stories rise. The final story is an octagonal bell chamber flanked by cylindrical pinnacles on the corners, set on octagonal buttresses that start from the ground. Giotto's solution corresponds to that of the slightly earlier tower of the Cathedral of Freiburg im Breisgau, Germany, but the appearance of the two buildings is entirely different; Giotto's spire and pinnacles are solid, while those at Freiburg im Breisgau, as in other German cathedrals, are open tracery. Actually, both the pitch of Giotto's spire and the character of its crockets correspond to those of the solid spires begun, but never carried out, on the famous towers of Reims Cathedral, a work that greatly influenced Italian artists. Moreover, the tracery of Giotto's windows, their beautiful pointed arches, and their crocketed gables are very close to those at Reims.

The lower story of the Campanile as actually built (fig. 77) makes sense only in relation to Giotto's total design. The hexagons of white marble seemingly suspended against pink marble panels (it is unclear whether or not at this stage of the design reliefs were intended) would have been repeated in the second story in three squares, one inside the other, centering on a quatrefoil window. Two such frames apiece appear on the third and fourth stories, one on the fifth, and none thereafter. Since the hexagons are off-axis with each other from panel to panel, the effect looking up would have been an exquisite oscillation of white hexagons against pink in the sunlight, to the height of about two hundred feet. There would have been seventy-five hexagons on each face of the Campanile, or exactly three hundred for the entire structure, which tells us something about Giotto's desire for transparent arithmetical simplicity. But there may be much more. In a medieval structure it is difficult to overlook the fact that the tower has four sides, the number of the Gospels (it could have been octagonal, like its top story, or round like the Leaning Tower of Pisa), and seven stories, the number of the Gifts of the Holy Spirit, and of the Joys and of the Sorrows of the Virgin; the hexagons are grouped in sevens, fours, eights (the numbers of the Resurrection), and twelves (the number of the Apostles and of the gates of the New Jerusalem); and the perfect number one hundred is multiplied in their total by the number of the Trinity.

Giotto was aware of what force wind pressure would exert upon his lofty bell chamber, and drew iron tie-rods running from the pinnacles through the oculi of the corner windows, possibly to some stabilizing framework inside. It is the more surprising that he decided to set enormous marble baskets of fruit on the three gables of his sixth story, crown his slender pinnacles with marble angels with widespread wings, and poise a colossal Archangel Michael, with wings and a banner, on the very tip of his spire, some three hundred feet above the ground, all of them exposed not only to wind but also to the disintegrative action of the rain, ice, and snow of Florentine winters, worse then than now. His design was not followed by his successors, only plundered (see fig. 77 and page 135), but after his death it was discovered that the walls of his first story were too fragile to uphold the weight of any tower whatever, and their thickness had to be doubled. After all, he was a painter—one never excelled in beauty of design or depth of feeling—and his tower was a painter's tribute to the glory of his beloved Florence.

THE UPPER CHURCH OF SAN FRANCESCO, ASSISI. matter of Giotto's early style has been left until this point, because it is one of the two or three most vexing questions in the whole history of art, and there is still no general agreement. The crucial problem revolves around frescoes in the nave of the Upper Church of San Francesco at Assisi: in particular, the series below the windows, on the projecting wall surface that was clearly built for the purpose, representing the Life of St. Francis in twenty-eight scenes. In each bay the wall is divided into three scenes—in the first bay, four—by painted spiral colonnettes of two differing patterns, standing on a corbel table, which are related to the spirals painted on the actual colonnettes ascending through the piers to support the ribs of the Gothic vault (see colorplate 11). Their spiral shape recalls the colonnettes of twelfth-century Roman cloisters. They appear to support a characteristic Roman architrave, ornamented by a central strip in simulated inlaid mosaic, surmounted by a cornice on painted consoles. The soffit of the entablature is coffered in two parallel strips, so that it looks quite deep. In an approach to one-point perspective, centered on the middle of each bay, all those elements appear to emerge from the wall, and their relief is enhanced by a systematic use of sharp light on the supposed projections and by soft

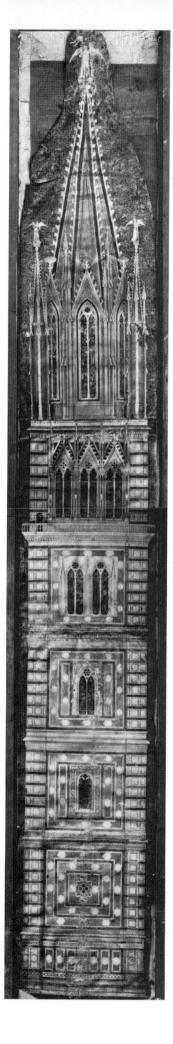

76. GIOTTO. Design for the Campanile of the Cathedral, Florence. c.1334. Tinted drawing on parchment. Museo dell'Opera del Duomo, Siena

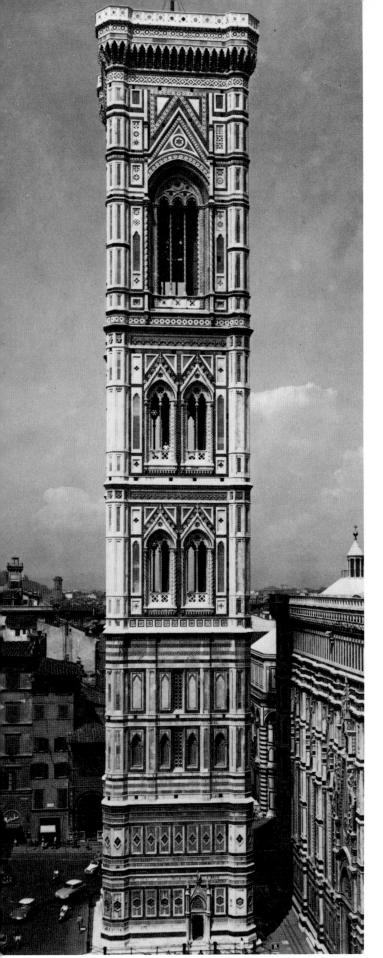

77. Campanile of the Cathedral, Florence. Lowest story by Giotto, 1334; next three stories by Andrea Pisano; remainder by Francesco Talenti, 1350s

shadow on the under surfaces. By these means the artist responsible for the general layout has established an effective illusion of a continuous portico as deep as the catwalk above it, reminding us of the porticoes in ancient Roman wall paintings, and through this portico one is permitted to read the vivid scenes recording with a brusque naturalism and intense conviction the Life of St. Francis, largely according to the *Legenda Maior* of St. Bonaventura.

In general, Italian scholars regard all but four of the scenes as early works of Giotto, before the Arena Chapel, though with a large amount of participation by pupils in some of the scenes. Foreign scholars tend to reject all of the scenes as by Giotto, and to date them somewhat later. One's views on the matter affect, of course, one's estimate of Giotto's style and personality. Just as important, the series itself is one of the most prominent, most extensive, largest (the figures, for the most part, approximate life size), and most interesting Italian fresco cycles of the Middle Ages. There were few and archaic models for some incidents (see fig. 24)—none at all for most of them—and the solutions to narrative problems are therefore often of striking originality, conceived in terms of a fresh, new naturalism.

There are no documents regarding the series. A Ferrarese chronicler called Riccobaldo wrote about 1313 (or so the passage is now reconstructed, since the original manuscript is lost) that the quality of Giotto's art is witnessed by "the works made by him in the churches of the Minorites at Assisi, Rimini, and Padua, and in the church of the Arena." Since the Arena Chapel frescoes are preserved, and since we know that paintings by Giotto once decorated the Franciscan churches of San Francesco at Rimini and Sant'Antonio in Padua, it is argued that Riccobaldo, writing while Giotto was still alive and working, was correct about Assisi as well, and that his remarks could only refer to the St. Francis cycle. In the fifteenth century Ghiberti wrote that Giotto "painted almost all the lower part," and in his second edition in 1568 Vasari finally assigned the St. Francis series to Giotto. A recently discovered document shows that Giotto repaid in Assisi in 1309 a substantial debt previously contracted there, but it does not mention the frescoes.

Neither Riccobaldo, Ghiberti, nor Vasari provides any solid evidence. The proponents of Riccobaldo have not taken it into account that he may have been referring to the paintings in the Magdalen Chapel in the Lower Church, quite possibly commissioned from Giotto and executed partly by him but largely by pupils. Nor has the question been examined of an altarpiece for the Upper Church, whose absence is one of the strangest phenomena at Assisi; such an altarpiece, presumably an elaborate polyptych, might very likely have been by Giotto. Ghiberti's ambiguous remark might also refer to the paintings in the Magdalen Chapel and to other cycles of

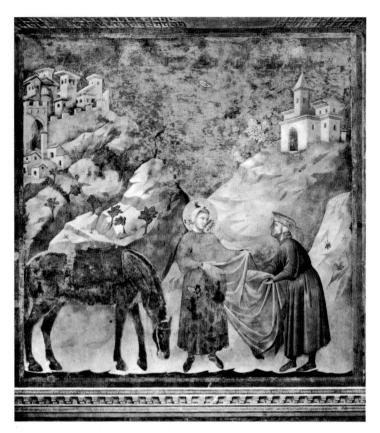

78. MASTER OF THE ST. FRANCIS CYCLE. St. Francis Giving His Cloak to the Beggar. Early 14th century. Fresco. Upper Church of S. Francesco, Assisi

frescoes in the Lower Church, painted by various followers of Giotto. As for Vasari, the extent of his information regarding works painted nearly three hundred years earlier at Assisi may be measured by the fact that he attributed Pietro Lorenzetti's *Crucifixion* to Cavallini.

Alistair Smart (see Bibliography) has shown how well the frescoes of the St. Francis series are organized in each bay as a triptych, as in Scenes IV-VI (colorplate 11), in which two incidents involving collapsing churches flank a central event taking place in an open piazza. (Smart also demonstrates that the sequence of incidents in the Legenda Maior was sometimes altered to bring out an underlying spiritual structure, involving arrangements of parallel scenes from side to side of the nave.) In Scene IV, St. Francis Praying before the Crucifix at San Damiano, the eye is assailed by the jagged masses of fragmentary walls, although the rubble has been neatly cleared away. In the second, St. Francis Renouncing His Worldly Goods, the piazza bordered by very un-Florentine and rather chaotic structures is split vertically, leaving on one side the raging father, on the other the naked saint cloaked by an embarrassed bishop, while above, at the left, can just be made out the hand of God to which Francis stretches out both his own in prayer. The Dream of Innocent III shows the pope reclining in a sumptuous interior framed by typically Roman architecture and ornament, while a serene St. Francis upholds the collapsing Basilica of San Giovanni in Laterano, identifiable in many details with the exact appearance of this church before its transformation in the seventeenth century. As throughout the cycle, the color is crisp and clear, depending on the three primary colors and white for a strong, decorative effect.

Scene II, St. Francis Giving His Cloak to the Beggar (fig. 78), is delightful, with its delicate color and the charm of the hillside town, complete with suburbs outside the gates, but a far cry from Giotto's rudimentary architectural forms. The upward flow of the hillside—its cliffs, scattered trees, town, and chapel—is unconvincing compared with the hard, simple masses of Giotto's rocks. Such complexities are completely alien not only to Giotto's landscape as we know it, but also to the specific directions given by Cennino Cennini, as deriving from Giotto. The landscape masses converge on St. Francis's head in a kind of X-shape, uncomfortable in itself and not especially dramatic.

Throughout the series, however, despite the originality of the conceptions and often brilliant bits of observation, the compositions are staccato and abrupt, as compared with the superb balance of Giotto. Facial expressions are uncommunicative, often inert. The figures are not coherent, the heads are not round; neither the impact nor the force of Giotto's figures can be felt. Profiles, so characteristic of Giotto, are rare in the St. Francis cycle; in this scene the beggar's is the only one. When Giotto's eloquent backs are imitated, the artist somehow gets their faces into view. Giotto's one-quarter views of faces rarely appear, and then awkwardly. Most of the faces are in Byzantine three-quarters view. Eyes are shown full-face, whatever the angle of the head; in threequarters faces, the distant eye remains flat, though wrapped around the curved cheek, while Giotto's distant eyes show his distinct awareness of three-dimensionality by being cut into the profile. To many critics, including the author of this book, the differences in style and quality between the St. Francis cycle and the known works of Giotto are too great to be embraced by the style of a single artist.

All scholars are agreed that Scene I and Scenes XXVI—XXVIII were painted by the St. Cecilia Master (see pages 88–90). Who, then, painted the other twenty-four? The consistency of the compositions throughout the entire cycle, including those by the St. Cecilia Master, has suggested to many authors that a single remarkable artist made detailed designs for all twenty-eight, to be approved by the Superior General of the Franciscan Order, and that these were followed in general and in most details. Probably these designs were on parchment or on paper, since no *sinopie* have come to light, even in the most damaged portions. Two major painters have been distinguished in addition to the St. Cecilia Master: one

79. MASO DI BANCO. St. Sylvester Resuscitating Two Deceased Romans. c. 1340. Fresco. Bardi di Vernio Chapel, Sta. Croce, Florence

was active from Scene II through Scene XIX; the second, less experienced in fresco, from Scene XX through Scene XXV, in addition to a host of assistants. The two masters (did they succeed each other on account of death, or what?) used white lead for highlights, with the same disastrous results as Cimabue encountered. Neither the St. Cecilia Master nor Giotto in his undoubted works ever used this pigment, which, as we have seen, Cennini condemns. The connections with Roman architecture and Roman painting are so strong that the first and second masters may well have been Roman, of a generation following that of Torriti and Cavallini, and left unemployed in Rome by the removal of the papacy to Avignon in 1305.

FLORENTINE PAINTERS AFTER GIOTTO

The authority of Giotto's style in Florence may well have impeded the emergence of other personalities of the first order. Nonetheless, several of Giotto's numerous Florentine assistants became important painters in their own right. Closest to the master, perhaps, is Maso di Banco (active 1340s), whose work has recently been convincingly reconstructed. Although Maso could never approach Giotto's breadth and harmony, he did achieve a handsome narrative and decorative style, especially in the frescoes of the Bardi di Vernio Chapel in Santa Croce, probably painted about 1340, after Giotto had died. The chapel is decorated with scenes from the Life of St. Sylvester, the pope who was believed to have dissuaded Emperor Constantine from curing his leprosy by bathing in the blood of many children slaughtered for the purpose, and instead managed to baptize him as a Christian. One miracle of St. Sylvester was the closing of the throat of a dragon whose breath had killed two wise men in the Roman Forum, and their resuscitation (fig. 79). Among Roman ruins, one sees the wise men lying on their backs, then suddenly alive and kneeling in thankfulness. This before-and-after representation is typical of Trecento miracle paintings. The massive figures and the unified space and lighting are all learned from Giotto, but Maso has gone further in the spatial complexity of the background. Nonetheless, the Roman ruins, with their flat wall-planes and empty arches, are impressive. Maso's facial types, of course, reflect Giotto's late style of the Santa Croce chapels, where Maso may well have assisted him.

A rare and beautiful study of Sts. Paul and Julian (see fig. 15) has been convincingly attributed to Maso on the

80. BERNARDO DADDI. Bigallo triptych. 1333. Panel. Loggia del Bigallo, Florence

basis of the close resemblance between the facial types and expressions, and the movement of the hands and the drapery forms, in these solemn figures and similar passages in Maso's work, especially the frescoes in Santa Croce. The two saints are shown seated, apparently on a bench. Each holds a sword, but for opposite reasons; St. Paul is the sword of the Church and grasps his weapon with both hands, but Julian committed parricide and holds the instrument of his crime downward with his left (see page 266), while with his right he strikes his breast in repentance. Perhaps the drawing was made for a panel. However, no such panels showing seated saints in converse remain from the Trecento. More likely these were two in a series of seated figures like those by Andrea da Firenze (not illustrated, but see page 126) that face the Triumph of the Church across the Spanish Chapel in Santa Maria Novella. Except for the deep and wordless

communication between them, the two saints recall their direct ancestors in the *Last Judgments* by Cavallini and by Giotto.

Like many such detailed studies from the Trecento and later, the drawing is done with brownish wash over preparations in silverpoint (an ancestor of the modern "lead" pencil) on paper tinted gray-green, and the lights picked out with white, thus approximating the three basic gradations of value Cennini describes in his directions for painting a fresco. Since no figure drawings attributable to Giotto himself are known, this profound and exquisitely rendered work is a precious witness to the probable role of drawing in Giotto's art, as well as to the draftsmanly procedures of the great master. Intense psychological interchange, the basic principle of Giotto's compositions, is established from the start. Then, after the general proportions and contours had been

fixed by line, light, gliding across faces and drapery masses with silken grace, projects the larger volumes and smaller forms in depth.

By all odds the most elegant and graceful of Giotto's followers was Bernardo Daddi (active c. 1312-48), a painter whose sensitivity was more suited to panel paintings than to frescoes, which in fact he rarely painted. The beautiful little triptych (fig. 80), dated 1333, and often copied or reflected in the works of contemporary masters, is typical of this delightful painter; his pictures are intimate, even those intended for important public positions, and show a different aspect of the Virgin and Child from the majestic images in the tradition that runs from Coppo di Marcovaldo to Giotto. Daddi's Virgin smiles gently as she admonishes her unexpectedly playful Child. The delicate Gothic forms of the throne provide an ample space for her, and diminish her apparent size, even though the two donors are tinier yet. In a space seemingly outside that of the inner image saints and prophets rise like a rose trellis. The delicacy and charm of the concept and drawing of the central panel are matched by the daintiness of the *Nativity* in the left wing. Mary has taken the Christ Child out of the manger and holds him on her lap. Even the Crucifixion on the right wing is hardly convincing as a tragic event, and the eye is at once drawn to the pelican at the apex of the Cross, striking her breast (as was believed in the Middle Ages) to feed her young, a symbol of the self-sacrifice of Christ. Daddi's lyric sweetness has been traced to the influence of Sienese art, but this is difficult to justify; most likely it is a happy conjunction between his own temperament, the rather relaxed taste of the 1340s, when he was the leading painter of Florence, and the example of ivory carvings brought from France, which often show a similar sweetness and playfulness. Withal, Daddi is never sentimental: his statement of form is as round and firm as one could wish from Giotto's protégé, his drawing is precise, his modeling clear, his color resonant. The facial types, with their comparatively short noses and round cheeks, are his own. The movement of his drapery folds confers on his compositions a melodic beauty not to be met with again until Domenico Veneziano, with whose graceful style Daddi has much in common.

The latest known work of Bernardo is a colossal Madonna and Child Enthroned with Angels (fig. 81), painted in 1346-47 for the altar in the shrine of Orsanmichele (see fig. 6), and later enclosed in an elaborate marble tabernacle by Andrea Orcagna (see fig. 113). Clearly something very strange has come over the Giottesque style. True, the Virgin still sits on a grand, Gothic throne, modeled in three dimensions, and is adored by angels. And in a manner typical of Daddi, the Child reaches for his mother's cheek—but he can only touch it with the tips of his thumb and two fingers, instead of a satisfying infant caress. The Virgin pays no attention to him, but looks out at us in a manner suggestive of Cimabue. Aside from the modeling of the throne, there is no indication of space. The carpet is parallel to the picture plane, and as in Cimabue the angels rise in a vertical superimposition the more astonishing in that their drapery is modeled with the full resources of Giotto's style. A chill has fallen upon Daddi's spontaneous sweetness. Perhaps he was required to repeat the composition of the miraculous Dugento Madonna damaged in the fire of 1304 at Orsanmichele, but did he have to take so resolute a step backward into the spaceless world of the Italo-Byzantine? Nonetheless, his colors blaze with an unexpected brilliance, and their splendor renders his last achievement his grandest.

Taddeo Gaddi (active c. 1328-c. 1366), another faithful follower of Giotto and father of Agnolo Gaddi, Cennino Cennini's teacher, could not compete with Daddi's tasteful style. His relatively clumsy Madonnas have the virtue of a rustic honesty, but his frescoes, for all their

81. BERNARDO DADDI. Madonna and Child Enthroned with Angels. 1346-47. Panel, 8'23/8" × 5'107/8". Orsanmichele, Florence

abruptness of form, can be impressive. Taddeo's principal achievement in the field of fresco painting is the interior of the Baroncelli Chapel (probably painted immediately after 1328), one of the larger chapels in Santa Croce. Apparently much of the work was done during Giotto's last years, so it may be said at least to reflect the master's ideas. Giotto even "signed" the altarpiece in the chapel, though few believe he painted much of it with his own hand. The *Annunciation to the Shepherds* (fig. 82) is the most spectacular scene, notable especially for its dramatic effect of night light, a vivid and important forerunner of more famous efforts in this di-

rection in the Quattrocento, such as the Nativities by Lorenzo Monaco (see fig. 125) and Gentile da Fabriano (see fig. 185), and Correggio's Cinquecento *Holy Night* (see fig. 606), with all its Baroque descendants. The angel comes sweeping by, casting a strong light into the dark hillside where the shepherds are guarding their sheep. This is by no means the only example of night light, but in this case it seems fair to connect it with the tradition of mystical illumination in the paintings of his master.

Taddeo's enormous and majestic *Tree of Life*, probably datable between 1355 and 1360 (fig. 83), for the refec-

82. TADDEO GADDI. Annunciation to the Shepherds. Probably after 1328. Fresco. Baroncelli Chapel, Sta. Croce, Florence

83. TADDEO GADDI. Tree of Life. Mid-14th century (c. 1355-60). Fresco. Refectory, Sta. Croce, Florence

tory of Santa Croce, badly affected by the flood of 1966, shows the robust vigor of this painter, as well as a fascinating display of iconographical richness; the subject illustrates one of the major works of St. Bonaventura, the "seraphic doctor" of the Franciscan movement. Christ hangs, not upon the conventional Cross, but upon the symbolic Tree of Life, which grew alongside the Tree of Knowledge in the Garden of Eden, and the medallions hanging from it, fruits of the marvelous Tree, contain bust portraits of the Four Evangelists and Twelve Prophets. At the right are *St. Benedict in the Desert* and the *Feast in the House of Levi*, at the left the *Stigmatization of St.*

Francis and a Scene from the Life of St. Louis of Toulouse. The Last Supper, below, is one of the many that still decorate so appropriately the refectories of Florentine monasteries and convents. The strong, simple, clear-cut figures, with their relatively coarse features and harsh expressions, form a strong contrast to the refinements of Bernardo Daddi, almost a caricature of Giotto's powerful forms with none of Giotto's expressive richness and depth. In its rejection of the optimism of the Baroncelli Chapel, the solemn, austere style of the refectory of Santa Croce belongs to another era, which will form the subject of Chapter 5.

SCULPTURE

Giotto's style dominates the art of the entire Trecento, including sculpture. The work of Andrea Pisano has a special relationship to Giotto's shop, admittedly close though never exactly defined. Andrea Pisano (c. 1290– 1348) is no relation to Nicola and Giovanni Pisano, but acquired his name through the fact that he came from Pontedera, an Arno Valley town then in Pisan territory. We have already noted the little reliefs representing painting, sculpture, and architecture (see figs. 7, 16, 17) with which Andrea ornamented the Campanile that Giotto designed for the Cathedral of Florence. Ghiberti claimed to have seen Giotto's original designs for these reliefs, "most exceptionally drawn." The Creation of Man (fig. 84), which begins the series, obviously comes straight from Giotto's little quatrefoil representing the same subject in the decorative framework of the Arena Chapel (see colorplate 8). The figures and their poses are almost identical, although the increased size of the image permits the Creator to be shown entire, as well as allowing the addition of a splendid array of trees, including both the fatal fig tree (the Tree of Knowledge), all too close to Adam, and the Tree of Life (Genesis 2:9), which grew next to it in the Garden of Eden, here represented as a palm tree, rising above the Lord's head. The reliefs illustrating the Life of St. John the Baptist that decorate the set of bronze doors completed by Andrea in 1336 for the south portal of the Baptistery of Florence, facing the

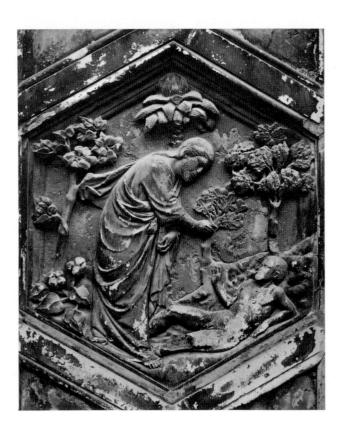

city, seem like simplified sculptural equivalents of Giotto's late pictorial compositions (fig. 85). Their quatrefoil frames, their clear-cut, simple stages, their limited depth, and their well-spaced, beautifully organized movement have nothing to do with the heavily charged style of the great Dugento sculptors, but—created during the last years of Giotto's life—they are directly related to Giotto's new vision of form and space, and especially to his economy of statement. Salome before Herodias (fig. 86) is one of these delicate and perfectly organized little scenes, neatly balanced inside the fashionable quatrefoil form imported from Gothic France. Andrea's doors, like Ghiberti's two great sets that followed in the Quattrocento, were made of bronze panels welded together, with figures and raised elements of ornament, architecture, and landscape covered with gold leaf and burnished. It was thought before World War II that the gilding had vanished in the course of time; but while Andrea Pisano's and Ghiberti's doors were being removed for safekeeping, it was discovered that the gold leaf, largely intact, had merely been covered, so gradually that no one had noticed it, by dust from the Florentine streets. Through this dust had spread a patina from the ungilded bronze surfaces, until all the gold became masked by a uniform greenish crust. After the war this was carefully dissolved and washed away, so that all three sets of doors were visible again in something fairly close to their original splendor; alas, at the time of this writing they are heavily darkened a second time, by forty years of automobile fumes.

MASTER OF ST. CECILIA

Up to this moment we have followed only the grand style in Florence, dominated by Giotto and his followers. But there were other artists who did not capitulate entirely. The best of these, a distinct and delightful artistic personality, is the Master of St. Cecilia, not otherwise identified, whose principal work is the handsome altarpiece that shows the Enthroned St. Cecilia and smaller scenes from her life (fig. 87). Only the monumentality of the saint recalls Giotto; the facial type is entirely different, and so is the complete lack of Giotto's precision of form. The soft figures of the St. Cecilia Master live an agreeable if shrunken existence at the bottom of the well-like spaces he has prepared for them. This painter understood the risks of Giotto's double scale for architecture and for figures, and he created rooms more accurately proportioned to his figures. He also suffered the consequences of his innovation, because his stories cannot be so easily read as Giotto's. His amusing figures with long bodies and tiny heads, and his freely invented architectural shapes so strongly projected and illuminated, form a pleasant antidote to the grand official style.

The St. Cecilia Master painted Scene I and Scenes XXVI–XXVIII in the Life of St. Francis in the Upper

opposite: 84. Andrea Pisano (from designs by Giotto?). Creation of Man. Mid-14th century (c. 1334–before 1348). Marble. Lower row of reliefs, Campanile, Florence (see fig. 77)

left: 85. Baptistery, Florence. c. 1060–1150. South Doors (left), Andrea Pisano, 1336;East Doors (right), Lorenzo Ghiberti, 1425–52

below: 86. Andrea Pisano. Salome before Herodias, panel on the South Doors, Baptistery, Florence. 1336. Bronze, 19¾×17"

Church of San Francesco at Assisi, the last to be done. Scene I was left to the end because the rood beam, now removed but which once carried a giant Cross by Giunta Pisano aloft in the center of the church, once ran from Scene I to Scene XXVIII. The supporting bracket, in fact, is still visible in the middle of Scene I near the top (fig. 88). The incident represented is the recognition of the future sanctity of the as-yet-unregenerate Francis by a simple man of Assisi, who spreads a cloak before him, on which Francis is about to set foot. The fresco has been described as the first modern street scene in Italian art. It takes place in the principal piazza of Assisi, before buildings some of which still stand, although the painter has played games with them. The Torre del Comune, brought to its first story of open arches in 1305 (another nice indication of probable early Trecento date for the entire cycle), is shown without its present final story, but it is also embellished with an elaborate adjacent Gothic palazzo that may have been planned but was never built and on the extreme right by a structure of cantilevered superimposed porticoes that never could have been built. In the center stands the little Temple of Minerva Asisium, a well-preserved Augustan building, which is here given five columns instead of its actual six so that the central column might appear to support the bracket above the pediment, in whose center is inserted an anachronistic Gothic rose window flanked by soaring angels in simulated relief. The painter has also substitut-

87. MASTER OF St. Cecilia. Enthroned St. Cecilia and Scenes from Her Life. Early 14th century. Panel, 33½×71¼". Uffizi Gallery, Florence

ed a strip of medieval Roman mosaic inlay for the actual Corinthian entablature and, in keeping with his special taste, slenderized the Roman columns to mere colonnettes. His scene, characteristically dominated by empty space, is carpeted by the simple man's cloak, and the

figures on either side, with their elongated bodies, small heads, and delicately drawn faces, correspond to those of the *Enthroned St. Cecilia*. We must mourn the loss of any other frescoes by this graceful and highly individual artistic personality.

88. MASTER OF ST. CECILIA. *St. Francis and the Madman*. Early 14th century. Fresco. Upper Church of S. Francesco, Assisi

Sienese Art of the Early Trecento

DUCCIO

mong the innumerable painters of high quality who flourished in Trecento Italy, by common consent only the Sienese master Duccio di Buoninsegna (active 1278-1318) can withstand close comparison with Giotto. The full story of the formation of his art has yet to be told, but two elements are certain. First, in a city that seemed—and still seems—to the logical Florentines to be individualistic, impulsive, and irrational, Duccio's behavior stood out as especially unruly. No less than nine separate fines, sometimes extremely heavy, are recorded in the documents as having been levied against the great painter for one transgression or another. Second, as far as we can determine, there was no Sienese master of comparable quality with whom Duccio could have studied, and his highly personal style was shaped in varying respects by influences from other centers. The Italo-Byzantine tradition, exemplified in Siena in the passionate art of Coppo di Marcovaldo, must have been enriched beyond measure as Duccio experienced, perhaps even watched in execution, the wonders of the new pulpit for the Cathedral, carved by Nicola Pisano and his band of assistants, including his gifted son Giovanni (see fig. 40). And in Florence itself the vision of Cimabue's colossal Enthroned Madonna and Child in Santa Trinita (see colorplate 4) must have excited the young painter.

In fact, the earliest major work we know by Duccio is the *Rucellai Madonna* (fig. 89), so called because it stood for centuries in the chapel assigned to the Rucellai family in Santa Maria Novella in Florence. It is probably to be identified with a large Madonna commissioned by the Company of the Virgin Mary in 1285.

In the Uffizi today, as we look from Cimabue's *Enthroned Madonna and Child* to the *Rucellai Madonna*, both now in the same room, we are confronted with a much softer and gentler personality than that of Cimabue. Duccio's Virgin is seated sideways on a throne seen slightly from the right, with her head bent. The six an-

gels upholding the Virgin's throne kneel on one knee, yet are superimposed against the gold background as if floating. Except for the cloth around the legs of the Christ Child, Duccio has completely abandoned the traditional gold striation used to indicate drapery by Italo-Byzantine artists and still used by Cimabue for the mantles in his Enthroned Madonna and Child. The Virgin's ultramarine cloak has darkened so much with time that it is difficult to reconstruct its original appearance, but the delicately crinkled, freely wandering gold border assumes a new, important role as a carrier of energy. The border is embellished with an almost imperceptible golden fringe, and upon the Virgin's shoulder and over her brow glow stars whose sixteen points suggest the points of the compass, for Mary's name was translated as "Star of the Sea" by innumerable Christian writers beginning with St. Ambrose. Probably the folds of the mantle originally were modeled like those in the often translucent drapery of the six angels, which are rendered in colors of a freshness and refinement unprecedented in Italian painting. Their flowerlike tones include a soft lavender, a delicate yellow, rose, and luminous gray-blues and gray-lavenders.

The ovoid shapes in the Virgin's face are derived ultimately from those of Coppo di Marcovaldo (see fig. 30), but they are less drastically stated, in keeping with Duccio's vacillating line and new coloristic refinement. The almond eyes are bordered by a dainty, curving line, and a gradual movement, scarcely interrupted by the usual spoonlike configuration at their intersection, unites the brows with the long and slender nose. The upper lip protrudes slightly above a tremulous lower lip and a chin that recedes to blend imperceptibly with the slender neck. The angels, whose faces are similarly constructed, all gaze in reverence toward the Christ Child, who turns in his mother's arms to address them with outstretched hand.

Refinement of surface is pushed to a new extreme. The arches of the Virgin's throne are hung with a splendid patterned silk, its folds indicated in soft strokes of wash

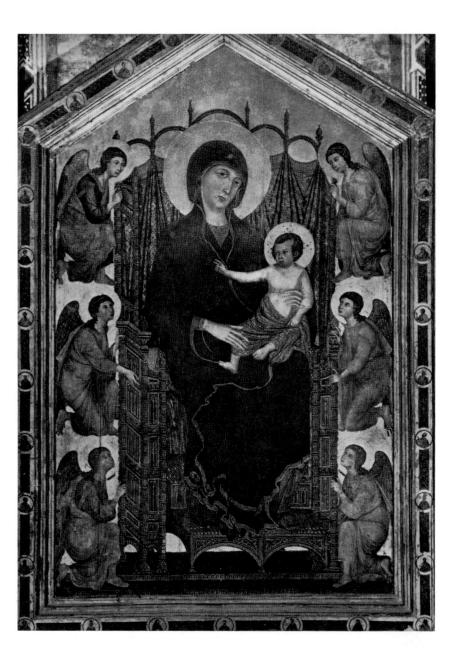

over the design. Tooling covers the gold haloes with an elusive network of ornament made up of interlocking circles containing foliate designs; this is derived, like the patterns of the silk, from French Gothic rather than Byzantine sources. Between the oddly Victorian-looking spindles of the throne, tiny French Gothic arches have made their appearance. The usual dot-dash motif in the gabled frame is now replaced by a series of small bust portraits of saints in medallions, of the utmost sensitivity in drawing and color, and the bands between these are now richly ornamented. Duccio's new and slightly Gothicized phase of the Italo-Byzantine style, as declared in this sumptuous altarpiece, must have had its effect on the contemporary generation of Florentine painters, including the youthful Giotto.

For Siena the Virgin Mary was not just the Mother of God and the Queen of Heaven, she was the patron saint of the recently established Sienese Republic; in fact, Siena's title was vetusta civitas virginis ("ancient city of

the Virgin"). In 1308 Duccio was commissioned to do a magnificent painting for the high altar of the Cathedral of Siena, the zebra-striped marble structure at the apex of the highest of Siena's hills. In 1311 the colossal altarpiece was carried in triumph to the Cathedral; a contemporary account describes it: "...accompanied by the members of the government, the clergy, and the people, carrying lighted candles and torches, to the sound of all the bells of the city, and the music of trumpets and bagpipes." It was not only a religious triumph for the city of the Virgin, but also an artistic one for the painter, for it was generally felt that the full prowess of the Sienese intellect was at last made visible in a work that could compete successfully with the achievements of Giotto in Florence and in North Italy. Unfortunately, the painting was removed from its altar in 1506 to make way for a new ciborium, statues, and candlesticks and transferred to the hospital church of Santa Maria della Scala. Vasari, when he wrote his Lives, was not even able to discover its location. Originally the Virgin in Majesty—or simply the Maestà, to give the work its Italian title—was a superaltarpiece. Its central panel (colorplate 12) represents the Virgin enthroned, adored by a court of kneeling and standing saints and angels; above are bust-length figures of prophets in separate panels, under arches. Below was a set of panels illustrating scenes from the Infancy of Christ, forming the strip later known in altarpieces as a predella. Above the whole were pinnacles containing scenes from the Life of the Virgin; these were surmounted by angelic figures. Since the high altar stood under the dome of the Cathedral, at the crossing between nave and transept, the center of a cluster of Marian worksthe pulpit by Nicola Pisano, and altarpieces by Simone Martini (colorplate 14), Pietro Lorenzetti (fig. 105), Ambrogio Lorenzetti (colorplate 15), and the lesser-known Bartolommeo Bulgarini—the back of the altarpiece, including its predella panels and pinnacles, was covered with scenes, depicting the Passion of Christ. The major panels of the front and back, and some smaller ones as well, still remain in Siena in the Museo dell'Opera del Duomo, but most of the pinnacles and predellas have been scattered to public and private collections in Europe and America. Many have been cut to rectangular

90. DUCCIO. Head of St. Catherine, detail of the front of *Maestà* (see colorplate 12). 1308–11.

Museo dell'Opera del Duomo, Siena

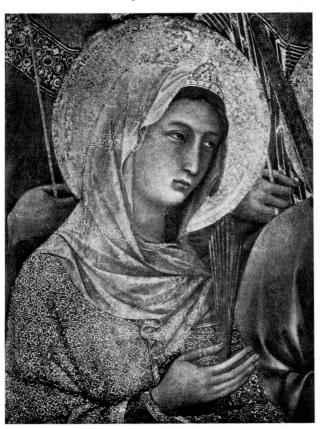

shapes. Two of the principal panels have never been found, and their subjects are conjectural.

Four Sienese saints kneel in the front row of the central panel. Six more saints stand behind them. Mary's intricately inlaid marble throne is flanked by four archangels who continue this central, standing row. A final rank of angels runs continuously from side to side of the panel, continuing behind and above the throne on which four of these angels rest their hands and prop their chins. In the resultant interlace of figures, heads, and haloes all united by the constant flow of drapery lines, ornamental masses, and brilliant color—separate elements do not stand out as they would in Giotto's manner of composition. Rather, the entire panel takes on the appearance of a length of fabric, of great richness and splendor. The Virgin holds the Christ Child on her lap, much as in the Rucellai Madonna, but he seems to have relinquished his teaching function and gazes directly outward at the observer; altogether, he is a more natural and human baby. In line with the artist's decreasing reliance on Byzantine motifs, gold striations appear only here and there in the richly modeled drapery that courses about clearly felt, if strongly attenuated, bodies. The Virgin's face has suffered from a disastrous overcleaning in the past. Judging from better-preserved Madonnas by Duccio, she must have been very beautiful, showing still further refinement of curvilinear motifs.

Duccio's sensitivity is beautifully displayed in the head of St. Catherine of Alexandria (fig. 90), to the extreme left of the panel. The old Byzantine demarcation of surface forms, including all but a hint of the spoon formation at the juncture of the eyebrows, is swept away in the continuous flow of surface. The mournful gaze of St. Catherine's eyes is typical of most of Duccio's figures. His treatment of the fabrics of her garments is particularly refined. A gold-embroidered scarf of translucent linen permits us to feel the shape of the saint's head, even to see her hair, through its liquid folds. Her mantle is painted over gold, the paint tooled away to show the underlying gold and thus suggest the sparkle of a gold-thread damask cloth, according to the procedure described by Cennini.

One of the finest sections of the front predella is in the National Gallery in Washington, D.C. (fig. 91). It shows the *Nativity* between tiny panels representing the prophets Isaiah and Ezekiel. Duccio has kept the cave of the Byzantine tradition, but has inserted into it the shed imported by Giotto from French Gothic representations, a compromise often felt to be symptomatic of Duccio's artistic position, intermediate between Byzantine and Gothic traditions. Mary, enveloped in her bright blue mantle, reclines on a scarlet mattress; she pays no attention to the Christ Child in the manger, adored by ox and ass. At the left sits Joseph, and the bath scene reappears below, the naked Christ Child plunged by the midwives into a chalicelike tub—as in Nicola Pisano's Pisa Baptis-

right: 91. DUCCIO. Nativity and Prophets Isaiah and Ezekiel, from the front predella of Maestà. 1308–11. Panels: center, 171/4 × 171/2"; laterals, each 171/4 × 61/2". National Gallery of Art, Washington, D.C. (Mellon Collection)

below: 92. DUCCIO.

Temptation of Christ, from the back predella of Maestà.

1308–11. Panel, 17 × 181/8".

Copyright The Frick

Collection, New York

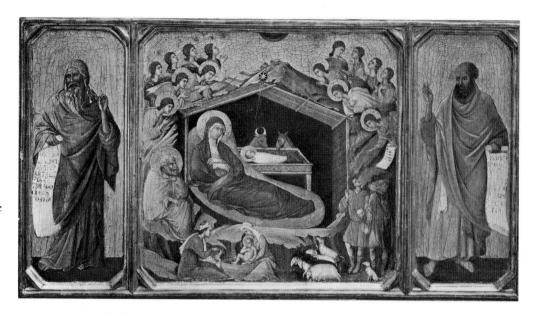

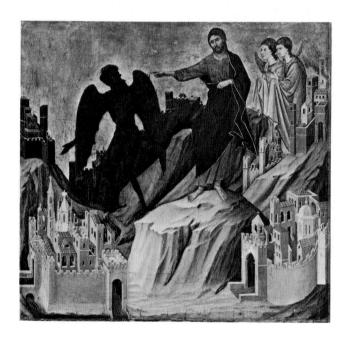

tery pulpit (see fig. 37). Fourteen angels stand behind the cave, eight looking upward to the arc of Heaven, six bending over, like the angels behind Mary's throne in the central panel. One angel waves a scroll announcing the happy event to the shepherds, whose sheep have already arrived upon the scene. The brilliant colors of Mary's cloak and mattress are set off by softer color ranges, such as the rose of Joseph's cloak and Isaiah's rich lavender mantle over a tunic of an entirely different rose, or the powdery blue of the angels' garments against the clear, singing blue of Ezekiel's cloak.

Another panel from the *Maestà* is the tiny scene from the back predella (fig. 92), showing one of the Temptations of Christ, who, according to the Gospels of Matthew and Luke, was led by Satan up to a high mountain and promised all the kingdoms of the world. It is charac-

teristic of a Tuscan artist that Duccio has represented the kingdoms as Italian city-states, some on plains, others on hilltops. He has been brave enough to include seven of these cities—no earlier Italian artist had attempted so much—using a different scale from that of the large figures of Christ and the Devil. Each city is a complete community, with walls, gates, streets, and public and religious buildings whose towers, domes, roof tiles, and battlements are picked out delicately in light. The space still penetrates only to a certain degree into the picture. but there is a feeling for distance, enhanced by the tiny scale of the cities. The complex, irrational, elusive nature of Duccio's world has little in common with the reasonable, ordered, tangible environment Giotto provides for his narrations. The rocks, for example, seem fluid as compared with Giotto's mountains. Linear motion twists and ripples through their surfaces, and breaks upward toward the standing figures. On this moving ground the figures cannot stand with the firmness and decision of Giotto's people; they maintain an uncertain footing, as if walking on waves. And Duccio's slender, sad Christ is utterly different from the majestic, forthright Gothic Christ of Giotto.

On the back of the *Maestà* the story of the Passion was told in thirty-four scenes, beginning with the *Entry into Jerusalem* (colorplate 13). The hilltop setting is similar to that of Siena itself, reflecting a Sienese Palm Sunday procession in which the bishop led a throng to one of the city gates to meet an actor garbed as Christ. Duccio has placed us exactly, in a farm separated from the highway by a wall with an open gate over which we watch the procession winding up along the highway to the towering city gate. We can see over the wall on the other side of the road into an orchard in which move people, some climbing trees as in Byzantine representations of the scene, others leaning over to cast olive branches on the way. As the text of the Gospel requires, some onlookers remove their mantles and spread them on the road. Duc-

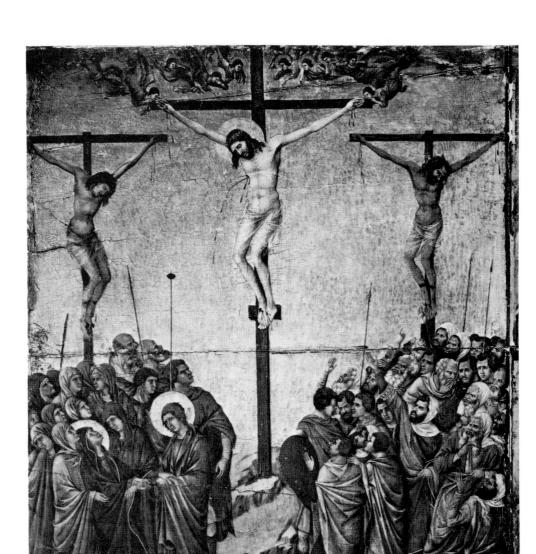

93. DUCCIO. Crucifixion, from the back of Maestà. 1308–11. Panel, 401/8 × 297/8". Museo dell'Opera del Duomo, Siena

cio has been very exact: not only is Christ on a donkey, but also the donkey's colt follows as well, according to the prophecy of Zechariah (Zechariah 9:9): "Behold, the king cometh...lowly, riding on an ass, and upon a colt the foal of an ass." The crowd surges out of the great gate, chattering and gesticulating; the Apostles follow Christ up the road. In these two human rivers about to meet we get all the feeling of a mob scene in a little Italian medieval city. We can look through the gate into the main street; there is even a balcony with a head protruding through a window. The Temple, strikingly like the Baptistery of Florence, rises in the distance, over trees and rooftops.

In the *Crucifixion* (fig. 93) Duccio has depicted a scene of mass violence and tragedy. As in Cimabue's fresco (see fig. 32), all three crosses are shown; Duccio has even

represented the legs of the thieves, broken to put an end to their agony, while Christ's legs were left intact in fulfillment of the prophecy recorded in the Gospel of St. John: "a bone of him shall not be broken." The lofty, slender crosses soar against the gold background, into which the eye seems to be able to penetrate as into golden air. Duccio has carefully distinguished the penitent thief, turned toward Christ, from the impenitent thief, who not only faces away but also is represented in a darker color. The angels do not form definite groups about Christ as in Giotto's Crucifixion (see fig. 66), but gather out of the clouds above him like a flock of birds. Below, the crowds of the Apostles, Mary, the Holy Women, the Chief Priests and Elders, and the Roman soldiers are separated into two waves, like the Red Sea before the Israelites. As in the religious text called Meditations on

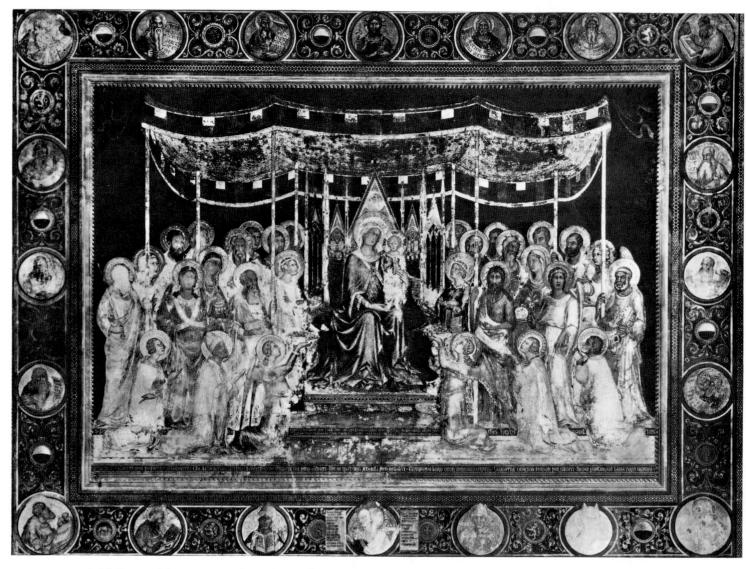

94. SIMONE MARTINI. Maestà. 1315; partially repainted 1321. Fresco. Council Chamber, Palazzo Pubblico, Siena

the Life of Chist, which used to be ascribed to St. Bonaventura but was probably written in Sienese territory by an early Trecento Franciscan mystic, Giovanni da San Gimignano, Mary swoons below the Cross, sinking powerless into the arms of the Holy Women as she looks upward toward the fragile body of her agonized Son, from whose side blood and water gush in powerful streams. Duccio's mastery of crowds and his ability to project human feeling are never more effectively shown than in this scene, with all its flashing eyes and reaching hands.

SIMONE MARTINI

Like Giotto in Florence, Duccio had his close imitators in Siena, some of them extremely sensitive artists. But his greatness as a painter seems to have been equaled by the freedom of his doctrine as a teacher, for he also initiated a remarkable succession of gifted painters in Siena,

each able to develop a style independent of the master and of each other. One of the most original of Duccio's supposed pupils was Simone Martini (active 1315–44), who worked on Duccio's later commissions, very probably on the Maestà itself, and afterward achieved great fame and influence far beyond the borders of the Sienese Republic. In 1315 Simone was commissioned to paint a Maestà of his own (fig. 94), a colossal fresco about forty feet wide, covering the entire end wall of the Council Chamber in the Palazzo Pubblico in Siena, from which vantage point the Virgin could direct and bless the deliberations of the Council of the Sienese Republic. In his arrangement of kneeling saints in the foreground, Simone was obviously indebted to Duccio, but the two kneeling angels are shown in profile, in the manner of Giotto. Duccio's thrones, Byzantine with occasional Gothic details, have now been replaced by a fashionable and completely Gothic throne with lofty wings whose

95. SIMONE MARTINI.

St. Louis of Toulouse
Crowning Robert of
Anjou, King of Naples.
1317. Panel, 78¾ ×
54¼". Museo
di Capodimonte,
Naples

tracery recalls the windows in French cathedrals. Above the throne and embracing almost all of the loosely grouped throng of saints and angels, Simone has created a unified space by the ingenious device of a huge canopy supported on eight poles arranged in depth—the same kind of canopy that still shelters the Eucharist today when carried in solemn procession in Italian churches or through streets and country roads. Simone's canopy is carried by saints, who turn and gaze outward toward the observer. Many portions of the huge work were painted a secco and have peeled off in the course of time, showing underdrawing in ocher on the intonaco. Either because certain sections were already in bad condition or because they were not satisfactory to the patrons, Simone was called upon to repaint them in 1321. It is instructive to compare the still almond-eyed, soft-featured heads, especially in the rear ranks of the Virgin's attendants, with the frankly Gothic ones in the foreground that are much more characteristic of Simone's later style—crisp and smart, with neat features, pursed mouths, and blond wavy hair.

Between the two campaigns of work on the *Maestà*, Simone was invited to Naples by the French king of that country, Robert of Anjou; he depicted the king kneeling to receive the crown from his brother, St. Louis of Toulouse (fig. 95), who was canonized in 1317—which event the picture was probably painted to solemnize. The composition was not, by any means, an easy problem. The artist had to reconcile a basic conflict between the vertical, frontal image of the saint, which demanded centralization, and that of the kneeling king, which could be placed only at one side. The resultant dilemma Simone converted into a positive advantage by the subtle relation of interweaving diagonals and diagonally directed curves; these are carried out with remarkable consistency in every element of the figures and drapery

patterns, from the base line up to the off-center placing of the angels who hold a heavenly crown above the enthroned saint. In this highly original, and at times almost abstract, composition Simone displayed his unusual ingenuity in handling boldly silhouetted areas and surface patterns that are still richer and more delicate than anything attempted by Duccio. Sometimes the patterns are actually embossed, but these quasi-sculptural surfaces are never permitted to compete with the basic element in Simone's maturing style—a taut, harsh, linear contour, as if the shapes were cut from sheet iron.

Possibly in the late 1320s Simone painted the rich series of scenes from the Life of St. Martin that decorate the chapel dedicated to that saint in the Lower Church of San Francesco in Assisi. In addition to a number of landscape views, Simone showed his narrative ability, enchanting colorism, and decorative genius in such interior scenes as the *Vision of St. Martin* (fig. 96) and the *Funeral of St. Martin* (fig. 97). In the former an aloof and princely Christ attended by angels appears to the saint,

who sleeps under a silk coverlet of rose and blue squares heightened by gold threads. The luxury of the setting almost overbalances the religious content, but the brilliance of Simone's linear organization and the expressiveness of his faces show the best qualities of his style. Less expected is the salty humanity of his observation in the Funeral of St. Martin. The saint lies in a three-bay Gothic chapel complete with lofty spiral colonnettes and Gothic tracery and extremely convincing in its spatial construction. Simone shows with evident relish such details as the youth kissing the ring of St. Ambrose, who has miraculously appeared to conduct the rite; the monks singing lustily; and the humble attendants dressed in skins who uphold with difficulty the gigantic wax torches at the foot of the bier. Nobody except Simone bestows much attention on the gorgeously dressed dead saint.

The most famous, and possibly the most brilliant, of all Simone's surviving works is the great *Annunciation* (colorplate 14) painted for Siena Cathedral in 1333, and

96. SIMONE MARTINI. Vision of St. Martin. c. 1328. Fresco. Lower Church of S. Francesco, Assisi

now, to the chagrin of many loyal Sienese, in the Uffizi in Florence. In this altarpiece Simone has abandoned the traditional clean-cut shape in favor of an elaborate construction of cusped arches and gables made of convex and concave curves, enriched by foliate crockets and punctuated by spiky pinnacles. The forms composing this dazzling display were, of course, French imports in the incipient Flamboyant Style. Simone has utilized them in a very subtle way to enhance the drama of the moment of the Incarnation—in fact, this is the earliest known example in which this incident was chosen as the subject of an entire altarpiece. At first sight the complex structure appears to be a polyptych, with its five arches and two lateral panels containing standing saints painted by Simone's pupil Lippo Memmi. But only two of these arches are supported by the customary twisted colonnettes. The two central colonnettes are unexpectedly absent, their capitals hanging in midair. The resultant suspense is increased by the blankness of the gold background at the center of the painting, traversed only by the words of the angel (Luke 1:28), "Ave gratia plena dominus tecum" ("Hail thou that art full of grace, the Lord is with thee"), embossed in the gold, as they come from the mouth of Gabriel to Mary's ear.

As in Giotto's fresco the heavenly messenger kneels, but the suddenness of his arrival is indicated by the ageold device of a cloak over his shoulders, still floating in the breeze. Why the cloak is checked like a Scotch plaid has never been explained, but neither has anyone objected; it is a delightful design, reminiscent of St. Martin's checked coverlet in the Assisi fresco. The Virgin shrinks backward at the news; indeed the Gospel account says that her spirit was disturbed within her at what manner of salutation this should be. The violence of her movement increases the explosive immediacy of the total effect. The sharp, taut curves of her attenuated body are richly contrasted by Simone against the protuberant masses of the angel, crowned with the olive leaves of the Prince of Peace and bearing an olive branch in his hand. In the center of the richly veined marble slab of the floor

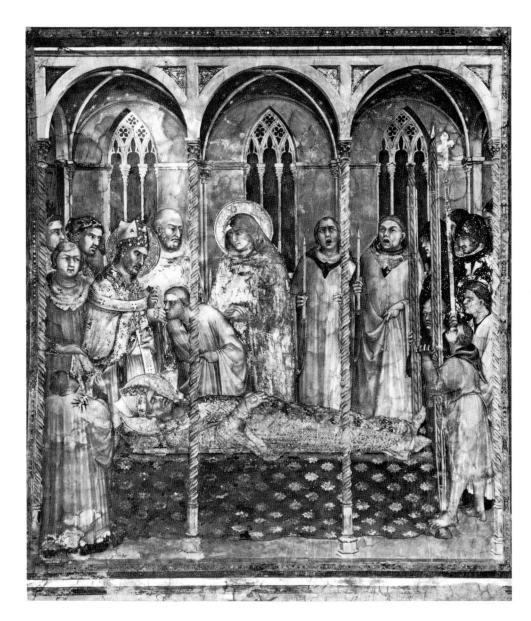

97. SIMONE MARTINI. Funeral of St. Martin. c. 1328. Fresco. Lower Church of S. Francesco, Assisi

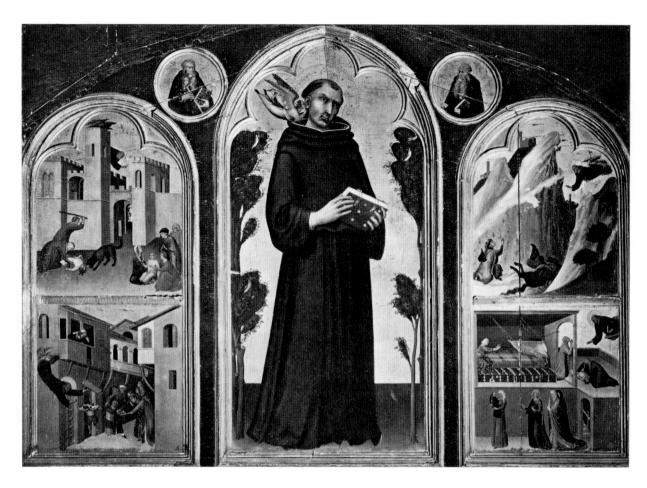

above: 98. Simone Martini. The Blessed Agostino Novello and Four of His Miracles. c. 1330. Panel. Sant'Agostino, Siena

below left: 99. A Miracle of Agostino Novello, detail of fig. 98

below right: 100. Simone Martini. Way to Calvary. c. 1340–44. Panel, $9\% \times 6\%$. The Louvre, Paris

stands a golden vase containing the lilies that symbolize Mary's purity. These, the olive leaves, and the curves of the drapery, not to speak of the features of Mary and Gabriel, display the same sharp, metallic quality seen in Simone's St. Louis of Toulouse. In accordance with the angelic prophecy the dove of the Holy Spirit overshadows Mary, but it seems to burst forth from a group of bodiless angels with crossed swallow's wings, beautifully harmonized with the cusps of the central Gothic arch. The hard, crisp lines of Simone's faces, particularly surprising in the distressed expression of Mary with her puckered brows and pursed lips, are enhanced by the glittering sunburst shapes incised in the gold background around the tooled haloes.

On occasion Simone could be a brilliant narrator, as in the delightful altarpiece in Sant'Agostino in Siena representing the Blessed Agostino Novello, flanked by four scenes of his miracles (fig. 98). In the central panel the Augustinian monk stands in a position that the patron doubtlessly requested, resembling that of Bonaventura Berlinghieri's St. Francis (see fig. 24) and other Dugento images of this sort, but Simone transformed this pose with great delicacy and allusiveness. The monk, holding a book—uninscribed, but possibly symbolic of the juridical learning for which Novello, briefly Prior General of the Augustinian Order, was respected at the papal court—walks toward us among the trees of a forest, lost in meditation, while an angel whispers into his ear words of a higher knowledge than any contained in books. All the subtlety of Simone's sense of line and space is evident in the flattened curves and the suggestion of diagonal motion in depth. The stubble on the monk's jaw and chin, beautifully rendered, foreshadows realistic effects to be exploited by Netherlandish artists in the following century. In the lateral scenes Agostino Novello, in posthumous miraculous appearances, heals a boy whose eye had been gouged out by a wolf, and restores to life a traveler who had fallen from his horse and a baby whose broken hammock had dumped him on the floor. Especially amusing is the scene in which the monk precipitously intervenes to grab a board dislodged from a balcony, before it hits the street (fig. 99). The child who trusted this treacherous support is shown on his perilous way down, then suddenly revived by Agostino's intervention, to the delight of his parents and relatives. Wood-grained balconies, nail-studded doors, and views into staircase halls recapture the Siena of Simone's day without sacrificing the innate austerity of pattern and the delicacy of color that render him one of the greatest masters of the Trecento.

Simone's last years were spent in Avignon, a Provençal city speaking a language sharply different from contemporary French, and then the seat of the papacy. Simone's followers, including his brother, left a number of works from this period of varying quality and condition, but only a few by Simone remain, notably a series of panels from a dismembered polyptych representing the Passion; the most dramatic of these is a startling Way to Calvary, now in the Louvre (fig. 100). Paradoxically enough, in these last small works actually painted in France, Simone's Francophile elegance seems to have vanished entirely, to be replaced by a sometimes coarse and violent feeling for immediate action. Christ is led forth from a very Sienese Jerusalem, seen from below with remarkable accuracy, but he is almost overwhelmed by the mob of loving, grieving Apostles and friends and by mocking Romans and Hebrews, including two irreverent and extremely convincing gamins. In the new interest in passionate drama, even the delicacy of Simone's color has given way to a fierce brilliance, centering around the scarlet robe of Christ. Simone's late style had no immediate issue in Italy, but it must have been a revelation to Northern European painters; certainly his art and that of his compatriots working in Avignon played a crucial role in the development of the new naturalism with which, under Jan van Eyck and the Master of Flémalle, the Netherlands were to astonish the world in the opening decades of the fifteenth century.

PIETRO LORENZETTI

Simone's chief competitors in Siena, the brothers Pietro and Ambrogio Lorenzetti, exercised undisputed domination over Sienese style after the great Simone's departure (Pietro, c. 1290-1348?; Ambrogio, d. 1348?). Which of the brothers was older depends on the stilldisputed interpretation of a document of 1306, referring to one Petruccio di Lorenzo who was paid for work done on an altarpiece in that year. In any case, the brothers, although they almost always worked and signed their paintings independently, show a certain affinity of style, remarkably detached from both the lingering Byzantinism of the Duccio School and the Francophile elegance of Simone. Pietro's earliest known work is the splendid polyptych (fig. 101) signed and dated in 1320, which now stands again in its proper place on the high altar of the Pieve di Santa Maria in Arezzo; in it the artist declares himself to be a mature master, in complete control of a brilliant new style. Pietro must have visited Florence, for the Gothicism and the intense humanity of his art, not to speak of the clear-cut features, stronger hands, and ample proportions of his figures, reveal an acquaintance with the art of Giotto and his followers. The decorative linearism of Sienese painting has become one of the clichés of criticism, but it is hard to find in this work, whose principal emphasis is on warm emotionalism enhanced by the broad, remarkably free movement of pictorial surfaces. In the central panel the Christ Child looks upward at his mother with a gaze whose happiness is answered by a look of searching, foreboding depth, typical of the passionate intensity that characterizes so much of Pietro's art. Similarly, the saints in the lateral panels turn toward each other as if in conversation even

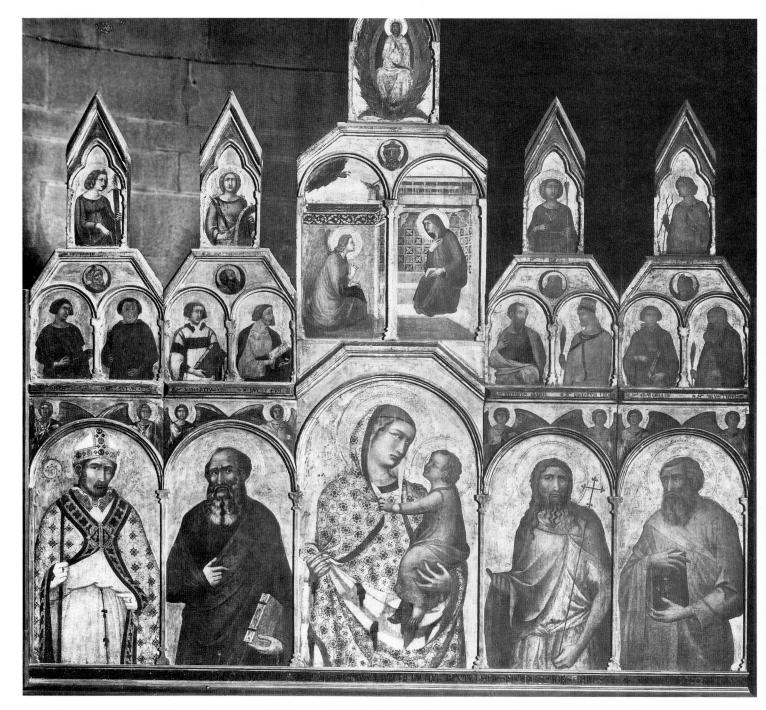

101. PIETRO LORENZETTI. Madonna and Child with Saints, Annunciation, and Assumption. 1320. Panel, 9'91/2" × 10'11/2". Pieve di Sta. Maria, Arezzo

as they look out questioningly toward the observer; in the upper register, just to the left of the Annunciation, St. Luke, closing his book, looks upward at the great event about which he had written so beautifully—perhaps also to remind us that he, too, was a painter and, according to a tradition depicted in many works of art, painted the Virgin's portrait.

Compared with the massive figures of the Giottesque tradition, however, Pietro's personages seem almost weightless; rather than assessing their volume, the eye is invited to explore the bewildering richness of the patterns on their clothing. The Virgin, instead of her customary blue mantle, wears a tunic and cloak made of the same white silk covered with a pattern based on groups

of four interlocking circles; the mantle is lined with ermine, whose dark tails punctuate unexpectedly the constant flow of surface design. In this great work there is little to suggest that Duccio's Maestà was finished only eleven years before and that Simone had still to complete his own version of that subject.

The extent of Pietro's participation in the frescoes representing scenes from the Passion of Christ in the left transept of the Lower Church of San Francesco at Assisi, as well as the date of the series, remains in doubt. His authorship of the Descent from the Cross (fig. 102), however, is beyond question, as are its dramatic power and the nobility and bold originality of its composition. The upper portion of the Cross, including the titulus, is cut off by the border of the fresco, leaving the long horizontal of the crossbar against a background that, on the right, is completely vacant. The gaunt body of Christ, the effects of rigor mortis clearly indicated in its harsh lines and angles, is lowered by his friends: Joseph of Arimathea holds the torso; St. John embraces the legs, pressing his cheek into one thigh; while Nicodemus, holding an immense pair of tongs, withdraws the spike from one pierced foot, Mary Magdalen prostrates herself to kiss the other. Another of the Marys holds Christ's right hand, and—most shattering of all—the Virgin presses the hanging head of her Son to her cheek in a way that unites the two heads, one right side up, the other upside down, the dead and the living eyes seemingly threaded on the same line. The broad, columnar masses of Giotto's figures, which undoubtedly influenced Pietro's repertory of forms, are simplified into vertical drapery lines that suggest little or no volume beneath them, yet they bind the fabric of the composition into a unity of almost unbearable tension.

Many of the other scenes, especially those leading up to the Crucifixion, are of a far lower quality, but the Last Supper (fig. 103) has been maligned in recent criticism. In spite of repainting, it is a remarkable work, and one of the most striking examples of the observation of light in Trecento art. Christ and the Apostles are gathered in a

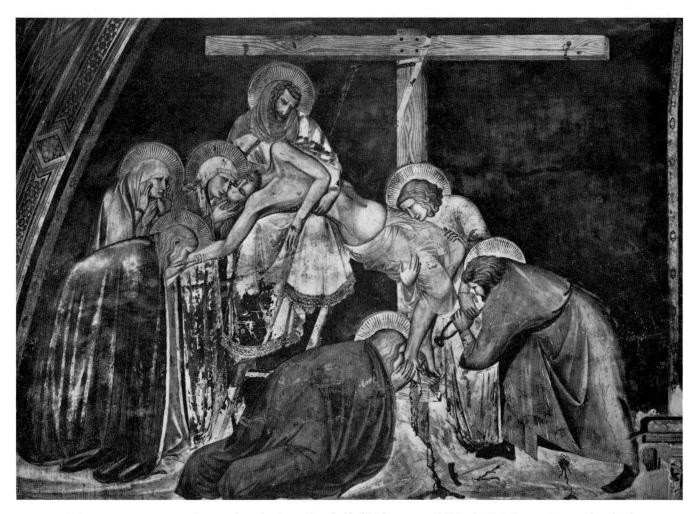

102. PIETRO LORENZETTI. Descent from the Cross. First half of 14th century (1320s-1330s). Fresco. Lower Church of S. Francesco, Assisi

hexagonal upper loggia that is almost filled by the table. In the rich ornament of this structure nude child-angels holding cornucopias, undoubtedly imitated from ancient Roman works, play an unexpectedly important part. While Judas at the left reaches greedily for the sop in wine that Christ hands to him to identify his betrayer—the symbol in later Christianity for the Eucharist leading to one's own damnation when taken unworthily-John presses his face into the Master's bosom. The varying reaction of the Apostles to Christ's dread revelation is contrasted with the complete unconcern of two servants conversing in the doorway, just as the spiritual food of the Last Supper is contrasted with the greedy dog licking the plates scraped in the adjoining kitchen. (Note the treatment of the same theme by Tintoretto 260 years later, fig. 667). Even more striking is the contrast of ma-

terial and spiritual light. The kitchen is illuminated by the fire in the fireplace, and the moon and stars are shown in a real sky outside, which is unprecedented and not to reappear until the 1420s (see fig. 185). But what source lights the ceiling of the loggia from below, when there is neither candle nor lamp? It can only be the light from the haloes of Christ and the Apostles.

At least in its present state, the most lyrical of Pietro's panels is his superb *Enthroned Madonna* (fig. 104), painted in 1340 for the Church of San Francesco in Pistoia, in Florentine territory—tacit admission that after Giotto's death in 1337 no Florentine painter could compete with the great Sienese masters. Although the simple columnar forms of the figures abound in references to the Giottesque tradition, the softness and lightness of the surfaces and a certain abstraction in the shapes of the

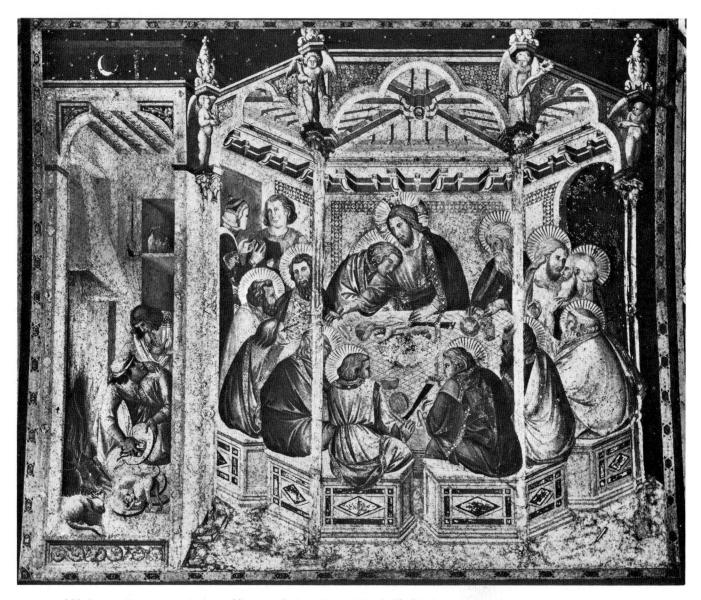

103. PIETRO LORENZETTI (executed by a pupil). *Last Supper*. First half of 14th century (1320s–1330s). Fresco. Lower Church of S. Francesco, Assisi

Colorplate 10. Giotto. Funeral of St. Francis (detail). Probably 1320s. Fresco. Bardi Chapel, Sta. Croce, Florence

Colorplate 11. MASTER OF THE ST. FRANCIS CYCLE. St. Francis Praying before the Crucifix at San Damiano; St. Francis Renouncing His Worldly Goods; Dream of Innocent III. Early 14th century. Fresco. Upper Church of S. Francesco, Assisi

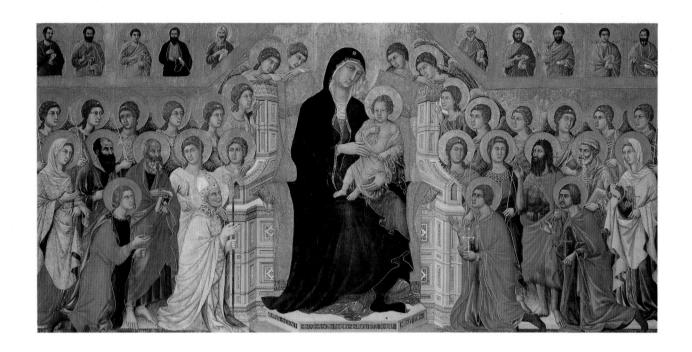

above: Colorplate 12. DUCCIO. *Maestà*. 1308–11. Central front panel, 7×13'. Museo dell'Opera del Duomo, Siena

right: Colorplate 13.

DUCCIO. Entry into Jerusalem, from the back of Maestà.

1308–11. Panel, 401/8 × 211/8".

Museo dell'Opera del Duomo,
Siena

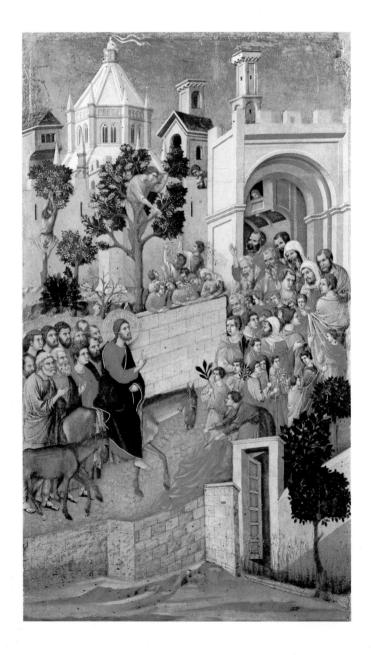

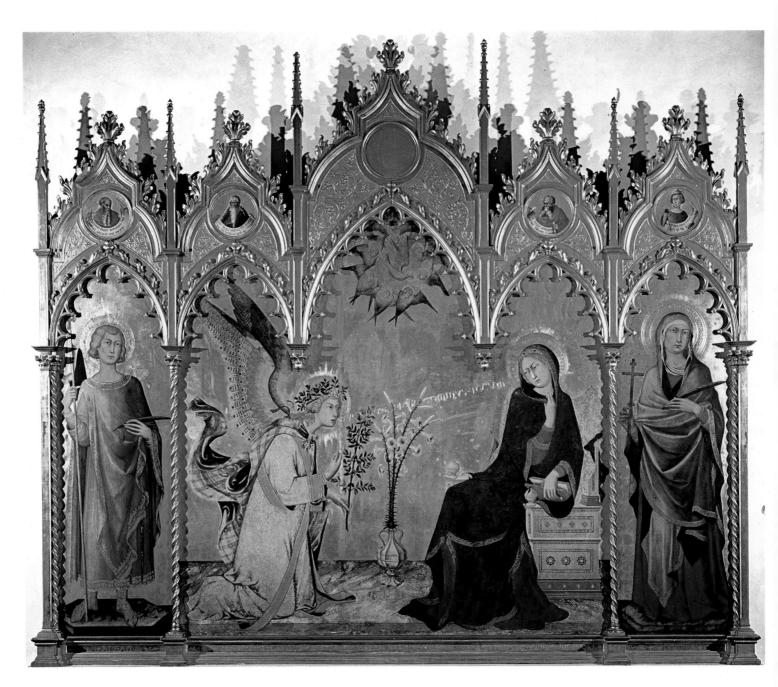

Colorplate 14. Simone Martini. *Annunciation*. 1333. Panel, $10' \times 8'9''$. Uffizi Gallery, Florence. (Standing saints by Lippo Memmi)

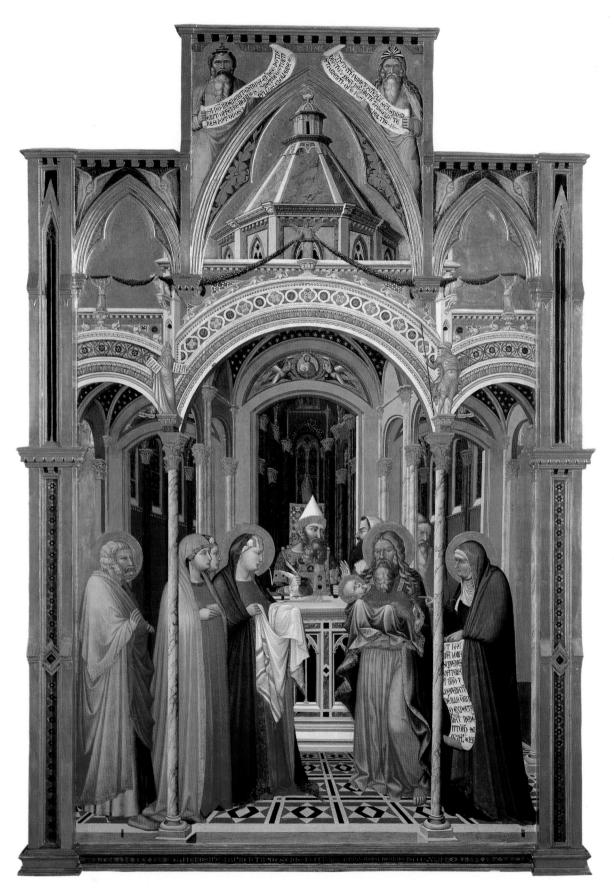

Colorplate 15. Ambrogio Lorenzetti. Presentation in the Temple. 1342. Panel, $8'5\%''\times5'6\%''$. Uffizi Gallery, Florence

Colorplate 16. AMBROGIO LORENZETTI. Allegory of Good Government: Effects of Good Government in the City and the Country (portion). 1338–39. Fresco. Sala della Pace, Palazzo Pubblico, Siena

Colorplate 17. Andrea Orcagna. Enthroned Christ with Madonna and Saints. 1354–57. Panel, c. $9' \times 9'8''$. Strozzi Chapel, Sta. Maria Novella, Florence

Colorplate 18. Andrea da Firenze. *Triumph of the Church*. c. 1366–68. Fresco. Spanish Chapel, Sta. Maria Novella, Florence

drapery masses make it impossible to mistake the picture for a Florentine work, even in a generation when Bernardo Daddi's human sweetness had essentially altered the grandeur of Giotto's heritage. The Christ Child playfully pushes his mother's chin and toys with one of her fingers. The beautiful blond angels do not all give the sacred figures their undivided attention; a few indulge in peripheral conversations. The almost Greek profiles, their straight noses and jaws deriving from the tradition of Giotto and the Pisani, are softer in definition than anything from the Florentine School. And the color, especially in the delicacy and sweetness of its blues, is remarkably well preserved. The clear, lovely blue, apparently mixed with some white, of the Virgin's erminelined mantle harmonizes exquisitely with the powdery, paler blues of the angels' tunics. In the designs at neck and sleeve lingers a bit of gold striation in the form of an embroidered pattern.

Two years later Pietro painted the *Birth of the Virgin* (fig. 105) as his contribution to the great cycle of Marian altarpieces that once adorned the Cathedral of Siena; it is a remarkable triptych, which, seemingly in competition with another by his brother Ambrogio (see colorplate 15), set a new level in the definition of space. The altarpiece is treated as if it were an actual building or a stage of some kind, the carved frame with its colonnettes, pointed arches, and pinnacles being the outward projection of the painted architecture (the present Italian policy of removing all restorations has left us with no colonnettes to support the arches); or, conversely, as if the represented space were behind the carved frame—to the extent of establishing three Gothic ribbed vaults, so

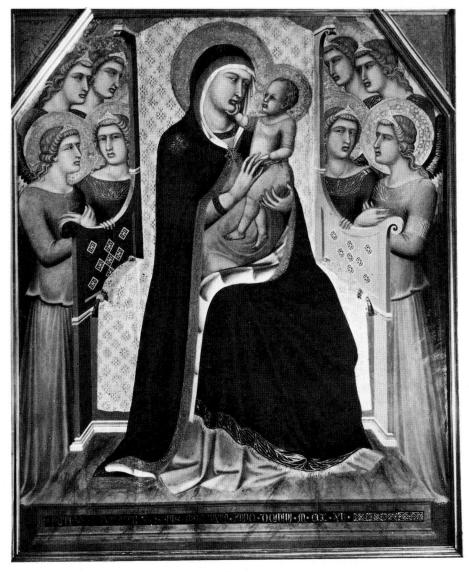

104. PIETRO LORENZETTI. *Enthroned Madonna*. 1340. Panel, 571/8 × 48". Uffizi Gallery, Florence

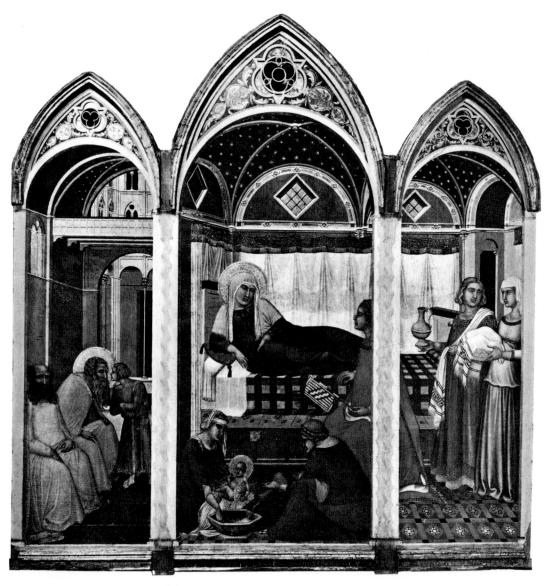

105. PIETRO LORENZETTI. Birth of the Virgin. 1342. Panel, 731/2×711/2". Museo dell'Opera del Duomo, Siena

that each arch of the frame does duty as the foremost arch of the vault beyond it. It is an astonishing bit of illusion, carefully maintained to give us the feeling that we could step over the threshold and enter the room where St. Anne lies on her bed with its checked spread, while the baby Virgin is being bathed and neighbors arrive bearing gifts. One lady even waves a beautiful striped fan to cool St. Anne (the Virgin's birthday was traditionally set at September 8, still the hot season in Tuscany). In the antechamber on the left St. Joachim receives the good news, and behind him we look into a space that might belong to some ecclesiastical building—a towering Gothic structure with at least three stories visible, the upper one cut off by the vault of the antechamber. The tall structure bears no relation to the habitation of Joachim and Anne, luxurious as that is, and it must be a symbolic reference to the Temple in which Mary was to be presented three years later. Ancient Roman painting, in the examples that remain in Rome, Pompeii, and Herculaneum, had often devised such illusionistic effects; these were revived in the enframements of the St. Francis cycle at Assisi to identify the painted colonnettes that divide the scenes with the clusters of actual colonnettes that form the piers of the Gothic structure. It is interesting to speculate how the two lateral panels of Pietro's triptych that contained standing saints, now lost, might have affected the general appearance of the altarpiece. Pietro's great work is the first of a long series that presents the entire space of the picture as an inward extension of the frame. In the perspective formulation of the space, Pietro at times seems to come close to the one-point perspective that rules pictorial art during the following century, but analysis will always show that the floors in the side panels have separate vanishing points, and that these do not correspond to the single vanishing point used for the construction of all

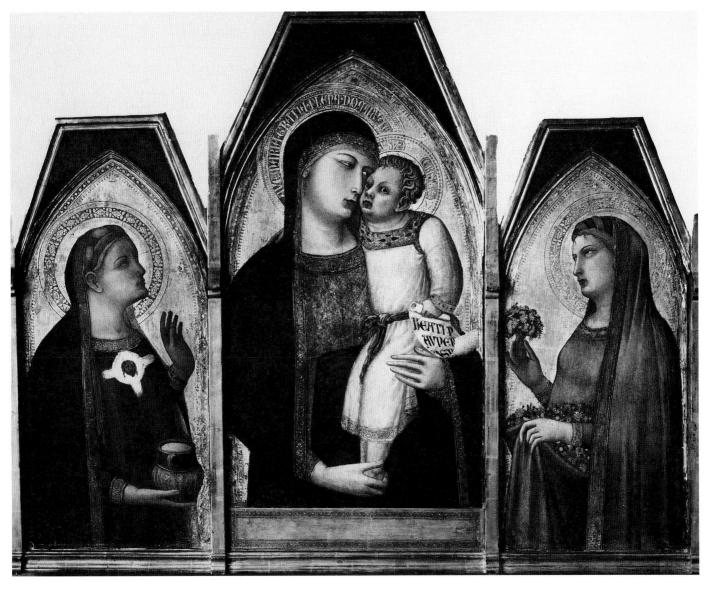

106. AMBROGIO LORENZETTI. *Madonna and Child with Saints*. Late 1330s. Panel, 58 × 89½". Pinacoteca, Siena

three vaults. Nonetheless, the Sienese Trecento painters, recklessly plunging into the hitherto unexplored realm of the rational formulation of visible space, went a long way toward the art of the Renaissance.

AMBROGIO LORENZETTI

Although gentler and more speculative in temperament than his passionate brother, Ambrogio Lorenzetti was quite as great a painter. He seems to have visited Florence on at least two occasions—in 1319, when he painted a *Madonna* for the Pieve in Vico l'Abate outside Florence, and in 1332–34, when he painted a polyptych for the Church of San Procolo, and joined, possibly because he had to in order to work in Florence, the Arte dei Medici e Speziali. Typical of the warmth and emotional richness of his altarpieces is the group of panels from a polyptych Ambrogio painted, probably in the late 1330s, for the now suppressed convent of Santa Petronilla in

Siena (fig. 106). In the central panel Mary, holding the bewitchingly natural Child by his feet as well as his thighs, presses him close to her so that their cheeks touch. Mary Magdalen lifts her left hand in delight at this image of maternal tenderness and holds forth her jar of precious ointment, while on her breast shines the face of the mature Christ, in the center of a cruciform burst of rays; St. Dorothy, who demonstrated the directness of her route to Paradise by a miraculous growth of flowers on her path, has picked a lapful of these posies, from which she has selected and tied a nosegay in tribute to the Madonna. No more sparkling representation of flowers can be found in the whole Middle Ages than this exquisite display. An almost Impressionist sense of the value of each color particle creates countless points of reflecting color, bright and clear and pure, against the soft gray-lavender tunic and mantle of St. Dorothy and leading up to the rose tunic of the Christ Child. The col-

or composition receives an unexpected accent in the black-and-orange ribbon interwound in St. Dorothy's soft, abundant tresses. Ambrogio's female forms are fuller than those of Pietro, his faces and throats softer, and his coloring even warmer. Rich rose tones play throughout the flesh. It is not hard to think of him as an ancestor of the great Venetian colorists of the High and Late Renaissance. At the same time, even the apparent spontaneity of his figural relationships produces delicate adjustments of linear pattern—in, for example, the haloes and the tooled borders that they intersect. The message of the altarpiece is summed up in the inscriptionsthe "AVE MARIA" incised in Mary's halo, and the scroll held by the round-eyed, curly-headed Child: "BEATI PAUPER...ISP...," referring to the first Beatitude, "Blessed are the poor in spirit, for theirs is the kingdom of heaven."

In the competition with his brother in 1342, Ambrogio clearly won. His great altarpiece of the Presentation in the Temple (colorplate 15) for the Cathedral of Siena. now in the Uffizi in Florence, penetrates architectural space in a manner unprecedented since Roman antiquity. The complex Gothic frame is not an integral part of the architecture, as in Pietro's Birth of the Virgin, but, with its colonnettes removed in the manner of those so spectacularly missing in Simone Martini's Annunciation, from the same cycle of Cathedral altarpieces, the frame gives the impression of a lofty gateway admitting the observer into the "courts of the Lord" (Psalm 84:2-4). Within and beyond the frame we gaze into the interior where the light is dimmed by a stained-glass window. While Ambrogio still maintains the double scale of medieval art—one scale for the figures, another for the setting—he has reduced the figures so as to make the architecture more credible. Slender columns uphold the blue. gold-starred, ribbed vaults of the nave. Behind the altar we look through reverse catenary arches into the dimness of the sanctuary with black marble columns and gilded capitals. For the first time in any Italian painting, we sense the actual immensity of a cathedral interior. The architecture is a strange amalgam of Romanesque and Gothic. Erwin Panofsky showed that in the Late Middle Ages, Romanesque architecture was considered to be of Oriental origin, so that the Temple in Jerusalem was generally represented with Romanesque round arches rather than Gothic pointed ones. Also, the polygonal building we so often see in the backgrounds of Trecento paintings, such as in the Entry into Jerusalem from Duccio's Maestà, is always the Temple, since the Crusaders had brought back descriptions of the Dome of the Rock in Jerusalem, the central-plan mosque built on the site of Solomon's Temple. In Ambrogio's picture, we see beyond the roof of the building to the great polygonal dome behind; it recalls the Baptistery at Florence, but is provided with Gothic windows in spite of the Romanesque shapes of the nave arches below.

For all his quiet drama, so like the ritual of Baptism today, Ambrogio has illustrated precisely the Gospel text (Luke 2:22–38). We see the gift of two turtle doves upon the altar, according to the Law. The aged Simeon, whom the Holy Spirit had told he was not to die until he had seen the Lord's Christ, holds the little Child in his arms, and murmurs the words of the "Nunc Dimittis":

Lord, now lettest thou thy servant depart in peace, according to thy word:

For mine eyes have seen thy salvation

Which thou hast prepared before the face of all people;

A light to lighten the Gentiles, and the glory of thy people Israel.

At the left side stand Joseph, Mary, and two attendants, marveling "at those things which were spoken of him"; at the right side the eighty-four-year-old prophetess Anna holds a scroll with the last verse of the passage from St. Luke: "And she coming in that instant gave thanks likewise unto the Lord, and spake of him to all them that looked for redemption in Jerusalem." With a wholly new sensitivity Ambrogio has been able to depict all the differences in age and feelings, from the tiny Child blissfully sucking his thumb and the gentle pride of his beautiful mother, her arms now momentarily empty, to the wrinkled age of the prophetess Anna and the immense weariness of Simeon, now to be released from the burden of life. Recent cleaning has revealed a color scheme of unexpected brilliance—crisp whites against clear primary tones-competing with the splendor of Duccio and

Ambrogio's most revolutionary achievement is doubtless the fresco series (1338–39) that, with no interruptions save the narrow borders framing each entire wall, lines three sides of the Sala della Pace, a chamber directly behind the wall of the great Council Chamber in the Palazzo Pubblico. Ambrogio's task was unprecedented. He was called upon to depict allegorically Good Government and Bad Government—a subject of intense significance to medieval Italian communes-and then to represent in detail the effect of these opposed regimes in town and country. Not unnaturally, he chose the most strongly illuminated walls for Good Government and its effects, leaving Bad Government to languish in the shadows on a wall that, alas, has also suffered considerable subsequent damage. Faced with such extensive surfaces, Ambrogio composed quite freely according to a panoramic principle that he seems to have invented. The compositions flow in a relaxed manner, without set geometric relationships, much like the spontaneous city plan of Siena itself. On one wall Ambrogio has enthroned the majestic figure of the Commune of Siena, holding orb and scepter, and guided by Faith, Hope, and Charity, who soar in the air about his head (fig. 107). On either side of Commune other Virtues, chosen for civic

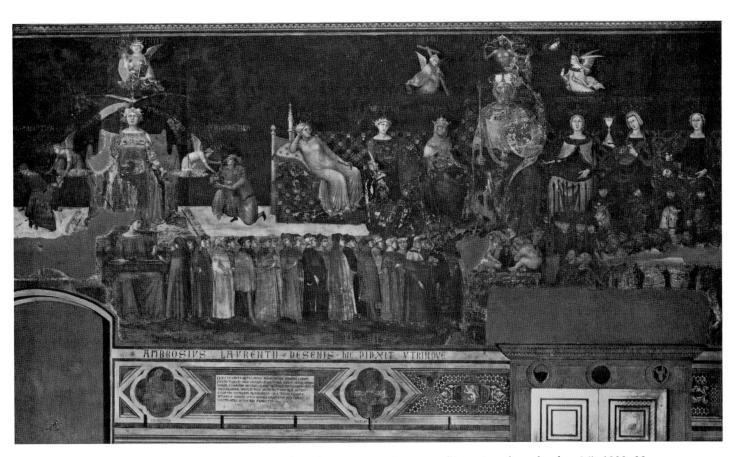

107. Ambrogio Lorenzetti. Allegory of Good Government: Commune of Siena (see also colorplate 16). 1338-39. Fresco. Sala della Pace, Palazzo Pubblico, Siena

significance, sit or lounge on a splendid damasked bench; to the left side Justice, above whose head floats Wisdom, dispenses rewards and punishments through the agency of winged figures that represent Commutative Justice, who gives arms to the noble and money to the merchant, and Distributive Justice, who crowns a kneeling figure with her left hand as she lops off the head of another with her right. Below the throne of Justice, Concordia presides over the twenty-four members of the great Council of the Sienese Republic. The style of the figures strongly resembles that of the most gentle, softly painted altarpieces by Ambrogio. One figure, the famous reclining Peace, is taken directly by Ambrogio from a Roman sarcophagus fragment, today in the Palazzo Pubblico; yet if the original were not still preserved one would scarcely suspect a classical prototype, so medieval is the style of Ambrogio's drapery.

The complete surprise is found in the fresco showing the effects of Good Government in town and country (colorplate 16; fig. 108)—a continuous view from a high point, embracing so vast a scene that no one photograph could contain it all (see fig. 4). We are taken, with great delight, through the streets, alleys, and squares of Siena (much as it still stands), over the city walls, and out into the open country. No such comprehensive panorama of the natural world and its human inhabitants is known to us from the entire previous history of art, and certainly nothing so ambitious was ever attempted later, save by the painters of purely informative, historical, decorative panoramas in the sixteenth century. Yet, since Ambrogio is, after all, still a medieval painter, he has not chosen a single point of view but rather shifts constantly from one to another to show us as much as possible of town and country and of what goes on in every corner of both. His world is absolutely complete, with buildings, people, trees, hills, farms, waterways, animals, and birds.

Since there is no real story to be told, Ambrogio is able, almost, to desert the double scale. Actually, the buildings are smaller than they would be in relation to people, but if Ambrogio had painted the people and animals as small as they should be they could hardly have been made out in so vast a worldscape. He has boldly decided to represent the entire city of Siena as it climbs up its hillside to the zebra-striped tower of the Cathedral, clearly visible in the upper left-hand corner. (This corner was repainted about twenty years later, but the Cathedral itself may still be there in Ambrogio's underlying original.) The city is all there, its towers, crenellations, Romanesque windows, Gothic windows both simple and mullioned, the beams outside the windows

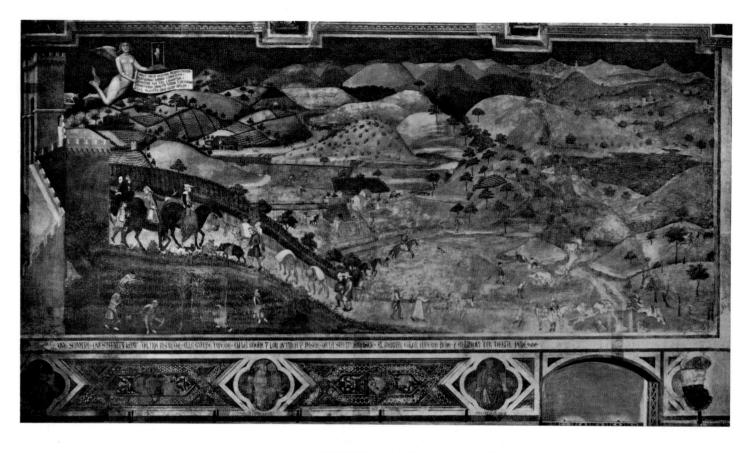

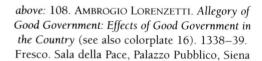

right: 109. Securitas and Sienese landscape, detail of fig. 108

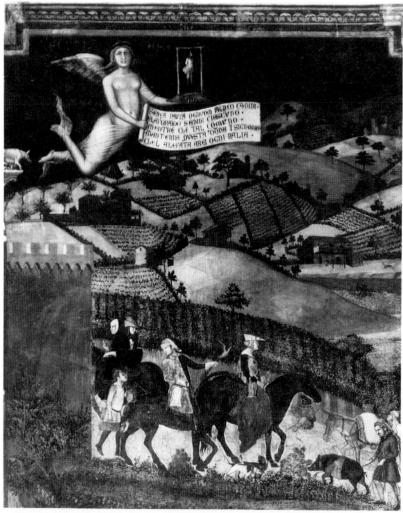

were descended from Remus), which looks off across the

Sienese contado.

This (fig. 109) is perhaps the most daring view of all. Ambrogio seems to have wanted to bring in the entire territory, off to the sea at Talamone (so labeled), Siena's ambitious new port, in order to display the prosperity of the Republic. Vines are tended, grain is harvested and threshed. As the peasants bring their produce and their animals (including a delightful saddlebacked hog) up the steep incline into the city, conversing happily the while, gentlemen and ladies descend into the country to go a-hawking. Considerately enough, they indulge in this sport only in the fields of stubble (never in the standing grain!). The apparently random activities depicted in city and country correspond exactly to the seven Mechanical Arts, according to Hugh of St. Victor. For example, dancing in the street, actually forbidden in medieval Siena, is related to the art of Music. Medicine, another Mechanical Art, includes both shopkeeping and spice selling, and is personified between them, for the teacher visible in the central arch wears a doctor's red gown. The labors in the fields take place in different months. But all apparently go on in summer, whose months appear in the upper border of the fresco (see colorplate 16). All activities center on the dominant Commune, providing a systematic panorama of medieval life. Presiding over these human activities is a sweet and largely nude lady labeled Securitas, who floats through the air; she brandishes a scroll proclaiming that all men walk in peace under her tutelage, and lightly holds in the other hand a gallows from which swings an executed disturber of the universal tranquillity. Our eye follows the vista off over hill after towered hill, farm after farm, but the spectacle still terminates against the blank slaty color of the wall itself at the horizon. It is too early, apparently, for the artist to want to paint the sky and clouds. These last are reserved, like Giotto's light effects, only for the religious vision. But as the landscape moves into the distance, it is clear that Gothic linear techniques no longer suffice for Ambrogio. He now represents details of plants and stubble by a few quick, sketchy strokes, a kind of shorthand that will have to await the Quattrocento and Masaccio for full exploration.

LORENZO MAITANI

At the end of the Dugento and in the early Trecento, Sienese sculpture was dominated by Nicola and Giovanni Pisano, and although some good local sculptors managed to free themselves from the Pisani tradition, the appearance of a real sculptural genius in Siena in the first third of the Trecento comes as a surprise. This extraordinary man was responsible for the finest work in the four huge panels of carved marble that separate and flank the entrance portals of Orvieto Cathedral, perched on a mighty tableland in present-day Umbria, and probably for the general design of all four. To Orvieto was carried in 1263 the bloodstained corporal (Eucharistic cloth), the relic of the miraculous Mass of Bolsena (see page 512), for presentation to Pope Urban IV, then in temporary residence there. From Orvieto in 1264 he proclaimed the still-celebrated Feast of Corpus Christi. A vast cathedral rose, somewhat too rapidly, to enshrine the relic, and in 1310 the Sienese architect and sculptor Lorenzo Maitani, about whom we know nothing else except the date of his marriage in 1302, was called as capomaestro. One of his responsibilities was the "wall figured with beauty, which wall must be made on the front part," clearly the four reliefs, each over thirty feet high. Maitani produced a drawing, one of two still extant, and died in 1330. The leading position he holds in the documents has caused him to be identified with the most gifted of the many sculptors at work on the panels, the upper portions of which, here and there, remain unfinished.

The reliefs represent the story of Adam and Eve (fig. 110), the Life of Christ, the Tree of Jesse, and the Last Judgment. The freedom of planning of the first and last reliefs displays the artistic vision of a mind that could on the one hand create images of exquisite poetry and on the other envision those of the utmost horror. Unlike fresco, the work proceeded from the bottom up, as the façade rose. From the start Maitani and his collaborators dispensed with the customary enframements and composed the little scenes in continuous strips like those on the ancient Roman columns of Trajan and of Marcus Aurelius, with figures close-packed as in the work of the Pisani. But in the second row a change takes place, quite possibly not foreseen at the start. In the center of each relief sprouts an immense vine, whose branches and ten-

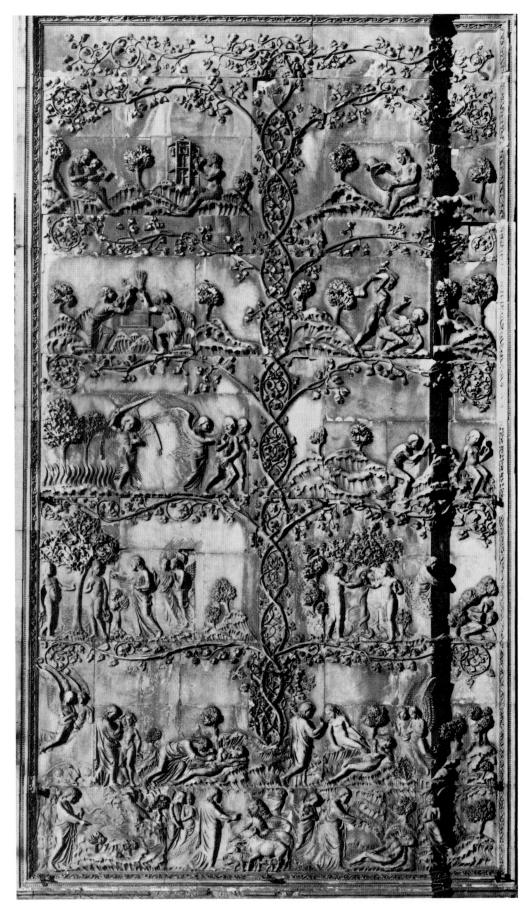

110. LORENZO MAITANI. Scenes from Genesis. c. 1310-before 1316. Marble. First pilaster of the façade, Cathedral, Orvieto

left: 111. LORENZO MAITANI. Creation of the Birds and Fishes, detail of fig. 110

below: 112. LORENZO
MAITANI. Detail of
Hell from Last
Judgment. c. 1310–30.
Marble. Fourth
pilaster of the façade,
Cathedral, Orvieto

drils form growing supports and frames for the little scenes. In the two central panels the vine is an acanthus, as in Roman medieval apse mosaics, and the scrolls curl tightly. But the branches of the vines in the right and left panels are more widely separated, leaving airy spaces above and around the figures. On the left the vine is ivy, the plant from which ancient victors' wreaths were formed (an odd accompaniment to the Creation story, which ends in Man's defeat), but on the right it is the grape vine, which recalls the Eucharistic miracle of Bolsena.

The Creation scenes are delicately imaginative (fig. 111). The Lord moves with infinite grace across the primal rocks, calling the fish to shadowy life in the swirls of the marble water and the birds to attention in the still impossibly small forests. Maitani—if this is indeed he has taken a tremendous step, in a direction not to be fully exploited until Donatello and Ghiberti, in lowering the projection of distant figures and birds to a few millimeters above the background elements, in contrast to the almost freestanding, heavily undercut foreground figures. The airy movements and diaphanous mantle of the Creator, moving among his works with delicate joy, hardly prepare us for the shock of Maitani's view of Hell, in the center of which, hardly above eye level (fig. 112), the tormented figure of one of the damned hangs by his arm from the jaws of a demon—a pose so compelling that, as the author noted to his astonishment in 1936, Michelangelo himself was struck by it, and transfigured it in his still-agonized dead Christ in the Pietà of the Cathedral of Florence (see fig. 706).

5 Later Gothic Art in Tuscany and North Italy

he greatest masters of Florence and Siena, especially the painters, created in the first four decades of the Trecento a new art that revolutionized the vision of all Western Europe and that seems to lead in a straight line to the Early Renaissance—some of whose major discoveries, indeed, Trecento artists in large measure anticipated. Without Giotto, Nicola and Giovanni Pisano, and Ambrogio Lorenzetti, the work of such leaders of the Early Renaissance as Donatello, Ghiberti, and Masaccio would be hard to imagine. Yet the history of art, like that of humanity itself, is seldom predictable and avoids straight lines. The art of the second half of the Trecento seems like a renunciation of the revolutionary achievements of the preceding generation and to have little to do with the Renaissance that followed; thus it is often disregarded or passed over with a few perfunctory phrases. Nonetheless, although the period can show no single artist of universal importance, it did produce works of striking originality, beauty, and expressive depth. Moreover, the sharp about-face from the "progressive" styles of the early Trecento can teach us much, not only about the relationship between art and society but also about hidden factors in Italian group emotion, which, when brought to the surface by an unexpected turn of events, can help to bring about unexpected stylistic changes.

For both Florence and Siena the 1330s and 1340s were decades of calamities in ever-increasing intensity. In Florence the flood of 1333, exceeded in depth only by that of 1966, struck the city with such violence that it tore down six hundred feet of city walls and towers along the Arno, and brought untold havoc to commerce, buildings, and doubtless works of art. Costly and frustrating military activities and a succession of political and economic crises were followed in 1343 by the failure of the important Peruzzi bank and in 1345 by that of the Bardi, chiefly due to the bankruptcy of their English branches, which were fatally involved in the military adventures of King Edward III. Soon every major banking house in Florence and even in Siena was drawn into ruin, with

serious consequences for economic and cultural life. A brief experiment with dictatorship under the duke of Athens in 1342-43 did little to help. During 1346 and 1347 agricultural disasters brought about widespread famine. The weakened and demoralized populations of Florence and Siena were in no position to resist when in 1348 the bubonic plague—the so-called Black Deathwhich had already caused heavy mortality in 1340, struck again with unbelievable intensity. There is no accurate way of measuring the human toll; estimates vary from a conservative fifty percent mortality in both cities to seventy-five or even eighty percent of the population, all swept away in one hot, terrible summer. Chronicles written by the survivors present a horrifying picture of streets piled high with rotting corpses, bodies stacked in immense ditches, complete economic stasis, runaway inflation, general terror. The effects on every aspect of culture, but especially upon art and religion, were devastating.

The artists of course suffered as bitterly as anyone else. Bernardo Daddi, Andrea Pisano, and probably Pietro and Ambrogio Lorenzetti died in the plague. Only Taddeo Gaddi survived to carry into the second half of the century the great tradition of Giotto. The demands for works of art seem also to have changed radically. In the general wave of self-castigation that follows catastrophe, religion offered an explanation in terms of divine wrath, as well as a refuge from the consequences of that wrath. The upheaval had decimated the ruling classes, and their places were filled with a new group of outsiders with conservative, non-Giottesque tastes. On all counts the ground was prepared for the growth of a new style that rejected as perilous the deep humanity and explorative naturalism of the early Trecento and turned toward both the supernatural and the Italo-Byzantine past, surviving from an era that must have seemed to many more secure, because less adventurous. In fact, the last great work of Daddi, the Madonna and Child for Orsanmichele-among other paintings-already shows symptoms of a reactionary stylistic trend.

MID-TRECENTO PAINTING IN FLORENCE

The neomedievalism of the mid-Trecento, not to speak of more positive qualities of the period, is abundantly visible in one of its most powerful works, the altarpiece painted by Andrea Orcagna (active c. 1343-68) between 1354 and 1357 for the Strozzi Chapel in Santa Maria Novella in Florence (colorplate 17). Although at first glance the elements of Giotto's style seem still to be present, this picture soon discloses that it has abandoned most of what Giotto and his contemporaries had tried to build up, beginning with the very shape of the altarpiece itself. (Although the frame dates from the nineteenth century, drawings made of the altarpiece before restoration show that it follows closely the original forms.) The panels and frame were completed before Orcagna signed the contract for the painting, but as he was at that very moment a practicing architect and sculptor on a grand scale (see below), the original frame must have been made from his designs. The crystalline shape of a Giottesque panel has now been discarded in favor of a Sienese profusion of ornament in the tradition of Simone Martini, but without any of Simone's grace of movement. The five gables of the polyptych are curiously truncated, and from their flat tops spring unexpected floral shapes. Especially surprising is the pair of loops sprouting from the sides of the central gable. Within the discordant rhythms of this frame, all the figures—seated, standing, kneeling, or floating-seem locked in a predetermined pattern amounting to stasis, rather than enjoying the free mobility of early Trecento figures.

In the center Christ is frontally enthroned, staring ahead. Yet no throne is visible; the crowned Lord is a mighty apparition in a golden mandorla bordered by two overlapping crescents of cherub heads and wings. Without looking at either of the kneeling saints, Christ extends his arms absolutely straight, presenting a book of doctrine (inscribed with biblical passages from Revelation and from Kings) to St. Thomas Aquinas, one of the greatest Dominican saints (Santa Maria Novella is a Dominican church) as well as the patron of Tommaso di Rossello Strozzi, who commissioned the altarpiece, and handing the keys to St. Peter, the Rock on whom the Church was founded. Behind these symbols of ecclesiastical authority stand Mary, patron of this church, and St. John the Baptist, patron of Florence. As in Daddi's Orsanmichele Madonna, no space is indicated clearly, and instead of a receding ground we find a gold-figured carpet parallel to the picture plane, of which it seems indeed to be a horizontal division. The humanity and thisworldliness of the early Trecento has been replaced by the authority of doctrine and by the immediacy of religious vision, disrupting—as did the miracle of the Annunciation in Simone's panel (see colorplate 14)—even the normal shape of a polyptych divided by colonnettes. The pyramid of the central group, occupying three arches, is abutted in the lateral panels by pairs of standing figures crammed into spaces deliberately too small to hold them. The arrangement is ostensibly symmetrical: the saints holding swords guard the flanks (St. Michael and St. Paul), those with tiered instruments of martyrdom (St. Catherine and St. Lawrence) stand next to them. But asymmetries appear: on the right side, both saints turn their heads toward each other in conversation; on the left, St. Catherine looks inward, St. Michael out toward the spectator. The precisely drawn heads, still within the general repertory of Giottesque forms, show nonetheless a wholly un-Giottesque tension of expression and form and a sharp concentration on linear detail. Christ stares outward with the impersonality of a Dugento Pantocrator (All-Ruler; see fig. 18). Frowns pucker the foreheads of the older saints: St. Peter, looking fixedly at the Lord with an expression of deep emotion, is drawn with a Dugentesque insistence on every line of the intricately curled beard and waved, crisply cut hair. A hint of Dugento compartmentalism has reappeared, not only in the armor-plate divisions of the hair but also in the sharply demarcated structure of the features and the neck. St. John the Baptist, the locks of his hair writhing like flames, looks outward and partly upward with an expression of mystic exaltation. Only the female or youthful faces are calm, if somewhat masklike. That of St. Thomas Aquinas suggests a portrait of a living person in its accuracy and refinement of observation. Throughout the composition the easy drapery rhythms of the early Trecento are replaced by generally harsh and complex shapes.

The subjects of two of the loosely organized scenes in the predella are not surprising. The first depicts St. Thomas Aquinas in ecstasy during the celebration of Mass, the second Christ walking on the water and saving Peter, the theme of Giotto's Navicella. These are directly related to the two saints in the foreground above. But the third, the saving of the soul of the emperor Henry II, is startling. According to a story preserved in the Golden Legend, Henry II's soul hung in the balance, which was weighed in his favor only by his gift of a golden chalice to the Cathedral of Bamberg, presumably as Tommaso Strozzi expected his gift of the altarpiece to determine matters in his own favor at a similar moment, which occurred only a few years later.

Orcagna joined the Arte di Pietra e Legname in 1352, and in 1355 was made *capomaestro* of Orsanmichele. Probably in that very year he commenced the fantastic tabernacle (fig. 113), finished in 1359, for which money was collected in 1348, just after the passage of the Black Death, to enshrine Daddi's huge *Madonna and Child Enthroned* (see fig. 81). The work is overwhelming as much on account of its size and magnificence as its quality. Its clustered pinnacles nearly touch the vault, and its white marble is encrusted with mosaic ornament in blue and gold. The transformation in style in only twenty years

left: 113. Andrea Orcagna. Tabernacle. Probably begun 1355; finished 1359. Marble, mosaic, gold, lapis lazuli. Orsanmichele, Florence. (*Madonna and Child Enthroned* by Bernardo Daddi, 1346–47)

above: 114. Andrea Orcagna. *Birth of the Virgin*. 1350s. Marble on mosaic background. Orsanmichele, Florence. Detail of fig. 113

can be illustrated by a comparison between the lucidity of Giotto's design for the Campanile of the Cathedral of Florence (see fig. 76) and the complexity of this structure, with its spiral columns, rich crockets punctuating not only the pediment but also the ribs of the central dome, and above all the mosaic inlays, organized in terms of the same statements, hesitations, and rejections we have found in the frame of the Strozzi altarpiece. The dome may even be Orcagna's entry in the contest for that of the Cathedral, like the dome portrayed in fresco by Andrea da Firenze (see colorplate 18). (In 1357, in fact, Orcagna submitted models for the piers of the Cathedral, but was passed over in favor of Francesco Talenti.) The smaller scenes in relief, especially the Birth of the Virgin (fig. 114), should be compared with the ritualistic mosaic of the same incident by Cavallini (see fig. 35). The floor is tilted and the bed curtains parted like those of a stage to display every detail—the midwife admiring the swaddled child, the background figure with the inevitable pitcher in one hand and in the other the salver customarily given to Florentine mothers after childbirth (and often painted by important masters), the bedroom walls apparently made of unplastered masonry, the open *imposte* (inner, solid shutters, still used in Italy and a necessity in the era before window glass) with even their nailheads showing—down to the very keyholes in the linen chest, which forms the pedestal of an Italian medieval or Renaissance bed (see figs. 96, 208). All this represents as sharp a departure from the ordered reliefs of Andrea Pisano as do Orcagna's dissonant drapery rhythms from the harmonious ones of Giotto.

Orcagna, whose real name was Andrea di Cione, was one of three brothers (Andrea, Nardo, Jacopo) whose populous studios dominated much of the painting of the third quarter of the Trecento in Florence. Nardo di Cione (active c. 1343–66), notwithstanding a deepseated difference in style between his own often still-Giottesque (or rather Daddesque) work and his brother Andrea's originality and emotional tension, produced the gigantic frescoes that provide the setting for Orca-

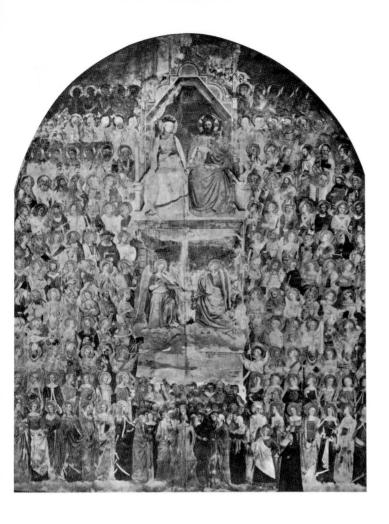

gna's altarpiece in the Strozzi Chapel. Almost invariably in frescoes of the Last Judgment, Hell was represented as merely one section of a single, all-embracing scene. In the Strozzi Chapel the position of the altar and altarpiece, and the window in the center wall, made it necessary to place Heaven on one side wall, Hell on the other. Although it contains many beautifully painted individual heads, Nardo's *Paradise* (fig. 115) is hardly more than a mass of costumed figures, row on row as if in church. But his *Hell* (fig. 116) is an astonishing performance, the first attempt at a complete illustration of its punishments as described by Dante, all enclosed in their proper circles of the *Inferno*. The explicit and detailed representation of these torments may well be another

left: 115. NARDO DI CIONE. Paradise. Mid-14th century (1350s). Fresco. Strozzi Chapel, Sta. Maria Novella, Florence

below: 116. NARDO DI CIONE. Hell (portion). Mid-14th century (1350s). Fresco. Strozzi Chapel, Sta. Maria Novella, Florence

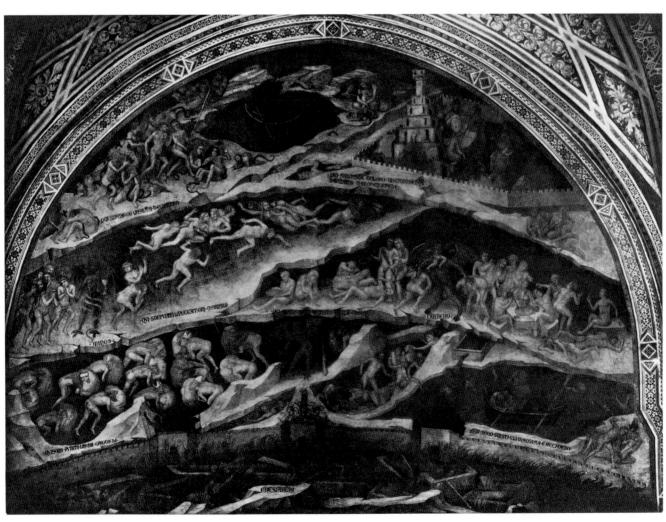

sign of the times. Nardo's style, however, seems to have been so completely formed before the catastrophes of the 1340s as to have resisted their subsequent influence in all but occasional aspects of the treatment of space, which he generally represents in much the same flattened manner as Andrea Orcagna. The exquisite little triptych in the National Gallery in Washington, D.C. (see colorplate 1), typical of the small-scale, folding tabernacles (used to aid private devotions) so popular in the Trecento, may well have been painted in a happier period. Here the influence of the gentle art of Bernardo Daddi is strong, not only in the delicacy of execution and of detail, but also in the square-jawed, large-eyed facial type. There is a softness and dreaminess about Nardo's people, and a languorous movement of the surfaces of both flesh and draperies, that are found in no other painter, save the imitators who made of Nardo's highly accomplished art a graceful countercurrent to the terribilità of his brother.

A less brilliant draftsman than any of the three Cione brothers, but nonetheless a fascinating figure in the complex picture of the third quarter of the Trecento in Florence, is Andrea Bonaiuti, known as Andrea da Firenze (active c. 1343-77). Relatively little of his work survives save for one splendid series of frescoes in Santa Maria Novella, lining the Spanish Chapel (built as a chapter house for the Dominican monks, but so called because it was later used by the Spanish community in Florence). The whole chapel interior, including the vaulted ceiling, was converted into an allegorical diorama surpassing in ambition even the Good Government frescoes by Ambrogio Lorenzetti. This time, however, the theme is ecclesiastical rather than secular government, and it was clearly the intent of the patron, a wealthy merchant named Buonamico Guidalotti, as well as of the Dominican monks themselves, to figure forth the role of the Dominican Order in the establishment of a new ecclesiastical orthodoxy. All the frescoes have to do with the sacred origins and supreme power of the Church in general, and the importance of the Dominican Order in particular. The most unusual of these representations is certainly the scene generally known as the Triumph of the Church (colorplate 18).

This fresco covers the entire right wall of the chapel. The lower half is concerned with religious life on earth, the upper third with Heaven, and the area between the two seems to be largely if not entirely controlled by the Dominican Order. In the lower left an immense, detailed representation of the Duomo of Florence, then incomplete and never to be finished according to this plan, is used to typify the Church on earth—a reminder, perhaps, of the fact that when the money was donated for the frescoes the archbishop of Florence was a Dominican, and that Andrea da Firenze himself was one of the consulting architects for the Duomo. The reigning pope, Urban V, is enthroned in the center of this section, with a

cardinal and a bishop on his right, Emperor Charles IV and the king of Cyprus on his left. The sheep at his feet, symbolizing the Christian flock, are guarded by blackand-white dogs—the domini canes (Dominicans = "dogs of the Lord") of the historic pun, and a crowd of ecclesiastical and secular figures gathers before the thrones. On the right-hand side is the world outside the fortress of the Church, a world in which, above blackand-white dogs rending wolves, Dominican saints admonish heretics and refute pagans. Above these groups vain and worldly figures are enjoying the fruits of the trees, dancing in the fields, making music, and embracing in the shrubbery. From this blind alley, humanity can be rescued only by the sacrament of Penance, administered by a Dominican, while another Dominican saint then shows eager humanity the way to Heaven. Before the splendid gates, opened by a somewhat reluctant St. Peter, angels crown the little souls, who forthwith disappear; Heaven, it seems, is the exclusive province of rejoicing saints, all drawn to a much larger scale. In the entire scene only the saints in Heaven can behold Christ himself who, with book and key as in Orcagna's Strozzi altarpiece, floats far above in his mandorla-shaped glory; below him the apocalyptic Lamb on his altar-throne is guarded by symbols of the Four Evangelists, and angelic cohorts praise the Eternal.

While Andrea da Firenze is uninterested in the naturalism that delighted us in the frescoes of Ambrogio Lorenzetti, he relies on the wide visual sweep that Ambrogio had discovered. Certainly no surviving painting from the first half of the Trecento in Florence shows anything like this detailed landscape, moving from range to distant range and culminating in castles and a little chapel. The foliage, however, is represented entirely according to formula, without any of the delicate observations and scribbled brushwork of Ambrogio. As Cennino Cennini was to prescribe, the nearer leaves are shown light, the farther ones darker—which is, of course, the reverse of visual experience. The landscapes of the Spanish Chapel were to be imitated until well into the early Quattrocento in Florence, when they were gradually supplanted by the new visual realism of the Early Renaissance. The space represented in the landscape is curiously negated by the composition and the coloring, which produce an effect of all-over patterning. This effect has been compared to the appearance of some splendid embroidered vestment. The colors, indeed, although often bright and clear, run to grayish reds, harsh oranges and greens, and unusual and not easily definable intermediate tones, rather than to the clear primary and secondary colors that so often dominate Giottesque schemes. Andrea has a keen eye for unusual facial types, but their expressions are generally uncommunicative and his drawing tends to dryness. His figures, moreover, do not move through and occupy space like those by Giotto and his followers, and appear flat and at times wooden.

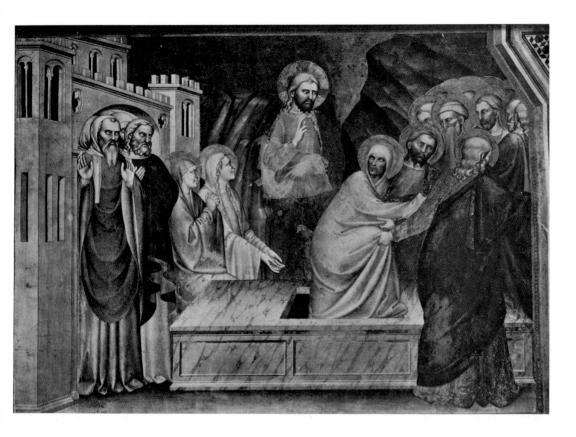

left: 117. GIOVANNI DA MILANO. Resurrection of Lazarus. 1365. Fresco. Rinuccini Chapel, Sta. Croce, Florence

below: 118. GIOVANNI DA MILANO. Pietà. 1365. Panel. Accademia. Florence

The most striking figure in these years of readjustment in Florence was an outsider, Giovanni da Milano (active 1346-66). This Lombard artist was working in Florence in the middle of the Trecento and painted a splendid series of frescoes in the Rinuccini Chapel at Santa Croce, beginning in 1365. In the Resurrection of Lazarus (fig. 117), Giottesque space is denied, as are the dignity and the physical beauty of early Trecento figures. Scowling bystanders emerge from a city gate that is tiny even by Trecento pictorial standards; they press their elbows into their sides as an apparently reproachful Lazarus is hustled out of the tomb. Christ himself looks powerless, devoid of the harmony of feature given him by the Gothic tradition. The most attractive element in the picture is the veined-marble tomb Lazarus is forced to leave. The soft, slightly overripe surfaces and feral expressions in the Rinuccini frescoes reappear with increased intensity in a Pietà, signed and dated in 1365 (fig. 118). This picture, showing the dead Christ upheld by the Virgin, Magdalen, and St. John, is certainly one of the earliest representations of this particular subject to be painted in Florence, and its expressive depth is typical of the contemporary trend toward as harrowing as possible a rendering of the sacrifice of Christ. His body is presented by the grieving figures to remind the observer of the suffering God endured for him. The technical brilliance shown in all of Giovanni da Milano's surviving work is here manifested in a steady, gliding quality of surface modeling unknown in any other Trecento master, as well as in a hairline delicacy of detail. The haunting face of the dead Christ surely provides one of the great moments of Trecento art.

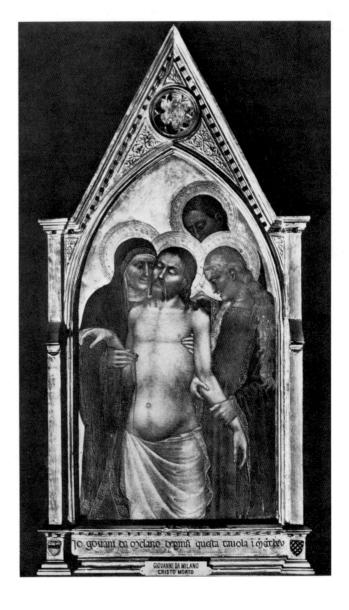

119. BARNA DA SIENA. Pact of Judas. 1350s (?). Fresco. Collegiate Church, San Gimignano

MID-TRECENTO PAINTING IN SIENA AND PISA

Although Siena produced a number of interesting painters in the third quarter of the Trecento, none of them rank with the universal masters of the great period of Sienese painting, the first four decades of the century. Indeed only one of these later artists, Barna da Siena, stands out as a creator; he is the only master who can compete with Giovanni da Milano in expressive depth and intensity. We know very little about Barna—not a single date—but he is traditionally believed to have been a pupil of Simone Martini (whose influence is often visible in Barna's surviving work), and to have died in a fall from a scaffolding. Barna's greatest known achievement, the series of frescoes of the Life of Christ that fills the entire wall of the right side aisle in the Collegiate Church at San Gimignano, is generally dated between 1350 and 1355, although there is little evidence to support this. The story of the infancy and adult life of Christ is treated in the upper two rows, in twelve scenes, while the events of Holy Week are given in fourteen scenes. And it is of the Passion scenes that we tend to think when forming an idea of Barna's personality. They are, in fact, rendered with a new emotional immediacy. The *Pact of Judas* (fig. 119), for example, while in superficial respects recalling earlier compositions of the subject, converts the incident into a rite of diabolical perversity. The architecture soars above the figures and reaches outward to embrace the spectator; Judas, the high priest, and the other priests are drawn together into a huddle so that their heads seem to form the voussoirs of a human arch.

In all Barna's Passion scenes Christ is desperately alone, but never more so than in the *Betrayal* (fig. 120). Even Judas's treachery seems scarcely more contemptible than Peter's mayhem on Malchus in the foreground, filling one-third of the scene—or the cowardice of the

120. BARNA DA SIENA.

Betrayal. 1350s (?).

Fresco. Collegiate
Church, San Gimignano

other Apostles, who abandon Christ to his fate. Even St. John, the Beloved Apostle, gathers his cloak about him and darts a look of terror over his shoulder as he scurries away. Christ is abandoned to an avalanche of steel. His quiet face resists Judas's glare although he is cut off from the outside world by helmets, spears, and shields. With their lunging movements and strange groupings, Barna's personages and drapery forms represent, more than do figures by any of his Florentine or Sienese contemporaries, an original and perhaps necessary departure from the early Trecento norms; these, in works by lesser followers of Giotto, Duccio, Simone, and the Lorenzetti, were on the way to becoming stereotypes. Barna does retain aspects of Simone's style, notably his crisp linearism and idiosyncrasies of facial construction, but uses these for an expressive purpose that is wholly un-Simonesque. Seen from a modern vantage point, Barna seems to show the way toward the art of the so-called Mannerists of the early Cinquecento, even to such Northern European geniuses as Bosch and Grünewald. In greater measure than perhaps any other master of his time, Barna reflects the tragic tensions of the Tuscan environment after the Black Death.

Another work of capital importance, less for the talents of the painter than for the subject and the spectacular scale and position of the work, is the series of frescoes that includes the *Triumph of Death* and the *Last Judgment* in the Campo Santo at Pisa. Although Italian scholars in particular are by no means agreed on the authorship of the cycle, no convincing arguments have yet been put forward against the attribution to a local Pisan painter called Francesco Traini (active c. 1321–63). The *Triumph of Death* (fig. 121) reflects in a provincial form the panoramic schemes of Ambrogio Lorenzetti. At the lower left (fig. 122) is shown the traditional meeting of the three living and the three dead, often represented in the

Late Middle Ages. Three splendidly dressed noblemen and their friends and attendants, while hunting, suddenly come upon three open coffins, each occupied by a corpse, one still bloated, the next half-rotted, the third reduced to a skeleton. Worms and serpents play over all three; one of the noblemen holds his nose at the stench, and even the hunting dogs sniff and draw back in disgust. To the right in the fresco young gentlemen and ladies, for all the world like the protagonists in Boccaccio's Decameron (written, of course, immediately after

the Black Death), sit in a charming grove playing music, caressing pets and each other, and paying no heed to the approach of Death, a terrible, white-haired hag flying toward them on bat wings and brandishing the axe with which she will cut them down. In the center is a heap of Death's recent victims, all richly dressed, above whose corpses demons carry off their helpless souls. The escape from this horror, apparently, is to be sought in the life of hermits in the wilderness, where they read, work, and contemplate on rocky heights (still Byzantine), fed by

121. Francesco Traini. Triumph of Death. Mid-14th century. Fresco. Campo Santo, Pisa

122. Detail of fig. 121

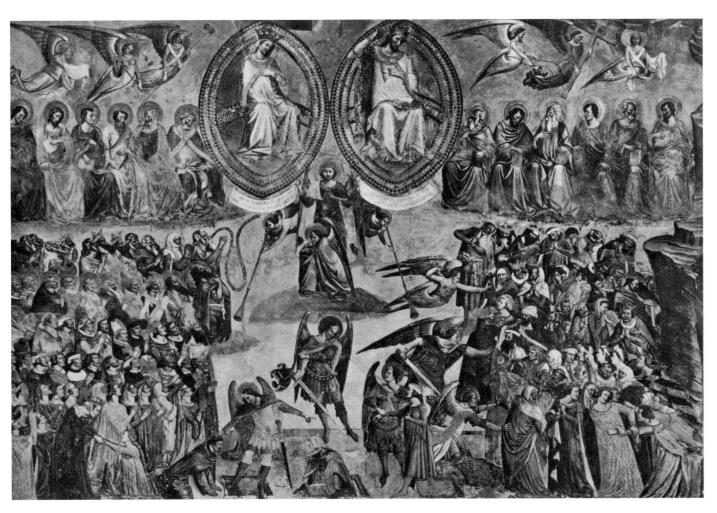

123. FRANCESCO TRAINI. Last Judgment. Mid-14th century. Fresco. Campo Santo, Pisa

milk furnished by an obliging doe. (A few years later Orcagna painted a similar scene in Santa Croce in Florence; a number of powerful fragments have recently come to light.) Traini's accompanying scene, the Last Judgment (fig. 123), shows a regally crowned Christ acting as the condemning judge, with no concern for salvation. Traini's Christ, seated in a mandorla, uses his left hand to display the wound in his side, as if vengefully; Mary, raised to new preeminence in a twin mandorla, puts her hand to her breast and shrinks back in fear. A tempest of emotion sweeps the terrified damned, expelled by archangels armed with huge swords, and the blessed as well, even the Apostles. Earth is reduced to one great tomb of square holes in which the dead arise. Recent research by Meiss has shown that Traini's frescoes were painted before, not after, the Black Death of 1348, but it should be recalled that the plague had already struck hard in 1340. Alas, these, like the other mural paintings of the Pisa Campo Santo, were irreparably damaged during World War II. Much has been saved by prompt and thorough conservation efforts immediately after the liberation of Pisa, directed by the Allied Military Government, and undertaken by Leonetto Tintori working under appalling conditions. Nonetheless, the remounted frescoes remain only pale reflections of what prewar visitors remember.

LATE TRECENTO ART

In the last quarter of the Trecento, no new figures of the first rank emerge in the other arts, either in Florence or in Siena. Government by committee was the order of the day in both centers, as a method of forestalling either dictatorship or revolution, though the personnel of any given committee might often rotate. Applied to artistic projects, the result of this patronage was a leveling process, stressing conformity at the expense of individuality. Vast architectural undertakings begun in earlier periods were either suddenly contracted, like the overly ambitious plans for the Cathedral of Siena, or unexpectedly expanded, like the Duomo of Florence, but no new buildings on the scale of these were commenced. Accomplished, sensitive painters and sculptors flourished, but their works, when compared with those of the Cione brothers, Giovanni da Milano, and Barna da Siena, not to

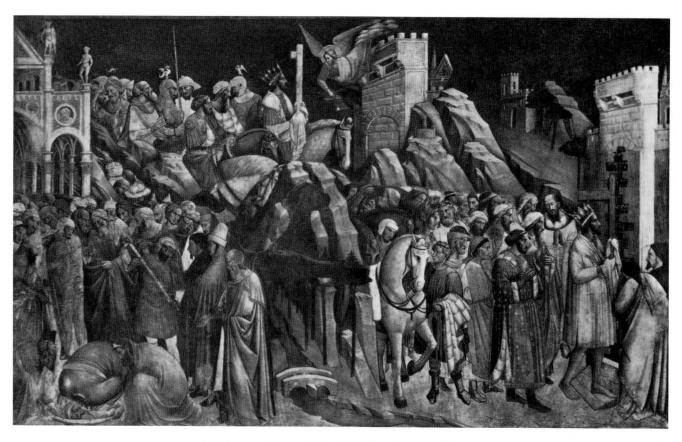

124. AGNOLO GADDI. Triumph of Heraclius over Chosroes, from Legend of the True Cross. c. 1390. Fresco. Sta. Croce, Florence

speak of the masters of the earlier Trecento, present a parade of craftsmanly skill rather than imaginative freshness or sensitivity to the visual world. In this bureaucratic society, which held oligarchical control over all activities of the state, the most characteristic painter, also the most firmly seated and influential, was certainly Agnolo Gaddi (active c. 1369–96), already referred to as the son of Taddeo Gaddi and the master whose precepts appear to be recorded in Cennino Cennini's book. In some ways Agnolo's artistic role, even his pictorial style, could be compared to that of Domenico del Ghirlandaio in the late Quattrocento, or of Vasari in the late Cinquecento. Agnolo was far from being a revolutionary or even a very inventive artist. Nonetheless, he had at his fingertips the entire resources of Trecento tradition; he could fuse his twice-removed Giottesque inheritance with the newer compositional and expressive devices of the midcentury artists.

Agnolo's principal work, for which he must have needed a large number of assistants, is the splendid series of frescoes (c. 1390), for the Church of Santa Croce at Florence, illustrating the Legend of the True Cross (a story whose best-known embodiment is the famous cycle by Piero della Francesca in San Francesco in Arezzo; see figs. 282-86, colorplate 36). Presented with the walls of the entire choir as a field for operation, Agnolo was able to compose and narrate on a gigantic scale. It was certainly characteristic of the period, and probably of Agnolo as well, that the dimensions of the individual scenes conform to those in the adjoining chapels on either side, painted by Giotto and his followers in the first half of the century. One doubts whether the full exploitation of the size of the field, which would have meant violating the established canon of proportions operative throughout the chapels, occurred to either the artist or patron. In any event, the story is narrated in the utmost detail throughout four superimposed registers. Within each frame two or three separate episodes may take place side by side, sometimes almost overlapping. Landscape or architectural elements serve only as dividers, in a manner reminiscent of the packed compositions of Nicola and Giovanni Pisano a century or so earlier. It has often been claimed that the apparently unreal juxtapositions of large and small, near and distant, in such a scene as the Triumph of Heraclius over Chosroes (fig. 124) indicate Agnolo's denial or even ignorance of pictorial space. Actually these juxtapositions are mere conventions enabling him to narrate all parts of the complex story with

equal visibility, and also preserving what to him must have been a matter of supreme importance, the all-over decorative unity of the wall, in form and fresh, clear color. A dispassionate observer in the choir of Santa Croce must acknowledge the decorative beauty of Agnolo's surfaces, treated almost like tapestry and maintaining the integrity of the building itself. In those scenes that did not have to contain more than one incident, Agnolo showed that his mastery of spatial recession was second to none in the Florentine Trecento. And even in the landscape dividers of the Chosroes scene, he utilizes very knowingly all kinds of suggestions of depth. Agnolo's landscape devices, drapery forms, and compositional methods seem to have determined the representation of such elements in Florentine painting until Gentile da Fabriano and Masaccio arrived on the scene. A lively and convincing pen-and-wash drawing, which is generally accepted as by Agnolo Gaddi, and is almost certainly the earliest Italian drawing from life preserved to us (see fig. 10), seems to have been made in preparation for some of the heads that crowd the frescoes in this impressive series. One bareheaded young man is shown slightly foreshortened from below as he looks upward. The others wear the customary Florentine cappuccio; one bends over as he writes or perhaps draws; the other three are seen in variants of profile view, including the one-quarter aspect, which often appears in Giotto's frescoes. At the top of the drawing a frontal lamb's head is provided with the word agnolo-the word can mean "angel" or "lamb" (agnello in modern Italian)—which could be a signature but also a notation by a later owner.

In all essentials, the Late Gothic style of Agnolo and his numerous followers and contemporaries remains, at least in sheer quantity of production, the dominant pictorial style in Florence well into the Quattrocento: it was what patrons wanted, and what the painters gave them, for an industrious half century or so. Among the host of competent practitioners of the craft of painting in this final phase of the Gothic style in Florence, a single magnificent artist stands out, known to us today as Lorenzo Monaco (Lawrence the Monk). Perhaps Lorenzo was born in Siena, certainly not later than 1371, and he died about 1425. From his possible Sienese origin many unwarranted conclusions have been drawn; it is not easy to find actual traces of the Sienese Trecento painters in Lorenzo's fundamentally Florentine style. His early works are strongly influenced by Agnolo Gaddi-drapery rhythms, landscape motifs, and such matters, which persist even in the works of Lorenzo's maturity.

But the sudden burst of linearity in the attenuated poses and sweeping curves of drapery betrays the arrival on the scene of a wholly new factor, the fantastic and gorgeous style that is known to scholars as the International Gothic, because it flourished over all of Northern Europe, from London to Prague. As far as Tuscan art is concerned, the "international" sobriquet is a misnomer.

It is often difficult to tell what center, in some cases even what country, homeless Northern pictures of this style actually come from. This is never the case with Tuscan paintings. The clarity of Tuscan forms, the firmness of Tuscan statement always prevail over the most exuberant Gothic movement. Certainly no one ever attributed Lorenzo Monaco's paintings to any other center than Florence, and in his case the problems that still plague critics are the distinctions between the master and his pupils. The dominant influence in his mature style is that of the great sculptor Lorenzo Ghiberti, which caused the extraordinary plastic vitality in the flowing drapery masses. These, in fact, resemble very strongly the drapery folds in Ghiberti's exactly contemporary sculpture and those in Ghiberti's gifted rival Nanni di Banco, and can even be compared closely with certain aspects of the art of the most revolutionary artist of the whole Quattrocento, Donatello himself.

But to place Lorenzo Monaco in the next chapter would ignore one transcendent factor: the decisive masters of the early Quattrocento were concerned with optical realism, and this to Lorenzo Monaco meant very little. It is not easy to reconstruct his environment. We know that he joined the Camaldolite Order at Santa Maria degli Angeli in Florence in 1391, rising to the rank of deacon. Yet by 1402 he was enrolled in the Arte dei Medici e Speziali under his lay name, Piero di Giovanni, and was living outside the monastery. Apparently he enjoyed the best of both worlds, for he retained his habit and the monastic status that it denoted, while continuing to paint a splendid array of altarpieces large and small, frescoes, and illuminated manuscripts. The Camaldolite Order, whose mother monastery still flourishes in a wonderful spot high in the Apennines, was the most mystical of the Tuscan religious communities. This mysticism received no more poetical expression than Lorenzo's otherworldly altarpiece, the Coronation of the Virgin (colorplate 19), finished in February 1414 (1413 in the Florentine calendar, since their year began on March 25) for the high altar of Santa Maria degli Angeli. In shape this huge triptych brings to fruition every force that had remained truncated and introverted in Orcagna's equally crucial Strozzi altarpiece. The gables erupt into separate pictures, each given spatial existence by its own canopy. In the central panel all divisions are swept aside by the onrushing tide of colors and forms. We are lifted far from earth into the empyrean, above the dome of the heavens, which we see in cross section, its component arches shaded in different tones of piercing blue and studded with golden stars. At the apex of the heavenly vault stands a fine Gothic tabernacle, culminating in a dome on a drum, reminiscent of that designed by Orcagna for Orsanmichele (see fig. 113). On a double throne in front of the tabernacle Christ turns to place a crown on the head of his mother. In the central gable God the Father, appearing on clouds flanked by seraphim, confers his blessing on the scene, while in the lateral gables are represented the announcing angel, flying against the gold background and trailing clouds, and the seated Mary.

For all their solidity as abstract shapes, the figures seem essentially bodiless; it is the crispness of the metallic contours and the power of line and shading that achieve the strong, sculptural effect. The dazzling color composition is based on the splendid bouquet of blues the dome of the heavens, the blue clouds, and blue shadows, not to speak of Christ's azure mantle—then on the gold background, and finally on the unexpected whites of the mantles. Far below, at the springing points of the outermost arches, kneel St. Benedict, of whose order the Camaldolites were a branch, and St. Romuald, founder of the Camaldolite community. Mary, in this exceptional Coronation, seems to have honored the Benedictine Order by adopting its white for her mantle, instead of the traditional blue. These whites are anything but inert: a rainbow of colors from the surrounding saints and angels is reflected into their shadows, and even the lights are often picked out in glowing yellow. Rainbow-winged angels swing censers below the throne. The angelic organist in the center was, unfortunately, cut away at a later period to accommodate a tabernacle for the Eucharist. How the composition of such altarpieces as this one took shape in the painter's mind can be followed in a vivid pen sketch (see fig. 9) probably done in preparation for six figures on the left side of a similar altarpiece now in the National Gallery in London. The rhythmic

surge from figure to figure takes shape with the first rapid strokes of the quill pen, breaking into ripples as the artist defines the folds and borders of individual tunics and mantles.

The exalted mood in the central panel of the Coronation is sustained, if in a lower key, in the delicate predellas below, the most enchanting of which is the little Nativity (fig. 125). While Lorenzo has adopted for these predella panels the French Gothic quatrefoil shape introduced by Giotto (see colorplate 8) and utilized by Andrea Pisano for the panels of the Baptistery doors (see fig. 86), it is symptomatic of the new freedom of Lorenzo's style that he has drawn out the shapes to half again their width as if by some strong, lateral distorting motion. The Nativity is based partly on the vision of St. Bridget, a fourteenth-century Swedish princess who lived in Rome and, during a visit to Bethlehem, saw the Nativity take place before her eyes in the Grotto itself. Not everything in St. Bridget's vision (she was canonized in Florence in 1420-22 by Pope Martin V) is taken up by Lorenzo, but the principal elements that he does show were to lead to a new version of the Nativity in the art of the Quattrocento—the Adoration of the Child. Mary kneels to worship her Child, who lies naked before her on the floor of the cave, shining with golden rays. Lorenzo has added to the cave of St. Bridget's vision the shed from Western tradition, and has equated its shape with the lozenge inside the quatrefoil. In the dark night outside this magical shelter, a luminous angel carries the message to the

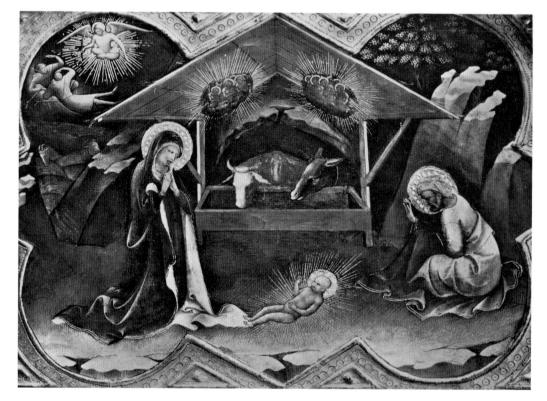

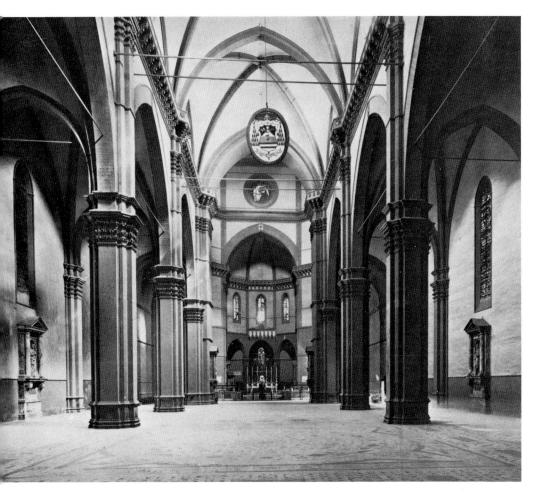

left: 126. Nave and choir, Cathedral, Florence. Begun by Arnolfo di Cambio, 1296; present appearance due to Francesco Talenti and others

below: 127. Plan of Cathedral and Campanile, Florence

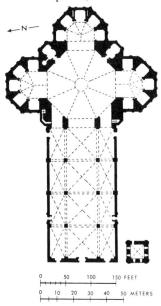

shepherds, who have fallen in astonishment on their distant peak. This and Lorenzo Monaco's other works represent a glorious, last eruption of the Gothic style in Florence. It is not only interesting how strongly his luminary display in the tiny predella panel differs from the treatment of the same scene by Gentile da Fabriano nine years later (see fig. 185), but also how much less real it seems than the rendering of supernatural light by Giotto in the Arena Chapel (see figs. 59, 60). For Lorenzo Monaco's visual poetry is essentially imaginative and unreal; the crucial developments of the early Quattrocento, on the other hand, were based on a new evaluation of the reality of day-to-day experience, and of the human being who experiences. This new evaluation Lorenzo Monaco could not share.

ARCHITECTURE

The major architectural monument of this period in Italian art was also one of the largest and most important structures then being contemplated—the Cathedral of Florence (figs. 126, 127). This had been commenced in 1296 by Arnolfo di Cambio to replace the then-existing Church of Santa Reparata, but work came practically to a standstill after Arnolfo's death in 1302. Among the artists who directed what activity continued can be numbered Giotto and Andrea Pisano. After the Black Death, however, the project for the Cathedral underwent essen-

tial modifications. Francesco Talenti was the architect who completed during the 1350s according to radically different designs the Campanile commenced by Giotto and continued in its second and third stories by Andrea Pisano (see fig. 77). A comparison with Giotto's beautiful design (see fig. 76) will show how Talenti adopted Giotto's French Gothic windows, but adapted them to the taste of the late Trecento. Talenti is only one of the personalities involved in a highly complex picture of group activity. In 1355 a commission was appointed; its personnel was to change, but it included at various times the painters Taddeo Gaddi, Orcagna, and Andrea da Firenze, and well-known sculptors and prominent citizens. Model after model for the church and its details was submitted to the commission, and accepted or rejected; somehow the work went on, although rejected ideas kept popping up again. One of these may well be the design recorded in Andrea da Firenze's fresco of the Triumph of the Church (see colorplate 18). It is by no means clear how much, if any, of Arnolfo's original design was kept, and how much of the present Duomo can be attributed to Francesco Talenti, to Fra Jacopo Talenti (no relation), to Simone Talenti (Francesco's son), and to the painters. A definitive project embodying the piers and cornice designed by Francesco Talenti was adopted by the commission in 1364 and embodied in a model constructed after the final decisions of 1367 by Giovanni

Ghini on the designs of Neri di Fioravante. The commission ordered the destruction of all competing designs and models, and absolute adherence to the official project. This included the commission's requirement that the bracketed cornice above the nave arcade should be kept as close as possible to the arches and that the vault should rise directly from the cornice, effectively eliminating a pointed clerestory, for which oculi were substituted. The plan was a striking compromise between a central plan and a Latin cross. Three octagonal "tribunes" (the Italian word seems the most useful one) radiate from the octagonal dome, under which the high altar was placed. On the outside, these tribunes culminate in semidomes that buttress the central dome, but at the time no one had the faintest notion how the dome was to be constructed.

The interior of the Cathedral consists of a nave composed of four gigantic bays, its lofty arches opening onto side aisles half the width of these bays but equally long. The nave corresponds to one side of the central octagon under the dome and provides the principal entrance to this majestic and unprecedented space. Clearly the building was planned to accommodate vast crowds, which could flow from one portion to the next without disturbing ceremonies at the high altar or in any of the fifteen chapels surrounding the three tribunes. The plan has a masterly simplicity and utility, and at times great beauty. Yet there are features in the church, such as the heavy cornice required by the commission, that strike modern observers as unfortunate. Possibly a talented architect, left to himself, would not have designed such a shape, but this was the penalty that had to be paid for government by committee, at once the great strength and the hidden weakness of the Florentine republican system. The artistic dangers it produced and the system itself were both to give way to a new range of values in the Quattrocento.

PAINTING AND SCULPTURE IN NORTH ITALY

In the Late Middle Ages and the Early Renaissance, the political life of North Italy was dominated by the relations between two major city-states-Venice and Milan—and such smaller centers as Mantua, Ferrara, Padua, and Brescia, whose communal governments had, at varying moments, been taken over by princes, founders of hereditary dynasties. Milan, near the northern edge of the Lombard plain, controlled trade routes to Northern Europe. It had once been capital of the Western Roman Empire, and was a flourishing commercial center. Its territory, however, was landlocked until the expansionist attempts of Duke Giangaleazzo Visconti in the opening years of the Quattrocento gained temporary control of Pisa. The opposition to Milanese imperialism, aimed at domination of the Italian peninsula, came from Florence, and was eventually successful. Florence found its only ally in republican Venice, whose outburst of independent artistic activity began in the middle of the Quattrocento and continued throughout the Cinquecento.

THE VENETIAN REPUBLIC. The existence of Venice is one of the miracles of history. The city was founded on marshy islets of the Adriatic by refugees from the Roman cities of the Po Valley, fleeing from the barbarian invasions of the fifth and sixth centuries A.D. Deprived of their territory and their ancient homes, these remnants of a formerly great culture learned to think of the sea as their sole resource and protection and of continental Italy, at their backs, as essentially hostile. The Venetian Republic, an oligarchy with an elected duke (doge, in Venetian dialect), was the only state in Western Europe that survived from antiquity into modern times without revolution, invasion, or conquest: that is to say, from the last years of the Roman Empire until Napoleon put an end to the Republic in 1792. Venice was, moreover, the only Italian state to achieve an empire, but it was a peculiar sort of empire. For many centuries the Venetians disliked and distrusted land power. Their interest was in commerce and their riches were fantastic, and both had to be protected. The security of the city was not hard to maintain. Its lagoons were superior to any fortifications devised by more ephemeral land-based states. The Venetian navy was the equal, at times the superior, of that supported by Genoa, the only serious maritime rival to Venice. But sea commerce needed bases, and the Venetians developed these throughout the Adriatic, Ionian, and Aegean seas, which became to all intents and purposes Venetian lakes. The Most Serene Republic of St. Mark, to give the Venetian state its full title, took over ports down the Dalmatian coast and throughout the Greek islands, and after the capture of Constantinople by the Crusaders in 1204, Venice enjoyed extraterritorial possession of one-quarter of that imperial city. In its initial stages the Venetian Renaissance was nourished by contacts with Florence, avidly sought by the Venetians. But before Florentine masters arrived in Venice in the first half of the Quattrocento, Venetian art, like Venetian life, had turned toward the East. In Greece and in the churches and palaces of Constantinople, the Venetians witnessed the effect of Byzantine mosaics at their grandest, and could in fact absorb the principles of the style from masters who were still turning out monumental works. In the Dugento the Venetians clothed the interior of the Ducal Basilica of San Marco with mosaics, relying far more on Byzantine examples and training, and even on actual Greek mosaicists, than on the Early Christian prototypes still visible in Venetian controlled or dominated areas. The general effect of the dim church, its every wall and vaulting surface covered either by slabs of veined marble or by mosaics in bright colors with glimmering gold backgrounds, is still enthralling.

It is generally believed that the very situation and ap-

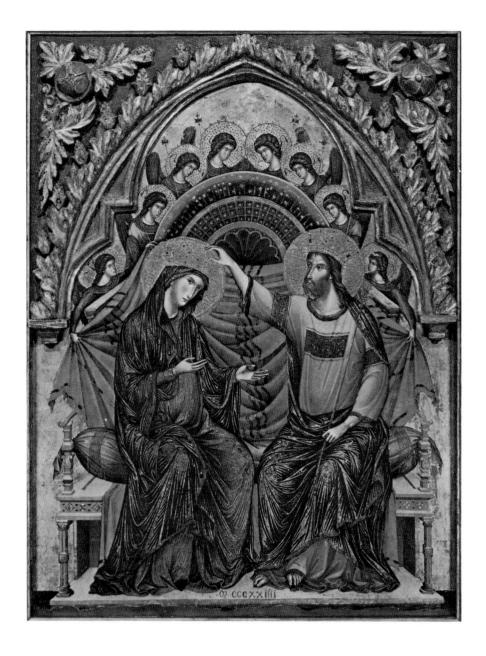

128. PAOLO VENEZIANO. Coronation of the Virgin. 1324. Panel, 39 × 301/2". National Gallery of Art, Washington, D.C. (Kress Collection)

pearance of Venice gave the inhabitants a special predisposition toward values of color and light rather than those of form and mass. At all times in its history the city has presented an amazing spectacle (see fig. 5). From the very start, the water surrounding the islets formed the principal thoroughfares for the inhabitants. The larger passages became the major canals, some of which provided anchorage for shipping, and still do. The others made up a labyrinth of tiny canals and basins. These at first were bridged by wooden structures, but gradually wood gave place to stone, also in the embankments of the canals. Land space was at a premium, so there were few open squares and almost no true streets. Narrow alleys separated the houses and provided passage for pedestrians. The houses of the great families, who alone participated in the government, faced the major canals and were approached by water, thus rendering unnecessary the massive exterior walls of the Florentine palaces, built for defense against street disorders. Most constructions had to be founded on wooden piles, driven into the muddy islets or even the underwater subsoil. Quite literally, the city floated. Its canals and basins, alleys and squares, all overflowed with a continuous and colorful pageant. Ships, flags, costumes, and wares of all nations mingled here, and the palaces of brick, limestone, or marble are illuminated almost as much by reflections from the water as by the direct light of the sun.

In the Dugento a lively school of panel painting arose in Venice, but Venetian painting found its first authoritative voice in Paolo Veneziano, whose signed works range from the 1320s to the 1360s. Paolo could hardly have been unaware of the achievements of Giotto in nearby Padua, but there is no indication that if he actually saw Giotto's frescoes they meant much to him. His pictures represent the highest refinement of Italo-Byzantine style, in all its familiar elements. In Paolo's earliest dated work, the Coronation of the Virgin (fig. 128) of 1324, the only foreign intrusions are the French or German Gothic decorative elements of the frame, but the freedom, freshness, and brilliance of Paolo's color epitomize the special quality of Venetian taste. The whole picture is organized in terms of the movement of color in waves. No clear-cut forms emerge, in the manner of Tuscan painting; the picture is a web of color and lines, a rich and luxurious fabric. (It is not irrelevant to the splendid surfaces of Venetian art that while the Florentines based their fortunes on banking and woolen cloth, the Venetians dealt principally in spices and silks.)

PADUA. Independent of the immediate sphere of Venetian influence in the late Trecento, the school of Padua is certainly entitled to be ranked as the most vigorous of all North Italian schools. The painters of Padua built upon Giotto's achievements in that city; indeed their art may in some aspects be considered a Giottesque revival. Not only Giotto but also his followers, especially Maso, may be sensed in these prolific fresco painters, who added striking naturalistic observations of their own in landscape, in the painting of animals, and in highly persuasive portraiture. The most successful painters of the period both came to Padua from outside—Altichiero from Verona, and Jacopo Avanzo from Bologna. Recent criticism has attributed to Avanzo most of the lunettes of the Life of St. James, painted about 1374 in the Chapel of St. James (today rededicated to St. Felix) in the Basilica of Sant'Antonio in Padua; and to Altichiero the huge

JACOPO AVANZO. Liberation of the Companions of St. James.
 1374. Fresco. Chapel of St. Felix, Sant'Antonio, Padua

Crucifixion in the same chapel, some of the other lunettes, and all of the frescoes in the nearby Oratory of San Giorgio (1380–84).

Avanzo's Liberation of the Companions of St. James (fig. 129) shows some of the qualities of the Paduan style. Ambrogio Lorenzetti and Francesco Traini had, of course, developed the panoramic background to a high degree (see figs. 108, 121), but no Tuscan painter presents us with this kind of nature—impassable, impenetrable, indecipherable. The human figures, many showing traits of physiognomy and drapery that remind us of Giotto and Maso, are dominated by a central mass of rocks. The foreground is even more hostile. A bridge has collapsed, and the persecutors of the saint's companions are precipitated into a stream. The floundering horses and humans are represented with striking fidelity. A Tuscan painter in the Trecento would not have put such a horse, seen from below, in the most prominent spot in the painting. In the Quattrocento, however, Paolo Uccello did exactly that in his Battle of San Romano (see colorplate 31), and considering the time he spent in Padua it is far from impossible that Avanzo's daring fresco put the idea in his mind.

In its density and richness Altichiero's Martyrdom of St. George (fig. 130) is equally non-Tuscan in spite of occasional echoes of Giotto in the faces. A whole palace with loggie and Late Gothic parapets occupies the stage and provides smaller stages for various episodes of the saint's life. The attempt to break him on the wheel fills the center foreground. At the sides move crowds of executioners and townspeople, terrified at the intervention of two angels who smash the wheel with their swords. As in Avanzo's frescoes, the complexity of the background. this time architectural rather than natural, envelops and dominates the figures. Altichiero's color, gorgeous in its muted tones of rose, green, and gold, is as foreign to Tuscan art as the extreme naturalism of the portrait types that emerge from the crowd. Especially striking is the almost nude body of the saint tortured on the wheel. represented without a hint of the classical beauty and harmony that were to obsess the Florentines in the Quattrocento, but sharply real in its emphasis on details of anatomical modeling and physical stress. It is not hard to imagine Gentile da Fabriano's reactions to this art when he came to North Italy and, in the opening two decades of the Quattrocento, became the region's most important artistic force (see page 178). If we attempt to reconstruct what must have been the influences operating upon the formation of the style of Domenico Veneziano, for instance (about whose early work in Venice we know nothing; see page 257), the Paduan tradition as enriched by Gentile will play an important part.

MILAN. An unexpected and very influential phase of North Italian naturalism arose late in the Trecento in Milan, which, in 1387, had lost its communal liberties to

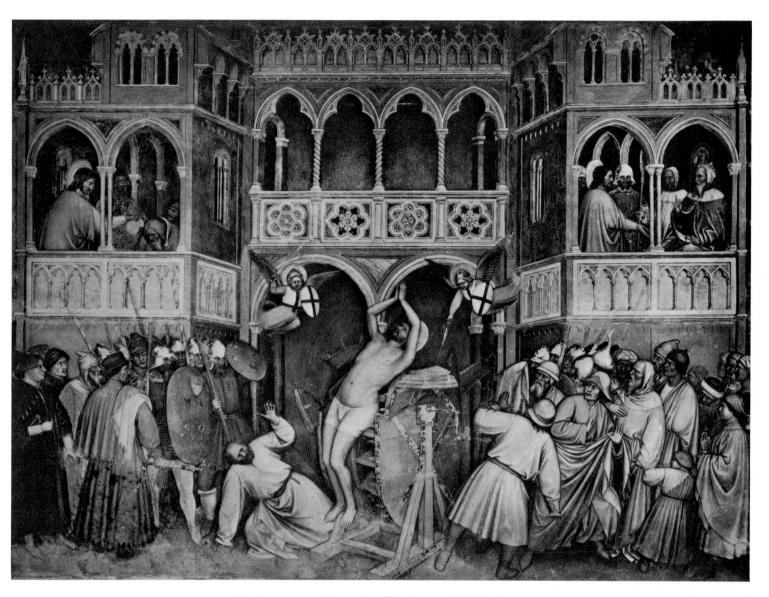

130. ALTICHIERO. *Martyrdom of St. George*. 1380–84. Fresco. Oratory of S. Giorgio, Padua

the Visconti family. For the next two centuries the Visconti, succeeded by their relatives the Sforza, held absolute sovereignty over a fluctuating territory including, at times, all of Lombardy and much of Central Italy as well. At Milan and at Pavia these rulers held courts whose magnificence was rivaled in Italy only by those of the Vatican and the Kingdom of Naples. Bernabò Visconti, count of Milan, is represented in a tomb monument by the Lombard sculptor Bonino da Campione (active 1357–85), carved before 1363 when the count still had more than twenty years to live. The base of the monument is a sarcophagus, carved in a style derived from that of Nicola Pisano, who, with his pupils, had worked in North Italian centers. On the sarcophagus stands an over-life-sized statue of Bernabò on horseback (fig. 131), clearly the ancestor of the famous Quattrocento eques-

trian monuments by Donatello and Verrocchio (see figs. 249, 337, 338), also commemorating North Italian leaders. But in contrast to these dynamic Renaissance successors, imbued with the influence of ancient Rome, the equestrian statue by Bonino, like those he made for other North Italian centers, remains absolutely immobile. The steed plants all four feet firmly on the base, and the rider stares grimly ahead. Nonetheless, it is an impressive work, through the sheer power of its presence, not to speak of the typical North Italian attention paid to the anatomy of the horse. According to Trecento sources, the statue not only was covered with silver and gold and supplied with a pennant, but also stood on the high altar of San Giovanni in Conca in Milan. Presumably the altar was freestanding, and one saw the whole composition from the left side, the dead Christ adored by angels raised above the altar slab on columns; but it is still hard to think of an equestrian statue in such a place.

In 1385 the mighty Bernabò was overpowered and imprisoned by his own nephew, Giangaleazzo Visconti, who assumed total power and in 1395 bought from the impoverished Holy Roman Emperor Wenceslas the title of hereditary duke of Milan. Aspiring to rule over all of Italy, Giangaleazzo became, as we shall see in the next

131. BONINO DA CAMPIONE. Monument to Bernabò Visconti. Before 1363. Marble. Castello Sforzesco, Milan

chapter, a mortal threat to the Florentine Republic and a force provoking its burghers into embattled unity. The duke gathered about himself a talented and original group of artists, some from Lombardy, others from France, Germany, and the Netherlands, to build the ambitious Cathedral of Milan, which was still far from completion when Leonardo da Vinci worked in that city a century later, and the Visconti funeral monastery, the Certosa of Pavia.

Animals constituted one of the favorite delights of North Italian courts. The pleasures of the chase and the joys of collecting rare animals and birds from as far away as Africa and the Near East enliven the art created for the new tyrants. Giovannino de' Grassi (active 1380s, d. 1398) was architect, sculptor, and painter to Giangaleazzo, and for a while capomaestro over the host of artists working on the Cathedral of Milan. He was also responsible for a beautiful book of animal studies in Bergamo, and for the first half of a magnificent Book of Hours (the richly illuminated prayer books that were also status symbols of the powerful and wealthy of the fourteenth and fifteenth centuries, especially in monarchical countries). The pages illuminated by Giovannino in the Visconti Hours, as the book came to be known, are among the most alluring products of Italian manuscript art. A sample page (colorplate 20) shows the portion of Psalm 118 (119 in Protestant Bibles) appointed for the prayer service called Sext (verses 81–88), but the illustrations have nothing to do with the scriptural lines. In the middle of the huge initial "D" sits King David, clothed in red, blue, and gold, in a gorgeously hung and carpeted Gothic interior. He reaches out his left hand while the Lord, a bit hard to find among the ornament at the right, upholds the orb of power. Compare this crowned David with typical Florentine representations of David, the shepherd-hero (see figs. 161, 247, 273, 336). The border ornaments, two conventional tree trunks of gold, about which twines ivy with golden leaves, grow from soft, green grass at the left, rocky slopes at the right, both sparkling with wildflowers. The grass is inhabited by Giangaleazzo's hunting dogs, who already sniff their prey, and the rocks by the quarry in the most spontaneous of poses—three handsome stags and a doe, crouching, climbing, grazing, even foreshortened from the rear. All the animals and flowers are painted with extraordinary freedom and freshness. Between the hunters and the hunted blazes a sunburst of blue and rose emitting golden rays and enclosing a calm and delicately painted profile portrait of Giangaleazzo himself before his elevation to duke. The entrancing naturalism of Giovannino and other Lombard illuminators, known to contemporary French artists as the "ouvraige de Lombardie," appears to have inspired to a considerable extent the art of the Limbourg brothers, and in Italy it exercised an incalculable influence on Gentile da Fabriano (see Chapter 8).

THE QUATTROCENTO

The Beginnings of Renaissance Architecture

p to this point we have been considering what might be referred to as premonitions of the Renaissance—the new light and the new humanism of the early Trecento, and the Trecento artists' occasional imitation of specific works of classical art. Architecture remained Gothic, although a Gothic much modified by Italian ideas of clarity and simplicity. In the early Quattrocento in Florence the vision of a completely new art first dawned on the minds of Italian masters—an art wholly dedicated to human standards and potentialities, and haunted by forms and ideas drawn from the vanished civilization of Greek, even more of Roman, antiquity in which these human standards had been raised to their highest power of expression. The first formulator of the theoretical principles of the new style, Leonbattista Alberti, who began writing his influential books some twenty years after the first new stylistic inventions of the Renaissance were made, refers to antiquity at every point. But he is also proud of the new ideas of his period. "Truly, if this was ever written by others," Alberti said at one point in his treatise On Painting (in Latin, 1435; as Della pittura, translated into Italian by Alberti in 1436), "we have dug this art up from under the earth. If it was never written, we have drawn it from heaven." In his prologue to the treatise he claimed "that it was less difficult for the Ancients-because they had models to imitate and from which they could learn—to come to a knowledge of those supreme arts which today are most difficult for us. Our fame ought to be much greater, then, if we discover unheard-of and never-before-seen arts and sciences without teachers or without any model whatsoever." As a supreme example of the new art, Alberti submits the dome of the Cathedral of Florence,

then being completed by Filippo Brunelleschi (1377–1446), to whom the prologue was addressed. "Who could be hard or envious enough to fail to praise Pippo [i.e., Filippo] the architect on seeing here such a large structure, rising above the skies, ample to cover with its shadow all the Tuscan people, and constructed without the aid of centering or great quantity of wood? Since this work seems impossible of execution in our time, if I judge rightly, it was probably unknown and unthought-of among the Ancients."

As we look at this dome, whose shape and proportions vie in grandeur with the hills surrounding Florence, it seems the product of a serene and harmonious period consecrated wholly to the kind of intellectual activities that Alberti and his fellow humanists extol. Nothing could be further from the truth. Like so many creative periods, the Early Renaissance was an era of storm and stress, of bitter conflict, of challenges never more than partly met. Seldom, however, in all history is the tragic gap between human problems and their solutions more evident than during the Italian Renaissance. Florence in particular, whose role in the modern world has often been compared with that of Athens in antiquity, resembled Athens in this respect as well. Only on an ideal plane, in their great monuments and works of art, did the Florentine people achieve the harmony, dignity, and balance that were denied them by the turbulent realities of their epoch.

During the formative period of the Early Renaissance, that is, the first third of the Quattrocento, the continued existence of not merely the Florentine Republic, but even of Florence as an independent state, was in serious doubt. In 1378 the guild system had come under attack

in the short-lived revolt of the Ciompi—the impoverished wool carders who occupied the bottom rung of the social and economic ladder. After ruthless suppression of the Ciompi, the oligarchy reestablished its domination through the major guilds and the Guelph party. The next threats came from without, from the rapidly expanding duchy of Milan, which, under the Visconti family, threatened to engulf most of the Italian peninsula. The duke of Milan, Giangaleazzo Visconti, by a system of alliances, threats, and intimidations, as well as by actual conquest, had gained control over all of North Italy save only the republics of Genoa and Venice, and much of Central Italy, including Siena, the ancient rival of Florence; thus Florence was surrounded on three sides. Eventually Giangaleazzo succeeded in cutting Florence off from the sea, and in the hot summer of 1402 he was poised in the Apennines, ready to descend on Florence and to wipe out that hotbed of bourgeois liberty. At that moment the plague, always smoldering, erupted again among his armies. In September Giangaleazzo was dead, and his jerry-built empire fell apart. The Florentines rejoiced at their deliverance and returned to their normal commercial and intellectual activities.

And then another Hitlerian figure emerged. King Ladislaus of Naples, having conquered Rome three times (on the third he put the city to fire and sword), threatened Florence from the south. Again disease came to the aid of the Florentines, and in 1414 Ladislaus died, blaspheming and cursing the Florentine Republic. It is important to remember that despite these two deliverances, which the Florentines ascribed to divine intervention, the city was ready to defend itself against either of these tyrants. With no alliances save an uncertain one with Venice, no military tradition to speak of, modest resources, and no standing army, the Florentines, armed only by their commercial power and their courage, in each instance prepared for the onslaught.

In the 1420s arose the third danger, and this time no convenient disease saved the Florentines. Filippo Maria, the son of Giangaleazzo Visconti, undertook to finish off his father's work and directed his politics from his castle at Pavia, a center of espionage and intrigue. The inexperienced Florentines suffered one humiliating defeat after another before they managed to pull together all the resources of the Republic. In 1427, to obtain the necessary sums for the war, the Florentines instituted the Catasto, the first graduated tax in history, based on ability to pay. The Catasto was a property tax, but the ancestor of the modern income tax in the sense that it was calculated according to the productivity of property, including artists' tools and materials; it also had a system of exemptions and deductions, and required a personal, written declaration. Large numbers of these survive, forming an invaluable source of information (although often deliberately misstated by the taxpayers themselves) about Florentine citizens of all ranks, including the artists and their families. The new system replaced the capricious exactions of medieval tax collectors with a workable, if far from watertight, mechanism for defining the financial responsibilities of every citizen toward the threatened Republic.

The war dragged on; Filippo Maria did not descend on Florence, but neither did the Florentines defeat him. The situation that developed is cruelly familiar to us today—a prolonged stalemate; nobody really won, yet danger overshadowed the people of Florence for years. It was in this atmosphere of crisis, and in spite of the cost of a battle for survival that has been compared to the Battle of Britain, that the masterpieces of Early Renaissance art were created. Military expenditures notwithstanding, the Florentines were able and willing to pay for costly structures and for huge works of sculpture in marble or in gilded bronze. The reason for this seeming extravagance was the distinct civic orientation of these new commissions. They, too, functioned as soldiers in the continuing struggle against absorption and dictatorship in the sense that they galvanized popular support for the life-and-death struggle of Florence by means of their profoundly felt yet easily recognizable symbolic content. In no way are these works of art to be understood as "propaganda"; the new public works of the first Renaissance style in Florence are too sincere and too intense for that. But they were—and this fact is of cardinal importance-meant for the man in the street and not for the pious in the churches who commissioned and prayed before glittering Gothic altarpieces by Lorenzo Monaco and his scores of competitors.

THE DOME OF FLORENCE CATHEDRAL

Brunelleschi's dome for the Cathedral (fig. 132), completed in spite of Florentine defeats, addresses not only the man in the streets of Florence, but also the inhabitants of that considerable section of the Arno Valley from which its bulk was visible. In 1403 Brunelleschi lost, to the sculptor Lorenzo Ghiberti, the competition for the second set of gilded bronze doors, on the north face of the Baptistery of Florence (see figs. 151, 153). He then largely abandoned the art of sculpture, at which he had been proficient, and dedicated himself entirely to architecture. As an architect he proved to be one of the great geniuses of history, so it is hard to consider Brunelleschi's humiliation in sculpture as anything but mankind's good fortune. Vasari tells us that Brunelleschi went to Rome to study and measure the remains of ancient architecture. He certainly came back to Florence with his own ideas as to how ancient elements could be utilized.

At the time of writing, the history seems to read as follows: We do not know when Brunelleschi actually designed the dome, but his father, Ser Brunellesco, had served on the committee of 1367. Prager and Scaglia (see Bibliography) have shown that Brunelleschi must have

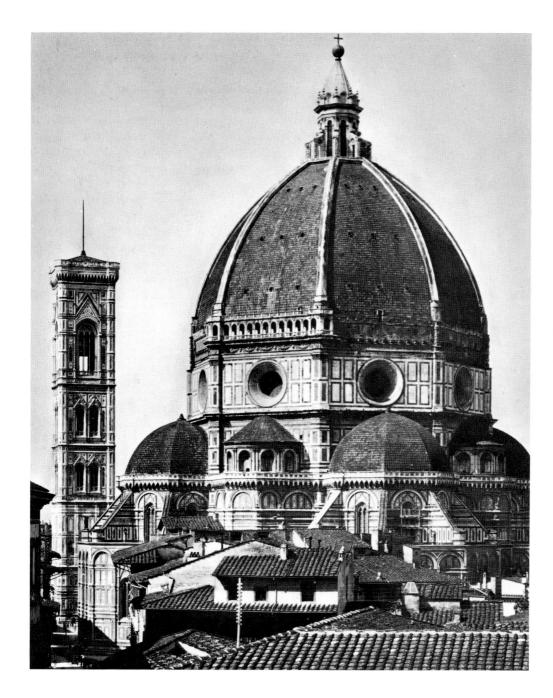

132. FILIPPO BRUNELLESCHI. Cathedral Dome, Florence. 1420–36; lantern completed second half of 15th century

been brought up with the model of 1367, and that he took part—along with Ghiberti, uncomfortably—in the committee of 1404, which obliged the Gothic architect Giovanni d'Ambrogio to lower his three projected semidomes to their present level. Vasari says Brunelleschi advised the Opera del Duomo (Board of Works) in 1407 to "lift the weight off the shoulders of the semidomes," in other words to insert a drum between them and the cental dome. In 1410 the Opera authorized such a drum. A wooden model, still in the Opera Museum, seems to represent this stage. In 1417 the Opera called in Brunelleschi as adviser, and the succeeding years were spent in building a masonry model, finally accepted in 1420.

Brunelleschi was limited by the nature of the existing structure that he was asked to complete. The plan of the Cathedral, commenced by Arnolfo di Cambio and expanded in the Trecento by his successors, could not be changed (see fig. 127); this included the octagonal base for the crowning dome. The nave, choir, and transept were already built, and the marble incrustation of the exterior, with its intricate Gothic ornamental shapes, was complete as high as the parapet above the side aisles and chapels. The idea of oculi (round windows) instead of Gothic pointed ones had been adopted in 1367, and the building of the clerestory in rough masonry was completed apparently by 1390. But the exterior of the clerestory, as we see it today, and the finished portions of the dome present a consistent appearance, whose harmony, clarity, and simplicity are strikingly different from the complexity of the Gothic shapes below them. The marble incrustation around the dome was carried out after Brunelleschi's death by Antonio Manetti Ciaccheri during 1452-59, but all incrustations on drum and clerestory probably reflect Brunelleschi's designs.

133. FILIPPO BRUNELLESCHI. Aedicula of a tribune, Cathedral, Florence. 1440s

In both the clerestory and drum each bay is divided into two superimposed rows of rectangular panels, each panel twice as high as it is wide. In the center of each bay an oculus seems to rest on the lower cornice and occupies a space equal to the width of a definite number of rectangular panels. Rectangles and circles on a square plane are elements of architectural draftsmanship that are carried out with basic geometrical instruments, the compass and square: Brunelleschi's architecture has been called "paper architecture," and to some degree it does preserve in stone the procedures of laying out architectural shapes on paper. Indeed, this beautifully simple partitioning conveys not only the principles but also the message of Brunelleschi's architecture. After the complexity of the committee-built medieval structure, he leads us by decree into a new world of simplicity and order, clear-cut proportion, and exact relationships. It is in the gigantic harmonies that Brunelleschi established for the Cathedral of Florence, rather than in the classical details that one makes out only at close range, that the individualism of the Early Renaissance is apparent. Especially the shape of the dome has an immense tension, resembling a Gothic vault more than the hemispheric dome of the Pantheon, which Brunelleschi had studied and measured in Rome. The eight massive ribs, like those of an umbrella, culminate and seem to be held together at the top by the marble lantern, designed to admit light into the interior. In the taut curves of its profile, the force of its volume, and the dynamism of its upward leap, the shape of Brunelleschi's dome suggests the new absolute of the Early Renaissance, the idea of the indomitable individual will, whose autonomy the embattled Republic was trying to preserve, against seemingly unbeatable odds. The construction, started in 1420, was completed in 1436 by an octagonal oculus on top, intended to do duty until the lantern could be commenced. By one of the symbolic accidents of history, it was under this dome that, three years later, the Roman pope and the Greek patriarch signed the treaty designed (uselessly, as it too soon appeared) to end the centuries-old schism between the two branches of Christianity. The dome remains a symbol today: the Florentine equivalent of the London cockney's declaration that he was born within the sound of Bow bells is "Io son fiorentino di Cupolone" ("I am a Florentine from the great dome").

The crowning lantern, and the four semicircular templelike tribunes with conical roofs that are wedged into the reentrant angles of nave and transept, represent a different period in Brunelleschi's development and are executed in a different style. The undated tribunes (fig. 133) are solid masses of masonry, intended apparently to buttress the enormous thrust of the dome above. Their exteriors are treated in a remarkably fresh and beautiful way, recalling the circular temples Brunelleschi had seen in Rome and its surroundings, but with the columns paired so that they would alternate with shell-headed niches. No longer can one find a trace of Gothicism; the capitals are Corinthian, and harmonize perfectly with the shafts, bases, and full entablature. But Brunelleschi has, as often in his architecture, introduced

an unexpected and almost inexplicable variant. Between the capitals and the entablature he has inserted little impost blocks, which give a lift to the half-circle of the entablature and the cone of roof above. The lantern (fig. 134) is a structure of great originality and freedom, bringing to a climax all the shapes and forces of the building. The eight ribs of the dome reappear in the form of eight buttresses, each pierced by an opening and culminating in a volute. The buttresses support the angles of the octagonal lantern; yet around each angle, as if continuing behind the volutes, is folded a handsome Corinthian pilaster, these pilasters supporting a complete entablature and enclosing eight arched windows. The lantern abounds in other fantastic variations on classical vocabulary. The window arches are stilted, and rest on capitals freely invented by Brunelleschi. The openings in the buttresses look like arches, but have lunettes filled with shell forms, and the arched frame, which begins like a column with a recognizable base, runs without interruption around the arch and down the other side to the other base. The splendid volutes fork as they rise into two scrolls, one curling downward and back, the other upward and back; each embraces sculptured flowers of the broad bean plant, whose pods fill the interstices. Some of these caprices are not to be seen in Brunelleschi's original model (badly damaged in the flood of 1966, but now repaired), and may be due to Michelozzo di Bartolommeo-who certainly finished the lantern. for Brunelleschi had died before it could even be commenced.

The lantern as built by Michelozzo culminates in a burst of delightful forms: an attic, composed of alternating niches and balusters surmounted by balls, supports a fluted cone that diminishes toward the gold orb and surmounting cross. It has been suggested that, for a while at least, the Florentines entertained the idea of leaving the great structure without a lantern. The interior would have been lighted by the shaft of light coming from the octagonal oculus now forming the base of the lantern, and from seventy-two tiny oculi, in three superimposed tiers, in both shells of the dome. Until these were closed on the inner shell in the sixteenth century, they provided three crowns of light for the now rather dark interior.

There is perhaps no greater tribute to the grandeur of Brunelleschi's forms than the section separating the drum and the dome, a stretch of rough masonry save for a gallery on one of the eight faces (see fig. 132). No one knows how Brunelleschi intended to complete this section. In the Cinquecento another competition took place, and the winning design by Baccio d'Agnolo was carried out for one face only; Michelangelo's bitter comment, "It looks like a cage for crickets," appears to have stopped the work then and there. The bare masonry is perhaps preferable, for the fragment of gallery seems as relevant to Brunelleschi's design as a patch of scrub vegetation on the face of a cliff.

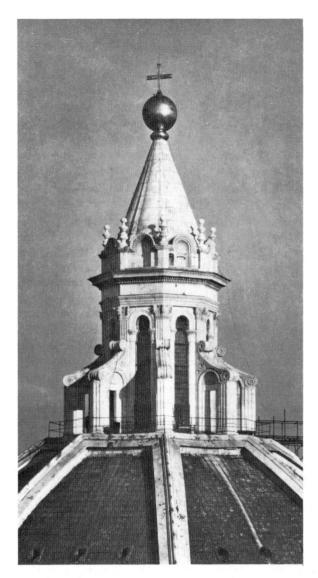

134. FILIPPO BRUNELLESCHI and MICHELOZZO DI BARTOLOMMEO. Lantern, Cathedral, Florence. After 1446

One of Brunelleschi's greatest sources of fame among his contemporaries was his method of solving the constructional problem of so great a dome—the largest since the Roman Pantheon and the highest ever built until that time. The officials of the Opera del Duomo were concerned about the colossal cost of erecting the centering of timber, the traditional means of supporting the masonry of a dome as it went up. For this centering an entire forest would have been required. A competitor of Brunelleschi went so far as to suggest building a core of earth, sown with silver and gold coins; when the doors were opened, the proverbial cupidity of the Florentines would ensure the rapid removal of the earth. Brunelleschi subsequently worked out his own method of laying brickwork in rings of horizontal masonry, cutting each ring occasionally with a vertical brick; these were so laid as to form staggered vertical rows that produced a diag-

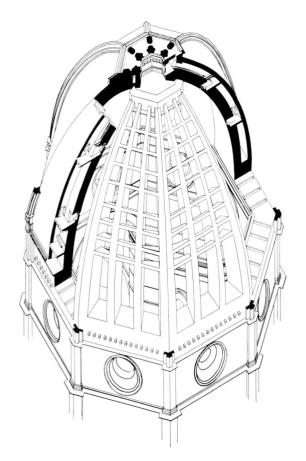

135. FILIPPO BRUNELLESCHI. Diagram showing construction of the Cathedral Dome, Florence

onal whorl converging on the keystone. Although this method was used in all his later domical constructions and those of his followers, it could not be employed in an octagonal dome; however, it provided a principle of herringbone construction that could be utilized at the Cathedral of Florence. The first levels of the dome were done in pietra forte, the traditional stone of the Florentine builders. From there on the work continued in brick. The dome is composed of an inner and an outer shell (fig. 135), both anchored to the eight principal ribs; between the shells there are, in addition, sixteen smaller ribs (which do not appear on the surface) connected to one another and to the main ribs by arc-shaped bands of stone, much resembling flying buttresses laid horizontally. The immense strength of the grid resulting from this system was reinforced at the haunch by an encircling chain of gigantic oaken beams held together by iron links. According to Brunelleschi's scheme the masons could work with simple internal scaffolding. This scaffolding, reproduced in drawings and engravings, was an arrangement of beams converging toward the apex, supporting floors that could be lifted as the work progressed. The masons did not have to carry the building materials on their shoulders to such dizzying heights. Another of Brunelleschi's inventions, a hoisting machine of hitherto unknown form and principles, did this work for them; it was such a success that the Opera del Duomo had to publish an order forbidding adventurous Florentines from hooking rides on Brunelleschi's hoisting machine!

In all the buildings that Brunelleschi designed from the outset, he abandoned the Gothic compound pier and the Gothic pointed and splayed arch. He substituted, definitively and at once, a vocabulary imitated—but greatly simplified—from classical antiquity and, it must be admitted, from Romanesque buildings, such as the Baptistery of Florence (see fig. 85) and the Church of San Miniato, still believed to be Roman in Brunelleschi's time. In all of his buildings, round arches with squared soffits are supported on columns derived from one of the Roman orders, by preference the Corinthian. This new vocabulary soon became standard, and it conferred upon the architecture of Florence an appearance responsive to the new ideals of measure and proportion.

THE OSPEDALE DEGLI INNOCENTI

The most striking embodiment of Brunelleschi's style in the crucial years around 1420 was the Ospedale degli Innocenti (foundling hospital); the statistical role of the hospital in the evolution of the Florentine people may be attested by the presence, in a recent edition of the Florentine telephone directory, of nearly eight columns of persons called Innocenti, or its derivatives. Although orphan asylums already existed, the Republic decided to care for the increasing number of foundlings, from infancy to the age of eighteen, including education and vocational training. The Innocenti was built at one side of a piazza terminating a newly opened street, the Via dei Servi, leading from the Church of the Santissima Annunziata to the Duomo (of which it then commanded an unobstructed view). What was meant to mirror the loggia on the other side of the square is not certain, but it is probable that the present harmonious series of arcades—the first of the great, unified squares of modern urban design—was planned from the first.

Brunelleschi's science of measure and proportion dominates the apparent simplicity of his graceful design (fig. 136). The long array of Corinthian columns supports round arches and an entablature; the cornice, somewhat lifted, serves as the base for a row of pedimented windows, one above the keystone of each arch. Since he was obliged to be absent from Florence during the crucial phase of construction, Brunelleschi provided the builders with something they had never seen, a measured drawing, and according to the biography of the great architect written by an anonymous pupil, possibly Antonio di Tuccio Manetti (not to be confused with Antonio Manetti Ciaccheri, see page 143), they had difficulty with the measurements and deplored the absence of the customary wooden model. Worse, Brunelleschi's

136. FILIPPO BRUNELLESCHI. Ospedale degli Innocenti. Begun 1419; completed mid-15th century. Piazza della SS. Annunziata, Florence

name eventually disappears from the documents concerning the hospital's erection, and the new supervisor omitted important elements, especially roundels in the frieze and pilasters between the windows of the second story, from Brunelleschi's design, to his dismay upon his return to Florence. Nonetheless, the arcade and its Corinthian pilasters embracing the terminal arches are as Brunelleschi planned them.

The entire structure, in both plan and elevation, is founded on two modules—the cube and the hemisphere. The distance between the centers of the columns equals the distance between the center of a column and the wall of the building itself. This same distance equals the height of a vertical support from the floor of the loggia to the sharp point where two arches seem to coalesce, a point just over the impost block that Brunelleschi generally liked to place above his capitals.

The choice of this junction point, rather than the springing point of the semicircular arches, is apparently Brunelleschi's way of taming the always inconvenient factor π , which is essential in determining the measurement of a circle. By this means the distance between the junction point and the base of the architrave may be established as one-half the height of a column, including

capital and base, but without plinth or impost block—or two-fifths the height of an entire support. Now we can understand the location of the cornice on which the windows rest: the distance from the top of the cornice to the base of the architrave equals the distance from the base of the architrave to the junction point of the arches. It is then used for the width of the principal doors and the height of the second-story windows; halved, it governs the width of the smaller doors and windows, the height of the architrave, and the distance between the top of the architrave and the second-story windows. These simple relationships—one to two, one to five, and two to five are carried even into the proportions of capitals and bases, and extended to the cubic proportions of the uniform rooms in the interior. Surely it had escaped neither Brunelleschi nor his patrons that Christ, the supreme exemplar of the charity for which the hospital was founded, is the Second Person of the Trinity, that the Wounds of Christ number five, or that the product of two and five is the number of the Commandments. This kind of measure is at the foundation of Renaissance art, which fuses faith and science, antiquity and Christian belief. The Divine Proportion was one of the goals of Renaissance theorists as well as of artistic creators, searching together for a new realm of experience in which a humanistic view of the universe could be justified on religious grounds.

Externally and internally the appearance of Brunelleschi's clear-cut, rational buildings is vastly different from that of Roman structures, although these provide the elements from which his new architecture is derived. Characteristically, he preferred the smooth shafts of Florentine Romanesque columns to the fluted ones he must have seen in Rome. He reserved fluting for pilasters, such as the handsome ones that embrace the outer arches of the Innocenti loggia and terminate its lateral extension; it is no surprise to discover that the columns are three-fifths the height of these pilasters. Brunelleschi consistently simplified and clarified Roman models. As compared with the richness and technical virtuosity of Roman Corinthian capitals, his capitals look almost toylike, their leaves, volutes, and abaci set out separately against a plain ground.

THE OLD SACRISTY OF SAN LORENZO

The sacristy of San Lorenzo (1421-25) known as the Sagrestia Vecchia (Old Sacristy) to distinguish it from its counterpart on the other end of the transept, the Sagrestia Nuova (New Sacristy) by Michelangelo that contains later Medici tombs, was intended as a chapel for the Medici family, first of all as a tomb chapel for Giovanni di Bicci de' Medici, founder of the family fortunes and Brunelleschi's first patron. As originally planned, this little building was largely independent of the medieval Basilica of San Lorenzo itself. With Giovanni's fortune supporting the work, it proceeded with great rapidity, and when completed in 1428 (perhaps 1429, consider-

137. FILIPPO BRUNELLESCHI. Plan of S. Lorenzo, including Old and New Sacristies

ing that the Florentine year began on March 25), the Old Sacristy was the first Renaissance space that could actually be entered. In plan (fig. 137) the interior of the Old Sacristy is an exact square, extended on one side by the smaller square of an altar space. This principal side of the room (fig. 138) is articulated by four fluted Corinthian pilasters and the entablature, continuous around the room but here broken by the round arch giving entrance to the altar space. This arch is embraced by one of the four larger arches, supported on outer pilasters that are actually folded into the corners of the room. The discrepancy between the larger square of the sacristy and the smaller circle of the dome is bridged by pendentives. The dome is ribbed like the star vault of a Gothic apse, but is a hemisphere (fig. 139). Twelve ribs spring directly from the circle, cutting the drum into twelve roundarched compartments, each containing an oculus. The ribs converge on a lantern outside, a dainty peristyle originally open to the sky. Since the circular base of the dome does not touch any of the four arches, its whole complex and luminous structure gives the impression of a vision—a kind of New Jerusalem (which had twelve gates) descending from Heaven. It may be significant that only the four spandrel medallions touch the arches and the circle, and these contain reliefs by Donatello representing scenes from the Life of St. John the Evangelist, who beheld the New Jerusalem.

The fenestration of the interior (blocked on the north side by the apse of San Lorenzo itself and by its flanking chapels, added later) is relegated to the second story. Here again Brunelleschi maintained a simple system of proportions: the height of the lower story to the top of the architrave equals the distance from the architrave to the circular base of the dome; this in turn equals the height of the dome to the base of the lantern. Each story is related thus to the height of the entire building as one to three. On each side of the Old Sacristy are seen three arched windows and three medallions. The sacristy has four sides. Three times four equals the number of the ribs and oculi of the dome. Again, it is no accident; three is the number of the Trinity and four that of the Evangelists, and the Apostles number twelve.

Something of the lightness and clarity of Brunelleschi's original design is, it must be admitted, cluttered by the powerful sculptures by Donatello—the relief panels of the doors, the reliefs filling the niches over the doorways, and the medallions. Brunelleschi thought so too, and protested. This is one of the many occasions when great artists of the Renaissance did not see eye to eye; considering the gulf between the serenity of Brunelleschi's ideas and the violence of Donatello's temperament, a clash between the two is hardly surprising. (In the last little masterpiece that will be considered here, the Pazzi Chapel, intended as a chapter house for the Monastery of Santa Croce, Brunelleschi selected his own sculptors—himself and the tranquil Luca della Robbia.)

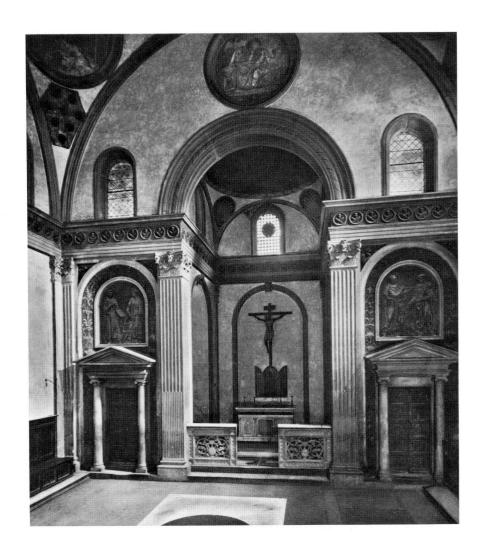

left: 138. FILIPPO BRUNELLESCHI. Old Sacristy, S. Lorenzo, Florence. 1421–28

below: 139. FILIPPO BRUNELLESCHI.
Dome, Old Sacristy, S. Lorenzo, Florence.
1421–28

SAN LORENZO AND SANTO SPIRITO

Brunelleschi was also responsible for a revolution in the plan of church interiors, and indeed for the relation between church buildings and the urban complexes surrounding them. He was commissioned to build two of the major churches of Florence, and in each case he also submitted designs for an adjacent piazza. He never saw either of these churches complete, and both of the projects for *piazze* were so altered as to retain nothing of his original plans. Nonetheless Brunelleschi's new ideas for church interiors and his dreams of harmonious urban design, even more spectacular than in the piazza bordered by the Innocenti, remained influential for centuries.

Neither the building history of San Lorenzo nor that of Santo Spirito is yet a matter of full agreement among art historians, especially at the crucial planning stage, nor in fact are the documents for San Lorenzo yet available. As far as can be surmised, however, the two great churches, closely interrelated, took shape in Brunelleschi's mind at about the same time. San Lorenzo had the advantage of Medici patronage, and consequently more expensive materials and elaborate workmanship, but was erected piecemeal and had to struggle with preexistent buildings, including the Old Sacristy. Santo Spirito,

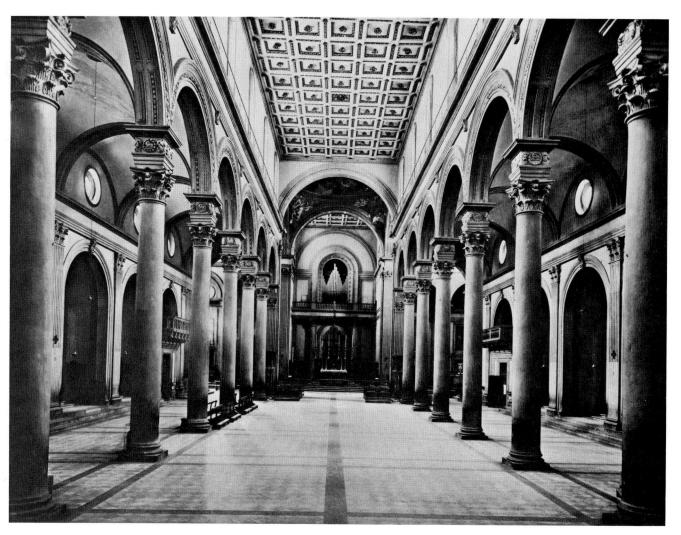

140. FILIPPO BRUNELLESCHI. Nave and choir, S. Lorenzo, Florence. Choir and transept begun c. 1425; nave designed 1434 (?); construction 1442 to 1470s

at least, could be designed from scratch, and in many ways it can be considered Brunelleschi's proof of what he could do when given a free hand to rectify all the unfulfilled opportunities at San Lorenzo. In planning both churches he swept away the whole history of medieval architecture—its complex vaulting systems, compound piers, and radiating chapels; he deserted even the openwork timber ceilings characteristic of Dominican and Franciscan churches in the Dugento and Trecento (see fig. 52). Clearly he desired to return to the simple, threeaisled system of Early Christian basilicas in Rome, which he must have thought was also exemplified in the Church of the Santi Apostoli in Florence. The flat ceiling of both San Lorenzo (fig. 140) and Santo Spirito (figs. 141, 142) is supported on a diaphragm wall unbroken save for the round-arched clerestory windows. The lower story is formed by a lofty nave arcade supported on monolithic Corinthian columns of great height, simplicity, and beauty. These are made to seem even taller by the intervention of impost blocks consisting of complete sections of Corinthian entablature, including the cornice between the capital and the arch. In keeping with

the principles of Brunelleschi's "paper architecture," all the interior details are simple and light, with delicate projections. The flat surfaces of the masonry are covered with stucco and painted white, while the supporting elements and trim, including the columns, arches, and the long unbroken lines of the entablature resting upon the arches, are made of a clear gray stone, which the Florentines call *pietra serena*. Brunelleschi's two-tone system, a cool, harmonious, and austere alternation of gray and white, remains constant in Florentine architecture for the interiors of churches, palaces, and private dwellings into the eighteenth and nineteenth century.

In contrast to the flat, coffered ceiling of the nave—gray, with carved and gilded moldings and rosettes at San Lorenzo, merely painted in the much later, cheaply finished ceiling of Santo Spirito—the side aisles are vaulted by the same little pendentive domes used in the Innocenti loggia, supported on transverse arches that repeat in lighter form the arches of the nave arcade. The long horizontal of the nave entablature is carried out in the walls of the side aisles as well, there resting on fluted pilasters. The height of each nave arch, including impost

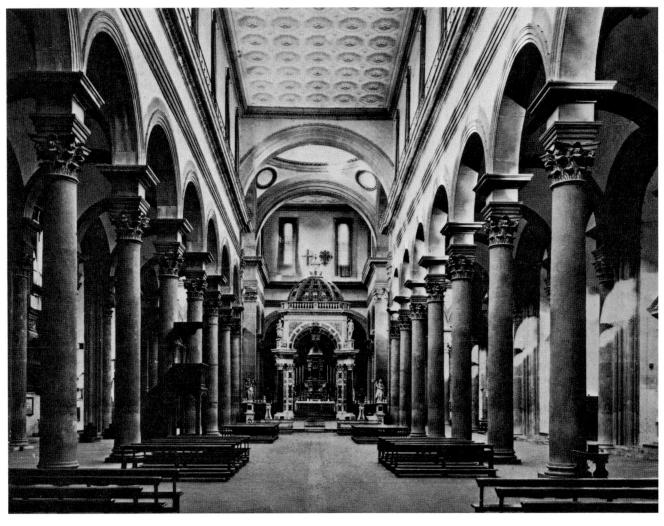

141. FILIPPO BRUNELLESCHI. Nave and choir, Sto. Spirito, Florence. Model submitted 1434–36 (?); construction 1446 to late 15th century

block, is half the height of each column with capital; the impost blocks, therefore, were another of Brunelleschi's devices to make the π conform to his own simple proportion system. Each bay of the side aisles is a square and each bay of the nave is two squares, forming a rectangle twice as wide as it is long (see figs. 137, 142). The width of the nave equals the height of the nave arcade, measured to the uppermost rim of the archivolts. These consistent proportions of one to three, one to two, and two to three are carefully emphasized: the marble inlay of the floor at San Lorenzo (never carried out at Santo Spirito) divides nave and side aisles into their component squares, but is so drawn as to indicate by doubled lines the width of the plinths as well, and the doubled lines are calibrated to establish the width of a plinth as one-fifth the distance between the plinths. And in the middle of the spandrel between each pair of nave arches appears a corbel (again, at San Lorenzo only, but possibly intended at Santo Spirito and never carried out); structurally useless, it aids the eye to measure the procession of cubes of space formed by the bays against the volume of the nave. The visitor is everywhere made aware not only

142.
FILIPPO BRUNELLESCHI.
Plan of Sto. Spirito
as originally intended;
dotted lines indicate
present exterior walls

of the grace of the individual shapes but also of their function in the harmonic structure of the church, and he can enjoy its systematic diminution as the eye proceeds down the visual cone of the interior. No wonder Brunelleschi has been traditionally credited with the invention of one-point perspective—a system that, as we have seen (see pages 114-15), was maturing long before his day, but for which he may well have provided the first mathematical procedure, soon replaced by a simpler theoretical construction preserved in the writings of Leonbattista Alberti.

Now for a summary of the building history of both churches and its consequences for their striking differences. In 1418 it was decided to extend the medieval Church of San Lorenzo with a new choir and transept. Construction was started in 1421, but all the houses on the site were not demolished for two or three years. Only about 1425, when the foundations of the new choir and transept were already laid, was Brunelleschi-triumphant in the neighboring Old Sacristy—called on the scene. He appears to have advised a complete change, from the intended octagonal Gothic piers to square Renaissance ones, faced by Corinthian pilasters, but it was no longer possible to make any changes in the plan. There was no talk of tearing down the original church, for which the new constructions were a mere addition. It is not clear how much was completed before the expenses of the war with Milan forced abandonment of the work. In 1434 houses flanking the church were torn down with the idea of creating a large piazza facing the Medici Palace. At this moment Brunelleschi, as the leading architect of the city, seems to have conceived his new plan for replacing the medieval church. At the same time he was involved in the project for Santo Spirito, to build a new and grandiose basilica to replace completely a small thirteenth-century structure. At San Lorenzo finances were a problem at that moment, and no chapels were planned to flank the central nave. (The present chapels were added only after 1470, and fit the structure badly.) Because of the transept and choir already started with pilasters, Brunelleschi was limited to the nave for his grand succession of columns, seven on each side.

At Santo Spirito, however, lateral chapels were planned from the first. Brunelleschi's model, probably datable in 1434–36, integrates the chapels in the total plan: they are now essential elements, semicircles whose other half could be inscribed within one triangle of an X formed by intersecting diagonals drawn within the square side-aisle bays. Thus the entire plan is a succession and interrelation of circles and squares. As if inspired by the radiating plan of the east end of the Cathedral, on which he was then still working, Brunelleschi made the arms of the transept and the choir of equal length, embraced by an ambulatory and radiating chapels. The ambulatory joins the side aisles and their semicircular chapels to form a continuous belt sur-

rounding the entire building—originally including even the façade. These chapels would, then, have created no less than forty apsidioles on the exterior, diagonally related at the external and reentrant angles, and forming a consequent play of curved forms against flat walls and roof lines, showing great plastic richness and luminary contrast. Within the self-imposed limitations of Brunelleschi's mathematical style, there could scarcely have been a stronger departure from the "paper architecture" of his early work. He is here concerned with solid rather than plane geometry. Alas, the forty apsidioles are not now visible on the exterior of the building—a flat wall masks all the little chapels—and the four chapels along the façade, which would have served as entrance porches, were never built.

At San Lorenzo, as at the Ospedale degli Innocenti, the arches do not arrive complete at the impost block, but coalesce before reaching it. At Santo Spirito, however, each arch is complete and self-contained. As compared with the flatness, lightness, and grace of San Lorenzo, the interior of Santo Spirito produces at once an impression of mass, space, and majesty. The columns are about twenty inches shorter than those of San Lorenzo, and the frieze so much wider that it functions as a separate space between two horizontal bands. The entablature is not supported by corbels that tick off the nave bays, nor does it rest on the arches of the nave arcade. The cornices on which the arches rest are heavier and project more sharply than those at San Lorenzo.

Even more important is the fact that the apsidal chapels are separated not by pilasters, as at San Lorenzo, but by half columns whose projecting masses are echoed in the moldings of the enclosing arches. Each apsidal chapel, moreover, is smooth and unbroken by any form save the small arched window, and thus seems related to the pendentive vault above. If Brunelleschi's original design continuing the side aisle around the inside of the façade had been completed, there would have been the staggering total of thirty columns and forty-two half columns. Even with the present entrance wall, whose appearance (according to the architect's anonymous biographer) is enough to make the great architect rise from his tomb, we are presented with a constant and very rich alternation between massive, convex gray forms and elusive, elastic, concave white forms; this effect corresponds to the continuous and delightful shifting of spatial views through always-changing relations of columns and arches. Unfortunately, the newly constituted body of citizens responsible for carrying out the construction of the church from public funds after the Florentine victory at Anghiari in 1440 (see page 457) did not accept the architect's brilliant idea of placing the church so as to face the Arno across a wide piazza, which would have had a crucial effect on the plan, and indeed on the entire appearance, of the city of Florence. This location would also have faced the voluminous traffic on the river from the

direction of Pisa, and Santo Spirito would then have been visible to viewers on the opposite bank.

San Lorenzo did not enjoy a state subsidy, and not until 1442 did Cosimo de' Medici agree to finance the building, work on which had been held up so long. Brunelleschi was destined to see his great architectural vistas only in imagination; when he died in February 1446, not one column for either of his basilicas had yet been quarried. Under the supervision of Michelozzo di Bartolommeo, work dragged on at San Lorenzo (with many errors of judgment) until after 1470; at Santo Spirito even longer, under a variety of masters. We have no idea how Brunelleschi intended either of the two facades to appear, as he seems to have been commissioned only to provide models for the body of each church. Santo Spirito has a rudely painted eighteenth-century facade, while that of San Lorenzo, in spite of Michelangelo's great dream of completing it (see pages 540–41 and fig. 567), remains blank to this day. Despite their vicissitudes, San Lorenzo and Santo Spirito remain two of the most beautiful of all Renaissance interiors.

SANTA MARIA DEGLI ANGELI

A little building that might have been one of Brunelleschi's masterpieces was the chapel of the Monastery of Santa Maria degli Angeli, the Florentine seat of the Camaldolite Order (see pages 219-20), whose prior was then the celebrated and widely traveled scholar Ambrogio Traversari. Started in 1434, the building never rose much above the foundations until recent times; the

143. FILIPPO BRUNELLESCHI. Plan of Sta. Maria degli Angeli, Florence. Anonymous drawing after Brunelleschi's design. Construction begun 1434

structure standing on the site today dates almost entirely from 1937, and only in its ground plan does it give any hint of how Brunelleschi's building would have looked. It was clearly intended only for the community of forty monks, and had no space for public worship. Insofar as can be determined from early drawings (fig. 143), the plan was basically that of a regular octagon, each side of which opened into a rectangular chapel with two lateral niches or apsidioles. Given the roughly triangular masonry masses separating the radiating chapels, the exterior would have had sixteen sides. The evidence regarding the possible appearance of the building if it had been completed is fragmentary, but it would certainly have been roofed by a dome (one is shown in a rough fifteenth-century topographical manuscript), surrounded by eight little gables, each containing an oculus. Each chapel must have been enclosed by an arch supported on pilasters, and the interior would have been lighted by the oculi above the arches. In this still-mysterious project of Brunelleschi's, we have the first step of the Renaissance in the direction of the central plan (a favorite in Early Christian times for tomb churches), which was to reach its culmination in some of the projects for the new St. Peter's in Rome.

THE PAZZI CHAPEL

The culminating achievement of Brunelleschi's career, in a sense, is the chapter house of Santa Croce, generally considered one of the jewels of Renaissance architecture; it was commissioned by the rich and powerful Pazzi family, and is therefore known as the Pazzi Chapel (fig. 144). The documents date the beginning of construction in 1433, and by 1442 work had advanced sufficiently to permit the entertainment of Pope Eugenius IV in what was probably a temporary wooden pavilion put up for the purpose above the building. But inscriptions have been found showing that the dome was finished in 1459 and the cupola inside the portico not until 1461, both long after Brunelleschi's death. At many places the masonry of the portico, supposedly a masterpiece by Brunelleschi, does not correspond with the building, suggesting that the architect may not have left any model for a portico. Giuliano da Maiano, with whose known style the portico closely corresponds (see page 293), a professional woodworker as much as an architect, put in a statement after the expulsion of the Pazzi in 1478 for a considerable sum owing to him for work in the chapel. Certainly, the elaborate surface detail is alien to Brunelleschi's taste at any point in his career.

In plan and construction (colorplate 21; fig. 145), the building represents an amplification and consolidation of principles announced many years earlier in the Old Sacristy of San Lorenzo (see figs. 137, 138); it is a rectangular structure of three stories, the second containing the arches and pendentives that support the third, a starvaulted dome culminating in a temple lantern. Here the

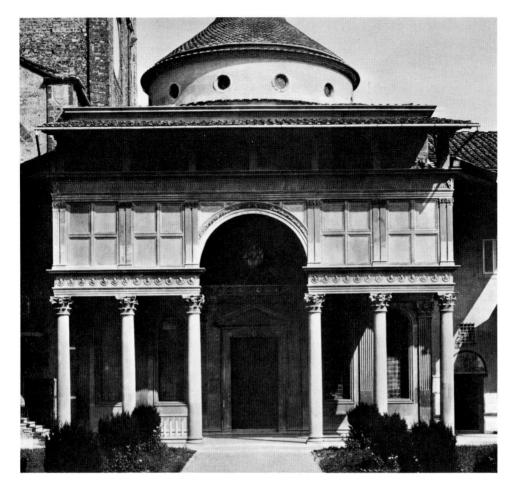

left: 144.
FILIPPO BRUNELLESCHI and
GIULIANO DA MAIANO (?). Pazzi
Chapel, Sta. Croce, Florence
(see colorplate 21). Begun 1433;
completed 1461

ahove: 145. FILIPPO BRUNELLESCHI. Plan of Pazzi Chapel

resemblance ceases. Probably because the Franciscan chapter of Santa Croce required a large meeting space, the central square is extended on either side by half the square. As a result, the building becomes an oblong hall, twice as wide as it is long; the center is roofed by the twelve-ribbed dome, the wings by barrel vaults. The short end walls of the oblong are articulated by two full Corinthian pilasters upholding a (nonstructural) arch, embraced by the barrel vault; this, in turn, is supported by quarter-width pilasters rather than pilasters folded into the corners, as in the Old Sacristy. The distance between the outer edge of one of these quarter-width pilasters and the inner edge of the next pilaster on the end walls is established by Brunelleschi as the basic module for the interior articulation (but not for the total proportions) of the entire chapel. The module is clearly indicated by the architect's use of his characteristic device, tiny corbels below the architrave. Thus the space between the inner edges of the central pilasters is two modules wide. The area of the altar space, measured from the inner edge of its front pilasters to the rear corners, is an exact square, two modules wide and two deep. The height of the order from its base (above the bench) to the top of the cornice is four modules: from above the bench to the bottom of the architrave, three and one-half. Each shaft is three modules high and one-third module wide, each capital one-third module high and one-half module wide at the abacus. The arched windows of the façade, their matching panels on the interior walls, and in consequence the twelve medallions above them and the square panels in the barrel vaults, all are five-sixths of a module wide at the outside.

The proportions of the three stories, however—architectural order, arches, and dome—are not identical, as they were in the Old Sacristy. Here they diminish as they rise. The height from the base of the architrave to the base of the dome is slightly less than that from the bench to the base of the architrave; the height from the base of the dome to the apex, or the ring at the base of the lantern, is slightly less than from the base of the architrave to that of the dome. The distance by which these basic divisions are decreased is in each case one-half module, or the width of an abacus. The result of this controlled diminution is that the Corinthian order, used throughout the chapel, gains greatly in importance and dominates the interior to an extent impossible in the Old Sacristy.

Brunelleschi's anonymous biographer tells us that all of his models were made to show structure alone, not ornament, and a certain fussiness in the detail of the Pazzi Chapel may well be due to Giuliano da Maiano after Filippo's death. But the structure is his, and as in his other works the clear-cut pilasters, capitals, window and panel frames, rosettes, corbels, arches, medallions, oculi, and dome ribs are all set out in *pietra serena* against the cool, white stucco of walls, vaults, and dome.

The only color is provided by the glazed terra-cotta reliefs in the medallions—predominantly the sky-blue of their backgrounds—and by the Pazzi coats of arms in the angles of the pendentives. In none of Brunelleschi's previous structures were the elements of his style articulated with such delicacy and flexibility.

At this juncture one might bear in mind the admonition of the important, if neglected, contemporary Florentine humanist Giannozzo Manetti, who states in his book On the Dignity and Excellency of Man that the truths of the Christian religion are as clear and self-evident as the axioms of mathematics. The rational, ordered clarity of Brunelleschi's religious buildings may disappoint those who, like Ruskin, are fascinated by the seeming infinity and spontaneity of Gothic architecture. Yet the Pazzi Chapel, and indeed all of Brunelleschi's churches, are religious architectural structures of the highest order. The humanist elite for whom Brunelleschi worked evidently thought that simple, clear geometric principles, such as those on which this architecture is based, could unlock mysteries at the heart of the universe and reveal the intentions of the Deity who was, if one only knew how to go about it, eminently understandable, and had created the universe for the enjoyment of man. Alas, Brunelleschi's vision of architectural harmony and perfection, reflecting the sublime order of the cosmos, was, like all human expressions, limited by the nature of history and doomed to incompletion. The only creation Brunelleschi ever saw finished, the Old Sacristy, was spoiled, in his estimation at least, by the encroachments of others. Despite the incomprehension of those who continued it, his truncated lifework remained to inspire every architect of the Renaissance.

THE MEDICI PALACE

According to Vasari and to the earlier Cinquecento sources he used, Brunelleschi submitted a model for a grand, new house to Cosimo de' Medici, generally known as Cosimo Vecchio (to distinguish him from the later Cosimo I, the first grand duke of Tuscany). The new house would have been situated on the Piazza San Lorenzo, its portal exactly opposite to that of the church, and both would have enjoyed the same lateral piazza, extending as far as the site of the present Medici Palace on the Via Larga—today Via Cavour—just outside the old city of Florence, where the older families lived, but well within the third circle of walls. Brunelleschi, according to this account, had put much thought into the design of the house; when Cosimo rejected it as too sumptuous, he was deeply offended, and he smashed the model, so we no longer have any real idea of Brunelleschi's domestic architecture. But Cosimo had already been forced to undergo a year of exile in 1433-34, and did not wish his residence to be so splendid as to make him appear what, in fact, he was—the uncrowned king of Florence. For by 1446, when the Medici Palace was probably begun, Cosimo had reinforced his financial power by a series of political maneuvers designed to secure the family from future exiles; in consequence, the Republic, although its machinery remained superficially intact, was directed by Cosimo. The relationship across the Piazza San Lorenzo would have been more suitable to the palace of a bishop than to that of a private citizen. which Cosimo still pretended to be, and there may well be truth in the literary accounts. In any case, Cosimo waited until Brunelleschi's death in 1446 before starting to build his palace on its present site, not visually related to the church, although the expenses for the two structures are almost inextricably interwoven in the Medici ledgers. The Italian word *palazzo* (palace) is used freely to refer to any large building, and town houses of Florentine merchants, even modest ones, are called palazzi. But the dimensions of the Medici Palace are by no means modest. Each story is more than twenty feet high, and the entire structure, to the top of the cornice, rises more than seventy feet above the street.

As his architect, Cosimo chose a curious personality, Michelozzo di Bartolommeo (1396-1472). Despite his long and active life and his associations with the geniuses of the age, such as Brunelleschi, Donatello, Ghiberti, and Alberti, Michelozzo was not an originator either as architect or sculptor. Neither can he be dismissed as a mere follower of greater masters. Clumsy he may be at times, stiff and even tasteless, constantly oscillating between Gothic and Renaissance, but he can also offer delightful architectural solutions, especially when designing on a small scale; in his sculpture, his strange rigidity and constriction can be very impressive. Cosimo's palace was bought at the end of the seventeenth century by the Riccardi family, who extended it by one portal and seven bays of windows, hence its present designation as the Palazzo Medici-Riccardi (fig. 146). These additions must be thought away if we are to find the original proportions of the façade. One must also, although with less pleasure, imagine the building without the pedimented windows of the ground floor, which were added in the second decade of the Cinquecento by Michelangelo at the request of Pope Leo X, then head of the Medici family. Originally, the entire corner was an open loggia, used for ceremonials of the Medici family. But even in Michelozzo's original design, the division of the second and third stories into ten bays each, over three on the ground floor, must have been completely alien to the architectural thinking of Brunelleschi or, not long afterward, that of Alberti. Like many of his minor contemporaries, Michelozzo adopted the vocabulary of the new architecture, but was not sympathetic to its mathematical principles-if, indeed, he understood them.

To modern eyes the most striking aspect of the Medici Palace is its unpalatial appearance. With the rough-cut stones of its ground floor, it looks like a fortress. Some-

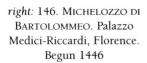

below left: 147. MICHELOZZO DI BARTOLOMMEO. Detail of cornice, Palazzo Medici-Riccardi, Florence

below right: 148. MICHELOZZO DI BARTOLOMMEO. Courtyard, Palazzo Medici-Riccardi, Florence. Begun 1446

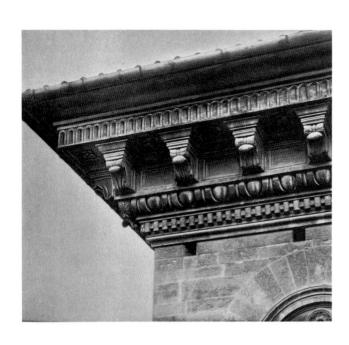

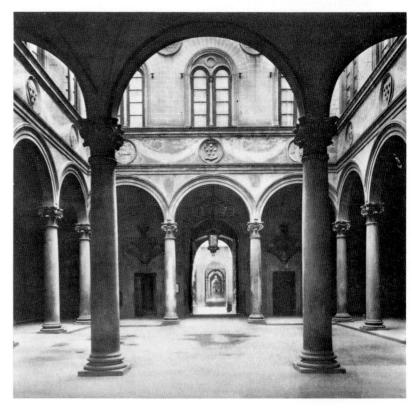

thing of the grimness of the medieval house-towers of Florence lingers in this design. It is not that the rustication really looks at all like that of medieval buildings. The blocks, haphazardly projecting, were imitated from the rustication of ancient Roman monuments, such as the Forum of Augustus, believed by Giovanni Rucellai to have been the "Palace of Caesar." Even in the turbulent civil existence of Florence, such rustication can have had no defensive nature, and indeed the projections would have been convenient for would-be scalers. The rustication must have conveyed to the Florentine passerby a moral quality—the Tuscan dignity and antique fortitude of the House of Medici. Many of the interiors—stripped, alas, in the disorders of 1494, when for the second time the Medici were driven from Florence—were luxuriously fitted. Today we miss especially the inlaid wooden wainscoting of the principal bedroom, which enclosed the battle scenes by Paolo Uccello (see colorplate 31), and Giovanni de' Medici's exquisite study with a glazed terra-cotta ceiling by Luca della Robbia. Extensive inventories made after the death of Lorenzo the Magnificent in 1492 show that the palace housed a treasury of Quattrocento painting, sculpture, and minor arts, not to speak of a splendid collection of ancient coins and gems.

Stringcourses separate the three stories. The second story is smaller than the first, the third smaller than the second. This progressive diminution in height is accompanied by correspondingly smoother surface treatments. The rude blocks of the ground story are replaced on the second by trimmed blocks with deep joints. The blocks of the third story are completely smoothed, the joints almost invisible. The random and unobtrusive fenestration of the ground story, intended to light small service rooms, gives way on both second and third stories to the mullioned windows characteristic of Florentine Quattrocento palaces. These windows, derived from the mullioned windows of Gothic structures such as the Palazzo Vecchio (see fig. 54), now utilize round arches supported on tiny, modified Corinthian colonnettes, and the lunettes are alternately decorated with Medici arms and Medici symbols. The windows appear to rest on the stringcourses and are the same height in both stories, but, as the height of the stories differs, one can hardly overlook the awkwardness of the contrast between the barren area above the second-story windows and the brief strip of wall above those on the third, especially since this strip is enshadowed by the immense projecting cornice. The cornice (fig. 147), although imitated from Roman models and complete with billet moldings, egg-and-dart moldings, and modillions, really echoes the traditional sharply projecting eaves that give to Florence and its subject towns so distinctive an appearance.

Like the larger medieval palaces, the Medici Palace was built around a central courtyard (fig. 148), where much of the life of the family, as well as its commercial and political activities, took place. The first story is a

149. MICHELOZZO DI BARTOLOMMEO. Library, Monastery of S. Marco, Florence. After 1436

continuous arcade, the second is closed by mullioned windows resembling those of the exterior, and the third was an open loggia, with small columns supporting an entablature and a beamed ceiling. The columns of the ground story at first sight resemble those of Brunelleschi's buildings, but they are heavier in their proportions, only seven and a half capitals high. Possibly Michelozzo felt that these proportions were necessary for the apparent function of the columns, supporting an enclosed second story. But with all its faults, the Medici Palace served as the model for Florentine palazzi for almost a century.

Among all the churches, chapels, palaces, villas, and monasteries carried out by Michelozzo, either alone or in collaboration with other and greater architects, one of his most charming creations is the little library of the Monastery of San Marco (fig. 149), part of the extensive rebuilding project supervised by Michelozzo and financed by Cosimo de' Medici in the years immediately following 1436. This structure consists of three aisles of equal height, the outer ones groin-vaulted, the central one roofed by a barrel vault and supported on an airy arcade of Ionic columns. Despite the constricted space, the slenderness of the elements gives lightness and daintiness to the interior, the look of a doll's house, which reappears in the architectural backgrounds of paintings by Fra Angelico (see fig. 210), who lived and worked in this monastery.

Gothic and Renaissance in Tuscan Sculpture

f architecture is the art in which the new principles of the Renaissance—especially the transformation of classical elements and the evolution of a mathematical proportion system—are most clearly evident, sculpture can dispute with architecture the leading place in the first decades of the Quattrocento. In the creations of an astonishing group of sculptors, in fact including four geniuses of a high order, new concepts of the dignity and autonomy of the individual human person profoundly affect modes of representation.

THE COMPETITION PANELS

Among the most ambitious sculptural projects of the Early Renaissance was the continuation of the doors of the Florentine Baptistery, of which one pair, showing the Life of John the Baptist, had already been made by Andrea Pisano (see fig. 86). Two more sets were now to be made, illustrating the Old and New Testaments. In 1401 the Opera (Board of Works) of the Baptistery opened a competition for the East Doors (under the supervision of the Arte di Calimala, the refiners of imported woolen cloth, oldest of Florentine guilds), facing the Cathedral whose nave was still being completed. Although the conflict with Giangaleazzo Visconti had struck a temporary lull, its most dramatic moment was to come while the finalists were at work on their reliefs. Seven sculptors were chosen to compete, all Tuscans, including the Sienese Jacopo della Quercia (c. 1374-1438), Filippo Brunelleschi, and Lorenzo Ghiberti (1381?–1455). When the models were submitted, sometime during 1402 and not later than March 25, 1403 (when the Florentine year 1402 ended), the palm went to Ghiberti, scarcely more than twenty at the time, and trained as a painter, rather than to the slightly older Brunelleschi or the middle-aged and more experienced professional sculptors. It was a surprising choice, but few save the anonymous biographer of Brunelleschi seem to have regretted it.

The subject given out for competition was the sacrifice of Isaac by his father Abraham at the Lord's command. The story had always been taken by Christian

theologians to foreshadow the sacrifice of Christ, but the officials of the Opera, as we shall see, may well have had a more immediate reason. Brunelleschi's and Ghiberti's reliefs, both preserved today in the Bargello in Florence, represent the same moments in the story: the boy kneels on the altar, his father about to put a knife to his throat; the angel intervenes; the ram is prominently visible in spite of the thicket. Below are the two servants, and the ass drinking water that gushes from a rock. The theme throughout both reliefs is divine intervention that delivers the Chosen People from impending doom, including even the substitute victim and the miraculous appearance of water. We must remember that the Florentines themselves credited the sudden death of Giangaleazzo in September 1402 to just this sort of last-minute personal interest on the part of the Deity. The exact date of the assignment of the reliefs is not known; it may very well have been after September, but the choice of subject may well have mirrored Florentine hopes for such a solution even before the unpredictable event.

Brunelleschi's relief was a brilliantly original creation (fig. 150), full of daring poses and bits of naturalistic observation. It is surprising, nonetheless, that the qualities of harmony and balance, toward which all of Brunelleschi's architectural activity is aimed, are absent from this somewhat overly dramatic relief. The angel, suddenly rushing in, grabs Abraham's right arm as he is about to plunge the knife into the boy's throat, while with his left hand Abraham is twisting Isaac's screaming head about so as to get a better hold. The carefully observed body of the boy is scrawny, the poses of all the figures tense, the rhythms of both drapery and figures sharp and broken.

The young Ghiberti, who was trained as a painter but had not yet matriculated in any guild, least of all the Arte della Seta to which the metalworkers belonged, nonetheless displays extraordinary accomplishment in handling and gilding of the bronze surfaces (fig. 151). Certainly he was subtler than Brunelleschi in his treatment of the subject. The boy looks upward for deliverance from death. Abraham, his left arm around the boy's

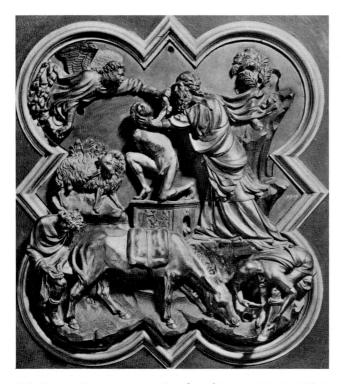

150. FILIPPO BRUNELLESCHI. Sacrifice of Isaac. 1402–3. Gilded bronze, $21 \times 17\frac{1}{2}$ " inside molding. Bargello, Florence

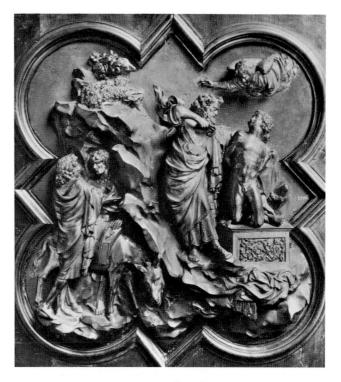

151. LORENZO GHIBERTI. *Sacrifice of Isaac.* 1402–3. Gilded bronze, 21 × 17½" inside molding. Bargello, Florence

shoulder, is poised with his knife pointed toward—but not touching-his son. The floating, beautifully foreshortened angel need only appear in the heavens and, with a single gesture of his uplifted hand, cause the sacrifice to stop. The ram rests quietly before his thicket. The servants converse gently. Physical contact and corporeal strain, so evident in Brunelleschi's relief, are translated by Ghiberti into spiritual relationships. And Brunelleschi's harsh and jagged movements become, in Ghiberti's relief, as graceful as those of dancers. Throughout Ghiberti's entire composition—in every figure, every drapery form, even in the far more complex rocks of the landscape—runs a beautiful flow of soft, curving rhythms, a continuous melody as perfect in its way as the harmony of Brunelleschi's later architectural creations but far above the odd discordances of his sculptured relief. Ghiberti's melody comes to its climax in the body of Isaac (fig. 152). Brunelleschi had, it is true, analyzed the human body with unprecedented understanding of naturalistic detail, but his end result was ungraceful. In Ghiberti's Isaac there appears for the first time a quality that, when academic theorists found it in the art of Raphael, they called natura naturata; we might translate the term "transfigured nature." Ghiberti's linearism has been called Gothic, on account of its superficial resemblance to that of Lorenzo Monaco (see colorplate 19). Nothing could be further from the truth. Ghiberti's line suggests, and is often derived from, that of classical antiquity. In the little gilded figure of Isaac, made in 1402-3, he created the first truly Renaissance nude figure; in it naturalism and classicism are blended and sublimated by a new vision of what a human being

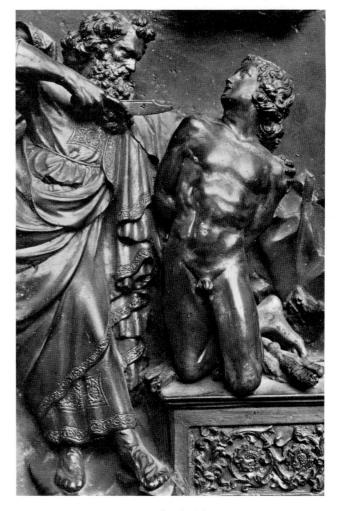

152. Isaac, detail of fig. 151

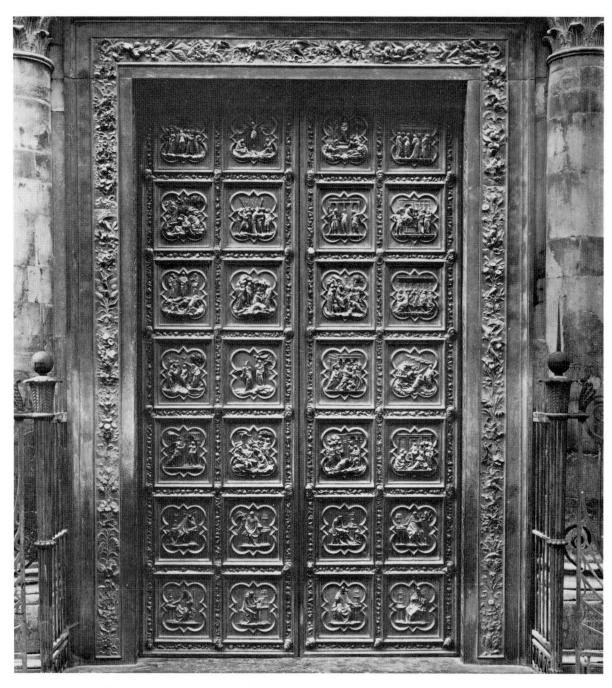

153. LORENZO GHIBERTI. North Doors. 1403–24. Gilded bronze. Baptistery, Florence

can be. The body displays all the strength and resiliency of a perfectly proportioned youth, overflowing with energy yet remarkably graceful. Not since the last Roman sculptor capable of doing so had imitated a Greek or Hellenistic original had such a nude been created. Ghiberti, without special study of anatomy as far as we know, seems to have possessed an instinctive knowledge of the difference between bony and muscular tissue, of the dynamic possibilities of muscles and the soft quality of overlying skin. Most beautiful of all, perhaps, is the expression of the boy—not only on his face but also in the spring and lightness of his whole pose, from the tip of the toe behind his body—a look of faith and joy at redemption from a terrible death.

Ghiberti was the author of a lengthy, and at times extremely difficult, work called in classical style the *Commentaries*. Much of the text deals with the relative merits of various artists of classical antiquity, whose works could have been known to Ghiberti only from literary sources. But the third Commentary, which takes up more than half the volume, is devoted to an analysis of the eye, its structure and its functions, and the relation of sight to the behavior of light. In this respect we should note how Ghiberti treats the eye in his sculpture. Before his time the eye was generally modeled as a blank surface, whether or not the cornea was painted on later (as in the case of a marble statue), or incised in order to receive colored inlay of ivory or glass paste. Ghiberti

makes Isaac's gaze infinitely more expressive by delicately incising the line of the cornea and the dot of the pupil. This treatment of the eye underscores other new optical qualities that show themselves in Ghiberti's sculpture. Near the beginning of the second Commentary he says, "Nessuna cosa si vede senza la luce" ("Nothing can be seen without light"); never before in sculpture had gilded surfaces been deployed as in this relief, sending light flowing across delicate textures, or reflecting it into shadows. And in almost all of Ghiberti's sculpture the eye is delineated in this new way, conferring vividness and sparkle to the expressions in his dramatic scenes.

GHIBERTI TO 1425

The Opera acquired the relief in 1403 and paid Ghiberti a sizable sum for gilding it. He started work on the doors (the ones that became the North Doors), which took him until 1424. Such a long time was required, of course, by Ghiberti's meticulous craftsmanship—the modeling of the wax, the casting in bronze, the chasing of the bronze, the gilding with gold leaf, and the final burnishing of the gold. Between the competition and the actual commission, however, the officials of the Opera changed their minds about the subject. Ghiberti now found himself confronted with the necessity of illustrating the New Testament instead of the Old, and the story of Abraham was saved for a third set of doors. The second doors, like those by Andrea Pisano, were organized in twenty-eight quatrefoils, arranged in seven rows of four (fig. 153). The quatrefoils in their square panels were, however, enclosed in a richer enframement than Andrea's relatively simple design. Through the margins flows a tide of vegetable and animal life—branches, foliage, fruit, insects, lizards, birds. And at each intersection of the border strips a head emerges from a tiny quatrefoil. These fortyeight heads (apparently representing prophets and prophetesses from the Old Testament) are all different: some are young, some old, some male, some female, some calm, some agitated. Most are strongly influenced by what Ghiberti had been able to discover in the remains of antique sculpture.

The lowest two rows were devoted to the Four Evangelists and, as their companions, the Four Fathers of the Church. Above these begin the New Testament scenes; the first is the *Annunciation* (fig. 154). Ghiberti's version is related to a number of Late Gothic Annunciations in Florentine art, particularly those by Lorenzo Monaco. In all of them Gabriel flies rather than walks into the scene—a visionary angel with clouds streaming from his feet, his wings beating, still airborne at the command of God the Father, who in Ghiberti's panel sends down the dove of the Holy Spirit to overshadow Mary. Ghiberti planned the scene with the utmost grace, elegance of line, and economy of detail. Already he seems to be somewhat hampered by the requirements of the Opera

154. LORENZO GHIBERTI. *Annunciation*, panel on the North Doors, Baptistery, Florence. Before 1407. Gilded bronze, 20½×17¾" inside molding

to conform to the Trecento shapes established by Andrea Pisano. He still keeps the background of bronze, but tilts the little portico before which the Virgin stands, and deploys the tiny supporting pier so as to indicate depth, thereby penetrating the flatness of the plaque. The descending, foreshortened figure of the Lord seems to emerge from and through the background, rather than being merely placed against it, as were Andrea's figures. In fact, in all the sculptures of the North Doors Ghiberti seems to struggle against the limitations of the frame, trying wherever possible to suggest the illusion of a deeper space. The drapery forms contribute to this illusion; Gabriel's cloak envelops his body in revolving masses that enhance its appearance of volume, and Mary's beltless tunic—a hint at conception—flows about her limbs to reveal their fullness and grace.

The Flagellation (fig. 155) takes place before a partly classical portico. One would like to know more about the dating of these reliefs: presumably this is among the later ones, for it must have been designed near the time when Brunelleschi was meditating on his new classical architecture for the Ospedale degli Innocenti and San Lorenzo (see figs. 136, 140). Perhaps the relief even precedes these buildings. A determined search of the backgrounds in Florentine painting and sculpture of the early 1400s might disclose numerous symptoms of the oncoming Renaissance, and the Roman Composite capitals

155. LORENZO GHIBERTI. Flagellation, panel on the North Doors, Baptistery, Florence. c. 1416–19. Gilded bronze, $20\frac{1}{2} \times 17\frac{3}{4}$ " inside molding

156. LORENZO GHIBERTI. Flagellation. c. 1416-19 (?). Pen and bister, $8\frac{1}{8} \times 6\frac{1}{2}$ ". Albertina, Vienna

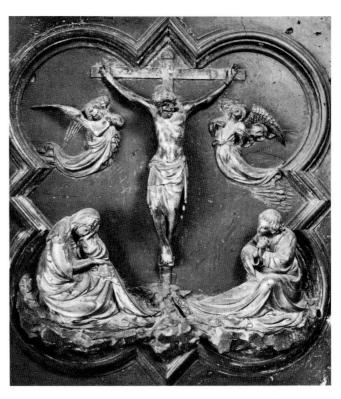

157. LORENZO GHIBERTI. Crucifixion, panel on the North Doors, Baptistery, Florence. 1407-c. 1413. Gilded bronze, 201/2 × 173/4" inside molding

of Ghiberti's colonnade should take an important place among these. The colonnade, however, is only a background for the perfectly coordinated interaction of the figures. Christ is tied to the central column. His body, still inviolate, continues in its suppleness and delicacy the new classical tradition Ghiberti had established in his Isaac, and his face discloses only patience. On either side the empty space sends the curving figure into higher relief. Like the parted waves of the Red Sea, the twisting movements of the two executioners, their now-missing weapons lifted, carry the eye backward and up into the lobes of the quatrefoil. Behind the executioners can be seen only the head, hands, and feet of a soldier and possibly of St. John. Among the surprisingly few drawings that survive by early Quattrocento artists, several fine examples can be attributed to sculptors; Ghiberti, in a pen sketch in the Albertina in Vienna (fig. 156), worked out various possibilities for the figures of the executioners before he arrived at the solution that identifies them with the forces of the frame. Interestingly enough, he toyed with the idea of a deeper building behind the figures, with a view of the coffered ceiling from below, done in a remarkable approach to one-point perspective.

The Crucifixion (fig. 157) is shorn of all elements of pain and terror, save only for the grief of the angels. The still figure on the Cross looks almost pityingly at Mary and St. John seated on the ground below. The curves of their bodies, following those of the quatrefoil, are completed by those of the angels. All the curves are subsumed in the concave lines of Christ's arms. A typically Ghibertian composition always shows a counterpoise of the compositional elements and the directional flow of rhythms that produces a perfect abstract unity. In the case of the Crucifixion, the opposition and swing of the rhythms raise this unity to the level of an unearthly harmony around the sacrificed Christ.

Ghiberti was called upon by the guild of Calimala, apparently about 1412, to execute in bronze the statue of the patron saint of Florence, St. John the Baptist (fig. 158), for the curious building called Orsanmichele (see fig. 6). This structure, originally a loggia, was rebuilt in 1337 as a combined shrine, wheat exchange, and granary. On the pillars at the ground floor level—the arches between were originally open to the interior—there were niches that since 1339 had been assigned to the leading guilds of Florence; the guilds had the obligation of filling them with statues of their patron saints, in marble or bronze. During the last two-thirds of the Trecento, only two statues had been set up. But under the stress of the attacks on Florence, first from Milan and then from

Naples, pressure on the guilds was revived, and they were given a very brief period to fulfill their obligations. All the statues were made between 1411 and 1429. Thus it was that a new race of heroic statues emerged in Florence, easily visible from the street since their feet were barely above the eye level of the passerby. Once it had begun, the march of Florentine statues did not stop for twenty years or so. At Orsanmichele and at the Cathedral, the centers of civic and spiritual life in the Republic, there appeared no less than thirty-four larger-than-life standing male statues, and still more were planned. It is striking that the great new figurative style of the Renaissance is seen first in sculpture, and only later in painting. Although what have been called the "sword-blade" rhythms of Ghiberti's drapery do indeed appear in Lorenzo Monaco's paintings, there is a humanity about Ghiberti's St. John that is missing from the painted fantasies of the monastic dreamer. The statue, at that time the largest bronze work to have been cast in Florence (see pages 25–26), shows us a saint who has lived long in the wilderness, whose hair and beard fall in disordered locks, whose eyes in their deep sockets gaze intently into the future (fig. 159). But all the apparent

158. LORENZO GHIBERTI. St. John the Baptist. c. 1412–16. Bronze, height 8'4". Orsanmichele, Florence

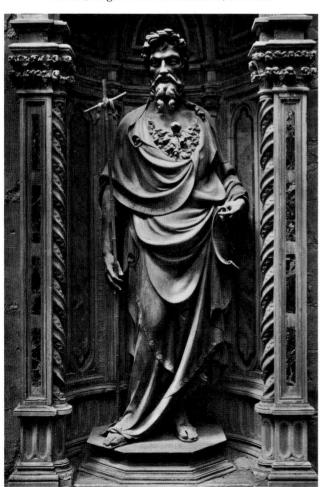

159. Head of St. John the Baptist, detail of fig. 158

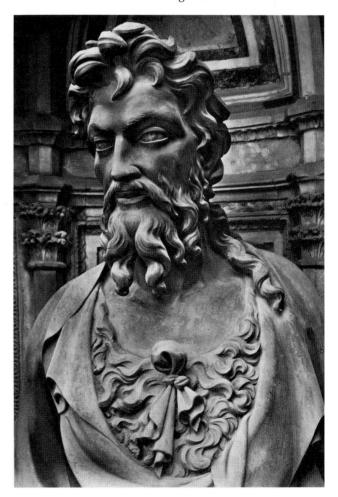

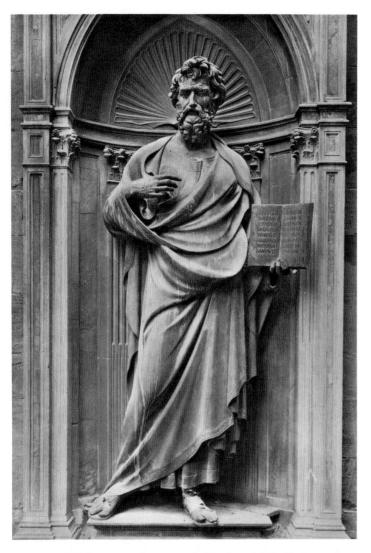

160. LORENZO GHIBERTI. St. Matthew. 1419–22. Bronze, height 8'10". Orsanmichele, Florence

wildness is governed by Ghiberti's inborn sense of unity through linear movement. The curves of hair and beard are remarkably stylish and contrast elegantly with the larger, stronger flow of the folds of the saint's huge cloak.

The St. John, with its bursting curves and deliberate exaggerations of shape, is still imbued with the ideas of the International Gothic, as indeed are the earlier panels from the North Doors (see fig. 154); the St. Matthew (fig. 160), however, commissioned in 1419 by the Arte del Cambio, or guild of the bankers, modeled in 1420 and set up shortly thereafter, represents the culmination of the new classical style. Only the pointed arch and florid gable of the niche still preserve Gothic elements. Otherwise, the grand figure, moving with perfect poise and balance before its semicircle of Corinthian pilasters, suggests the dignity and ease of a classical philosopher portrait. In ancient style, St. Matthew places his weight on one foot, leaving the other free to move. His right hand points toward his breast, his left holds his open Gospel book so that we may read, in grand Latin capitals, the first chapter recounting the genealogy of Christ. Such a figure is perhaps unthinkable without the intervening statues for Orsanmichele by Donatello and Nanni di Banco (see figs. 164, 168), in which, as we shall see, manifestoes of a new classicism were launched. But Ghiberti's version of the classical style is his own; flowing through it are the same linear ease, freedom, and harmony that are visible in his most "Gothic" works. The grand head, with its mountain of short curls, epitomizes the meditative intellectuality of Ghiberti's art.

DONATELLO TO 1417

Ghiberti's great contemporary Donato di Niccolò Bardi (1386–1466), known to posterity as Donatello, seems to have been as tense and impulsive as Ghiberti was serene and shrewd. Although he was a descendant of a branch of the great Bardi family (see page 76), Donatello was brought up in a more plebeian tradition than was Ghiberti. He was a member of the Arte di Pietra e Legname, the guild of the workers in stone and wood. Donatello made many works in bronze, but he certainly did not think as a metalworker thinks; neither can it be said that he was bound by the conventions of stoneworkers. He saw things in his own vivid and revolutionary way. He shared neither Brunelleschi's concern for proportion nor Ghiberti's feeling for line. He worked directly with the materials, seeing their possibilities almost as if he were painting in them. More than any of the contemporary innovators, he was fascinated by the optical qualities he could observe in the world around him and by the intense inner life of his subjects. The result is an art disturbing in its immediacy, careless of surface refinements, but able to reach a level of force and drama hitherto unknown in Italian sculpture.

One of Donatello's earliest known works is the marble David (1408; fig. 161), now in the Bargello in Florence. It was intended for a position on one buttress of the north transept of the Cathedral of Florence, high above the ground. Its fate was, in some respects, similar to that of the even more famous David carved almost a century later by Michelangelo (see fig. 477); in 1416, the Priori of the Republic called for Donatello's statue to be sent over from the Cathedral without delay to be set up in the Palazzo Vecchio, clearly as a symbol of the Florentine Republic, oddly enough, two years after the death of King Ladislaus of Naples. The right hand originally held a bronze strap for the slingshot (only the marble portion enclosing the stone now remains, on Goliath's brow), and on this strap were inscribed in Latin the words: "To those who bravely fight for the patria the gods will lend aid even against the most terrible foes." The youthful David wears a crown of leaves and flowers that have been identified as amaranth, the plant symbolizing the undying fame of heroes in classical antiquity. After the statue had already been completed, the Florentines saw a new significance in it, and there is considerable evidence that Donatello even added the bronze sling and reshaped the

161. DONATELLO. David. 1408; reworked 1416. Marble, height 6'3" (including base). Bargello, Florence

statue somewhat, in conformity with its new meaning and new location.

In the linearity of the drapery, echoes of the Late Gothic may still be discerned, but the folds do not flow as easily as in the work of Ghiberti. Nothing flows easily in Donatello—his work is always tense, sometimes deliberately harsh. The boy stands proudly yet awkwardly, his left hand bent upward on his hip, his right (which once held the sling) hanging loose, his head tilted. The lines of the drapery, now momentarily free, now tied to the figure and to each other, oscillate back and forth in sharp curves, from his right foot upward toward the head. This head is perhaps the strangest part of the statue. Instead of the pride of the victor, which the subject and especially the inscription would lead us to expect, we see a mouth half open as if muttering, and eyes widened in a detached stare. Clearly, Donatello's David derives no pleasure from his victory. It is as if conflicting states of triumph and doubt, pride and remorse, had produced emotional paralysis. In the glazed look of this youth, Donatello's tragic imagination admits us to a world of psychological tensions only dimly suspected by artists before his time.

The entranced look of the boy is contrasted with the unexpected peace in Goliath's severed head. Goliath's eyes are closed; no blood flows from the stone embedded in the skull. The sculptor is fascinated throughout by textures; although a hint of Late Gothic serpentine line still flows through the hair and beard, they also form unkempt masses that interest Donatello in their contrast to David's smooth cloak and smoother neck and cheeks. Even at this early stage in Donatello's style, curious sculptural effects are already happening. Projections and hollows in the marble no longer correspond to projections and hollows in the represented object or person, which can be felt with the fingers or analyzed in profile, and therefore proved to exist. Donatello has a way of flattening contrasts in form and of utilizing projections and hollows to attract light and cast shadows.

This optical tendency will increase sharply in Donatello's work. His first contribution to the guilds' common program to fill the niches of Orsanmichele was a marble St. Mark (1411–13; fig. 162), patron saint of the Arte dei Linaioli e Rigattieri, or linen drapers and peddlers. A greater contrast could hardly be imagined than that between this statue and Ghiberti's roughly contemporary St. John the Baptist (see fig. 158). The "sword-blade" drapery forms of the Late Gothic have completely disappeared. The figure stands upon his cushion (cushions were among the "notions" peddled by the Rigattieri) as if it were solid, and the strikingly real drapery seems to pulsate and subside over the solid underlying torso and limbs. Donatello seems to be telling us that cloth, the product of the patron guild, really behaves in this way. Why, one wonders, had the Florentines, whose fortunes were so largely founded on the manufacture, processing, and sale of cloth, not paid more attention to its properties before, instead of being seduced by abstract formulas, whether Byzantine, Giottesque, or Late Gothic? But now, with the foundations of their economy threatened, their attention and especially Donatello's keen vision were drawn toward realities, and this may have been one of them. St. Mark's mantle, like David's, is tied about the shoulders and the swelling chest. Pouches and folds of cloth fall around the hips, without concealing their structure. The left knee comes forward through the folds. Like so many Donatello hands, the right hand clutches nervously at the hanging folds about the right leg.

It has been rightly claimed that this statue represents so abrupt a break with tradition that it is to be considered a mutation, and therefore a fundamental declaration of the new Renaissance position with respect to the visible world. Yet it has not been noticed that this new position may really be stated with very simple and practical means. Vasari tells us that a sculptor should first model his clay figure in the nude. Next he should dip sheets of cloth in what potters today call "slip" (a very

162. DONATELLO. *St. Mark.* 1411–13. Marble, height 7'10". Orsanmichele, Florence

163. Head of St. Mark, detail of fig. 162

thin paste of water and clay), hang these masses of cloth on the clay figure until the drapery falls in just the proper folds, and let them harden. He can then make the fullscale statue in marble or bronze on the basis of his draped model. In one of Donatello's later works, Judith and Holofernes (see fig. 292), we can actually see the unrepaired cast of the cloth over the forehead where the slip broke away. Vasari tells us that the officials of the guild objected to the statue in Donatello's studio, refusing to allow it to be set up in their niche. He pleaded with them to let him work on it in its final position, pretended to do so, behind a screen, and then called in the officials, who enthusiastically approved. Presumably, Donatello had precalculated the long torso and short legs to look right under perspective distortion when seen from street level.

Donatello's statue, with its new structural and optical realism, is formidable not only in the conviction of its rendering but also in the concentrated power of the face. The stasis reached in the David has been broken, but the underlying tensions are more strongly visible than ever. St. Mark seems, on the one hand, to assess the outer world and its dangers and, on the other, to summon up the inner resources of the self, which must be marshaled against them. This noble face—terribile would be the Renaissance word for it—can be thought of as a symbolic portrait of the ideal Florentine under stress, so ringingly described at that time by the humanist propagandists for the embattled Republic. It is a summation of the virtues demanded from all in an age of crisis. The eyes flare, the brow knits, the head lifts, the figure draws back in pride and a new moral grandeur. (An interesting counterproof of the connection between the Florentine political situation and the art born of crisis is that the styles of Florence's opponents, Milan and Naples, remained for some time flamboyantly Gothic.)

In the details of the *St. Mark*, Donatello's optical effects show a sharp increase (fig. 163). Curls of hair and beard are not modeled in the round as the Pisano family or even Ghiberti would have done; grooves and scratches substitute for form, sometimes filed down in order to suggest reality as it is revealed in light and shade. Donatello's interest in optical effects leads him to carry his analysis of the eye itself much further than Ghiberti had done. He abandons Ghiberti's incised cornea edge and drilled pupil, which attempt, even in the statues for Orsanmichele, to preserve the external shape of the eyeball; in Donatello's *St. Mark* the pupil is dilated, becoming a deep hole, so that for the external shape are substituted shadows intended as black-and-white equivalents for the tonal values within the transparent cornea.

The triumph of Donatello's new style is celebrated in his famous *St. George* (fig. 164), also for Orsanmichele. Like the *St. Mark*, this statue was made for a medium-sized guild, which could not afford the cost of a work in bronze. The marble original, removed from its niche at

the end of the nineteenth century to protect it from the weather and now in the Bargello, was replaced, ironically enough, by a cast in bronze. St. George was the patron saint of the Arte dei Corazzai e Spadai, the guild of armorers and sword makers, whose stock must have gone up sharply in the hectic days when Florence was threatened by Ladislaus. We cannot, alas, any longer see the St. George as Donatello intended him to look. A socket held in his right hand, still bearing traces of corroded metal, and drill holes in the back of the head indicate that the figure once sported the products of the guild he protected—a helmet and a jutting sword. These have long since disappeared. The helmet would have covered much of the young man's curly locks, and the sword must have protruded menacingly into the street. The taut lines of Donatello's figures, already so evident in the marble David (see fig. 161), are clarified here: in the shield, poised on its pointed tip; in the sharply pointed, steel-clad feet; and in the pointed shapes of the drapery. The line seems to rise boldly from the shield to embrace the entire body, and indeed this essential shape is repeated again and again throughout the larger and smaller masses of the statue, including the characteristically knotted cloak.

The face comes as a surprise (fig. 165). It is not the face of an ideal hero but of a real hero, a man who knows what fear is, not a favored individual impervious to the notion of danger. The history of human crises is studded with people who never did a brave thing until an emergency called forth a spurt of brilliant action. Donatello's St. George shows us a sensitive, reflective face, with delicate features—a pointed nose, a slightly receding chin, dilated eyes looking outward as if fearful of the approaching combat, and a brow puckered with nervous tension. Every muscle is taut. As in the St. Mark, this entire human being seems to be marshaling his resources against the danger from without. "In times of safety anyone can behave well," said Niccolò da Uzzano, one of the humanist leaders of the Florentine Republic; "it is in adversity that real courage is shown." This passage and others written and spoken by the humanists in those times of crisis reveal the same essential qualities of thought and feeling seen in the St. George and, in fact, in most of the monumental statues of the new age. Even more important, such words disclose something of the motive power behind the new style.

The most startling innovation of the *St. George* composition in Orsanmichele is the little marble relief (fig. 166) representing the young hero's conquest of the dragon that adorns the base of the niche. The marble for this relief, an especially fine piece, was ordered in 1417, a year to be regarded as one of the crucial dates in artistic history. Until this moment, all art since that of ancient Egypt conceived of the background of a relief as a level plaque, in front of which the figures seemed to be placed or from which they seemed to emerge. Even Ghiberti, although apparently wanting to penetrate the inert back-

164. DONATELLO. *St. George*. c. 1415–17. Marble, height 6'5". Bargello, Florence

166. DONATELLO. St. George and the Dragon, relief on the St. George tabernacle, Orsanmichele, Florence. 1415–17. Marble, $15\frac{3}{8} \times 47\frac{1}{4}$

ground, did so only by means of spatial implication. In traditional relief sculpture figures were either carved almost in the round, barely adhering to the background slab, or systematically (often progressively) reduced in projection in the manner of low relief. A cross section of an ancient or medieval relief (except for crude, provincial works) would show the background slab as a straight line; rising from it would be a series of more or less undercut projections corresponding to cross sections of the figures. But a cross section of Donatello's St. George and the Dragon would be illegible, a mere series of shapeless bumps and hollows. All of Donatello's experiments in the optically conceived details of his statues come to a climax in this relief. Here projections and depressions are subtly manipulated to attract light and cast shadow.

Donatello's relief sculpture no longer corresponds to the idea of the object, nor to the object as we know it, but exclusively to the image of the object that light casts upon the retina. There could be no more crucial distinction, for in it is manifest the division between medieval and modern art. The eye is now supreme. The little arcade to the right is not in precise one-point perspective, any more than is Ghiberti's roughly contemporary Flagellation drawing (see fig. 156), but comes remarkably close. The new technique is so subtle as to dissolve entirely the barrier between represented object and background. Donatello pierces the marble itself, turns it into

air, to show us distant hills, trees, and clouds (real ones, this time, not the visionary appendages seen in the Trecento and even in early Ghiberti), altered progressively in their precision of statement by the depth of the intervening veil of atmosphere. All this is done in a sketchy, remarkably unsculptural manner, employing the chisel as if it were a drawing instrument. The Italian expression for Donatello's new invention is rilievo schiacciato (flattened relief), an inaccurate term, for he does not just flatten the forms but abandons wholly the previous notion of relief in favor of optical suggestion. Unfortunately, the delicacy of his effects has become considerably blurred by the streaking of dirt and the decomposition of the surface, but what remains is amazing. The horse rears from the shock of the rider's lance plunged in the dragon's breast, the princess clasps her hands piteously, the arcade and the rocky ground carry the eye back into misty distance, and the intervening air is even stirred by breezes.

Clearly, Donatello's effects were calculated for the position of the relief on the north side of the building, exposed to a soft, diffused, unchanging light reflected from the buildings across the street. The entire relief depends on the autonomy of a single pair of eyes at a single point in space. Implicit in this fact is a new concept of the individual, wholly alien to the medieval notion of corporate society within which the person is a single component, but already prophetic of the powerful individuals

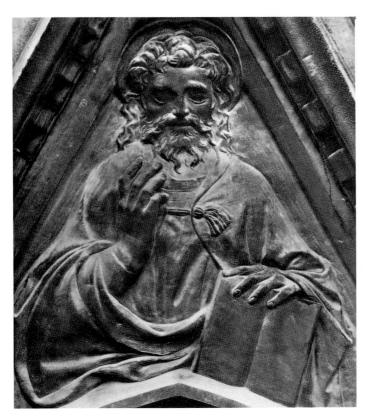

167. DONATELLO. *God the Father*, gable on the St. George tabernacle, Orsanmichele, Florence. 1415–17. Marble, height 27"

who were to create the new world of the Renaissance—and later, alas, to destroy it by failing to create a society in which such individuals could collaborate. It is by no means coincidental that the new idea should first appear in a relief of the victory of St. George over the dragon, which reenacts symbolically the triumph of Florence against Ladislaus. There were imperfections in Florentine democracy, but the declarations of her humanists and, from the other side, the denunciations of liberty by apologists for the dictatorships leave no doubt that to contemporaries the freedom of the individual was at stake. This concept of freedom is the wellspring of the new style.

In Northern Europe a similar development was taking place in the art of the Netherlandish miniaturists and panel painters; their delightful enthusiasm for the visible world, and every tiniest object and living being that it contained, resulted in a technique whose accuracy always eluded the Italians. But the illustrations of the *Turin-Milan Hours*, the earliest works by Jan van Eyck that show a stage comparable to the new point of view revealed in Donatello's little relief, are datable probably in the 1420s. Paradoxically, Donatello's sculptural relief is the most advanced *pictorial* composition of its time.

Lorenzo Monaco and his Late Gothic contemporaries give no hint that they knew what Donatello was about. In the gable above (fig. 167), as in two other niches at Orsanmichele, appears the benign figure of God the Father, here blessing and protecting the patron saint in his battle and, by extension, the guilds, the Republic, and freedom itself. The Lord is also depicted in *rilievo schiacciato*, so delicately that his head appears to be leaning down, foreshortened, as he lifts his right hand in benediction.

NANNI DI BANCO

A contemporary of Ghiberti and Donatello in the program at Orsanmichele, and scarcely less gifted than they. was a short-lived sculptor, Nanni di Banco (1385?-1421). Brought up by his sculptor father in the Cathedral workshop, Nanni was responsible for several important sculptures intended for the Cathedral and for the statues in three niches at Orsanmichele. The most striking of these is certainly the Four Crowned Martyrs (fig. 168), undocumented but generally dated about 1413. These martyrs were, according to legend, Christian sculptors in ancient Rome who preferred death to the betrayal of their religion by carving a statue of the god Aesculapius as commanded by the emperor Diocletian. Nanni has assembled them here in an outsized and very Gothic niche. But the sculptors themselves, enveloped in huge folds of togalike cloaks, could hardly look more Roman. Their grand bearing is clearly imitated from Roman statues that Nanni had seen and studied. Their heads, strikingly reminiscent of Roman portraiture, have also the vitality of contemporary Florentines, so much so that some scholars have professed to see in two of them portraits of Nanni himself and his sculptor brother Antonio. The propagandists for the Milanese and Neapolitan autocrats had recourse to examples drawn from Imperial Rome; the apologists for the Florentine Republic cited in rebuttal the virtues of Republican Rome and the Roman people, whose true heirs they felt themselves to be. And it is, of course, Republican popular models that these statues call to mind. Even the volgare ("vulgar," i.e., Italian or, more narrowly, Tuscan) speech was defended by the humanists as the true successor to Latin.

There is something conspiratorial about this confrontation of four men united in a common resolve to die for their principles. Their niche, of course, was the property of the Arte di Pietra e Legname (the guild of workers in stone and wood), in which Nanni had been inscribed since 1405. In this manner of depicting their patron saints, the officials of the guild must have wanted Nanni to apotheosize the guild, as Donatello was shortly to do for the armorers in the *St. George*. The four standing figures grouped in a semicircle are an unprecedented composition in Italian sculpture. They were to exercise a profound effect on the humanistic art of the Quattrocento, especially on the painters Masaccio and Andrea

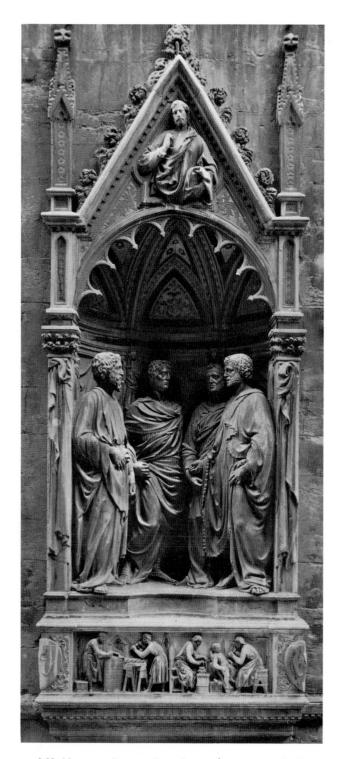

168. NANNI DI BANCO. Four Crowned Martyrs. c. 1413. Marble, life-sized. Orsanmichele, Florence

del Castagno. The four gaze outward or downward, not at each other, as if each were inwardly assessing-and accepting—the full consequences of the terrible resolution. The movements of the drapery folds seem in some cases to sweep the four together, in others to hold them hesitantly apart. But the figures are united by two simple devices. First, the pedestal is carved in an arc that roughly follows the pattern of the feet. Second, the entire niche is draped in broad folds acting as a countermovement to those of the martyrs. Details of features, hair, and beards either long or stubbly (the decision not to shave was, in certain periods of Roman history, a penitential resolve) contain, in addition to their Latinism, many survivals of the Gothic, natural enough in a sculptor educated in a fairly conservative tradition. Nanni, despite his enormous technical ability, is and remains out of touch with the optical interests of Donatello. His drapery masses and details, locks of hair and beard, stubble, wrinkles, and veins are precisely modeled in the long tradition of sculptural sculpture, never flattened or sketched in the illusionistic method of Donatello. Nanni's is, however, a robust and forthright style, and his art has an inner power associated with the rough dignity of his physical types. In the gable above, leaning out of a quatrefoil as from a window, he shows us God the Father, fully modeled and without a halo; in the relief below, four stoneworkers, not in togas, build a wall, carve a column, measure a capital, and finish a statue of a nude putto (winged child).

It is, of course, idle to speculate on what might have been the achievements of an artist who died young. But the single-minded force of Nanni's art makes us wonder whether the course of the Quattrocento might not have been different if he had lived to midcentury. The culminating work of Nanni's brief career is his relief the Assumption of the Virgin (fig. 169), which fills the gable of the Porta della Mandorla, the north lateral doorway of the Cathedral of Florence that draws its name from the mandorla (almond-shaped glory) in which the Virgin ascends to Heaven. The work, commissioned in 1414, was said to have been incomplete at Nanni's death in 1421, but this statement may refer only to the setting up of the ensemble. As compared to the gravity of Nanni's work at Orsanmichele, his Assumption is strangely turbulent. Four sturdy, adolescent angels lift the strongly molded mandorla, and from within it the Virgin, supported by seraphim, hands down her golden belt to the kneeling St. Thomas. The belt, doubtless made of gilded bronze, has vanished but the iron hooks that held it in place can be seen between the thumb and forefinger of each of Mary's hands. The usual witnesses of the miracle are absent, so that the scene acquires the character of a private revelation to St. Thomas, the most famous of doubters. Since the only other being who is present, except for the angels (three more, making music, fill the point of the gable), is a bear cub trying unsuccessfully to shake acorns from an oak tree, that little creature must have some symbolic significance. Perhaps Nanni intended to contrast the impossibility of gaining bounty through force, exemplified by the animal's greed and rage, with the golden gift received by St. Thomas through divine grace.

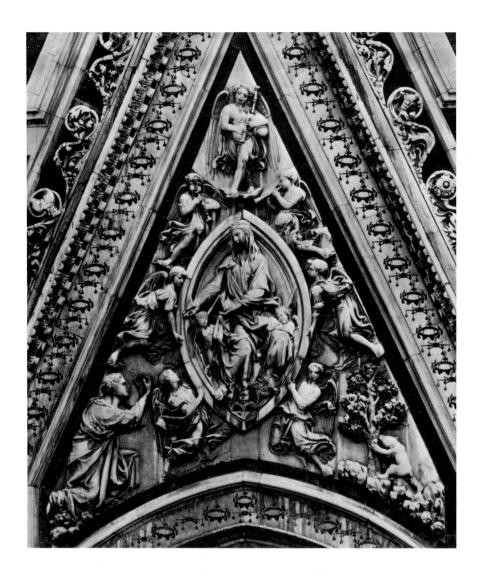

169. NANNI DI BANCO. Assumption of the Virgin, gable on the Porta della Mandorla, Cathedral, Florence. 1414-21. Marble

The storm of flying folds, which have palpable weight and thickness and seem to beat against the marble background more effectively than do the angels' tiny wings, might almost be characterized as proto-Baroque. These tumbled masses of real cloth are agitated by the upward movement of Mary's little spaceship, or they envelop figures of an insistent corporeality. And the faces of these figures are full of the individuality, inner awareness, energy, and beauty that are recognized as hallmarks of Renaissance style. Nanni's faces and drapery were imitated repeatedly by Renaissance masters, from Luca della Robbia to Botticelli. Nanni was in the forefront of the Florentine Renaissance, in full control of its naturalistic and classical resources save for the optical principles, which he must have known but seems to have resisted. So indeed did Michelangelo some eighty years later, when he rejected the entire optical tradition as antithetical to the principles of sculpture in stone. Perhaps Nanni, imbued from childhood with the sight and sound of stonecarving, held a similar belief. The ornamental portions of the Porta della Mandorla, like the Cathedral of which it is

part, had been the collaborative product of the Florentine committee system. In a manner not unlike the crowning of the Cathedral by Brunelleschi's inspired dome, the sculptural problem of the Porta della Mandorla was solved by individual fiat.

DONATELLO c. 1417 TO c. 1435

Donatello was involved repeatedly in work for the Cathedral of Florence, even contributing two small heads to the Porta della Mandorla after Nanni's death. Throughout the twenty years from 1415 to 1435 the great master and his most gifted pupil carved and set in place in the niches of the Campanile (see fig. 77) a series of seven marble prophets in the round, which completes the march of the statues. These statues were found to have suffered so badly from the elements that they have been transferred to the Museo dell'Opera del Duomo. But the statues as they are exhibited today have lost an essential element of their former effect: the tension between a statue and its niche, evident in works of this type by the three great masters of Early Renaissance sculpright: 170. DONATELLO. Zuccone, seen here on the Campanile, Florence (now in Museo dell'Opera del Duomo, Florence). 1423–25. Marble, height 6'5"

below: 171. Head of Zuccone, detail of fig. 170

far right: 172. DONATELLO. Jeremiah (formerly on the Campanile, Florence). 1427–35. Marble, height 6'3". Museo dell'Opera del Duomo, Florence

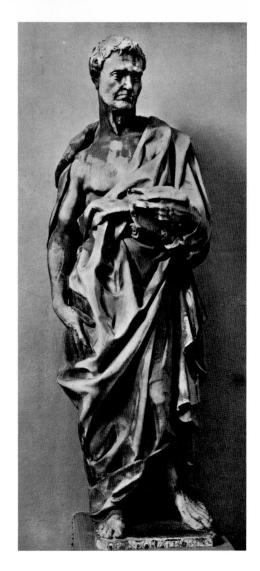

ture—Donatello, Ghiberti, and Jacopo della Quercia until Michelangelo makes his statues burst from their niches. At Orsanmichele the statues could address the man in the street from not far from eye level. But the Campanile niches are about thirty feet above the ground, and Donatello, relatively conservative in his treatment of the earlier statues in the cycle, began to realize that he would have to adopt more drastic methods. The most impressive of the group are certainly the so-called Zuccone ("Big Squash," i.e., "Baldy") and the Jeremiah. No one knows their true identity; probably the Zuccone represents Jeremiah and the Jeremiah Habakkuk. But the psychological tension in these figures surpasses in intensity anything that Donatello had as yet created. In Gothic cathedrals and throughout Italian Trecento art, Old Testament prophets and New Testament saints (with the obvious exception of St. John the Baptist) are gentlemanly characters with flowing robes and well-combed hair and beard, ready for appearance at the heavenly court. Not so these emaciated creatures, throbbing with the import of their messages. In every line of their stance and in their unforgettable expressions, they show the fiery intensity of the Prophetic Books. They are deliberately ugly, and in their ugliness Donatello's conviction has found a strange beauty. The Zuccone (fig. 170), 1423–25, draws his chin in, gazes bitterly down on the streets and palaces of Israel, opens his mouth in condemnation of its iniquities, and proclaims a rule of righteousness and peace. The figure, drawing itself together, is skin and bone under the rough heaps of cloth that do duty for a cloak. The hand clutches convulsively at the strap and the rolled top of the scroll. The bald head is carved with brutal strokes, left roughly finished (fig. 171). A few marks suffice to show the stubble on the chin, the flare of the lips, and the eyebrows. Donatello now uses his optical knowledge to calculate the effect of the statue on an observer thirty feet below. This achievement was greatly admired in the Renaissance, even more than the finish, lost at a distance, of works by such sculptors as Luca della Robbia.

The figure generally identified as *Jeremiah* (fig. 172), 1427–35, is equally terrifying. One wonders where Donatello could have found his models for these statues, which suggest the intensity of Théodore Géricault's nineteenth-century portraits of the insane. Denunciatory types still roam the streets of Florence, and we may presume that in Donatello's day there were more of them, who had more to say. Certain features in Donatello's heads suggest the realism found in Roman portrait busts, but they go far beyond it, always transfigured by Donatello's immense imaginative powers. In the pulsating structure of these folds, in the disordered locks, the tense poses, and the searing glances, the Christian con-

flict between the Virtues and Vices, so often represented symbolically in Gothic sculpture and painting (such as in Giotto's grisaille frescoes at Padua; see figs. 69–71), becomes a modern equivalent for the name this conflict had borne since Early Christian times—the Psychomachia, or Warfare in the Soul.

Donatello's optical principles as well as the vitality of his dramatic style reach a climax in the first of his numerous narrative reliefs, the Feast of Herod (fig. 173) for the baptismal font of the Cathedral of Siena, a massive project in which the great master was involved with three other sculptors, including Ghiberti and the Sienese pioneer Jacopo della Quercia. Donatello's contribution, executed between 1423 and 1427 but most probably about 1425, is certainly closer to a consistent statement of one-point perspective than any earlier work in Western art. The invention of perspective was credited to Brunelleschi by his anonymous biographer and by Vasari, although the question remains one of the most vexing and intricate in the entire history of ideas. The biographer describes in detail a painting by Brunelleschi of the Baptistery of Florence and the surrounding buildings, as seen from just inside the open door of the Cathedral. The sky was in burnished silver, to reflect the real sky and passing clouds and thus complete the sense of reality. The observer was to contemplate the panel by looking, through a peephole in the back, at a mirror held an exact cubit in front of the painted surface. He was

173. DONATELLO. Feast of Herod, panel on the baptismal font, Cathedral, Siena. c. 1425. Gilded bronze, 23½" square

assumed to be standing about three cubits inside the Cathedral door and sixty cubits from the front of the Baptistery. Measurements taken of all the buildings, reduced in this 1:60 proportion and set forth on a plan, would then be projected onto the panel. Brunelleschi's resultant graph of space was derived from architectural methods and related to his system of proportions. The observer's actual position in space was a prime determinant, and the method seems to have been used in the early Quattrocento, in a somewhat reduced form, by a few adventurous souls, notably, as we shall see, the painter Masaccio.

But instead of employing this method, Donatello has projected into the relief surface an entirely imaginary architecture bearing no relation to the surrounding reality or to the precise position of the observer. He has constructed his architecture by using the device that Alberti was later to describe as the visual pyramid in the systematic formulation published in his Della pittura. Donatello's relief, in those of its major elements that can be checked—floor lines, moldings, and the recession of capitals and lintels—does indeed appear to be a cross section of just such a visual pyramid, culminating in a single vanishing point. Only the parapet at the left, behind Herod, refuses to conform.

Donatello, always an enemy of regularity, has characteristically introduced so many different levels and so many architectural features that do not correspond from one side to the other that it is impossible to trace all the recessions accurately. He has also defined two curious triangular recesses in the parapet; these not only recede at angles counter to that of the visual pyramid, but also are not coordinate with one another. But one device is truly extraordinary: he has interrelated the square slabs of the inlaid floor diagonally, so that the extended diagonal of one becomes the diagonal of the next square up in the next row, and so on. As a result, he imposes on the basic system of orthogonals, which meet at a vanishing point within the frame, a secondary system of diagonals that meet at another vanishing point outside the frame. This produces an external control for establishing a systematic diminution of the distance between the transversals in depth. We will see later, when analyzing Alberti's perspective (see page 230), the significance of this secondary system, but it is certainly a key point of Alberti's theory and enables him to substitute an orderly method of diminution for the haphazard tricks used in the Trecento. Donatello, if our analysis is correct, seems to have hit on this method ten years or so before Alberti published its formulation.

Nothing in Donatello's architectural perspective, with its views through three successive levels separated by arches and piers, prepares us for the happenings in the foreground space. There the scheme is disrupted by the event—the presentation of St. John's severed head on a platter to Herod. The moment Donatello has chosen is the explosion of an emotional grenade, producing a wave of shock reactions among the spectators. Herod shrinks back; a guest expostulates; another recoils, covering his face with his hand; two children scramble away, yet stop short against the frame, still looking. The shock has not yet reached the figures at the right. Salome dances and attendants look on, one with his arm about another's shoulder. The perspective network of interlocking grids, with all their magical delicacy of statement, is half submerged in the rush of tiny, conflicting drapery folds. Donatello's tragic scene was to influence the greatest Italian artists, including Leonardo da Vinci, whose Last Supper (see colorplate 67) adopts and refines the dramatic principle on which this history-making relief was based.

JACOPO DELLA QUERCIA

A fourth decisive sculptor of the Early Renaissance, who should be ranked close to Donatello and Ghiberti, was a Sienese—Jacopo della Quercia (1374?-1438). If Vasari's accounts of Jacopo's early life are at all accurate, he must already have enjoyed a considerable career as a sculptor before taking part in the competition for the doors of the Florentine Baptistery in 1401. Little is preserved that can be attributed with certainty to Jacopo's early period. While the most serious loss is the panel he entered in the competition, one would also like to know how his equestrian tomb monument in Siena looked. It was made, alas, of wood, oakum, and tow. From the few surviving records we glean a picture of Jacopo as an impetuous and unreliable man—a picture not at variance with the temperament shown in his work.

The major sculptural cycle dating from Jacopo's middle period is the Fonte Gaia in Siena (fig. 174); it was a fountain in the Piazza del Campo, or public square, in front of the Palazzo Pubblico and was called "gay" on account of the celebrations that attended the opening of the first reliable public water supply brought to the center of this hilly city. Although the fountain was commissioned in 1409, Jacopo did not start work until 1414, nor finish it until late in 1419.

The fountain consisted of a central rectangular basin into which water poured from many spigots fixed in the base of a surrounding parapet that was sculptured in high relief. The central niche contained the seated Virgin and Child, since the Virgin was the patron saint of Siena. In eight niches, four on either side of the Virgin, sat eight Virtues. The niches at either end contained, respectively, the Creation of Adam and the Expulsion from Eden, to indicate the curse of Original Sin from which Mary and Christ had redeemed mankind—liberated by Baptism, the sacrament of water. On the terminals of the flanks stood statues of the foster mother and the real mother of Romulus and Remus, for Remus was considered to be the father of Senus, founder of the city of Siena. By the nineteenth century the fountain had fallen into such

174. JACOPO DELLA QUERCIA. Fonte Gaia (before dismantling), Piazza del Campo, Siena. 1414-19

175. JACOPO DELLA QUERCIA. Wisdom, from the Fonte Gaia. 1414–19. Marble, slightly less than life-sized. Palazzo Pubblico, Siena

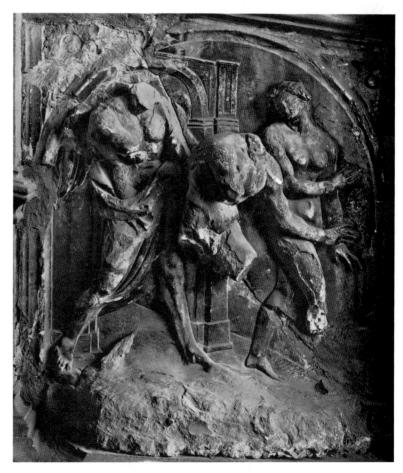

176. JACOPO DELLA QUERCIA. *Expulsion*, relief from the Fonte Gaia. 1414–19. Marble. Palazzo Pubblico, Siena

177. JACOPO DELLA QUERCIA. Main Portal, S. Petronio, Bologna. 1425-38

ruin that it had to be dismantled and replaced by a copy. The fragments of the original are now in an upper loggia of the Palazzo Pubblico. From the beautiful Wisdom (fig. 175), the best preserved of the group, we can see that Jacopo was well aware of the gathering energy of the Renaissance movement in Florence. Within their low, rather squat niches, the masses of all the figures exert great power. The bodies refuse to sit quietly, in the Gothic fashion. They twist and turn in powerful angles counter to the embracing arches. The drapery, surging in independent motion over the limbs, overflows the niches. Where the heads are preserved, they show more than a trace of the lingering Ducciesque facial type, blended with a classicism that recalls the preferences of Nanni di Banco (see fig. 168). The badly battered Expulsion (fig. 176) remains a work of immense power despite its condition. Adam and Eve, their muscular bodies strongly projected, are expelled from the gate of Eden by an athletic angel whose touch they are powerless to resist. The spiritual conflict evident in Donatello's art is translated by Jacopo into terms of physical action. It is not hard to see why this heroic style appealed to the

youthful—even the mature—Michelangelo, who must have studied Jacopo's works with care and adopted his ideas repeatedly.

In many respects the art of Jacopo della Quercia is a curious phenomenon. He had little interest in the architectural achievements of the Florentine Renaissance and paid no attention to its spatial harmonies, and his rare landscape elements remained Giottesque to the end of his days. Yet in his reliefs for the portal of San Petronio at Bologna (1425–38; fig. 177) he raised the representation of the human body to a level of dignity, beauty, and power achieved by no other master before Michelangelo. Even in the reliefs, however, he worked intuitively, without the subtle exploration of anatomical elements so impressive in the art of Ghiberti and Donatello. He projected a world of action in which figures of superhuman strength turn, struggle, collide. Despite Jacopo's characteristic distortions (heads, hands, and feet are always too large) and frequently crude execution, his reliefs at San Petronio are irresistible. Fortunately, the projections are not high, so the panels have survived in better condition than the fragments of the Fonte Gaia.

In the Creation of Adam (fig. 178) a solemn, longbearded Creator, provided with a triangular nimbus to indicate all three persons of the Trinity, stands on earth: with his left hand he gathers about him his enormous mantle, whose sweeping folds contain all the power of Donatello's and Nanni's drapery and none of their feeling for real cloth, while with his right he confers on Adam a living soul. The figure of Adam, whose name in Hebrew means "earth," is read together with the ground from which he is about to rise. In contradistinction to Ghiberti's delicately constructed nudes (see fig. 237), this is a figure of immense athletic power, broadly built and smoothly modeled. Jacopo may have patterned the pose and treatment of the figure after the Adam in a still strongly classical Byzantine ivory relief, now in the Bargello in Florence and possibly available to Jacopo. It is common knowledge that Jacopo's noble figure, in turn, exercised a strong influence on the pose used by Michelangelo in the Creation of Adam on the Sistine Ceiling (see fig. 522). Of the Garden itself, only the ominous Tree of Knowledge is visible, represented as a fig tree.

The evil effects of this tree are eloquently represented in the Temptation (fig. 179), which generally static scene Jacopo has turned into a throbbing drama. The Serpent, to demonstrate his supernatural qualities, slides through the tree trunk and emerges on the other side. With one hand, a sinuous and sensuous Eve repulses the Serpent's advance while with the other she nonetheless accepts the fruit. Eve's body, surely the most voluptuous female nude since classical antiquity, must have been influenced by an ancient statue of Venus. Apparently the earliest of a long line of such nudes in Renaissance art, she is the ancestress of Venuses by Botticelli and Titian. But with a gesture of fury Adam turns away from Eve, expostulating with his head turned back toward his right shoulder, his eyes glaring, and his left hand indicating the new need for the fig leaves.

Most intense of all is the Expulsion (fig. 180), its composition roughly the same as that of the relief on the Fonte Gaia. At San Petronio, however, the figures are well enough preserved to exhibit the full interplay of muscular forces. Adam attempts to resist, but the angel's left hand is enough to stop his right arm, and the angel's fingertips control the herculean bulk of Adam's body. Eve now hides her nakedness in the pose of a Venus pudica (modest Venus), a type favored by Greek sculptors and their Roman copyists, Jacopo's response to Masaccio's vision of the same composition (see fig. 197 and page 191). Although occasionally there are superficial resemblances between Jacopo and Nanni, especially in facial types, the barren action-world inhabited by Jacopo's titanic figures was, at least in the Quattrocento, accessible only to his own tormented imagination.

right: 178. JACOPO DELLA QUERCIA. Creation of Adam, panel on Main Portal, S. Petronio, Bologna. 1425-38. Marble, $33\frac{1}{2} \times 27\frac{1}{4}$ "

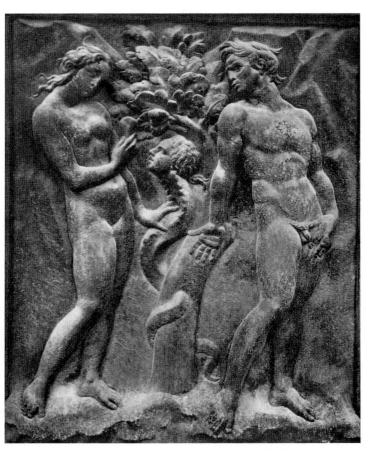

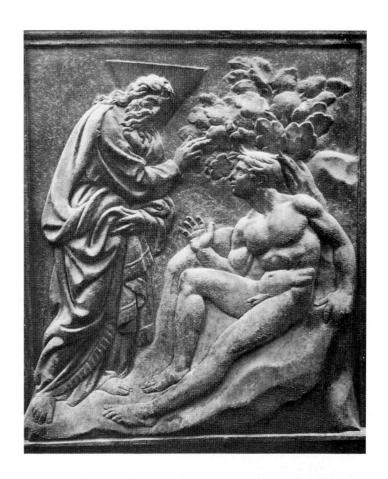

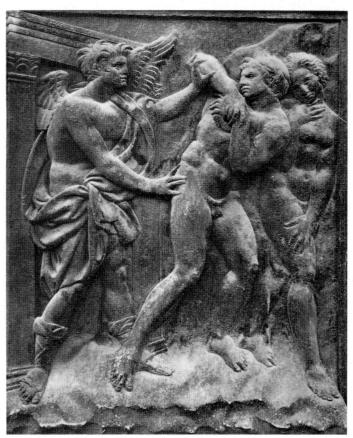

Gothic and Renaissance in Florentine Painting

uring the first and second decades of the Quattrocento, the sculptors carried the banner for the new Renaissance style in the figurative arts in Florence. The painters were occupied in the execution of countless altarpieces for Florentine churches and chapels, and an occasional fresco cycle, all in variants of the Gothic style. Not that their works were without quality. Lorenzo Monaco was a very gifted artist, and many of his minor contemporaries were also sensitive to the formal and coloristic possibilities of the style. But compared to the four pioneer sculptors, the painters seem standardized. They were not concerned with the human and stylistic problems that inspired the sculptors, and their productions appear to belong to another era. In their midst there emerged, about 1420 or 1421, a non-Tuscan master of extraordinary vivacity and originality, who, judging from the importance of his commissions, must have created a sensation.

GENTILE DA FABRIANO

Gentile da Fabriano (d. 1427) has suffered from two contradictory misconceptions at the hands of art historians. First, it was generally considered that he was born long before the earliest probable date, and his undated works were therefore placed far too early; second, he was thought to have been a conservative master. Our earliest documentary reference concerning Gentile shows him to have been living in Venice in 1408, far from his native town of Fabriano in the Marches on the east coast of Italy. His activities are then recorded in some detail up to the first dated work that has reached us, the Strozzi altarpiece, which was finished in the month of May, 1423 (see colorplate 22). Gentile's birth date is usually set about 1370; two important works, both painted for churches in Fabriano and both earlier than the Strozzi altarpiece, are thus dated before 1400, at which time their style would have been more than revolutionary. In other instances (e.g., Fra Angelico and Castagno) when an Italian artist's supposed early period lacks any dates,

his birth date when discovered has turned out to be comparatively late and the "early period" vanishes. This may be the case with Gentile, once a conclusive document comes to light. He could have astonished the Venetians with his splendid new style when he was in his early twenties, and thus been born about 1385. In the Sala del Gran Consiglio (Hall of the Great Council) of the Doges' Palace in Venice, Gentile was called upon to paint a fresco (now lost) of a naval battle between the Venetians and Emperor Otto III, in the midst of which a great storm had arisen. Gentile's depiction of the battle, the storm clouds, and the waves was said to be so realistic that it filled observers with terror.

From 1414 to 1419 Gentile was in Brescia, painting a chapel at the command of Pandolfo Malatesta; the work is also now lost. He met there Pope Martin V, who, in 1417, has been elected at the Council of Constance to end the Great Schism, which, together with the earlier "Babylonian Captivity" of the papacy in Avignon, had long divided the Church. Gentile was to follow the pope to Rome, but he did not arrive there until 1426 and commenced a now-lost series of frescoes in San Giovanni in Laterano, interrupted by his death, a consequence perhaps of the malaria that felled many other visitors to the Eternal City.

The Valle Romita altarpiece was painted for a convent in Fabriano, and is generally dated in 1400 or even earlier. To this author it appears impossible to date the painting nearly a quarter century before the Strozzi altarpiece, of which it seems to be an immediate antecedent. Moreover, the altarpiece contains numerous traces of Gentile's stay in Venice and close study of Venetian Trecento painting (see pages 136–38). More probably the work was done in Fabriano in 1420, when Gentile declared his intention to live and die in his native city. The central panel represents the *Coronation of the Virgin* (fig. 181), which Gentile saw in terms far more naturalistic and less schematic than did Lorenzo Monaco (see colorplate 19). Christ and Mary need no throne. They sit suspended in

the light of the gold background with its incised rays, the dove of the Holy Spirit floats between them, and God the Father above, surrounded by seraphim, extends his arms. From this empyrean height we look down on the top of the dome of heaven, presented as if it were an architectural model bisected to show the interior, studded with stars and hung with sun and moon. The outer surface of the dome is paved with small gold and marble tiles, on which kneel eight music-making angels.

The soft, full faces, the heavy-lidded eyes, the languorous expressions, the gentle flow of silky drapery folds all foretell what we are to find in the Strozzi altarpiece. And the rich coloring, as well as many details of drawing, suggests close knowledge of Venetian painting. Mary's blond hair may be seen under her veil, Christ's reddish brown locks stream over his neck. Mary's gold-bordered azure mantle opens to reveal a lining of muted crimson lighted with tiny strokes of gold, while the mantles of God the Father and of God the Son are a splendid vermilion, modeled in a darker admixture of the same hue. A brighter blue, starred with gold, lines Christ's mantle, and this is played against the flat, almost jarring vermilion of the seraphim surrounding the Father. The gold background is tooled in conventionalized flames issuing from the circle of coin dots around the sacred pair, and incised rays surround the entire group. The effect of the scene is that of some natural celestial apparition, like the Aurora Borealis. Although the exuberant draperies of the four standing saints in the lateral panels are closely related to the International Style, their surface has a softness that is Gentile's own, as is the naturalism of the deep, springy carpet of flowers on which the saints tread. The rocky backgrounds of two of the four little scenes (fig. 182) hardly differ from their Trecento forebears, but the architectural elements in the other two (fig. 183) are new and full of Venetian Gothic windows

above: 181. GENTILE DA FABRIANO. Coronation of the Virgin, from the Valle Romita polyptych. c. 1420. Panel, 701/8 × 311/8". Brera Gallery, Milan

left: 182, 183. GENTILE DA FABRIANO. St. John the Baptist in the Desert (left) and Assassination of St. Peter Martyr (right), panels from the Valle Romita polyptych. c. 1420. Each 23½ × 15¾". Brera Gallery, Milan

and chimneys that were not to be found in Gentile's rather bleak hometown of Fabriano. In all probability the polyptych was done shortly before Gentile left Fabriano for Florence (whence the pope in his peregrinations had already moved), sometime during 1421.

Palla Strozzi was the richest man in Florence. He commissioned Gentile to paint his masterpiece, the Adoration of the Magi (colorplate 22), completed 1423, for the sacristy of the Church of Santa Trinita. The subject was unusual for a Florentine altarpiece and the splendor of its treatment unprecedented: both were justified by the destined location of the panel, for in the Adoration of the Magi the infant body of Christ was first shown to the Gentiles. The theme and the gorgeous garments were thus appropriate to a sacristy where the clergy vested themselves to carry the Host (the Corpus Christi) to the altar. The shape of the frame recalls the earlier Strozzi altarpiece for Santa Maria Novella by Andrea Orcagna (see colorplate 17), but the forms are now swept together by a vitality so exuberant that it is difficult to follow the linear rhythms, as one more easily does in Lorenzo Monaco's clear-cut shapes. Lorenzo's polyphony is, as it were, replaced by a burst from a full orchestra. The complex forms of the left and right gables embrace tiny roundels in which the Annunciation is reenacted, while in the central gable a very youthful Lord blesses the scene. Prophets that recall those by Giovanni Pisano in the Pistoia pulpit (see fig. 44) recline in the spandrels. In the predella the Nativity, the Flight into Egypt, and the Presentation in the Temple appear almost as one continuous strip. The order of the latter two is reversed (the Presentation is celebrated forty days after the Nativity, whereas the Holy Family spent seven years in Egypt, according to the Golden Legend). The new life that proliferates throughout the ornamentation comes to a delightful and unexpected climax in the painted flowers and fruits that burst from windows in the lateral piers of the frame to curl even over the gold itself.

In the left arch the three Magi gaze at the star from the top of a mountain. Before them stretches a wavy sea, at whose shore ships await them. In the center arch the kings ride in glittering cavalcade up a curving road toward the open gate of Jerusalem on a hill. In the right arch they are about to enter the walled town of Bethlehem. In the foreground they arrive at their destination the cave of Bethlehem, with ox, ass, and manger, the ruined shed, and the little family. Dressed in their most splendid garments, the kings have now dismounted. The oldest Magus prostrates himself before the Christ Child on Mary's knees, his crown beside him on the ground; the second kneels and lifts his crown from his head; the third and youngest stands waiting his turn, still wearing his crown. Attendants crowd the stage: some restrain horses (the animals shown, as becomes customary in Italian art, from the front and from the back), others toy with monkeys and hunting leopards, or release fal-

184. GENTILE DA FABRIANO. Attendants, detail of Adoration of the Magi (see colorplate 22). Finished 1423. Panel. Uffizi Gallery, Florence

cons to attack game birds. The panoramic views and the rendering of farms, distant houses, and vineyards lend color to the belief that Gentile had visited Siena, and seen the Good Government series by Ambrogio Lorenzetti (see figs. 108, 109). Even more deeply, however, he was influenced by the art of North Italy, both the wild landscape backgrounds and the wonderful animals of the ouvraige lombarde (see pages 140, 378). If Gentile really is an exponent of the International Gothic, it is certainly a phase that is remote from the Late Gothic painters in Florence. Gentile is uninterested in profiles. Edges are softly brushed and fade gently into the movement of surface. Line, throughout Gentile's work, is felt only as a directional flow within the tissue of matter and space, whether the flow of the processions in the background, or the flow of a horse's proud body, or the flow of silks, velvets, and brocades. Every bird and animal, every detail of the fabrics, is represented with scrupulous delicacy, and also with a new psychological realism. Irreverent attendants exchange glances and jokes as their royal masters are caught up in the miracle, or look upward in suspense at the behavior of the birds (fig. 184). The two midwives, like guests at a bridal shower, examine a golden jar—one of the royal gifts—as if to assess its value. The ox looks patiently down toward the Child; over the rim of a king's halo the ass stares with enormous eyes, his ears lifted to catch and interpret the unaccustomed sounds; the chained monkeys chatter happily together. In the background dogs chase hares, horses prance and rear, one horse kicks another (who complains), two soldiers waylay and mug a wayfarer. Never before in Italian art had such an attempt been made to re-create in painting the whole fabric of the visible world. Nor is the rendering merely encyclopedic. Gentile is satisfied only with surfaces of real vibrancy, achieved by coloristic means. As compared to the brilliance of Lorenzo Monaco, Gentile's color is subdued

185. GENTILE DA FABRIANO. *Nativity*, on the predella of the Strozzi altarpiece (see colorplate 22). Finished 1423. Panel, 121/4 × 291/2".

Uffizi Gallery, Florence

and rich, full of subtle hints and reflections. Here and there are signs that Gentile had studied Florentine sculpture and that he knew what his younger contemporary Masaccio must already have been up to: for example, the beautifully rounded head on the third king's right, or the sharply foreshortened figure who relieves this glittering youth of his golden spurs. Nonetheless, with all this display of visual richness and this naturalism, basic archaisms remain. Gentile is unaware of the new perspective ideas: his double scale for figures and setting is still Trecentesque; gold leaf over molded gesso is used for all the gold damasks and gilded ornaments in order to raise the gold farther from the surface; and the landscape distances carry us to the horizon, only to end in a gold background.

In the three magical predella scenes, however, Gentile abandons, for the first time as far as we know in Italian painting, the abstract background in favor of the real sky with all its atmospheric and luminary effects. Like the *Nativity* by Lorenzo Monaco (see fig. 125), Gentile's

(fig. 185) is also founded on the vision of St. Bridget, but now all of the light effects are real rather than conventional. Although the pool of light in which the Child lies is still a surface of gold leaf with incised rays, a believable light shines upward from the Child upon the ceiling of the cave and the faces of the kneeling ox and ass; it illuminates the Virgin and casts her shadow on portions of the shed not lighted from below; it casts the shadow of the shed itself upon the underside of the leanto where the midwives have taken shelter—one curious, the other napping; it even picks out the branches of the leafless tree under which Joseph sleeps, making a tracery of light against the dark hills. While one portion of the hills is illuminated by a flood of gold from the angel who descends to bring the glad tidings to the shepherds, the remainder billows softly against the night sky freely dotted with shining stars. The exquisite nature poetry of this little scene is, to be sure, still partly Trecentesque. The illumination of the scene is provided, and the shadows are cast, by miraculous rather than natural light.

186. GENTILE DA FABRIANO. Flight into Egypt, on the predella of the Strozzi altarpiece (see colorplate 22). Finished 1423. Panel, 121/4 × 431/4". Uffizi Gallery, Florence

Yet this is the first painting we know that not only contains the source of illumination within the picture, but also consistently maintains its effect on all represented objects. The supernatural is treated as if it were natural, so natural, in fact, that the painting is hardly conceivable without the supposition that Gentile made a model of his stage set and figures, and put a candle inside it. The little ruined structure is, of course, the same one he painted in the principal panel above. (The only difference is that between December 25, in the predella, and January 6, in the main panel, the barren ground has brought forth flowering or fruit-laden trees.) Apart from the religious meaning of the scene, the effect is naturalistic, convincing, and deeply poetic—especially the dark and distant hills and the starry sky.

Equally convincing is the Flight into Egypt (fig. 186). The little family, still attended by the two midwives, moves along a pebbly road that curves first toward us and then away again, through a rich Florentine landscape toward a distant city. More orange trees have appeared along the route, whose farms and hillsides are lighted, in gold leaf, by a huge sun, raised in gesso and also gilded. The distant hills and towers rise against a soft, blue sky, the first real sky we know in Italian art, darker toward the zenith, lighter toward the horizon. One fortified villa is partly hidden by drifting clouds. So velvety is the landscape, so natural the light on rocks, pebbles, foliage, and people, and so free the brushwork that we easily accept the scene as a natural account, in spite of the persisting medieval double scale. Gentile's stay in Florence was short, but his influence there was incalculable. To him belongs, as far as can be determined, the credit for being the first Italian painter to carry out the atmospheric discoveries Donatello made and those realized in the North in the miniatures of the Limbourg brothers. He is also, as far as we now know, the first Italian painter to depict shadows cast consistently by light from an identifiable source, and the originator of an almost endless series of night scenes, a rarity in the Quattrocento but later a commonplace. Well had Gentile put into practice Ghiberti's simple maxim-"Nothing can be seen without light."

MASOLINO AND MASACCIO

No artists in Florence in the early 1420s understood more clearly Gentile's innovations than two painters who were strange opposites, mysteriously conjoined by their collaboration in several works as well as by their sharing of the name Tommaso (Thomas). One, however, was known as Masolino ("Little Tom"), the other as Masaccio (untranslatable, but certainly no compliment, since the suffix "accio" in Italian usually means "ugly"). Perhaps these nicknames were coined to distinguish the two painters according to their appearance and character. Certainly their sobriquets are useful to us in separating their sharply different styles. Masolino, little concerned with the problems and ideals that troubled and inspired the great sculptors of the time, creates an artificial world of refined shapes and elegant manners, flowerlike colors and unreal distances. In the stream of Renaissance art, Masolino made hardly a ripple. But Masaccio was one of the greatest painters of the entire Western tradition and as careless of "beauty" in his works as he was apparently neglectful of appearances in real life; he leads us, by means of a new vision of color and its role in the perception of light and form, deeper and deeper into the world of space, emotion, and action that the sculptors had discovered. And yet the two managed to work together.

Maso di Cristofano Fini-Masolino-was born in Panicale, a small group of houses in the upper Valdarno (Arno Valley), in 1383, according to the account generally believed. He may have been the artisan who assisted Ghiberti in the North Doors of the Baptistery. Not until 1423 did he join the Arte dei Medici e Speziali, and that is the year of his first dated work. Is it possible that he reached the age of forty in professional anonymity? More likely Ghiberti's assistant was another Maso di Cristofano; Masolino probably joined the guild at the usual age, which would bring his birth date somewhere about 1400. Much of his life was spent away from Florence. His most adventurous trip took him to Hungary, in the service of the Florentine condottiere Pippo Spano, from September 1425 to July 1427. Later, at a time still to be determined, he worked in Rome, and then, about 1435, in the tiny Lombard village of Castiglione Olona. He died in either 1440 or 1447.

Maso di Ser Giovanni di Mone Cassai—Masaccio was born December 21, 1401, in what is today San Giovanni Valdarno, a flourishing town not far from Panicale. He joined the guild in Florence in January 1422, and worked there and, in 1426, in Pisa. In the summer or autumn of 1428 he went to Rome, where he died. If, as is generally claimed, this event took place in November 1428, the artist did not reach his twenty-seventh birthday. Complete proof of this date has never been brought forward, however, and it is possible that Masaccio succumbed during the malaria season of 1429.

The old tradition that Masolino was Masaccio's teacher, along with many another misconception about the origins of the latter's style, was laid to rest in 1961 by the discovery of an astonishing early work by Masaccio, a Madonna and Child with Saints (fig. 187) in the little Church of San Giovenale at Cascia di Reggello on the slopes of the Pratomagno, the mountain mass that dominates Masaccio's native town of San Giovanni and also can be seen from Florence. The roughness, impulsiveness, and freedom of this triptych, dated April 23, 1422, justify Vasari's account of Masaccio as an artist who cared nothing about material considerations, neither the clothes he wore, the food he ate, the lodgings he inhabited, nor the money he received, so completely was he on

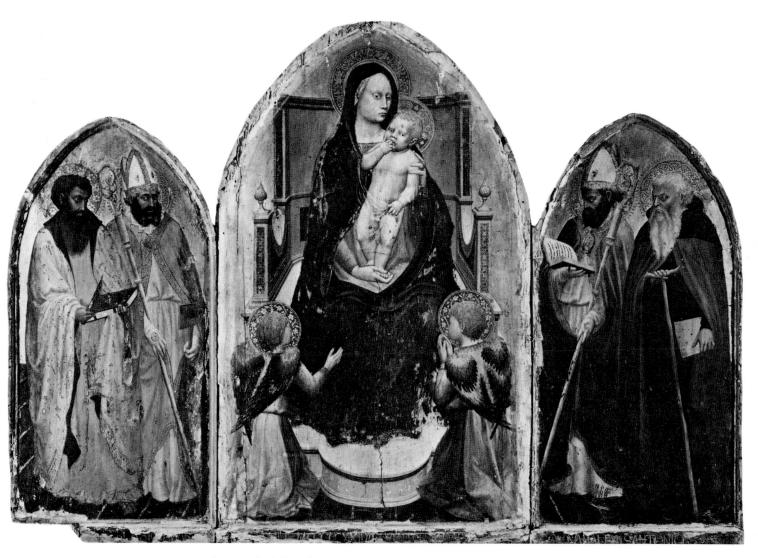

187. MASACCIO. *Madonna and Child with Saints*. 1422. Panel, 42½×60½". S. Giovenale, Cascia di Reggello (on deposit at the Uffizi Gallery)

fire with the "cose dell'arte" (literally, "the things of art"). The twenty-year-old master painted an ill-favored Madonna, with high forehead, staring eyes, and weak chin, gawky on her traditional inlaid marble throne. The Child, too, is homely and stiff-limbed, and especially ungraceful in the way he holds with his left hand a bunch of white grapes and a translucent veil in a hopeless attempt to hide his nakedness, while stuffing two fingers of the right into his mouth. Two angels, one praying, the other gesturing, kneel before the throne. While their wings preserve the old rainbow gradation, the feathers are as disheveled as those of street sparrows. On either side stand pairs of saints, uncomfortable and morose. But under the guise of workaday naturalism, of course, the triptych discloses a strong religious content: the grapes are those of the Eucharist, and the Virgin holds the Child by the foot as the priest holds the monstrance containing the Host at Benediction.

In the whole triptych no trace remains of the Late Gothic, nor of Ghiberti's mellifluous folds (see fig. 158). At first sight there appears no influence of Gentile either, but it is present nonetheless, though Masaccio's domes-

ticity is in vivid contrast with the courtly splendor of the Strozzi altarpiece (see colorplate 22). Gentile must already have been in Florence for several months at the time Masaccio's triptych was completed, and his style offered the young painter a liberation from precise Gothic brushwork. The heads and wings of the angels, the hair and beards of the saints show a freedom and sketchiness that could have come from no other source. But already the boy has gone farther than Gentile was ever to go. He needs no night illumination to prove the existence of form. The hands and limbs and, above all, the folds of the angels' tunics exist as ordinary daylight reveals them. At twenty Masaccio has assimilated the lesson of Donatello's *St. George and the Dragon* (see fig. 166), carved scarcely five years before.

In 1423, one year later, Masolino signed the dainty *Madonna and Child* (fig. 188), a picture whose style, closely related to those of Lorenzo Monaco and Ghiberti, shows not a trace of the brutal naturalism of his fellow *valdarnese*. The delicately modeled, egg-shaped head of the Virgin, typical of Masolino's female faces throughout his career; the sweetness of the Child and the tenderness

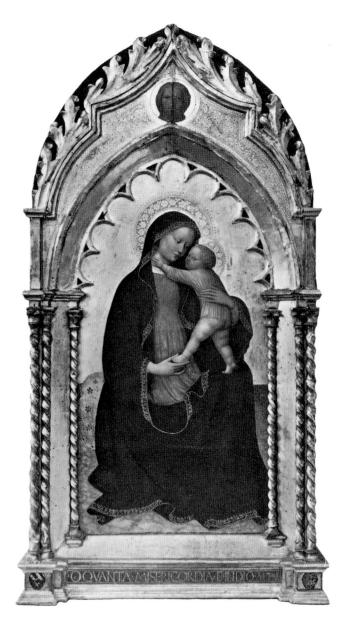

188. MASOLINO. Madonna and Child. 1423. Panel, $37\frac{3}{4} \times 20\frac{1}{2}$ ". Kunsthalle, Bremen

with which he touches the Virgin's neck while she holds his foot; the easy curvilinear flow of the drapery—all are within the conventions of conservative Florentine style. Only the roundness of the modeling in light and shade betrays that Masolino, too, had attempted to learn some of the new lessons.

In the same year, if this author's currently unpopular view is correct, the two young artists collaborated in their first major joint undertaking, a splendid altarpiece ordered by Pope Martin V for a chapel in the Church of Santa Maria Maggiore at Rome that has been reconstructed by scholars from its scattered pieces. Although the lawless conditions still prevailing in the Eternal City after Martin V arrived in 1420 might have made painting difficult, the pope nevertheless embarked at once on a

program of restoration of the major Roman churches. Nothing prevents the supposition that he was in Rome when he ordered the altarpiece and that the artists painted it in Florence. The work was painted on both front and back. The central panel of the front, now in Naples, represents the Founding of Santa Maria Maggiore (fig. 190), whose plan was quickly traced on the ground by Pope Liberius after it had been outlined by a miraculous snowfall in August. The left panel, in the National Gallery in London (fig. 189), represents St. Jerome and St. John the Baptist; the right, in the Johnson Collection in Philadelphia (fig. 191), shows St. John the Evangelist and St. Martin of Tours, the latter a likeness of Pope Martin V wearing a cope bordered with little columns, a play on his family name, Colonna. The program was altered later, when Masolino repainted the saints on the back of the altarpiece and, on the front, changed Pope Liberius into St. John the Evangelist and St. Matthias into St. Martin of Tours. It is here suggested that this change was made at the pope's request when Masolino arrived in Rome, presumably in 1427 or 1428, in order to augment the importance of papal power in the principal image in the center.

Most scholars now agree that the London panel is by

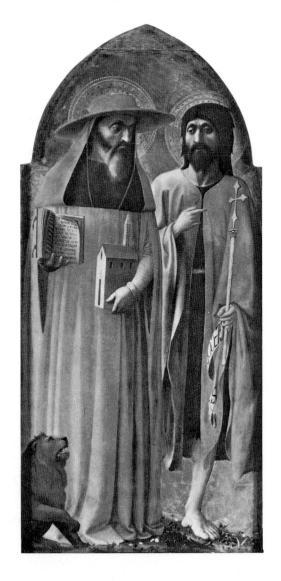

opposite below: 189. MASACCIO. St. Jerome and St. John the Baptist, from the Sta. Maria Maggiore triptych. c. 1423 (?). Panel, 451/4×211/2". National Gallery, London

below left: 190. MASOLINO. Founding of Sta. Maria Maggiore, from the Sta. Maria Maggiore triptych. c. 1423 (?). Panel, $56\frac{3}{4}\times30$ ". Museo di Capodimonte, Naples

below right: 191. MASOLINO. St. John the Evangelist and St. Martin of Tours, from the Sta. Maria Maggiore triptych. c. 1423 (?); reworked 1427 or 1428 (?). Panel, $39\% \times 20\%$. John G. Johnson Collection, Philadelphia

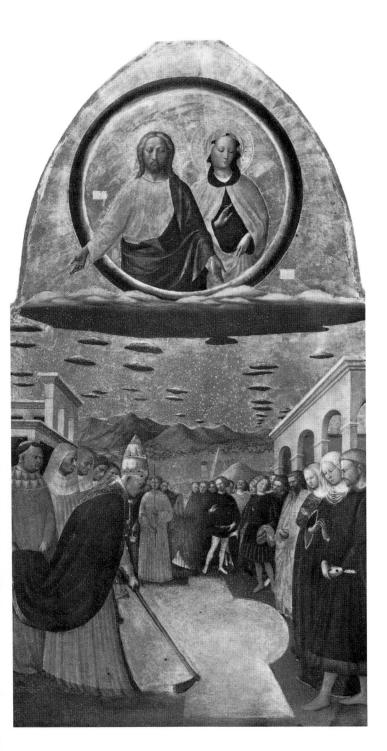

Masaccio himself and shows the full depth and power of his new style. All other panels are accepted as the work of Masolino. But the immense distance of the central panel represents a principle of great daring, however unconvincing it may be in its details. The arcades repeat the characteristic motives found in the backgrounds of panels on the North Doors of the Baptistery (see fig. 154), and the arches are not projected in perspective. The background is still gold. Above a bank of clouds Christ and the Virgin float side by side within a blue circle representing the heavens, while smaller clouds recede rapidly into the distance. Flakes of snow fall across the gold to form on the ground the shape of the new basilica. Even though the pyramid of Gaius Cestius and the mound known as the Testaccio are seen in the background, and the composition is derived from a mosaic on the façade of Santa Maria Maggiore, the painters need not have gone to Rome in order to represent these elements, which the pope may have specified. On the other hand, no one familiar with Rome would have painted as flat the Esquiline Hill on which Santa Maria Maggiore stands (two miles distant from the pyramid, over hills, valleys, houses, and ruins) or inserted a background of Florentine hills.

Under the guise of the miracle of the snow, the altarpiece must have represented in the pope's mind his own historic mission to reunite the Holy Roman Church, devastated by generations of schism. St. Jerome, one of the four Church Fathers, holds a model of a church in one hand and an open Bible in the other, in which can be clearly read the first verses of Genesis: "In the beginning God created the heavens and the earth. And the earth was without form and void; . . And the spirit of God was borne over the waters...." St. Antonine of Florence, who was in Florence at the time the altarpiece must have been painted, traces the conception of Mary mystically to this very passage in Genesis, in which maria, the Latin word for "seas," later appears. He narrates the Miracle of the Snow a little farther on, right after the Assumption of the Virgin, a subject painted by Masolino on the back of this altarpiece (not illustrated). In these first moments of Creation in which the Lord floated over the water, St. Jerome appears to be finding a prophecy of the planning of Santa Maria Maggiore by means of the congealed water falling from Christ in Heaven. Next to St. Jerome stands the most watery of saints, John the Baptist, his cross perched on another slender column to remind us that Florence, whose patron the Baptist is, had sheltered the Colonna pope.

Though there are earlier altarpieces with central scenes flanked by standing saints, no such composition as this had ever been seen before. And the rapidly receding space of the central panel, at times imperfectly controlled, is closer to Donatello's St. George relief of 1417 (see fig. 166) than to the careful perspectives of Masolino's paintings in the late 1420s and 1430s (see fig. 195, colorplate 26). The space may be an idea of the young Masaccio, but the figures in their curvilinear primness are typical of Masolino, as are the faces, whose surfaces remind us of porcelain or of polished metal in their smoothness and hardness.

The St. Jerome and St. John the Baptist is by Masaccio, and more advanced than the rough statements of form in the San Giovenale altarpiece, the earliest known manifesto of the young man's new naturalism; but it is still far from the balanced harmonies of mass and space so impressive in the Brancacci Chapel (see colorplate 23) and the Trinity (see colorplate 25). As sullen as the San Giovenale saints, these two figures also stand compressed into a single panel, against a gold background with only a patch of earth providing a suggestion of recession. The brushwork is no longer so free. The intimations of plasticity apparent in the San Giovenale angels are here controlled in order to produce firm and unified surfaces that turn in depth around volumes that exert, at times, an almost hallucinatory sense of plastic existence. The heavy features of the two men, the shoulders and ankle of St. John, the little cubic church model, the open book with its foreshortened masses and its pages turning in depth, all show a new study of the basic principles of

representing forms in space and light. The power and simplicity of the fold structure disclose the painter's knowledge of what Nanni di Banco and Donatello had achieved at Orsanmichele (see figs. 168, 164). Yet Masaccio refines and simplifies the sculptors' statements, making them if anything more sculptural, according to the paradox often seen in the early Quattrocento, when painters and sculptors attempt each to beat the other at his own game.

In the sphere of content these saints may be closest to Donatello, but they lack the fiery urgency of his heroes. They seem depressed, moody, as if crushed by the impossibility of realizing their mission. The fatalism of these faces will reappear when least expected in Masaccio's art, at the most exalted moments of his mature new style (see figs. 198, 200). And they are homely, as always in his work, with big noses, low and heavy cheekbones, and eye sockets sloping outward and downward from the bridge of the nose. St. John, the great Precursor, points toward Christ in the central panel, and flowers (each simple and perfect in the way it occupies space) spring upward in "the way of the Lord," but his scroll hangs limply and his hair clings to his head in matted clumps.

THE BRANCACCI CHAPEL. The supreme manifesto of the new pictorial style was the decoration of the chapel of the Brancacci family in the Church of Santa Maria del Carmine in Florence, a cycle that was to become a model for Florentine artists in the Late Renaissance, including Michelangelo, who came to draw from the great frescoes and thus learn the new art of chiaroscuro (light and shade). In the cloister alongside the church was then Masaccio's celebrated fresco of the Sagra (consecration) of the new church; in this work Masaccio had represented, with all the vivacity of his art and according to his new principles of chiaroscuro, a procession of contemporary Florentines, all recognizable. This influential work is long since destroyed, and we have only a few drawings-some by Michelangelo-showing how certain figures or groups of figures once looked. In 1771 a fire wrecked the interior of the church, and its smoke darkened and damaged the frescoes of the Brancacci Chapel. Even worse, in the remodeling of the church it was proposed that they be torn down, and indeed the series lining the vault and the lunettes was destroyed; only the intervention of the artists of Florence saved the

The old arguments surrounding the authorship of the frescoes that remain in the Brancacci Chapel have by now been laid to rest. It would appear that the series was started by Masolino after his activity in Empoli in 1424 and therefore as early in 1425 as frescoes could be painted. (Unfortunately, recent archivistic research has not succeeded in verifying Vasari's account that the frescoes were commissioned by Felice Brancacci.) The entire series, including the lost frescoes (but with two exceptions, as we shall see), represented scenes from the Life of St. Peter, the first pope. This was an important subject in Florence, for the dominant Guelph party had an alliance with the papacy, Pope Martin V was himself in Florence for two years, and the Florentines were making constant attempts to secure papal support in their struggles with Milan.

Masaccio must have been summoned in 1425 to collaborate with Masolino in the painting of the second tier of frescoes, the uppermost ones still remaining in the chapel. Included in this section is Masaccio's acknowledged masterpiece, the Tribute Money (colorplate 23). The subject (Matthew 17:24–27), seemingly trivial and seldom represented before in the history of Christian art. nonetheless dominates the room. When Christ and the Apostles arrived at Capernaum, Peter was confronted by the Roman tax-gatherer demanding the usual halfdrachma tribute. Peter, returning to Christ for instructions, was told that he would find the tax money in the mouth of a fish near the shore of Lake Galilee. He did as he was told, and the tax-gatherer departed. Out of this episode Masaccio has built a scene of the utmost grandeur. He has also revised the story. The tax-gatherer comes directly before Christ and the Apostles, who are not represented "at home," as in the text, but before a wide Arno Valley landscape culminating in the mass of the Pratomagno; the house is relegated to one side. On the left Peter finds the fish in shallow water, and on the right he pays off the tax-gatherer, but the center of the stage is occupied by the confrontation of temporal and spiritual power and the instructions of Christ to the Apostles, whose faces betray surprise, indignation, concern. The year in which the fresco must have been painted was one of the most dangerous in the history of the Florentine Republic, which had just suffered crushing defeats at the hands of Filippo Maria Visconti, duke of Milan. In order to distribute equitably the financial burden of the war, the Florentines were debating the new tax called the Catasto, based on ability to pay, and provided with a system of exemptions and deductions (see page 142), a welcome substitute for previous taxation procedures. St. Antonine of Florence interpreted the incident of the Tribute Money as Christ's instruction that all men, including ecclesiastics, must pay taxes to earthly rulers for the support of defense measures. (The subject is connected with the efforts of the Florentine Republic to tax Church holdings and the clergy, some of whom were jailed for nonpayment.)

Apparently, the Lord's blessing of taxation in Florence is what Masaccio was called upon to represent in 1425, and that is why he placed the scene on the banks of the Arno and endowed it with such solemnity. A similar semicircular arrangement of heavily cloaked figures is to be seen in Nanni di Banco's Four Crowned Martyrs (see fig. 168); the young Masaccio may even have been watching when the group was set up in its niche at Orsanmichele. Certainly he studied the behavior of light on the powerful figures, faces, and drapery masses created by contemporary Florentine sculptors. In his landscape, however, he has surpassed sculptors and painters alike. The vast distances of Ambrogio Lorenzetti and Andrea da Firenze had been depicted partly from above and always ended at the abstract background, as if they were extensions before an impenetrable wall. Masaccio has adopted Donatello's low point of view and atmospheric distance, and Gentile's complexity of construction (if not his surface richness), but has produced a landscape of a grandeur that was unknown before his time, indeed was seldom rivaled later. The impenetrable wall is dissolved, as the predella panel was in Gentile's Strozzi altarpiece (see fig. 186). The eye is taken inward harmoniously, with none of Gentile's still-medieval leaps in scale, past the plain and the riverbanks, over ridges and distant mountains, to the sky and the clouds. In this setting Masaccio's rugged figures stand and move at their ease. They and the landscape are represented with the full power of the new style that Masaccio had been developing in accordance with Donatello's new optical principles. He has abandoned the last shreds of Trecento linearism and analysis of detail. Objects, forms, strong faces, figures, masses of heavy drapery, nobly projected legs, all exist in light that sculptures them and sets them forth in space. Restoration, still in progress at the time of this revision, has removed layers of grime revealing, as was predictable, high, clear color representing a return to Giotto, but even brighter than had been expected. Masaccio's supposed deep shadow has turned out to be lamp smoke, and undreamed of delicacies of pictorial surface, muscular contour, and landscape detail have come to light, impossible at the moment to photograph and publish.

The background is filled with soft atmosphere. Misty patches of woodland are sketched near the banks. Masaccio's brush moves with an ease and freedom unexampled in Italian art since ancient Roman times. It represents not hairs but hair, not leaves but foliage, not waves but water, not physical entities but optical impressions. At times the brush must even have administered backhand jabs at the intonaco in a manner suggesting the divided touch of nineteenth-century Impressionism. Each stroke of Masaccio's brush, in fact, is equivalent to a separate reflection of light on the retina. The equation of a single stroke with a single particle of reflected light, over smooth or broken surfaces, may also be found in Northern European art, in the works of Jan van Eyck. Yet most of these were painted five or more years later than the probable date of the Tribute Money.

The celebration of individual responsibility joins with the individual point of view in Masaccio's fresco, which depicts the Apostles not as the officials of the oligarchy, but as "men in the street," the artisans and peasants on

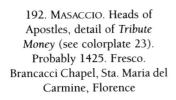

left: 193. MASACCIO. St. Peter Baptizing the Neophytes. Probably 1425. Fresco. Brancacci Chapel

below: 194. Kneeling Man, detail of fig. 193

195.
MASOLINO.
Healing of the
Cripple and the
Raising of
Tabitha.
Probably 1425.
Fresco.
Brancacci
Chapel

whose support the Republic depended (fig. 192). They are presented with conviction and sympathy—sturdy youths and bearded older men, rough-featured, each an induplicable human personality, each endowed with the fortitude that can still be counted on, as modern events have shown, when the Florentine people face adversity. Even the tax-gatherer, as astonished as the Apostles at the message of Christ, seems to participate with them in the ritual act that embodies the new revelation.

As if to symbolize both the spatial existence of the figures and the individuality of the personalities, the haloes are projected in perspective, and touch or overlap at random angles. And then, strangely enough, we are confronted with the unexpected fact that the face of Christ is by Masolino! Analysis of the fresco has proved beyond doubt that Masaccio worked from the outside in, and that this head was the last to be painted. The only explanation seems to be that the two painters collaborated amicably, and that both considered the gentler style of Masolino more suitable to the depiction of Jesus than the rougher manner of Masaccio.

On the same upper tier, just to the right of the altar, Masaccio painted St. Peter Baptizing the Neophytes (fig. 193), the scene set high in the Apennine headwaters of the Arno. Here the artist has shown himself the equal of Ghiberti (see fig. 155) and Jacopo della Quercia (see fig. 178) in the representation of the nude figure, whose volumes still assert themselves in spite of the heavily damaged surfaces. Subsequent generations were impressed by the realism of the shivering figure awaiting his turn at the bone-chilling ritual, the man drying himself with a towel, and the splendidly built youth kneeling in the foreground, over whose head St. Peter pours water (fig. 194). The nude is handled broadly, perhaps not with the subtlety of surface we find in Ghiberti, but conveying a real sense of being cold and naked in the presence of inhospitable nature. The volumes of the figures are indicated in Masaccio's new chiaroscuro technique, smooth and consistent in the surfaces of legs, chests, and

shoulders, strikingly sketchy and free in the loosely indicated heads in the background. The two young men at the extreme left, wearing the typical Florentine *cappuccio* wrapped around an underlying *mazzocchio* (wire or wicker framework), appear to be portraits (see page 245 and fig. 260).

Masolino's principal contribution to the frescoes of the upper tier opposite to the Tribute Money is the Healing of the Cripple and the Raising of Tabitha (fig. 195), miracles performed by St. Peter in the neighboring cities of Lydda and Joppa. Masolino certainly was not up to a composition as close-knit and unified as that of the Tribute Money, but recent research by Umberto Baldini has shown that this scene and the Tribute Money were constructed on the same perspective cone. Masolino had to create on this basis a composition in two separate scenes; he simply telescoped the space between them by means of a continuous Florentine city background, whose simple houses, projected in perspective, are now sometimes attributed to Masaccio. On the left St. Peter and St. John, with typical Masolino faces and haloes parallel to the picture plane but draperies imitated from the grand volumes of Masaccio, command the cripple to rise and walk; on the right they appear in the home of Tabitha (on the ground floor, not the upper story mentioned in the text), and raise the fortunate lady from the dead. The two foppish young gentlemen in the center of the fresco are by no means supernumeraries: they are the messengers sent from Joppa to fetch St. Peter and St. John with the greatest speed, although their doll-faces betray little sense of urgency. Their dress sets them apart from the Florentines, who were still forbidden to wear splendid brocades and short garments. In contrast with the grandeur of Masaccio's two scenes, this one is unimpressive. Masolino's drapery lacks the fullness and suppleness of Masaccio's, and there is little sense of the underlying figure. Expressions seem forced, the drama unconvincing. and even the shapes at times unfortunate, as for instance the vertical cleavage between the houses in the back-

196. MASOLINO. *Temptation*. Probably 1425. Fresco. Brancacci Chapel

197. MASACCIO. *Expulsion*. Probably 1425. Fresco. Brancacci Chapel

ground, carried down into the line of St. John's back.

Nowhere do the styles and temperaments of the two friends collide (to modern eyes) so abruptly as in the narrow scenes representing the *Temptation* (fig. 196) and *Expulsion* (fig. 197) on the upper tier, facing each other across the entrance to the chapel. Masolino and Masaccio may well have found reasonable the division of labor—to Masolino the less dramatic scene, to Masaccio the moment of universal tragedy. (Both subjects, of course, signify the Original Sin from which Baptism in the Church frees us, and they are therefore related to the

general message of the cycle.) So Masolino painted a gentle Adam, his face almost identical with that of Christ in the *Tribute Money*, and an equally mild Eve undisturbed by the trouble she is about to cause, throwing one arm lightly around the tree trunk while, from the bough above, the serpent's human head tries to attract her attention. The surfaces of nude flesh appear soft, yet the figures seem incapable of flexing themselves. The feet hang instead of stand, and the volumes do not turn in space.

Masaccio's Expulsion was influenced by Jacopo della

Quercia's relief on the Fonte Gaia, but the painter projected the scene with even greater intensity. He abandoned the physical contest between the angel and Adam; a calm celestial messenger hovers above the rudimentary gate, holding a sword in his right hand and pointing with his left to the barren world outside Eden. Adam moves forth at the angel's bidding as if driven by a spiritual force. He hides his eyes with clutching hands as if unable to contemplate either his own guilt or the horror before him, his mouth contorted, the muscles of his abdomen convulsed, his limbs shivering. Eve, her hands assisting the leaves that hide her nakedness, opens her mouth in a cry of despair. Superficially, the drama has been reduced to its essential elements—two naked, suffering humans striding out into the cold. No more is necessary. Yet one senses beyond it the greater tragedy of exclusion from God and from the Christian community, whose rites and rules are celebrated in the other frescoes.

The lower tier must have been painted by Masaccio alone, after Masolino's departure for Hungary in September 1425. Since Masaccio was occupied in Pisa with an elaborate polyptych throughout most of 1426, his work in the Brancacci Chapel must have come to a stop

in late November or December of 1425, when impeded by cold weather. The truncated cycle was never resumed until Filippino Lippi completed it in a radically different style, much later in the Quattrocento. Why did Masaccio not resume in 1427 where he left off painting in 1425? As yet no evidence is available. The scenes flanking the altar on either side are both by the master, and share a common perspective that converges behind the altarpiece. On the left is St. Peter Healing with His Shadow (fig. 198), a subject as rare as the Tribute Money and, in fact, difficult to represent in the era before cast shadows had entered an artist's repertory. The setting is a narrow Florentine street bordered by one rusticated house (a damaged section of the intonaco was replaced by a restorer who could not match the perspective lines of the original) and by other houses whose projecting rooms are supported on struts. As the architecture recedes, St. Peter walks toward us, not even looking at the sick who crowd before him and across whom his magical shadow passes. The bearded man in a short blue stonecutter's smock may be a portrait of Donatello, and the beardless youth who looks out at us in the manner of all Renaissance self-portraits Masaccio himself. So vivid and so searching is the artist's depiction of the faces of the two

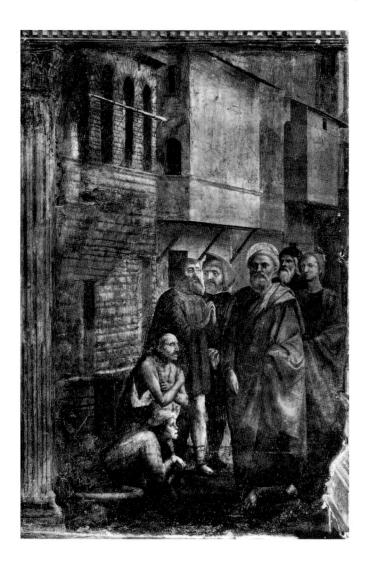

left: 198. MASACCIO. St. Peter Healing with His Shadow. Probably 1425. Fresco. Brancacci Chapel

below: 199. Crippled Man, detail of fig. 198

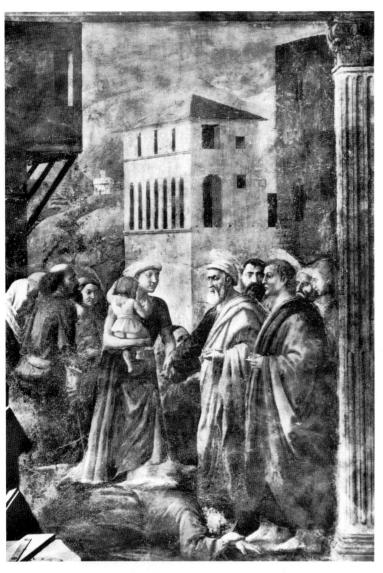

200. MASACCIO. Distribution of the Goods of the Church. Probably 1425. Fresco. Brancacci Chapel

cripples at the lower left (fig. 199), so eloquent is the play of light and shade, that we are reminded of the seventeenth century more than of the fifteenth.

On the right-hand side of the altar, the Distribution of the Goods of the Church (fig. 200) is a scene in the middle of any village in the Florentine contado. St. Peter and four other Apostles, enveloped in their majestic cloaks, distribute alms to the poor, who are at once as rough and as noble as they—the peasant woman holding her child dressed in a tiny shirt comes from the same stock as any of Masaccio's Madonnas. In front of this evocation of the concern of the Christian community for its members is stretched the corpse of Ananias, the Christian who held back a part of the price of a farm and was struck down at St. Peter's feet; a grim reminder of the fate of a tax delinquent. (Masaccio's tax declaration of 1427 is still preserved, written in his own hand, the words and phrases set forth with the simple dignity one would expect from him.) The movement of the architecture into space is even more striking here than in the adjoining fresco, owing to the view of the projecting room from below, so that its hidden front wall must be imagined to move inward toward the altarpiece. The houses frame a view over the freely painted Florentine landscape dominated by a towered villa.

In these paired frescoes a change has taken place in Masaccio's style and mood. The masses are more densely packed than in the frescoes in the upper tier, the space less open and free; the forms, when approached closely, are less consistent in structure, the surfaces more loosely sketched, the expressions more tense and even worldweary. In the *Raising of the Son of Theophilus* (fig. 201), one of the two major frescoes of the lower tier (the opposite fresco was done entirely by Filippino Lippi), the art-

201. MASACCIO (completed by FILIPPINO LIPPI). Raising of the Son of Theophilus. Probably 1425. Fresco. Brancacci Chapel

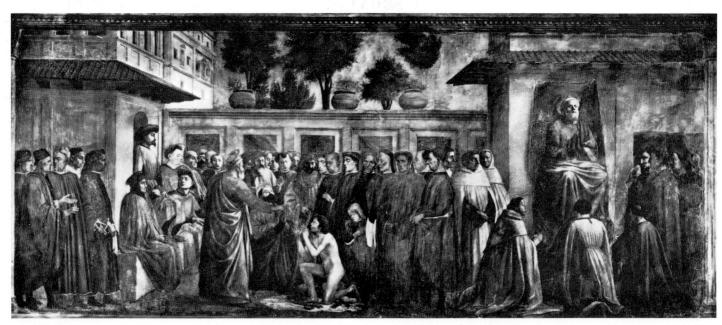

Colorplate 19. LORENZO MONACO. Coronation of the Virgin. Finished February 1414. Panel, $8' \times 12'3''$. Uffizi Gallery, Florence

Colorplate 20. GIOVANNINO DE' GRASSI. Psalm 118:81.

Page from Visconti Hours. Before 1395. Tempera and gold on parchment.

Biblioteca Nazionale, Florence

Colorplate 21. FILIPPO BRUNELLESCHI. Interior, Pazzi Chapel, Sta. Croce, Florence. Begun c. 1433; completed 1461. (Glazed terra-cotta medallions by BRUNELLESCHI and LUCA DELLA ROBBIA)

Colorplate 22. Gentile da Fabriano. Adoration of the Magi (Strozzi altarpiece). Finished 1423. Panel, $9'10'' \times 9'3''$. Uffizi Gallery, Florence

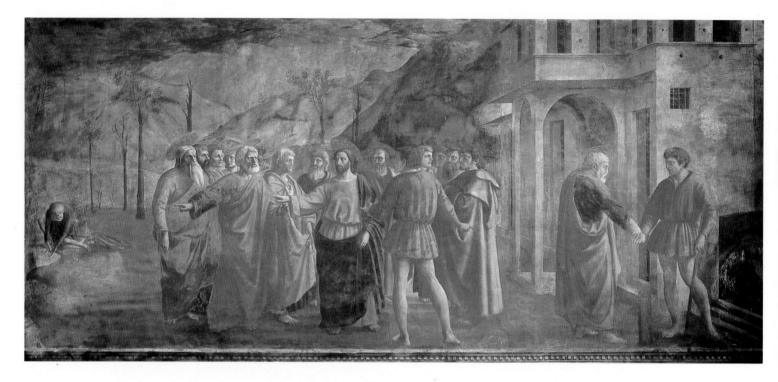

Colorplate 23. MASACCIO. Tribute Money. Probably 1425. Fresco. Brancacci Chapel, Sta. Maria del Carmine, Florence

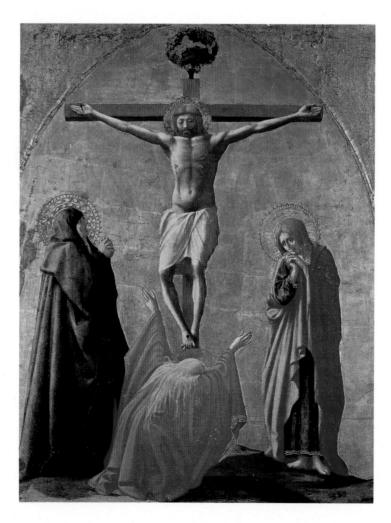

Colorplate 24. MASACCIO. *Crucifixion*, from the summit of the Pisa polyptych (for Sta. Maria del Carmine, Pisa). 1426. Panel, 301/4×251/4". Museo di Capodimonte, Naples

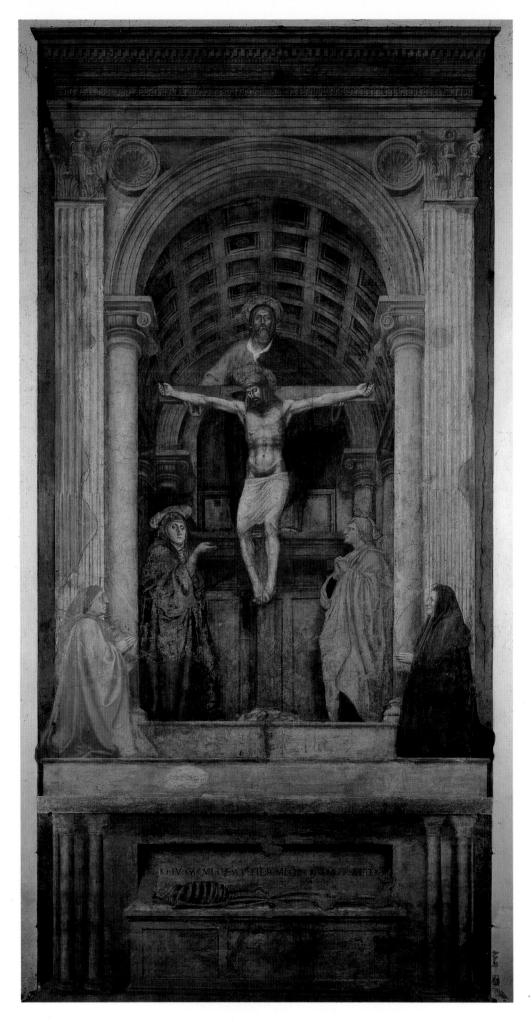

Colorplate 25. Masaccio. *Trinity.* Probably 1427 or 1428. Fresco, $21'\times10'5''\times10^{1}$ (including base). Sta. Maria Novella, Florence

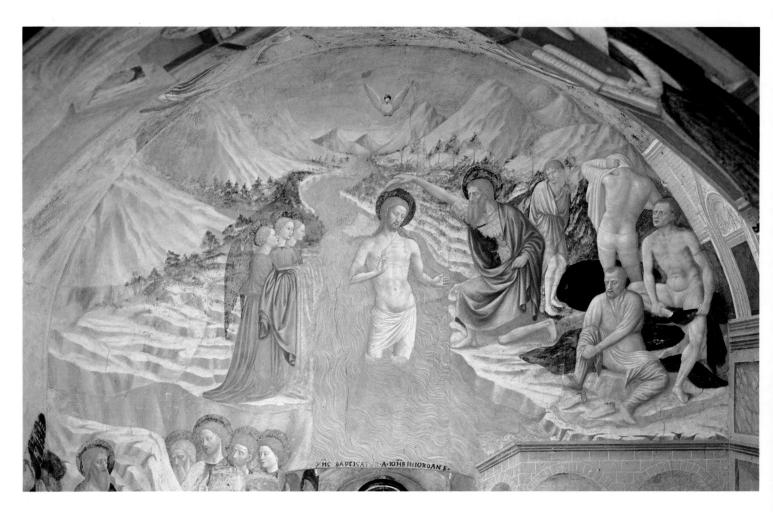

Colorplate 26. MASOLINO. Baptism of Christ. 1435. Fresco. Baptistery, Castiglione Olona

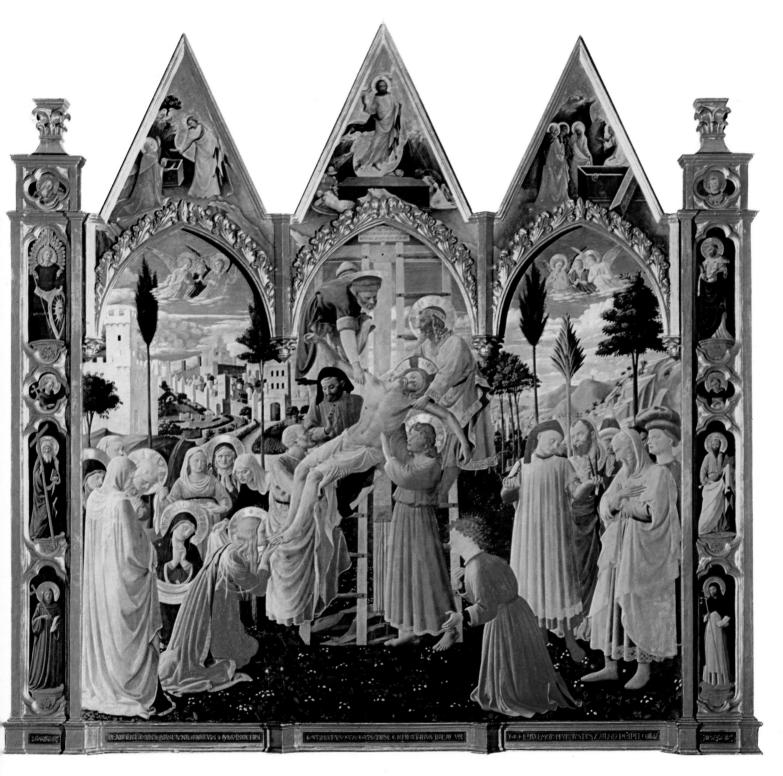

Colorplate 27. Fra Angelico. *Descent from the Cross.* Probably completed 1434. Panel, $9'1/4'' \times 9'41/4''$. Museum of S. Marco, Florence. (Frame and pinnacles by LORENZO MONACO)

Colorplate 28. Fra Angelico. *Visitation*, on the predella of the altarpiece for San Domenico, Cortona. c. 1434. Panel, c. 9×15 ". Museo Diocesano, Cortona

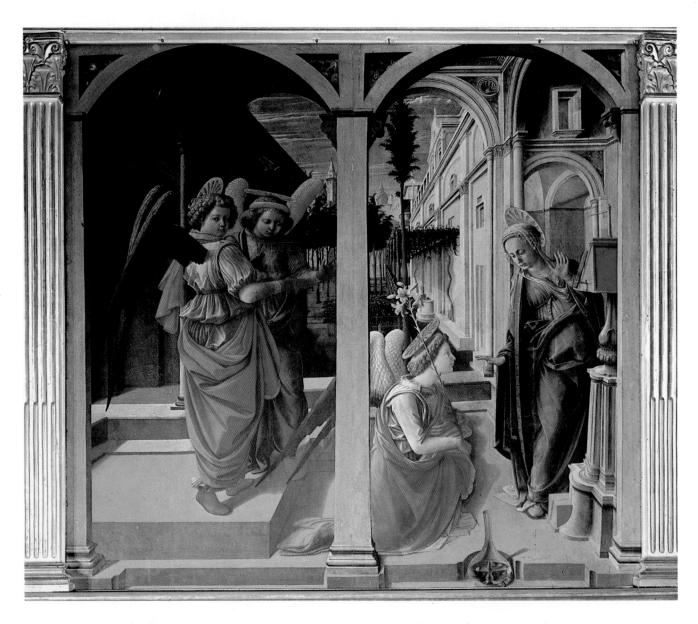

Colorplate 29. Fra Filippo Lippi. Annunciation. c. 1440. Panel, $69 \times 72''$. S. Lorenzo, Florence

ist has adopted an S-shaped plan in depth (as compared to the open circle of the *Tribute Money*) with one center revolving around the miracle at the left, the other around St. Peter adored by Carmelites at the right. Both curves of the S, one moving toward us, the other away, are locked in a rectilinear architectural enclosure, formed partly by the palace of Theophilus, partly by the austere architectural block before which St. Peter is enthroned, looking upward in prayer.

The architectural setting is by Masaccio, as are almost all the figures except for three at the extreme left and some of those of the central section, including the delicate kneeling boy, which are by Filippino. The palace of Theophilus resembles no structure known in Quattrocento Florence, but the lower story has a fine series of Brunelleschian Corinthian pilasters, and the pedimented windows of one wing strongly resemble those of the Ospedale degli Innocenti (see fig. 136). A wall divided into panels of inlaid colored marble runs across the back of the scene. Its appearance so strongly suggests that of Quattrocento tombs, such as those of Lionardo Bruni and Carlo Marsuppini (see figs. 256, 296), and the backgrounds of paintings containing the symbolism of death, such as Castagno's Last Supper (see colorplate 34) and Baldovinetti's Annunciation (see fig. 317), that a similar meaning may have been intended in this case. Above the wall new life arises in the trees and potted plants, placed in asymmetrical sequence against the sky and so freely painted that they were long considered an addition by Filippino.

More strongly than elsewhere in the chapel one senses in this fresco a strict submission of the human individual to geometric law. The columnar or conical volumes of the figures, projected so convincingly in depth and in light, adhere to the patterns of the embracing curvilinear and rectilinear ground plans within which they are set. Only the central St. Peter (by Masaccio, with the exception of the outstretched hand) is free to act and move. The conversion of the wicked Theophilus through the saving of his son's life has been plausibly explained as an allegory of papal—and by extension, Florentine—power against the Milanese. The head of Theophilus, in fact, with its particular style of beard and moustache, approaches an actual portrait of the long-dead Giangaleazzo Visconti. The meaning of the fresco is reduced to simple and compelling terms in its composition: St. Peter appears twice, at the two foci of the S-plan; other mortals, including Theophilus, are only elements in the structures that revolve around the Church.

THE PISA POLYPTYCH. Masaccio worked in Pisa from February to December of 1426 on a polyptych commissioned by one Giuliano di Ser Colino degli Scarsi, a notary, for the Church of Santa Maria del Carmine there. At an unknown date it was removed from its altar and dismembered, the panels scattered and some lost. The ef-

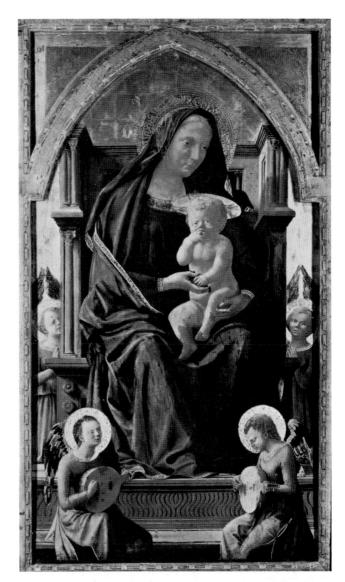

202. MASACCIO. *Enthroned Madonna and Child*, from the Pisa polyptych (for Sta. Maria del Carmine, Pisa). 1426. Panel, 53¹/₄ × 28³/₄". National Gallery, London

fect of the *Enthroned Madonna and Child* (fig. 202) is so overwhelming that it is always a surprise to discover her modest dimensions. That her monumentality makes her resemble in apparent size the giantesses of Picasso is a tribute to Masaccio's extraordinary ability to elevate human figures with all their physical defects to a sublime level of grandeur and power.

Some of the majesty of the figure doubtless derives from the fact that we read the two-story throne with its freestanding Corinthian columns as a work of architecture, imagining Brobdingnagian proportions for its occupant by analogy. She towers above the cornice, her blue cloak falling in heavy folds about the masses of her shoulders and knees. It is not impossible that Masaccio used in this case a clay figure with actual cloth disposed over it to chart the behavior of light and shade, as we know Verrocchio and his pupils later did and as Gentile must have done to study the light effects in the predella

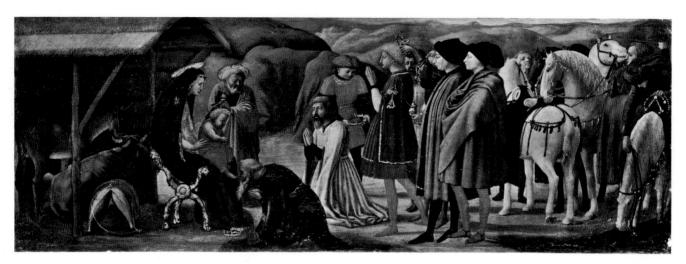

203. MASACCIO. *Adoration of the Magi*, from the predella of the Pisa polyptych (for Sta. Maria del Carmine, Pisa). 1426. Panel, 81/4×24". Picture Gallery, Dahlem Museum, Berlin

to the Strozzi altarpiece (see fig. 185). There would seem to be no other way for Masaccio to have produced with such accuracy the shadows cast on the throne by its projecting wings or by the Virgin herself. The plain faces conform to a type seen over and over again in Masaccio's work—broad at the cheekbones, with outward-sloping eye sockets, small eyes, large noses, and slightly receding chins. The Child, now totally nude, is again eating the Eucharistic grapes (see fig. 187), solemnly handed to him by his impassive mother. The panel is damaged; here and there considerable passages of paint have broken away, but worse is the overcleaning, which has reduced the face of the Virgin to its underpaint. The architectural details, including the firm, hard rosettes and somewhat inconsistent strigil ornament (imitated from ancient and medieval sarcophagi still in Pisa; see Nicola Pisano's manger, fig. 37) of the pietra serena throne, as well as the lutes in the hands of the two little angels, are so brilliantly projected as to seem magically threedimensional. Inexplicably, all but one of the haloes are set parallel to the picture plane and thus read together with the gold background; that of the Christ Child is foreshortened in depth.

The little Crucifixion in Naples (colorplate 24) was intended for the summit of the altarpiece. Masaccio has gone a step further in understanding perspective than did Donatello (see fig. 166), and determines the actual perspective spot where the observer must stand to see all the forms correctly. The Cross, for example, is seen from below, and the body of Christ is foreshortened upward, with the collarbones projecting in silhouette and the face inclined forward, therefore parallel to the upturned face of the spectator. The gold background, used throughout the polyptych save in one of the predella panels, may have been specified by Giuliano di Ser Colino, but so convincing is the sense of space created by Masaccio's perspective that the gold seems no longer flat; rather it sinks into the distance and creates the illusion of golden air behind the figures on Calvary. Old photographs show

the titulus on the Cross (INRI—"Jesus of Nazareth, King of the Jews"), but this bit of repaint came off in a recent cleaning to disclose a bush growing from the head of the Cross; it must once have contained the pelican striking her breast to feed her young, which symbolized in medieval belief the Sacrifice of Christ for mankind.

The sacrifice is Masaccio's theme, rather than the historical incident, reduced here to only four figures— Christ, Mary, St. John the Evangelist, and the Magdalen. The Magdalen prostrates herself before the Cross, her arms thrown wide so that the Cross seems to grow upward from her gesture of despairing guilt to culminate in the arms of Christ stretched in pitying self-immolation. "For he shall grow up before him as a tender plant, and as a root out of a dry ground," said the prophet Isaiah, and the comparison is carried out by the tender plants that grow here and there in the Place of the Skull, as they did before St. John the Baptist in the Santa Maria Maggiore altarpiece (see fig. 189) and as they will before the infant Baptist in Michelangelo's Doni Madonna (see colorplate 69). The Magdalen's sinking figure, her traditional yellow hair and red mantle in jarring contrast with the soft rose tone of the Evangelist's cloak, nonetheless leads toward him with the line of her right hand. St. John, wrapped in his own grief, seems to shrink into himself under the Cross. Mary expands, a noble presence in her blue mantle whose voluminous folds are set forth with all the conviction of Masaccio's style at its best. No longer is she the swooning Virgin so common in Trecento art. Stabat mater, St. Antonine insists, is "erect, not fainting on the ground ... afflicted, but not tearing her hair or scratching her cheeks or complaining to the Lord." She stands firm under her Son's Cross, her hands folded in prayer, her eyes gazing inward rather than upward, her mouth open as she calls to him. Christ, pale in death, his eyes closed and the crown of thorns low upon his brow, seems to have chosen this end by a supreme act of will, and to be suffering still. The *Christus* triumphans of the twelfth century, the Christus patiens of the Dugento, and the *Christus mortuus* of Giotto and his followers are fused and transfigured by Masaccio's new humanity. And in these four tiny figures Masaccio achieved in Christian terms a drama of Aeschylean simplicity, universality, and power. All the grandeur of the Brancacci frescoes is here in miniature, all the beauty of light on the gradations of the fold structures revolving perfectly in space, all the consistency and breadth of anatomical masses, all the strength and sweetness of color. And nowhere more than in this panel did Masaccio's style deserve the characterization given to it in the later Quattrocento: "puro, senza ornato" ("pure, without ornament").

The epic breadth of Masaccio's art is maintained even in the predellas. The central Adoration of the Magi (fig. 203) may represent Masaccio's comment on the profusion of Gentile's Strozzi altarpiece (see colorplate 22), painted only three years before, although the interval seems more like fifty. For Masaccio has now adopted a single, eye-level point of view that allows him to fill the foreground with figures; he then discloses, between or just above them, a landscape consisting of a few simple masses receding with far more spatial conviction than the splendid miscellany in Gentile's world. The distant bay and promontories suggest the seacoast near Pisa; the barren land masses may be based on the strange eroded region called Le Balze, near the Pisan fortress-city of Volterra. The low view allows the artist to compose a magnificent pattern of volumes and spaces: standing cylinders of legs, both human and equine, and the flat shadows cast by these legs on the ground. Masaccio's soberly clad kings enjoy the services of only six attendants as they arrive before the humble shed. The vividly portrayed Giuliano di Ser Colino and his son stand in contemporary costume just behind the kings, the patterns of their cloaks worked into the structure of the composition. Everywhere one finds new delicacies of foreshortening: ox, ass, and saddle, all turned at various angles to the eye and therefore differently foreshortened; the white horse who lifts one hind hoof gently and turns his head so that we can just discern his beautiful right eye; the groom at the extreme right who leans over toward us.

The same spatial principle compressed into minuscular scope is turned to great dramatic effect in the panel representing the *Crucifixion of St. Peter* (fig. 204). This subject had always presented difficulties, owing to St. Peter's insistence that, to avoid irreverent comparison with Christ, he be crucified upside down. Masaccio meets the problem by underscoring it; the diagonals of St. Peter's legs are repeated in the shapes of the two pylons based on the pyramid of Gaius Cestius in Rome, between which the cross is locked. Within the small remaining space the two executioners, faceless as their heads are bent down, loom toward us with tremendous force as they hammer in the nails. For sheer power the interpenetrating volumes and spaces of this composition were never to be surpassed in Renaissance art.

THE TRINITY FRESCO. Masaccio's most mature work is the fresco representing the central mystery of Christian doctrine, the *Trinity* (colorplate 25), in the Church of Santa Maria Novella in Florence. Various dates have been proposed for it. To this author the fresco can be understood only when dated at the end of Masaccio's known development, after the Pisa altarpiece and the Brancacci Chapel, therefore in 1427 or 1428, shortly before the artist's departure for Rome. The fresco, badly darkened, used to be seen before World War II in the position to which it had been moved, on the façade wall

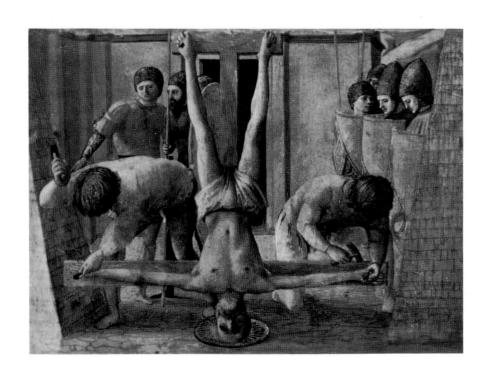

204. MASACCIO. *Crucifixion of St. Peter*, from the predella of the Pisa polyptych (for Sta. Maria del Carmine, Pisa). 1426. Panel, 81/4 × 12". Picture Gallery, Dahlem Museum, Berlin

just inside the entrance of the church. It has since been returned to its original position in the left side aisle, and a curious feature, mentioned by pre-Vasarian sources but long hidden from sight and absent from old photographs, has been discovered—a corpse (or, rather, a skeleton) lying below the painted steps and bearing the epitaph IO FU GIA QUEL CHE VOI SIETE E QUEL CHIO SON VOI ANCO SARETE ("I was once that which you are, and what I am you also will be"). The altar slab and painted Composite capitals indicated in the colorplate are restorations. To avoid obscuring the skeleton, the altar, a mere table, must have been erected over the tomb slab. The configuration of corpse and religious image is related to tomb iconography, and the tomb of a member of the Lenzi family, who served as gonfaloniere (standard-bearer) of the Florentine Republic and who died in 1426, was once visible in the floor in front of the fresco.

The setting of the *Trinity* is a magnificent Renaissance chapel. Its Corinthian pilasters flanking a coffered barrel vault conform so closely to the architecture of Brunelleschi and are projected so accurately in terms of his perspective principles that he was at one time held responsible for the actual painting. Now this correspondence is considered one more example of the constant interchange of ideas between the great masters of the new style. Vasari comments eloquently upon the effect the illusionistic architecture exerts, a dissolution of the wall to establish an apparently real chapel behind it. The date of so elaborate a construction seems inconceivable earlier than the relatively primitive architecture of the Pisa altarpiece and even of the Brancacci Chapel.

In the narrow space before the chapel kneel two members of a contemporary Florentine family—possibly the occupant of the tomb in front—a man in the costume of gonfaloniere and his wife. Within the chapel Masaccio has shown a Golgotha, reduced to symbolic terms—the sacrifice of Christ for mankind through the will of the Father, who stands on a kind of shelf toward the back of the chapel, gazing fixedly outward and steadying the Cross with his hands. The Christus mortuus (see fig. 66) seems only to have endured pain and to be no longer actively suffering. Between the heads of Father and Son floats the dove of the Holy Spirit. Below the Cross, Mary does not look at her Son but indicates him to us-without apparent emotion. St. John, no longer grief-stricken, is lost in adoration before the mystery. The brilliantly real portraits of the kneeling man and wife are stoically calm. Calvary has been stripped of its terrors. The immediate tragedy of the Crucifixion, as seen in the Pisa altarpiece (see colorplate 24), is not represented here, but rather the sublimity of Christ's sacrificial death for mankind. The kneeling Florentines pray to Mary and St. John, who in turn intercede with the Crucified, who, in terms of his sacrifice, atones with the Father for the sins of the departed, as for those of all mankind. Under the austere forms of the architecture, the pyramid of figures ascends from the mortals in our sphere outside the arch to God at its apex. The perspective, on the other hand, converges in a descending pyramid to a point behind the lightly painted mound of Golgotha—at exactly eye level. Ascending and descending pyramids intersect in the body of the sacrificed Son. In its reduction to geometrical essentials that unite figures and architecture, forms and spaces, the composition could not be more closely knit. Its inexorable power embodies as well as anything in Renaissance art Giannozzo Manetti's contention that the truths of the Christian religion are as clear as the axioms of mathematics. The Blessed Trinity is shown to be the root of all being, and the principle of sacrifice to dwell at the heart of the universe.

Within the imposing structure the individual parts are projected with all Masaccio's knowledge of stereometry. Photographic details of arms, hands, and architecture show startling sculptural reality. The very nails that hold Christ's hands are set forth in accordance with the perspective of the chapel. Yet the surface is rendered with a new breadth and freedom, even for Masaccio, and with somewhat less insistence on the value of ugliness. This last work of the youthful artist prompts many a speculation about what he might have accomplished had he lived longer. All posterity joins with Brunelleschi in his sad comment when informed of Masaccio's death, "Noi abbiamo fatto una gran perdita" ("We have had a great loss").

THE CASTIGLIONE OLONA FRESCOES. What of Masolino meanwhile? He, too, came to Rome. For a brief time the two friends may have collaborated there, although there is little trace of Masaccio's style in the surviving frescoes in San Clemente. Some years later (in 1435, if the date of the inscription can be believed) we find Masolino working in the little Lombard village of Castiglione Olona, north of Milan on the way to Como, where he carried out two delightful series of frescoes for the powerful Cardinal Branda. The Baptism of Christ (colorplate 26), with all its grace and charm, contains only an occasional echo of Masaccio, for example in the figures undressing or drying themselves at the right. But these are soft people, not Masaccio's rugged heroes, and Masolino's dainty Christ seems almost to dance in the ornamentalized water. Masolino has learned how to construct one-point perspective, with strings and a nail, but this fantastic landscape carries little conviction of a real spatial experience. Hills, rocks, water, and drapery all flow delicately together as in the Baptistery competition relief of 1402–3 (see fig. 151), which Ghiberti himself at this later date had long outgrown. What is new in Masolino is the quality of the infinite, luminous extent of earth; this will be helpful for the new generation, laden with the immense burden of forms and emotions left to them by the young giant Masaccio.

The Heritage of Masaccio and the Second Renaissance Style

rom our present vantage point, Florence at the time of Masaccio's death seems the undisputed leader of the new style in painting. But in 1428 Masaccio's influence was neither as immediate nor as far-reaching as Giotto's had been or as that of Masaccio's sculptural contemporaries already was. The Florentine situation was not like that in contemporary America, where artists must compete for timeliness in a market that has no mercy for yesterday's ideas. It would be more fitting to compare Florence with Paris of the 1880s, when the paintings by the Impressionists and their successors were bought by a small elite, while historical, classicistic, and genre painters still ran the Salons. Parallel with more progressive styles, the Gothic continued in Florentine painting throughout the 1430s and even the 1440s and 1450s. Altarpieces with gold backgrounds, pointed arches, tracery, and pinnacles were ordered and executed in quantity, as if Masaccio had never lived. He had no close followers of any real quality, but his ideas bore fruit in the work of two important painters who seem younger only because they survived him by decades— Fra Angelico and Fra Filippo Lippi—and in that of other masters born before Masaccio or a decade or so later. In the work of these painters, and in the mature creations of the sculptural rivals Ghiberti and Donatello, we can watch the transformation of the early Quattrocento stylistic heritage into something approaching a common style.

The artists of this second Renaissance style, which flourished in the 1430s, 1440s, and 1450s, lived in and worked for a society that was changing rapidly from the defensively republican Florence of the first third of the Quattrocento. Although hostilities continued until 1454, when the Peace of Lodi put an end to serious external warfare for forty years, the political and territorial independence of Florence was no longer threatened. But its republican integrity was, and by midcentury the oligarchical state, in whose government the artisan class was permitted at least token participation, persisted in name only. Political and economic rivalry had resulted

in the expulsion of Cosimo de' Medici from Florence in 1433. He left as a private citizen; he returned in 1434 as, to all intents and purposes, lord of Florence. Cosimo and his descendants seldom held office, but they maintained themselves in power by manipulating the archaic lotteries that governed the "election" of officials. Until the second expulsion of the Medici, in 1494, a period including two generations, the Florentine Republic was in effect a Medici principality, and the Medici treated with foreign sovereigns as equals. Paradoxically, this period comprised the decline of all the great Florentine banking houses, beginning with that of the Medici, but it also saw the establishment of a new social and intellectual aristocracy among the Medici and their supporters. These humanistically oriented patrons commissioned buildings, statues, portraits, and altarpieces according to their new classical tastes. Augustan elegance replaced the rougher republican virtues predominant in the art of Masaccio, Nanni di Banco, and the early Donatello. Although sumptuary laws still forbade luxury and display in personal adornment, the Medici buildings—the palace and a number of villas—set the tone for a new existence of ease and grace.

At this juncture it is convenient to treat Fra Filippo Lippi (c.1406–69) and Fra Angelico (c.1400?–1455) together. A famous letter gives us authority to do so. It was written from Perugia in 1438 to Piero the Gouty, son and eventual successor of Cosimo de' Medici, by another, presumably younger, painter, Domenico Veneziano, who was then trying to obtain a commission in Florence. Domenico lists Fra Filippo and Fra Angelico as the two most important painters of the day, both overwhelmed with commissions. In their roughly parallel development we can watch the emergence of the new Renaissance style. It is wise to remember, however, that both painters were, by and large, contemporaries of the masters we shall treat in the next chapter, and absorbed in solving much the same artistic problems.

Fra Giovanni da Fiesole, known to us as Fra Angelico, has long been called *Beato* (Blessed) by the Italians,

though he was not actually beatified until 1983. His life of piety and the humility of his religious work rendered the title appropriate. Fra Filippo Lippi, on the other hand, was defrocked, and for the best of reasons. Although Fra Filippo had a personal and visible connection with Masaccio, we know nothing for certain about his early style. We discuss Fra Angelico first because he was, according to all surviving evidence, the leading painter of Florence in the 1430s, and it was he who interpreted the conquests of Masaccio in a form that exercised a profound and lasting influence on Renaissance art.

FRA ANGELICO

In accordance with a tradition preserved by Vasari, Fra Angelico was assumed to have been born about 1387. A notation, now proved false, in the margin of a monastic register led scholars to think that he took his vows as a monk in 1407. Discoveries have shown that in 1417 this prolific artist was still a layman named Guido di Pietro. already receiving commissions as a painter. Not until 1423 was he mentioned as Fra Giovanni da Fiesole. Depending on his age at the time of his vocation, he must have been born sometime between 1400 and 1402. He was therefore only in his middle fifties at the time of his death in 1455. For the span of more than a generation, he was an artist in the service of the Dominican Order, first in San Domenico in Fiesole and then in San Marco in Florence under the priorate of an extraordinary individual, Antonino Pierozzi, later to become archbishop of Florence and to be canonized in the sixteenth century as St. Antonine of Florence. Eventually, Fra Angelico succeeded St. Antonine as prior of San Marco. Even before his death Fra Giovanni was extolled by a Dominican

205. FRA ANGELICO. Head of Christ, detail of *Descent from the Cross* (see colorplate 27). Probably completed in 1434. Panel. Museum of S. Marco, Florence

writer as "the angelic painter," which is the source of the name by which he is now universally known.

The earliest fully Renaissance painting by Fra Angelico is his Descent from the Cross (colorplate 27). This work was commissioned by Palla Strozzi from Lorenzo Monaco for the sacristy of the Church of Santa Trinita, so that its subject, the Sacrifice of the adult Christ, would complement and fulfill that of the exhibition of the Christ Child in Gentile's Adoration of the Magi (see colorplate 22), painted for the same room. Lorenzo was able to complete only the painting of the pinnacles before his death in 1425, and at some later date the unfinished work was given over to Fra Angelico. The painting of the central panel may have been started in the early 1430s and must have been well under way or even finished by November 1434, when Palla was exiled from Florence for good. If this dating is correct, Fra Angelico's Descent from the Cross represents the first successful Italian attempt to set a group of figures into a harmoniously receding landscape space rather than on the foreground stage used by Masaccio.

At first sight the artist seems hampered by the preexistent frame. Then one realizes with what skill Fra Angelico has exploited the Gothic arches for the purpose of his Renaissance composition, utilizing the central panel for the Cross and the ladders, and anchoring the corbels to the gates of the city of Jerusalem on one side and to a grove of trees on the other. This monastic painter presents us with a perfect world, in which every shape is clear and every color bright and sparkling. But the preternatural grace and delicacy of Angelico's forms and colors do not diminish either the slow intensity of the drama or the bite of visual reality. Christ is gently lowered from the Cross by Joseph of Arimathea and Nicodemus, received by John, Mary Magdalen, and others, and mourned by the kneeling Virgin and the Marys on the left, and on the right by a group of men in contemporary Florentine dress. The young man kneeling in adoration and the older man wearing a red cappuccio and exhibiting the crown of thorns and the nails are characterized as beati (blessed) by gold rays emanating from their heads. Under this guise the older man may be a portrait of Palla Strozzi, the youth his son who died at sixteen, and the other standing figures members of the Strozzi family.

All of the figures are grouped on a flowering lawn, and Golgotha is reduced to a symbolic rock. All are united by their common adoration of the sacred body, depicted with Fra Angelico's characteristic reticence and grace. His superior, St. Antonine, was to preach and write about horrifying details of the agony of Christ. But in Fra Angelico's reserved rendering one barely notices the stripes of the scourges on Christ's torso or the blood from the crown of thorns on his forehead. All attention is concentrated on the quiet face (fig. 205), of a poignant beauty, across which glides a gentle light that dwells on the partly open lips, the nostrils, the closed eyelids, the

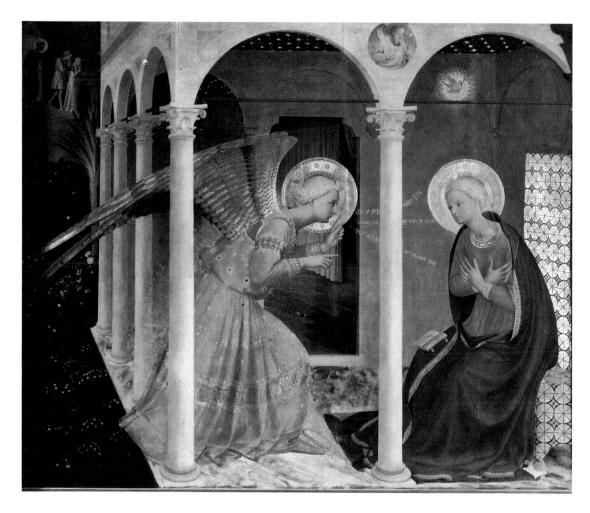

206. FRA ANGELICO.

Annunciation
(altarpiece for S.
Domenico, Cortona).
c. 1434. Panel,
63×71". Museo
Diocesano, Cortona

arching brows, and the silky surfaces of waving hair and beard.

The other personages are reduced to quasi cylinders, as hard as Giotto's figures, yet illuminated with such clarity that their three-dimensional reality is striking. Fra Angelico's method of stylization presents the distant Jerusalem as an array of multicolored cubic and pyramidal shapes revealed in light, crowned by a zigguratlike castle. He even contrasts the huddled buildings within the city walls with the straggling houses outside the extremely Florentine gates, where the farms and orchards begin. A storm cloud threatens the city, casting shadow over some of it. On the right-hand side of the panel, ilexes, a palm, and a cypress provide a loose screen through which one looks into a Tuscan landscape of billowing hills punctuated by towns, villages, farmhouses, castles, and villas irradiated in the long, low light, then up to a sky filled with soft clouds. A work of the utmost beauty whatever its date, Fra Angelico's Descent from the Cross was a milestone in the early 1430s. At that moment, no painter in Europe save Jan van Eyck could surpass his control of the resources of the new naturalism, and none could match his harmony of figures and landscape forms.

Among the works by Fra Angelico dating from the 1430s, the best known is the splendid *Annunciation* now in the Museo Diocesano in Cortona (fig. 206), painted

for the Church of San Domenico in that ancient Tuscan town on a promontory high above the Chiana Valley. Opinions still vary about the date of the altarpiece, but the latest evidence favors a dating about 1434. Fra Angelico has set the scene in a portico of slender Corinthian columns that more resemble the colonnettes in the mullioned windows of mid-Quattrocento palaces than the cylinders being planned at that moment by Brunelleschi (see fig. 141), and they lack most of Brunelleschi's learned apparatus of classical detail. Fra Angelico has divided his panel vertically into thirds; two are occupied by arches of his portico, the other by a receding perspective of three more arches and a little garden. The angel enters the portico, bowing and genuflecting before Mary as he delivers his greeting. Mary, seated on a chair draped with gold brocade, abandons the book on her lap to cross her hands on her breast in acceptance of her destiny. Gabriel's words run from left to right, as they should, but Mary's reply (Luke 1:38), "Behold the handmaiden of the Lord; be it unto me according to thy word," since it must be read from Mary to the angel, is written upside down. The angel's words are not those customarily given, but the later verse (Luke 1:35), "The Holy Spirit shall come upon thee, and the power of the Highest shall overshadow thee." Directly above Mary's head, in the shadow under the blue, star-studded ceiling of the portico, floats the dove of the Holy Spirit emitting

golden light, while the sculptured portrait of the prophet Isaiah looks down from a medallion in the spandrel. Behind the angel's head, through a doorway and past a partially drawn curtain, one sees Mary's bedchamber.

The garden at the left, a symbol of Mary's virginity that will reappear in a host of Annunciations throughout the Quattrocento, illustrates the words of the Song of Songs, "A closed garden, my sister, my spouse." Following St. Antonine's doctrine of the "garden of the soul," the life and environment of religious meditation recommended by the saint (who had been repeatedly connected with the Dominican community in Cortona) in his works in Italian intended for his penitents, Fra Angelico protects the little plot with a fence. Mystically, he has also identified the garden with Eden, for at the upper left we see the weeping Adam and Eve being gently but firmly expelled. This association is natural enough since, according to St. Paul, Christ is the second Adam and, by extension, Mary the second Eve. What a change from Masaccio's tragic vision (see fig. 197) of the Expulsion in the Brancacci Chapel! Angelico avoids not only Masaccio's dramatic action but also the nudity, and clothes our first parents in the coats of skins that the Lord God made for them, according to Genesis. Fully aware of Masaccio's method of constructing forms and spaces, Fra Angelico nonetheless restrains chiaroscuro as firmly as he does emotion. His figures are barely corporeal. Slender and refined, their limbs are only just discernible under their enveloping garments. Their faces are drawn with the utmost purity and adorned by exquisitely tended blond hair, and they wear simple but still gold-edged clothing; their physical existence is rendered visible by the subtlest gradations of lighting. The perfectly poised shapes, the flawless rhythms of contour, the harmonies of space and light are summed up in the freshness of Fra Angelico's color. Supplied with wings like plates of beaten gold, the angel is dressed in a tunic of clear, bright vermilion; the wings are barred with red feathers, the tunic with bands of gold embroidery. Mary's blue mantle contrasts with the sparkling folds of her cloth of honor, as the snowy columns do with the richly veined marble of the floor, or the white steps with the flowered lawn. As remote from the world as the imagination of a sensitive child, Fra Angelico's masterpiece, perhaps for that very reason, admits us to a realm of unmarred celestial beauty.

In the predella scenes, however, the real world reappears. The Visitation (colorplate 28) leads the eye downward from the curving drapery lines of the two cousins to where an old woman labors up the hill toward us; then past her to depths gulfing away, more felt than seen, their distance enhanced by cloud-shadows. Mary "went into the hill country with haste" (Luke 1:39), and a glance at St. Antonine's Summa shows that he attached particular importance to this hilly background for what is, in effect, the first recognition of the divinity of Christ—the prenatal joy of John the Baptist in the womb

of Elizabeth. The background elements are identifiable as the town of Castiglion Fiorentino, the distant tower of Montecchi (still visible to travelers between Florence and Rome), and the wide lake (see fig. 446) that then filled the Chiana Valley—perhaps the earliest recognizable portrait of a known place as distinguished from the customary jumble of assorted monuments. Beyond the sun-drenched town the plain fuses with the sky in imperceptible gradations of summer sunlight and ocher haze. The spatial experience of landscape is realized more fully in this tiny panel than in any previous Italian work.

In 1436 the decaying buildings of San Marco in Florence were taken from a negligent order of Sylvestrine monks and given to the Dominicans of Fiesole. Beginning in 1438, the Dominicans, supported by contributions from Cosimo de' Medici, employed Michelozzo (see fig. 149) to effect a complete rebuilding of the church and adjoining monastery. Pope Eugenius IV was present at the consecration of the church in 1442, under its new prior St. Antonine. For the high altar Fra Angelico painted a superaltarpiece, probably installed by 1440 (fig. 207). In this work the artist, too often considered a reactionary figure, showed himself abreast of the latest contemporary art theory and worthy of the high rank accorded him by Domenico Veneziano in his letter to Piero the Gouty of 1438.

In spite of a disastrous overcleaning in the remote past, the principal panel is still a wonderful work. The gold curtains, their loops continued across the top of the picture in festoons of pink and white roses (the rosary was a Dominican invention), part to show the court of Heaven united in a garden of paradisiac splendor. At the center, so placed that all perspective lines converge upon her, the Virgin is enthroned in a Renaissance niche whose Corinthian order is so closely related to portions of Michelozzo's architecture at San Marco as to suggest that he may have shown Fra Angelico how such things should be designed. Gold brocades curtain the throne and provide a barrier over which one looks into a grove of fruit trees, cedars and cypresses, palms and roses, for Christ is the fruit of the Tree of Life, and Mary, according to a symbolism derived from the apocryphal Book of Wisdom, is a cedar of Lebanon, a cypress on Zion, a palm in Cades, and a rose tree in Jericho. Before the throne a circle of angels and conversing saints gathers on the steps and on the Turkish carpet whose divisions provide the converging orthogonals of the perspective construction. In the foreground the circle is continued by the kneeling patron saints of the Medici, Cosmas and Damian, and completed by a small simulated panel of the Crucifixion, a picture within a picture. This device establishes the picture plane from which the construction is projected, and also reminds the observer that only the Cross admits him to Paradise. (St. Antonine is explicit on this point.)

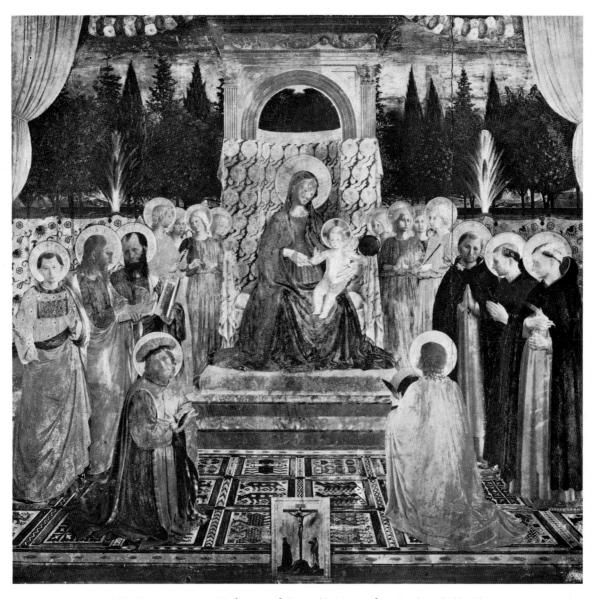

207. FRA ANGELICO. *Madonna and Saints* (S. Marco altarpiece). c. 1438–40. Panel, 86% × 89%". Museum of S. Marco, Florence

Clearly the composition, the Madonna with a group of conversing saints, is the ancestor of innumerable representations of the so-called Sacra Conversazione (sacred conversation), so dear to Renaissance patrons and painters. It is less often observed that the perspective construction over rising levels, the lofty central arch, and the pyramidal grouping of serene figures within a circle seen in depth are the nucleus of Raphael's School of Athens (see fig. 536). Very possibly Fra Angelico's painting and other centralized, multifigural compositions within an architectural perspective, such as Ghiberti's almost contemporary Meeting of Solomon and the Queen of Sheba in the Gates of Paradise (see fig. 236), had a strong influence on the young Raphael when he worked in Florence in the early Cinquecento. Both Ghiberti and Fra Angelico must have witnessed solemn group conversations on exalted themes, for in 1439, when this picture was being painted, the Council of Ferrara moved to Florence, and under Brunelleschi's recently completed dome the Eastern and Western Churches attempted to heal their division.

More completely than any work of Fra Filippo Lippi, Fra Angelico's San Marco altarpiece embodies the ideals of the new phase of the Florentine Renaissance. The pictorial space, measured by systematic perspective from the foreground plane to the horizon seen beyond the trees, provides a place and a dimension for every person and thing. The space is projected by dividing the lower edge of the painting into equal segments, represented by the squares in the carpet, then drawing orthogonals from these segments to the central vanishing point. One of the foreground saints looks outward as he unobtrusively points with his right hand, directing our eye into the center of the picture. These devices correspond exactly, as we shall see, to the doctrines of Leonbattista Alberti, who had arrived in Florence a few years before and had circulated, only two or three years before this picture was painted, the Italian version, Della pittura, of his

208. FRA ANGELICO. Miracle of the Deacon Justinian, on the predella of the S. Marco altarpiece. Panel, $14\frac{1}{2} \times 17\frac{3}{4}$ ". Museum of S. Marco, Florence

work De pictura (On Painting). In spite of the ruinous condition of the panel, the broad, harmonious movements of the drapery masses in space may still be made out. Details such as the luminous pearls that adorn the vestments of St. Lawrence at the extreme left show Fra Angelico's awareness of the mystical meaning of jewels as embodiments of divine light in the works of the Van Eycks, some of which may well have appeared in Florence by the late 1430s.

In the numerous panels preserved from an unusually extensive predella, representing in detail the legend of Sts. Cosmas and Damian, Fra Angelico displayed his versatility in handling figures, and also the natural world with its luminous and atmospheric effects. At first sight the interiors seem to be standard Trecento boxes, as in the Miracle of the Deacon Justinian (fig. 208), showing the deacon's gangrenous leg exchanged for a healthy one in a dream by the two saints who float in trailing soft clouds. The space is, however, illuminated naturalistically by light coming in from the front and slightly left, so that the upper frame casts a shadow across the right wall. A second source of light is the tiny window on the left wall, through whose bottle-bottom panes light filters onto the embrasure. A third is the light reflected upward from the floor; and there is a fourth, in the corridor just visible through the open door at the right. In the separate effects of light from these four sources, in their interplay on walls, furniture, curtains, the red and blue gowns of the saints, and the humble objects of still life, and in the delicacy with which these lights suffuse the shadows Fra Angelico has produced a triumph of observation.

Fra Angelico's landscapes are even more original than his interiors. The predella panels include several scenes representing thwarted attempts to martyr Sts. Cosmas and Damian, culminating in their successful beheading (fig. 209), a scene staged against a Florentine landscape of crystalline beauty. In the foreground, on a road bordering a flowery meadow, the bodies of the two saints and their severed heads, still bearing haloes, tumble on the ground. One of their three younger brothers still kneels, his neck spouting blood, his head rolling beside the others. The other two, blindfolded and resigned, await the executioner's sword. The suavity of the poses of the standing and moving figures, and the understatement of their facial expressions, ranging from the remorse of the officer to the calm brutality of the soldiers, display the artist's penetration into both physical and psychological activity. The execution, the like of which could doubtless often be witnessed in the Florence of Fra Angelico's day, takes place, with all the ghastly irrelevancy of a modern traffic accident, among the sunlit spaces and clear-cut cubic or curving forms of the walled city and the Tuscan hills, crowned by castles and villas, which rise range on range into the sky and the floating clouds. The five characteristically Florentine cypresses, their lower branches pruned to reveal long, slender trunks, possibly symbolize the five martyrs. But their aesthetic function, as in the Descent from the Cross (see colorplate 27), is that of a screen against which to measure the extent of the landscape; nothing like its convincing continuity had ever been seen in postantique painting, not even in the Netherlands.

Fra Angelico and his assistants, probably also monks, were required to provide—certainly under the direction of the prior, St. Antonine—paintings for the monastery of San Marco-chapter house, corridors, doorways, even the forty-four monks' cells, all executed rapidly between the end of 1438 and late 1445, when Angelico left for Rome. Recent cleaning has removed much repaint from some of these frescoes and has revealed an unsuspected luminosity of color in all. Their style differs sharply from that of the altarpieces for public view, and there is even a distinction between the frescoes destined for the monastic community as a whole and those in the

209. FRA ANGELICO. Beheading of Sts. Cosmas and Damian, from the predella of the S. Marco altarpiece. Panel, 141/4 × 18". The Louvre, Paris

individual cells. At the head of the staircase, which every monk used many times a day, the master himself painted the most famous (fig. 210) of his numerous versions of the Cortona Annunciation (see fig. 206), this one supplied with the monitory inscription, "As you venerate, while passing before it, this figure of the intact Virgin, beware lest you omit to say a Hail Mary." As befitted not only the fresco medium but also the monastic destination of the picture, the bright colors and gold of the Cortona altarpiece give way to pale, chaste tints. Moreover, the architecture is now seen directly from the front, so that the lateral columns recede toward a single vanishing point placed slightly to the right of center in the visual field. The step is drawn as one of the orthogonals of a

visual pyramid projected from the foreground plane, in accordance with Alberti's perspective theory. The greater weight of the columns and the care with which the capitals are rendered probably witness Fra Angelico's interest in Michelozzo's architecture, then in construction all about him. But one may wonder whether Michelozzo approved the use of four Corinthian and four Ionic capitals in the same portico!

The mood here is calmer and more contemplative than in the ecstatic Cortona Annunciation. Mary holds no book; she has apparently been meditating rather than reading. She sits on a rough-hewn, three-legged wooden stool, and her clean chamber, stripped of furniture, looks on the world through a barred window. The fence

210. FRA ANGELICO. Annunciation. 1438-45. Fresco. Monastery of S. Marco, Florence

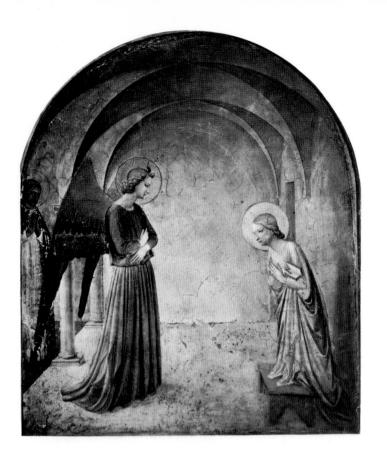

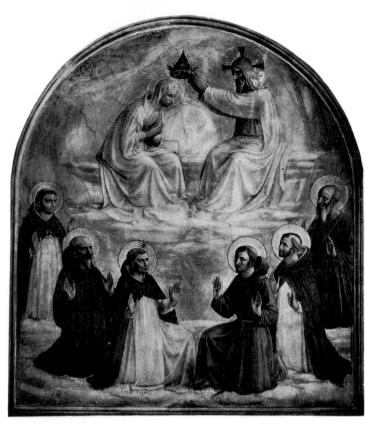

around her Antonine "garden of the soul" is higher and stronger, and one is reminded of St. Antonine's admonition to sweep clean the room of one's mind, and to distrust the eye, the window of the soul. "The death of sin comes in at the windows, if they are not closed as they ought to be," says Antonine in analyzing the Annunciation. Fra Angelico has made the window the eye of his fresco, the center of perspective lines (this same barred window appears in Giotto's *Annunciation* in the Arena Chapel; see figs. 59, 60).

Within the monks' cells, the awed observer penetrates into ever deeper regions of the soul. Each fresco is about six feet high and, like an image from a projector, floats on a white wall under the cell's white groin vault. Everything in these images is pure, clean, disembodied. The world retreats, and only the single meditative subject is suspended in the almost empty cell. The Annunciation (fig. 211) shows a standing angel and a kneeling Virgin who holds her open book to her breast. The angel has entered with the light, which falls on the Virgin; both are united with the rising and falling rhythms in the painted architecture, an expansion of the cell itself. There is no garden, and outside the arcade only St. Peter Martyr witnesses the event, a surrogate and example for the monastic denizen, who, under the hypnotic influence of the pale colors, clear shapes, and harmonious spaces, experiences in himself the miracle of the Incarnation. The Coronation of the Virgin (fig. 212), a sublime occurrence in an icy heaven, glitters with the colors of snowreflected light in the lilacs and greens that vibrate softly throughout the cloudy throne and the glowing white of the garments. Christ places a crown on the head of the reverent Virgin seated on his right, her hands clasped on

her breast as in the *Annunciation*. Franciscan and Dominican saints, knowing the miracle without having to see it, kneel below in adoration, disposed in an arc on the floor of clouds. The *Transfiguration* (fig. 213) becomes at once a revelation of Christ's divinity and a prophecy of the crucified and risen Lord. He stands, arms spread, enveloped as in the Gospel account by "raiment white and glistening," its shapes as severe as the folds of a Roman toga. He is surrounded by a mandorla, composed of the unaltered white *intonaco*, above the Apostles represented in smaller scale, their clear drapery folds curving to one or another side as they fall in terror before him.

The cell frescoes were painted *after* those affirmations of Renaissance style that are embodied in the altarpieces we have seen, as well as in a parade of panels with which Fra Angelico filled the 1430s. Superficially, these more meditative images may appear as regressions to the Middle Ages. True, in the visions of the San Marco cells, operating largely through austere color and purified shape, no worldly concerns trouble the spirit. In each painting, however, Fra Angelico probes keenly into the sensibilities of the individual observer, as Donatello had done in his psychological sculpture (see figs. 162, 170); and in each fresco the individual is the center, as he is in the Renaissance perspective system. In this deeper sense, therefore, these paintings are fully Renaissance. Rather than looking back to the Middle Ages (and they recall no known medieval prototypes), the frescoes of the San Marco cells may be considered prophetic of the mysticism of seventeenth-century painters, such as the personal revelations by El Greco, Rembrandt, and, above all, Zurbarán.

In 1445 Fra Angelico was called from his monastery to

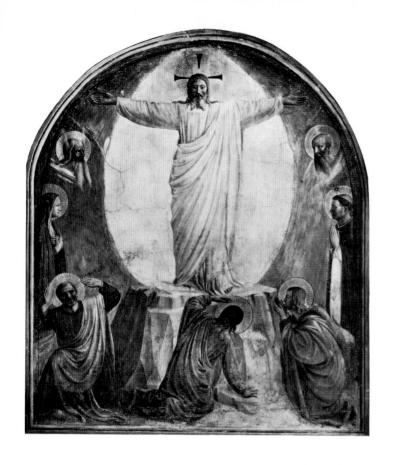

a grander plane. Pope Eugenius IV, expelled from Rome in 1433 by the rebellious populace, had taken refuge in Florence where, for ten years, he held court. After the consecration of San Marco in 1443, the pope slept at that monastery in the cell of Cosimo de' Medici, already frescoed by Fra Angelico, and became acquainted with his work. After his return to Rome, the pope found a new field for the painter, who at that time was unrivaled in Italy. For five years Fra Angelico continued to work in Rome under Eugenius and, in 1447, his successor, the humanist Pope Nicholas V, embellishing the reconstructed buildings of the papal city. We read of an altarpiece for the high altar of Santa Maria sopra Minerva, a large frescoed chapel for St. Peter's, a study and two chapels for the Vatican. Most of these have disappeared: the private chapel of Nicholas V is now the solitary witness to Fra Angelico's achievements in the Eternal City.

The chapel is frescoed with scenes from the lives of two deacon martyrs, St. Lawrence and St. Stephen,

opposite left: 211. Fra Angelico. Annunciation. 1438–45. Fresco. Monastery of S. Marco, Florence

opposite right: 212. FRA ANGELICO. Coronation of the Virgin. 1438–45. Fresco. Monastery of S. Marco, Florence

above: 213. FRA ANGELICO. *Transfiguration*. 1438–45. Fresco. Monastery of S. Marco, Florence

right: 214. FRA ANGELICO. St. Lawrence Distributing the Treasures of the Church. 1448. Fresco. Chapel of Nicholas V, Vatican, Rome

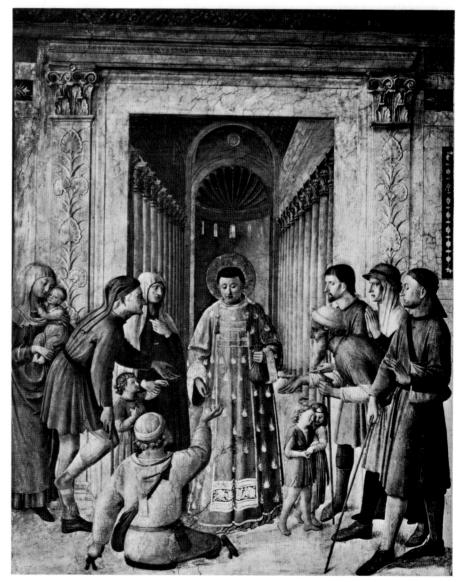

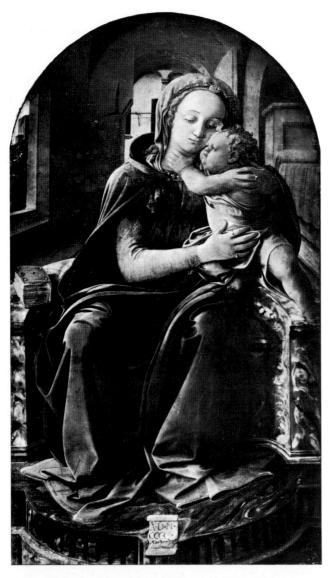

215. FRA FILIPPO LIPPI. *Madonna and Child* (Tarquinia *Madonna*). 1437. Panel, $45 \times 25 \frac{1}{2}$ ". National Gallery, Rome

painted by Fra Angelico in 1448 with the help of numerous assistants. In these cycles the artist displays the range of his ability to handle figures in architectural and landscape settings and, despite the modest scale of the chapel, the subject matter of the individual scenes leads him to endow them with a new and very Roman grandeur. One of the finest is St. Lawrence Distributing the Treasures of the Church (fig. 214). The saint, whose dalmatic is decorated with golden flames referring to the fire of his martyrdom, stands before the open Renaissance portal—no longer in any way Brunelleschian-of a basilica that was doubtless intended to suggest St. Peter's as it was to have been restored by Nicholas. The monolithic columns, for more than a millennium part of the common experience of Christianity, are represented in all their solemnity. From there on the details are invented—a vaulted ceiling painted blue and decorated with gold stars, impossible to set on the fragile and tottering Constantinian structure; a groin-vaulted crossing; and an apse with a conched semidome—all representing no more than the current architectural taste at the papal court. The illusion of space is so persuasive that one notes with surprise that Fra Angelico has retained the Trecento double scale for figures and architecture. His strict sense of form, his habitual reserve, and the simplicity and strength of his patterns endow the assembly of paupers and cripples with no less a majesty than that of the great colonnade opening behind them. And as age, misery, weariness, and disease are represented without sentimentality, so is the delight of the two children in the largesse they have received. In the chapel of Nicholas V, and doubtless in the vanished frescoes of Fra Angelico's Roman period, he proved himself one of the great Florentine masters of form and space, and a worthy precursor of Piero della Francesca, who must have studied these works with care. Aside from those of this one period, few of Fra Angelico's works seem to have been lost; our selection from an embarras de richesses has been made to show crucial phases in the development of the style of this master, who was considered at the papal court as "famous beyond all other Italian painters."

FRA FILIPPO LIPPI

He was born about 1406—thus about half a decade later than Fra Angelico—into the large family of an impoverished butcher, in the poor quarter surrounding the monastery of the Carmine in Florence. Together with an equally unwanted brother, he was entered at that monastery at an early age, and took his vows in 1421. He is said by Vasari to have decided to become a painter when he watched Masaccio at work in the Brancacci Chapel in Santa Maria del Carmine. The mistake of making Filippo a monk was compounded by his appointment to the chaplaincy of a convent in Prato, where, according to Vasari, the middle-aged Filippo's attention was deflected from the Mass he was celebrating by the charms of a young nun named Lucrezia Buti, whose religious dedication seems to have been no stronger than his own. We know from an anonymous denunciation, made to the Office of the Monasteries and of the Night, that from 1456 to 1458 Lucrezia, her sister Spinetta, and five other nuns were living in Filippo's house. During this period Lucrezia presented Filippo with a son, later to become the painter Filippino Lippi, and although she returned to the convent, their relations by no means ceased, and a daughter, Alessandra, appeared. There was other trouble: patrons claimed that Filippo did not fulfill his contracts; an assistant, Giovanni di Francesco, claimed that he was not paid; Filippo found himself in difficulty with ecclesiastical and secular authorities, and he was tried and even tortured on the rack. Had it not been for the intervention of Filippo's principal patron, Cosimo de' Medici, with Pope Pius II, the story might have ended very badly. But Filippo was allowed to marry Lucrezia, and their children were legitimized. Although both Filippo and Lucrezia left their religious communities for good, he still clung to his monastic habit and continued to sign himself Frater Philippus. The irresponsibility of Filippo's life corresponds, in a sense, to the undisciplined quality of his style.

Filippo seems to have accompanied the exiled Cosimo northward in 1433, and in 1434 he was working in Padua. Nonetheless, it is difficult to see in the work done after his return, saturated with Masaccio's influence, any real trace of his North Italian stay.

The first dated painting by Filippo that we know, a Madonna and Child (fig. 215) painted in 1437 for the ancient Etruscan city of Tarquinia (called Corneto during the Renaissance), is the most like Masaccio of them all. The heavy-featured, plebian type chosen for the Madonna, and the simplicity of the domestic interior complete with a bed and a view into a courtyard, are as reminiscent of Masaccio as are the heavy shadows throughout the painting. Only the veined marble throne and the pearled diadem seem out of place. A touch of naturalism is the absence of a halo for either of the sacred figures. But a closer look discerns Filippo's inability to approach anything like the consistency of Masaccio's

style. The powerfully lighted drapery masses in the foreground project erratically, and the interior space seems throttled around the center. As will be seen in all his paintings, Filippo was unable to paint hands convincingly. And the homely gestures and attitudes natural in Masaccio are here forced, even gross, especially the grasp of the Child, who seems to be reaching for his mother's throat. The most striking feature of the style is the reappearance of contour. Apparently, Masaccio's chiaroscuro did not seem sufficient to Filippo, for around every form he supplied hard, drawn edges, accenting them by gradation of tone to give them the look of sharp lines. Yet for all its uncertainties the painting is a compelling work, filled with the wistful melancholy that was to characterize many of Filippo's compositions.

In the same year as the Tarquinia Madonna, Filippo began the splendid altarpiece for the chapel of the Barbadori family in the Church of Santo Spirito in Florence (fig. 216). Clearly it is this work that Domenico Veneziano, in his letter of 1438, said would take Filippo at least five years to complete. The panel shows the Virgin standing before her throne in a kind of courtyard above

216. FRA FILIPPO LIPPI. Madonna and Child with Saints and Angels (Barbadori altarpiece). Begun 1437. Panel, $7'1\frac{1}{2}'' \times 8'$. The Louvre, Paris

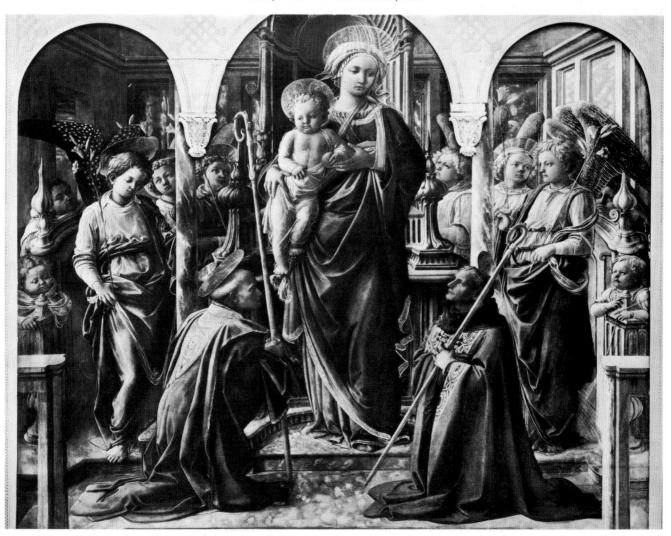

whose surrounding cornice blue sky can be seen. The architecture is Renaissance in every detail, however capricious, and the pointed arches of a Gothic triptych have been discarded in favor of round ones. The Virgin uses a sling to hold her Child quite casually on one hip, as Italian mothers still do. Before her kneel Sts. Fredianus and Augustine, and youthful, blond angels throng about them. The picture is suffused with Masaccesque shadow that is softer and richer than in the Tarquinia Madonna. The coloring, smoldering and subdued, is typical of the tones of Filippo's early work: soft, deep greens, sonorous, metallic reds, and smoky plum tones predominate. The clear yellow of one little angel to the Virgin's left, or the surprising orange-red of the Virgin's tunic, here and there pierce and enliven this chromatic scheme, as do occasional touches of metallic gold. The haloes of Mother and Child, apparently for the first time in Italian painting, seem made of transparent crystal flecked with gold, not the usual disks of solid metal.

As in the Tarquinia Madonna, the proportions of figures and faces are full and heavy, and the masses are strongly projected by means of chiaroscuro but more successfully integrated. In fact the pyramidal composition of the central figures is imposing. The child-angels

217. FRA FILIPPO LIPPI. Madonna and Child. c. 1455. Panel, 351/2 × 24". Uffizi Gallery, Florence

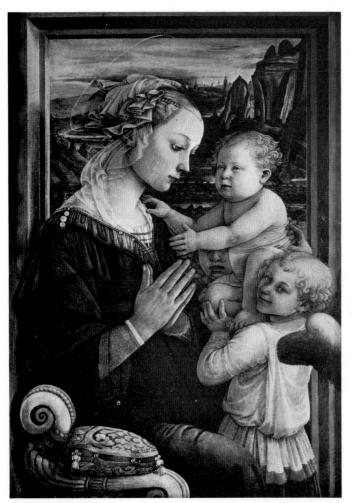

look like neighborhood youngsters dressed up and supplied with wings and lilies, as we know they were for festival occasions. At the Carmine, for example, Filippo could witness the Ascension of Christ each year, reenacted for the pleasure of the local population: a hole cut in the vault made it possible for "Messer Domenedio" (as the documents call him) to sail through the crossing vault right in front of the Brancacci Chapel. And the nearby Church of San Felice put on a similar annual show, designed by Brunelleschi himself, dramatizing the Annunciation. The angel Gabriel came down in a copper mandorla in the midst of the church, ran across a stage in front of the altar, delivered the angelic salutation to Mary waiting in her little habitation, listened to her reply, then reascended into a blue dome lined alternately with lighted lamps for stars and with living child-angels standing on clouds of carded wool, held in by iron bars so that they could not fall even if they wanted to (says Vasari). The flavor of these popular festivals animates Filippo's paintings. And deep in the shadows that play over these chubby-cheeked angels one can make out at the extreme left, chin on balustrade, the coarse yet dreamy features of Filippo himself in his early thirties, in Carmelite habit, looking out at the observer.

Perhaps the finest of these early paintings is the Annunciation (colorplate 29), still in its place in San Lorenzo and in its original Brunelleschian frame. The flattened, or reverse, catenary arches painted inside the frame, supported on the central lofty pier, are a bit surprising, as if Filippo were unable to relinquish entirely the Gothic division of an altarpiece into separate panels. But he gives us as a background a magnificent perspective into a monastery garden, at once the garden of the Temple with which Mary was connected, and the Closed Garden of the Song of Songs, an age-old symbol of her virginity, which will reappear in numerous Quattrocento paintings. Cecil Gould has shown that Mary's agitated pose as she stands at the reading desk is derived from the Annunciation by Donatello in Santa Croce (see fig. 245), but the mood of the picture has little to do with that stern sculptured monument to classicism. As yet unexplained is the presence of the two curly-haired, puffy-faced angels in the left-hand panel, not required by the text. One lifts his hand in wonder as he looks downward, the other gazes out over his shoulder at the observer and points to the Annunciation—a device to lead the observer's eye into the painting that was authorized by the influential theorist Leonbattista Alberti, who had, as we shall soon see, recently arrived in Florence. A captivating feature of the picture is the crystal vase in the foreground, from which Gabriel has apparently just plucked the lily of Mary's virginity. There was no room for the vase on the floor, where it would have conflicted with the figures, so Filippo carved out a false niche so that the vase could appear to rest on the frame. With its shining water and soft shadow, it creates a microcosm

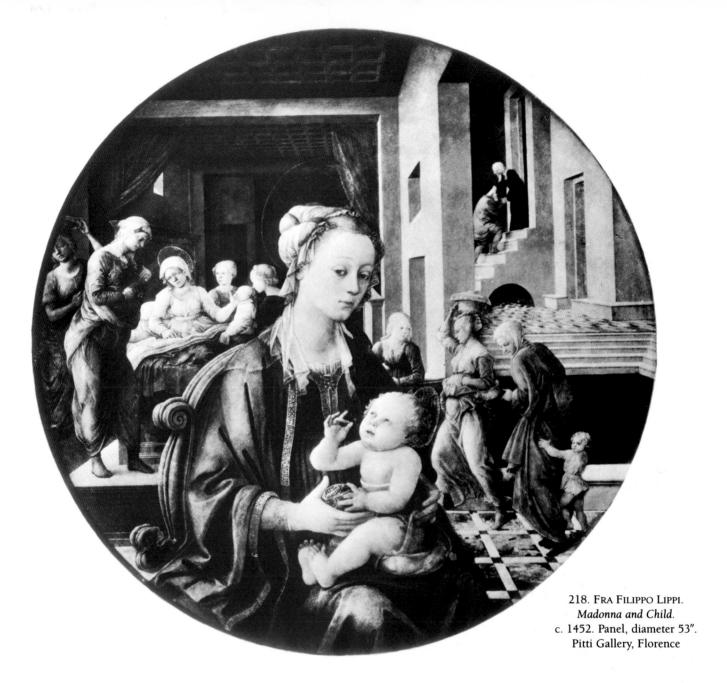

that contrasts with the expanse of the softly painted garden, with its flowers, trees, and arbor, and the blue sky beyond. It is an effect of the kind one would expect from a Netherlandish rather than an Italian master, but perhaps Filippo had by this time seen paintings by Jan van Eyck. The tones of the drapery of the foreground figures contrast just as surprisingly with the brilliant orange building terminating the garden.

Fra Filippo's Madonna and Child in the Uffizi Gallery (fig. 217) is in keeping with the taste of the new age. Mary is lovelier and more fashionable than any of Filippo's earlier Madonnas. She is seated at the window of a hilltop villa affording a view over a rich landscape of plains, distant mountains, a city, and a bay. With her eyes modestly downcast, she lifts her folded hands in prayer before the Child, held up to her by two angels, one of whom, far from angelic in appearance, grins at the spectator. The elegance of mid-Quattrocento taste may be seen not only in the delicacy of the new physical ideal but also in the refinement of the costume, espe-

cially the headdress, artful in its disarray. Above the combed-back blond hair, its plaits mingled with the transparent linen veil, a chaplet of graduated pearls is carefully arranged to make a nice peak on the forehead, and outshone by the gigantic pearl at the top of the headdress-literally worth a king's ransom. The forehead is an object of special beauty, to be achieved, if necessary, by plucking or even shaving, in extreme cases as far back as the top of the skull. The whole head thus resembles a glowing, beautifully set pearl. St. Antonine of Florence, confessor to the Medici family, explains the "pearl of great price" (Matthew 13:46) as the Incarnation of Christ, which is surely the meaning of this wondrous treasure poised on the Virgin's head, on the line between earth and sky. Behind the Virgin's head we look off to the sea, and over that of the Christ Child tower lofty rocks, one of which seems about to fall. In the same chapter Antonine refers to Mary as the sea (see page 186) and expounds the prophecy of the Virgin Birth seen throughout the Middle Ages in a vision of the prophet Daniel (2:31-35), who saw a stone cut without hands, which fell from a mountain, smashed the idol with feet of clay, and then grew to be a mountain that filled the whole earth. The smiling angel holds the Christ Child by his right thigh, and Antonine in the same chapter refers to the passage in Revelation (19:16) that describes Jesus as having "King of Kings and Lord of Lords" written on his thigh. But the religious symbolism of the picture is subordinated to Filippo's enthusiasm for the beauties of light and atmosphere, rocks and fruitful plains, cities and soft cloud masses, lovely young women and healthy babies, tasteful garments and splendid furnishings. Needless to say, Masaccio's chiaroscuro has vanished along with the solemnity of a bygone way of life, and figures are illuminated by a soft, all-over glow without harsh shadows, considerably reducing the sense of volume so striking in Filippo's earlier works.

Another Madonna more concerned with the satisfactions of this life than the promise of the next is the delightful tondo (circular picture) now in the Pitti Gallery, probably the one on which Filippo was working in 1452 for the prosperous merchant Leonardo Bartolini (fig. 218). The tondo became a popular shape for domestic religious images in the Quattrocento, but despite recent investigation its origin and precise meaning remain obscure. It has been derived from the mirror, characteristically circular in the Middle Ages and the Renaissance and an age-old symbol of the Virgin. But it might with equal propriety be related to the painted birth-salvers, wooden plates generally presented to highborn ladies on the delivery of a child, especially in the present instance, for the architectural background consists of the rooms of a patrician domestic interior of the Quattrocento. On the left side the birth of the Virgin is depicted as if it had occurred in the Renaissance house of a well-to-do Florentine family, attended by maidservants carrying gifts. At the upper right there is a staircase on which St. Anne receives the returning Joachim. The fabric of planes and volumes, resulting from the severe wall surfaces, splendid inlaid marble squares of the floor, coffered ceilings, and steps of varying breadth and pitch, creates one of the finest spatial compositions this usually uncontrolled artist ever achieved. The youthful Virgin sits at the focal point of all the perspective—which conforms to the usual rules—but offcenter in the tondo. She was certainly drawn from the same model as the Uffizi Madonna, a creature of winsome delicacy and grace, looking shyly yet knowingly out at the observer. Her Child holds a cut pomegranate with one hand, and is about to pop a seed into his mouth with the other. Like Masaccio's grapes (see figs. 187, 202), this realistic motive has a religious meaning; the pomegranate is red like the blood of Christ, and its seeds are held within its shell like individual souls within the encompassing Church. In the elegance and wistfulness of this painting, surely the high point of Filippo's mature style, the sources of Botticelli's art can already be discerned.

Fra Filippo left two splendid fresco cycles. The frescoes that fill the chancel of Prato Cathedral were executed over a considerable period, from their enthusiastic inception in 1452, through the date of 1460 found on one of the frescoes, into 1464, when the officials of the Cathedral (then still a parish church) complained bitterly to Carlo de' Medici that Filippo had not completed the job, up to at least 1466, when the elusive painter left for his final undertaking at Spoleto. Much of the work was done from Filippo's designs by his pupil, Fra Diamante, and many of the compositions are unconvincing. But the soft, rich, blue-green tonality dominating the series unites them in spite of their defects. And everywhere they overflow with fascinating details, showing the human sweetness and warmth of Filippo at his best. The Life of St. John the Baptist, for example, that unrolls in many episodes through an uncoordinated landscape, contains such moving bits as the scene (fig. 219) where the boy says farewell to his family before going off into the wilderness—a largely linear composition, which still contains a few echoes of Masaccio's grand drapery style.

The handsomest of the scenes is also the latest, the Feast of Herod (fig. 220), a work of great originality. A splendid garden courtyard is the setting for the celebration, floored with inlaid marble in a pattern that contributes the basis for a commanding perspective. The bordering walls are constricted toward the rear in a shape somewhat like that of the throttled space in the Tarquinia Madonna (see fig. 215), and shrubs and trees appear above balustrades or are set in front of walls. The perspective lines shoot inward past the central table of Herod himself, seated directly below the arms of the wealthy Datini family, donors of the cycle, to windows opening on a view of a rocky landscape with a distant city. On this gorgeous stage the action moves in three episodes. At the left, cut off from the festivities by a gigantic man-at-arms, Salome receives on a platter the head of St. John the Baptist, from which she looks away (the actual decapitation, impossible to photograph, is painted around the corner of the chancel, in the semidarkness next the window). In the center she does her little dance, oddly unsteady, poised on her left foot, while her right foot, right hand, and assorted ribbons saw the air. This touchingly awkward figure, for all its shortcomings of draftsmanship, is the direct ancestor of the most refined motion-poses of Fra Filippo's pupil Botticelli (see colorplate 45). At the right Salome kneels, still not looking at the head she presents to Herodias, and at the extreme right two servants clutch each other as one stealthily turns to gaze.

Fra Filippo was scarcely the artist for the Medici to select to paint a series of penitential pictures, but possi-

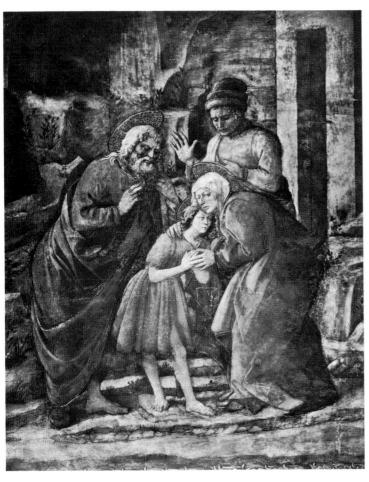

219. FRA FILIPPO LIPPI. St. John the Baptist Bids Farewell to His Family. 1452–66. Fresco. Cathedral, Prato

bly in the late 1450s he was in no position to refuse. The flourishing world of the Renaissance had taken, at this time, a disagreeable turn. In 1448, one hundred years after it first appeared in Florence, the Black Death reemerged in a severe form, and returned annually for three summers. Thousands of Florentines succumbed, and the hordes of Northern pilgrims to the papal jubilee of 1450, passing through Tuscany, carried the plague with them and died miserably in the streets of Rome. As fortune would have it, the archbishop of Florence at this time was St. Antonine, whom we have already met as prior of San Marco when Fra Angelico lived and worked there. A man of blameless personal life, Antonine allowed the vast revenues of the archdiocese to accumulate and lived in a simplicity unexpected in the mid-Quattrocento. Except on ceremonial occasions, he wore his threadbare Dominican habit. He may well have been responsible for the content of two paintings painted by Fra Filippo for Lucrezia Tornabuoni, wife of Piero de' Medici—one work was intended for her penitential cell at the monastery of Camaldoli, high in the Apennines, the other for the altar of the chapel in the Medici Palace (fig. 221)—for the moral treatise by St. Antonine on the art of living well, written for Lucrezia's sister, was copied in his own hand for Lucrezia. These are strange pictures. At first sight they seem to represent the Nativity, but there is no cave, no shed, no Joseph, no angels, no ox, no ass. The Virgin kneels and adores her Child in the middle of a wilderness—a fir forest in which many chopped-down trees can be seen. In the picture painted for the Medici Palace, now in Berlin, God the Father, visible to the waist, appears in the dark air and the dove of the Holy Spirit descends from the clouds below him. Nearby stands St. John the Baptist, a lad of five or six

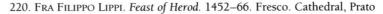

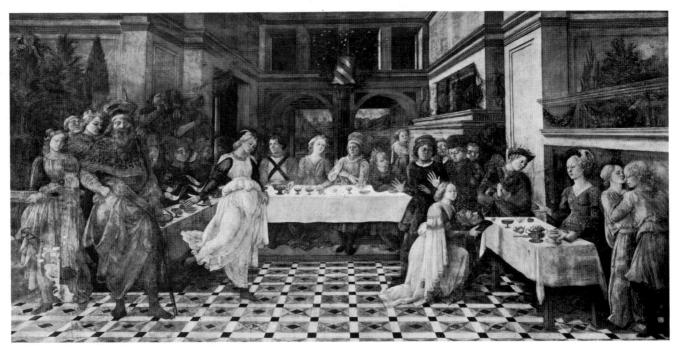

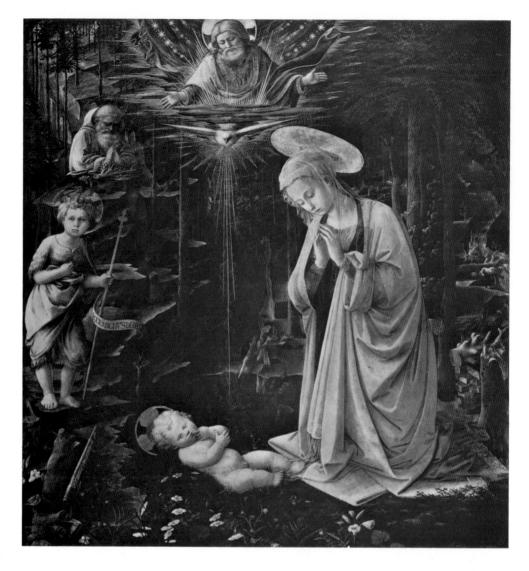

221. FRA FILIPPO LIPPI. Madonna Adoring Her Child. Late 1450s. Panel, $50 \times 45^{5/8}$ ". Picture Gallery, Dahlem Museum, Berlin

although he was actually only six months older than his cousin Jesus. In the lower left-hand corner is an ax jammed into a tree trunk, with FRATER PHILIPPUS P (the "P" is for pinxit—"painted") on its handle. It was long ago pointed out by Meyer Schapiro that this image was derived from the Baptist's own words (Matthew 3:10): "And now also the ax is laid unto the root of the trees: therefore every tree which bringeth not forth good fruit is hewn down, and cast into the fire." Since the painting seems to date about the time of the Lucrezia Buti scandal (see page 214), Filippo's signature on the ax handle may record his penance. But logging was an essential daily activity of the monks at Camaldoli, who lived a rigorous existence in clearings they made in the fir forest, each monk in a separate hut, where he celebrated solitary Mass and lived on what he could raise in his garden plot. Taking the Camaldolites as his theme, St. Antonine recommends to penitents a life of religious meditation in what he called "the little garden of the soul," very like the garden plot in which we see Mary kneeling to adore her Child. First one should cut down the trees, he says, then uproot the stumps and brambles, then fence in the garden and appoint a guardian for the gate, and only then will the flowers of a good life spring up. He also offers for admiration St. John the Baptist—the last and greatest of the prophets, the first and greatest of the martyrs, who went into the wilderness before the age of seven. Most important, he quotes Christ's saying (Matthew 12:50): "For whosoever shall do the will of my Father which is in heaven, the same is my brother, and sister, and mother." St. Antonine claims that the true penitent can identify himself with the Virgin, and that through creating the "garden of the soul" the Christ Child can be born again in our hearts. (Antonine derived this doctrine from the teaching of his great mentor and his predecessor as prior of San Domenico in Fiesole, Giovanni Dominici.) So around the Child, flowers spring up to form a garden protected by saints, while cut-down and uprooted trees fill the background. Fire comes down from Heaven—the fire of the Holy Spirit with which St. John said Christ would baptize (Matthew 3:11). In the deep blue-green gloom of the forest, Mary and the praying saint (Romuald, the founder of the Camaldolite Order) adore the Child. A new subject in Christian art has appeared, the Adoration of the Child, appropriate to a new phase of Quattrocento thought and feeling, about which more will be said in Chapter 12.

10

The Second Renaissance Style in Architecture and Sculpture

ALBERTI

he new stylistic concerns of the mid-Quattrocento come to a clear focus in the life, thought, and artistic activity of Leonbattista Alberti (1404–72), whose shadow has been cast so often across the preceding four chapters. This humanist, who never signed a contract for a work of architecture, sculpture, or painting, was deeply immersed in the theory of all three arts, and on all of them left a lasting influence. He was the author of a series of Latin works, ranging from poems and comedies to treatises on law, the horse, the family, and the tranquillity of the soul. In 1435 he published (i.e., circulated in manuscript form) his Latin treatise De pictura (On Painting), followed in 1436 by Della pittura, a somewhat abridged and less erudite version in Italian. He had read and pondered the difficult treatise De architectura by the Roman first-century architect and engineer Vitruvius, and before 1450 he had produced his own counterpart entitled De re aedificatoria libri X (Ten Books on Architecture) and at an unknown date, but probably not long after the other theoretical works, his De statua (On the Statue). There is a doctrine evident in all his writings, and of this the architectural works associated with his name constitute a visual embodiment: to Alberti the quality chiefly to be sought in human life was virtus. By this term he meant not "virtue" in the Christian sense, but "humanity"—the quality that distinguishes man from the lower animals, comprising intelligence, reason, knowledge, control, balance, perception, harmony, dignity. Alberti's was by no means a democratic theory, and it was intended for the delectation of the same elite who, in the Florence of the mid-1430s, were gaining the political and economic power they were to hold until nearly the end of the century.

Without exception, the Florentine humanists came from the dominant social and economic class, and Alberti belonged to one of the grandest of the Florentine families. But it had been expelled from the Republic in 1402; Leonbattista was born out of wedlock, in exile, in

Genoa, in 1404. He received a humanistic education at the University of Bologna, where he took his doctorate in canon law at the age of twenty-four and became acquainted with the humanist scholar Tommaso Parentucelli, later to become Pope Nicholas V. Deriving no steady income from family sources, he was dependent on stipends from patrons, princes both secular and ecclesiastical—including the Este of Ferrara, the Malatesta of Rimini, the Gonzaga of Mantua, several cardinals, and at least two popes, not to speak of the Florentine merchant prince Giovanni Rucellai. As a young man he traveled widely in Germany and the Low Countries, eventually became a papal abbreviatore (brief-writer), and for more than thirty years enjoyed the benefice, or revenue, of the Church of San Martino a Gangalandi, in the Arno Valley. (He seems to have expiated his habitual absence from San Martino by a bequest to build a handsome Renaissance apse-still standing-apparently from his own design.) Alberti's role at the courts of his princely patrons was that of adviser, and his artistic influence, especially in the realm of architecture and city planning, extended far beyond the buildings that, in one way or another, he designed himself.

A style, almost a way of life, becomes associated with Alberti's personality. His first appearance in Florence was in 1434, the year of Cosimo de' Medici's return from exile. But Alberti, in his own words, "went to Florence seldom and remained there little." His two great architectural creations in his ancestral city were not imitated by Florentine patrons or architects, although his architectural ideas had an enormous effect on other Italian centers, and the Roman High Renaissance is inconceivable without his inventions. His notions of the construction and organization of pictorial space, and of the compositional and narrative methods that painters should follow, make intelligible the developments we have observed in the preceding chapter in the art of Fra Angelico and Fra Filippo Lippi. They also clarify the pictorial styles of Paolo Uccello, Domenico Veneziano, Andrea del Castagno, and Piero della Francesca, the four

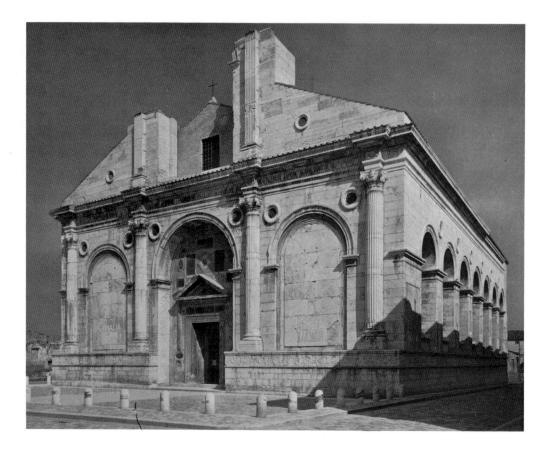

222. LEONBATTISTA ALBERTI.Malatesta Temple(S. Francesco), Rimini.Exterior designed 1450

painters whose art sums up this Golden Age of the Quattrocento, not to speak of the pictorial sculpture of the mature Ghiberti and Donatello.

THE MALATESTA TEMPLE. At midcentury Alberti was given an opportunity to put his classical ideas into visible form in an ambitious structure, destined, alas, to remain a beautiful fragment. The Adriatic city of Rimini was at that time under the rule of one of the least scrupulous yet most erudite of Renaissance tyrants, Sigismondo Malatesta, beside whose crimes and cruelties the worst excesses of twentieth-century gangsters pale into insignificance. Sigismondo enjoys, in fact, the distinction of having been the only man in history publicly consigned to Hell while still alive; the ceremony was performed with due solemnity by the humanist pope Pius II in front of St. Peter's. In the pope's eyes, one of Sigismondo's most irritating offenses was the conversion of the monastic Church of San Francesco at Rimini into a sort of temple to Sigismondo himself and his principal mistress, Isotta degli Atti, for whom he had caused his wife to be suffocated. The desecration of the Christian building had started unobtrusively. In the Gothic church, two funerary chapels were erected for Sigismondo and Isotta and decorated by the Florentine sculptor Agostino di Duccio and the Tuscan painter Piero della Francesca (see page 275). Matteo de' Pasti, the Veronese architect who was responsible for the remodeling, continued to clothe the Gothic arches of the interior in Renaissance dress, destroying earlier works, including frescoes by Giotto. At the jubilee of Pope Nicholas V in Rome in 1450, Sigismondo seems to have made the acquaintance of Alberti, who was then advising the pope on redesigning the papal city. For Sigismondo, Alberti envisioned a splendid temple, enclosing and concealing the work of Matteo de' Pasti (of which Alberti expressed sharp disapproval in a letter of 1454) inside a new exterior shell. Only the nave exterior was brought anywhere near completion.

At present, the beauty of the lower story of the façade (fig. 222) makes one doubly regret the mutilated state of

the upper story. The dominant motive of the façade was to have been a triple arch, based on the triumphal arches of Constantine and Septimius Severus in Rome, appropriate for the transformed purpose of the building. The shapes and proportions of the elements, however, were borrowed from the Arch of Augustus in Rimini, a few hundred yards from the Malatesta Temple. Early in the construction, Alberti was forced to convert the lateral arches into shallow niches and to continue the plinth underneath them; had he been present to supervise the stonecutting in person, the details would doubtless have been somewhat less coarse. In other respects the lower story was carried out substantially as he desired. Four fluted, engaged columns uphold the massive entablature. The three arches of the façade, and the seven deep arches (always an uneven number of openings) on each flank (fig. 223) containing simple sarcophagi for the humanists of Sigismondo's court, are supported not by columns, as in a Brunelleschian building, but by piers. Alberti once broadly defined beauty as "the harmony and concord of all the parts, achieved in such a manner that nothing could be added, taken away or altered." In keeping with this basic statement, he wrote explicitly that arches are openings in a wall, and should therefore be sustained by sections of the wall; columns, on the other hand, belong to decoration, not to beauty, and are therefore to be treated as applied elements in a building, not as supporting members. The resultant emphasis on the block of the building itself is alien to Brunelleschi's architecture of plane, space, and line, and represents a fundamental change in the conception of a Renaissance structure. The effect of massive grandeur is enhanced by the strong projection of arches, cornices, triumphal wreaths (enclosing slices of porphyry columns filched from Sant'Apollinare Nuovo in Ravenna), and the extraordinary capitals. A second glance at these apparently Roman Composite capitals discloses that they were invented by Alberti out of volutes, egg-and-dart moldings, and acanthus leaves, and adorned by winged cherub heads. Matteo de' Pasti described Alberti's designs for the capitals as "bellissimi" ("most beautiful"), and so they are.

Matteo's medal (fig. 224), struck in 1450 for the laying of the cornerstone, shows the façade culminating in a single central bay on the second story, consisting of a triple mullioned window enclosed by an arch supported on two columns and decorated by abundant sculptural ornament. Pilasters were substituted for columns in the execution, and only one was completed. The appearance of the present stump is no worse than that of the sloping roofs that abut it. These were to have been half-arches, according to the medal and to a number of buildings in Venice and Dalmatia that reflect Alberti's design. The central arch and the lateral quarter-circles were intended as external reflections of the barrel vault over the nave and the half-barrel vaults over the side aisles, which were

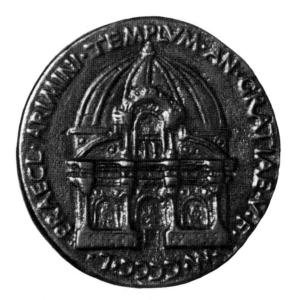

224. LEONBATTISTA ALBERTI. Malatesta Temple.

Design for exterior, on bronze medal by

MATTEO DE' PASTI. 1450. National Gallery of Art,

Washington, D.C. (Kress Collection)

to have been built of wood to convey the feeling of stone and to confer a spatial effect of simple grandeur on the nave already cluttered by Matteo's revetment. Alberti's intervention in the construction came in time to have the Gothic chancel and sanctuary entirely demolished to make way for what was to be the crowning feature of the building, the never-constructed dome visible in the medal.

How would this dome have looked, and how would it have been connected with the nave? Alberti's own words lend substance to conjectures based initially on the medal, which shows a hemisphere divided by ribs, springing from a cylindrical drum. Although Alberti admired Brunelleschi's dome for the Cathedral of Florence (see fig. 132), he insisted that its proportions were incorrect because they did not correspond to those invented by the Romans, as demonstrated in the Pantheon, his ultimate authority. In all probability, therefore, we must imagine a rotunda surmounted by a hemisphere, as in the Pantheon, where the total height (rotunda plus dome) is equal to the diameter. Possibly the arches along the nave exterior were intended to continue around the rotunda as well, although this is sheer conjecture. If Sigismondo's own disastrous fortunes had not prevented completion of the Malatesta Temple, the subsequent history of ecclesiastical architecture might well have been different.

THE PALAZZO RUCELLAI. A strikingly original contribution to the history of Renaissance palace design was the façade of the Palazzo Rucellai in Florence. The palace belonged to a wealthy Florentine merchant, Giovanni Rucellai—whose informative journal, the *Zibaldone*, has recently been published—and Vasari attributed the design of the façade to Alberti. Its general principles were

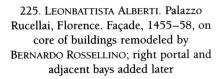

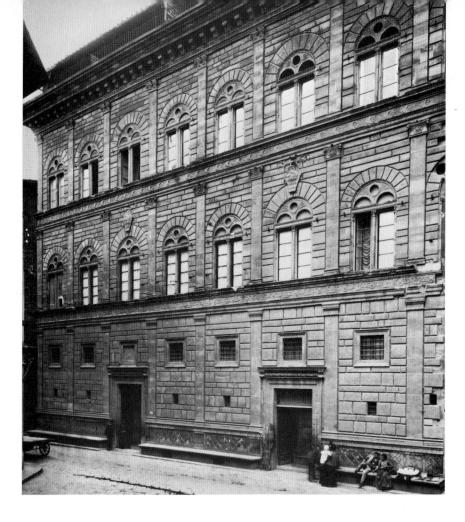

followed in many other buildings, some actually built, others merely designed (see figs. 231, 386).

The harmonious and classical design of the façade of the Palazzo Rucellai (fig. 225) may be taken as an answer to Michelozzo's rough-hewn Palazzo Medici (see fig. 146), started nine years earlier, but already seeming to belong to another age. The basic elements of the Palazzo Rucellai are the same as those used by Michelozzo—a rusticated three-story building with entrance portals and high, square windows on the ground floor, mullioned windows on the second and third, and a massive crowning cornice. But in the Palazzo Rucellai these features have been absorbed into an overall system of proportions. The three stories are of equal height. The rustication, consisting of smooth, platelike pseudoblocks of stone (the real joints do not always correspond to the apparent ones), is identical in all three stories. Most important of all, the rustication is not allowed to assert itself as the dominant element of the structure, but is held in check by a superimposed architectural screen, three stories of pilasters supporting entablatures; the whole structure suggests the appearance of the Colosseum at Rome. This classical screen architecture, without structural function, established for the Renaissance observer the erudition of the humanistic patron and the humanistic architect.

In the Palazzo Rucellai, articulation and details are stated with the utmost elegance. Roman practice placed an Ionic order above a Doric or Tuscan, Corinthian above Ionic; Alberti maintained that if one knew the grammar of ancient architecture well enough, one could at times devise one's own vocabulary. Thus the ground story is Tuscan and the third Corinthian, but the second story displays graceful capitals of new invention, composed of a single layer of acanthus leaves grouped about a central palmette—a fitting intermediate stage between the Tuscan and the Corinthian. The width of the Tuscan capitals is equal to the height of the entablature (architrave and frieze), and to that of the entablature of the second story as well. The rectangular portals and the square windows are bordered by frames scaled to harmonize with their respective dimensions. Within the tightly knit structure the only random element is provided by the free placing of the joints in the rustication, and even here the resultant intersections are as delicate and austere as those in an abstract painting by Mondrian. Against this rectilinear system, projecting so slightly that the pilasters are very nearly flush with the masonry, the modeled ornament of the portal cornices and the friezes containing Rucellai family symbols provide the only enrichment.

All the foregoing indicates a designer of the highest originality and brilliance, thoroughly supporting Vasari's attribution of the façade to Alberti (sustained by at least two other sixteenth-century sources). But still other sources from the earlier sixteenth century mention that the "model" of the building was done by the architect and sculptor Bernardo Rossellino (see pages 228, 243), and several writers have contended that it was he, not Alberti, who designed and built the façade. Unfortu-

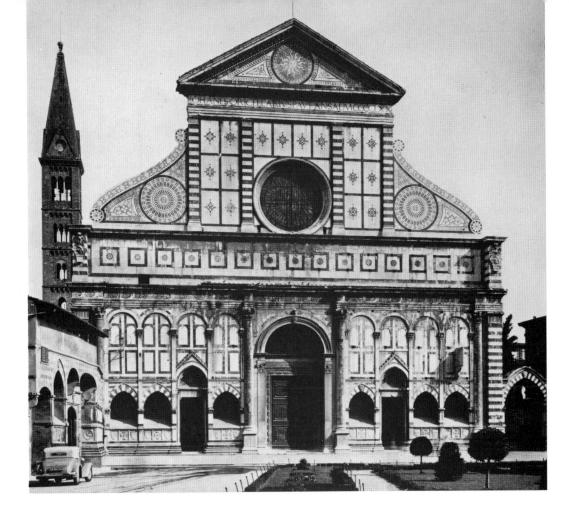

226. LEONBATTISTA ALBERTI. Façade, Sta. Maria Novella, Florence. c. 1456–70

nately, Giovanni Rucellai himself, although he mentions his palace as his chief achievement in building, about 1464, does not identify either his architect or his builder. Neither does Filarete (see page 425), who was in Florence in 1461 and described the façade of the Palazzo Rucellai as "all made in the antique style."

The most persuasive solution is that the design by Alberti consisted of only five bays, reading from the left, and would therefore have been centralized, as Alberti claimed buildings always should be, in conformity with the centralization of the human body, according to whose principles buildings must be designed. In fact, documents indicate that just such a five-bay façade was actually built, starting about 1455 and completed in 1458, onto a core of remodeled earlier structures, with which the portal does not exactly correspond. The sixth and seventh bays were added later as Giovanni Rucellai acquired more land, and the eighth bay remains fragmentary because the owner of the next house refused to sell. Moreover, the quality of the carving in the sixth and seventh bays is nowhere up to the level of that in the first five. This again would indicate that Giovanni called in Bernardo to extend his palace.

Santa Maria Novella. Alberti also furnished the designs for other great projects commissioned by Giovanni Rucellai, especially the façade of the family church, Santa Maria Novella (fig. 226), which has little in common with the Trecento church behind it (see fig. 50) save the harmony of its design. The huge white-and-green mar-

ble structure, apparently commenced in 1456, about a decade later than the façade of the Palazzo Rucellai, is the only Florentine church façade on a grand scale to be built during the Renaissance. In its design Alberti followed the Romanesque façade of San Miniato al Monte, a church overlooking Florence, and divided the structure into a wide, arcaded lower story and a second story consisting of a narrow central temple crowned by a pediment. Between the two stories he inserted a handsome mezzanine that serves as an attic for the one and a plinth for the other, and framed the second-story temple on either side by magnificent volutes. With this device he presented an ingenious solution to a problem that had perplexed designers of church façades for a millennium: how to unite the narrow upper story with the lower story whose width was determined by the side aisles of a basilican interior. In France and England, the awkward sloping roofs of the side aisles were masked by lateral towers; in medieval Italy, massive screens were commonly used. But Alberti's volutes make a virtue of necessity by turning the straight slopes of the roof lines into a delightful double curvature.

Alberti had another problem to cope with, namely the extant pointed arches enclosing sarcophagi on the ground level of the façade. He was able to resorb these inconveniently Gothic elements into his Renaissance design by surmounting them with a round-headed blind arcade, and by repeating their horizontal green-and-white banding in the corner pilasters and in the four great pilasters of the second-story temple. An elaborate

system of proportional relationships between the rectangular and circular polychromed marble incrustations confers geometrical unity upon the structure. The result is one of the most impressive and influential façades in the history of Italian architecture.

SANT'ANDREA. Alberti's triumph as a church architect was his design for Sant'Andrea at Mantua (fig. 227), although all of it was built after his death (the present dome, added in the eighteenth century, has nothing to do with his intentions). Christian priest or no, Alberti never abandoned his humanist attitude long enough to write the word "church"; one always reads "temple." The ancient Romans, of course, knew how temples should be designed and never used for them the basilican plan; the Romans intended the basilica only as a court of law, with proceedings taking place in the twin apses, while the nave accommodated litigants and spectators, and clients conferred with their attorneys in the side aisles. However, this three-aisled plan was adopted for the Early Christian basilica and, with modifications, it remained standard for church design throughout the Middle Ages. The three-aisled plan, Alberti maintains, was manifestly

unsuited to the worship of "the gods" (never "God"), for the columns conceal ceremonies taking place at the altar. So out went eleven hundred years of Christian architecture. Illumination, moreover, should be calculated so as to inspire awe and reverence for the mystery of "the gods." As Eugene J. Johnson has shown (see Bibliography), the reason why Ludovico Gonzaga, marquis of Mantua (see fig. 410, colorplate 58), commissioned the building of so gigantic a church was the necessity of exhibiting the relic of the Sacred Blood of Christ, which St. Longinus was supposed to have brought to Mantua, to the throngs of pilgrims who came to venerate it. In fact, at least nine major churches owe their existence to the wave of popular religiosity that, in the late Quattrocento and early Cinquecento, took the form of the adoration of miraculous relics; five of them are treated in this book (see figs. 313–315, 375–377, 506, 616–618), and none could utilize the basilican plan. For Sant'Andrea, Alberti invented a new plan (fig. 228), based on the barrel-vaulted chambers of the ancient Roman Temple of Venus and Rome just across from the Colosseum. The gigantic barrel vault of Sant'Andrea (fig. 229) produces a single, overwhelming spatial effect, concentrating on the high

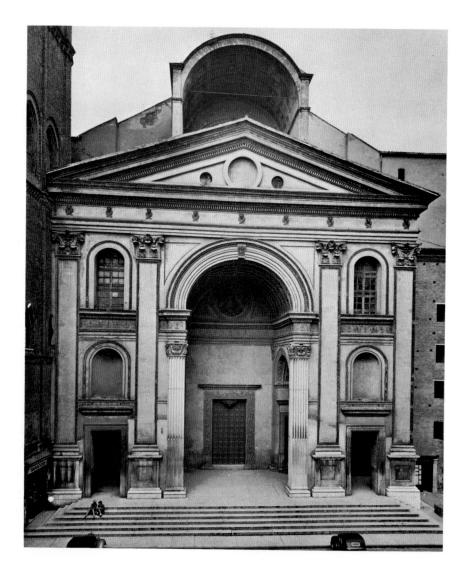

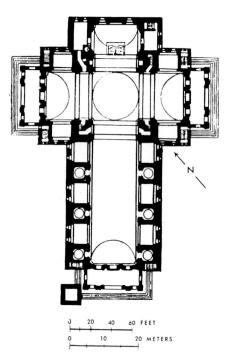

left: 227. LEONBATTISTA ALBERTI. Sant'Andrea, Mantua. Designed 1470

above: 228. Plan of Sant'Andrea, Mantua

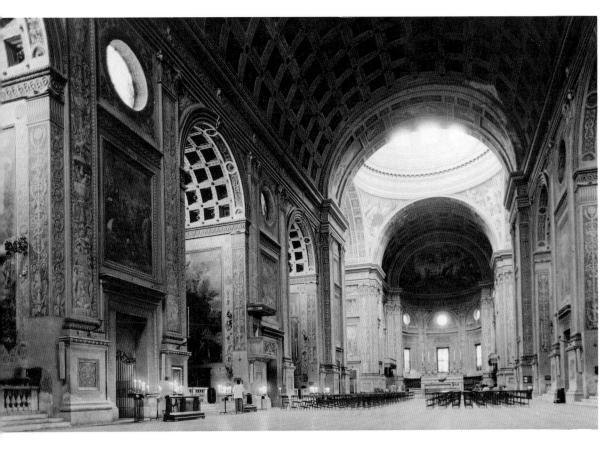

229. LEONBATTISTA ALBERTI. Nave, Sant'Andrea, Mantua. Designed 1470

altar, which Alberti doubtless intended for a central position under the dome. Nothing hides the ceremony. The lateral arches admit worshipers not to side aisles but to secluded chapels, each crowned with its own barrel vault running at right angles to that of the nave. The singleaisle plan is matched by a single-story elevation, for the barrel vault rests, without clerestory, directly on the nave entablature; this in turn rests upon piers, articulated by pilasters, in alternation with the arched entrances to the chapels. Alberti's new type of church interior was repeated endlessly throughout Europe, from the St. Peter's of Bramante and Michelangelo to the churches of the Baroque. Alberti depended for illumination on the dome itself, the huge oculus of the façade, and the smaller oculi in the chapels; all of these showed only the sky, wherein dwelt "the gods." In the façade, whose unexpected scale depends on its relation to the small piazza in front of the church, Alberti established the motive of coupled giant pilasters flanking the arches and interlocking with a smaller order of pilasters supporting the transverse barrel vaults, which was to form the modulus repeated throughout the interior of the church. The capitals and bases of the exterior were replaced in the early nineteenth century. The arch above the pediment (see fig. 227), however useful in shading the oculus, could not have been intended by Alberti.

ARCHITECTURE AFTER ALBERTI. All over Italy the influence of Alberti's ideas was felt. The plans of Nicholas V for the new papal Rome, centered for the first time on a

230. Circle of LEONBATTISTA ALBERTI. Courtyard, Palazzo Venezia, Rome. After 1455

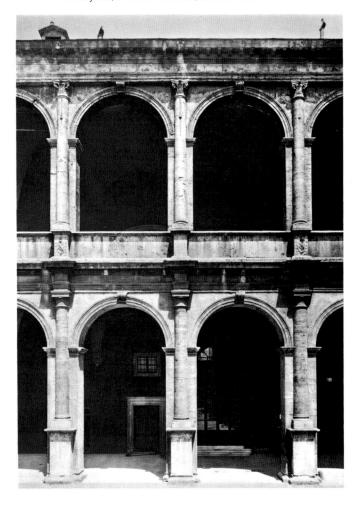

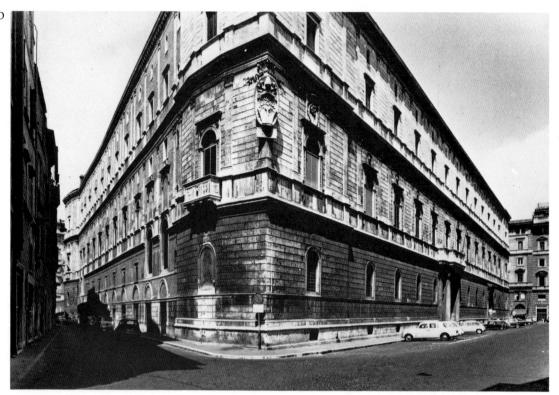

231. Palazzo della Cancelleria, Rome. Designed before 1489

rebuilt St. Peter's and on the Vatican, would have been developed by Alberti. Roman buildings in considerable numbers are derived directly from his inventions, and link him with the new and more grandiose Rome of the High Renaissance and the Baroque. Interestingly enough, none of the architects of these Roman buildings has been securely identified. The courtyard of the Palazzo Venezia in Rome (fig. 230), built after 1455, at a time when Alberti was still connected with the papal court, imitates the arcades and engaged columns of such nearby Roman buildings as the Colosseum and the Theater of Marcellus (see the drawing by Giuliano da Sangallo, fig. 310). Several church façades built in the 1470s and 1480s, after Alberti's death, are variants of Santa Maria Novella. It seems unlikely that Alberti would have approved the colossal Cancelleria (fig. 231)—its principal façade is nearly 300 feet longwhich dilutes the scheme of the Palazzo Rucellai over vast areas of masonry, intermingled with single-arch windows, heavy cornices, and ornamental motives. The use of pilasters as a screen architecture suggests the ideal cities of Luciano Laurana's panels (see fig. 386) and reappears in several other Roman palaces. Originally designed for Cardinal Raffaello Riario before 1489 (see his portrait at the right hand of his uncle Sixtus IV in the fresco by Melozzo da Forlì, fig. 382), the building is impressive enough to have been attributed to Bramante who did not arrive in Rome until ten years after it was

Pius II's plans for converting his native village of Corsignano into the papal city of Pienza (*Pius* and *Pienza* were plays on the pope's family name of *Piccolomini*)

were carried out by Bernardo Rossellino, the same master who had remodeled the core of the Palazzo Rucellai and probably extended the façade. He had also commenced under Nicholas V the projected reconstruction of St. Peter's in Rome, doubtless under supervision of Alberti. At Pienza he imitated with little grace the system of the Palazzo Rucellai in the huge Palazzo Piccolomini (one bay is visible at the right of fig. 233). The piazza at Pienza is the first of the new Renaissance town designs that was actually built (fig. 232). Although its details might well have offended Alberti, especially the irrational superimposition of arcade on colonnade in the façade of the little cathedral, the supremacy of the building block in the design of the confronting church and palaces (fig. 233), to which pilasters, columns, and arches are added as decoration, conforms to Alberti's notions.

Plans and façades of churches built in Florence in the mid- and late Quattrocento show strong Albertian influences. The imposing Palazzo Pitti in Florence, commenced for Luca Pitti, a wealthy merchant, was long attributed to Brunelleschi until the discovery that construction did not begin until 1458, twelve years after the death of the great pioneer. The palace was extended twice, during the late sixteenth century by Bartolommeo Ammanati (see fig. 713) and in the seventeenth by Pietro da Cortona, as the official residence for the Medici as grand dukes. The Quattrocento structure (fig. 234) was originally limited to the central seven bays, and it is not known whether there was to have been a courtyard at all. The rudeness of the rustication and the grandeur of the three superimposed arcades, obviously based on the ancient aqueducts whose ruins still march across the

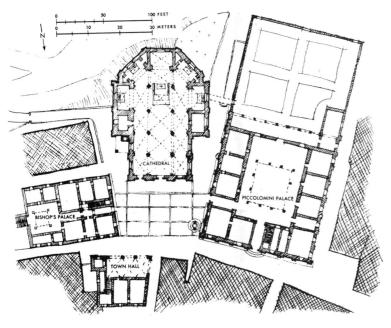

above: 232. Bernardo Rossellino. Plan of Piazza Pio II, Pienza. 1459–62

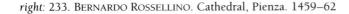

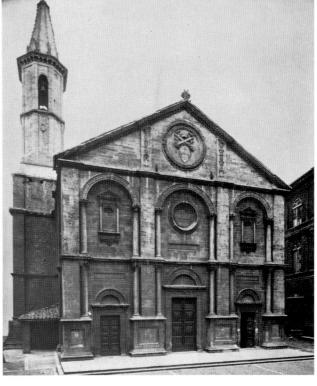

countryside around Rome, are alien to the artistic taste and practice of Brunelleschi, but believable for a follower of Alberti. The most likely candidate seems to be the Florentine architect Luca Fancelli, who was deeply imbued with Albertian ideas, was in Florence at the time, and built much of Sant'Andrea in Mantua after Alberti's designs.

Most important of all, Alberti's ideas on city planning, expounded in *De re aedificatoria*, were read and pondered by other architects, and resulted in projects far

more ambitious and comprehensive than Brunelleschi's piazze, notably the dreams of Filarete for Sforzinda (see fig. 436) and the urbanistic harmonies of Luciano Laurana (see fig. 386).

ALBERTI AND THE ART OF PAINTING. Alberti's relation to the pictorial art of his time is striking, if sometimes difficult to assess exactly. It is still a moot point among scholars whether some of his ideas on perspective might have been a codification of what the painters and sculptors

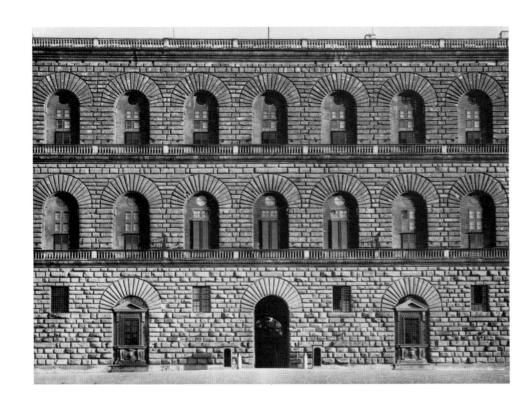

234. LUCA FANCELLI (?). Façade, central portion. Begun 1458. Palazzo Pitti, Florence

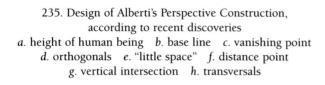

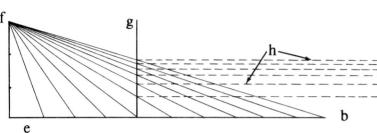

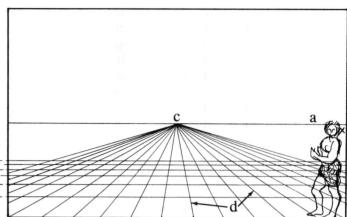

about him had long been doing on their own. Alberti's perspective theory is derived in great part from medieval studies on optics in the Aristotelian tradition. In any case his Latin treatise on painting, *De pictura*, of 1435 (and *Della pittura*, the Italian version, of 1436), is the first known treatise on painting, as distinguished from handbooks of shop practice, such as Cennino Cennini's *Libro dell'arte*.

Brunelleschi's perspective theory provided no system for projecting imaginary spaces and their contents within a pictorial field. Alberti's formula, however questionable from a modern scientific standpoint, produced a result that was aesthetically attractive and visually convincing (fig. 235). By and large it was followed, though not necessarily as rigidly as Alberti seems to propose. He required the artist first to establish the height of a human being in the foreground of his field, then to divide the base line of the field into segments corresponding to one-third of this height, each segment called a *braccio* (or cubit). At the height of the person above the base line, the artist was to set the vanishing point and connect it with diagonal lines to the divisions of the base line. These lines are the so-called orthogonals.

Then the question arose, how were the transversals the parallel horizontal lines crossing the ground plane to be established? A recently discovered passage, missing in the Italian text but present in some of the Latin manuscripts, including one annotated by Alberti himself, shows that on a separate surface (called "little space" by Alberti), which could be another piece of paper or another part of the wall surface, the artist was to draw another horizontal line divided into segments in the manner of the original line, and to set the distance point perpendicularly above it at the same height as the vanishing point in the first construction, again drawing a set of diagonal lines from point to base. The viewer's distance from the picture was then expressed in terms of a vertical intersecting the new diagonals at whatever point the artist wished. Then, setting the two constructions on the same level at any convenient distance, the artist could draw horizontal lines from these intersections in the second construction across to the first. These horizontal lines would become the desired transversals in the first construction, and form trapezoids in conjunction with its orthogonals. The results can be easily counterproved by drawing diagonals through the corners of the trapezoids. These diagonals will always pass through the centers and corners of all diagonally related trapezoids in the first construction.

Alberti's perspective was, quite simply, a graph of space. It provided a single, harmonious system for the relative proportions of every figure, object, and spatial division within a pictorial field. It did not, of course, take note of another fact, that not only the orthogonals but the transversals, too, if prolonged to their obvious conclusion, would converge on vanishing points at either side. So, above and below, would all the verticals. Such vanishing points would be situated far outside the frame of the usual fresco scene or panel painting, unless this were to have panoramic dimensions, but some degree of convergence would always be perceptible. Doubtless Alberti was aware of this fact, but to incorporate it in a painting would have resulted in a curving construction, familiar to us from panoramic photographs, that would do violence to the pictorial surface, whether panel or wall-indeed, to the basic Italian notions of the harmony between pictorial illusion and architectural surfaces and volumes. Not until architectural shapes themselves became flexible in the late sixteenth century did painters actually depict curved pictorial space.

The remainder of Alberti's treatise is chiefly devoted to what he calls *istoria* (history, story, narrative) and how it should be represented. His three principles of pictorial art are circumscription, composition, and reception of light. These include his notions on drawing, division of the pictorial surface, light and shade, and color, to which he was extremely sensitive. His recommendations for balanced color chords constitute a direct attack on the often aggressive coloristic arrangements of

the Trecento. Alberti is concerned with consistency and propriety in the representation of persons of various ages and various physical and social types, with their reactions to the dramatic situations in which the istoria places them, and with the delicacies of anatomical rendering of bodies and features. He wishes the narrative to unfold in copiousness and variety, of humans, animals, and objects, in poses and movements full of grace and beauty—all these in opposition to the figural alignments common not only in the Trecento but even in the compositions of Masaccio. Above all, Alberti is profoundly aware of the magical qualities in pictorial art, which he says are the foundation of religion and the noblest gift of "the gods." "Painting," he tells us, "contains a divine force which not only makes absent men present, as friendship is said to do, but moreover makes the dead seem almost alive." The last words of Della pittura sum up what Alberti desired: "absolute and perfect painting."

In many respects Alberti's manifesto harmonizes with the art of Masaccio, the only painter he mentions in the preface to Della pittura, but it comes far closer to the painting of Fra Filippo Lippi and Fra Angelico, whom Alberti must have known personally. The new perspective governs Fra Angelico's Annunciation in the San Marco corridor (see fig. 210)—as distinguished from his pre-Albertian treatment of the same subject at Cortona (see fig. 206)—as well as the entire spatial system of the San Marco altarpiece (see fig. 207). The frequent use by both Fra Filippo and Fra Angelico of the foreground figure apostrophizing the spectator, the copiousness and variety of their compositions, and their sensitive analysis of the reception of light correspond to Alberti's principles, as indeed do many of the ideas of younger masters. By the end of the century some of the classical subjects he recommended were adopted by such painters as Botticelli.

In the 1430s and 1440s the two surviving giants of early Quattrocento Florentine sculpture, Ghiberti and Donatello, underwent striking changes of style, fully in keeping with Alberti's new doctrine if not always in strict accordance with the details of his formulas. Both masters may have become acquainted with Alberti during their visits to Rome prior to Alberti's return to Florence in 1434, for the tone of the dedication in his Della pittura of 1436 suggests long friendship. The relationship must have been close once Alberti became established in Florence.

GHIBERTI AFTER 1425

Ghiberti's Gates of Paradise (fig. 236) were so profoundly influenced by Alberti's ideas as to constitute, in a sense, a programmatic exposition of the full resources of Albertian theory. When given the commission for the final set of doors for the Florentine Baptistery in 1425, Ghiberti was in his late forties. Lionardo Bruni proposed a scheme composed of twenty-eight scenes, like the previous sets by Andrea Pisano and Ghiberti himself (see figs. 85, 153). A second project reduced the number of scenes to twenty-four, judging from the divisions still visible on the backs. The final scheme shows only ten great square fields, each a complete picture. Not only are the constricting Gothic quatrefoils abandoned, but so is the notion of a consistent bronze background. Each square is totally gilded, background and all, so that the sculptor could proceed with the representation of depth as if he were a painter. Donatello had, of course, already done so in his St. George relief (see fig. 166), but without approaching Ghiberti's precision and mastery at this mature phase of his style.

The present title of the doors derives from the fact that they open on the paradiso, the Italian term for the area between a baptistery and the entrance to its cathedral. Michelangelo, playing on this word, is reported to have said that the doors were truly worthy to be the Gates of Paradise, and the nickname stuck. The modeling in wax of all ten scenes and the surrounding sections of frieze has been convincingly dated in the brief span between 1429 and at the latest 1437, when all were certainly cast in bronze. Finishing, gilding, and other processes took longer, and it was not until 1452 that the doors were set in place.

Each panel deals with one or more incidents from the story of an Old Testament figure, all arranged within a consistent space, stretching from the foreground into a more and more remote distance. Although the individual scenes were each cast in a single piece, the foreground figures are so projected as to be almost statues in the round. The projection decreases as the figures diminish in size and recede into the background, and the most remote are scarcely raised above the surface. The illusion of depth is thus highly convincing, and it is enhanced by the use of the gold over the entire relief, giving the feeling that the space is pervaded by a kind of golden atmosphere.

The first scene, the story of Adam (fig. 237), shows the Creation of Adam at the lower left, that of Eve in the center, the Temptation in the distance at the extreme left, and the Expulsion from the Garden at the extreme right. The still helpless Adam is being lifted from the ground by the Lord, who walks quietly upon the earth. Surprisingly enough, much greater emphasis is placed on the Creation of Eve, which occupies the center of the panel. The explanation lies in the long-held doctrine of Christian theologians that the Creation of Eve from the side of the sleeping Adam foretold the creation of the Church that issued, in the form of the blood and water. from the wounded side of Christ upon the Cross. This parallel was embodied in many images in medieval manuscripts and stained glass, and specifically set forth in a striking chapter of the Summa of St. Antonine of Florence, first noted by the author in 1954. In all probability, St. Antonine was responsible for the programs of

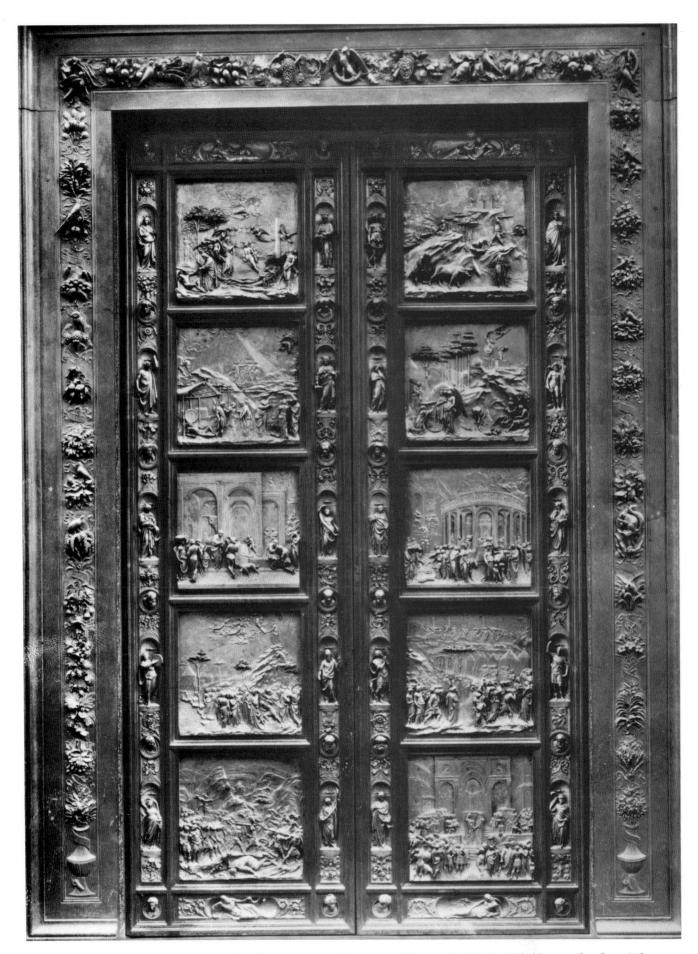

236. LORENZO GHIBERTI. Gates of Paradise (East Doors), Baptistery, Florence. 1425–52. Gilded bronze, height c. 15'

237. LORENZO GHIBERTI. *The Creation*, panel on the *Gates of Paradise*, Baptistery, Florence. 1425–37. Gilded bronze, 31½" square

numerous important works of art (see pages 208, 210, 212, 219, 285). At the time the program for the Gates of Paradise was under discussion in 1424-25, he was at San Domenico in Fiesole—greatly venerated—and his presence has been recorded in Florence. When the doors were installed in the Baptistery, he was archbishop of the city, and in a sense it was his Baptistery. His chapter is a sermon on St. John the Baptist, to whom the Baptistery is dedicated, and compares him in the words of Christ to a lantern whose light thrown upon the Old Testament brings forth the New. The ten stories chosen by St. Antonine are contained in nine of the ten panels of the doors, and vary only occasionally from the treatment given by Ghiberti. His chapter concludes with four major prophecies of the Virgin Birth, one of which is Ezekiel's vision of the porta clausa ("closed door") of the sanctuary (see pages 67, 237); like the porta clausa the Gates of Paradise are customarily shut, and face toward the East. In our scene one of the Rivers of Paradise, foretelling the water of Baptism, flows below the sleeping figure, and Eve, whom the Lord brings forth gently by her wrist, is upheld by four angels (probably symbolizing the four Gospels), while seven more angels (the number of the Gifts of the Holy Spirit, as well as of the Joys and Sorrows of the Virgin) hover above.

Ghiberti's handling of the male nude had been strikingly effective in the competition relief (see fig. 151) and in the North Doors of the Baptistery (see fig. 155). For the first time, in the *Creation* relief, he presents female nudes of lissome grace, across whose silken surfaces the

238. LORENZO GHIBERTI. Story of Abraham, panel on the Gates of Paradise, Baptistery, Florence. 1425–37. Gilded bronze, 311/4" square

light seems alternately to glide and linger. These are among the first deliberately sensuous female nudes of the Renaissance, not classical in their proportions but nonetheless akin to the frank voluptuousness of the nudes Ghiberti admired in Rome. The full volumes of flesh, both male and female, are gracefully contrasted with the long, parallel folds of drapery and with the airy wedge-shaped striations of flying cloud that create a shimmer of golden light around the angels and the floating crowned Lord in the circles of Heaven, who ordains the Expulsion. Still, Ghiberti has pierced the background only to the extent necessary to stage the Temptation a few yards off, and there is no distant view or horizon line.

By the time he made the Abraham scene in the second row, however (fig. 238), Ghiberti had dissolved the background to permit the eye to see, beyond the slender trunks of trees, the profiles of distant hills against the sky, similar to the distant views through screens of trees in Fra Angelico's probably contemporary Descent from the Cross (see colorplate 27). Indeed it is unlikely that the two compositions were independent of each other. Because many pictorial values are inaccessible to sculpture and therefore are absent in Ghiberti's reliefs, it has been suggested that Angelico must have invented the device, but there is no proof. Here again the Old Testament scene prefigures the New, for the Sacrifice of Isaac, the subject of the 1402 competition, reappears in the background as a foreshadowing of the Sacrifice of Christ, the three angels appearing to Abraham is a revelation of the Trinity, and the meal prepared for them by Sarah prophesies the perpetual banquet of the Eucharist; all are expounded in the same text by St. Antonine. The prominence given to the fountain flowing from a spring in the side of the cliff is in accordance with St. Antonine's emphasis on the water of Baptism.

Not even the distant space in the Abraham scene, and the grace and beauty of the drapery forms, prepare us for the achievements of Jacob and Esau below, in the third row (colorplate 30). In this relief, whose harmony of space and figures was not surpassed by the masters of the High Renaissance, Ghiberti has adopted the perspective construction formulated by Alberti in *De pictura*, which he had not employed in the scenes of the upper two rows. Presumably the relief was composed shortly after Alberti's arrival in Florence in 1434. The sculptor was not willing to renounce the protruding apron, which he had also used for the panels in his North Doors. The apron, however, now became a base line, divided into cubits precisely as Alberti indicated, and from these divisions he projected his receding orthogonals to their central vanishing point, which served also for the recession of the walls and ceilings of the soaring palace loggia. The pavement squares in the patch of terrace at the extreme right do not recede to this vanishing point, and therefore apparently do not correspond to the Albertian construction. But Ghiberti must have realized that these squares, if drawn in rigid conformity to Alberti, would have been compressed into absurdly distorted shapes, as the reader can easily verify by drawing out the construction. For the Achilles' heel of one-point perspective becomes evident at the sides of an extended view, which expose the necessity, avoided by Alberti, of making the transversals curve away from the picture plane.

On the rooftop Rebecca, feeling her sons struggling

within her, receives God's explanation of two hostile peoples to spring from her womb. Under the left arch she appears in childbed; in the center, partly concealed by the foreground figures, Esau sells his birthright; and, on the right, "taught by God" according to St. Antonine, Rebecca rehearses Jacob in his "pious fraud," to be accomplished by the meat and skin of the kid he holds. St. Antonine's interpretation culminates in the foreground, where Jacob, symbolizing the Christians, receives the blessing on the step, which foretells his approaching vision of a ladder to heaven, and the shocked and disappointed Esau signifies the Jews.

The very architecture of the scene is Albertian. First of all, the arches are supported by piers, not columns, and the Corinthian order, in the form of applied pilasters, belongs to decoration (see page 223); presumably Alberti entertained such ideas long before he wrote them down in *De re aedificatoria*. Despite the airy beauty of the building, Ghiberti did not fully understand its details. He did not know what to do when he reached the corner capitals, which remain lopsided. But the architecture is Albertian in a deeper sense, for Jacob and Esau is probably the earliest space construction in Italian art that totally abandons the double scale of the Middle Ages in favor of Alberti's doctrine of visual unity. A single scale for figures and architecture that could still preserve the legibility of the narrative is achieved by setting the buildings a measurable distance behind the foreground figures and allowing some of the incidents to move back into it. The figures, too, demonstrate Alberti's contention that the artist should represent bodies, around which drapery should move so as to reveal the beauty of the limbs beneath. Ghiberti has done this with matchless grace in the four figures at the extreme left (fig. 239). Effortlessly, the Gothic linearity of Ghiberti's earlier

left: 239.
LORENZO GHIBERTI.
Detail of Jacob and
Esau, panel on the
Gates of Paradise,
Baptistery, Florence
(see colorplate 30).
c. 1435

right: 240. LORENZO GHIBERTI. Self-Portrait, in medallion at lower right of Jacob and Esau. c. 1435

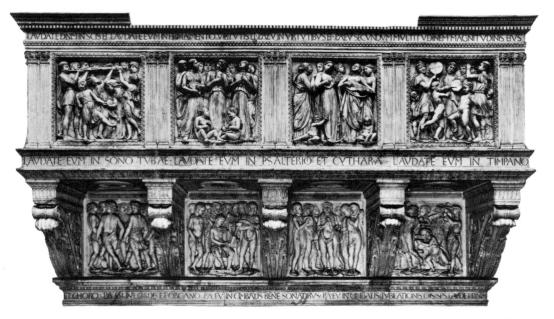

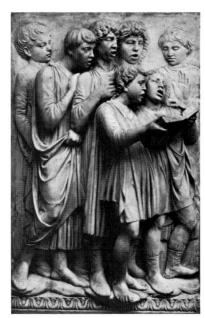

left: 241. LUCA DELLA ROBBIA. Cantoria. 1431-38. Marble, length 17'. Museo dell'Opera del Duomo, Florence

right: 242. LUCA DELLA ROBBIA. Singing Boys, end panel on the Cantoria. Marble, c. 38 × 24"

drapery style has been transformed in the *Gates of Paradise* into a manner so Greek that it reminds us of the fourth-century Tanagra figures. Every motion is harmonious, whether within each figure, between one figure and the next, or among groups of figures within the perfectly coordinated space. What was there left for Raphael to do? In his self-portrait in one of the medallions of the frame (fig. 240), placed just above the eye level of the observer and alongside his conspicuous signature (visible in colorplate 30), Ghiberti has shown himself as he neared the end of his career. Wise, cultivated, shrewd, sensitive, it is an unforgettable self-assessment. In Alberti's phrase, Ghiberti has made "the dead seem almost alive."

LUCA DELLA ROBBIA

Alberti's introductory note to *Della pittura* contains one name that has surprised most students, since Luca della Robbia does not seem to belong in the same league as Brunelleschi, Ghiberti, Donatello, and Masaccio, the other artists mentioned. To posterity, the name Della Robbia has become associated with the graceful but predominantly decorative works in glazed terra-cottagenerally white figures against a blue background, done according to a technical formula invented by Luca—that were used in many buildings in Florence and its surroundings. The style was continued by Luca's nephew and successor, Andrea della Robbia, and by a host of assistants who prolonged the activities of the workshop well into the sixteenth century. But in the 1430s Alberti could believe that Luca would remain on the high plane occupied by the other four great masters. Alberti's confidence was doubtless based on the splendid marble Cantoria (choir gallery) carved by Luca in 1431-38 for a

position over the doorway to the left sacristy of the Cathedral of Florence, thus overlooking the high altar. Luca's gallery (fig. 241), as well as that by Donatello over the door of the right sacristy of the cathedral (see fig. 243), was removed for a grand-ducal wedding in the seventeenth century, and both are preserved in the Opera del Duomo. In the documents, Luca's is mentioned as the organ loft, but that by no means excludes the presence of singers and perhaps instrumentalists as well, for whom the seventeen-foot length of the gallery would have provided sufficient room in those days of small choirs and portable organs.

Luca's gallery, supported on five acanthus consoles, consists of a parapet divided by five pilasters. The eight square spaces in the two stories, as well as the two oblong panels at either end of the gallery, are filled with music-making children and adolescents conceived as illustrating Psalm 150, which is inscribed in its entirety on the frieze and the two stylobates. The boys and girls do indeed praise the Lord "with the sound of the trumpet...with the psaltery and harp...with the timbrel and dance...with stringed instruments and organs ... upon the high-sounding cymbals." They are beautifully grouped in compositions that are carefully centralized within each panel, moving, playing, singing in relaxed happiness, yet so arranged and projected as to recall the Augustan frieze on the Ara Pacis, that elegant Roman monument to early Imperial taste and erudition. These young people who stand so harmoniously, whose clothing falls so naturally into shapes reminiscent of Roman togas, nevertheless possess street-child faces as winsomely commonplace as those by Fra Filippo Lippi (see fig. 217). Luca's smooth surfaces and sometimes inert modeling diminish the tension characteristic of Flor-

right: 243.

DONATELLO. Cantoria.
1433–39. Marble and mosaic, length 18'8".

Museo dell'Opera del Duomo, Florence

below: 244.

DONATELLO. Putti,
detail of the Cantoria.

Marble and mosaic,
height 38½"

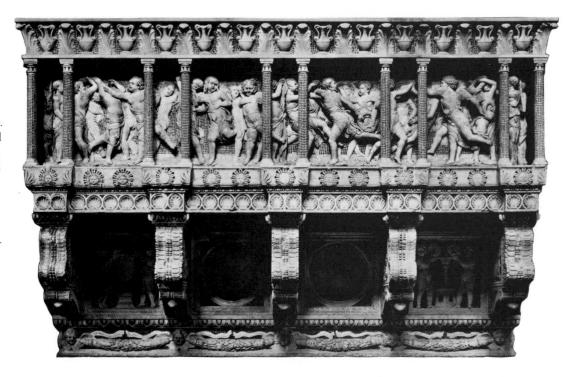

entine art at its greatest, but his youths and maidens, especially the famous singing boys—some treble, some bass (fig. 242)—have won and will retain a high place in popular imagination.

DONATELLO c. 1433 TO c. 1455

What a contrast between Luca's serenity and the violence of Donatello's facing Cantoria! The great master seems to have sacked ancient art thoroughly during his stay in the Eternal City in 1432, and to have assembled his loot somewhat indiscriminately upon returning to Florence. While all the elements of his Cantoria (fig. 243) are to be found in antiquity—the egg-and-dart molding, the acanthus, the palmette, the shell, the urn, and the mask—they never appear in classical art in such combinations or in such proportions. The very architecture that these elements occupy so strangely is itself unconventional and unexpected. Instead of single consoles, Donatello has employed unmatched pairs, one right side up, the other upside-down, in near collision. Stylobates are dissolved in ornament; architrave and frieze are absent, supplanted by a monstrous, heavily ornamented cornice. The very substance of colonnettes and backgrounds is disintegrated by the insertion of hundreds of tiny disks of tan or light-brown marble.

Behind the colonnade, paying no attention to it, surges a torrent of infantile life (fig. 244). Donatello's children refuse to be constricted by the neat frames of Luca della Robbia, but riot throughout the space in a paean of jubilation. They shout, scream, push and pull each other, kick wildly as they run. Their transparent tunics cling to their chubby limbs. Feathery wings erupt unexpectedly from their shoulders. The result is a work of intense dynamism and gorgeous chaos. Although Donatello's style was at this time by no means univer-

sally appreciated in Florence, subsequent generations rated his *Cantoria* much higher than Luca's smooth and static work; Vasari, for example, wrote with enthusiasm of the sketchy freedom of Donatello's surfaces, which produces from a distance an effect of far greater vigor.

The undated but probably almost contemporary Annunciation relief in Santa Croce in Florence (fig. 245) shows another aspect of Donatello's new classicism. The enframing architecture is almost as unconventional as that of the Cantoria (note the terra-cotta putti balanced on the corners or perched on the arched pediment, the colossal egg-and-dart molding that invades the frieze, the masks forming the capitals), but over the sacred scene within has fallen a sepulchral chill. Mary is shown at her reading desk, gently recoiling from the message of the kneeling angel. Both figures, in cold gray limestone with only an occasional detail of border or button picked out in gold, move against a background whose richly ornamented and gilded panels suggest the shape of a

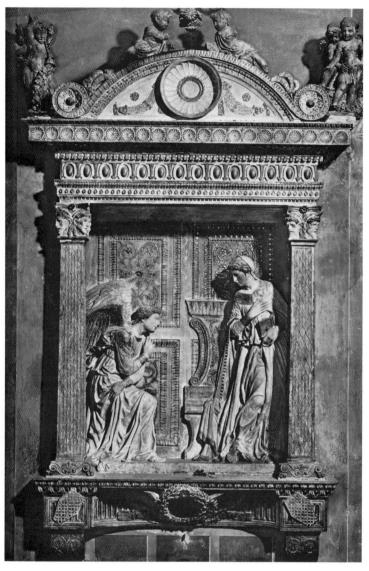

245. DONATELLO. *Annunciation*. c. 1433. Limestone with gilt (terra-cotta putti), 13′9″×9′. Sta. Croce, Florence

great door (exploiting the joint between the two slabs of stone as the gap between its two leaves). There is, in fact, no other way to account for the forms, fully characteristic of Renaissance doors and not to be found elsewhere. This door is the *porta clausa* (closed door) of Ezekiel's vision, the age-old prophecy of the virginity of Mary, for which reason, as we have seen, the Annunciation (such as that by Giotto in the Arena Chapel; see figs. 59, 60) was customarily depicted in the spandrels on either side of the entrance to the sanctuary. The lack of the usual hardware associated with doors should trouble no one, as a similar *porta clausa* in Piero della Francesca's *Annunciation* in San Francesco in Arezzo (see fig. 285) possesses neither handle, lock, nor hinges. The closed gate of Ezekiel needs none.

The faces of both Mary and the angel, with their Greek noses and low, straight foreheads from which the hair is drawn rippling back on either side, are among the most classicistic passages in Donatello's work (fig. 246). But

246. Head of the Virgin, detail of fig. 245

neither these nor the evident classicism of the stylized drapery can submerge the emotional tension characteristic of Donatello's art throughout his long life, and evident here in the instability of the poses, in the complexity of the surfaces, and in the contrast between "deaf" areas of limestone and insistent background motives in sharp gold.

The least expected work of this period in any medium is Donatello's nude David in bronze (fig. 247), possibly the earliest known nude freestanding statue in the round since antiquity. (It is noteworthy, however, that when Andrea Pisano and Nanni di Banco wished to represent a sculptor [see figs. 16, 168], they showed him carving a male nude.) After Donatello's heroic marble David of 1408 (see fig. 161), we hardly look for a work of this sort. A soft, rather effeminate boy of twelve or thirteen, clothed only in richly ornamented leather boots and a large pointed hat crowned with laurel, stands with his left hand on his hip and a great sword in his right. His right foot rests upon a wreath, while his left foot toys idly with the severed head of Goliath, one huge wing of whose helmet caresses the inside of the boy's right thigh. The lascivious content of the statue, while it may reveal aspects of Donatello's own character, poses problems concerning the meaning of the work, probably destined for the Medici. The least accessible of these riddles is the cold detachment shown by this preadolescent boy as he looks out over and beyond the decapitated head and the observer, untroubled by the web of desire and violence in which he stands (fig. 248). The author has pointed out that David conquering Goliath in the Speculum humanae salvationis (a fourteenth-century compendium of imag-

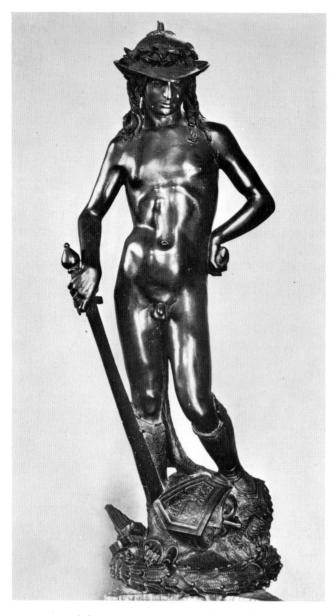

left: 247. DONATELLO. *David*. c. 1440. Bronze, height 62¹/₄". Bargello, Florence

right: 248. Head of David, detail of fig. 247

ery connecting personages and events of the Old and New Testaments, widely reprinted in the fifteenth) symbolizes Christ triumphant over Satan, and that the laurel crown on the boy's hat and the laurel wreath on which he stands are allusions to the Medici family in whose palace the work was seen in 1469. One might add that the parallel between David and Christ was repeated by St. Antonine in his *Summa*, and that the victory might allude to that of the Florentines, under Cosimo's hidden control, over Filippo Maria Visconti at Anghiari in 1440 (see page 457).

Donatello's sculptural activity in Florence was interrupted by his departure for Padua in 1443. He remained there for eleven years, a fact that changed the entire course not only of sculpture but also of painting in North Italy. A whole school of painting grew up in Padua

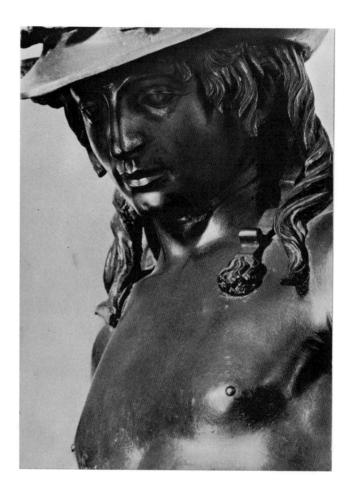

around the personality of Donatello—during his presence, as he himself put it, among the Paduan "fogs and frogs." Vasari tells us that the great sculptor disliked the adulation he received in Padua and was relieved to return eventually to Florence, where he knew he would receive from the carping Florentines nothing but criticism, which would spur him on to greater achievements. Whether or not Vasari records Donatello's actual words, his comment admits us to an essential aspect of the Florentine Renaissance, in which intense conflict of wills was a major determinant of style.

The great Florentine sculptor was probably called to Padua to execute the colossal equestrian statue in bronze of the Venetian condottiere Erasmo da Narni, called Gattamelata ("Calico Cat"), which still stands in the square in front of the Basilica of Sant'Antonio where Donatello placed it after its completion in 1453 (fig. 249). Although the funds were provided by the dead general's family according to a stipulation in his will, this kind of monument, previously reserved for rulers, must have been authorized by a decree of the Venetian Senate. The Gattamelata is by no means the first equestrian monument of the Late Middle Ages and Renaissance in Italy. Donatello had in Florence an immediate pictorial forerunner in Paolo Uccello's Sir John Hawkwood (see fig. 259). The Tuscan examples, however, including a lost gilt statue by Jacopo della Quercia made of wood and tow (see page 174), had been intended for interiors. In

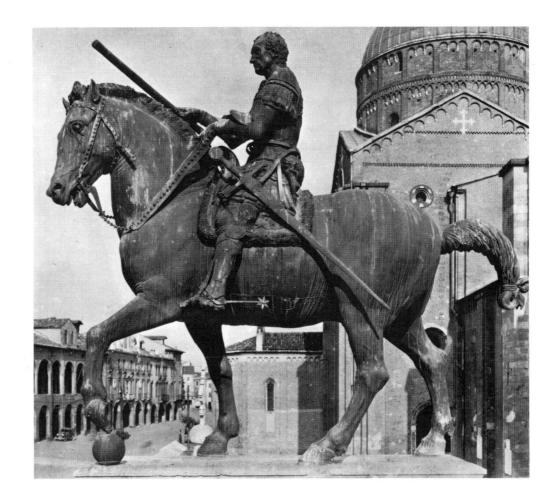

right: 249. DONATELLO. Equestrian Monument of Gattamelata. 1445–53. Bronze, height 12'2". Piazza del Santo, Padua

below: 250. Head of Gattamelata, detail of fig. 249

the Trecento, the ruling Scala family of Verona built out-door tombs surmounted by equestrian statues, Bonino da Campione had done his amazing monument to Bernabò Visconti (see fig. 131), and only two years before Donatello's trip to Padua, Niccolò d'Este was commemorated by an equestrian statue by two otherwise unknown Florentine sculptors, which was set up before the Cathedral of Ferrara, where it remained until it was destroyed in 1796.

Donatello was influenced somewhat by ancient Roman examples, two of which were extant in Italy in his day: the Marcus Aurelius in Rome, then thought to represent Constantine, and the so-called Regisole in Pavia, an Imperial statue now lost. But Donatello's end result surpasses the Marcus Aurelius in majesty and, above all, in determination. Moreover, the artist has outdone his previous self. The subtleties and hesitancies so evident in his Florentine statues, even those whose details are simplified in accordance with their location high on the Campanile, would have been ineffective in the vast space in which the Gattamelata was to be placed. He therefore restricted his design to the boldest masses and the most powerful tensions. All minor shapes that might compete with the broad curves of the battle charger's anatomy are suppressed. The horse's tail is tied at the end, to form a taut arc. His left forehoof forms another, toying with a cannonball as the foot of the bronze David dallies with the head of Goliath. From above the horse's head down

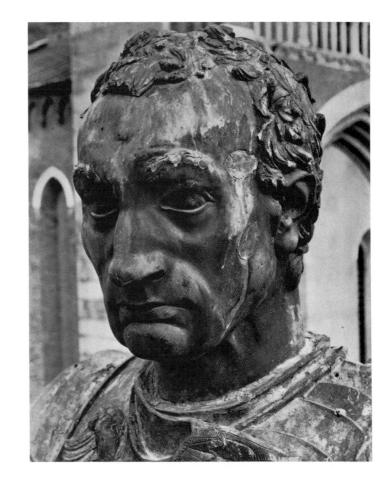

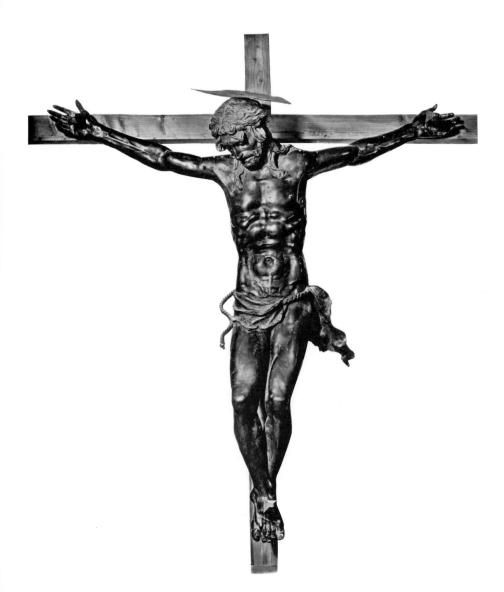

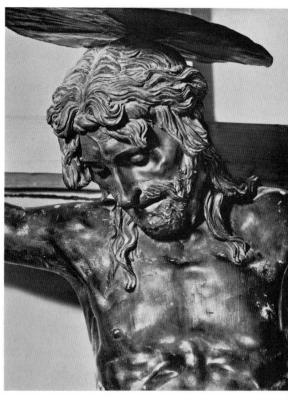

left: 251. DONATELLO. Crucifix. 1444–47. Bronze, height c. 71". High altar, Sant'Antonio, Padua

above: 252. Head of Christ, detail of fig. 251

to his hind leg, a powerful diagonal formed by the general's baton and sword ties the composition together. Donatello had never seen Gattamelata and made no attempt to reproduce his features. The compressed lips, the firmly set jaw under pulsating facial muscles, the heavy, arched brows and close-cropped curls, and especially the wide eyes used to gazing into distances, pertain to an ideal conception of how a general in the prime of life ought to look (fig. 250). The horse, with his swelling veins, open jaws, and flaring eyes and nostrils, seems an extension of this overpowering personality. Seldom in the history of portraiture can one point to so majestic an image of command. The later Quattrocento historian Vespasiano da Bisticci, so devoted to the contemporary cult of personality that he wrote a book on the "singular men" of the fifteenth century, never set before his public a character more imposing than this one.

The details play their part in the total picture. The general is dressed in the cap-a-pie armor of the fifteenth century, complete with giant broadsword and greaves. But the artist desired to endow the Renaissance leader with the grandeur and glory of antiquity. From ancient Roman military costume he borrowed the kilt and short

sleeves made of leather thongs. Victory masks and winged genii, flying or on horseback, populate the surfaces of the armor and the saddle. On the breastplate, a winged victory crying out in fury enhances by contrast the composure of the general. Every element contributes to the impression of great emotional and physical forces under stern control. This is the ideal man of the Renaissance, the exemplar of Albertian *virtus*.

While he was at work on the equestrian statue, dealing in absolutes on a colossal scale, Donatello was concerned with very different matters in another major commission, the high altar of Sant'Antonio, decorated with four large narrative reliefs, a number of smaller ones, and seven life-sized statues in bronze. The altar, repeatedly remodeled in the sixteenth and seventeenth centuries and erroneously restored at the end of the nineteenth, no longer looks at all as Donatello intended. But the reliefs and statues are unchanged. The bronze Crucifix that now stands above the altar (fig. 251) was originally to be placed elsewhere in the church, and it is the first work Donatello completed in Padua. Christ is depicted as a powerful, athletic man with a handsome, rather classical face (fig. 252) whose sensitive features

display great intelligence and the ability to endure pain calmly in the manner of an ancient Stoic. Light glides easily across the strong arms, extended hands, sturdy rib cage, firm thighs. To display the body more completely, the loincloth is parted to show the nude left flank. If one may speak of a classical Crucifixion, this is it.

In Florence, Donatello had made remarkable experiments with relief narration and illusionistic space in his large-scale stucco medallions for the spandrels of the

Old Sacristy of San Lorenzo (see fig. 139). But the stories that unfold in the four major bronze reliefs of the Padua altar are so much more elaborate in their representation of architectural backgrounds as to seem Donatello's answer to Ghiberti's *Gates of Paradise* (see fig. 236). Not only are they, as we might expect, deliberately less harmonious than the graceful compositions of Ghiberti; they also present a new and explosive conception of space as an alternative to what may have seemed to

253, 254. DONATELLO. *Miracle of the Believing Donkey* (above) and *Miracle of the Irascible Son* (below), reliefs on the high altar, Sant'Antonio, Padua. 1446–53. Bronze, each 22½ × 48½"

255. MICHELOZZO DI BARTOLOMMEO. Faith, on the Tomb of Bartolommeo Aragazzi, Cathedral, Montepulciano. c. 1430. Marble, life-sized

Donatello a slavish incorporation by Ghiberti of Albertian principles.

In the Miracle of the Believing Donkey (fig. 253), Donatello has illustrated simply and directly a tale from the legend of St. Anthony, which recalls how a Provençal visitor to Rimini refused to believe in the Real Presence in the Eucharist unless his donkey knelt down and worshiped it, which the obliging animal promptly did. Donatello has shown the saint turning from the altar to the donkey with the consecrated Host in his hands, the beast kneeling on the top step, and crowds of the faithful peering out from behind the altar and around columns and piers, swept by a wave of astonishment. The powerful poses and the sketchily rendered, agitated drapery

masses create a continuous surface of great excitement. But the viewpoint is low, excluding any Albertian floor construction of receding transversals intersecting with a pyramid of converging orthogonals. This is lucky, as the scene is so wide that the Albertian system would have been reduced to absurdity at the corners. The figures are dwarfed by a vast construction with three great barrel vaults recalling those of the Basilica of Maxentius, known in the Renaissance as the Temple of Peace. Donatello has altered their appearance considerably, substituting a horizontal grid for the original octagonal coffering, filling the windows with metal grilles through which one sees other barrel vaults and other grilles, and placing between the arches two lofty pilasters with modified Corinthian capitals upholding an entablature. The resultant spatial formulation tends to break forward and outward, rather than to recede smoothly into the distance as in the Gates of Paradise. It is this kind of space, among many other aspects of Donatello's art, that fascinated the youthful Mantegna when he worked and studied in Padua during the period of Donatello's sojourn (see page 385).

The Miracle of the Irascible Son (fig. 254) is spatially even more surprising. Here St. Anthony heals the leg of a young man who had cut off his foot in remorse for kicking his mother. The setting is a stadiumlike structure that has been identified as an outdoor ball court, ancestor of the modern football field—somewhat too grimly appropriate to the incident. Most of the elements recede properly, but a fantastic palace in the background and a structure with a flight of steps in the right foreground are set at angles to the main axis and refuse to conform, as if to provide a spatial fracturing appropriate to the theme. Clouds float in Donatello's sculptured sky, and a great sun throws clustered sword-shaped rays upon the rapidly receding benches and swarming figures. Donatello's dramatic compositions must have provided a revelation to the North Italian painters of his day, and their influence continued for the next century and a half.

FLORENTINE TOMB SCULPTURE. Throughout the Late Middle Ages and the Renaissance a major field for sculpture in Italy was the funerary monument, not only the simple tomb slabs carved by Donatello, Ghiberti, and many others but also splendid sepulchers placed against a church wall, displaying the effigy of the deceased in a setting of architectural magnificence, sanctified by the presence of Christian images, notably the Madonna and Child. Together Donatello and the chameleon Michelozzo did such a tomb for the deposed antipope John XXIII (Cardinal Cossa) in the Baptistery in Florence, and Michelozzo made one for the Aragazzi family in the Tuscan hill town of Montepulciano. The vigor and forthrightness of Michelozzo's sculptural style (fig. 255), as well as its strong classicism, place him at this juncture within the range of the second Renaissance style, especially close to Luca della Robbia, if more energetic and more tormented.

Another master of tomb sculpture was Bernardo Rossellino (1409–64), the fourth of five brothers, all stonecutters, from Settignano (Antonio, the youngest, will be discussed in Chapter 12). As an architect Bernardo had worked at the Palazzo Rucellai, in a not-too-happy con-

256. Bernardo Rossellino. Tomb of Lionardo Bruni. c. 1445. White and colored marbles. Sta. Croce, Florence

nection with Alberti (see page 224). On his own, he remodeled for Pius II the papal city of Pienza (see page 228). His most conspicuous sculptural work was the tomb of Lionardo Bruni, the chancellor of the Florentine Republic in its darkest moment, a sort of Quattrocento Churchill, and one of the most eminent humanist scholars of the age (fig. 256). Bruni died in 1444, and his tomb must have been built and carved shortly thereafter. It was paid for by the Republic and set up in the right side aisle of Santa Croce. Bernardo, possibly under Albertian direction, devised a system of marble paneling under an embracing arch, which was followed in other tombs and in some ways imitated by painters of the second Renaissance style, especially Andrea del Castagno and Piero della Francesca. In front of the white marble and the deep-red porphyry panels lies the effigy of the chancellor, holding one of his own books, on a bier upheld by the eagles of his victories. Angels in low relief, posed like winged victories, support a tablet with a Latin inscription recording the grief of the Muses over his death. Above, the Virgin holds the Christ Child in a circle of Heaven with praying angels on either side; high above, youthful nude angels steady the shield of Florence displaying the *marzocco* (lion) of the Republic. Bernardo, as a sculptor, cannot vie with the best, but he had control of the repertory devised by greater masters, such as Donatello and Luca della Robbia. He was a powerful portraitist, showing with forthright realism the rugged features of the old statesman turned toward us, his brow crowned with laurel (fig. 257). In this clear-cut, simple arrangement of handsome geometrical forms that bear out the dignity of human beings, Bernardo established the standard type of the Florentine wall tomb.

257. Head of Lionardo Bruni, detail of fig. 256

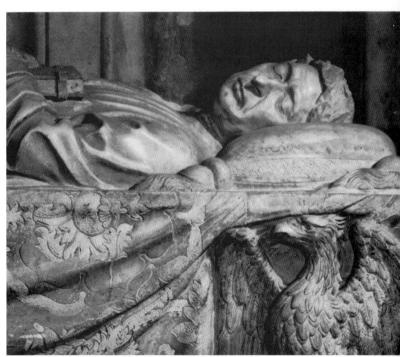

11

Absolute and Perfect Painting: The Second Renaissance Style

our painters, each more or less closely associated with the others and with Alberti, sum up the possibilities and embody the ideals of the second Renaissance style: Paolo Uccello, Domenico Veneziano, Andrea del Castagno, and Piero della Francesca. We must bear in mind that, while they were painting, Fra Angelico and Fra Filippo Lippi were still at work, that the age gap between the four "later" and the two "earlier" masters was slight (in the case of Uccello, nonexistent), and that there must have been considerable interchange among them. In the works of their imitators, after the midcentury, the styles of all six tend to fuse.

PAOLO UCCELLO

Paolo di Dono, known as Paolo Uccello (1397–1475), is an odd and appealing figure. His life was long, yet he painted little. Although he occasionally received an important commission, he never was responsible for a single major altarpiece or fresco cycle. At least twice, his patrons complained of the unconventionality of his work. In his tax declaration of 1469, he laments that he is old and infirm, has no means of livelihood, and that his wife is sick. Posterity has reproached him for having wasted time with perspective. Vasari tells us that Uccello, entirely by means of perspective theory, was able to project a polyhedron with seventy-two sides from each of which projected a stick bearing a scroll; and also that he refused to follow his wife into the bedchamber with the classic rejoinder, "What a sweet mistress is this perspective." Probably it was a game to him (fig. 258), and there is much to show that he did not take the new science with the solemnity recommended by Alberti.

Little remains to give us an idea of Uccello's artistic achievements before his fortieth year. Unless certain decorative mosaic designs in San Marco can be attributed to him, the work he did in Venice in 1425–31 is lost. His earliest dated painting is the colossal fresco in the Cathedral of Florence, painted in 1436 on commission from the officals of the Opera del Duomo, an equestrian monument to the English condottiere Sir John Hawk-

258. PAOLO UCCELLO. *Perspective Study of a Chalice*. 1430–40. Pen and ink, 13%×9½". Gabinetto dei Disegni e Stampe, Uffizi, Florence

wood (fig. 259), known to the Italians as Giovanni Acuto, to whom a monument in marble had been promised just before his death in 1394. Donatello had seven years to assess the painting before departing for Padua in 1443. There are numerous points of resemblance between the *Gattamelata* (see fig. 249) and the *Hawkwood*,

notably the horse's stride with both legs on one side advanced, both on the other retracted; the pose of the rider's legs; the raised baton. Uccello, however, expressed little of the tension that makes the *Gattamelata* unforgettable. The baton is lightly lifted, the forehoof paws the air, the tail flows free. Nor does he outfit the condottiere with Roman trappings. Contemporary armor, cloak, and cap do well enough.

The pedestal rests on a base that is supported by three consoles, not unlike those designed by Luca della Robbia five years earlier for his Cantoria in the same cathedral (see fig. 241). The architecture was originally projected in perspective from a point of view far below the lower border of the fresco, at about the eye level of a person standing in the side aisle. The fresco, transferred twice, is now hung too low. But the horse and rider are seen from a second point of view, at about the middle of the horse's legs. If he had projected the horse and rider from below, in conformity with the pedestal, the observer would have looked up to the horse's belly, as in Avanzo's fresco, which Uccello must have known in Padua (see fig. 129), and seen little of the rider but his projecting feet and knees and the underside of his face. But might not Uccello, a lifelong practical joker, have done exactly that? Perhaps at first he did. The officials of the Opera objected to his painting of the horse and rider and compelled him to destroy that section of the fresco and do it over again. The explanation for this often-noted circumstance may well have been Uccello's view of the great man from below.

Uccello's sovereign artistic achievement is the fresco representing the *Deluge* in the Chiostro Verde (Green Cloister) of Santa Maria Novella in Florence (fig. 260), part of a series started earlier by various Quattrocento painters, including Uccello himself, and heavily damaged (ironically enough, considering Uccello's subject) by the disastrous flood of 1966 as well as, it would appear, by previous inundations. The cloister acquired its name by reason of the fact that the frescoes were painted for the most part in a *terra verde* (green earth) monochrome. The *Deluge* also employs ocher, but no other color. The style of the painting, with its new emphasis on monumentality and spatial unity, is thoroughly consistent with what other Florentine painters were doing about 1445–47.

Despite the damage the work has sustained, it is still a majestic creation. Uccello has shown us two scenes within the same lunette, thus giving two views of the Ark, one from the side and another from one end. The two views form the walls of a huge ideal corridor creating an Albertian perspective cone. As there is no border dividing the episodes, the figures in one scene tend to overlap those in the other to the detriment of easy legibility. On the left the Ark is afloat, beset by thunder, lightning, wind, and rain. A bolt of lightning (fig. 262) strikes near the point to which the perspective of the

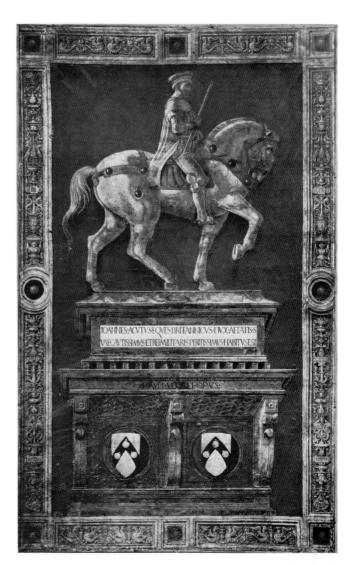

259. PAOLO UCCELLO. *Sir John Hawkwood*. 1436. Fresco, transferred to canyas. Cathedral, Florence

sloping flank of the Ark rapidly vanishes, casting on the planking shadows of the tree being blown away by a little wind-god (whose representation is recommended to painters by Alberti) hurtling through the air past the Ark. Doomed humans lay hopeless siege to the floating fortress, one brandishing a sword as he rides a swimming horse, another threatening him with a club, a third clutching at the Ark with his fingers (fig. 261). Others attempt to stay afloat on wreckage or in barrels. The club-bearer wears around his neck, like a life preserver, one of the favorite subjects of Uccello's perspective investigations, the mazzocchio, a faceted construction of wire or wicker around which the characteristic turbanshaped headdress of the Florentine citizen was draped. The hair on one side of his head remains neatly combed, but the wind has disheveled the other and it streams before him. A ladder floats parallel to the Ark, thereby providing two more Albertian orthogonals.

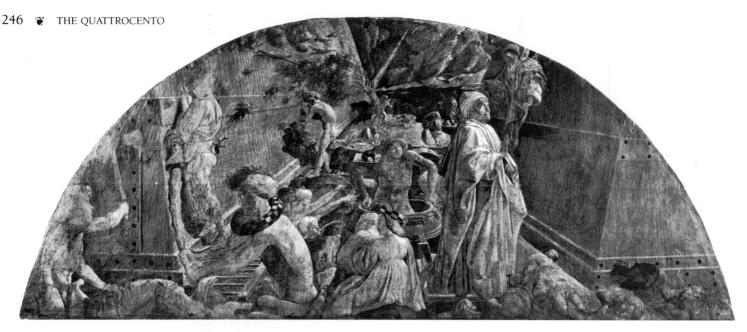

260. PAOLO UCCELLO. Deluge. c. 1445-47. Fresco. Chiostro Verde, Sta. Maria Novella, Florence

261. Detail of fig. 260

On the right side the Ark has come to rest, and from its window leans Noah, to whom is returning the dove sent forth to discover dry land. Below the Ark can be made out the corpse of one drowned child, and a raven picks out the eyes of another. No one has yet identified successfully the heavily cloaked man standing in the right foreground with one hand raised as if in thanksgiving, while two mysterious hands clutch his ankles from the water below. The power of the drapery masses, the intensity of the facial characterizations, the sense of high tragedy in the individual figures and groups and of cataclysm in the entire scene are all compelling enough to make us overlook the unfair riddles Uccello seems to impose. For all the deliberate unreality of its spatial connections, the *Deluge* is a grand painting in the continuing tradition of Masaccio, but charged throughout with the intellectuality of the second Renaissance style.

More artificial in effect, and even more fully imbued with Uccello's perspective obsessions, are the three panels representing the Battle of San Romano (colorplate 31, fig. 263), which once decorated the end wall of a bedchamber in the Medici Palace that was later occupied by Lorenzo the Magnificent. The three panels are now divided among the National Gallery in London, the Uffizi in Florence, and the Louvre in Paris, and their separate vicissitudes have reduced them to widely varying states of preservation. Originally, they ran just above a wooden wainscoting, to which they were united by gilded frames, possibly containing pilasters to tie the panels to the ceiling as well, as was customary in all such series of panels in Florentine palaces. End to end, the series in place measured more than thirty-four feet. The panels were designed to form a continuing interlace of horses, horsemen, and weapons on a flat foreground stage, separated by a screen of fantastic fruit trees from a back-

262. Detail of fig. 260

ground landscape continuous throughout all three scenes. United with the architecture of the vaulted room, the panels must have combined the coloristic brilliance of painting with the grandeur of a sculptural frieze.

The events represented happened in 1432, but schol-

ars have dated the panels in the 1450s, when the Medici Palace was nearing completion. They may have been designed earlier, not far from the date of the *Deluge*, whose sculptural and perspective effects reappear in these panels. But not its intensity: the rearing horses in Uccello's

263. PAOLO UCCELLO. Battle of San Romano. c. 1445. Panel, 6' × 10'6". National Gallery, London

panels seem transplanted from a carrousel, and the impression is one of a tournament rather than a military engagement. This is partly due, of course, to Uccello's stylization of contour and modeling in the horses and in the armor, consistently reduced to brilliant ornament rather than grim reality.

These toy people do not really wound each other or really bleed. Perhaps their apparently wood, plaster, or metal substance contains no blood. Even more, the unreality of the scene derives from the rigidity of the perspective construction. Most of the broken lances, like the floating ladder in the Deluge, have fallen in conformity with Albertian orthogonals. So have the pieces of armor, including, in the lower left-hand corner of the Uffizi panel, a shield around which is wrapped a little scroll bearing Uccello's signature, with all the letters receding in perspective. Horses and horsemen are seen in side view or in perspective foreshortening arranged so that they recede into depth or plunge toward the spectator, often at right angles to the orthogonals formed by the lances. In one instance, at the lower left of the National Gallery panel, a soldier has managed to die in perspective. It is as though perspective were not a phenomenon of vision but a magical structure implicit in the air itself, like the cleavage lines in rock, enforcing acquiescence on all persons and objects.

In the midst of such a web of interwoven geometrical compulsions, practical jokes, and abstract beauty, the deep humanity of certain faces comes as a surprise, especially the searching portrait in the London panel of Niccolò da Tolentino, captain of the Florentine forces, or the delicate profile of the little blond page behind him. The pictures are all badly worn, in many places almost down to the underpaint, but the clarity of the division into planes of tone and of the contours that in some cases are actually incised—originally meant to be partially veiled under layers of finer modeling—is very informative about Uccello's procedure. The background land-scape looks stylized but resembles the little, rippling hills divided into narrow field strips still visible near San Romano in the Arno Valley, not far from Pisa. All sorts of

things go on in this background: hand-to-hand combat, soldiers in hot pursuit of the enemy, a dog in equally hot pursuit of a rabbit, and unconcerned peasants serenely bringing baskets of grapes to the wine press—all in the midst of trees and hedgerows that look almost Japanese.

Uccello's latest known work, apparently, is the predella (fig. 264) that was all he ever finished for a larger commission, the altarpiece of the Church of Corpus Domini in Urbino. Apparently he was offered the commission in 1468, painted the predella, and then started on the altarpiece itself. The work, to judge from the surviving records, did not satisfy the Compagnia del Corpus Domini, who dismissed Uccello and tried unsuccessfully to persuade Piero dello Francesca to take over the job in 1469. Only in 1473 was the commission finally given to the Netherlandish painter Justus of Ghent, who painted his famous *Institution of the Eucharist*.

Whatever the authorities of Urbino may have felt about Uccello's predella, its poetry and wit and the brilliance of its design have delighted the twentieth century. The subject is an anti-Semitic legend—of the kind circulated throughout history with appalling consequences, yet very lightly treated by Uccello—concerning a poor Christian woman who was forced by a Jewish pawnbroker to redeem her cloak at the price of a consecrated Host, which he proceeded to roast on a trivet in the fireplace. Streams of blood poured from the Host, arousing the attention of bailiffs, who battered down the door, burned the Jew and his family at the stake, and hanged the repentant woman, after the Host had been returned to its altar by the pope himself. Uccello narrates the frightful story almost in the manner of a comic strip, peopling his airless spaces with little personages whose chinless faces and pointed noses go far toward justifying the dissatisfaction of the Compagnia del Corpus Domini. In the first scene, the interior of the shop, Uccello has given us an exemplary visual statement of Albertian perspective construction. But in the next scene, beyond the intervening spiral baluster (fully projected in perspective, of course), he displays the Achilles' heel of Alberti's system. The interior of the Jew's living room is

264. PAOLO UCCELLO. Miracle of the Host, first two episodes of a predella. 1468. Panel, dimensions of whole predella $1'4\frac{1}{2}" \times 11'6"$. Galleria Nazionale delle Marche, Palazzo Ducale, Urbino

Colorplate 30. LORENZO GHIBERTI. *Jacob and Esau*, panel on the *Gates of Paradise*, Baptistery, Florence. c. 1435. Gilded bronze, 31½" square. (Note Ghiberti's signature)

Colorplate 31. PAOLO UCCELLO. Battle of San Romano. c. 1445. Panel, $6' \times 10'7''$. Uffizi Gallery, Florence

Colorplate 32. DOMENICO VENEZIANO. *Madonna and Child with Saints* (St. Lucy altarpiece). c. 1445. Panel, 82×84". Uffizi Gallery, Florence

Colorplate 33. Domenico Veneziano. St. John the Baptist in the Desert, from the predella of the St. Lucy altarpiece. c. 1445. Panel, $11 \times 12\%$ ". National Gallery of Art, Washington, D.C. (Kress Collection)

Colorplate 34. Andrea del Castagno. Last Supper. 1447. Fresco. Cenacolo of Sant'Apollonia, Florence

Colorplate 35.

ANDREA DEL CASTAGNO.

Vision of St. Jerome.
c. 1454–55. Fresco.

SS. Annunziata, Florence

Colorplate 36. PIERO DELLA FRANCESCA. Battle of Constantine and Maxentius, from Legend of the True Cross. Probably 1452–57. Fresco. S. Francesco, Arezzo

Colorplate 37. PIERO DELLA FRANCESCA. Flagellation of Christ. Probably 1463–64. Panel, 231/4×32". Galleria Nazionale delle Marche, Palazzo Ducale, Urbino

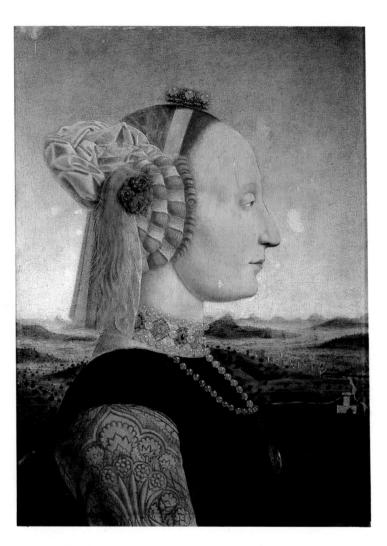

Colorplate 38. Piero della Francesca. Battista Sforza. After 1474. Panel, $18\frac{1}{2} \times 13^n$. Uffizi Gallery, Florence

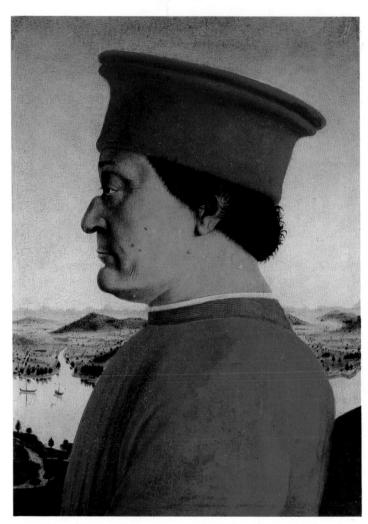

Colorplate 39. PIERO DELLA FRANCESCA. Federico da Montefeltro. After 1474. Panel, $18\frac{1}{2}\times13''$. Uffizi Gallery, Florence

shown from a point of view slightly to the right of its outer wall, so that the street is visible at the same time. As a result, the floor tiles become absurdly flattened at the extreme left into trapezoids that bear no relation to the actual phenomena of vision. For Uccello has prolonged the perspective construction laterally to the point where, as we have seen in discussing Alberti's perspective theory (see page 230), the transversals begin to draw away from the foreground plane in the form of a curve in order to recede to their own vanishing points. There can be little doubt that Uccello made this construction with tongue in cheek.

DOMENICO VENEZIANO

A probably younger contemporary of Paolo Uccello was a foreigner in Florence: Domenico Veneziano (c. 1410-61), as his name discloses, came from Venice. His artistic origins and the dates of many of his surviving works are as mysterious as the date of his birth. Presumably he was influenced in his early work by the rich legacy of Gentile da Fabriano in Venice, and by the early Quattrocento art of Lombardy, especially by Pisanello (see pages 378-81), with whose works those of Domenico have often been confused. He may even have studied the manuscript paintings of the Franco-Flemish school, such as the works of the Limbourg brothers. Probably he knew the frescoes by Masolino at Castiglione Olona (see colorplate 26). Domenico may have worked in Florence more than once before he came there to stay in 1439. A splendid circular painting of the Adoration of the Magi, almost three feet in diameter (fig. 265), gives considerable evidence that Domenico was familiar with the ideas and works of Masaccio and even those of Fra Angelico. Like Fra Angelico's Descent from the Cross (see colorplate 27), the painting makes sense as an attempt to set a manyfigured composition deep in a naturalistic space. The tondo shape was an innovation, rapidly taken up both in sculpture and in painting by other Quattrocento masters including, as we have seen, Fra Filippo Lippi (see fig. 218), on whose art Domenico was to exert a strong influence. The arrangement of Mary, the Christ Child, and the first Magus is similar to that in Masaccio's Pisan Adoration of the Magi (see fig. 203), but in reverse. The horses seen from front and rear are suggested by Masaccio's work, but rearranged and simplified in a manner later exploited by Piero della Francesca in his frescoes at Arezzo (see fig. 282). The costumes, like those of Gentile da Fabriano's Magi and their retinue (see colorplate 22), would have been illegal in Florence, but that did not prevent the Florentines from enjoying the representation of forbidden fruits. After all, the Magi came from afar, and were therefore not subject to Florentine sumptuary laws. Foreigners in Florence must have looked strange in this respect, as witness the two outlandish messengers in Masolino's Raising of Tabitha (see fig. 195). Domenico has endowed two of his little figures with the towering hats of Greek courtiers, others with costumes bearing French and Italian mottoes inscribed in Gothic letters.

All are projected in space and light as only the close study of Masaccio and Fra Angelico could have enabled Domenico to do. Their heads and their globular or cylindrical headgear or masses of curled hair, their swinging sleeves of velvet, brocade, and fur, their stockinged legs, all revolve flawlessly in light and shade, overlap, and diminish as they recede into the distance. But no one in Florence could have taught Domenico to paint the landscape background, a souvenir of North Italy, specifically the shores and sub-Alpine surroundings of Lake Garda, with sailboats speeding before the breeze, houses, towers, castles, vineyards, fields, flocks and their shepherds, a road and its travelers, and a corpse swinging on a roadside gibbet. Only familiarity with Netherlandish painters such as the Master of Flémalle, with whose backgrounds this has much in common, might have prompted such attention to nature. Domenico may have brought a drawing of Lake Garda with him and incorporated the scene into his painting, for at the right he has added a rocky promontory which has nothing to do with Lake Garda, and is inherited from traditional medieval landscape forms. Masaccio had developed a proto-Impressionist brushwork in his landscape backgrounds. Yet nowhere in his works do we find anything like the ease of the little touches which do duty for foliage or people in the expansive countryside that opens up in Domenico's tondo.

In 1438, as we have seen (see page 205), Domenico was in Perugia, and wrote to Piero the Gouty, son and heir of Cosimo de' Medici, "I have hope in God to be able to show you marvelous things." Perhaps this tondo was one of them, as it was in the Medici Palace in 1494, as the mottoes have been recently identified as Medicean, and as the standing figure to the right of the second Magus has been recognized as a portrait of Piero de' Medici. If so, the tondo must be dated in 1438-39. At any rate, Domenico was at work in Florence in 1439 on a series of frescoes, now lost except for a few fragments, for the small Church of Sant'Egidio in the Hospital of Santa Maria Nuova. Here the youthful Piero della Francesca, among others (see page 269), served him in a minor capacity. Probably about 1445 Domenico painted his principal surviving work, the so-called St. Lucy altarpiece (colorplate 32), for the little Church of Santa Lucia dei Magnoli in Florence. The central panel admits us to a small courtyard in which are enthroned the Virgin and Child, flanked by Saints Francis, John the Baptist, Zenobius, and Lucy. The triptych format, which survived in the three-arched frame of Filippo Lippi's Barbadori altarpiece (see fig. 216), is echoed only in the three pairs of pointed arches of the loggia under which Domenico's gracious Virgin is seated.

Color was the artist's major concern. The entire panel

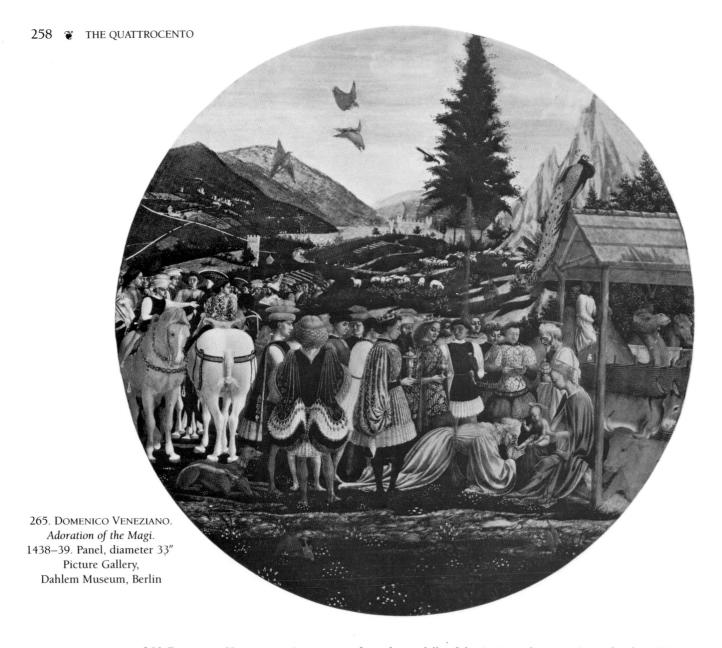

266. Domenico Veneziano. *Annunciation*, from the predella of the St. Lucy altarpiece (see colorplate 32) c. 1445. Panel, $10^{5}/8 \times 21^{1}/4''$. Fitzwilliam Museum, Cambridge, England

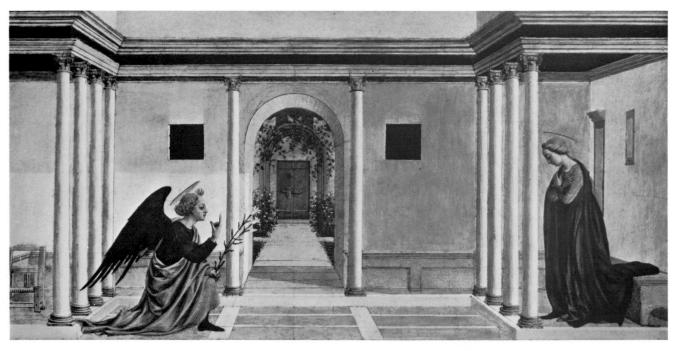

glows with color of a kind so foreign to Florentine experience as to account for Vasari's belief that Domenico painted in oil. The architecture itself—its white marble colonnettes crowned with gilded capitals of a modified Corinthian type, its arches, spandrels, exedra, steps, and elaborate pavement, all inlaid in rose, white, and green marbles—is conceived in color. Moreover, all its shadows are illuminated by the reflections from its many sunbathed surfaces. "Marvelous things" do indeed take place in the softly colored shadows of the exedra and its shell niches, in the groin vaults, and especially on the fabrics—the gold damask of the Virgin's dais, the soft, blue cloth of her cloak, the green velvet of the sabletrimmed mantle thrown over her chair, the vestments of St. Zenobius, the rose-colored cloak of St. Lucy, and the pearls that shine in the neckline of her tunic and that of the Virgin. In St. Zenobius' miter Domenico has even distinguished between the dull tone of the seed pearls in the embroidery and the luster of the massive pearls studding the miter at intervals.

This is not to say that the Venetian newcomer was unaware of Florentine conquests in the realm of form. The mounds and furrows into which time has divided the faces of the three male saints indicate that Domenico studied carefully the sculpture of Donatello and Ghiberti. The firmly constructed muscular forms of St. John's arms and legs would have been approved by Leonbattista Alberti, and the easy flow of the drapery folds is in full harmony with the finest passages in the Gates of Paradise (see fig. 236). Yet these forms have been created less by the traditional Florentine means of drawing in line, followed by shading, than by the changing play of color in light. Nowhere is Domenico's new formal colorism more apparent than in the lovely figure of St. Lucy herself, extending the palm of her martyrdom and the platter on which rest her eyes, which she plucked out and sent to a young man who had admired them excessively (the Virgin rewarded her with a new pair). Light, as has recently been shown, is especially appropriate to St. Lucy, who became the patron saint of vision. The light dwells in the shadows of the cloak and projects its forms, all in tones of glowing rose. The saint, in her perfect calm and poise, typifies the new aristocratic ideal of the Florentine upper middle class. With the utmost elegance and refinement Domenico has studied the way in which masses of St. Lucy's blond hair are brought back and curled under, and then contrasted with the wispy locks that controlled accident allows to escape, in order to bring out the sensitive pallor of the face and of the artificially lofty forehead. The entire head is like one of Domenico's giant pearls, so gently does the light glide across it, and across the silken surface of throat and neck. Even the haloes are transformed from the traditional Florentine golden platters to disks of the purest crystal rimmed with gold.

The Annunciation (fig. 266), once the central section of the predella, is now in the Fitzwilliam Museum in Cambridge, England. The event takes place in a small colonnaded court whose elegant forms contrast with the rough bench on which Mary had been seated and with the simple rush chair, almost identical with those still used in Italian farmhouses. The angel kneels, bearing the lily and pointing upward, while Mary resignedly crosses her hands upon her bosom. Through an arch we look into the little closed garden, symbol of Mary's virginity, as we have already seen in the Annunciations by Fra Angelico (see figs. 206, 210). The garden walk ends in a formidable porta clausa, a gateway studded with nails and secured with a huge wooden bolt. The rendering of the garden, however, is prophetic of the gardens painted by Velázquez in the seventeenth century. The roses growing in their beds and the vine clambering over the trellis are painted in small, separate touches of the brush in a manner somewhat recalling the foliage in Masaccio's frescoes (see page 187), but more striking here since it was intended to be seen at close range. For Domenico Veneziano the individual touch of the brush is equated with the individual ray of sunlight reflected from a leaf or a petal.

An even more intense rendering of sunlight is given in another panel from the same predella, in the National Gallery in Washington, D.C. (colorplate 33), representing the youthful St. John the Baptist in the Desert. In the Trecento St. John had often been shown trudging cheerfully off into the rocks, cross-staff in hand. Domenico's picture is unusual in that it depicts the boy wistfully dropping his clothes on the rocky ground as he is about to assume the camel's-skin raiment of his sojourn in the desert. With a sensuous grace typical of the new Renaissance delight in the body, the youth is exposed to the full glare of the sun. The almost Greek rendering of the nude figure is in keeping with Ghiberti's finest achievements in this regard, such as the Isaac of the competition relief and the Christ of the Flagellation (see figs. 151, 155). The unreal, still somewhat Byzantine forms of the surrounding mountains, much like the rocks on the right in the Adoration of the Magi (see fig. 265), are made believable by the wildness of their contours and above all by the fierce sunlight, which changes their facets from white to blue-white and yellow-white. The same light reflects from the rounded forms of the boy's body and dwells on every pearly stone along the way.

ANDREA DEL CASTAGNO

Domenico's contemporary in Florence, and probably his friend as well, was Andrea del Castagno (1417/19–57), a man of such different temperament and artistic ideas that the association of the two artists still eludes understanding. According to Vasari, Castagno was a man of coarse and violent nature, so jealous of his friend Domenico's skill at painting in oil in the Venetian manner (although, as we shall see, oil was not generally adopted in Venice until about 1475) that one night he murdered poor Domenico, and no one would have known who killed him if Castagno had not confessed the crime many years later, on his own deathbed. This story, which blackened Castagno's reputation for three hundred years, met with an obstacle a century ago, when the eminent archivist Gaetano Milanesi unearthed the artists' actual dates and discovered that Castagno died four years before his supposed victim. Yet with that much smoke there is usually some flame, and Castagno probably was a difficult and irascible individual. Certainly, the human dilemma he presents to us contrasts vividly with the serene and sunlit world of the nature-loving Domenico. Andrea came from a hamlet called Castagno (Chestnut Tree) at the head of a steep-walled valley near the crest of the Apennines, yet nature seldom appears in his work. His deepest interest is in man, and the man he presents is characteristically the truculent mountaineer of his Tuscan surroundings.

When Andrea del Castagno was in his mid-twenties, he was already at work in Venice, where Paolo Uccello and Fra Filippo Lippi had preceded him in bringing the new ideas of the Florentine Renaissance to the city of the lagoons. Formerly attributed to Andrea Mantegna, the *Death of the Virgin* mosaic in the Mascoli Chapel, in

the left transept of San Marco (fig. 267), is now generally accepted as having been made from Castagno's designs (save for the six Apostles at the extreme right, added by the Venetian painter Michele Giambono) in 1443, the vear of Donatello's arrival in Padua. The Florentine Renaissance is here in all its most recognizable elements. The standing Apostles on either side flank a majestic arch recalling Brunelleschi's architecture and the dominating form in Masaccio's Trinity (see colorplate 25). The arcaded street in the background is not just a foretaste of Alberti; the forms are very close to those developed by Donatello for reliefs in the Old Sacristy of San Lorenzo only a few years earlier (see fig. 139). The Virgin on her bier, her head tilted slightly toward the observer and her right hand clasped over her left, is influenced by effigies in Florentine tomb sculpture. The two grand Apostles at the left, clad in voluminous folds of good Florentine cloth, recall at once the statues on Orsanmichele, particularly Donatello's St. Mark (see fig. 162). The ornament of the frieze above the arch resembles the marble decorations for the portals of the Cathedral of Florence, for whose construction the sawmill run by Castagno's father produced some of the timber. Accompanied at the lower extremity by turbulent clouds,

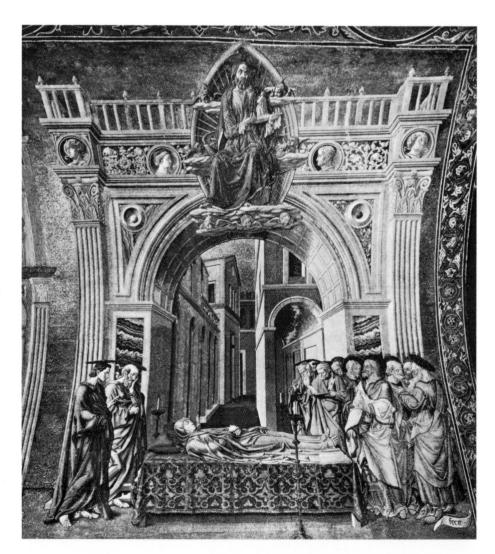

267. Andrea del Castagno and Michele Giambono. Death of the Virgin. 1443. Mosaic. Mascoli Chapel, S. Marco, Venice

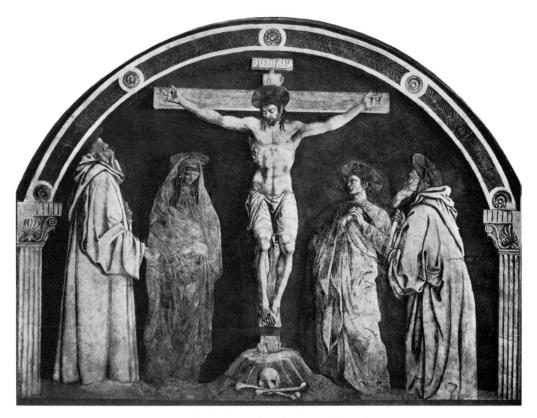

268. Andrea del Castagno. *Crucifixion with Four Saints*. c. 1445. Fresco. Cenacolo of Sant'Apollonia, Florence

and so placed as to violate the very keystone of the arch, the mandorla of Christ (influenced by Nanni di Banco's form in the Porta della Mandorla; see fig. 169) moves upward with an explosive power. The colossal Christ holds stiffly in his extended fingers a taut cloth, on which kneels weightlessly the Lilliputian soul of his mother. The rugged features of Christ and the Apostles and the plain, country face of the dead Virgin are characteristic of Castagno's figure types throughout his brief career. His Death of the Virgin, with its simple, trianglewithin-a-square composition, its large arch embracing a grand perspective, and its majestic alignment of sculptural figures, must have been a revelation in still-Gothic Venice. The influence of the composition was incalculable throughout the Quattrocento in Venice, in Padua, and indeed throughout North Italy.

Another early work is Castagno's fresco of the *Crucifixion* (fig. 268) painted about 1445 for one cloister of the monastery of Santa Maria degli Angeli in Florence, where Lorenzo Monaco had lived and worked until only twenty years before. Imperfectly transferred from its original site several decades ago, the fresco is now installed in the refectory, or *cenacolo*, of the former convent of Sant'Apollonia, today converted into a Castagno museum. We see a mountaineer Christ, a powerful man suffering for his friends, nailed to a wooden cross whose grain is depicted with all the care and knowledge of a sawyer's son. Mary is a weeping, toothless peasant woman with collapsed features, wringing her hands, and St.

John—clearly after the same model as the St. John at the left in the *Death of the Virgin*—is a stalwart, square-jawed youth. On either side are St. Benedict and St. Romuald, as in Lorenzo Monaco's *Coronation of the Virgin* (see colorplate 19). The shape of the flattened arch must have been determined by the architecture of the cloister.

The proletarian figures in their sculptural drapery, rapidly painted (a single day for a full-length figure), stand in dignified sorrow before a dark blue background probably depicting the darkness that fell over the land during the Crucifixion. Although, as we shall presently see, Castagno was capable of mocking Albertian perspective, he was well aware of its principal elements and has placed the viewpoint of the observer slightly to the left, so that St. Benedict's head is partly cropped by the arch. The stoic Christ, big-boned and heavy-muscled, his fingers still curved in pain toward the spikes, is one of Castagno's most original inventions. In every shape he seems obsessed by sculpture and impervious to the atmospheric style of Domenico Veneziano. His forms are always powerfully modeled, always surrounded by an incisive and tortuous contour, never freely brushed or veiled in atmosphere. Yet, paradoxically enough, his volumes do not revolve in space as successfully as do Domenico's more pictorial shapes.

THE CONVENT OF SANT'APOLLONIA. Today Castagno's masterpiece seems to be his fresco of the *Last Supper* for the convent of Sant'Apollonia (colorplate 34). The work

was, however, inaccessible to Castagno's contemporaries, possibly almost as soon as it was finished in 1447, since the convent was under clausura, and the fresco escaped notice until the Kingdom of Italy expropriated the monasteries in the late nineteenth century. As we saw in the case of Taddeo Gaddi (see page 87), the Last Supper was chosen for monumental representation in refectories to remind the religious at every meal of Christ's sacrificial self-perpetuation in the form of bread and wine. Castagno has set the scene in a paneled chamber, hardly intended to represent, as in the Gospel account, the upper room of a house in Jerusalem. In fact, it seems to be an independent construction one story high and roofed with Tuscan tiles, its front wall removed in the convention of a stage. The rich paneling of veined marble and porphyry squares in a white marble enframement is identical with that used for the sepulcher of Christ in Castagno's badly damaged frescoes of the Entombment and Resurrection (fig. 269); these are above the Last Supper on the same wall so that they could be read together with it, and they flank the central Crucifixion. Similar paneling was used in actual Florentine tombs of the period, especially that of Lionardo Bruni by Bernardo Rossellino (see fig. 256). In his widely circulated Life of Christ, the fourteenth-century German Carthusian monk Ludolph of Saxony, while discussing the Passion, reminds his readers that the monastic life is a kind of entombment, for the religious are entombed in their monastic buildings as was Christ in the sepulcher.

According to well-established tradition, Judas is seated on the outside of the table (fig. 270) but does not dip his hand into the dish with Christ, as described by St. Matthew and St. Mark and as almost universally represented in Italy, notably by Giotto in the Arena Chapel and by Taddeo Gaddi. Instead Judas takes the sop in wine to signify his betrayal, as recounted by St. John: "He it is to whom I shall give a sop, when I have dipped it." Here too Ludolph of Saxony seems to have been Castagno's source: he tells us that this sop had not been blessed by Christ and therefore was not true Eucharist, yet that all those who receive the Sacrament unworthily (and, according to St. Paul, are therefore guilty of the body and blood of Christ) are comparable to Judas the betrayer. Castagno carefully contrasts Christ's hand blessing the bread and wine to be consumed by the Apostles with that of Judas already holding his sop. At this point in the Gospel of St. John, as Ludolph reminds us, the Devil entered into Judas; this has clearly happened, for the betrayer has assumed a diabolical aspect, with hooked nose, jutting beard, hornlike ears—and yet, in the very moment that he seals his own fate, a fixed look of desperation. Paying no attention to Judas, Christ gazes pityingly down toward John, the Beloved Apostle, who lays his head on his arm in grief—according to Ludolph, John is more "sublime" than Andrew, who is therefore on John's left. Behind Judas, Peter looks on as if

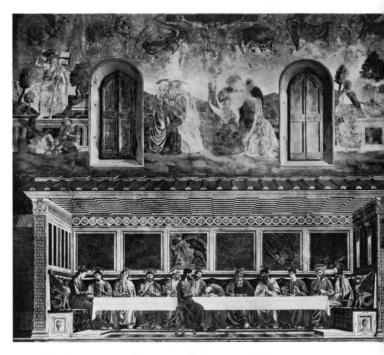

269. Andrea del Castagno. Refectory wall showing Last Supper and, above, Resurrection, Crucifixion, and Entombment. Fresco. Cenacolo of Sant'Apollonia, Florence

with foreknowledge of his own approaching denial of Christ, his left hand crossed over his right wrist to give the appearance that it actually grows there, a gesture apparently intended as a sign of fraud.

The revelation of the betrayal, which Ludolph says entered the heart of each Apostle like a knife, causes each to reflect on his inner life and, for some, his eventual martyrdom. In an unprecedented manner that is clearly dependent on Ludolph, Andrew holds up to the praying Bartholomew the knife with which Bartholomew was to be flayed alive. Next to Peter, James, who was to be beheaded, gazes fixedly at the glass of wine he holds to his lips with both hands, as the locks of hair start upward from his head. Thomas, who was to receive the Virgin's golden belt as she was assumed into Heaven (see fig. 169), looks sharply upward, in a daring if not wholly successful attempt at foreshortening. Turning to one another and searching their individual souls, the Apostles express their consternation at the dread disclosure. They hold their hands over the consecrated bread, or to each other in expostulation; Simon, second from the right, holds his hand to his cheek in the same Byzantine gesture of grief displayed by Mark in the Death of the Virgin (see fig. 267). So Castagno unfolded visually for the nuns, doubtless under expert theological direction, the import of the Last Supper, the Betrayal, and the Eucharist for their daily existence, as Christians and as religious. Perhaps by way of grim reminder for these good ladies, he added simulated statues of harpies above great amphorae, or wine jars, at both ends of the bench. Harpies were the terrible female birds who carried souls to Hell, where Dante met up with them "sitting upon strange trees"; they were also ancestresses of the witches still firmly believed in during the Renaissance.

By surprising formal paradoxes Castagno has reinforced the dramatic intensity of the scene. He arranged the twelve figures locked behind the white bar of the tablecloth in such a way that they neither correspond numerically to the six panels behind them nor in any instance repeat the same relation of figure (or figures) to panel. We read the room as square, because it has six panels on each side and is six panels wide. Yet each side frieze counts only seventeen guilloches (seventeen is still the unluckiest of numbers in Italy), while in the back frieze there are thirty-three and a half (Christ at the time of this event was a few months more than thirtythree years of age). Is the room intended to be oblong, and are the side panels therefore half as wide as those at the back? And if so, what is the shape of the ceiling panels, which number sixteen in depth but only fourteen across? We are never told, nor are we permitted to unravel the flickering pattern of the floor lozenges.

An observer standing in the refectory of Sant'Apollonia receives a striking impression of three-dimensional reality, and tends to attribute it to Castagno's mastery of Albertian perspective, although it is deliberately inaccurate. True, he established a consistent vanishing point for the ceiling, significantly enough, in the middle of the tablecloth, directly below the hands of St. John, but this could easily have been accomplished by means of a chalk line and a nail. The orthogonals of the footrest, however, do not recede to this point nor, for that matter, to any

common vanishing point. The orthogonals formed by the frieze do not converge but remain very nearly parallel throughout their course, and the ceiling panels are identical in their depth from front to back, with no diminution.

There may have been a reason for such departures from Alberti's rational perspective and proportion system on the part of an artist who was certainly familiar with Albertian theory. If Castagno had used a consistent one-point perspective, he would have placed the observer at a single point in the refectory, yet he wanted the illusion to be valid to every nun in the room. He did his best, therefore, to achieve a visually and emotionally convincing reality by other means. One of these is the remarkable lighting, coming as it does from two windows substituted for marble panels on the same side of the painted room as the real windows of the refectory, dwelling on the broadly modeled features, sending sharp reflected lights into shadows, modeling the tubular fingers and the massive drapery. Together with this clear light, Castagno's vigorous contours help to establish a sense of pictorial relief that seems a conscious emulation of sculptural prototypes made twenty or thirty years earlier at Orsanmichele or on the Campanile. Then, unpredictably, the tensions inherent in the marble itself erupt convulsively in the panel behind the complex group comprising the Prince of Peace, the Prince of Apostles, the Prince of Evil, and the Beloved Disciple. The surge and flow of this veining, if photographed by itself, could be mistaken for an Abstract Expressionist painting of the 1950s.

To Castagno the ultimate reality is always that of direct emotional experience, and thus his art at times

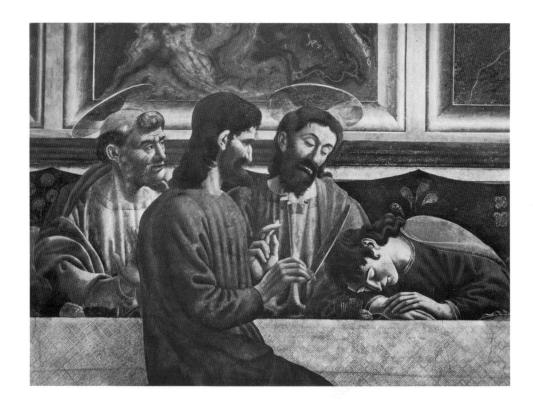

270. Andrea del Castagno.

Detail of *Last Supper* (see colorplate 34). 1447. Fresco.
Cenacolo of Sant'Apollonia,
Florence

seems to foreshadow that of Caravaggio in the late sixteenth and early seventeenth centuries. The inner drama of betrayal, self-searching, resignation, fear of death, crushing grief, hope of salvation goes on within the souls of these virile Apostles and is revealed on their impressive faces, old and bearded, young and strong, handsome or ugly, tormented or secure. With great simplicity and dignity, Castagno presents the silent dialogue of their sculptural hands, and even the humble appurtenances of the meal—the bread, the glasses of wine, the plates of salt. He worked with great and increasing speed. The entire Last Supper was painted in only thirty-two sections, probably within even fewer working days. Castagno began the figures with Andrew, at the right of center, and worked toward the right, painting each day one figure from table to halo. Then, in a single day, he painted the bust and hands of Christ and the head and hands of Judas. In another day he painted John. He then worked even more rapidly, for James and Peter were painted in a single day, as were Thomas and Philip. Only after the tablecloth was painted did he insert the body of Judas from neckline to foot. Although the harsh grandeur of this fresco, its curiously astringent colorism, and its deep penetration of the human dilemma remained hidden for more than four centuries, perhaps this work and the Crucifixion, Entombment, and Resurrection above

were briefly seen and admired by Castagno's contemporaries before the convent doors closed upon them.

LATER WORKS. A sharp contrast to the Last Supper, in content and in style, is provided by Castagno's frescoes depicting famous men and women, commissioned originally in 1448 by the Carducci family to decorate the loggia, or garden portico, of their villa at Legnaia, to the southwest of Florence. The greater part of the series, comprising nine standing figures, was detached from the walls of the Villa Carducci in the nineteenth century and is now preserved in the Castagno Museum at Sant'Apollonia. There were a number of such series in Quattrocento villas and palaces in various portions of Italy, although few survive today. These images were intended to awaken emotions ranging from civic pride to delight in the erudition of observer and patron. The frescoes on one end wall of the loggia, representing the most famous men and women of all—Adam and Eve and the Virgin and Child—have only recently been rediscovered in the Villa Carducci, in bad condition. No one knows what was to have gone on the other end wall, and nothing is there now. The detached sections show three Florentine military leaders (Pippo Spano, Farinata degli Uberti, and Niccolò Acciaioli), three great women (the Cumaean Sibyl, Queen Esther, and Queen Tomyris), and three

271, 272.
ANDREA DEL
CASTAGNO. Pippo
Spano (left) and
Cumaean Sibyl
(right), from a
series of Famous
Men and Women,
detached from
loggia of Villa
Carducci, Legnaia.
1448. Frescoes.
Cenacolo of
Sant'Apollonia,
Florence

Florentine poets (Dante, Petrarch, and Boccaccio). When they were detached, the frescoes were divided into separate panels, which destroyed Castagno's desired illusion of a continuous portico formed by square piers, between which the figures were to stand against his favorite background of simulated veined marble, granite, or porphyry slabs.

Pippo Spano (fig. 271), whose real name was Filippo Scolari, was a Florentine soldier of fortune in the service of the king of Hungary, and as we have seen (see page 182), Masolino went to Hungary with him. Since Pippo died in Hungary shortly after Castagno's birth, the fresco is in no sense a portrait. But it is a vivid image of a swashbuckling condottiere standing with feet apart, grasping a huge scimitar in both hands, and glaring at any number of potential enemies. Only the underpainting of the short tunic was in true fresco; the final layer of blue shadows, added a secco, has peeled off, leaving the white plaster, which causes an apparent reversal of lights and darks. The Cumaean Sibyl (fig. 272) is depicted as a tall, athletic young lady of great elegance and beauty, holding one of her nine books in her left hand and pointing heavenward with her right, robed in an iridescent tunic with powder-blue highlights and rust-colored shadows and crowned with a diadem.

In the brief period since Castagno painted the Last Supper, his style has changed radically. The figures are still strong and wiry, but the diffused lighting cancels the earlier strong shadows and harsh modeling in favor of a system of minute lines that indicate contours, details of garments and ornament, locks of hair, and even individual hairs in the beard and eyelashes. Doubtless the new linear style was made to please a different type of patron and to harmonize with the setting of a villa, in which Castagno's earlier mountaineers would hardly have known how to behave. The perspective—not visible in the illustrations but easy to reconstruct from the surviving fragments—could not possibly be unified, any more than that of the Last Supper, and for the same reason. A consistent one-point perspective would have looked incorrect save from a single spot in the loggia. But Castagno made every effort to suggest reality. The feet, for example, overlap the ledge on which they stand and seem to project through the picture plane as through a plate-glass window, into the actual space of the room. And the folds of the skirts, seen from below, recede convincingly into depth.

Surely from the same period dates the heroic *David* now in the National Gallery in Washington, D.C. (fig. 273). The picture owes its shape to its purpose as a shield, presumably for ceremonial use in pageants. As contrasted to the static *Davids* by Donatello, Castagno's lithe and wiry youth is shown running, swinging his sling in his right hand, and stretching his left arm to guide the trajectory of the stone, while the movement causes his short garments to flutter in the air above the

273. Andrea del Castagno. *David.* c. 1448. Leather on wood, height 45½". National Gallery of Art, Washington, D.C. (Widener Collection)

tense muscles of his legs. So impressive is the apparent naturalism of this pose, one of the first great action figures of the Renaissance, that it comes as a surprise to learn that the stance was probably suggested by a Hellenistic statue of a horrified pedagogue, part of the famous group representing Niobe and her slaughtered children, now in the Uffizi. The sculptors of the opening decades of the Quattrocento had turned to the authority of classical antiquity for their philosopher-saints and for their relatively quiet male and female nudes. Castagno now finds in ancient art suggestions for a pose that enlists the total resources of the body. Despite the deliberate archaisms of the linear shapes, the closely patterned hair, the stylized clouds, and the still-Gothic landscape forms, Castagno has taken a giant step along the road later trodden by Antonio del Pollaiuolo, Leonardo, Michelangelo, and eventually the sculptors and painters of the Baroque. At the same time he has not forgotten Donatello, by whose severed Goliath heads his own representation was deeply influenced.

274. ANDREA DEL CASTAGNO. *St. Julian.* c. 1454–55. Fresco. SS. Annunziata, Florence

The unhappy events described in Chapter 9, which darkened Florence at midcentury, may have prompted Castagno to open up new regions of inner experience in two extraordinary altar frescoes probably painted in 1454–55 for the newly rebuilt Church of the Santissima Annunziata, then being completed according to the design of Michelozzo and the overall guidance of Alberti. St. Julian (fig. 274) projects with great intensity the guilt that must have been universally felt in the Florence of the plague and of the ascetic archbishop St. Antonine. According to legend, Julian killed what he thought were his wife and her lover in a dark bedroom, only to discover that he had in fact murdered his parents. Tormented by his terrible deed, he crosses his hands upon his breast (his left hand is twisted to suggest that it committed the crime) and looks downward and inward with an expression of painful emptiness. At one side is a Tuscan farmhouse, scene of the double murder, and on the other, in the distance, the saint kneels in penance in a little country chapel. Above, yet invisible to him, hovers a bustlength vision of Christ as Salvator Mundi (Savior of the World), holding orb and cross in his left hand while absolving the sinner with his right. Small inscriptions spell out the meaning of the scene, but they are hardly necessary in view of the wordless communion between the two figures, both in smoothly modeled, rose-colored cloaks against the blue sky. Both are young, Christ beardless and St. Julian showing on his chin the beginning of a youthful beard. The broad, sculptural handling of the features and the delicate use of reflected light recall the treatment of the Apostle heads in the *Last Supper*, but the subtle contours and fine linear patterns, especially the gold pigment lighting the hair, set this work apart from the artist's more rugged earlier style. One can only regret the loss of the lower portion of the figure (especially the beautiful hunting dog admired by Vasari), destroyed when a higher altar was placed in front of the fresco in the sixteenth century.

At the next altar is Castagno's Vision of St. Jerome (colorplate 35), a devastating companion piece. Previously, St. Jerome had customarily been represented as a theologian and philologist among the books and papers in his study, deep at work on his translation of the Scriptures and well supplied with references to his supposed rank of cardinal. Instead Castagno places him among the rocks of the Egyptian desert—looking like any barren hill to the north of Florence—where, stripped to his undergarment, he has been beating his breast with a jagged rock in a paroxysm of self-punishment. St. Antonine describes the torments St. Jerome endured in the desert, quoting in extenso a letter by St. Jerome himself. Probably this new penitential image of the saint in the wilderness, which, like the almost equally influential image of the Adoration of the Child, lasted throughout the Ren-

275. ANDREA DEL CASTAGNO. St. Jerome, detail of *Vision of St. Jerome* (see colorplate 35). c. 1454–55. Fresco. SS. Annunziata, Florence

aissance in Florence and Venice, owes its origin to the Florentine archbishop.

On either side of St. Jerome stand St. Paola and her daughter St. Eustochium, followers of St. Jerome. Above the heads of all three saints floats the Trinity, Father holding sacrificed Son, and Holy Ghost in the form of a dove, all sharply foreshortened as they glide out of the picture toward the observer. The two child-seraphim below Christ's chest were clearly an afterthought, since they were added a secco and have partially peeled away. Possibly the clergy were offended by the audacity of Castagno's foreshortened Trinity and required this addition. Yet we look down on the top of the crossbar, down on Christ's head crowned with the rope of flagellation (Girolamo dei Corboli, patron of the chapel, was a member of the Girolamite community of flagellants), rather than with thorns, down even on his gold halo. One hardly knows whether to be more astonished by the tortured face of the saint, his features and neck muscles twisted like a rope (fig. 275), or by the intensity of his inner convulsion, or by the gloomy appearance of the Eternal Father, staring fixedly over pendulous lower lids as if despairing of the fate of his own creation. Even more frightening than the forms and expressions is the color of the picture, drowned in blood. Blood runs from the gashes in St. Jerome's bony chest, drips from the wounding rock toward the open mouth of the angry lion (the saint's customary attribute), oozes in thick gouts from the pierced side of Christ upon his floating Cross, suffuses the sky with the blood-red color of the clouds. Only, as we shall see in the next chapter, in the work of the aged Donatello will we again experience in Italian art such an outburst of pathological religiosity.

A curious sidelight on Castagno was furnished by the generally disastrous flood of 1966, which so threatened the *Vision of St. Jerome* that it had to be detached from the wall. Beneath appeared a sinopia by a different hand—that of Castagno's supposed victim, Domenico Veneziano. Yet an examination of the landscape backgrounds of both frescoes in the Santissima Annunziata (see fig. 274, colorplate 35), in comparison with, for example, the schematic landscape of the *David* (see fig. 273), shows the intervention of Domenico's light brush and divisionistic handling of color. Could Domenico have relinquished the *St. Jerome* to Castagno as unsuited to his genius, only to have Castagno appeal to him later to paint the landscape, which only Domenico knew how to do? Such a possibility is not beyond imagination.

A final glimpse into the mind of the mature and increasingly pessimistic Castagno is afforded by his colossal equestrian fresco of *Niccolò da Tolentino* (fig. 276), commissioned in 1456 as a pendant to the neighboring portrait of *Sir John Hawkwood* by Paolo Uccello (see fig. 259). As we have seen, Uccello had already painted Niccolò's likeness in the *Battle of San Romano* (see fig. 263), and it is perhaps significant that Uccello was not chosen

276. ANDREA DEL CASTAGNO. Niccolò da Tolentino. 1456. Fresco, transferred to canvas. Cathedral, Florence

to paint the second simulated statue for the cathedral. A comparison between the two is inevitable, and not entirely in Castagno's disfavor in spite of the monstrous head he gave to the horse (why, one wonders, since Castagno's birds and animals are usually so fine?). The beauty and simple harmony of Uccello's twenty-years-earlier image are gone. Perhaps such qualities were no longer accessible in the 1450s, not even to Uccello. Castagno's warrior uses his baton to prop his mailed arm as he marches implacably forward. Characteristically for Castagno, the perspective scheme is so handled that no single point of view can be deduced. Yet the hard light throws into relief the simulated stone of the tomb, its giant balusters, inscriptions, and shell, and the muscular torsos of the nude youths on either side, holding shields bearing the devices of Niccolò and of the Florentine Republic. The convulsive shapes of the horse's muscles, face, and tail, and of the rider's petrified cloak, produce

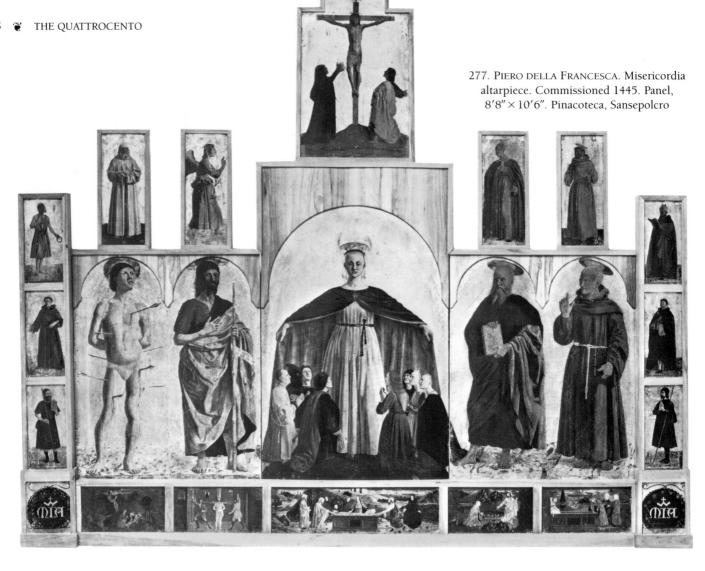

an effect utterly different from that of Uccello's noble work. So, too, does the coloring, for Castagno has substituted ocher and black for Uccello's shimmering violet and green.

The recurrent plague, whose effects Castagno must often have witnessed, carried off his wife in August 1457 and, eleven days later, the artist himself. They were buried, apparently in a mass grave, at Santa Maria Nuova. Castagno's life was short and his achievement seems incomplete. He was ranked by his contemporaries among the leading masters of a period whose classical ideals and whose inner tensions he embodied almost to the full. His art was completely concerned with man, and with man's terrible dilemmas and tragic destiny. Nature was very nearly excluded from it, and painting for him rivaled sculpture in the conquest of form.

PIERO DELLA FRANCESCA

The artist who seems to us today to fulfill the Albertian dream of absolute and perfect painting in every respect save that of motion is Piero della Francesca. He was not a Florentine; perhaps by choice, perhaps through necessity—we shall never know—he stayed remote from the Tuscan metropolis. Save for occasional visits to Florentian metropolis.

ence, he lived in Borgo San Sepolcro (Borough of the Holy Sepulcher), a Tuscan market town then still a possession of the Papal States. Apart from the recent excrescences outside its walls, Borgo San Sepolcro has changed little since Piero's day. The name della Francesca, formerly believed to refer in some way to Piero's mother, Romana, is a feminine variant of the family name dei Franceschi. Both versions appear in early documents, which reveal the family as the prosperous owners of a wholesale leather business, a dyeing establishment, houses, and farms.

Before the beginning of the present century, Piero's art was thought an oddity, familiar only to a few erudites who found in it little merit and saw the artist as standing apart from the mainstream of the Italian Renaissance. Even Vasari, to whom we are indebted for much information about Piero that might otherwise have been lost, was more concerned with the painter as a regional celebrity (Vasari's native Arezzo is the provincial center to which Borgo San Sepolcro turned) than as an important artist. Only the new appreciation of form, aroused by the art of Cézanne and his immediate successors in painting and in sculpture, has raised Piero to his present pinnacle of admiration as one of the greatest painters in history.

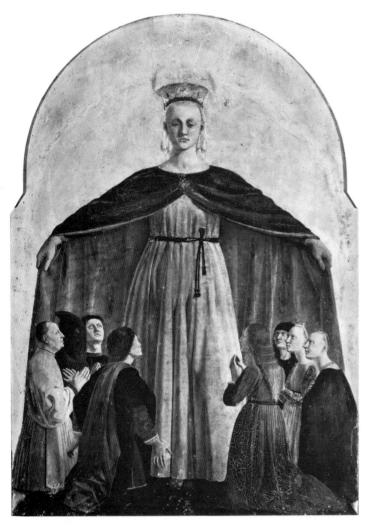

In 1442, Piero was made a member of the Priori (town council) of Sansepolcro (as Borgo San Sepolcro is called today) and retained this office for the rest of his life. His rustic town, set in the upper Tiber Valley among the massive, largely barren foothills of the Apennines, provides the atmosphere of rude dignity and calm that prevails throughout Piero's "noneloquent" art (the phrase is borrowed from Bernard Berenson), helping Piero to un-

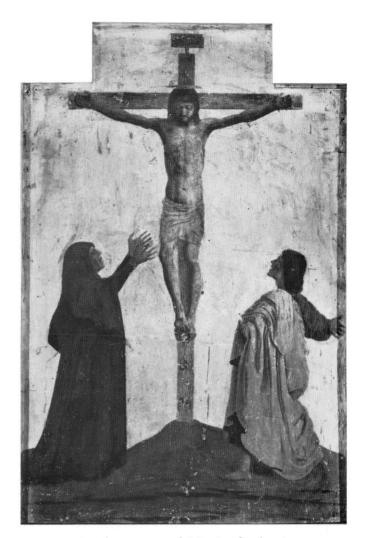

279. Crucifixion, top panel, Misericordia altarpiece

derplay delightfully the grandest dramas of secular and religious history. His three years or so in the Florence of Alberti, Luca della Robbia, Ghiberti, and especially Fra Angelico and Domenico Veneziano provided him with the technical resources, the knowledge of perspective theory, form, light, and color on which he could proceed alone. He certainly studied the heritage of Masaccio with great care. He may have returned to Florence from time to time, and become acquainted with the work of Castagno. He may also have worked with Domenico again, at Loreto. But in the intellectual isolation of Sansepolcro, often compared to Cézanne's isolation at Aix, he set himself a lifelong series of new problems, all bearing on the subject that concerned him most—the total visual unity of the picture. In this tranquillity he seems also to have meditated long and deeply on ultimate questions regarding the relation of man to his universe.

Piero's earliest known work is a polyptych commissioned in 1445 for the Compagnia della Misericordia in Borgo San Sepolcro, painted slowly during the next few years and finished by assistants much later (fig. 277). The Misericordia (Mercy), which still flourishes in Tuscan towns, especially Florence, is an organization of laymen, similar to American rescue squads, who dedicate a

portion of their time to works of mercy, especially the bringing of the sick to hospitals and the dead to burial. In order to replace an earlier polyptych, the Misericordia stipulated the antiquated format of Piero's altarpiece, which, with its several stories and standing saints in three sizes, reflects the towering Sienese structures familiar to the townsmen (see Pietro Lorenzetti's polyptych in Arezzo, fig. 101). The altarpiece was once badly damaged by fire, and its frame is lost, but presumably Piero was constrained to emulate even the moldings and decorations of the Trecento. The resulting proliferation of tiny compartments must have pained him, but perhaps no more than the gold background, which he never used willingly.

The central panel (fig. 278) represents the Madonna of Mercy, patroness of the Misericordia and a familiar figure in Tuscan cities. She towers as grandly and as rigidly as an Egyptian statue, calmly stretching out her blue mantle, symbol of Heaven, over the kneeling townspeople, four men and four women. One man, second from the left, wears the black habit of the Misericordia, with the hood pulled over his face so that his eyes look through slits, as it is still worn today when the Misericordia carry the dead. As in all images of the Madonna of Mercy, the mortals appear in tiny scale compared with the colossal Virgin, who seems as vast as the heavens whose protection she symbolizes. Her columnar form, its regularity only slightly interrupted by the advancement of her left knee, is the central axis of the domelike space created by her mantle, within which the eight figures kneel in a circle. Vasari tells us that Piero generally made models, clothed them in actual drapery, and studied for hours the behavior of light on these folds. Here he seems to have done exactly that, setting a strong side light on the slightly varying tubes and masses of hanging or bunched folds of cloth or on the smoothly sculptured countenances shown full-face, profile, three-quarter view, lifted and foreshortened, or in a one-quarter profil perdu reminiscent of Giotto (see fig. 56). Yet this light operates without recourse to the deep shadows of Masaccio and the early work of Filippo Lippi. Filled with color, it produces soft variations of light, direct and reflected, suffusing all shadows in the manner invented by Fra Angelico (see colorplate 28) and immediately developed by Domenico Veneziano (see colorplate 32). Line is almost absent, and with the aid of an occasional hint of linear perspective in the overlapping lower contours of the garments or the projection of heads, Piero's light is the true creator of form. The deep, soft textures of cloth, hair, and skin possess a velvety bloom that helps him to establish tactilely convincing projections, recessions, and enclosures. Characteristically, the glances of the figures are calm, and their firmly modeled lips are closed, even in prayer. Piero permits himself to represent only an occasional gesture of deep emotion, only an infrequent dalliance with a delicately waved mass of blond

hair or a sparkling jewel or gold-embroidered sleeve.

The Crucifixion (fig. 279) at the apex of the altarpiece, like that painted by Castagno for Santa Maria degli Angeli (see fig. 268), is a commentary on Masaccio's Pisan Crucifixion (see colorplate 24), yet offers no communion between the Crucified and his mourners. Piero has locked the Cross to the frame and shown Christ as inert. unresponsive to the grief expressed in the reaching gesture of Mary, the wide-flung arms of St. John. Only the crowned mother in the image below, robed in the mantle of Heaven, can bridge the gulf fixed between God and man. The figures below the Cross are the more devastating because such demonstrations are so rare in Piero's art. Technically, his study of the sharply foreshortened left arm of St. John ranks as one of the most brilliant analyses of this sort until Michelangelo's drastic foreshortenings on the ceiling of the Sistine Chapel.

About 1450, if the generally accepted but conjectural date is correct, Piero painted a Baptism of Christ (fig. 280) for the priory of San Giovanni, later moved to the principal church, now the Cathedral of Sansepolcro. This painting, bought in 1861 by the National Gallery in London, shows in the beauty of its outdoor setting Piero's command of the naturalistic conquests of the second Renaissance style—one thinks immediately of Fra Angelico's Descent from the Cross (see colorplate 27) which is both limited and deepened by Piero's insistence on representing Scripture in terms of daily experience. Christ stands in the Jordan, a glassy little stream like any tributary of Piero's Tiber, in front of an ordinary Tuscan landscape with tan and olive hills and fields carved out of the resistant earth, under a well-pruned tree, up to his ankles (in the photograph the line is not visible) in the clear water, through which one can see the stones on the bottom.

St. John steps from the bank to pour the water over Christ's head in a sparkling mass from a simple earthenware bowl. Three blond angels, who might be peasant children supplied with wings and flower garlands for the occasion, attend the ceremony, two looking on with mild surprise, the third paying no attention as he holds his companion's hand and leans upon his shoulder. Clearly Piero admired the classic naturalism and fluted drapery of Luca della Robbia's Cantoria (see fig. 241), whose singing boys these figures recall. Piero's Christ is astonishing in the homeliness of his features, unprecedented in the Italian tradition, dominated (with the sole exception of Castagno) since Giotto's day by the Gothic conception of a handsome Christ with fine, clear-cut features. Piero has painted a Tuscan farmer, with heavy cheekbones, thick lips, large ears, lank hair, and wiry beard. Perhaps Piero remained closer not only to ordinary humanity but also to the biblical word-picture of the Messiah, "He hath... no beauty that we should desire him" (Isaiah 53:2).

Piero was concerned with the visual relation between

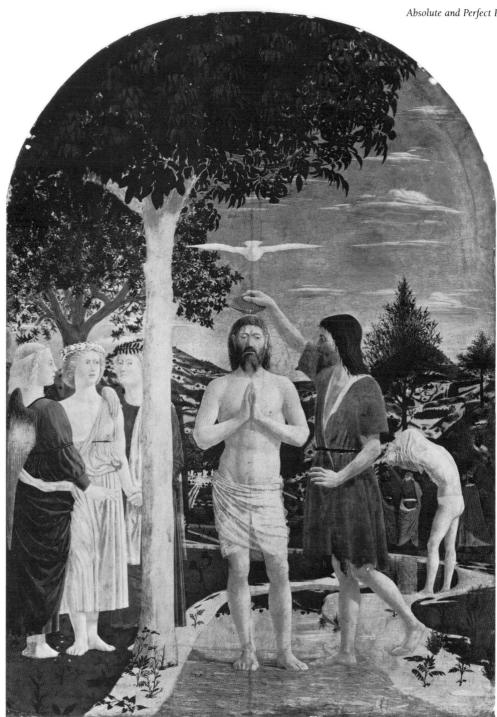

280. PIERO DELLA FRANCESCA. Baptism of Christ. c. 1450. Panel, $66 \times 45^{3/4}$ ". National Gallery, London

the legs of Christ—towering cylinders of light—and the cylindrical white trunk of the tree. The legs are as quiet as the trunk, equally rooted in the earth, equally responsive to the light of the sky. In the same way he approximates the Third Person of the Trinity, the beautiful white dove of the Holy Spirit, to the clouds in the blue sky so that one looks a second time to distinguish them. And is there no representation of God the Father, or at least the hand of God? It is not needed; the blue sky will do. Piero is always a nature poet, who sees revelations in the simplest things—the Son in a tree, the Holy Spirit in a cloud, the Father in the sky. Piero's color is slightly

bleached, similar to the quiet coloring of everything in his own countryside, where the intense light will not permit bright colors to survive. Shadowless, this white glare models the smooth, shining forms of Christ's torso, reveals the thighs through the translucent linen of his loincloth, and models the figure of a man in the middle distance pulling his garment over his head as he prepares for Baptism, his arms also visible through the white linen.

Beyond the second curve of the stream stand bearded figures whose towering headdresses recall those of the Greek prelates and courtiers Piero had seen in 1439,

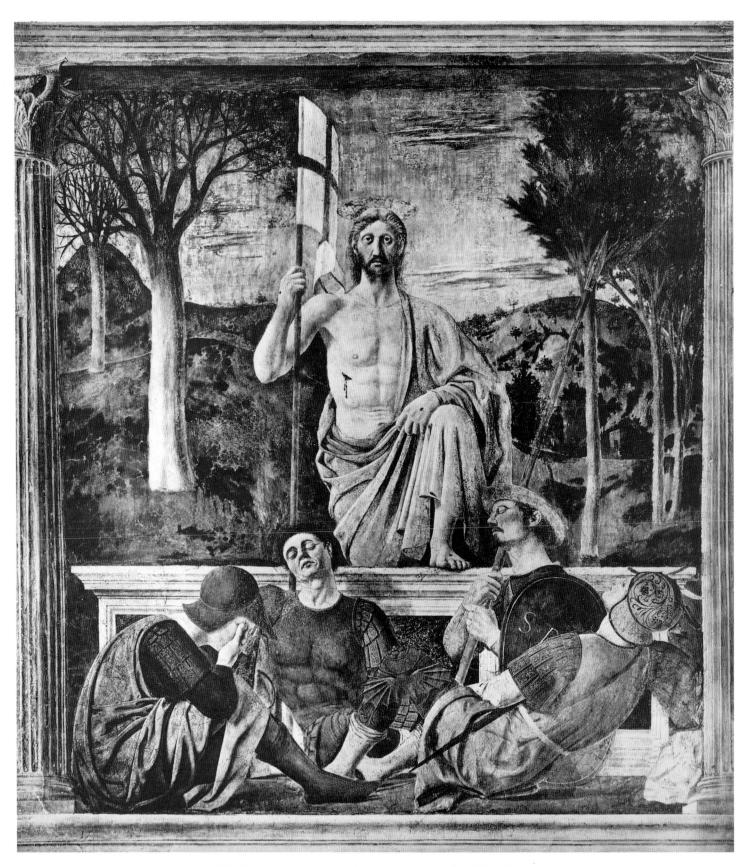

281. PIERO DELLA FRANCESCA. Resurrection. Early 1450s. Fresco. Pinacoteca, Sansepolcro

when the Council of Ferrara removed to Florence, ancestors of the headgear still worn by Orthodox priests. Between pebbly banks recalling Domenico Veneziano's shining stones (see fig. 265), the priests and their robes are reflected in the crystal water, as clear as it is bright. So is the terraced slope of the hill above, hanging upside down in this natural mirror. Piero must have watched such phenomena during country walks, and he must have painted slowly. Neither his analysis of nature nor his vision of humanity could be set down at Castagno's impulsive speed. To our surprise, for example, just between Christ's hip and the tree trunk we get a view of Sansepolcro, its towers touched by light, and of the straight road running toward Anghiari. Background details are, of course, painted freely, without a line, for Piero had mastered Domenico Veneziano's doctrine of light and his equation of the single brushstroke with the separate sparkle of light from a facet of the visible object.

Piero's most famous fresco is his *Resurrection* (fig. 281), painted for the Town Hall of Sansepolcro and moved from an adjoining room to its present position in the early sixteenth century. The date of the painting is still disputed, but some moment in the early 1450s would not be far from the truth. The Holy Sepulcher was the symbol of Sansepolcro and appeared on its coat of arms. Piero compressed the scene to its essentials and represented the Resurrection not as a historical event—it is nowhere described in the Gospels—but as a timeless truth upon which one can meditate on any rocky hillside above Sansepolcro, in any gray dawn. For the fresh light that pervades the picture is that of dawn on these barren slopes and cloud-strewn skies.

Christ stands with his right foot in the sarcophagus, his left planted on the upper molding, his left hand resting on his knee, his right grasping the red-cross banner of triumph, whose folds float behind him. A pale rose cloak, almost white, moves in majestic folds about the figure, leaving the right side bare to reveal the spear wound. The classic forms of the muscular torso are modeled by the dawn light coming from the left. Above the pillar-throat, the face, as unbeautiful as that of Christ in the Baptism and as frontal as that of the Virgin in the Misericordia altarpiece, is nobly projected. The smooth, curving lips seem to have been carved in pale stone. The wide-open eyes disclose no secrets of death, but rather stare into the inmost consciousness of the observer. Before the tomb the four watchers sleep fitfully, their bodies grouped as in a sheaf, the folds of their blue and green cloaks set forth in the crosslight. According to Vasari, the soldier into whose face we look is a self-portrait of the artist. The large eye sockets, broad cheekbones, square jaws, and firm chin recall those of Etruscan sculpture, and are still visible in many Tuscan villages and

The trees on the left are barren, on the right in full leaf. In a picture so densely organized, such a circumstance can hardly be devoid of meaning. On his way to Calvary, Christ had said, "If they do these things in a green tree what shall be done in the dry?" (Luke 23:31), meaning, "If they do this to me while I am still alive, what will they do when I am dead?" The idea of green trees and withered trees was connected with the Tree of the Knowledge of Good and Evil and the Tree of Life, standing together in the Garden of Eden. In this case the trees doubtless symbolize the world before and after the Crucifixion and Resurrection.

SAN FRANCESCO, AREZZO. The Resurrection contains abundant evidence of Piero's slow technical procedures. Unlike Castagno, he took a working day for each face and a day for the torso, neck, and right arm of Christ. He must have proceeded with all deliberate speed in his only major fresco cycle, which decorates the chancel of San Francesco in Arezzo (figs. 282–286, colorplate 36), but perhaps not as slowly as has generally been assumed. The commission had been given to one of the last surviving painters in the Gothic tradition, Bicci di Lorenzo, who died in 1452 after almost completing the vault decoration. Recent plotting of the days' work in the chancel (Piero often applied wet cloths to the plaster at night so that he could work two days on a single section) has shown that the painting need have occupied him no more than two years. The preliminary calculations and the working drawings and cartoons, however, are another matter, and they may have required more time than the actual painting. The most logical assumption is that the project was planned at once and proceeded steadily until completion in 1456-57. The master had at least two assistants, but the designs and the principal figures are from his own hand. The entire chancel was damaged by the infiltration of water, and many sections of intonaco have fallen away. These were replaced with inept tintings in past restorations, but all excrescences have now been removed and the accompanying photographs show the restored state.

The subject, the Legend of the True Cross, was a medieval fabrication of fantastic complexity. Piero was surely familiar with the series on the same theme by Agnolo Gaddi and his school, which fills the chancel of Santa Croce in Florence (see fig. 124). The tale begins with the final illness of Adam, who, an angel tells his son, can be cured only by a branch from the Tree of the Knowledge of Good and Evil. Seth returns from Eden to find Adam already dead; the branch is planted on his grave, where it takes root and flourishes. Later, King Solomon desires to use a beam from the new tree in the construction of his palace. It proves too large, and is therefore placed across the brook Siloam, where the queen of Sheba discovers it on her trip to Solomon's court. Gifted with prophecy, she recognizes that this beam will serve to produce the True Cross on which the greatest of all kings will hang, kneels down to worship it, and proceeds onward to tell

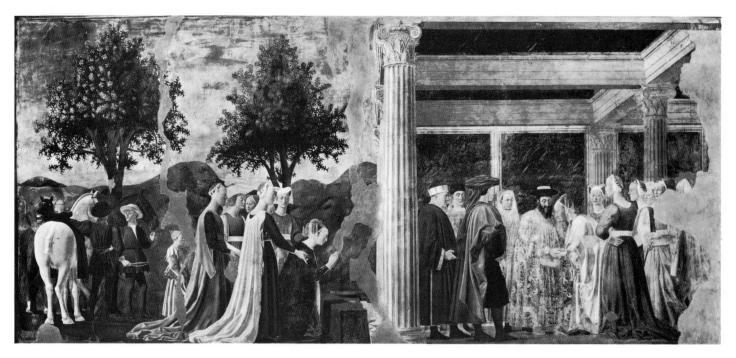

282. PIERO DELLA FRANCESCA. Discovery of the Wood of the True Cross and Meeting of Solomon and the Queen of Sheba, from Legend of the True Cross. Probably 1452–57. Fresco. S. Francesco, Arezzo

Solomon, who thereupon has it buried deep in the earth.

The scene then shifts to the struggle between Emperor Constantine and the rival emperor Maxentius. An angel appears to Constantine in a dream, saying, "In this sign thou shalt conquer." Protected by faith in the Cross, Constantine vanquishes Maxentius at the Milvian Bridge outside Rome. Helena, Constantine's mother, then desires to find the True Cross itself, which has been buried after the Crucifixion, along with those of the two thieves. Only a Jew named Judas knows where. He is constrained to tell by being lowered into a dry well and starved. By these means he is also converted to Christianity (he later becomes a bishop). The three crosses are dug up, but they show no external differences, and the True Cross cannot be identified. Luckily a funeral procession is passing by, the three crosses are held, in turn, over the corpse, and the cross that makes him sit up is, naturally, the True Cross. Later, this falls into the hands of the Persian emperor Chosroes, who attaches it to his throne. The Byzantine emperor Heraclius defeats Chosroes in a great battle and brings the Cross back in triumph to the walls of Jerusalem.

Confronted with such a tale, Piero must have sighed. His sense of order was equal to the occasion, however, and he retold the story in his own way. Following in general the chronological sequence, it extends down the right wall and up the left, but several episodes are rearranged to make analogous scenes face each other, and the structure forms a visual harmony rather than a temporal sequence. Among the six scenes illustrated here, for example, he paired on facing walls the scenes dominated by women (the queen of Sheba and the empress Helena) and those of battles won by emperors, and on

either side of the window, as we shall see, he placed visions of the Cross.

The story of the queen of Sheba (fig. 282) is divided into two episodes: at the left, the queen and her attendants discover the wood of the Cross, and at the right they are received in the portico of Solomon's palace. In the first episode the horses are shown held by grooms in the middle distance, foreshortened from front and rear in the manner of Gentile da Fabriano and Masaccio (see colorplate 22, fig. 203). In the foreground can be seen the beam, moving diagonally toward the picture plane across a tiny brook running past the bases of the palace columns. The shadow of the kneeling queen falls across the beam in accordance with the actual light from the window of the chancel. (In most Florentine Quattrocento wall paintings, the illumination of the room they decorate is similarly exploited.) In his choice of types for the queen and her six ladies-in-waiting Piero characteristically avoids conventional beauty; their features are large, sometimes even coarse. Their garments are not elaborate, compared with those of Fra Filippo's Madonnas (see figs. 217, 218); their hair is simply dressed, and they wear few jewels. Yet these stately women make their Florentine contemporaries look overdressed. This is due partly to the carriage of their heads, the coolness of their gaze, and the authority of their gestures, but even more to the simplicity of Piero's forms and lines. The heads with their plucked foreheads become porcelain spheroids, the long necks conoids; the grand folds of the cloaks descend in parabolic curves. Small wonder that reproductions of these heads were so widely circulated when the post-Cubist styles of Braque and Picasso were first acclaimed!

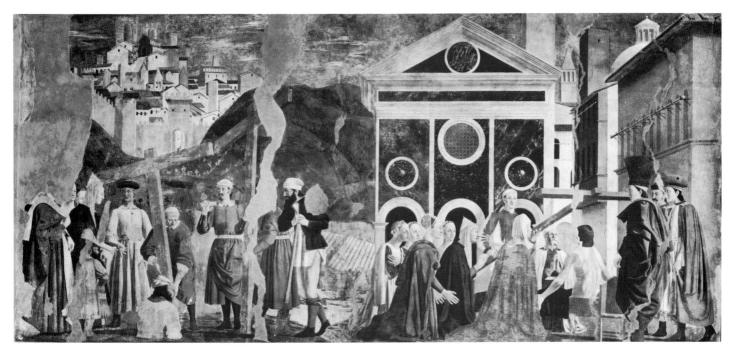

283. PIERO DELLA FRANCESCA. *Invention of the True Cross* and *Recognition of the True Cross*, from Legend of the True Cross. Probably 1452–57. Fresco. S. Francesco, Arezzo

The second episode takes place in the classical architecture of Solomon's palace, and here we are faced for the first time with the relation of Piero della Francesca to Leonbattista Alberti. The massive proportions of the Composite order that Piero has chosen for the portico recall those of Alberti's Malatesta Temple at Rimini (see fig. 222), and it is no surprise to discover that in 1451 Piero had painted a portrait of Sigismondo Malatesta kneeling before St. Sigismond, in a fresco decorating one chapel of that church, then being rebuilt as a temple. He must also have absorbed Alberti's perspective doctrine in Florence, and many years later Piero himself was to write the first Renaissance treatise on perspective (see page 283).

Piero broke with one cardinal principle of Alberti's theory of design, for the external façade of the portico, if complete, would have consisted of two bays articulated by three columns, and Alberti, it will be remembered, required an odd number of openings and an even number of supports. Piero's ceiling is an unbuildable set of gigantic veined marble slabs like those of the wall incrustation, but laid on the white marble beams that run from column to column. But the cool white columns and the deep-toned green marble panels make a splendid enclosure for the meeting of the two monarchs. Piero has set his vanishing point low, on a level with the eyes of the kneeling queen, and it is centered in the field of the entire scene just outside the portico, causing the volutes and acanthus leaves of the second and third capitals barely to protrude, one below the other, along the profile of the first column.

Within the colored light of the portico, the same queen and the same ladies, done from the same cartoons

reversed (a dodge Piero often employed), are received by a sumptuously dressed Solomon, whose gold-brocaded ceremonial robe was painted *a secco* and has, therefore, largely peeled away. The queen's revelation of the future use of the wood of the Cross is received with astonishment by the courtiers, who look about like members of the Priori of Sansepolcro, of whom, indeed, they may be portraits. One almost certainly is: the second face from the left—bony, detached, calm, and staring directly at the spectator as faces rarely do in Piero's work—corresponds feature by feature, allowing for the foreshortening, to Piero's supposed self-portrait in the *Resurrection*. It is a face of hardly more than thirty years, which, since the fresco must date 1452–57, tends to confirm a date in the 1420s for Piero's birth.

In the companion piece on the opposite wall (fig. 283) there are again two episodes: at the left is the *Invention of* the True Cross (as the discovery is generally entitled), in which Empress Helena—her face line for line the same as that of the queen of Sheba—directs the excavation of the first two of the three crosses. This takes place outside the gates of Jerusalem, which is still recognizable as a portrait of Arezzo as one enters from Florence. Not only the cathedral can be made out, but also below, at the extreme right, the flank of San Francesco itself. The almost cubistic simplification of the architectural masses recalls Fra Angelico's treatment of the same subject in his Descent from the Cross (see colorplate 27), which Piero must have studied with care. The semicircle in which the massive figures are disposed around the central cross emerging from the earth is made easier to grasp by the low point of view, which increases the apparent diminution of figures more distant from the eye. When

we look at the other half of the scene, we find that the height of this eye level is again that of a kneeling figure, the empress adoring the True Cross. The same point of view is adopted in both scenes for the same iconographic reason—reverence before the Cross.

The episode at the right, Recognition of the True Cross, is dominated by what is surely one of the most beautiful façades in Renaissance architecture. This is the more astonishing when we realize that Piero could not at this time have seen a single Renaissance church façade. None had yet been built. But the simple masses of his structure, divided into proportionally related rectangular, circular, and semicircular areas, the arches supported on piers, the clear-cut distinction between the beauty of the main design and the additive nature of the ornamentation (restricted here to an incrustation of enormous marble slabs within which the veins move like ocean waves) point to a knowledge of Alberti's ideas. Piero is also keenly aware of his historical detachment from earlier styles. Above a street bordered with severe Tuscan houses are seen a Romanesque campanile, two medieval shaftlike house-towers, and a Brunelleschian dome culminating in a beautiful little circular temple-lantern, obviously based on the one designed by Brunelleschi for the Old Sacristy of San Lorenzo in Florence. Before these disparate yet harmonious architectural masses, Piero has disposed his kneeling, waiting figures, while the magical form of the True Cross, its planes clearly defined in light, is projected toward us, above the nobly designed torso of the man suddenly brought back to life.

Then come the two battles, facing each other across the chancel. Had Piero seen Uccello's battle scenes (see colorplate 31, fig. 263) in Florence? Everyone seems to think so (and this would indicate an early date for Uccello's panels). But however brilliant, they are toylike compared with the solemn events that Piero depicts, scenes in which the realities of conflict, defeat, and death are deeply felt. Piero has contrasted the two battle scenes more sharply than the two scenes of discoveries. This was inevitable because Constantine defeated Maxentius through the Cross alone, while Heraclius defeated Chosroes in massive, hand-to-hand combat. The damage to the Battle of Constantine and Maxentius (colorplate 36) is the most serious in the entire cycle, amounting to the loss of about one-third of the surface, irregularly spotted so that portions are indecipherable (although preserved in a nineteenth-century copy). Piero intended to depict the army of Constantine advancing from the left as far as the river, and at the right that of Maxentius, discomfited and in rout as their leader struggles ignominiously to get his horse out of the stream. Maxentius' army survives only in fragments—a head here, the flank of a horse there.

Did Piero expect us to believe that this tiny stream could defeat an army? Certainly not, any more than Castagno wanted to convince us that David had decapitated

Goliath when we can see him just beginning to launch the stone. To put the Tiber into the picture at its proper scale would have reduced the figures to miniature size. Piero inserted a symbolic Tiber and, having done so, painted it as the narrow upper Tiber that flows by Sansepolcro, mirroring trees and farmhouses and providing a haven for three white ducks. His stony horses approach the edge, stare at the water, and paw the air, while against the blue morning sky Constantine holds forth the small white cross in whose sign he conquers. Some of the firmly modeled horses are chestnut, others soft gray, still others pure white. The cylindrical forms of their legs are crossed to make patterns of roundness against the flat stripes of shadow. Similar patterns are created by the brown, gray, and white lances against the sky. While the dragon and Moor's-head banners of the defeated army totter in disarray, the black Imperial eagle on its yellow banner floats in triumph over Constantine's

Constantine, as has often been pointed out, wears the characteristic sharp-visored hat (and indeed bears the recognizable features) of the Byzantine emperor John Palaeologus, the penultimate successor of Constantine, whom Piero must have seen in Florence in 1439. Piero set the emperor on his white horse a little back from the picture plane as he would doubtless have appeared in an actual procession, overlapped by a figure in armor, so that we see only his head in profile, and his outstretched hand. But what armor! Never before had armor been painted so magnificently. To Uccello the segments of armor presented a series of forms that he could fit into his ingenious patterns. To Piero, these surfaces of polished steel could draw to themselves, break up, and reflect to the observer's eye the glory of the morning light. And it is this light, all silver and blue, that makes the spectator catch his breath when first he walks into the chancel of San Francesco in Arezzo.

For the battle scenes Piero chose a point of view slightly higher than that of the discovery scenes, just even with the feet of the riders, so that one looks upward to the belly of the rearing horse at the extreme left. The horse is foreshortened toward us, and in fact looks at us as his rider tries to control him. This device, coupled with the roundness of the modeling, creates an illusion of real depth that Piero apparently wanted, to break up the flat procession of equestrian figures across the wall.

The Battle of Heraclius and Chosroes (fig. 284) has not generally been favored by critics. True, it has little of the luminary magic so impressive in the Battle of Constantine and Maxentius, for such a display would have been lost on the particular wall it occupies. The Church of San Francesco is not oriented, but faces west; the Battle of Heraclius and Chosroes is on the south wall and never receives direct light. Piero includes no landscape, concentrating instead on the battle. He was guided in part by Roman battle sarcophagi, which were to be seen in Flor-

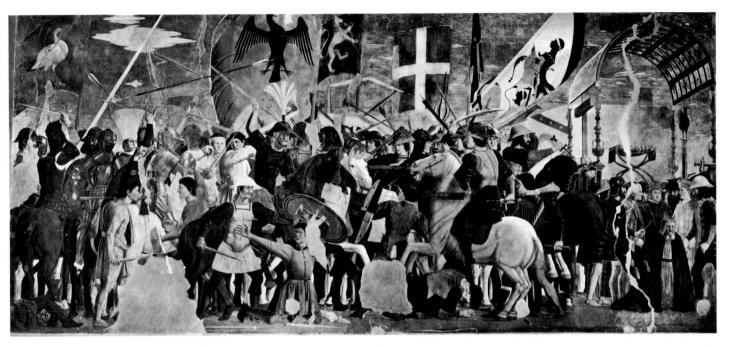

284. PIERO DELLA FRANCESCA. Battle of Heraclius and Chosroes, from Legend of the True Cross. Probably 1452–57. Fresco. S. Francesco, Arezzo

ence or Pisa. The relief plane of the composition, as well as such motives as the horse rearing over a fallen enemy. recalls Roman sculpture. One of the most celebrated military encounters of Piero's day, the battle of Anghiari (see page 457) took place within sight of Sansepolcro in 1440, by which year Piero may already have returned to his birthplace, and he could not have avoided hearing eyewitness accounts of the struggle. His battlefield is a stretch of ground on which a number of persons, mounted or on foot, have huddled for the purpose of murdering each other, and Piero has studied with care the grim mechanics of the slaughter. There are no beautiful patterns here, no lovely light; the shining armor has no allure. The legs of horses and people block and defeat the eye. Masses of steel and flesh collide. Occasionally, one makes out an incident of utter brutality, as when, with a cold look, a soldier near the throne jabs his dagger into the gushing throat of another, or one of pathos, as we watch the doomed crawl of the figure below the rearing horse, or look into the eyes of the severed head at the extreme left. The dethroned monarch, still wearing his crown, kneels as he awaits the blow of the executioner's sword, his ignominy underscored by the kicking hooves that just miss him. Above him we see the True Cross blasphemously incorporated into the throne. The fresco is a forbidding work but full of extraordinary details of form and observation.

Even more misunderstood is the *Annunciation* (fig. 285), at the lower left of the chancel window. Some have tried to show that it is not an Annunciation at all but a vision of Empress Helena; others have claimed that the scene is wholly out of place in the Legend of the True Cross and must have been inserted later. Certain curious aspects of the subject, as well as its relevance to the Leg-

end, are clarified by St. Antonine, archbishop of Florence at this time. The Virgin stands under a loggia consisting of a single bay; she looks down toward the Angel Gabriel, who genuflects as he arrives. In the sky, above a low wall treated with the same white marble moldings and cornice and the same veined marble incrustation as the rest of the architecture, appears God the Father, his hands outstretched as if he were sending down the dove of the Holy Spirit (if so, it must have been painted a secco and since peeled off, for no trace of it remains). The loggia is formed by two splendid Composite columns, similar to those of Solomon's palace. To the right is the open door of Mary's bedchamber, complete with intarsia bed, curtains, and an arched bower; to the left is the famous porta clausa of Ezekiel's vision, symbol of Mary's virginity, paneled as in Donatello's Annunciation (see fig. 245). Among St. Antonine's writings is the declaration that the porta clausa is the way to salvation. Yet he reminds us that Christ himself said, "Narrow is the gate and strait the way that leads unto salvation," by which he meant the Cross. St. Antonine reconciles the two doctrines with ease: the Cross can be mystically identified with the porta clausa, and it was therefore symbolically present at the Annunciation.

Of this fact Piero has given a strong hint. The entire picture has a cruciform scheme. The suggestion of a cross is reinforced by the beam before the second-story window. Instead of the customary lily, Gabriel holds in his left hand a palm, symbol of eternal life. With the apparition of God the Father above her, Mary looks downward almost sadly. As the miracle of conception takes place within her, the light from the real window of the chancel falls upon her womb; the light also pierces the open arched window above her, a symbol of divine

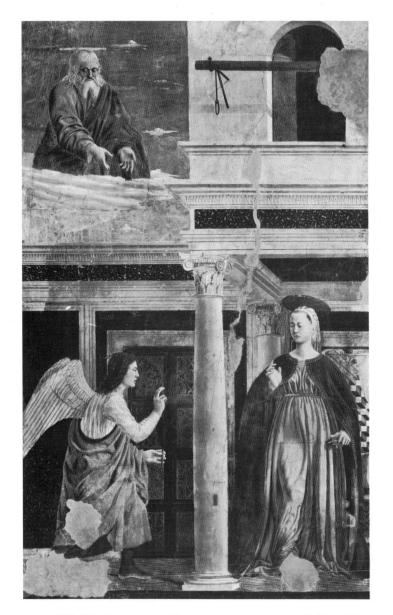

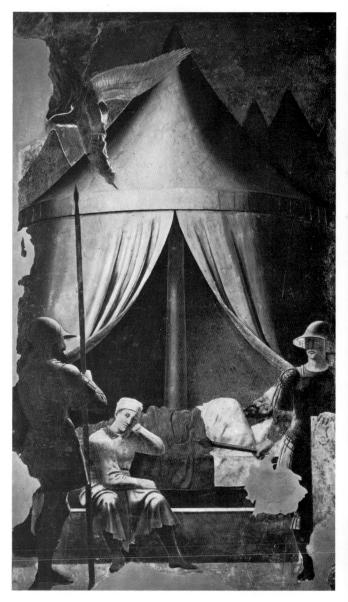

285, 286. PIERO DELLA FRANCESCA. Annunciation (left) and Vision of Constantine (right), from Legend of the True Cross. Probably 1452–57. Fresco. S. Francesco, Arezzo

revelation, and throws the shadow of the portico upon the *porta clausa*, the closed door of her virginity. Into this simple, massive composition, all in rose, blue, white, and the rich dark colors of the veined marble, Piero has compressed—in the outward guise of three figures, two doors, a column, and a window—the deepest mysteries of Christianity, all revealed by the miracle of light. It is, perhaps, typical of the absolute oneness of Piero's universe that he chose the same bearded model for the impious and humiliated Chosroes who had compelled his followers to worship him as God, for God the Father sending his Son for the redemption of mankind, and for Solomon receiving the queen of Sheba.

To the left of the window Mary becomes the greatest of queens by virtue of the Cross, and to its right the same Cross makes Constantine emperor, also through light. The Vision of Constantine (fig. 286) has long been justly celebrated as one of the noblest of Early Renaissance

night scenes. But we must not forget its ancestry, in the luminary revelations of Taddeo Gaddi, Pietro Lorenzetti, and Gentile da Fabriano (see figs. 82, 103, 185). Constantine's pointed tent fills the scene almost from window to wall. Behind it at right and left stand four other tents, two of them just touched by moonlight. The curtains are parted to show the emperor asleep upon his bed, on the bench of which sits a servant, propping his head on one hand. One guard armed with a lance looks at Constantine, the other, holding a mace, looks outward. No waking figure is aware that an angel has appeared over the group—hard to decipher because considerable *intonaco* is lost in this area—flying into the picture and downward in a manner invented by Paolo Uccello; the angel's head is partially obscured by his right shoulder, and his right arm is extended, ending as has not previously been noticed—in a left hand, the index finger pointing downward, perhaps to indicate that the occurrence is not a fact but a dream (see page 262 for a comparable instance). And suddenly the light is there, although from no recognizable source, illuminating the figures and the tent, shining even through the feathers of the angel's wing. No one seems to notice this miraculous radiance. The Cross, supposedly the subject of the vision, is nowhere visible. As in the *Annunciation* on the other side of the window, it is implicit in the picture's construction, and the shapes of the two scenes even correspond, pillar for pillar, horizontal for horizontal. Male and female, day and night, the cycle comes in these last two scenes to its perfect fulfillment.

Much has been written about Piero's color in the Arezzo cycle. His palette is limited to a few simple tones. Especially impressive, when one stands in front of the frescoes, is the complete reality of this color, truly the subdued color range of Central Italian landscape and light, vegetation, architecture, and people, so exactly studied that one is convinced these objects and people are really there, still fresh within the wall plane in spite of the damage. Then reality itself becomes miraculous. Piero may have found the majestic order and harmony of his compositions in nature, but this order, as his intellect displays it, is beyond and above nature, and transfigures the walls of the modest chancel, as well as the entranced observer, with the illusion of a higher reality, the more convincing in that it idealizes nothing.

URBINO. Piero's reluctance to stay in Florence should not lead us to conclude that he did not travel. He seems to have worked in Ferrara awhile, at the court of the Este dukes, and certainly left a mark on the Ferrarese school. In 1459 he painted an important fresco (now lost) in the Vatican. He may indeed have visited Rome earlier, for his handling of figures in architectural and landscape settings at San Francesco owes much to Fra Angelico's frescoes in the Chapel of Nicholas V (see fig. 214). But Piero's strongest ties outside Sansepolcro were with the neighboring mountain principality of Urbino, then ruled by Count Federico da Montefeltro, elevated to duke in 1474. Urbino's territory was largely unproductive and the count's revenues small. He came, however, from a family of long military traditions, and his talents were highly valued by the popes, who made him Captain General of the Church and relied on his aid in warfare against rebels, including Sigismondo Malatesta. Young men came from as far away as England to Federico's palace to study the art of war and to acquaint themselves with the principles of noble conduct and gentlemanly behavior. Under his rule Urbino became less a second Sparta, as might have been expected, than a tiny Athens. Federico was a wise and learned man, scholar and bibliophile, and surrounded himself with humanists, philosophers, poets, and artists, including Piero della Francesca, so many of whose tastes he shared. Under Federico's successors the cultural preeminence of Urbino lasted well into the seventeenth century. Federico's palace, a masterpiece of Renaissance architecture (see colorplate 54), contained many important works of art. In his tiny Studiolo (study; see fig. 387), center of his intellectual life, was placed Piero's single surviving narrative panel painting, the Flagellation of Christ (colorplate 37), of still uncertain date. The setting is the portico of Pilate's palace, which Piero has imagined as strikingly similar to Solomon's palace in the Arezzo series. What has perplexed all observers is the placing of Christ and his tormentors deep at the left of the picture, while in the right foreground stand three figures who seem to have nothing to do with the subject and do not even look at what is going on. There have been at least nine major interpretations of this enigmatic work, including those appearing in previous editions of this book. Most of these contain elements of great value; the present attempt borrows from them and tries to bring them into a coherent and intelligible focus, consistent with the historical situation at the time.

Crucial is the vanished inscription Convenerunt in unum, read at the bottom of the panel, presumably on the frame, by the German scholar Johann David Passavant in the early nineteenth century. The words appear in Psalms 2:2: "The kings of the earth stood up, and the rulers were gathered together against the Lord and against his Christ." In fifteenth-century breviaries this verse appears in the Antiphon for Matins of Good Friday, immediately followed by the words of the Apostles from Acts 4:26 as a specific image of the trial of Jesus, naming both Herod and Pilate. It has often been suggested that Piero's picture refers allegorically to the capture of Constantinople by the Turks in 1453, and the torments then inflicted on the Church, still today known as the mystical body of Christ, could easily be symbolized by the Flagellation. An old tradition in Urbino identified the youthful, barefoot figure on the right, clothed only in a long, unornamented red garment, as Duke Oddantonio, Federico's half-brother (Federico, though older, was illegitimate). Recently the face has been identified as an exact portrait of Oddantonio, who was murdered in his nightshirt. It has also been shown that the splendidly robed figure at the right has a red ducal mantle thrown over his right shoulder, barely visible, and is thus in all probability a portrait of Duke Guidantonio, father of both Federico and Oddantonio. A third portrait has been identified: Pilate, who superintends the torture from a throne and wears the hat of the Byzantine emperors (see page 276), is recognizably the Turkish usurper Mahomet II. In all likelihood, then, the remaining man in the foreground is a portrait as well. Dark-eyed, bearded in the Greek fashion, he also wears a Greek hat. He gazes earnestly outward, and his mouth is open in speech as he gestures to his two listening companions. We are led to conclude that the suffering of Christ and the contemporary events it symbolizes are the subject of his discourse, placed deep in space as the Flagellation is remote in

time. It is here suggested that the speaker is a Greek scholar at the court of Urbino who expounds to the departed dukes the meaning of the event taking place behind him. It should be remembered that in 1463 began the ill-fated efforts of Pope Pius II (see pages 228, 370– 71) to promote a Crusade to rescue the Holy Land from the Turks—he died at Ancona in 1464 before he could embark on this adventure—as well as the campaign of Federico to gain for himself the ducal mantle of his father and half-brother. Deep in the portico Christ stands calmly, awaiting the blows about to fall upon him from executioners in Turkish dress. He is bound to a column on which stands a golden figure of a nude man, recently connected with the golden statue of the Sun, one of the principal monuments of Constantinople. In his left hand the figure holds forth a colossal pearl, whose significance as the Incarnate Word we have already seen (see page 217), and the entire ceiling panel above the statue is illuminated by a strong light from this pearl as from an electric bulb. The picture, in its private position, was probably intended to embody Federico's own ideals for his mission as Captain General of the Church involving the liberation of the Holy Land and Constantinople, the holy city of the East, and his own eventual reward, the ducal mantle of his predecessors. The architectural setting of the portico, as well as the buildings surrounding the square, has been constructed with such accuracy that modern scholars have been able to play Piero's perspective backward, so to speak, and reconstruct the plan of the inlaid marble floor. This turns out to have been put together according to precise mathematical principles. The orthogonals of Piero's perspective are projected from divisions in the base line, as Alberti says they should be, but he has placed the point of view slightly below the figures' hips rather than at eye level as Alberti recommends. In consequence, the foreground figures loom grandly and their colloquy becomes all the more important. The architectural details are studied with even greater refinement than at Arezzo, and the ceiling is coffered rather than filled with impossible monoliths. Presumably, we are not asked to believe that a single unsupported beam could span the entire width of the portico, but merely that necessary columns have been removed for our convenience, according to a stage convention quite common in Quattrocento painting, so that we may see Pilate sitting impassively upon his throne. Outside, inside, and around the portico Piero's sunlight works its usual magic, reflecting from the snowy marbles, penetrating the deep-toned slabs of onyx and porphyry, and carrying the tones of blue and rose, red and gold, that suffuse the whites in the indirect illumination of the portico. An utter miracle of color perception is the play of lavenders and blues that make up the shadows in the white garments of the turbaned executioner. All in all, the interlocking web of form, space, light, and color represents Piero's most nearly perfect single achieve-

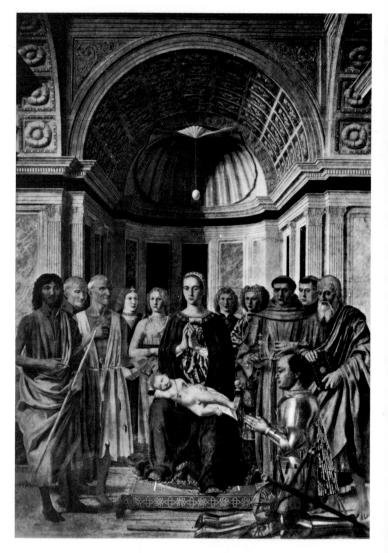

287. PIERO DELLA FRANCESCA. *Madonna and Child with Saints*. Between July 1472 and September 1474.
Panel, 98×79". Brera Gallery, Milan

ment. If the Albertian ideal of absolute and perfect painting could be embodied in a single picture, this is it. Piero seems to have thought so too, for he signed the panel conspicuously. Through what compensatory modesty, then, did he choose the lowest step of the throne for the signature?

In July 1472, Federico's beloved wife, Battista Sforza, who had governed Urbino capably during his frequent absences, died in her twenty-sixth year, six months after the birth of her ninth child and first son, Federico's long-expected heir, Guidobaldo, a veritable sacrifice of her life for the perpetuation of the dynasty. Federico was inconsolable, stopped all work on his palace, and began the construction of a new church of San Bernardino across the valley from Urbino, and visible in the background of Raphael's *Small Cowper Madonna* (see fig. 483). For this church he commissioned Piero to paint one of his finest works, the *Madonna and Child with Saints* (fig. 287). In the nave of an Albertian structure (it

is not clear whether it is a church, for there is no altar nor any religious symbol), brilliantly projected and perfectly painted, in front of the crossing leading to a barrel-vaulted chancel, sits the Virgin with her hands folded in prayer, and on her lap sleeps her Child. Four angels stand behind her throne, and around it on either side stand six saints looking outward, downward, or inward, but not at her or at the Child. On the right kneels Federico himself, wearing a beautiful suit of shining steel armor, from which he has removed helmet and gauntlets so that he may pray. From the shell of the apse, divided half in shadow and half in light, hangs a single gigantic egg suspended by a silver cord. Throughout the picture total stillness reigns.

In a classic study, Millard Meiss unraveled the secrets of this work. Behind Federico stands his patron saint, John the Evangelist, but the spot before St. John the Baptist, where Battista (Baptist) Sforza should be kneeling, is vacant through her death. So exact is Piero's perspective that the real size of the represented egg can be measured, and identifies it as that of an ostrich (the egg here is somewhat larger than normal, but the Virgin is also larger than the saints on either side). Ostrich eggs often hung over altars dedicated to the Virgin—one still hangs in the Baptistery of Florence-and others appear in works by Mantegna and Giovanni Bellini (see fig. 403, colorplate 63), for it was believed that the ostrich let her egg hatch in the sunlight, without the intervention of the bird itself, thus according to medieval logic a symbol of the Virgin Birth that occurred without the agency of any mortal. The ostrich was also believed to subsist on a diet of nails, nuts, bolts, screws, and other hardware, appropriate for the soldier Federico, whose need for iron and steel was considerable, and it was therefore his symbolic bird, appearing on his coat of arms. Finally, the ostrich was an absent mother, and Battista was now gone. It has been shown that representations of the sleeping Christ Child generally, though not always, foretell the death of the adult Christ, and the awakening of the Child his Resurrection. The event for which Federico and Mary are both praying, and the assembled saints and angels waiting, is the wakening of the Christ Child, the Resurrection that will assure Battista's eternal life. The flawless Albertian architecture, the soft interior light penetrating into it and reflected from porphyry and onyx, the extreme delicacy of the subdued color, especially the silvery blond of the angels' hair, enhance the magical blend of harmony and suspense.

Piero's portraits of Federico and Battista (colorplates 38, 39) were designed not only to be seen together as a kind of diptych but also to stand freely, so that the triumphs of husband and wife, painted on the backs of the two panels (figs. 288, 289) could be enjoyed as well as the portraits. The ducal mantle worn by Federico in the triumph scene dates the panels after September 1474, when he was elevated to his long-desired rank (he does

not wear the mantle in the Madonna and Child with Saints), and when Battista had been dead for more than two years. Probably Piero worked from the still-extant death mask; the features also correspond to those shown in Francesco Laurana's bust (see fig. 385). It is hard to remember that Battista, therefore, appears as a countess and her husband as a duke. Federico's terrible profile, disfigured by a sword blow in a tournament that cost him his right eye and the bridge of his nose, was done from the same cartoon as the portrait in the Madonna. Both heads are in absolute profile, as became common in portraiture of the third quarter of the Quattrocento, but Piero has set them against immense and continuous landscape depth. In this respect he may have been influenced by such earlier Florentine works as the Madonnas by Filippo Lippi and Alesso Baldovinetti (see fig. 217, colorplate 42), although he goes far beyond these pioneer efforts. These views are not those visible from the Palazzo Ducale of Urbino; the Urbino landscape is quite different, cut off by lofty ranges with some jagged peaks, and devoid of water. The little city in Battista's portrait is probably identifiable as Gubbio, second city of the Montefeltro dominions, where Battista had taken her children during the construction of the palace in Urbino, where she gave birth to Guidobaldo, and where she died.

The portraits are intensely Piero in their combination of unsparing realism with inner nobility. Motionless as pharaonic statues and with heads held so high that their chins are silhouetted against the sky above the horizon, these two heads create an effect of the utmost grandeur. No more convincing symbol could be found of the Renaissance ideal of the dominance of man over nature. Piero's cool light plays full on the face of Battista, leaving that of Federico somewhat in shadow. His olive skin is set against her pallor, his low-set red hat and tunic against her fashionably high forehead, blond hair, and splendid jewels. Every element of luxury in the hair, its veil and its jewels, has been submitted to the sense of order that dominates both portraits. The headdress conforms to the architecture of the head, and the pearl-studded jewels against the sky seem like a lantern crowning a dome. And those pearls! Even more effective than the shining armor in the Arezzo frescoes, they concentrate the cool radiance of the landscape and sky in their chain of lucent globes, deliberately joined with and contrasted with the chain of square, gray towers of the fatal Gubbio.

In these ideal landscapes behind the figures, Piero has set himself new problems—first, that of atmospheric perspective. He makes us aware of the intervening veil of atmosphere, which, even in a Tuscan summer, contains some moisture, inevitably softening contours as the elements recede. But these hills, so strangely formed, have a second, more important, purpose. Piero was in touch with the major intellectual and especially scientific currents of his time, and must have known his Tuscan contemporary Paolo del Pozzo Toscanelli, who believed the

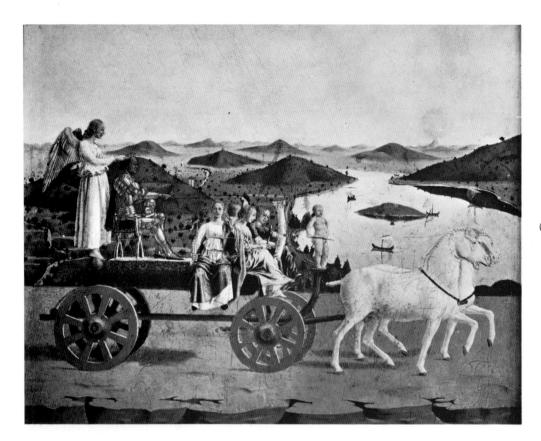

288. PIERO DELLA FRANCESCA. Triumph of Federico da Montefeltro (upper portion, reverse of colorplate 39). After 1474. Panel. Uffizi Gallery, Florence

world was round (and made the map that started Columbus on his voyage). Piero set out to prove this proposition visually, by establishing a continuous plain of a kind rarely to be found in Central Italy. He then studded the plain at recurrent intervals with conical hills that have the texture and atmosphere of Tuscan hills but are not connected in ranges—just so many isolated anthills. The rate at which these cones diminish in the distance and the rate at which their intersection with the plain vanishes demonstrate that the plain is part of the surface of a sphere. Even the horizon line is slightly but visibly curved.

For some reason the atmosphere is somewhat thinner, the contours harder and clearer, in the two triumph scenes, and the immensity and curvature of the earth are therefore more easily measurable. Above high parapets bearing Latin inscriptions recording the fame of Federico and the virtue of Battista, the triumphal cars driven by winged love gods approach each other on a lofty tableland before the landscape, the car of Federico drawn by two white horses, that of Battista by a pair of brown unicorns, symbols of chastity. A winged Victory holds the ducal coronet above the head of Federico, whose shoulders bear the ducal mantle. On his car sit the four Cardinal Virtues. His wife is attended by a handmaiden and, apparently, a nun, and by the three Theological Virtues. The clear colors of the costumes and armor ring like silver bells against the infinite depth of the landscape, into whose olive-colored hills and valleys a lake brings the sky by reflection. The luminosity of the pictures is so great and the color tones so softly painted that the pictorial possibilities of tempera as a medium seem

almost to have been exceeded. Here for the first time one clearly senses that Piero had knowledge of the art of Jan van Eyck and Rogier van der Weyden. Although research has yet to clarify such problems, it would seem unlikely that Piero's luminary effects could have been achieved in tempera and impossible that anything like them could have been done without oil glazes in Netherlandish style.

In Piero's later work his habitual calm hardens almost into stasis, his concern with the mechanics of mass and support diminishes, but his interest in the most subtle manifestations of color and light (and correspondingly in the art of the Netherlands, which had won such conspicuous conquests in this field) deepens and intensifies. An especially magical work is the Nativity of about 1480 (fig. 290) in the National Gallery in London, for which no document is known, but which appears to have remained in the artist's family after his death. No miracle of light is necessary here, for the event takes place on a sunny day in the Tiber Valley. Before a ruined wall, hastily converted into a shed by means of a lean-to roof, Mary kneels adoring her Child, who, naked and as yet without hair, stretches out his arms to her. (Piero seems to have utilized a doll for his model, and the effect resembles porcelain.) Behind Mary a weary and unconcerned Ioseph clasps his hands on his crossed knees as he sits on a saddle, not even looking at the two shepherds who point upward toward the star, outside the picture. Behind the Child stand five angels. Three of them, dressed in tunics and playing lutes and a viol, could have stepped out of Luca della Robbia's Cantoria (see fig. 241); the other two, apparently vested as deacon and subdeacon at the

289. PIERO DELLA FRANCESCA. *Triumph of Battista Sforza* (upper portion, reverse of colorplate 38). After 1474. Panel. Uffizi Gallery, Florence

first Mass, sing joyously. The ox, symbol of the Gentiles, looks quietly toward the Child; the ass, representing the Jews, brays in derision.

Never was Piero's color purer or more lyrical, especially in the passage of blues through the garments of the foreground figures—deep blue, light blue, blue-gray, violet-blue, blue-white, like the tones found in a gigantic bluejay. All around flows Piero's silvery air, especially enchanting about the face of the calm Virgin, with her pearl-studded hair and tunic. In the clear distance the Tiber Valley opens to the left; the river reflects the sky and the bordering rocky bluffs and scattered trees. On the right the principal church of Borgo San Sepolcro, which then contained Piero's *Baptism*, can be seen above the roofs and streets of the town, its campanile competing with the neighboring house-towers. The figures of the shepherds were apparently never finished; the linear underdrawing in perspective is clearly visible.

Piero lived on for about twenty years more but seems to have given up painting for his studies on perspective and mathematics. His principal theoretical works are preserved in his own handwriting, and include *De prospectiva pingendi* (*On Painting in Perspective*), in which he treats a series of problems in perspective as propositions in Euclidean style, and *De quinque corporibus regolaribus* (*On the Five Regular Bodies*), a study of geometry. According to Vasari, the aged Piero was blind, and in the mid-sixteenth century a man still lived who claimed that, as a boy, he had led Piero about Borgo San Sepolcro by the hand. This story has been doubted, but it must contain more than a grain of truth even though in 1490, two years before his death, Piero still wrote a clear and

beautiful hand. Writing, especially with the aid of a glass, might have been possible for the artist even if he could not see well enough to paint panels and frescoes.

So the second Renaissance style ends in the contemplation of those mathematical harmonies that, for the Quattrocento humanists, contained the secrets of the universe and served to admit a perfectible mankind to the workings of the mind of God.

290. PIERO DELLA FRANCESCA. *Nativity.* c. 1480. Panel, 49 × 48½". National Gallery, London

Crisis and Crosscurrents

hroughout our study of the first half of the Quattrocento, we were concerned with no basic stylistic conflicts between the leading Florentine artists, but only with variations of manner, taste, and content. In our imaginations these architects, sculptors, and painters present the appearance of a little band of hardy conspirators—let us say the heroic artists of Nanni di Banco's Four Crowned Martyrs (see fig. 168) united against the representatives of the entrenched Gothic style. By the 1430s the eventual outcome of the struggle was no longer in doubt. All the major commissions were going to the innovators, and not only their Gothic opponents but also some of their weaker supporters were banished to the villages or constrained to seek their fortunes in still-Gothic centers such as Milan or Venice. Qualitatively speaking, the triumph of the Renaissance masters was absolute. Florence could show no purely Gothic artist, after Lorenzo Monaco, important enough in his own right to require admission to such a book as this one. By the middle of the Quattrocento even the crafts had succumbed to the demands of the new era. Furniture, textiles, metalwork, leatherwork, ceramics, all had adopted Renaissance taste. Companies of painters were formed to turn out birth salvers, painted chests, processional banners, painted pennons, shields, and bridles, not to speak of colored reliefs by the sculptors and painted outdoor tabernacles and altarpieces for village churches, using ideas and motifs—sometimes even by means of stencils-borrowed from the revolutionary painters whose works we have just discussed.

In the 1450s, just when the Renaissance style was beginning to seem as standard as had that of Giotto in the 1320s (see page 62), there appeared a little rift that widened so rapidly that within a few years there was no longer a single dominant style but several, almost equally important, in the sharpest contrast to each other and, in general, to the previously dominant second Renaissance style (see pages 205, 244). For the next fifty years these contrasting, sometimes conflicting currents are to characterize Florentine art.

Consider the dramatis personae. Brunelleschi, Masaccio, Nanni di Banco, Jacopo della Quercia all were dead. After the installation of the Gates of Paradise in 1452, Ghiberti had retired to his moated grange to live the life of a country squire. Fra Angelico was at work on a series of tiny panels, masterpieces of personal religious and artistic introspection. Alberti, Fra Filippo Lippi, and Piero della Francesca were largely or entirely active outside Florence and so, until 1453, was Donatello. We do not know much about Domenico Veneziano in the 1450s, but he seems to have fallen under the spell of his violent friend Castagno, whose style had taken a strange and shocking turn. So did that of Donatello, on his return to Florence. Yet along with these two great masters, so deeply affected by the terrible events of the time, comes a group of sculptors and painters who depict for us a life of unshadowed delight.

We have already seen that the plague of 1448, exactly a century after the Black Death, had serious consequences for Florence and Rome (see pages 218-19). Moreover, it kept coming back. The humanist pope, Nicholas V, who as Master Tommaso of Sarzana had been a university companion of Alberti, fled the Eternal City to the remote safety of Fabriano, to which papal soldiers then forbade further access. In Florence, however, St. Antonine, the ascetic archbishop, set a better example, remaining in the city and organizing house-to-house efforts to aid the sick, bring the last comforts of the Church to the dying, and bury the dead. Events succeeded each other with frightening rapidity. Stefano Porcari, a Roman noble, led a conspiracy to assassinate the pope at High Mass on Easter Sunday. Halley's comet, considered a harbinger of disaster, hung over Europe in the summer of 1453. Repeated earthquakes shook Central Italy, especially Florence, whose inhabitants slept outdoors for a month. Finally, also in 1453, Constantinople, the last citadel of the Greek Orthodox Church, fell to the massacring Turks.

In due time Florence recovered from all these disasters, and the Peace of Lodi, in 1454, which put an end to

most armed conflict in North Italy and in Tuscany for forty years, brought the illusion of restored tranquillity. But something had happened to the energies of the Florentines. On the surface the government of Cosimo de' Medici worked well enough. The old man and his sons controlled politics from behind the scenes by ensuring that only names approved by the Medici party went into the leather purses from which were drawn bimonthly those who were to fill public office. Cosimo also made certain that his chief enemies, or those of whom for one reason or another he disapproved, were so heavily taxed that they fled the Florentine state rather than submit. A conspicuous victim of this practice was the great humanist and philosopher Giannozzo Manetti.

Under such circumstances it might easily be assumed that the Medici bank and allied commercial establishments would flourish and expand. Exactly the opposite was the case. Cosimo gave less and less attention to his banking, his sons Piero and Giovanni received little training in finance, and Piero's sons Lorenzo and Giuliano even less. Perhaps as a result, perhaps as part of a general European business decline in the second half of the fifteenth century, the Medici bank was forced to close one after another of its European branches, and its volume of transactions declined precipitously. The fiscal corrosion was contagious, and by 1495 almost every bank in Florence had closed its doors.

Yet the splendor of the Medici family, emulated by all who sought their favor, took little account of the weakening of its financial base. Architects, sculptors, painters, and artisans were kept busy designing, building, and decorating the palaces whose graceful shapes now interrupted with increasing frequency the severity of the medieval streets, or the villas that rose (often converted farmhouses) in the nearby countryside, surrounded by formal gardens.

Cosimo, an amateur architect in his own right, was succeeded in 1464 by his sickly son, Piero the Gouty, whose tastes for refinement and luxury were rapidly satisfied by the artists. Piero's successor in 1469 was Lorenzo the Magnificent, who managed adroitly to keep up the fiction of republican liberties at home while freely treating as an equal with kings and princes abroad. In a conspiracy headed by the Pazzi family, but involving the archbishop of Pisa and even Pope Sixtus IV, an attempt was made in 1478 to assassinate Lorenzo and his brother Giuliano. Again the time chosen was High Mass on Easter Sunday—in the Cathedral of Florence, under Brunelleschi's dome—and the signal was the priest's communion. Giuliano succumbed, but Lorenzo escaped and began a witch-hunt of his enemies. The anti-Medicean party, largely of popular origin, grew during the last years of what can only be known as Lorenzo's reign, the flames of their anger fanned by the sermons of a Ferrarese monk, Girolamo Savonarola, successor of St. Antonine and Fra Angelico as prior of San Marco. After Lorenzo's death in 1492, the fate of his incompetent elder son, Piero the Unlucky, was sealed. In 1494 Piero and his brothers—Cardinal Giovanni, later Pope Leo X, and Giuliano, later duke of Nemours-were forced to flee the city, and the Medici Palace was sacked by mobs and its treasures dispersed. Small wonder that the humanistic premises of the second Renaissance style—intellectuality, order, harmony—had lost their relevance. Whatever styles succeed each other, or coexist, in the third and fourth quarters of the Quattrocento in Florence, the second Renaissance style is not one of them.

DONATELLO AFTER 1453

Among the works by the aged Donatello after his return to Florence is a strange and harrowing figure of Mary Magdalen (colorplate 40), carved in poplar wood for the Baptistery. Emaciated from her long sojourn in the desert, clothed only in the tangled mat of her own hair, this skeletal, even spectral, apparition with haggard eyes, shrunken cheeks, and almost toothless mouth (fig. 291) seems the very antithesis of the noble figures created by Florentine masters only a few years before—and still being created by Piero della Francesca in his provincial isolation. Donatello's Mary Magdalen has lost not only physical dignity but even mobility; the vertical figure is as closely confined to the wooden shaft from which it was carved as any columnar statue on a Gothic portal.

St. Antonine has much to say about the Magdalen, "dishonest in mind and body," and quotes the writings of St. Bernard, "O soul...why dost thou not leave the body... so vile and fetid." The disastrous flood of 1966, which immersed Donatello's statue to above the knees in mud and oil, necessitated a complete cleaning of the surface. The brown paint added in the seventeenth century was removed, disclosing that Donatello had originally painted the limbs of his psychotic creation to indicate the tan produced by the desert sun, and he had gilded her monstrous hair! Like the late works of Castagno (see colorplate 35), those of the more-than-thirty-yearsolder Donatello admit us to a hitherto unexplored inner world of emotional stress, and study with fascination the ravages of time and decay on the human body, whose youthful beauty a happier generation had discovered with joy.

In 1456 Donatello made and signed an equally disturbing bronze group of Judith cutting off the head of Holofernes (fig. 292), apparently for the courtyard of the Medici Palace. Today the statue again stands before the Palazzo Vecchio in Florence, where it was set up after the second expulsion of the Medici, in 1494, as a symbol of revolt against tyranny. (From 1506 to 1919 it stood nearby, in the Loggia dei Lanzi.) But when it belonged to the Medici, the group had another meaning, indicated by an inscription describing how the head of Pride was cut off by the hand of Humility. In all probability St. Antonine provided the Medici with a written program for the

right: 291. Donatello. Head of Mary Magdalen, detail of colorplate 40. 1454–55. Wood with polychromy and gold. Baptistery, Florence

below left: 292. Donatello. Judith and Holofernes. 1456. Bronze, height 7'9" (including base). Piazza della Signoria, Florence below right: 293. Judith, detail of fig. 292

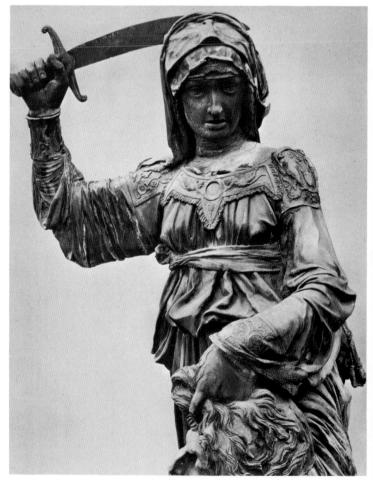

statue, preserved in the text of his Summa. He compares Judith's victory over Holofernes with that of Mary over sensuality (luxuria), which derives from pride (superbia), the primordial sin, source of all the others. Judith was a widow, and Antonine claimed that the Lord preferred widows to married women. Her purity under the blandishments of the pagan general awaiting her in his tent is compared to the virginity of Mary; she, like Mary (in a simile borrowed from the Song of Songs), is a camp of armed steel, an army terrible with banners. Donatello's Judith stands there almost transfixed by the dreadful rite in which she is engaged. She has already struck Holofernes once and cut deeply into his neck, in fact broken it. The sword is raised for the second blow as she gazes outward with unfocused eyes, her lower teeth biting her upper lip (fig. 293). One foot is planted on Holofernes' hand, the other directly on his groin. Holofernes' cushion is pierced at the corners; the group was intended as a fountain!

In the reliefs on the base are depicted mysterious rites performed by children, in one case jumping in and out of a gigantic caldron. Quoting St. John Damascenus, St. Antonine had claimed that, in addition to baptism by water, there was baptism by the spirit (John the Baptist had prophesied baptism by the Holy Spirit and by fire; see page 220) and by blood. The latter was considered equal to baptism by water in remission of guilt and superior in that it bestowed the palm of martyrdom and conferred even more grace. The slaughter of unborn or unbaptized infants by infidels fell under this category; the murdered children could thus be considered formally baptized and gain entrance to Paradise.

The compression of the *Magdalen* operates in the tense shapes and halting movements of the *Judith* as well,

intensified by the convulsed masses of cloth that cover the figure. As we have seen in the case of the *St. Mark* (see pages 165–66), Donatello used actual cloth soaked in a thin paste of clay, and applied it to the nude clay statue, modeling it in place. In the band over Judith's forehead some of the clay came off before the figure was cast in bronze, showing the underlying rough cloth. Donatello, who probably liked the accidental effect, did not repair the break, and so his method is preserved for us beyond question.

Even more startling in their expressionistic content and technique than the *Magdalen* and *Judith* are the reliefs by Donatello, finished in part by his students, for the two pulpits intended for the reading of the Gospel and the Epistle on either side of the nave of San Lorenzo in Florence. The pulpits were never set up in Donatello's lifetime, and the Gospel pulpit seems to be the earlier of the two, its reliefs left incomplete when Donatello left for a stay in Siena toward the end of 1457 and finished by his pupils after the master's death.

All the reliefs are done in a style whose freedom and sketchiness, even brutality at times, are extraordinary even for Donatello, and do not recur until the twentieth century. The scenes on the Gospel pulpit are framed by fluted pilasters, although they frequently negate the implications of their supposed frames. One of the most impressive is the *Lamentation* (fig. 294), which takes place below the three crosses, moving diagonally into the picture but cut off by the frame. To make the spatial relations even more disturbing, the ladder is leaning against the side of the empty central cross, moving diagonally in the opposite direction. The thieves are still attached; one sees only the lower legs and feet of the penitent thief. A strangely old Christ, with long, flowing hair and beard

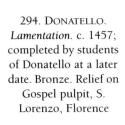

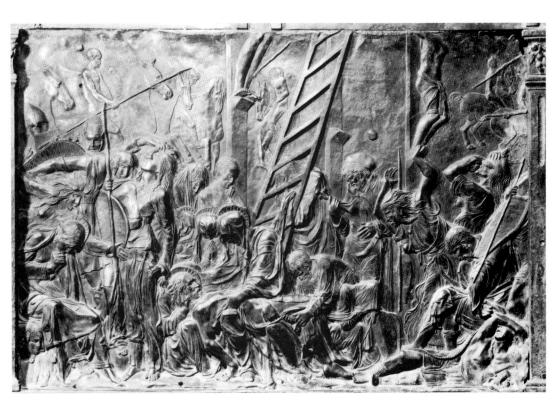

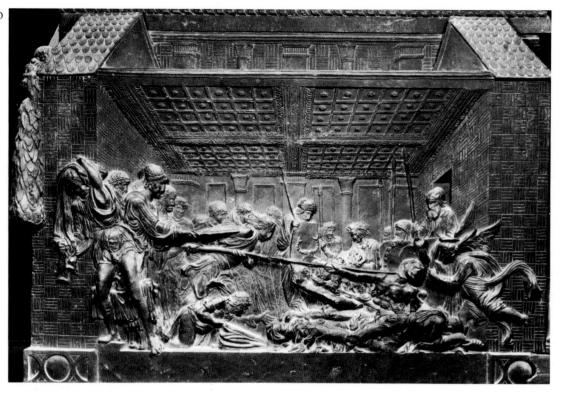

295. DONATELLO. *Martyrdom of St. Lawrence*. 1465. Bronze. Relief on Epistle pulpit, S. Lorenzo, Florence

mingling in a torrent, lies across the knees of the grieving Virgin, his arm hanging and his head upheld by an unidentified figure whose own head it totally conceals. There are insoluble mysteries. Four screaming, maenadlike women rush about; which one is the Magdalen? Who is the seminude figure reclining at the lower right corner, with nipples like those of a woman? Why are the soldiers on horseback not only completely nude but also deprived of any ground to stand on? Some of the surface finish, particularly the hammering of the bronze, is attributable to students, but they have left Donatello's cubic formation of draperies, especially the left sleeve of the Apostle holding Christ's legs, intact—prophetic of Rosso Fiorentino (see colorplate 79).

The arrangement for the Epistle pulpit is an exact reverse; in an unprecedented illusionistic configuration, the architecture—low brick walls roofed with scale tiles—projects outward at disconcerting speed from the scenes within, whose figures seem to erupt into the very space of the church. The Martyrdom of St. Lawrence (fig. 295), inscribed 1465, is the last dated work of the aged master. The explosive architectural setting enhances the frightfulness of the event. The executioners are forcing the saint by means of a huge, forked stick not onto a grill but directly onto the blazing logs; one blows the flames with bellows, another is felled by the heat at the lower right, another rushes away at the left, while an angel floats in to receive the soul of the dying martyr. As if in total disregard of the tumult and horror below, the elements of a noble architecture carry the ceiling into strikingly deep space or appear far above and beyond it.

In his last works the aged sculptor, one of the founders of the Renaissance and prime mover of every change in its evolution, still undisputed master of its every technical device, abjured his own ideals in an excess of fervor, much as Michelangelo was to do under a similar situation of social stress a century later (see pages 648, 657). But in the 1450s only Donatello and Castagno possessed the insight into human suffering to enable them to explore the darker regions of experience.

DESIDERIO DA SETTIGNANO

Their imitators could not follow, even when they tried. For example, Desiderio da Settignano (c. 1430–64), known today as the prime exponent of *rilievo schiacciato*, produced a weaker version of the *Magdalen* (there are several). Yet Desiderio was one of the most skillful masters of the age. He was born and trained in Settignano, village of stonecutters and also home of the Rossellino family, where later Michelangelo was to acquire his love of marble. Few sculptors in all history have known the possibilities and limitations of marble with such intimacy as Desiderio.

In 1453 he was commissioned to construct and carve a tomb in Santa Croce for another Florentine humanist-chancellor, Carlo Marsuppini (fig. 296), as a pendant to that of Lionardo Bruni by Bernardo Rossellino on the opposite side of the nave (see fig. 256). Of necessity the general proportions of the pilasters and arches are similar in both monuments, but that of Marsuppini produces at once an impression of greater lightness and grace, achieved by a number of devices. The sarcophagus and bier are lower, the white marble moldings narrower, and Desiderio has divided the incrustation behind into four slabs rather than three. These are in consequence much narrower and higher than their counterparts on the

Bruni tomb, accenting verticality and openness. Instead of loading the nude angels and heavy shield onto the keystone of the arch as Bernardo had, Desiderio crowns the structure with a lofty marble lampstand and marble frame imitated from Roman originals, in keeping with the purely classical nature of the epitaph. From the lampstand, garlands hang in long curves that repeat the concave curve of the pall over Marsuppini's bier and the broader sweep of the garlands on the plinth. Adolescent genii, clothed and wingless, come running around the top ledges of the cornices to lift up the garlands. At the base of the pilasters two little putti hold shields with

the Marsuppini arms (fig. 297). By these means the composition is opened outward into the space of the church. The sarcophagus is curved rather than block-shaped—a kind of expanded Roman funerary urn—and Roman vine-scroll ornament of great refinement animates its surfaces and dissolves its angles. Even the sacred figures in the tympanum are more lively: the angels bend forward as they pray; the smiling Virgin leans back slightly, the better to contemplate her Child as he blesses.

Desiderio was probably the greatest sculptor of children in history. His earnest little putti are bewitching, as are the children in his low-relief *Madonnas*, like the beautiful one in the Philadelphia Museum of Art (fig. 298). Desiderio made a specialty of luminosity in marble. He was aware, as no sculptor had previously been, of how light sinks into the marble crystals, is held there, and then given back to the delighted eye. Desiderio,

left: 296. DESIDERIO DA SETTIGNANO. Tomb of Carlo Marsuppini. After 1453. White and colored marbles. Sta. Croce, Florence

below: 297. Putto, detail of fig. 296

298. DESIDERIO DA SETTIGNANO. *Madonna and Child.* c. 1460. Marble relief, 231/4×171/4". Philadelphia Museum of Art (Wilstach Collection)

299. DESIDERIO DA SETTIGNANO. *Head of a Child.* c. 1460. Marble, height 10½". National Gallery of Art, Washington, D.C. (Mellon Collection)

clearly, aimed at achieving in marble the light effects created in paint by Fra Angelico and Domenico Veneziano and in gilded bronze by Ghiberti. He knew that the crystalline structure and brilliant whiteness of marble meant that any shadow would be partly dissolved by the light from the crystals, partly irradiated by the reflections from surrounding illuminated surfaces. The schiacciato technique, by means of which Donatello established form and space through the sheer movement of tone, could be further refined to suggest the ambience of light diffused through the atmosphere. In the children on the Marsuppini tomb these effects are obtained by breadth of surface, understatement of cutting, and a delicate polish. But at the end of his brief career, in the Madonnas and in the irresistible child's head (fig. 299) in the National Gallery in Washington, D.C. (which may be a contemporary portrait intended to appear as the Christ Child), Desiderio renounces polish and lets the marble crystals speak for themselves by suppressing surface definition—apparently by filing it off so as to blur lines and soften the junction of shape with shape, as if all were seen through a luminous haze. Bernini in the seventeenth century and Rodin in the nineteenth must have studied the transitory effects of expression and the fluid luminosity of Desiderio's marble sculptures. Precious and limited though he may have been-for Desiderio was incapable of coping with the deeper human emotions—he remains the very personification of the ideal of elegance and refinement, sensitivity and grace, of the new Florentine aristocracy of the midcentury, shaken perhaps but by no means uprooted by the grim Antonine interlude.

ANTONIO ROSSELLINO

The most gifted sculptor of the 1460s and 1470s was the youngest of the five Rossellino brothers, Antonio (1427-79), by whose nickname ("Rossellino" means simply "little redhead") the whole family was to become known posthumously. Antonio's masterpiece is the Tomb of the Cardinal of Portugal at San Miniato in Florence (fig. 300), central jewel in a brilliant complex of architecture, sculpture, and painting, which achieves as never again in the Quattrocento a real decorative unity. The cardinal, a prince of the Portuguese royal family, was made a cardinal at the age of twenty-two and died of tuberculosis in Florence only three years later, expressing a desire to be entombed at San Miniato. Immense sums were instantly forthcoming for the funerary chapel, for not only was one cousin king of Portugal, but also another was Holy Roman Empress, and the cardinal's aunt, most important of all, was duchess of Burgundy, then the richest state in Europe as the result of a marriage that Jan van Eyck had helped to arrange. The chapel was designed by Antonio Manetti, pupil of Brunelleschi and executant of the Church of Santo Spirito, and the architectural detail was carved by Giovanni Rossel-

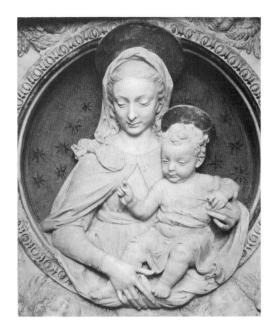

left: 300.
Antonio Rossellino.
Tomb of the Cardinal of Portugal. 1460–66.
White and colored marbles, and traces of polychromy and gold. Chapel of the Cardinal of Portugal, S. Miniato, Florence

above: 301. Virgin and Child, detail of fig. 300

below left: 302. Head of the Cardinal of Portugal, detail of fig. 300

below right: 303. Angel, detail of fig. 300

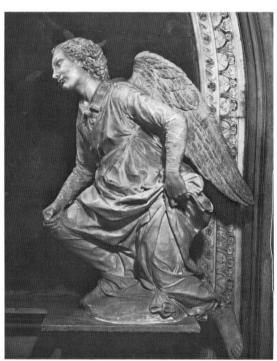

lino, third among the five brothers. Work started in 1460 and was carried out with great rapidity, as is shown in a series of recently discovered documents that clock the work on the chapel almost from day to day. Antonio's beautiful marble tomb was supposed to have been completed in 1462, but the cardinal's body was not laid to rest in it until 1466.

Although Antonio was helped in the actual carving by several assistants, and the documents show that a share of the work was allotted to Bernardo Rossellino, neither the records nor the appearance of the monument leave us in any doubt as to the identity of the designer and leading master. As compared with any of the earlier tombs, a tremendous change has taken place. To use an overworked polarity, up to that moment the Renaissance tomb was a static monument; Antonio has made it dynamic. Everything that was at rest or, at most, in gentle motion in the Bruni and Marsuppini tombs is soaring here. There is no closed architectural structure. Marble curtains, common in Gothic tombs and used by Donatello and Michelozzo in their monument to the antipope John XXIII, are reintroduced, but they have been drawn aside as if to disclose a vision. In the shadow of the arch stands the tomb itself. The young cardinal, vested as a deacon and wearing a bishop's miter, lies upon a bier above a marble coffin that Antonio imitated—at the cardinal's own request—from an ancient Roman porphyry sarcophagus that stood at that time in the portico of the Pantheon. On the richly ornamented pilasters that embrace the sarcophagus, two marble angels seem to have just alighted, reverently genuflecting. One bears the crown of eternal life and the other the palm of victory (now lost). No panels divide the background, which, save for the ornamental structure in the center, is a continuous surface of deep red-veined porphyry, once covered with gilded designs to resemble a brocaded cloth of honor in which the porphyry would represent red velvet. Against this splendid background, two white marble angels fly in, holding a circular white marble wreath; within this, against a bowl-shaped ground of blue with gold stars, the Virgin and Child bless the departed cardinal (fig. 301). Just for this instant the heavenly vision rests, poised against the architecture by the efforts of the two winged cherub heads; yet in a moment all might disappear.

The angel with the crown is clearly by the conservative Bernardo, whose phlegmatic style it shows in every line, but the ecstatic angel who once held the palm (fig. 303) shows all the new lightness and dynamism of Antonio's style, in its delicately crumpled drapery surfaces and in the gossamer shimmer of the light over features and hair, foretelling the Baroque style of the young Bernini in the seventeenth century. Antonio was as fully aware as Desiderio of the brilliance of marble, but found other means of exploiting it. The smoothly flowing surfaces of the Madonna and Child, whose placing was so

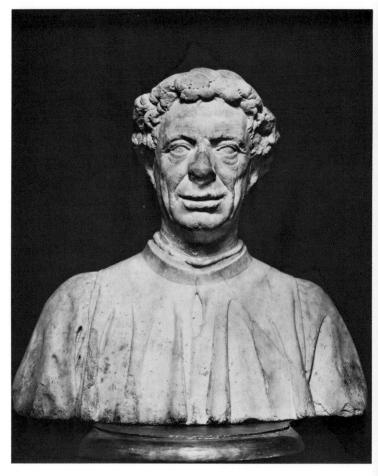

304. Antonio Rossellino. *Bust of Matteo Palmieri*. 1468. Marble, height 21". Bargello, Florence

calculated that the light in the chapel never leaves her benign features, show that Antonio aimed at unification of sculptural means through light used to enhance the forms of flesh and of drapery. Antonio's immediate charm may be less beguiling than that of Desiderio, but his sculptural control is greater. Like Desiderio, he died too young. One is tempted to speculate on Antonio's probable effect on the young Michelangelo if Antonio had lived out a normal life span; as it was, Michelangelo was deeply impressed by his Quattrocento predecessor's mastery of form derived from actual flesh-and-blood shapes, and by the intense, sometimes mournful sweetness of his work.

Most touching of all, perhaps, is the young cardinal himself, who seems to dream of the Paradise to which the sacred figures are promising him entrance—although it lies all around the observer as he stands in this most perfect of chapels. Desiderio, so the documents tell us, supplied a head of the cardinal, doubtless a death mask, since the cardinal was in no condition to pose for a sculptor during his final agony in Florence. From this, Antonio worked out a portrait at once persuasive in its reliance on reality and flawlessly organized as a work of art (fig. 302). The same sense of soft gradation of luminous surfaces, the same harmonious control of volumes, the same subtle modeling is carried into some of the

smallest details of the tomb, especially the little plinth (see fig. 300), whose execution was divided between Antonio and Bernardo but which clearly was designed by Antonio. Winged youthful genii hold cornucopias on either side, flanking unicorns; to these is attached a garland of fruits and flowers, above which, in the center, a death's head smiles as if the tomb were indeed only a portal to a life of gladness. In classical harmony of masses and in breadth of handling, Antonio's nude figures are well on their way to the still-mysterious nude youths of Michelangelo's Doni Madonna (see colorplate 69) and Sistine Ceiling.

The liveliness, vigor, and harmony of form that always mark Antonio's style are abundantly evident even when his subject offered no beauty of feature, as in the case of the humanist Matteo Palmieri. Antonio's bust of Matteo in the Bargello (fig. 304), despite the damage to which the surface has been subjected in the course of time, is one of the most striking of all the bust portraits that became a special artistic type in Florence in the middle and later Quattrocento. The coarse and puffy features of the subject radiate intelligence and good will; it is indeed a "speaking likeness." Yet beyond this realism lies Antonio's instinctive sense of how to control the masses so that they harmonize, fold against fold, wrinkle against

> 305. BENEDETTO DA MAIANO. Bust of Pietro Mellini. c. 1474-76. Marble, height 21". Bargello, Florence

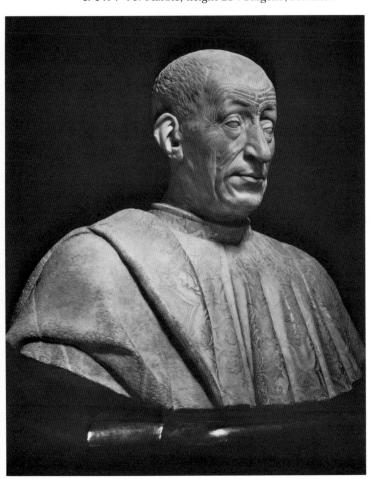

wrinkle; and a surprising nobility of form emerges from what could have been, in the hands of a lesser artist, a mere caricature.

BENEDETTO AND GIULIANO DA MAIANO

A host of gifted marble sculptors were at work in the later Quattrocento, in the following of the Rossellino brothers and Desiderio or entirely independent; one of the most vigorous was Benedetto da Maiano (c. 1442-97), who also came from a family of stonecutters. Maiano is still today a perfect Quattrocento village, untouched because it lies entirely within the boundaries of a great Florentine estate under severe legal restrictions against change. It is close to the still-operative quarries from which was carved the pietra serena used for the columns, arches, and trim of Renaissance churches and palaces in Florence and its surroundings. Benedetto's bust portrait of Pietro Mellini (fig. 305), in the Bargello, presents a topographic survey of the wrinkled features of the elderly subject with an exhaustive accuracy possibly inspired by Netherlandish art. For by 1483 the Portinari altarpiece of Hugo van der Goes (see fig. 357) had arrived in Florence and taken up its residence on the high altar of Sant'Egidio, flanked by the (now lost) frescoes of Domenico Veneziano (assisted by Piero della Francesca, Castagno, and Baldovinetti). Certainly Hugo's great painting astonished the Florentines. Yet even if Benedetto has observed his subject with Flemish precision, he has endowed him with Roman majesty. This, more than any other portrait bust of its time, approaches the honesty of Republican and early Imperial Roman portraiture. It should be noted, too, that architectural rather than exclusively sculptural and pictorial relationships have been stressed in the infinite network of interlocking wrinkles that at once divides and builds up the features.

Both Benedetto and his brother Giuliano da Maiano were architects as well as sculptors. Giuliano (1432–90) is best known as a woodworker and executor of architectural ornament, but since his name turns up so often in documents connected with the Pazzi family, he has been credited with the design of two major works of architecture long attributed to Brunelleschi, the façade of the Pazzi Chapel (see fig. 144) and the Palazzo Pazzi-Quaratesi (fig. 306). Although both attributions are tentative, the fragility and slightness of these designs are in keeping with what we know about Giuliano. It has recently been discovered that the façade of the Pazzi Chapel was not completed until 1461, fifteen years after Brunelleschi's death. There is no bond between the building itself and the portico, which was clearly an afterthought. This evidence reinforces the sharp contrast between the sometimes trifling detail of the upper story and the simplicity of Brunelleschi's geometrical architecture. The tiny paired pilasters behind which the central arch seems to be disappearing, the molded panels of pietra serena,

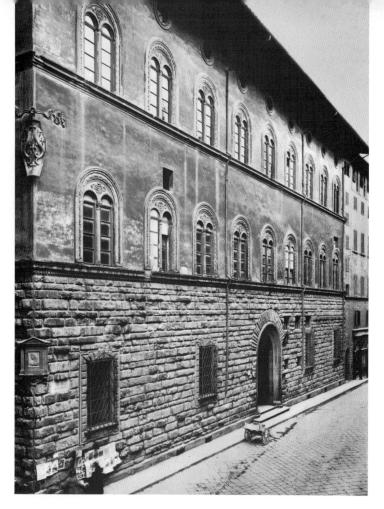

306. GIULIANO DA MAIANO. Palazzo Pazzi-Quaratesi, Florence. 1460s

and the entablature with its strigil motif are more appropriate to work in wood than to stone architecture. In all probability, therefore, if Brunelleschi did leave a design for the portico and façade, little of his ideas now appears there.

A similar taste is at work, and with similar results, in the façade of the Palazzo Pazzi-Quaratesi (fig. 306), datable in the 1460s. The heavy rustication of the ground story and the round-arched, mullioned windows of the upper two stories are obviously derived from the Palazzo Medici-Riccardi by Michelozzo di Bartolommeo (see fig. 146). But above the ground story the rustication disappears. The walls are covered with smooth intonaco, doubtless intended for fresco painting or for the graffiti (scratched and tinted ornamental designs) so common on house façades in Florence and its subject cities. The floral ornament of the window arches resembles that on the rich central arch of the Pazzi Chapel. No crowning cornice was ever constructed, and perhaps none was intended. Its absence, coupled with the row of delicate oculi that light an attic story, completes the effect of decorative charm in such strong contrast with the rude power of the Palazzo Medici-Riccardi or the harmony of the Palazzo Rucellai. Nonetheless, the Palazzo Pazzi-Quaratesi is typical of many smaller palaces—town houses we would call them today—that rose here and there in Florence in the second half of the century.

The Palazzo Strozzi is an exception (fig. 307). Of such gigantic scale and massive bulk that it dwarfs any other residence in Florence, the Palazzo Strozzi represents the culmination of the Florentine palace type and the direct origin of the foursquare block-palaces that were to ornament Cinquecento Rome. The design (fig. 308) is probably to be attributed to Benedetto da Maiano, Giuliano's powerful younger brother, whom we have seen as a sculptor. However that may be, a still-extant wooden model for the palace was done, confusingly enough, by still another Giuliano, Giuliano da Sangallo, whose work will be treated shortly. Furthermore, the colossal cornice, so necessary a feature of the design, was added only many years later by Simone del Pollaiuolo, called Il Cronaca, who succeeded Benedetto as architect. Unfortunately, the cornice stops halfway along the Via Strozzi façade, and it is still unknown whether or not the cornice conforms to Benedetto's original design.

The great Florentine banker Filippo Strozzi wanted (so the sources tell us) to build a palace that would outshine any other in Florence. Mindful of the fate of his exiled ancestor Palla, however, Filippo slyly showed designs for a more modest structure to Lorenzo de' Medici. Lorenzo thought them insignificant and urged Filippo to build something more imposing, as befitted the magnificence of the Strozzi family and of Lorenzo's Florence. This gave Filippo the green light to do what he had intended to do all along. He and his architects succeeded, not only in the noble exterior but also in the superb courtyard. The finished building differs from all other Florentine palaces of the Medici-Riccardi type, including Giuliano da Sangallo's model, in its unification of all three stories by means of a rustication whose projection is so slightly graduated from one story to the next as to seem uniform throughout. Within the confines of the three-story type, doubtless required by the patron, Benedetto won a signal victory in the battle for the harmony of all the parts, an Albertian ideal less honored than it might have been by Florentine architects after Alberti's departure. Alas, Filippo Strozzi died in 1494, by which time his great palace had reached only the height of the iron rings (used to tie the reins of horses to) partway up the lowest story.

Giuliano da Sangallo, in both his wooden model and his Palazzo Gondi, had already substituted smoothly rounded blocks of masonry for the rugged masses scattered freely about the lower story of the Palazzo Medici. Benedetto further domesticated these plates of stone in the Palazzo Strozzi, causing the archivolts of portals and windows to expand into them so that each arch springs from unbroken horizontals and each keystone exactly touches the joint for a new course. The small square windows cut here and there in Michelozzo's building are brought to heel by Benedetto and given independent frames. They rest upon and are crowned by unbroken masses of stone, so that they are anchored into the total

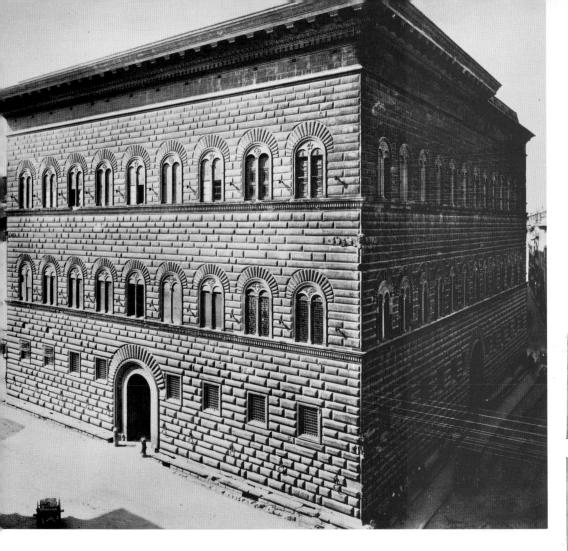

left: 307. BENEDETTO DA MAIANO and IL CRONACA. Palazzo Strozzi, Florence. 1489–1507

center: 308. Plan of Palazzo Strozzi, Florence

below: 309. BENEDETTO DA MAIANO and IL CRONACA. Courtyard, Palazzo Strozzi, Florence

fenestration of the palace. Nonetheless, Benedetto, afraid of too rigid an application of his principle of harmony, varied the width of the courses and set up little currents of verticals within the horizontal system so that, in the lower story, verticals multiply sharply toward the corner of the block and decrease just as sharply in the second and third stories.

The oblong courtyard (fig. 309) is the finest Quattrocento courtyard in Florence, partly on account of the greater space at Benedetto's command and the greater height of his columns and arches, as compared with the relatively squat proportions adopted by Michelozzo in the Palazzo Medici (see fig. 148). But there are further refinements. Mullioned windows were abandoned in favor of arches supported on piers; those on one side of the court were open (since filled with glass), and on the other sides the arches enclose cruciform windows surmounted by oculi in the lunettes. The third story is an open loggia, composed of delicate Corinthian columns on high podia united by an open balustrade. Since these columns support, as often in such Florentine galleries, a wooden beam shadowed by the eaves instead of a stone entablature, they seem almost freestanding. Thus the courtyard opens not only outward in its expanded plan but also upward in an unprecedented movement of superimposed verticals of the greatest harmony and beauty.

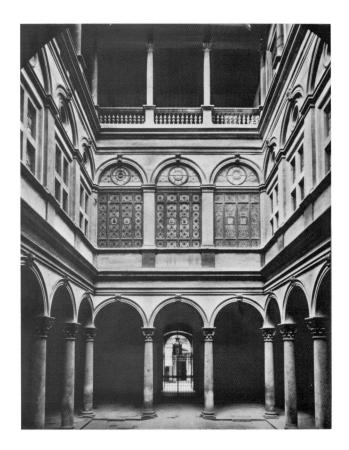

GIULIANO DA SANGALLO

Giuliano da Sangallo (1443?-1516) was the first eminent member of a numerous dynasty of architects that included two others of great importance, Giuliano's brother Antonio the Elder and their nephew Antonio the Younger. Giuliano was the most imaginative Florentine architect of the later Quattrocento, and so deeply imbued with the rarified classicism of the age that his buildings provide a setting for the life we know from the writings of contemporary historians and philosophers. His vast knowledge of Roman antiquity was derived from careful study of the monuments of the Eternal City and its surroundings. Many of his beautiful drawings of these buildings (fig. 310) are still extant and provide information not only to the art historian, regarding the interests of the Renaissance, but also to the archaeologist as well, for a number of the structures he drew have since disappeared. At the same time Giuliano never forgot his Tuscan, specifically Brunelleschian, heritage. Although he was probably only a year older than Bramante, founder of High Renaissance architecture, Giuliano lacked a certain spark in later life and, despite his resi-

310. GIULIANO DA SANGALLO. Theater of Marcellus.
Drawing. 1480s. Biblioteca Apostolica Vaticana,
Vatican, Rome

dence in Rome, was unable to produce any convincing work in the new, grand style.

But his Florentine buildings of the 1480s are delightful, especially the villa at Poggio a Caiano (fig. 311). about five miles to the west of Florence, built for Lorenzo de' Medici. Poggio a Caiano (poggio is Italian for "hill") is on a modest eminence near the southern edge of the plain of Prato. The villa site was chosen so as to command views of the plain and the Apennines to the north and the ridge of Monte Albano to the south. Giuliano treated the structure as a simple block with unrelieved walls and sharply projecting eaves, set in the center of an extensive terrace, which was remodeled when the double staircase and crowning clock were added in the eighteenth century. But the beautiful temple portico is original (fig. 312), and in more than one sense. It was apparently the first of a long line of such temple porticoes, so characteristic of Renaissance and Baroque villas, and doubtless was Giuliano's own suggestion, a fruit of his Roman studies. The low, broad, open proportions are unexpected. They find their justification in the function of the portico as embedded in the flat and unrelieved intonaco of the villa wall. This cream-colored plane, like the page of a giant book, is used again and again in Florentine Renaissance villas as a ground on which the windows, doors, and porticoes in pietra serena may be grouped or scattered. Only the quoins at the corners seem to support the eaves, and there is no attempt to organize the entire façade as North Italian architects were later to do. Quite likely Giuliano was familiar with Etruscan temples, which had similar low, expanded proportions. In any event, an Augustan Roman temple, with its closely grouped columns and vertical emphasis, would have been out of keeping with the broad villa

Having established his principle of horizontality, Giuliano enhanced it by a number of devices, including the weight of the pedimental moldings and the shape of the ribbons stretching out from the Medici arms—not fluttering as was usual for such representations, but filling the pediment with four continuous S-shapes, played against each other in superimposed pairs. The columns are Ionic, but with a broad, fluted necking band that serves to diminish their apparent height and increase the importance of the capitals, in keeping with the weight and force of the pediment. Behind the pediment, a barrel vault roofs a loggia where, in the early morning or late afternoon, the Medici and their guests could walk or sit in the shade. A similar barrel vault, much larger, roofs the central hall of the villa, later to be decorated by one of Pontormo's loveliest frescoes (see fig. 595). The cream color of the *intonaco* and the gray of the *pietra serena* are relieved by a splendid glazed terra-cotta frieze, whose white figures against a blue ground unfold legends of the gods, very much alive at the court of Lorenzo. Neither the sculptor of the frieze nor all the subjects have yet

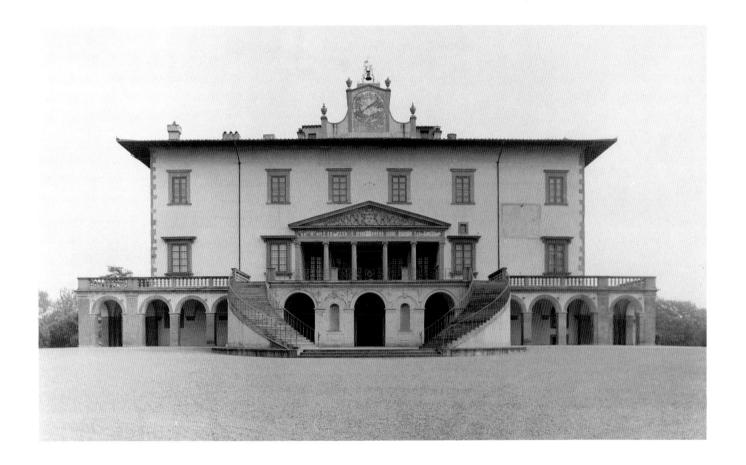

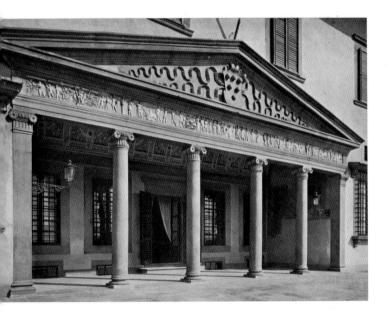

above: 311. GIULIANO DA SANGALLO. Villa Medici, Poggio a Caiano. 1480s

left: 312. Portico of Villa Medici, Poggio a Caiano

been identified. With the delights of Poggio a Caiano in our memories, we can only dream of what a paradise Giuliano would have created in Naples, if its king had built the vast palace Giuliano wished to design for him.

Giuliano's other principal extant structure is the Church of Santa Maria delle Carceri at Prato (fig. 313),

built, like so many of the important churches of the later Quattrocento and early Cinquecento, to enshrine a miraculous image. The plan of Santa Maria delle Carceri (fig. 314) is a Greek cross, like that of Alberti's San Sebastiano in Mantua. It is surmounted by a dome with twelve ribs, twelve oculi, and a lantern (fig. 315), closely following Brunelleschi's domes for the Old Sacristy of San Lorenzo and for the Pazzi Chapel (see fig. 139, colorplate 21). But Giuliano has modeled his forms more richly, in accordance with the taste of the time, and inserted a balustrade between the circle above the pendentives and the base of the dome. The frieze, in blue and white terra-cotta, is rich with lampstands, garlands, and ribbons; and the capitals, probably carved by Giuliano himself, are all figured and all different. The exterior, unfortunately left unfinished, is a masterpiece of marble incrustation in the Albertian tradition, as represented by the famous Urbino panels (see fig. 386). A Doric lower story is surmounted by an Ionic story of two-thirds its height, both with pilasters clustered toward the corners. The proportions of the stories are brought into harmony

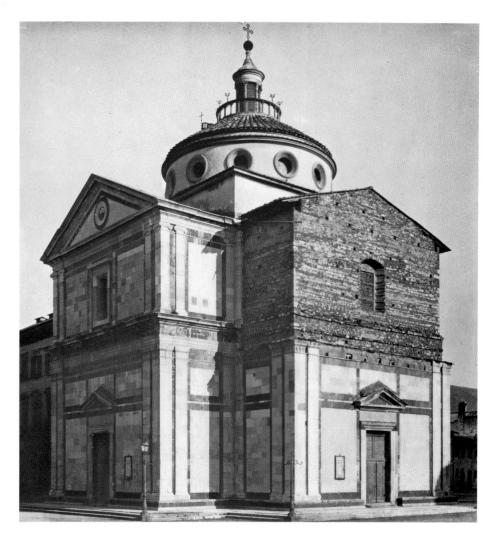

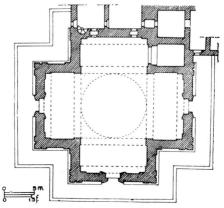

left: 313. GIULIANO DA SANGALLO. Sta. Maria delle Carceri, Prato. 1485–92

above: 314. Plan of Sta. Maria delle Carceri, Prato

below: 315. GIULIANO DA SANGALLO. Dome, Sta. Maria delle Carceri, Prato. 1485–92

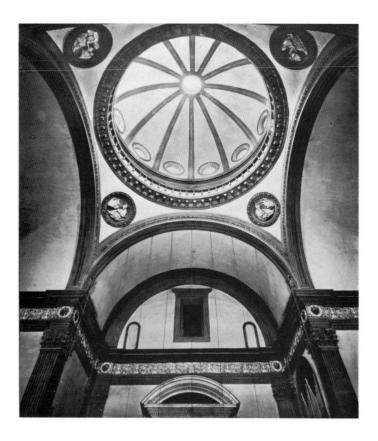

with each other by the device of paneling off the upper third of the lower story with the green marble bands (the same Prato marble used for the green incrustations of buildings in Florence) that surround all the panels.

BENOZZO GOZZOLI

The painter who more than any other seems to typify the luxurious proclivities of the 1450s was Benozzo Gozzoli (1420-97), and his career, like that of many another fashionable decorator, went up and down together with the fortunes of his patrons. Benozzo's long artistic activity commences in the studio of Fra Angelico, whose chief assistant he was in painting the chapel of Nicholas V in the Vatican (see fig. 214). At the close of that commission he worked independently in Umbria, but there was little apparent reason to justify Piero de' Medici's choice of Benozzo in 1459 to paint a continuous fresco around the walls of the chapel in the Palazzo Medici in Florence (colorplate 41). Perhaps there was no one else at that moment in Florence competent to do the job; perhaps Fra Angelico had established Gozzoli's reputation. It was an inspired choice, yet never again was Benozzo able to obtain a commission of such importance, and he wandered from one lesser center to another, ending up in his seventies as a painter of country tabernacles.

The Medici belonged to one of the religious organizations that flourished in the Renaissance, a Company of the Magi, and perhaps for that reason stipulated the Journey of the Magi as the subject of the chapel decorations. Certainly, the bright frescoes of Benozzo had nothing to do with the penitential mood of the St. Antonine-dominated Madonna Adoring Her Child painted by Fra Filippo Lippi for the altar of the little chapel only a few years before (see fig. 221). Perhaps in 1459, after the archbishop's death, the Medici may have felt like children let out of school. The walls of the cramped and constricted chapel are painted away with a continuous panorama covering every wall except for the tiny windows that admitted insufficient light and were later closed by the addition of the new wing when the Riccardi family bought the palace. The theme is the same one that fills the background of Gentile da Fabriano's Strozzi altarpiece (see colorplate 22), but it has been updated. And the landscape is derived from the surroundings of Florence, including castles and villas in Medici possession. There is no proof for the often-repeated assertion that the first Magus is a portrait of Cosimo de' Medici, the second of John Palaeologus (neither is visible in the illustration), and the third of the young Lorenzo, but the last two identifications are not impossible to accept. The second Magus does somewhat resemble the Byzantine emperor whose face was so familiar to the Florentines twenty years before, and the crowned youth is shown against a laurel plant (Lorenzo is Laurentius in Latin, or "laurel-growing"). The man on the white horse leading the cavalcade at the left has been securely identified as Piero the Gouty by Gombrich. At one point Benozzo himself appears, labeled around his hat. The retinue is certainly studded with contemporary personages, a number of whom eye the spectator. The array of ceremonial costumes and horse trappings, studded with gold and blazing with red, blue, and yellow against the green of the foliage and the blue-green of the distance, is further strengthened by the red of the Florentine costume still worn by all but the foreigners. The whole surface is held together by strong verticals, such as the trunks of the topiary trees and lofty cypresses, and by the bold curves of the roads.

Benozzo shows that he is familiar with the repertory of the Florentine masters. He can give us distance, set horses in perspective, draw figures in action. Yet there is something archaistic in his insistence on line. Not so much in the rock shapes—anyone who has gone up the Via di Vincigliata above the Berenson villa will recall similar cliffs and jagged rocks everywhere among the cypresses—but in the equally sharp insistence on every last detail. The figures, for all their vivacity and motion, seem like polychromed wood carvings. This mannered archaism is delightful in the Medici Chapel, because it harmonizes so perfectly with the decorative purpose of the frescoes, but it did not enable Benozzo to compete

316. BENOZZO GOZZOLI. St. Augustine Given to the Grammar Master. 1465. Fresco. Sant'Agostino, San Gimignano

with the great masters of the ensuing years of ferment and change.

Among the best works of Benozzo's later life are the frescoes (1465) that fill the chancel of the Church of Sant'Agostino at San Gimignano (fig. 316). Benozzo's drawing has slipped a bit, and the faces are more wooden than ever, but he does present us with a disarming picture of life in a Florentine subject town, in the loggie, streets, and churches that make up his setting. Gothic windows and battlements compete with the newest inventions of the Renaissance, all neatly drawn and daintily colored, as doll-like people still dressed in the tubular folds of Fra Angelico act out the stories. Perspective is no problem; Alberti had shown the way and his precepts had only to be followed. Figures in the foreground, architectural spaces leading from the middle ground into the distance-Fra Angelico and Ghiberti had also set these up very nicely. Again, the artist had merely to follow. Benozzo's chief charm to us, and probably his chief drawback to the canny Florentines, was an unconquerable naïveté. St. Monica primly pushes her slightly distrustful son into the hands of a too-eager grammar master, whose pupils follow obediently, but the most striking object in the picture, to modern eyes, is the exposed backside of a howling baby at the right, dragged off over his father's shoulder.

ALESSO BALDOVINETTI

A somewhat more scientific combination of archaism and research is to be found in the work of a gifted master, who somehow never quite seemed to fulfill his great initial promise—Alesso Baldovinetti (1425–99). Among all the artists of the Florentine Renaissance, Alesso was the only one to have been brought up in comfortable

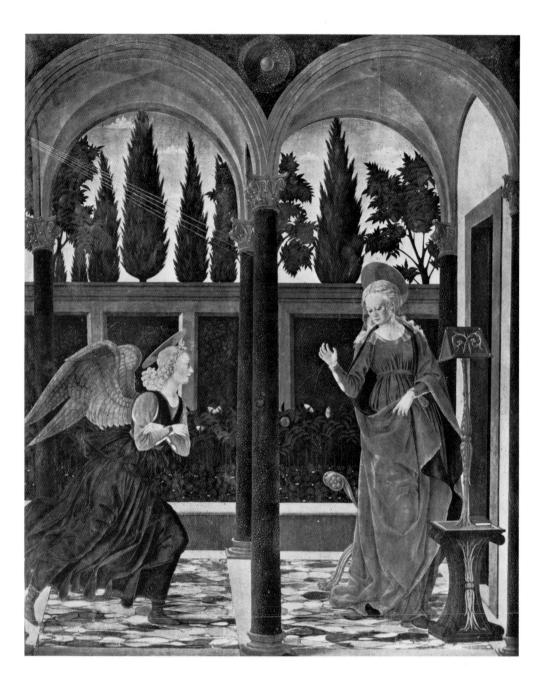

317. ALESSO BALDOVINETTI. Annunciation. Before 1460. Panel, $65^{3/4} \times 54''$. Uffizi Gallery, Florence

patrician surroundings. The Baldovinetti were among the oldest families in Florence; the name proclaims their Gothic origin (Baldovino = Baudouin = Baldwin), and their house-tower still stands in Florence, visible from the Ponte Vecchio. Alesso was, for a while, apprenticed to Domenico Veneziano as a successor to Piero della Francesca in the lost frescoes of Sant'Egidio, and he completed the series on his own many years later for the cost of the materials alone. He soon came under the influence of the terrible Andrea del Castagno, and in his journal records having painted a Hell scene "with many infernal furies" more or less from Castagno's dictation, when the latter was ill at Santa Maria Nuova. But the natural gentleness of Alesso's personality had little in common with Castagno the mountaineer, from whom he seems to have absorbed chiefly a devotion to line and pattern. It is a different kind of pattern, though, filled

with Domenico Veneziano's light and spun out to delightfully improbable conclusions. Whimsical, witty, dry, charming, and unsentimental, eventually conservative to such an extent that he seems to have cut himself off from the mainstream of Florentine ideas, Baldovinetti was nonetheless capable of creating images of enduring beauty, elevation, and refinement. In the 1460s he was the best painter in Florence.

Just before 1460 he painted the Annunciation (fig. 317), formerly in the little Church of San Giorgio alla Costa in Florence, and now in the Uffizi. It is one of the loveliest creations of the Quattrocento. Mary receives Gabriel in the little loggia whose colonnettes recall those of Domenico Veneziano in the St. Lucy altarpiece, completed about a dozen years before (see colorplate 32). Beyond a low parapet one looks into Mary's closed garden, above whose wall peer fruit trees (perhaps the cedro, the huge Italian lemon) and cypresses. According to the Book of Wisdom, Mary is a cedar of Lebanon (also cedro in Italian) and a cypress on Mount Zion. Mary and Gabriel, with their tiny heads and long, slender bodies, represent the utmost in patrician hauteur and refinement of bearing. Gabriel, his blond tresses as elegantly curled as those of any page in Gozzoli's frescoes, trips in to bear the news to Mary. In a pose derived from Donatello's Annunciation (see fig. 245), she turns from her reading (at a tall reading desk of great elegance), draws her cloak about her, and lifts her right hand in a gesture of combined wonder and docility.

The color is as refined as the content and the form, and as unexpected, especially in the dull red of the arches. The rose and powder blue of Mary's tunic and mantle are reversed in the garments of the angel. Brighter tones, including pinks and yellows, are picked up in the flowers and in the haphazard pattern of the marble scraps that compose the pavement of the little terrace. Capitals, ornament, and haloes are painted—not real—gold, to show Alesso's command of the new rendering of light. But all in all, although the colors are highly saturated, the effect is soft, as if they were being viewed through Polaroid glasses.

The same grace and wit are visible in Baldovinetti's *Madonna and Child* in the Louvre (colorplate 42), a work

of about 1460. It should be set against the earthiness of Fra Filippo's nearly contemporary Madonna and Child in the Uffizi (see fig. 217), on the one hand, and the remoteness of the Montefeltro portraits by Piero della Francesca, which this picture undoubtedly influenced, on the other (see colorplates 38, 39). The Virgin is seated precariously on a backless chair behind a parapet, above an endless vista of the Arno Valley—a winding tributary stream, farms, roads, a bridge, cypresses, and the hills diminishing in precise order into the western light, under a sky in which a few sunny summer clouds seem to hang. Mary folds her hands in pious adoration of the Child on the parapet, who appeals to her to finish swaddling his soft little body. Baldovinetti records the subtlest gradations of tone (learned from Domenico Veneziano) that pass over the mask of his shy little princess—hardly sixteen years old, one would imagine. One can dwell on the ordered flow of blond locks under the point d'esprit of Mary's veil, escaping in a neatly geometrized ponytail down her back or enjoy the shadow of her head on the golden disk of her halo.

The delicacies of Alesso's Arno Valley landscape should be kept in mind as we examine his major work, a mural at the Santissima Annunziata (fig. 318) that occupied him off and on from 1460 to 1462. This very length of time should indicate that he did not follow the tradi-

318. ALESSO BALDOVINETTI.

Nativity. 1460–62.

Fresco. Atrium,

SS. Annunziata, Florence

above: 319. Alesso Baldovinetti. Annunciation. 1466–67.Fresco and panel. Chapel of the Cardinal of Portugal,S. Miniato, Florence

right: 320. Head of the Virgin, detail of fig. 319

tional piecemeal method, by means of which Andrea del Castagno, let us say, could have knocked out a fresco this size in a month. That method was all right for Castagno, who cared little about diffused light or about the total visual unity that was a dominant obsession of Albertian doctrine and of the painters who followed it. Baldovinetti seems to have concluded that it was impossible to obtain such unity, and more especially the extreme subtleties of his light gradations, by traditional means. He therefore did only portions of the picture, generally the landscape or the underpaint, in true fresco, waited until the plaster had thoroughly dried, and then proceeded to paint a secco as if he were working on an altarpiece. Such a procedure would have been dangerous, of course, even in an interior, but the Nativity was in the atrium of the church, exposed to winter fogs and sometimes rains. In time the a secco faces, hands, and drapery of the principal figures have peeled off, showing flat surfaces in which Alesso's underdrawing is visible. Even so, the painting is beautiful in the airy openness of its setting, with the small figures, the lofty ruin and shed, the trees, the angels hanging in the blue air, and the view over the plain of Prato to the foothills of the Apennines.

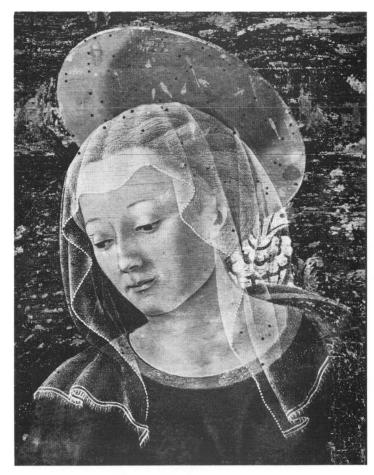

The details are wonderfully accurate, and the space is filled with the light of a clear winter's day in this beautiful valley. In the tradition of Fra Angelico, Baldovinetti has simplified every house and tower to its cubic essentials, but has given us a continuous expanse of plain unprecedented before his time.

Baldovinetti was the perfect choice when, in 1466, the executors of the Cardinal of Portugal wanted a painter to decorate the walls, lunettes, and spandrels of the Chapel of the Cardinal of Portugal in San Miniato. The tomb by Antonio Rossellino (see fig. 300) had been completed that very year. The best-preserved of Baldovinetti's paintings there is the Annunciation (fig. 319), designed to go over the empty throne symbolic of the cardinal, facing the Rossellino tomb. Again Baldovinetti had to experiment, possibly because of pressure to finish the paintings rapidly. While the background, with the cypresses on Mount Zion and cedars of Lebanon, is painted in fresco, the wall and bench were done on unprimed oak panel, doubtless in the artist's studio in the winter months of 1466–67. Here and there the color has peeled away to show the grain.

Baldovinetti must have been as impressed as everyone else in Florence by the purity, beauty, and youth of the cardinal so untimely dead, and more so by the presence of Antonio Rossellino's masterpiece across the chapel. A new solemnity enters Baldovinetti's work. The model for the Virgin (fig. 320) is the same as the bewitching girl who posed for the Louvre Madonna and Child (see colorplate 42), but she accepts her new role seriously, lifting her right hand as she places her left on her body, within which she seems to feel conception taking place. The angel kneels before her, dressed, like the cardinal on his tomb, in the dalmatic of a deacon; a circle of coral beads crowns his head, a ruby carved into the shape of a strawberry rests on his brow, peacock eyes flash from his wings. The new severity of the background converts the veined marble and porphyry paneling of the San Giorgio Annunciation (see fig. 317) into something more befitting its sepulchral purpose. All is symbolic; there are seven panels above, like the seven Gifts of the Holy Spirit or the seven Joys and seven Sorrows of the Virgin (these and many more were listed in a special paragraph on the mystical significance of the number seven by St. Antonine of Florence). The twelve panels of the bench must refer to the Twelve Apostles, and the carved golden lily that in the Rossellino tomb symbolizes the cardinal's purity enters the composition to become the lily of Mary's virginity. The choice of the Annunciation, a strange subject for a tomb chapel, is entirely appropriate to the symbolism of the pictorial decoration of the chapel, built around the theme of the closed gate of Ezekiel, connected with the Annunciation by long tradition (see page 67) and in the same image by Donatello (see fig. 245) and by Piero della Francesca (see fig. 285).

Among Baldovinetti's other paintings the most easily

accessible to us is certainly a brilliant female profile portrait in the National Gallery in London (fig. 321), surely the ultimate in patrician Florentine Quattrocento elegance. This cool, blond lady, whose slender features can still be seen in the Florentine aristocracy today, is posed in the conventional profile view that persists until almost the end of the century. Baldovinetti has maintained the crisp lines of her profile and the dainty, clean flow of her ponytail as they shine against the blue-gray of the background, which can be read either as the sky or as an abstract blue ground. It is typical of his quiet humor that he never tells us.

Neither did Baldovinetti really know how to extricate himself from his intellectual and aesthetic impasse. The torch passed to others, and while geniuses of a high order were transforming the very idea and purpose of art in the last decades of the century, Baldovinetti, like Gozzoli, worked in the past.

321. ALESSO BALDOVINETTI. *Portrait of a Young Woman*. c. 1465. Panel, 25×16". National Gallery, London

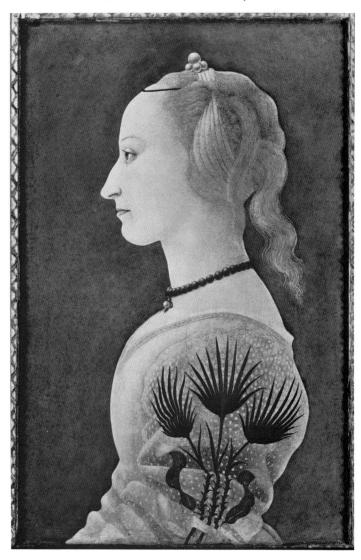

13 Science, Poetry, and Prose

t the beginning of the final third of the Quattrocento, few of the founders of Renaissance art were still alive. Piero della Francesca was painting in Urbino and Borgo San Sepolcro, Alberti designing for Florence and Mantua. Luca della Robbia was old and his style had deteriorated. Uccello was not working at all. The new generation of painters and painter-sculptors was encouraged by what appears, in view of the universal economic decline, as spendthrift patronage on the part of the great Florentine families, providing an enormous demand for their art. The period was dominated by five giants, Antonio del Pollaiuolo, Andrea del Verrocchio, Sandro Botticelli, Filippino Lippi, and Domenico del Ghirlandaio. Toward the middle of the period, new courses were to be laid out for art by the universal genius Leonardo da Vinci and by two visitors to Florence, Luca Signorelli and Pietro Perugino, but none of the three were in Florence for very long at this time, and for one reason or another their activity, like that of the Florentine Piero di Cosimo, belongs to other chapters.

Despite their relative freedom, our five great artists were to a certain extent limited by the discoveries of their predecessors. The methods of depiction of space, form, and light were now known, and there seemed little point in merely repeating them. But many new fields still remained for exploration, and the five leading masters set out to investigate them, in three different directions. Doubtless each direction appealed to a somewhat different sector of Florentine society. None of the three can be labeled conservative. All were basically new, and all were destined to have a strong influence on the course of history.

The first of these later Quattrocento tendencies begins with the premise that all of nature is one: that there is no essential difference between man and other animals; that plant, animal, and human physiology are as worthy of study as the principles of form, space, and light; and that motion, growth, decay, and dissolution are more truly characteristic of our world than are mathematical relationships or, indeed, any other apparently enduring verity. The greatest exponent of this vitalistic, animistic,

dynamic, scientific trend (these are epithets, not names) is Pollaiuolo, but similar concerns motivated Verrocchio as well, if to a less marked degree. It is interesting that these two masters, to whom form is a by-product of motion, are not just the only two painter-sculptors of the period, but the most original sculptors. Pollaiuolo seems to have appealed especially to the ultimate elite, the circle of Lorenzo de' Medici.

The second current is concerned less with the outer world, from which, indeed, it seeks to withdraw, than with the life of the spirit. In its search for expressive values this lyrical, poetic, romantic current (again these are mere characterizations) often ignores tangible reality in favor of abstract values of line and tone, and deals with subjects that can gratify emotional yearnings. The unchallenged leader in this movement is Botticelli, but Filippino Lippi at times keeps pace with him and at times goes beyond him into the realms of the unreal. This second current seems to have pleased less the Medici themselves than their hangers-on, especially the Neoplatonic philosophers.

The third trend emphasizes the here and now, in terms of which scriptural narratives and the legends of saints are retold. The foregrounds are filled with contemporary Florentines, the backgrounds show how Florence looked or how its inhabitants thought it should look. Prose, not poetry, is the aim of the artist—exact and descriptive, but also well balanced, measured, composed, and intelligible. Underneath an exterior of admirable craftsmanship, this naturalistic current (again, not a title) deals subtly with psychological values. Ghirlandaio remained the master of the prose style, and his shop was the most heavily patronized in Florence, for he appealed to the well-to-do citizen without intellectual pretenses, the successful merchant and banker.

ANTONIO DEL POLLAIUOLO

When scriptural themes are treated by Antonio del Pollaiuolo (1431/32–98), they take on a fierce air that has little to do with any religious purpose. He excels in subjects of action, especially mythologies, in which his pes-

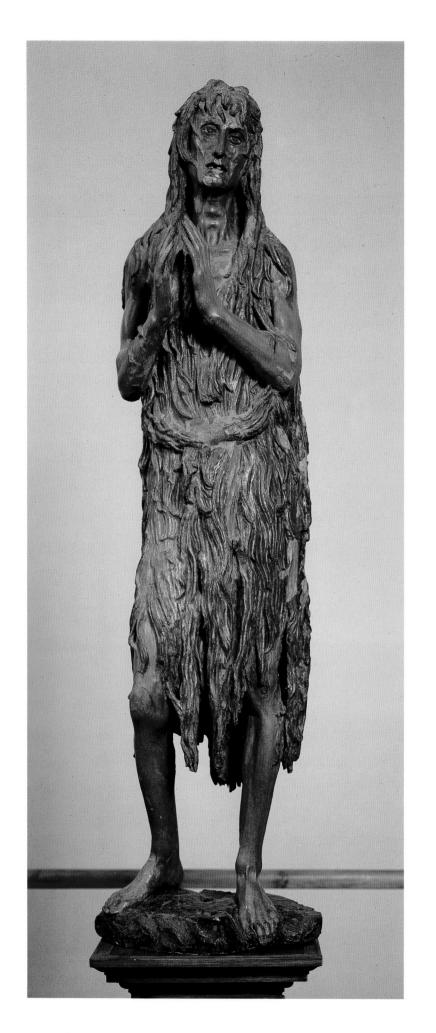

Colorplate 40. DONATELLO. Mary Magdalen. 1454–55. Wood with polychromy and gold, height 74". Baptistery, Florence

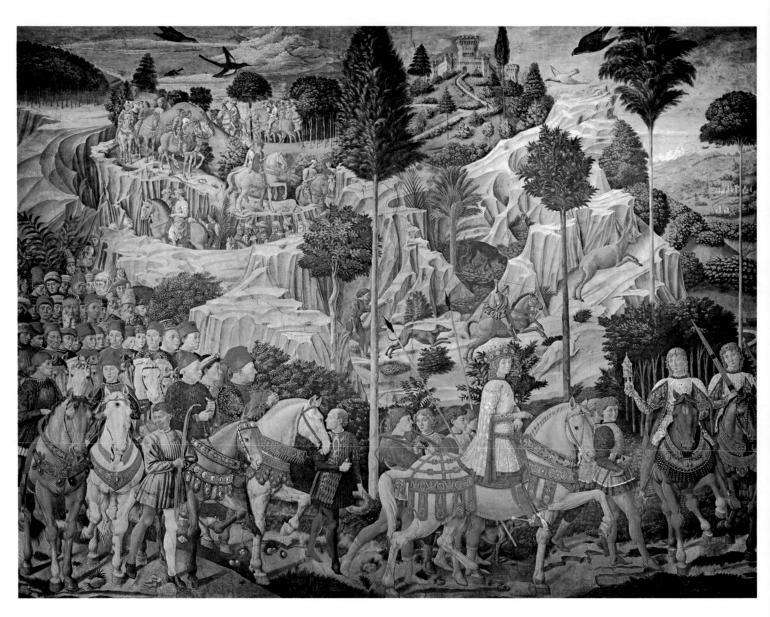

Colorplate 41. BENOZZO GOZZOLI. *Procession of the Magi.* 1459. Fresco. Chapel, Palazzo Medici-Riccardi, Florence

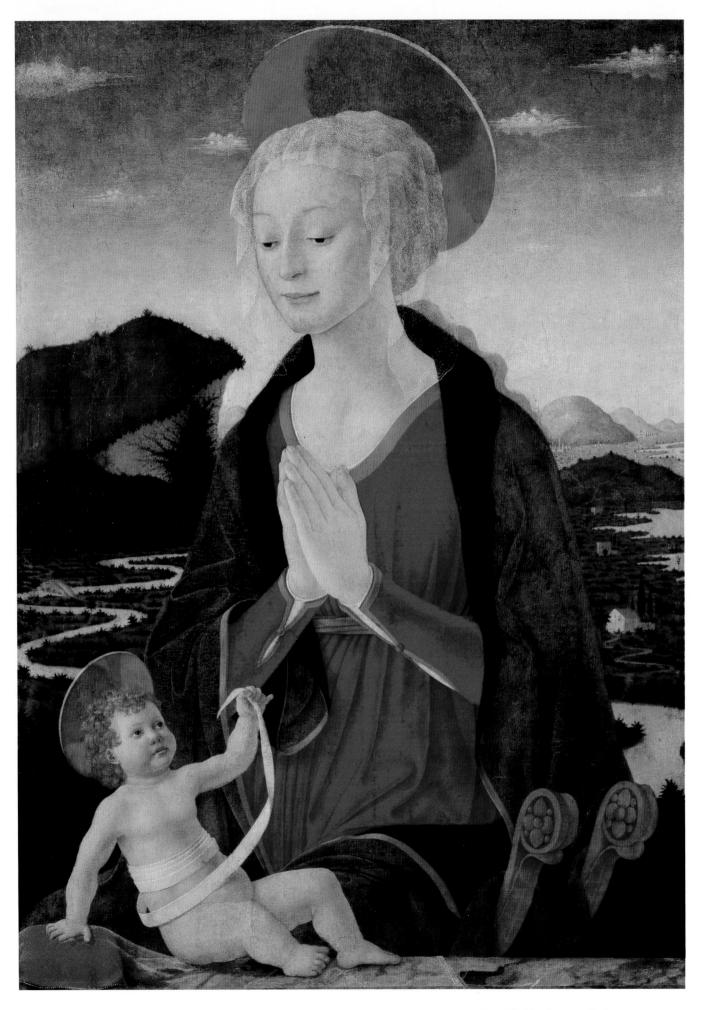

Colorplate 42. Alesso Baldovinetti. Madonna and Child. c. 1460. Canvas, $41 \times 30''$. The Louvre, Paris

Colorplate 43. Antonio del Pollaiuolo. St. Sebastian. Finished 1475. Panel, $9'7'' \times 6'8''$. National Gallery, London

Colorplate 44. SANDRO BOTTICELLI. Adoration of the Magi. Probably early 1470s. Panel, $43\%\times52\%''$. Uffizi Gallery, Florence

Colorplate 45. Sandro Botticelli. Primavera. c. 1482 (?). Panel, 6'8" × 10'4". Uffizi Gallery, Florence

Colorplate 46. SANDRO BOTTICELLI. Birth of Venus. After 1482. Canvas, 5'9" × 9'2". Uffizi Gallery, Florence

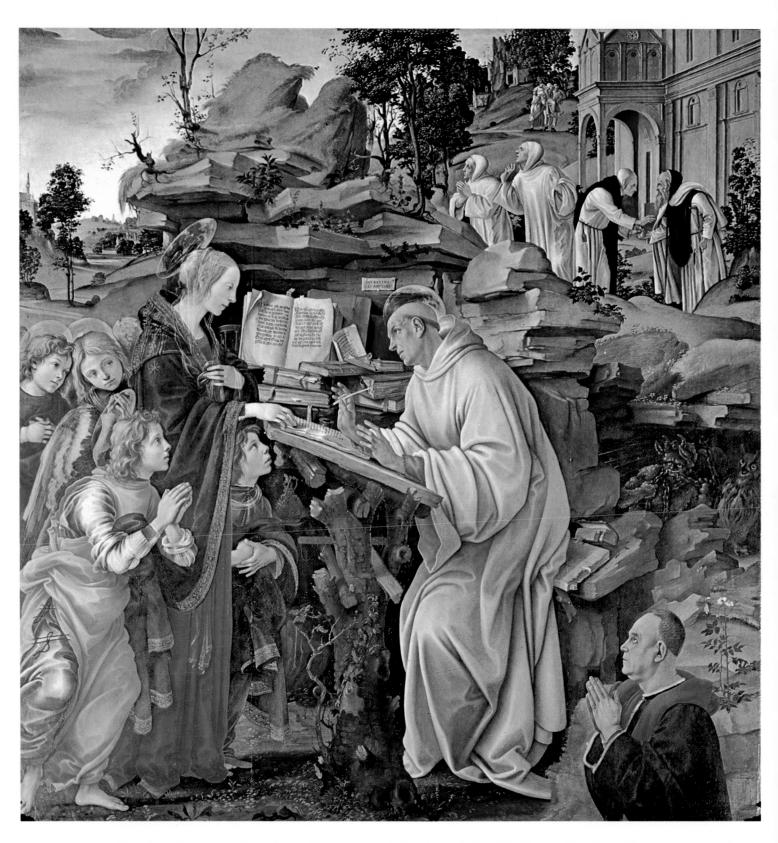

Colorplate 47. FILIPPINO LIPPI. Vision of St. Bernard. c. 1485–90. Panel, 82×77". Church of the Badia, Florence

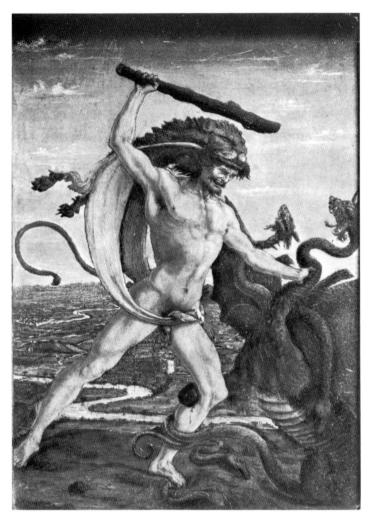

322. ANTONIO DEL POLLAIUOLO. *Hercules and the Hydra*. c. 1460. Panel, 6¾ × 4¾". Uffizi Gallery, Florence

simistic naturalism can be allowed free rein. His name means poultry-keeper; Antonio's father seems to have exercised this humble profession. Piero, Antonio's older brother and assistant, was a painter—a dull one, judging from his one signed work. Antonio began as a goldsmith and maker of embroideries with gold and silver thread. One would expect to find him a master of linear precision, and so he is, but his fascination with the human figure in motion is a surprise. No artist in any medium since Hellenistic times had treated this theme with anything approaching his ability. Castagno (who greatly influenced Pollaiuolo) had tried, in his *David* shield (see fig. 273), but how stiff this attempt seems compared with Pollaiuolo's violent figures!

About 1460 Antonio painted for the Medici Palace three large pictures, on canvas rather than panel, representing the Labors of Hercules. Hercules was a favorite Florentine hero, appearing on the seal of the Republic in the late Dugento and turning up in monumental art as early as the reliefs by Andrea Pisano on the Campanile of the Duomo. The originals are lost, but Antonio executed small replicas of two of them, *Hercules and the Hydra*

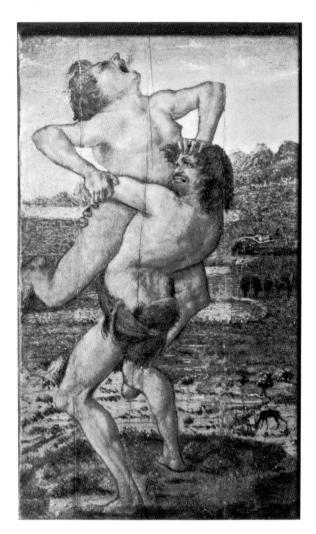

323. ANTONIO DEL POLLAIUOLO. *Hercules and Antaeus*. c. 1460. Panel, 6¹/₄ × 3³/₄". Uffizi Gallery, Florence

(fig. 322) and *Hercules and Antaeus* (fig. 323). These pictures disappeared in 1944 when German soldiers were moving the contents of a deposit of pictures from a Florentine villa, where they had been put for safekeeping during the war. Not until twenty years later did the tiny paintings come to light, under dramatic circumstances, in San Francisco. They are now back in the Uffizi, little the worse for their adventure.

As did Piero della Francesca in the Montefeltro portraits (see colorplates 38, 39), Antonio silhouettes his people against distant earth and sky. But Piero shows man in serene control of nature; in Antonio's art man erupts from nature and is pitted against it in mortal combat. Compositionally, the necks and tail of the manyheaded hydra are the dark counterparts of the winding Arno. Hercules is no less feral than the lion whose skin he wears, no less cruel than Antaeus, whose strength derives from his mother, the Earth. It would have been possible to represent Hercules as a glorious hero, superior to the forces of evil that he vanquishes. Antonio draws no such distinction. In rendering the human figure, he exploits not the nobility of its forms or the play of light

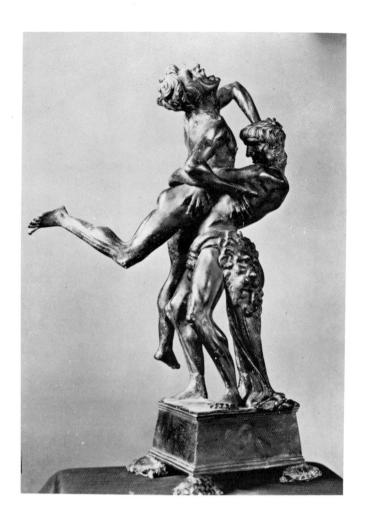

upon its surfaces, but the strain imposed on muscles and even bones by its activity. The body is pushed to the limits of its capability. He must not only have studied the behavior of bodies in motion, but also perhaps went so far as to dissect corpses, as Michelangelo and Leonardo were later to do, in order to ascertain how the muscles, tendons, and bones were related in the complex structure of the human body. As Baldovinetti did, Pollaiuolo lets our eyes wander over the rich tapestry of the earth in the backgrounds: the Arno Valley in Hercules and the Hydra, with a microscopic Florence at the extreme left. and the seacoast in Hercules and Antaeus, with a little city at the right and the Apuan Alps above.

Probably during the 1470s, Antonio repeated the Antaeus composition in a little bronze group (fig. 324) that broke all the rules of sculpture. The contours of medieval and Renaissance statues and groups had been limited by the ideal contours of the mass, even when the bronze medium theoretically allowed a free rein. Pollaiuolo's revolution—and indeed, that of Verrocchio as well—consists in the liberty won by the figures to move in any direction necessitated by their actions. To be sure, Antonio Rossellino had led the way, in the dynamism expressed by the soaring angels and floating Madonna tondo above the tomb of the cardinal of Portugal. But that composition was still determined by an a priori form imposed upon the moving figures and groups. Pollaiuolo's figures are not posed in a configuration; their actions, rather, determine the composition, whose con-

above: 324. ANTONIO DEL POLLAIUOLO. Hercules and Antaeus. Probably 1470s. Bronze, height 18" (including base). Bargello, Florence

right: 325. ANTONIO DEL POLLAIUOLO. Battle of the Ten Nudes. 1465. Engraving, $15\frac{1}{8} \times 23\frac{1}{4}$ ". The Metropolitan Museum of Art, New York (Joseph Pulitzer Bequest, 1917)

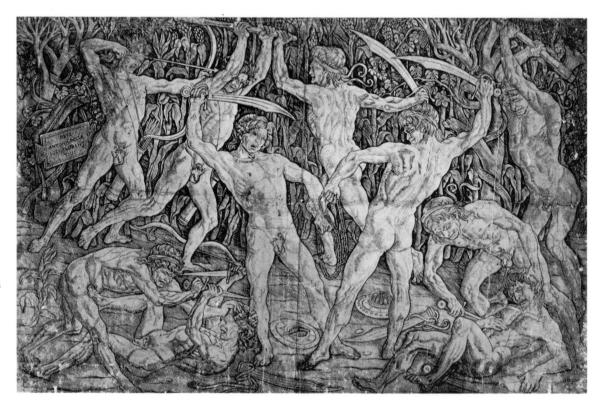

tours are those of flying legs and arms, clutching toes, noses, open mouths, even unruly curls. For the first time, surrounding space itself is electrified with the energies developed within a sculptural group.

In his famous engraving, the Battle of the Ten Nudes (fig. 325), Pollaiuolo's control of anatomy seems somewhat less secure, but possibly this impression is due in part to the inadequacy of his shading, still in an early stage of development compared with the refinements shortly to be introduced by the German engravers, especially Martin Schongauer and Albrecht Dürer. The contours of Antonio's figures are superior to the hatching, and responsive to every motion of the muscles they describe. The subject has eluded identification by scholars; perhaps it is merely Antonio's idea of a Roman gladiatorial combat, since the two central figures—one is substantially the other with his back turned—grasp a heavy chain. The theme appears to be that of death, which none but a bowman can escape. At the lower left a nude is about to dispatch a prostrate foe, but his intended victim plants a foot in his groin and aims a dagger at his eyes. Two swordsmen in the foreground are equally matched and will presumbably dispose of each other, as will the figures just behind them, armed with sword and ax. At the right a man withdraws his sword from the side of his dying enemy, unaware that he is about to be slaughtered by the uplifted ax of a man behind him, who in turn does not notice the arrow aimed at his head by the archer at the upper left. The composition of intertwined figures in two superimposed registers to indicate depth may have been suggested by ancient Roman sarcophagi, especially those dealing with the story of Hercules, which Antonio must have studied as he worked on his painting of that very legend. But he has set these figures against a background of dense vegetation, which consists of coarse corn, olive trees, and grape vines; these provided the food and drink of gladiators. As much as the actions, the expressions of pain or cruelty on the faces of Antonio's figures convey the horror of a scene that has its only medieval counterpart in the torments of Hell displayed in representations of the Last Judgment (see fig. 116).

Equally unrestrained is the dance of nude figures painted by Antonio—presumably in the 1470s—on a wall in the Villa La Gallina, near San Miniato, above Florence (fig. 326). Their present appearance is deceptively like the red figures of Greek vase painting, since the painted surface has completely fallen away and all we can now see is the underdrawing. Originally, they must have been carefully modeled. One figure, at the extreme left, moves in a pose frequently to be met with in ancient sculpture, but the other poses seem derived from direct observation. They are so uninhibited, in fact, that one surmises that Antonio may have had models dancing about his studio, as Rodin was later to do. The subject of the Dance of the Nudes is no more easily accessible than that of the Battle of the Ten Nudes. Perhaps Antonio set himself the theme of corporate play in the one and mass

326. Antonio del Pollaiuolo. *Dance of the Nudes* (portion). Presumably 1470s. Fresco underdrawing. Villa La Gallina, Florence

327. Antonio del Pollaiuolo. Apollo and Daphne. Undated. Panel, 115/8 × 77/8". National Gallery, London

murder in the other, as opposed but equally unthinking activities of the human animal.

Christian subjects seem to have interested him little, and he generally turned over such commissions in whole or in part to his brother. But the order for a monumental altarpiece on the subject of the Martyrdom of St. Sebastian for the chapel of the Pucci family at the Santissima Annunziata, where it would be seen in competition with three great frescoes by Andrea del Castagno (one now lost; for the two extant, see colorplate 35, fig. 274), could not be resisted. The painting, finished in 1475 and now in the National Gallery in London (colorplate 43), is Antonio's most ambitious extant work, and a milestone in Renaissance art. For the first time an entire large-scale composition is produced by the method we have just seen demonstrated—the actions of the figures rather than their mere disposition. The pyramid is hardly a new idea in pictorial composition, but Antonio's pyramid is the product of the figures and their movements: St. Sebastian tied to his tree and the six archers who fill him

with arrows. The minute the last arrow is discharged and the bowmen leave, the pyramid will dissolve. The painting, object of great admiration even in Vasari's time after all that Leonardo and Michelangelo had achieved in the intervening period, was clearly a showcase for the demonstration of Antonio's prowess. Not the eye-rolling face of the saint—he left that to Piero—but the six archers, three longbowmen and three crossbowmen. Two of the latter are winding away at their machines, in positions of strain that display everything Antonio knew about muscular tension.

In reality there are only three poses among six men. Antonio has turned each figure around for his counterpart on the other side of the tree, as if he had reversed a clay model instead of the common practice of reversing the cartoon. Sculptor that he was, he may have done exactly that, although the flesh is so convincing that it looks as if he had living men pose for him in the final stages. Antonio's three-dimensional archers are the more impressive since those in the foreground are nearly life-sized. Michelangelo must have been impressed by this painting, because he not only used the pose of the nude crossbowman for one of the famous nude youths on the Sistine Ceiling, but also remembered it as late as the Last Judgment for an angel hauling two souls into Heaven. Moreover, Antonio's incisive contour, a new kind of analytic line describing shapes with such delicacy that we can feel them revolve in depth, leads directly to Michelangelo.

The Arno Valley landscape that fills the background gave Antonio an opportunity to exercise his superb skill in the rendering of nature. But he must have done this to please himself, because at the height of eight feet above the altar in the Santissima Annunziata this landscape was well-nigh invisible. Even in the National Gallery today most of the delicacy of observation is lost. At the upper left appears a triumphal arch, adorned with rapidly drawn battle reliefs, and looking more like a ruined Renaissance façade than like anything in Rome. In the distance, enveloped in nature, should lie Rome—which Antonio had not yet visited. He merely substituted Florence, with an occasional hint of a Roman theater, dome, or obelisk. The shapes of the surrounding hills are taken from those near Florence, and so is the point of view. In order to study this landscape Antonio must have stood on Monte Albano near Carmignano, above Poggio a Caiano, where Giuliano da Sangallo was shortly to begin the construction of the Medici villa. From this spot the city becomes a speck in the luminous, blue-green valley. From the remotest hills on the horizon, half dissolved in light and haze, the landscape moves toward us, upredictable and mysterious as life itself. Antonio was interested not in the abstract shapes Baldovinetti found in nature, but only in the spontaneity of growth and the movement of atmosphere over hills and farms and among the single or grouped trees. The Arno sweeps into view, moving

too rapidly to offer reflections in the manner of Piero della Francesca's still waters. Then the water hits a dam and a shoal, and the surface breaks into rapids. We know that Antonio used oil as a medium in his altarpiece for the chapel of the cardinal of Portugal in San Miniato; perhaps he used it here as well, or at least oil glazes, to convey the soft effects of light, distant haze, soft foliage, and rushing water. Below the mound and before the stream, horses prance and rear as their armored riders await the return of the executioners. The pyramid produced by human cruelty will shortly vanish, less permanent even than the ruin of man's triumph, leaving the tormented saint to hang, alone in the midst of the forces of nature.

Antonio's unprecedented ability to render the transitory effects of nature is displayed at closer range in some smaller works, of which the most brilliant is the tiny Apollo and Daphne in the National Gallery in London (fig. 327). Before the characteristic curves of the Arno, touched in with an almost Impressionist softness of brushwork, the god, a long-haired adolescent in a short brocade tunic, rushes across the meadow in the evening light, in hot pursuit of the maiden. He is on the point of embracing his prize, whose leg brushes tantalizingly across his naked thigh, yet in the moment of victory he finds only defeat. Daphne's left leg has already taken root, her arms have become branches, and she looks down smilingly, for in another minute she will have become a laurel tree. Perhaps this picture was intended as an allegory of the invincibility of Lorenzo de' Medici's government, for the laurel was his plant and also that of his second cousin and neighbor, Lorenzo di Pierfrancesco de' Medici (see page 330). Two branches might even refer to both. But to Antonio the subject may just as well have provided still another example of the insignificance of man and the eventual triumph of nature.

One of the finest Florentine portraits of the Renaissance is Antonio's head of an unknown young woman (fig. 328), in the Museo Poldi Pezzoli in Milan. This is one of the last profile portraits, for the type was soon to give way to the three-quarter or full-face view, which tells the observer far more about the subject. Antonio nonetheless still delighted in the profile, whose rigidity yields to vibrant life in his hands. His analytic line responds to every nuance of shape in the face of—to judge from this portrait—a refined, self-contained, and shrewd young woman. We can follow the line with delight as it models her delicate features almost without the aid of variations of light.

By the last decade of the Quattrocento, Antonio's influence in Florence and elsewhere was enormous. In 1489 Lorenzo de' Medici described him as the leading master of the city: "Perhaps, by the opinion of every intelligent person, there was never a better one." Oddly enough, for an artist of his nature and interests, Anto-

328. Antonio del Pollaiuolo. Portrait of a Young Woman. 1460s. Panel, 181/8 × 133/8". Museo Poldi Pezzoli, Milan

nio's final commissions were papal tombs, first that of Sixtus IV and then that of his successor Innocent VIII. The all-bronze tomb of Sixtus IV (figs. 329, 330) occupied the artist and his shop nine years, from the pope's death in 1484 until 1493. Seen from above (fig. 329), the work has been described as a giant book cover. The recumbent pope, wearing tiara and pontifical vestments, is surrounded by reliefs representing the seven Virtues (four cardinal, three theological). Below these, in the concave compartments of the inclined flanks of the tomb, separated by acanthus consoles, are ten Liberal Arts. It is noteworthy that Perspective has entered this august company (fig. 331); she is provided with a book in which one can read a quotation paraphrased from the medieval philosopher Peckham, and, in her left hand, an oak branch (the pope came from the Della Rovere family, whose name means "oak") and an astrolabe. The inclusion of this astrolabe shows, apparently, that in the Renaissance navigation and exploration were considered part of perspective, the definition of space.

left and below: 329, 330. Antonio del Pollaiuolo. Tomb of Pope Sixtus IV. 1484–93. Bronze, length 14'7". Vatican Grottoes, Rome

above: 331. Perspective, detail of fig. 330

The portrait of Sixtus is as harshly honest as any of the Florentine marble busts, dwelling with fascination on the hawklike features and sagging flesh. Superficially, the crumpled drapery masses of the papal vestments and the innumerable folds of the tunics and mantles worn by the allegorical figures suggest the latest style of Donatello. In actuality, they are the sculptural counterpart of the drapery shown in the paintings of Antonio and Piero del Pollaiuolo.

ANDREA DEL VERROCCHIO

After the ease and vivacity of Antonio del Pollaiuolo's art, the clumsier and more solemn work of Andrea del Verrocchio (1435-88) may at first sight appear unattractive. Andrea's nickname (verrocchio means "true eye") refers not to his exceptional powers of vision but to the fact that he was as a youth the protégé of an ecclesiastic called Verrocchio. His most notable work of painting is the Baptism of Christ (fig. 332)— an altarpiece made

for the monastic Church of San Salvi just east of Florence, but now preserved in the Uffizi-which suffers a partial eclipse due to the fact that about 1470 or so, in the course of the execution of the altarpiece, Verrocchio's young pupil Leonardo da Vinci was allowed to paint some spectacularly beautiful passages in the picture. Forgetting Leonardo for a moment, Andrea's painting in itself is simple and grand, in the rude tradition of his earlier namesake, Andrea del Castagno. The two kneeling angels, Christ, and St. John the Baptist are aligned across the foreground, but so loosely as to afford wide views into a distant landscape. Between the palm tree of eternal life on one side, its fronds studied in perspective, Uccello-style, and the pine-crowned bluff on the other side, the figures are spread out like anatomical charts. Bony masses, the insertion of muscles and tendons, the play of light over torsos, limbs, and hands are analyzed with all the care of Pollaiuolo but none of his verve. The picture is impressive in its directness. The Baptist looks

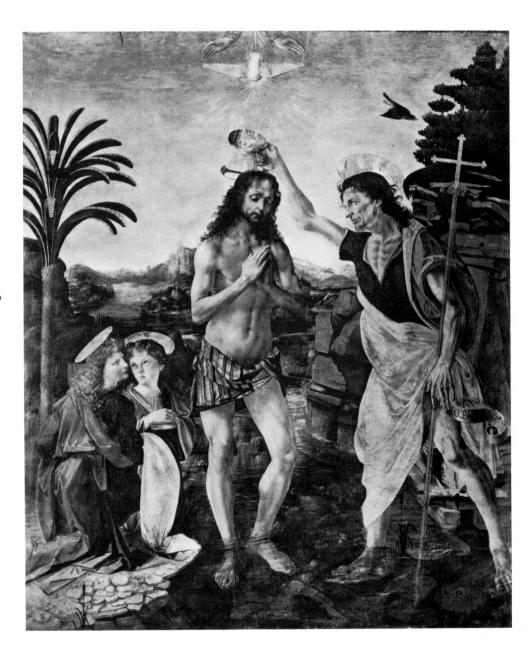

332. Andrea del Verrocchio and LEONARDO DA VINCI. Baptism of Christ. c. 1470. Panel, $69\frac{1}{2} \times 59\frac{1}{2}$ ". Uffizi Gallery, Florence

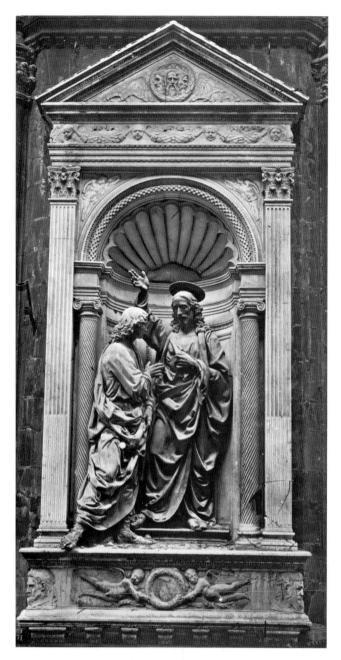

333. Andrea del Verrocchio. *Doubting of Thomas*. 1465–83. Bronze, life-sized. Orsanmichele, Florence. (Marble niche by Donatello and Michelozzo)

at Christ with total devotion, and in the cavernous eyes and pale features of Christ it is not amiss to read foreknowledge of the Passion.

The *Baptism* is closely related to a vastly more important work, a sculptural group on which Verrocchio lavished all his skill in drawing and composition, all his knowledge of anatomy, and all his depth of feeling—the *Doubting of Thomas* at Orsanmichele in Florence (fig. 333). The marble niche had been commissioned in 1423 by the Parte Guelfa, then the dominant force in Florentine political and economic life, to occupy the center of the principal façade of Orsanmichele, and executed by Donatello and Michelozzo to enclose the former's magnificent gilded bronze statue of St. Louis of Toulouse. In

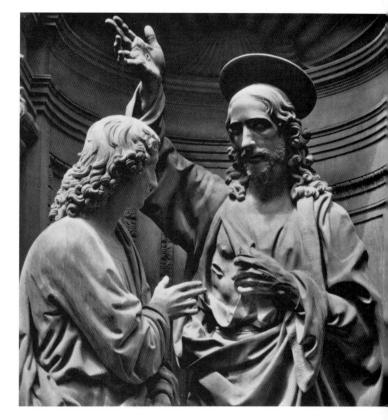

334. Christ and St. Thomas, detail of fig. 333

1460 the niche was sold, for unknown reasons, to the magistrates of the Mercanzia, or merchant's guild, and Donatello's statue was moved to Santa Croce. The subject of the new group, probably ordered from Verrocchio in 1465, may have been chosen because of the magistrates' own insistence that in all their deliberations they required, as St. Thomas did, tangible evidence.

There was room for two statues in Donatello's niche, but not according to the principles of composition prevailing in the later Quattrocento. Verrocchio clearly wanted to bring out the full intensity of the moment in which St. Thomas, gazing down at the wound exhibited by his risen Lord, draws back, not daring to touch it with his hands as he had asked to do. The composition overflows the limits of the niche, and St. Thomas stands on the marble ledge below. Thus the figures had to be reduced almost to high relief. It was discovered, in fact, when the group was removed from the niche for protection in World War II, that the two statues have no backs, but are hollow shells of bronze.

Drama is centered less in the individuals (both faces are quiet, even reserved) than in the pregnant space between them—the wound revealed by one hand, approached by another (fig. 334)—or even the space above them, for Donatello's shell niche assumes a new meaning, that of eternal life promised by the Resurrection. Nowhere does drapery build up the figures in the manner of the Early Renaissance. Rather, in its countless tiny pockets, it shatters the forms into shimmering facets of

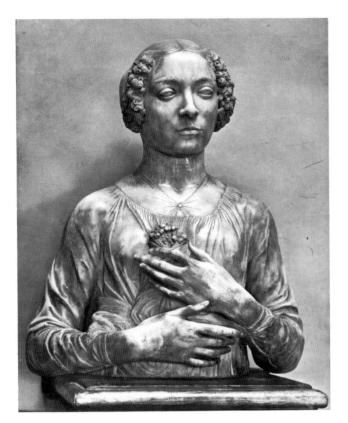

335. ANDREA DEL VERROCCHIO. Bust of a Young Woman. 1480s. Marble, height 24". Bargello, Florence

light and dark, the sculptural counterpart of Pollaiuolo's free brushwork, within which only the general rhythm of the figures is felt, but not their mass. Donatello's device of using cloth soaked in hardened slip, emulated by Verrocchio (according to the sources) with the substitution of plaster for clay, is employed for different ends. The restless activity of the drapery, like the quivering of the fingers and the rippling descent of the curls, carries a new kind of feverish emotion. The Christ is the same we have seen in the Baptism, with the same haunting expression. On the border of his mantle are written his words, "Thou hast believed, Thomas, because thou hast seen me; blessed are they who have not seen and yet have believed." The work is so great and its content so deep that the question of the participation of the young Leonardo arises almost automatically. Perhaps this is because Verrocchio has been persistently underrated. When the group was placed in its niche in 1483, the diarist Landucci described the head of Christ as "the most beautiful head of the Savior that has yet been made."

Verrocchio's honesty radiates from the Bust of a Young Woman in the Bargello (fig. 335), often identified, but without proof, as Lucrezia Donati, mistress of Lorenzo de' Medici. We note at once how sharply the style of fashionable appearance has changed since the days of Filippo Lippi and Piero della Francesca, along with artistic taste. Gone are the plucked, domelike forehead, the penciled eyebrows, and the taut hair whose tresses were

artfully intermingled with veils and pearls. The subject's hair is parted in the middle to reveal a natural brow, drawn to the sides, and allowed to escape in clustered curls. The eyebrows are left broad and full, as objects of visual, almost tactile enjoyment; the costume is an unadorned tunic, and there is not a pearl to be seen. With her large and graceful hands the lady holds to her breast a small bouquet of flowers enveloped in a portion of her garment. This is the new naturalism of the advanced 1480s. Verrocchio has carried it out in every detail of the work, bringing to the marble the fullness and richness of actual flesh, both with and without the covering of the translucent garment.

336. Andrea del Verrocchio. David. Probably early 1470s. Bronze, height 495/8". Bargello, Florence

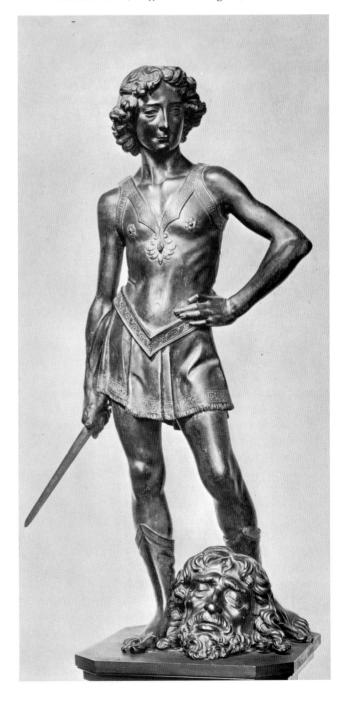

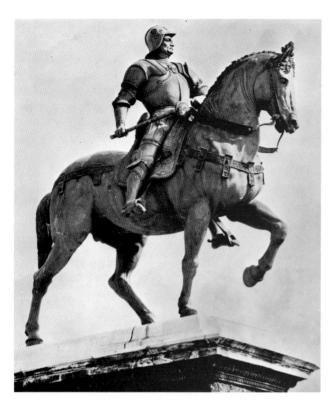

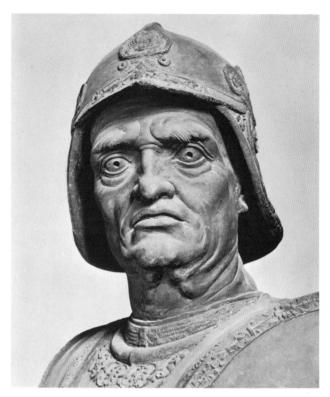

above right: 339. Head of Colleoni, detail of fig. 337

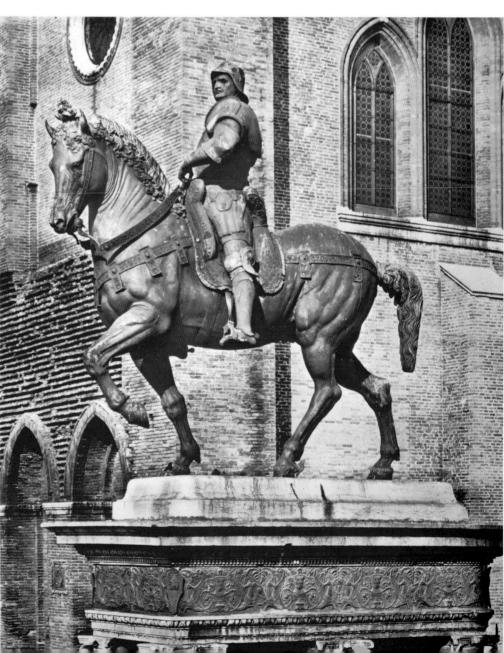

When commissioned by Lorenzo de' Medici to do a bronze David, probably in the early 1470s, the practicalminded Verrocchio clothed the angular boyish figure in leather jerkin and skirt (fig. 336), in contrast to the nudity of Donatello's earlier masterpiece (see fig. 247), and armed him with a dagger suitable to his stature rather than with the enormous sword grasped by Donatello's David. The expression of Verrocchio's David is far from triumphant—pensive rather, withdrawn, and gentle in the moment of victory. But the beauty of this figure eludes photography and can be appreciated only as the observer moves around it, watching the smooth surfaces flow together to reflect light from the bronze, supported by the most delicate of underlying linear structures.

Verrocchio's final work is also his grandest. The condottiere Bartolommeo Colleoni from Bergamo (d. 1475) left to the Venetian Republic a considerable sum of money, providing that an equestrian monument to him in bronze be set up in the Piazza di San Marco, nerve center of Venetian life. The authorities hedged, and destined the statue for a less important square, in front of the Scuola di San Marco, and thus, in a sense, conforming to the letter of Colleoni's stipulation. When and how Verrocchio came into the picture is still far from clear, but in 1483 a wandering monk recorded seeing on exhibition in Venice three colossal horses by three competing masters. Verrocchio died before he could cast his completed clay model in bronze. This work was eventually done by a Venetian bronze founder, Alessandro Leopardi, who also designed the base on which the monument was finally set in 1496 (figs. 337, 338). Leopardi deprived many details, particularly the ornament and the mane and tail, of the vitality that Andrea would have given them if he had been able to do the chasing himself. But the total effect of the statue as one comes upon it, crossing the little bridge into the Campo San Zanipolo, is stupendous.

In keeping with the new interests of his period and the stylistic current to which he belonged, Verrocchio has abandoned Donatello's static concept of the equestrian monument (see fig. 249). This is now the actual general, helmeted and armed with a mace, riding his charger into battle. In every mass and every silhouette the group commands surrounding space. The horse's left foreleg steps freely, without the constricting effect of Donatello's cannonball; the horse's veins and muscles swell, his head is turned, his muzzle drawn in. The rider stands erect in the stirrups, his torso twisted against the movement of the horse's head, his dilated eyes staring, his jaw clenched (fig. 339). Never was concern with the moment of drama more powerfully expressed in sculpture than in Verrocchio's last work.

SANDRO BOTTICELLI

The unquestioned leader of our second, or poetic, current in later Quattrocento Florentine art is Sandro Botti-

celli (1445–1510). Moreover, in any twentieth-century list of the greatest painters Italy ever produced, Botticelli demands a position. Yet he could never emulate the monumentality and humanity of Giotto, Masaccio, and Michelangelo, the spatial harmony of Piero and Raphael, the endless inventiveness of Leonardo, the natural beauty of Giovanni Bellini, the free colorism of Titian and Veronese. Lorenzo de' Medici, who patronized Botticelli little and Pollaiuolo much, preferred the latter. Then what accounts for Botticelli's present standing, which has endured for at least a century and seems unlikely to diminish? The answer is complex, but no more so than Botticelli himself. Partly, he seems to be beloved because in his art he withdrew from the world around him, and withdrawal is natural to humanity under circumstances of stress—at times even necessary. Partly, it is because Botticelli, more than any other master in Italian art more even than Cimabue, his greatest predecessor in that vein—knew what line could accomplish, and wove linear compositions with such subtlety and brilliance that the developed polyphonic music of the sixteenth century comes to mind as a parallel. Partly—and this is seldom admitted—it is because in his later works, with their barren, unmodeled architectural backgrounds, he achieved a sense of fatality so forbidding as to become oppressive. But the hardness so nakedly evident in Botticelli's last style underlies the drawing and organization of all his pictures, whatever the apparent languors of the figures he paints. It would be a great error to consider Botticelli ever weak or to allow the veil of sentimentality drawn over his personality in the Victorian era to mask in any degree the rigor of his style.

A number of Romantic misconceptions cloud our understanding of Botticelli, beginning with his name. Walter Pater, prince of Victorian aesthetes, used to repeat the word "Botticelli" to himself over and over, deriving from its cadences a hypnotic enchantment. But the unromantic fact is that Alessandro di Mariano Filipepi had an older brother, Giovanni, who was a successful broker and who was nicknamed "il Botticello" ("the keg"). Sandro appears to have been cared for by this brother, and it was therefore natural to call him "del Botticello," which in time became Botticelli. Next we might consider the proverbial flatness of Botticelli's style, out of which critics have made so much. To Fra Luca Pacioli, assistant and follower of Piero della Francesca, Botticelli was one of the greatest masters of perspective! Botticelli's perspective, and indeed his form, are special, and run counter to the tradition of Alberti and Piero della Francesca, but both elements are prominent nonetheless, and significant for the understanding of his art. Finally, to dispel the illusion of Botticelli's gentleness, we might glance at some of the events in his Sistine Chapel frescoes, especially Moses killing the Egyptian taskmaster (see fig. 342) or the fate of Korah, Dathan, and Abiram (see fig. 344).

Botticelli could scarcely have had more comprehensive training. He got his start as an assistant to Fra Filippo Lippi (they became so close that the wayward monk entrusted Botticelli with the guidance of his twelve-years-younger son Filippino). The shadow of Masaccio's mantle, therefore, descends on Botticelli; certainly he knew the tradition, and from the very man who had watched Masaccio paint. Later, Botticelli was active in the shop of Verrocchio, along with the younger Leonardo da Vinci, and his knowledge of the scientific tendency was completed by association with the Pollaiuolo brothers, with whom he collaborated on one project. His own style, therefore, despite all echoes of Fra Filippo and Verrocchio, takes on the character of a personal revolt against the weight of Florentine intellectual doctrine. This style, antiatmospheric, antioptical, antiscientific almost from the start, is strongly colored by his own neurotic personality, and to this two apparently trivial events give us some insight. One is his dispute with a neighbor—not with the Vespucci, the grand Florentine family one of whose sons, the explorer Amerigo, gave our continent its name, but with the weaver who owned the house on the other side and disturbed Botticelli with the noise of his looms to such a degree that the artist threatened him with violence and was haled into court. The other event, not documented, relates how Botticelli woke from a dream that he was married and walked the streets of Florence for the rest of the night in terror that the dream might return.

Botticelli's Adoration of the Magi now in the Uffizi (colorplate 44) was painted for an eccentric Florentine merchant, Guasparre del Lama, probably in the early 1470s, and was placed on an altar just inside the façade of Santa Maria Novella. The subject is one of the most common in the later Quattrocento, and Botticelli painted it seven times in the course of his career. As has been shown in connection with Benozzo Gozzoli's frescoes (see page 299), the Medici belonged to a Company of the Magi. Traditionally, the Medici are supposed to have been represented as the Magi in this panel, although only the aged Cosimo, who had died in 1464, several years before the picture can have been painted, is perhaps identifiable—as the first and oldest Magus kneeling before the Christ Child. The first Magus holds the Christ Child's feet, and to cover them he utilizes a veil that goes over his shoulders; this is similar to the humeral veil of ancient origin worn by the priest at the more recent ceremony of the Benediction of the Sacrament; the priest covers his hands with this veil when holding by its foot the monstrance containing the Eucharist, the body of Christ, for the adoration of the faithful. The Adoration of the Magi was the first occasion when the body of Christ was shown to the Gentiles. At the feast of Corpus Christi, the Sacrament was carried in solemn procession from Santa Maria Novella, past the very altar on which Botticelli's painting was to be placed, to the Duomo, Santa Maria del Fiore. Botticelli's picture is thus, apparently, a perpetuation of this annual event in which the Medici took part, and to its religious significance a certain political ingredient must be added.

A further detail connects Botticelli's paintings of the Adoration of the Magi with the Passion. In most of these works by Botticelli and others, there are conspicuous remains of a vast structure with arches and columns, presumably a temple, within which the stable that shelters the Holy Family appears as a rapidly erected shed. Christ said to the Jews (John 2:19-22): "Destroy this temple and in three days I will raise it up.'... But he spoke of the temple of his body. When, therefore, he was risen again from the dead, his disciples remembered that he had said this." Usually, the ruins are justified by critics as examples of the interest of Botticelli and others in classical antiquity, but this does not tell us why grandiose ancient ruins turn up in humble Bethlehem, why they first appear in Adorations of the Magi and not in other subjects and only after Botticelli's painting for Santa Maria Novella. The simple shed is indeed a structure that could be built in three days, and the Corpus Domini procession explains its use as a contrast between the Old Law, ruined at Christ's coming, and the New, a contrast often met with in Quattrocento painting. These jagged stones, built into the shape of a corner, separated from the line of arches at the left and supporting the shed of the New Law, recall another passage from the Gospels (Matthew 21:42-44; Luke 20:17-18), when in the Temple Christ quoted Psalm 117 (118 in Protestant Bibles): "The stone which the builders rejected, the same is become the head of the corner," and continued, "Whosoever shall fall upon this stone shall be bruised: and on whomsoever it shall fall, it will grind him to powder." The "stone which the builders rejected" became one of the most familiar allusions to the Resurrection in Christian literature and art. So in this very corner new vegetation grows from the cracks in the stones, and the peacock, bird of eternal life, perches upon one of them. Recent cleaning has also revealed a broad landscape at the right, with a distant bridge, towers, and mountain formerly concealed by the frame. These elements, too, may have symbolic meaning

Botticelli's first major exploration of the unreal was accomplished with the benefit of the devices invented by the Renaissance to conquer the real. The ghostly arches move in flawless perspective; the massive corner at the right is projected with hallucinatory three-dimensionality. Yet the two perspectives are never permitted to connect into one Albertian visual cone. Unlike that of Piero, Botticelli's perspective space is fragmentary, dreamlike, and even when it seems real, its very reality is only the surreality that torments us in dreams.

The Star of Bethlehem hovers over the Virgin and Child, who are enthroned upon a rock that hints at Calvary. A gentle Joseph stands behind and slightly above

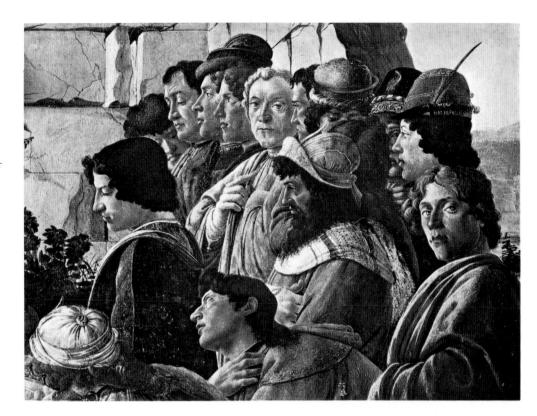

right: 340. SANDRO BOTTICELLI. Group of figures, detail of Adoration of the Magi (see colorplate 44). Probably early 1470s. Panel. Uffizi Gallery, Florence

below: 341. SANDRO BOTTICELLI. Self-portrait. detail of Adoration of the Magi (see colorplate 44)

them. Below the first Magus the two other Magi kneel in intense conversation—apparently Giovanni (d. 1463) and Piero the Gouty (d. 1469), Cosimo's sons. The youth at the extreme left, embraced by a friend as he listens to the words of a somewhat older mentor who points to the sacred figures, may be Lorenzo. At the right (fig. 340), a bouquet of faces turns and twists in delicate formal and spatial interchanges, until reaching a dark-haired youth gazing downward, who strongly resembles in profile the portraits of Giuliano, Lorenzo's brother. The folds of the cloaks worn by all the figures move in linear variations toward the central group. From some of the faces—delicately illuminated and foreshortened from above, below, behind—radiates a surprising fervor, from others a haunting languor, as they contemplate the miracle. All, down to the most distant, are projected with equal sharpness by means of sculptural contours and incisive light, yet none of the heads seems truly round.

The cool young man in the gold-colored cloak at the extreme right (fig. 341), gazing directly at the spectator in the characteristic manner of a self-portrait, has generally been accepted as one. The heavy-lidded eyes, the commonplace nose, the slightly pouting mouth with open lips, and the heavy chin are pervaded by an expression blending keen intelligence and deliberate withdrawal. It is not hard to believe that the sensitive and melancholy Botticelli looked like this at about twentyseven.

Botticelli's first monumental fresco commission, oddly enough, was to depict the rebels of the Pazzi conspir-

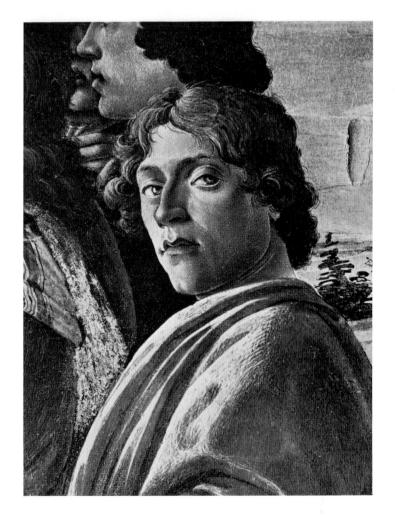

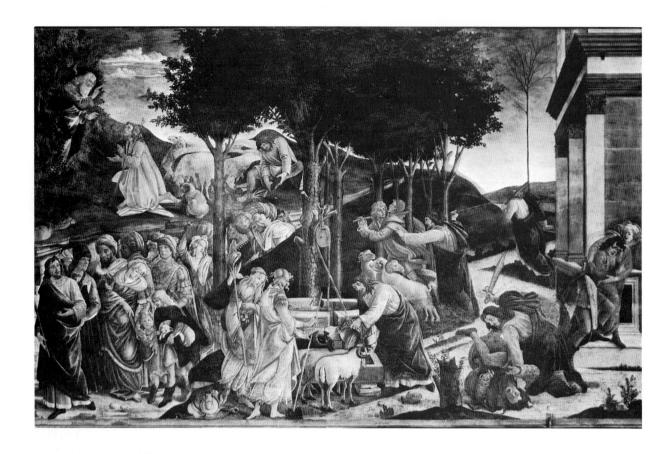

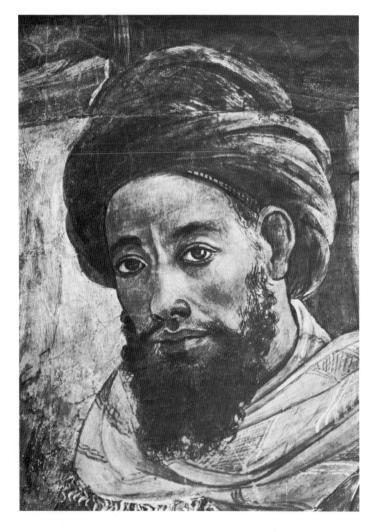

above: 342. SANDRO BOTTICELLI. Youth of Moses. 1481–82. Fresco. Sistine Chapel, Vatican, Rome

left: 343. Head of an Israelite, detail of fig. 342

acy of 1478, hanged and writhing, on the walls of the Customs House in Via de' Gondi. These frescoes were destroyed after the expulsion of the Medici in 1494, but possibly their success (certainly not their subject, as Pope Sixtus IV was implicated in the conspiracy) suggested that Botticelli be called to Rome in 1481, together with his fellow Florentines Cosimo Rosselli and Domenico del Ghirlandaio and the Umbrian Perugino, to decorate the chapel newly constructed by Pope Sixtus and known today as the Sistine Chapel. (Sixtus is Sisto in Italian, and the chapel was soon called Cappella Sistina, whence the English word "Sistine.") Resembling an assembly hall more than a religious building, the Sistine Chapel was intended to accommodate not only the Masses and other services of the papal palace, but also the conclaves of cardinals, which it still does. Today only the unusual tourist can detach himself from the frescoes painted on the ceiling by Michelangelo between 1508 and 1512 (see figs. 514-526, 528, 529, colorplates 72, 73) in order to contemplate the comparatively fragile Quattrocento paintings for whose display the broad, unbroken wall surfaces below the windows were built (see fig. 512). Studies have shown that the scenes from the Life of Moses on the left wall, and from that of Christ on

the right, were chosen to represent crucial episodes in the history of spiritual leadership in the Old Testament and the New, prefiguring and justifying the traditional claims of the papacy to universality. Vasari believed that Botticelli was placed in charge of the entire decorative program, and a recent attempt has been made to place Perugino in this role.

If anyone exercised a commanding position, it must have been the pope. Moreover, some credit ought to be given to the common sense and good taste of all the artists, none of whom were likely to wish their paintings in so spectacular a place to appear out of harmony with the others. In the Chapel of the Cardinal of Portugal, for example, every visitor is struck by the decorative beauty of the ensemble, yet the architect had died before the project got under way, the sculptors and painters represented conflicting tendencies, the paintings—all of them—were an afterthought, and no one artist stayed on the job from beginning to end. In the case of the Sistine Chapel, it is safe to suppose that the pope and his advisers determined the subjects and the narrative method, giving the artists general guidelines as to unity and leaving them to work out in conference the obvious consistency of scale, horizon line, palette, and the like. On closer examination it becomes evident that none of the original four artists—or Pintoricchio or Signorelli, both of whom were later brought into the project—were willing to sacrifice their artistic identity. Sharp discrepancies of feeling and quality, and even of compositional principles, are to be found throughout the series. And none of the major masters went home with a trace of any of the others recognizable in his style.

In each of the surviving frescoes of the original Quattrocento cycle (two were torn down to make way for Michelangelo's Last Judgment in the Cinquecento and two were repainted completely), the foreground is almost filled with figures that narrate the principal incidents and are scaled at roughly two-fifths the total height of the scene. One-fifth above their heads is placed the vanishing point for the landscape—which ought to govern the recession of the foreground architecture as well, but does not always do so. This leaves two-fifths, onefifth, two-fifths as the horizontal division of the scenes, crossed by a vertical division into thirds, which is always respected but never insistent, save in the three scenes by Botticelli. With typical Florentine rigor, he treats each scene as a triptych, grouping the foreground figures and vertical masses such as architecture and trees into a central block flanked by two supporting wings.

The Youth of Moses (fig. 342) shows at the right Moses killing the Egyptian taskmaster. In the center Moses drives away the Midianites who were molesting Jethro's daughters and then, lower down, draws water at a well for two of them. At the left, bearing a rod, he leads the Israelites out of Egypt. In the background Moses is represented three more times, first fleeing the scene of the

slaying, then removing his sandals, then kneeling before the Burning Bush in which God appears to him. In general, the frescoes, which had to be painted rapidly to satisfy the pope, are executed more coarsely than Botticelli's panels. Yet this one abounds in beautifully conceived figures and groups, from the scene of terror at the right, to the delicate idyll in the center (in which the long-haired daughters of Jethro anticipate the Three Graces in the *Primavera*; see colorplate 45), to the gentle group at the left, with its vivid contemporary likenesses. One wonders who was the turbaned Israelite (fig. 343) whose curly beard and luminous eyes Botticelli has represented with such sensitivity.

In the Punishment of Korah, Dathan, and Abiram (fig. 344), the story is narrated from left to right, and fused with other incidents concerning Moses. At the left the earth opens up to swallow the seditious Korah, Dathan, and Abiram (only two figures are shown—the first may already have vanished into Hell) and flames arise to consume them. In the center six figures offering the false fire to the Lord from censers at an altar (a compromise between the two sons of Aaron and the two hundred and fifty Israelites, all punished in the same way but in two different narratives-Leviticus 10:1-2 and Numbers 16:2-35) are consumed by fire from Heaven. On the right Moses seeks refuge from the seditious Israelites who tried to stone him. The accurate representation of the Arch of Constantine, which dominates the central episode, is supplied with a new inscription from St. Paul (Hebrews 5:4): "Neither doth any man take the honor to himself, but he that is called by God, as Aaron was." Read together with the altar and the punishment, the arch prefigures the mission of the Roman Church, especially as Aaron wears a papal tiara. The usual brilliant display of linear patterns and sharply lighted forms appears throughout Botticelli's densely packed groups. Moses is older here (fig. 345), with long white hair and beard, and his countenance, of a mystic intensity, leads to the more celebrated Moses of Michelangelo (see fig. 531). The two clusters of rays issuing from Moses' forehead have a curious history. When Moses came down from Mount Sinai the second time, rays of light shone from his face. In translating the Bible into Latin, St. Jerome balked at attributing light to anyone who antedated Christ. The Hebrew word could also be rendered "horns," throughout Christian art Moses is represented with horns. In St. Paul's Epistle, however, the word "rays" was allowed to stand. Botticelli's Moses is a compromise two horns made up of rays! It can hardly be a coincidence that each cluster contains ten rays, the number of the Commandments.

More formal and classical than the Uffizi version (see colorplate 44), the Adoration of the Magi in Washington, D.C. (fig. 346), may reflect Botticelli's stay in Rome. The free figural arrangements of the earlier picture have given way to a circle seen in depth, in the manner of Fra

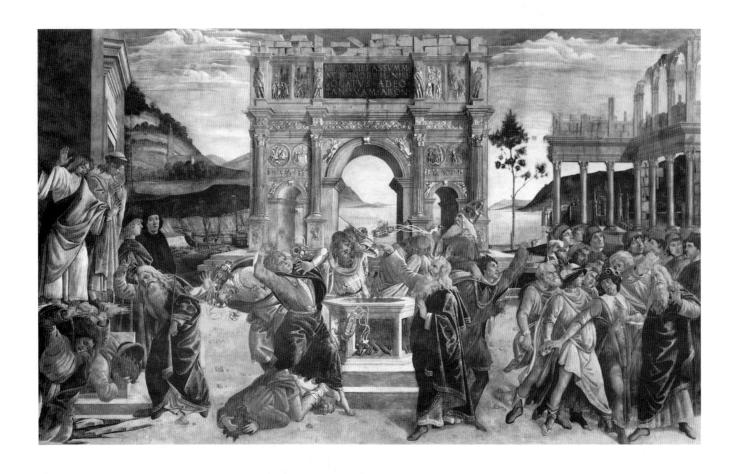

above: 344. SANDRO BOTTICELLI. Punishment of Korah, Dathan, and Abiram. 1481-82. Fresco. Sistine Chapel, Vatican, Rome

left: 345. Head of Moses, detail of fig. 344

Angelico's San Marco altarpiece (see fig. 207), broken only in the center foreground so as to give the spectator a clear view of the Virgin and Child. The haunted arches and shattered corner wall of the Uffizi picture here suggest an imposing Roman monument. The shed roof, less hastily built, was planned to substitute with fresh, firm lines the angle formed by the piece of entablature about to topple at the left. Its great beams recall the open timber ceilings of the Early Christian basilicas Botticelli saw in Rome, particularly Old St. Peter's.

Botticelli has chosen the point of view of a hypothetical spectator standing at the center and well within the picture, on a line with the two Magi nearest the Madonna. All the other worshipers, therefore, and we along with them, are excluded from the scene by the entire width of the grassy lawn, which we instinctively attempt to traverse in order to make the architectural perspective come right. We are caught up, therefore, involuntarily in the yearning of the worshipers toward the sacred figures. As will shortly be seen, Botticelli must have been aware of the beliefs and teachings of the Platonic Academy formed within the court of Lorenzo de' Medici. One of these doctrines was the principle of *desío* (desire, longing, yearning), by which the soul, in its earthly exile, could traverse mystically the gulf separating it from its true home in God. It is such *desío*, nascent in the Uffizi picture, that in the Washington version assumes the power of a natural force, activating every figure in the composition, and us along with them.

None of the faces can be identified as portraits, and, owing to the smaller scale of the Washington painting, none could be presented in such detail as in the Uffizi picture; yet even in these cameo faces Botticelli has achieved subtle psychological effects. Considering the difficulty of dating most of Botticelli's works, it is hypothetical whether the picture was conceived before or after the unfinished *Adoration of the Magi* by Leonardo da Vinci (see fig. 455). In any event, the two paintings cannot be separated by more than months, and almost certainly the two Verrocchio pupils knew each other's compositions. They may even have quarreled about them, as we know they did over perspective and land-scape. The little background scene at the upper right, in which the grooms are having some difficulty restraining

their unruly horses, is common to both pictures, although more tempestuous in the work by Leonardo—who, in his writings, tells us that Botticelli claimed it was possible to paint a landscape by throwing a sponge filled with paint at the panel and turning the smears into landscape forms. Leonardo added that Botticelli painted bad landscapes. From Leonardo's scientific—or quasi-scientific—point of view, they were bad landscapes, of course, but they are still beautiful, and this is one of the finest. In their broad contours they enhance the movement of the figures, as in their blue-greens they provide a foil for the brilliant reds, clear blues, and strong yellows of the costumes. And in their soft shapes and great spaces they echo sympathetically the desío that runs through the group of worshipers.

Like Pollaiuolo, Botticelli was called upon to paint the mythological subjects fashionable at the court of Lorenzo and in the elegant villa society of the Florentine patriciate. Throughout the series the graceful, sculptural figures, nude or nobly draped, stand, recline, or move always in the foreground, filling the frame, from top to bottom, with the gravity and dignity of those Botticelli had seen in profusion in classical marble reliefs in Rome. In the last fifty years, Botticelli's mythologies have been

346. SANDRO BOTTICELLI. *Adoration of the Magi*. Probably 1482–83. Panel, 27%×41". National Gallery of Art, Washington, D.C. (Mellon Collection)

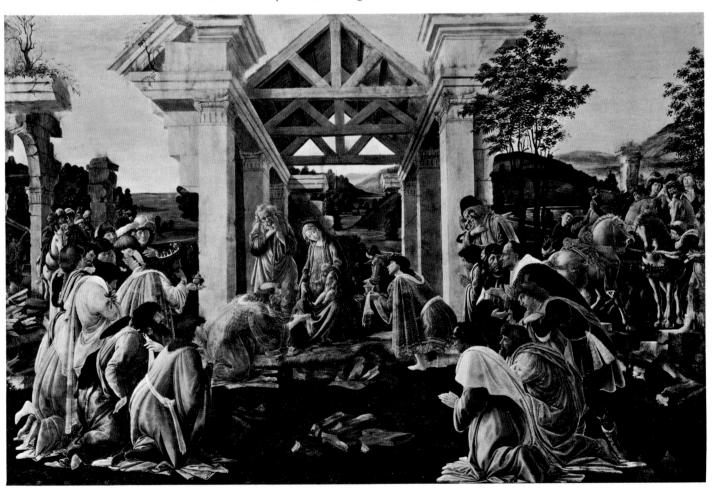

explained through the writings of the Florentine Neoplatonists, notably Marsilio Ficino. The interpretations are complicated by the kaleidoscopic nature of the Neoplatonic writings, which often demonstrate how a host of different meanings can be derived by a humanist from the same classical legends. Some persuasive elements have been here selected from still-controversial interpretations, and new elements added; someday, perhaps, a "lucky find," as Gombrich puts it, may show us just what these tantalizing images were really intended to mean.

Let us start with Pallas and the Centaur, in the Uffizi (fig. 347), probably painted shortly after 1482. The goddess, almost life-sized, advances with infinite grace toward a cringing centaur whom she grasps by the hair. According to Gombrich, Ficino taught that Minerva, goddess of reason, appealed to the head (she herself had sprung from the head of Jove), that is, to the intellect, the highest of human faculties. The animal part of the centaur could easily symbolize the darker side of human nature, which must be tamed by divine wisdom. Lorenzo the Magnificent himself wrote that the divine daughter

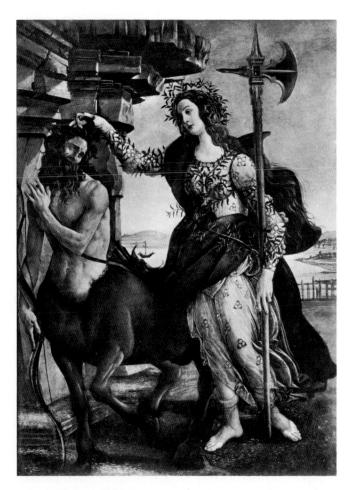

347. SANDRO BOTTICELLI. Pallas and the Centaur. After 1482. Canvas, 811/2 × 581/4". Uffizi Gallery, Florence

of the Thunderer "places her hand upon lower powers." Without discounting the lofty moral allegory claimed for the picture, its political allusions, equally lofty to the Renaissance mind, cannot be put aside. Minerva is often known to the Neoplatonists by her Greek name of Pallas. The Medici arms consisted of six golden balls (palle in Italian), and the Medici supporters were known as palleschi. In the kind of pun that delighted the Renaissance, Pallas (pallade in Italian) was an obvious Olympian patron for the wise Medici government, especially welcome since she was well armed. Pallas' diaphanous tunic is profusely ornamented by the Medici symbol of three interlocked rings, and her arms, head, and breasts are entwined with Lorenzo's own laurel branches. Jagged rocks are the realm of the centaur; behind Minerva lies an open landscape containing a tranquil sea on which sails a ship full of people. Interestingly enough, her pose almost exactly repeats that of Verrocchio's St. John the Baptist (see fig. 332), including the placing of the halberd, which she carries lightly in the crook of her left arm, steadying it with her fingertips just as St. John does his reed cross. Since Botticelli worked in Verrocchio's shop, this resemblance is not likely to be a coincidence, especially as the halberd is parallel with the picture plane, so that its cruciform shape is evident. Botticelli must here be asking the observer to equate the role of the goddess inspiring the Medici government to control animal passions with that of the Florentine patron saint in calling men to repentance.

A discovery by Webster Smith throws quite a different light on the matter. In 1499 the picture hung just outside the Florentine bedroom of Lorenzo di Pierfrancesco de' Medici, second cousin of Lorenzo the Magnificent, and was not known as Pallas and the Centaur until 1516. The goddess does not resemble Botticelli's other representations of Minerva, but rather "Venus armed," who was worshiped, according to Pausanias (a copy of whose book was in Lorenzo di Pierfrancesco's library) on the island of Cythera. "Venus armed" with Giuliano de' Medici kneeling before her appears as a woodcut illustration in a late fifteenth-century edition of Poliziano's poem La giostra.

In a persuasive attempt to unravel the mystery of the painting, Ronald Lightbown notes that in the 1499 inventory the female figure is listed as Camilla, who appears in Virgil's Aeneid as a Latian princess and chaste huntress dedicated to the service of Minerva, whose olive branches (not laurel) she wears. Lightbown shows that the halberd is the weapon not of Minerva (she always bears a spear) but of guards, and he noted that the centaur, typical personification of lust, was about to shoot and apparently to break into the fence—and that Semiramide, Lorenzo di Pierfrancesco's bride, was herself a princess from Latium. It is easy, therefore, to read the message as an allegory of marital chastity, in keeping with its position outside Lorenzo's nuptial chamber.

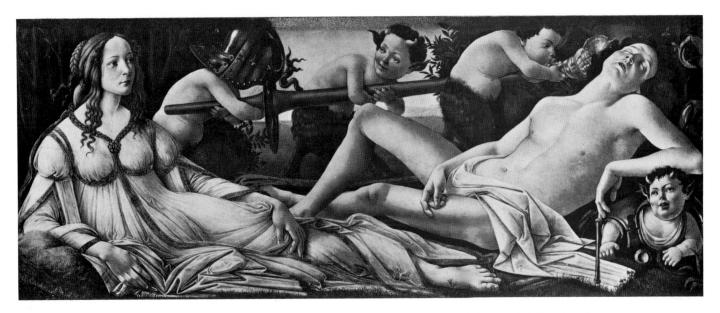

348. SANDRO BOTTICELLI. Venus and Mars. c. 1483. Panel, $27\frac{1}{4} \times 68\frac{1}{4}$ ". National Gallery, London

Mutually exclusive interpretations of the picture's iconography need not disturb our enjoyment of its style. The jagged rocks contrast, in their brilliantly illuminated bulk, with the weightlessness of the bodies. These have now assumed proportions characteristic of Botticelli's mature style, with necks and torsos prolonged so that arms and legs are the same length. Once one has entered Botticelli's Looking Glass Land, however, the conventions of the real world are forgotten, and one readily accepts the new race of beings he invented. And, whether she turns out to be Pallas, Venus, or Camilla, Botticelli's fresh and girlish creation is beautiful—divinely beautiful.

Whoever was responsible for them, the conceits behind Botticelli's mythologies are, of course, highly artificial, but no more so than the way of life prevailing in the society for which Botticelli painted, or the unrelentingly linear style of the master himself. Regardless of Christian disapproval, the ancient gods had survived in one form or another throughout the Middle Ages, especially as planetary personifications, exercising great power over human life and destiny. But in their vicissitudes they had lost their ancient appearance, and they reenter Quattrocento life on a grand scale, without much visual resemblance to classical representations, and with an allegorical meaning closely paralleling that of Christian subjects. Botticelli's Venus and Mars (fig. 348), for example, is not intelligible in terms of the naked Venuses of antiquity. Here we behold a chaste and lovely creature, barefoot but clothed in a high-cut garment with double sleeves and voluminous folds that only hint at the existence of her limbs and breasts and conceal her waist entirely. Mars, a slender youth, lies on the ground, naked save for a strip of white cloth. While he sleeps, four impudent baby satyrs make sport with his armor and spear, and one of them blows through a conch shell into his ear, in an attempt less to wake him, apparently, than to lull him into deeper sleep, all at the behest of the enchantress Venus.

Like many of Botticelli's mythologies, this one has been often connected, on slight evidence, with the tournament of 1475, celebrated in Poliziano's poem *La giostra*, in which Giuliano de' Medici received the victor's crown from the hands of the fair Simonetta Vespucci. But the picture, as Gombrich has demonstrated, must have some connection with the numerous Vespucci family, Botticelli's neighbors: the wasps buzzing about the head of Mars come from the Vespucci coat of arms (*vespucci* in Italian means "little wasps"). More than one passage from classical literature was doubtless used by whatever humanist devised the program for the painting. Especially relevant is Marsilio Ficino's astrological characterization of Mars as:

... outstanding in strength among the planets because he makes men stronger, but Venus masters him... Venus, when in conjunction with Mars, in opposition to him, or watching from sextile or trine aspect, as we say, often checks his malignance...she seems to master Mars, but Mars never masters Venus.

Whether or not the painting was intended to celebrate a Vespucci wedding (and it would seem a left-handed compliment to the bridegroom), the laurel branches behind both Mars and Venus suggest that its meaning, in the palmy days when, due to Lorenzo's adroit politics, peace seemed eternal, was, as in the *Pallas and the Centaur*, the subjugation of violence by the higher powers of culture and the intellect. The overpowering languor of the *Venus and Mars* is induced as much by its long, low shape as by the subtly depicted sleep of Mars, his face lighted from below. Lightbown has enticingly suggested that both the defeat and the slumber of Mars were occasioned by amatory activities with Venus. Her appearance

opposes this idea, especially her long, white, opaque garment, which effectively subdues her charms if it does not entirely conceal them, and her high girdle, symbol of chastity. It might be remembered that Mars was considered in Florence a hostile antitype of St. John the Baptist, who took over his temple and made it into the Baptistery.

In the universally beloved *Primavera* (colorplate 45), we cross the portals of sleep and enter the very dream. The scene is a grove of dark orange trees, thickly massed. Their intertwined branches and golden fruit fill the upper portion of the picture. Between the trunks one glimpses the sky and, at one point, a hint of a distant landscape. Just off center stands a maidenly figure, one hand raised as if in benediction. At the extreme right Zephyrus, the wind god, enters the scene in pursuit of the nymph Chloris, from whose mouth issue flowers as she is transformed (according to Gombrich) into Flora, goddess of Spring. Next we see her fully metamorphosed, strewing flowers from her flower-embroidered garment upon the already flowering grass. On the left Mercury points with his caduceus at tiny clouds that drift among the golden fruit. Next to him the Three Graces dance in a ring; above, the blindfold Cupid shoots blazing golden arrows in their direction. The saintly lady in the center, so much like one of Botticelli's Madonnas (her pose has been compared to that of the Virgin in Baldovinetti's Annunciation; see fig. 317), is Venus.

The picture, like Pallas and the Centaur, has been located in the private apartments of Lorenzo di Pierfrancesco de' Medici in his town house near the Palazzo Medici and not in his villa at Castello, where Vasari saw it half a century later. Probably in 1478, Marsilio Ficino wrote to Lorenzo, then only fourteen or fifteen years old, a letter whose importance for the understanding of the Primavera was demonstrated by Gombrich and in which Ficino recommended to the youth the espousal of Venus:

> Venus, that is to say, Humanitas, ... is a nymph of excellent comeliness, born of heaven and more than others beloved by God all highest. Her soul and mind are Love and Charity, her eyes Dignity and Magnanimity, the hands Liberality and Magnificence, the feet Comeliness and Modesty. The whole, then, is Temperance and Honesty, Charm and Splendor. Oh, what exquisite beauty!...My dear Lorenzo, a nymph of such nobility has been wholly given into your hands! If you were to unite with her in wedlock and claim her as yours she would make all your years sweet.

Ficino's Venus, fittingly described as a Christianized deity, was an allegory of all those moral qualities that, it was thought, a cultivated Florentine patrician should possess. The Graces are harder to interpret; Ficino himself supplies a number of shifting explanations. Even if we have difficulty following the more farfetched attempts to find a mystical order in Ficino's very disorder. we cannot go wrong if we regard the Graces as emanations of Venus, embodying the beauties she creates. Alberti, moreover, had recommended that painters recreate Seneca's description of a painting of the Three Graces, to be shown nude or in transparent garments, dancing together with intertwined hands. One gives forth the benefits of Venus, the second receives, the third gives forth again. A treasury of classical sources has been amassed for most of the elements in the painting, drawn from Horace, Ovid, Lucretius, and Columella.

Recently all didactic interpretations have been discounted in a new emphasis on the correspondence of Venus' enchanted garden with that of the Hesperides, from whose groves of golden apples (oranges), according to the Roman poet Claudian, believed in the Renaissance to have been a Florentine, all clouds were excluded. This is just what Mercury is doing with his caduceus, so that the sacred ritual may take place unhindered, and why he turns his back to the other figures. Armed and helmeted, he stands guard in a pose derived from those of the Davids by Donatello and Verrocchio (see figs. 247, 336). Venus, moreover, in addition to being decorously clothed, wears the headdress of a Florentine married woman. Sensuality in the depiction of female anatomy is exquisitely, even a trifle coldly, modulated by transparent garments. And for the first time, thanks to a cleaning, we can now actually see the delicate lines of breath from Zephyrus' mouth instilling new life in the nymph Chloris, so that her mouth in turn may sprout flowers, and that she may be reborn as Flora. Lovers of English poetry will think at once of Chaucer's

Whan Zephirus eke with his swete breeth Inspired hath in every holt and heeth The tendre croppes...

Appropriately, therefore, this picture was placed outside the nuptial chamber of Lorenzo di Pierfrancesco, whose wedding took place in July 1482, and Botticelli's untended garden boasts no less than forty-two varieties of mostly flowering plants, all common to a Tuscan summer.

The last word about this perpetually alluring allegory has yet to be written. For example, the orange grove, so strikingly similar to the one that miraculously separates the foreground from the background in the San Romano panels (see fig. 263) of Paolo Uccello (although oranges cannot be raised outdoors in the Arno Valley), may have other connotations. The author notes that to a Florentine Quattrocento eye this host of golden balls could hardly have failed to suggest the Medici arms, borne by Lorenzo di Pierfrancesco as well as by Lorenzo the Magnificent. Also, Mercury's beautiful rose-colored chlamys is strewn with golden flames, and these are a proper at-

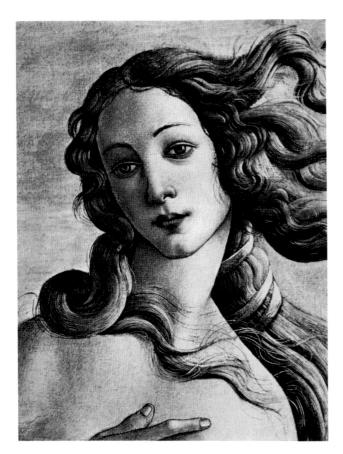

349. SANDRO BOTTICELLI. Head of Venus, detail of Birth of Venus (see colorplate 46). After 1482. Canvas. Uffizi Gallery, Florence

tribute of Mercury. But such flames belong equally to St. Lawrence (Lorenzo), and embroider his vestments in Fra Angelico's San Marco altarpiece (see fig. 207), done for Cosimo de' Medici, and many other representations; the meteor showers that descend on the earth in August each year are known in Italy as "fires of St. Lawrence" because they occur at the time of his feast. Nor is this attribute of both Lorenzos limited to Mercury: Venus' white gown is bordered at the neckline with a continuous row of golden flames, and two loops composed of these flames encircle her breasts. Finally, Mercury, aside from his innumerable duties—which included leading souls to Hades and the Three Graces wherever Venus wished—also bore the responsibility for doctors, whose symbol he bears. Medici means "doctors," and the Medici patron saints were doctors. The metaphor was standard in any eulogy of the Medici family.

The entanglements of Botticelli's mythologies typify the learning and social graces of a society bent on reviving antiquity on a new scale, less for the moral lessons that Alberti would have had it inculcate than for private delight. Botticelli's painting has given this rarefied ideal its perfect embodiment, and at the same time transcended it in poetic elevation. In a foreground composition recalling Roman relief sculpture, before the dark green leaves and giant golden fruit of the grove that shuts out the world, the pale, long-limbed figures move with a solemn and melodious grace, their golden tresses and diaphanous garments rippling about them. The circumstances of real existence no longer apply. These lovely creatures seem weightless; their long feet enter but do not press the blades of grass and the flowers. The composition wavers as the winds of spring blow through it. Cupid's arrows are intended to inflame the hearts of the Graces with love, and yearning streams from their eyes. Yet there is nothing weak or hesitant about Botticelli's style, however soft are the figures it describes. In his hands line is a penetrating instrument, flexible but unflagging, uniting with a characteristic lighting from the side to pick out in sculptural relief every feature, every long tress, every jewel. All surfaces are smooth, all masses firm, no edge is veiled in atmosphere, no brushwork visible. The recent cleaning has revealed unsuspected beauty of color and delicacy of drawing and painting, now that a thick layer of darkened varnish, dirt, and even some repainting has been removed. We note one curious fact—in Botticelli's developed style most faces are tilted sharply to one side, and the axis of the eyes slopes at a stronger rate than the rest of the face, as though the lower eye were sliding downward. Although this may be more of a persistent mannerism than a conscious device, its effect is to increase the disturbing unreality of the style.

Slightly smaller than the *Primavera*, painted on canvas (a surface usually reserved for ceremonial banners), and recorded in no inventory, the Birth of Venus (colorplate 46) was seen together with the Primavera in Lorenzo di Pierfrancesco's villa at Castello by Vasari in the mid-sixteenth century. Although this picture really does correspond to a passage in Poliziano's La giostra, Gombrich successfully adduced Ficino's interpretation of the mythical birth of Venus from the sea, which had been fertilized by the severed genitals of Uranus: an allegory of the birth of beauty in the mind of man through the fertilization of matter by divinity. Imagine what a ferocious painting Pollaiuolo would have created on such a theme! Botticelli has turned the cruel myth into an image of grace and beauty, likened to the traditional composition of the Baptism. Venus has arisen from an improbable sea, and barely stands on—rather than in a beautifully painted cockleshell, while the wind gods waft her to shore, where she will be immediately robed by a waiting Hour. Even this nude Venus, deriving from classical statues of the Venus pudica (modest Venus) type, hides her nakedness with her hands and with her long golden hair, which comes sweeping about her. The waiting Hour has her bosom wreathed in laurel, as does Pallas in Pallas and the Centaur (see fig. 347). The sea itself is almost flat, with tiny V-shapes drawn to represent the waves. Flowers drift through the air along with Venus, whose unearthly beauty is heightened by the use of gold pigment to highlight her hair (fig. 349). All the atmospheric and voluminous qualities for which the Ren-

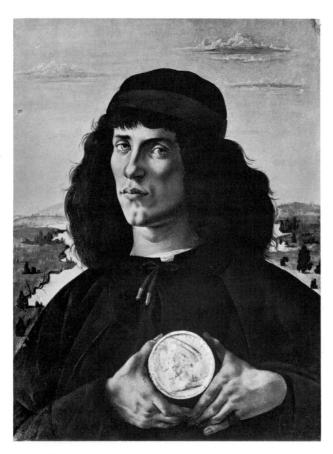

350. SANDRO BOTTICELLI. Young Man with a Medal. 1470s (?). Panel, $22\% \times 17\%$ ". Uffizi Gallery, Florence

aissance had striven are ruled out in this picture, which is completely dependent on the incomparable delicacy of Botticelli's line. His proportions show here their greatest exaggeration. Yet the entrancing flow of the long neck and the sloping shoulders, the torrent of honeyed hair about the cool body, transport the observer beyond the will to judge.

Along with the mythologies, we ought certainly to consider Botticelli's most striking portrait, the Young Man with a Medal (fig. 350), in the Uffizi. The medal itself, in raised and gilded gesso, represents Cosimo de' Medici, recognizable and clearly labeled, but the youth, who displays his support for Cosimo so ostentatiously, has never been identified. Could he be Lorenzo di Pierfrancesco? We know two portraits of him, both in profile, on medals, and they do not noticeably resemble each other. But the more convincing of the two shows the flaring eyebrow, bulbous nose, heavy, broad cheekbones, full lips, and long though slightly receding chin of the Uffizi portrait. The placing of the head in three-quarter view against the sky is unusual in Quattrocento portraits. The characteristic discrepancy in the level of the subject's eyes is accented by the off-center placing of the hands holding the medal, the twist of his left hand, the tilt of the medal opposite to that of the axis of the eyes, and the sharp inward angle of the hat and hair at the right. The sculptural modeling of the hands and face

contrasts with the flattened landscape and its maplike riverbank.

Some of the transformations that take place in Botticelli's style in the later 1480s make themselves felt as early as the Enthroned Madonna with Saints (fig. 351), an altarpiece painted for the Church of San Barnaba, probably in the mid-1480s, and now in the Uffizi. Youthful angels part a royal curtain of crimson and ermine before the throne of the wide-eyed Queen of Heaven, while others uphold the crown of thorns and the nails. On the steps are carved the words, "Virgin Mother, daughter of thy Son," from Dante's Paradiso. To the Virgin's right stand Saints Catherine, Ambrose, and Barnabas, to her left Saints John the Baptist, Augustine, and Michael. This is the most monumental of Botticelli's large-scale panels, so massive in its grouping of figures and architecture, so dense in its richly colored simulation of metal, marble, and textiles, as to produce the effect of a carved and polychromed relief. Delicate variations from exact symmetry are the only factors that disturb the almost Byzantine rigidity of the composition, yet the faces are as sensitive as ever, especially that of the gaunt St. John the Baptist, an unexpected apparition in Botticelli's art—a haunting figure, looking outward through unfocused eyes glazed with pain.

Like this great altarpiece, the Annunciation—painted in 1489–90 for the Church of Santa Maria Maddalena dei Pazzi and now in the Uffizi (fig. 352)—shows the gathering intensity of Botticelli's religious fervor. The event takes place in a room furnished only by the lectern at which Mary had been reading. Through the open door one looks into Mary's closed garden. From behind the lily held by the angel a tree rises, as if to fulfill the prophecy of Isaiah, "A shoot shall grow from Jesse's rod," and to foretell the Tree of the Cross. The buildings in the background, intended to be read together with the garden and the tree, may likewise be symbolic.

The barrenness of the architecture, like a draftsman's rendering rather than a painting of a real room, provides a strangely unresponsive setting for the emotionality of the figures. Mary, whose pose derives from the Annunciations by Donatello (see fig. 245), Fra Filippo (see colorplate 29), and Baldovinetti (see fig. 317), now sways as if caught in a rushing wind. The biblical text says only that "her heart was disturbed within her," but Botticelli has represented her as ready to swoon at the awesome news, in much the same way that she was shown by the Sienese artists as swooning under the Cross. Her eyes are almost closed, her features deadly pale. The flow of Botticelli's line is the vehicle no longer of a Renaissance love of beauty but of a new and passionate form of Christianity that points the way toward the Florentine Mannerism of the Cinquecento and toward the mysticism and the distortions of El Greco.

The wild emotions, grim architectural lines, and deaf colors of Botticelli's late style suggest that he was a will-

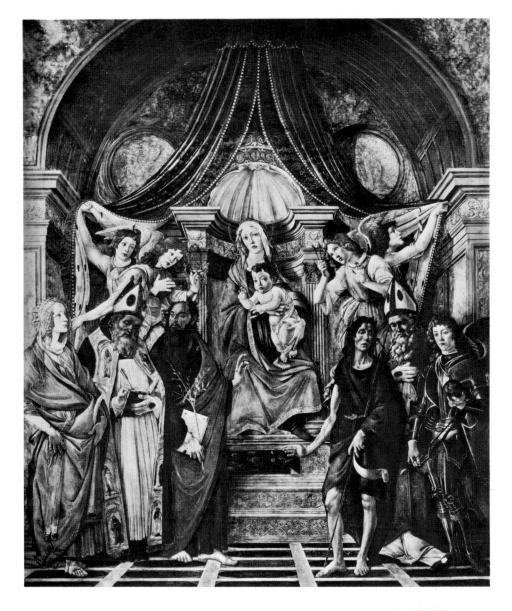

left: 351. SANDRO BOTTICELLI. Enthroned Madonna with Saints. Mid-1480s. Panel, 11'2"×8'10". Uffizi Gallery, Florence

below: 352. SANDRO BOTTICELLI. Annunciation. 1489–90. Panel, $59 \times 61^{3/4}$ ". Uffizi Gallery, Florence

ing listener to the sermons of the fiery Ferrarese monk Girolamo Savonarola, who arrived at San Marco in 1482, heir to the asceticism of St. Antonine, remained until 1487, and returned in 1490, to be appointed in 1493 vicar general of the Tuscan congregations of Dominicans. Unlike his younger brother Simone, Sandro never became a partisan of the political movement Savonarola set in motion. The adherents of the Dominican preacher were known as the piagnoni ("weepers," from piangere, "to weep"), and in them was mobilized much of the popular resentment against the Medici supporters, or palleschi. Savonarola preached cycles of sermons in the Duomo, the only building in Florence that could hold his enormous audiences. He denounced the sins of Florence and the worldliness of the Renaissance with such force that his hearers wept openly and bitterly. Sometimes we are in doubt as to exactly what he said, because the piagnoni were weeping such floods of tears that they could not take accurate notes. His prophecies of destruction to be visited on Florence began to come true in the shape of the arrival of the conquering armies of King

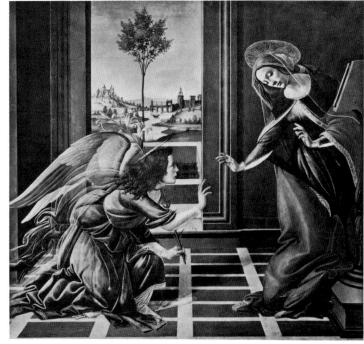

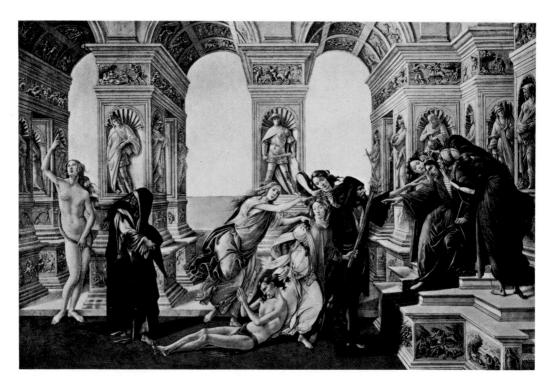

353. SANDRO BOTTICELLI. Calumny of Apelles. 1497-98 (?). Panel, $24\frac{5}{8} \times 36''$. Uffizi Gallery, Florence

Charles VIII of France in 1494, after the expulsion of Piero the Unlucky from Florence and the sack of the Medici Palace. The peace that had reigned with few interruptions in Central and North Italy for forty years was over, and it became painfully evident to all that the Italian states could not stave off domination by the rising centralized monarchies of France and Spain, not to speak of the Holy Roman Empire. Eventually, Savonarola took over the government of the Republic, but the forces arrayed against him, including the papacy under Alexander VI, finally proved too much, and in 1498 Savonarola and two of his chief monastic assistants were hanged in front of the Palazzo Vecchio and their bodies burned on the gallows. The place is marked by a slab, and is still reverently visited by Florentines on the anniversary of Savonarola's martyrdom.

Botticelli's moralistic fervor during this period is illustrated by one of his most impressive late works, the Calumny of Apelles (fig. 353), which he painted for his own pleasure and gave to his friend Fabio Segni. The work was done to carry out a suggestion of Leonbattista Alberti, who, in De pictura, had counseled artists to recreate from the description by the Greek author Lucian a vanished painting by the great master Apelles. Botticelli has followed the letter of Alberti's advice. Beside the throne of Midas, the unjust judge, stand Ignorance and Suspicion, lifting his donkey ears to whisper their advice. Led by the hooded, bearded Hatred, and attended by Deceit and Fraud who adjust her jewels, Calumny, bearing a torch, drags her victim, a nearly naked youth, for judgment, while Penitence, an old woman, rends her garments and the naked Truth points to heaven.

It is not hard to imagine with what calm Piero della Francesca might have treated this subject. Botticelli's picture is one of the most tormented Quattrocento paintings. Some of the oppressive effect of the Calumny is produced by its illogical space. The perspective has been described as "flawless," and most of the lines do vanish toward a common point, located appropriately enough behind the eyes of Fraud. But the central pier of Midas's judgment hall supports a cornice and two barrel vaults projected to a somewhat lower vanishing point. Moreover, the long, low format of the picture bares the Achilles' heel of Albertian perspective—the projection of the objects at either extreme. The lateral piers would clearly have to be trapezoidal in plan. The scheme is further complicated by the placing of the throne at the right rather than, as one might have expected, at the center of the composition, which creates an axis of interest conflicting with the visual axis of the perspective. Finally, the podium and the steps are allowed to project from the space of the picture into that space where we stand, with frequent zigzags to break up the straight orthogonals.

The architecture presents a series of highly animated surfaces and no clear-cut masses. Not only the second story but also the front arches of the first are cut off by the frame. Heavy entablatures with simulated sculptural friezes representing classical subjects dwarf the supporting piers, which are pierced by transverse passages and penetrated by niches. From these niches protrude statues, a Judith with the head of Holofernes at the extreme right, for example, and at the center a warrior in the pose of Castagno's Pippo Spano (see fig. 271). More reliefs pullulate across both levels of the double podia on which

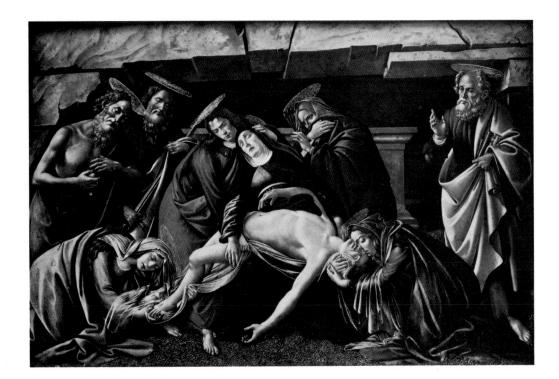

354. SANDRO BOTTICELLI. Pietà. Late 1490s (?). Panel, $54\frac{3}{8} \times 82''$. Alte Pinakothek, Munich

the piers rest. Even the coffers of the vault are filled with reliefs.

Within this active architecture whose windows look out on the maplike monotony of the marine horizon, the frenzied figural composition is the more disturbing in that it is rendered with all Botticelli's formidable skill in draftsmanship. Echoes of earlier graceful figures occur here and there. The handmaidens of Calumny recall Jethro's daughters (see fig. 342), and Truth is an obvious reference to the Birth of Venus (see colorplate 46). But the dreamlike quality of Botticelli's painted mythologies has turned into a nightmare. Mannerism, the dominant style in Florentine painting of the 1520s, is strikingly prefigured in this work, which also exceeds the most extravagant aspects of Donatello's late style. It has often been suggested that the iconography was prompted by a desire to defend the memory of Savonarola—whose excommunication in 1497 and execution in 1498 had a profound effect on Botticelli-against the accusations brought by persons as wicked, and punished by a judge as weak, as those depicted here. This solution is rendered all the more plausible by the tattered Dominican habit in which Penitence is dressed. Yet no one seems to think that the picture can be as late as 1497 or 1498. Why not?

The style and content of the Calumny appear with resounding effect in contemporary religious works by Botticelli, such as the harrowing Pietà (more specifically a Lamentation) painted for the convent of San Paolino in Florence (fig. 354). In a poem attributed to Savonarola, it was considered prophetic that a sculptured Pietà at Bibbona, near Volterra, had been working miracles ever

since 1492. In this painting, pervaded by the self-flagellating gloom of Savonarola's doctrines, we do indeed dwell in the tomb with Christ. Botticelli's favorite jagged rocks form the entrance to the tomb and enclose both the mourning figures and us. Within is only the sarcophagus—and blackness. The pose of the Christ, with his long, hanging arm, was drawn from a window designed by Castagno for the dome of the Cathedral of Florence, Santa Maria del Fiore. Botticelli seems also to have been impressed by Pietro Lorenzetti's harsh Descent from the Cross (see fig. 102), from which he adopted not only the appearance of rigor mortis but also the upsidedown confrontation of the Magdalen's face (in Lorenzetti's fresco, it is the Virgin's) with that of Christ.

In 1500 there comes a relaxation in Botticelli's style, in the Mystical Nativity in the National Gallery in London (fig. 355), probably painted only for the artist's satisfaction. At the top is a Greek inscription, which reads:

> This picture I, Alessandro, painted at the end of the year 1500, during the trouble in Italy in the halftime after the time which was prophesied in the 11th of John and the second woe of the Apocalypse when the Devil was loosed upon the earth for three years and a half. Afterward he shall be put in chains according to the twelfth woe, and we shall see him trodden underfoot as in this picture.

In spite of Botticelli's inscription, the picture has been extremely difficult to interpret, as only a few elements from the rich torrent of imagery in Revelation, chapters 11 and 12, are illustrated by Botticelli; some of his figures and groups are not in those chapters, and there is more than an echo of certain specific sermons by Savonarola. The second woe, describing the fiery prophecies of two "witnesses" and their death at the hands of the Antichrist, was surely taken to mean the martyrdom of Savonarola and his principal follower, Fra Domenico da Pescia. But what of the "half-time after the time"? This can only refer to the half-millennium after the millennium after the Nativity of Christ, the subject of the picture—in other words, the year 1500. The "trouble in Italy" is not hard to identify, considering that the armies of Cesare Borgia were then loose in Tuscany. After all this passes—so Botticelli dreams—we will all be brought to where the mystic Woman of Revelation 12 has found refuge with her Child in the wilderness, all devils will be chained under the rocks (we see this in the lowest foreground), angels will embrace us, and we may dwell in safety. Angels with olive branches draw shep-

355. SANDRO BOTTICELLI. *Mystical Nativity.* 1500. Canvas, 42³/₄ × 29¹/₂". National Gallery, London

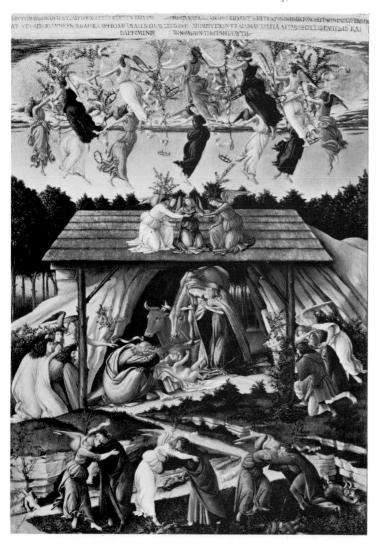

herds to adore the Child. In the heavens above, twelve angels, carrying olive branches from which dangle crowns, dance in a ring, the age-old symbol of eternity. This final regression assuages the longings of Botticelli's lifetime. The embrace of peace, the circling patterns, the sheltering wood, the protecting mother are a ritual of surrender through which the painter's fever is stilled at last. Even the color is transformed: the jewellike blues, yellows, reds of this tranquil picture are a release from the harsh tones that characterized the period of stress through which the artist had passed.

But he had made his choice. In renouncing the contemporary world he suffered the corollary penalty: the world renounced him. During the last ten years of his life—from about fifty-five to sixty-five, that is—Botticelli painted little. Although he was consulted along with other eminent masters about the placing of Michelangelo's David in 1504, the Florence of Leonardo, Michelangelo, and the young Raphael had no work for him. Commissions went to lesser artists who could emulate the new style of the High Renaissance. If we are to believe Vasari, Botticelli became prematurely old and walked with two canes. We are painfully familiar with the fate of artists who are no longer "with it." Yet Botticelli has conquered in the end. While most of the painters who enjoyed the commissions he was denied are of interest today only to historians, Botticelli's appeal is so universal as to render his best paintings timeless.

FILIPPINO LIPPI

The fourth great Florentine painter of the end of the Quattrocento, Filippino Lippi (1457/8–1504), is doomed to remain in Botticelli's shadow. This is unfair—because Filippino was a splendid artist in his own right—but inevitable, since he got his second start in Botticelli's shop at the very moment when that master was enjoying his greatest success. Filippino received his early training from his father, Fra Filippo Lippi, accompanied him to Spoleto in 1466 (see page 218), and remained there until Fra Filippo's death in 1469. Filippino's association with Botticelli lasted for a number of years, perhaps until the latter was called to Rome in 1481. In 1484 Filippino was asked to complete the frescoes by Masaccio in the Brancacci Chapel at the Carmine (see pages 191–92).

About 1485, on the basis of comparisons with dated works, we should place the magnificent *Virgin and Child with Angels* in the Corsini Gallery in Florence (fig. 356)—the largest painted tondo of the Quattrocento—which displays to the full the artistic and poetic resources of Filippino's style. Nonetheless, the influence of the young Leonardo da Vinci, who had left Florence for Milan in 1483, can be felt in all Filippino's works of this period, in which he abandoned the resolute linear clarity of Botticelli for the soft *sfumato* ("smoky") manner of Leonardo. Another very prominent element in the

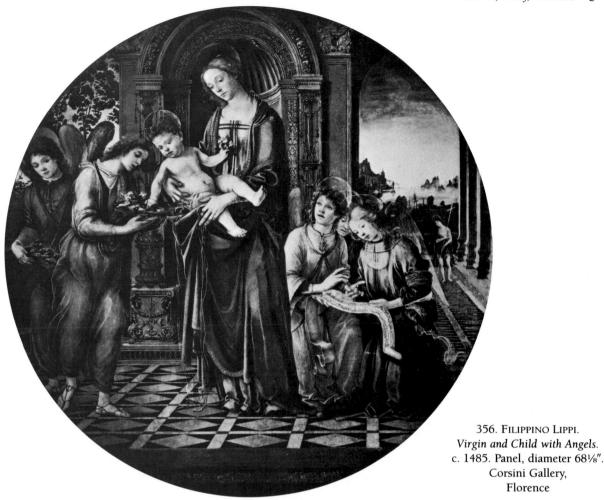

Corsini tondo is derived from Leonardo—the mysterious landscape in the background, toward which the perspective of the Virgin's palace moves. A seaport with towers, breakwaters, and a lighthouse is enclosed by jagged mountains, suggesting the distant Apuan Alps that can be seen from Florence against the sunset on a clear evening. A similar port scene with the same fantastic elements appears in the background of Leonardo's Annunciation (see fig. 453). On the left shoulder of Filippino's exquisite Madonna shines the golden star seen in many representations of the Virgin in the Trecento and Quattrocento. The star is hers by virtue of the meaning of her name "Star of the Sea" (see page 91), and the innumerable passages in theological writings from St. Augustine onward that apostrophize her as "port of the shipwrecked." St. Bernard combines both images, calling her "star directing us to God, to the port of our salvation." The port scene is visible in other representations of the Virgin, many with the star on her shoulder, datable in the 1480s. There may be some connection between Filippino's work and the Consoli di Mare (Consuls of the Sea), a special body of Florentine officials responsible for the administration of the Florentine ports at Livorno and Pisa, especially since the tiny figure of St. John the Baptist, the patron saint of Florence, can be seen far down the long perspective, silhouetted against the harbor.

The richly decorated niche gently pushed to the left of center so that the view of the distant sea may be more prominent is hung on either side with rosaries of early form (see Glossary). Before the niche stands the tall and slender Virgin, holding the naked Child. Two graceful adolescent angels, with pale faces and shadowy eyes, present the Child with bowls of roses, from one of which he has culled a nosegay for his mother. Before the long perspective kneel three equally haunting angelic figures, singing from a scroll of music spread in their hands. Sensitivity is a trait that Filippino shares with Botticelli; if anything, he surpasses his master in that single regard. But the lesson of Leonardo's sfumato and soft edges has been learned. A flow of tone veils exact statements and melts precise edges. Occasionally, the surfaces are divided into facets or patches like those that will appear in the paintings of Michelangelo and Andrea del Sarto and will be exploited by the Florentine Mannerists, on whom the work of Filippino seems to have had a certain influence. Entirely his own is the movement of glowing color blues, rose tones, greens, violets—in the often diaphanous drapery. And even in view of the elements derived from Leonardo, we must recognize a new personal style, full of a sad delicacy of observation and expression, particularly in the delineation of youthful faces, elusive and poetic in feeling, shimmering in tone.

Filippino's peculiar magic is at its strongest in the Vision of St. Bernard (colorplate 47), now on an altar in the great church called the Badia of Florence, but originally painted, probably about 1485-90, for the monastic Church of Le Campora at Marignolle, on a promontory just outside the walls of Florence. Jacobus de Varagine's Golden Legend tells us that one day, when St. Bernard was feeling so tired and ill that he could scarcely hold his pen, the Blessed Virgin, for whose cult he had done so much, came to strengthen him. In Cinquecento representations of the vision, Mary and her accompanying angels float as a heavenly apparition. Here she stands quietly before St. Bernard's outdoor writing desk, attended by wide-eyed child-angels who watch in wonder or genuflect and pray, as she lays one slender, white hand with infinite lightness upon St. Bernard's rumpled page. He stops writing and looks up in adoration, and between the bloodless profile of the blue-mantled Mary and the weathered face of the monk a Trecento manuscript stands open so that one can read the words of the account of the Annunciation in the Gospel of St. Luke. Filippino must have meant us to feel that Mary came to St. Bernard as the Angel Gabriel had come to her, and that in this vision the Christ Child is born a second time—as St. Antonine would have put it—in St. Bernard's heart. Rocky ledges, more softly painted than was Botticelli's custom, surround the saint and carry the eye up the hillside (which probably gives the appearance of the Via le Campora in those far-off days) to where monks look upward, astonished, at the empty air through which Mary and her attendant angels have descended. In the lower right-hand corner the donor, Francesco del Pugliese, a wealthy cloth merchant, folds his hands in prayer, and in a hole in the rocks just above his head can be seen a demon gnawing his chains in defeat, flanked by a huge owl.

The extreme faithfulness of the rendering of faces and hands, rocks and trees, even the appearance of the child angels themselves, recalls an artistic event of great importance for Florentine art (although it is to be doubted whether Botticelli paid much attention to it). Filippino and other Florentine painters were certainly profoundly impressed when, probably in 1483, a great altarpiece representing the Adoration of the Shepherds by Hugo van der Goes (fig. 357), then the most important painter of the Netherlandish School, was set up by Tommaso Portinari on the high altar of Sant'Egidio, between the nowvanished frescoes of Domenico Veneziano and his young assistant Piero della Francesca, and, later, Castagno and Baldovinetti. Although the Florentines had certainly seen some small examples of Netherlandish painting, especially a St. Jerome by Jan van Eyck and Petrus Christus belonging to Cosimo de' Medici, the total realism of these Northern masters had never before been spread before them on the scale of the Portinari altarpiece. It proved a revelation, and Filippino must have studied the melancholy faces of the Portinari children with care, as there is more than a reflection of them in the four little angels.

In this composition Filippino has achieved something similar to the broken quality of Verrocchio's sculptured drapery surfaces (see fig. 334). The forms move restlessly, shimmer in small facets, pervaded by movement but without any sense of overall mass. In Filippino's major Florentine commission, the frescoes of the Strozzi Chapel at Santa Maria Novella, this floating, antimonumental style comes to its climax. The series, relating the life and

357. Hugo van der Goes. Adoration of the Shepherds (Portinari altarpiece). Late 1470s. Panels: center, 8'4" × 10'; laterals, each 8'4" × 4'8". Uffizi Gallery, Florence

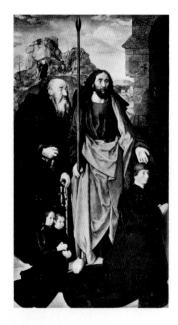

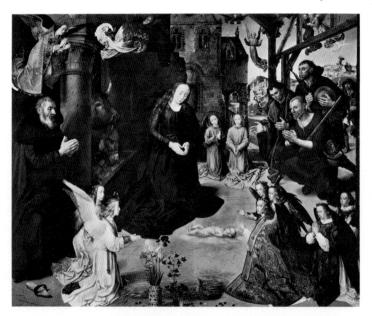

358. FILIPPINO LIPPI. Exorcism of the Demon in the Temple of Mars. 1487–1502. Fresco. Strozzi Chapel, Sta. Maria Novella, Florence

miracles of St. Philip, was commissioned in 1487 by Filippo Strozzi, builder of the great palace (see fig. 307), but Strozzi gave Filippino permission to go first to Rome for an important commission in Santa Maria sopra Minerva, and died in 1494 without ever seeing his frescoes, which were not completed until 1502.

In these frescoes, indeed in many of Filippino's later works, his sensitivity becomes almost pathological. The *Exorcism of the Demon in the Temple of Mars* (fig. 358) is one of the strangest pictures of the whole Florentine Renaissance. Apocryphal sources relate how St. Philip went to Hierapolis in Asia Minor and there entered the Temple of Mars. From the base of the statue of the god burst a demon in the shape of a dragon, emitting fumes so poisonous that the king's son fell dead. St. Philip proceeded to exorcise the demon; this greatly displeased the priest of Mars and led to the saint's subsequent crucifixion. Filippino has created a brilliant architectural frame for

the picture, united in fact with the screen architecture in which he clothed the entire chapel. The details are all borrowed from the decorations he had seen in Rome in the Golden House of Nero, portions of which had just been unearthed under the ruins of the Baths of Trajan. Since these decorations were found in what seemed to be a grotto, they were known as grotteschi, the origin of our word "grotesque." They generally consisted of lamps, urns, consoles, masks, harpies, lion's feet, and other Roman decorative elements of the first century A.D., either combined in a linear succession climbing the faces of piers and pilasters, or woven into a fantastic web, which could encase an entire wall or vault. Filippino's enframement is one of the first examples, if not the first, of the grotteschi to reach Florence; yet despite its classical origin, this type of ornament has been handled so as to harmonize with the Gothic architecture of Santa Maria Novella.

Within the frame stands the altar, a huge exedra flanked by Corinthian colonnades, enclosing the statue of Mars. On the podia, herms, supposedly marble sculptures, twist as if alive. The ledges above them are crowded with trophies and, behind Mars, with amphorae of various sizes and shapes. On the cornice appear statues of kneeling, bound captives with winged Victories holding palms above their heads, and these almost mesh with three painted lamps represented as hanging on triple chains from the mouths of three putti, in a row from outside the frame. The intervening space is thus canceled out, and the illusion becomes even more contradictory by reason of the placing of some figures outside the frame at the bottom, yet inside the picture. By such devices the hard-won perspective space of the Renaissance is renounced—even though individual elements are correctly projected—by an artist who, along with Botticelli, was classified by Fra Luca Pacioli in 1494 as one of the masters of perspective.

Mars, looking more like a living person than like a statue, presides over this topsy-turvy world, brandishing a shattered lance with one hand while with the other he caresses what is supposedly a wolf, however much it may look like a hyena. The priest cringes before his altar in terror at the supernatural power of St. Philip's lifted hand. On either side stand priests, courtiers, and soldiers, wearing Filippino's idea of Near Eastern costume. All shape and consistency have been drained from their bodies; they are mere bundles of cloth. The dignity of the human person has vanished from Filippino's art along with the clarity of the space that man aspires to traverse and control. Despite differences of costume, age, hair, beards, skin color, all faces are essentially the same, pervaded with the same look of incipient nausea, and painted as always with the utmost delicacy of surface and freedom of brushwork. It was hardly necessary for Filippino to show three of the bystanders holding their noses, for the emanations from the little monster in the center of the stage have attacked figures and setting. What a way we have come from Masaccio! Filippino's fresco is, in the last analysis, the painting of a bad smell.

At the upper right-hand corner, so high and far that one hardly notices him, Christ appears in a rift in the clouds, carrying his Cross and offering his blessing. One is reminded of the contemporary works of Hieronymus Bosch in the Netherlands, an artist equally obsessed with the worthlessness of man. It is a strange end for Filippino and for the poetic current in late Quattrocento art, but not dissimilar to what happened to Botticelli in the despairing Calumny of Apelles (see fig. 353), probably for much the same reasons. For the Florentines at the turn of the century, no affirmation of faith in man was any longer possible. It was to require a new political movement, and the stature of greater artists than Filippino or even Botticelli, to achieve a new vision of human destiny. Filippino died in 1504 at the age of forty-six, only three months after having submitted his evasive judgment on the placing of Michelangelo's David (see fig. 477), the first mighty work of the new period, which Filippino, like Botticelli, was temperamentally unsuited to enter. We are told that all the workshops of Via dei Servi closed in respect as his body was carried from the Church of San Michele Visdomini to its final rest in the Santissima Annunziata. Ironically enough, it was for this very Church of San Michele Visdomini that Jacopo Pontormo, only thirteen years later, after the evaporation of the short-lived High Renaissance, was to paint an altarpiece that has been regarded as the first open manifestation of Mannerism, a style that owes much to Filippino's introspection and expressiveness.

DOMENICO DEL GHIRLANDAIO

Our account of the Florentine Quattrocento ends with Domenico del Ghirlandaio (1449-94), who, in a career even briefer than that of Filippino, rose from still-unidentifiable artistic origins to become beyond any competition the leading personality in the Florentine school, if measured by the standard of worldly success. Domenico, together with his brother Davide and their brotherin-law Bastiano Mainardi, not to speak of an army of assistants, captured easily the major commissions for public painting in Florence—frescoes and altarpieces and many lucrative portrait orders as well. Like Agnolo Gaddi at the end of the Trecento (see page 132) and Giorgio Vasari in the third quarter of the Cinquecento (see page 664), Ghirlandaio and his school represented the official taste of the period. The scientific pursuits of Pollaiuolo and Verrocchio might appeal to Lorenzo the Magnificent, the arcane researches of Botticelli to Lorenzo di Pierfrancesco and his friends, but the ordinary Florentine businessman knew what he liked, and was possibly irritated by so much fierce knowledge on the one hand and so much wild imagination on the other. Ghirlandaio's prose style suited the successful merchant

Its subsequent fate is instructive. When the Quattrocento was rediscovered in earnest by nineteenth-century critics, Ghirlandaio's meticulous and convincing view of the life about him impressed a generation that never quite understood Masaccio and cast only a scornful glance in the direction of Uccello and Piero della Francesca. Then came the revolution of "Form" in the wake of Cézanne, Picasso, and the Cubists, and that of "Expression" after Van Gogh, Rouault, and Nolde, and Ghirlandaio fell from grace a second time. He made no new discoveries about form or space, and he had no real sense of drama or even of line and pattern. So Ghirlandaiowho to Ruskin was the master of painting in Quattrocento Florence—dwindled to minor significance in twentieth-century eyes. Gradually, in the last three decades, Ghirlandaio's real merits have become appreciated again. After closer study, his art has shown at least three

359. DOMENICO DEL GHIRLANDAIO. Last Supper. 1480. Fresco. Refectory, Ognissanti, Florence

important qualities, any one of which should guarantee him a permanent position. He had the freshest and most consistent color sense of any Florentine painter of his day; he was familiar with the achievements of his contemporaries in the field of architecture and was thus able to compose figures and architectural spaces into a complex unity beyond that achieved by Quattrocento painters anywhere else in Italy; and, finally, in his rendering of human beings, his reserve veils an unsurpassed delicacy in the analysis of character.

Domenico Bigordi was the son of a dealer in the golden garlands worn by wealthy ladies, and therefore acquired his father's nickname of Ghirlandaio (Garland Maker). He was trained as a metalworker, and we are not sure just how, when, or with whom he went into painting. His earliest works are clumsy, and a certain naïveté remains throughout his career. Eventually, he absorbed some of the contributions of Pollaiuolo and Verrocchio, but he remained remote from Botticelli and Filippino. The last fourteen years of Ghirlandaio's life mark his rapid ascendancy as a painter, so rapid in fact that he could not work fast enough to satisfy the demand. His Last Supper, painted in 1480 for the refectory of the monastery of Ognissanti (fig. 359), was dependent on Castagno-probably not the work at Sant'Apollonia (see colorplate 34), which Ghirlandaio may never have seen, but a lost composition for Santa Maria Nuova. The table is situated in an upper room with a view over citron trees and cypresses into a sky in which soar falcons and pheasants. St. Peter lifts the knife behind Christ, while St. Bartholomew, behind Judas, raises his folded hands in prayer. Nowhere is there a single face as intense as those in Castagno's fresco, yet the subtle analysis of the inner life of the Apostles is not to be underrated. Nor is the freshness of Ghirlandaio's color, or the poised balance of the composition grouped about the console supporting the vaulting of the refectory, or the hard simplicity of the handling of the faces and drapery.

Domenico and his brother Davide had already been called to Rome in 1477. Domenico's contribution to the frescoes of the Sistine Chapel in 1481 is the Calling of Sts. Peter and Andrew (fig. 360). The space of the fresco is formed by a glacial lake—suggestive of Lake Garda in North Italy—stretching into the luminous distance, with cliffs, walled cities, and monasteries on its near banks. In the middle ground, on the left shore, Christ is shown calling Peter and Andrew from their nets; on the right he welcomes James and John, while Zebedee remains in the stern of their boat. In the foreground Peter and Andrew, both shown with white beards, kneel before Christ, who consecrates them in their mission, the foundation of the Church. In addition to the attendant figures in the left foreground, the right foreground is filled with contemporary portraits, as in the Sistine frescoes of Botticelli. Ghirlandaio must have studied Masaccio's Tribute Money (see colorplate 23), and, although he was incapable of the intensity of Masaccio's drama, he controlled firmly the light on the drapery masses and presented the faces, especially that of Peter, with earnestness and calm.

The chapel in Santa Trinita in Florence, dedicated by the wealthy banker Francesco Sassetti to the Life of St. Francis, shows Ghirlandaio at the height of his achievement. He apparently cared little about the execution of

360. DOMENICO DEL GHIRLANDAIO. Calling of Sts. Peter and Andrew. 1481. Fresco. Sistine Chapel, Vatican, Rome

those frescoes placed too high to be seen easily from the floor, but he lavished his best craftsmanship on the lowest row, including the Miracle of the Child of the French Notary (fig. 361). In the background, to the left, the little boy can be seen falling out the window of the Palazzo Spini, but in the center St. Francis appears half-length in the air, accompanied by clouds, and blesses the child, who sits upright on his bier, to the general satisfaction of the figures on either side. There is something about the fresco that reminds us of folk art, especially the ex voto scenes that are still today painted for Italian village churches to record the miraculous intervention of saints in the lives of the faithful. Moreover, Ghirlandaio has taken great pleasure in showing us what the Piazza Santa Trinita, outside the church where the Sassetti Chapel is situated, was like in his own day. On the left rises the Palazzo Spini-Ferroni, on the right the beautiful Romanesque façade of Santa Trinita (replaced with a Mannerist structure by Bernardo Buontalenti in the late Cinquecento), and in the distance one can see the Ponte a Santa Trinita, lined with houses (this was substituted, after the flood of 1555, by the monumental bridge designed by Bartolommeo Ammanati with Michelangelo's intervention; see fig. 714). At the extreme right Ghirlandaio himself looks out toward us.

The smoothly illuminated faces of the foreground figures are of the greatest beauty—as, indeed, are those of the Funeral of St. Francis (fig. 362). Ghirlandaio has placed the funeral scene in a colonnaded Renaissance loggia, whose forms recall the architecture of Giuliano da Sangallo (see fig. 315), undoubtedly an acquaintance. Unexpected for this generally rather phlegmatic painter is the poignancy of the group around St. Francis, whose emaciated face, certainly drawn from a corpse, is gently lighted from below. Weeping monks kneel to kiss the saint's hands and feet or look into his closed eyes. The knight of Assisi is placed on the far side, bending over to touch the wound in St. Francis's side. Noblest of all is the rendering of the bishop of Assisi and his two youthful attendant monks at the left. The bishop, his glasses perched on his nose, calmly reads the commitment service. The light glides over his old features and the youthful faces of the two monks with a grace and firmness displayed by no other painter of the time.

Ghirlandaio's masterpiece is doubtless the *Adoration* of the Shepherds (colorplate 48) on the altar of the Sassetti Chapel; its frame rises into the Miracle of the Child of the French Notary so that the bier seems placed on its cornice. The kneeling Virgin adores the Christ Child lying on one corner of her mantle, pillowed beneath by a

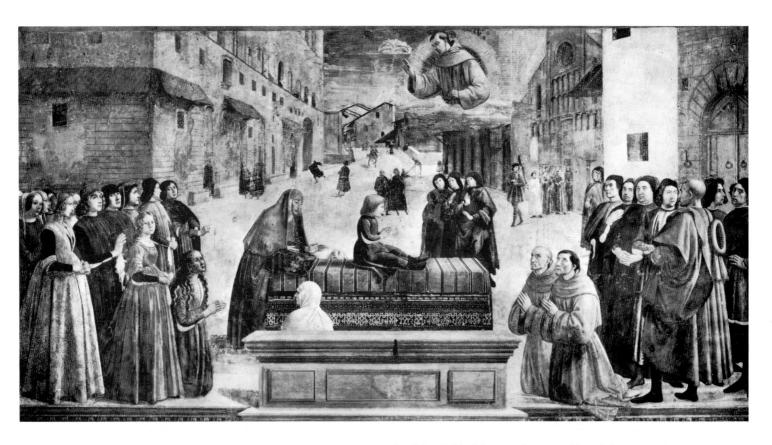

361, 362. Domenico del Ghirlandaio. *Miracle of the Child of the French Notary* (above) and *Funeral of St. Francis* (below). 1483–86. Frescoes. Sassetti Chapel, Sta. Trinita, Florence

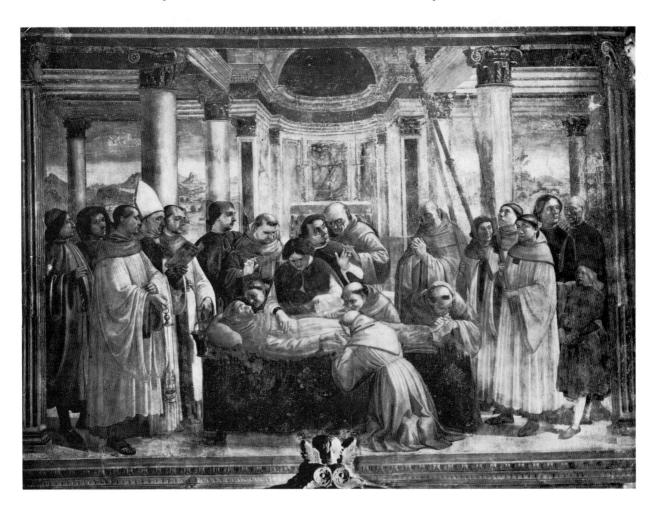

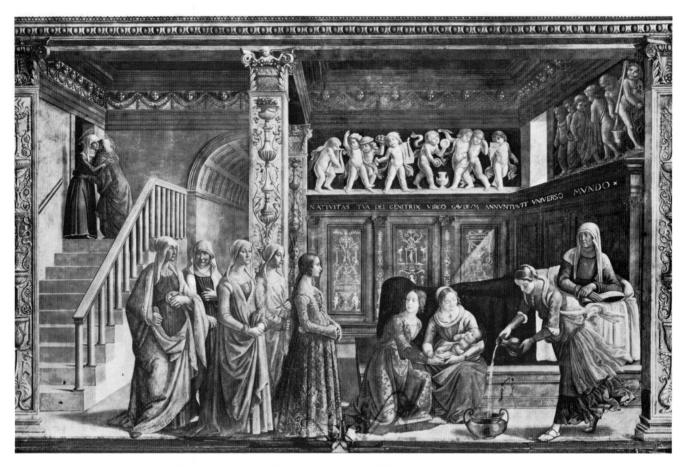

363. DOMENICO DEL GHIRLANDAIO. Birth of the Virgin. 1485–90. Fresco. Cappella Maggiore, Sta. Maria Novella, Florence

bundle of hay. Two elegant square Corinthian piers, one of which bears the date 1485, support the roof of the shed. The ox and ass look earnestly out and down over the manger, a Roman sarcophagus bearing an inscription recording a divine promise of the resurrection of the former occupant. In the background appears a Roman triumphal arch with an inscription of Pompey the Great. All these classical elements witness Ghirlandaio's fascination with Roman antiquity. Around the hillside in the distance comes the train of the Three Magi, passing through the triumphal arch and moving toward the foreground. The miracle of the picture is the naturalism of the painting of the ox and ass, of Mary, of Joseph looking up toward the distant angel, and above all of the three shepherds; all of these show devoted study of Van der Goes' Portinari altarpiece (see fig. 357). More even than Filippino, Ghirlandaio must have admired this work, but not its disturbed emotional depths so much as the honesty and completeness with which every tiniest detail was rendered. The types and poses of his shepherds, of course, come straight out of the Portinari altarpiece, but the differences are instructive. For all his absorption in Netherlandish naturalism, the artist is a Florentine,

and he has assimilated the new discoveries into the overall monumentality, compositional harmony, and tonal balance of an Italian Renaissance altarpiece.

Ghirlandaio's major commission was the colossal series of frescoes filling the chancel of Santa Maria Novella, commissioned in 1485 to replace the badly damaged paintings by Orcagna, but finished only in 1490. The series was done for the wealthy Giovanni Tornabuoni, a relative by marriage of the Medici, and Ghirlandaio was under such pressure that he enlisted his whole shop in the undertaking, including possibly the thirteen-yearold Michelangelo Buonarroti. On one side the frescoes narrate the Life of Mary, on the other that of St. John the Baptist. Although the execution, especially in some of the uppermost scenes, is occasionally hasty, the compositions are the most brilliant of Ghirlandaio's career, supported by a beautiful architecture closely connected, like that in the Sassetti Chapel, with the personality and ideas of Giuliano da Sangallo and full of elaborate decorative detail. The Birth of the Virgin (fig. 363) takes place in a perfect Giuliano da Sangallo interior. St. Anne reclines on a bed that is surrounded by paneling inlaid with Roman designs, in which one can read both Ghir-

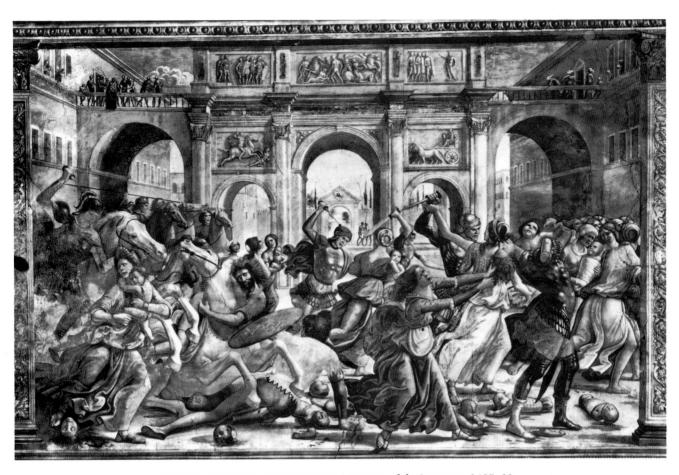

364. DOMENICO DEL GHIRLANDAIO. *Massacre of the Innocents*. 1485–90. Fresco. Cappella Maggiore, Sta. Maria Novella, Florence

landaio's family name and his nickname. The child is held by two attendants while a third pours water for her bath. Giovanni Tornabuoni's young daughter Ludovica stands there dispassionately with four attendant ladies, dressed in quiet splendor that surely violated the Florentine sumptuary laws. The details, including the frieze of putti, are painted with Ghirlandaio's hard-won precision of observation, smoothness of surface, and exact perspective consistency. The dignity and balance of the spatial composition certainly had a formative effect on Michelangelo.

An unexpected side of Ghirlandaio's nature is seen in the *Massacre of the Innocents* (fig. 364), a dramatic scene that takes place in front of a Roman triumphal arch based on the Arch of Constantine but not an exact rendering. The whole square is filled in the foreground with soldiers on galloping horses, an arrangement that was certainly influenced by Roman battle scenes, especially the Trajanic reliefs on the Arch of Constantine. The mothers clutch their babies, and the ground is littered with the bodies and severed heads of little children. While the details are unequal in quality, some passages show great power, foretelling in the violence of their

movements the battle scenes of the early Cinquecento.

Our farewell to Ghirlandaio might best be made with the universally loved portrait of an old man with a child, possibly his grandson, in the Louvre (colorplate 49). The subject has never been identified, although the deformed nose would seem to be easily traceable. There exists a drawing of the old man on his deathbed (once in Vasari's collection); probably Ghirlandaio used this drawing in the painting. All the best qualities of his art appear here—the honesty of detail, studied with such respect that it loses its ugliness; the inner gentleness of expression; the graceful light on the smooth and consistent surfaces; the brilliance of the color; the beauty of the distant landscape; and the strange rigidity and inflexibility of the elements of the composition, which combine a distinct archaism with all the studied naturalism of the artist's drawing.

The five authentic Florentine geniuses of the figurative arts, together with their innumerable imitators, bring to its close a century of unrivaled artistic fertility. But it is a real close—a blind alley, in fact. The new century found it necessary to make a new beginning and to move in a sharply different direction.

14 The Renaissance in Central Italy

he dominance of Florence did not mean that the Central Italian cities outside her political control felt obliged to imitate the artistic ideals of the Florentine Renaissance. The problems of Central Italian towns had little in common with the civic tasks considered urgent by the Florentines. Their trade was generally limited, their horizons personal. If these states escaped absorption by Florence—whose territorial ambitions were aimed largely at protecting the Arno Valley, from its headwaters to the sea—they fell under the sway of other powers, chief of which, in the second half of the century, was the papacy. The old communal form of government might linger on, but most towns owed their fealty to the States of the Church. This was true to a lesser extent even of some of the independent sovereigns of the region, such as the counts (later dukes) of Urbino and the lords of Rimini. Throughout the southern portion of Tuscany and the regions known (according to their designations in the modern Italian state) as Umbria, Latium, and the Marches flourished a number of local schools, and here and there emerged an occasional genius where there was no real school at all, in the manner of Gentile da Fabriano at the beginning of the century. The most important schools developed, naturally enough, in the two most populous centers, Siena and Perugia.

SIENA

By the early Quattrocento the bonds that formerly linked Siena with its Trecento confidante, Florence, had almost dissolved. Siena submitted to the temporary overlordship of Giangaleazzo Visconti of Milan, thereby outflanking Florence from the south. Against Guelph Florence, Siena supported the Holy Roman Empire, and was visited in state by the emperors Sigismund and Frederick III. At the end of the Quattrocento, the city was under the rule of a dictator, Pandolfo Petrucci. It is no wonder that Siena could show no Masaccio, no Brunelleschi; that for its artists perspective was a plaything rather than an instrument; that antiquity made a tardy

and fragmentary appearance in their work; that they were little interested in the Early Renaissance and less in the High Renaissance; and that they slipped into Mannerism without a qualm.

There is, of course, a major exception—Jacopo della Quercia (see pages 174-77)—that proves the rule, but even Jacopo worked as much in Lucca and Bologna as in his native city and, in the competition of 1402 for the doors of the Baptistery, made a valiant attempt to storm Florence (see page 158). We may wonder what the Florentine artists thought of Siena. Occasionally one went there. The reliefs contributed by Donatello and Ghiberti to the baptismal font in the Cathedral of Siena (see fig. 173) were soon, if a bit awkwardly, imitated by the Sienese artists. Donatello returned in the 1450s to do some of his finest late work for Siena, and a spark of that strange style caught fire in the minds of local sculptors. Bernardo Rossellino was called to Siena by the great Sienese humanist Aeneas Silvius Piccolomini, when he became Pope Pius II in 1458, for various architectural projects there and, as we have seen, in the Piccolomini village of Corsignano, rechristened Pienza (see figs. 232, 233).

There are many other contacts as well, one-way save for Jacopo della Quercia, but Siena in the Quattrocento went in its own Gothic direction. The patrons kept right on wanting pointed arches and gold backgrounds, and there is no record that the painters protested. They idolized their Trecento predecessors (see Chapter 4) to the point of making exact copies of their works. Yet these same painters were very close to nature. Almost without the usual intermediary of villas and suburbs, the open country began, and in places still begins, at the walls of Siena, with broad, low ranges of hills and spacious views, compared with which the steep slopes and greater heights that ring Florence seem constricting. Without the aid of Florentine science—by sympathetic vibration, so to speak, with the world around them-Sienese painters made certain discoveries about art, particularly about landscape, that were denied to the more systematic Florentines. In the tedium of his country town in southern Tuscany, even Piero della Francesca found much to learn from the Sienese.

SASSETTA

Before he left for Florence, Piero may well have met the greatest Sienese painter of the Quattrocento, Sassetta, who came to Sansepolcro in 1437 to contract for the altarpiece for the Church of San Francesco. Sassetta's masterpiece was in position in 1444, a year before Piero accepted the commission for his own great early work, the Misericordia altarpiece (see fig. 277). Stefano di Giovanni (c. 1400-1450), called Sassetta for unknown reasons, may have come from Cortona. The Sansepolcro altarpiece, its original elements now widely scattered, is his major work. It was freestanding; the front showed the Enthroned Madonna and Child between four saints in four separate panels. Eight panels illustrating scenes from the Life of St. Francis originally accompanied the St. Francis in Ecstasy on the back of the polyptych. Smaller panels, about whose places in the polyptych there is no universal agreement, have either turned up in different museums and collections or are being anxiously looked for.

To all who have stood in its presence, the St. Francis in Ecstasy radiates an inexhaustible mystery and beauty (colorplate 50). In its original position it was intended to be seen in the restricted space of a monks' choir, like the one Piero della Francesca was to decorate for San Francesco at Arezzo, and it must have exercised a commanding effect. In a pose strikingly similar to that Fra Angelico used for his transfigured Christ at San Marco (see fig. 213), St. Francis extends his arms as he glides miraculously over the sea. Like a statue from a cathedral portal, he stands upon prostrate Wrath, who is a crowned and bearded figure attended by a lion. To the left reclines Lust, a nicely dressed young lady, leaning on a boar and looking in a mirror. On the right Avarice, a shriveled old woman dressed in black and accompanied by a wolf, keeps her money bag in a rectangular press. Above the saint soar the Franciscan Virtues, shown as three dainty blond maidens, Chastity with her lily, Poverty dressed in rags, and, in the center, Obedience with her yoke. The inscription on St. Francis's halo apostrophizes him as Patriarch of the Poor.

In the saint's pose and expression, rapture and calm appear in perfect accord. The forms of the drapery and the limbs beneath are modeled in broad, clear-cut masses by a light source from above. Their weight and thickness are emphasized to the point where we are tempted to suppose that Sassetta had been to Florence and studied Giotto and even Masaccio. The features are equally sculptural, but the head as a whole is curiously projected. Sassetta, in a still-Byzantine fashion, has used the bridge of the nose for the center of the face. But a circle described from this point corresponds only to the

365. SASSETTA. *Marriage of St. Francis to Lady Poverty*, from the back of the Sansepolcro altarpiece. 1437–44. Panel, 34%×20½". Musée Condé, Chantilly

inner circle of the halo, and of this the forehead and hair fall short, apparently a device to indicate that they were tilted back. When we approach more closely, we fall under the spell of the old Sienese linearism: what appear to be wrinkles in the saint's forehead, temples, and cheeks are drawn as artificially parallel curves, moving in elliptical, parabolic, or figure-of-eight patterns with dizzying effect.

Around the saint blazes a mandorla composed of red seraphim with interlocked wings, a traditional Trecento device. These have largely peeled away from the gold background, but originally their effect must have been striking. The gold is really a sky rather than an inert ground, for the shore with its bare hills and towers appears many miles away, in the golden air through which

366. SASSETTA. *Pact with the Wolf of Gubbio*, from the back of the Sansepolcro altarpiece. 1437–44. Panel, 345/8 × 201/2". National Gallery, London

we are transported. The words "medieval" and even "Oriental" are often pronounced before this picture. It is true that many echoes of Simone Martini and the Lorenzetti linger on and that a mysterious affinity seems to lead us to Chinese Buddhist sculpture of the finest periods. None of these resemblances, however, should blind us to the essential: that without reference to Florentine perspective, Sassetta has created distant space into which his landscape elements convincingly recede, and has set a solid, reasonably illuminated figure in front of, in fact partially within, this space. These are Renaissance elements, and they place Sassetta, from his vantage point within the walls of Siena, in tacit harmony with what was then going on in Florence.

In the smaller scenes Sassetta gives free rein to his

imagination and his perception of space. The Marriage of St. Francis to Lady Poverty (fig. 365) first shows the saint stepping happily forward to place a ring on the finger of the central one of three gentle damsels who stand before him; then the three float off for celestial regions, their attributes (especially the yoke of Obedience) silhouetted against the sky, while Poverty turns a nostalgic glance backward toward her bridegroom. The subtly flattened curves of the three Virtues, in both their apparitions, harmonize with the shape of the trefoil Gothic frame. At the lower right Sassetta makes an obeisance to Duccio in the shape of a little city that might have come right out of one of the panels of the Maestà (see fig. 92). But between St. Francis and the Virtues a long white road runs across the checkered valley floor to branch into curves among distant ranges—not just a backdrop, but real mountains, which loom before us with distinct personalities and their own aura of shadow, their contours rippling in the evening air. No Florentine, not even Fra Angelico, had achieved so compelling a sense of natural space.

The Pact with the Wolf of Gubbio (fig. 366) shows St. Francis taking the right front paw of a fearsome wolf, which he had persuaded to renounce devouring the inhabitants of the city in favor of a steady and harmless diet to be provided for him at public expense. Below the city gate, which looks like one of those in Siena (Sassetta had doubtless never been to Gubbio), sits a notary, holding the pact ready for the wolf's signature. The authorities of the town gather before the gate in wonder and thanksgiving, while the women and children peek less trustingly between the machicolations. The road leading into the forest is bordered by well-cleaned bones, and by two foreshortened fragments remaining from the wolf's latest meal. Again Sassetta, along with the narrative whimsy, has given us an experience of infinite landscape depth. We look past the rocky shoulder to the remote horizon, punctuated by the towers of two Sienese towns. Many a traveler along the Via Cassia has seen the towers of Montalcino and San Quirico d'Orcia rise like this. Most striking of all, Sassetta has included a flight of cranes in formation high in the blue, to indicate great distance by contrast. This device was not to be used systematically until the days of Jacob van Ruisdael in the seventeenth century.

GIOVANNI DI PAOLO

The slender figures, pinched features, and button eyes so charming in Sassetta's paintings are reduced to the point of caricature by his prolific contemporary Giovanni di Paolo (1403?–83). We do not know which of the two was the older. There was a Giovanni di Paolo born in 1403, but hundreds of people must have shared that name in Siena in the early Quattrocento. Our artist was painting in 1420—not uncommon for a seventeen-year-old in the Renaissance, but unlikely. In the course of his long life he painted enough to fill two galleries in the

Pinacoteca at Siena, not to speak of altarpieces scattered throughout the town and the contado, and his paintings turn up in collections throughout the world. When one becomes used to the artist's acidulated style, which gets coarser and wilder as he grows older (admittedly most of the dates published for his activity are sheer caprice), it becomes unexpectedly pleasant, and the fantasy and color are irresistible. Giovanni copied Ambrogio Lorenzetti and purloined from Ghiberti, Donatello, Lorenzo Monaco, and Fra Angelico. But after such masterpieces as the Madonna and Child in a Landscape in the Boston Museum of Fine Arts (fig. 367), we can forgive him anything. Mary sits upon a cushion in a flowered clearing surrounded by a splendid orange grove, suggesting that Giovanni had already seen Uccello's Battle of San Romano panels (see colorplate 31, fig. 263). In the background a landscape, whose perspective orthogonals stubbornly refuse to converge, stretches off to the crack of doom, giving forth rippling waters and checkerboard fields that alternate at intervals with sugarloaf hills, recalling the Urbino portraits by Piero della Francesca, which Giovanni may also have known (see colorplates 38, 39). On the basis of costume alone, the panel and its replica (or prototype?) in Siena could not be dated earlier than the 1460s.

Both the archaistic charm of Giovanni di Paolo and his magpie borrowings are abundantly visible in the panels

367. GIOVANNI DI PAOLO. *Madonna and Child in a Landscape* (*Madonna of Humility*). c. 1460s. Panel, 22 × 17".

Museum of Fine Arts, Boston (Marie Antoinette Evans Fund)

368. GIOVANNI DI PAOLO. St. John Entering the Wilderness. Mid-15th century. Panel, $27 \times 141/4$ ". The Art Institute of Chicago (Mr. and Mrs. Martin A. Ryerson Collection)

of the Life of St. John the Baptist, which he painted for a still-unknown purpose at some time about the middle of the Quattrocento. In the scene showing *St. John Entering the Wilderness* (fig. 368), in the Art Institute of Chicago, two episodes are superimposed. First we see the little St. John stepping bravely out of a Sienese city gate that sharply recalls both Duccio and Simone Martini in every detail of architecture and rendering. He gazes out on a cultivated plain made endless by Giovanni's characteristic device of what we might call one-legged perspective—orthogonals that never meet. Up above, the world suddenly bursts into wild, flamelike mountains, directly imitated from those depicted with such vivid effect by Lorenzo Monaco in the opening years of the century (see

fig. 125). The two episodes are separated by no more than a tiny grove of distant trees, producing the effect of a sudden and disconcerting change in scale and in landscape character as the eye moves up the panel.

DOMENICO DI BARTOLO

A somewhat less attractive figure but the first Sienese painter whose relation to the Florentine Renaissance can be measured in terms of specific elements is Domenico di Bartolo (c. 1400-47). The influence of Masaccio is very apparent in Domenico's Madonna of Humility (fig. 369) in the Pinacoteca in Siena, probably, judging by its modest size, painted for a private patron. The representation of the Madonna seated low upon a cushion is a Sienese invention that has been traced back to the immediate entourage of Simone Martini and thus quite possibly derives from that master himself. But by the early Quattrocento it was very widespread and could be found

369. DOMENICO DI BARTOLO. Madonna of Humility. 1433. Panel, 365/8 × 231/4". Pinacoteca, Siena

not only in Florence but also in North Italy. Domenico has packed his frame as tightly as possible with figures of Masaccesque bulk, projected in perspective. The cartellino (scroll) in the foreground, at the bottom of which he has written that he "painted and prayed to" this Madonna in 1433, antedates any such cartellino we have in the work of Paolo Uccello (see colorplate 31). Some of the faces and hands strikingly resemble those in the paintings of Fra Filippo Lippi dating five years or so later (see figs. 215, 216), so that we can mentally reconstruct, on the basis of Domenico's picture, the lost early style of Fra Filippo. Domenico's attempt at Masaccesque rudeness does not succeed. His basically Sienese linearism requires that every shape be surrounded by a clear, unbroken contour, which largely negates the effect of the Florentine modeling. The Christ Child stuffs fingers into his mouth, instead of grapes, and the angels with their elaborate curls and solemn faces have nothing to do with Masaccio's ragamuffins. Moreover, the coloring shows the pearly, silvery quality that is one of the most appealing traits in much of Sienese Quattrocento painting.

Domenico's major surviving achievement is his series of large frescoes painted from 1440 to 1447 on the walls of the Pellegrinaio, a receiving ward still in use in the Sienese Hospital of Santa Maria della Scala. No such continuous Florentine fresco cycle survives between the Brancacci Chapel and Fra Filippo's Prato frescoes, and our interest in Domenico's series is heightened by their secular subjects, dealing with the charitable and civic as well as the medical activities of the hospital. The arched frames are determined by the Gothic vaulting above. Through them we look, as through windows, straight into the fifteenth century. The perspectives are controlled in an Albertian sense except for the tilted floors. Often the viewpoints are taken from within the rooms of the hospital and show decorations still in place today, or allow us to look through the door across the square to the portal of the Duomo of Siena. Even the invented architecture in some of the frescoes is so cut up by represented marble incrustations that it harmonizes with the actual architecture of the Pellegrinaio.

In their unabashed naturalism the frescoes recall less the formally organized compositions of the early Florentine Renaissance than the more freely arranged and topical paintings of the Netherlands, with all their wealth of imagery drawn from contemporary life. In their character as window views into actual space, Domenico's hospital frescoes are direct ancestors of the fresco series in the Piccolomini Library, only a few hundred yards away at the opposite corner of the Duomo, painted by Pintoricchio during the opening years of the Cinquecento (see colorplate 52), just as in their naturalism and free disposition of figures they are forerunners of the narrative method of Domenico del Ghirlandaio in the 1480s (see figs. 361-363). This may not be entirely accidental, as among Ghirlandaio's earliest important commissions

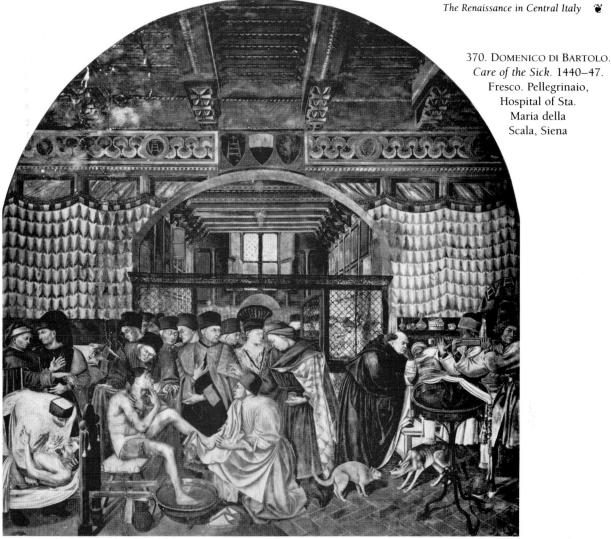

was a frescoed chapel in nearby San Gimignano. Even Domenico's figure style has shed its Florentine monumentality yet, interestingly enough, has not reverted to the archaisms of Giovanni di Paolo or of Sassetta. In the scene representing the Care of the Sick (fig. 370), Domenico displays at once a portrait realism that would have pleased Castagno and a sensitive treatment of the nude figure. The sick man being placed in bed at the extreme left and the wounded man next to him being washed must rank among the most convincing figure paintings of the Quattrocento.

MATTEO DI GIOVANNI

The Sienese painters of the next generation absorbed the details of Renaissance architectural backgrounds without the spirit of Renaissance architecture, and the mannerisms of Botticelli without his grace. Their awkwardness, to modern eyes, is nonetheless endearing, and it must be admitted even by those who find their rigidity repellent that these are not provincial masters. In their self-imposed isolation, they treat the Florentine inventions with a certain cunning, inverting them to achieve the poetic purposes of their art. One of the most subjective of these masters of the late Quattrocento is Matteo di Giovanni (1435?-95), whose family came from Sansepolcro, where Matteo himself may have been born. He was certainly brought up in Siena, however, and by the 1470s maintained a very productive shop there. Matteo is best known for his four monumental images of the Massacre of the Innocents, three for Sienese churches and one for the pavement of the Duomo. It has often been suggested that the popularity of this gory subject at just that moment is due to the massacre of Christian children by the Saracens at Otranto in South Italy in the year 1480. Even if true, this contention could hardly account for the existence of so many representations of the incident by a single painter if he had not already shown some inclination for such subjects. Matteo's Massacre of the Innocents (fig. 371) painted in 1482 for the Church of Sant'Agostino in Siena is fairly typical. The ponderous arches and strong, modified Corinthian columns of the setting in Herod's palace suggest that Matteo had been to Rome. It will be recalled that, only a few years later, Ghirlandaio set his Santa Maria Novella Massacre of the Innocents (see fig. 364) in front of a Roman triumphal arch. But Matteo has left no foreground space. Every cu-

371.
MATTEO DI GIOVANNI.
Massacre of the Innocents.
1482. Panel, 95 × 94½".
Sant'Agostino, Siena

bic inch of Herod's hall is occupied by screaming mothers, dead or dying babies, and bloodthirsty soldiers. Even the marble pavement is carpeted with infant corpses, among which the figures trample horribly. Impassive courtiers flank Herod's throne, but the gloating king himself is a monster: one trembling hand is outstretched to order the butchery; the other, tense, clutches the marble sphinx on the arm of his throne. From the stair rail beyond a metal grille, children watch the slaughter with open delight. Of all the lifelike faces in the group, the head of a soldier near the right-hand column is the most arresting because he pauses in his bloody task to look straight at the spectator, with all the revelatory quality of a self-portrait. Can this be Matteo himself, glorying in his holocaust? Sensitive observers have noted, however, that Matteo's pictures are more innocent than they appear at first sight. The little bodies are stabbed but not mutilated, and the swords are raised above the children as in a nightmare. Only in a single instance, before Herod's throne, does a weapon penetrate a child, through the mouth (Ghirlandaio was far more explicit). The horror is unreal and intended to be

so. For all the contorted quality of the poses, the drawing is sometimes beautiful, and so is the color—the same smothered reds, soft golds, and blues one finds throughout Matteo's work.

VECCHIETTA

The visits of the Florentine sculptors Donatello and Ghiberti and the intermittent presence of the Sienese Jacopo della Quercia provided the impetus for a considerable school of Sienese sculptors. It is ironic that one of the most memorable of these, Lorenzo di Pietro, called Vecchietta (1412–80), was far more prolific if less exciting as a painter. He seems to have been involved at an early age in the frescoes at Castiglione Olona, picked up elements from the great Florentine painters at midcentury, and executed one of the frescoes in the Hospital of Santa Maria della Scala. However, he is most strongly remembered for a vivid Risen Christ (fig. 372), which he did for his own tomb chapel at Santa Maria della Scala. The bronze figure, harrowing in its insistence on such realistic details as the network of swollen veins that ornaments legs, arms, and torso, betrays in exaggerated form the sinuous grace of Ghiberti and the expressionism of the late Donatello. No finer statue exists from the second half of the Quattrocento in Siena. The extent of the artist's own personal involvement is evident from the touching petition he addressed to the hospital officials in the last days of 1476 that he might be permitted to place the statue in his chapel. Perhaps for this very reason he was enabled to break the fetters of stylistic archaisms and borrowings that generally bind him and to produce so compelling a witness of late Quattrocento religiosity.

FRANCESCO DI GIORGIO

Siena's equivalent of the multifarious Florentines, who so often combined excellence in two arts, was Francesco di Giorgio (1439–1502), who did well at three. He was, in fact, the only Sienese Quattrocento artist save Jacopo della Quercia to acquire standing in other portions of

372. VECCHIETTA. *Risen Christ.* 1476. Bronze, height 6'. Sta. Maria della Scala, Siena

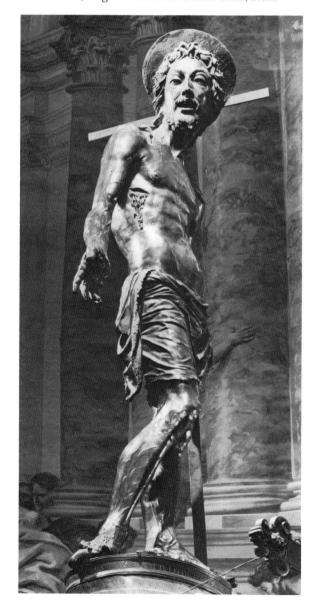

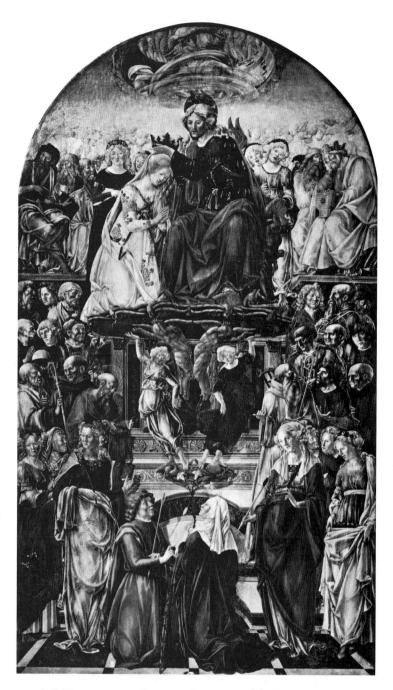

373. Francesco di Giorgio. *Coronation of the Virgin*. 1471. Panel, 11′ × 6′6″. Pinacoteca, Siena

Italy, for he worked at the courts of Urbino, Naples, and Milan, in which latter metropolis he became acquainted with and was certainly influenced by Leonardo da Vinci. Of his numerous paintings one of the most impressive is the huge *Coronation of the Virgin* (fig. 373); it is probably identical with an altarpiece on this subject painted by Francesco in 1471 for the Benedictine monastery of Monte Oliveto Maggiore, situated in wildly eroded country a score or so miles from Siena. The spatial composition of the towering altarpiece is difficult but by no

means impossible to unravel. A marble floor recedes to a flight of steps, which ends in a wall articulated by pilasters and paneled in veined marble. The floor and the steps are crowded with kneeling and standing saints, not all of whom are identifiable. On the top of the wall sit prophets, among whom St. John the Baptist is placed. In midair floats a platform composed entirely of cherub wings and heads, supported by floating angels and cherubs, and on the platform Mary kneels to receive her crown from Christ. Above the heads of these sacred figures one sees a weirdly foreshortened figure of God the Father, feet first, surrounded by a spinning cloud that has been identified with the *primum mobile* as described by Dante. Around God are seven concentric circles, which are the seven heavens, each connected with a planetary sign from the zodiac. At the apex of the altarpiece, inside the highest circle, one is taken aback to find a voluptuous array of female nudes, but it seems that Dante claimed that the final heaven, or empyrean, was pieno d'amore ("full of love").

However well Francesco may have been able to manage perspective in his architectural backgrounds, he has almost renounced it in this complex composition, intended to stand as a synopsis of the Christian universe,

374. Francesco di Giorgio. Flagellation. Late 1470s. Bronze, 22 × 16". Galleria Nazionale dell'Umbria, Perugia

including nine hierarchies of angels and eight of souls. In spite of the developed Renaissance drawing and modeling of the figures and their drapery, the general effect is that of an abstract schema, like Duccio's *Maestà*, which nobody in Siena ever quite forgot (see colorplate 12). The mournful faces and staring eyes are as characteristic of Francesco's paintings as are the halting linear flow in drapery and hair and the delicately awkward posing of necks and hands. The eye-smiting color of the work, dominated by reds and orange-reds and several shades of bright blue, must have exercised a tremendous effect in the interior of the church at Monte Oliveto Maggiore.

Francesco's sculpture shows an even closer acquaintance with the great Florentine masters, not only Donatello and Ghiberti, who had intimate connections with Siena, but also the very latest—Antonio del Pollaiuolo. The dazzling Flagellation relief (fig. 374)—probably modeled and cast in bronze for Federico da Montefeltro during Francesco's stay in Urbino in the late 1470s may have provided a model for the seated Herods of the four versions of the Massacre of the Innocents by Matteo di Giovanni. That is, however, the least of its merits. The relief is so advanced in style that the first scholar to notice it attributed it to Vincenzo Danti (see page 658), a sculptor of the middle of the Cinquecento; it is so high in quality that other competent critics gave it to Bertoldo di Giovanni (Donatello's pupil), to Verrocchio, and even to Leonardo da Vinci himself before its authorship and probable date were determined by comparison with known sculptures by Francesco di Giorgio. The relief provides a striking contrast to the quiet Flagellation by Piero della Francesca (see colorplate 37), also for Urbino.

The extraordinary spatial impression, obtained by the recession of architectural masses on either side and by the dominant central portico, goes back to Ghiberti's reliefs on the Gates of Paradise (see colorplate 30, fig. 236). But the free handling of the surface of the clay, left rough and sketchy after its translation into bronze, is derived from Donatello's late relief style. The tormented pose of Christ, with his head thrown back and his legs bent, and the yelling executioner moving at the limit of his powers suggest the wild poses and expressions of Pollaiuolo, not only in his paintings but also in his Hercules and Antaeus group (see fig. 324). The graceful position of the almost nude figure at the right, leaning on a spear, is one of the finest sculptural conceptions of the Quattrocento. It has been noted that the figures seated on the steps are a compositional device picked up later by Raphael and by Andrea del Sarto. Altogether the relief is an extraordinary piece of work, in conception and in execution; its only fault, perhaps, lies in its abrupt jumps from low to high projection.

The buildings Francesco portrays are new in style, and so were those he designed and built. The most striking feature of the palaces that form the background of the

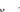

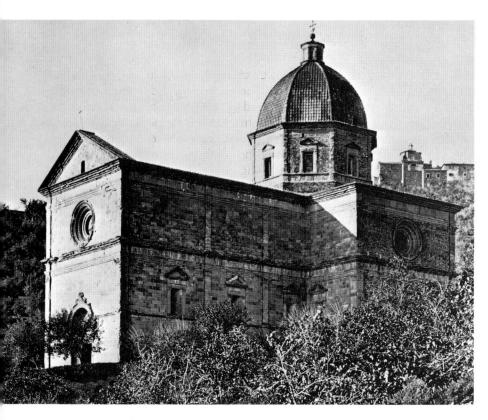

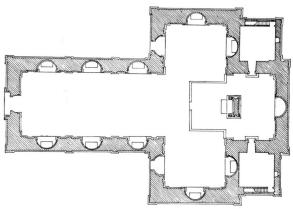

Flagellation is that they are conceived as single-story structures, crowned by unusually deep and handsome entablatures and raised on ground stories treated like gigantic podia. In contradistinction to the three-story palaces characteristic of Florence itself-and other cities, whether or not directly imitating Florence— Francesco has emphasized what is later to be known as the piano nobile ("noble story"), often provided with handsome balconies from which the inhabitants could survey the street below. This type seems to have been Francesco's invention. Bramante, greatest architect of the Roman phase of the High Renaissance and himself a citizen of Urbino, doubtless received the idea from Francesco. Second in importance is the great emphasis given to the windows. No longer are they merely openings in a rusticated wall—in fact rustication itself is abandoned; they are, rather, independent tabernacles, possessed of their own sharply projecting frames, sometimes even consisting of lateral pilasters supporting a pediment and resting upon a continuous cornice. These, too, were taken up by Bramante, Raphael, and Antonio da Sangallo the Younger in their Roman palaces and by Michelangelo, and they remain a constant feature of monumental architecture through the Baroque period.

Some of the grandest constructions of the late Quattrocento and early Cinquecento were the sanctuaries destined to enshrine miracle-working images of the Virgin. Giuliano da Sangallo's Santa Maria delle Carceri in Prato (see figs. 313–315) was such a sanctuary, and so was Francesco di Giorgio's major building, the huge Church of Santa Maria del Calcinaio (fig. 375), in an olive grove on a slope leading up to Cortona, and offer-

above left: 375. Francesco di Giorgio. Sta. Maria del Calcinaio, Cortona. Begun 1484–85; completed 1515

above right: 376. Plan of Sta. Maria del Calcinaio, Cortona

below: 377. Francesco di Giorgio. Interior, Sta. Maria del Calcinaio, Cortona

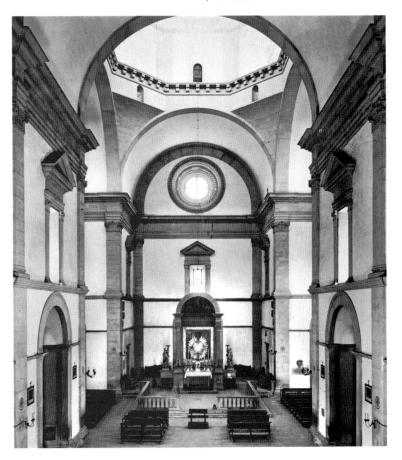

ing views of exceptional beauty over the Chiana Valley. A miraculous image was found there by a limeburner in 1484, and the influx of pilgrims at once became so great that Francesco was called upon to design a church large enough to contain them, impossible for a central-plan building, such as had come into fashion in the 1480s. The church was not completed until 1515, long after Francesco's death, but the initial phases of the construction seem to have proceeded rapidly, as there was already enough to dedicate in 1485. The shape is a Latin cross (fig. 376) whose nave is composed of three bays of diminishing width in order to increase the apparent depth of the church as seen from the entrance. The flexibility of proportions is made possible by Francesco's daring abandonment of the usual articulation of a church in terms of arcades or colonnades. His is a lofty two-storied hall, roofed by a barrel vault (fig. 377) as in another great pilgrimage church, Sant'Andrea at Mantua (see fig. 229), and articulated by pilasters; the lower section of each pilaster is flat and unmolded, so that it is read as a mere strip, while the upper section is a complete, modified Corinthian order, upholding the same kind of entablature and cornice one sees in the sculptured palaces of the Flagellation. Thus, although the ground-story niches suggest the arches of the characteristic nave arcade, their function seems that of supporting the piano nobile, to which all attention is directed. The tabernacle windows, identical inside and outside, with their sharply projecting pediments, are the direct ancestors of the powerful tabernacles that play so important a role in the architecture of Michelangelo (see fig. 578). The four ends of the cross are equally flat, the entablature runs unbroken around the entire church, the walls and barrel vaults are unrelieved in their plain white intonaco and therefore suggest a space even larger than the one they actually enclose. The tabernacles in pietra serena, therefore, operate as independent sculptural entities, active within an apparently limitless expanse of white. The dome is octagonal, supported on a peculiar compromise between Renaissance pendentives and Romanesque squinches, but even these are no stranger than the fact that the four arches penetrate the octagonal drum, a device that increases the apparent height of the building.

In his paintings, more in his sculpture, and most of all in his archaeological drawings, theoretical investigations, and architectural creations, Francesco di Giorgio emerges from archaistic Siena into an all-Italian arena. A similar course, leading from provincial isolation to strong influence upon other centers, is followed by the Quattrocento School of Perugia.

PERUGIA

Since 1701 Perugia has been the capital of the region of Umbria. In the Middle Ages and the Renaissance, however, the name "Umbria" was little known, having lapsed with the dissolution of the Roman Empire. In ancient

times Perugia was an important Etruscan center and belonged to Etruria. In the Middle Ages the communal government asserted itself against the duchy of Spoleto, and in the Renaissance Perugia came under the control of the Baglioni family while owing ultimate allegiance to the papacy. In the rhymed chronicle by Giovanni Santi, the father of Raphael, dating from 1478, Perugia is in Etruria (Tuscany). The designation "Umbrian" for Perugia is therefore avoided in this book.

Perugia, one of the most spectacular medieval cities still preserved in Italy, stands on the top of a near-mountain, dominating a considerable section of modern Umbria and southern Tuscany. Although the city embellished itself with a number of splendid buildings, and although the most important Roman, Florentine, and Sienese painters worked at nearby Assisi, Perugia did not produce an important school of painting in the Dugento or the Trecento. Its finest work of sculpture before the Quattrocento was the Fontana Maggiore, the great fountain carved by Nicola Pisano and his assistants. But in the 1430s the presence of Domenico Veneziano in person and of a notable altarpiece by Fra Angelico (who may well have visited the town)—not to speak of the activity of Benozzo Gozzoli at nearby Montefalco in the early 1450s—awakened local masters to the new achievements of Florentine art.

PERUGINO

The leading painter of the Perugian School was Pietro Vannucci (c. 1445-1523), who may have been born in Città della Pieve but is known today simply as Perugino ("Perugian"). He it was who brought the city from artistic obscurity to considerable influence and, as the respected teacher of Raphael, may be said to have had a hand in the shaping of the High Renaissance. Where Perugino received his earliest artistic training is not known, but as early as 1472 we find him in Florence, where he is listed as a member of the Company of St. Luke. He may have worked with Verrocchio for a while, and certainly absorbed Florentine notions of perspective and figure drawing; but he rapidly developed a distinctive style, although not all aspects of this style are admirable. Today Florentines can be heard mentioning Perugino's name with a touch of scorn, because he had little or no feeling for religious subjects (Vasari said he was an atheist) and tended to reduce figure types to routine patterns. Nonetheless, Perugino became the master of a kind of spatial composition unknown before his day and inaccessible to the more intellectual Florentines.

The principles and effectiveness of Perugino's space composition are already evident in his first major work, the Giving of the Keys to St. Peter (colorplate 51), painted in 1481 for the Sistine Chapel as a part of the program of decoration commissioned by Pope Sixtus IV. Perugino has recently been credited with the supervision of the entire cycle because he painted not only this subject of

primary importance to papal claims, but also other crucially placed scenes, and the altarpiece as well. In point of fact, none of the painters called to Rome in 1481 had had much experience with monumental frescoes and all were relatively young; the impression of consistency among the frescoes may result (as we have seen, page 327) partly from overall supervision by the papal court, partly from the good taste and common sense of the artists themselves, willing to work together in the interest of the success of the principal pictorial undertaking of the decade. Perugino was asked to represent the moment when Christ gives to St. Peter the keys to Heaven and Earth, and the structure in the center of the vast piazza behind the figures is doubtless intended to represent the Church, founded on the rock of St. Peter. It is flanked by triumphal arches, modeled on that of Constantine but with a few added and not-too-classical embellishments, including three candlesticks on each arch, suggesting the candlesticks that, since the thirteenth century, had a definite place on Christian altars and are often represented there (six appear on the altar in the St. Francis cycle in Assisi, prepared for the saint's canonization, five were on the high altar of the Cathedral of Siena in 1439, and four appear on the altar of the predecessor of the Sistine Chapel, in a manuscript representation of about 1470– 80). These arches bear inscriptions that compare the building achievements of Sixtus to those of Solomon. In the middle ground the scene in which Christ says "render unto Caesar that which is Caesar's" is shown to the left; to the right is the stoning of Christ, who according to the Gospel of St. John hid himself, then passed through the midst of his assailants.

The all-embracing perspective of the piazza is constructed more or less according to Alberti's system, although with larger squares than those he recommended. It recalls, in fact, the contemporary drawing by Leonardo da Vinci for the Adoration of the Magi (see fig. 456), a scheme that, as we shall see in Chapter 16, Leonardo eventually abandoned. The drawing and projection of figures and drapery masses are everywhere deeply indebted to Florentine doctrine, with echoes of important painters and sculptors from Masaccio to Verrocchio. The cool precision of the unsparing contemporary portraits (fig. 378) is not excelled even by Ghirlandaio. And the ideal church blends elements drawn from Brunelleschi's dome and the Florentine Baptistery (see figs. 132, 85). Yet the effect of the fresco is strikingly un-Florentine, for that matter un-Sienese. The word that occurs to us automatically as we contemplate Perugino's composition is "openness." Florentine spatial compositions always appear circumscribed, by the frame itself, by figures, or by architecture. Perugino allows the eye to wander freely through his piazza, filled with little but sunlight and air, open at the sides so that we can imagine its continued indefinite extension. No such immense pavement, of course, was ever built or even contemplated in the Ren-

378. PERUGINO. Head of a Man, detail of *Giving of the Keys to St. Peter* (see colorplate 51). 1481. Fresco. Sistine Chapel, Vatican, Rome

aissance; it would have been useless, impractical, and in bad weather intolerable. But in Perugino's painting it provides a refreshing sense of liberation from material restraints, as if the spectator could glide freely in any direction. The perspective is truncated by the distant building so that it cannot be accurately followed to the vanishing point. Its inward motion dissolves, rather, in the low hills on the horizon, which substitute their gentle curves for the severe orthogonals of the piazza. The hills diminish so as to form the bowl landscape believed to be a characteristic of the art of the region, but which is in fact restricted to the paintings of Perugino and his immediate followers. That this is really the landscape one sees from Perugia, or in fact anywhere in presentday Umbria, may be debated. But that a painter with Perugino's extraordinary sensitivity to space might be strongly affected by the flightlike liberation of the views stretching out from the heights of Perugia is more than possible. At any rate, an open space, intuitively perceived rather than rationally organized, is the hallmark of his style.

Perugino's figures, moreover, are only superficially Florentine. They stand with a natural ease, an absence of tension that was never achieved in the work of any Quattrocento Tuscan. The weight is generally placed on one

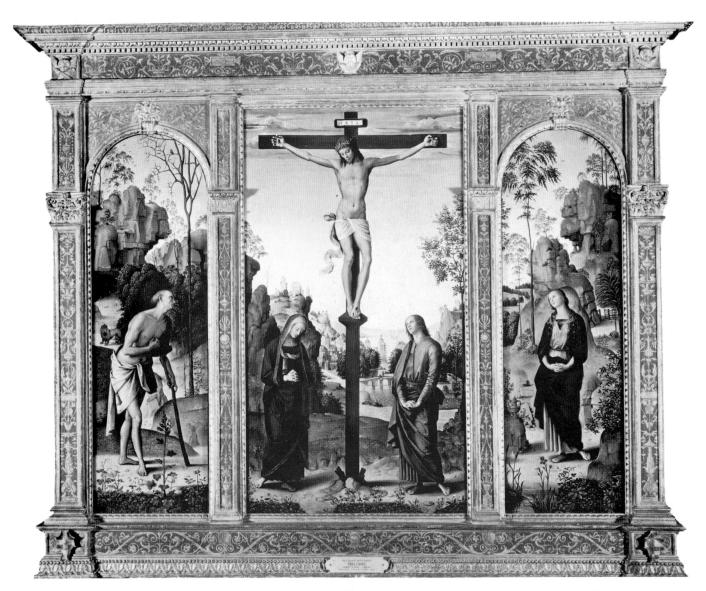

379. PERUGINO. *Crucifixion with Saints*. Before 1481. Panel, transferred to canvas: center, $40 \times 22 \frac{1}{4}$; laterals, each $37\frac{1}{2} \times 12$ ". National Gallery of Art, Washington, D.C. (Mellon Collection)

foot, the hip slightly shot, the knee bent, the head tilted, so that the figure seems to unfold gently upward like the growth of a plant. Raphael was to adopt this S-shaped figure principle from Perugino, and it was to survive, in altered and spatially enriched form, to the very last phases of his art. Perugino's figures, like those of the other collaborators in the Sistine frescoes, occupy only a shallow foreground plane, but they detach themselves much more strongly from the distant space than do those of the other masters in the chapel. The simple grace of their stance makes their drapery flow more smoothly, and in consequence a soft and very agreeable looping motion carries the eye almost effortlessly across the foreground from one graceful figure to the next.

One of Perugino's most successful altarpieces, the Crucifixion with Saints in the National Gallery of Art in

Washington, D.C. (fig. 379), probably dates from before Perugino's activity in Rome and shows considerable influence from the Netherlands, particularly the finished, cool, perfect style of Hans Memlinc. The triptych differs from Florentine representations of the Crucifixion in the absence of the usual emotions. Christ hangs calmly on the Cross, in fact seems almost to stand on the footrest; Mary looks downward, St. John looks upward, and neither betrays a trace of grief, any more than does St. Jerome in the left panel or Mary Magdalen in the right. We are startled, moreover, to notice that Mary Magdalen's pose is almost a carbon copy of St. John's: there is no difference between them, save for a slight change in the position of the clasped hands. Perugino seems to have made a pattern book of stock poses for saints and to have repeated them uncritically and endlessly, not only from

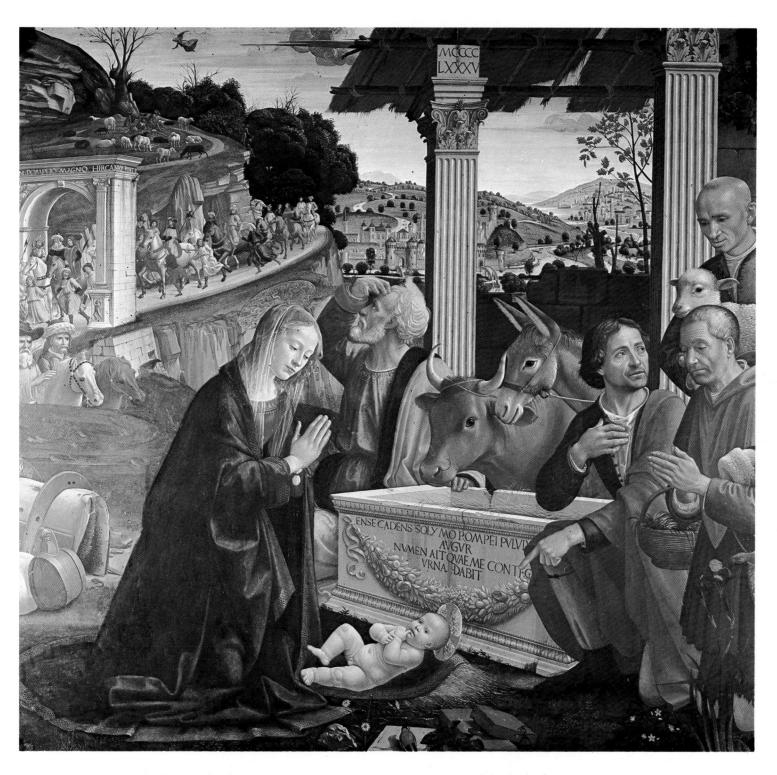

Colorplate 48. DOMENICO DEL GHIRLANDAIO. Adoration of the Shepherds. 1485. Panel, 65¾" square. Sassetti Chapel, Sta. Trinita, Florence

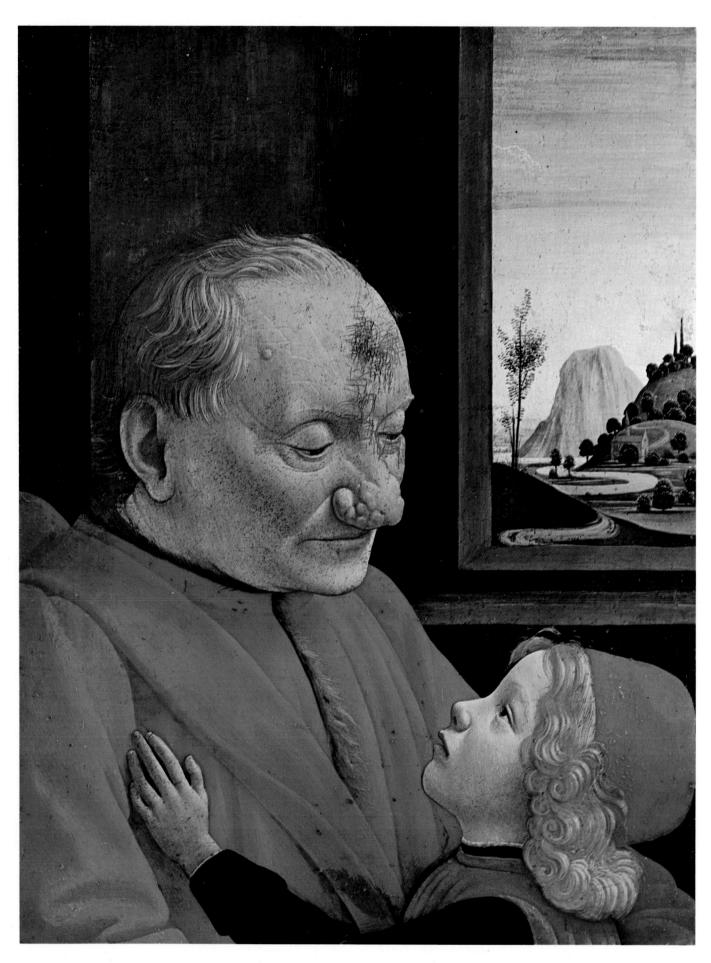

Colorplate 49. Domenico del Ghirlandaio. Old Man with a Child. c. 1480. Panel, $24\% \times 18\%$ ". The Louvre, Paris

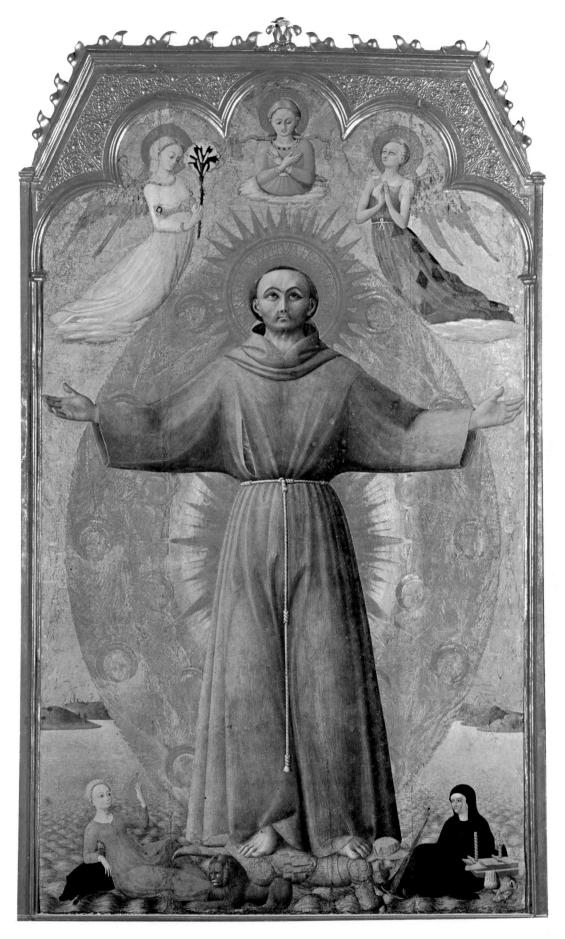

Colorplate 50. SASSETTA. *St. Francis in Ecstasy*, from the back of the Sansepolcro altarpiece. 1437–44. Panel, 80½×48″. Berenson Collection, Villa I Tatti, Florence. (Reproduced by Permission of the President and Fellows of Harvard College)

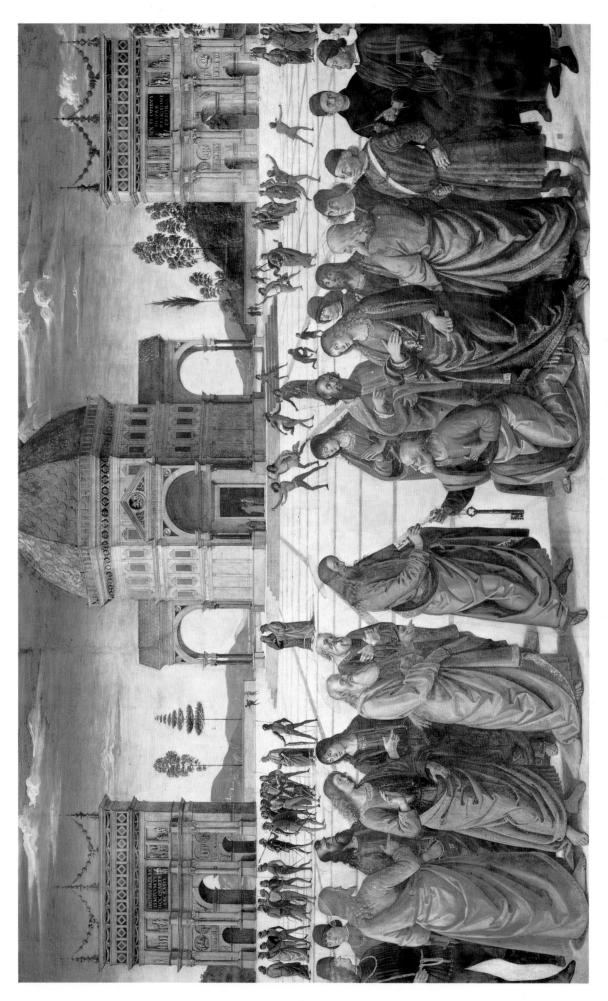

Colorplate 51. PERUGINO. Giving of the Keys to St. Peter. 1481. Fresco. Sistine Chapel, Vatican, Rome

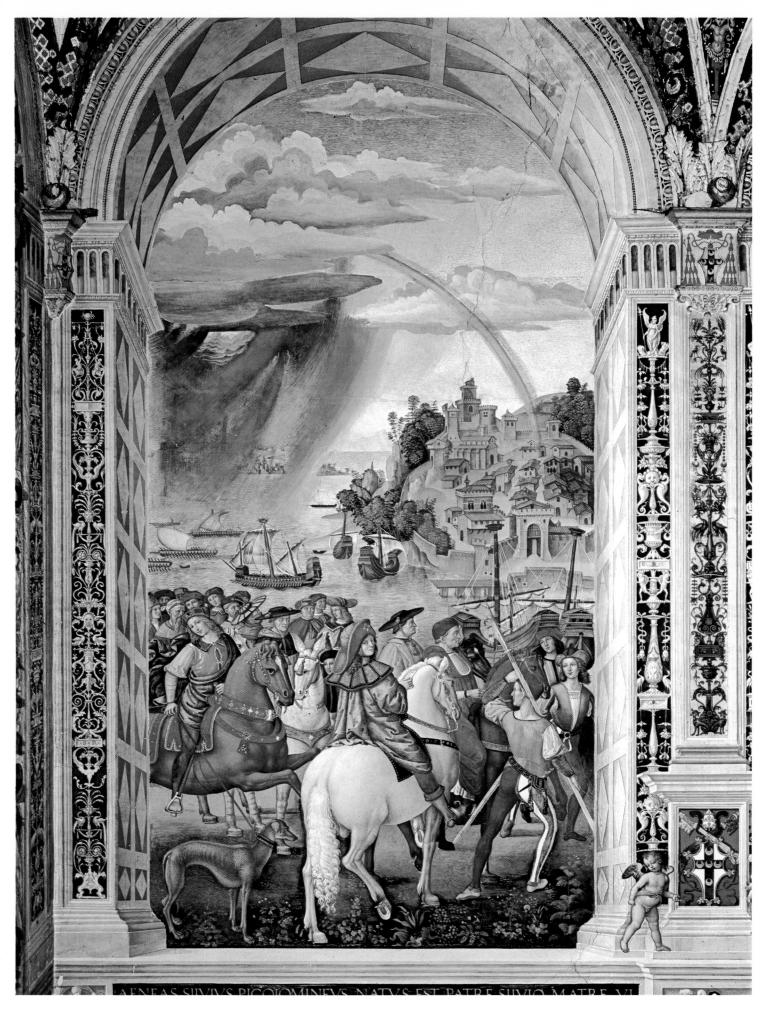

Colorplate 52. PINTORICCHIO. *Departure of Aeneas Silvius Piccolomini for Basel.* 1503–8. Fresco. Piccolomini Library, Cathedral, Siena

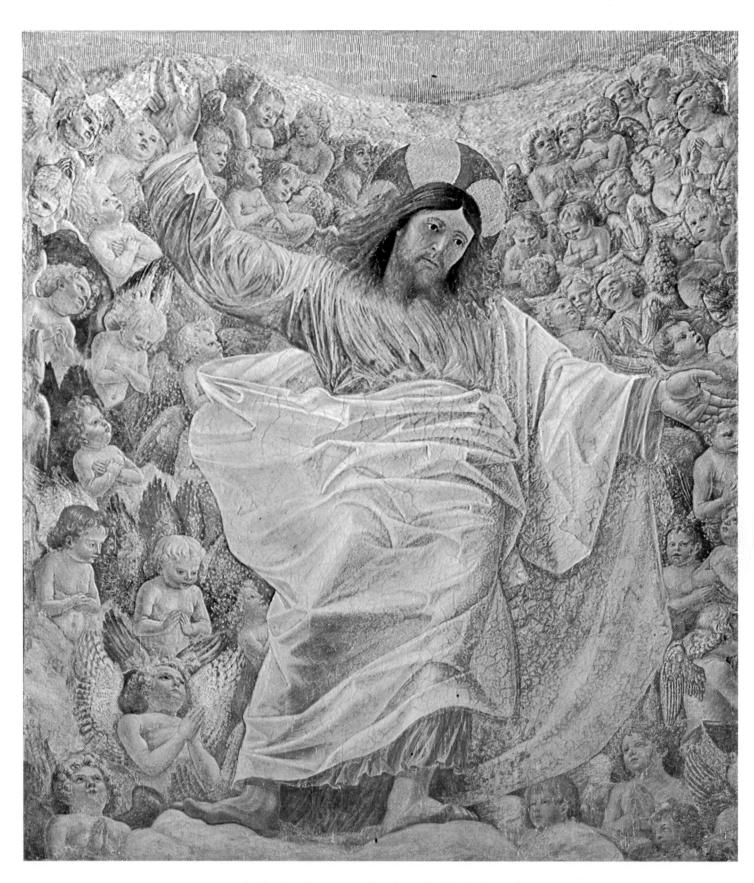

Colorplate 53. MELOZZO DA FORLÌ. *Christ in Glory.* 1477–80. Fresco (detached). Quirinal Palace, Rome

Colorplate 54. LUCIANO LAURANA. Courtyard, Palazzo Ducale, Urbino. c. 1465-after 1479

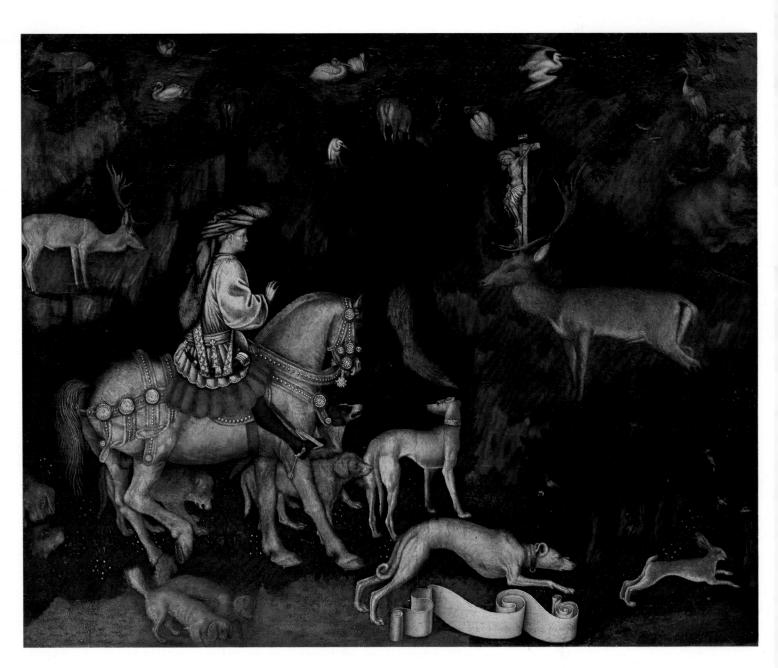

Colorplate 55. Antonio Pisanello. Vision of St. Eustace. c. 1440 (?). Panel, $21\frac{1}{2}\times25\frac{3}{4}$ ". National Gallery, London

one picture to the next but also even within the same picture. Yet the color of the painting is so cool and silvery, the finish so sensitive and exact, the pervasive mood so poetic that we can overlook the absence of emotions the artist could not feel. Nature is his real subject, and against this the sacred figures are set with little more purpose than to give human scale to the landscape and distance to the sky.

This is not yet the bowl landscape of Perugino's developed works. The fantastic rocks crowding the sky are characteristic of a region of eroded plateau in the upper Arno Valley, below the Pratomagno, stretching from Cascia di Reggello, where Masaccio's earliest work was found, to the outskirts of the little town of Pian di Scò. Here Perugino must have studied the rock formations, the clumps of trees above them, and the roads winding through them (one of these roads led from Florence southward toward Arezzo and Perugia). He exploited to the full the impact of the jagged profiles and the sparse foliage against the sky, much as he did, for sheer artistic effect, the floating S-curves of Christ's loincloth, a motif borrowed from Rogier van der Weyden. Much of the effect of the picture is gained from the precision of selected detail (leaves, twigs, wildflowers, a castle or two) against smooth surfaces of ground or sky.

Perugino was a remarkable portraitist, and in this respect also he seems to have been influenced by Memlinc. His portrait of Francesco delle Opere (fig. 380) in the Uffizi is certainly one of the noblest of the Quattrocento and the direct ancestor of portraits by Raphael, such as those of Angelo Doni and Maddalena Strozzi Doni (see figs. 484, 485). The subject is placed behind a ledge—a typical Netherlandish device—on which he rests his hands, one of which holds a scroll bearing the motto "TIMETE DEUM" (Fear God). The bowl landscape is half-filled with an expanse of sea forming a distant horizon, over which rises the coldly modeled, carefully observed head, its long locks of hair streaming out against the sky. This is one of Perugino's typical skies, beautifully graduated from milky blue at the horizon to a resoundingly clear and deep blue at the zenith. The natural balancing of mass and void, the harmonizing of the contours of the sitter with those of the sloping hills and feathery trees, above all the sense of quiet and easy control mark a new stage in the development of portraiture.

The culmination of Perugino's mature style, to a point where it is very difficult to separate it from the youthful work of Raphael, is to be seen in his splen'did altarpiece for the Certosa at Pavia, commissioned about 1496 but still unfinished in 1499. The three central panels, representing the *Virgin Adoring the Child, St. Michael*, and *Tobias with the Archangel Raphael* (fig. 381), are now in the National Gallery in London. Although the panels have lost several inches at the bottom—sacrificing a recumbent Satan in front of St. Michael, part of the sack on which the Christ Child sits, and the dog in front of To-

bias—the effect is still one of calm repose. Joseph is absent, yet the presence of Mary, the Christ Child, and a great sack in an open landscape was doubtless intended to suggest the Flight into Egypt, and the Rest on the Flight was a common subject in the Netherlands at this time. The sacred figures are guarded by St. Michael, dressed in armor of glittering steel and bearing a marshal's baton; on the other side stands Tobias, holding the fish that was the object of the long quest on which he was led by the Archangel Raphael, to whom he looks trustingly (the liver of the fish was supposed to cure the blindness of Tobias' father, Tobit). Tobias was a favorite subject for altarpieces commissioned by mercantile families sending a young son to work in a branch office in a distant city. Though the facial types are by now fully standardized, the heads are drawn and painted with the greatest apparent spontaneity, as indeed are the tranquil valley between its usual feathery trees and the three angels lightly dancing in the deep blue sky. It is no wonder that the question of Raphael's participation, quite possible if the work dragged on after 1500 when he began to work with Perugino, has arisen. The question can be answered no more easily than the analogous suspicions that attend the participation of the young Leonardo in the work of Verrocchio.

380. PERUGINO. Francesco delle Opere. 1494. Panel, $20\frac{1}{8} \times 16\frac{7}{8}$ ". Uffizi Gallery, Florence

381. PERUGINO. Virgin Adoring the Child, St. Michael, and Tobias, with the Archangel Raphael. c. 1499. Panels: center, 50 × 25"; laterals, each 50 × 223/4". National Gallery, London

Like all Central Italian painters who made their reputations in the 1470s, save only Leonardo da Vinci, Perugino arrived at the threshold of the High Renaissance and was temperamentally unable to cross it. The grand style emerged in Florence, developed in Rome, and was eventually transformed into Mannerism, while Perugino, in Perugia, went right on painting his oval-faced Madonnas and serene landscapes (Florence had no work for him anymore). He outlived Raphael by three years.

PINTORICCHIO

The last important painter of the Perugian School, Bernardino di Betto (c. 1454-1513), known to posterity by his nickname of Pintoricchio, cannot compare in scope or quality to Perugino at his best. But he is, nonetheless, endearing on account of his decorative and narrative charm—a kind of Perugian Benozzo Gozzoli. The success of his work cannot be gauged by reproductions. even in color, because a great deal depends on the artist's instinctive sense of the relation between his fresco and the space for which it was painted. A visit to the frescoed rooms and chapels of Pintoricchio is thus a rewarding but incommunicable experience. Pintoricchio emerged upon the Roman scene as Perugino's co-worker in the Sistine Chapel frescoes, and he returned to paint an entire apartment in the Vatican for Pope Alexander VI, as well as chapels and ceilings in various Roman churches.

His masterpiece is generally conceded to be his fresco cycle for the Piccolomini Library of the Cathedral of Siena (colorplate 52), commissioned in 1502 by Cardinal Francesco Piccolomini, nephew of Pope Pius II. After the death of Alexander VI in 1503, Cardinal Piccolomini succeeded him as Pope Pius III, but reigned only ten days. However, the huge fresco series financed by the Piccolomini heirs kept Pintoricchio busy until 1508.

The long, narrow room, in shape and construction resembling the Sistine Chapel, was built to contain the splendid library of illuminated manuscripts assembled by Pius II, who, when still Aeneas Silvius Piccolomini, was one of the most learned humanists of his age and who, after his election, poured much of the revenues of the papacy into his library. The frescoes were designed to narrate an embellished version of the career and exploits of Aeneas Silvius, before and after his election. Their stilted flattery contrasts with the salty memoirs of the pope himself; these, though long suppressed save in an expurgated version, have been preserved and furnish us with perhaps the most vivid eyewitness account of events of the mid-Quattrocento. The frescoes fill ten lofty compartments, which run around the room, from the dado above the reading desks to the arches supporting the mirror vault of the room. The compartments are separated by painted pilasters that culminate in gilded stucco corbels, and they are framed by illusionistic arches whose jambs and soffits are decorated with a diamond-shaped marble incrustation (painted, of course); the pilasters and the outer panels of the jambs contain a continuous decoration in *grotteschi* (see page 341). Each compartment allows us to look out, as though through the arch of a gigantic loggia, into a scene from Aeneas Silvius' life, painted in clear and brilliant colors that are in general well preserved. The pageantlike incidents of this mythologized biography display a gorgeous panoply of costumes against fanciful architectural or landscape backgrounds, save when a recognizable setting was required by the narrative.

In one scene (colorplate 52) Aeneas Silvius, as secretary to Cardinal Capranica, starts off from Genoa to the Council of Basel (later declared an anticouncil), at which his performance was in reality so disloyal to the papacy that he had later to do penance before Pope Eugenius IV. In the distance we see two caravels at anchor in the port, and at sea is depicted the earlier incident in which the cardinal's galleys were lashed by a storm. Genoa, of course, never looked like this. Pintoricchio has represented a little Italian hill town like those on the shore of Lake Trasimeno, with a Romanesque church and a castle on top of the hill. But if his Genoa is derived from local experience, so is his storm. This is one of the earliest naturalistic storm scenes preserved to us, made especially convincing by the way in which the artist has shown the long, dark veils of rain bent by the force of the wind and the sharp contrasts in colors among the thunderclouds. The rainbow in the distance is positioned so as to harmonize with the arch above. It does not pay to look too closely at Pintoricchio's faces, often schematically drawn, and even less to examine the heads of his horses and mules. The easy crowding of people and faces in the composition, while below the craftsmanly rigor of a Ghirlandaio, let us say, is at the same time more relaxed and natural. As has been previously noted (see page 352), Pintoricchio owed a debt to the similarly illusionistic frescoes of Domenico di Bartolo done two generations earlier for the Hospital of Santa Maria della Scala on the other side of the Piazza del Duomo from the Piccolomini Library.

MELOZZO DA FORLÌ

Every now and then in Italian art painters of great ability arise, apparently from nowhere, in centers that lack an important school of painting that could have formed and directed their early work. Gentile da Fabriano was such a case, so was Piero della Francesca, and so, a little later, was Melozzo da Forlì (1438–94). Perhaps their very isolation helped to make these masters among the most original and self-reliant of all. Melozzo has not, of course, escaped being called "Umbrian," although Forlì, the monotonous city of his birth and early activity, is not in Umbria and never was. It is in the Romagna, a string of papal-dominated communes along and near the Adriat-

ic, and not far from Ravenna, whose mosaics may have given the young Melozzo some inspiration, at least in the use of color and the combination of figures with architecture. He was one of the most sensitive and inventive painters of the later Quattrocento, easily of the rank of Ghirlandaio and Filippino Lippi, and was so recognized by Giovanni Santi, father of Raphael, before Melozzo's thirtieth year, as well as by other Quattrocento writers. Yet by the time Vasari published the first edition of his Lives in 1550, Melozzo had been so far forgotten that Vasari insisted the Santi Apostoli frescoes (see page 373) were by Benozzo (Gozzoli!). Even today, Melozzo's detachment from the great creative centers of Tuscany and Central Italy and the very slight volume of his surviving work result in his being often overlooked.

He began his visits to Rome as early as 1460, and a few years later was active at the court of Urbino, where he worked for Federico da Montefeltro and must have come in contact with Piero della Francesca. Although Piero was certainly the dominant influence on his art, Melozzo's perspective interests seem to have been well established even earlier. He must also have been impressed by Netherlandish art, particularly that of Justus of Ghent, who was active at Federico's court, and, unexpectedly enough, by Italo-Byzantine art as well, for he made two documented copies of a Dugento Madonna (one of the innumerable images of the Virgin supposedly painted by St. Luke), one of which has been recently identified. There is no record that Melozzo ever went to Florence or Siena-or even Mantua, where Mantegna was working—save for brief intervals, from 1459 until his death. But Melozzo must have known about Mantegna's work through a local artist, Ansuino da Forlì, who worked for a while side by side with Mantegna in Padua. It is likely that Melozzo encountered Leonbattista Alberti in Rome, and certain that he was familiar with Alberti's teachings.

From 1474 to 1477 Melozzo was at work in the Vatican Library, newly rebuilt and reorganized by Pope Sixtus IV. Most of his frescoes there have perished, since the room has long since been converted to other uses and the books moved to another site, but in 1821 Melozzo's fresco of Sixtus IV Appointing Platina was removed from the wall and transferred to canvas (fig. 382). It is the first surviving papal ceremonial portrait of the Renaissance (as distinguished from tomb effigies or from the portraits of popes disguised as their Early Christian predecessors in the paintings of Masaccio, Masolino, and Fra Angelico). The fresco once adorned the end wall of the library and was undoubtedly integrated with the system of decoration carried out by Domenico del Ghirlandaio and by his brother Davide. Two painted piers, treated as real ones and casting convincing shadows, admit us to an audience chamber in the Vatican, one no longer extant—if, indeed, it was not invented by Melozzo as a background for this painting. At the right sits the pope in a Renaissance armchair upholstered in velvet and stud-

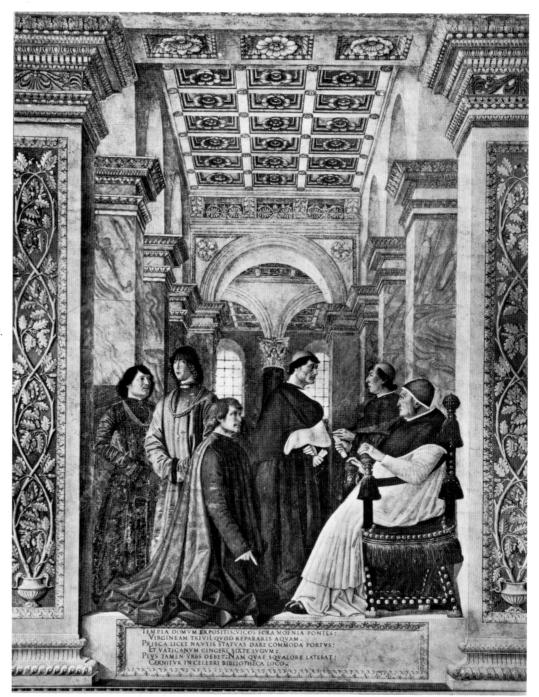

382. Melozzo da Forlì. Sixtus IV Appointing Platina. 1474-77. Fresco, transferred to canvas. Pinacoteca, Vatican, Rome

ded with brass-headed nails. At his right stand his four nephews, including the square-jawed Cardinal Giuliano della Rovere, later to become Pope Julius II. Before him kneels the humanist Platina, the new director of the library, pointing downward to a Latin inscription that he had composed extolling the building achievements of the pope. To heighten the sense of illusion, Melozzo has allowed the folds of Platina's cloak to escape from the picture and overlap the frame.

The figural composition is dominated by the architec-

ture, so projected in perspective as to place the eye of the observer at the level of the pope's knee. The power of the construction resides not in comparative scale, for the room is not large by Renaissance standards, but in the simplicity and bulk of the masses that compose it and in the clarity of the ornamentation, every detail of which can be separately read. Square, marble-encrusted piers, culminating in simple but heavily ornamented entablatures, support unmolded arches that offer them no competition. Immediately above the arches rests the ceiling, divided into three rows of coffering. An arch at the end of the room discloses a transverse chamber, whose similarly coffered ceiling is upheld by an arcade of which we are permitted to see one handsome Corinthian column, placed directly behind, and thus associated with, Cardinal Giuliano, pillar of Sixtus' administration. Rosettes, palmettes, and acanthus, bead-and-reel, and other ornaments, all drawn by Melozzo from ancient Roman architecture, gain further force by being picked out in gold. The powerful, entwined oak branches on the faces of the foremost piers (the coat of arms of the Della Rovere family, to which Sixtus IV belonged, is an oak tree) are silhouetted against a clear blue.

Melozzo has shown six figures standing, sitting, or kneeling without any coherent ceremonial grouping. Yet each person is motionless, each face firmly composed and staring directly ahead. Melozzo's substances are firm, his line definitive, his drapery forms crisp (like the Italo-Byzantine ones he once copied). The hardness of these unsparingly drawn and perfectly projected portraits relaxes only in the lyric beauty of the coloring. The strong crimson of the papal cope, biretta, and chair contrasts with the pure vermilion of the cardinal's habit and with the brilliant violet, ultramarine, and blue-green in the other costumes. This coloristic display is intensified by the coolness of the pearly marble piers and the sparkle of the gilded ornament.

Melozzo's grandest commission was the huge apse fresco for the Early Christian Basilica of Santi Apostoli in Rome, given him presumably in 1477 by Cardinal Giuliano della Rovere, whose titular church, San Pietro in Vincoli, was not far away. The remodeled basilica was consecrated by Sixtus IV in 1480, at which time the decorations were completed. In the early eighteenth century the church was remodeled again, and Melozzo's fresco was destroyed, save for the central section and a dozen or so fragments now in the Vatican. From these it is possible to gain some notion of how the composition must have looked. Around the cornice at the base of the semidome of the apse stood a row of Apostles, looking up. Above them was another semicircle, of angels playing musical instruments. Then, in the center of the vault, appeared Christ in the middle of clouds and putti (colorplate 53), his arms extended, his right hand blessing, his hair and beard floating in the breeze, his wide-open eyes gazing calmly downward. All the figures were painted as if seen from below, sharply foreshortened as painters had been doing since the days of Castagno and Uccello. But for the first time, as far as we know, in the entire history of art, a large-scale, monumental composition was, in this lost fresco, entirely seen from below, so that the mass of the building in which it was painted dissolved to give the illusion that the figures were standing or moving in the air outside. Melozzo's visionary composition was the inspiration of many ceiling painters, from Michelangelo, Raphael, and Correggio in the sixteenth century to the great decorators of the Roman Baroque and the Venetian Rococo. Melozzo's idea was not wholly original. A vault is often termed il cielo (the sky) in Italian documents. The association of the dome with Heaven is the subject of an immense literature. The tiny dome over the altar space of the Old Sacristy of San Lorenzo in Florence contained a picture of the constellations at a specific moment, somewhat on the order of a modern planetarium. Moreover, the Early Christian apse mosaic of the Church of Saints Cosmas and Damian in Rome shows Christ walking toward us on sunrise-tinted clouds through an azure Heaven, and possibly some similar mosaic may originally have decorated the apse of Santi Apostoli. But the crucial step—the treatment of the dome as a vision into space—was taken by Melozzo alone. Could the notion have come to him as he looked up through the oculus in the dome of the Pantheon into the sky above?

The central section of Melozzo's fresco, Christ in Glory, now in the Quirinal Palace in Rome, hints at the openness of Melozzo's lost composition, unexpected after the density of his Sixtus IV Appointing Platina. The full effect of even this fragment cannot be experienced unless the reader holds the illustration about thirty degrees above his head, tilted slightly toward him. Then the figure will appear to float on its clouds and among its ranks of child-angels, as Melozzo intended. His linearity and his insistence on solid form are just as strong here as in the Sixtus IV in every facet of the drapery and above all in the putti, yet the winds of Heaven blow freely through the composition. As usual, the color is brilliant. The rosy putti boast red and green wings, the white cloak and violet tunic of Christ glow against a bright blue sky, and the halo (also those of the Apostles and music-making angels preserved in the Vatican Pinacoteca) is dotted with gold, so as to achieve in fresco something of the sparkle of mosaic. Melozzo enjoyed the title of pictor apostolicus (apostolic painter), as the official artist to Sixtus IV. After his spectacular success as a painter of monumental frescoes, one wonders why his work is not to be found in the Sistine Chapel; none of the artists the pope called to Rome for that commission could show anything approaching Melozzo's experience.

In any event, Cardinal Girolamo Basso della Rovere, one of Sixtus' nephews who appears in the group portrait, called him to Loreto, on the Adriatic coast below Ancona, possibly while the work in the Chapel was still in progress, to decorate the Sacristy of St. Mark in the Basilica of the Santa Casa (fig. 383). This remarkable building had become a favorite project of the Della Rovere family and was being constructed by Giuliano da Sangallo to enshrine the house of the Virgin Mary, which had been obligingly brought to Loreto by angels in the thirteenth century. Although Melozzo never had a chance to complete the commission, which involved a series of wall paintings as well, it is the only one of all his

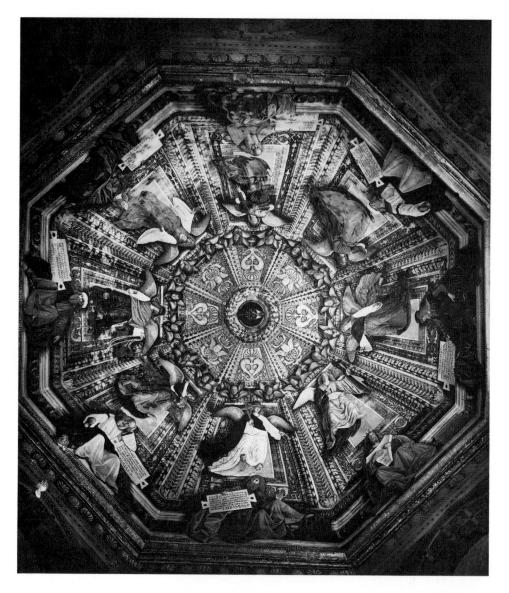

right: 383. MELOZZO DA FORLÌ. Dome, Sacristy of St. Mark, Basilica of the Santa Casa, Loreto. 1480s. Fresco and panel

below: 384. Angel, detail of fig. 383

decorative cycles, in Rome, Forlì, or elsewhere, that survives in its original spot, unaltered, since a bomb in World War II obliterated his ceiling decorations for San Biagio in Forlì.

Melozzo's scheme for the sacristy consisted in first clothing the eight faces of the dome in painted ornamental paneling composed of all of his favorite elements guilloches on the ribs, acanthus, bead-and-reel, palmettes, and dolphins—converging on a central garland of Della Rovere oak leaves that embraces the cardinal's coat of arms. This illusionistic structure remains unbroken by the figures that sit or float within it, apparently in the actual space of the sacristy. The painted cornice framing the dome is treated as a parapet on each segment of which sits a prophet holding a handsome tablet inscribed with his name and a passage from his writings prophesying the Passion (save only David, who holds his psaltery, while his tablet is propped beside him on the ledge). Above each prophet hovers an angel holding one of the instruments of the Passion; above the angels, finally, as a kind of repetition of the inner garland of oak leaves, is a miraculous circle composed of sixteen six-

winged seraph heads—112 brightly colored wings in all! The frescoes are so well calculated that the observer standing in the sacristy is convinced that Melozzo's beautiful figures are in fact sitting or floating above his head, and Melozzo even exploits such details as the soles of the angels' feet, shod or unshod, seen from below, and makes the angels' wings cast shadows on the painted architecture of the dome (fig. 384). Throughout the work the drapery glows with Melozzo's usual brilliance of color, and every face and every lock of hair are painted with his customary firmness. In 1484 Melozzo returned to Forlì, possibly on account of the death of Sixtus IV. His connection with Rome, and therefore with monumental painting on a grand scale, was never resumed.

THE LAURANA BROTHERS

In the late Quattrocento, Urbino shared with Rome the position of cultural capital of Central Italy, and it is fitting, therefore, that this chapter should close with the work of two brothers whose achievements in sculpture and in architecture helped to confer on the little town the status it long enjoyed. Both of the brothers were born in Dalmatia, which is today part of Yugoslavia, but which had been colonized by Venetians and was open to the influences of Italian culture; some of the finest works of Venetian Quattrocento architecture are to be found in Dalmatian cities. Francesco Laurana (c. 1420-1503), the sculptor, moved from one dynastic court to another and was responsible for the only Quattrocento triumphal arch (that of Ferdinand of Aragon in Naples) that is still preserved. His finest achievements were his female portrait busts, and that of Battista Sforza, countess of Urbino (fig. 385), whom we have already seen in Piero della Francesca's profile portrait (see colorplate 38), may serve as typical of Francesco's ideals of elegance and of his archaistic restrictions of style. These heads have much in common with those to be found in Piero's Arezzo frescoes (see figs. 282, 283) in their insistence on geometric or quasi-geometric volumes and clear contours, and owe next to nothing to Florentine sculpture of the period. The transitions from shape to shape, apparently so sharply simplified, are in reality rich and subtle, and repay the most careful observation. Form flows into delicately distorted form with the same beauty that the twentieth-century sculptor Brancusi found in waveworn pebbles.

After an extended search for a master "learned in the mysteries" of classical architecture, in 1468 Federico da Montefeltro appointed as chief architect of his unfinished palace, now the Palazzo Ducale of Urbino, Francesco Laurana's brother Luciano (d. 1479), probably already at work on the palace for two years, saying that he could find no one in Tuscany, "fountainhead of architects." The chief glory of the Palazzo Ducale is its courtyard (colorplate 54), whose construction can be dated during the years of Luciano's activity, and it is

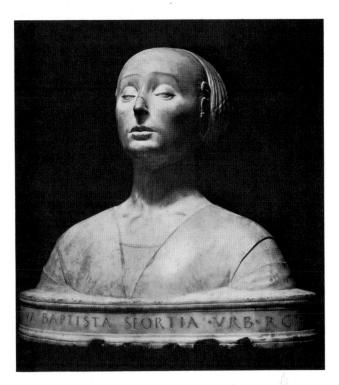

385. FRANCESCO LAURANA. *Battista Sforza*. c. 1473. Marble, height c. 20". Bargello, Florence

therefore generally assumed that he was its architect. After Luciano's death in 1479, Francesco di Giorgio was brought to Urbino to complete some of the decorative detail.

In contemplating the design of Luciano's courtyard, we must mentally strip the building of the two small, ugly stories built much later and finish it at the crowning cornice of the second story. Thus reduced, the courtyard emerges as one of the most harmonious constructions of the Renaissance. Luciano adopted the simple arithmetical proportion scheme of Brunelleschi. Each bay is an exact square, surmounted in the ground floor by semicircular arches. The second-story windows are twothirds the height and one-third the width of each bay. But Luciano avoided some major Florentine difficulties. First, he managed to unite both stories in a single scheme, rather than allowing a solid second story to weigh down upon an open arcade. Second, he turned each corner in a way that completes both corner arches instead of allowing them to cut each other and come to rest on the same corner of the same capital in the uncomfortable way we find in all Florentine courtyards (see figs. 148, 309). The first problem he solved by giving the second story an order of Corinthian pilasters to harmonize with the Composite columns of the arcade and by setting these stone pilasters against a wall of tan brick, continued in the spandrels of the arcade. The result is not quite the same as the screen architecture of the façade of the Palazzo Rucellai (see fig. 225). The columns,

386. LUCIANO LAURANA (designed by; probably painted by PIERO DELLA FRANCESCA). View of an Ideal City. Third quarter of 15th century. Panel, 235/8×783/4". Galleria Nazionale delle Marche, Palazzo Ducale, Urbino

pilasters, entablatures, and windows against a darker background of shadow or of brick give the Palazzo Ducale the appearance of an open framework, unprecedented in Renaissance architecture.

The second problem necessitated even greater ingenuity. Luciano decided to treat each face of the courtyard as if it were a separate façade, complete in itself. He therefore terminated each side of the colonnade with a giant pilaster at each end and each side of the *piano nobile* with a pilaster culminating in a modified Doric capital with fluted necking. At the corners of the arcade level the cornices of intersecting façades just touch; along what was once the skyline they fuse, so that a single unbroken cornice crowned the entire courtyard. Luciano's solution results at arcade level in an L-shaped compound pier containing two pilasters and two half-columns on the courtyard side, while on the inside, under the groin vaults, both faces of the pier remain flat.

Whether or not Luciano's solutions are fully consistent with the doctrines of Alberti, they would probably have pleased him. Certainly he would have enjoyed and possibly did-the two friezes, whose only ornaments are splendid inscriptions extolling the virtues of Federico in handsome Trajanic capital letters. As compared with the verticality and density of Florentine Renaissance architecture, the columns, the pilasters, the windows, even the letters of the inscriptions are widely spaced, so that the dominant direction of the courtyard is horizontal. The skill with which the intricate problems of form and space are solved, and the consequent appearance of integrated and harmonious calm, mark a determined step in the direction of High Renaissance architecture. Bramante, born in Urbino in 1444 and therefore twenty-four years old at the time Luciano was appointed to his historic task, found his own artistic origins in this building, and the young Raphael walked through these perfect arcades.

In all probability we should look to Urbino for the origin of two mysterious painted panels, one in Balti-

more in the Walters Art Gallery, the other still in Urbino and housed in the Palazzo Ducale (the present National Gallery of the Marches). Both of these panels show enormous piazze, bordered by palaces and centering around monuments of a more-or-less classical nature. A number of ingenious solutions, none wholly convincing, have been suggested to explain the purpose of these panels. The Urbino panel (fig. 386), empty of figures, has been persuasively attributed to Piero della Francesca or a close follower. The old attribution of the architectural designs for the panels, as distinguished from their pictorial execution, to Luciano Laurana has much to recommend it. The architecture looks like that of the Palazzo Ducale at Urbino, but the best support for the theory is the fact that the characters in the inscriptions at upper left and right in the original panel (invisible in the illustration), although too badly damaged to be read as words, are Slavic, and probably Old Church Slavonic, written in Cyrillic character, and therefore doubtless by a Slav and not an Italian.

The three-story palaces are built on the same principle of open framework filled in by screen walls, some dark against light, some light against dark, and the palace at the extreme left goes so far as to show only a single solid story. Both palaces at the right are enclosed by façades that terminate, like those of the courtyard of the Palazzo Ducale, before reaching the corner, so as to avoid corner columns. The general feeling of breadth and openness in the proportions and the spacing of these beautiful buildings is very like what we find in the Palazzo Ducale and quite opposed to the tensions of Florentine architecture in general and Giuliano da Sangallo's in particular. The problem is as far from solution as ever, but the architecture itself is worthy of close study. Some of the ideas are unprecedented, such as the rows of pediments crowning some of the palaces, and the entire view clearly represents the kind of city that the Early Renaissance wanted to build but could never achieve, in fact, save on the tiny scale of Pienza (see fig. 232).

The wonderful round building in the center is more beautiful than most of the centralized structures actually built during the Renaissance. The small windows, restricted to the upper story, correspond perfectly to Alberti's desired illumination for a "temple" (see page 226). Moreover, the lantern, lighted by bottle-bottom windows, is capped by a crystal orb, surmounted by a cross (impossible to see in this illustration). The building was surely intended to represent a "temple" (Albertian parlance for church), which at the center of a city always dominates the three-aisled basilica, clearly visible at the right, intended for a law court as Alberti would have wished, and given no religious insignia. Almost certainly, Laurana's ideal temple inspired a more famous work, the Tempietto of Bramante (see fig. 498).

A more stable society under autocratic rule was required for the realization of this kind of fantasy, which had to await the later sixteenth century and found its full fruition only in the Baroque. Such architectural perspectives were characteristic of the so-called *intarsie*, panels of inlaid cabinetwork composed of several varieties of differently colored woods, which were the delight of the late Quattrocento and the Cinquecento for the decoration of small rooms and especially of choir stalls. This

chapter may well conclude, therefore, with a glance at the astonishing intarsia decoration of Federico da Montefeltro's little study in Urbino (fig. 387), where his favorite manuscripts were kept and where he readstanding—at a desk from which he could also look out through Luciano's marble arches to the blue mountains of his domain. Whoever the unknown designer of the intarsie was, he certainly worked in harmony with Luciano's architecture and possibly in part from his designs or suggestions. The lower portion of the room is treated to simulate latticed cabinets, one with a door appearing to be open to show some of its contents. Then comes a zone of ornaments, including the symbols of the duke, then a framework of pilasters, between which one looks into niches with statues, into cabinets with books, candle, and hourglass (through another open door!), into a cupboard filled with the duke's armor, and into an architectural perspective with a magnificent distant view of mountains and lakes. All the intellectual refinements of an ideal life were concentrated here, within the confines of a tiny chamber, executed with consummate illusionistic skill to please the noblest of Renaissance princes. Neither the perfection of this art nor the kind of personality that commissioned and inspired it was ever to recur.

387. Studiolo of Federico da Montefeltro, Palazzo Ducale, Urbino. 1470s. Intarsia

Gothic and Renaissance in Venice and North Italy

he Po Valley, studded with magnificent cities— Bergamo, Brescia, Verona, Vicenza, Como, Cremona, Lodi, and Pavia, to mention only a fewhad been transformed politically and socially during the Trecento by the rise of tyrannies (see page 136). During the Quattrocento these despotisms were the scene of a flourishing court life and immense artistic activity. The most splendid of the smaller courts were those of Mantua, under the Gonzaga family, and Ferrara, ruled by the Este. But Milan, first under the Visconti dukes and then under their relatives the Sforza, became one of the richest and most powerful principalities in Europe, able to attract artists of the highest genius. At the other side of the North Italian triangle, the Republic of St. Mark was beginning to turn its sights toward the Italian mainland, largely because the loss of many of its remote outposts and much of its commerce to the expanding Ottoman Empire forced Venice to look toward Central and Northern Europe for trade. At this point it transferred its previous system of colonial government to the absorption and administration of inland bases, protecting the new trade routes over the Alps. Padua, Treviso, Vicenza, and Verona joined the ranks of Venetian subject cities, and in 1498 the Lion of St. Mark appeared on the ramparts of Bergamo, from which, on clear days, Venetian soldiers could discern the distant Cathedral of Milan. Despite conflicts with the French conquerors of Milan at the end of the Quattrocento, and even with every major power in Western Europe arrayed against Venice in the League of Cambrai in the early Cinquecento, the city survived very well, maintaining its land power and much of its maritime empire until the end. Among the many smaller independent states of North Italy, only Mantua and Ferrara kept their independence throughout the Renaissance, probably because they were convenient buffer states both for Milan and for Venice. The flowering of Venetian Renaissance art dates from the period of Venetian continental expansion.

In the early Quattrocento Lombard naturalism had an electric effect in Florence when imported by Gentile da

Fabriano (see page 180). But in general it was Florentine artists who migrated northward. Padua and Venice were visited by Paolo Uccello in 1421, Fra Filippo Lippi in 1433–34, Andrea del Castagno in 1442–43, Donatello from 1443 to 1453, and other Florentine artists. The reason is not hard to find; at that moment Venice was producing no artists to compare with the Florentine masters in quality and power. The Renaissance was a Florentine import, and only in the single personality of Domenico Veneziano did Venetian ideas and inventions have any effect in Florence. Within a generation the tide began to swing the other way, and long before the end of the Quattrocento Venice assumed unchallengeable superiority in certain special aspects of painting, a position it was to maintain for a century and a half.

PISANELLO

The tradition of North Italian naturalism went on, after Gentile's death, in the work of his associate and follower Antonio Pisanello (before 1395–1455). Although from a Pisan family, Pisanello was born in Verona. As a young man, he worked with Gentile on frescoes, now lost, in the Doges' Palace in Venice and later continued Gentile's work in Rome, after the latter's death. Pisanello seems never to have painted or to have wished to paint in Florence. He worked as a medalist for several North Italian princes and was especially close to the Este family, dukes of Ferrara.

A highly accomplished example of Pisanello's art is the now-detached fresco of *St. George and the Princess* (fig. 388), painted about 1433 for the Church of Sant' Anastasia in Verona. Compared with contemporary Florentine art, or even with Pisanello's North Italian Trecento predecessors, the picture is static; people and animals merely stand and do not look at each other. But the fresco (or what is left of it, since much of the splendid ornament was painted *a secco* and has peeled away) is a tour de force of North Italian naturalism.

Pisanello's animals come out of this North Italian tradition. His sketchbooks recording many different spe-

388. PISANELLO. St. George and the Princess. c. 1433. Fresco. Museo Civico, Verona

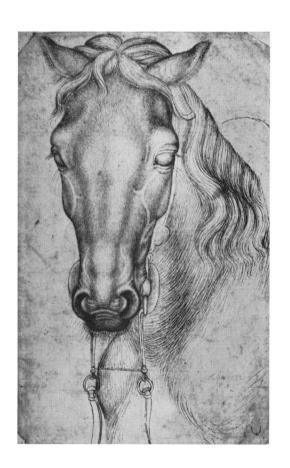

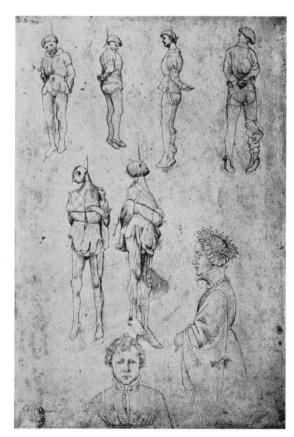

far left: 389.
PISANELLO. Study of the Head of a Horse.
Pen, 101/8 × 73/4".
Cabinet des Dessins,
The Louvre, Paris

left: 390.

PISANELLO. Study of Hanged Men. c. 1433.
Pen over metalpoint, 111/8×75/8".

British Museum, London

cies of beasts are convincing not only in their minute fidelity to every detail of animal structure (fig. 389), and to the very texture of fur and feathers, but even more in the intensity with which the personality of each animal emerges. In *St. George and the Princess* the real protagonists seem to be the hunting dogs and the horses pawing the earth. Pisanello inherits from Gentile the front and back views of horses (see colorplate 22), but makes more impressive use of them, in the tradition of Jacopo Avanzo (see fig. 129).

Beyond the splendidly dressed people—especially the princess with her lofty forehead, towering headdress, and sleeves sweeping the ground—who remind us of the numerous watercolor designs Pisanello made for elaborate costumes, there appears a row of low hills, and then the battlemented towers, traceried Gothic gables, domes, pinnacles, and spires of a North Italian city. Before the city gates two partially decomposed corpses hang from a gallows (such a motif reappears five years later, at the most, in Domenico Veneziano's Adoration of the Magi, see fig. 265), at the left are uplands divided into fields and farms, then the sea with a ship under sail. The soldiers in the middle distance show strongly Asiatic facial types, possibly observed from Mongol or Tartar slaves. Many of Pisanello's preparatory drawings for the fresco survive, including animal studies and exact renderings of the corpses (fig. 390). When the fresco was in good condition, the naturalistic effect of the foreground animals and figures must have been overpowering, for they were exactly drawn, beautifully shaded, and perfectly projected in depth. Pisanello seems to show in his paintings no real interest in perspective, Florentine style, and here certainly he made no effort to achieve a unified space and controlled recession. Yet an important perspective drawing by Pisanello survives as witness to his control of the Albertian formula for the construction of spatial recession. It is Tuscan intellectuality that does not appeal to him. Once Tuscan system and order are released, the profusion of the natural world pours out to fill every possible space. Perhaps the only real difference between Pisanello and his Florentine contemporary Paolo Uccello is the former's unwillingness to make the world conform to patterns imposed by man. In detail, their paintings are sometimes strikingly similar. And if this North Italian interest in nature rather than in man is Gothic, then so is Antonio del Pollaiuolo or Leonardo da Vinci, both of whom subordinated man to nature and led the Florentines toward a new phase of the Renaissance.

Pisanello's animals take over the brilliantly painted but heavily darkened panel (colorplate 55) probably representing the Vision of St. Eustace (although a similar legend is told about St. Hubert). Eustace was out one day hunting deer when a fine stag appeared before him, bearing the crucified Christ between his antlers. Eustace was converted on the spot. The legend refers to Psalm 42, "As the hart panteth after the water brooks, so panteth my soul after thee, O God." No profound religious experience seems to be going on inside Pisanello's St. Eustace, who presents himself in profile, sporting the latest excesses of North Italian fashion, and lifts one hand in mild astonishment. The horse snorts, rears back, paws the ground with one hoof. Space continues on all sides and up—a deep forest that obeys no rules of perspective, but gives the artist a dark background against which to project the jewel-bright costume and the live, alert, tense animals and birds. Besides the glorious stag that bears the Crucified, another trembles in the dimness at the left, at the upper left a doe crouches, and at the center a stag drinks from a watercourse enjoyed by swans, cranes, and pelicans (a bird symbolic of Christ), one of whom is in flight. A bear inhabits the shadows toward the upper right, and around the saint's horse crowd at

391. JACOBELLO DEL FIORE. Justice with Sts. Michael and Gabriel. 1421. Panels: center, $82 \times 76\frac{1}{2}$ "; left, $82 \times 52\frac{1}{2}$ "; right, 82×64 ". Accademia, Venice

least three varieties of hunting dogs. One hound sniffs at the rear of an offended greyhound, while a second greyhound gives solemn chase to a hare, measuring the taut curves of his body against the cramped ones of a scroll, which, sadly enough, is blank.

EARLY QUATTROCENTO PAINTING IN VENICE

In the early Quattrocento, Venetian pictorial efforts, interesting as they may be to specialists, have a limited appeal to the general public. Jacobello del Fiore (d. 1439), for example, who signed in 1421 the huge triptych representing Justice with Sts. Michael and Gabriel (fig. 391) for the Doges' Palace, could not possibly compete with the contemporary painters of Florence or Siena. His Gothic frame, whose flattened shapes are derived from contemporary work in Austria, encloses a seated and crowned Justice, holding sword and balance and flanked by lions. In the left wing St. Michael slays an inoffensive dragon, in the right Gabriel bearing a lily appears as if on his way to the Annunciation. Elements of Gentile's art linger on, especially in the raised stucco modeling of the gilded portions, but it is clear that Jacobello had little touch with Gentile's naturalism.

Antonio Vivarini (c. 1420-76/84), together with his still-mysterious brother-in-law Giovanni d'Alemagna (d. 1450), both from the island-city of Murano near Venice, painted in 1444 a large altarpiece representing the Coronation of the Virgin (fig. 392) in San Pantaleone in Venice. Here Gothic, Byzantine, and Renaissance elements blend in a strange amalgam. The space of the picture is formed by five tiers, like choir stalls, to hold seated saints and prophets in ceremonial array, as if Heaven were the apse of a gigantic church. Three more rows of angels bring the altarpiece to a domelike top. The entire center of the structure from the checkered marble pavement to the apex of the living dome is filled with a fantastic throne containing Late Gothic motifs of double curvature and vaguely Byzantine columns with foliated capitals. Between the columns and around them, infants (probably the Holy Innocents) carry the symbols of Christ's Passion, and between the spiral columns of the upper stories of the throne, whose back is also formed by angels, God the Father blesses Christ, who crowns his mother, while the dove of the Holy Spirit hovers between them. The painting of individual faces and the handling of light and shade on the drapery show that Antonio and Giovanni had learned an occasional lesson from the Florentine visitors, but the picture remains provincial despite its naïve charm. The artist would probably not appreciate our amusement at St. Luke's doglike bull cuddling beside his master, who, with professional pride, exhibits his framed portrait of the Virgin. The Vivarini family and its pupils remain a conservative current in Venetian painting through two generations and into the sixteenth century.

392. ANTONIO VIVARINI and GIOVANNI D'ALEMAGNA.

Coronation of the Virgin. 1444.

Panel, 90 × 69½". S. Pantaleone, Venice

JACOPO BELLINI

The parade of geniuses starts with Jacopo Bellini (active c. 1423-70) and continues with his son-in-law Andrea Mantegna (1431-1506) and his two sons, Gentile (1429-1507) and Giovanni Bellini (c. 1430-1516). Jacopo got his start under Gentile da Fabriano, which is probably why he named his oldest son Gentile (born two years after the death of the great Quattrocento master). In 1423 and 1424 Jacopo was in Florence in the service of Gentile da Fabriano; in fact, he was summoned to court for beating a boy who climbed on the wall of Gentile's courtyard and threw stones at valuable sculptures and paintings. At first sight Jacopo's work is disappointing. His Madonnas, such as the example presently in the Accademia in Venice (fig. 393) and datable in the late 1430s, show a lingering trace of Byzantine remoteness and rigidity. A closer look discloses that Jacopo had a clear understanding of Renaissance principles. The parapet on which he has placed the Christ Child's cushion, Mary's elbow, and a closed book is convincingly projected; so is the book. There are Byzantine echoes in the gold pigment used for highlights—a last remnant of the old gold striations—but these do not muffle the artist's firm and consistent control of form. Bodily volumes under

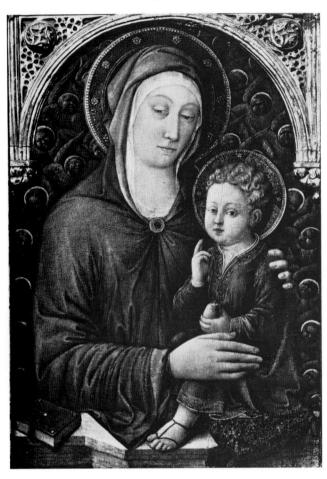

393. JACOPO BELLINI. *Madonna and Child*. Late 1430s. Panel, 37 × 26". Accademia, Venice

the envelope of drapery turn in depth; light shimmers on the drapery folds, which behave like cloth. The wealth of short curls on the Child's head is beautifully rendered. All in all, the elements of the picture, even to the innumerable winged seraph heads in gold that compose the background, are treated with a harmony and restraint that Antonio Vivarini never could have fathomed.

Highly regarded by poets and writers of his time in North Italy, Jacopo was in Ferrara in 1441 working for Lionello d'Este, and the little *Madonna and Child with Donor* (colorplate 56) dates from that time if the donor is, as he seems to be, a portrait of Lionello. The Gentilesque elements in the picture are very evident, if softened by Jacopo's special ability to caress silken drapery folds, but the scope of the landscape background is far beyond Gentile's phase of development. Technically this is a Virgin of Humility, seated low on a cushion like the probably later examples by Giovanni di Paolo (see fig. 367), which show an immense view over the distant world. But Jacopo's Madonna rises grandly against the sky, and the words repeated on her halo, "Hail Mother, Queen of the World,"

explain her dominance of the landscape. The tiny scale of the donor kneeling before her is an archaism that recurs even in the Cinquecento. A semicircle of trees, in whose shadow a deer grazes, separates the sacred figures from the most ambitious landscape view of the decade. Jacopo's vision has taken in farms, two castles, four cities, three Magi on horseback, riding toward a shed in which the Holy Family may be dimly seen, and a great range of mountains not done after drawings from nature (they are conventionalized in their shapes), but particularly convincing because of the way in which their summits are touched with light. Even more persuasive is the sky, with its low banks of clouds illuminated from below by this same light, apparently the last glow of afternoon. The soft, heavy atmosphere common in North Italy appears here for the first time in painting. These clouds with gently glowing undersides will reappear again and again as a standard motif in the art of Jacopo's more gifted son, Giovanni. Despite the fact that Jacopo has attempted no perspective unity in the Florentine sense, nonetheless his exquisitely modeled anatomical shapes are nicely projected in space, and so is the Child's halo.

Far more than Jacopo's paintings, his drawings remain a testament to an extraordinary compositional imagination. These were made, as has recently been shown, not on separate sheets of parchment but in bound drawing books whose purpose is not known. Two survive, one in the British Museum, the other in the Louvre. Both are datable close to 1450, and both include an extraordinary array of subjects-scriptural, mythological, archaeological, purely fantastic. Often the composition, begun on the recto (right-hand page), laps over onto the verso (back) of the preceding folio or facing page. The books were inherited by Gentile Bellini, who retouched in pen his father's rubbed and faded leadpoint drawings in the Paris volume; those in London remain in leadpoint. The books appear to have been consulted as compositional models by several Venetian painters, including Mantegna and Giovanni Bellini, until well into the sixteenth century, and thus seem prophetic of great events to come. They show that Jacopo had learned the principles of Albertian perspective since the days of the Louvre Madonna and Child with Donor (see colorplate 56), without losing his North Italian interest in a broad, panoramic conception of nature. His adherence to Albertian rules occasionally constrains him to present us with absurdly rapid perspective recessions. But his adoption of the single point of view enables him to keep the horizon in its proper place, exploit glimpses among and between foreground objects, and dissolve the last vestiges of medieval double scale in favor of a single scale that places humanity in an unflattering relationship to architectural and natural space. In his Nativity (fig. 394), for example, Joseph sleeps in the foreground. Mary is reduced to twothirds his size because she kneels a little deeper into the constructed space, while shepherds and wayfarers con-

left: 394. JACOPO BELLINI. Nativity. c. 1450. Leadpoint. British Museum, London

below: 395. JACOPO BELLINI. Flagellation. c. 1450. Leadpoint with pen retouching. The Louvre, Paris

tinue the diminution systematically to the point where distant Bethlehem, like any city on the northern edge of the Po, rises with its walls and towers in the lee of the mountains. While still betraying Byzantine mannerisms of landscape construction, these masses recede into even smaller hills, castles, and cities, visible between the uprights of the shed. Renaissance order has been imposed on the miscellaneous world of North Italian art, without weakening the dominance of nature. The figures are mere specks in this landscape world.

The same principle is exploited to an even greater degree in Jacopo's Flagellation (fig. 395). We see an enormous Gothic palace, vaguely like the Doges' Palace in Venice, with an open loggia, balconies, classical reliefs, and statues adorning its walls, and an even larger distant building culminating in two towers. In the foreground a marble bridge arches over a waterway. Tiny figures appear here and there on the steps, on the balconies, and in distant courtyards. Only after examining the drawing for a while do we notice that the nude Christ, not even seen in his entirety, is tied to a column in the loggia and scourged by order of Pilate, who sits in a niche against the wall while bystanders look on idly. Those nearest us are, of course, represented as larger than Christ. Jacopo has gone a long way since the Louvre Madonna and Child with Donor. In these drawings, which reduce the principal personages to distant specks, Jacopo shows that this is the way great events happen, not neatly centered and aggrandized, but only as part of a universal texture of experience, largely uncaring. Jacopo's adoption of Albertian perspective gave him the most powerful of instru-

396. JACOPO BELLINI. Crucifixion. c. 1450. Leadpoint. British Museum, London

ments to demonstrate his views and to prove, moreover, the basic contention of North Italian (as distinguished from Florentine) art: that nature dominates man.

Jacopo could also be a more traditional tragic dramatist. In such compositions as the *Crucifixion* (fig. 396), Jacopo could imagine a scene of epic breadth—Calvary set before the walls of Padua, with the three crosses seen diagonally (apparently for the first time) and the backs of the soldiers on horseback turned toward us, thus throwing the horses into sharp foreshortening and the crosses into the middle distance. At its very height Venetian historical painting under Tintoretto and Veronese

never surpassed the spatial daring of Jacopo's extraordinary perspective composition.

ANDREA MANTEGNA

Andrea Mantegna, who married Jacopo Bellini's daughter Nicolosia in 1453, was the leading Quattrocento painter of the North Italian mainland, and must be numbered among the greatest masters of the Renaissance. Born, probably in 1431, in Isola di Carturo, near Padua, the boy was trained and adopted by a certain Francesco Squarcione, part painter, part collector, part dealer, part

entrepreneur, who seems to have employed several talented boys, whose services he farmed out to prospective patrons. Eventually, Mantegna got free from Squarcione, but not without legal difficulties. When the artist was still only eighteen, so young that his contract had to be signed for him by his older brother, he was engaged in an important series of frescoes in the chapel of the Ovetari family in the Eremitani Church in Padua, together with such established masters as the team of Antonio Vivarini and Giovanni d'Alemagna and the Paduan painter Niccolò Pizzolo. Mantegna's earliest paintings there are not particularly original in style. Giovanni died in 1450, Vivarini withdrew in 1451, and in 1453 Pizzolo was killed in a quarrel. A new contract in 1454 assigned some of the subjects to Mantegna and others to such minor masters as Bono da Ferrara and Ansuino da Forlì. Eventually, both withdrew, leaving the field to Mantegna, who emerged with superb paintings in a wholly new style, finished before February 1457, when the artist was in his twenty-sixth year.

In the second row above the floor of the narrow chapel, Mantegna painted two scenes from the Life of St. James, united by a common perspective, with the vanishing point concealed by the frame between the Baptism of Hermogenes (fig. 397) and St. James before Herod Agrippa (fig. 398). The garland of fruits and flowers is hung by putti in the very space of the chapel, from outside the corners of the frames and above the frames, across both frescoes, culminating in the Ovetari arms at the center. In these first mature works Mantegna shows his interest in the compositional designs of his father-inlaw (whom he had visited in Venice in 1453), his absorption of the principles of Albertian perspective (which were to fascinate him for the rest of his life), and above all the profound impression made by the work of Donatello in the reliefs for the high altar of Sant'Antonio, finished in the same year of 1453 (see figs. 253, 254). The marble pavement on which Hermogenes kneels, and which seems continuous with that of the square before the throne of Herod Agrippa, forms a thoroughly Albertian perspective grid whose receding orthogonals and correctly diminishing transversals establish mathematically the relative sizes of the figures. At this moment not even Piero della Francesca could produce so doctrinaire an exposition of Albertian perspective as did Mantegna, who even ticked off the foreground slabs in cubits.

This much of Tuscan rationalism and order made its way into North Italian style, but it was not enough to rule out the profusion of North Italian realism. The classicistic architecture of piers and arches, provided with an apparently invented "classical" relief including the familiar Renaissance detail of the horse seen from the rear, leads up to a potter's shop in which Mantegna has painted with great care a fine variety of jars and cups and even the wood grain of the rough counter built into an arch. He has also shown precisely how the water from St.

James' pitcher strikes the center of Hermogenes' bald cranium and splashes outward into a tiny fountain of separate drops, like pellets of quicksilver. A typical detail of Mantegna's naturalism is the infant at the left, who wants to take part in the ceremony but is easily restrained by an older boy leaning against the base of a pier.

On the right St. James is brought before Herod Agrippa in front of a Roman triumphal arch, not a direct imitation of any specific Roman examples but a re-creation of Roman art in an Albertian manner, working from a knowledge of its principles. Mantegna belonged to a group of humanists in Verona who constituted themselves into an academy; they went for boat rides on Lake Garda, enlivening the trips with readings from classical authors, and also made some archaeological investigations on their own. Mantegna must have had an enormous repertory of drawings from classical remains, into which he could dip for specific details.

The atmosphere is perfectly clear, so that every tiniest element in the fresco, as in all Mantegna's paintings, is visible with biting clarity, off to the last tree and the last castle on the farthest hill. The rocks are formed in accordance with the sweep of those in Jacopo Bellini's drawings (see fig. 396), but without Jacopo's fluidity. The same curves are carried up into the sky by the flight of birds. The experience of Donatello's sculpture, and perhaps even his personal influence, seems to have made Mantegna more sculptural in his paintings than was Donatello in his highly pictorial reliefs. Every figure seems carved in stone, harshly projected in the light that comes from the direction of the apse windows of the chapel. In Mantegna's draped figures, cloth does not fall over the limbs in masses, as in the paintings of Masaccio and his followers, but clings like the clay-soaked cloth of Donatello's figures (see fig. 162). The soldier at the left, leaning against the frame and looking bitter, has always been held to be a self-portrait of Mantegna (fig. 399), with a face ravaged by inner torment though he is still in his early twenties. It is a formidable face, corresponding to the difficult, domineering character we know Mantegna to have possessed, looking very like the bust that appears in his tomb chapel in Mantua, and so stony in its consistency, so harsh in its details, that the artist seems almost to have done it with a chisel instead of a brush. In the midst of the solemnity of St. James' judgment, Mantegna still found room for naturalistic byplay. The boy who holds the soldier's shield and wears his enormous helmet looks right, while the eyes of the mask on the shield look just as sharply to the left. And the sword has been neatly placed parallel to the transversals of the pavement.

The lowest register of frescoes of the Life of St. James begins just above the eye level of a person of average height during the Renaissance. The last two scenes, therefore, are planned as if Mantegna had a stage in front of him, filled with models of human beings seeming to

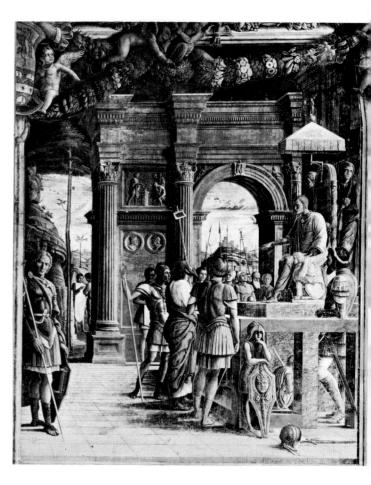

move downward as they recede from the eye. Thus only the feet of the figures nearest to the picture plane appear, in fact even break through the picture plane; the others are cut off by the lower edge of the fresco. In the St. James Led to Execution (fig. 400), we look up at nearby buildings portrayed with a sharply real effect, which is intensified by the random placing of medieval structures in a curving street—their arches and battlements rendered with the same scrupulous attention to detail as the classical elements Mantegna clearly recommended and preferred—and by the heads popping out of windows above us. The coffering of an arched gateway is also seen from below. But a moment's reflection will disclose that if Mantegna had been consistent in his view, he would have made the verticals converge as they rise, because they are orthogonals leading to another vanishing point, high above the scene. That he did not do this, any more than Masaccio did in the Trinity (see colorplate 25), is doubtless due to his unwillingness to violate the verticality of the wall on which he was painting and, in consequence, the structure of the entire chapel.

Again Mantegna picks up, records, analyzes, and sets into its exact relationship in a universal mathematical structure every facet of human experience. The penitent breaks from the crowd to ask and receive the blessing of the compassionate saint on his way to death; the soldier uses a staff to hold back a woman who wishes to follow. Mantegna's strict sense of form invests humble faces with an unexpected majesty. The sad countenance of the

397, 398. Andrea Mantegna. *Baptism of Hermogenes* (left) and *St. James before Herod Agrippa* (right). 1454–57 (destroyed 1944). Frescoes. Ovetari Chapel, Eremitani Church, Padua

399. Head of a soldier, detail of fig. 398

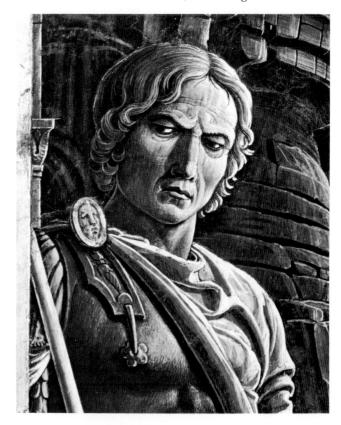

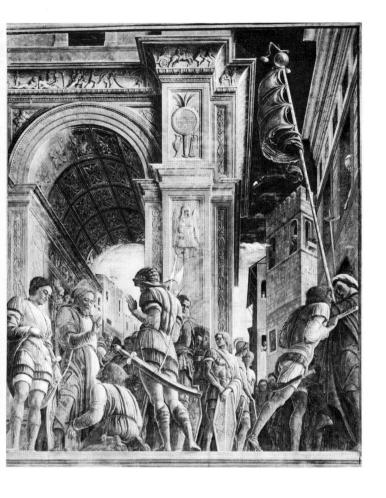

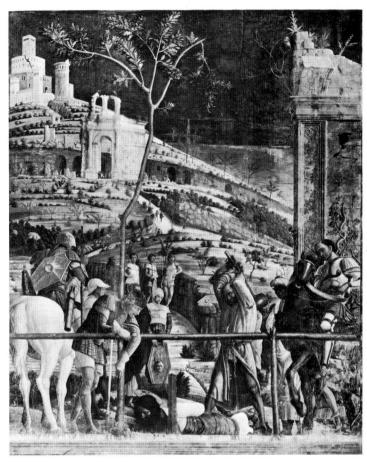

400, 402. Andrea Mantegna. St. James Led to Execution (left) and Martyrdom of St. James (right).
1454–57 (destroyed 1944). Frescoes. Ovetari Chapel, Eremitani Church, Padua

401. Head of St. James, detail of fig. 400

saint (fig. 401) is carved and compartmentalized with the same lapidary clarity as every other object, down to the masonry blocks in the buildings.

The final fresco is the Martyrdom of St. James (fig. 402), depicting the saint's beheading. Mantegna has shown a mechanism that required the saint to lie prone, foreshortened toward us in depth, under a blade that slides in the channels in two posts, while an executioner is about to strike the blade with a gigantic mallet. When the blow falls, the severed head will roll into the chapel where we stand. Although this is difficult to see in the photographs, the illusion of objects outside the picture plane, therefore in the space of the chapel, was increased by placing the painted rail of the sapling fence outside the painted frame, and the picture plane is further violated by the soldier who leans forward over the fence. A powerful tension in depth is established by the rise of the hill—its classical ruins brilliantly illuminated against the slaty, dark-green sky common to all the frescoes in the chapel—to a castle on the hilltop. As we wait for the blow to fall, we note that one bough has already snapped at the top of the tree in the foreground, that the executioner's sleeve has ripped from his garment with the strain of the uplifted mallet, and that a gigantic crack cuts through the keep of the castle from the top almost to the foundation. The contrast between this terrible tension and the calm of the soldiers idly watching the execution, together with the various illusionistic devices, is, of course, intended to identify the observer with the event through suspense and apprehension. We look directly into the gentle features of the head about to be cut off and roll upon us.

The blow fell, delivered by another executioner. On March 11, 1944, a stick of American bombs, intended for the nearby railway yards of Padua, rained wide of their mark and demolished the Ovetari Chapel, indeed the entire east end of the Eremitani Church. Only pathetically small remains of Mantegna's frescoes were recovered, and these are now mounted in the rebuilt chapel upon frescoes reconstructed from photographs, together with a single, already badly damaged scene from the Life of St.

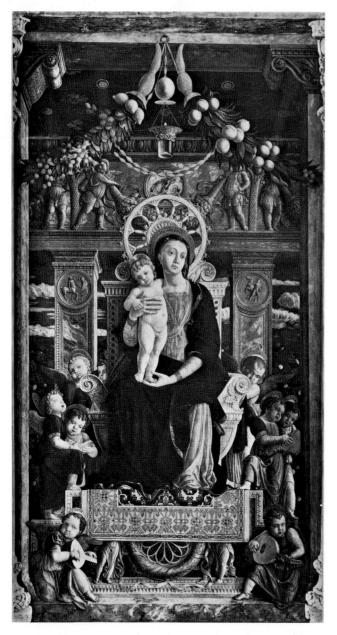

403. Andrea Mantegna. *Enthroned Madonna and Child*, central panel of the S. Zeno altarpiece (see colorplate 57). 1456–59. Panel, 86½×45½". S. Zeno, Verona

Christopher that had been removed earlier from the walls for safekeeping. The reconstruction, however painstaking, gives only an echo of the lost masterpieces.

Mantegna's first major altarpiece is now in its original position in the Church of San Zeno in Verona (colorplate 57), for which it was painted between 1456 and 1459, although two of the predella panels are in provincial French museums and the third, the Crucifixion, is in the Louvre; all three are replaced in the original frame by copies. The altarpiece has often been characterized as a pictorial version of Donatello's sculptural altarpiece for Sant'Antonio in Padua, and it probably does repeat some of the great sculptor's architectural and figural arrangements. The frame is a sumptuous carved and gilded wooden temple, whose arched pediment and entablature are supported by four columns of a modified Corinthian order. These columns appear to be engaged to square (painted) piers within the picture, forming one side of a square loggia, the "forecourt of the Lord," as seen in Fra Filippo Lippi's Barbadori altarpiece (see fig. 216) and in the St. Lucy altarpiece by Domenico Veneziano (see colorplate 32). In the center the Virgin is enthroned on a classical marble seat (fig. 403), with a large marble wheel behind her head to enhance the effect of the actual halo, which Mantegna has sharply reduced. In the side panels stand eight saints, in meditation or conversation, diminishing in size as they recede inward. Their costumes are painted in reds, yellows, greens, and blues of great clarity and brilliance against the veined marble of the painted architecture, the deep blue of the sky, and the icy white of the distant clouds. In the foreground, passing between the gilded columns and the painted piers, hangs a garland of fruits and flowers issuing from two cornucopias attached to a ring directly above the Virgin's head. From the same ring hangs an egg, doubtless symbolizing the Virgin Birth, as in Piero's later Madonna and Child with Saints (see fig. 287), and from the egg a crystal lamp full of oil, with a flame burning. The two garlands are connected by an early rosary (see Glossary). Around and below the throne, putti sing or strum on lutes. A typical Mantegna trick is the superb Oriental rug under the Virgin's feet, which hangs in front of the sculptured putti on the pedestal of her throne, concealing them to the waist.

Considering the brightness of the colors and of the gold, the power of the architectural masses, the sharp definition of the forms, and the consistency of the spatial formulation, the illusion of reality—a higher reality—within the temple frame is overpowering. It is, of course, the sort of thing that had been initiated by Pietro Lorenzetti in his *Birth of the Virgin* (see fig. 105), although Mantegna probably had no knowledge of that picture. The illusionistic altarpieces of North Italy start from Mantegna's grand formulation at San Zeno and continue in a rich series through the works of major and minor masters well into the Cinquecento.

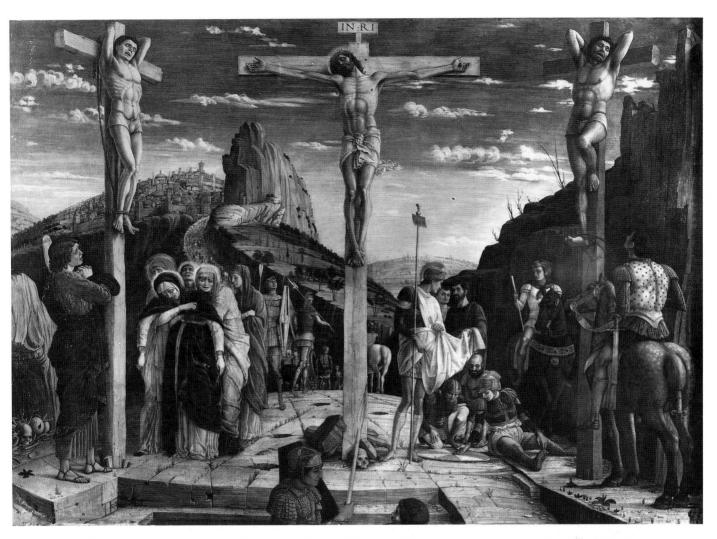

404. Andrea Mantegna. *Crucifixion*, from the predella of the S. Zeno altarpiece (see colorplate 57). 1456-59. Panel, $26 \times 35\%$ ". The Louvre, Paris

Even more impressive than the altarpiece itself is the Crucifixion from the predella (fig. 404), so majestic in its composition and so intense in its tragic emotion that in reproduction it looks like a monumental fresco instead of a modest panel. The three crosses on Golgotha—the Place of the Skull—are set in holes made in a rounded, skull-shaped stone outcropping and held in place by wedges and rocks. At first sight the cracks in the stone appear to conform to Albertian orthogonals, but they do not intersect rationally. In front the rock is cut into steps, forming a partly hidden foreground space from which two soldiers emerge; behind the Cross of Christ the hill curves smoothly downward, carrying the departing soldiers with it, toward Jerusalem, whose roofs, domes, walls, and towers follow the curves of the hill like the distant city in the Martyrdom of St. James (see fig. 402). Beside the ascending road, filled with the crowds returning from the spectacle of the Crucifixion, towers a gigantic crag, broken into wild and beautiful rock masses. The crosses of the two thieves, as in one of Jacopo Bellini's drawings (see fig. 396), are turned inward, and the bodies of the thieves seem to grow out of the landscape. But the Cross of Christ is so placed that his toes, deprived of the usual footrest, issue from the junction point between the two distant hills, his body is fully silhouetted against the sky, and his arms are thrown wide, in a heroic gesture of suffering. In this pose the discordant elements of the landscape are brought together, and the lines of the arms and the turn of the head are related to the horizontal clouds in the cold sky. Strengthened by the severe restraints that always operate in Mantegna's style, the tragic contrasts of the scene—the suffering women (their haloes have dissolved into soft-edged, gold clouds), the indifferent soldiers, and the beauty of the landscape and cityscape—make this small picture one of the grandest Crucifixions in Italian art.

Closely related to the San Zeno altarpiece, indeed a second version of the same subject painted in one of the

405. Andrea Mantegna. Agony in the Garden. c. 1460. Panel, $24\frac{3}{4} \times 31\frac{1}{2}$ ". National Gallery, London

three predella panels, is the Agony in the Garden (fig. 405), done for a Paduan private citizen and now in the National Gallery in London. Here Mantegna repeats the hardness of sculptured form, the enameled brilliance of color, and the ringing clarity of atmosphere of the San Zeno altarpiece, and, as in all his early works, he drives perception to its utmost limits, so that the last stone, the last mountain, the last rabbit in the road are projected with flawless precision. The composition of both of Mantegna's versions of the Agony in the Garden derives directly from one of Jacopo Bellini's drawings, even to the ominous bird perched on a dead branch, but all the rock masses and human forms have been subjected to Mantegna's relentless passion for definition and organization. Jerusalem appears as a mixture of the North Italian medieval cities Mantegna knew well and the Rome he knew as yet only from drawings and descriptions. Mantegna's Christ kneels, contemplating not the chalice usually presented to him by an angel ("Lord, let this cup pass from me, but thy will, not mine, be done!") but a little phalanx of child-angels bearing symbols of the Passion, advancing toward him on a floating island of cloud. Particularly striking is the foreshortening of one of the sleeping Apostles, which may have been suggested to the artist by some vanished work of Paolo Uccello in Padua or Venice. The feet of one of the Apostles lead us down

right: 406.
ANDREA
MANTEGNA.
Circumcision, lateral
panel of a triptych.
1464 (?). Panel,
34×17". Uffizi
Gallery, Florence

opposite left: 407.
ANDREA
MANTEGNA.
Adoration of the
Magi, central panel
of a triptych.
1464 (?). Panel,
30¼×29½". Uffizi
Gallery, Florence

opposite right: 408.
ANDREA
MANTEGNA.
Ascension, lateral
panel of a triptych.
1464 (?). Panel,
34×17". Uffizi
Gallery, Florence

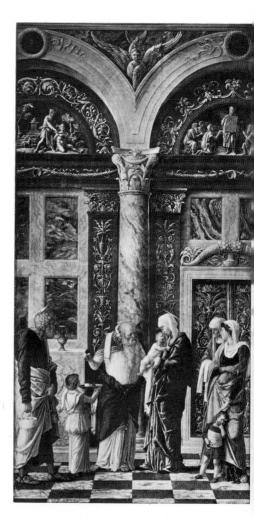

the road to where, in the middle distance, Judas brings the Roman soldiers to arrest his Master.

After years of negotiation, in 1459 the young artist finally renounced his independence and went to Mantua as official painter to the court of Marquis Ludovico Gonzaga, where he worked for nearly half a century, becoming one of the first princely artists of the Renaissance. There he continued to paint altarpieces and frescoes for churches, chapels, and palaces, to design pageants, to paint allegorical pictures, and to perform many official tasks that fell to the lot of a court artist. From this Mantuan period is to be dated a so-called triptych, now in the Uffizi in Florence, possibly a heterogeneous group of panels assembled at a later date from those originally lining the chapel in the Gonzaga castle. The left panel shows the Circumcision (fig. 406), the central the Adoration of the Magi (fig. 407), and the right the Ascension (fig. 408)—subjects more closely related than one might think. In the Circumcision Christ fulfills the Law of the Jews. In the Adoration of the Magi he is first shown to the Gentiles. In the Ascension (Mark 16:15) he commands the Apostles to evangelize all mankind.

To the astonishment of visitors to the Uffizi who see the picture for the first time, the panel on which the *Adoration* is painted is actually concave. It is a kind of shallow niche, probably a perspective device. For if the spectator places himself at the center of the circle of which this panel, in plan, is an arc, then the picture plane, equidistant from him at all points, will disappear, and he will be related directly to the objects within the picture and will be able to move easily up the road into the distance. Mantegna always tries to lead us across the threshold of his pictures, like Alice into Looking-Glass Land, and here he does it with great success. By 1464, or thereabouts, he had discovered and put into practice the principle of the panoramic curved screen, which is now used in cinemas throughout the world for exactly the same reason.

The rock formations and the stone road sweeping toward us in a flattened, reversed S-curve are again derived from Jacopo Bellini's drawings, but enhanced by every subtlety of Mantegna's perspective, naturalistic observation, and splendid color, richer and somewhat softer than in the works of the 1450s but no less intense. He may already have used oil glazes to obtain some of the deep glow in this and other paintings of his mature and later years. Mantegna's camels are the first convincing ones we have seen, and for the first time in Italian art he shows the third Magus as black. One unexpected detail is the shape of the star, which has seven points for the Seven Joys of Mary (of which the Adoration is one) and also one long ray shaped like a sword, as if in fulfillment

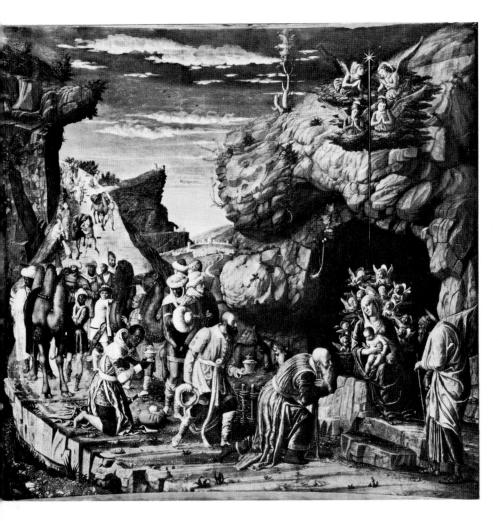

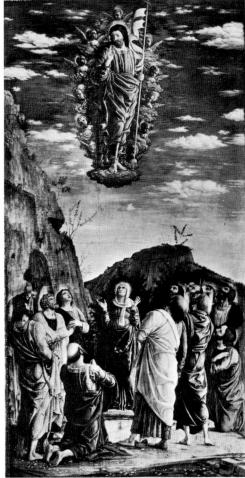

of the prophecy of Simeon (Luke 2:35), "A sword shall pierce through thy soul also." Thus the cave of the Nativity foretells the cave of the Entombment, according to their mystical identity in Christian thought. All three paintings are fairly well preserved. They are meticulous in the delicacy of their perception of structure and detail in rocks and drapery. Actually projecting past the vertical, the towers of what is apparently the medieval predecessor of the Renaissance Castle of San Leo, which still stands on its lofty crag in the Marches, appears in the background of the *Adoration*.

The Circumcision, stylistically the latest of the panels, is about to take place in the Temple. There was a sizable Jewish community in Mantua, protected by the Gonzaga family, and doubtless it provided Mantegna with the necessary technical information. The architecture in the background is very beautiful, not only in its understanding of the new classical forms of the Renaissance, but also in the glow of its rendering of veined marbles and gold. Mantegna has suggested a space reaching beyond the narrow limits of the panel by allowing the frame to cut two arches; the column in the center symbolizes at once the Church itself and the column at which Christ's blood was next to be shed, in the Flagellation. The delicately drawn simulated reliefs in the lunettes make this allusion quite clear. On one side is shown Moses holding up the Tables of the Law, on the other the Sacrifice of Isaac, which foretold that of Christ. The folds of cloth here, as throughout the three panels, are painted with scrupulous delicacy, and the picture contains Mantegna's usual touching children—a boy who obediently holds the plate with the roll of bandages and the bottle of water, and an infant who turns away from the scene to suck his finger.

The Ascension is another example of the direct reliance by Mantegna on one of Jacopo Bellini's compositions. However, the son-in-law has supplied a solid cloud mass for Christ to stand upon as he ascends, rather than having him merely standing in thin air as in Jacopo's drawing. Haloes, which always seem to have bothered Mantegna, are again dissolved so that they become vaguely circular mists of gold around the heads rather than the characteristic dinner plates, which even the Tuscans had tried to vary by turning them to crystal. Coloristically, this panel is perhaps the most radiant of all, with its blues, yellows, and reds, and its resoundingly blue sky.

In 1466 and 1467 Mantegna made two trips to Florence. This was probably the painter's initial contact with large numbers of Florentine works of art. He must have been profoundly impressed by the art of Castagno (whose earlier works he had been able to study in Venice), especially the *Vision of St. Jerome* in the Santissima Annunziata (see colorplate 35) and the *Death of the Virgin*, destroyed in the seventeenth century but in Sant' Egidio in Mantegna's time. Mantegna emulated the

sharp foreshortening of these pictures (Castagno's dead Virgin was seen feet foremost and so, for that matter, is the one in the drawing books of Jacopo Bellini) in his famous Dead Christ (fig. 409) in the Brera Gallery in Milan, his single surviving painting on this subject. The picture shows Christ lying on a marble slab, with a white cloth over his legs, his head raised on a pillow so that we can look into the closed eyes, still haunted by pain, and the slightly parted lips. Strange as it may seem in an era in which the fact of death is glossed over and people "pass away," this grim reminder of our mortality is probably the painting that was placed by Federigo Gonzaga, first duke of Mantua, just outside his bride's chamber in 1537. In the Quattrocento the death of Christ was a matter for frequent personal meditation. In his Imitation of Christ Thomas à Kempis exhorted his readers to "dwell in the wounds of Christ," which is what Mantegna has asked his observers to do. His sculptural form provides the body, and in consequence the open wounds, with the most convincing three-dimensionality. The perspective recession has the effect of catapulting the body, wounds and all, past the frame and into the observer's inner life. Nor can the viewer escape, for the feet, projected from his point of view, follow him wherever he stands in the gallery, and the wounds always lie open to his gaze and seemingly to his touch, as to that of St. Thomas.

It has sometimes been objected that the head is too large and the feet too small. This appearance is caused by the fact that, as in Uccello's dead soldier in the *Battle of San Romano* (see fig. 263), the projection is that seen by one eye only; no other form of projection is possible in a single image drawn or painted on a flat surface. The perspective we actually experience in daily life is not monocular, of course, but binocular. We see two slightly variant views separated by the distance between our

409. Andrea Mantegna. *Dead Christ.* After 1466. Canvas, 26¾ × 317/8″. Brera Gallery, Milan

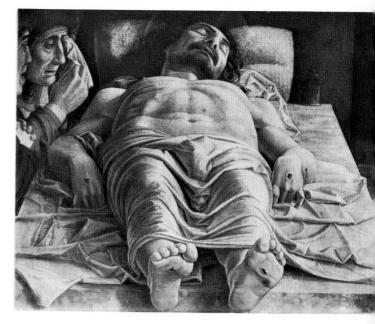

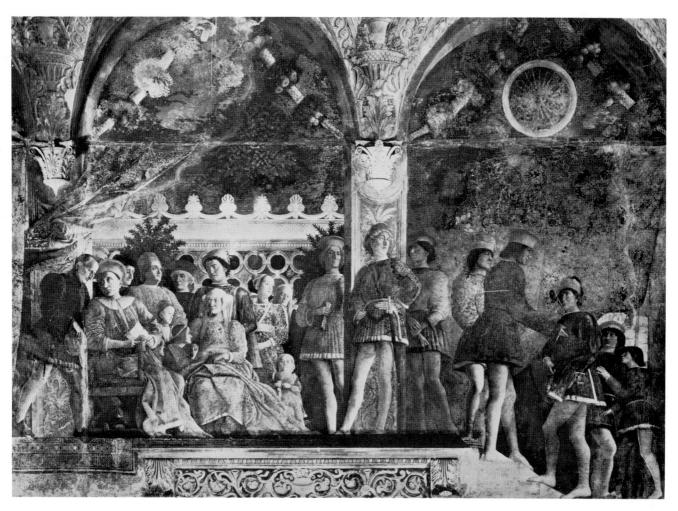

410. Andrea Mantegna. *Ludovico Gonzaga*, His Family, and Court. 1465–74. Walnut oil on plaster. Camera degli Sposi, Palazzo Ducale, Mantua

eyes, and as a result the feet of a recumbent figure pointing toward us, seen from both sides at once, loom larger. But an experiment—looking at a figure or a statue in this position with one eye—will show that Mantegna's perspective and proportions are correct.

The *Dead Christ* is painted on canvas (which always grays down the colors of a tempera painting), and may therefore have been intended as a processional banner for some society or confraternity dedicated to the Corpus Christi. A copy of this picture exists without the somewhat unconvincing mourners at the left, who in the original look as if they had been inserted as an afterthought, possibly by a pupil. The reader would do well to cover these faces for a moment. He can then look into the lonely countenance of Christ without this distraction, and the picture will gain immeasurably in depth and majesty.

The happiest manifestation of Mantegna's genius is the room known today as the Camera degli Sposi (Room of the Bride and Groom), which he painted over an ex-

tended period from 1465 to 1474 for Ludovico Gonzaga and his family in one of the towers of their castle, looking out over the lakes that then surrounded Mantua. Over the fireplace Mantegna painted the marquis and the marchioness (Barbara von Hohenzollern), together with their children, courtiers, and their favorite dwarf (fig. 410), gathered on a terrace enclosed by a high parapet; this is formed by linked circles of white marble filled with disks of veined marble and crowned with a handsome row of palmettes. The mantelpiece seen at the bottom of our illustration is real, but it is used as a pedestal by a nonchalant painted courtier with one hand on his hip. At the left a messenger, who has just brought the marquis a letter, listens intently to his instructions. The group portrait has often been compared to that of Sixtus IV Appointing Platina (see fig. 382), painted only a year or two later by Melozzo da Forlì in the Vatican Library.

Mantegna has grouped the figures with ease and simplicity, but within the apparent spontaneity of their relaxed attitudes he has found an infinity of beautiful

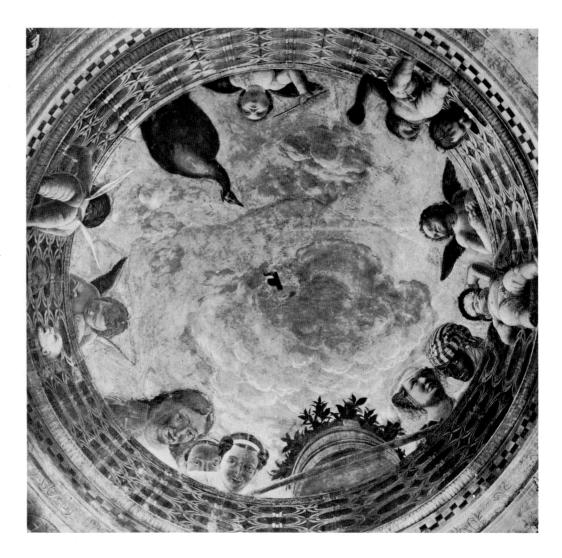

411. Andrea Mantegna. Ceiling fresco. 1465–74. Camera degli Sposi, Palazzo Ducale, Mantua

relationships of form and surface. The portraits, few of which can be securely identified, are all rendered with Mantegna's customary precision. His style, however, has changed sharply since the early work. The forms are not so strongly projected, and the color is gentler and softer, without the harshness of the Eremitani frescoes or the brilliance of the San Zeno altarpiece.

The paintings are continuous on two of the four walls and over the vaulted ceiling. The scene on the adjoining wall (colorplate 58) has so far eluded identification with any known event and is probably symbolic. At the left stands Ludovico, at the right his older son and successor, Federigo, and in the center his second son, Cardinal Francesco, made titular of Sant'Andrea in 1472, while in the foreground the youthful protonotary Ludovico is greeted by his two younger brothers. The background, possibly symbolic of Rome, is one of Mantegna's dream cities, with Roman ruins and statues outside its lofty walls and a castle above. Again the costumes, particularly the conical doublets and parti-colored hose, provide Mantegna with a fine series of elements for his geometri-

cal composition. In spite of the loss of large areas of the surface, made up by recent inpaint that is hatched so as not to be confused with the original, the glow of the color is one of the chief delights of Mantegna's painted room. There is, however, a considerable coloristic difference between the ceiling, painted in fresco, and the walls, which Mantegna carried out with a vehicle of walnut oil.

Mantegna's special trick comes in the ceiling, which was painted to resemble relief sculpture in marble and mosaic in gold (fig. 411). Then in the center, unexpectedly, we look straight upward through a cylindrical parapet—also painted, constructed in the same manner as the one in the group portrait—into the sky above. Little putti, alarmingly foreshortened from below, stand just inside the rim, others poke their faces through what turn out to be empty circles, and laughing ladies-inwaiting look over the parapet at us. As a final prank, Mantegna has perched a heavy tub of plants on the edge of the parapet, propped only by a pole that might roll away at any moment.

In 1488 Mantegna at last went to Rome, where he was able to study classical antiquities in large numbers, not to speak of the frescoes recently painted for Sixtus IV. In 1489 and 1490 he painted a tiny chapel for Pope Innocent VIII, which survived until its destruction in 1780 to make way for a new wing of the Vatican Museums. On his return to Mantua, Mantegna's style suffered a certain desiccation. His late paintings, although still recognizably the work of a great artist, substitute a curiously dry intellectuality for the force and brilliance of his youthful and mature styles. The grandeur of form, the depth of feeling, and the power of color are no longer there. The finest painting from Mantegna's later years is probably the Madonna of the Victory (fig. 412), now in the Louvre. The picture was painted for a penalty of 150 ducats, extracted in expiation from a Jew who in 1493 had removed a painting of the Madonna and Child from the wall of a house he had bought—even though he had received the bishop's permission to take it down. In the meantime, in 1495, Marquis Gianfrancesco Gonzaga, husband of the famous Isabella d'Este, was involved in a somewhat questionable victory over the French at Fornovo, and the subject was changed from a Madonna of Mercy to the Virgin and Child with the military saints Michael and George, the latter holding a broken lance, and Sts. Andrew and Longinus, patrons of Sant'Andrea in Mantua, all protecting the armored and kneeling marquis. The infant St. John the Baptist appears at the right on the pedestal of the throne; kneeling next to him is an old woman, who in all probability is his mother, St. Elizabeth, patron saint of Isabella. On the pedestal is a simulated relief showing the Temptation of Adam and Eve, from whose consequences Christ and the Virgin have redeemed us. The figures are enclosed by the Virgin's regal bower, a charming construction of espaliered orange trees, supported by a carved wooden arch with Mantegna's favorite palmette motifs and a fine profusion of gourds on vines. From the apex of the bower a branch of rose-colored coral—efficacious in warding off the evil eye—hangs from a necklace, apparently another early form of the rosary, composed of six coral beads alternating with one in crystal. In the openings of the bower perch parrots and cockatoos. The Virgin's throne culminates in a sixteen-pointed wind rose, one of the symbols of the Gonzaga family.

The picture abounds in delicate devices, such as the off-center placing of the Virgin's footstool to compensate for the fact that she must extend her hand on one side only and direct her attention downward to Francesco. The details are painted with an even greater refinement of linear accuracy than in Mantegna's earlier periods, but the form has lost its bite and the color is muted, without any hint of the Venetian colorism that we shall shortly consider. In his old age the princely artist, working in isolation from other Italian schools, living in considerable splendor in the classical house he had designed for

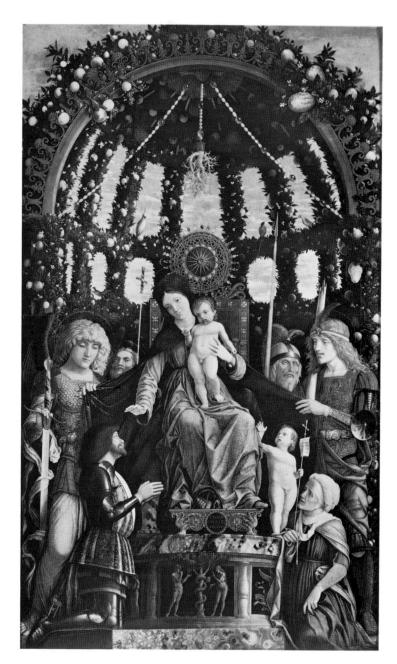

412. Andrea Mantegna. *Madonna of the Victory*. 1493–96. Canvas, 9'2" × 5'10". The Louvre, Paris

himself in Mantua, had become unmistakably if brilliantly reactionary.

Mantegna's classical proclivities endeared him to Isabella d'Este. This learned princess took pleasure in her Grotta (Cave), a combination study and treasure chamber that she had built in the Castle of St. George at Mantua, not far from the Camera degli Sposi, commissioned by her husband's grandfather Ludovico. Here the Gonzaga inventories disclose that she kept in carved and gilded wooden cabinets an amazing collection of classical gems, coins, medals, precious and semiprecious stones,

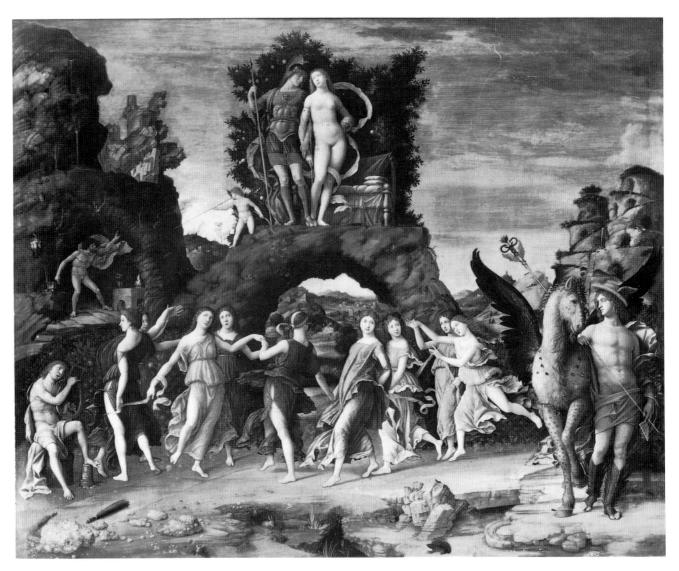

413. Andrea Mantegna. Parnassus. 1490s. Canvas, 631/2×751/8". The Louvre, Paris

vases, manuscripts, gold and silver work, and other rarities. The space between these and the carved and gilded ceiling, loaded with Isabella's private mottoes and emblems directed by her literary interests, was to be filled with paintings, two of them by Mantegna. In the Parnassus (fig. 413), already in place in 1497, Mars embraces a Venus very different from Botticelli's shy creature (see colorplate 46), in front of a couch perched on the kind of natural bridge Mantegna always enjoyed painting. Cupid blows what looks like a glassblower at Vulcan, Venus' deceived husband, who menaces the happy couple from a cavern illuminated by the soft glow from his forge. In front of the natural bridge, Apollo provides music on his lyre for a dance performed by the nine Muses, while Mercury at the right leans gently against Pegasus, the winged horse. It is a delightful classical fantasy, full of involved relationships of line and form and

the muted colors of Mantegna's late style. This painting, replete with references to ancient sculpture that Mantegna had studied, celebrates the wedding of Gianfrancesco and Isabella on February 11, 1490, when the planets Mercury, Mars, and Venus all stood within the sign of Aquarius, as did the westernmost bright star of the constellation Pegasus. The colors of Mars' garments, Venus' scarf, and the coverings of the couch are the mingled colors of the Este and Gonzaga families. The painting, whose elements were doubtless specified by Isabella (we have her explicit instructions for other pictures done for the Grotta), was clearly an allegory of marital harmony, under which the arts, led by music, would flourish. The smooth surface finish probably represented a concession to the tastes of Isabella and her desire to create a unity between her jewellike treasure chamber and the jewels it contained. Mantegna's death

in 1506 was felt as a personal tragedy by the Gonzaga family, for whom he had worked for nearly half a century. Albrecht Dürer, on his second visit to Italy, was on his way to visit this painter, to whom he owed so much, when death intervened.

GENTILE BELLINI

In Venice, meanwhile, the Bellini family was busily creating a new style. Today when we hear the name Bellini, we think of Giovanni, one of the greatest masters of Italian art. Yet in the Quattrocento it was his older brother Gentile who first won large, official commissions. Gentile painted for the same kind of public as Ghirlandaio. and he recorded the contemporary Venetian scene as faithfully as Ghirlandaio did that of Florence. He was equally conventional, but by no means equally skillful or sensitive. A case in point is the Procession of the Relic of the True Cross (fig. 414), now in the Accademia in Venice, painted in 1496 for the Scuola di San Giovanni Evangelista. The scuole (schools) of Venice were not educational institutions but confraternities, on the order of the Misericordia in Florence, dedicated to good works under ecclesiastical auspices, but with a definite premonitory flavor of the modern fraternal orders. There was always a large hall, used as a combined hospice for the poor and hospital ward, often a meeting room as well; of necessity there was a chapel. In a climate inimical to frescoes, paintings on canvas formed suitable

decorations for these public rooms, and the huge framed scenes comprise a large part of the production of some of the leading masters from the time of Gentile Bellini through the Cinquecento. The relic of the True Cross, the pride of the Scuola di San Giovanni Evangelista, is shown as it was carried, in 1444, in solemn procession through the Piazza San Marco in a golden reliquary under a canopy. The brothers of the order, dressed in a monkish habit, are doubtless individual portraits, as are many spectators. Yet all are represented as almost identical wooden effigies, ranged before the square. The principal interest of this prosaic work is its description of contemporary Venetian life and buildings. The Basilica of San Marco and the Doges' Palace are now much as they were then, although the original Byzantine mosaics of San Marco and Uccello's St. Peter, under the first pinnacle at the left, have long since been replaced. We can gain an idea of their original appearance only from Gentile's painting.

The one colorful episode in the artist's otherwise routine life was his stay at the court of Sultan Mahomet II in Constantinople in 1479–80. Most of the paintings he did for the sultan are lost. Especially sad is the disappearance of his decorations for the imperial harem in the Topkapi. One of his portraits of Mahomet (fig. 415) is now in the National Gallery in London. Despite its heavily rubbed condition, the picture has considerable coloristic charm, and its combination of Oriental and Renaissance ele-

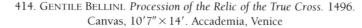

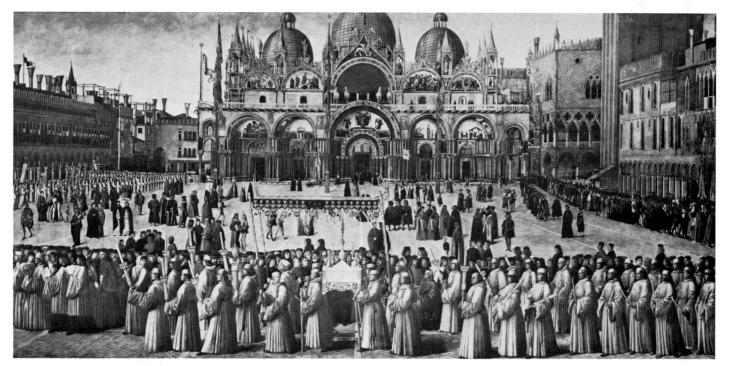

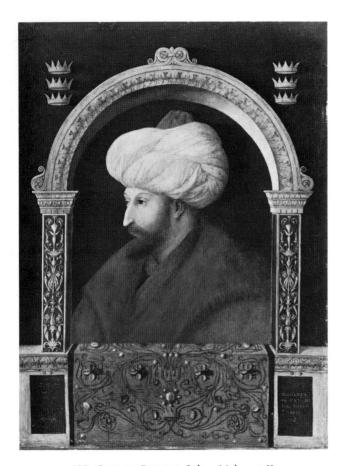

415. GENTILE BELLINI. Sultan Mahomet II. 1480. Canvas, 27¾ × 20¾". National Gallery, London

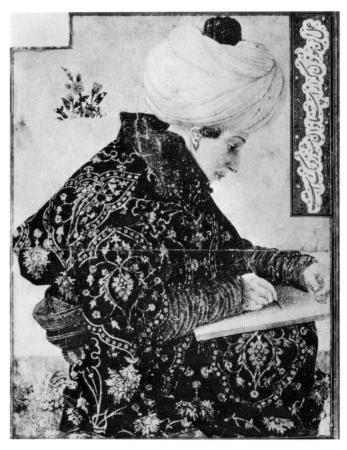

416. GENTILE BELLINI. *Portrait of a Turkish Boy.* 1479–80. Pen and gouache on parchment, 71/4 × 51/2". Isabella Stewart Gardner Museum, Boston

ments is delightful. Even more winning is the Portrait of a Turkish Boy (fig. 416) in the Gardner Museum in Boston, which reveals that, at least for a Turkish public, Gentile showed a considerable sensitivity to the kind of composition by areas that does not emerge in Western art until the late nineteenth century, again under Oriental influence. Gentile's life in Constantinople provided material for many anecdotes, of which the best is probably the story of how he showed the sultan a painting of the severed head of St. John the Baptist, a frequent subject in North Italian art, from whose contemplation the observer was supposed to derive great spiritual benefit. The sultan considered the picture quite unnaturalistic, and to prove his point called up two slaves, one with a sword. "This," said the sultan to Gentile, after the headsman had given one expert blow, "is how a freshly severed head should look!" Gentile, deciding that his life might be longer if less lucrative in Venice, soon left for home.

ANTONELLO DA MESSINA

At this juncture the orderly progress of Venetian art is interrupted by the appearance of one of those extraordinary geniuses who turn up every now and then as if to refute theorists who like to relate history in terms of necessary developments from stage to stage. Real life seems able to provide an infinity of surprises for us—such as the peripatetic Gentile da Fabriano early in the Quattrocento or El Greco in the late Cinquecento. As his name suggests, Antonello da Messina (c. 1430-79) came from the Sicilian city of Messina, where there had been no artistic tradition since the days of the twelfth-century mosaicists. Active as master of his own shop in Messina in 1456, he nonetheless traveled widely, always returning to his native city. He arrived in Venice in 1475, stayed there only a year and a half, and changed the whole course of Venetian painting. Old sources always credit Antonello with having introduced the Venetians to the technique of painting in oil. While this may not be strictly true (oil painting was known in Venice and Florence as well at a much earlier date, and Antonio del Pollaiuolo and Piero della Francesca surely experimented with it), he did show the Venetians how oil could be used to give previously unknown atmospheric, luminary, and coloristic effects to landscapes, interiors, and figures. Venetian painting before Antonello and Venetian painting after Antonello are radically different, and it is impossible to escape the assumption of his responsibility for the change.

Where did he learn to paint in oil? He possibly learned from a Flemish-influenced painter named Colantonio, with whom Antonello may have been apprenticed in Naples. But as early as 1456 he was recorded at the court of Galeazzo Maria Sforza in Milan, where he was paid on the same basis as Petrus Christus, a pupil of Jan van Eyck. He certainly saw and studied Jan van Eyck's paintings in Naples and was a worthier disciple of the great leader of Netherlandish painting than any Northerner, including Petrus Christus.

Antonello was the son of a stonecutter, and had a sculptor's sense of form. Richard Offner suggested once that Antonello had studied Archaic or Transitional Greek sculpture in Sicily. Certainly he was able to blend a Netherlandish passion for the infinitesimal details of visual reality and for the saturation of vision in light and shadow with a quintessentially Mediterranean purity and clarity of form. But neither these disparate influences nor their unexpected combination in a single artistic personality can account for the phenomenon of Antonello, if indeed anything can account for genius.

One of Antonello's earliest pictures, possibly as early as 1450-55, is the little St. Jerome in His Study (colorplate 59), in the National Gallery in London, a work so Netherlandish in style that a Venetian who saw it in 1529 thought it might have been painted by Hans Memlinc or even by Jan van Eyck himself. St. Jerome reads quietly, apparently in an alcove of a monastic library. We are admitted to his study through a carefully rendered illusionistic stone arch similar in effect to those used by Rogier van der Weyden in a number of altarpieces but in shape typical of Spanish Gothic forms in Sicily. A brass bowl, and a peacock and a quail with their backs to each other populate the step, beautifully lighted from the left. This same light throws the shadow of the arch on the interior of the library, and competes with the distant diffused light from the windows on the other side. St. Jerome's desk and shelves are mounted in the brightest section, just below a mullioned clerestory window. Behind him, in the shadowy region between the two lights, his lion strolls across the elaborate majolica floor—a kind of pavement widely used in South Italy and Sicily and even, occasionally, in Tuscany. In true Van Eyck tradition the picture is complete down to the tiniest detail of architecture and still life, including the characteristic Netherlandish motif of the towel hanging on a nail. The light effects on the stone, the floor, the atmosphere of the room, and the landscape visible through the windows are balanced and controlled in a manner beyond the abilities of any other Italian master of the period, and probably beyond the possibilities of the tempera medi-

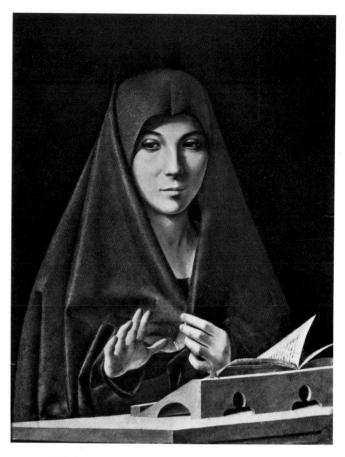

417. ANTONELLO DA MESSINA. Virgin Annunciate. c. 1465. Panel, 17¾ × 13¾". Museo Nazionale, Palermo

um. Such effects of diffused light and shade and muted color suggest the Van Eyck technique of oil painting and oil glazes. More important, the little picture, like a painting by Jan van Eyck, is a complete microcosm of its own, yet reflects as in a sphere of crystal the vastness of the outside world.

Antonello's Virgin Annunciate (fig. 417), in the Museo Nazionale in Palermo, is one of the masterpieces of Quattrocento painting. Its style differs somewhat from the Netherlandish manner of St. Jerome, and the picture must have been painted much later, perhaps about 1465. Antonello has not represented the Annunciation as an event, but rather the idea of the Annunciate Virgin as a devotional image, timeless and abstracted from the text, like the Adorations and Pietàs so common in Tuscany. The book of the prophet Isaiah (probably) is open on a little lectern before her, her right hand is lifted gently, her left draws her glowing blue veil a shade closer over her bosom, and the light reveals the perfect sculptural forms of her face while the shadow plays softly over her neck. In the manner of Jan van Eyck's portraits, the background is black, which of course imparts an even greater intensity to the blue veil and removes the image from

any connection with the surrounding world. The scene is laid, so to speak, in nowhere.

The serious face, with its grave, composed features, is the face of a Sicilian peasant girl, with the Greek nose still common among Sicilians. Under the arched dark brows the brown eyes show very subtly a realization of the meaning of the Incarnation. In the smoothly controlled and projected forms of the face, the influence of Greek sculpture seems very probable. Yet the clarity of form, the brilliance of the illumination, the emphasis on inner psychological experience, and the background in nowhere point ahead more than a century to the revolutionary works of Caravaggio.

Antonello da Messina was one of the greatest portraitists in history. An arresting example of his prowess and insight in this demanding art is his *Portrait of a Man* (fig. 418), in the National Gallery in London. The picture was once somewhat longer but was cut down in the eighteenth century. The portion removed had an inscription that is believed to have identified it as a self-portrait, but it may merely have been a signature. It is a portrait of astonishing psychological depth and control and the greatest dignity of form, a painting in which Antonello

418. Antonello da Messina. *Portrait of a Man.* c. 1465. Panel, $14 \times 10^{\prime\prime}$. National Gallery, London

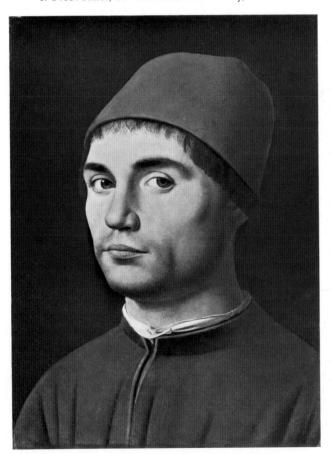

has fully exemplified both of the major tendencies blended in his style. No Netherlandish painter ever surpassed his observation of the movement of light across the varying textures of the skin of the different portions of the face, the faint stubble of the beard, the separate dark hairs escaping from the red cap or composing the powerful eyebrows, or the luminosity of the clear eyes. The plastic force of the forms is in the sculptural tradition of the *Virgin Annunciate*. It is tempting to persuade ourselves that we really are looking into the eyes of this calm assessor of the human condition. If so—and there is no way of proving it—the picture dates from about 1465

The small Crucifixion (fig. 419) in the National Gallery in London exhibits, just below the Cross, the little cartellino (piece of paper) that often appears in North Italian paintings of the Quattrocento, bearing in this instance Antonello's signature and the date 1475. In all probability the picture was painted after his arrival in Venice. The composition, with the Virgin and St. John seated at either corner, is close to that of Ghiberti's Crucifixion on the North Doors of the Baptistery of Florence (see fig. 157), which city Antonello may well have visited on his way northward. In the unearthly stillness of the broad, softly colored, tan and olive landscape, there is a suggestion of Piero della Francesca, and in the harmony between the extended arms and the shape of the landscape there is a hint of Mantegna. But Antonello needs none of Mantegna's passionate violence (see fig. 404) to evoke the mystery of death and of Christ's sacrifice in the warmth of the sun-filled earth and cloudless sky. This, too, is Golgotha, the Place of the Skull. Not only is Adam's skull visible in its proper place below the Cross, but also, as we watch, a host of other skulls, almost indistinguishable from the earth, fills the middle distance before the row of trees. Yet there is no gruesome emphasis on this detail. One notices it with surprise but accepts it with calm. Such is the meditative unity of the picture that life and death seem mysteriously one, regeneration and resorption part of the same process, a reconciliation to death so necessary a part of the law of life that grief is superfluous.

This gentle visual and spiritual unity was produced through subtle gradations of color and tone and through the miracle of the oil technique. Yet, since no events in human existence can remain stationary without stagnation, the very attainment of such unity will shortly destroy it, and we will see in the Cinquecento how, within the web of visual experience, the brush will suddenly liberate itself from both form and color, and declare its own independence of action and, therefore, its own autonomy as an instrument of emotional rather than purely visual expression.

A final work by Antonello, dating probably from the end of his stay in Venice, is the *St. Sebastian* (colorplate 60) in Dresden, almost contemporary with the altarpiece

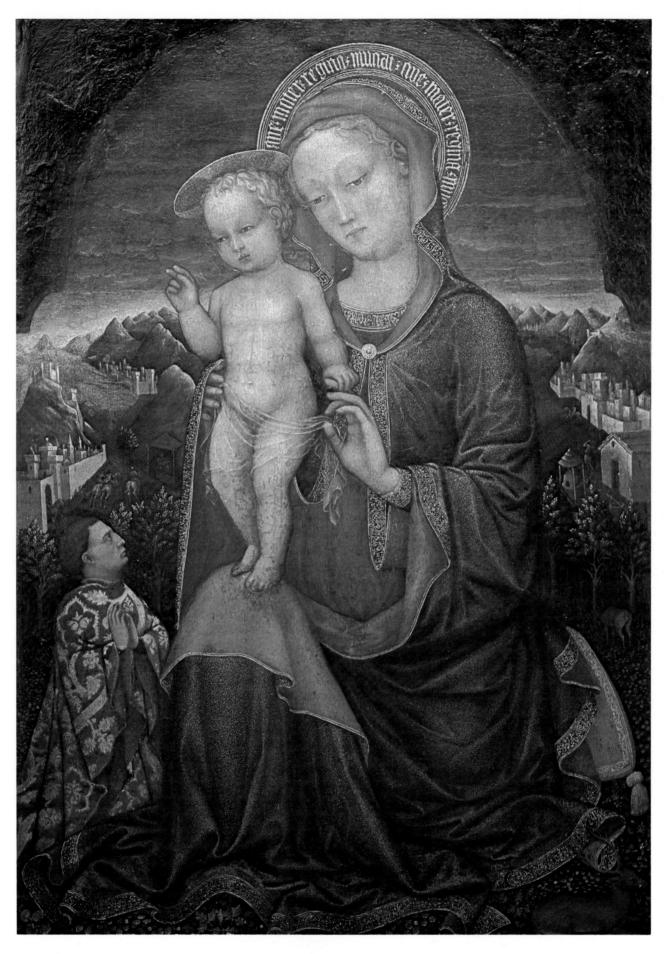

Colorplate 56. Jacopo Bellini. Madonna and Child with Donor. c. 1441. Panel, 23×16 ". The Louvre, Paris

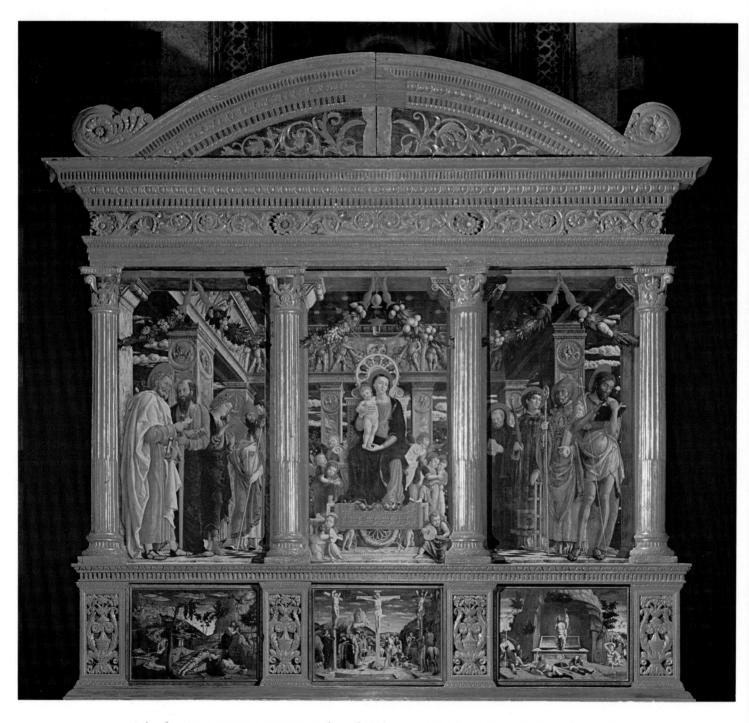

Colorplate 57. Andrea Mantegna. Enthroned Madonna and Child with Saints (S. Zeno altarpiece). 1456–59. Panel, height $86\frac{1}{2}$ ". S. Zeno, Verona

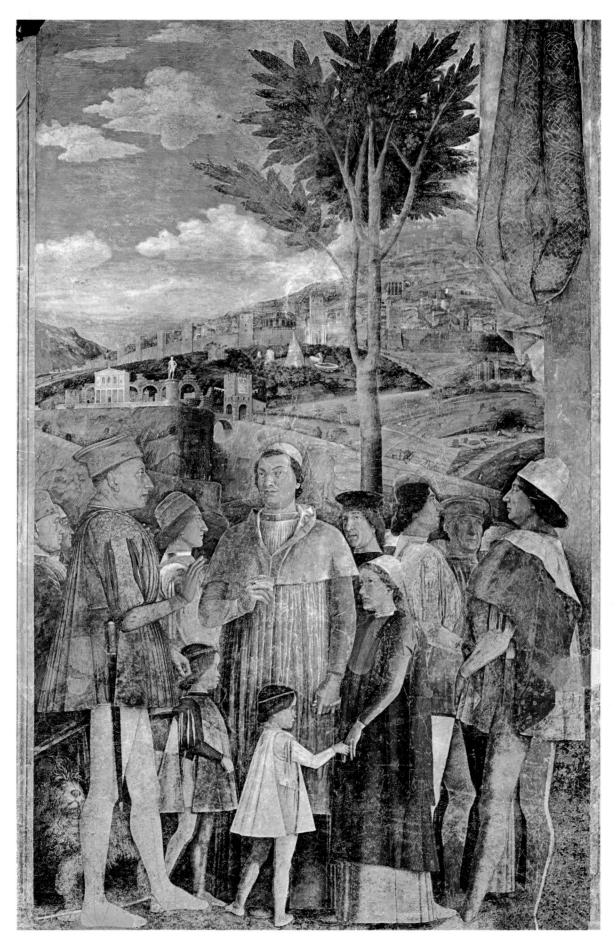

Colorplate 58. Andrea Mantegna. Arrival of Cardinal Francesco Gonzaga. Completed 1465–74. Walnut oil on plaster. Camera degli Sposi, Palazzo Ducale, Mantua

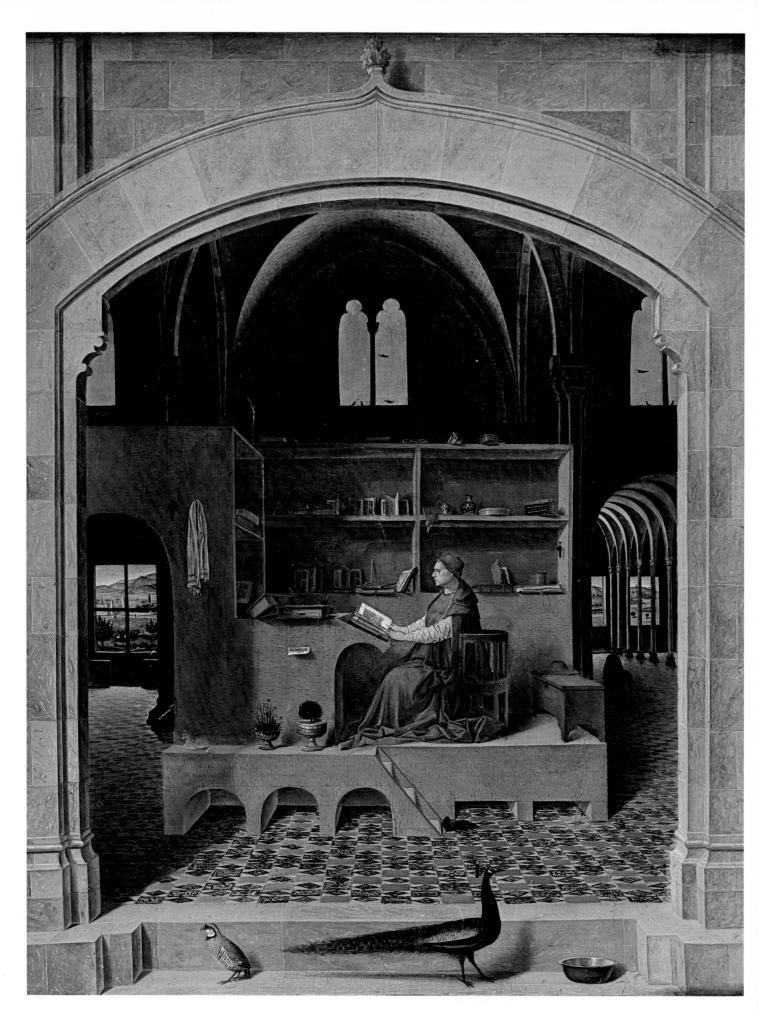

Colorplate 59. Antonello da Messina. St. Jerome in His Study. Possibly c. 1450–55. Panel, $18\times14\%''$. National Gallery, London

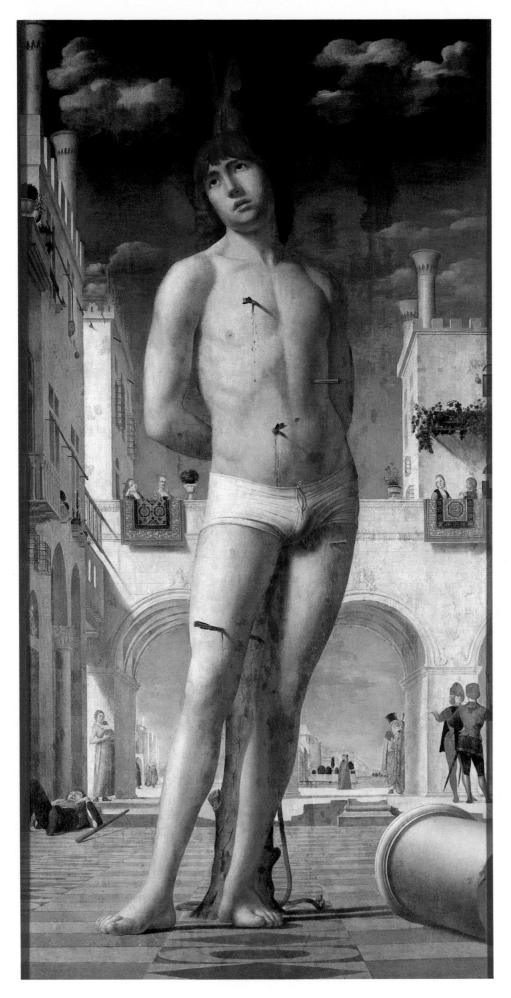

Colorplate 60. Antonello da Messina. St. Sebastian. c. 1475. Canvas, transferred from panel, $67\frac{1}{4}\times33\frac{7}{8}$ ". Gemäldegalerie, Dresden

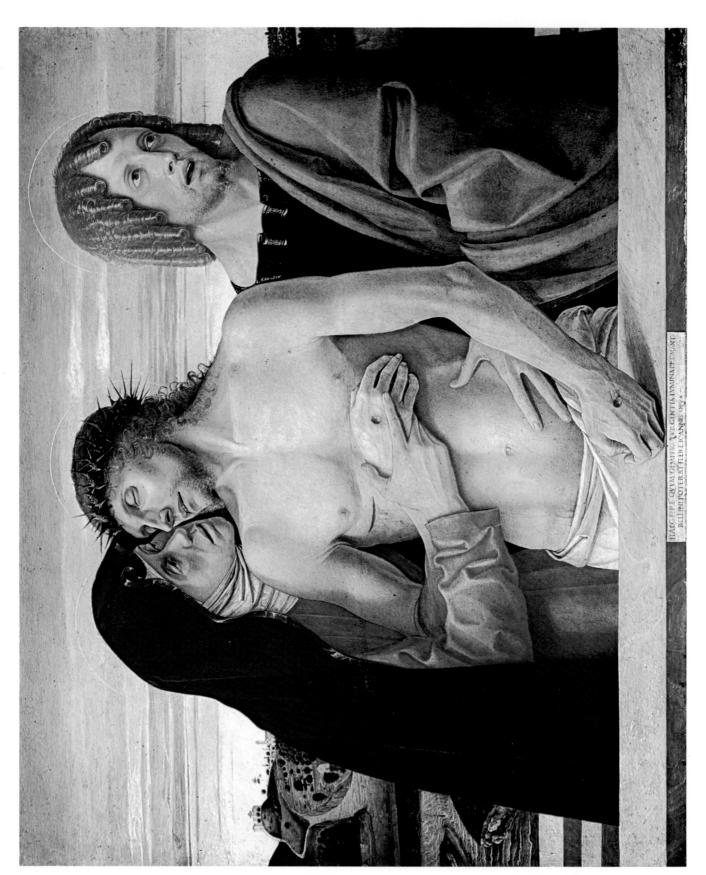

Colorplate 61. Giovanni Bellini. Pietà. c. 1468–71. Panel, 33%×42". Brera Gallery, Milan

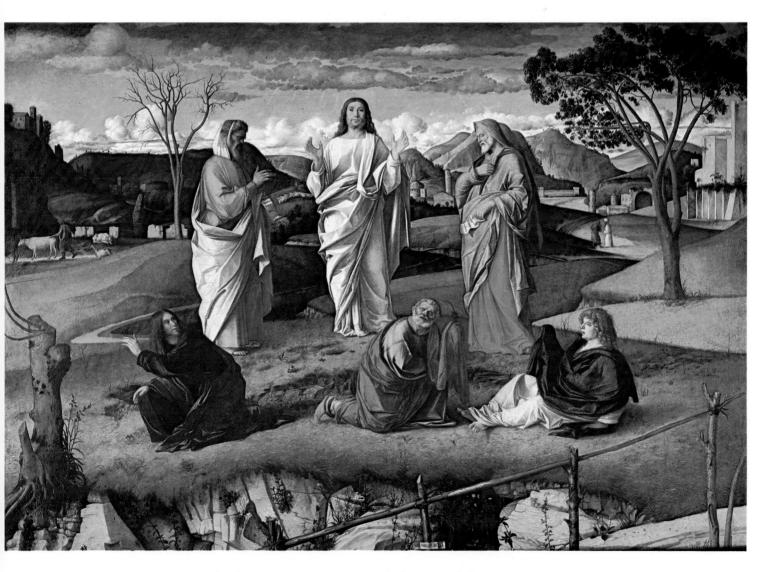

Colorplate 62. Giovanni Bellini. Transfiguration of Christ. Late 1480s. Panel, 45 1 /4 \times 59 $^{\prime\prime}$. Museo di Capodimonte, Naples

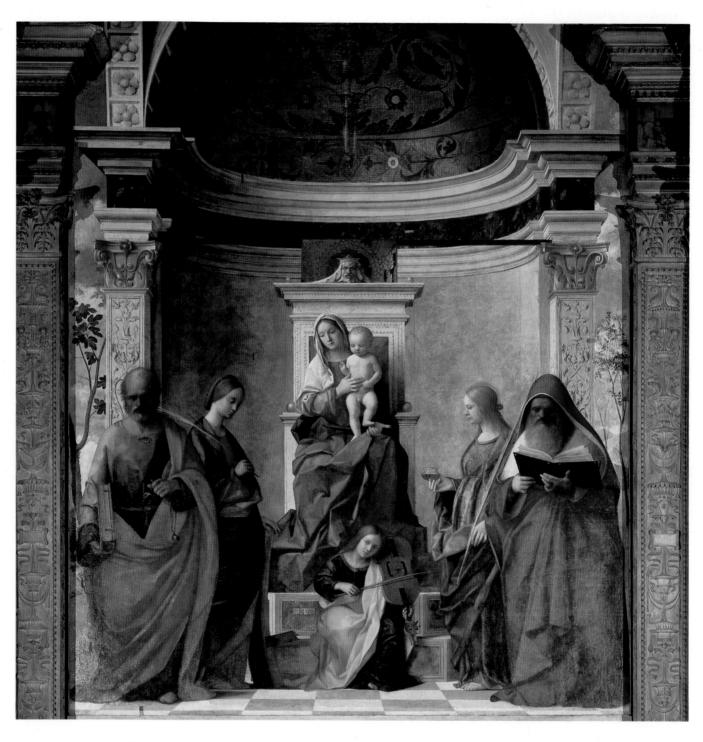

Colorplate 63. GIOVANNI BELLINI. Enthroned Madonna with Saints (S. Zaccaria altarpiece). 1505. Canvas, transferred from panel, $16'51/2'' \times 7'9''$. S. Zaccaria, Venice

on the same subject by Antonio del Pollaiuolo (see colorplate 43), but as different as possible within the requirements of the subject. Antonello has chosen a late moment in the story (as did also Mantegna in three separate representations). The attack is over and the soldiers have left. One sleeps in the sun, projected feet first, Mantegna-style, and two more chat before an arcade in the middle distance. The saint, pierced by four arrows and tied to a tree, stands looking upward with an expression of calm trust rather than the expected suffering. It is a figure at once commonplace and noble, beautifully drawn and serenely painted. In the reciprocal rhythms of the harmonious stance and in the low viewpoint of the brilliant perspective construction, set just below the knees of the saint, Antonello shows himself the master of the classic style created by Mantegna. Figure and architecture thus tower above us as in the St. James Led to Execution (see fig. 400). But the only vestige of Mantegna's archaeological interests is the broken column. Instead of the usual loincloth, the saint wears fifteenthcentury undershorts, and the buildings are contemporary Venetian houses, even to the flaring cylindrical chimneys. A dreamy afternoon sunlight warms alike the buildings, the people watching from carpet-hung balconies, the flowers in the window boxes, the Greek priests in the middle distance, the landscape beyond, the smooth, glowing skin of the nude figure, and the clouds in the sky. The painting is the epitome of Antonello's art.

GIOVANNI BELLINI

Now it is possible to turn to the work of the last and greatest member of the Bellini family, Giovanni Bellini or, in Venetian dialect, Giambellino, who brought Venetian painting to the threshold of the High Renaissance. Yet his evolution is incomprehensible without the Sicilian interloper for whom, in fact, Bellini had the deepest admiration and from whom he learned the new possibilities of oil painting. It is in keeping with Bellini's character, which was in the last analysis poetic, that we possess so little exact information about him. Most of his paintings, especially the early ones, are undated. We have no evidence for the date of his birth save that he signed a document as a witness in 1459, when he was already living away from his father and brother, and that in 1506, when Albrecht Dürer visited Venice for the second time, he wrote that although Bellini was very old he was still the best painter in Venice. Taken together these two facts would seem to place Bellini's arrival on this planet somewhere in the early 1430s, fairly close, therefore, to the birth date of his precocious brother-in-law, Andrea Mantegna. He is recorded as a painter before 1460, and he was painting up to the time of his death in 1516, so his pictorial career lasted for about two generations, a record that only Michelangelo and Titian would surpass. Most striking of all is the fact that, although the same poetic temperament can be felt in all Bellini's paintings,

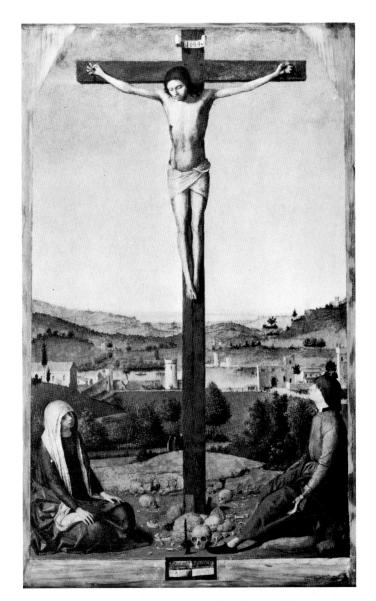

419. Antonello da Messina. *Crucifixion*. 1475. Panel, 16½×10". National Gallery, London

the difference in style between the earliest and the latest is so great as to make it hard at first to believe they were done by the same man.

Bellini's earliest works show a strong surface affinity with Mantegna's style, but underneath they betray a stronger disparity. The sculptural hardness of the masses, the firmness of the linear contours, the crispness of every detail, the careful construction of the picture as a whole suggest Mantegna; but never, even in his earliest paintings, does Bellini present us with the same consistency, the same rigor of organization, the same finality. Unlike that of Mantegna, his world is not accessible to analysis throughout and cannot always be rationally stated. Forms are often set next each other with slight attempt at connection; they coexist, united by community of feeling. The grave, pensive *Madonna and Child*

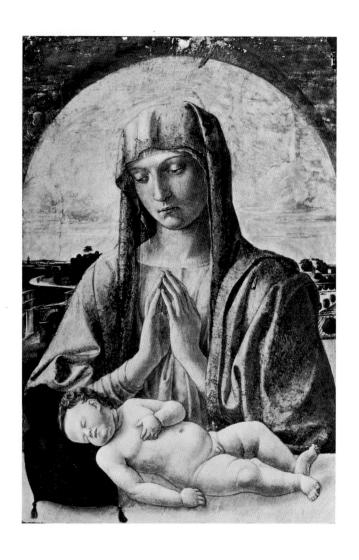

(fig. 420) in the Metropolitan Museum of Art in New York is typical of Bellini's numerous early Madonnas. Mantegna's steely intellect would surely have devised a design of greater coherence. But he could never have imparted this kind of mood to the picture: Mary looks sadly down to her sleeping Child, whose slumber foreshadows, as always, the death of the adult Christ, and lifts her hands in prayer, her face suffused by light from below—the sea light of Venice reflected from canals and palaces, which Bellini shows even on Madonnas set in landscapes. These backgrounds offer easy roads and gentle slopes; increasingly, they envelop and console the figures. Never does Bellini display the enameled brilliance of color so striking in the contemporary works of his intransigent brother-in-law. At the start he prefers pearly harmonies of pale flesh tones, soft roses, soft grayblues, and gray-greens. Only later and with the use of oil does his color warm and deepen, and then the sea light, strengthened by the new coloristic discoveries, permeates the solid forms.

Bellini's Agony in the Garden (fig. 421), for example,

left: 420. GIOVANNI BELLINI. Madonna and Child. c. 1465–70. Panel, 28½×18¼". The Metropolitan Museum of Art, New York

below: 421. GIOVANNI BELLINI. Agony in the Garden. c. 1460. Panel, 32×50". National Gallery, London

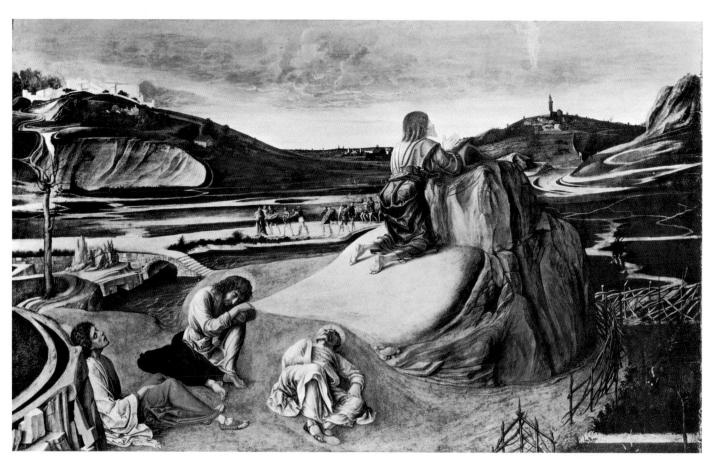

not far from that by Mantegna (see fig. 405) in shape or, probably, date, and generally hung quite near it in the National Gallery in London, offers itself almost too easily as an object of comparison. Both derive compositionally from the inventions of Jacopo Bellini. But Mantegna's stoicism has vanished from Giovanni's composition along with the grandeur of the landscape and the classical reminiscences. We have only the dullness of the North Italian scene, where the Venetian plain meets the hills near Padua; a hill town on one side; a clustered village on the other; and in between a badly eroded vallev through which flows the brook Hebron, not moving directly toward us as in Mantegna but disappearing behind rocks at the left. The river, the steps, the buildings, the rocks cannot be followed at every stage, as one can follow the voices in Mantegna's polyphonies. The painting is darkened by a predawn penumbra. The light of Good Friday has just started to color the undersides of the clouds, like those we saw in Jacopo Bellini's Madonna and Child with Donor (see colorplate 56). The color scheme is dominated not by the reds, yellows, and blues of the garments, but by the tones of the still-shadowed earth. No longer a Stoic hero as in Mantegna, Bellini's Christ lifts his head just above the horizon against the first dawn as he contemplates a single transparent angel holding a chalice of shining pain. Instead of Mantegna's Roman platoon, Bellini's Judas leads a ragtag of sleepy soldiers, and in the foreground Bellini is less interested in perspective projection than in the fitful slumber of the Apostles, who have experienced more than they can bear. Bellini's message is a sympathetic reaction of surrounding nature to human and divine experience. What he lacks in intellectual acumen he more than makes up in poetic intuition and spiritual depth.

Of all the early works, the most searching is doubtless the Pietà (colorplate 61) in the Brera Gallery in Milan, again closely related to the compositions originated by Jacopo Bellini. Within the tomb whose ledge is so disposed across the foreground that it suggests the parapet of Jacopo's Madonna compositions, stand Mary and St. John the Evangelist supporting the dead Christ with their hands, holding him up that we may see. His head, still crowned with thorns, tilts over toward that of Mary, who brings her cheek almost to his and searches the pale face and the sunken eyes. Thin streams of blood have congealed below the lance wound and along the left forearm. These are the brightest tones in the picture. Mary's blue mantle has darkened; her rose tunic and the blue cloak of St. John are grayed down. The warm colors of their flesh almost blend with the greenish tones of Christ's gently illuminated body, and they and the tan and olive landscape are locked between the upper and lower blue-gray horizontals of marble and of cloud. Bellini does not need Mantegna's perspective to project the dead Christ into the observer's heart. His intuition accomplishes this, beyond our capacity to forget.

Never again are Giovanni's dramas so intense or his appeal to emotion so explicit. As his style matures, the content of his pictures becomes warmer and richer along with his sun-drenched color. His first real triumph in the new style is the huge altarpiece representing the Coronation of the Virgin (fig. 422), commissioned by Costanzo Sforza, lord of Pesaro, for the Church of San Francesco in that Adriatic city. The altarpiece, with its carved and gilded frame of Renaissance architectural design enclosing smaller panels rising vertically on either side and a series of predellas, lacks only its culminating Pietà, now in the Vatican Pinacoteca. Internal evidence has recently shown that the altarpiece was in all probability painted in the early 1470s, just before Antonello's arrival in Venice. The space of the central panel is largely occupied by an elegant Renaissance throne in white marble. It encloses a frame formed by a guilloche pattern in colored marble through which, as through a window, we look into a superb landscape representing, certainly by direct order of Costanzo Sforza, his fortress of Gardara. Bellini has represented the castle just as it may still be seen only a few miles from Pesaro. The grouping of the saints in depth on either side of the throne is reminiscent of Mantegna's San Zeno altarpiece (see colorplate 57), but what is startlingly new is the brilliant sunlight that plays upon the scene, sparing only the face of the Virgin, and even that is gently irradiated by reflections from the marble pedestal. The saturated colors have lost the dull, mat quality of those in Giovanni's earliest works. Reds and blues appear in the drapery in great intensity, and passages of especial splendor are afforded by the glowing white and gold damask of Christ's tunic, which sums up the warmth and beauty of the sunlight. The greens of the foliage and the rosy reflections on the clouds, not to speak of the reds, whites, and blues of the cherubim above, carry this new joy in color throughout the landscape and the surrounding atmosphere. Giovanni must have been using a medium containing some oil; it is difficult to see how he could have obtained such effects in any other way. Recent investigations have disclosed that he was also using varnishes in which a certain amount of color was dissolved, not only for glazing effects but also for some actual painting. The new sonority of color in the Pesaro altarpiece has the unexpected effect of increasing the roundness of the forms, more sculpturally convincing and less linear than ever before in Bellini's work

The little scenes built into the sides and bottom of the great gold frame are even more surprising in their increased freedom from Mantegnesque discipline. The figures are surrounded, bathed, warmed in a natural environment that eludes all definition. In the *Adoration of the Child* (fig. 423), for example, hills, roads, and streams not only lose their palpable continuity—this had already taken place in the *Agony in the Garden* (see fig. 421) and other early works—but even, along with

right: 422. GIOVANNI BELLINI. Coronation of the Virgin (Pesaro altarpiece). Early 1470s. Panels: central panel, $8'7'' \times 7'10''$. Pinacoteca, Pesaro

below: 423. GIOVANNI BELLINI. Adoration of the Child, on the predella of the Pesaro altarpiece. Early 1470s. Panel, $16^{3/4} \times 14''$. Pinacoteca, Pesaro

trees and castles, merge their contours in the surrounding atmosphere. The real subject of Bellini's picture seems to be the light of early evening in an enchanted valley, and we look for a moment before we discover the Christ Child lying, as in Baldovinetti's Nativity (see fig. 318), on the ground before the kneeling Virgin, or the three tiny cherub heads, symbol of the Trinity, from which emerge golden rays as well as the Star of Bethlehem. The new feeling for the poetry of nature, which first began to appear in the paintings and drawings of Jacopo Bellini, assumes such importance in a long procession of masterpieces by his younger son that it does not seem farfetched to wonder whether Giovanni, if he were given to verbal defense of his religious and philosophical position, might not have declared himself a pantheist. Although nature is reduced to only two brief echoes in the background, one at either side, Bellini's Enthroned Madonna and Child (fig. 424) shows a steady

424. GIOVANNI BELLINI. Enthroned Madonna and Child (Frari altarpiece). 1488. Panel. Sacristy, Sta. Maria Gloriosa dei Frari, Venice

increase in the artist's enjoyment of natural light. The painting, which is signed and dated 1488, is still in the position for which it was originally painted, in the Sacristy of Santa Maria Gloriosa dei Frari. Giovanni has borrowed his brother-in-law Mantegna's device of the temple frame (see colorplate 57), into which one looks as into a shrine. In this case the illusion of reality is still greater, partly because the very capitals inside the picture are identical with those of the frame, but even more so because the picture is painted in oil, which enables the artist to maintain, as Antonello did, the absolute continuity of an atmosphere into whose shadows light is dissolved. It is as if the marine magnificence of the gilded Renaissance frame, with its dolphins and winged tritons, were casting a golden light into the recesses of Mary's shrine, to be given forth again in softer keys by the (painted) gold mosaic of the vaults, and still more softly by the colored silk and gold brocade of the cloth of honor filling the niche behind the throne. The forms are no longer so clearly stated; the contours of the most important faces and figures, and the boundaries between major masses shown in full light, merge with the atmosphere as richly as in the tiny scenes from the frame of the Pesaro altarpiece. Only oil medium and oil glaze can account for this transformation, and certainly it was prompted by Bellini's wonder—recorded by the sources—at Antonello's work. By now he has understood even better than Antonello how to present the fluid fabric of light and atmosphere that surrounds us. In this new delight in optical beauty, however, some observers may feel that certain precious qualities of Bellini's early works have been lost. The poignancy and, at times, the bitterness of those pictures have no place in the world of opulence and ease that Bellini depicts in his years of success. His Madonnas are full-faced, large-eyed creatures, untroubled by any premonition of the Passion. And his children, especially the two happy, fat-legged musicians before the Virgin's throne in the Frari altarpiece, have forgotten the deeper aspects of the Christian experience that tormented their predecessors.

Giovanni's altarpieces now assume tremendous scale. One of the most imposing is the Enthroned Madonna and Child (fig. 425) in the Accademia in Venice, generally known as the San Giobbe altarpiece because it was painted for the chapel in the Venetian Hospital of San Giobbe (or St. Job). Not only Job, but even Moses is a saint in Venice, each with his own church! Probably the picture, like the Frari altarpiece, dates from the late 1480s. It is closely related to a painting of the Madonna Enthroned in a Church, now lost save for a few fragments painted by Antonello in 1476, and also to the Madonna and Child with Saints by Piero (see fig. 287). But Bellini has now dared to give the figures not only what would have been their real proportions in comparison with the architecture—Piero had already done that—but also their real position within the space of the church instead of before it. As a result, the standing figures are less than one-third the height of the barrel vault above them, and even the Virgin's towering marble throne does not elevate her head as high as the mathematical center of the picture, which is occupied by the golden cross issuing from a floral design on the marble disk above her head. These proportions show that Bellini was accustomed to composing on a grand scale, placing life-sized figures in vast surroundings. We tend to forget this fact, because almost all of his many-figured historical compositions were destroyed in the fire of 1577 that gutted the Doges' Palace in Venice, in which were also lost treasures by many other masters, including Titian. If all the compositions painted by Giovanni to fulfill commissions originally given to Gentile (left incomplete when the older brother went to Constantinople in 1479) were still extant, we would have a more balanced picture of Giovanni's capabilities. At any rate, the spatial effect of the shadowy interior of a Venetian Renaissance church, enclosing and dominating the softly lighted figures, is an essential element in the composition. On Mary's left, the beautifully painted St. Sebastian, more classical in feeling than Antonello's homely representation of the same saint (see colorplate 60), is in his proper place as protector of the sick. The old man with long white beard and folded hands at Mary's right is, as we would expect, Job, patron saint of the hospital on account of his many physical and mental sufferings. The lofty space of the picture gives free rein to Bellini's mature style, and the details show not only the sweetness of texture and expression we expect after the Frari altarpiece, but also a new freedom and sketchiness in the use of the brush.

Two sublime examples of Bellini's pantheism seem to date from this period. The *Transfiguration of Christ* (colorplate 62) differs from the artist's earlier rendering of the same subject. The event is now shorn of all apparent

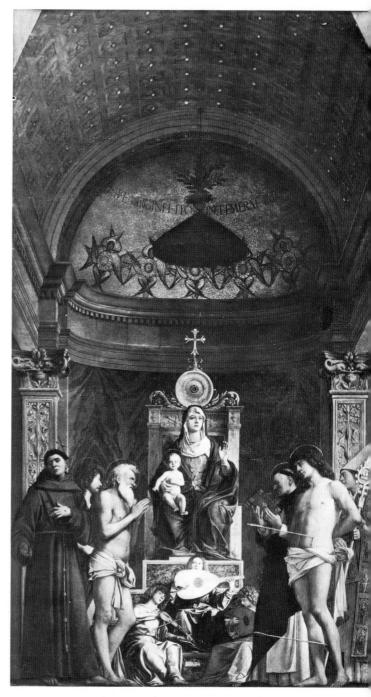

425. GIOVANNI BELLINI. *Enthroned Madonna and Child* (S. Giobbe altarpiece). Late 1480s. Panel, 15'4" × 8'4". Accademia, Venice

supernatural character, and Mount Tabor, traditionally represented as quite an eminence, is reduced to a slight rise. Broad, brown, slowly moving meadows interlock with one another along low, projecting escarpments. The afternoon is well advanced. At the left a farmer leads an ox and a goat past a monastery on a crag, already darkening in the evening shadows; at the right churches, cylindrical towers like some in Ravenna, and partially

ruined city walls still catch the light, which also dwells on the lower slopes of nearby mountain masses. In the center of this bleak yet mysteriously beautiful landscape stands Christ, his elbows to his sides, his hands and head silhouetted against the low and shining white clouds, his face turned toward us but his eyes just avoiding our gaze. The text (Mark 9:2-9) says that "his garments became shining, exceeding white as snow." Bellini has shown him in a color that grows out of the land and unites it with the sky, for the shadows are tinged with tan and green, and the whites are those of the lower layer of clouds shining against the darker masses above. Moses and Elijah, whose broadly sculptured drapery masses epitomize in their coloring the meadows and the mountains, stand with all the majesty of the Old Testament. Before this group, rather than below it, the three Apostles have fallen to the ground and dare not look back. Bellini's Transfiguration is a revelation of God in nature, which can take place any calm evening anywhere. Yet Bellini has cut us off from this revelation—and not only by the device of Christ's averted gaze. A sapling fence moves diagonally across the foreground, and immediately behind it opens a rocky chasm—suggestions, per-

haps, of the barrier of death and the gulf of the grave that lie between us and final understanding.

Even more explicit is the St. Francis in Ecstasy (fig. 426). This is not the Stigmatization we might expect, for that has already taken place, as we can see in the saint's wounded hands. Rather it is an ecstatic communion of St. Francis with God in nature. He stands before a cave supplied with a grape arbor (an obviously Christian symbol) that shades his rough desk, on which only a book and skull appear. With hands outstretched, he looks upward in the direction of a slender sapling that bends toward him, as water flows from a stone spout attached to a little spring below. Both are references to Moses—the burning bush and the water struck from the rock—in line with the attempts of St. Francis' followers to depict him as a second Moses. Beyond a standing crane and a motionless ass, exemplar of patience, a shepherd watches over his flock. On the fertile valley, the rich hillsides, the outcroppings of rock, the tranquil city, the humans, animals, and plants, and especially on the chanting saint, the sunlight pours. Every object is represented with a Netherlandish fidelity to fact worthy of Antonello at his best. Yet not even Antonello could

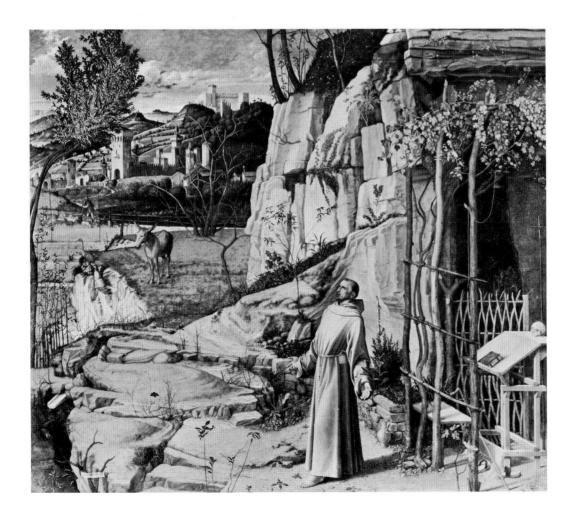

426. GIOVANNI BELLINI. St. Francis in Ecstasy. c. 1485. Panel, 49 × 55 1/8". Copyright The Frick Collection, New York

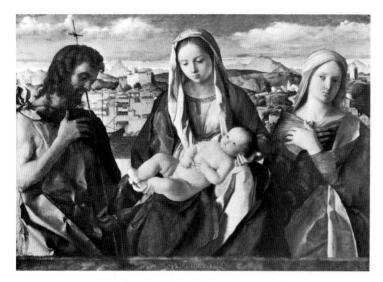

427. GIOVANNI BELLINI. Virgin and Child between St. John the Baptist and St. Catherine. c. 1500. Panel, 211/4 × 297/8". Accademia, Venice

have constructed a picture of such grandeur or carried our eyes (as can in reality be done only on days of ringing clarity) through luminous air of such brilliance, or through so perfectly controlled a succession of distances.

As the Quattrocento ended and the new century began, the tide of Bellini's art grew ever deeper and stronger. Sharing only with the youthful Leonardo da Vinci the honor of being the greatest European painter of his day, the aged Bellini seems to have experienced no slackening of observation or imagination, no dulling of sensitivity, no loss of skill. His sun-filled altarpieces and Madonna images, such as the Virgin and Child between St. John the Baptist and St. Catherine (fig. 427), take us into a new world of liberated color. Bellini's favorite low light of waning afternoon plays on the distant port (probably a symbol of Mary) with its fortifications and towers, the still more distant crags of the Dolomites, and the clouds that gather about them. It sends blue and lemon-yellow lights from the landscape over the still faces whose outlines grow dimmer and softer than anything we have yet seen. There are astonishing passages of coloristic movement, such as the enormous range of hue within the orange satin lining of St. Catherine's cloak, or the rich interweaving of blues, roses, and violets in her brocaded tunic. The splendor of reflected color lightens even the ascetic garb and features of the Baptist. At a moment when Florentine art, it must be admitted, had retreated into itself, Bellini was carrying Venetian painting far along the road that leads to Velázquez, to Vermeer, and eventually to Monet, Seurat, and Cézanne.

If he was not already a High Renaissance painter in the great late altarpieces—such as the Enthroned Madonna with Saints (colorplate 63), signed and dated 1505, in

San Zaccaria in Venice—it is hard to say why not. Certainly this was the kind of painting that deeply impressed Fra Bartolommeo when he visited Venice in 1507, that he emulated on his return to Florence, and that Raphael in turn derived from him. At first sight the general formulation seems almost identical with that of the San Giobbe altarpiece (see fig. 425), but there is a profound difference. Despite the way in which the enclosing painted shrine has been extended by the marble architecture of Mauro Codussi's built-in frame (see page 423), it is not at all related to the position of the spectator nor to his angle of vision. The viewpoint is ideal, as in Leonardo's Last Supper (see colorplate 67), painted only a few years earlier, and on a level with the heads of the saints, although those heads are placed nine or ten feet above the floor, given the height of the intervening altar and its steps. And of the seven figures in the painting, not one looks at another, and the only one who looks at us is the angel playing a viol. As a result, the intimacy, immediacy, and sweetness of the altarpieces of Bellini's maturity are replaced by a certain remoteness, increased by the meditative calm of the saints, each wrapped in a voluminous mantle, each separated from the next by an enveloping tower of light, atmosphere, and spiritual isolation. The outlines are now vaguer than ever, sometimes almost completely dissolved in light or in shadow, but the great master's control of form remains absolute. Every mass is felt in its essence, every relation is harmonious and clear, brought out against the creamy marble and blue-green-gold mosaic of the shrine by the singing brilliance of the garments—the Virgin in bright blue, the saint on the left in russet and gold, the angel in yellow with orange shadows, and St. Jerome in an astonishing red enlivened by crisp white. Even this noble altarpiece is by no means Giovanni Bellini's swan song, but for the next eleven years of his life he had to compete with, and was eventually influenced by, his gifted pupils and successors: Giorgione, whom he outlived, and Titian, who was to live almost beyond the chronological limits of the Renaissance.

Giovanni Bellini's role in Venetian art of the late Quattrocento, however, was roughly comparable to that of Giotto in Florentine painting nearly two centuries before. To keep up with his innumerable commissions Giovanni had to maintain a large staff of assistants, who painted, entirely or almost entirely from the master's sketches and directions, many a Madonna that bears the Bellini signature. These followers and numerous other imitators of varying degrees of talent and fidelity succeeded in so popularizing the Bellini manner in Venice and its subject cities that it became the dominant style. But, again as in the case of Giotto, Giovanni Bellini's style was not the only one, even at the moment of his triumph. Gentile Bellini's prosy narrative style went right on, and so did the Mantegnesque manner of the Vivarini family.

VITTORE CARPACCIO

Second in quality and importance only to Giovanni Bellini in Venetian painting just before and just after the turn of the century is the fascinating figure of Vittore Carpaccio (originally Scarpaza, then Carpathius, c. 1460–1526). Carpaccio, underrated by all the Cinquecento sources, owes almost nothing to Giovanni Bellini and only the idea of the crowded, newsy anecdote to Gentile. His style, in the last analysis, is his own, and it is a highly fanciful one, full of witty observation and astringent poetry, embodied in a wholly new kind of composition.

Carpaccio was the perfect painter for the scuole, and he spent most of his artistic career decorating them with narrative canvases of considerable size; few commissions for altarpieces and Madonnas were given to him. Most of his time in the 1490s was spent in carrying out the most extensive of these narrative cycles, for the Scuola di Sant'Orsola. The legend of this saint (Ursula in English)—depicted by other artists in the fifteenth century, especially well by Hans Memlinc-tells how the pagan son of the king of Britain sought the hand of the Christian Ursula, daughter of the king of Brittany, who exacted as her condition for the match his conversion to Christianity and a three-year cooling-off period during which she and her ten maids of honor, each accompanied by a thousand virgins, could make a pilgrimage to Rome. On the way back, alas, the eleven thousand and eleven virgins were waylaid by the Huns at Cologne and slaughtered, down to the last virgin. Carpaccio divided the story into eight scenes lining the chapel of the now-destroyed *scuola*, and these have been recomposed, together with the central altarpiece, in the Accademia in Venice.

One of the most accomplished of the series is the long canvas painted in 1495 showing the departure of the young prince from Britain, his arrival in Brittany, and the departure of the betrothed couple for Rome (fig. 428). Although Britain at the left and Brittany at the right are separated by a large and handsome flagpole set in a cylindrical marble pedestal, the same sunny sky with big, floating clouds unites them both. And why notbecause for Carpaccio they are merely two sides of the same ideal harbor, in which both the naval power and the palatial splendor of imperial Venice can be celebrated as a background for the hundreds and hundreds of tiny figures. Britain could be any Venetian port along the Dalmatian coast or in the islands of the Aegean, with a hilltop castle above the rising fortifications of a seaside city. The two fortresses by the water have been identified as the Venetian strongholds at Rhodes and Candia. Whether or not Carpaccio had seen these buildings, he had certainly watched the careening of ships in the naval arsenal of Venice, and he represents this essential repair procedure of the pre-drydock era with great concentration. Brittany is Carpaccio's fantasy on the theme of Quattrocento Venice, with marble-clad palaces, domes,

428. VITTORE CARPACCIO. Departure of the Prince from Britain, His Arrival in Brittany, and Departure of the Betrothed Couple for Rome. 1495. Canvas, 9'20" × 20'. Accademia, Venice

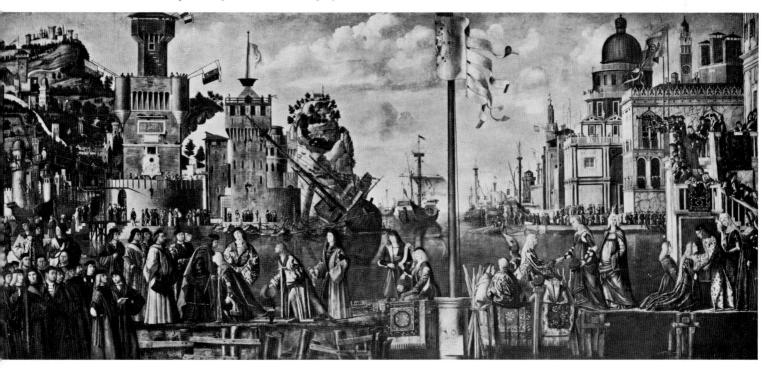

429. VITTORE CARPACCIO. *Dream* of St. Ursula. 1495. Canvas, 9' × 8'9". Accademia, Venice

and towers crowding to the sea. The verticals of towers, flagpoles, and masts and the diagonal of the careened galleon give him strong, straight lines with which to bind the diffuse composition together—motives that traverse, organize, and contain the space and the figures. This method of composition will be revived much later on a grand scale by Paolo Veronese (see pages 626–31), when faced with the problem of far larger compositions of figures in an architectural setting.

The narrative moves gently from left to right along the wharves, as though these constituted a bridge across the English Channel from Britain to Brittany like the bridge the Venetians build from the Giudecca to Venice every year for the Feast of the Redeemer, although we are of course supposed to imagine a sea trip in between. First, the young prince kneels to take leave of his father; then we see him in a gorgeous brocaded costume meeting his bride for the first time; then, prince and princess kneel before the king of Brittany; then, to the sound of five trumpets from a marble staircase, the young couple and the first contingent of virgins move in the distance toward the longboat that will take them to the waiting ships. Carpaccio's colors are generally subdued by a rich, all-over golden tonality, doubtless produced by glazes, so that even the occasional strong reds, blues, and greens are never permitted to speak clearly. The shapes are

controlled by his preference for triangular areas, often balanced on their points—people, costumes, drapery passages, sails, banners, architectural shapes. The result is a fully Venetian web of space and tone in which the triangles are embedded like fragments of glass in a kaleidoscope. The subtly observed, delicately lighted, strongly individual faces seldom betray emotion. Many are doubtless contemporary portraits; perhaps the artist himself peers at us from the worldly crowds who throng his docksides and marble piazze. The figures, as well as the rich details of the contemporary setting, are rendered in a series of sure, parallel touches that owe nothing to the rounded style of Giovanni Bellini and less to the constructive methods of Andrea Mantegna. In fact, Carpaccio abandons traditional linear drawing and shaded modeling in favor of a technique of pure brushwork.

The Arrival of the Ambassadors of Britain at the Court of Brittany (colorplate 64) depicts an earlier episode in the legend. In the center the ambassadors kneel before the enthroned monarch, flanked by four of his councillors. On the right, an iron grating rises to disclose the king's domestic dilemma. Seated at the edge of the bed, his crowned head propped on one hand, he listens wearily while his solemn daughter ticks off on her fingers the conditions she intends to impose for the marriage.

Generally placed a year or two later than the scene

430. VITTORE
CARPACCIO.
Meditation on
the Passion.
Late 1490s. Panel,
27³/₄ × 34¹/₈".
The Metropolitan
Museum of Art,
New York

previously discussed, the composition is somewhat more tightly knit and the details, especially the architectural masses, more strongly projected. The painting abounds in delightful bits, especially the shrewd and worldly portraiture, the wittily drawn distant figures, and the intimate scene in the king's bedchamber, on whose wall hangs what appears to be an early Madonna by Giovanni Bellini. Heaven knows why, a tiny flight of marble steps arches over another grated aperture, as if to afford us a special entry into the king's privacy, and at the foot of the steps sits an old woman with a cane, paying no attention either to us or to her sovereign. The rich golden tonality, which in Carpaccio's paintings generally subdues the underlying colors, saturates the broad expanses of marble slabs and splendid fabrics with the glow of afternoon.

Carpaccio's dry, reticent, yet warmly poetic style appears at its very best in the *Dream of St. Ursula* (fig. 429). With one hand under her cheek, the saint sleeps "at attention" in a high-ceilinged bedroom, which a goldenhaired angel enters with the morning sunlight to bring her the palm of her approaching martyrdom. Every detail of the room is observed with Antonellesque fidelity, down to the mortar and pestle that hang on a nail under the candle before the painting on the wall, the three-legged stool, the reading table with lectern and portable

library that accompanied the saint on her trip, the wooden clogs before her bed, and the crown carefully laid on the bench at its foot. The light effects enhance the magic of the scene, ranging from the flood of sunlight accompanying the angel and the sharp ray running along the ceiling from the oculus window at the right to the softer effects in the anteroom and the diffused sparkle of the bottle-bottom windows. All are unified by the softened red and greenish-gray tones that predominate in the room and are bound into cubes of pure space by the contours of the room and by the delicate spindles of the bedposts and the lines of the canopy. Someday perhaps the iconographers will discover why over one door there is a beautifully painted nude statue of a water carrier and over the other a very provocative Venus on her shell. Neither seems to have much to do with the chaste saint, sleeping so peacefully in her lonely bed.

Probably in the late 1490s Carpaccio painted his most moving work, the *Meditation on the Passion* (fig. 430). The dead Christ is seated as though asleep on a ruined throne, between two leathery, old, bearded hermitsaints. St. Jerome, on the left, is recognizable enough, with his faithful lion in the background. In an attempt to unravel the iconography of the picture, written in 1935 when the author was a college senior, he identified Jerome's deeply tanned companion as Job, on account of

his similarity to the same Old Testament figure as he appears in Bellini's San Giobbe altarpiece (see fig. 425). Reminders of death appear everywhere: a skull and bones rest on the ground under Job's knees; St. Jerome's staff culminates in a hand clutching a bone; his rosary is a set of human vertebrae, threaded to make beads. Yet the dead Christ seems to dream. A warm afternoon sunlight glows on the scene and on the aged faces, and is reflected upward into the features and closed eyes of Christ. The background is sharply divided. The left side, dominated by a withered tree (see Piero della Francesca's Resurrection, fig. 281), is a wildly rocky mountainside on one of whose rare patches of grass a doe grazes, oblivious of the fate that has befallen her mate, who is borne to earth by a leopard, while a fox above turns to look at the incident from the mouth of its den. On the right another stag escapes a pursuing leopard into a rich landscape of farms, orchards, castles, and a peaceful town, in front of which grows a green tree. St. Jerome once wrote a complete interlinear commentary on the Book of Job in which he interpreted Job's famous words (19:25), "I know that my Redeemer liveth, and that in the last day I shall see God," as a prophecy of Christ's Resurrection and, through him, that of all mankind. In the preceding verse Job had asked that his words be "graven with an instrument in flint stone," and this is just what Carpaccio has done, for among the generally meaningless tracks on the block on which Job sits, Ralph Marcus read, "My Redeemer liveth. 19." Doubtless, then, the landscape is symbolic. The stag, always the symbol of the human soul (Psalm 42: "As the hart panteth after the water brooks, so panteth my soul after thee, O God."), is torn by the leopard on one side and escapes on the other, just as Job, tormented to the ultimate, was finally blessed by the Lord. The bird, symbol of Christ's Resurrection, flies upward from the ruined throne of the Old Law, and the crown of thorns has fallen from Christ's head.

Carpaccio never surpassed the glowing landscape and the pearly clouds of this painting, nor the rendering of light on ordinary human flesh, nor the personal religious poetry that gives it meaning. Neither did he ever grow past this point. In fact, his late work represents a sharp decline. After 1510 he could not compete with the High Renaissance style of Titian and obtained commissions only in such places as the fishing town of Chioggia or the provincial centers of Istria and the Dalmatian coast. Like Botticelli, Filippino, and Perugino, or, as we shall see in the next chapter, Signorelli, he could not comprehend the new era.

CARLO CRIVELLI

The last Venetian Quattrocento master we shall consider, Carlo Crivelli (c. 1435–c. 1495), is even harder to place than Carpaccio. Although a Venetian by birth, he spent almost all of his active life far from Venetian territory. He might logically be considered a Central Italian

431. CARLO CRIVELLI. *Pietà*. c. 1470. Panel, 28 × 18½". John G. Johnson Collection, Philadelphia

painter if it were not for the fact that his early style was formed by the Paduan school. Poor Carlo—our first information about him is a court judgment against him in 1457 for having "kept hidden for many months" the wife of an absent sailor, "knowing her carnally in contempt of God and of Holy Matrimony." He was sentenced to six months in prison and a heavy fine, and it is presumed that he left Venice soon after his release. Still signing himself proudly "Carolus Crivellus Venetus," he spent his time in the Marches, principally at Ascoli Piceno, but at other centers as well, where his sharply individual style had considerable influence on the local masters.

Throughout Crivelli's known activity of about thirty years, this style developed little. He left Venice before the flowering of Giovanni Bellini's atmospheric art, taking with him his own linear version of the Paduan manner. Every hair, vein, and muscle is relentlessly contoured, every form sharply projected. Sometimes the drops of Christ's blood, the tears of his mourners, and the attributes of saints are modeled in gesso before being painted. His color as well as his form is always dominated by

metal and stone, which appear in profusion. In 1492 he was still using a gold background. Yet, paradoxically enough, the general effect of a Crivelli painting is not hard. The stone is colored marble, containing rich fluctuations of tone, the metal is gold or silver or both. The result is something like a tapestry with gold threads—sumptuous, russet, deeply glowing but subdued. This is Crivelli's own version of the Venetian web.

A mature work, probably datable about 1470, is the Pietà (fig. 431), typical of the tragic intensity of Crivelli's rendering of the Passion. Probably this panel was part of a polyptych, the other panels of which have not as yet been identified. Donatellesque child-angels, screaming with grief and pain, uphold the dead Christ within an altarlike sarcophagus, before a cloth of honor made by tooling and painting the gold background. His head is thrown back, his mouth hangs open. A gigantic spear wound yawns in his side, and one huge nail wound in his left hand is shown in profile so that its depth may be assessed. The taut veins, tendons, and wrinkles are projected by Crivelli's sharp surface hatching to an almost unbearable degree. Yet his sense of pattern is so strong and his golden tonality so insistent that not even the strongest projections produce any sense of disunity.

In his latest works this strange master was able to achieve an unexpected harmony and beauty of form, color, and surface. The Madonna della Candelletta (fig. 432) is perhaps his supreme achievement. Crivelli signed himself as "eques" (knight), a slight inflation of the rank of "miles" (soldier) conferred upon him in 1490 by Prince Ferdinand of Capua, later King Ferdinand of Naples. The picture gets its title from the little candle that burns at the lower left before Mary's throne. The side panels of the triptych, whose center was once formed by the Madonna della Candelletta, are now in the Accademia in Venice, and their absence increases—fortuitously and enjoyably, to modern eyes—the verticality of this picture. The Virgin, with her jeweled crown of golden fleurs-de-lis, sits upon a veined marble throne whose bench, pedestal, and base all move out of the frame at either side so that they appear as richly variegated stripes of glowing fabric across the surface rather than as solid entities in depth. The Squarcionesque garlands of fruits and leaves, which Crivelli had brought with him as part of his standard repertory from Venice, are here united into a little bower, in the manner of Mantegna's Madonna of the Victory (see fig. 412), which was painted, however, after Crivelli's death. Not even the superb dark blue and gold velvet brocade of Mary's mantle or the red and gold of her sleeves can compete with the magnificence of the apples, cucumbers, and above all the pears, one of which she presents to the Christ Child. These great, rounded shapes with their metallic colors and rippling leaves dominate the entire picture with a kind of magic intensity. Even Mary's beautiful face, with its downcast eyes and solemn frontality, is deliberately likened in shape to

432. CARLO CRIVELLI. *Madonna della Candelletta*. Early 1490s. Panel, 86×29½". Brera Gallery, Milan

right: 433. MAURO CODUSSI. Façade, S. Zaccaria, Venice. Second half of 15th century

below: 434. Mauro Codussi. Façade, Palazzo Vendramin-Calergi, Venice. Begun c. 1500; completed 1509

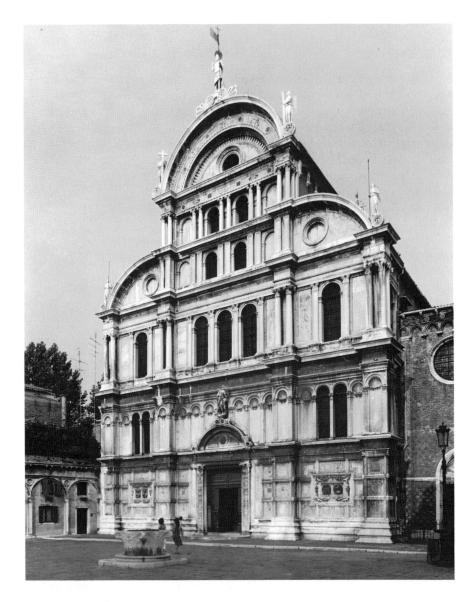

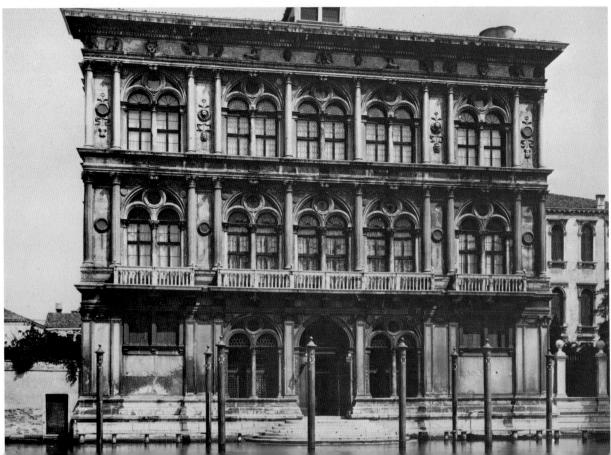

the apples and the pears, and shines as softly as they do. Again Crivelli projects his forms sharply and lets the light cast shadows of these shapes on the marble, and again the total effect is that of a precious fabric, holding every form in its web like the jewels that stud a Renaissance textile. Crivelli's was a strongly personal style of the highest degree of refinement and brilliance, hermetically sealed from the great ideas of his Venetian contemporaries, from whom the artist exiled himself, cut off from any exit into the Renaissance, yet certainly one of the major achievements of Venetian and North Italian art of the Quattrocento.

LATE QUATTROCENTO ARCHITECTURE IN VENICE

In its entire history Venice produced few architects of importance and none to match its painters. Venetian builders, for the most part imported from other regions, fell heir on the one hand to the splendors of the Byzantine tradition—inevitable, with the Basilica of San Marco in their midst—and on the other to the rich linear complexities of the Flamboyant Gothic Style brought from France and Germany. In Carpaccio's backgrounds (see colorplate 64, fig. 428), the Byzantine and Gothic currents blend imperceptibly, clothed with the same rich marble paneling and impregnated by the same Venetian sunlight they seem created to exploit. Only here and there are Carpaccio's hybrid buildings punctuated by arched windows and delicate pilasters borrowed from the Florentine Renaissance. Such, indeed, was the first timid appearance of the Renaissance in Venetian architecture, built almost exclusively by Lombard masters, and many examples still survive throughout the city. During the last third of the Quattrocento, a family of builders, stonecarvers, and sculptors actually called Lombardo, from Carona, near Lugano, today in Switzerland but then in Lombardy, competed with a far more inventive architect, Mauro Codussi (c. 1440–1504), another Lombard, from Bergamo. Codussi (also spelled Coducci) was in much closer touch with the great ideas of the Central Italian Renaissance, and by the end of the century he dominated the changing appearance of Venice and was, more than any other single individual, responsible for the appearance of a truly Venetian Renaissance style in architecture.

The towering façade of the Quattrocento Gothic Church of San Zaccaria in Venice was almost exclusively the creation of Codussi (fig. 433). The preexisting lowest story, a sort of pedestal with rectangular paneling and insistent—if unorthodox—lower moldings, established a mood of complexity from which Codussi could hardly vary. He added an astonishing series of four superimposed stories in the new classical style, exploiting by their projections and recessions, as well as by their ornamentation and veined marble material, the play of light one would expect from Venetian painting of the period.

The buttresses are continued upward, dividing into three segments the arcade of the second story and assuming the form of paired, freestanding Corinthian columns in the third and fifth. The proliferation of windows of differing sizes and proportions, the superimposition of orders utilizing different numerical systems, and the oddly stumpy proportions of the final Corinthian colonnade produce an effect of irregularity and improvisation entirely alien to the Albertian tradition. Yet it is from Alberti's idea for the Malatesta Temple (see fig. 224) that Codussi derived the dominating shape of his great structure, the lofty central arched pediment, flanked by quarter-circles on either side. This arrangement he had used earlier in the more modest Church of San Michele in Isola in the lagoon north of Venice, and it had reappeared on other churches on both sides of the Adriatic.

Protected by their canals, Venetian palaces did not require the fortresslike construction of even the most princely dwellings of Florence, Siena, Rome, and other Central Italian cities. Throughout the Late Middle Ages and into the most extreme manifestations of Venetian Gothic in the Quattrocento, Venetian builders constructed the façades of palaces along the Grand Canal (relatively few Venetian oligarchs would live anywhere else) according to a system devised as early as the eleventh century and characterized by long rows of arches and windows opening onto the canal with its constant parade of traffic. The lowest story was centered on a triple-arched entrance, providing admission to the palace courtyard and to stairways from the private landing. and flanked by service rooms lighted by relatively small windows. This tripartite division was maintained in the second and third stories, although enormous windows ran throughout. The culmination of the palace type of the Venetian Quattrocento, indeed the bridge to the great masterpieces of the High Renaissance in Venice, was the brilliant marble façade designed and built by Codussi about the turn of the century for the palazzo of the rich and powerful Loredan family, which is now known as the Palazzo Vendramin-Calergi (fig. 434). Ironically enough, the work was completed, after Codussi's death. by the Lombardo family in 1509. But the work in all of its essentials is Codussi's, and in the relationship between columns and windows achieves a balance and maturity of proportions that had eluded him at San Zaccaria. Florentine double-light windows appear, but in a wholly un-Florentine way are enlarged to the point where their jambs are contiguous with the embracing Corinthian columns and the wall disappears. Even the tympanum of each embracing arch is pierced by an open oculus, an echo of the lingering tradition of Gothic tracery. The entire façade seems to consist of a framework around openings, a succession of delicate clusters of columns and colonnettes, with brief intervening spaces of veined marble further enlivened by sculptured ornament and porphyry disks in stories separated by balconies and rich

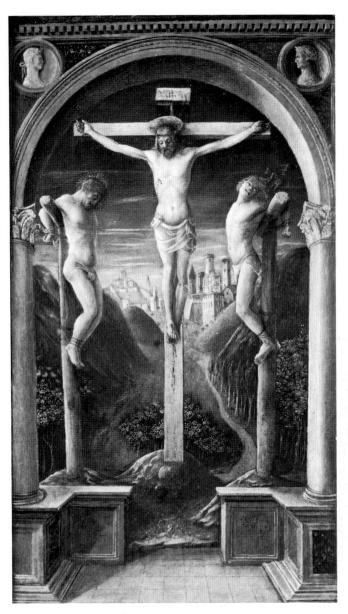

435. VINCENZO FOPPA. *Crucifixion*. 1456. Panel, 26¾×15". Galleria dell'Accademia Carrara, Bergamo

entablatures and crowned by a majestic cornice. There could be no more extreme contrast between pictorial architecture of this sort and the roughly contemporary Palazzo Strozzi in Florence (see fig. 307), where every effort seems to have been made to enhance the forbidding density of the *pietra serena* masonry; yet in harmony and balance there is little to choose between them. But in common with all the palace façades along the Grand Canal, the Palazzo Vendramin-Calergi enjoys the incomparable advantage of being reflected in the water, whose glittering light in turn softens all shadows and dematerializes all forms.

LATE QUATTROCENTO ART IN MILAN

The vast expansion of artistic activity in Milan in the second half of the Quattrocento is due less to the genius of the local artists, as in Florence, Siena, Perugia, Padua, and Venice, but rather as in Rome to the tastes and ambitions of their patrons. In fact, not a single Lombard artist of the Quattrocento can be ranked with the great masters of the Early Renaissance in Central Italy and in Venice, and the triumphs of art in Milan toward the close of the century are due to two titans from Central Italy, Leonardo da Vinci and Donato Bramante. Their Milanese achievements (see pages 449–54, 483–84) might well appear at the close of this section were it not that the High Renaissance in Florence and in Rome (see Chapters 16 and 17) would be incomprehensible without them.

Francesco I, the founder of the Sforza dynasty in Milan, was of low birth but a successful general; he married the illegitimate daughter of Filippo Maria Visconti, and three years after the latter's death without male issue in 1447, Francesco managed to extinguish the revived Milanese Republic, assuming the hereditary dukedom. His son, Galeazzo Maria, duke from 1466 to 1476, was a tyrannical and cruel ruler but an insatiable patron of the arts. After his murder in 1476, when he left a son too young to govern, the reins of government were taken over by his brother, Ludovico il Moro, who eventually was declared duke in 1494. Ludovico turned out to be one of the most enlightened of Renaissance rulers and patrons of art, under whom magnificent buildings arose and art collections assembled, the former now largely transformed or destroyed, the latter almost entirely dispersed. His expulsion from the dukedom by the French in 1499, in spite of his brief return in 1500, and his death in a French prison mark the end of a brilliant era.

VINCENZO FOPPA

The most original Lombard painter of the Quattrocento was Vincenzo Foppa (c. 1428–1515), from Brescia, who in his unusually long career left an impressive array of panels and fresco cycles. His earliest dated work, the Crucifixion of 1456 (fig. 435), is one of his finest. Its relation to Quattrocento art in Padua and in Venice is clear enough. The embracing arch and the imperial profile portraits in the spandrels have been borrowed from Castagno at the Basilica of San Marco (see fig. 267), and the pose of the impenitent thief, not to mention the treatment of the background landscape, betrays a knowledge of Jacopo Bellini (see fig. 396, colorplate 56); there is even a suggestion of the predella of Mantegna's San Zeno altarpiece (see fig. 404). Nevertheless, the muscular vigor of the bodies, the violence of the expressions and the poses, and the disregard for structure in order to obtain a tragic immediacy of action are Foppa's own, and very Lombard, as is the uncanonical way he treats the elements of classical architecture. A grayness of coloring

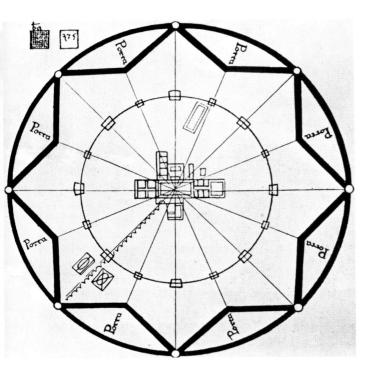

436. ANTONIO FILARETE. Plan of Sforzinda. c. 1457–64. Biblioteca Nazionale, Florence

pervades his entire output, which has been compared, in its later phases, to the naturalism of Dutch painting in the seventeenth century.

FILARETE

Antonio Averlino (c. 1400-after 1465) was a curious Florentine sculptor and architect who adopted the name Filarete (from the Greek, "love of virtue"). His bronze and silver doors, whose ineptitude was justly condemned by Vasari, were executed for Pope Eugenius IV and hung in Old St. Peter's in 1445; they are still in place in the new building. Filarete left Rome under a cloud and sought employment in Milan, where in the early 1450s he began working for Francesco Sforza. His ideas, founded on what he could glean from Alberti in Rome, came into conflict with the entrenched conservatism of local Gothic builders, especially the Solari family (see below), which doomed his projects from the start. But his treatise on architecture, under strong Albertian influence, was presented in duplicate manuscript form to Piero de' Medici in Florence, who could do little save dream of such undertakings, and to Galeazzo Maria Sforza, who possessed the power to carry them out. Filarete describes in detail the practical, as well as the theoretical, aspects of his vast Ospedale Maggiore for Milan, two enormous cross-squared structures united on either side of a central piazza, containing a lofty church. The basic plan was actually followed, and the building, in spite of later alterations and terrible damage from aerial bombardments, still exists. Even more fascinating was Filarete's plan for an island city to be built heaven knows where and named Sforzinda after the ruling family of Milan (fig. 436). The exterior walls were to be shaped like an eight-pointed star, with eight gates at the reentrant angles, and in the center in true Albertian style was to be the palace of the prince and a nucleus of public buildings. Such a centralized city, impossible even for despots such as the Sforza, was actually carried out at the close of the sixteenth century in the pentagonal plan for Livorno, designed by Bernardo Buontalenti for Grand Duke Ferdinand I de' Medici, and in the spiderweb of canals surrounding the central medieval core of democratic Amsterdam. The vast constructions of Ludovico il Moro, including the villa, castle, scientific farms, and central square of Vigevano, built by Bramante, and the system of canals—some of which are still in use—in Milan, show the imprint of Filarete's ideas.

THE CERTOSA DI PAVIA

The vast monastic constructions of the Certosa (Carthusian monastery) in the flat country outside the old Lombard capital of Pavia were, aside from the Cathedral of Milan itself, the major architectural undertaking of the Visconti and Sforza dukes. Begun in 1396 under Giangaleazzo Visconti, the great church, destined for the ducal tombs, was taken up by the Gothic architect Giovanni Solari; with him his son Guiniforte was associated in 1459. Basically a Gothic structure, the cruciform church was planned on a succession of squares-four for the nave, one each for the arms of the transept, and one for the apse—not unrelated to the plan of the Cathedral of Florence. From the exterior (fig. 437) the church is a picturesque agglomeration of superimposed external arcades of stone, set in the brick walls essential throughout much of Lombardy. Renaissance details in capitals and arches have begun to permeate the basically Gothic

The original façade of the Certosa di Pavia was to have corresponded in shape to the typical cross section of a Christian basilica. Some of the sculptural decoration survives from this façade, commenced in 1473. The most expressionistic reliefs have been attributed to the Milanese sculptor Cristoforo Mantegazza (d. 1482). A violent Expulsion from the Garden (fig. 438) shows God himself driving Adam and Eve angrily to their fate, in a tremendous gesture of condemnation. Influences of Jacopo della Quercia are absorbed by the usual Lombard realism, transforming the supple musculature of the great Sienese master into forms of striking angular tension. There may even be traces of the late expressionism of Donatello.

A wholly new façade, of overwhelming richness and splendor, was added by Ludovico il Moro, beginning in 1492, from the designs and under the supervision of the

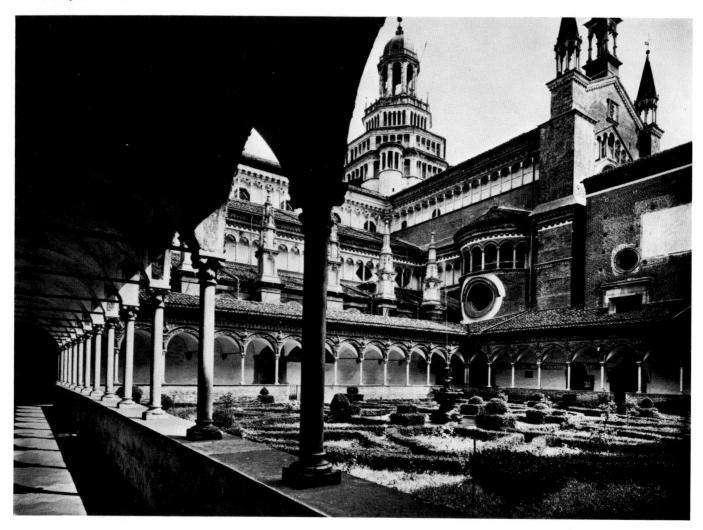

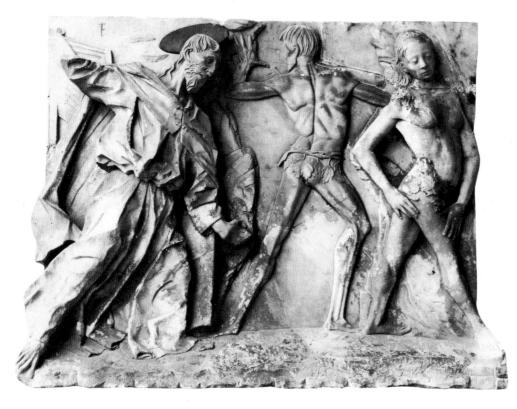

above: 437. GIOVANNI and GUINIFORTE SOLARI. Certosa, Pavia. Begun 1396; finished after 1492. View from the cloister

left: 438. Cristoforo MANTEGAZZA. Expulsion from the Garden. c. 1480. Marble. Certosa, Pavia

opposite: 439. GIOVANNI ANTONIO AMADEO. Façade, Certosa, Pavia. 1473-first half of 16th century. Marble

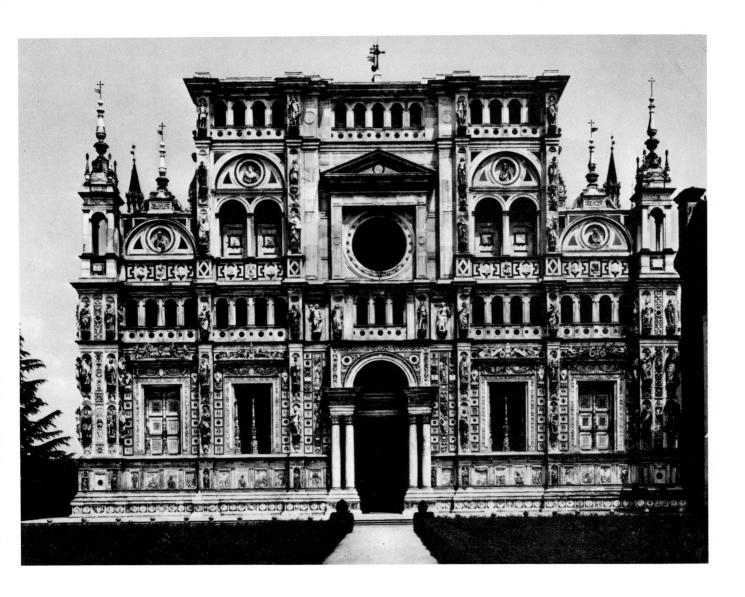

Pavian architect and sculptor Giovanni Antonio Amadeo (1447-1522). The gorgeous fabric (fig. 439) was built entirely of marble, imported from Carrara on the other side of the Ligurian Alps at staggering cost. The enormous mass of marble is divided and subdivided into seemingly innumerable windows and other openings rectangular, arched and round, single, double, quadruple, and quintuple—and enriched with sculptural reliefs and carved ornament of bewildering complexity. Despite the hints of a Flamboyant Gothic past that make the Certosa façade appear the utter opposite of Florentine rationality, a certain logic does run through it all; the elements are largely of classical derivation, the successions can be deduced, and the single statues and reliefs enjoyed, although none show the intensity of Mantegazza. Neither do they show sufficient individuality of style to make secure attribution possible, but this is to be expected in art created by hosts of workmen for a despotic patron.

QUATTROCENTO PAINTING IN FERRARA

We cannot leave the North Italian Quattrocento without a mention, however brief, of the vigorous school of painting that flourished at Ferrara. Although none of the numerous Ferrarese masters reached the exalted rank of Mantegna, Antonello, or Giovanni Bellini, collectively they maintained a high level of fantasy and of skill, and the three best of them can at least be discussed along with Carlo Crivelli. Ferrara is a flat city spread out over a considerable area of lowland a few miles south of the Po River, with which it is connected by waterways. In the middle of the thirteenth century, Ferrara came under the power of the Este family and was the seat of its magnificent and cultivated ducal court until 1598. During this period of prosperity and free spending, foreign artists of first importance were called by the Este dukes, especially Niccolò III (1384-1441) and Lionello (1404-50). These included Pisanello, Jacopo Bellini, Leonbattista Alberti, Rogier van der Weyden, Piero della Francesca, and Mantegna. From slender beginnings a local school began to emerge about 1450, absorbing a great deal from the visits of the powerful figures from abroad, but distinguished almost at once by some very special qualities. The utter flatness of Ferrara and its surroundings, the absence of anything that might be called landscape, the comparative dullness of the wide, straight streets and low houses

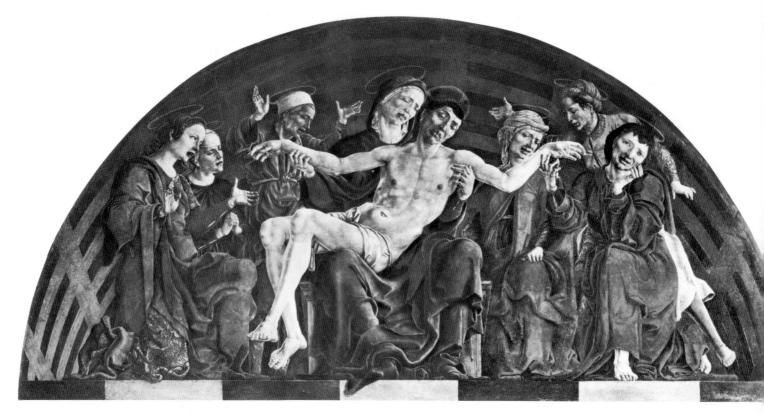

440. COSIMO TURA. *Pietà*, from summit of the Roverella altarpiece (see colorplate 65). c. 1480. Panel, 4'4" × 8'9". The Louvre, Paris

seem to have had the effect of spurring the painters to great imaginative efforts to overcome the pervasive monotony.

The oldest of the three outstanding Ferrarese painters was Cosimo Tura (c. 1430–95), an artist in whose perverse and disturbing style the sculptural elements drawn from Piero della Francesca and from Mantegna are twisted into shapes of tension and torment. One of his most imposing works is the Roverella altarpiece, painted for the Church of San Giorgio Fuori in Ferrara at a date close to 1480, and now separated and scattered among a number of museums in Europe and the United States. The central panel, a towering *Enthroned Madonna and Child with Angels* (colorplate 65), is startling in its plastic intensity and coloristic irresponsibility. Why should Renaissance architectural elements alternate between pea green and poison pink, or angels be so gaudily dressed?

A barrel vault encloses the space, but only its rear pilasters are visible; the others are cut off by the frame, so that the interior is not experienced as an architectural whole. The shell above the Virgin's throne supports another shell upside down, on and above which, in a curious semicircular balcony, statues of the Four Evangelists' symbols appear. Winged putti flank the arch, and from their cornucopias dangle bunches of grapes. Instead of pilasters, the throne bears the tablets of the Ten Commandments in Hebrew (abbreviated). On the steps

of the fantastic structure stand two angels playing tiny treble viols while two others sit strumming lutes. Below, two more angels kneel, one pressing the keys of a charming little organ with spirally arranged pipes, the other working its bellows with the fingers of one hand. The cramped, crowded space is characteristic of Tura's work; even more so are the contorted shapes, which for all their wildness radiate a strange beauty. Tura has deliberately exaggerated the movement of incisive line, the modeling, and the play of reflected lights to produce effects that aim at sculptural hardness but turn soft as one watches. This knotted, involved, elaborate style, for all its harshness, can be very poetic. It is, perhaps, the Ferrarese answer to Botticelli, but without any of the latter's mysterious grace.

North Italian painters and sculptors knew few restraints in the expression of grief, and Tura's intense emotion can become almost grotesque in its violence. This is especially true in the *Pietà* from the summit of the Roverella altarpiece (fig. 440). We look upward at another barrel vault repeating that of the Madonna panel that was originally just below it, but with more coffers. Across the Virgin's knees is spread the contorted body of Christ, his arms held out by gesticulating, wildly lamenting figures, whose heavy-boned faces and coarse features make Castagno's mountaineers look patrician. Yet however exaggerated, the emotion demands respect on ac-

count of its directness and sincerity, and the tortured shapes achieve a certain nobility in their lofty position.

The second of the leading Ferrarese painters is Francesco del Cossa (c. 1435-c. 1477). The Griffoni altarpiece, painted by Cossa in 1473 for San Petronio at Bologna, was divided between two museums. The St. John the Baptist from this altarpiece (fig. 441) is an excellent example of the style of this son of a stonemason, who shows in all his pictures a special interest in architecture and in the stones, carved or otherwise, of which it is built. Even his fantastic landscapes become a kind of natural dream architecture. The Ferrarese were accustomed to nothing but plains; since landscape (to paraphrase Voltaire) "n'existait pas, il fallait l'inventer." Handsome as Cossa's painting of the red-cloaked, vaguely Castagnesque figure is, the eye is immediately struck by his rocky pinnacles, his Pelions piled on Ossas, his vast, open arcades and natural bridges supporting turreted castles and domed churches in impossible positions. Cossa's cloudless blue sky and brilliant light—another invention, because Ferrara, like all Po Valley towns, is notoriously humid at all times and foggy much of the year-reveal with relentless clarity this stony world and all the objects in it, whether carved by nature or by human fantasy. Such is the magical intensity of some of Cossa's projections—notably the early form of rosary

right: 441. Francesco del Cossa. St. John the Baptist, from the Griffoni altarpiece. 1473. Panel, $44\frac{1}{8} \times 21\frac{3}{8}$ ". Brera Gallery, Milan

below: 442. Francesco del Cossa. April. Early 1470s. Fresco. Sala dei Mesi, Palazzo Schifanoia, Ferrara

443. ERCOLE DE' ROBERTI. St. John the Baptist. Last quarter of 15th century. Panel, $21\frac{1}{4} \times 12\frac{1}{4}$ ". Picture Gallery, Dahlem Museum, Berlin

hanging from rings around a pole and the crumpled scroll bearing St. John's words, "Behold, a voice crying in the wilderness"—that his art served as a model for some of the Surrealists of the 1930s.

The most remarkable surviving monumental project of the Ferrarese masters is the series of frescoes lining the Sala dei Mesi (Hall of the Months) in the Palazzo Schifanoia at Ferrara, a pleasure palace enlarged by Duke Borso d'Este in 1470 and frescoed in the immediately succeeding years. When complete (several scenes have now been lost), the frescoes were closely related to the calendar illustrations that appear frequently in Northern European manuscripts. Each section showed

the triumphal car of the deity who presided over that month, below it the pertinent signs of the zodiac, and in the lowest row a number of the activities and labors appropriate to the month. As now cleaned and consolidated, the frescoes show all the freshness and brilliance of Ferrarese coloring as well as the charm of Ferrarese imagination. There is as yet no complete agreement regarding the attribution of all of the scenes. Tura may have been involved in the scheme, also Ercole de' Roberti (see below), but the leading master was apparently Cossa. April (fig. 442) is characteristic of his style. The triumphal vehicle of the fully dressed Venus is a kind of barge drawn over waves by swans, while on either bank of this inlet elegantly dressed ladies and gentlemen in pleasant gardens indulge in amorous courtship, parodied by omnipresent couples of white rabbits and presided over by the Three Graces at the upper right. Like the other frescoes in the room, this scene is felt as a continuous tapestry in two dimensions, without focus or plastic unity, despite the fascination of the details and the occasional penetration into depth. One can only imagine what a great Florentine or Venetian master would have made of such an opportunity. The very extent of the Sala dei Mesi reveals the Achilles' heel of the Ferrarese, who for all their multifarious gifts never quite achieved the greatness their highly original style so often suggests.

For example, Ercole de' Roberti (1456-96), the youngest of the three major painters of Quattrocento Ferrara, reveals at his best some of the finest qualities of his era. yet he was able to sustain them only briefly. If he had always painted at the same exalted level of inspiration that renders his St. John the Baptist (fig. 443) in Berlin so impressive, he would have been a great master. This haunting work makes even Cossa's beautiful rendition of the saint (see fig. 441) look pedestrian. The mysticism of Roberti's emaciated figure, rising in skeletal gauntness high above a distant horizon, seems a premonition of the towering saints of El Greco a century later. The rocks are those of Tura and Cossa, but their scale has been reduced and also their substance. The interlocking planes of the ledge on which St. John stands melt as we watch, and the sea mists that rise around the promontory, the port, and the ship are suffused with a Bellinesque rosy glow. The anguished head of the saint recalls forcibly that of St. John the Evangelist in Bellini's Brera Pietà (see colorplate 61). Roberti never resolves for us the relation between foreground and background, separated by a ruled line that makes the latter look like a backdrop. Perhaps he did not intend to; perhaps the ambiguity is part of the mystery of the image, which leaves us in constant doubt as to the substance of reality. But that was the very question to which the activities of a new genius were to provide unexpected answers in the last decades of the Quattrocento, thereby to transform the whole nature of Italian art in the Cinquecento.

THE CINQUECENTO

The High Renaissance in Florence

LEONARDO DA VINCI

eonardo da Vinci (1452–1519) was born only seven years after Botticelli and Perugino, and five years before Filippino Lippi, all three of whom belong indisputably to the Quattrocento. Moreover, all of Leonardo's greatest artistic achievements were either completed or well under way before the death of Filippino, the first of the three to die, in 1504. The fact that we tend to think of Leonardo as a Cinquecento artist, and to speak of him together with Michelangelo, born in 1475, or with Raphael, born in 1483, is a striking indication of his importance as the creator of at least the first, or Florentine, phase of the High Renaissance—even though he spent most of that period in Milan. The shopworn remark about great men being "ahead of their time" is in the case of Leonardo a statement of fact.

He was ahead of his time not only in painting, sculpture, and architecture, but also in engineering, military science, botany, anatomy, geology, geography, hydraulics, aerodynamics, and optics, to mention only a few branches of human knowledge to which he made crucial original contributions. Of immeasurable greatness in both art and science, Leonardo was able to make his innovations in both by virtue of his profound conviction that the two were intimately interrelated. Not interchangeable—for science was to him always an investigation of reality, and art an expression of beauty—but analogous in that in both his artistic and scientific activities he rejected authority and explored the natural world insofar as possible on his own. In an era in which the revived authority of antiquity competed with that of still-dominant Christianity, he had remarkably little respect for either source. Final authority to Leonardo emanated from a single origin: the human eye. He maintained that no activity was nobler than that of sight. No matter what its pretensions to divine revelation or philosophic authority, no mere text could be permitted to block the evidence of sight or to impede the process of induction therefrom.

... Now do you not see that the eye embraces the beauty of the whole world? It is the lord of astronomy and the maker of cosmography; it counsels and corrects all the arts of mankind; it moves men to the different parts of the world; it is the prince of mathematics, its sciences are certain; it has measured the heights and sizes of the stars, it has found the elements and their locations ... has generated architecture, perspective, and the divine art of painting. Oh most excellent thing above all others created, what peoples, what tongues shall be those which can fully describe your true operation? This is the window of the human body, through which it mirrors its way and brings to fruition the beauty of the world, by which the soul is content to stay in its human prison ...

We know a great deal—almost too much—about what Leonardo thought and felt from his voluminous writings. Thousands of pages of these survive, on separate sheets or gathered into notebooks, ranging from quick jottings to careful and extended analyses. Although he never assembled them into any sort of order, Leonardo's notes crackle with new ideas and new observations on numberless aspects of nature and of man. Some of these observations were not to be made again by others, much less systematized into a coherent body of theory, for decades or even for centuries. Seldom in his pages do we encounter a classical name—in contrast to Alberti and Ghiberti, for example, who are always citing classical authors or artists. Infrequently do we find references to God, and occasionally we meet with caustic

comments on organized Christianity (e.g., Why are we supposed to worship the Son when all the churches are dedicated to the Mother?), but nature is mentioned reverently on almost every page. If Leonardo had a religion, it was a kind of nature-mysticism, accessible through sight, and it was this only partly expressed conviction that united his art and his science.

The reverse of the coin is Leonardo's detachment from human beings and their ways. Greatly though he admired the human body as a work of nature, he felt that man did not deserve so fine an instrument. He called men "sacks for food," or worse, "fillers-up of privies." In spite of Leonardo's unusual charm of appearance and manner and his great conversational gifts, there is not in all those thousands of pages a line to show that he ever cared deeply for any other human being. Florentine though he was, he could detach himself sufficiently from

the concerns of his native republic to work cheerfully for Ludovico Sforza, duke of the traditionally inimical Milan, or even for that evil genius of the late Quattrocento, Cesare Borgia, son of Pope Alexander VI, against whose armies the Florentines were trying courageously to preserve their doomed liberties. His very landscape drawings, the first mountain studies known to us (fig. 444), recall in an odd way the attachment of Adolf Hitler to mountain heights on which he could dream of power and annihilation. And although, unlike Hitler, Leonardo seems to have been as inaccessible to hate as to love, and never to have done harm to any human being, he was capable of plotting human destruction with dreadful instruments of warfare or relishing the final disappearance of humanity in a universal deluge (see fig. 466).

Leonardo may have derived some of his Olympian aloofness from the very circumstances of his birth. He

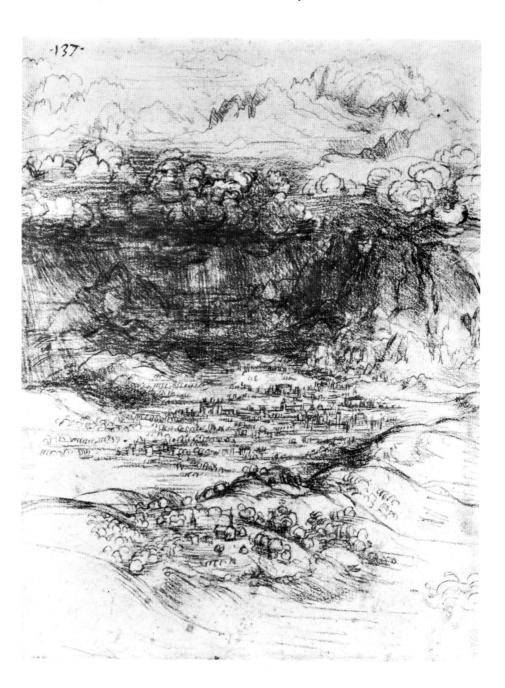

444. LEONARDO DA VINCI. Storm Breaking over a Valley. c. 1500. Red chalk on white paper, 8 × 6". Royal Library, Windsor

was the illegitimate child of a notary named Piero in the little town of Vinci, on a hillside overlooking the Arno Valley about twenty miles west of Florence, where the river enters a narrowing rocky gorge. At an early age the child was taken from his peasant mother, Caterina, about whom we know next to nothing, and brought up by his father and his father's wife. A notary in Italy verifies the legality of contracts, takes a percentage from both contracting parties, and can make himself prosperous. This Piero seems to have done. But Leonardo's life was clouded by his illegitimacy, which brought with it legal disabilities. He was further cut off from ordinary men by his left-handedness. Although the Italian expression for "left-handed" is the mild word mancino, this may be because "left" in Italian is sinistro, which comprised in the Renaissance, as it does today, a variety of unpleasant meanings, such as sinister, wicked-looking, unfavorable, or, as a noun, disaster. Leonardo made no attempt to alter his peculiarity and both drew and wrote with his left hand—from right to left, for his own benefit exclusively. To read his writings, in addition to the usual linguistic and paleographic training, the student must equip himself with a mirror. Possibly Leonardo's very detachment may have permitted him to soar intellectually above human preconceptions and rendered him attentive to much that escaped ordinary mortals.

Over and over in Leonardo's writings one encounters the lament, "Who will tell me if anything was ever finished?" True indeed, his own pursuit of mysterious and elusive nature was never finished, but neither was quite a number of his own works, and few of the finished ones survive in anything like what Leonardo wished to be their proper appearance. Sadder yet—so Leonardo's contemporaries complained—his scientific and mechanical interests impeded his painting. A fuller picture of his interests and his style can be gained from his innumerable drawings, both the studies intended for specific works of painting and sculpture and the sketches that illustrate almost every page of his notes.

Not the smallest living thing is neglected in these drawings. A cat, an insect, a flower are worthy of prolonged and sympathetic study. In his drawing of a starof-Bethlehem and other plants (fig. 445), for instance, Leonardo analyzes the shapes of the leaves with the greatest accuracy but is also concerned with the rhythm of the plant's growth, the elusive quality of natural life and motion, so that the leaves seem to unfold before us like those in the slow-motion films that form a part of ordinary classroom instruction in botany. The organisms grow and unfold, swirl, open, and blossom before us. At the same time Leonardo can move from the microcosm to the macrocosm with the ease of the Netherlandish masters, such as Jan van Eyck, whose work he may well have studied, but with more explicit reason. During his stay in Milan, within sight of the Alps, he climbed their slopes frequently and recorded what he saw. He

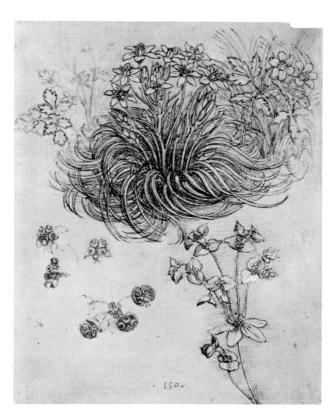

445. LEONARDO DA VINCI. Star-of-Bethlehem and Other Plants. c. 1505–8. Pen and red pencil, $7\frac{3}{4} \times 6\frac{1}{4}$ ". Royal Library, Windsor

noticed, for example, the existence of fossilized shells embedded in sedimentary rocks, and calculating the time required to produce such a phenomenon and carry the shells to such heights, concluded that the world could not have been created in 4004 B.C. as theologians maintained. This argument was still timely in the middle of the nineteenth century! Leonardo conveyed in his mountain drawings the elation of the climber's spirit on reaching a summit and beholding a wide view over other mountains and plains. And he described triumphantly the painter's power to reproduce this:

If the painter wishes to see beauties that charm him, it lies in his power to create them, and if he wishes to see monstrosities that are frightful, ridiculous, or truly pitiable, he is lord and God thereof; and if he wishes to generate sites and deserts, shady and cool places in hot weather he can do so, and also warm places in cold weather. If he wishes from the high summits of the mountains to uncover the great countrysides, and if he wishes after them to see the horizon of the sea, he is lord of it, and if from the low valleys he wishes to see the high mountains, or from the high mountains the low valleys and beaches, and in effect that which is in the universe for essence, presence, or imagination,

446.
LEONARDO DA VINCI.
Bird's-eye View
of Chiana Valley,
Showing Arezzo,
Cortona, Perugia,
and Siena.
c. 1502–3. Pen and
ink and color,
10¾×15¾".
Royal Library,
Windsor

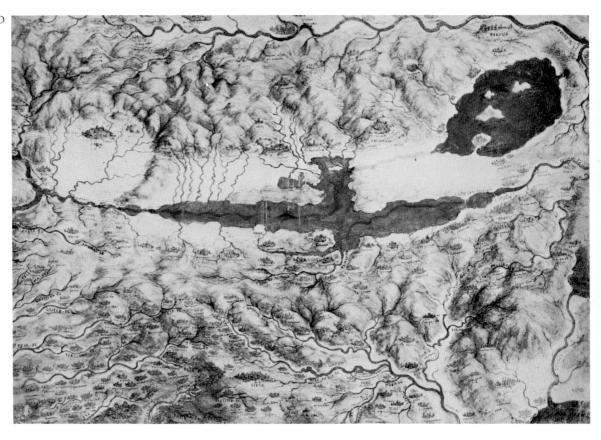

he has it first in his mind and then in his hands, and these are of such excellence that in equal time they generate a proportionate harmony in a single glance, as does nature.

This is what Leonardo has done in another drawing (see fig. 444), depicting in strokes and shading with red chalk a vast landscape, stretching from rolling hills over plains with a towered city and up into the cloudy Alpine valley and above the storms to the snowcapped summits.

Aside from the satisfaction that such studies gave him, they served a distinct purpose in assisting Leonardo to advance one of his favorite causes, perhaps his only passionately held conviction—the superiority of the painter. God has often been called an artist and the process of Creation compared to artistic activity. Leonardo reversed the metaphor and saw the artist's creativity as analogous to that of the Deity:

The deity which invests the science of the painter functions in such a way that the mind of the painter is transformed into a copy of the divine mind, since it operates freely in creating many kinds of animals, plants, fruits, landscapes, countrysides, ruins, and awe-inspiring places.

In Leonardo's day the listing of the Liberal Arts still rejected painting in spite of earlier efforts to include it (see page 15). In the material that was to go into his *Treatise on Painting* (compiled only after the master's death by his pupil Francesco Melzi), Leonardo argued at

length not only for the inclusion of painting among the Liberal Arts but also for its precedence over poetry or music, since these depend on the ear, and the eye is the superior organ. He had little trouble convincing his readers that it is better to be deaf than blind. He pointed out that when the last note of a song has died away, the music is over and must be played again to exist, while a picture remains constantly there. He asked if anyone ever traveled a great distance to read a poem, while miraculous pictures are the goal of countless pilgrimages.

After many similar arguments, Leonardo turned to sculpture, which he was bent on excluding from the Liberal Arts, or at least on maintaining in a rank far below that of painting. The elegantly dressed painter can sit in a lovely studio, with soft breezes entering from the gardens through the open windows, and listen to beautiful music as he works without physical strain. The poor sculptor must attack the stone with hammer and chisel, sweating violently the while, covering himself with marble dust, which mingles with the sweat to form a gritty paste as he deafens himself with the noise of hammer and chisel on stone.

Leonardo's landscape studies entered still another phase—that of practical utility for drainage, irrigation, water transportation, and military campaigns. He did a number of bird's-eye views showing a considerable area of Central Italy. One map (fig. 446) stretches from Arezzo at the left to Perugia at the extreme upper right, with Siena just to the left of lower center. Apparently, this was made for the project of diverting water into the Arno

from a lake that then existed in the center of the agricultural Chiana Valley, but it might also have had some purpose in Cesare Borgia's campaigns. Leonardo also drew genuine relief maps in the modern sense, shaded according to altitude, without benefit of surveying instruments.

Leonardo studied the human body as it had never been studied before. Drawings from the nude modelsuch as one done about 1503-7 in red chalk, a medium that Leonardo was one of the first to use (fig. 447)show a new attentiveness to the structure of the body, the consistency of its successive layers, and their effect upon the surface as the light plays across it. In his writings he admonishes the artist not to exaggerate the musculature, like the mistaken masters who make their figures look like "sacks of nuts" (could he have meant Signorelli-or Michelangelo?), and in his drawings always concentrates on the grace and ease of the total human figure. Yet he carried anatomical dissection to unheard-of lengths, quite late in life, about 1508 in fact, in Milan, where he is said to have dissected upward of fifty bodies, of men, women, and children. His innumerable anatomical drawings, although always beautifully

done, often have less to tell us about the exterior than about the interior of the body, and were frequently made for purely scientific purposes, including the cross sections of the act of coitus and of a womb containing a fetus. All are part of Leonardo's ceaseless exploration of the secrets of the natural world and of human life, and occasionally are influenced by tradition at the expense of observation. His analysis of the body and limbs to show how muscles and tendons inserted into bones, how joints and muscles worked, had an immediate bearing on the academic art of the High and Late Renaissance but little on Leonardo's own, which had come almost to a stop at the time he embarked on his most extensive series of detailed anatomical studies. Another drawing, in pen (fig. 448), shows us how Leonardo compared the behavior of the muscles overlying the bones of the human leg to that of ropes, as if, in his combined scientific and creative studies, he could make a machine that would function like a human being.

Although they have little importance for his artistic work, the machines designed by Leonardo are extremely interesting in themselves, and the drawings are so accu-

447.
LEONARDO DA VINCI.

Male Nude.
c. 1503–7. Red chalk,
10¾ × 6¼".

Royal Library,
Windsor

448.

LEONARDO DA VINCI.

Studies of a Left
Leg, Showing Bones
and Tendons.
c. 1508. Pen and
ink, 8½ × 4¼".
Royal Library,
Windsor

449. LEONARDO DA VINCI. Plans and Perspective Views of Domed Churches. c. 1490. Pen and ink. Institut de France, Paris

450. LEONARDO DA VINCI. Head of Apostle for Last Supper; Architectural Studies for Sforza Castle. c. 1495. Red chalk; pen and ink, $9\frac{3}{4} \times 6\frac{3}{4}$ ". Royal Library, Windsor

rate and the principles involved so well understood that a considerable number of these machines were actually built by an Italian engineer just before World War II. These models, which were in Tokyo during the war, were destroyed by American raids, but they were later rebuilt and for many years circulated by the International Business Machines Corporation. They include refinements of all sorts of known mechanical principles; improvements of pumps, dredges, pulleys, tackles, and weapons ranging from crossbows to chariots equipped with multiple rotating scythe blades for dismembering the enemy; and improvements to artillery and to defenses against these innovations. Among his inventions may be numbered an automotive machine equipped with a differential transmission, a mobile fortress somewhat like a modern tank, and a flying machine—all of which, however, lacked an adequate source of power. But Leonardo's optical studies and his invention of new machines for grinding concave mirrors resulted in a telescope that was in existence by 1509, a century before Galileo.

Although as far as we know Leonardo never built a building, his architectural drawings promulgated new principles of design that had a far-reaching effect on buildings built by others, and thus Leonardo may be said to have founded the High Renaissance style in architecture just as he did in painting. For Leonbattista Alberti, whom the youthful Leonardo may possibly have met and whose ideas he could hardly have been kept from knowing, the best form of building was certainly a centralized structure (see page 225), since architecture is founded on nature, and nature, in plants and the structure of animals, is centralized. Leonardo was reproached by Vasari for wasting time covering sheets of paper with meaningless squares, triangles, circles, and so forth. What he was actually doing was exploring as many permutations and combinations of basic geometrical figures as possible to provide himself with material for the ground plans of his buildings. A number of beautiful architectural drawings by Leonardo remain in which he starts, at the right of course, with plans composed of these geometrical elements, and then erects churches in perspective upon the plans. A drawing in the Institut de France (fig. 449) first shows an octagonal church surrounded by eight domed circular chapels, each with eight niches, then a diamond plan with apses on the sides and towers on the points, then sketches for two more plans below. But if the plans are Albertian, the details of the architecture strongly recall Brunelleschi's dome for Santa Maria del Fiore and his plan for Santo Spirito (see figs. 132, 142). The end

result, however, is something entirely new. The building is no longer a juxtaposition of flat planes as in Brunelleschi or an inert mass as in Alberti, but a living organism radiating outward from a central core, like the petals of a flower, the legs of a crustacean, or the rays of a snow crystal. What Leonardo discovered—and this is certainly the basis of High Renaissance composition in any artistic field—is a total organization that is the product of the dynamic interrelationship of its moving components. Antonio del Pollaiuolo had hit on something similar in the ephemeral pyramid of archers of his St. Sebastian (see colorplate 43). Or had he? Could the youthful Leonardo already have suggested the notion to him? This is the kind of suspicion that can, in all probability, never be either satisfied or dismissed. In any case, Leonardo did not stop at individual buildings or parts of buildings, such as the beautiful domed turret for the Sforza Castle that he studied several times in the Windsor drawing for the Last Supper (fig. 450). He designed crucial elements for the solution of acute urban problems of his own day, such as systems of underground canals for the removal of refuse, streets for horse-drawn traffic, and elevated walkways and pedestrian malls for

human enjoyment. None of this came to usable reality at the moment, any more than did his designs for a flying machine, but the ideas are typical of Leonardo's essential outlook, concerned with the discovery of principles of order in the apparent disorder of life.

What fascinated him his whole life long, perhaps more consistently than any other natural phenomenon, was the behavior of water, and his notebooks abound with schemes for providing it in abundance to cities, rendering it useful and free of obstruction in harbors, making it a safe means of transportation in rivers and canals. For such purposes one has to know how water works, and to this end Leonardo sat hour by hour to study the patterns produced by a stream of water striking a body of water (fig. 451), penetrating it in spiral eddies, emerging again on the surface in bubbling circles, or the configurations formed by a board suspended first at an angle, then straight, in contact with the surface of a rushing stream. He notes that such shapes resemble the curls of hair (fig. 452), and he shows clearly how the principles of spiral growth that appear in the leaves of his plants are to be found in water as well.

Since most of the problems connected with the inter-

451. LEONARDO DA VINCI. Studies of Water Movements. c. 1505. Pen and ink, $11\frac{1}{2} \times 8''$. Royal Library, Windsor

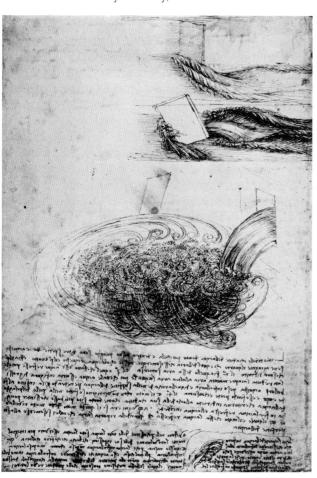

452. Leonardo da Vinci. Studies of Water (portion of drawing). 1490–95. Pen and ink; area shown, $6\times8\frac{1}{2}$ ". Royal Library, Windsor

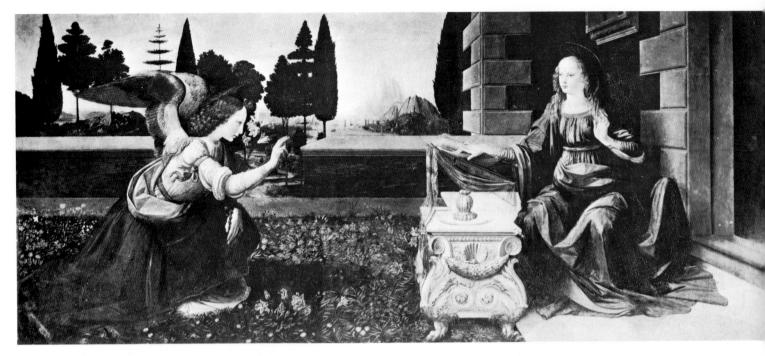

453. LEONARDO DA VINCI. Annunciation. Late 1470s. Panel, 383/4×851/2". Uffizi Gallery, Florence

relationship of the phenomenally gifted youth and his master, Andrea del Verrocchio, with whom Leonardo worked for several years after about 1470 in Florence. are of a subtlety that has thus far placed them beyond solution by the best critics, we shall limit ourselves to a few words about the pupil's participation in a single work, the Baptism of Christ by Verrocchio (see fig. 332). About most of the painting there can be little doubt; Verrocchio's hand is everywhere apparent. But of the two kneeling angels, the curly-headed boy at the right, who still belongs to the world of Fra Filippo Lippi, is no match for his companion at the left, who looks from his eyes as indeed through the windows of the soul, and whose hair streams from his forehead to his shoulders with the mysterious beauty of Leonardo's water patterns. The water above him, whose shimmering surface breaks into rapids over underlying shoals, whose juncture with the surrounding rocks is masked by mists, whose very origins defeat our imaginations, this too is by the man who was to paint the elusive watercourses that irrigate the background landscape of the Mona Lisa (see fig. 463). Very possibly the clear and beautiful water in the foreground as well comes from the miraculous intelligence of the youthful Leonardo.

One of his few remaining works from this Florentine period and of the even fewer from any period that survive in good condition is the magical *Annunciation*, datable somewhere in the late 1470s, from the monastery of Monte Oliveto, just to the southwest of Florence (fig. 453). The Virgin is seated calmly on the threshold of a splendid villa, with granite walls and perfectly projected quoins of *pietra serena*, a combination unknown to Florence. Her book rests on a lectern made from a Roman sepulchral urn, whose lion feet, acanthus body, volutes,

and shell Leonardo has rendered with a fidelity that may have influenced Ghirlandaio in his *Adoration of the Shepherds*, painted in 1485 (see colorplate 48). She recognizes the angel's message only by lifting her left hand in a gesture of patrician surprise. Not a trace of emotion disturbs the composure of her delicate features. Gabriel, a slender and beautiful child, kneels before her on a rich carpet of grass and flowers, each one of which is rendered with all Leonardo's botanical accuracy and rhythmic flow. Over the low garden wall we look through cypresses and topiary cedars to a distant port, with towers, lighthouses, and ships, much like that by Filippino in the Corsini *Virgin and Child with Angels* (see fig. 356) and probably painted for the same reason—Mary's titles of "Star of the Sea" and "Port of the Shipwrecked."

The picture seems decades later than Ghirlandaio's Adoration rather than several years earlier. Neither Ghirlandaio nor any other Florentine contemporary was capable of painting the atmospheric veil that Leonardo interposes between the object and our eye (and about which he discourses at length and with great accuracy in his writings). The blue air becomes denser as we look toward the shimmering mountains on the horizon, at just the point where the Apuan Alps appear above the Arno Valley in the afternoon light, seen from Monte Oliveto. The drapery of the Virgin and the angel, occupying depth with convincing accuracy, reveals Leonardo's method as recorded by Vasari (fig. 454). He used to soak a piece of soft linen in gesso and arrange it over a lay figure (mannequin), allow it to harden, move the resultant model into a satisfactory illumination, and then draw it with a brush on linen canvas before starting to paint the final picture.

The two faces show an unearthly softness and light-

ness, without any shadows, even though a light has entered the picture with the angel, cast his shadow on the grass, and created a strong play of shadows in the drapery folds over Mary's knees. Yet every nuance of shape in the faces is clear, firm, and beautiful. Leonardo speaks in his notebooks of the use of light to give a grace to faces. He warns against drawing or painting faces in the harsh, direct light of the sun, reminding us of the beauty of faces passing in the street in the morning before the sunlight has appeared, or in the early evening when the sun has just gone down. At that time you see soft and mysterious expressions, forms that you cannot quite grasp, and the faces take on an inexplicable loveliness and grace. To produce such effects in the studio, he recommends painting all four walls of a courtyard black, stretching a sheet of linen over the courtyard, then placing the model under this linen, so that a diffused light will irradiate the face, with no sharp reflections or shadows to break up the forms. This is exactly the effect that Leonardo has achieved in his mysterious and enchanting Annunciation.

Both these technical procedures for the rendering of light reveal the essence of Leonardo's attitude toward light. Darkness precedes light in his thought (e.g., the black-walled courtyard, the darkness of the room behind the cloth-and-gesso drapery). Light penetrates this dark-

454. LEONARDO DA VINCI. Study of Drapery. 1470s. Silverpoint, ink, wash, and white on red prepared paper, $10 \times 7\%$ ". National Gallery, Rome

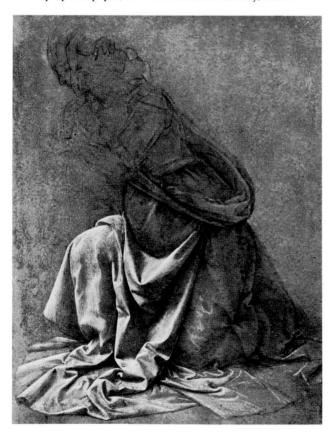

ness but cannot entirely replace it. In Leonardo's paintings, therefore, form and color must compete for their very existence against the circumambient dark—as well as against the overlying bluish atmosphere. Color, as a result of this effort, enjoys a new and deeper resonance, and form a more convincing three-dimensional existence. In the artificially bright world inhabited by most of Leonardo's Florentine contemporaries, Botticelli or Ghirlandaio let us say, form is a shell and color an enamel.

Leonardo's first Florentine masterpiece is the Adoration of the Magi (fig. 455). Commissioned in March 1481 by the monks of San Donato a Scopeto, a now-vanished monastery formerly outside the Porta Romana of Florence, the picture was left unfinished when the artist departed for Milan some time late in 1481 or early in 1482. But unfinished is hardly the proper word for a picture in the condition of the Adoration of the Magi. There is not a touch of color on it, not even underpaint. What we see is only the underdrawing, and not even that is complete! To understand the painting properly we should imagine it as having been brought to the same state of utter perfection as the Annunciation. Nonetheless, the methods used by the young artist in his underdrawing are not only exciting in themselves but also offer us the visual proof of his attitude toward light, reinforcing the verbal knowledge we obtain from his writings.

Again it is difficult to make oneself recognize Leonardo's true chronological position as a contemporary of the masters treated in Chapter 13. This dramatic and revolutionary picture comes only a few years after Botticelli's altarpiece on the same subject for Santa Maria Novella (see colorplate 44), and probably before his painting of the Adoration now in Washington, D.C. (see fig. 346). Out of the considerable number of surviving drawings for Leonardo's Adoration, the most important is certainly the splendid perspective study (fig. 456) that shows that he originally intended the picture to include the ruins and shed of the Botticelli tradition. At the right only a few elements of the architecture appear, but at the left a vaulted arcade and two flights of steps support the timber roof. The drawing is, of course, one of the most celebrated examples of Albertian one-point perspective, but it is seldom mentioned that Leonardo has also disclosed the Achilles' heel of this system, that is, the extreme distortion imposed by the Albertian method on the squares at the upper right and left of the construction—the inherent defect that apparently induced Ghiberti to abandon the vanishing point entirely in the upper right of his terrace in Jacob and Esau on the Gates of Paradise (see colorplate 30). The principal groups of figures do not appear at all—Leonardo studied them separately in many other drawings—but on the steps and on the ruins move members of the train of the Three Magi. A camel crouches below the steps, and in the background, just at the vanishing point of the perspective, a man tries to

455. LEONARDO DA VINCI. Adoration of the Magi.
Begun 1481. Panel, 8' × 8'1".
Uffizi Gallery, Florence

456. LEONARDO DA VINCI.

Architectural Perspective
and Background Figures, for
the Adoration of the Magi.
c. 1481. Pen and ink,
wash, and white,
6½×11½". Gabinetto dei Disegni e Stampe, Uffizi, Florence

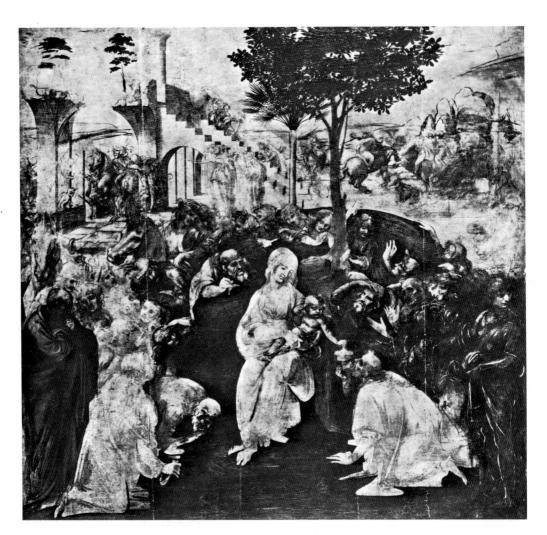

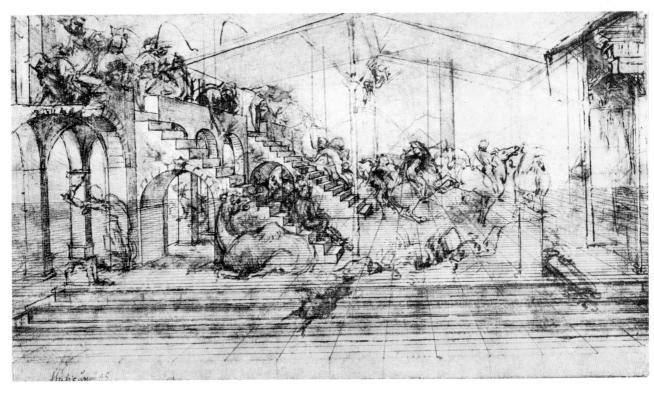

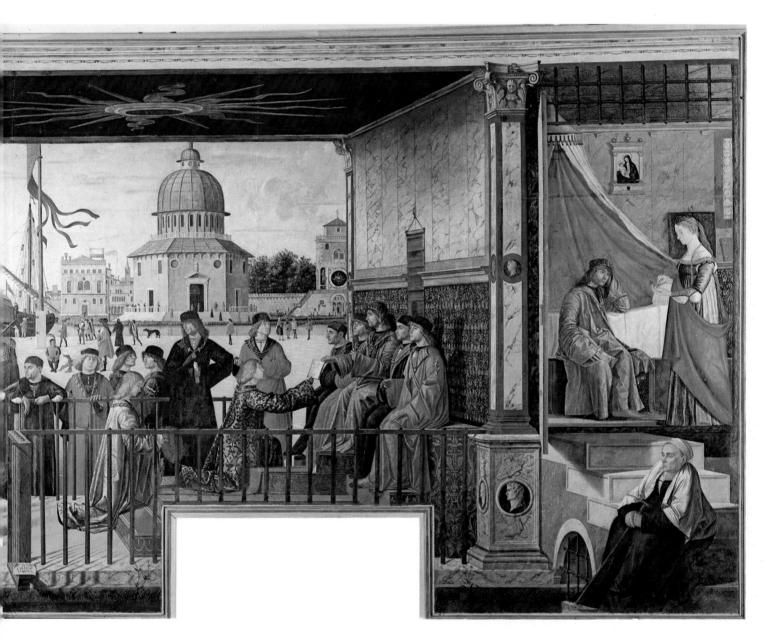

Colorplate 64. VITTORE CARPACCIO. Arrival of the Ambassadors of Britain at the Court of Brittany. c. 1496–97. Canvas, $9' \times 19'4''$. Accademia, Venice

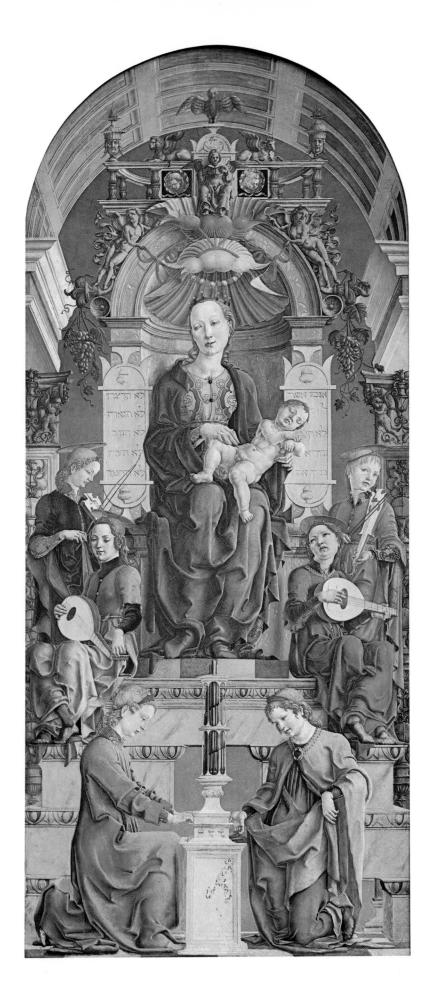

Colorplate 65.
COSIMO TURA.
Enthroned Madonna
and Child with Angels,
from the Roverella
altarpiece. c. 1480.
Panel, 94 × 40".
National Gallery,
London

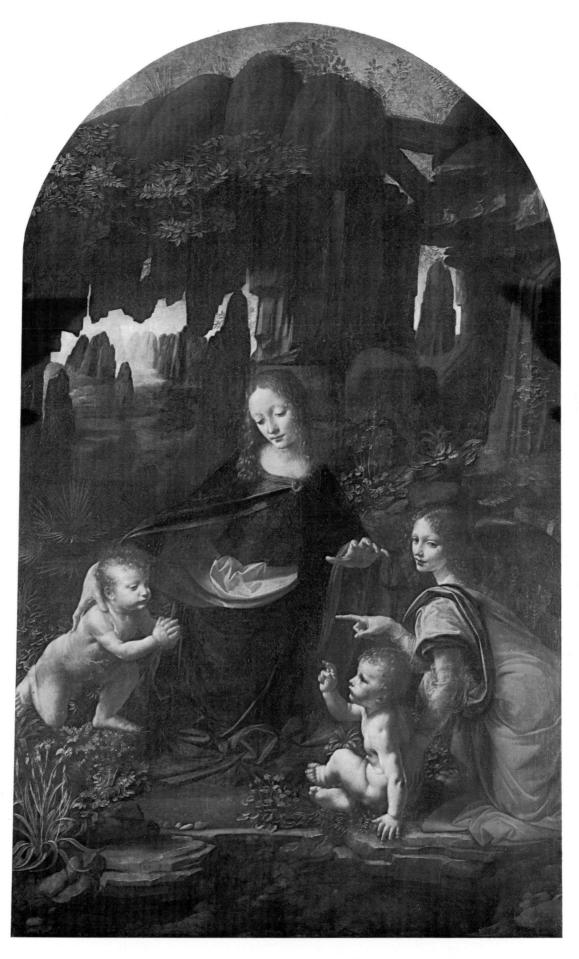

Colorplate 66. Leonardo da Vinci. *Madonna of the Rocks.* Begun 1483. Panel, transferred to canvas, $78\frac{1}{2}\times48''$. The Louvre, Paris

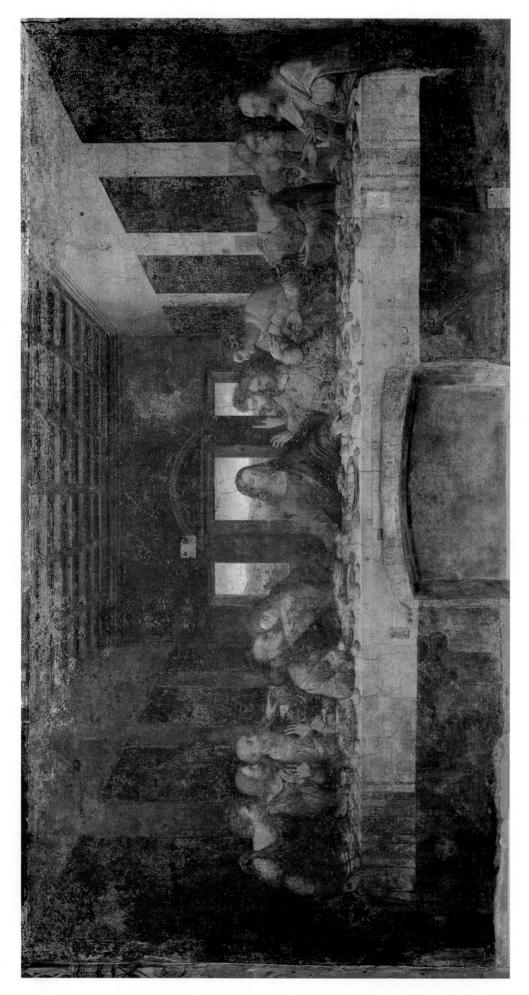

Colorplate 67. LEONARDO DA VINCI. Last Supper. 1495-97/98. Fresco. Refectory, Sta. Maria delle Grazie, Milan

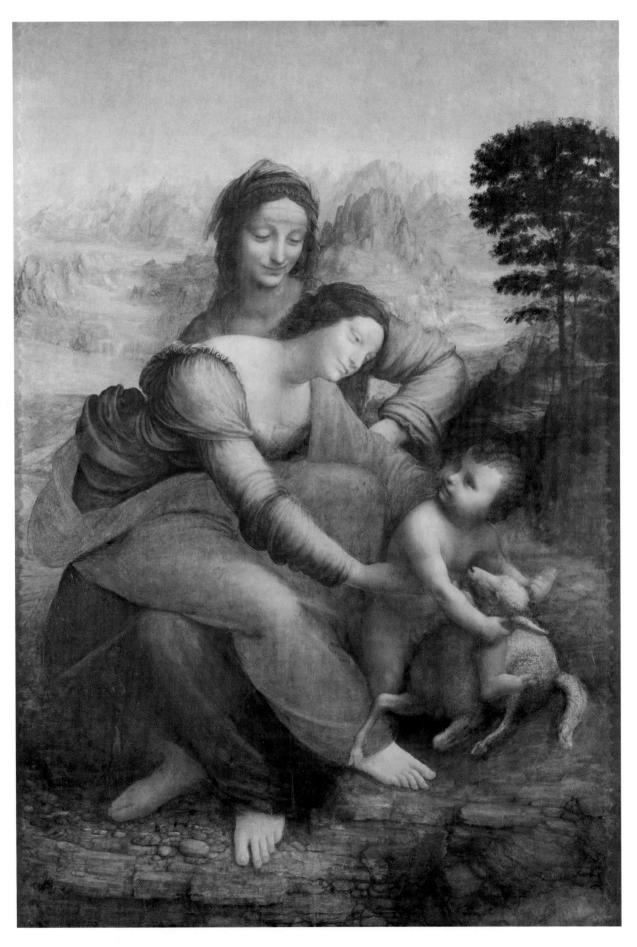

Colorplate 68. Leonardo da Vinci. Madonna and St. Anne. c. 1508–13 (?). Panel, $66\frac{1}{4}\times51\frac{1}{4}$ ". The Louvre, Paris

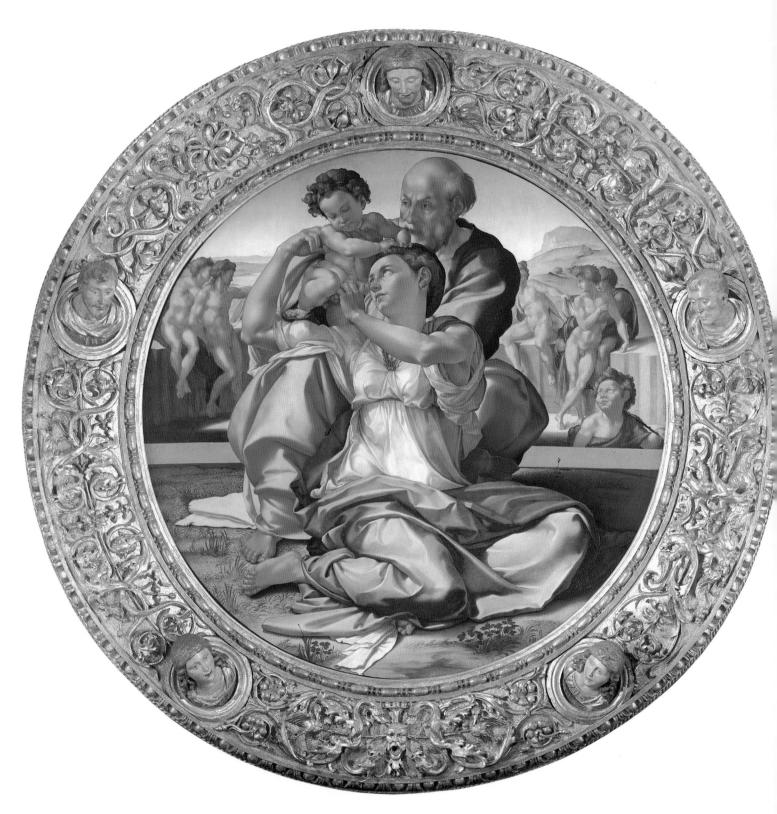

Colorplate 69. MICHELANGELO. *Doni Madonna*. c. 1503. Panel, diameter 471/4". Uffizi Gallery, Florence

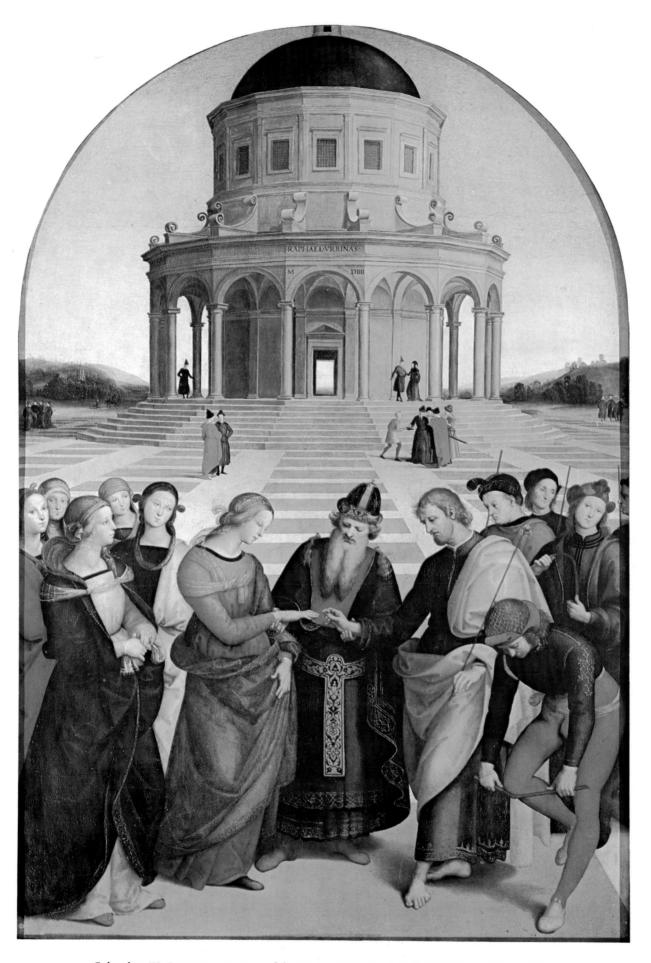

Colorplate 70. RAPHAEL. Marriage of the Virgin. 1504. Panel, $67 \times 46 \frac{1}{2}$ ". Brera Gallery, Milan

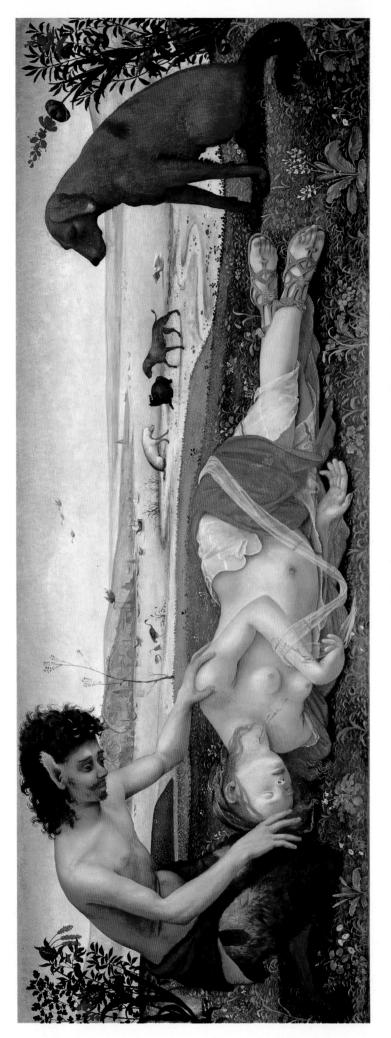

Colorplate 71. PIERO DI COSIMO. Mythological Scene. c. 1510. Panel, 25%×721/4". National Gallery, London

maintain his balance on a rearing horse, while another horse kicks backward with both legs, doubtless motifs Leonardo had observed in the *Battle of San Romano* by Paolo Uccello (see colorplate 31). These are no Uccello rocking horses; they are as replete with uncontrollable energy as the water that so fascinated Leonardo, and like the rushing water they will reappear again and again in his imagination as symbols of the mysterious forces of nature against which man is eternally pitted.

In the painting itself Leonardo omits the shed entirely and consequently its elaborate perspective construction, no longer relevant to the problems that concerned him. The ruins remain, abbreviated somewhat—still in flawless perspective—but relegated to a background position. The arches are broken, so that there is no longer room for the figures and horses, who now surge beneath them. The camel has vanished, and both horses rear on their hind legs, as if their riders were in combat. Whatever theological significance the stable might have possessed has now been assumed by the broken arch, of which Christ was the keystone, and by the gigantic tree, perhaps suggesting the Tree of Life (the palm tree, symbol of eternal life, grows beneath its branches).

But Leonardo's principal concern is not such traditional symbols, it is the study of the Adoration of the Magi as a moment in human group psychology in which crowds are drawn together by their electric excitement over a single extraordinary event, and this is what Botticelli probably drew from him in the Washington, D.C., Adoration (see page 329). Whatever their ostensible subject, in fact, Leonardo's compositions are always systematic expositions of his psychological theory. The yearning that sends all three Magi to their knees runs like a storm through the crowd of attendants, building up a pyramid composed of psychological relationships, with the Virgin's head as its apex, in the manner of Pollaiuolo's pyramid derived from physical activity (see page 316).

Wherever we are able to observe their technical procedures from unfinished or damaged works, or deduce these procedures from pictorial surfaces, we find that earlier painters drew contours on the white priming and applied color between them. Leonardo inundates the white with a dark wash as the underpaint for the envelope of shadow so apparent in the Annunciation. The light areas—the figures—are the residue, but the darkness has invaded many of them. After the motion of the shadows has come to rest, he begins to define their edges with the brush. To Leonardo, therefore, the traditional roles of light and darkness are simply reversed. Darkness is universal and primal, and light must struggle against it. Light fascinated him at all times, and his notes record endless luminary experiments and analyses, including even a projector powered by a candle. Once the basic light areas received definition, Leonardo proceeded to sharpen the details, always as a movement of dark against light. A few touches make a beautiful young head or a ravaged old one spring into being, full of life and emotion, in a matter of a few minutes. At times ghostly in its softness, at times volcanic in its power, the fluid dark pours through figures, horses, and vegetation. The left-hand tree over the ruins shows the method clearly. Leonardo has merely given the surface a few horizontal strokes of the brush held in his left hand, and these represent the foliage. Later he would have united these masses with a trunk and branches.

Leaving the picture in its present state, so that the unfortunate monks had eventually to order another one from Filippino Lippi, Leonardo left Florence in 1481 or 1482 for a stay of nearly twenty years in Milan. In his letter of application to Duke Ludovico Sforza the artist speaks eloquently about his ability as civil and military engineer and about all his wonderful inventions to further the duke's conquests and to render life more agreeable in his capital. He suggests his sculptural project for a statue of the duke's late father on horseback, and only at the very end mentions his gifts as a painter! Of these, however, he was to show splendid evidence shortly after his arrival in the Lombard metropolis in the form of the celebrated Madonna of the Rocks. Two versions of this picture survive, one in the Louvre (colorplate 66) and the other in the National Gallery in London. One (possibly both) was painted for the Confraternity of the Immaculate Conception, which had a chapel in San Francesco Grande in Milan, as part of an elaborate altarpiece by Leonardo, two of his pupils, and an independent sculptor, according to a document of 1483. The London version can be traced continuously from its original altar until its sale to an English collector in 1785. Could it have been substituted at some time and for some unknown reason for the Paris version? There is no general agreement, but the majority of Leonardo critics concede that, whatever the facts may eventually turn out to be, the Louvre panel is earlier and entirely by Leonardo, whereas the London panel, even if designed by the master, shows extensive passages of pupils' work consistent with the date of 1506, the moment of a controversy between the artists and the Confraternity.

The subject of the Louvre picture has no direct relation to the Immaculate Conception, which is the doctrine that Mary was free from all stain of Original Sin. But this belief, promulgated in two bulls written by Pope Sixtus IV close to the date when Leonardo painted the picture and represented in a sculptured image in the same altarpiece (above or below the painting), at the very least infiltrated its meaning. The artist has shown the youthful Virgin kneeling on the ground, her right arm around the also kneeling infant St. John the Baptist, her left hand extended protectively over the head of the seated Christ Child, before whom John's hands are folded in prayer. A beautiful kneeling angel at the extreme right steadies the Christ Child with his left hand and

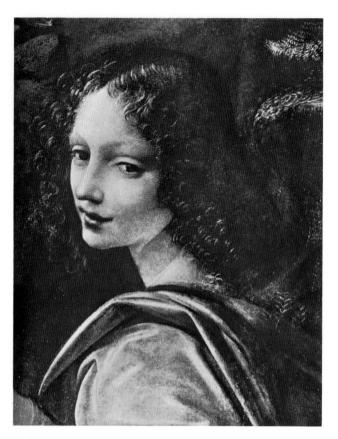

457. LEONARDO DA VINCI. Head of Angel, detail of *Madonna of the Rocks* (see colorplate 66). Begun 1483. Panel, transferred to canvas. The Louvre, Paris

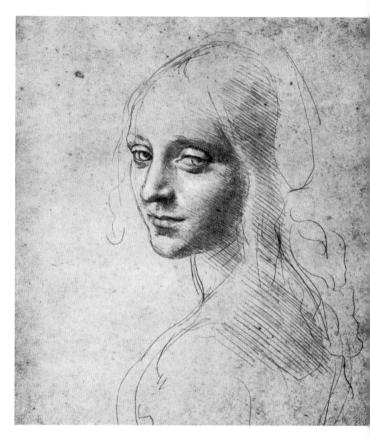

458. LEONARDO DA VINCI. Study of the Head of the Angel, for Madonna of the Rocks. c. 1483.

Silverpoint and white on prepared paper,

71/4×61/4". Royal Library, Turin

looks outward toward (but not directly at) the spectator (fig. 457), while pointing with his right to John, the Precursor. The most extraordinary aspect of the painting is its dark and gloomy background, a wilderness of jagged rocks rising almost to the apex of the arch, through which, as through the mouths of caverns, we look into mysterious vistas flanked by still more rocky pinnacles, rising from dim watercourses until they lose themselves in the half-light of misty distances. It has often been stated that these rocks are Leonardo's memories of the quarries of Maiano, from which came the pietra serena for the buildings of Florence. Even if this were true (and there is no resemblance), we would still be left wondering what possessed Leonardo to paint Florentine quarries in the background of a Milanese altarpiece. The cave of the Nativity and the cave of the Sepulcher were mystically identified according to tradition. St. Antonine claimed that both are foretold in the Song of Songs (2:14): "My dove, in the clefts of the rock, in the hollow places [caverna] of the wall, show me thy face." The dove is of course the Virgin, and the shadowy caves in the rocks suggest our dark mortality, into which Divine Light enters in the Incarnation, and in the Atonement, through the intermediacy of Mary as the immaculate vessel of God's purpose. However much or little importance Leonardo attached to the assigned subject, he saw it as a richly romantic

vision, and painted shadows of unprecedented depth and poetic beauty, within which the light from above picks out sweet faces and delicate hands, warm flesh and exquisite curls, merely hinting at the shapes of geological formations and wild vegetation. This is the complete fulfillment of his new kind of light shining in the darkness, the preparatory underdrawing for which we can study in the *Adoration of the Magi*. Even in these wild surroundings, the dynamic pyramid of High Renaissance composition emerges from the interactions of the figures.

There are a number of wonderful drawings for various portions of the picture, but none finer than the silverpoint study for the head of the angel (fig. 458), done from a female model on prepared, rose-colored paper and delicately heightened with white. In order to make this miraculous drawing Leonardo must have used the method recommended in his notebooks—seating a model in a black courtyard beneath a linen sheet—and he has reproduced the effect of this type of illumination with separate strokes of the silverpoint so sensitive, so soft, so close to each other that they almost blend into a misty, gliding, all-over tone. The light "to give a grace to faces," as Leonardo put it, strikes these deeply luminous eyes, truly the windows from which the soul of the model looks toward us.

Leonardo's prolonged stay behind the iron curtain, so to speak, was busied with many projects for the duke of Milan, ranging from military and civil engineering to richly costumed pageants enlivened by delightful mechanical devices. We know both too much and too little about the great monument that was his major artistic undertaking for the duke. The statue of Francesco Sforza was to have been equestrian, and judging from one of the most fiery of the preparatory drawings that have been connected with the commission (fig. 459), the general was to have been seated on a rearing horse, which he is reining in, while its forehooves are about to descend upon a hapless enemy. As we have already seen in the background of the Adoration of the Magi (see fig. 455), the struggle between man and beast, like that between man and water, was a recurrent motif in Leonardo's imaginative life. Nonetheless, the military leader restraining a rearing steed has a long history in ancient art, not as an independent statue but in historical reliefs, many of them as accessible to Leonardo as they are to us. Piero della Francesca had revived the motif in the Battle of Heraclius and Chosroes (see fig. 284), but it remained for Leonardo to translate the notion into a colossal statue in the round. Actually, no such statue was ever executed by any sculptor until Bernini's ill-fated commission for Louis XIV in 1669. We have no way of telling why Leonardo renounced the dramatic idea—imagine how wonderful it would have been in a great piazza in Milan!—in favor of an accepted Donatello-Verrocchio striding pose (see figs. 249, 337). In fact, there are drawings that show he developed both ideas simultaneously. Possibly the duke objected to the unconventional idea, possibly it posed insoluble technical problems in bronze casting. For a while the duke considered taking on some other artist for the project, but in 1490 Leonardo set to work, on the basis of exhaustive and very beautiful anatomical studies of horses, and produced not only a full-scale model some twenty-four feet high in clay or plaster in 1493 but also complete plans for the casting in bronze. Alas, the drawings are our only evidence for the monument. The military crisis in which the duke found himself in 1498, after the accession to the French throne of Louis XII (who, as a descendant of the expelled Visconti, laid claim to the duchy of Milan), made it impossible for Leonardo to obtain the necessary metal. The French invaders who chased out Ludovico Sforza in 1499 used Leonardo's colossus for target practice. What was left of it soon fell to pieces, and its grandeur can be revived in our imaginations only as we peruse the glorious drawings.

The Last Supper (colorplate 67), painted in 1495– 97/98 in the refectory of Santa Maria delle Grazie in Milan, is too often known through prettified versions that conceal its condition. This is largely due to a disastrous technical innovation on the part of the artist. A man as sensitive as Leonardo to the slightest throb of light in atmosphere was bound to be impatient with the piecemeal fresco method, which could not have provided him the time necessary to impart his customary shadowy unity to the entire painting and perfect luminous finish to the details. It will be remembered that, for similar reasons, Baldovinetti had combined underpaint in fresco with a finish in tempera at the Santissima Annunziata (see fig. 318). Leonardo painted directly on the dry intonaco with some kind of oil tempera, whose exact composition is not yet known. According to the literary accounts, he would sometimes stand on the scaffolding an entire morning without picking up the brush, studying the relationships of tone. When completed, the painting inspired extravagant praise, but in 1517, while the artist was still alive, it had started to deteriorate due to the proverbial Milanese humidity, and when Vasari saw it a generation or so later, he found it almost indecipherable. The mural was repainted twice in the eighteenth century. It suffered from the brutality of French soldiery, Napoleonic this time, and from the monks who cut a door through it, and was again repainted in the nineteenth century. Allied bombs in 1943 almost destroyed the vaulted ceiling above it, but the painting, protected by a shelter of sandbags supported on a scaffolding of steel tubing, resisted remarkably well. Extensive conservation efforts after World War II disclosed that more of the original remained under the repaint than anyone had dared to hope, and the picture is again something to be enjoyed.

The popular reproductions of the Last Supper have

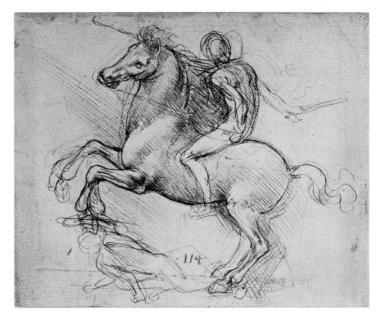

459. LEONARDO DA VINCI. Horseman Trampling on Foe. c. 1485. Silverpoint on greenish ground, 6×71/4". Royal Library, Windsor

probably blinded us somewhat to the precise meaning of this powerful composition. In his preliminary drawings (fig. 460), Leonardo toyed with the idea of placing Judas on the outside, as painted by Castagno (see fig. 270) and by Ghirlandaio (see fig. 359), keeping in mind the text from the Gospel of St. John (13:26) that those artists had illustrated, according to which Judas is indicated as the betrayer by the sop in wine that Christ hands to him. (In the Gospels of Matthew and Mark, Christ says, "He who dippeth with me in the dish," and in Luke, "He whose hand is with me on the table.") Clearly Leonardo refers to the text from Luke, for Judas is seen with his hand on the table stretching after the bread. In his Summa, St. Antonine of Florence had expounded on the universally known doctrine of St. Paul (I Corinthians 11:29) contained in a passage immediately following that used for the Consecration in both Catholic and Anglican rituals, "For he that eateth and drinketh unworthily, eateth and drinketh judgment to himself." In all certainty the actual consecration is not represented, because Christ is not breaking the bread nor is the chalice shown. Rather Christ displays the bread gently with his right hand and indicates the wine with his opened left, as if to exemplify the doctrine of St. Paul, especially appropriate as instruction for the religious assembled for their own meals in the refectory, as was customary for Last Suppers. In an epitome of doctrine rather than mere illustration of incident, Leonardo has fused this episode with a slightly earlier moment—never before represented—as recounted by Matthew, Mark, and Luke. "Verily I say unto you, that one of you shall betray me. And they were exceeding sorrowful, and began every one to say unto him, Lord, is it I?" Instead of designating the betrayer, Leonardo has shown the bombshell effect of the announcement at the supper, sparking instant wonderment on the part of the Apostles as to his identity, and intense searching of their own souls.

Donatello had burst such a grenade in his Feast of Herod (see fig. 173)—Leonardo has gone further. He has, in fact, made the Apostles act according to his own mechanistic Renaissance view of psychology, thus revealing the underlying mathematical unity of all life. As if by inexorable law, the revelation of betrayal automatically factors the number twelve into four groups of three each. Certainly Leonardo was aware of the symbolic meaning of these numbers in Christian tradition. Three, the number of the Trinity, is the most sacred of all. It is also the number of the Theological Virtues. Four is the number of the Gospels, of the Cardinal Virtues, of the Rivers of Paradise, of the seasons of the year, of the times of day. Three plus four make seven, the number of the Gifts of the Holy Spirit, the Joys of the Virgin, the Sorrows of the Virgin. Three times four make twelve, not only the number of the Apostles in the picture, but also of the gates of the New Jerusalem, the months of the year, the hours of the day, the hours of the night. Christ, the divider, appears at the center of both light and space, the vanishing point of the perspective and the second window of a group of three, whether the group is read from the left or from the right. Windows are, as we have often seen, constant symbols of revelation, and Christ is the second person of the Trinity. Numerical tradition is exploited by Leonardo not only to make the divisions of his composition immediately significant to his audience, but also to create mathematical order out of dramatic confusion and to point up the instant effect of the divisive revelation of betrayal on the inner lives of the Apostles by identifying their automatic reactions with the operation of the underlying number system.

In preliminary composition sketches made before he had hit on this system, Leonardo labeled each Apostle, and in one of his manuscripts describes their respective attitudes and emotions. He later studied each from live models, some of whose names are known. Many beautiful drawings are preserved, including one in red chalk for the terror-struck head (see fig. 450), generally considered to be that of St. James but corresponding to the figure labeled St. Matthew in the composition drawing, recoiling as from a blow, his eyes staring, his mouth open. (At a later time the same sheet was used for studies of a complex Renaissance dome, probably to be set on one of the corner turrets of the Sforza Castle in Milan.) In the painting, this horrified figure sinks back between St. Thomas with his pointing, probing finger and St. Philip, whose love for his Master streams from his eyes. his hands pressed to his breast as he protests that the betrayer cannot be he (fig. 461).

We have only to look for Judas. Suddenly we see him; he is the only Apostle who need not protest. He knows. He is also the only Apostle who reaches for food (bearing the implication of having received the Sacrament unworthily), the only one who recoils from the Master, the only one whose face is not in the light. And his dark bulk is contrasted in the same group with the lighted profile of St. Peter and the radiant countenance of St. John, whom, in defiance of all tradition, Leonardo has placed at Christ's right. The resigned expression on the countenance of Christ, turned away from Judas, suggests his words in all three synoptic Gospels, "And the Son of man indeed goeth... but woe to that man by whom the Son of man shall be betrayed."

Here and there, especially in the pewter plates, the freshly unfolded tablecloth, the simple wineglasses, and the ordinary rolls set upon the table, we can catch an echo of what must have been the surface quality of the original painting. Meticulous restoration, still in progress at the time of this revision, is revealing a hoped-for delicacy of touch and luminosity of color in the better-preserved areas, and among other surprises has shown that St. Matthew did not wear a beard, but appeared substantially as he is shown in the preparatory drawing (see fig. 450). Every silken curl, every passage of flesh must

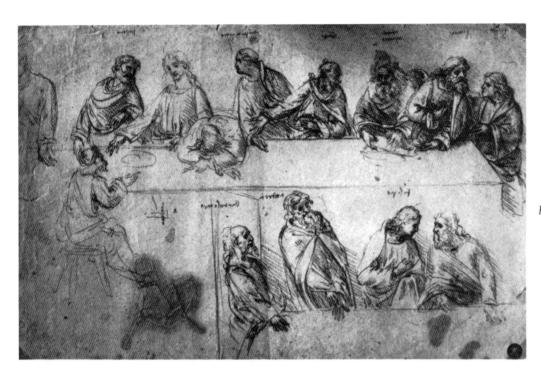

left: 460. Leonardo da Vinci. Study of Composition of Last Supper (see colorplate 67). c. 1495. Red chalk, $10\frac{1}{4} \times 15\frac{1}{2}$ ". Accademia, Venice

below: 461. LEONARDO DA VINCI. Three Apostles, detail of Last Supper (see colorplate 67). 1495–97/98. Fresco. Refectory, Sta. Maria delle Grazie, Milan

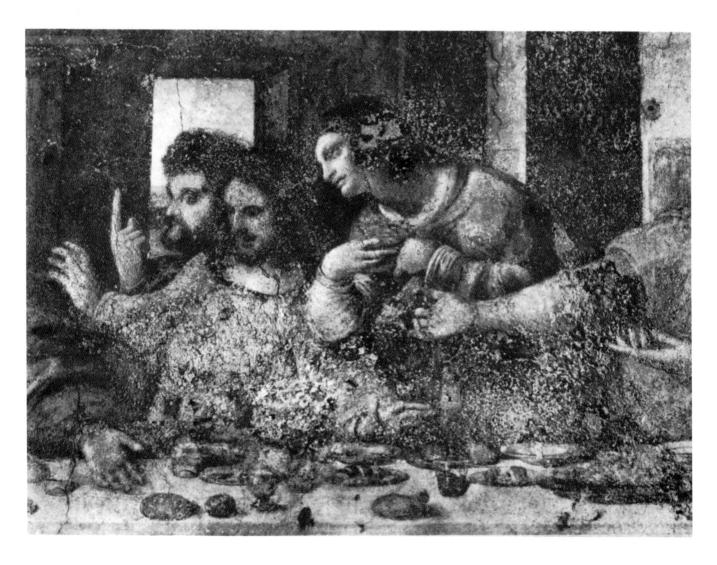

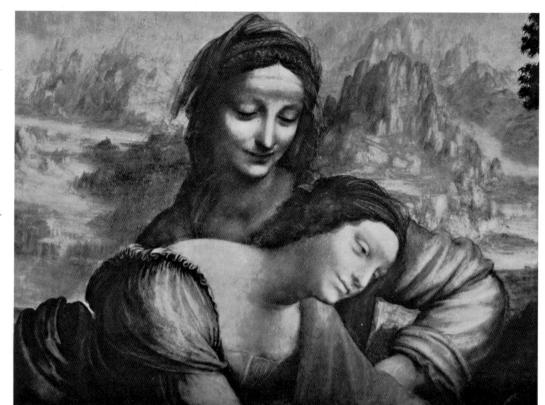

462. LEONARDO DA VINCI.
Detail of *Madonna and*St. Anne (see colorplate 68).
c. 1508–13 (?). Panel.
The Louvre, Paris

once have been perfect. Leonardo's forms have lost their definition but not their impact, his space its precision but not its depth. The psychological effect of the ruined masterpiece still brings the observer to silence.

In the Last Supper Leonardo has taken a step as definitive as that taken by Donatello eighty years before in the St. George and the Dragon relief (see fig. 166), but in a totally different direction. He has broken, in fact, with the Quattrocento tradition culminating in the illusionistic systems of Mantegna and Melozzo, which decreed that represented space must be an inward extension of the room in which the spectator stands. Although Leonardo's perspective is consistent, there is no place in the refectory of Santa Maria delle Grazie where the spectator can stand to make the picture "come right." Never can the represented walls of the upper chamber in Jerusalem be seen as continuations of the real walls of the refectory on the other side of the picture plane. The Albertian role of the picture as a vertical intersection through the visual pyramid has been abandoned. The painting is now a projection on an ideal plane of experience in which lower realities are subdued and synthesized. This is a perfect perspective, which could be seen by no pair of human eyes, and within it are set forth larger-than-life human beings who exist and act and move on a grander plane than we. Ideal volumes inhabit ideal space to expound an idea. The joy of the Quattrocento in visual reality and vivid anecdote has been replaced by a wholly different satisfaction, that to be obtained from imagined grandeur and noble concepts. We are now truly in the High Renaissance, whose basic idea is Leonardo's single-handed

creation, to be adopted later by Michelangelo and Fra Bartolommeo, Raphael and Andrea del Sarto.

It is noteworthy that this new and grander vision of ideal reality came into the artist's mind at just the moment when the reality of the Italian political situation was tacitly and universally recognized as hopeless. After the French invasion of Italy and the Battle of the Taro in 1495, it was painfully clear that no matter who may have claimed victory in that disastrous encounter, divided Italy was and would remain impotent in the face of the unified monarchies of Western Europe. Despite the appeals of Machiavelli and others, it was only a matter of time before the Italian states, with the exception of the Genoese and Venetian republics, would be overwhelmed by the forces of foreign tyranny, by whose courtesy, once the struggles had subsided, Florence and the Papacy could maintain a shadowy independence. The High Renaissance in both Florence and Rome has to be understood as an extension into an ideal plane of those images of human grandeur and power that the Italians knew were in real life doomed. It is a valiant but despairing effort, and there is always something dreamlike about even its noblest productions, as compared with the more pedestrian solidity of the early Quattrocento images.

Save for a five-year stay in Milan from 1508 to 1513, Leonardo was never again to spend more than two or three years, sometimes only a few months, in the same city. We have records of his returning to Florence and visiting Rome repeatedly, staying in Venice and in Parma, and traveling about with the army of Cesare Borgia. From this discreditable association date many of the

master's most daring engineering and cartographic exploits.

In 1501 Fra Pietro da Novellara, acting as agent of Isabella d'Este, wrote from Florence to the marchioness that Leonardo had made a wonderful cartoon

depicting a Christ Child about one year old who, almost slipping from his mother's arms, grasps a lamb and seems to hug it. The mother, half rising from the lap of St. Anne, takes the Child as though to separate him from the lamb, which signifies the Passion. St. Anne, also appearing to rise from a sitting position, seems to wish to keep her daughter from separating the Child and the lamb, and perhaps is intended to represent the Church, which does not wish the Passion of Christ to be impeded. And these figures are life-sized, but they are in a small cartoon, because they are all either seated, or bending over, and one is placed in front of another, moving toward the left, and this study is not yet finished.

The cartoon was exhibited at the monastery of the Santissima Annunziata, for whose church, with its rotunda by Michelozzo from Alberti's designs, masterpieces by Castagno, Baldovinetti, and Pollaiuolo had been painted in the course of the fifteenth century. As has been shown by Carlo Pedretti and analyzed in a recent study by the author, the cartoon was designed for a picture to be placed on the high altar of the church, in a huge carved and gilded structure long since dismantled. The cartoon has also been lost, but its composition is known from a surviving sketch, and corresponds to Fra Pietro's description, moving to the left. It excited great admiration and wonder, and influenced the Florentine artists immediately and profoundly, especially Fra Bartolommeo, the young Michelangelo, and the still-younger Raphael, for those very qualities that Fra Pietro sets forth—the compression and overlapping of figures that enabled the artist to pack three life-sized human beings into a small cartoon. But the general public also thronged to see it, probably because in April 1501 they implored the intervention of St. Anne, traditionally a great protector of the Florentine Republic, at a moment of mortal danger from the armies of Cesare Borgia. At least thirty-three reflections of Leonardo's composition survive, almost all devotional images for private patrons, indicating a strong desire for the composition in this very context.

The Madonna and St. Anne (colorplate 68), deriving from the lost cartoon, painted for a still-unknown purpose, was imitated by Raphael in 1507, but the background landscape surely dates from much later, probably from the artist's stay in Milan between 1508 and 1513. It was one of three paintings—the others were the Mona Lisa and the St. John the Baptist (not illustrated)—that Leonardo took to France and kept with him till his death. If the Last Supper is the first High Renaissance wall painting, then the Madonna and St. Anne is the first example of the application of the new principles of scale and compression to panel painting. In the Last Supper the four figural groups are the product of the emotions and actions of the moment; in the Madonna and St. Anne the figures that make up a single group are now actually intertwined, and the tendency toward a living pyramid that began with Pollaiuolo's St. Sebastian (see colorplate 43) has reached its climax. It is no accident that the composition produced by the interaction of its component figures is an essential of classic art; although Leonardo could not have known this, the same principle can be seen exemplified in the pedimental sculptures of the Parthenon, as compared with the mere alignments of earlier Greek pediments. For Leonardo the activating principle of his classic composition and the origin of form itself is motion, which in his writings appears to be at the heart and core of his universe.

The barren appearance of certain portions, notably the face of the Virgin, is due to past overcleaning. We miss not only the expected veils of highlights and soft shadows but also the eyebrows and eyelashes, which have been rubbed off, and here and there the underdrawing shows through the surface of the cheeks and the neck (fig. 462). The Virgin's blue mantle has apparently lost some of its quality, but in the rest of the drapery and in the sweetly sad face of St. Anne, as well as in the foreground with its rocky layers and rounded pebbles, Leonardo's surface is very nearly intact, palpable where he wished it to be so through his mysterious sfumato. Throughout the painting the enameled brilliance of late Quattrocento coloring—Ghirlandaio's, for example has been replaced by a subdued resonance reflecting the sobriety of the new era.

The figural pyramid divides the incomparable mountain landscape: not a poetic landscape portrait like those of Bellini, evoking the precise mood of a time and place—any more than Leonardo's perspective can be related to a specific moment of vision—but a composite of observations and memories collected in his Alpine wanderings. The fantastic spires recall most vividly the Dolomites above Belluno, then in Venetian territory, accurately enough in fact to make the rocky pinnacles of Leonardo's earlier backgrounds seem mere inventions. Escarpments, ramparts, crags, lakes, rivers, cascades recede and blend into the distance, lost, recovered, and lost again behind gossamer blue until neither observation nor imagination can any longer distinguish solids in the pearly shimmer. Through this vast landscape and its watery and atmospheric envelope runs an unaccountable movement, a universal upheaval, as if the elements harmoniously balanced in the foreground figures were now in conflict with each other, as doubtless in Leonardo's imagination they were—the conflict between rock and water, solidity and motion that can result only in final chaos and dissolution. One striking element, in-

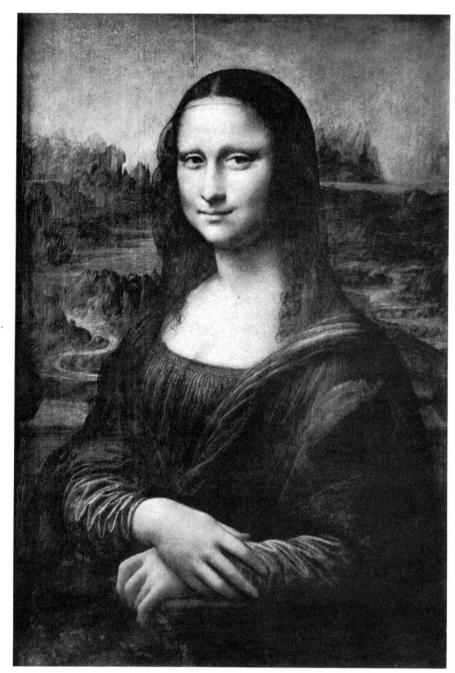

463. LEONARDO DA VINCI. *Mona Lisa*. 1503. Panel, 301/4×21". The Louvre, Paris

deed the largest in the entire landscape, is the tree rising in the middle distance at the right, recalling the similarly placed tree in the *Adoration of the Magi* (see fig. 455), and possibly bearing a similar significance of the Cross, situated as it is directly above the lamb of the Passion. Its apparent height exceeds that of the loftiest ranges and its calm contrasts with their turmoil.

According to Vasari, Leonardo worked for three full years on the portrait of Lisa di Antonio Maria Gherardini (wife of the prominent Florentine citizen Francesco del Giocondo), then (1503) twenty-four years old. The painting, universally known as the *Mona Lisa* (fig. 463), was done, therefore, between the cartoon and the final picture of the *Madonna and St. Anne*, and like that masterpiece was kept by the artist and taken by him to

France. These factors, plus the presence of an imaginary mountain landscape divided by a woman's head in both, require us to consider the two paintings together. In the *Mona Lisa*, in fact, Leonardo treated the single figure much as he had the intertwined group in the *Madonna and St. Anne*. The rare, earlier full-face or three-quarter Italian portraits, such as Botticelli's *Young Man with a Medal* (see fig. 350) and Perugino's *Francesco delle Opere* (see fig. 380), concentrate on the head and shoulders, cutting the body at mid-chest, and raise the hands so they may be visible within the frame. Leonardo continues the composition well below the waist, so that both arms appear complete, bent at the elbow. The left forearm lies along the arm of a chair running almost parallel to the picture plane, the right hand falls across it, the

fingers sloping down. Both hands are utterly relaxed, completing in their unity the gentle spiral turn of the torso and the head. Not just a bust, but the whole woman sits there, majestic as in a full-length portrait. This was a wholly new format and was followed almost without exception in Italian portraiture—and indeed Northern European as well-from that moment through the nineteenth century. The result, Leonardo's invention, is that the subject looks larger and grander than in Quattrocento portraits, in keeping with the new dignity demanded of the High Renaissance ideal of human appearance.

The calm hint of a smile, about which so much has been written, and the complete composure of the idle hands were characteristic for a generation whose standards are summed up in the untranslatable word sprezzatura, from disprezzo (disdain), one of the norms of aristocratic behavior that Baldassare Castiglione attempted to establish in his book of dialogues called Il libro del cortegiano (The Book of the Courtier). Castiglione did not mean disdain for others, of course, but the serene unconcern about economic realities or financial display that often denotes the inheritors of wealth and

But there is obviously a deeper and more personal level of content in this work that has evoked such a flood of literature in the last century, and whether or not Freud was correct in all details of his interpretation of Leonardo's character, there is abundant evidence to suggest that his feelings toward women were ambivalent. Not particularly good-looking even by the standards of her time (compare her with the loveliness of the model who posed for the angel in the Madonna of the Rocks; see fig. 457), this remote and self-possessed individual could scarcely have exercised a romantic attraction over the artist, even if her husband did permit a visible three-year tribute. Moreover, her personality cannot be dissociated from the surrounding landscape, with which it must have seemed even more intimately connected when the columns at either side (only the bases are still visible) were intact. As it is, motif after motif is continuous in figure and landscape. The locks of hair falling over the subject's right shoulder blend with rocky outcroppings through which a road winds; the translucent folds of the linen scarf over the left shoulder are continued in the line of a distant bridge. As one watches, this wife of a Florentine burgher assumes chameleonlike roles always more poetic and more threatening.

But what a nature she dominates! It is the same world of roads, rocks, mists, and meres that constitutes Leonardo's backgrounds from the Baptism of Christ on (see fig. 332), devoid of humans or animals, habitations, farms, fields, or even trees, but now provided with Dolomitic crags like those in the Madonna and St. Anne. The only works of man to be seen are the roads and the bridge, and they lead only to futility—indistinguishable waters and unscalable rocks. As the levels rise into evermore-inaccessible fastnesses from left to right, one is tempted to ask whether this is not what "woman" meant to Leonardo in his fifties. Most subtle of all is the placing of the highest level of mist in such a position that it accentuates the expression of the slightly narrowed eyes. The hands and garments still retain their musical veil of shadowy atmosphere; the face, alas, has been stripped by overcleaning to the greenish levels of the underpaint.

In 1503 Leonardo was given by the Florentine Republic under Piero Soderini the commission for what might have been the greatest of all his mural paintings if it had ever been brought to completion, the Battle of Anghiari for the Palazzo Vecchio. Although the picture is totally lost, and although only the central section of the vast composition can be reconstructed with any degree of certainty, a consideration of the painting is not just a matter of historical record. During the brief period when the unfinished work was in existence and sections of the cartoon survived, both were seen by thousands and exerted a fundamental change on the whole idea of battle painting, an influence that lasted through the Late Renaissance and the Baroque up until the heroic machines of the Napoleonic painters and even the battle compositions of Delacroix. Leonardo's picture was intended to commemorate the victory of the Florentine forces in 1440 against those of the Milanese duke Filippo Maria Visconti, who was abetted by the treachery of Rinaldo degli Albizzi and other Florentine exiles. In the days when the Republic still had to contend with the invading forces of Cesare Borgia, it is understandable that the government would wish to revive visually this triumph over an ancient enemy for the walls of the Sala del Cinquecento (Hall of the Five Hundred), newly added to the rear of the Palazzo Vecchio by Simone del Pollaiuolo, called Il Cronaca, to accommodate the Council of the Republic. Apparently, Leonardo painted only the central section of his composition; for the rest, perhaps divided by windows, we have only his vivid sketches. The painting was executed in another of Leonardo's ill-fated experimental techniques that rapidly came to grief. The picture was abandoned by the artist in 1506, and its ruins were eventually cleared away in 1557 by Vasari to make way for his new (and generally boring) series of murals intended to glorify the Medici principate under Grand Duke Cosimo I, the very opposite of the original purpose of the room and its decorations. (Efforts to find traces of Leonardo's painting under Vasari's frescoes have recently been under way, but the results are inconclusive and likely to remain so until the overlying fresco by Vasari can be removed.)

These decorations were also to include, apparently on the other half of the same wall, but perhaps on the opposite side of the room, the Battle of Cascina by Michelangelo (see fig. 479), and briefly at least, in 1504-5, the two giants of the High Renaissance worked for, if not in,

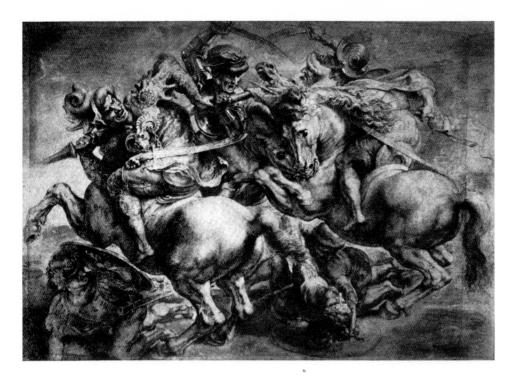

left: 464.
LEONARDO DA VINCI.
Battle of Anghiari.
1503–6 (destroyed).
Copy of central
section by PETER
PAUL RUBENS (c. 1615).
Pen and ink and
chalk, 17¾×25¼″.
The Louvre, Paris

below: 465.

LEONARDO DA VINCI.

Two Sheets of Battle

Studies. c. 1503. Pen
and ink, each c. 6×6".

Accademia, Venice

the same room. Our best idea of the original appearance and effect of Leonardo's lost painting is furnished by a drawing from the hand of another genius, Peter Paul Rubens (fig. 464), who saw only inferior copies of the original painting that perished before he was born, yet who was able to re-create something of its furious dynamism through the power of his own imagination. The central scene depicted the contest of four horsemen for the possession of the standard of the Republic. Among Leonardo's claims for the superiority of painting over poetry was the immediacy with which the painter could represent the smoke rising from the battlefield, the dust of the ground mingled with blood and turning into a red mud under the hooves of the horses, the faces of the victors distorted by rage and exultation and those of the vanquished by pain and despair—a far cry from the stately compositions of the Quattrocento. But he says nothing regarding his means for achieving the plane of cosmic struggle to which he has elevated the single incident of this battle for the standard. For he has converted the four horses and their riders, whose ancestors we have already seen in the background of the Adoration of the Magi (see fig. 455) and in the rearing horseman of the Sforza monument (see fig. 459), into a tornado of intertwined figures. The High Renaissance figural composition, attained by the interaction of the forces of its component figures in the *Madonna* and *St. Anne* (see colorplate 68), reaches in this scene an intensity so great that we are torn between the fascination of watching the beautiful interplay of rhythmic elements—the streaming manes and tails, for example—and the urge to turn in fear from the snarling ferocity of the horses, who almost outdo their riders in hatred. Their hooves interlock, they fight with their teeth, as the riders' swords clash in midair, and the whole quadruple contrivance of horses and riders

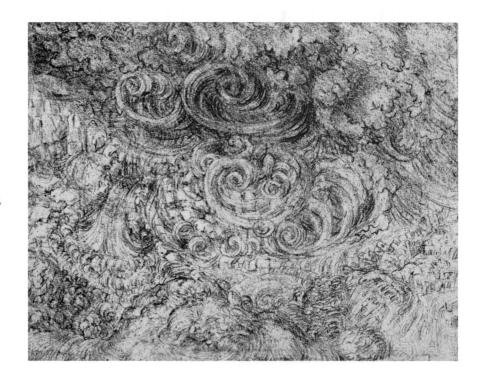

466. Leonardo da Vinci. Deluge. c. 1514–19. Black chalk, $6\frac{1}{4} \times 8\frac{1}{4}$ ". Royal Library, Windsor

crushes other fallen warriors below it. Still more encounters must have filled the remaining spaces, as they cover many sheets of Leonardo's sketchbooks (fig. 465), but their precise arrangement has eluded art historians despite a rich literature of controversy. The battlefield was the flat plain between Anghiari and Sansepolcro, which is dominated by the kind of hills that appear in the pictures of Piero della Francesca (see colorplates 38, 39).

To the consternation of his contemporaries and to the infinite regret of posterity, Leonardo painted little or not at all during the last ten years of his life. He returned to Milan in 1506, where he was occupied for a while in the design of another never-executed equestrian monument, for Giangiacomo Trivulzio, marshal of the Italian armies of King Louis XII of France, and accepted the appointment as Peintre et ingénieur ordinaire to the king, which apparently involved little work and gave the artist a handsome stipend. Except for a brief sojourn in Florence in 1508, he remained in Milan, largely occupied with his scientific, especially anatomical, studies until 1513, when he went to Rome at the invitation of Pope Leo X. The entire tempestuous Roman phase of the High Renaissance had largely passed by, with the completion of the Sistine Ceiling by Michelangelo and the first two of the Vatican Stanze by Raphael. Leonardo must have seemed like an apparition from another era. He had a suite of rooms placed at his disposal in the Vatican Belvedere, where he continued with his studies and inventions, which are said to have included a pair of lizardskin wings mounted on golden wires and attached to a tiny corset around the waist of a live lizard, which could thus march about like a little dragon, displaying its wings in the sunlight. The grandiosity of Michelangelo, then working in seclusion on the statues for the second version of the Tomb of Julius II, can have held little appeal for Leonardo, nor is there any record that Leo X, with all the artistic activity then going on in the so-called Golden Age of the High Renaissance, ever thought of entrusting him with actual commissions.

The old man's peripatetic existence between Florence, Rome, and Milan continued until 1517, when he accepted the invitation of King Francis I of France to spend his remaining years at the little château of Cloux, near Amboise, where his only duty was to talk to the king. According to accounts by contemporary witnesses, his conversation was charming, radiating his immense learning and imagination. But his artistic activity? Among the few evidences generally attributed to these last years are drawings of water (fig. 466), whose limitless powers Leonardo had spent much of his life studying, utilizing, canalizing, taming; now the waters are unchained, descending upon the earth to destroy all the works of man. Leonardo claimed that water was more dreadful than fire, which dies when it consumes that which feeds it, while a river in flood continues its destructive course until it rests at last in the sea.

But in what terms am I to describe the abominable and awful evils against which no human resource avails? Which lay waste the high mountains with their swelling and exalted waves, cast down the strongest banks, tear up the deep-rooted trees, and with ravening waves laden with mud from crossing the ploughed fields carry with them the unendurable labors of the wretched tillers of the soil....

How familiar these words must sound to the survivors of the Italian flood disasters of recent years! But in the mind of the old man who for several years had been unable to create, destruction itself was raised to a positive value, and the force of water in these final drawings, engulfing barely visible human constructions, assumes beautiful and terrible spiral shapes, as prophetic of the abstract art of the twentieth century as were Leonardo's inventions of much of modern science. Mourn as we will all that he did not create, all the time spent on inventions that no one used and on the discovery of scientific principles that had only to be rediscovered centuries later, we can at least console ourselves with the brief bursts of light that the drawings give us from one of the greatest imaginations known to history, and with the few faded and damaged paintings, still of matchless beauty.

MICHELANGELO TO 1505

In the Florence that Leonardo abandoned for Milan in the early 1480s another genius of astonishing precocity and longevity, Michelangelo Buonarroti (1475-1564), was, as he put it himself, drinking in the love of stonecutters' tools with his wet-nurse's milk. By the time Leonardo returned in 1500, the young sculptor was a formidable competitor to him in the art of painting as well, perhaps more directly predestined by his fierce loyalty to the Florentine Republic to act as its new chief protagonist in the production of a new kind of heroic imagery that would figure forth the Republic's repeated challenge to remorseless history. Michelangelo, rather than Leonardo, was the dominant personality of the Florentine and later the Roman versions of the High Renaissance. In fact, he dominated the entire sixteenth century to such a degree that it was impossible for other artists to escape his influence completely. One could accept him (and succumb) or rebel against him, but not ignore him. In every conceivable way Michelangelo's character and stylistic credo place him in profound opposition to Leonardo. Where Leonardo was skeptical, Michelangelo believed; where Leonardo was apolitical, Michelangelo was, above all, a Florentine; where Leonardo looked on the world and man with superior detachment, Michelangelo was obsessed by guilt; where Leonardo was intellectually and physically charming but cared little for those he attracted, Michelangelo was spare, taciturn, and irascible, yet consumed with a deep love for others, which only in his old age was requited by the adoring reverence of his pupils; where Leonardo was endlessly absorbed in the mysteries of external nature, of which the human being was only a single facet, Michelangelo scorned landscape, which appears in his art only occasionally as a fragment of hardly more than Trecentesque bleak rock or blasted tree; where Leonardo considered the eye the window through which the soul was enabled to assess precisely the nature of the physical world, Michelangelo in his writings either extolled the eye's spheroid beauty moving inside the head, or shrank from the shattering emotional effect of the spiritual radiance from eyes he loved too well. Throughout the seventy-five years of Michelangelo's known artistic production he was interested in one subject and in one only—the life of the human soul as expressed in the beautiful structure and movements of the human body, which he often called the "mortal veil" of divine intention.

Michelangelo was born in a wild and barren region of the Apennines, in the tiny village of Caprese, clinging to the ruins of a medieval castle. His father, an impoverished but pretentious gentleman named Lodovico di Simone Buonarroti, was podestà (governor) of Caprese, a Florentine outpost above the Tiber Valley. Before the child was quite a month old, Lodovico's one-year term came to an end, and the family returned to Florence, but even in his old age the artist attached special importance to having seen the light of day in the rarefied air of this world of stone. He was set to nurse on a small family property at Settignano, home of Desiderio and the whole Rossellino family and, indeed, a village of stonecutters. His remark about the origin of his love of stonecutters' tools can scarcely be ignored in the light of his fondness for representing in drawings and in sculpture the relatively uncommon theme of the Virgin nursing her Child.

In 1549, when the artist was already old, he was subjected to a questionnaire circulated among the greatest artists of the day by the humanist and historian Benedetto Varchi, regarding the relative merits of painting and sculpture. We already know what Leonardo's answer would have been, had he been still alive. Michelangelo's celebrated reply stated that "the nearer painting approaches sculpture the better it is, and that sculpture is worse the nearer it approaches painting. Therefore it has always seemed to me that sculpture was a lantern to painting and that the difference between them is that between the sun and the moon." By sculpture Michelangelo explained that he meant that which is produced "by force of taking away [i.e., by carving off]; sculpture that is done by adding on [i.e., by putting on pieces of clay one after another] resembles painting." He thus placed himself in firm opposition to such sculptors as Ghiberti and Donatello, who based their works, whether in bronze or marble, on preliminary studies in clay or wax, exploiting optical and pictorial effects. (His theoretical opposition did not prevent him from making preliminary sketches and even finished models for his marble sculptures out of clay, wax, and other soft materials.) Vasari, who worked for a while as a sculptural assistant to Michelangelo, utilized what is probably the great artist's metaphor when he compared the process of carving a statue from a block of marble to that of lowering the water from the figure in a bath. For the sculptor drew the contours on the faces of the block, especially the front, and then pursued the profiles inward until the process of removal of the stone liberated the indwelling figure. This procedure, in one of his poems, Michelangelo compared to that of the Creator himself in liberating man from

The boy's intense desire to become an artist was, as so

often in the lives of later masters, thwarted by his family, especially his father and uncle. The brothers fancied themselves, as Michelangelo was later to do, as descendants of the counts of Canossa and therefore above mechanical labors. Eventually, they yielded and placed the lad in Domenico del Ghirlandaio's studio in 1488, at the age of thirteen. He must have been remarkably skillful already, for he drew an annual salary, instead of having his father pay for his indenture, as was the custom with young apprentices. He could have found no better teacher in the Florence of his day from whom to absorb the traditions and the techniques of the Quattrocento, if in somewhat dehydrated form. In many a passage in the Sistine Ceiling one still feels the solidity of Ghirlandaio's form and spatial structure, and even fifty years after his apprenticeship, when occupied with the Last Judgment, Michelangelo was still contemptuous of the newfangled methods of painting in oil, preferring the ancient Tuscan fresco technique. In none of his paintings does he accept the shadows and atmosphere of Leonardo, for example, but always insists, where the subject permits, on the clarity and brilliance of the Florentine tradition. He may very well have taken part in the execution of Ghirlandaio's great fresco cycle in the chancel of Santa Maria Novella (see figs. 363, 364), although any attempt to identify figures by the thirteen-year-old painter seems doomed to futility. He did not serve out his three-year contract because after barely a year an opportunity opened that foreshadowed his eventual emergence in the forefront of the highest European political and intellectual life. He was invited into the house of Lorenzo the Magnificent, stayed in the Palazzo Medici on the Via Larga (see fig. 146), and worked in a kind of free art school about which we could wish we knew more. It was held in the now-vanished Medici gardens, farther up the same street, opposite the Church of San Marco. There he was able to study works of ancient art, especially marble sculpture, as well as the more precious cameos and medals and Renaissance paintings preserved in the palace. He was under the tutelage of Bertoldo di Giovanni, a not overly gifted sculptor who had been an assistant of Donatello's in the master's old age. Thus the youth could absorb much of Donatello's doctrine at second hand. In his expeditions to Santa Croce and the Carmine, he drew from the frescoes of Giotto and Masaccio (see Chapters 3, 8). It was in the Brancacci Chapel, in fact, that Michelangelo's bitter comment on the ineptitude of a drawing by the young sculptor Pietro Torrigiani earned him the blow that broke his nose and disfigured him for life.

At Lorenzo's table whoever arrived first sat closest to the Magnifico, and Michelangelo sometimes found himself sitting above Piero the Unlucky, Lorenzo's eldest son and eventual successor; Giuliano, later to be ruler of Florence; and Giovanni, later Pope Leo X. It was a heady atmosphere of political power and intellectual performance, for although Michelangelo in all probability never

467. MICHELANGELO. *Madonna of the Stairs*. 1489–92. Marble, 21¾ × 15¾". Casa Buonarroti, Florence

learned more than a few phrases of Latin, he did come in contact with the Neoplatonists in Lorenzo's circle. Much—in the opinion of the present writer far too much—has been made out of these youthful influences, which it took the determined Neoplatonist Varchi to discover in Michelangelo's poetry and which none of his contemporaries ever saw in his art.

Probably from these years, and therefore before Michelangelo was eighteen, dates what is generally accepted as the artist's earliest extant work, the small marble relief known as the Madonna of the Stairs (fig. 467), done in a style that Michelangelo never utilized again and that is deeply influenced by the rilievo schiacciato of Donatello (see fig. 166), as well as, possibly, by some ancient relief or even cameo then in the Medici collections. The classic dignity and harmony of the profile pose remind us, in all likelihood fortuitously, of Greek fifth-century grave steles. For the first and only time in the work of Michelangelo, we are not exactly sure what forms exist under the shimmering drapery that covers the Virgin's limbs (it was later said of him that his figures were nude even when clothed), and there are certain other visible witnesses of youth and immaturity. But the back and right arm of the Christ Child are extraordinary, already surpassing the greatest sculpture of the Early Renais-

left: 468.
MICHELANGELO.
Battle of Lapiths
and Centaurs. c. 1492.
Marble, 33¼×35½".
Casa Buonarroti,
Florence

below: 469. Lapiths and Centaurs, detail of fig. 468

opposite: 470.
MICHELANGELO.
Crucifix. 1492.
Painted wood,
height 53".
Sto. Spirito,
Florence

sance in fullness of muscular power. This same back was reused many years later in the Day of the Medici Chapel (see fig. 573). It will be noted that in this very first work the boy has shown the nursing Madonna, which will also reappear in grander dimensions in the Medici Madonna (see fig. 571). The mood of sadness that pervades the relief is probably due to Michelangelo's not unusual attempt to suggest at the moment of Christ's infancy his Passion and death. The stairs—derived perhaps from Ghirlandaio's Birth of the Virgin (see fig. 363)—probably indicate Mary's role as Stairway to Heaven, as Howard Hibbard has shown (see Bibliography). The child figures, who are probably angels—wingless as almost always in Michelangelo's work—are engaged in spreading what seems less like a cloth of honor than a shroud. These background figures are unfinished, having yet to receive the final polish, while their heads are scarcely more than blocks. Already in the great sculptor's adolescence is manifest the strange artistic paralysis that prevented him from finishing to the last detail all but a handful of his sculptural works and even some of his paintings.

Another splendid relief dating from the Medici period is the *Battle of Lapiths and Centaurs* (fig. 468), whose extreme violence contrasts sharply with the elegiac sweetness of the *Madonna of the Stairs*. Both strains coex-

isted in Michelangelo's complex and conflicting nature, and the dichotomy between them may be witnessed again and again, often within one and the same work. The Battle of Lapiths and Centaurs was described in many a gory page of Ovid, and there have been fruitless attempts to identify the various figures and even to question the subject entirely. What is more to the point is that Ovid's detailed account of the mutual mayhem between the centaurs (who descended upon a Lapith wedding feast in an attempt to carry off the women) and the enraged defenders has been reduced by the sculptor to symbolic and aesthetic terms. No blow ever connects with its intended victim, no stone actually strikes a human head, no club disfigures a human body. Occasionally, in this vibrant interlace of struggling figures, two actually wrestle, but this is as far as the artist will let himself go in depicting brutality (think of what Antonio del Pollaiuolo would have done with such a subject!). The struggle of human beings represents, as much as anything else, the struggle within the human spirit, the torment to which the artist's own writings bear such anguished witness. And if the Madonna of the Stairs is the direct ancestress of the sibyls of the Sistine Chapel and of the Medici Madonna, the tiny figures of the Battle of Lapiths and Centaurs are equally demonstrable progenitors of the herculean nudes who carry out a more sublime

warfare in the Battle of Cascina and the Last Judgment. The nudes are also, for the most part, unfinished, and some heads in fact are still so rough that they can hardly be distinguished from the rocks wielded by the centaurs (fig. 469). With his characteristic abhorrence of the monstrous-indeed of any violence done to the beautiful human body—Michelangelo has so subordinated the horse parts of the centaurs that they are difficult to make out even in the original. The Battle of Lapiths and Centaurs may fairly be characterized as the most advanced figural composition of its time (several years earlier than Leonardo's Last Supper) in Florence or anywhere else, putting to shame the relatively stiff arrangements of Pollaiuolo (see fig. 325). It is worth noting, however, that in Michelangelo the figural interlace does not, as in Pollaiuolo and as in Leonardo, add or multiply to construct a total geometrical shape, but only produces a tissue out of which no clear-cut form can be deduced. It is difficult to imagine any classical work among the statuary fragments, sarcophagi, and such relatively minor ancient objects available to him that this astonishing teenager had not already surpassed both in quality and in depth of feeling.

And then with the death of Lorenzo in 1492 it was all over, and the boy found himself back in the modest house of his father in the stone street following the curves of the old Roman arena, near Santa Croce. If the sources are to be believed, Lorenzo's son and successor, Piero the Unlucky, did call the boy back to the Palazzo Medici for a few months but had no more important work for him than a statue in snow. The recently rediscovered wooden Crucifix that Michelangelo made for the prior of Santo Spirito (fig. 470) was doubtless done at this time. It is a remarkable work, in a languorous style that contains more than an echo of Botticellian grace. The figure is absolutely nude, in keeping with the artist's reverence for the human body as the mortal veil of divine intention, never more completely manifest, of course, than in the Incarnation. Thus, to the scandal even of his contemporaries, Michelangelo repeatedly and consistently depicted Christ to be as gloriously nude as any mythological Greek hero. The sculpture, the only work in wood that we know by Michelangelo, contains many foreshadowings of his later statues on a grander scale, especially the Dying Slave (see fig. 532), while the curiously schematic face recalls some in the battle relief. Michelangelo is reported to have carved the Crucifix in requital for the prior's permission to dissect corpses in the Hospital of Santo Spirito. Although his anatomical studies certainly never reached the scientific level of those carried out later by Leonardo, this was by no means the end of Michelangelo's researches on the subject. A handful of dissection drawings probably by Michelangelo still survives.

The young man's brief visit to Venice in 1494 seems to have had little effect on either the guest or the host city,

but his stay during the winter of 1494–95 in Bologna, where he executed three statuettes to complete the tomb of St. Dominic, brought him in touch with the sculptural reliefs of Jacopo della Quercia (see figs. 178–180), which must have been a revelation of the expanded powers and dignity of the human body, whether heroically nude or enveloped by surging waves of drapery movement. Jacopo's influence on Michelangelo's style was immediate and profound, playing an important role in the formation of some of the grandest images on the Sistine Ceiling. Also, although its precise connection with specific works has never been successfully demonstrated,

471. MICHELANGELO. *Bacchus*. 1496–97. Marble, height 79½". Bargello, Florence

an important effect upon the young artist's mind must have been exerted by Savonarola, whose preaching influenced Botticelli so deeply. In his old age Michelangelo still read the works of the martyred preacher and still recalled the sound of his voice.

Although the Rome of 1496, dominated by the evil genius of the Borgia pope Alexander VI, can have afforded little spiritual inspiration for the twenty-one-year-old artist, it did provide his first contact with the great mass of Roman architecture, sculpture, and painting, whose influence upon his art was incalculable. The sensuality of the Bacchus (fig. 471), done in 1496-97 for a rich Roman named Jacopo Galli, a statue in whose forms Michelangelo explored the chords and cadences of human flesh in a manner unprecedented since antiquity, bears eloquent testimony to the extent to which pagan beauty fascinated the taut young Florentine. The completely nude god, his head wreathed by vine leaves and bunches of grapes, is shown visibly affected by his product, while the grapes he lets fall from his panther skin are caressed by a boy satyr. There may just possibly be a hint of Christian content in the statue in that Christ, like Bacchus, was a god of wine (the Eucharist), and the mystery of drunkenness was considered comparable to that of death and, in representations of the Drunkenness of Noah, was deliberately compared to the death of Christ. But it seems more probable that Michelangelo's image was entirely pagan. The flat face of the marble block, still maintained in part in the relief-like character of the carving of the satyr and the grapes, contrasts with the unusual fullness and richness of the bodily masses, which have, however, their counterpart in some of the nudes of the Sistine Ceiling.

In 1498 Michelangelo, then twenty-three, accepted a commission for what became one of his most famous works, the Pietà for St. Peter's (fig. 472), ordered by a French cardinal who did not survive to see the masterpiece completed. The sculptor made a special trip to Carrara, the first of many, to find marble of the highest quality for the group, which, according to the contract, was to be "the most beautiful work in marble which exists today in Rome." Few would dispute the accuracy of the young man's boast. (All traces of the mutilation by a deranged visitor with a hammer in 1972 have been delicately and carefully removed.) Today one must view the work against a Baroque background of multicolored marble, whose opulence would certainly have offended Michelangelo: also, it is raised to such a height that in order to see it at all from below it had to be tilted forward by means of a prop of cement inserted at the back. The group was certainly intended to be placed low enough so that one could look directly into the face of Mary. After the muscular violence of the Battle of Lapiths and Centaurs and the sensuous richness of the Bacchus, it may seem strange that Michelangelo should return to the Botticellian slenderness of the Crucifix, but these three

right: 472.
MICHELANGELO.
Pietà. 1498/99–1500.
Marble, height 68½".
St. Peter's, Vatican, Rome

below: 473. Head of Christ, detail of fig. 472

apparently contrasting veins—and other besides—coexisted within the imaginative life of an artist too spontaneous and original ever to be reduced to a single stylistic formula or to submit to a single category of taste. Never did he carry refinement and delicacy to a higher pitch than in the complex and spasmodic linear rhythms of the drapery or the exquisitely finished bony torso and wiry limbs of the Christ. Line in this work seems at crucial points to cut into the marble flesh, especially in the features of Christ and Mary, setting up a conflict between form and contour that was to persist for several years in Michelangelo's style. For example, the delicate curls of the moustache and beard of Christ (fig. 473) are actually incised into the surface of the marble as if the hairs were ingrown. No trace of pain remains in the dreamy face; the wounds are barely noticeable.

In Michelangelo's lifetime there was some pointless speculation about the discrepancy between Mary's ap-

parent age and her actual years (she should be about eighteen years older than her Son, who was thirty-three at the time of his death), but if anything the artist has made her look younger. Michelangelo answered with a perhaps deliberately mystifying remark to the effect that a pure virgin will retain the appearance of youth much longer than a married woman. Michelangelo's friend Giovanni Strozzi provided a commonsense solution when, many years later, he composed for the copy of the Pietà in Santo Spirito a quatrain of his own, based on the lines from Dante that had appeared on the steps of Botticelli's Enthroned Madonna with Saints (see fig. 351): "Virgin Mother, daughter of thy Son." Michelangelo represented not an incident but a timeless doctrine. The Virgin is shown according to Roman Catholic belief as the mortal vessel of Divine Grace, the body through which divinity took on man's flesh. The question of age is thus irrelevant. Any attempt to translate a painting or sculpture by Michelangelo into terms of literal reality arrives at absurdity, because throughout his life the artist

Vasari records that when the group was first exhibited in St. Peter's an astonished crowd of Lombards thought it was by a fellow countryman, whereupon Michelangelo stole into St. Peter's at night and carved his signature, the only genuine one that appears on any of his sculptures. In view of the artist's own remark about how he drew in the love of stonecutters' tools with his wet-nurse's milk, it is noteworthy that the place he chose for this unique signature was the strap that crosses, and presses so tightly against, the young mother's bosom. Neither to Michelangelo nor to the artists of his time would there have been the least suggestion of irreverence in such a fact, or any conflict between the universal and the personal levels of symbolism apparent in the group.

was interested in the inner meaning conveyed by his works, not in the literal illustration of anecdotes.

The only preserved panel picture Michelangelo painted entirely himself (and even this is incomplete here and there in the background) is the Doni Madonna (colorplate 69), so called because it was painted, probably in 1503, to celebrate the wedding of Angelo Doni, a prosperous weaver, to Maddalena Strozzi of the famous banking family. Both were immortalized a few years later in Raphael's classic portraits (see figs. 484, 485). Although the painting is a tondo, a form often associated with marriage in Renaissance art, the composition is indebted to Leonardo's lost cartoon for the Madonna and St. Anne (see page 455), which Michelangelo, with other Florentine artists, must have seen in 1501, when he had already returned to Florence from Rome and was at work on the David. The strained poses of the principal figures and the metallic color (the orange of Joseph's mantle clashes with Mary's rose tunic) have somewhat curtailed the popularity of the Doni Madonna. Recent cleaning has shown the color to be even brighter, leading the way to the astonishing color recently revealed in the Sistine

474. MICHELANGELO. Youths and Infant St. John the Baptist, detail of *Doni Madonna* (see colorplate 69). c. 1503. Panel. Uffizi Gallery. Florence

Ceiling. Nonetheless, the compressed grouping has the power of a spring tightly coiled within the circular frame, and this power is increased by the sharp and brilliant modeling of the sometimes angular, sometimes curving folds of the drapery masses and stabilized by the horizontal band of stone separating foreground and background. In the smoothly polished surfaces and brilliantly exact contours of the foreground figures, Michelangelo carved the muscular structure of the masses as if he were working with marble instead of pigment. The modeling of the nude youths in the background, however, is much softer (fig. 474); possibly Michelangelo began all the figures in this fluid style, only later bringing them to the obsessive finish seen in Mary and the Christ Child. Whatever their actual state—and certain portions are clearly unfinished—these nudes, direct ancestors of the celebrated nudes of the Sistine Ceiling, show an attitude toward pulsating human flesh as a continuous substance very different from the perfectly articulated and smoothly functioning human machines designed by Leonardo (see fig. 447).

The difficult meaning of the picture has provoked some farfetched and even absurd explanations. While, like so many of Michelangelo's abstruse visual symbols, the *Doni Madonna* may perpetually defy exact interpretation, certain elements are clear. Mary and Joseph appear to be presenting or giving the Child. The secret prayer

for the Octave of Epiphany, which appears as early as the Roman Missal of 1474, exhorts the Lord to look down in mercy on the gifts of his Church, by which we offer "that which is signified, immolated, and received by these gifts, Jesus Christ"; doni is the Italian for "gifts," dona the Latin. The curious dry font or tank on whose edge the nude youths sit or lean is a half moon, the symbol in the Strozzi arms, which appear in the original frame of the painting. It was customary for family names to appear pictographically. Pebbles (sassetti) are evident in some of Ghirlandaio's Sassetti Chapel frescoes, and we have seen the importance of such symbols in works designed for the Medici. Even more strongly visible are the symbols of the Della Rovere family in the Sistine Ceiling (see pages 496-97). The Epistle for the Fifth Sunday after Epiphany, also in the 1474 Missal and in its medieval sources, and significantly enough in the modern Mass of the Holy Family, is drawn from Colossians 3:12-17, and in the preceding chapter St. Paul characterizes the new moon as a "shadow of things to come, but the body is of Christ." The Epistle deals with Baptism as a death to the old life and a resurrection in Christ, and the infant Baptist appears in the font. (The first four sons of Angelo and Maddalena Doni, all of whom died shortly after birth, were named Giovanni Battista.) The Epistle adjures us to strip ourselves of "the old man with his deeds" and put on the new, and it lists two groups of five vices, each of which must be renounced. There are five nude youths (and five sculptured medallions in the frame Michelangelo designed for the picture). Five virtues are to be put on instead, "mercy, benignity, humility, modesty, patience." The five youths have partly or entirely removed their colored garments, and are stretching out white cloths. We are asked to forgive one another "if any have complaint against another," and the two youths at the left turn their attentions toward those at the right, as if to dissuade them from their quarrel.

Some symbols are traditional. A conspicuous flower rising against the stone enclosing the dry font recalls Isaiah's prophecy of the Virgin Birth, "for he shall grow up before him as a tender plant, and as a root out of a dry ground." The bay of water in the background, which we have seen in Filippino Lippi, Giovanni Bellini, and Leonardo, recalls Mary's title as "Port of the Shipwrecked." The strange pose of the Christ Child, treading the Virgin's arm between his foot and the knee of St. Joseph, may refer to the prophecy of the Virgin Birth in Lamentations, "The Lord hath trodden the virgin the daughter of Judah, as in a winepress." But the position of the Virgin, seated lower than her husband, in spite of Mary's exalted rank as Queen of Heaven, comes again from the Epistle to the Colossians (3:18), "Wives be subject to your husbands," and the total configuration comes from the Epistle for the Sunday in the Octave of the Epiphany, repeated as Communion today in the same Mass of the Holy Family (Luke 2:51), "Jesus descended with them ... and was subject to them." In all probability the picture was intended to celebrate the virtues of Christian marriage in terms associated with Angelo and Maddalena themselves, and to place their conjugal life under the protection of the Holy Family, although we should not exclude the possibility that the death of their first child is somehow alluded to. In this case the date of the painting may be later.

The *Doni Madonna* is inseparable from the *Bruges Madonna* (fig. 475), probably carved at about the same time and sold in 1506 to a Flemish wool merchant in Florence, who took it to the Church of Onze Lieve Vrouwe in Bruges. The Child, whose gravity and beauty shine so

475. MICHELANGELO. *Bruges Madonna*. 1503–4. Marble, height 48". Church of Onze Lieve Vrouwe, Bruges

476. MICHELANGELO. *Taddei Madonna*. c. 1500–2. Marble, diameter 43". Royal Academy of Fine Arts, London

unexpectedly from his chubby features, must have been done from the same model used for the Doni Child. Although the group today looks small against the elaborate later sixteenth-century background of black-and-white marble, the figures are life-sized. The Virgin is seated upon rocks, with one knee slightly elevated, like that of Joseph in the *Doni Madonna*. Between her knees the Child, still holding her hand, ventures forth with one foot. The head of the pensive Virgin, derived from that of Mary in the *Pietà*, is much more ample in proportion, with a new emphasis on the breadth of the forehead and the soft fullness of the eyebrows. The Virgin's arms emerge from slits in her mantle, and were badly chipped when the statue was moved to Paris by Napoleon's troops.

As compared with the *Pietà*, the group is far more compact, and both drapery and anatomical forms are simpler and grander, the masses already foretelling some of the majesty of the Sistine Ceiling. For the most part, the statue is lovingly finished, although there are tiny passages at the back that never received their final polish. Only occasionally in Michelangelo's mature work will we reencounter the haunting magic of the Virgin's countenance or the sense of deep and sad repose in every line and surface of this tranquil group.

In sharp contrast is the dynamism of the *Taddei Madonna*, a tondo, also undated but probably contemporary, that Michelangelo blocked out for Francesco Taddei but never completed (fig. 476). The Christ Child is shown fleeing to the protection of his mother's arms from a bird held out to him by the infant St. John, under

which apparently playful imagery is concealed a deeper meaning. The bird is a persistent symbol of the human soul, and the Baptist, whose baptismal bowl is clearly visible, is really relinquishing to Christ his responsibility for the cleansing of the soul from sin—a responsibility that can be discharged, of course, only through Christ's Passion and death. A second level of meaning probably involves the protection of the Florentine Republic, in which Francesco held high office, and of which St. John is the patron saint. In the early Cinquecento, when the territorial integrity of the Republic was threatened at first by the armies of Cesare Borgia and later by the attempts of the Medici to return to power, images of the Virgin and Child with the Baptist in the open landscape are sufficiently numerous to form a special type (see pages 473-74). Once the Medici regained control of the Republic after 1512, the type to all intents and purposes died out. It was shown long ago that Michelangelo derived the pose of the Child from a Roman sarcophagus representing Medea about to slaughter her children in revenge for Jason's marriage. The parallel between the sacrificed children of the barbarian princess and the sacrifice of Christ would not have offended the Renaissance.

The unfinished portions of the Taddei Madonna show various stages of Michelangelo's procedure. The hair of the Baptist and portions of the hair of the Christ Child, like the whole of the background, are merely roughed out with the pointed cylindrical chisel. One can still observe the marks of the drill used to profile major elements. The Baptist has reached a much higher state of completion under the strokes of the coarse, two-toothed chisel, and the face of the Virgin and almost all of the Christ Child are finished in all essentials with the threetoothed chisel, by whose manipulation Michelangelo was able to achieve a breathing, pulsating surface of great attraction, not only to modern eyes but also to Vasari, who was voluble in his praise. All that is missing is the finishing with a file and the polishing with pumice and straw pads. The passionate grouping within the circle, a variant on the problem of the Doni Madonna, results in an extremely powerful composition, but despite the excitement of the unfinished surface it would be a mistake to suppose that Michelangelo consciously intended the work to look as it now does. It is hard to believe that the Taddei Madonna would have lost any of its fire if it had been carried to the same pitch of completion as the Pietà or the Bruges Madonna.

During the opening years of the Cinquecento, when Michelangelo was creating these and other works for public and private patrons, he was also carrying out a far greater responsibility, the colossal *David* in marble (fig. 477) for one of the buttresses of the Cathedral of Florence, the commission for which he accepted in 1501. The huge marble block had been in the open air outside the Cathedral since the 1460s, when it had been aban-

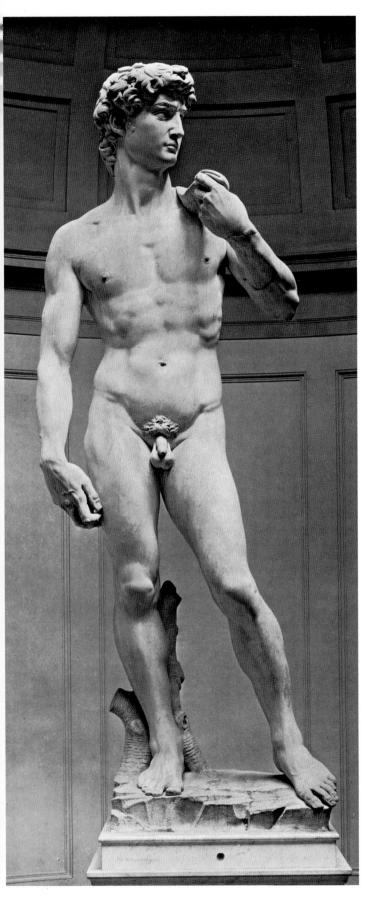

above: 477. MICHELANGELO. *David*. 1501–4. Marble, height 14'3". Accademia, Florence

above right: 478. Torso of David, detail of fig. 477

doned by the sculptor Agostino di Duccio. Agostino was really executing a model designed by the aged Donatello, and probably the latter's death caused the officials of the Opera del Duomo to lose interest in the project. Donatello's colossal *Joshua*, in terra-cotta painted to resemble stone, had long been in position on a neighboring buttress and survived there well into the seventeenth century, and Donatello and Brunelleschi had made a model for a *Hercules*.

Michelangelo proceeded on the basis of his own small model in stucco. Such was the magnificence of the David when Michelangelo completed it in 1504 that the Florentines were reluctant to have it placed so high and, as in the case of Donatello's marble David nearly a century earlier, the Republic took over. A commission was formed to decide where the statue should go, and it heard testimony from Filippino Lippi, Botticelli, Leonardo, Giuliano and Antonio da Sangallo, Piero di Cosimo, and other artists, as well as artisans and other citizens. Many of the opinions are recorded, very nearly verbatim. Leonardo wanted the colossus to be in the Loggia dei Lanzi, the great three-arched portico for public ceremonies, to the west of the Palazzo Vecchio. The Sangallo brothers insisted that it be kept out of the rain because the marble was soft and had suffered from exposure already. Piero di Cosimo suggested that the commission ask Michelangelo. There is no record that it ever did, and no one knows what his opinion would have been. But it is most unlikely that he would have favored a position in the Loggia dei Lanzi, which would have condemned the statue's beautiful back to permanent shadow, not to speak of dwarfing the colossus by contrast with the huge, open arches of the Loggia. In any case, the statue went where the herald (araldo) of the Republic wanted it to—in front of the principal entrance to the Palazzo Vecchio as a symbol of the valiant Republic, which had elected Piero Soderini gonfaloniere for life and was staking everything on the Republic's continued freedom from the Medici. It took four days to haul the statue on rollers from Michelangelo's studio to its final position, and one night it was attacked with stones by a band of youths, probably Medici supporters.

The political symbolism of the work, recognized by the officials of the Republic in 1504, had been present from the start in all the colossi planned for the Duomo, a building of the highest civic as well as religious importance (see page 144). The David differs from its many Florentine predecessors first of all in its total and triumphant nudity, in keeping with Michelangelo's views on the divinity of the human body, and second in its great muscularity. Oddly enough, the prudery of Soderini's Republic kept the statue hidden from public gaze for two months until a brass girdle with twenty-eight hammered copper leaves could be devised and hung about the young hero's waist!

Michelangelo's hero is a boy of perhaps sixteen, not fully grown, but with the powerful muscles of a child of the people, rather than an effete aristocrat like Verrocchio's David (see fig. 336). As usual with Michelangelo's statues, this one has suffered from anecdotal interpretations, which claim that the youth is gathering himself up for the onslaught, about to launch the stone, and so forth. The slingshot is carried in the left hand, true, and the strap does go over the right shoulder, but the sling is limp, the right hand carries the stone loosely, and there is little tension in David's arms or legs. Michelangelo's David, his first adventure in the new realm of the colossal, is intended as a symbol, not only of the Republic, but also of all humanity raised to a new power—a plane of superhuman grandeur and beauty that does not ignore, rather ennobles, the faults of the real human being and is therefore immediately accessible to us.

At the time of the third expulsion of the Medici from Florence, in 1527, a bench was thrown from the window of the Palazzo Vecchio, shattering the David's left arm and hand. The pieces were rescued by Vasari and Francesco Salviati, in their teens at the time, and kept until they could be reattached many years later. Just as the Sangallo brothers predicted, the soft marble of the statue eventually suffered further from exposure, and the finish on the top of the head and the upper surfaces of the shoulders is completely gone; in several other places it is badly damaged. In consequence, the statue was removed to the Accademia in the nineteenth century, where it now competes with the pseudo-Renaissance architecture but at least stands in a good light and is safe from further damage.

The proud youth's pose and the shallow dimensions of the block must both be understood in terms of the position that the statue was originally intended to occupy. The David was to have been placed on one of the pedestals with which each buttress of the Duomo ends. In this way the young hero would have looked outward defiantly over the city, seeming to emerge from the very forces of the architecture. The knotty muscles and heaving rib cage (fig. 478), the heavy projections of the hair, the sharp undercutting of the dilated eyes and frowning brow were intended to register from a distance. In the noble forms of the face especially, the conflict of mass and line, which we have seen as early as the Pietà, reaches a climax of intensity.

After the heroic scale of the David, nothing could be quite the same again. Perhaps it was not possible for either the artist or his patrons to descend from such altitudes to the realities of daily existence. In any case, shortly after the David was set in place, the sculptor received his first commission for a colossal work of painting, a fresco of the Battle of Cascina for the Palazzo Vecchio, to face the Battle of Anghiari, on the cartoon for which Leonardo had already been working for a year (see page 457). There is no evidence that Michelangelo objected or declared that painting was not his profession. The moment chosen for his subject may seem trivial—the Florentine soldiers, cooling off in the Arno, are called out by a sudden alarm and caught in the act of struggling into their clothes and armor. Yet, like its predecessor, the Battle of Lapiths and Centaurs (see fig. 468), the *Battle of Cascina* gave Michelangelo the opportunity to project on a plane of intense physical action the emotional stresses of his own existence, as well as to demonstrate his unchallenged mastery of the nude human body. Working in secret in the Hospital of Sant'Onofrio, he produced a composition on several levels, a marvelous web of interlocking figures, turning, twisting, crouching, climbing, tugging boots over wet legs, blowing trumpets, reaching to help comrades. The author has suggested that Michelangelo derived much of his knowledge of action figures climbing out of the water and pulling on clothes from a Florentine public bath, which Leonardo frequented every Saturday for the same purpose. According to Vasari, some were drawn with crosshatching, others with shading and lighted with white: "Thus seeing such divine figures some said that they had never seen such things by his hand or any other, so that to such divinity of art no other mind could ever attain."

Although Michelangelo probably commenced the actual painting of the huge fresco after his return to Florence from Bologna in 1506, neither the unfinished painting nor a scrap of the cartoon remains. The latter, during its brief existence, became something of an art school in its own right and was widely imitated by Flor-

479. MICHELANGELO. *Battle of Cascina*. 1504–6 (destroyed). Early 16th-century copy of central section, by Aristotile da Sangallo. Grisaille on panel, 30×52". Collection the Earl of Leicester, Holkham Hall. (Courtesy Courtauld Institute of Art, London)

entine masters of the High Renaissance and the Mannerist period as an example of how nude figures in action ought to be drawn. The best evidence we have for the original appearance of the cartoon is a splendid series of drawings by Michelangelo for most of the figures in the foreground, as well as for the battles of mounted warriors taking place in the background at either side. A copy (fig. 479), probably by Aristotile da Sangallo, shows only the central part of the composition, which must have been an awesome thing, bursting not only with a new vision of the powers of the human body but also with a new conception of the excitement of human destiny. Clearly Pope Julius II knew exactly what he was doing when he summoned this sculptor to paint the ceiling of the Sistine Chapel. It was inevitable from then on that an artist so superbly endowed would be called from Florence onto the wider stage on which the triumphs and the tragedies of Late Renaissance history were to be enacted. Michelangelo's mature work, then, belongs to the following chapter.

RAPHAEL IN PERUGIA AND FLORENCE

After Leonardo and Michelangelo, the third and youngest member of the great trio of High Renaissance masters, Raffaello Santi (or Sanzio; 1483–1520), known as Raphael, comes almost as an anticlimax. He was not an innovator, as were Leonardo and Michelangelo. His

work, at least until the last few years of his short life, is generally devoid of excitement. He seldom attempted to push his innumerable paintings to the same point of completeness—or incompleteness—as did his older contemporaries, and he often glossed over imperfect observation or handed grand ideas to more or less gifted pupils for execution. Yet in the imagination of four centuries, Raphael has stood as the perfect High Renaissance painter, probably because of his idealism. In his art, noble individuals move with more than natural dignity and grace through a calm, intelligible, and ordered world. His pictures mirror Renaissance aspirations for human conduct and Renaissance goals for the human mind. He developed an extraordinary method of synthesizing the movements of his figures and the ample spaces of his compositions into ideal structures, beautifully integrated and harmonized from the picture plane to the point of infinity. But Raphael's order is not merely intellectual or contrived. It springs from a spirituality that transcends many of our accepted notions of Renaissance worldliness. His very figures seem to be impelled by a mysterious energy coursing through them in smooth spirals, causing them to twist and turn gracefully to the oval and spherical forms Raphael preferred throughout his career. So easy is this motion, so harmonious the relations of the figures, that even at moments of high drama his pictures radiate a superhuman calm.

Raphael was born in Urbino and brought up in its extraordinary atmosphere of literary, philosophic, and artistic culture and cosmopolitan elegance. His father was Giovanni Santi, a mediocre painter and versifier on whose rhymed chronicle we depend for much of our information about the reputation of Quattrocento painters. Both father and son seem to have had access to the Montefeltro court and to the wonderful Palazzo Ducale (see colorplate 54). There, in spaces of the utmost harmony and beauty, the young Raphael could absorb influences from the art of Piero della Francesca, Botticelli, the Laurana brothers, Uccello, Melozzo da Forlì, the Spanish Alonso Berruguete, and the Netherlandish Justus of Ghent. From its windows and from the steep streets of the city lined with austerely simple brick houses, Raphael looked out over a magnificent mountain landscape stretching off to always farther horizons, filled with color and light.

When Raphael was only eleven, his father died. We are not certain at what age he went to Perugia to be apprenticed to Perugino, but according to Vasari he was brought to Perugino's studio by Giovanni Santi, who had

> 480. RAPHAEL. St. George and the Dragon. 1504-5. Panel, 111/8 × 81/2". National Gallery of Art. Washington, D.C. (Mellon Collection)

called the artistic dictator of Perugia "equal in age and endeavor" to Leonardo. It has been recently shown that from the age of sixteen the boy was already influencing other artists in the region. At any rate, Raphael absorbed with alarming facility both the virtues and the clichés of Perugino's style and rapidly became the outstanding member of a busy workshop containing many faithful executants. At the same time he picked up the atelier system, which, later on, during his maturity in Rome, was to help him keep abreast of a massive production schedule. Often it is nearly impossible to separate the style of Raphael from that of his master. The young artist's hand must have been at work in many of Perugino's major commissions. And even in the Marriage of the Virgin (colorplate 70), which Raphael proudly signed and dated in 1504, his debt is obvious; we think immediately of Perugino's Giving of the Keys to St. Peter (see colorplate 51). There is the same array of foreground figures, the same polygonal background temple, the same intervening piazza. Even the clear, simple colors of the painting—the cloudless blue sky, the strong, deep blues, roses, and yellows of the drapery, the sun-warmed tan of the stone, and the blue-green hills—derive from what has been called Perugino's stained-glass coloring.

A second glance will disclose how greatly the twentyone-year-old painter improved on his master. The unearthly serenity of this altarpiece, which is the crowning achievement of Raphael's earliest period, results from a truly High Renaissance integration of form and space. It was commissioned for an altar dedicated to the Virgin's ring in a church in Città di Castello, where Raphael painted several other pictures. According to the Golden Legend, the suitors for Mary, a virgin in the Temple, were to present rods to the High Priest, and Mary's hand was to be granted to him whose rod bloomed. The fortunate Joseph is shown with his flowering rod in one hand, while the other, bearing a ring, is joined to Mary's by the High Priest. On the left stand the other temple virgins, on the right the rejected suitors, one of whom breaks his rod over his knees. The figures, resilient with the grace of Raphael's early style, are woven into a closely knit unity inaccessible to Perugino's art. The perspective of the piazza originates with these figures, and its orthogonals culminate smoothly in the upward flow of the steps toward and into the Temple, while its vanishing point is set beyond the open doors of the structure. One looks directly, therefore, through the core of the building to the remote horizon, a curve of hills that embrace and, as it were, cradle the building, whose dome identifies itself with the apex of the arch represented by the frame. The same gentle motion that carries the Temple to the heights of heaven guides (through the agency of the High Priest) the hand of Joseph, as if the bridal of the earth and sky were being celebrated in the act of matrimony, as it is throughout the entire composition.

The architecture of the Temple undoubtedly reflects

the ideas of Raphael's fellow townsman, the much older Bramante, who two years earlier had been authorized to create the famed Tempietto of San Pietro in Montorio (see fig. 498), which, however, was not completed until after 1511, and of which this painted structure appears to be a precursor. One wonders what Bramante, or any other practicing architect, would have thought of the scrolls treated like metal springs in which Raphael's characteristic spirals discharge against the sky. Despite its radial character, reflecting the architectural ideas of Leonardo (see fig. 449) even more than those of Bramante, Raphael's design—a multifaceted building, each of whose sides is treated as a separate plane-still belongs to the Quattrocento. Its lofty shape also contains more than a hint of the Dome of the Rock (on the site of Solomon's Temple in Jerusalem and often identified with it by travelers), some knowledge of whose shape may very well have reached Raphael's inquiring mind.

In gratitude for the Order of the Garter conferred upon him by Henry VII of England, the duke of Urbino commissioned Raphael in 1504 to paint a little picture of England's patron, St. George, as a Knight of the Garter slaying the dragon (fig. 480). It was presented to the king by Raphael's friend Baldassare Castiglione, author of Il libro del cortegiano, whom the artist later immortalized in a splendid portrait (see fig. 545). The combat between St. George and the dragon had been represented by Raphael earlier in another small picture. But the National Gallery painting already betrays the influence of Florentine art, especially of Leonardo's Battle of Anghiari, to such a degree that it seems reasonable to suppose that the painter had in the interim visited the Tuscan metropolis. He must have also visited Rome, as the Torre della Milizia, a medieval structure still standing in the Imperial Fora, is clearly portrayed just above the muzzle of the horse. It is the most important dramatic work Raphael produced before his series of frescoes in the Vatican. The broad, curving rhythms of Raphael's forms are integrated in a new way. The warrior saint on his rearing white charger is crossed with the masses of the landscape in a great X-shape, so that the downward thrust of the lance discharges into the monster's breast all the gathered-up energies of the picture. From the painter's proud signature on the bridle to the watchspring curves of the horse's tail and the brilliant clarity of the foliage, every form has taken on a metallic tension, sureness, and precision. Yet the young artist has rendered with almost Netherlandish delicacy such luminous effects as the gleaming armor and the reflection of the princess in the

Probably at some time in 1505 Raphael decided to settle in Florence, where Perugino had spent so long a time and painted so many frescoes and altarpieces. He fell into an avid market. Appetites that had been excited by the unattainable Leonardo and Michelangelo could be satisfied rapidly by the facile Raphael. In three short

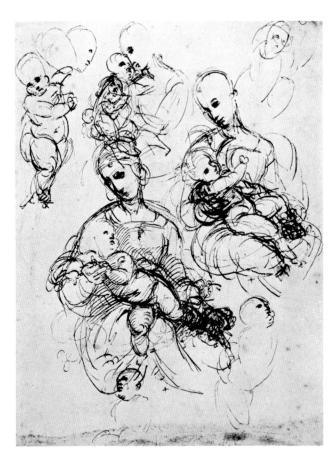

481. RAPHAEL. Studies of the Madonna and Child. c. 1505–8. Pen and ink, $10 \times 7 \frac{1}{4}$ ". British Museum, London

years, in addition to other major works, he painted no fewer than seventeen still-extant Madonnas and Holy Families for Florentine patrons. Unaffected by the conflicts and insoluble problems that tormented the great Florentine artists, the newcomer glided from one harmonious creation to another as serenely as a perfect figure skater. The energy that courses through Raphael's Florentine Madonnas comes from within. A great many beautiful pen drawings (fig. 481) survive to show exactly how he worked. Even before he had decided just where the features were to go, Raphael let his hand revolve in a series of spontaneous curving motions, not unlike the flourishes of old-fashioned, copperplate penmanship. The resultant ovoid and spiral forms, a true choreography of the pen, carry the energies of the figures at a moment prior to the determination of form and underlie the smoothly finished shapes of the completed paintings.

Once the relationship of volumes was decided, Raphael condensed them into a Leonardesque pyramid. One of the finest and probably the first of the series, dated in 1505 by the inscription on the border of the Virgin's garment, is the beautiful *Madonna of the Meadows* (fig. 482), which still contains distinct echoes of Leonardo's *Madonna and St. Anne* (see colorplate 68), especially in the placing of the Virgin's leg and foot. Most of the series belong to this new type, which we might call the Madonna of the Land; in this type is seen an open expanse of

left: 482. RAPHAEL.

Madonna of the Meadows. 1505.
Panel, 44½×34½".

Kunsthistorisches Museum, Vienna

below: 483. RAPHAEL.

Small Cowper Madonna. c. 1505.
Panel, 23½×17¾".

National Gallery of Art,
Washington, D.C.

right: 484. RAPHAEL. Angelo Doni. c. 1505. Panel, 24½×17¼". Pitti Gallery, Florence

far right: 485. RAPHAEL.

Maddalena Strozzi Doni. c. 1505.

Panel, 24½×17¼".

Pitti Gallery, Florence

Florentine countryside and hills placed under the protection of the Virgin and Child and of the infant Baptist, patron of the city. The background often shows, as here, the body of water that appears in the Doni Madonna and its many Florentine predecessors and probably has the same meaning (see page 467). Raphael has, as throughout the series, let the Virgin's neckline dip to follow the curves of the horizon and built up her shoulders to make them higher than the hills. The clear, simple coloring and the easy upward movement of reciprocally balancing forms into the cloudy blue are Raphael's own, as is the return of energy from the downcast eyes of the Virgin to the group below. But the astonishing purity of form, particularly in the head of the Virgin, suggests that even in such a fully flexible High Renaissance painting as this he had been studying the unearthly perfection of Fra Angelico's shapes and lines (see fig. 210). The halo, now reduced to a simple circle of gold seen in depth, enhances the grace of the linear movement and completes the balance between the ovoid forms and the distant landscape spaces.

To the eyes of Leonardo or Michelangelo, if they bothered to examine these productions of an interloper, Raphael's finished Florentine Madonnas must have looked

less complete than the unfinished passages in their own works, because Raphael apparently refused to recognize the intricate problems of anatomy and expression that were all-important to them. To Raphael a picture was complete once its main masses were posed in a satisfying relationship and line, color, and surface moved freely and easily. At this point in his career he was not interested in defining shapes further. Nonetheless, in these Florentine Madonna compositions Raphael presents an existence nobler and more serene than ours, in which pictorial harmonies seem less a human creation than an emanation from the divine figures he portrays. These gentle, blond Virgins and gravely sweet children are gracefully poised against the answering background of hills and deep-blue sky.

In the Small Cowper Madonna (fig. 483), one of the most intimate of the series, the Virgin is seated upon a low bench before a landscape of open, road-traversed meadows and clumps of trees, reflected in a still lake on one side, on the other climbing the rounded slopes of a hill. On its summit stands a church recalling the similarly placed sanctuary of San Bernardino outside the walls of Urbino. The asymmetry of the landscape reflects the upward lift of the Child's figure. The smooth, gliding forms of the Virgin's hair are continued in the veils that descend from her head and course lightly about her shoulders and bust. The Child's head moves slightly away as his arms complete the circling motion of the veils. And the two divergent yet harmonious shapes are echoed in the two haloes, delicate lines of gold against the blue. It was the beautiful and deceptively easy example of Raphael's Madonnas, not the unattainable ideals of Leonardo and Michelangelo, that was repeated ad infinitum by the secondary painters of Florence for the next fifteen years.

It is a curious fact that some of the most convincing and accurate portraitists (Holbein, Poussin, Ingres) sharply separated this vein of their production from the idealism of their more formal work. Raphael was their ancestor. Cool and detached by nature, he did not interpose his own feelings between the sitter and the observer, with the result that the essence of his subject's character is summed up as never before in Italian portraiture and rarely since. Even here, it should be noted, he did not dwell on the individual idiosyncrasies in the manner of the great Netherlandish realists. He set his Florentine patrons, like his Madonnas, against a background of landscape and sky delicately adjusted to the shapes of their bodies and to the forces of their personalities.

Angelo Doni, for example (fig. 484), who had only very recently received Michelangelo's bitter masterpiece (see colorplate 69), relaxes outdoors with one arm on a balustrade, the shaggy masses of his hair reflected in the trees at the lower right, the bulky shapes of his arms and hands in the low hills of the background. The full, matronly forms of his wife, Maddalena Strozzi Doni (fig. 485), are also integrated with the landscape, to the point

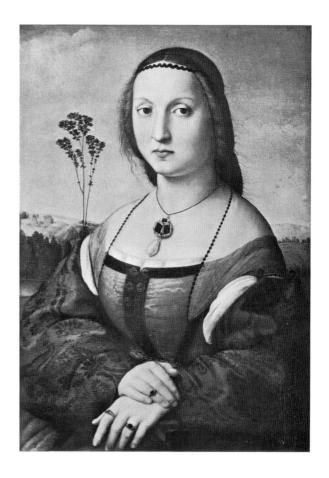

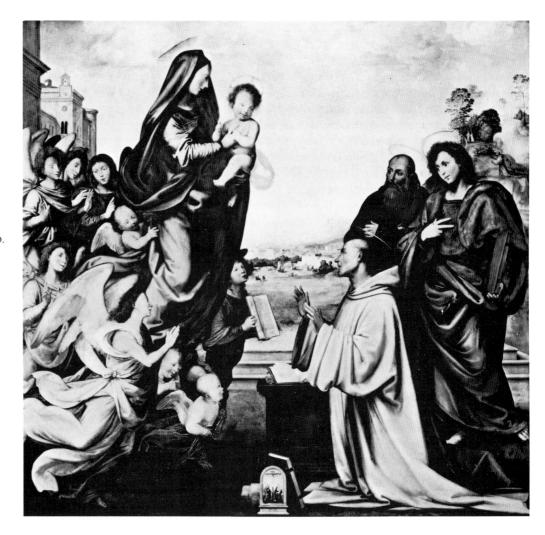

486. Fra Bartolommeo. Vision of St. Bernard. 1504–7. Panel, 84 × 861/4". Accademia, Florence

that the artist repeated the beaded border of her transparent shoulder veil in the foliage of the slender tree at the left. As in Perugino's Francesco delle Opere (see fig. 380), a great effect of energy floating freely in space is obtained by individual wisps of hair silhouetted against the sky. The wealthy young wool merchant is impressive—cool, self-contained, intelligent, firm. His wife has a harder row to hoe, in competition with her obvious prototype, the Mona Lisa (see fig. 463). There are no mysteries concealed by this commonplace young woman-but neither, at this juncture, are there many in Raphael's art, save for his uncanny sense of proportion and balance. To the successful young painter, in full command of as much as he needed of the resources of the new style, the unknowable of Leonardo may not have seemed worth knowing. He was satisfied with his compositional perfection and, as never in his Madonnas, devoted some overtime to the careful modeling of the features and hands of the husband and wife, even to their rings, to the damask and moiré of Maddalena's dress, and to the careful approximation of her pudgy shoulders and full bosom to the shape and texture of the colossal baroque pearl that hangs from her pendant. Like Michelangelo, Raphael was destined to enter a new dimension once he left Florence for papal Rome, and that crowning phase of his activities belongs to the following chapter.

FRA BARTOLOMMEO

From his Florentine drawings, we know that Raphael was familiar with the works of Leonardo and Michelangelo available to him in Florence. Strikingly enough, he did not put his new knowledge to work in the paintings of the period, beyond the obvious compositional borrowings we have already seen. But he learned and adapted a great deal from, and possibly also imparted much to, a generally underrated Florentine, Baccio della Porta (1472–1517), known to us as Fra Bartolommeo after his assumption of the monastic habit and his temporary retirement to San Marco in 1500. By the time Raphael arrived in Florence, the converted painter was back at work again on his lyrical Vision of St. Bernard (fig. 486), begun in 1504 and an obvious attempt to update Filippino Lippi's masterpiece on the same subject (see colorplate 47) in terms of the High Renaissance style. Everything immediate, personal, and introspective and all references to daily existence have been discarded by the new idealism. The monk kneels before a classical pedestal on which books are open, but we are not asked to imagine that this is, as in Filippino, his outdoor study. He is where he is for compositional and symbolic pur-

poses, and he is backed up by two other saints (apparently Anthony Abbot and John the Evangelist) from other eras. The steps in the middle ground are there only to lead us to the distant landscape, to the architecture, and above all to the entering Virgin.

Again in contrast to Filippino's version, Mary is a heavenly vision, touching nothing earthly with her feet or hands, and is borne by angels as she carries her smiling Child, while one of the angels holds before the saint an open book at which he does not even glance, so lost is he in the ecstatic realization of a transcendent superreality. The picture is in bad condition—much of the surface is lost—but the atmospheric landscape is intact, and the elements of figures and drapery move with a seraphic grace that must have struck the young Raphael with the force of revelation. Fra Bartolommeo did not entirely invent, but merely modernized, this kind of broad curvilinear movement. Although his forms possess all the gravity and amplitude of the High Renaissance, he had certainly been admiring the linear sweep of his great monastic forebears such as Lorenzo Monaco, whose Annunciation (with a similarly floating Angel Gabriel) was already in place on an altar of the Badia, for which church Fra Bartolommeo's painting was intended. And the unusual device of a little picture-within-a-picture of the Crucifixion is an obvious borrowing from Fra Angelico's altarpiece for Fra Bartolommeo's home monastery of San Marco (see fig. 207). Fra Bartolommeo has gone so far as to lean a book against it! For him, as for Fra Angelico, the device serves as a foreground counterpart for the vanishing point of perspective, in an attempt to achieve a total spatial harmony. His is probably the first of a long series of High Renaissance visionary Madonnas, which deserve study as a separate and highly characteristic theme for this period, and it is the direct ancestor of Michelangelo's floating Virgin for the 1513 version of the Tomb of Julius II (see page 505) and of Raphael's Sistine Madonna (see fig. 543). The purity of Fra Bartolommeo's lines and volumes was a major source of inspiration for Raphael well into his Roman period.

LUCA SIGNORELLI

Two masters, Luca Signorelli and Piero di Cosimo, generally considered to belong to the Quattrocento and indeed so placed in most accounts of Italian painting, are discussed here largely because their major works are incomprehensible without prior consideration of the early achievements of Leonardo and Michelangelo, especially the latter. One would have to strain a point to consider either painter a true representative of the High Renaissance, and neither was much of a worldly success after about 1505, in competition with the developed Cinquecento style of Michelangelo, Raphael, and their many imitators.

Signorelli (after 1444–1523), often erroneously listed as an Umbrian, was born in Cortona in southern Tus-

cany (a Florentine subject town since 1411) and was trained initially, according to Vasari, by Piero della Francesca. He later went to Florence, where he worked for many years, deeply influenced by the vivid new style of Antonio del Pollaiuolo, which we discussed in Chapter 13; his early works could well be considered along with those of Pollaiuolo. He was rated high enough to be called to complete the cycle of frescoes on the walls of the Sistine Chapel (see page 327), apparently abandoned in 1482 by the original group of painters assembled by Pope Sixtus IV. He painted for the Medici during the late 1480s and early 1490s, and his masterpiece in the field of panel painting, the School of Pan (fig. 487), was doubtless deeply influenced by the classicism of the circle surrounding Lorenzo the Magnificent, who greatly revered this sylvan deity. The destruction of the picture in the mysterious fire of 1945 that consumed so many works of art from the Berlin museums was one of the most tragic art losses of World War II. The School of Pan has never been adequately interpreted. Apparently, it represented the great god Pan instructing a group of largely nude divinities (Bacchus and his followers? place deities? nymphs?) and aged shepherds in the rudiments of the art of music, by means of flutes cut from reeds. As a mythological picture, its poetry is unsurpassed. The crescent moon hangs over Pan's streaming tresses, and the low light of late afternoon models the noble figures like so many statues in the Medici gardens. In no other work is the never-never land of classical antiquity, as the Early Renaissance dreamed of it, so idyllically re-created. But Signorelli had his prototypes. Although her rather graceless torso may cause us to forget it for a moment, the hips, legs, and feet of the marmoreal nude at the left were taken directly from Botticelli's Birth of Venus (see colorplate 46). At the same time, Signorelli had access either to Michelangelo's Bacchus (see fig. 471) in Rome after 1496, or to preliminary drawings the sculptor might have made for it in Florence before his departure, for the nude figure at the right exactly reproduces the Bacchus from the back in almost every respect, down to the characteristic tension of the calf of the bent leg.

Like Leonardo and Michelangelo, Signorelli was fascinated by the human body in movement, and he showed his interest in spectacular fashion and on a grand scale in a series of frescoes painted from 1499 to 1504 in the San Brixio Chapel off the right arm of the transept of the Cathedral of Orvieto. Fra Angelico had commenced in 1447 a fresco cycle illustrating the Last Judgment but had finished only two of the vaulting compartments of the two-bay chapel before he was called to Rome by Pope Nicholas V. Signorelli was originally employed only to finish Fra Angelico's paintings in the vaults, but in 1500, before the termination of the original commission, he won the assignment to paint on the walls of the chapel what were to be the first colossal dramatic paintings of the Cinquecento and one of the major artistic glories of

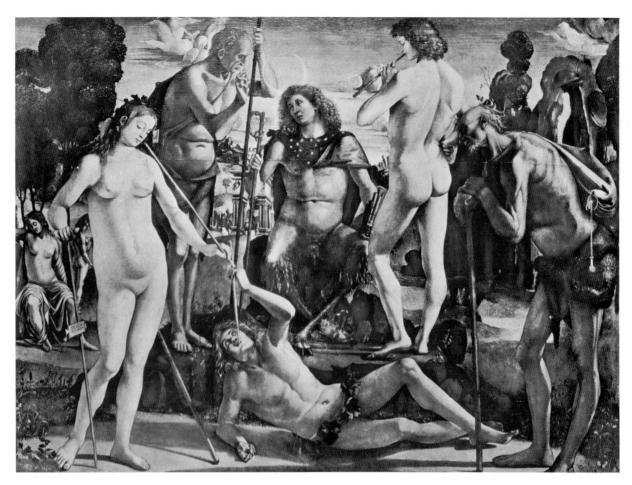

487. LUCA SIGNORELLI. School of Pan. c. 1496 (destroyed 1945). Panel, 6'41/2" × 8'5". Kaiser Friedrich Museum, Berlin

Orvieto. One step into the interior, and the observer is caught up in a world of terrible action, well-nigh beyond the limited powers of the artist. Three of the six episodes of the end of the world are shown here. In the first we see the Preaching of the Antichrist (fig. 488), as described in Matthew 24:5–31. Christlike only in his garments, hair, and beard, but terrible in his expression, the Antichrist repeats the words whispered into his ear by a demon. Around him stand people of all ages, of whom many are portraits (Dante is recognizable in the second row, to our right). In the background rises the Temple, a Renaissance structure more ambitious than carefully articulated, its porches filled with soldiers who have stripped it of its vessels, now piled as gifts before the Antichrist, and who are beheading innocent people at the right, throttling and stripping victims at the left. The Antichrist is represented again in the middle, raising a dead person, and finally cast down in a shower of golden rays by an angel at the left. The foreshortened figures tumble even into the foreground, in front of Signorelli, who has depicted himself full-length in contemporary costume and included Fra Angelico at his side. The somewhat disordered composition is based partly on Perugino's Giving of the Keys to St. Peter (see colorplate 51), and the personages, impressive from a distance, are coarsely and roughly painted, in both faces and drapery.

The Resurrection of the Dead (fig. 489) was the most ambitious nude composition of its day, prepared for in a splendid series of model studies in chalk, yet it would have been unthinkable without Michelangelo's Battle of Lapiths and Centaurs (see fig. 468), and in almost no time it was to be superseded by the Battle of Cascina (see fig. 479). The bulging nudes, which seem to be made of stone or wood ("sacks of nuts" was Leonardo's grim phrase), crawl out of the stony plain before us—a plain that is self-sealing, apparently—and strut or even dance about, sometimes embracing amiably, sometimes in conversation with jealous skeletons who have not got their flesh back. This is, of course, just the kind of grotesque situation Michelangelo instinctively avoided when he painted his own Last Judgment (see colorplate 101). The gold of heaven has descended to the springing point of the arch, pitted with little cup-shaped depressions to produce a glittering reflection (this device will be adopted immediately by Raphael in the Disputa; see fig. 534). Two colossal archangelic trumpeters blow vigorously from clouds just below the gold.

The wildest scene is, of course, the *Damned Consigned* to *Hell* (fig. 490). Heaven has shrunk back to the apex of the arch and is guarded by Michael, Raphael, and Uriel, clothed cap-a-pie in shining armor, while demons with bat wings carry off protesting mortals through the air.

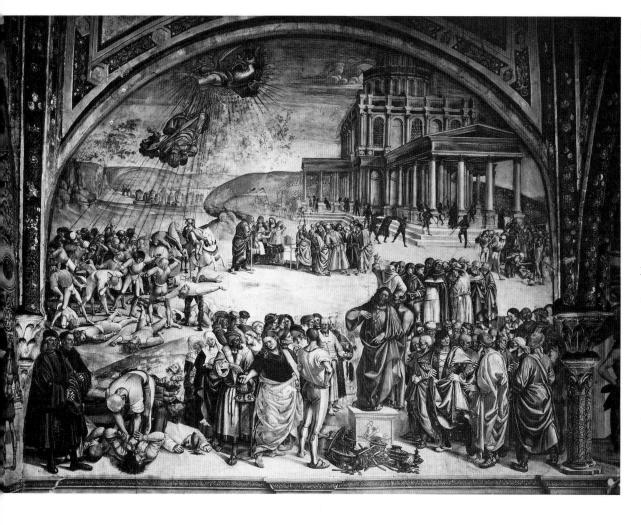

488.
LUCA SIGNORELLI.
Preaching of
the Antichrist.
1499–1504. Fresco.
S. Brixio Chapel,
Cathedral, Orvieto

489. LUCA SIGNORELLI. Resurrection of the Dead. 1499–1504. Fresco. S. Brixio Chapel, Cathedral, Orvieto

490. LUCA SIGNORELLI. Damned Consigned to Hell. 1499–1504. Fresco. S. Brixio Chapel, Cathedral, Orvieto

The foreground is filled with a wild, howling tangle of devils and mortals, on whom highly specific torments are inflicted. One poor woman lies on her stomach, while a demon lifts one of her feet and tears her toes apart. Other demons rip off the ears or sink their teeth into their victims. Signorelli's wild imagination and rude vigor are enhanced by the unexpected brilliance of the coloring. The tan and white flesh tones themselves are vivid enough, but the demons are often parti-colored like the garments of contemporary German soldiery, portions orange, portions lavender, portions green. After a while things begin to look a bit mechanized, partly because Signorelli employed several assistants, and as a result the details are sometimes clumsy. But the entire effect is beyond anything that had ever been seen in Italy before, and is still overwhelming. Poor Signorelli; the palm was too easily wrested from him by Michelangelo and Raphael, and there is something pathetic in the spectacle of the old man visiting Rome in 1516 and telling Michelangelo he will pray for the success of the sculptures of the Tomb of Julius II. He returned to Cortona, where, for the balance of his life, he and his pupils turned out a long series of uninspired altarpieces inhabited by the same wooden population.

PIERO DI COSIMO

Piero di Cosimo (1462–1521) was, if anything, overendowed with that precious quality in which Signorelli was so woefully deficient, humor—not only in his art but also in his way of life. He hated thunderstorms and fire, the latter to such an extent that he was afraid to cook, and lived on hard-boiled eggs, which he prepared fifty at a time. He never allowed anyone to prune his fruit trees or weed his flowers. He represents a pleasant deviation from the orderly development of Italian art, unexpected in that he took quite literally and lived to the full the naturalism of the Pollaiuolo-Verrocchio-Leonardo current. His whimsical Madonnas, Holy Families, and Adorations provide a welcome relief from the wholesale imitation of Raphael in early Cinquecento Florence.

Piero's so-called portrait of *Simonetta Vespucci* (fig. 491)—the inscription was added later—as Cleopatra with the asp coiled about her bosom is an especial delight. The serpent biting its tail is a device of Lorenzo di Pierfrancesco de' Medici. Piero enjoyed setting up the shapes of the lady's head and pert profile against the thunderclouds both white and black, the mound of her soft, warm bosom against the shape of the hills, and so

on. The whole picture is as unweeded and unpruned as Piero's garden. An even more beautiful example of his wildness is the long panel representing a Mythological Scene (colorplate 71), often believed to represent the death of Procris, daughter of Erectheus, king of Athens. According to Ovid, Procris was pierced through the bosom by a javelin thrown by her husband, Cephalus, who mistook her for an animal concealed in the forest. Here an almost-nude woman, wounded in the throat, is mourned by a half-comprehending satyr, whose grief is as touchingly represented as is the wordless sympathy of the dog. Piero must have felt a deep kinship with animals; no Renaissance painter surpassed him in this respect. His simple, descriptive style is a far cry from the elaborate technique and observation of Leonardo, but is adequate to his subjects.

Small wonder that Francesco del Pugliese, the wealthy cloth merchant who commissioned Filippino Lippi's Vision of St. Bernard (see colorplate 47) and is portrayed in the lower right-hand corner of that painting, engaged Piero to paint—at some time in the 1490s—a series of small panels representing the early history of man, which Panofsky has shown illustrate an account preserved in Lucretius. One of these (fig. 492) depicts a universal warfare raging between humans, animals of all sorts, and half-human creatures such as centaurs and satyrs in a (typically) unpruned forest and at the mercy of Piero's hated fire, which breaks out here and there in wild gusts, and from which birds quite sensibly flee. How such an evolutionistic view of mankind was to be reconciled with the account in Genesis we can only guess. Certainly, Piero's panels are related to, and probably in their muscular vigor even influenced by, Michelangelo's youthful relief of the Battle of Lapiths and Centaurs (see fig. 468). But, like Signorelli in his Orvieto

491. PIERO DI COSIMO. Simonetta Vespucci. c. 1501. Panel, $22\frac{1}{2} \times 16\frac{1}{2}$ ". Musée Condé, Chantilly

frescoes, Piero depicts just what was most repugnant to Michelangelo—humanity in a subhuman stage and subject to the depredations of antihuman creatures and forces. In the following chapter we will see how, with impassioned energy, Michelangelo and other artists attempted to raise humanity again to a divine level.

The High Renaissance in Rome

he next phase of Italian art and history is dominated, at the outset at least, by a single astonishing figure, Pope Julius II. As Cardinal Giuliano della Rovere, this forceful Ligurian exercised great power during the pontificate of his uncle, Sixtus IV, and during the following reign of Innocent VIII. When Rodrigo Borgia ascended the papal throne as Alexander VI, Giuliano left Rome, eventually for France. His election as pope in 1503, following the ten-day pontificate of Pius III, was the signal for a real revolution, starting in the Vatican and expanding to Rome, to Central Italy, to the entire peninsula, eventually to all of Europe. Julius II loathed the memory and the crimes of the Borgias to such a degree that he refused even to use the rooms decorated by Pintoricchio in which Alexander VI had once lived. He immediately set about a mighty program of reform—the reform of the Church in head and members. In the secular sphere this was matched by his reestablishment of law and order in the crime-ridden streets of Rome and by the subjugation of the rebellious Roman nobles. Next he reconquered the lost provinces of the papacy. Then he proceeded to drive the foreign invaders out of all of Italy, beginning with the French in the North. His striking success would doubtless have been followed by an expulsion of the Spaniards in the South and the unification of the peninsula under papal leadership if death had not stopped the pope's meteoric career after ten years. Nonetheless, Julius II succeeded not only in establishing the borders of the Papal States but also in inspiring a new confidence and vitality in Renaissance Catholicism.

In any event this single last decade of the pope's life—his sixties—treated Europe to the spectacle of the supreme pontiff standing in armor beside his blazing cannons, excoriating his enemies in language both coarse and violent, beating his cardinals over the shoulders with his cane when they delayed in following him through snow breast-high on the horses, growing a great, prophetic beard in defiance of all custom and tradition, and acting in general like an unchained giant

loose on the map of Italy. The unsystematic and conservative attempts of the Quattrocento popes to convert the picturesque agglomerations of medieval Rome into a classical city were immediately superseded by Julius' determination to rebuild whole sections, to drive broad avenues, bordered with palaces, through hovels and ruins alike, and to replace the millenary Basilica of St. Peter's with a grand new temple, embodying at once the imperial splendor and the spiritual drive of his new regime. Intellectually and artistically, Julian Rome was an exciting place to live. It was also unbearably dusty and noisy from incessant demolitions and reconstructions, and it was repeatedly threatened by the collapse of the pope's political schemes and invasion by his enemies.

It has been said Julius chose the High Renaissance as the artistic style that would best embody his new ideals. He had little choice. One can hardly imagine him calling upon Botticelli or Perugino to create the visual symbols for his new militancy. High Renaissance style, forged in the crisis of republican Florence, was a perfect instrument for him, and Michelangelo an ideal artist; so, unpredictably, Raphael also was to become; and so was the greatest of High Renaissance architects, older than either but a contemporary and eventually close friend and confidant of the pope, Bramante. The painters summoned by Sixtus IV for his first program in the Sistine Chapel had returned to their cities without having created a common style (see pages 327, 370). But, whether or not they knew it was happening, the three great artists who carried out Julius' mighty projects did, to an extent, submerge their own individualities as they were fired by the example and the inspiration of their incredible patron. The Roman period of the High Renaissance is sharply distinct from its Florentine predecessor, grander in scope, freer in its dynamism, and it developed with lightning rapidity from phase to always more majestic phase. In the sense that he determined what was to be built, carved, or painted, and by whom; what were to be the subjects; how they were to be treated; which among several alternate projects was to be executed; how the finished work should feel—Julius did indeed exercise a formative influence on High Renaissance style and should be considered as much one of its creators as, in another period, Pericles was for the Classical style in Athens. Such was the grandeur of Julius' undertakings that Italian art, even in Venice, could never again return to its former, more modest, self.

BRAMANTE

Donato di Pascuccio (1444–1514), known as Bramante, from Urbino, started as a painter of considerable if not overwhelming gifts and first appears as an architect in Milan in 1485, when, already over forty, he undertook the rebuilding of Santa Maria presso San Satiro (fig. 493). Basically Albertian in its single-story, barrelvaulted nave, whose round arches are supported by piers divided by Corinthian pilasters, the church culminates in a grand crossing crowned by a Pantheon-like dome that gives us a hint of how Alberti's domes for the Malatesta Temple (see fig. 224) and Sant'Andrea at Mantua might have appeared. The most startling element of the interior, however, and a very instructive one as well, is the splendid choir, which appears to stretch for three bays beyond the crossing, under a barrel vault like that of the nave. But if the observer's eye can move into this distance, his feet cannot follow. The choir does not exist. It is a triumph of the Renaissance art of harmonious deceit on a grand scale (fig. 494). Where we think we see a choir, there is the street outside; the illusion is created by stucco relief on a flat wall, like the splendid architectural spaces designed on a small scale by Ghiberti for the backgrounds of the *Gates of Paradise* (see colorplate 30). The actual depth is only a matter of a few inches. The false choir of Santa Maria presso San Satiro is an indication of Bramante's lifelong preoccupation with space, and a remarkable premonition, in miniature, of how the interior of St. Peter's would have looked if it could have been completed and decorated according to his plans.

The Church of Santa Maria delle Grazie in Milan had been started by Guiniforte Solari in Gothic style in 1463, but in 1492 Duke Ludovico Sforza ordered the newly built choir torn down and replaced by a splendid Renaissance structure, for which Leonardo's numerous drawings for a central-plan church (for example, see fig. 449) may have been intended, to house the tombs of the Sforza dynasty. Although no document connects his name with its construction, the present apse, transept, crossing, and dome are universally attributed to Bramante under the influence of Leonardo da Vinci, whose ideas on radial architecture they clearly reflect. This architecture, whether or not all its surface decorations were designed by Bramante himself, is composed, like the architecture in Leonardo's drawings, of various permutations and combinations of cubes, hemispheres, half-cylinders, and

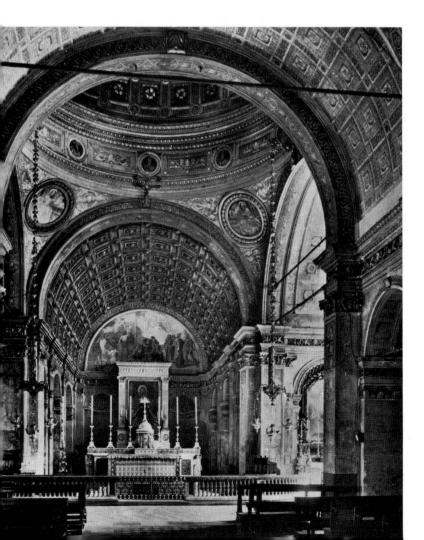

left: 493. Bramante. Interior view toward choir, Sta. Maria presso S. Satiro, Milan. 1485

below: 494. Bramante. Plan of Sta. Maria presso S. Satiro, Milan

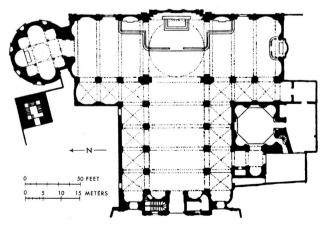

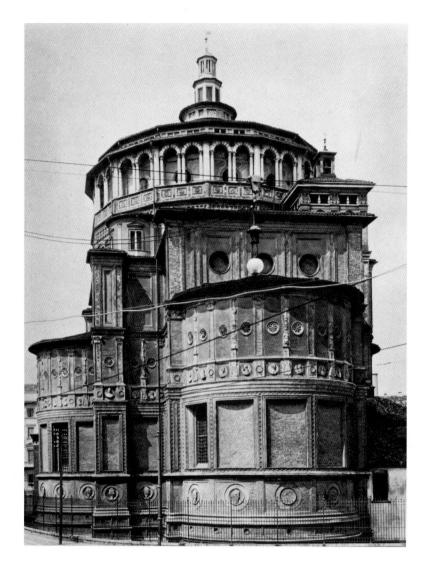

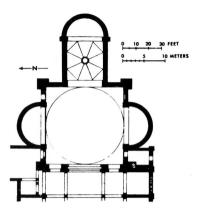

left: 495. Bramante. Sta. Maria delle Grazie, Milan. Begun 1492

above: 496. Bramante. Plan of Sta. Maria delle Grazie

below: 497. BRAMANTE. Interior view toward choir, Sta. Maria delle Grazie, Milan. Begun 1492

so on (figs. 495, 496). Bramante transformed the oculi of the preexistent Gothic church into floating circles that move throughout the exterior design as ornament, not only in the various superimposed layers of the building, but also in the flat, floating circles of the peristyle and its crowning cornices. In the spacious interior (fig. 497), from which apses open outward like the membranes of inflated balloons, the floating circles rotate around the great arches upholding the dome in the manner of cars on some gigantic Ferris wheel.

The fall of the Sforza dynasty in 1499 left Bramante without work at what was, for the Renaissance, the fairly advanced age of fifty-four. He migrated to Rome, and there immediately commenced a rich architectural activity in the last years of the pontificate of Alexander VI. Under Julius II, Bramante became the leading architect of the High Renaissance, and developed at extraordinary speed and with unexpected originality and power. The most original of his works in the papal city, in fact one of the most influential buildings in architectural history, is the little circular structure known as the Tempietto ("little temple"; fig. 498). Authorized in 1502 by Ferdinand and Isabella of Spain to be erected on the spot where St. Peter was believed to have been crucified, alongside the

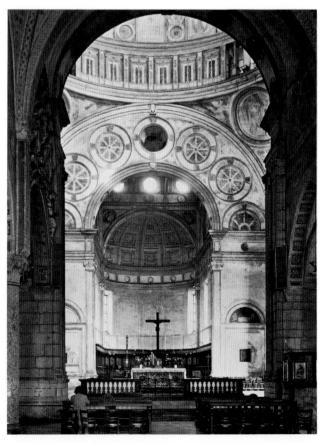

right: 498. BRAMANTE. Tempietto, S. Pietro in Montorio, Rome. Authorized 1502; completed after 1511

below left: 499.
BRAMANTE.
Plan of Tempietto,
S. Pietro in Montorio,
Rome (from SEBASTIANO SERLIO,
Il terzo libro d'architettura,
Venice, 1551)

below right: 500.
BRAMANTE.
Elevation of Tempietto,
S. Pietro in Montorio,
Rome (from SEBASTIANO SERLIO,
Il terzo libro d'architettura,
Venice, 1551)

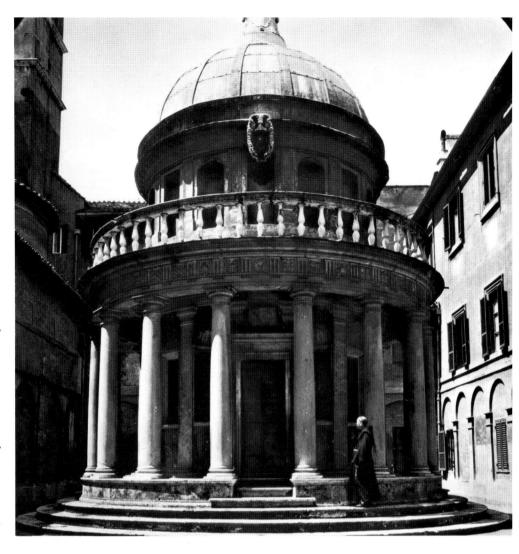

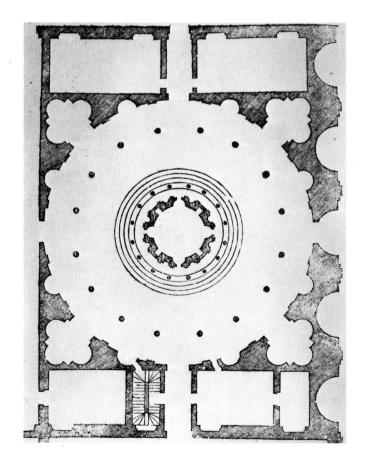

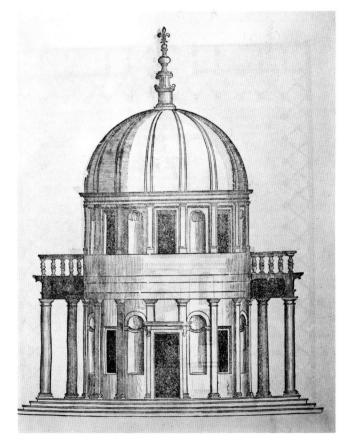

Church of San Pietro in Montorio, the Tempietto was probably not built immediately. The building was not mentioned in Francesco Albertini's guide to Rome of 1511, which does describe the less important nearby church, and the style of the Tempietto is incompatible with that of Bramante's first works in Rome. So what used to be the most secure architectural date of the Roman High Renaissance is now completely at sea.

Instead of the Corinthian and Ionic orders generally preferred by Quattrocento architects, Bramante chose the Roman Doric, severe and regular on account of the prescribed alternation of triglyphs and metopes. The circular shape, however, whose effectiveness he had been able to observe in the round temples of Rome and Tivoli, not to speak of the ideal temple designed by Luciano Laurana (see fig. 386), gave him a new flexibility and enabled him to abandon once and for all the planimetric quality of the box architecture of the Quattrocento, already doomed by Leonardo's radial schemes, even though that master retained the idea of flat planes to bound many individual elements. The building has no single elevation. The Tempietto exists in space like a work of sculpture, and, as we move about it, its peristyle and steps revolve around the central cylinder.

The full spatial effect Bramante intended for his little masterpiece can be realized today only if we attempt to re-create the surrounding circular courtyard, whose plan and elevation were preserved in the mid-Cinquecento architectural treatise of Sebastiano Serlio (figs. 499, 500). The widely spaced columns of the outer peristyle of this courtyard are related radially to the columns of the Tempietto, which all move outward from the center of the building, so as to tie the solid structure to its frame by means of an imagined web of relationships cutting across the surrounding space. The resultant perfect interrelationship of forms and spaces, brought into a simple unity that is the product rather than the sum of its parts, makes the Tempietto the architectural equivalent of Leonardo's vanished cartoon for the Madonna and St. Anne (see page 455), even if it may not be the first true High Renaissance structure preserved today. It may be said that, through the work of his somewhat older friend Bramante, Leonardo's new ideas founded not only the Florentine but also the Roman phase of the High Renaissance. Not only the intellectual perfection and spiritual poise, but also the inherent majesty of this building, all of whose solids and spaces are so perfectly harmonized, resoundingly justify the choice of Bramante as papal architect by Julius II, even if they can no longer be used to explain it.

In 1506, with the excuse that it threatened imminent collapse, the pope commissioned Bramante to rebuild the Basilica of St. Peter's, archetype of Early Christian church architecture in the West, sanctified by more than eleven hundred years of ritual and filled with monuments of sculpture and painting. Nicholas V had trans-

ferred the seat of the papacy from the Lateran Palace to the Vatican, and had commenced a new apse for St. Peter's by Bernardo Rossellino, possibly designed by Alberti, outside the Early Christian apse that it was eventually destined to replace. Julius II decided to sweep aside the ancient basilica and the new apse, even, to Michelangelo's intense anger, the monolithic columns that lined the nave, brought down with such violence that they shattered on the pavement. The pope's gesture of combined negation and affirmation was to launch the greatest constructional dream of the Renaissance on its perilous course. Twelve architects and twenty-two popes later, the building was completed, barely recognizable in its Michelangelesque shell and Baroque extensions.

The very grandiosity of the Julius-Bramante project is perhaps a symptom of the weaknesses of the High Renaissance as well as a symbol of its ideals and aspirations. The immense structure could not possibly have been completed during the reign of the aging pope, but it was commenced with surprising speed considering the conditions of constant disorder and attack that Julius and his papacy had to face. There is far more of Bramante's actual construction in the present interior than most had realized, but we can construct its exterior appearance only through surviving drawings by others and through the medal (fig. 501) struck by Caradosso, Bramante's collaborator for architectural ornament in Milan. The first idea for Bramante's structure has generally been interpreted as one-half of a Greek-cross plan (fig. 502), with four equal arms ending in apses, including in its reentrant angles four smaller Greek crosses built on an analogous plan but with two of the four apses dissolved into the arms of the larger cross. In the outer angles were to go four lofty towers, and the towers and apses would have been connected by open three-bay loggie. An observer entering at one of the principal portals would have looked through relatively simple spaces straight through the building and out to the opposite portal, but the view from one of the loggia entrances would have been formed by a more complex succession of spaces, culminating in the central area and then repeated in reverse. There is no proof, however, that the half plan was ever to have been doubled; the missing section might have comprised a nave, making a Latin cross. In any case it was never carried out. The church whose construction Bramante commenced was to have had an apse of three bays, and the apse and apsidal transepts were to have been surrounded by ambulatories (fig. 503). The tomb of St. Peter was to remain at the crossing, where it is today. The single-story, barrel-vaulted structure, recalling the interior of Santa Maria presso San Satiro, would have been crowned by a colossal dome on pendentives (fig. 504)—not the still-Florentine, vertical-ribbed dome of the Tempietto, but substantially the dome of the Pantheon, set on a peristyle of Corinthian columns on

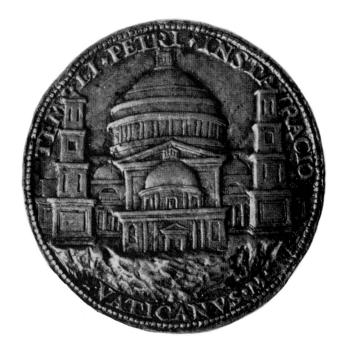

below left: 502. Bramante. Plan of St. Peter's. 1506. Pen and wash. Gabinetto dei Disegni e Stampe, Uffizi, Florence

right: 503.
BALDASSARE PERUZZI.
Perspective Study, with Section
and Plan, of St. Peter's
(partially embodying
Bramante's second plan).
Pen and ink and
pencil. Gabinetto
dei Disegni e Stampe,
Uffizi, Florence

above right: 504.
Donato Bramante.
Elevation and section
of Dome, St. Peter's,
Vatican, Rome
(from Sebastiano
Serlio, Il terzo
libro d'architettura,
Venice, 1551)

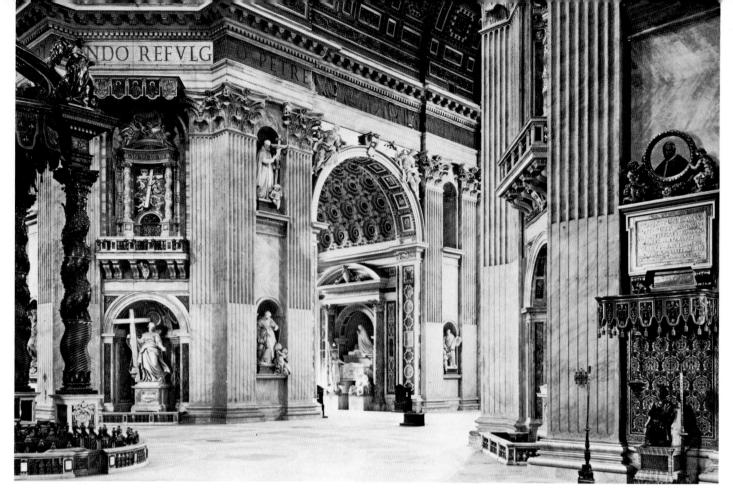

505. Interior view at crossing, St. Peter's, Vatican, Rome

the exterior reflecting a similar but smaller gallery of columns on the inside of the dome, both peristyles radially related in plan and in height to the springing point. The hemispherical dome, with its basic horizontality of elements, would have created an impression of masses at rest, deliberately contrasting with the soaring towers, which from any vantage point would partially have concealed its outline. Except for the raised level of the floor, the interior was built substantially as Bramante planned it (fig. 505). By 1514 the architect, then seventy years old, was able to see the four arches of the dome, the Corinthian order including marble shafts, capitals, and entablatures, and the four pendentives in place, as well as the new foundations of three of the arms of the cross and of some of the chapels. The four arches and their supports, built on such a scale, could never again be changed, and in fact are there and visible from the inside today, in spite of the layers of ostentatious marble and gold ornament that cover them. Much of the nave of Old St. Peter's still stood. A temporary construction sheltered the tomb of the Prince of the Apostles, but the dome that Bramante intended to glorify this spot was never even commenced according to his plans. From the outside the building belongs to Michelangelo and to the ensuing Baroque.

Some insight into the sensation of peace and harmony Bramante's St. Peter's might have radiated, had it ever been completed according to his own designs, is offered by the beautiful pilgrimage church of Santa Maria della Consolazione at Todi, in Umbria, superbly situated just outside the medieval city against a background of some of the loveliest landscape in Central Italy. Begun in 1508, the church was long believed to have been based on a model by Bramante himself, although the only architect's name recorded is that of the otherwise obscure Cola da Caprarola (fig. 506). Four polygonal apses, each roofed by a semidome, radiate outward from a central square in a plan that strikes most visitors as perfection itself, although there was apparently some question at first as to whether the crowds might not necessitate a nave as at Santa Maria del Calcinaio at Cortona (see fig. 375). The delicacy of the window frames, entablatures, and corner pilasters as contrasted with the broad wall surfaces creates an effect of fragility and lightness unique among all central-plan churches of the Renaissance. As fate would have it, the Consolazione also could not be completed until the following century, so the entrance, balustrade, and crowning dome showed Roman taste of a later era.

Another vast project designed in 1505 by Bramante for Julius II, two years after his accession, and, like St. Peter's, left truncated at the architect's death, was the rebuilding of the Vatican, which he was to unite to the earlier country house of the Belvedere, nearly a thousand feet away at the top of a hill, by means of two enormous corridors enclosing garden terraces, staircases, and fountains following the slopes of the hill (fig. 507). For this purpose Bramante devised a flexible system that

right: 506.
COLA DA CAPRAROLA
and OTHERS.
Sta. Maria della Consolazione.
Begun 1508. Todi

below: 507.
BRAMANTE.
Belvedere, Vatican, Rome.
Begun 1505 (anonymous
16th-century drawing).
Collection Edmonde Fatio,
Geneva

below right: 508.

BRAMANTE
and OTHERS.
Portion of north façade,
Belvedere Court,
Vatican, Rome.
Begun 1505

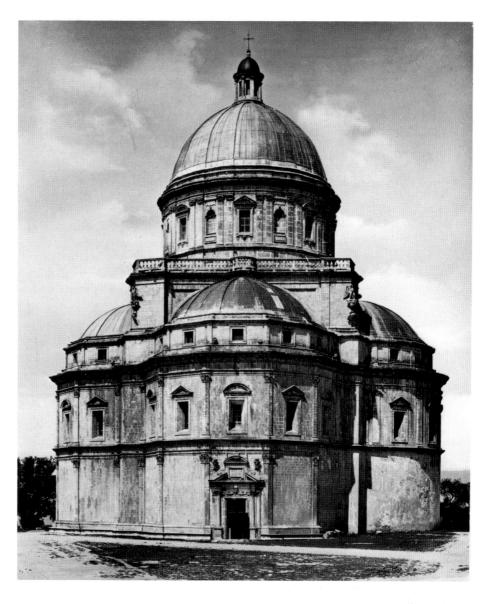

consists of coupled Corinthian pilasters enclosing niches, and flanking arches that are let into the rusticated masonry of the intervening wall masses (fig. 508). The huge barrel vaults of St. Peter's echo Alberti's Sant'Andrea (see fig. 229); the screen architecture of the Belvedere reflects Alberti's formulation of the Palazzo Rucellai (see fig. 225) and the Albertian panels by Lau-

Rap Veinas ex Lands Const. exfinition.

509. BRAMANTE. Façade, Palazzo Caprini, Rome. c. 1510. Engraving by LAFRERI, 1549

rana (see fig. 386), not to speak of the Cancellaria (see fig. 231) and other Roman palaces. But the ambition of the total scheme transcends anything ever attempted in the Quattrocento. Together the pope and the architect who read Dante to him in the evenings, both in their sixties, imagined the most extensive palace plan to occur to Western man between the days of Emperor Hadrian and those of Louis XIV. Time itself was against them, and their Kubla Khan dream was foredoomed to incompletion. Later, it suffered insensitive additions and an amputation of the vista by a new arm connecting both sides. Yet not even the inevitable fate of the vision detracts from its beauty and its courage.

Little remains of the many other official buildings designed and in some cases actually built for the grand new Rome of Julius II. Although long since destroyed, the Palazzo Caprini—also known as the House of Raphael, because the great artist bought it in 1517—cannot be overlooked (fig. 509) because in this structure Bramante provided the model for patrician town houses for centuries, replacing the three-story structure with screen architecture of superimposed orders so widespread since Alberti. In the Palazzo Caprini Bramante followed the typical Roman custom of devoting the ground floor to shops and setting above it a piano nobile destined for the owner. Characteristically, the ground floor was heavily rusticated, to provide a base on which, not Albertian pilasters, but engaged half-round columns could stand in all their beauty, coupled to provide a rich alternation between flat and grouped cylindrical masses. This notion was so successful that it was repeated a number of times in Roman palaces and in North Italy as well.

MICHELANGELO 1505 TO 1516

In 1505, the second year of Julius' pontificate and one year before he commissioned Bramante to rebuild St. Peter's, the pope called Michelangelo from Florence to design and carve for him a tomb of unexampled formal richness and dramatic intensity, to be placed in Old St. Peter's. We are not sure of the exact intended location in the basilica, but it is possible that the warrior-pope, engaged in rejuvenating and rebuilding the Church, intended his tomb to confront that of the Prince of the Apostles, on whose rock the Church was founded. To carry out his commission Michelangelo abandoned his many undertakings in Florence, including the cartoon of the Battle of Cascina. We have today nothing but verbal accounts, written much later, a few drawings, and the carved decorations of the lower story with which to reconstruct the three-story mausoleum. Scholars disagree sharply on many elements, but not on the following: Michelangelo made a number of preliminary designs, one of which was selected by the pope. This was for a freestanding structure containing an oval burial chamber in which the sarcophagus was to have been placed. The lower story of the exterior was to be decorated by niches containing statues of Victories flanked by herms, to which were to be attached bound and struggling male Captives. There were to be at least eight Victories and sixteen Captives, but one theory calls for ten Victories and twenty Captives. On the second story were to be placed statues of Moses and St. Paul and of the Active Life and the Contemplative Life.

The principal dispute arises over the appearance of

the final story. Vasari wrote: "The work rose above the cornice in diminishing steps, with a frieze of scenes in bronze, and with other figures and putti and ornaments in turn; and above there were finally two figures, of which one was the Heavens, who smiling held on his shoulder a bier together with Cybele, goddess of the earth, who seemed that she was grieving that she must remain in a world deprived of every virtue by the death of this man; and the Heavens appeared to be smiling that his soul had passed to celestial glory." Despite the fact that no text mentions any statue of the pope, two influential theories hold that the bier supported such an effigy. Charles de Tolnay claimed the pope was recumbent (which would have made him almost invisible from the floor), Panofsky that the explicit Italian word for bier really meant the sella gestatoria, or portable papal throne, and that Julius II was to have been shown carried live into the next world, blessing as he went. The marble block for a papal effigy was actually delivered. In all probability this was to have been a recumbent figure but destined for the only logical place, the sarcophagus in the burial chamber. A suggested reconstruction of the 1505 design, culminating in a bier according to Vasari, is given here (fig. 510).

After Michelangelo had spent a year of immense labor, shadowed by many disasters, bringing the marble blocks from Carrara to the Piazza San Pietro, and had started much of the carving, the pope suddenly interrupted the commission in Holy Week of 1506. Although the circumstances were narrated several times by Michelangelo

510. MICHELANGELO. Tomb of Pope Julius II. Reconstruction drawing of project of 1505

511. MICHELANGELO. *Pitti Madonna*. c. 1506. Marble, diameter 33½". Bargello, Florence

himself, with always richer and more picturesque detail, it is still not clear why the work was stopped. Presumably funds had to be diverted to the rebuilding of St. Peter's by Bramante. In any case the magnificent dream, destined to become a nightmare to Michelangelo for the next forty years, was still the first instance in which he combined figures and architecture, and was therefore the germ of his major pictorial work, the Sistine Ceiling. Element after element designed for the 1505 version of the tomb came to fruition on the ceiling, and the ceiling in turn was to act as a crucible for new sculptural ideas to be utilized in later versions of the tomb.

How much of the architecture and of the more than forty over-life-sized statues that we are told were to have adorned the tomb had Michelangelo completed before he left in anger for Florence in 1506? Surprisingly enough, only the niches with their rich decorations. There is evidence to show, however, that the poses of the two so-called *Slaves* now in the Louvre (see figs. 532, 533) and the *Moses* (see fig. 531) were determined at this time, and these were already blocked out.

After Michelangelo's outraged flight to Florence, he returned to the *Battle of Cascina*, and according to a letter from Piero Soderini, leader of the Republic, the artist was actually at work painting the fresco itself. That same moment is the most likely date for the *Pitti Madonna* (fig. 511), whose compact masses and blocklike shapes, protruding from the tondo form with such force that they nearly demolish it, mark a stage well beyond the delicacy of the *Bruges Madonna* or the relatively open composition of the *Taddei Madonna* (see figs. 475, 476). In the complex, contrapposto pose of the *Pitti Madonna*, as well

as in her prophetic gaze, it is possible to discern something of the new grandeur and monumentality of the sculptural style at which Michelangelo had arrived in the truncated project for the Tomb of Julius II, if not indeed an actual pose of one of the never-executed figures for the second story.

Although the pope had already started to dream of inviting Michelangelo to paint the ceiling of the Sistine Chapel, instead Julius executed a dazzling march to Bologna in 1506, recaptured the city, and from that vantage point requested the outflanked Florentines to send Michelangelo up to him. The next eighteen months the sculptor was to spend modeling and casting in bronze a colossal papal portrait statue. The finished work enjoyed an existence of little more than three years before antipapal forces, again in control of Bologna, had it pushed from its pedestal on the façade of San Petronio to destruction on the piazza below, melted it down, and cast the bronze into a cannon, called La Giulia, to fire at the pope. The life of the colossus was so short that no reliable evidence, not even a sketch or description, has come down to us. We have nothing but our imaginations with which to reconstruct what must have been a vividly dramatic statue. Perhaps some hint of its vanished grandeur is embodied in the enthroned prophets of the Sistine Ceiling.

Scarcely back in Florence in the spring of 1508, Michelangelo was called again to Rome; the dream of painting the Sistine Chapel had become a definite commission. The decorative and historical program of Sixtus IV (fig. 512) stopped at the level of the windows, between which were simulated statues of popes. The flattened vault was merely painted blue and dotted with gold stars. Here, according to Michelangelo's own later account, the pope wanted him to paint the Twelve Apostles, one in each of the spandrels between the twelve arches upholding the vault. The central part of the ceiling was to be filled by "ornaments according to custom," apparently an elaborate network of painted ornamental motifs and geometrical fields. Michelangelo objected that the design would be "a poor thing." "Why?" asked the pope. "Because they [the Apostles] were poor too," replied Michelangelo. And then, still according to the artist's own version (written much later at a time when he was threatened with lawsuits over the nondelivery of the tomb), the pope told him he could paint anything he liked. There is no reason to doubt that the expansion of the original program was due to Michelangelo's dissatisfaction. But despite the aura of romantic independence with which Michelangelo has been enveloped ever since the nineteenth century, it is hard to accept the idea that so determined a pope would, in violation of more than a thousand years of custom, have entrusted a complex theological program at the nerve center of Western Christendom to a layman who in all probability could not read Latin.

It is believed by many that Michelangelo had a theological adviser, and it has been proposed by the author that this adviser was Marco Vigerio della Rovere, Julius' fellow Franciscan, fellow townsman, contemporary, and first cousin once removed, on the pope's first list of cardinals elevated in 1503, and a close and trusted counselor. The Christian Decachord, published by Vigerio in Rome in 1507 and dedicated to the pope, contains many indications that Vigerio was called to advise Michelangelo in the preparation of the subjects for the second program, infinitely more ambitious than the first.

Now the Twelve Apostles in the spandrels gave way to an alternation of prophets from the Old Testament and sibyls from classical antiquity, seated on gigantic thrones, arranged so that prophets alternate with sibyls around the ceiling and prophets face sibyls across the ceiling, with the exception of the key positions at either end of the chapel, in each of which a prophet is enthroned (fig. 512). The thrones themselves, mere square niches with massive cornices upheld by pairs of putti painted to resemble marble sculpture, are a part of the vast simulated architecture of the ceiling, for their verticals are prolonged into ten bands that reach across the chapel to merge with the thrones on the opposite side. A strip of sky is visible above the thrones of the prophets and sibyls at either end of the ceiling. At left and right above each throne, save those at the ends, sit two nude youths (twenty in all), holding lengths of cloth that pass through slits in the rims of ten medallions painted to resemble bronze and placed above the heads of the prophets and sibyls.

The spaces between the ten transverse bands are filled by nine scenes from Genesis, five small and four large. Continuous cornices above the thrones form a frame around the central area; at the corners of this frame and above the vaulting compartments that surmount the side windows, the cornice seems to be supported by the horns of twelve rams' skulls. The twenty-four spaces remaining between the vaulting compartments, the cornice, and the thrones are filled by bronze-colored nudes only faintly visible from the floor. The footstool of each of the ten thrones is wedged between the frames of the vaulting compartments. The four corner spandrels contain four more scenes from the Old Testament, and the eight vaulting compartments and the (formerly) sixteen lunettes above the windows contain figures representing the forty generations of the ancestry of Christ. (Two lunettes were later destroyed by Michelangelo himself to make way for the Last Judgment, which fills the end wall of the chapel.) The prophets, sibyls, nudes, and scenes are painted in naturalistic colors, and the nudes and their accessories are often permitted to overlap the scenes. The bands simulate marble architecture; some figures simulate bronze sculpture, others marble.

The scenes have no spatial relation to the surrounding figures, and the whole structure cannot be seen from a

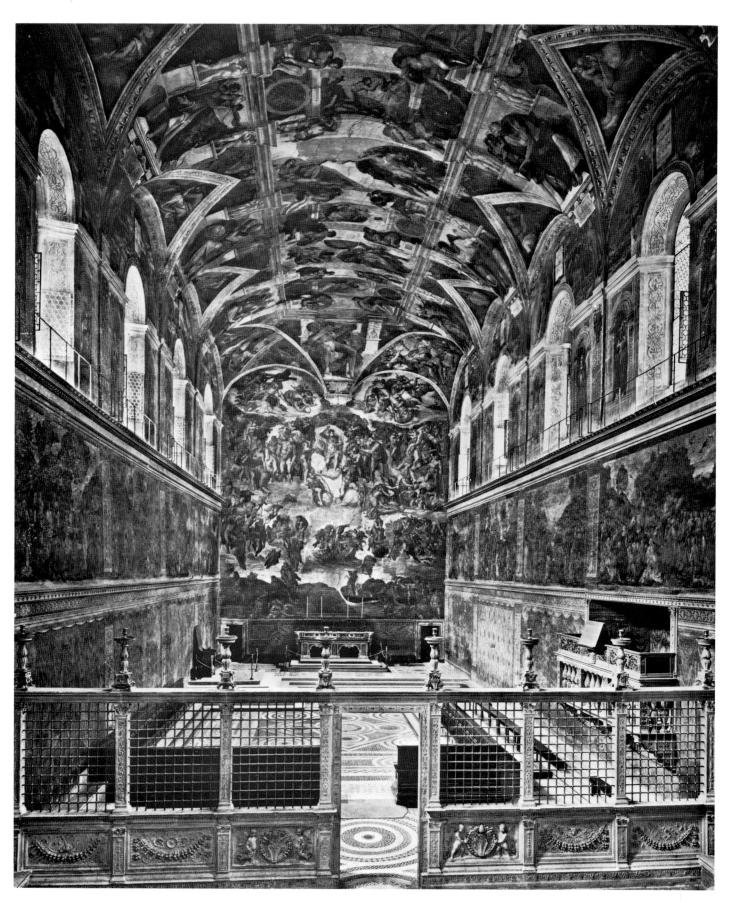

512. General view toward altar, Sistine Chapel, Vatican, Rome

513. MICHELANGELO. *Study for Sistine Ceiling* (portion of sheet). c. 1508. Ink and black chalk.

British Museum, London

single valid viewpoint. In order to see the scenes right side up, one must stand at the entrance to the chapel, but then they have to be read *backward* in time, from the story of Noah overhead to the Creation at the far end, and only one of the prophets and sibyls will appear upright. The ceiling is therefore composed of four converging and conflicting directions of vision. And although at key points it is tangent to the architecture of the chapel, it is not derived from the preexistent shapes and spaces but is wholly autonomous. In the last analysis, a vision is incommensurate with the material world, and the Sistine Ceiling is, above all, a colossal vision.

The meaning of this vision has been the subject of much controversy. The solution suggested here is that of the author. The prophets and sibyls can hardly be considered as prophesying the events in the central Old Testament scenes from the Creation through Noah, for these had long since taken place. According to one of the basic principles of Christian theology, they see *in* these Old Testament events the great revelation of the New Testament, the coming of Christ. For this reason the ancestors of Christ are represented in the lunettes around the windows as physical carriers of what the prophets and sibyls see in spirit. The meanings of their Hebrew names, as understood by medieval theologians, exactly tally with the meanings that the prophets see in the central narratives.

Another level of symbolism is provided by the garlands of oak leaves held by a number of the nudes. Rovere, the family name of Sixtus IV and Julius II, means "oak"; an oak tree was on the family arms decorating the

marble barrier then dividing the chapel at the center; and oak leaves turn up in innumerable other places in the original Quattrocento decorations. Six of the seven prophets are concerned with the vision of the Tree of Life, which also figures in the poetic account of the writings of the sibyls. The Tree of Life, a Franciscan doctrine from the days of St. Bonaventura (see Taddeo Gaddi's fresco; fig. 83), was a natural parallel to the Della Rovere oak. Six of the nine Genesis scenes prominently display trees or wood, and two others are invaded by masses of oak leaves and acorns held by the neighboring nudes. The symbolic structure of the ceiling can be interpreted in terms of the prophetic allusions seen by the pope in the tree on his own coat of arms, at the moment when he considered himself divinely chosen to lead the battle for the survival and renewal of the Church. We have no way of knowing how readily Michelangelo accepted this complex structure of interlocking allusions, but he provided it with an appropriate visual equivalent in the intricate design relationships of the ceiling. Moreover, he was able to find in each of the scenes and in each of the figures a content so deep and a formal grandeur so compelling that it is generally difficult to think of these subjects in any other way. Inspired by the message and starting with his new vision of human beauty, Michelangelo rose to heights from which he alone, among all Renaissance artists, saw the Creator face to face.

He set to work at once, producing the two or three hundred preliminary drawings that had to be made before the large cartoons could be started. Many of the drawings survive (fig. 513) to show the labor that must have gone into every detail, but the cartoons have perished. They were laid up against the surface of the coat of intonaco applied freshly each day, and the outlines traced through with a stylus rather than by the traditional method of pouncing. The stylus marks can often be clearly seen, even in photographs. Michelangelo designed a new kind of scaffolding that could bring him up to the proper level, without support from either the ceiling or the floor. As the author and Fabrizio Mancinelli have shown in recent independent studies, this scaffolding was based on beams known as sorgozzoni projecting like brackets diagonally upward from holes made in the walls on either side of the springing points of the window arches. These holes have now been unblocked, and are in use as a base for the rails on which runs the mobile steel scaffolding for the restoration under way as this revision is being written. Michelangelo's scaffolding was shaped like a vault in itself and, except for periodic removal and replacement of the boards so that the work could be seen from the floor, was in place for the entire four and a half years of his undertaking. It permitted the artist to walk about as he wished, and to paint from a standing position, not lying down as was once widely believed. The scaffolding also enabled him to carry out all the exactly measured framework of illusionistic ar-

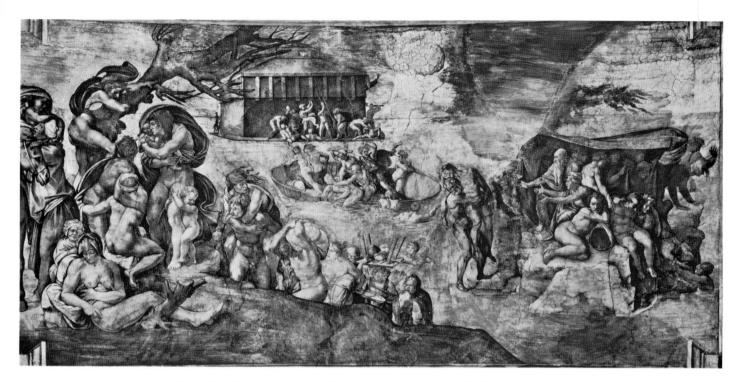

above: 514. MICHELANGELO. Deluge. 1509. Fresco. Sistine Ceiling, Vatican, Rome

below: 515. Father Carrying Son, detail of fig. 514

chitecture, a very delicate procedure, since the chapel narrowed toward the altar. By September 1508 Michelangelo was already painting, and by January 1509 already in difficulties. Apparently he did not know enough about the proper composition of the *intonaco*, despite advice from his friend Giuliano da Sangallo, then also at the papal court, because the *Deluge* became moldy and had to be scraped off and redone.

The course of his work ran parallel with the most dramatic events in the action-charged pontificate of Julius II. When Michelangelo ran out of money, which happened twice, he had to go up to Bologna and beg from the pope, who was in the midst of the crucial phase of his war against the French. At the time of Michelangelo's second trip, in December 1510, the pope had already grown the long beard that gives him such a prophetic appearance on all his late portraits. Quite possibly, the artist was moved by the spectacle of the old man's heroism, as well as by his magnificent vision of a new Italy. Whatever the source of his inspiration, the artist became more deeply involved as the work proceeded. The first section of the ceiling to be undertaken—populated by relatively small scale, neatly drawn figures and comprising the Noah scenes and the flanking prophets, sibyls, and spandrels—is relatively timid in handling. The grandeur of the ideas and the heroic postures of the figures seem to be held in check by the very precision of the sculptor's linear drawing. In its panoramic view filled with tightly drawn figures resembling sculptural groups, the Deluge (fig. 514), first of the larger scenes, suggests what must have been the original appearance of the Bat-

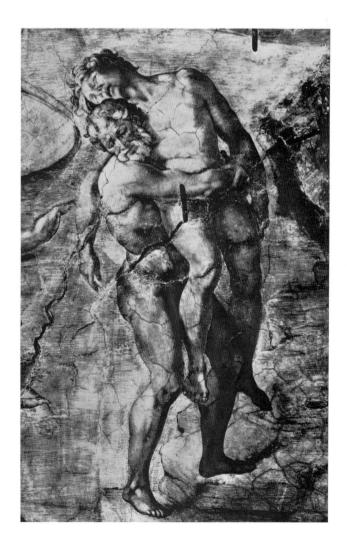

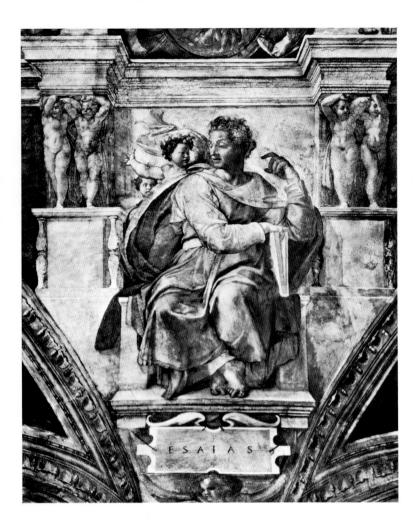

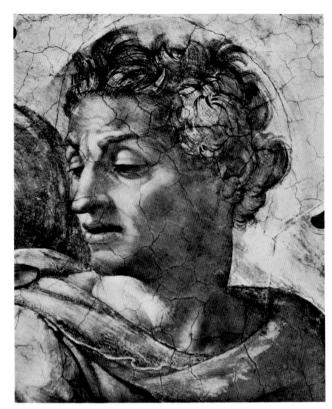

left: 516. MICHELANGELO. *Prophet Isaiah*, Sistine Ceiling. 1509–10

above: 517. Head of Prophet Isaiah, detail of fig. 516

tle of Cascina (see fig. 479). Despite the excellence of the individual figures and the dramatic power of the conception, the composition is somewhat scattered as compared with the unity of the later scenes.

The deluge is depicted at a moment when only two rocks remain above the rising waters. On one stands a withered tree, on the other a green tree (largely destroyed in an explosion in 1797), which recall Christ's words when led to Calvary: "If they do these things in a green tree, what shall be done in the dry?" The implied reference to the Tree of Life and the Tree of Knowledge (see the discussion of Piero della Francesca's Resurrection and the True Cross frescoes, in Chapter 11) gives meaning to the groups of helpless men, women, and children struggling to save themselves and their household goods from the waters. In the center the Ark, which prefigures the Cross as an instrument of salvation, moves rapidly into the distance. The scene is filled with beautiful bits of observation, none more moving than the father who holds in his arms the body of his drowned son (fig. 515). Michelangelo's precision is carried even to the sympathetic treatment of homely benches and pots, in the midst of this cosmic disaster.

One of the finest of the prophet figures in the first half of the ceiling is *Isaiah* (fig. 516), seen as relatively youthful though gray-haired, with a poet's face ravaged by profound thought (fig. 517). He is, of course, the prophet of the Virgin Birth and of the Passion, of the rod out of the stem of Jesse, and of the branch out of his roots. Wrapped in bitter meditation, Isaiah closes his book and turns in a majestic movement, about to drop his left hand on which his head had apparently been propped, as he listens to one of his accompanying putti (each of the prophets and sibyls has two attendant figures, who exhort or inspire). He turns his face from the *Deluge* (above and to his left); the Lord had promised him, "For as I have sworn that the waters of Noah should no more go over the earth; so have I sworn that I would not be wroth with thee."

After the first section of the ceiling was completed in September 1510, the planks of the scaffolding were removed, and Michelangelo had his first chance to see how the work looked from the floor. Even within the first section, we can see that his style was changing as he worked and that the figures were growing in size and breadth. The second section expands still further the newly discovered scale. The Temptation and Expulsion had always been depicted separately, as by Masaccio and Masolino in the Brancacci Chapel (see figs. 196, 197). In his *Fall of Man* (fig. 518) Michelangelo has united the subjects by means of the huge tree that almost fills the scene from side to side and echoes the shape of the Della

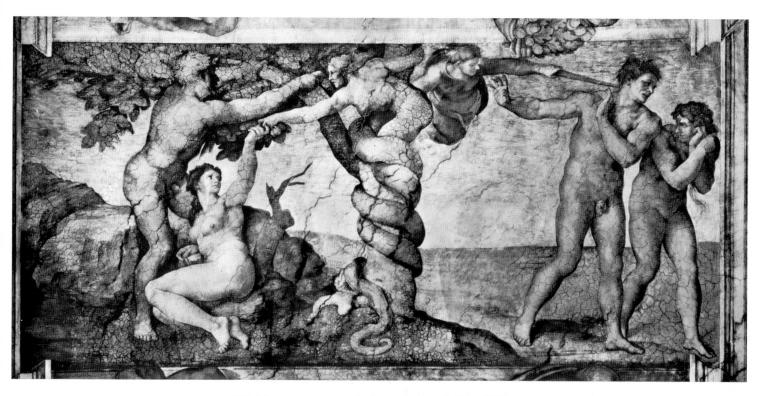

518. MICHELANGELO. Fall of Man, Sistine Ceiling. 1510.

Rovere tree on the marble barrier. In a single overarching shape, the crime leads to its punishment. The tempting Satan and the avenging angel function as branches. On the left the Tree of Knowledge is a fig tree; on the right it appears to be a Della Rovere oak, due to the leaves hanging into the scene from one of the nudes. Vigerio described the Temptation as an antitype of the Last Supper, and the fruit of the Tree of Knowledge as an opposite to the Eucharist, fruit of the Tree of Life. He tells us how Adam "turned his eyes from the morning light which is God, and gave himself over to the fickle and dark desires of the woman," which is exactly what is happening in the fresco

For the first time Michelangelo's figures fill the entire foreground space and are scaled to harmonize with the surrounding nudes. The swelling movement is so ample as to dissolve the formerly polished surface of his anatomies in a rich play of shapes and tones. Foreshortened masses and features appear in a manner that will be more fully exploited in the later scenes. The expressive depth has also increased greatly. In no earlier works do we find any face approaching in anguished intensity of feeling that of the expelled Adam. The right half of the scene is a deliberate commentary on Masaccio and Jacopo della Quercia (see fig. 180) — their separate scenes brought within the concept of High Renaissance harmony and compositional logic.

Cumaea (fig. 519), immensely old, incredibly muscular, is enthroned directly above the spot where originally stood the marble barrier that separated the section of the chapel reserved for the papal court, ambassadors, and other favored political and religious figures from that to

which outsiders were admitted. Turning her wrinkled face toward the altar (fig. 520), from which all figures outside the scenes are illuminated, she reads a book while her attendants hold another. Beautiful in her youth, she was loved by Apollo, who granted her as many years as the grains of sand she held in her hand but, when she refused him, doomed her to look her age. She is the sibyl of the Roman Mysteries because her Sibylline Books were believed to be preserved on the Capitoline Hill, and she symbolizes therefore the age and strength of the Roman Church. Her attendants, recalling the Child of the Bruges Madonna, look gently down on the weather-beaten buttresses of the aged face and the herculean left arm, foretelling in its superhuman might the famous arm of the Moses. Michelangelo placed the Cumaean Sibyl next to the scene of the creation of Eve from Adam's side (fig. 521), which Vigerio, following long tradition, compared to the creation of the Church from the side of Christ. The Lord, visible for the first time in the Sistine Ceiling, stands on the ground, his eyes averted, his heaven-mantle wrapped about him. In all five representations of the Lord, this mantle is violet, the color of priestly vestments and altar decorations during the penitential seasons of Advent and Lent. As Adam sleeps, the tree above him is made to suggest the form of a cross. These massive volumes, recalling Masaccio in their bulk and even in their free pictorial surface, hardly prepare us for our sudden flight into the heavens once the marble barrier is passed.

Until the current restoration of the ceiling is finished, it is premature to make pronouncements about the chronology, but it appears that these two scenes and their

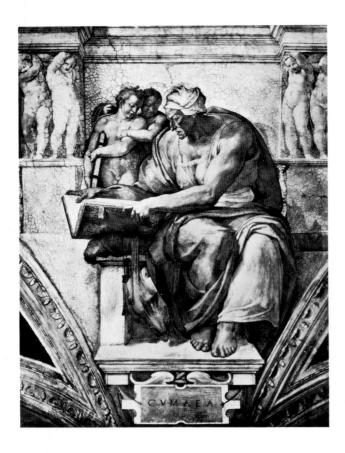

attendant prophet and sibyl must date to the autumn of 1510 and the return of the pope to Rome the following summer, his armies routed, and the city awaiting the attack of the French that never materialized. On August 14, 1511, the eve of the Assumption of the Virgin, the pope attended the first Mass in the chapel after the planking had been removed for the second time. In the final section of the ceiling, concomitant with the revival of the papal hopes and the triumph of his armies,

with Swiss help, both form and spirit change beyond recognition. The first thing we notice is a sharp increase in the scale of the figures. The prophets and the sibyls, who have empty space around them in the first section of the ceiling and fill their thrones in the second, now overflow them. The very footstools have to sink and the surrounding ornament to give way under these figures, now nearly half again larger than their predecessors. Fewer, more colossal figures in the scenes create simple patterns of

above left: 519. MICHELANGELO. Cumaean Sibyl, Sistine Ceiling. 1510

above right: 520. Head of Cumaean Sibyl, detail of fig. 519

left: 521.
MICHELANGELO.
Creation of Eve,
Sistine Ceiling. 1510

terrible beauty, or move into depth within frames now too small to hold them. God himself, absent from the first four scenes, standing on earth in the *Creation of Eve*, now floats through the heavens in all of the last four scenes, and we with him.

Of all the images that crowd the immense complex of the ceiling, the Creation of Adam (fig. 522) is the one that has most deeply impressed posterity. Here we are given a single, overwhelming vision of the sublimity of God and the potential nobility of man, unprecedented and unrivaled in the entire history of visual art. Borne aloft in his wide-floating mantle bursting with the forms of wingless angels, the Lord moves before us, his calm gaze accompanying and reinforcing the movement of his mighty arm. He extends his forefinger, about to touch that of Adam, whose name means "earth," and who reclines on the barren coast of earth, barely able as yet to lift his hand. The divine form is convex, explosive, paternal; the human is concave, receptive, and conspicuously impotent. All the pomp and splendor of customary depictions of the Almighty have vanished. The Lord is garbed only in a short tunic, which reveals the power of his body and limbs. Even Michelangelo's precise depiction of muscles, veins, wrinkles, fingernails, and gray hair does not reduce the universality of this celestial apparition (fig. 523), which radiates a power so immense as to seem a fitting embodiment of such a modern idea as cosmic en-

above: 522. MICHELANGELO. Creation of Adam, Sistine Ceiling. 1511–12

below: 523. Head of the Lord, detail of fig. 522

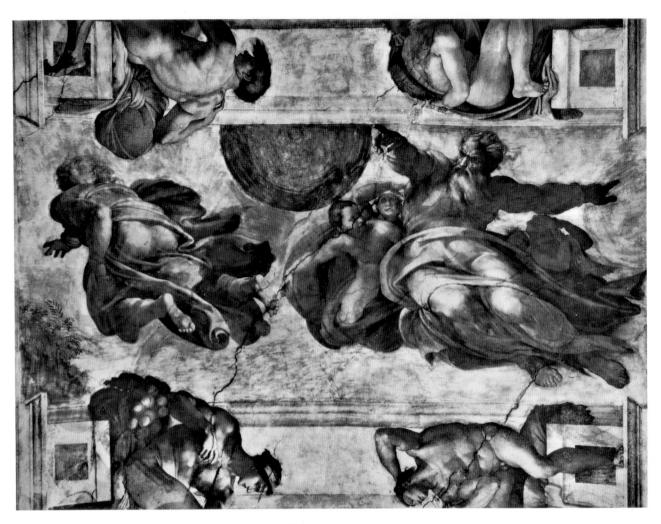

524. MICHELANGELO. Creation of Sun, Moon, and Plants, Sistine Ceiling. 1511-12

ergy. Love and longing stream from the silent face of Adam toward the Omnipotent, who is about to give him life and strength. In the breadth and nobility of the proportions, in the pulsation of the forms and the flow of their contours, above all in the intensity of feeling that moves through every plane, Adam is one of the most beautiful human figures ever imagined. A century of Early Renaissance research into the nature and possibilities of human anatomy seems in retrospect to lead to this single, unrecapturable moment, in which all the pride of pagan antiquity in the glory of the body, all the yearning of Christianity for the spirit have reached a mysterious and perfect harmony.

The incipient, infecundating contact about to take place between the two index fingers has often been described as a spark or current, an electrical metaphor foreign to the sixteenth century but natural enough considering the river of celestial life surrounding the Lord and ready to flow into the strengthless, waiting body. Michelangelo's new image symbolizes, rather, the instillation of divine power in humanity, which took place at the Incarnation. Given Vigerio's repeated insistence on the doctrine of the two Adams, and the position of the scene immediately after the barrier to the sanctu-

ary, a spot customarily reserved for the Annunciation, one recalls Isaiah's prophecy of the Incarnation:

Who hath believed our report? and to whom is the arm of the Lord revealed? For he shall grow up before him as a tender plant, and as a root out of a dry ground....

The mighty right arm of the Lord is revealed, naked as in no other of his appearances in art prior to this time, or even elsewhere on the ceiling. And directly below Adam, the arm of the veiled youth above the Persian Sibyl projects into the scene, coming as close to touching Adam's thigh as the Creator does his finger. This hand holds a cornucopia bursting with Della Rovere leaves and acorns, appearing to grow from the dry ground. But the final explanation of the content of the Creation of Adam lies in the third and fourth stanzas of the hymn Veni Creator Spiritus, which Charles Seymour (see Bibliography) brought forth in this connection, since the Mass of the Holy Spirit was sung in the Chapel at the morning vote of each conclave for the election of a pope, and this very hymn before the afternoon vote. The author's literal translation discloses a strikingly close relation of text to image:

Thou, sevenfold in thy gifts,
Finger of the paternal right hand,
Thou, duly promised of the Father
Enriching our throats with the word,
Let thy light inflame our senses,
Pour thy love into our hearts,
Strengthen us infirm of body
Forever with thy manly vigor...

So is explained in terms of divine guidance for the papacy not only the outpouring of love into the heart of Adam but the impotence of his body until the Lord fills it with manhood. The Della Rovere acorns (*glandes*) are, as the author pointed out in 1950, visually compared with the genitals of the nudes. In High Renaissance Rome such explicit symbolism was considered neither indecent nor irreverent, in contrast to the Florence of Soderini, which required a girdle for the *David*.

Never was the "melodious line" of Michelangelo more beautiful than in this scene, for which a surprising number of life studies still exist. They are splendid drawings, but they show that the miraculous power and perfection of Michelangelo's figures were derived from his own imagination. Muscles that in the live model were knotted and awkward are transfigured in the fresco by the force that flows through them, as well as by the inner logic of the lines, which relates profiles on opposite sides of a single limb to each other like intertwined subjects in a polyphonic composition.

The final large scene depicts two incidents in one, the *Creation of Sun, Moon, and Plants* (fig. 524). In a simple cruciform gesture, the Lord, sweeping through the heavens attended by four angelic figures, points—and the sun and moon spring into being. According to the account in Genesis, this event occurred on the fourth day. Michelangelo has shown at the left the Lord, from the back, stretching forth his hand on the third day to call plant life from the earth. In an Augustinian interpretation of the ceiling Esther Gordon Dotson has called attention to St. Augustine's quotation of the words of the Lord to Moses (Exodus 33:22–23):

And when my glory shall pass, I will set thee in a hole of the rock, and protect thee with my right hand until I pass:

And I will take away my hand, and thou shalt see my back parts: but my face thou canst not see.

Michelangelo has represented the Creator exactly according to these lines, hidden face, right hand, back parts, and all. The scene is also placed directly over Botticelli's fresco of the Youth of Moses, and the throne of the Della Rovere pope.

The wide-flung arms culminating in sun and moon remind one that these luminaries, darkened at the Crucifixion, were customarily represented at either hand of the Crucified, for at this moment the veil of the Temple was rent in twain. The composition is dominated by a conspicuous rip between the two ragged heaven-mantles of the Creator, which in Michelangelo's other images of the Creator surround him in broad circles. At the left, one looks in vain among the plants growing up at the Lord's command for a tree capable of "yielding fruit after its kind," until the eye falls on the leaves and fruit of the Della Rovere oak tree invading the field at the lower left from one of the nudes outside, but read in a continuous line with the other plants.

After the relative restraint of the preceding scenes, the violence of the Creation of Sun, Moon, and Plants comes as a shock. On the right the Lord hurtles toward us in space, but as swiftly moves away again. The awesome expression of his countenance and the force of the volumes combine to raise the image to a new plane of grandeur. The sun and moon whirl, but half out of the space of the picture. All the masses are now foreshortened in depth according to the new and final style. Vasari wrote in wonder that the Lord's right arm could be inscribed within a square, yet seemed completely projected in depth. And the whole group is so huge that, if brought to the foreground plane, it could not be contained within the frame. A new pictorial freedom accompanies this new expressive depth. Broad sweeps of the brush indicate torrents of beard and hair, from which a few wisps escape and dissolve into air. Line is still operative, as always in Michelangelo, and very powerful, but it has lost much of its precision and is no longer the sole means for creating volume.

The last scene, the first in time, brings the *Separation of Light from Darkness* (fig. 525) directly over the altar on which Mass was celebrated, and now even the point of view changes. For the only time in the entire ceiling, one of the scenes is presented as if viewed from below. With his arms raised like those of the priest at the Consecration of the Host, the Lord shows his plan for human salvation as preexistent from the moment in which he separated the light from the darkness. This vision of the archetypal message of Catholic Christianity is illuminated in Vigerio's *Christian Decachord* by a dialogue across the ages between Moses and St. John the Evangelist, the Alpha and the Omega of the Scriptures:

Moses: In the beginning God created the heavens and the earth.

John: In the beginning was the Word.

Moses: The earth was without form and void.

John: The Word was with God and the Word was God

Moses: Darkness was on the face of the abyss. *John*: In Him was life and the life was the light of men, and the light shineth in darkness.

Moses: The Spirit of God floated over the waters. *John*: And the Word was made flesh.

In the words of the Gospel of St. John, repeated until

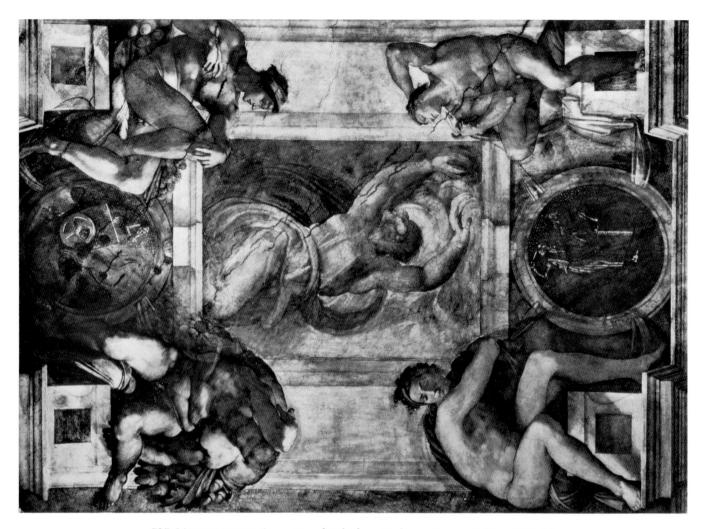

525. MICHELANGELO. Separation of Light from Darkness, Sistine Ceiling. 1511-12

recently after every Mass, Moses (on the left wall of the chapel) is united with Christ (on the right) through the Christian revelation of the meaning of Moses' words. The message of the entire pictorial cycle of the chapel, ceiling and walls, culminates as it should above the altar, where takes place the sacrifice of the Eucharist, fruit of the Tree of Life. Above us the Creator moves beyond the frame, in the same direction as the ribs of the vault, his face turned from us so that it is seen only from below, his shape still obscure, upholding like Atlas the very weight of the heavens as he floats.

The *Libyan Sibyl* (fig. 526), last of her line, has stripped off her outer garments, which lie against the back of her throne, and turns in a superb contrapposto movement to close her book and replace it on its desk while she looks downward at the altar, ready to step from her throne. Scroll under arm, one of her attendant putti points to her as both putti depart. She has no need of book or scroll; her whole being is absorbed in the ultimate reality on the altar. One of the finest surviving nude studies for the Sistine Ceiling, the red chalk drawing in the Metropolitan Museum of Art in New York (fig. 527), shows that, like all the female figures on the ceiling, Libyca was done from a male model. In the final painting

Michelangelo has softened the harsh rack of male bone and muscle with a smooth veil of adipose tissue. At the lower left-hand corner of the study, he repeated the face, apparently in an effort to transform the commonplace features of his male model into the Hellenic beauty of a sibyl. Michelangelo has also analyzed repeatedly with great care the structure of the crucial foot and hand, which bear enormous weights. In the fresco these vital fulcra are sharply defined and illuminated, as all the masses of book, drapery, and body are brought to bear upon them.

The twenty nude youths, glorying in their beauty and power, may appear at first sight out of place in a Christian chapel, the more so in that most of their poses are drawn from pagan prototypes well known to the Renaissance. There is, however, a long tradition for nudity in Christian art: all souls are naked before God and are so depicted in the Last Judgment (Signorelli, for instance; see figs. 489, 490). The youths are obvious descendants of the five who appeared a few years earlier in the background of Michelangelo's *Doni Madonna* (see colorplate 69). Their function in the ceiling—upholding not only the medallions, most of which depict biblical scenes from Kings, but also garlands of Della Rovere leaves now

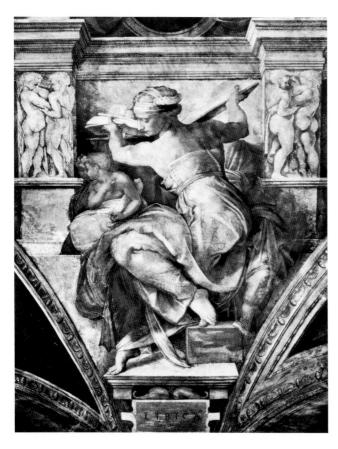

526. MICHELANGELO. *Libyan Sibyl*, Sistine Ceiling. 1511–12

Throughout the twenty nudes runs a surprising variety of types, movements, poses, and expressions, often responding to the scenes they flank. The nobility of their forms, the melodious course of their contours, and the light shining on adolescent skin reflect in smaller scale the quality of Adam in the *Creation of Adam*. One of the finest is the heroic youth reclining in serene strength above *Jeremiah* (visible at the upper left of fig. 525), his right hand gently touching his breast as if he were repeating the communicant's phrase, "Domine, non sum dignus" (Lord, I am not worthy), and while the broad masses of his frame balance each other in perfect equilibrium, his wide-open eyes gaze calmly into the abyss where the Lord divides the light from the darkness.

527. MICHELANGELO. Study for Libyan Sibyl. 1511. Red chalk, 11\% \times 8\sqrt{2}". The Metropolitan Museum of Art, New York

The spandrels at the four corners of the chapel were painted together with the adjacent sections of the ceiling. There is, therefore, a strong discrepancy in style between the first two, fairly timid in composition, and the powerful masses and drastic foreshortenings of the second two, which date from the final campaign. All four represent scenes from the Old Testament that prefigure the coming of the Savior through violence and death. Through the words of Christ himself, the Brazen Serpent (fig. 528) foreshadows the Crucifixion: "Even as Moses lifted up the brazen serpent in the wilderness, so shall the Son of man be lifted up." At the left of the spandrel the young Moses lifts a woman's hand to the thaumaturgic image, strongly suggestive of the serpent that winds around the tree in the Fall of Man (see fig. 518), much as Adam lifts his hand toward the life-giving Creator. On the right those who have not yet beheld the serpent of brass writhe in a fantastic tangle of arms, legs, and painracked bodies, seen from below in unheard-of foreshortenings. Never had figures been so treated, not even at the most extreme moment of the so-called Hellenistic Baroque style. The Mannerist painters of the late sixteenth century and the great Venetian Tintoretto were to draw continuing lessons from the extraordinary freedom of

right: 528. MICHELANGELO. Brazen Serpent, spandrel of Sistine Ceiling. 1512

below: 529. MICHELANGELO. Ruth, Obed, and Boaz, lunette of Sistine Ceiling. 1512. (Salmon in vault above)

this composition, in which ground and background, up and down, in fact all the relationships of everyday existence are dissolved by the storm of shapes.

It is now clear that Michelangelo painted the sixteen lunettes containing the forty generations of the ancestry of Christ neither in a single campaign at the very end, nor immediately after the scenes, prophets, and sibyls in the vault directly above them, but in groups corresponding to the campaigns of 1508-10, 1510-11, and 1511-12, once that entire section of the vault had been completed. He devised a special scaffolding for the purpose, a design for which, containing also a sketch for the Creation of Adam, was published by the author. Probably this scaffolding was hung from the central scaffolding and could be moved from bay to bay as the artist worked. The names of the ancestors, as we have seen (see page 494), were translated into Latin and interpreted by means of symbolic texts from the Bible. For example, Ruth (fig. 529) clasps the sleeping Obed in her arms, his swaddling clothes suggesting grave wrappings. Obed ("serving") was connected with the text, "Who being in the form of God...took upon himself the form of a servant...he humbled himself, and became obedient unto death, even the death of the cross." Ruth's husband, Boaz, a bent old man, gazes at the caricature of his head on the staff he holds. His name means "in him is wood" or "in fortitude." (It will be seen that Raphael's Fortitude in the Stanza della Segnatura grasps the trunk of a Della Rovere tree; see fig. 538.) Wood is robur in Latin, a form close to Rovere; the lunette is located both below the Creation of Sun, Moon, and Plants, which foretells the Cross, and above the scene of the Burning Bush in Botticelli's Youth of Moses (see fig. 342), as well as above the very throne of the aged pope, whom the terrible old man with his jutting beard, at the right in the lunette, undeniably resembles. Apparently, Michelangelo concealed here a caricature of his powerful patron. The relaxed style and the often ironic and bitter content of these last lunettes have provoked many comparisons to Daumier.

Michelangelo painted all the lunettes at breakneck speed, directly on the wall without the aid of cartoons. The earlier ones were done in two days apiece, one day for each group of figures (if the adults stood erect they would be nine feet high!). Those in the second half of the chapel, beyond the barrier, Michelangelo brushed in even more rapidly, working against a deadline, generally painting an entire lunette in a single working day, omitting the ornamentation of the earlier group to save time.

The current restoration is freeing Michelangelo's surfaces from successive layers of lamp, candle, and incense smoke and a coating of animal glue and even Greek wine added in the eighteenth century to brighten things up; when this layer darkened with time, another campaign resorted to extensive repainting. How sloppy was the application of glue is evident in the *Fall of Man* (see fig. 518), where the huge sponge used to coat the fresco has

hit the right leg of the standing Adam and missed his flank, and in two uneven strokes has covered Eve's profile and the back of her head at the left, leaving a pale streak running from her forehead down into her neck.

At the time of this revision, all the lunettes and the Noah scenes with their attendant prophets and sibyls have been released from the straitjacket of later accretions, and work has commenced on the Fall of Man. The astonishing results have banished forever our conceptions of a grayed-down, marbly Michelangelo-based entirely on the layers of smoke, dust, and glue through which one had to look. The colors are, if anything, even more brilliant than those of the Doni Madonna (see colorplate 69). Stripped of what were in effect scuba suits of dirt, the nudes glow with strong flesh colors, and are more delicately modeled than had been thought possible. The drapery vibrates with electric contrasts of hue and much iridescence, creating effects of startling vivacity. Isaiah, for example (see fig. 516), wears a tunic of a clear rose color, a blue cloak with a brilliant green lining, and an underskirt and sleeves of changing tones of gray, vellow, and lavender. Two of the earlier lunettes (colorplates 72, 73) display this newly discovered and sometimes dissonant chromatic intensity. In the Eleazar and Matthan lunette (colorplate 72) the cinnamon-red cloak of the graceful, pensive young Matthan is scarcely more surprising than the brilliant orange and green iridescence of the tight-fitting hose that clothe his smoothly contoured legs. Cinnamon and green compete in the garments of Eleazar's wife, while in the Azor and Sadoc lunette (colorplate 73) the clear light rose of the garment of Azor's mother competes with the bright green of Sadoc's sleeve and the lemon-yellow of his cloak. Even the formerly monochromatic architectural enframement is now visible in at least three different hues-pale gray with a faint admixture of green for all the moldings and cornices, creamy white for the pedestals and the flat slabs behind the prophets and sibyls, and soft lilac for the background and trim of the lunettes; only the latter was faintly perceptible before restoration. These new revelations will necessitate some rethinking of our attitude to the coloring of the Mannerists of the following decade.

Sadoc, his sad face furrowed by troubling thoughts, turns toward us and gazes downward, burying his bearded chin in his hand. His name is translated "justified," and the biblical text used to interpret it is Isaiah 53:11, "By his knowledge shall this my just servant justify many, and he shall bear their iniquities." Sadoc has a more personal meaning for us as well; he is a self-portrait of Michelangelo, who, ravaged at thirty-four by the labors of the ceiling, wrote to his brother Buonarroto in Florence on October 17, 1509, "I am here in great suffering and the greatest physical labor, and I have no friends of any kind and I want none." On All Saints' Eve of 1512, after four and a half years of burning creativity and

530. MICHELANGELO. Tomb of Pope Julius II. Reconstruction drawing of project of 1513

crushing stress, the chapel was reopened to an awestruck public.

After the death of Julius in February 1513, Michelangelo returned to the abandoned project of the tomb, now a necessity. Many of the stones, deserted all this time in the Piazza San Pietro, had "gone bad" (Michelangelo's phrase). Some had even been stolen. Julius' heirs no longer wanted a freestanding tomb, possibly because they were not sure whether under a new pope it could still be placed in St. Peter's. One of the original rejected designs was revived, and about this we know a good deal, from drawings and from the contract. The tomb was to be connected with the wall of the church on one side (fig. 530). The burial chamber was gone; the pope was to be interred in a sarcophagus on the second story and was to be shown either lifted from it or lowered into it by angels. Doubtless this was to utilize the same block ordered earlier, and possibly even the pose designed earlier for the recumbent statue in the burial chamber. Above, in a lofty niche, was to stand the Virgin, floating as if in a vision, holding the Christ Child in her arms, recalling Fra Bartolommeo's Vision of St. Bernard (see fig. 486). There were to be standing saints in other niches, but the rest was to have looked largely as in the 1505 project, save that the Victories would be reduced to six and the Captives to twelve, and the space intended for the door to the burial chamber would be filled with a relief.

Although Michelangelo worked at great speed for three years to advance the tomb, only three of the statues were brought even close to completion: the world-famous Moses (fig. 531), now actually in place on the reduced version of the project dedicated in 1545 (see fig. 693), and two Captives, for which there was no longer any room and which in consequence Michelangelo gave away, the so-called Dying Slave (fig. 532) and the Rebellious Slave (fig. 533). Moses was to have occupied a corner position on the second story, and therefore would have been seen sharply from below. The reader fortunate enough to see the original should attempt to view it from a crouching position. The torso is unusually long because of the necessity of seeing it from below. Moses, of course, has not just come down from Mount Sinai, as the tourist is told, nor is he angry at the Israelites for worshiping the Golden Calf. If Michelangelo had intended any such meaning, he would have represented Sinai, the Israelites, and the Golden Calf. Moses holds the Tables of the Law and looks outward, not in anger but with prophetic inspiration, as the man who on Sinai saw and talked with the Lord. Like the David (see fig. 477), the statue is symbolic rather than anecdotal. The horns on Moses' brow are, of course, the horns generally shown there in Christian art, through a possibly deliberate mistranslation of the original Hebrew word for "shining," used in Exodus to describe Moses' face the second time he came down from Sinai (see page 327). At the time of the Golden Calf episode, Moses' countenance did not yet display either horns or light.

The mighty figure is closely related to some of the most powerful prophets and sibyls on the Sistine Ceiling. The magnificent left arm repeats almost exactly the muscular left arm of the Cumaean Sibyl (see fig. 519). The face, disturbed by the fire and thunder of the mountaintop revelation, is derived directly from Michelangelo's own face-to-face colloquies with the Almighty, especially in the Creation of Sun, Moon, and Plants (see fig. 524). The immense vitality of the lawgiver and precursor of Christ is expressed in the increase in the volume of drapery, as in the mantle boiling over the right knee, and in what is probably the most spectacular beard in the history of human imagination. This cataract tumbles in irresistible waves, billows, and freshets from the prophet's cheeks and chin down over his deep chest. While the bulk of the locks are pulled aside by the index finger and second finger of the right hand, they almost join the loose lock, then arrive in the gigantic lap, hidden behind the left hand.

Michelangelo is known to have made detailed scale models for his earlier statues, and one for the *Moses* was surely seen by Raphael as early as 1511 (see page 511). But the bulk of the carving must have been done in 1513–16. In a letter of 1542, Michelangelo mentions the *Moses* as almost finished, although he may have done some more work on the face just before the statue was

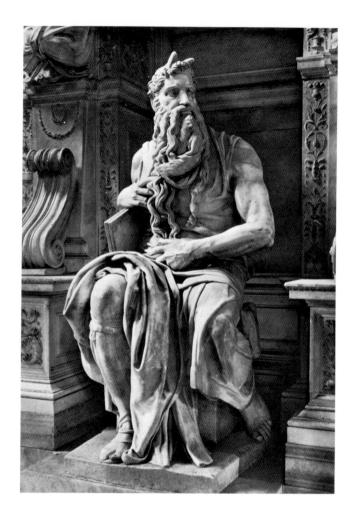

placed on the tomb. Certainly, the movement of planes and rich softness of surfaces are very unlike the tight, hard precision of Michelangelo's earlier sculptural style. Perhaps this was due to his intervening experience as a painter.

The two Captives in the Louvre may have been intended for positions on either side of a corner culminating in the *Moses* on the second story, and have been so indicated in this reconstruction (see fig. 530).

The Dying Slave (fig. 532) is, of course, not dying, but simply overpowered by the bonds against which he plucks idly, as if he were drowsy, overcome by the stupefying effects of a potion. His tall figure seems ready to collapse, or rather to sink slowly downward. During the period when this statue must have been worked on, and during the ensuing decade or so, Michelangelo often drew figures almost or even entirely without contours, resorting only to shading in leadpoint to indicate the rhythmic swelling and subsidence of this ocean of turbulent life. Here, throughout the back and left arm, in the belly and the beautifully rendered flank, this pulsation reaches a new peak of intensity. The legs and the feet are delicately handled, down to the last silken passage of skin around a thigh or calf, and the faintest change in the pressure of toes and the tension of ligaments. Contour still operates throughout the body, sweeping along with the roll of the intervening volumes. One wonders, in view of the contrast between the absolute finish of the

left: 531. MICHELANGELO.

Moses. 1513–16;
1542–45. Marble, height 7'8½".
S. Pietro in Vincoli, Rome

right: 532. MICHELANGELO. Dying Slave. 1505–6; 1513–16. Marble, height 7'6". The Louvre, Paris

far right: 533. MICHELANGELO. Rebellious Slave. 1513–16. Marble, height 7'5%". The Louvre, Paris

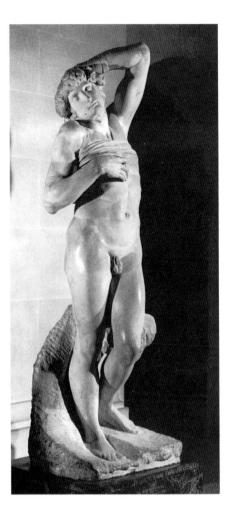

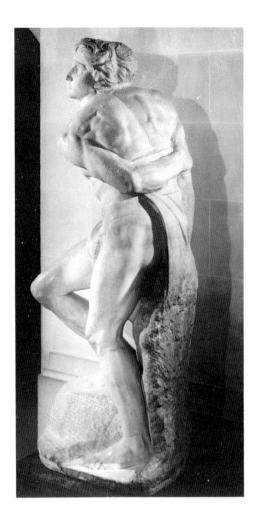

legs and the rough stone next them, whether the artist did not intend to carve jagged rocks, as in the *Bruges Madonna* and the *David* (see figs. 475, 477).

The Dying Slave may have been blocked out in 1505-6, and Raphael surely studied the model for it in 1510 (see page 511). Seething with hopeless rage, the Rebellious Slave (fig. 533) struggles against the slender bands tying back the immense torso, the powerful arm, and the heaving masses of bone and muscle that comprise the back. Although in a sense prefigured by some of the most massive nudes in the latest section of the Sistine Ceiling, this being comes from another race. He is crushed, tormented, anguished, and his forms have lost the resiliency of youth. The face, unfinished and also badly cracked, seems to have held less interest for the artist than the body. With its backward twist and rolling eyes, it suggests the agonized Laocoön, but the mouth is closed. Some of the drill marks are visible at the roots of the hair and among the locks. The crisscrossing sweeps of the three-toothed chisel, employed almost like a brush, are worlds apart from the neat, engraverlike hatching of the Taddei Madonna (see fig. 476). The muscles are no longer individually defined and separated, but flow together in a tide that even obliterates the boundaries between leg and torso, or torso and arm. It is as if the figure were formed from some primal bioplasm, pulsating with human life, but not yet functionally differentiated.

Previous interpretations of the meaning of the 1505

project for the Tomb of Julius II (see fig. 510) present it as an ascension from a life of misery and struggle on earth through a severely abridged succession of Neoplatonic realms to the ultimate perfection of the pope's translation to a heavenly existence at the summit. This view would seem to suffer if no statue were to have been placed at the top; as we have seen, there is no evidence that one was to go there. An even worse blow is the probability that the 1513 project (see fig. 530), culminating in the vision of the Virgin and Child flanked by saints, depends on an alternative design presented by Michelangelo in 1505. Insofar as we know, Julius II never showed much interest in either Neoplatonism or its advocates but was passionately concerned about the papacy and his own messianic role. During his thirty-two years as cardinal of San Pietro in Vincoli (St. Peter in Bonds), Julius had been known by the name of his church, as contemporary panegyrics and lampoons constantly remind us. The tomb itself was eventually erected in San Pietro in Vincoli, and, as we will see, Raphael made St. Peter in his Liberation of St. Peter from Prison (see fig. 541) a recognizable portrait of Julius. The Introit of the Mass of St. Peter in Bonds contains the verse from the 138th Psalm (the 139th in Protestant Bibles),

> Lord, thou hast proved me, and known me: Thou hast known my sitting down and my rising up.

The Latin sentence says "my resurrection," and that is what we were intended to see-dimly through the tomb's chamber door in 1505, triumphant on the second story in 1513: the resurrection of the pope, like St. Peter, from the earthly prison to eternity.

The mysterious bound prisoners were called by Vasari, in the 1550 edition of his Lives, the provinces captured by the pope, and by Michelangelo's pupil Ascanio Condivi, the Liberal Arts captive at the pope's death. In his 1568 edition Vasari tried to combine both ideas. In 1505 Julius' captive provinces and his patronage of the arts were both still in the future. Actually, the Mass of St. Peter in Bonds provides an explanation:

O God, Who made the blessed Apostle Peter to go from his bonds absolutely unharmed, absolve us, we pray, from the bonds of our sins, and graciously keep all evil from us.

The prisoners, then, twisting and writhing in their bonds, are held by sin, and by the example of St. Peter they can appeal for deliverance, which takes place in the niches in the shape of the Victories. The herms (termini is the word usually used) are symbols of death, as in the ring and motto of the terminus adopted by the humanist Erasmus as a reminder of death, and to these termini the Captives were bound, only by narrow bands of cloth. The Latin word vincula was translated in the Douai (Roman Catholic) version of the Bible consistently as "bands." It is hard to think of any other explanation for the extraordinary feature that in Michelangelo's Captives has excited so much wonderment on the part of spectators and so little interest from scholars. Both in the 1505 and the 1513 versions, the tomb would have been an unprecedented combination of architecture and sculpture, rich in its surfaces, powerful in its vertical motifs made of struggling figures, imposing in its presentation of Apostle and prophet, compelling in its suggestions of the torment of earthly existence and the heavenly release, transparently simple in its message.

In the unfinished marble behind the Captives in the Louvre, apes can be seen—only lightly roughed in behind the Rebellious Slave but clearly visible and holding a small object alongside the left knee of the Dying Slave. Rival interpretations of these animals as (a) the subhuman tendencies in mankind, characterizing as evil the matter to which the Captives are fettered, or (b) the figurative arts (art the "ape of nature") may both contain an element of truth. The Christian interpretation of the Captives in the bonds of sin and death is not incompatible with the Neoplatonic doctrine of the Lower Soul tied to matter. And Michelangelo may really have meant the apes to suggest—impishly rather than seriously—that the visual arts had died with Julius II, for Leo X gave him for the moment no commissions. But if the figures had been entirely finished the apes would have vanished, as there is no room for them on the pedestals.

RAPHAEL IN ROME

While Michelangelo was at work on the first campaign of the Sistine Ceiling, the young Raphael arrived in Rome, exactly when or why we are not sure. His style soon appealed to the pope, who stopped the work of the more conservative Giovanni Antonio Bazzi called Sodoma and turned over the official decorations of the Vatican apartments (the Stanze, or rooms) to the new representative of High Renaissance classicism. The first to be painted, from 1509 to 1511, was the Stanza della Segnatura, named after the highest papal tribunal, held under the presidency of the pope and requiring his signature. Raphael left Sodoma's ceiling ornamentation intact and merely set up walls of brick in front of the preexisting and perhaps unfinished frescoes, thereby slicing off some of the decorations of the embracing arches. On these curtain walls he painted his own frescoes, which were to set forth the new ideals of Julius' reign and to provide a new amplitude and harmony of space and form. The first of the wall frescoes to be carried out was the Disputa (fig. 534), or Disputation over the Sacrament, in which Raphael expanded the dome shape of the Marriage of the Virgin (see colorplate 70) into an airy architecture composed of clouds and figures. The subject is the most complete exposition of the doctrine of the Eucharist in Christian art. The sacrament is traced from its origin in heaven, where God the Father, Christ, the Virgin, and St. John the Baptist are enthroned among an alternation of saints from the New Testament and patriarchs and prophets from the Old in a majestic semicircle of clouds, while angels fill the golden sky above. Overshadowed by the dove of the Holy Spirit between the Four Gospels carried by child-angels, the Host appears on an earthly altar below, at the center of the perspective, displayed in a shining monstrance.

The rapt tranquillity and perfect peace of the heavenly figures are deliberately contrasted with the active groups of theologians on earth, coming from all parts of Christendom and from all ages and times to vie in learned discussions on the nature of the sacrament. At the left St. Jerome, his head bowed, contemplates the Vulgate, his translation of the Bible, while St. Gregory, a portrait of Julius II before he grew the famous beard, gazes at the revelation upon the altar. Among the figures at the right can be made out Sixtus IV, standing, and Dante. Raphael has endowed all the earthly figures with a new sculptural quality and a new gravity of bearing, as if inspired by the grandeur of the Eternal City. He has set them in an ideal perspective, which, as in Leonardo's Last Supper (see colorplate 67), is no longer the point of view of an actual person standing in front of the fresco but that of a colossus. As a student once noted, such High Renaissance paintings depict not another room but another realm.

While Raphael was painting the Disputa, Michelangelo, only a few score yards away across an intervening

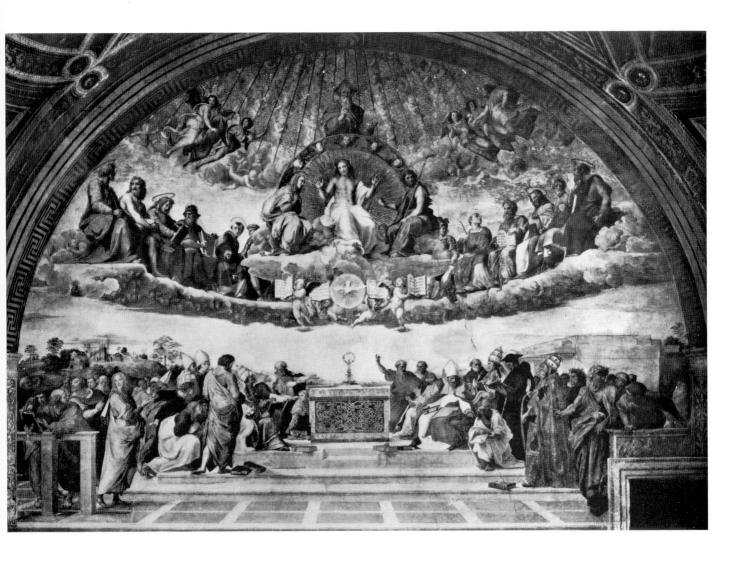

above: 534. RAPHAEL. *Disputa* (*Disputation over the Sacrament*). 1510–11. Fresco. Stanza della Segnatura, Vatican, Rome

below: 535. Angels, detail of fig. 534

court, but behind locked doors, was at work on the Sistine Ceiling. Raphael's new monumental figures are his independent response to the new needs of the High Renaissance. At the apex of the celestial dome (fig. 535), still covered with gold leaf and pitted as in Signorelli's Orvieto frescoes (see fig. 489), cloudy angelic shapes take on substance along glittering, incised rays, and before them soar archangels, their hands linked, their drapery billowing in the golden light. In these, as in the statuesque mortals below, the eye easily follows the spiral axis characteristic of Raphael's figures throughout his career. Their garments continue the spirals in broad airy curves that envelop the angels in a melodic motion, still faintly Botticellian but far more ample and serene.

The medallions inserted by Raphael in the ceiling decorations project a system of knowledge, below which the frescoes of the four walls are organized. Theology, of course, is enthroned above the *Disputa*. Below Philosophy, and facing the *Disputa*, is the latter's counterpart, the so-called *School of Athens* (fig. 536), whose misleading title dates back only to the eighteenth century. The picture, universally recognized as the culmination of the High Renaissance ideal of formal and spatial harmony, was intended to confront the *Disputa*'s theologians of Christianity drawn from all ages with an equally impos-

above: 536. RAPHAEL. School of Athens. 1510–11. Fresco. Stanza della Segnatura, Vatican, Rome

left: 537. Raphael. Fighting Men (study for relief sculpture in School of Athens). 1510–11. Red chalk over leadpoint, 15 \times 11". Ashmolean Museum, Oxford

ing group of philosophers of classical antiquity, likewise engaged in solemn discussion. As in the *Disputa*, the figures are arranged in statuary groups, but now in a circle in depth, like that used by Ghiberti in his *Solomon and the Queen of Sheba* (see fig. 236) and by Fra Angelico in the San Marco altarpiece (see fig. 207). The perspective loses itself at the far edge of the floor of the imagined building.

This is a noble structure, a single story in the Roman Doric order preferred by Bramante, and its grand barrel-vaulted spaces suggest less the obvious prototype in Alberti's Sant'Andrea, which Raphael could not have seen, than Bramante's designs for St. Peter's (see fig. 503). At left and right are niches in which Apollo and Minerva preside over the assemblage. There are, however, strange aspects to this architecture. It is very hard to decipher what kind and what shape of building Raphael intended

538. RAPHAEL. Three Cardinal Virtues: Fortitude, Prudence, and Temperance. 1511. Fresco. Stanza della Segnatura, Vatican, Rome

to represent, and even harder to understand what was intended to hold up the central circular gallery. For it has only two supports, the two barrel vaults; the pendentives, with their circular medallions, end at the sides as if they were turning into walls.

In the center stand Plato and Aristotle, the two greatest philosophers of antiquity. Plato holds the Timaeus in his left hand and points with his right to heaven, the realm whence his ideas radiate to their embodiment in earthly forms, while Aristotle holds the Nichomachean Ethics and points downward to earth as his source for the observation of reality. At the left Socrates can be seen engaging some of the jeunesse dorée of Athens in argument, enumerating particularly cogent points on his fingers as he goes. The old man sprawling on the steps is Diogenes. Others, surrounded by youthful pupils, are recognizable: at the lower left Pythagoras demonstrates his proportion system on a slate; at the extreme right Ptolemy contemplates a celestial globe held before him, and just to the left Euclid bends down to describe a circle on another slate. Euclid is a portrait of Bramante-appropriate considering the latter's concern with geometry. Just behind Ptolemy, Raphael and Sodoma can be seen side by side. (One wonders how much Sodoma, whose frescoes were being covered up, appreciated the compliment.)

A single, lonely, and mysterious man sits in the foreground, his left elbow on a marble block, his head propped on his hand. Oblivious of the others, wrapped in his own thoughts, he writes on a piece of paper before him. Instead of the flowing mantles of the other philosophers and their attendants, this bearded, burly man wears the short, hooded smock and soft boots of a sixteenth-century stonecutter. Significantly enough, he is absent from the still-preserved cartoon for the figures, and is therefore an addition inserted during the process

of painting. This man, whose features are clearly those of Michelangelo, is Raphael's portrait of the great Florentine. Apparently Raphael went into the Sistine Chapel with the rest of Rome in August 1511, experienced the new style with the force of revelation, and returned to pay this prominent tribute to the older master. Perhaps he had actually seen the sculptor sitting dejectedly in the Piazza San Pietro, alongside one of the blocks for the Tomb of Julius II. At any rate, his own style was never again to be quite the same. This very figure shows a mass and power not to be found elsewhere in the School of Athens, nor indeed in Raphael's entire earlier production. The head, torso, and legs of the Apollo to the left above the head of this figure are so obviously based on the Dying Slave that Raphael must have been able to draw at least from Michelangelo's model. And such magnificent drawings as the study of fighting men for the relief below Apollo (fig. 537) show all the knowledge of anatomy and action Raphael had learned from the great sculptor.

At once he put Michelangelo's new discoveries to work in the lunette representing Three Cardinal Virtues: Fortitude, Prudence, and Temperance (fig. 538)—the fourth, Justice, is in the ceiling roundel above. All the amplitude, all the monumentality of the last phase of the Sistine Ceiling are here, but neither the blockiness nor the tension. Raphael has infused his own grace into the grand manner. Form and line sweep with ease from figure to figure, and all the surfaces glow with the fresh, blond tones and silvery light seen throughout the entire room. Fortitude, of course, holds on to a Della Rovere oak tree, and her legs and drapery are derived so directly from those of the Moses as to indicate that again Raphael drew from Michelangelo's model. Prudence, as in Piero's Urbino portrait (see fig. 288), has two faces, one young, looking into a mirror, one old and bearded, looking

left: 539. RAPHAEL. Mass of Bolsena. 1512. Fresco. Stanza d'Eliodoro, Vatican, Rome

opposite: 541.

RAPHAEL.

Liberation of St. Peter from Prison.
1513. Fresco.

Stanza d'Eliodoro,

Vatican, Rome

below: 540.
RAPHAEL. Angelic
Messengers, detail of
Expulsion of
Heliodorus (see
colorplate 74). 1512.
Fresco. Stanza
d'Eliodoro, Vatican,
Rome

backward. *Temperance* displays a splendid bridle, whose long loops continue the curves of the composition.

The classic poise and precision of Raphael's Roman style are already showing signs of giving way to a new, almost Baroque manner in this lunette. This dramatic phase, in turn, comes to its climax in the second of the chambers, the Stanza d'Eliodoro, apparently commissioned by Julius II in August 1511, when he still wore the beard he had grown the preceding winter. As early as February 1512, the pope removed his beard because things were "at a good point." There is, in fact, an early study by Raphael for one of the wall compositions that shows him without it. After the news of the battle of Ravenna, which seemed at first to be a defeat, reached Rome on April 14, 1512, the pope must have grown his beard again. He is shown wearing it in three wall frescoes of the Stanza d'Eliodoro, which could not have been painted between August and cold weather (there is no fireplace in the room), and he is still wearing the beard on Michelangelo's final version of the tomb (see fig. 693). Over one of the windows Raphael painted the Mass of Bolsena (fig. 539), recounting a famous miracle that took place in the year 1263 (see page 119). A Bohemian priest, who could not bring himself to believe in the Real Presence of Christ in the Eucharist, was celebrating Mass when, to his astonishment, the consecrated Host shed drops of real blood in the form of a cross on the corporal (cloth) on which it was resting. The blood-stained corporal, still preserved today as a sacred relic in the Cathedral of Orvieto, was adored by Julius II for a full day during his first conquering march northward in 1506. Apparently, he attributed his easy victories then, and his triumph over the French after Ravenna—the news of which reached him on June 29, 1512—to the intervention of this relic and had himself represented as though present at the original event.

The compositional movement, hampered by an offcenter window, lifts gracefully through the group of

mothers at the lower left to the torch-bearing acolytes, the amazed priests, and the calm pope, now seen in profile with his full beard. A heavier, fuller architecture, with powerful Ionic columns, is glimpsed beyond the curve of the wooden niche behind the altar. Below, at the right, kneel the officers of the Swiss troops who spearheaded Julius' triumph in 1512. In these figures Raphael has achieved superb portraits of forthright military men, whose splendid uniforms of black and yellow are painted with the full coloristic richness of the artist's mature style. Throughout the picture there is a greater breadth of handling than anywhere in the Stanza della Segnatura and a sonority of tone completely new in Raphael's style, dominated by the black and gold of the chasuble (decorated only with Della Rovere leaves) and the crimson of the papal mozzetta.

The fresco after which the second stanza was named depicts the *Expulsion of Heliodorus* (colorplate 74), an incident from the Book of Maccabees. One of the Seleucid monarchs, successors of Alexander the Great, sent his general Heliodorus to carry off the treasure of the Temple in Jerusalem. In the midst of the raid a heavenly rider in armor of gold appeared upon a white charger accompanied by two youths "notable in their strength and beautiful in their glory." They beat the pagan general, who fell blinded before them, dropping the treasure upon the Temple floor. As in the *Mass of Bolsena*, the pope saw a parallel between this event and his own battle to expel from the fold the rebellious cardinals who had followed the command of the king of France in attacking

the papacy. The fully bearded pontiff enters the scene on his *sella gestatoria*; one of the bearers (in the foreground, with the square beard) is Marcantonio Raimondi (1487–1534), whose engravings popularized Raphael's compositions as those of no previous Italian painter had been, and the other is Raphael himself, partly hidden behind the chair and displaying an incipient beard.

Raphael's spirals (see fig. 537) have entered on a new phase of heroic action in the whirlwind group at the right (fig. 540), and have been invested with the weight and muscular power of Michelangelo. The ignominy of the despoiler and the howling rage of his attendants are contrasted with the inspired anger of the celestial messengers, who float just above the pavement, leaving shadows on the marble. Like all riders on rearing horses for the next three centuries, the celestial warrior exhibits the influence of Leonardo's Battle of Anghiari (see fig. 464). The architecture has changed sharply since the School of Athens (see fig. 536); the masses are heavier and more compact, the space more restricted, the movement more powerful. The scene evokes a coloristic response of greater depth and resonance—the vaults of the Temple shine with a deeper golden light; in harmony with the Mass of Bolsena, the color chord is dominated by the splendid reds and blacks of the pope and his entourage, against which the paler tones of the kneeling women form the most delicate of contrasts.

Over the window opening toward the Belvedere and the Vatican Gardens, and facing the Mass of Bolsena, Raphael painted the Liberation of St. Peter from Prison (fig.

left: 542. RAPHAEL. Expulsion of Attila. 1513–14. Fresco. Stanza d'Eliodoro, Vatican. Rome

opposite: 543. RAPHAEL. Sistine Madonna. 1513. Canvas, 8'8½" × 6'5". Gemäldegalerie, Dresden

541), illustrating a passage from the Acts of the Apostles, 12:6–9:

The same night Peter was sleeping between two soldiers, bound by two chains: and the keepers before the door kept the prison. And behold, an angel of the Lord stood by him: and a light shined in the room: and he striking Peter on the side raised him up, saying: Arise quickly. And the chains fell off from his hands.... And going out he followed him, and he knew not that it was true which was done by the angel: but thought he saw a vision.

Under the guise of this miracle, the deliverance of the papacy from the French invader is represented. For when Julius II received the news of his unexpected victory in 1512, he was praying at the Church of San Pietro in Vincoli (St. Peter in Bonds—of which, it will be remembered, he had for so long been cardinal). That night, in a reenactment of the liberation of Peter by the angel of light, Julius led to the Castel Sant'Angelo a procession carrying more torches than Rome had ever seen. But not long after, in 1513, probably while Raphael was painting this fresco, the pope died, and the work took on a new meaning—the liberation of the old warrior from the earthly prison into eternal light.

Raphael's fresco transforms the light of the window into the light of heaven, in keeping with the age-old symbolism of the window as revelation. His prison is a single massive arch built of rusticated stones like those Bramante was using at the time for the new palaces (still today unfinished) designed for the papal administration. The grate through which we look into the interior of the

dungeon was derived from Italo-Byzantine representations of St. John the Baptist in prison, but with a spectacular effect due to Raphael's new understanding of light. And the light effects are everywhere. Rusty clouds drift in front of a waning moon, torches gleam on the armor of the guards, but the light from the angel transcends them all, fills the prison, and shines in the dark streets through which walks the spellbound St. Peter.

The room is completed by one final, dramatic fresco, the Expulsion of Attila (fig. 542). This event took place in the fifth century, when Pope Leo I, unarmed, routed the terrible king of the Huns outside Ravenna through the miraculous intervention of St. Peter and St. Paul. Raphael has set the event instead before the gates of Rome, as an allusion to Julius' expulsion of the French invaders, perhaps even to the deliverance of the papal city from Louis XII, who, in the disastrous summer of 1511, could have taken it easily and did not. The familiar shapes of the constructions on the Palatine Hill, the standing half of the Colosseum, and a Roman aqueduct can be seen in the distance at the left, while, at the right, the advance of the ravaging barbarians is marked by flames in the forest. The seemingly wild confusion of the foreground resolves itself rapidly, as we watch, into a collision between the calm might of heaven at the upper left and the impotent fury of paganism at the right. Riding on his white mule, the pope extends one white-gloved hand, the two saints float above holding their swords, and Attila's horse, checked in mid-career, turns away terrified. The other warriors rear back on their steeds, a wind sweeps over them, the flags fly, the trumpets sound, but the shock of spirit on matter has stalled the advance.

The movement not only of the figures but also of the forms and colors in this epoch-making work has often been described as "Baroque" or "proto-Baroque," and at times we seem almost to be looking at a work by Rubens, who could not have done what he did in the way of battle scenes had it not been for this seething example. It should not be forgotten, however, that this kind of dynamic battle composition had been invented and magnificently drawn by Leonardo in his Battle of Anghiari (see fig. 464). Raphael had already expressed his admiration for Leonardo's rearing horses in his little St. George and the Dragon (see fig. 480). Perhaps his interest in Leonardo's art was revived by the appearance of the master himself in Rome in 1513 while this fresco was being painted. It was completed after the death of Julius II, who should have been seated on the white mule; instead the comfortable figure of Giovanni de' Medici appears twice, once as cardinal at the extreme left, once as Pope Leo X, arrogating to himself the miracle of Leo I.

The old pope was gone, yet Raphael had one more chance to immortalize him. The *Sistine Madonna* (fig. 543), which hung for centuries on the wall behind the high altar of San Sisto at Piacenza in North Italy, may have earlier fulfilled another purpose. It was once suggested that this noble painting, most celebrated of all of Raphael's Madonnas and the first to be painted on canvas, was originally intended as a funeral image, to be hung above the bier of Julius II and then sent to Piacenza simply because the principal church dedicated to St. Six-

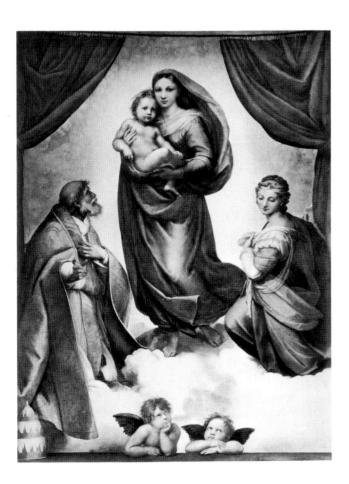

tus, patron saint of the Della Rovere family, was situated there. It has been pointed out, however, that the pope had promised the painting to Piacenza in appreciation for the assistance given to him by that city in his warfare against the French. Nonetheless, the picture assumed a commemorative role. As can be verified by comparison with medals and other portraits beginning with that by Melozzo da Forlì (see fig. 382), Sixtus is an obvious portrait of Julius II, his beard and moustache now shaggy and unkempt as in his last, illness-ridden days, just as we see him in the Liberation of St. Peter. The ornament of his cope is made up largely of oak leaves, and an acorn crowns his tiara, laid on a brown strip of wood on which two disarming putti (very Venetian) lean their elbows as they gaze upward. This wood has been reasonably identified as the lid of Julius' coffin, with the papal tiara placed above his head, as the crown still is today in royal funerals. At the right kneels St. Barbara, gazing downward, an especially appropriate pendant for Julius II since she was the patron saint of men-at-arms. Because she was liberated from a tower (its battlements can be glimpsed between her back and the curtain), she is the patron saint of the hour of our death, above all of a death without the sacraments, and liberation from the earthly prison. Finally, the suddenly parted curtains reveal to us a vision that comes straight from the Salve Regina:

Come thou then, our Advocate, turn upon us thy compassionate eyes, and after this exile show unto us Jesus, the blessed fruit of thy womb. . . .

The loveliest of Raphael's Virgins walks toward us from beyond the stars, holding up her Child for us. Mother and Child look upon us with eyes of unusual size, depth, and luminosity, of calm and perfect understanding. It might be added that Mary's pose as she walks across the clouds is identical with that imagined by Michelangelo, probably as one of the alternates for the accepted design of the Tomb of Julius II in 1505 and certainly for the definitive version in 1513 (see fig. 530). Either the idea of the floating Virgin arose in the pope's mind and was communicated to both artists, or it was invented by Michelangelo in 1505, not long after the completion of Fra Bartolommeo's closely related *Vision of St. Bernard* (see fig. 486), and like so many of Michelangelo's ideas reached Raphael later.

Very naturally this allegory of the pope's entry into Paradise is universally revered as an image of ideal motherhood. In its broad rising and descending curves (so easy to analyze that they have received almost more than their critical due), its subtle balance of masses, its rich tonalities of gold and green, gray and blue, its air of peace and fulfillment, the *Sistine Madonna* is one of Raphael's supreme creations. No one could have predicted at the time of the arrival in Rome of Perugino's facile pupil, fresh from absorbing what he could understand of Leonardo and Michelangelo in Florence, that in a few short

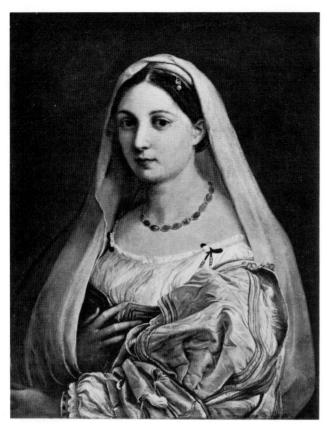

544. RAPHAEL. *Donna Velata* (*Veiled Woman*). c. 1513. Canvas, 33½×23½". Pitti Gallery, Florence

years Raphael of Urbino would earn the rank of a great master, entitled to speak with the full authority of High Renaissance utterance.

As a portraitist Raphael was second to no other Renaissance painter. Whoever she may have been—and it is likely that she was the famous Fornarina ("baker's daughter") recorded by Vasari—the sitter for the socalled Donna Velata (fig. 544) is the same dark-eyed creature Raphael used as a model for the Sistine Madonna. Today it amazes us that this warmest witness to Raphael's enthrallment with feminine beauty should ever have been denied his authorship. Yet it took a passionate defense by the critic Giovanni Morelli in the 1880s to dispel doubts about the authenticity of the portrait. In color this is the richest of all Raphael's portraits, fresh and glowing after its recent cleaning, so much so as to suggest very strongly that the artist had by this time absorbed still another achievement of a school to which he was not born—the colorism of Venice. No trip to the lagoons is recorded for Raphael, but Sebastiano del Piombo (see page 524) had brought to Rome in 1511 a repertory founded on the achievements of the aged Giovanni Bellini; the young, already dead Giorgione; and the still younger but abundantly living Titian. Only by assuming a measure of Venetian influence is it possible to understand not only the rich color chords of the frescoes in the second stanza, but even more the dazzling white-and-gold drapery of this enchanting portrait, the

resonant depth of the dark eyes and chestnut hair, the brilliance of the pale flesh, the soft glow of the stones in the necklace, and the luminous marvel of the pearl hanging from the woman's veil. In its miraculously correct asymmetrical placing, this jewel brings all the other ellipses of the composition into perfect relation with each other.

The portrait of *Baldassare Castiglione* (fig. 545), painted about 1515, is also typical of the moment of perfect balance that Raphael had achieved in Rome. As we have seen (see page 473), Castiglione's *Il libro del cortegiano* expounded and established the qualities to be expected of an ideal gentleman in the High Renaissance. In his cool composure the count, a close friend of the painter, exemplifies the *riposo*, or inner calm, he recommends as one of the essentials of gentlemanly character. The picture has been cut at the bottom, but old copies show it with folded hands in their entirety. If it were complete, the appearance of closed harmony and poise would be even more impressive.

The black, white, and soft gray of the costume embody the elegant sobriety and restraint successfully preached by Castiglione to a society grown weary of the flamboyant colors of late Quattrocento dress. Raphael develops this monochromatic scheme with surprising resonance against the golden gray of the background, warmly reflected in the lights on the richly painted sleeves, all greatly increased in luminosity by the recent cleaning. Rembrandt once tried to acquire this painting at auction. Forced to retire when the bidding went out of his reach, the great Dutch painter never forgot the composition, and twice did his own self-portrait in the pose and style of the Castiglione. There could be no higher tribute to the human depth and coloristic richness of a painting that is seemingly so reserved. Even in the midst of Raphael's maturity and his new-found colorism, the spiral principles of his earliest compositions are still at work and can be easily followed in the masses of the costume and hat and the tilt of the head.

The death of Julius II brought to the papal throne as Leo X a boyhood acquaintance of Michelangelo's, Cardinal Giovanni de' Medici, second son of Lorenzo the Magnificent. Perhaps with strong memories of the young sculptor's behavior in the Palazzo Medici, the new pope, an easy-going, luxury-loving, corpulent man only thirtyeight years old at the time of his election, had little interest in a close association with him now that he had reached maturity and great fame. "È troppo terribile," said the pope; "non si puol pratichare chon lui" (He is too violent; one can't deal with him). The commissions in the Vatican, therefore, went to others, chiefly to Raphael and his increasing entourage. For them Leo provided a relaxed atmosphere that may have been delightful after the stormy trajectory of Julius II but was also acutely dangerous to Christianity and to the papacy. The Vatican was filled not only with artists, poets, phi-

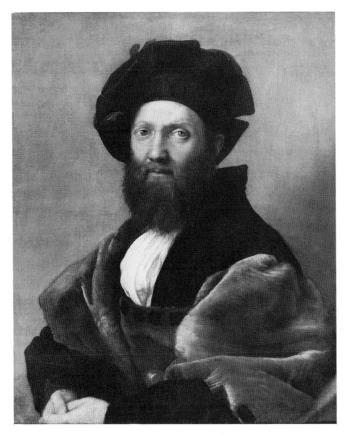

545. RAPHAEL. *Baldassare Castiglione*. c. 1515. Canvas, 32¹/₄ × 26¹/₂". The Louvre, Paris

losophers, and musicians, but also with dancers, animal-tamers, clowns, and burlesque performers, to whom almost equal importance was attached. Pious pilgrims from Northern Europe were shocked by the appearance of the pope and his cardinals in hunting dress and would have been even more outraged if they could have attended Vatican ceremonies, including funerals and beatifications, at which the Olympian deities were extolled at the expense of Christianity. Worst of all, the peaceable pontiff, who had immediately dropped the aggressive political policy of his terrifying predecessor, had no comprehension of his spiritual mission either, and no inkling of what effects the revolt led by Martin Luther was bound to wreak. His learned and well-composed bulls were not enough to stop the Reformation.

A few years after his accession to the throne of St. Peter, possibly as early as 1517, the pope sat for a group portrait in which Raphael established a new level for searching analysis of character and its communication in visual forms (fig. 546). The pope is shown, typically, occupied not with affairs of state but with antiquarian erudition and the delight of possession. He sits before a table, at which he has been enjoying the perusal of a splendid Trecento illuminated manuscript, so accurately represented that the original, still preserved in Naples, has been identified. Beside the manuscript rests a superb silver bell, with gold top and gold borders, covered with classical vine scrolls. Doubtless Raphael rendered both

manuscript and bell with the aid of a glass, like the goldframed one the pope has been using. At the pope's right stands his cousin, Cardinal Giulio de' Medici, son of the murdered Giuliano and subsequently Pope Clement VII; on Leo's left stands his nephew Cardinal Luigi de' Rossi. Both faces are picked out by the unprecedented crosslight; both are impassive but unhappy masks, Luigi looking toward and past us, Giulio staring into nowhere. The composition is an X-shape, or would be if it did not lack one leg at the lower right. The also-unanswered diagonal of the architecture at the top, which moves into depth from left to right, lends a strange quality of baselessness to the painting. The unsatisfying quality of the forms is increased by the dissonance between the slightly orange reds seen in the cardinals' attire and the tablecloth, and the purplish crimson of the pope's biretta and mozzetta. Just above the convergence of these conflicting forms and colors floats the pope's puffy countenance, rendered, as are his shapely hands, with a striking fidelity to every facet and nuance of skin and flesh. In this atmosphere of tension, irresolution, and gloom, only the compressed surge of crimson in the mozzetta and the blizzard of changing whites in the damask sleeve provide

546. RAPHAEL. *Pope Leo X with Cardinals Giulio de' Medici and Luigi de' Rossi.* c. 1517. Panel, 60½ × 47″. Uffizi Gallery, Florence

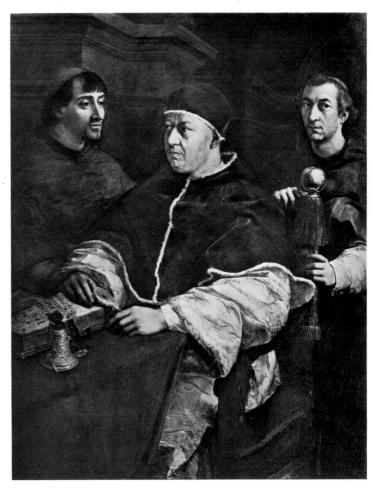

any release. The polished brass sphere on the chair back contains a distorted reflection of the room, on the order of the famous convex mirror in the background of the Arnolfini Wedding by Jan van Eyck, and although one can clearly make out the window at the right from which comes the illumination of the figures, Raphael's own figure, definitely there, is reduced to a few vague vibrations by the glare.

Under Pope Leo X, Raphael rose to a scale of power and wealth never previously enjoyed by any artist. At Bramante's death in 1514, Raphael inherited the post of papal architect, to continue the construction of St. Peter's. He was showered with commissions for Madonnas. portraits, frescoes, and mosaics. He was asked to paint a third stanza (the Stanza dell'Incendio), to design the decorations of the other rooms in the Vatican, including the loggie built by Bramante and a loggetta and bathroom for Cardinal Bibbiena, one of the least edifying cronies of Leo X. Raphael directed new buildings, including at least one church and one palace, and an imaginative villa for Cardinal Giulio de' Medici (see fig. 549). Into the bargain Raphael was appointed as the first superintendent of antiquities we know anything about, and given full power over all excavations in the papal dominions. One of his major projects was a map of ancient Rome with all of its monuments carefully traced and identified. To keep up with this massive and manifold commitment, even the facile Raphael had to employ a number of assistants, probably not the "army" so often referred to, but including at least two gifted artists, Giulio Romano (see pages 585–87) and Perino del Vaga (see pages 561–62) and several other less competent pupils. On occasion independent painters were called in to aid in special assignments. As a result, the execution is at times uneven and the pupils' lesser personalities painfully evident. Even some of Raphael's contemporaries, in an era particularly indulgent to the workshop system, deplored these lapses. There is evidence to show that Raphael often asked his pupils to turn out trial scale models of pictures on the basis of his small sketches or even verbal directions. When preserved, these models are invariably by the pupils, with an occasional possible correction from Raphael. They seldom, however, correspond exactly to the finished compositions, which would indicate that the master then stepped in and somewhat reset the stage. It is surprising that under the pressures exerted upon Raphael in these seven years any substantial proportion of the finished paintings could have come from his brush, and yet, all in all, more than half the surface is surely by him, especially in the most important commissions. Most of the detailed life studies, however, are by the pupils, who then presumably enlarged (and in this process usually destroyed) the approved version of the model into a full-scale cartoon and carried out the preliminary procedures of the actual painting. Only by this system of preplanning the design

and execution of the paintings was it possible for Raphael to carry out so much himself, on a grand scale, and with all the freshness of original creation.

The grandest of all the pictorial projects assigned to Raphael in this hectic period was a series of ten tapestries, for which he was asked to produce ten full-scale cartoons in color (colorplate 75, figs. 547, 548). These he painted in approximately eighteen months during 1515–16 for execution by tapestry weavers in Flanders. The finished tapestries, representing scenes from the Acts of the Apostles, were to complete on the lower walls of the Sistine Chapel the iconographic cycle that, under Quattrocento artists, had depicted the Life of Christ and the Life of Moses and, under Michelangelo, had been vastly extended to include, among other subjects, the ancestry of Christ and the prophets and sibyls who foretold the coming of Christ through the medium of scenes from Genesis. Raphael must have been acutely aware not only that his compositions were to be on display at the center of papal power, but also that with them he would be invading the sanctuary of Renaissance painting consecrated to Botticelli, Perugino, Signorelli, Ghirlandaio, and Michelangelo himself. While so exalted a destination probably did not cause the successful master to alter his style in any essential, it did inspire him to devote all his energies—and probably those of the whole shop as well—to covering with figural compositions an area of about twelve hundred square feet, almost half the size of that painted in the Sistine Chapel by all the Quattrocento painters put together.

The combination of grand-scale figures with the new architecture of the High Renaissance and with landscape backgrounds produced compositions that were intensely exciting in their dense packing of elements and in their dramatic power. Moreover, since the cartoons were reproduced in many new series of tapestries throughout the sixteenth, seventeenth, and eighteenth centuries, and in numerous engraved copies as well, they became the most influential of all of Raphael's compositions. The work of such classicistic masters as Poussin, Domenichino, David, and Ingres is scarcely conceivable without them. The material success of the undertaking was far from complete, however. Although Raphael knew that he must design his compositions for execution in reverse, it is not clear whether he understood how different his colors would look when translated by the weavers into dyed wools heavily intermingled with gold threads. The tapestries were subsequently in part mutilated, three cartoons were lost, and the other seven were acquired by King Charles I of England in 1630. The original cartoons had been cut in strips for the convenience of the weavers and were not remounted and exhibited as works of art until 1699. Today they are shown at the Victoria and Albert Museum under near-ideal circumstances of space and light. In spite of the numerous retouches, particularly to hide the joints in the paste-up,

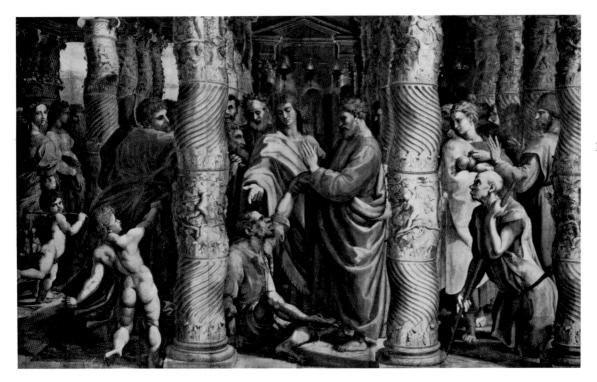

left: 547.
RAPHAEL.
Healing of the
Lame Man.
1515–16. Cartoon,
watercolor
on paper,
11'3"×17'7".
Victoria and
Albert Museum,
London

below: 548. Male Heads, detail of fig. 547

the majesty of the forms and the brilliance of the coloring are unforgettable, not to say also upsetting to traditional notions of the gentleness of Raphael's art, based largely on his early Florentine Madonnas.

The cartoons were painted in a glue-based watercolor, over often-visible charcoal preparation, which was probably drawn by the pupils, especially Giulio Romano, un-

der Raphael's supervision. But by far the greater part of the color was laid on by Raphael himself, and there are astonishing passages in which all the lyric beauty and all the emotional fire of his mature style at its best come through to us unaltered. Heads, drapery, landscape, even at times architecture, are painted with a sketchy openness and freedom not accessible at this moment even to the Venetians—in fact, not seen in Western art since the occasional medieval revivals of ancient illusionist painting technique. Perhaps Raphael's own immersion in antiquity, deeper, more prolonged, and more lasting in its effects than that of any other Renaissance artist until this time, had familiarized him with Roman first-century painting.

But there are other sources as well. It has often been noted how closely Raphael had studied Masaccio's frescoes in Santa Maria del Carmine (see colorplate 23) and how eloquently he was able to revive in the tapestry cartoons Masaccio's method of enhancing the physical bulk and psychological substance of his figures by enveloping them in voluminous mantles that, so to speak, extend their presences into the surrounding space. It has been pointed out that Raphael may have revisited Florence briefly in 1515, just before his embarkation on this portentous cycle. To an artist with Raphael's keen sense of history it must have seemed essential to return to the source of Renaissance inspiration, and specifically to the very images in which the concept of barefoot apostolic humanity had first been invested with dignity and power. To keep the figures large in comparison with their setting, they are locked into masses of foreground architecture, which is cut off at the top by the frame yet breaks here and there to allow us to see, in the middle distance, the full extent and proportions of a classical order.

Raphael was able to contrast the diffuse and largely decorative effect exerted by the late Quattrocento wall frescoes in the Sistine Chapel, in which one must often search for the subjects, with the telling power of Michelangelo's colossal scenes on the ceiling, especially those drastically simplified subjects with which his tapestries would be placed in instant comparison. He therefore set the average height of a standing foreground figure at approximately eight feet, more than two-thirds the total height of the scene within the border. The effect of these heroic proportions against the restricted space, combined with the reality and approachability of Raphael's physical types, gives a new turn to the Renaissance vision of an ennobled humanity. For this is no longer, as in the ceiling frescoes, a nude, predominantly male ideal race: through study of Masaccio, the man and woman in the street are raised to such powers and are framed rough garments, bare feet, and all-by the greatest riches of classical architecture.

In the Healing of the Lame Man (fig. 547), for example, the group is centralized at the Beautiful Gate of the Temple, the Porch of Solomon (Acts 3:1–11), to which the people ran, greatly wondering. (St. Peter lifts the lame man by the left hand, instead of the right as in the text, because Raphael knew that in the tapestry the composition would be reversed; for the same reason St. Peter blesses with his left.) The setting is surprising and unparalleled in its proto-Baroque vibrancy of form, light, and color. Apostles, mothers, children, cripples move between spiral columns, which will doubtless suggest to the reader the famous baldachin of St. Peter's, built by Gianlorenzo Bernini in the seventeenth century. Here, however, Raphael was trying for historical correctness. The screen before the chancel of Old St. Peter's had been formed by four Late Antique spiral columns, probably brought to Rome in the fourth century A.D. from Syria, and it was believed that these came originally from the Temple of Solomon. Against one of them, in fact, it was thought that Christ often leaned to rest while teaching, and in the Cinquecento those obsessed by demons used to tie themselves to it to effect a cure. The columns, of course, had to be removed temporarily during the construction of Bramante's St. Peter's, but they were relocated in various parts of the new building. Familiar to thousands and painted by the French fifteenth-century master Jean Fouquet as part of the Temple, the columns were reduced by Raphael to about one-third their actual height, so that St. Peter is as tall as three sections of a column, whereas in reality he should cover only one section. The alternation of spirally fluted sections with those decorated by vine scrolls and putti has been retained by Raphael, who found great plastic and pictorial excitement in both motifs. The gorgeous columns, multiplied to several rows in depth, enshadow the porch, providing a richly colored darkness against which the principal figures are fitfully illuminated. Their pulsating

contours are played off against the other forms, notably the broad outlines of St. Peter's cloak. The light flashes against eyes filled with wonder, and against shaggy hair and beards that have been compared to landscape masses (fig. 548). They do indeed remind us of crags and forests in their wildness, yet the spiral harmonies of Raphael's line are present in every glittering stroke of the brush. In the nobility of his youthful St. John, shining against the dimness of the lamp-lit sanctuary, one is reminded of the Christ in Andrea del Castagno's St. Julian (see fig. 274).

In its classic balance of figural and architectural masses, St. Paul Preaching at Athens (colorplate 75) is the most widely imitated of all the cartoons. It was to be placed alone, just outside the marble barrier, as a symbol of the preaching mission of the Apostles to all mankind, which accounts for the dramatic device of the steps jutting from the foreground down into the portion where sit or stand the Athenians, with whom Cinquecento visitors to the chapel could thus identify themselves. St. Paul, raising his hands, reminds his hearers of their altar to the unknown God (Acts 17:23): "Whom therefore ye ignorantly worship, him declare I unto you." The statue of Mars turns his back (of course he carries his shield on his right arm and his spear in his left hand for subsequent reversal), but the Athenians listen, some with quiet conviction, others greatly disturbed. In the rapt countenance of the heavyset Roman soldier directly behind the preaching Apostle the features of Leo X can be easily recognized. St. Paul, a commanding figure, is derived immediately from Masaccio's St. Peter in the Tribute Money, St. Peter Baptizing the Neophytes, and the Raising of the Son of Theophilus (see colorplate 23, figs. 193, 201). The dramatic central group, their bodies twisted, the folds of their draperies agitated as by a storm, is one of the finest passages from Raphael's later period. The man and woman at the lower right, however, like the two putti at the left of the Healing of the Lame Man, show the coarser style of Giulio Romano. The brilliant color, above all the splendid reds and blues, was of course lost when toned down in the now-faded tapestries, but at the Victoria and Albert Museum it sings clearly.

The architecture is noteworthy, in more ways than one. The round temple is a recognizable tribute to Bramante, as are the unfinished rusticated buildings, recalling his structures, still unfinished today, for the papal tribunal in Via Giulia. The broken arch over St. Paul's extended hands may also contain a reference to Christ, in the Psalmodic phrases (Psalm 117 [118]:22), repeated by Christ himself (Matthew 21:42): "The stone that the builders rejected, the same is become the head of the corner." The harsh angles and masses of the jutting steps, and the projecting postaments of the arcade that produce a kind of checkerboard of light and dark are unexpected instances of the mature Raphael's interest in

549. RAPHAEL. Interior, Villa Madama, Rome. c. 1515–21 (decorations by GIULIO ROMANO, GIOVANNI DA UDINE, and BALDASSARE PERUZZI)

geometry. The grandeur of the severe classical style in architecture is contrasted with the remote, dimly seen background of shaggy, ivy-covered towers that tells us more about Cinquecento Rome than about ancient Athens.

Raphael's most ambitious architectural undertaking-save for St. Peter's itself, on which little was accomplished—was a vast villa, known today as the Villa Madama, designed for Cardinal Giulio de' Medici (fig. 549). Originally, it was intended to have a two-towered façade facing St. Peter's, a circular courtyard, domed and porticoed rooms, gardens exploiting the slope of the hillside in descending levels, and many delightful fantasies and inventions. While the project continued after Raphael's death in 1520, that of Pope Leo X in 1521 put a sudden end to the Golden Age, and Cardinal Giulio was more interested in hanging on to Medicean control of Florence than in spending vast sums in Rome. Even after his accession to the papacy as Clement VII in 1523, little more was done. The existing fragment is still enchanting, even though the spacious landscape, which even in recent memory opened before it, is now a barren expanse of six-story apartment houses and squatters' shanties. The great hall, with its powerful, single-story arches, terminal groin vaults, and central dome, all looking out through three arches to the garden, was a new invention on Raphael's part, gracefully harmonizing the architectural space with nature outside. The delicate decoration, in the form of stucco grotteschi and little paintings, clothes Raphael's simple forms; it was carried out after the master's death by his pupils Giulio Romano and Giovanni da Udine, as well as by his associate, the Sienese painter-architect Baldassare Peruzzi. The present illustration was taken after the Fascist renovations, which included a polished marble floor more appropriate to a luxury hotel. A straw in the wind may be seen in the cardinal's instructions to the painters regarding the scenes to be represented: he did not care what the subjects were so long as they were recognizable, so that one would not have to add explanatory inscriptions, like the painter who wrote "this is a horse." Ovid would do as well as anything else, the cardinal said, but the Old Testament was only good enough for the loggia of His Holiness.

Nevertheless, the same patron gave Raphael the opportunity to express a new phase of his art, which, if he had lived, might have had vast repercussions for Italy and perhaps all of Europe. For in 1517 Cardinal Giulio commissioned the busy master to paint for his cathedral at Narbonne in France a large panel representing the Transfiguration (colorplate 76), with which we can fittingly conclude this account of Raphael's career, although we will return to him briefly at the close of this chapter. Such was the power of the completed picture that the cardinal kept it at San Pietro in Montorio in Rome rather than sending it to France. The story, recounted by Matthew, Mark, and Luke, tells how Christ went with the Apostles Peter, James, and John to the top of a high mountain, and there suddenly Moses and Elijah were with them on either hand, and Jesus' countenance shone with light, and his raiment was "white and glistening." Then a bright cloud came upon them, and the voice of the Father could be heard as at the Baptism saying, "This is my beloved Son in Whom I am well pleased." They feared greatly as the prophets entered into the cloud, and when the cloud passed away Jesus was again alone with the Apostles. So much is represented, in their own ways, by Fra Angelico (see fig. 213) and by Giovanni Bellini (see colorplate 62), but the sequel is rarely shown—the demoniac boy whom the Apostles could not cure by their own efforts in Christ's absence, but whom he was able to heal immediately on his return.

A kind of prison gloom, a darkness deeper than any known to Leonardo and lighted only by fitful flashes, reigns over the tormented world below. But in the upper section the radiance of divinity and the wind of the spirit, which proceed in a tempest from the bright cloud, catch Christ upward into their midst; they illumine and sustain the floating prophets in widening circles of rapturous contemplation, and blind and prostrate the three Apostles in an unbearable intensity of revelation. Raphael's characteristic spiral movement sweeps through these figures: St. James struck to the ground as if by lightning, St. Peter writhing in torment, and St. John traversed by

divine energy as if by electric current (fig. 550), one hand moving freely in the air, the other hiding his eyes from the transcendent and omnipotent light.

The picture is designed in a giant figure of eight, and was intended to show man's powerlessness when separated from the source of all energy in God. The lower portion was partly executed by pupils, especially Giulio Romano, who did all the preliminary and coldly competent figure drawings. The possessed boy and his family are typical of Giulio's style, which we will find later in his independent works in Mantua. But the wonderful St. Andrew at the lower left (fig. 551), turning from his book in amazement as the others argue hopelessly or point to the summit, is not Giulio's. This entire group is surely by Raphael himself, and St. Andrew, with his outstretched hand and his foot projecting out of the picture plane, not to speak of the intense contrasts of light and dark around him, provided a vital model for certain arresting productions of the young Caravaggio in Rome seventy years later.

Recent cleaning has revealed astonishing coloristic brilliance. The lower half of the picture displays with the intensity of stained glass the reds, blues, yellows, greens, and pinks of the garments against the encompassing dark. In contrast, the color of the upper portion testifies, perhaps, to Raphael's interest in Venetian art, but since every new influence he absorbed became rapidly his own, the blending blue and gold that shift through Christ's glistening raiment shine with an incomparable radiance, transfiguring us as we gaze, uniting us with the heavenly effulgence and the soaring wind.

How was it that so serene, so successful, so rich a man as Raphael could imagine so mystical a subject and convey it with such power? Oskar Fischel suggested that in his later years Raphael frequented the meetings of a

550. RAPHAEL. St. John the Evangelist, detail of Transfiguration of Christ (see colorplate 76). 1517. Panel. Pinacoteca, Vatican, Rome

group of priests and laymen that called itself the Oratory of Divine Love, an organization about which far too little is known. By March 1517, perhaps even earlier, the society had Leo's grudging approval; thus, at least seven months before Martin Luther nailed his ninety-five theses to the door of Wittenberg Cathedral, the Catholic Reformation was quietly under way.

The goal of the new movement was the reform of the Church from within, not by means of a new monastic order, but through the parishes. The program was simple: common prayer and preaching, frequent Communion (Communion was a rarity in those days), and works of neighborly love. One of the founders, Giovanni Carafa, eventually became Pope Paul IV. Together with another co-founder, Gaetano da Thiene, later canonized as St. Cajetan, Carafa spread the doctrines of the group into North Italy. Although the Oratory was dissolved in 1524, its members expanded its original work in that of the newly founded Theatine Order. It may well be that we should look in the activities of this self-effacing, quietist group for the sources of Raphael's mysticism. It is worth remembering that Gaetano was often prostrate in ecstasy for hours before the Eucharist, like Raphael's three Apostles, and that he preferred to celebrate Mass at an altar where the sacrament was already reserved, so as to obtain, as he put it, "greater light and heat."

On Good Friday, April 6, 1520, after a brief illness, Raphael died at thirty-seven. At his own request, his funeral was held in the Pantheon in Rome and the Transfiguration hung above his bier. His tomb was made there so that, through the open circle in the apex of the dome,

> 551. RAPHAEL. St. Andrew, detail of Transfiguration of Christ (see colorplate 76). 1517. Panel. Pinacoteca, Vatican, Rome

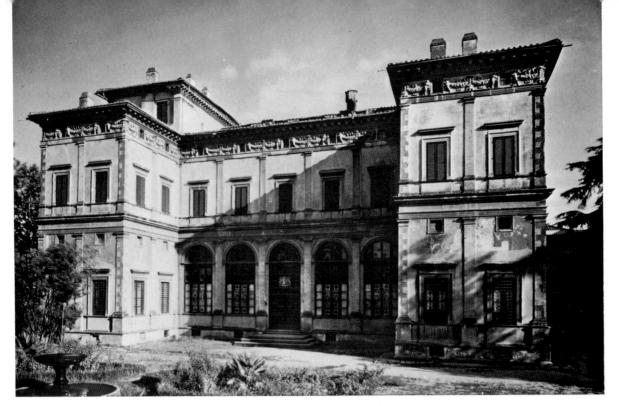

above: 552. BALDASSARE PERUZZI. Garden façade, Villa Farnesina, Rome. 1509-11

below: 553. BALDASSARE PERUZZI. Plan of Villa Farnesina

the unimpeded light of heaven could shine down upon it. Raphael's death was universally mourned. With him passed an unrecapturable moment when the noblest ideals of classical antiquity and the highest aspirations of Christianity could coexist in complete harmony.

Or had it not already passed? In the mind of Raphael, it probably had, as early as 1516 or 1517, although he went on painting for the gilded society of the Golden Age. He participated twice, in fact, in the most delightful artistic undertaking of the Roman High Renaissance, an enchanting little palace known to us today as the Villa Farnesina (fig. 552) because at a later date it was bought by the Farnese family and added to their possessions in Rome—connected, in fact, by means of a bridge across the Tiber to the Palazzo Farnese on the opposite bank (see fig. 620). In use by autumn 1511, the palace was built about 1508 or 1509 for Agostino Chigi, a Sienese banker who had established in Rome the headquarters of his far-flung financial empire, and who underwrote with calm impartiality the conquests of Alexander VI and Cesare Borgia, the ambitious projects of Julius II, and the pleasures of Leo X. From its very purpose—a retreat to enshrine Chigi's beloved Imperia, the most celebrated courtesan in Rome-down to the final details of the decoration and symbolic imagery, the palace is thoroughly and exquisitely pagan. Although the outbuildings and gardens overhanging the Tiber have largely perished, and although the almost pastoral quiet this paradise once enjoyed is now replaced by the thunder of Roman traffic on both sides, there is still nothing like the Farnesina anywhere on earth. It is a delicious venture into Olympus, or Elysium, or both.

The Farnesina ensemble is the masterpiece of Rapha-

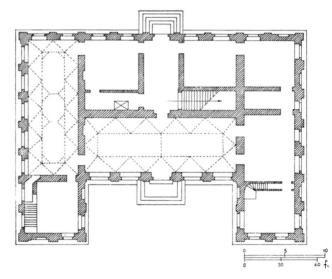

el's Sienese associate, the architect and painter Baldassare Peruzzi (see pages 584-85). The palace, a long rectangle with projecting wings, a plan well known in ancient Roman villas, opens on the gardens by means of a five-arched loggia (fig. 553). Its two stories are articulated in an Albertian screen architecture using Tuscan orders, whose slender pilasters—in every building and every painting Peruzzi maintained a characteristically Sienese sense of linear grace—flank windows only about half their height. No balustrades or balconies alter the severity of the general disposition, but the brick walls, covered with intonaco, were once decorated with the delicate incised ornament common in palaces and villas of the Renaissance throughout Tuscany and now preserved, alas, generally in dilapidated or badly restored condition. At the Farnesina it has disappeared entirely, and only the sumptuous, modeled terra-cotta frieze

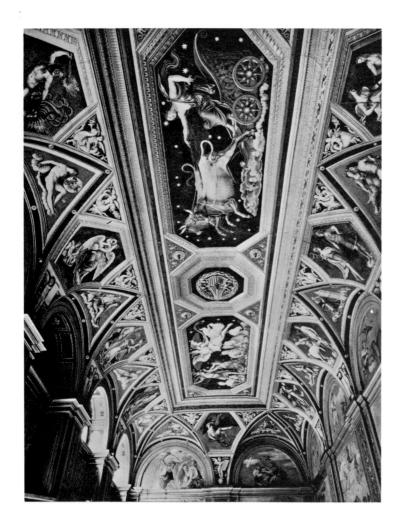

crowning the second story remains to hint at the shapes once included in a filigree of decoration all over the nowbarren walls. In the lower story, runaway mezzanine windows beat at the architrave from below; in the second, they have escaped entirely, but in a typically Peruzzian imaginative device the architect has set the putti to trap them, and so they do, when not engaged in holding garlands.

In the frescoes that embellish the interior were employed the talents of the finest painters then working in Rome, save only the increasingly withdrawn Michelangelo. Peruzzi himself carried out the entire fresco series

in two major rooms and most of that in a third, but he was joined in the undertaking by Sebastiano del Piombo, by Sodoma, and even by Raphael, who returned to the scene two years before his death, bringing several pupils, including Giulio Romano. Imperia died before she could enjoy many of the splendors of her new villa, but Chigi consoled himself with a Venetian trouvaille, the lovely Andreosia, by whom he had four children (whom Leo X baptized) before he finally married her (Leo officiating, of course). The great hall of the Farnesina, the Sala di Galatea (fig. 554), is lined, insofar as it was carried out, by a cycle of frescoes unprecedented in the completeness of their pagan imagery. We move entranced from one group of ancient dieties to another, reveling as did Chigi, his mistress, and his glittering court in this brilliant revival of a mythology that, though it never fully succumbed to the attacks of Christian theologians, lived in the Middle Ages a half-life of shadows and disguises, and was only now and then fully lighted during the Early Renaissance. But the gods and heroes who throng the two central panels, the ten hexagons, and the fourteen vault compartments turn up in surprising relationships.

above left: 554.
BALDASSARE PERUZZI. Ceiling frescoes. c. 1511. Sala di Galatea,
Villa Farnesina, Rome

left: 555. BALDASSARE PERUZZI. Perseus and Medusa, ceiling of Sala di Galatea (see fig. 554)

above right: 556.
BALDASSARE PERUZZI.
Aquarius, compartment of ceiling,
Sala di Galatea (see fig. 554)

These Fritz Saxl explained by translating the deities back into their stellar and planetary equivalents. Careful plotting of the exact relative position of these equivalents on the ceiling of the Sala di Galatea produced the configuration of the heavens above Central Italy on the night of December 1, 1466, and thus the presumed birth date of Agostino Chigi, whose horoscope, complete down to the last detail, the ceiling panels turn out to represent.

To embody this intellectual conceit, Peruzzi produced a pictorial style that is at once chilly, artificial, elegant, and beguiling. One of the two long central panels shows the constellation *Perseus* (fig. 555), with the hero himself about to decapitate Medusa, while the winged Fame blows her trumpet in the direction of the Chigi arms, modeled in stucco in the center of the ceiling. The composition is as linear and shallow as Peruzzi's architecture, completed only shortly before he embarked on the frescoes. The arrangement of figures, strictly adhering to the foreground plane and silhouetted singly or in groups against a background that, for all its stars, remains inert, displays the restrained luxury and mannered tastefulness of a giant Augustan cameo; possibly it was inspired by one.

Aquarius (fig. 556), clearly further identified as Ganymede, shows Peruzzi's figure style at its best. Although doubtless exactly contemporary with the most advanced achievements of his friend Raphael in the Stanza della Segnatura, Peruzzi's slender, supple figure with its streaming hair, and the gigantic eagle, which seems to have flown off the lectern of some Gothic pulpit, owe remarkably little to the leaders of High Renaissance painting in Rome. His is an individual style, rejoicing in manifold subtleties of line and dry, quiet color. As an architect, moreover, Peruzzi was very insistent on the quality and autonomy of his represented architectural detail, which is projected accurately in a perspective seen from the center of the room.

The lunettes are not directly connected with Chigi's horoscope, and they represent mythological events that took place in the airy regions below the heavens. They were assigned to the Venetian Sebastiano del Piombo (c.

557. SEBASTIANO DEL PIOMBO. Fall of Icarus. c. 1511. Fresco. Lunette of Sala di Galatea, Villa Farnesina, Rome

558. RAPHAEL. *Galatea*. 1513. Fresco. Sala di Galatea, Villa Farnesina. Rome

1485–1547), who brought a new ingredient of colorism to the predominantly sculpturesque pictorial style of early Cinquecento Rome. In the Fall of Icarus (fig. 557) the blue sky with drifting clouds, which runs through Sebastiano's lunettes, opens out below the embracing arch as if we were looking through half-moon windows into the air outside. The contrast between Sebastiano's openness and Peruzzi's flatness is sharp, and was probably deliberate. Sebastiano's large, soft figures float in and float out of these pseudo-windows with remarkable weightlessness. Tonally and coloristically, they are beautiful, painted with a broad, easy flow of the brush directly dependent on the early Titian, and indeed more suitable to oil on canvas than to fresco. But Sebastiano's anatomical constructions leave a good deal to be desired. It is not hard to see why a few years later we find him writing letters to Michelangelo, begging for drawings of arms, legs, and torsos.

The walls of the Sala di Galatea were to be decorated by a variety of painters with large frescoes representing divinities of earth and sea. Unfortunately, only Sebastiano's *Polyphemus* and Raphael's glorious *Galatea* (fig. 558) were ever painted. Ironically enough, after all the delicate calculations of Peruzzi and the labors of Sebastiano, Raphael contributed a single painting and walked

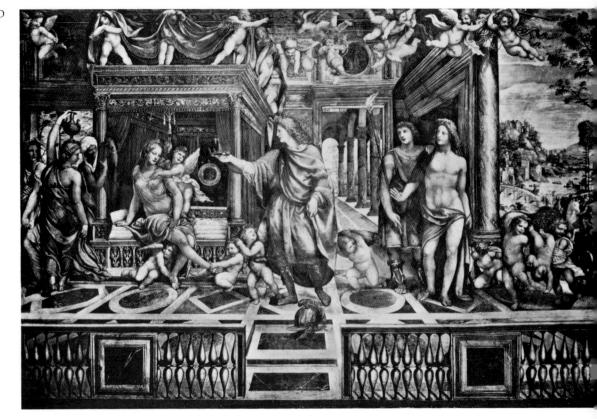

559.
SODOMA. Marriage
of Alexander and
Roxana. c. 1517.
Fresco. Bedroom,
Villa Farnesina,
Rome

off with the honors. According to his own account, he based his image of the lovely sea nymph not on any single beautiful woman but on an idea he had of female perfection, combining elements he had seen in various women. He might have added that he utilized for the graceful contrapposto pose one of his finest male figures, the philosopher standing at the left of the seated figure portraying Michelangelo in the School of Athens (see fig. 536), with raised left knee, twisted torso, lowered right shoulder, and right arm crossing the body. Galatea is even more compactly arranged, but with her head turned upward so that her glance unites with the motion of the cupids above her. As a result, she concentrates within her own suave and voluptuous figure all the energies of the figure-of-eight composition, an idea Raphael was to retain and redevelop subsequently in the Transfiguration (see colorplate 76).

Very little of Ovid's text seems to have interested Raphael. He has omitted Galatea's sixteen-year-old lover, Acis, whom Polyphemus was so soon to destroy, and has shown the Nereid in triumphant control of her own beauty, oblivious of the amorous gaze of the monster Polyphemus from the adjoining bay. Raphael had toyed with the idea of a Birth of Venus in an earlier drawing, and retained from this subject the shell-chariot as seen by Botticelli, to which, however, he added paddle wheels, apparently as stabilizers. The chariot is drawn by two dolphins whose reins Galatea holds, and is accompanied by a procession including tritons blowing a conch and a trumpet, sea horses, Nereids, and sirens. Although the composition is centralized, the movement

of the chariot from left to right is accented by impulses from the lighted arcs of the painted drapery whose curves are repeated in the splendid Eros floating in the foreground.

The whole picture is suffused by a broad sea light, which reveals against the green water the soft flesh tones of the female figures and the splendidly tanned musculature of the male torsos. The red cloak and golden hair of Galatea float in a wide rhythm around and behind her. The cool, clear, sunny colors of the fresco suggest a date immediately after the completion of the *Three Cardinal Virtues* lunette in the Stanza della Segnatura in 1511 (see fig. 538) rather than the richer, looser, darker style of the Stanza d'Eliodoro, which many critics feel must have intervened. Raphael's triumph inspired some of the most beautiful compositions of classicistic art in the seventeenth century, especially several by Nicolas Poussin.

After the nobility of the *Galatea*, the intrusion of the minor master Sodoma (1477?–1549)—of Lombard origin, but a resident of Siena—comes as something of a shock. Yet it is in a sense justified, for his *Marriage of Alexander and Roxana* (fig. 559), despite shortcomings of composition, perspective, and anatomy, was based on a Raphaelesque drawing, which, in turn, may have followed suggestions emanating from Raphael himself. The relaxed Roxana sits on the edge of a gorgeous bed whose posts are gilded Corinthian columns, while three putti assiduously disrobe her. Another tugs Alexander in her direction; serving maids depart; and on the right the almost nude god of marriage, accompanied by a torchbearer, presides over the occasion, unembarrassed by

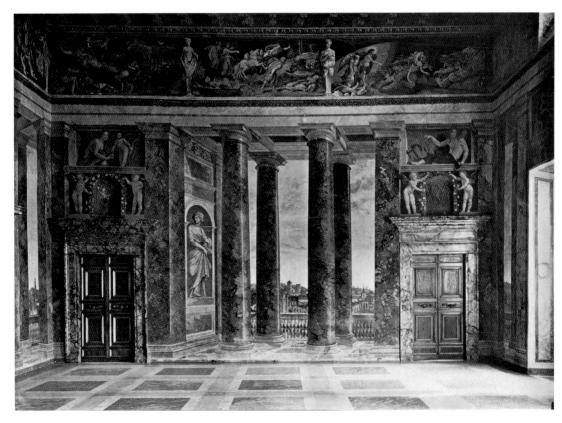

left: 560.

BALDASSARE PERUZZI.

Wall fresco.

1515–17. Sala

delle Prospettive,

Villa Farnesina,

Rome

below: 561. RAPHAEL and ASSISTANTS. Frescoes, Loggia di Psiche, Villa Farnesina, Rome. 1518–19

swarms of supernumerary putti on the ground. Luxurious in its surfaces, overripe in its coloring, this frankly voluptuary fresco stands at the antipodes of the moralized mythologies of Botticelli, and would quite probably have horrified the late Quattrocento. Yet it was as nothing compared with the erotica soon to follow, popularized after Raphael's death by Giulio Romano and Marcantonio Raimondi.

The most startling room on the upper story is the Sala delle Prospettive (fig. 560), in which Peruzzi, in 1515-17, unexpectedly revived the perspective of Melozzo da Forlì and Mantegna, possibly under the influence of both; their illusionistic works in the Vatican and in the Church of Santi Apostoli were in place and intact. The perspective, of course, was planned to function correctly from a standpoint toward the left of the room. First Peruzzi has designed a splendid architecture of dark, veined marble piers and columns with gilded capitals, enclosing an actual architecture of veined marble door frames. The frescoed architecture is so precisely painted that it is almost impossible to distinguish in the photographs, and difficult even when standing in the room, where the real marble ends and the illusion begins. Through the lofty columns one looks out to a painted terrace opening onto a continuous landscape—country facing what was then country, urban facing Rome itself—with no intervening windows that would confuse the real world with the pictures.

This tale of enchantment culminates in the series of frescoes painted in 1518–19 by Raphael's pupils, certainly from his sketches, under his direction, and occa-

sionally with his direct intervention, in the garden loggia of the Farnesina, the Loggia di Psiche (figs. 561–563). By running a band of leaves, fruits, and flowers along each groin of Peruzzi's vaults, and by connecting these

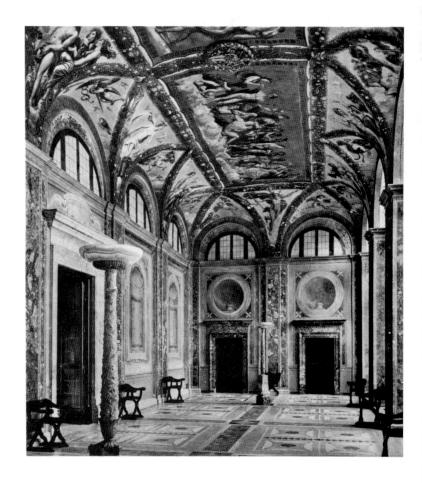

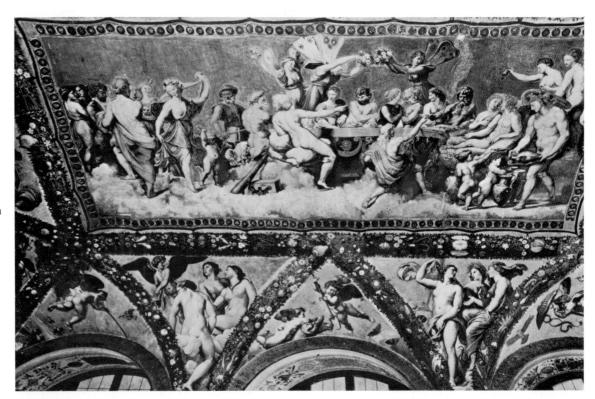

562. RAPHAEL and ASSISTANTS. Wedding of Cupid and Psyche, western half of ceiling, Loggia di Psiche

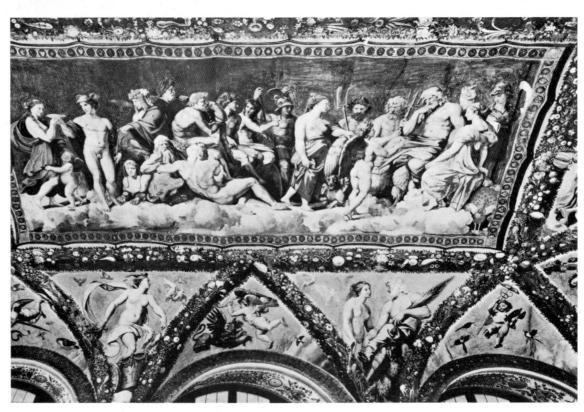

563. RAPHAEL and ASSISTANTS.

Psyche Received on Olympus, eastern half of ceiling,

Loggia di Psiche

bands with others extending the length of the ceiling, Raphael turned the architecture into an open bower. The episodes of the story of Cupid and Psyche are seen against the blue sky as if the figures had appeared in the openings of the bower, and the two culminating scenes fill two enormous simulated tapestries or painted awnings (Raphael had used a similar device in the ceiling of

the Stanza d'Eliodoro). The appearance of the interior, therefore, is all air and tension—the tension of the bower and the light tug of the awnings. Within this graceful illusion only those incidents of the legend of Cupid and Psyche that took place in heaven are represented. Perhaps the others were to go on the walls, now filled only by simulated architecture; perhaps the cycle was to be

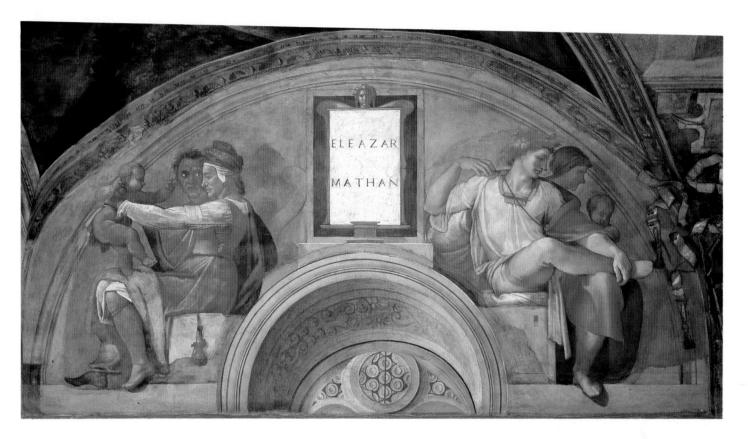

Colorplate 72. MICHELANGELO. *Eleazar and Matthan*. 1508–10. Fresco. Lunette of Sistine Ceiling, Vatican, Rome

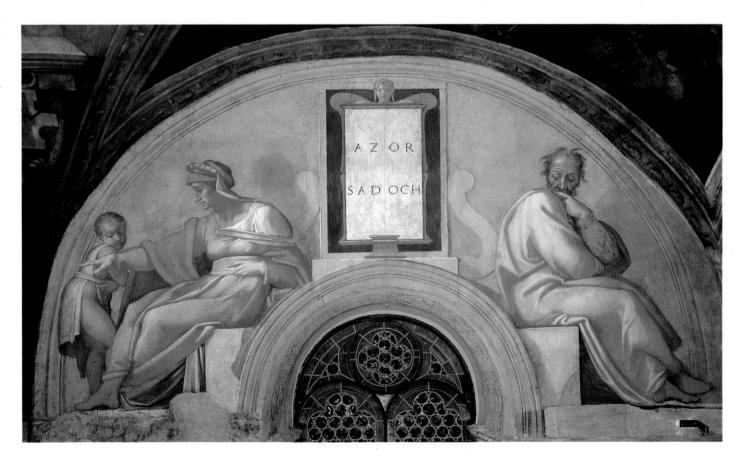

Colorplate 73. MICHELANGELO. *Azor and Sadoc*. 1508–10. Fresco. Lunette of Sistine Ceiling, Vatican, Rome

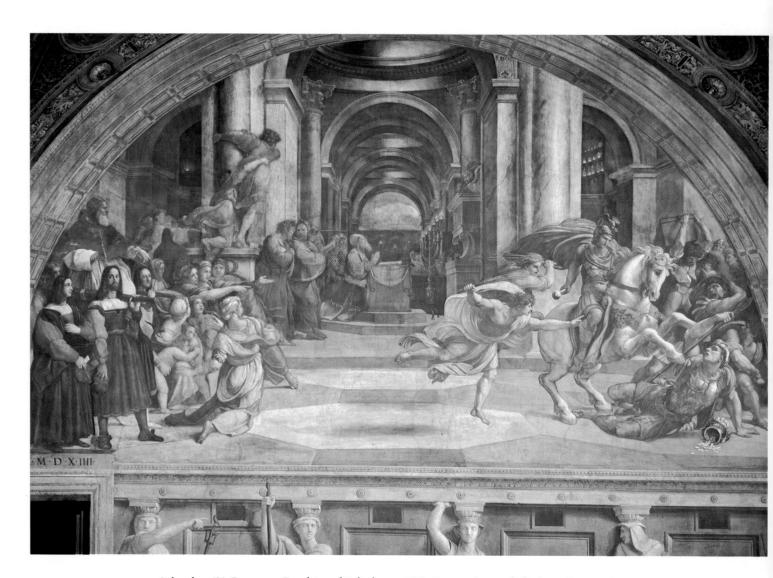

Colorplate 74. RAPHAEL. Expulsion of Heliodorus. 1512. Fresco. Stanza d'Eliodoro, Vatican, Rome

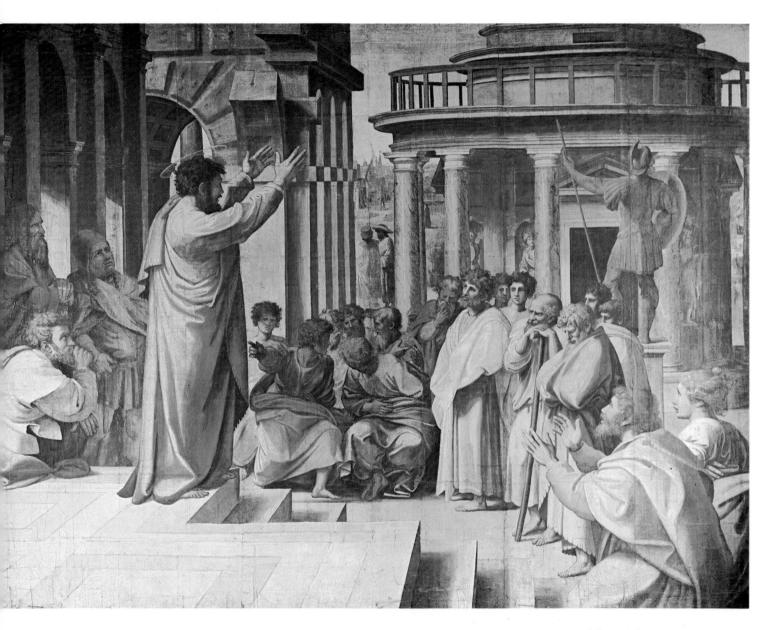

Colorplate 75. Raphael. St. Paul Preaching at Athens. 1515–16. Cartoon, watercolor on paper, $11'3'' \times 14'6''$. Victoria and Albert Museum, London

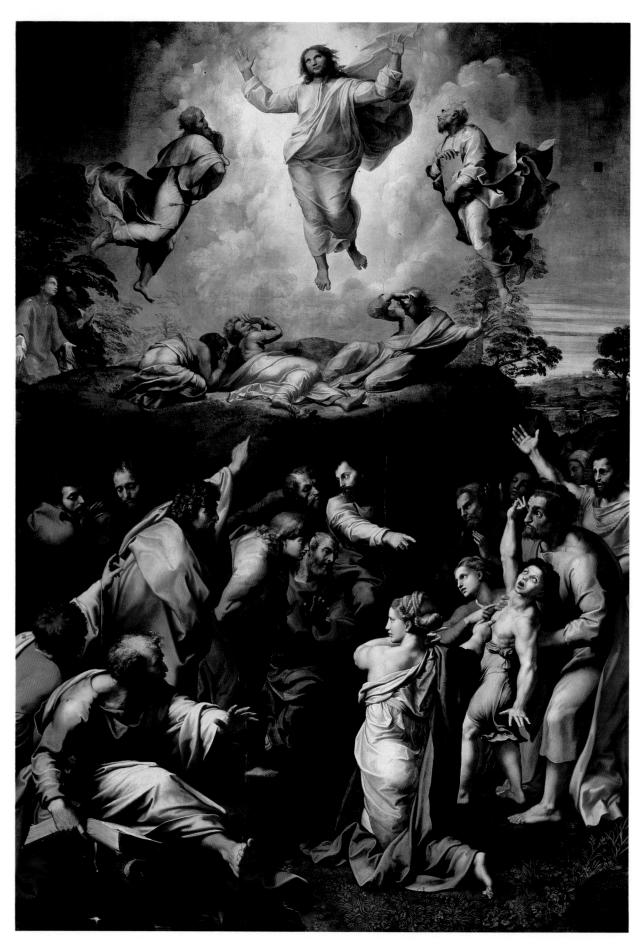

Colorplate 76. RAPHAEL. *Transfiguration of Christ.* 1517. Panel, 13'4"×9'2". Pinacoteca, Vatican, Rome

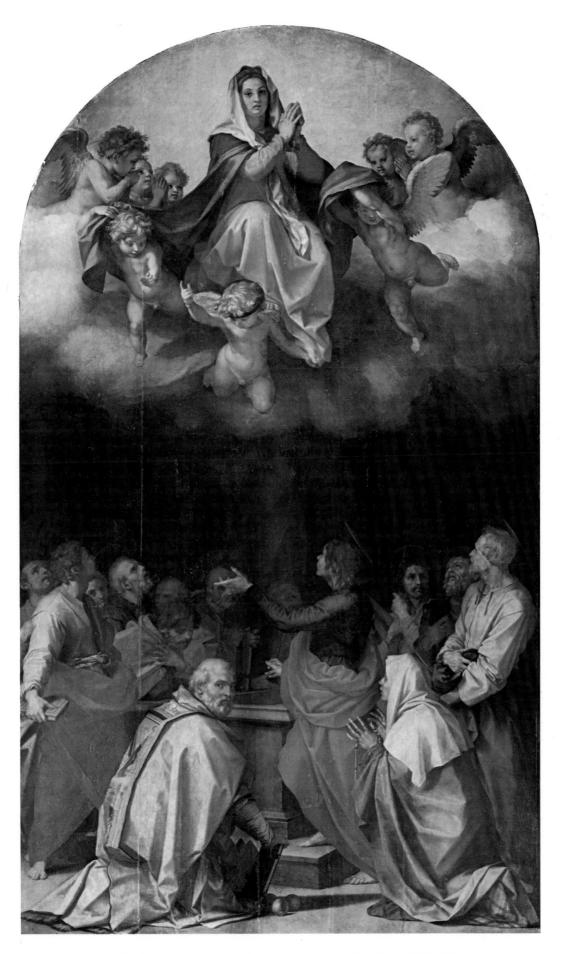

Colorplate 77. Andrea del Sarto. Assumption of the Virgin. 1526–29. Panel, $93 \times 81''$. Pitti Gallery, Florence

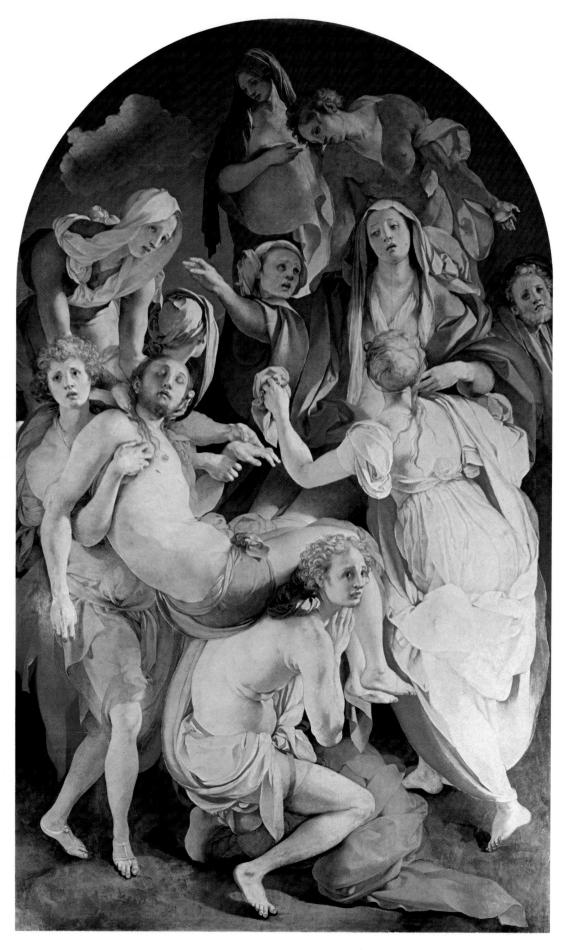

Colorplate 78. Pontormo. *Entombment*. 1525–28. Panel, $10'3''\times6'4''$. Capponi Chapel, Sta. Felicita, Florence

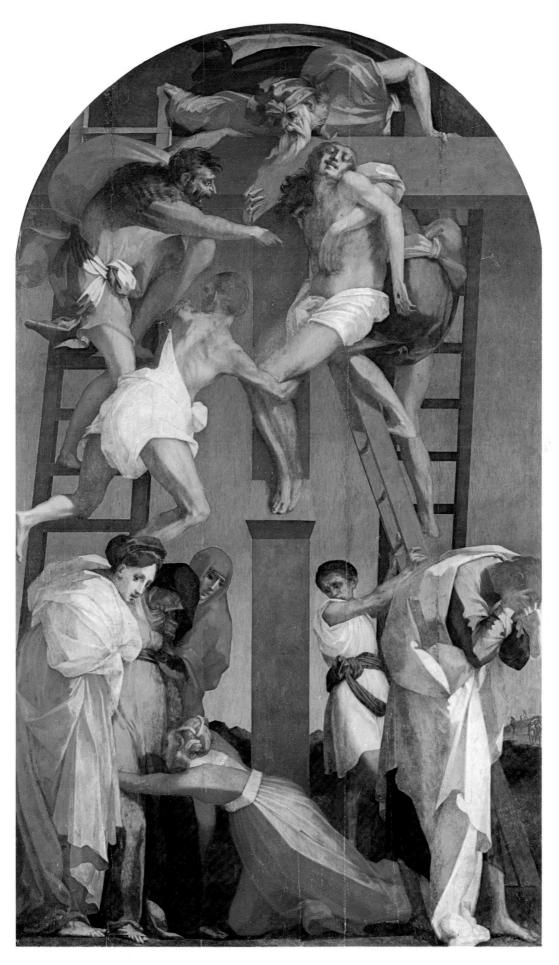

Colorplate 79. Rosso Fiorentino. Descent from the Cross. 1521. Panel, $11' \times 6'6''$. Pinacoteca, Volterra

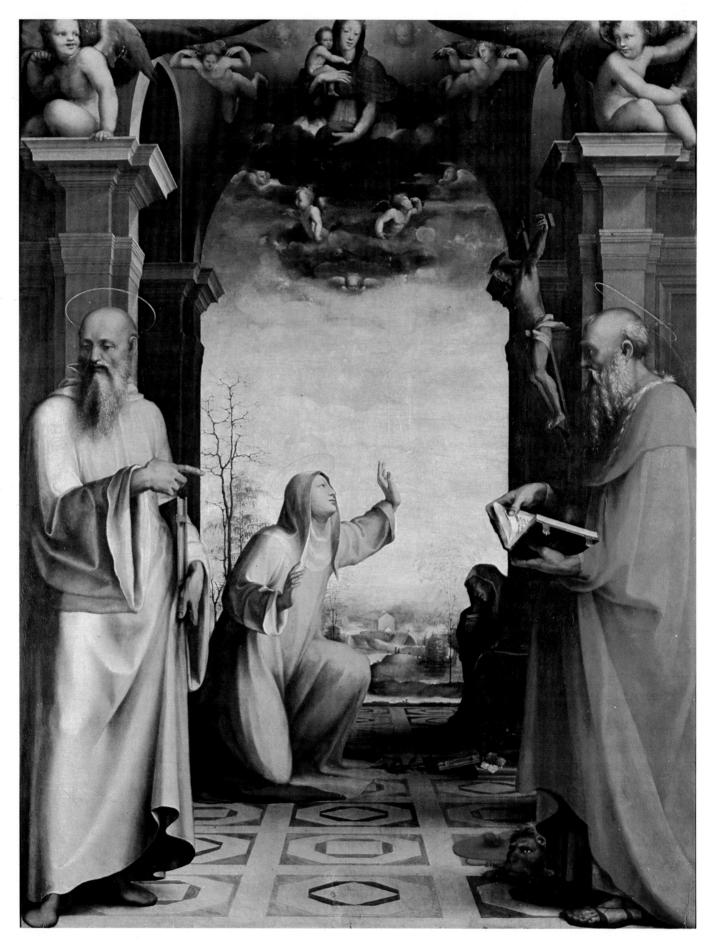

Colorplate 80. Domenico Beccafumi. Stigmatization of St. Catherine. c. 1518. Panel, $80\% \times 61\%$ ". Pinacoteca, Siena

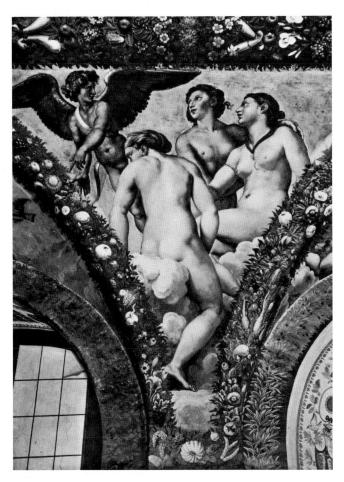

564. RAPHAEL and GIULIO ROMANO. Cupid Pointing Out Psyche to the Three Graces, compartment of ceiling, Loggia di Psiche

restricted to the airy episodes. It is possible to argue both ways, and there is no evidence. Although the ample, noble female figures of Raphael's mature imagination are often hampered by the pupils' inadequate execution, those carried out by Giulio Romano are quite grand. One of the finest is *Cupid Pointing out Psyche to the Three Graces* (fig. 564), far less supple than the *Galatea*, certainly, but full of a new sense of statuesque volume, heavy and hard as marble, and characteristic of Giulio as we have seen his style in the *Transfiguration*. There are, however, coloristic passages of great beauty in the oftenimitated back of one of the Graces, and these must come from Raphael's own brush, which doubtless intervened at crucial moments again and again in works laid out by his pupils.

Within eight years after the completion of the last paintings in the Farnesina, not only were Raphael, Chigi, and Leo X in their tombs, but also, as we shall see in the next chapter, the neopagan world in which they moved had been swept out of existence. Sensitive ears could discern many a rumble of the approaching earthquake, and doubtless Raphael heard them; his heart was not in the fairy tales of the Loggia di Psiche but in the ultimate realities of the *Transfiguration*. It is perhaps fitting to close our account of the Roman High Renaissance on a

prophetic note. Sebastiano del Piombo's Flagellation in San Pietro in Montorio (fig. 565), begun in 1516, admits us to a darker world of experience to which we will soon become accustomed, as it was to be the scene of daily existence for most of Central Italy for decades. Christ, based on a drawing by Michelangelo given to Sebastiano at his own request, is tied to a column that culminates outside the limits of the picture and that appears to grow directly from the actual altar below. Since the mural exploits the curve of the chapel wall, on the principle of Mantegna's Adoration of the Magi (see fig. 407), the wall disappears, leaving the marmoreal figure, painted with a wholly new mastery of anatomy, to be assailed by the swarthy executioners who appear to have sprung from the columns. This powerful conceit, which converts a painting into a work of sculpture and projects Christ's suffering in three dimensions, returns us to the personality of Michelangelo, then absent in Florence. After Raphael's death, about which his contemporaries wrote as if it were the death of a saint, no one in Rome could continue in his vein. Other tendencies and other ideals rapidly replaced the harmonies of Raphael, and the most impressive new developments came from either the Florence of Michelangelo or the Venice of Giorgione and Titian.

565. SEBASTIANO DEL PIOMBO. *Flagellation*. 1516–21. Fresco. Borgherini Chapel, S. Pietro in Montorio, Rome

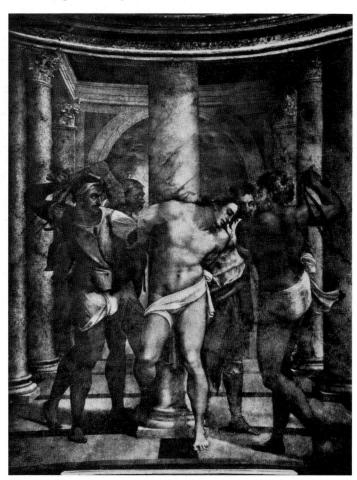

High Renaissance and Mannerism

In the entire history of writings on Italian art, no single development has caused so much confusion or frustration as the fluctuating critical fortunes of the group of artists at work in Central Italy immediately following the culmination of the High Renaissance. That is, perhaps, no mystery, because no other phase of Italian art is so surprising, so capricious, or so difficult to fit into reasonable accounts of historical evolution. And this in turn reflects the surprises, caprices, and difficulties of Italian Cinquecento history. In keeping with the policy followed throughout this book, an attempt will be made to interpret intellectual concepts and artistic events in terms of history, but first it will be necessary to examine briefly the nature and origin of the much-discussed expression "Mannerism."

A glance at many of the illustrations in this chapter as compared with those in the two preceding ones should be sufficient to persuade the reader that something very strange has happened. These pictures, statues, and buildings do not fit the ideals of the High Renaissance as we have watched it develop. In contemplating the tensions, distortions, visual and emotional surprises of the strange years around 1520, artists and writers of the seventeenth and eighteenth centuries were acutely aware of what they could characterize only as a decline. In their attempts to reestablish a classical style, they referred contemptuously to what they called maniera ("manner"), a word derived from the Italian word for "hand" (mano) and intended to signify the ascendancy of manual practice over visual observation and intellectual clarity. The belief in a post-High Renaissance decline in Central Italian art persisted throughout the nineteenth century; the decline was attributed either to excessive imitation of Michelangelo or to the pernicious influence of Giulio Romano, or to both.

Shortly before the outbreak of World War I, in an artistic atmosphere heavily charged with the revolutionary developments of twentieth-century art, the works of certain extreme painters, either condemned or ignored for more than three hundred years, began to excite sympa-

thetic interest. The phenomenon was superficially not unlike the revival in the 1880s of such once-forgotten masters as Botticelli, or of Piero della Francesca about 1900, but it was complicated by the difficult and contradictory nature of the material.

The first scholars who discussed the period seriously—notably Walter Friedlaender—saw a parallel to the antiacademic manifestoes of the early twentieth century in the position taken by such painters as Pontormo or Rosso Fiorentino against the principles of Michelangelo and especially Raphael. The later general adoption of the word maniera produced a modern linguistic equivalent, "Mannerism," and the post-High Renaissance generation of artists was somewhat hastily dubbed Mannerists. The expression was fraught with danger, since in most languages "mannerist" and "mannerism" describe something quite different from the often startlingly original works of art under discussion. (These, incidentally, could not really be considered maniera in the seventeenth-century sense of the term, either, but the word stuck nevertheless.) Although Friedlaender never pushed his ideas to such an extreme, many writers thought that in Mannerism they had found a new period to be set between the High Renaissance and the Baroque, forming a Hegelian succession of thesis, antithesis, and synthesis.

Like all intellectual abstractions uncritically imposed upon the reluctant events of history, the concept of Mannerism has had an unfortunate effect. In the attempt to "define" the principles of the style and apply them to the analysis of literature and music, even of life and behavior, Shakespeare became a Mannerist, and Hamlet and Queen Elizabeth I were both Mannerist characters. Recent critics have become increasingly disturbed by such ideological excesses and have drawn attention to the coexistence of High Renaissance and Mannerist artists in the same artistic center at the same moment; to the great intellectual difficulties attending any attempt to force the painting of the Venetians, let us say, or the architecture of Palladio into the Mannerist mold; and to the

sharp discrepancy between the artistic generation of about 1520 and the masters of the second half of the Cinquecento in Florence and Rome, who were indeed mannerists (with a small "m") in the traditional sense. Some writers have preferred to restrict the word "Mannerist" to these later artists, who will be treated briefly in Chapter 20, and much can be said to justify this point of view, etymologically and historically. Others, with somewhat less reason on their side, have recommended complete abandonment of the word "Mannerism," a losing battle considering all the ink that has been spilled in the past sixty years.

One sensible course might be to recall that diametrically opposed styles, sometimes as many as three at once, coexisted at other periods in Italian art as well, as, for example, the period treated in Chapters 13 and 14, or even, for that matter, the Early Renaissance itself. The expression "Mannerist" will be used in the following pages, not because it is any more accurate than "Gothic," let us say, as an artistic term, but because it has become so deeply embedded in our experience that we cannot just forget about it. Misnomer though it may be, the term 'Mannerism" is doubtless here to stay.

As we look back on the history of Italian art, we note that its chief sources of power were to be found in the republics and the Church, not solely because these were the patrons who could commission the most ambitious works of art, but also because they constituted the social forces that sustained and to a degree inspired the artists. Throughout the Renaissance both Church and republics came under intermittent but sometimes fierce attack. Nonetheless, they resisted and survived, and some of the crucial manifestations of Italian artistic genius (the Early Renaissance in Florence, the High Renaissance in Florence and Rome) derive much of their conviction and even, in sometimes measurable form, essential traits of their style from the artists' own debt to these very sources. Conversely, at moments when the sources weakened or threatened to dry up (the mid-Trecento in Florence and Siena, the late Quattrocento in Florence and Rome), we have noticed disturbing phenomena of individual vacillation and group disparity.

In Chapter 17 we have already had some insight into the dangerous transformations that, under Leo X, sapped the very substance of the Church. The state of affairs in Florence, meanwhile, was no less unfortunate, and was bound in time to grow worse. Ever since their expulsion in 1494 the Medici had been scheming to return to their native city. Their reinstatement in 1512 followed the terrifying sack of the neighboring town of Prato by Spanish troops serving under Julius II and the expulsion of Piero Soderini, who fled to exile in Ragusa (present-day Dubrovnik). While the old pope lived, the Medici ruled Florence again in the unobtrusive person and mild government of Giuliano, youngest brother of Cardinal Giovanni. Giuliano believed in a form of control from behind the scenes, in the traditional manner of the Medici, leaving the framework of the Republic externally intact. Giovanni's elevation to the papacy as Leo X in 1513 brought about a sharp change. He replaced Giuliano with their nephew Lorenzo, who entertained sterner ideas. In 1516 the pope, having driven out the rightful duke of Urbino, invested Lorenzo with the duchy. To the great distaste of the Florentines, Lorenzo maintained a ducal splendor in their midst and behaved as if he were in fact duke of Florence. Leo X used Lorenzo as a pawn in his dynastic ambitions, and married him off to a French royal princess. As fortune would have it, the princess died in childbirth in April 1519, and six days later Lorenzo followed her to an early grave. The direct male line of Cosimo de' Medici was thus extinct.

For four years power in the Florentine state was exercised by Leo's cousin, Cardinal Giulio de' Medici, still without disturbing the now-sham Republic. Leo's death in 1521 brought a non-Italian pope to the chair of St. Peter, a pious and learned Dutchman who, as Adrian VI, made a sincere effort at internal reform and control of the Lutheran rebels. He also ejected the entire entourage of Leo X, including the artists, and all artistic projects in the Vatican came to a halt. After less than two years, Adrian died suddenly, under general suspicion of poison. Giulio de' Medici was elected Pope Clement VII and continued to control the Florentine Republic. It was not long before the Florentines realized that, under the Medici popes, they had lost not only their internal liberties but also their external independence. From her position as one of the last, proudest, and greatest of the medieval republics, founder of the idea of liberty in modern times, Florence had sunk to the status of a captive province of the papacy. Commercial activity stagnated, and so did morale. Money and power were centered in Rome.

MICHELANGELO 1516 TO 1533

In the midst of this discouraging picture, Michelangelo reappeared in Florence at the end of 1516 to carry out a spectacular commission, Pope Leo's project for a splendid façade to complete the Church of San Lorenzo. This Medicean church had become more important than ever as a symbol of dynastic power now that the head of the family, named after the patron of the church, was a duke, and still more once he had become allied with the royal family of France. In the very year of his death, Giuliano da Sangallo, now well over seventy, submitted several drawings of alternative projects for the façade, all of them beautiful and one spectacular. This visionary design (fig. 566) masked Brunelleschi's clerestory and the unfortunate lateral chapels added along the side aisles with a two-story temple, flanked by freestanding, fourstory campanili, topped by tiny cruciform temples, ending in pyramids, crosses, and orbs. The central pediment would have bristled with sculpture, notably a statue of the seated Leo X, flanked by saints as if in an altarpiece.

In both the central façade and the corner towers, the superimposed engaged colonnades would have culminated in square piers at the corners. Although the campanili recall those designed for St. Peter's by Bramante (see fig. 501), Giuliano's designs did not taper upward. Moreover, his Doric order is imitated almost exactly from one he had drawn with care from the Basilica Emilia. In all these respects his unused drawing was followed by his younger brother Antonio in the campanili and interior of the Madonna di San Biagio at Montepulciano (see figs. 616, 618) only a few years later. Why, then, does Giuliano's grand design miss the point of High Renaissance composition? Not only because the mullioned windows are an anachronism recalling the Palazzo Medici and its successors, but also because the gorgeous effect is a cumulative one, derived from multiple, superimposed elements, rather than from the principle of dynamic growth that infuses the architecture of Leonardo and Bramante.

The commission went to Michelangelo, who steadily purified and concentrated his own designs into an extraordinary project, whose conflicting forces were locked together and stabilized. For three years the great master worked on plans for the façade, intended in his own words as a "mirror of architecture and sculpture of all Italy." The eventual two-story structure, almost free-standing, with returns facing the sides, was to have included twelve large-scale standing statues in marble, six seated ones in bronze, and fifteen reliefs. Michelangelo wasted many months quarrying the marble, first at Carrara, then at Seravezza, within the boundaries of the

Florentine Republic; to reach the new quarries of the latter, he had even to build a road through the mountains. Although we still know far too little about the final projected appearance of the façade, the wooden model built to Michelangelo's specifications still exists (fig. 567). Into its dense and compact structure of interlocking elements, we have mentally to insert the powerful statues and reliefs in marble and bronze, which, if we know anything at all about Michelangelo's sculpture, we suspect must have been intended to jut forth from the niches and the frames, imparting a passionate interplay of masses and of lights and darks to a scheme that otherwise looks prophetic of the classicism of seventeenthcentury France. Michelangelo's sculptural ideas, expressed in his lost models for the statues and his drawings, recently identified hypothetically by the author (see Bibliography), must have had an overwhelming effect on his Florentine contemporaries.

And then suddenly, in March 1520, the contract for the façade of San Lorenzo was annulled and the marbles abandoned, to the artist's violent indignation. The reason, however, in the author's view, is not hard to find. The death of Lorenzo in May of 1519 had deprived the façade of its principal *raison d'être*, and the money was needed for another project, in which Michelangelo was also involved, the tomb chapel for the two dukes, Lorenzo and Giuliano (who had died in 1516), as well as for the Magnifici, Lorenzo (died 1492) and Giuliano (murdered in 1478). According to a document discovered recently, plans for the funerary chapel (fig. 568) were divulged in great secrecy by Cardinal Giulio to a

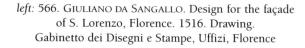

below: 567. MICHELANGELO. Model for façade of S. Lorenzo, Florence. 1517. Wood. Casa Buonarroti, Florence

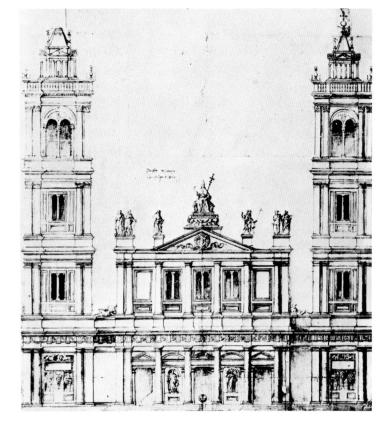

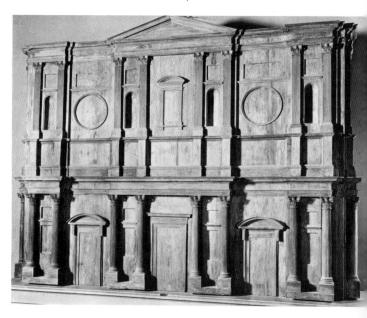

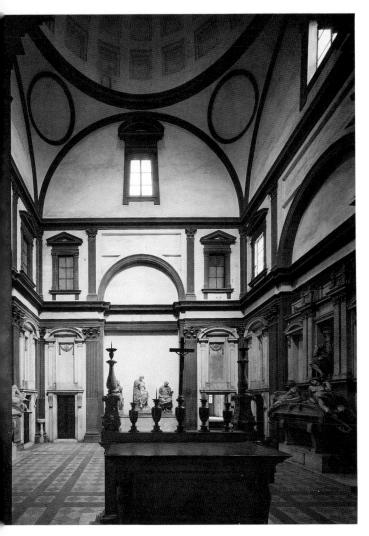

568. MICHELANGELO. Medici Chapel, S. Lorenzo, Florence. 1519–34

canon of San Lorenzo in June 1519, less than a month after Lorenzo's death. Construction began in November 1519, and Michelangelo was the architect from the start. He was apparently under the obligation to build on a plan that would be a twin to Brunelleschi's Old Sacristy on the left side of the transept (see figs. 137, 138). The windows on the exterior of the Medici Chapel, however, made to harmonize with the Old Sacristy, do not always correspond to those on the interior. Michelangelo arranged the lighting very carefully to produce the subdued, allover illumination essential for the prevailing mood of his architectural and sculptural compositions.

The work progressed irregularly and was never entirely completed. Some of the sculptures were never finished, others and the still-hypothetical paintings never started. Nevertheless, the Medici Chapel is the only one of Michelangelo's great architectural-sculptural fantasies to be realized in anything approaching entirety, and has been recognized ever since as a resounding triumph. The tombs and their sculptures must have been designed very rapidly, because by April 1521 Michelangelo was in

Carrara with all the measured drawings, ready to order the marble blocks. The correspondence and the many preserved sketches indicate that a freestanding monument was at first planned, with the four tombs on four faces, and include later proposals for wall tombs. The final arrangement placed the two dukes in their present wall tombs and relegated the Magnifici to a third wall, under the statues of the Madonna and St. Cosmas and St. Damian, between the entrances and facing the altar. This wall was never completed: the *Medici Madonna* (see fig. 571) was left unfinished, and the statues of the patron saints were relegated to pupils.

During the pontificate of Adrian VI, no marble was shipped, but early in 1524, a few months after the accession of Clement VII, the blocks began to arrive in Florence. By March 1526 four statues were almost finished, and in June two more were begun and one was ready to start; the only other important figures planned were the four river gods (never started but known from drawings and a model). But by June 1526 Clement's political machinations had involved the papacy beyond rescue, and hostilities had broken out between the pope and Emperor Charles V. In September the Vatican itself and St. Peter's were attacked and plundered by the Colonna party, and in January 1527 the pope ordered the fortification of Rome against the imperial forces. Early in the morning of May 7, 1527, began the terrible Sack that put an end to the High Renaissance, or what was left of it, in Rome. After months of unspeakable horror—looting, burning, rapine, torture, murder, desecration—the pope, a prisoner in Castel Sant'Angelo since June, escaped and fled to Orvieto on December 7. This was the greatest humiliation the papacy has ever endured, and throughout Christendom statesmen, scholars, and the general populace felt it to be the judgment of God for the paganism of Medicean Rome.

In the contemporary sources four intertwined themes can be distinguished: a sense of deep collective guilt, a desire for punishment, a need for healing the wounds inflicted by punishment, and a longing for a restoration of order in which the individual would no longer be free to seek his own destruction. Nor do these themes date only from the Sack of Rome. Itinerant preachers had long predicted the ruin of the Church, and years earlier Machiavelli had declared in Florence that

the nearer people are to the Church of Rome . . . the less religious are they. And whoever examines the principles upon which that religion is founded and sees how widely different . . . its present practices and application are, will judge that her ruin or chastisement is at hand. . . . The evil example of the court of Rome has destroyed all religion and piety in Italy.

Not until October 1528 was the pope able to return, poverty-stricken, to his burned-out and half-depopula-

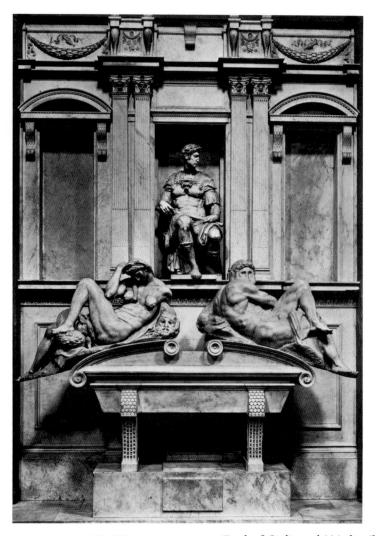

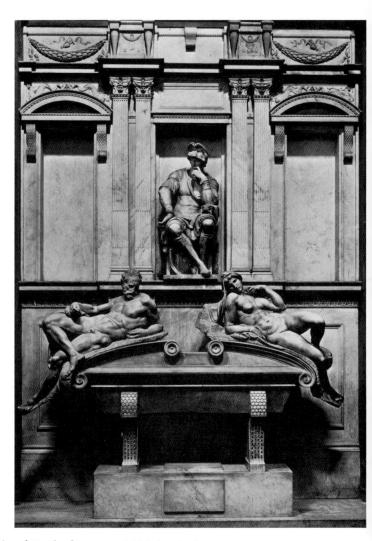

569, 570. MICHELANGELO. Tomb of Giuliano de' Medici (left) and Tomb of Lorenzo de' Medici (right), Medici Chapel, S. Lorenzo, Florence. 1519–34

ted capital. Florence, meanwhile, had thrown off the Medici yoke for the third time and reestablished the Republic. After the siege and capture of Florence by an unexpected combination of papal and imperial forces in 1530, in an alliance that was to pin despotism on most of Italy, Baccio Valori, the Medici governor of the city, gave orders for Michelangelo's assassination, because the artist had aided the Republic in fortifying itself against invasion. Temporarily, the canon of San Lorenzo, Giovanni Figiovanni, to whom humanity owes a debt of gratitude, hid the great artist; then Clement issued an order that justifies his name, sparing Michelangelo so that he might continue work on the Medici Chapel. This proceeded in a desultory fashion, interrupted by the artist's trips to Rome. Aided by Emperor Charles V, Clement had installed Alessandro, probably the illegitimate son of Lorenzo, but widely believed to be the son of the pope himself, and known for his vices and his cruelty, as the first hereditary duke of Florence; the Republic was at an end. When the pope died in 1534, Michelangelo was in Rome and was unwilling to risk his life to the limited mercies of Alessandro. Not even after the duke's assassi-

nation in 1537 would he return to Florence. Not until 1545 were the statues placed on the tombs by Michelangelo's pupils. Only those of the dukes were completed down to the penultimate details, and the four statues of the Times of Day still show passages of rough marble.

In his architectural formulation Michelangelo added an extra story to the Brunelleschian scheme, doubtless to raise the windows, the principal sources of illumination, above the neighboring housetops. In his Corinthian pilasters of pietra serena, however, he maintained so close a correspondence to Brunelleschi's norms that, before the establishment of the facts, a number of scholars maintained that the entire first story was erected by a conservative architect before Michelangelo took over the job. The beautiful coffering of the Pantheon-like dome, bare and white today, was originally ornamented in color by Giovanni da Udine, Raphael's specialist in decoration, but Clement had the decorations whitewashed. The flat, traditional two-tone architecture of pietra serena supports and trim, bordering white intonaco walls and pendentives, is set in opposition to a second marble architecture, richly carved and polished, ostensibly enclosed by the first yet refusing to remain within its enclosures. Incommensurate in style, character, substance, proportion, and scale with the first architecture, the second consists not only of the tombs with their statues but also of handsome tabernacles of unprecedented shape and still-enigmatic purpose. These protrude so far beyond the pilasters that they nearly meet at the corners in front of an imprisoned Corinthian capital.

On the sarcophagi of the dukes (figs. 569, 570), crowned by strange consoles in the shape of flattened elliptic arcs not meeting at the center, recline male and female figures representing Night and Day, Dawn and Twilight. In the square-headed niches of the second story sit the dukes, shown as beardless, handsome young men in Roman armor. The often-heard criticism that the Times of Day appear to be slipping off their sarcophagi would be less justified if the river gods, planned for the square plinths at either side, had been executed; the river gods would have completed a roughly circular composition of figures outside the sarcophagi. There is considerably less excuse for the old superstition that the Times of Day protrude because they do not fit, and were therefore intended for some other project in the chapel. Michelangelo's figures always tend to outgrow their enclosures (think of the steady expansion in size of the prophets and sibyls of the Sistine Ceiling), and one can watch the

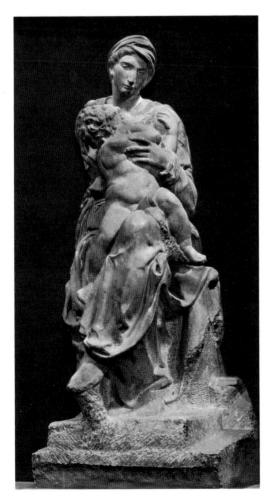

571.
MICHELANGELO.
Medici Madonna.
Designed 1521;
carved 1524–34.
Marble, height
99½". Medici
Chapel,
S. Lorenzo,
Florence

continuous increase in size of the Times of Day throughout the voluminous mass of sketches for the ducal tombs.

The meaning of the chapel has long been obscured by the contention that every major monumental complex of imagery by Michelangelo is to be interpreted as a synopsis of the Neoplatonic cosmogony, on the grounds that in his boyhood Michelangelo was acquainted with Neoplatonists at the court of Lorenzo the Magnificent, and that in Michelangelo's old age some of his poems (not, it should be noted, his works of visual art) were analyzed by a Neoplatonist, Benedetto Varchi, and found to contain Neoplatonic concepts. There is no other evidence. On the face of it a papal chapel, intended for the perpetual celebration of Mass and the saying of prayers for the salvation of departed Christians, would seem to require a Catholic content. But the Neoplatonic hypothesis has become, to its believers, an article of faith, and yields with difficulty to probability or even fact.

On a sheet of studies for architectural details in the chapel, Michelangelo wrote the following impressive words:

The heavens and the earth Night and Day are speaking and saying, We have with our swift course brought to death the Duke Giuliano; it is just that he take vengeance upon us as he does, and the vengeance is this: that we having slain him, he thus dead has taken the light from us and with closed eyes has fastened ours so that they may shine forth no more upon the earth. What would he have done with us then while he lived?

Michelangelo did not follow his own notes literally, because the eyes of all the figures save those of *Night* are wide open. Under a sketch for the third wall, then planned to contain the tombs of the Magnifici and the *Medici Madonna*, he wrote:

Fame holds the epitaphs in position; it goes neither forward nor backward for they are dead and their working is finished.

That the beautiful ducal statues were not intended to be recognizable portraits of the bearded Medici dukes is again shown by Michelangelo's words recorded by a contemporary:

... He did not take from the Duke Lorenzo nor from the Lord Giuliano the model just as nature had drawn and composed them, but he gave them a greatness, a proportion, a dignity ... which seemed to him would have brought them more praise, saying that a thousand years hence no one would be able to know that they were otherwise.

Roman armor was appropriate to captains of the Roman Church, which the dukes were, and even more so to Roman patricians, a rank conferred on Lorenzo and Giuliano in a splendid ceremony on the Capitoline Hill in 1513, complete with Roman trophies and Medici symbols, personifications of the rivers Tiber and Arno, and an altar at which Mass was celebrated.

In the chapel the statues of the dukes, as well as the priest behind the altar, gaze toward the *Medici Madonna* (fig. 571), the *Virgo lactans* or nursing Virgin, the oldest and one of the most persistent motifs in Michelangelo's imagination (see *Madonna of the Stairs*; fig. 467). *Day* (fig. 573) and *Twilight*, both male, face the life-giving mother and her Son; *Dawn* and *Night*, both female, turn from her. *Dawn* is characterized as a virgin, with firm, high breasts and the symbolic belt, or "zone"; *Night* (fig. 572), whose abdomen and breasts are distorted by child-birth and lactation, as a mother. Only in the Virgin Mary are the two states miraculously united. While the Times of Day grieve in childless defeat, Mary, with a look of unutterable love, presses her divine Child to her breast.

The celebration of the Mass of the Dead (which in the late seventeenth century was still being celebrated in the chapel four times daily) is the central energizing principle of the chapel. Even the pearly radiance so carefully calculated by Michelangelo suggests the Light Perpetual that was to shine upon the departed dukes. The celebrant was probably to have looked up from the *Virgo lactans* to a fresco of the *Resurrection* in the now-blank lunette. (Such an image would have been required by the dedication of the chapel to the Resurrection.) One drawing on the subject by Michelangelo (fig. 574) does correspond to the shape of the lunette, and can be connected with no other commission. After the darkness of his Passion and death, Christ leaps gloriously from the tomb—totally nude, as always in Michelangelo's Resurrection

drawings. The Resurrection, of course, is the theme of the Epistle for the Mass of the Dead. Recent suggestions locate frescoes of the attack of the Fiery Serpents and the delivery by the Brazen Serpent, for which an otherwise unexplained Michelangelo drawing survives, over the ducal tombs. But in neither sketch does the Brazen Serpent itself appear, probably because it foretold the Cross, and the crucifix on the altar would fulfill that function. The papal bull *Exsurge*, *Deus*, launched against the Lutheran heretics by Leo X on June 15, 1520, while Michelangelo was at work on the plans for the Medici Chapel and its imagery, throws considerable light on this aspect of the chapel's meaning:

Arise O God and judge Thine own cause [Psalm 73(74):22] ... rise up, O Peter ... defend the cause of the Holy Roman Church, mother of all Churches ... there rise up lying teachers, introducing sects of perdition ... whose tongue is fire, restless evil, full of deadly venom ... they begin with the tongue to spread the poison of serpents.

Leo's appeal to the Resurrection was personal, for he was crowned on Easter Saturday, a day marked in Florence by the triumphal festival of the Explosion of the Chariot, at which moment Christ was, until the Second Vatican Council, in Florence at least, officially resurrected.

The river gods have been identified as the four rivers of Hades by the proponents of a Neoplatonic interpretation, one of whom has gone so far as to zone off the whole lower section of the chapel, including the departed dukes and the Virgin and Child, as a symbolic Hades! The four rivers of Paradise would appear more appropriate to the comfortable region where Mary and her Son

572. MICHELANGELO. *Night*, on the Tomb of Giuliano de' Medici, Medici Chapel. Designed 1521; carved 1524–34. Marble, length 76½"

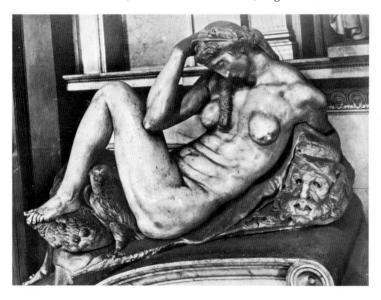

573. MICHELANGELO. *Day*, on the Tomb of Giuliano de' Medici, Medici Chapel. Designed 1521; carved 1524–34. Marble, length 80¾"

574. MICHELANGELO. Resurrection. 1520–25 (?). Black chalk, $9\frac{1}{2} \times 13\frac{5}{8}$ ". Royal Library, Windsor

belong, and to which such efforts were devoted to ensure the dukes a safe entry. More likely, the general significance of the rivers was geographical, since Vasari, who was one of Michelangelo's assistants in the chapel, remembered that he "wished all the parts of the world were there." Tiber and Arno, present at the Medici ceremony of 1513 in Rome, are possible candidates, but there may have been no intention to identify any of them precisely.

Seated in the power of their office and the beauty of their eternal aspect, the dukes are liberated from the remorseless circle of the Times of Day and the Parts of the World, by faith in the resurrected Christ and the nourishment of Holy Mother Church. The imagery of the chapel is also, of course, connected with the growing appeal to absolutism on the part of many Italians in the Cinquecento, as the sole release from the chaos to which centuries of republican civil strife had brought them. In Il principe (The Prince), Machiavelli had vainly appealed to Duke Lorenzo to liberate and unify Italy. The idea of the magically charged and supernaturally justified Prince, successor to the discredited ideal man of the High Renaissance, was the great collective fantasy with which Late Renaissance Italy tried to assuage its sense of its own inadequacy to unite before the multiple threats from the North. That the dukes themselves, especially Lorenzo, were so openly recognized as worthless could, under such circumstances, only lend the legend stronger wings. Understood for centuries as an allegory of princely and papal power, the symbolism of the chapel, which in other hands would have become mere pomp, was transfigured by the intensity of Michelangelo's genius into an at once tragic and heroic view of human destiny.

The compositions of the two ducal tombs are opposites in subtle and significant ways. It has often been noted that while *Giuliano* is characterized as open and cheerful, *Lorenzo* is closed, moody, self-contained, and deserving of his nickname, *Il Pensieroso*. The contrast may have suggested the opposition in John Milton's fa-

mous poems L'Allegro and Il Penseroso. Giuliano idly holds several coins, as if in intended largesse; Lorenzo plants his elbow on a closed money box, decorated with a fierce mask variously identified as belonging to a bat or a lynx. The light that plays freely on the beautiful countenance of Giuliano is prevented from reaching the blank face of Lorenzo, enshadowed by his immense helmet and half-hidden by his left hand. Night and Day, arranged at angles counter to the shape of the volutes, toe sharply out; Dawn and Twilight, weighed down by the prevailing gloom, conform to the volutes and toe downward.

Giuliano and Lorenzo, while related to some of the types and poses of the Sistine Ceiling, are noticeably less massive and less energetic. A strange lassitude overcomes them both. (It is worth remembering that while at work on the statues Michelangelo, then only in his late forties, wrote that he was already old, and that if he worked one day he had to rest four.) Shoulders slope, muscles sag, veined hands hang heavily. The drowsy face of Giuliano (fig. 575), for all its rich beauty of line and surface, is completely drained of the fire and conviction of the David, let us say, or of the prophets of the Sistine Ceiling. In both ducal figures the lines are longer, the proportions slighter, the angles smoother, the execution less crisp than might have been expected. Although the Times of Day are extremely muscular—the pulsating masses of Day's gigantic back surpass anything that even Michelangelo had achieved in the projection of male musculature—they either writhe in helpless involvement with their own uncontrolled limbs or droop in painful weariness. The male faces are unfinished. Day's is merely blocked out, but in the rough surfaces of Twilight's sad head many have discerned the familiar contours of Michelangelo's own disfigured face. The finished (or almost finished) female faces are strangely ornamental and, although superficially unreal, nonetheless deeply poetic. Night, with her strongly Hellenic nose and not quite closed eyes, a great star caught in the cres-

above: 575. MICHELANGELO. Head of Giuliano de' Medici (see fig. 569)

below left: 576. MICHELANGELO. Dawn, on the Tomb of Lorenzo de' Medici, Medici Chapel. Designed 1521; carved 1524–34. Marble, length 81"

below right: 577. MICHELANGELO. Head of Dawn, detail of fig. 576

cent of her diadem, dreams fitfully of her lost children. The tragic Dawn (figs. 576, 577), her brows knitted in a shape recalling the facial structure of the Italo-Byzantine Madonnas of the Dugento, grieves over her childlessness. Michelangelo's mighty female forms were done from male models; in fact many male studies for the Night are still preserved. Breasts were attached later. Much is made of the ornamental shapes of attenuated thighs, shins, and ankles, carrying into the figural masses the taut arcs of the sarcophagi. The Medici Madonna (see fig. 571) was reshaped many times and cut down in the process; the lower portions reveal the original scale of the group. Although the beautiful face of the Virgin and the body of the Child have not received their final polish, Michelangelo's sensitive use of the threetoothed chisel gives to these passages an atmospheric quality, as if seen through a veil of haze.

The total effect of the sculpture is disturbing. So even are the details of the ornament. The leering mask, symbol of false dreams—for which Michelangelo cut away the original left arm of Night and started a new one twisted behind her shoulder-brings into larger focus the steady procession of tiny, snarling masks that compose the frieze running behind all the Times of Day, indicating that death is a nightmare from which we will awaken. Of any other awakening, it would appear, the Florentines of the 1520s were by no means convinced. The architecture of the chapel, the mood of its statues, and the new and artificial ideals for the human body and face had an immediate and profound effect on contemporary artists at work in Florence. In what has come to be known as the Mannerist crisis, the Medici Chapel is the central monument.

While engaged in the carving of the statues for the Medici Chapel, Michelangelo was taking a still more radical step in the development of new architectural forms. A new library for San Lorenzo, to house the great Medicean collection of books and manuscripts, had been on Cardinal Giulio de' Medici's mind as early as June

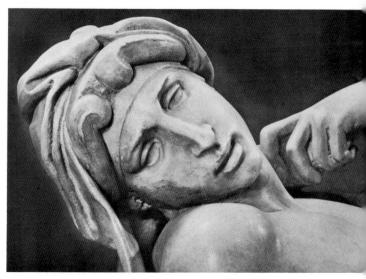

578.
MICHELANGELO.
Entrance Hall,
Laurentian Library,
S. Lorenzo, Florence.
1524–34; staircase
completed 1559

1519, but the commission for the structure was not given to Michelangelo until after Giulio became Pope Clement VII in November 1523. The Laurentian Library had to be constructed as a third story on top of the monastic buildings connected with San Lorenzo. Construction began in 1524, was halted in 1526, recommenced along with the Medici Chapel after 1530, and was abandoned when Michelangelo took up residence in Rome in 1534. In 1557 he sent a model for the staircase, but he never saw the building in its present form.

The entrance hall is the most startling portion of the library (fig. 578). Its two stories are composed of superimposed orders of slender, coupled Tuscan columns, which ostensibly support the abbreviated entablatures but in reality are placed like statues in niches in the wall, whose embrasures contain flanking pilasters. This extraordinary idea, which seems to have been developed from the walled-in pilasters in the corners of the Medici Chapel, produces an apparent reversal of the functions of wall and column. What is revived, on a grand scale and in architectural terms, is nothing less than the old conflict between line and mass, which we have seen in Michelangelo's early sculpture. Mass protrudes into the space of the room, line cuts against it. Locked in conflict, the opposed forces produce a strange, cold, and tragic beauty of shape and line, painfully elaborated in the finespun motives of the ornamental panels and reduced in the weird tabernacles to forms of mortuary chill and utter unreality. Not since Minoan times had supports tapered downward, as these pilasters do, and never had they been cut into three unequal segments by variation in surface fluting.

The staircase, whose solution came to Michelangelo in a dream, freezes the principle of conflict in its opposition of ascending lateral flights flanking the descending central stair with its bow-shaped steps extending outward.

At first sight the long reading room looks more conventional (fig. 579). The pilasters support; the walls do not move inward; there are no floating consoles. And

579. MICHELANGELO. Reading Room, Laurentian Library, S. Lorenzo, Florence. 1524–33

then, as the observer analyzes the structure and the space, he comes to realize that the battle is still on, and he is caught in it. Pilasters, matching ceiling beams, and floor patterns produce a continuous and total cage of space in which the reading desks (also designed by Michelangelo) are trapped, two to a bay, and the reader with them. Similar linear refinements are elaborated in the structure of the windows and the tabernacles, but the precision of the ornamental statement serves only to underscore the most disturbing aspect of the room—it has no reasonable terminus. Since all the bays are identical, like cars in a train, the succession could contain two more or three less without effect on the purely additive composition.

Today we see the Laurentian Library without its crowning feature, which would have completed the procession of painful spatial configurations with a climax analogous to the effect of Poe's *The Pit and the Pendulum*. The deliberately dreary parade of identical bays was to have led to the strangest spatial idea of the entire Renaissance (fig. 580), a triangular rare-book room enclosing a triangular maze of reading desks and lighted from concealed sources. In point of fact, the space available to Michelangelo between preexistent buildings outside *was* triangular, but a lesser artist would have tried his best to cut the corners and fit a rectangle, or at most a circle, into the unbearable triangular shape. Michelangelo made a virtue of necessity. Alas, his rare-book room was never built.

Four more *Captives* and one *Victory* (see figs. 582–587) for the Tomb of Julius II are preserved in Florence, and the most reasonable assumption is that Michelangelo set to work on them in Florence after all Medicean operations were suspended late in 1526. The most troublesome of the heirs of Julius II, Francesco Maria della

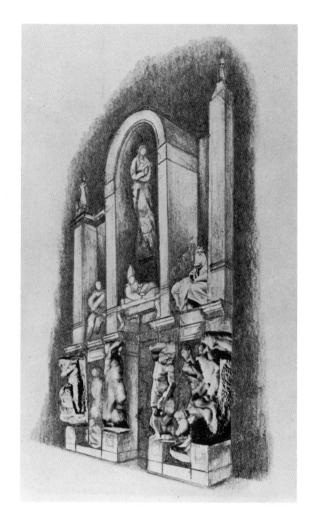

Rovere, duke of Urbino, had recaptured his duchy after the death of Leo X in 1521 and was, of course, an implacable enemy of the Medici. As ally of the Florentine Republic, he passed through Florence twice during this period, at the head of a powerful force, and it can be assumed that he used his presence there to bring pressure on Michelangelo to complete the tomb. The Florence Captives are larger than those in the Louvre (see figs. 532, 533), but would certainly have been carved down, as was Michelangelo's practice with all statues, for this, the fourth project, formalized in a written contract only in 1532. The tomb was now to have been a simple wall tomb (fig. 581), with the Moses still on the upper story and the pope reclining on his right elbow on a transverse sarcophagus. The strange Victory (figs. 582, 583), changed from female to male, has often and erroneously been connected with Michelangelo's passion for the handsome and cultivated young Roman nobleman Tommaso Cavalieri, in terms of the last lines of one of Michelangelo's sonnets:

> It is no marvel if nude and alone I am the prisoner of an armed cavalier.

But it is the prisoner here who is clothed and the nude victor unarmed!

The entire meaning of the tomb has changed since the

left: 581.
MICHELANGELO.
Tomb of Pope
Julius II.
Reconstruction
drawing of project
of 1532

right: 582. MICHELANGELO. Victory. 1527–28. Marble, height 8′6¾". Palazzo Vecchio, Florence

far right: 583. Head of Victory, detail of fig. 582

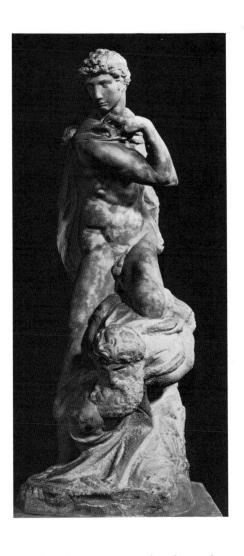

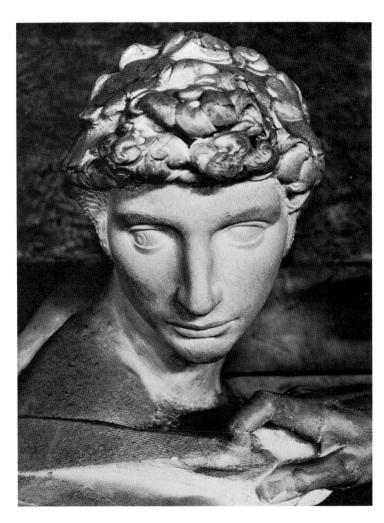

earlier projects. The idea of resurrection has been discarded; the Captives, like Atlas figures, support the cornice, straining under its enormous weight. The Victory, too, has changed its meaning with its sex. The youthful figure is engaged in subduing rather than liberating a captive, yet withdraws at the moment of triumph. A revival of the old Psychomachia raging in the souls of Donatello's figures (see page 173) takes place not only in the Victory but also in the newly liberated Florence. Niccolò Capponi, gonfaloniere of the Republic, asked the Florentines in 1527: "Do you hold dear the conquering of your enemies, or that your enemies do not conquer you? Then conquer yourselves, put down wrath, let hatred go, put aside bitterness." Speaking of the miserable state of the Medici pope, prisoner in Castel Sant'Angelo, he warned: "Not the words that are said, ignominiously or injuriously, against enemies, but the deeds that are done, prudently or valorously, give, won or lost, the victory." These words were delivered in the great hall of the Palazzo Vecchio, which still may have held the beginnings of the Battle of Cascina (see fig. 479) and certainly showed the unfinished Battle of Anghiari (see fig. 464). The following year, in the same place, Capponi pointed out that the Florentines had won their victory without bloodshed, through the intervention of God: "To his divine Majesty, therefore, we have to lift the eyes of our mind, recognizing God alone as our King and Lord, hoping firmly in him, who has undertaken the protection of this city and state...."

The twisted Victory group, one of Michelangelo's most original conceptions, was planned to stand vertical but is now tilted somewhat forward. Originally, the young hero stopped his struggle to look upward toward heaven, drawing with one hand the mantle, age-old symbol of heavenly protection, around him. It is to Donatello's marble David (see fig. 161) and his St. George (see fig. 164), both also expressing passionate civic conviction, that we must look for certain aspects of the style of Michelangelo's tense and haunting group. Seen upright, the group loses its strained and tortured appearance, and harmonizes with the architecture of the tomb for which it was designed (see fig. 581). Quite as important, it regains its lofty dignity—a kind of soaring quality, intended not only for its aesthetic result but also for its moral significance. The taut effect of the erect and rangy victor is communicated to all his muscles and to his very expression, intent on communication with divinity, like an Abraham or a David. While the beard of the vanquished is largely uncut marble, elsewhere almost all the work with the toothed chisel has been completed. Here and there the splendidly muscled torso, alive with shifting tensions, has even received its finish. Only the right eye,

right: 584. MICHELANGELO. "Crossed-Leg" Captive. 1527–28. Marble, height 8'10". Accademia, Florence

far right: 585.
MICHELANGELO. "Beardless"
Captive. 1527–28. Marble,
height 9'1". Accademia,
Florence

strangely enough, has been given an incised iris. Possibly Michelangelo was already aware of the logical difficulties in the way of this originally Ghibertian device, which he was to renounce altogether in finishing the statues for the Medici Chapel. As in the closely related face on the *Medici Madonna* (see fig. 571), one sees the countenance of the *Victory* (see fig. 583) as through a haze of chisel strokes. This figure, beautiful as a Hellenic warrior, sensitive as Donatello's *St. George*, remains one of Michelangelo's most penetrating if least understood creations.

It is unrealistic to guess at what might have been the order of the four *Captives* (see figs. 584–587) on the lower story of the version of the tomb formalized in the 1532 contract. Some of the motifs may go back as far as the 1505 project (see fig. 510), notably the classical pose with legs crossed (fig. 584). When Michelangelo came to carve the statue, however, he made it writhe and twist in a wholly new manner, transmitting the weight from the upraised left elbow through the body to the unaided left foot. To support this weight the torso arches and the chest lifts as though in pain, and the bearded head is

tilted back. The beardless *Captive* (fig. 585) supports the weight in an axis running from left elbow to right foot, but in a languorous, almost dreamy way. The titanic, bearded *Captive* (fig. 586), whose anguished face and expanding chest carry memories of the *Laocoön*, loses somewhat in the execution because of the clumsy cutting of the legs, probably the result of an ill-fated later attempt to finish what Michelangelo had left unfinished.

In all four statues Michelangelo's chief interest lay in the torsos, which are, from the front at least, fully developed with the toothed chisel and lack only surface finish. Sometimes an arm or a leg is brought to a similar condition, but never a head. The heads remain either roughed in or, as in one striking instance (fig. 587), still encased in the block, save for features faintly visible on one side as through a dense cloud of marble. Sometimes the statues have been started from two sides at once, sometimes from three, but in each case the back is still concealed within the block. One can usually follow the contours around the torso with considerable clarity up to the point where the shape suddenly disappears. For all their enormous volume, not to speak of their superhuman

far left: 586. MICHELANGELO. "Bearded" Captive. 1527–28. Marble, height 8'4¾". Accademia, Florence

left: 587. MICHELANGELO. "Blockhead" Captive. 1527–28. Marble, height 8'7½". Accademia, Florence

strength, the figures are oddly soft. The vast areas of muscle and skin heave, swell, subside, shine silkily against the drilled blocks of stone. Whatever might have been Michelangelo's conscious intent—and he must have thought he would finish the statues—their present condition reveals essential aspects of his nature as well as the turmoil of the years during which he worked on them. To watch these giants struggle to free themselves from the surrounding marble has been for viewers during four centuries a strongly empathetic experience. If the great artist could miraculously return and carve away all the rough marble, we would probably miss it.

ANDREA DEL SARTO

The absence from Florence after 1508–9 of the three greatest inventors of the High Renaissance style left a clear field for lesser masters. One of these, Andrea del Sarto (1486–1530), soon became a great one, separated from the very highest rank only by an inexplicable but often-deplored vacuity of feeling and statement. Perhaps it was this same vacuity that preserved him, because he sailed through the so-called Mannerist crisis, which af-

fected Michelangelo so deeply, untouched by the disorders of the era. Yearning and melancholy one finds in his style, but never the collective neurosis that infected his scarcely younger contemporaries. One senses here and there in Andrea's early work faint echoes of Leonardo and slightly stronger ones from his near-contemporaries Raphael and Fra Bartolommeo; however, the broad naturalism of Andrea's teacher Piero di Cosimo, in whose shop he remained from about 1498 to 1508, is very evident in his earliest important achievement, the fresco cycle of five scenes from the Life of St. Philip Benizzi. This was painted in 1510 for the atrium of the Santissima Annunziata, which had long been resplendent with Baldovinetti's Nativity (see fig. 318). Throughout the series Andrea retained the outdoor light and atmospheric amplitude of Baldovinetti, demanded actually by the site itself, which was filled with sunlight. The fantastic landscape masses, jutting rocks, and trees half-dead and halflive in the Punishment of the Gamblers (fig. 588) obviously derive from Piero di Cosimo. One can imagine how much more Piero, whose eccentricities, by the way, drove Andrea from his studio, would have made of the bolt of lightning that severs the tree and kills the gamblers. At any rate, Andrea's landscape shapes and spaces move with the somnolent ease of a lowland river, full, swollen, and deep, carrying a great load of substance and color and submerging the well-drawn but somehow insignificant figures. His fresco surface, lightly and freely brushed, glows with flower tones against the blue-greens in the ascending landscape.

In the grave and grand Annunciation of 1512 (fig. 589), painted for the Monastery of San Gallo and one of Andrea's most serenely beautiful creations, he adopts something of the measured dignity of the High Renaissance style, already practiced for several years by Fra Bartolommeo (see fig. 486). The large-scale figures almost fill the foreground, and are united with the remote distance by a well-constructed perspective. Mary stands before the Temple, whose portico surprisingly resembles that in Ghiberti's Jacob and Esau scene on the Gates of Paradise (see colorplate 30). Unusually, Gabriel approaches from the right, kneeling on a cushionlike cloud that is the only gaffe in the otherwise flawless picture. The broad, graceful figures and grand heads turn beautifully in relation to the distant perspective, whose apex is placed behind the head of a seated, almost nude figure.

above right: 588.
ANDREA DEL SARTO.
Punishment of the Gamblers,
from Life of St. Philip Benizzi.
1510. Fresco. Atrium,
SS. Annunziata, Florence

right: 589.
ANDREA DEL SARTO.
Annunciation. 1512.
Panel, 71½×71½".
Pitti Gallery, Florence

opposite: 590.
ANDREA DEL SARTO.
Birth of the Virgin.
1514. Fresco. Atrium,
SS. Annunziata, Florence

Could this be Isaiah, whose prophecy Mary was reading as she sat at the step of the closed fountain, the symbol of her virginity? The deep, blue sky, of almost Peruginesque clarity, harbors only an occasional cloud; from one of these comes the dove of the Holy Spirit. The massive color scheme of smothered reds, blues, and oranges accords with the new seriousness of Andrea's art.

In 1514 he returned to the Annunziata to paint the celebrated Birth of the Virgin (fig. 590), a High Renaissance commentary on the diffuse miscellany of Domenico del Ghirlandaio's delightful fresco on the same subject (see fig. 363). The patrician interior reflects the architectural ideals of Giuliano da Sangallo (see pages 296–98). The massive figures, echoing Raphael's Stanza d'Eliodoro and Michelangelo's Sistine Chapel lunettes, are united by the same kind of curving rhythm that in the St. Philip Benizzi series flowed through the landscape. The deep shadows of the mature Raphael have also made their way to Florence, which had generally remained impervious to Leonardo's mysterious chiaroscuro. The angels on their clouds above the bed canopy, joining the dancelike movement of the foreground figures, were derived by Andrea from an engraving by Albrecht Dürer. Joseph, in the center toward the back, is lifted in reverse, almost bodily, from Raphael's portrait of Michelangelo in the School of Athens (see fig. 536).

In the altarpiece of the *Madonna of the Harpies*, signed and dated 1517 (fig. 591), best-known of a host of Andrea's Madonnas, he has arrived at a noble statement of

the Florentine version of Roman grandeur, again not without a conspicuous borrowing. Vasari tells us that Andrea painted the St. John the Evangelist on the Virgin's left from a clay model by Jacopo Sansovino, which the sculptor submitted in his competition with Baccio da Montelupo for the statue of the saint at Orsanmichele. It has not, apparently, been noted that the real inventor of the figure was Raphael; Sansovino, too, merely adopted and reversed the philosopher holding a book, between Pythagoras and the portrait of Michelangelo, in the School of Athens. Since Raphael himself reused the same figure in the Galatea (see fig. 558), the whole cycle of reciprocal borrowings demonstrates the lack of any sense of personal ownership of a figural motif among High Renaissance masters, and their great interest, on the contrary, in extracting the maximum effect from a handsome invention. The increased dignity, even majesty, of Andrea's forms, the severity of his architectural background, the force and dominance of his figures as well as their sculptural roundness and integrity, and his splitting of the drapery surface into facets like the planes of marble carving reflect the formidable presence of Michelangelo in Florence.

These various elements of style and motive are assimilated very easily by Andrea, whose noble altarpiece is, in the last analysis, completely original. It is unified by his own sense of formal harmony and deep-toned color, as well as by his characteristic melancholy sweetness, unconvincing in the expression of St. Francis but irresistible in the face of the lovely Virgin. The harpies who guard her throne are doubtless there, as in Andrea del Castagno's Last Supper (see colorplate 34), to fulfill their role as leaders of souls to another world. The strong, simplified composition, the poise and counterpoise of masses, and the eloquence of figural style achieved by Andrea in this and other contemporary pictures gave him the deserved leadership of Florentine painting toward the end of the second decade of the Cinquecento. So far, in spite of a pervasive note of gloom even in the happiest paintings, there is not a hint of the so-called Mannerist crisis, nor will there be, save in an occasional emotional outburst, to the end of Andrea's days.

In 1523, along with his wife, Lucrezia del Fede, her daughter, and her sister, Andrea fled the plague, which had returned to Florence, for the more healthful air of the Mugello, the broad, luminous valley that separates the first range of hills to the north of Florence from the major rampart of the Apennines. There, in 1524, in the village of Luco, he painted a *Lamentation* (fig. 592) that transforms grief into lyric exaltation. In deliberate reminiscence of a well-known composition by Perugino, the dead Christ is upheld in a seated position by the kneeling St. John the Evangelist at the left, while the Virgin holds his left hand and looks downward. Mary Magdalen, kneeling in prayer before the feet she once washed with her tears and dried with her hair, withdraws into medita-

591. Andrea del Sarto. *Madonna of the Harpies*. 1517. Panel, $81\frac{1}{2} \times 70^{\prime\prime}$. Uffizi Gallery, Florence

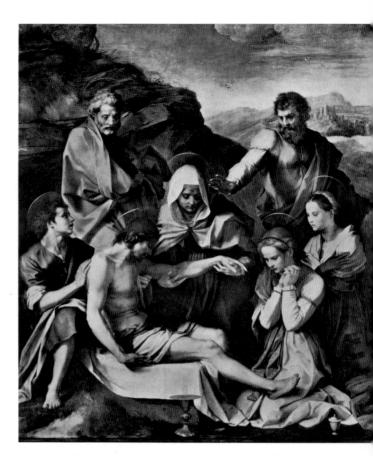

592. Andrea del Sarto. *Lamentation*. 1524. Panel, 94×80". Pitti Gallery, Florence

tion. This is not a historical scene; St. Peter and St. Paul appear at either side, one contemplative, the other reaching out toward the body as if to warm his hand, and St. Catherine looks quietly from her kneeling position, her hands folded on her bosom.

Although the dedication of the church in Luco to St. Peter and the fact that its abbess was called Catherine account for the presence of these two saints, we need more than that to elucidate the warmly personal character of the picture, one of the most haunting of the numerous Pietàs that after about 1517 or so appeared throughout Central Italy. No more are we invited, as in the Quattrocento, to dwell on the wounds of Christ, to lacerate ourselves with his sufferings. Rather his body is presented mystically in the form of the sacrament, and indeed in Andrea's painting the chalice stands in the center foreground, covered by the paten on which the Host appears, mysteriously erect. It is the Eucharist, not the wounds, that draws the gaze of all the saints save John, who looks, as he was bidden, toward the blessed mother. Andrea's wife, stepdaughter, and sister-in-law posed for the Virgin, the Magdalen, and Catherine; the town of Luco appears in the background in the evening light, against the hills of the Mugello.

It is hard to explain the intimacy of this family-style *Lamentation* by any other supposition than the arrival in Florentine territory of the quietist doctrines of the Oratory of Divine Love. The sacrament, "source of light and

heat," draws all to itself, and we forget the pathos of the darkened face of Christ as we contemplate his perpetuation in the shining wafer.

Two huge altarpieces by Andrea representing the Assumption of the Virgin, both based on the same general composition, face each other in the Palazzo Pitti, although they were never intended to be seen together. The later of these (colorplate 77) was painted for the Church of Sant'Antonio dei Servi in Cortona, and although commissioned in 1526 it may not have been finished until the year before Andrea's death. Although, like so many of Andrea's Madonnas, this one is a portrait of his wife, there is an air of magic unreality about the whole picture. Mary, seated on clouds, folds her hands in prayer and hangs in the light, surrounded by the sturdy and beautifully modeled putti Andrea had learned to paint with such conviction. The light shines on the circle of powerfully drawn standing and kneeling saints, including the local St. Margaret of Cortona in the right foreground. Then darkness closes in, the golden light fails, and in massive shadows that point the way toward Rembrandt we can discern the rocky cliffs of the background. In its combination of clarity and dimness, substance and dissolution, reality and vision, the picture seems to belong more to the seventeenth century than to the sixteenth. Or is that because we still do not fully understand the complexity and richness of the Cinquecento?

PONTORMO

Andrea del Sarto remained a High Renaissance painter even in his most mystical phase. But in the person of his younger pupil, Jacopo Carucci da Pontormo (1494–1557), the forces of the Mannerist crisis reach their culmination. Pontormo, indeed, opens up for us a world of combined fantasy and perverseness, poetry and torment, unprecedented in the entire history of visual art and expressed in forms of disturbing beauty.

As a youth of eighteen, according to Vasari, Pontormo had studied in succession with Leonardo da Vinci, Piero di Cosimo, and Andrea del Sarto. Temperamentally, he was certainly closer to Piero than to the relatively phlegmatic Andrea, and indeed in his later years Pontormo was also to become a recluse, shutting himself away from the world in a studio accessible only by means of a ladder, which he could draw up after him. But even in his early works the strangeness of his personality and style is

readily visible. In his Visitation, for example (fig. 593), painted in 1514–16 for the atrium of the Santissima Annunziata and thus in direct competition with Baldovinetti's Nativity and Andrea's seven frescoes (see figs. 318, 588, 590), Pontormo already saps the foundations of High Renaissance structure. At first sight his composition looks like an exaggeration of High Renaissance symmetry. The main incident is centralized; a terminal female figure at the right balances one at the left; the figures are arranged neatly within the architectural setting. And then, instead of balancing the woman seated on the stairs at the left with a similar motif at the right, Pontormo breaks the symmetry by introducing a small boy, completely naked, taking a sunbath on the steps while he looks down at his left leg and scratches it gently. This figure totally transforms the composition, leading the eye out of (or into) the picture at one side and initiating a strong and unexpected lateral surge inward and upward along lines continued by the kneeling St. Eliza-

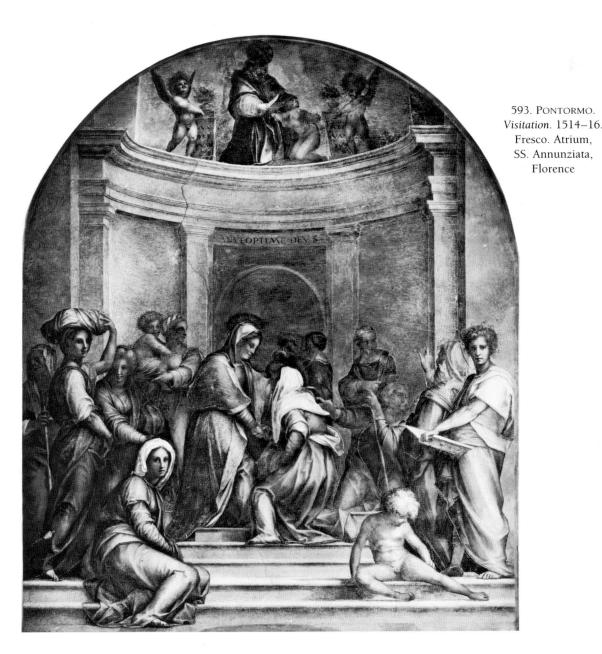

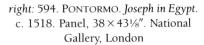

opposite: 595. PONTORMO. Vertumnus and Pomona. Probably 1520–21.Fresco. Villa Medici, Poggio a Caiano

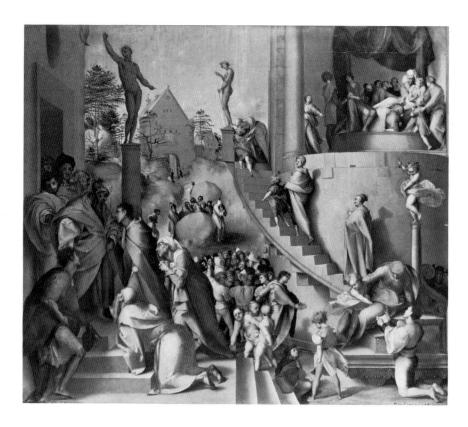

beth. The bright and sometimes jarring color combinations, based on Michelangelo's lunettes (Elizabeth wears a golden yellow tunic with a sea-green outer sleeve and a violet inner sleeve), heighten the unconventionality of the figural composition.

One wonders why the Visitation, which took place in front of Elizabeth's house, should be staged in a monumental exedra at the apex of a pyramid of steps, but there appears to have been a ritual intention in that the eye is immediately led to the apex of the arch where, instead of the expected semidome, we see the Sacrifice of Isaac taking place between chanting putti upholding urns full of flowers. As we have seen in the case of Ghiberti (see page 158), the Sacrifice of Isaac was traditionally held to foretell that of Christ. Its juxtaposition here with the Visitation converts the prenatal meeting of Christ and St. John the Baptist into a prophecy of their martyrdoms (expressed sacramentally rather than dramatically), fulfilling the will of God extolled in the inscription over the arch, in what resembles a ceremonial grouping of worshipers around an altar in an apse. Mary is often interchangeable with the Church in Christian symbolism, and John the Baptist is the patron saint of Florence. In view of the works painted by Pontormo at just this moment for the new pope, Leo X, it is surely possible to find in Elizabeth's profound obeisance to her cousin, amid general rejoicing, a reference to the new submission of Florence to the Church. Nothing, however, is likely to account for Pontormo's inclusion of the little, naked, unconcerned sunbather.

Nor does even this instance of Pontormo's irresponsibility prepare us for the full onslaught of Mannerism in his contributions to the nuptial chamber of Pierfrancesco Borgherini. The Palazzo Borgherini (now Palazzo Rosselli del Turco), a splendid example of Florentine High Renaissance architecture, still stands in Borgo Santi Apostoli. Pierfrancesco, a close friend of Michelangelo and by all accounts a delightful person, ordered for it a series of paintings of the Story of Joseph from Andrea del Sarto (suggested by Michelangelo), Pontormo, and two other leading Florentine painters, to run around the room incorporated in the wainscoting, which unpublished research by Anne Barriault has shown was customary in such cycles. In its crowd of nervous figures, statues pulsating on the tops of slender columns, uncertain and unprotected staircases spiraling into nowhere, broken and spasmodic rhythms, irrational light and space, and avoidance of centrality, symmetry, or any other form of unifying compositional device, Pontormo's Joseph in Egypt (fig. 594), painted about 1518, makes a total break with the High Renaissance, in spite of the artist's consummate mastery of High Renaissance drawing and modeling. But even in his pictorial treatment, he has tightened the soft, diffuse quality of his brushwork in the Visitation, derived from Andrea del Sarto, and presents us with rubbery surfaces whose smoothness makes the compositional chaos even more disturbing. The picture splits up into little vignettes, some very close to us, some far away, yet without apparent connection, exploiting irrational jumps in scale, from Pharaoh's dream at the upper right, to the discovery of the cup in the center, to the reconciliation of Joseph and his brethren at the left. How Ghiberti would have shuddered at the sight of the deliberate destruction of everything he had tried to create in his harmonious rendering of the same story in the Gates of Paradise!

Through the whole picture, with its brassy colors, runs a strange terror resulting in an almost physical tremor, like chills and fever. A center-background group of figures, clinging about the edge of a gigantic boulder, unable to move, seems transfixed, as one is in dreams, by a power beyond comprehension or control; they have been interpreted in terms of the brethren's lament (Genesis 47:19): "Wherefore shall we die before thine eyes, both we and our land?" The relevance of the verse for contemporary Florentines, well aware that they had lost both freedom and independence, may not be altogether accidental. The Germanic buildings in the background are derived from the engravings of Albrecht Dürer. Vasari, indeed, blamed Pontormo for having sacrificed Italian grace to Northern strangeness in his figures as well. Parenthetically, the anxious boy in contemporary costume seated on the step in the foreground was identified by Vasari as Pontormo's pupil and adopted son, Agnolo Tori, called Bronzino (see Chapter 20).

A wholly different mood is celebrated in the lyrical fresco Pontormo painted, probably in 1520–21, for the Villa Medici at Poggio a Caiano (fig. 595), which had been built some forty years earlier by Giuliano da Sangallo for Lorenzo the Magnificent (see fig. 311). Leo X wished the great hall of the villa to be decorated with classical subjects, and placed Cardinal Giulio in charge of the project at the same time that the cardinal was superintending (if one dare use that word) the progress of Michelangelo's designs for the Medici Chapel. Andrea del Sarto and others were commissioned to paint the side walls and Pontormo the end walls, but at the death of Leo in 1521 the work was interrupted, not to be resumed until much later in the century. Of Pontormo's share,

only one lunette was ever done, but that is a fabric of utter enchantment. Vasari tells us that the subject was to be Vertumnus, Roman god of harvests, and Pomona, goddess of fruit trees, and was provided by the eminent humanist Paolo Giovio. Recent research tends to confirm this account. The motto "GLOVIS" below the oculus (not visible in the illustration) was that of Lorenzo de' Medici, duke of Urbino, who died in 1519, immortalized in Michelangelo's tomb (see fig. 570). Read backward, it comes out "si volge," or "it turns," a reference to the constant reversals of fate that characterized the history of the Medici. Another inscription, above the oculus (also not shown here), comes from Virgil's Georgics (I, 21), in which the gods are depicted in bucolic activities. Vertumnus and Pomona are united by the great garland of fruits and vegetables under the window, and especially by the laurel branches, symbols of the dead Lorenzo, which seem to grow from its very frame (see page 330), and with which Pomona has filled her lap. While old Faunus, god of the woods, crouches in the corner, Vertumnus turns his adoring gaze at the beautiful Apollo seated on the low wall in a strikingly natural and revealing pose, picking laurel branches that grow from the window, which so easily symbolizes heavenly light; he is flanked by a clothed and chaste Diana, above Pomona, on the other side of the wall, also flanking the oculus and holding a laurel branch. The content of Pontormo's lunette is remarkably close to that of Ariosto's elegy for Lorenzo, "Ne la stagion..." The sunlit scene of this enchanted terrace is somewhat deceptive, due to its soft, golden range of colors. Within the bucolic spontaneity of the lunette, there lurks a set of compositional principles as dangerous for the unity and logic of the High

Renaissance as any of the fevers in Joseph in Egypt. The oculus window, for example, is treated as if it were a solid disk, the low walls as if they were golden air, the ground is nonexistent, space is nowhere defined, the figures are poised on the horizontals as if balanced on wires, and the whole illogical composition is on three levels, delicately laced together by the spreading laurel branches. Every seemingly relaxed pose is in reality quite tense, sometimes extended to the utmost-compared with the poses in Michelangelo's Sistine Ceiling or Raphael's Stanze, which, no matter how active, always harbor a reserve of latent energy. All Pontormo's poses are calculated so as to bring out unexpected, sometimes unconventional aspects of the figures and arrestingly new and beautiful linear rhythms. Where in Renaissance art have we seen, or will we see again, a front view of a stretching youth (a god, no less!) with his legs spread wide, above another front view of a dog with its back arched, also stretching itself? While the animal naturalism of such poses negates the idealism of the High Renaissance, it should be noted that these poses also preclude the possibility of easy motion. Figures and vegetation are fixed in an unalterable web of delicate color and endless line.

Pontormo's masterpiece is the altarpiece on the subject of the *Entombment* (colorplate 78), the nucleus of

596. PONTORMO. Head of Young Man, detail of *Entombment* (see colorplate 78). 1525–28. Panel. Capponi Chapel, Sta. Felicita, Florence

the cycle of paintings done by the artist in 1525-28 for the Capponi family in their chapel in Santa Felicita, and a work of the utmost poignancy and beauty. But is this an Entombment? Or a Deposition? There is no tomb, there are no crosses. Stranger yet, no clear demarcation separates earth from sky, and the only identifiable object in the background is a floating cloud. Like Andrea del Sarto's Lamentation (see fig. 592), this is a meditative picture, as remote from historical reality as from grief and pain. Its real space is the inmost soul of the observer—and the artist—and its real subject is the Eucharist. Two unidentifiable youths carry the lithe but lifeless body of the Lord. Two women tend to Mary, who, like Andrea's St. Paul, stretches out one hand above the shining body. The wounds are washed and barely visible. The figures ascend in the mysterious space like a fountain in a Renaissance garden, the spray wafted by the wind. Every motion is slow, dreamlike, and unreal. At the top St. John, the Beloved Disciple, bends over, not through his own volition but as if carried by the now descending waters of the fountain and the arch of the frame, stretching out his hands toward the body. No one weeps. The faces betray either an intense yearning, answered by the ghost of an expression on the closed eyes and parted lips of Christ, or a look of surprise, as if the observer had intruded unasked upon the common act of love that unites them. The colors, deriving in part from the recently revealed colors of the Sistine Ceiling, pass all belief—pinks, sharp greens, pale but intense bluesand appear in the most improbable places, including what looks like the nude flesh of the two youths but on inspection turns out to be their tight-fitting leather jerkins, as if colored lights were playing over the fountain of figures. At the upper right (fig. 596) the young man with blond curls and beard, full lips, and wide-staring, hypnotized eyes is Pontormo himself. In looking at that face one can understand why, as Vasari relates, Pontormo walled up the chapel for three years and let no one enter while he painted so private a testament. As we seek to understand the painting, we would do well to remember that close to the year in which it was painted the Theatines under St. Cajetan had instituted the perpetual adoration of the Blessed Sacrament.

With the Capponi altarpiece the great period of Pontormo is over. He survived into the era of the *maniera*, which had no room for his poetic intensity, and he became morose and warped, ingrown and strange. His *Last Judgment* frescoes (1546–51), filling the chancel of San Lorenzo, were destroyed in a later remodeling of the building. What we can imagine from the style of the existing drawings (fig. 597) belongs rather to the subsequent era of absolutism in Florence than to the disordered world of the Mannerist crisis. The autonomy, even the beauty, of the human figure are now completely swept away by the movement of the linear composition. But in his day of greatness, Pontormo revealed hitherto

597. PONTORMO. Study for Deluge (portion of sheet). c. 1546. Red chalk. Gabinetto dei Disegni e Stampe, Uffizi, Florence

unrecognized regions of imagination and of feeling, and his best works are among the finest paintings of the sixteenth or any century in Italian art.

ROSSO FIORENTINO

Pontormo's exact contemporary, Giovanni Battista di Jacopo, known to us by his nickname of Rosso Fiorentino (1495–1540), was by no means so strongly troubled by sincerity or so visually acute. Resourceful and at times even brilliant compositionally, Rosso is with rare exceptions shallow, and can never approach either the refinement of draftsmanship or the delicacy of color that distinguish the paintings of Pontormo. Rosso's entry in the perpetual competition of early Cinquecento painting preserved for us in the atrium of the Santissima Annunziata is an Assumption of the Virgin, painted in 1517 (fig. 598). No one could accuse this of being a great painting, and it falls below the level of even the least impressive of Andrea del Sarto's early frescoes of the Life of St. Philip Benizzi. But the compositional devices, even though they at times descend to the level of trickery, are nothing if not amusing.

The ground is crowded with the Twelve Apostles, wall-to-wall with no landscape background. Their massive cloaks, which seem less an emulation than a caricature of the characteristic heavy drapery of Andrea del Sarto in the *Birth of the Virgin* (see fig. 590), collide alarmingly and at one point boil over the lower edge of the frame and drip into the spectator's space. But Rosso reserves his best efforts for the upper portion, in which the Virgin is shown ascending, with the help of angels, so fast that she will soon be snapped out of the picture altogether. She is being forced into a ring of smirking putti, whose arms and clasped hands make a continuous circle in depth, from which their little feet fly out—also toward the spectator—as the human ring revolves. All

this takes place to the music of one lute and one flute played by angels in the lower tier. To cap the climax, two of the putti hold the girdle that Mary, as customarily, is dropping to St. Thomas, tie it in knots, and tease him by dangling it in front of his nose! Not even Piero di Cosimo ever got away with quite such a trick, which is completely in tune with the coarse, rough surfaces and the strange, sometimes almost drunken expressions of the Apostles.

Vasari is eloquent about the pranks played by this impish redhead (rosso means "red"), notably the torments he inflicted on the hapless monks of Santa Croce, on whom he let loose his pampered and mischievous monkey—loved, we are told, like his own child. Rosso did not abandon his practical jokes even when treating the most serious subjects, as in the Descent from the Cross originally painted for the Cathedral of Volterra (colorplate 79), but showed that he could raise these devices to the level of high tragedy. The Cross and the three ladders, powerfully projected in a low side light, carry the figures against a leaden sky, below which only a few distant hills appear. There is no center; as in the exactly contemporary Poggio a Caiano lunette by Pontormo (see fig. 595), the composition weaves a fabric of shapes that seek the frame rather than the central axis. Again as in Pontormo, the figures assume poses of the utmost, and therefore powerless, extension, or are cramped in postures from which they cannot move freely. But there the resemblance stops. Rosso's muscle-bound figures are hard, as if carved from wood, and their bodies and faces are formed of cubic shapes derived from the bleak planes of the Cross and the ladders. In the kneeling, stretching Magdalen under the Cross, an astonishing knife-edge crease splits the figure from elbow to knee, into light and dark halves, and to show this is no accident, her belt is bent as it goes around the crease.

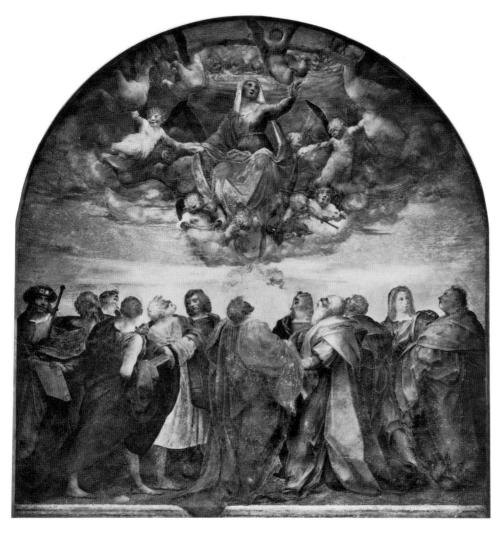

left: 598.
ROSSO FIORENTINO.
Assumption of the Virgin.
1517. Fresco. Atrium,
SS. Annunziata, Florence

below: 599.
ROSSO FIORENTINO.
Head of Joseph of Arimathea,
detail of Descent from the Cross
(see colorplate 79). 1521.
Panel. Pinacoteca, Volterra

below opposite: 600. ROSSO FIORENTINO. Moses and Jethro's Daughters. c. 1523. Canvas, 63 × 46½". Uffizi Gallery, Florence

Other figures, however, are treated on a different principle. The head of the weird Joseph of Arimathea, gibbering over the top of the Cross, seems composed only of twisted rags (fig. 599). St. John the Evangelist, turning away from the Cross and covering his face with his hands, collapses into a bundle of cloth, caught pitilessly in the raking light. One recalls Isaiah's denunciation of human justice as the filthy rags of self-righteousness (64:6), a metaphor taken up by St. Paul and dwelt upon at length by St. Antonine of Florence; yet at least the religious could still point to a final solution in a just but loving God. But in Rosso's devastating picture we turn from the wooden blocks and crumpled cloth that represent man, once the measure of all things, to the face of the supposed Savior, and find nothing but a smile of detached and secret satisfaction. In Rosso's denunciation of God and man (painted just a year after the death of Raphael), we sense not only the deadly emptiness of the chronic jokester but also the dilemma of a lost generation. The picture dates, of course, six years before the Sack of Rome in 1527, an event that had little direct effect on art aside from economic loss, but may be regarded as the climax of that disorder of which Rosso's wellnigh blasphemous painting is an unforgettable symbol.

Even in his withdrawal, Pontormo's inner music provides solace; Rosso offers nothing but despair and mockery.

Rosso went to Rome, was there right through the Sack, and suffered severely. His striking Moses and Jethro's Daughters (fig. 600), whose almost Rococo color scheme of pink and blue contrasts grimly with its brutal subject matter, makes sense only as a comment on the drastically foreshortened figural heap developed by Michelangelo in the Brazen Serpent spandrel (see fig. 528). Moses, flailing away with his fists, creates the apex of an apparently conventional High Renaissance pyramid based on the prostrate Midianites. But the pyramid is dissolved and tied to the frame by a ferocious, oncoming Midianite at the upper left and a very provocative daughter of Jethro at the upper right, whose feminine charms are either entirely unveiled or else covered by filmy drapery that reveals more than it hides. The construction of the figures in terms of light and dark patches is based on Michelangelo's practice of laying on underpaint. But the lack of resilient contours based on anatomical analysis results in an artificial edge that separates the foreshortened figures into almost abstract planes of tone, subdivided by the patches. Rosso's flight from the horrors of the Sack of Rome, his subsequent wanderings in Umbria and Tuscany, and his move to France, where he and other Italian émigrés created a French version of the Mannerist style, lie outside the province of this book.

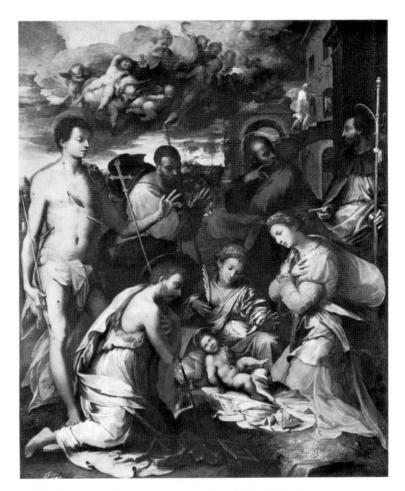

601. PERINO DEL VAGA. *Adoration of the Child.* 1534. Panel, transferred to canvas, $108\frac{1}{4} \times 87\frac{1}{8}$ ". National Gallery of Art, Washington, D.C. (Kress Collection)

PERINO DEL VAGA

A third Florentine Mannerist, Piero Bonaccorsi, known as Perino del Vaga (1500/1-1547), differs sharply in the preciosity and poeticism of his style from the tormented art of Pontormo and Rosso, possibly because of his years of association with Raphael in Rome. Perino bridges, in fact, the historical gap between the Roman High Renaissance and the *maniera*, the dominant style of the middle and late Cinquecento, of which he was one of the founders. After the Sack, he took refuge in Genoa, where he was the only gifted artist. His Adoration of the Child (fig. 601) is usually called a Nativity, although neither shed, manger, ox, ass, nor shepherds are represented. Signed and dated 1534 on the little foreshortened tablet in the foreground—a device borrowed from Albrecht Dürer—the lofty altarpiece was commissioned by the Basadonne family for the Church of Santa Maria della Consolazione. In the center foreground the Christ Child, whose excited pose is derived from one of Michelangelo's nudes in the Sistine Ceiling, looks and points upward toward the cloud-borne God the Father at the top of the picture, accompanied by strikingly nude child-angels. Around the Child and Mary stand or kneel

six saints, only one of whom, Joseph, was present at his birth. Sebastian on the left and Roch on the right were protectors against the plague; John the Baptist (adult here, but believed to have been only three months older than the Christ Child), Catherine of Alexandria, and James the Greater were possibly required by the Basadonne family. The languid grace and sensuous flesh of Sebastian, who toys with an arrow he has just extracted from his leg, and the polished shoulder of John the Baptist contrast with the extreme density of crinkled and shimmering draperies that obliterate every anatomical form of the female bodies. An acute sensibility of expression, suggesting that of Filippino Lippi, is combined with chiaroscuro derived from Raphael's latest works and with a completely personal metallic brilliance of color. Surprisingly, a shaft of light at the upper right strikes a male figure from whose right hand dangles a slaughtered lamb, symbol of Christ's sacrifice, as he climbs a stairway reminiscent of that in Leonardo's Adoration of the Magi (see fig. 455).

Perino's impressive cycle of frescoes for the Palazzo del Principe in Genoa, belonging to the powerful Doria family, was painted somewhat earlier than the Basadonne altarpiece, probably beginning in 1529, and has survived only in part. The most surprising is the *Fall of the Giants* (fig. 602), an enormous ceiling painting, although, like those by Michelangelo and Raphael, it does not indulge in illusionistic views from below. The sub-

ject, a typical Mannerist invocation of authority, invites comparison with Giulio Romano's bombastic and totally illusionistic treatment of the same theme, probably during the same years (see pages 586–87 and figs. 627, 628). Both may well have been suggested by the arrival of Charles V in Italy in 1530 to bring order out of chaos. Significantly enough, he landed in Genoa, where he was greeted with cries of "Long live the emperor of the world!" Jupiter, whose face is almost identical with that of God the Father in the Basadonne altarpiece, brandishes his thunderbolt from the foreshortened circle of the zodiac, surrounded by Perino's typically soft and sensuous deities. Meanwhile, the giants, gigantic in size alone and oddly flaccid in musculature, pile up on the ground in dreamlike attitudes, nerveless before the thundering king of the gods. It may be no accident that Domenico Beccafumi was in Genoa at some undetermined time in the 1530s, but certainly after he painted the Fall of the Rebel Angels, so close to this work in subject and in treatment (see fig. 604).

DOMENICO BECCAFUMI

Domenico Beccafumi (1485–1551), the greatest Sienese painter since Sassetta, ranks nearly with Pontormo in the imaginative breadth, the sensitivity, and the poetry of his pictures, not to speak of their consummate craftsmanship. The traditional Sienese grace of line and surface and delicacy of color, hard to find at times in the

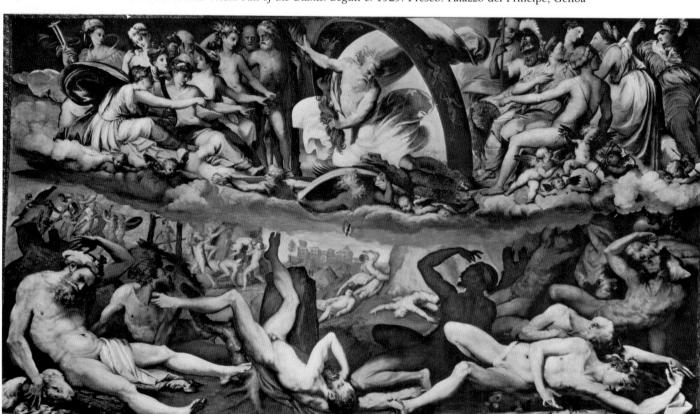

602. PERINO DEL VAGA. Fall of the Giants. Begun c. 1529. Fresco. Palazzo del Principe, Genoa

drier and more classicistic Peruzzi, function at full intensity in Beccafumi's paintings. His Stigmatization of St. Catherine (colorplate 80), painted for the monastery of Monte Oliveto in the desolate, eroded countryside to the east of Siena, might at first glance be taken for a High Renaissance work, and has been dated in 1515, the height of Raphael's Roman career; but it was more likely painted about 1518, and shows many traits that we are accustomed to call Manneristic. Its symmetrical format goes past Raphael, back to Perugino. The inlaid floor is projected from the foreground plane, through an arch, to the outer edge of a terrace in a manner suggesting the School of Athens (see fig. 536). The grand simplicity of the architecture is in keeping with Bramante's noblest style. The softening effect of the chiaroscuro recalls Leonardo's sfumato. And then differences appear. The floor patterns, apparently based on systematic alternations of formal elements and color schemes, are so pervaded by shifting lights as to offer no rational sucessions. The two foreground piers are so closely associated with the flanking St. Benedict and St. Jerome that at a certain point the piers and figures merge. The bases of the piers are replaced by the feet of the saints; the folds of the saints' habits flow in a manner that reveals less the shapes of their bodies than the rigid verticals of the piers. The arches, pendentives, and vaults (in Italian vele, or veils) become real veils or curtains upheld by putti, then dissolve to admit the small-scale visionary apparition of the Virgin and Child. The clouds below the sacred figures fade off into the haze that conceals the sky, and this, in turn, blends into the ground mists floating upward, exquisitely observed and painted, from the hillocks and valleys of the landscape.

A High Renaissance master would have preferred to place the central figure *really* in the center. Beccafumi shows St. Catherine kneeling on the left, delicately lifting her left hand higher than her right so that both hands

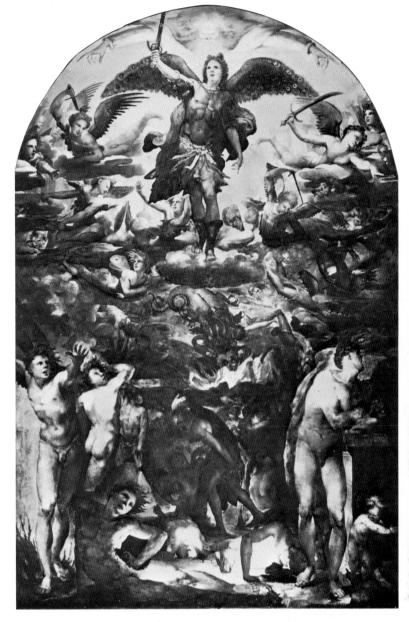

604. DOMENICO BECCAFUMI. Fall of the Rebel Angels. c. 1524. Panel, 11'41/2" × 7'4". Pinacoteca, Siena

603. DOMENICO BECCAFUMI. Communion of St. Catherine, on the predella of the St. Catherine altarpiece (see colorplate 80). c. 1518. Panel, 12×17¼". Pinacoteca, Siena

and her breast, awaiting the stigmata, continue the line of the cornices and the arms of the Cross, at right angles to the lowered head of the Crucified. In this way what we would expect to be an orthogonal in space becomes a diagonal in a single plane. At the same time the orthogonals of the floor, instead of carrying our eye, as Raphael's do, to a clearly seen horizon, lead us only into impenetrable mist, and that mist, rather than any person or object, occupies the exact center of the composition. Features are brilliantly modeled, but their shadows are murky. Drapery masses shine like flames; while the edges are clear enough, the exact shape of any fold eludes our baffled perceptions. Things and beings lurk in the shadows—St. Catherine's lily and book, St. Jerome's lion. In his language of diaphanous color and

tremulous line, Beccafumi seems to be telling us that all substance is an illusion, all earthly reality vanishes into the shadows and the luminous mist. Not only does he transform substance, he also annihilates space. The predella (fig. 603) shows St. Catherine, like the contemporary St. Cajetan, unwilling to approach the altar because of her conviction of unworthiness. Yet she is miraculously given Communion by an angel who traverses in a single reach the entire intervening space of the church space pervaded by an otherworldly light more solid than the figures.

About 1524 Beccafumi painted his Fall of the Rebel Angels (fig. 604), a huge altarpiece intended for the Church of the Carmine in Siena. Although to our eyes this is one of the most eloquent documents of the malaise of the 1520s, it was perhaps too extreme for the Sienese monks, who refused to accept it and required another picture, not painted by Beccafumi until much later, in which God the Father played a more assuring and authoritative role. In the original painting, all is chaos. St. Michael brandishes his sword at the apex of the arch; his spread wings flicker with peacock eyes; in the clouds about him other angels flail away with sabers and short swords at those few rebels who are still falling through the clouds. At the bottom of the picture where, in a disconcerting way, Beccafumi has placed the observer, Hell opens. Soft-bodied, pale, nude fallen angels, mostly wingless now, twist and turn in an agonized dance, gesticulate and cry out, fall to the ground writhing as the heat torments them. In a manner utterly unprecedented in Italy, Beccafumi allows us to look into the phosphorescent lights of Hell, more solid than the figures. ("No light, but rather darkness visible/Served only to discover sights of woe . . . " Did John Milton in his travels ever see this picture?) And then one looks for God, and finds him above St. Michael, half lost in the mist, his head foreshortened toward us, his powerless arms spread out along the inside of the arch, his fingers crooked and weak. How far from the paternal majesty and mighty arms of a High Renaissance image of the Deity is this remote and menacing phantasm!

CORREGGIO

The contrast between High Renaissance and Manneristic tendencies that characterizes Florence and Siena in the early Cinquecento separates in a similar way Correggio and Parmigianino, the two great masters of the Po Valley city of Parma, which had not heretofore produced a painter worthy of note. Antonio Allegri, known as Correggio (1494-1534) from the small North Italian town of his birth, would have been of merely art-historical interest if he had remained on the level of his provincial, youthful works, somewhat too deeply influenced by the ideas of Leonardo, which he generally absorbed at second hand. But in 1518 Correggio arrived in Parma, and there appears to have fallen under the spell of the Roman

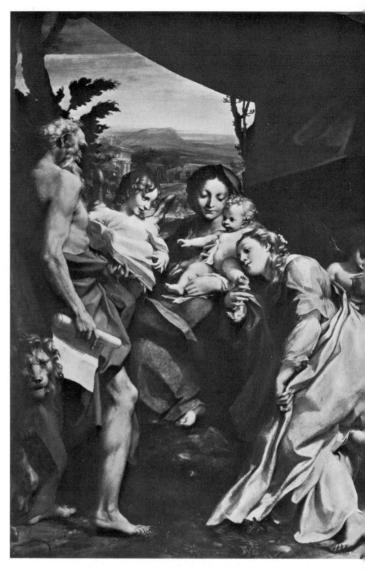

605. CORREGGIO. Madonna and Child with Sts. Jerome and Mary Magdalen. After 1523. Panel, 7'81/2" × 4'71/2". Pinacoteca, Parma

High Renaissance, again not from originals but from such works as drawings and engravings. He may also have seen paintings by Raphael himself in Bologna and in Piacenza (the Sistine Madonna was then in Piacenza; see fig. 543), but sixteenth-century writers agree that he never went to Rome. Modern writers, on the other hand, are far from certain, and the question may never be settled. The weight of evidence seems to favor such a visit, but if it did not actually take place, Correggio's would not be the only instance of such High Renaissance influence from a distance; the same thing happened in the case of Titian in Venice, as we shall shortly see in Chapter 19. Regardless of how Correggio absorbed his detailed knowledge of what was going on in Rome, the central fact is the sheer genius with which he transformed the Roman heritage into his own personal style, becoming in a few years one of the two or three leading masters of North Italy.

From the start of Correggio's mature period, he seems to have been bent on substituting emotional for formal

principles in the unification of his compositions, religious and secular alike. No longer are the components of a Sacra Conversazione sedately balanced around a central Madonna figure, as in Giovanni Bellini and still in Raphael. Rather they are drawn together in unconventional, diagonal, and changing relationships by a warm magnetism halfway between love and animal attraction. In the bewitching Madonna and Child with Sts. Jerome and Mary Magdalen (fig. 605), commissioned in 1523 for the Church of Sant'Antonio in Parma, we can experience this delightful principle at work. Mary holds the naked and velvety Christ Child in the crook of her left arm. The Magdalen presses her cheek against the Child's left thigh, bringing one tiny foot toward her lips (the altarpiece was painted for a woman). While caressing her mass of silken hair with his left hand, he concentrates all his attention on stretching his right hand toward the open book lifted up to him by the aged St. Jerome, clad only in a cloak thrown about his loins, as a beautiful, youthful angel turns the pages. In the midst of our enjoyment of this apparently spontaneous burst of mutual affection, we realize that behind the playful scene is a deeper message. The Magdalen's angel displays the jar of precious ointment, and the Magdalen herself was destined to wash the feet of the adult Christ with her tears and dry them with her hair. The Child, meanwhile, for all his babyish expression is conferring divine blessing and authority on St. Jerome's Latin translation of the Bible from its ancient sources, represented by the scroll in the saint's right hand.

Human attraction and sacred purpose are inextricably blended in Correggio's art. His tumultuous shapes, whether of cloth that flows like melting marble, or of tanned male and white female and infantile flesh, or of torrential, honeyed hair, are swept together by this single organizing principle into a sweet climax, half erotic and half religious. Truly, it is love that makes Correggio's world go round. While in a sense he thus seems to prefigure such sixteenth-century mystics as St. Theresa, who experienced ecstatic and very nearly erotic visions only a few decades later, it is fair to question whether Correggio himself ever had any mature realization of what he was doing. At best his imagery remains on a level of irresponsible sweetness, unquestioning and childlike. He never seems to have felt, as Raphael and Michelangelo did all too deeply, the inherent conflict between the two realms he so happily united. But his forms are so soft, his light and shade so melting, his surfaces so delicious, his people so well-nigh irresistible, that it would be a harsh Puritan indeed who could take him to task. In point of fact, his religious paintings, in spite of their often more-than-questionable details, never as far as we know fell victim to the strictures of the Council of Trent, which so sternly forbade nudity in religious works. Moreover, Correggio's very principle of emotional composition, as much as his actual shapes and surfaces, became an essential ingredient of religious art in the Baroque period, inspiring such devout masters as Rubens and Bernini.

In 1522, a year earlier than the preceding picture, Correggio accepted the commission for one of his most familiar works, the Adoration of the Shepherds or, as it is more generally called, Holy Night (fig. 606), although it was not placed in the Church of San Prospero in Reggio Emilia until 1530. Now the "light and heat" that St. Cajetan had sought in the Eucharist are fused with St. Bridget's vision of the shining Child and identified with Correggio's own energizing principle of love. A believable if incandescent baby, beautifully foreshortened, lying on a bundle of wheat (a reference to the Eucharist), is the source of light for the entire painting, as in Gentile da Fabriano's little predella panel painted almost exactly a century earlier (see fig. 185). He illuminates Mary's sweetly smiling face; the midwife who draws back and raises her hand as if in a momentary attempt to protect herself from the intense radiance; two shepherds, the young one looking up rapturously at his stalwart companion; and the five boy-angels, nude save for occasional pieces of drapery, who sweep in on a cloud at the upper left in poses of brilliant foreshortening and sensuous

606. CORREGGIO. Adoration of the Shepherds (Holy Night). 1522. Panel, 8'5" × 6'2". Gemäldegalerie, Dresden

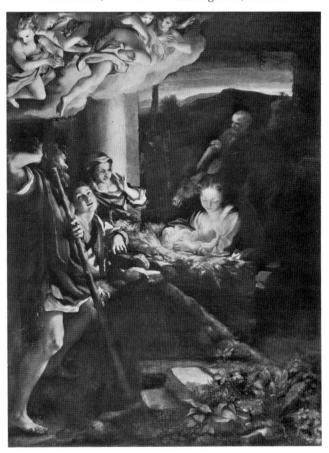

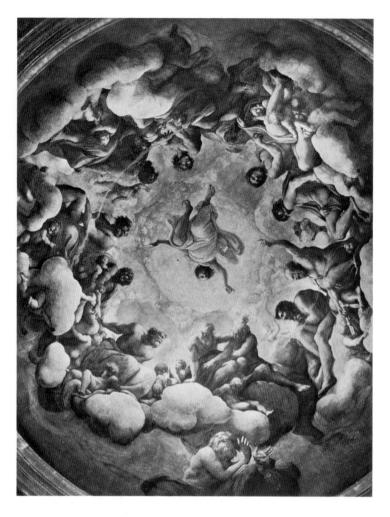

607. CORREGGIO. Vision of St. John the Evangelist. 1520–24. Fresco in dome. S. Giovanni Evangelista, Parma

608. An Apostle, detail of fig. 607

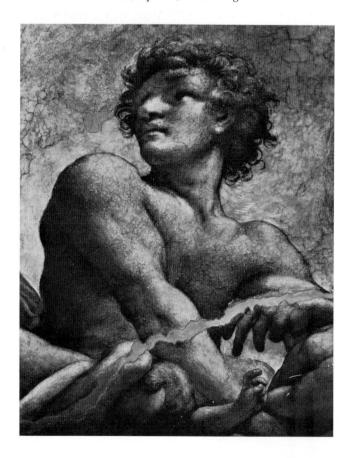

abandon. The same light just hints at the faces of Joseph and of the ox and ass behind Mary, leaving in darkness the distant hills, over which can be seen the first glimmer of dawn. In 1640 the Este family, then dukes of Modena, got possession of the painting and carried it off to their palace, to the infinite sorrow of the inhabitants of Reggio Emilia; the parish priest inscribed its loss in San Prospero's register of the dead. Either this picture or one of its many descendants inspired, in 1646, Richard Crashaw's *Hymn in the Nativity*, with its recurrent refrain:

We saw thee in thy baulmy Nest,
Young dawn of our aeternall DAY!
We saw thine eyes break from their EASTE
And chase the trembling shades away.
We saw thee; and we blest the sight,
We saw thee by thine own sweet light.

Historically, Correggio's major triumphs were his dome compositions, which opened up a whole new field for religious painting, particularly in the seventeenth and eighteenth centuries. The first of these, painted in 1520-24 for the splendid High Renaissance Church of San Giovanni Evangelista in Parma, represents the Vision of St. John the Evangelist (fig. 607). Clearly, Correggio took as his point of departure Mantegna's ceiling composition for the Camera degli Sposi (see fig. 411). The drum of the dome, one of the first elliptical spaces ever constructed, serves as a frame through which one looks into the open sky. On clouds banked round the cornice of the drum the Twelve Apostles are seated in pairs (fig. 608), their poses strongly recalling Michelangelo's nudes on the Sistine Ceiling, while in the center Christ ascends into heaven. There are other suggestions of the Sistine Ceiling as well; the figures have adopted a Michelangelesque grandeur and muscular power, and are supported by putti like those who carry Michelangelo's Deity on his flights through space. The foreshortenings betray a knowledge of the Brazen Serpent (see fig. 528), and the idea of looking through an opening across which floats a divine figure must have been suggested by the Separation of Light from Darkness (see fig. 525). But the handling of the forms shows Correggio's own melting style, without any of Michelangelo's terrible tension or linear power. And who but Correggio would ever have dreamed of giving us a view of the ascending Christ from below—partly wrapped in a floating cloak, to be sure, but sharply foreshortened from a most unconventional angle and apparently upside down. The visitor actually standing in the chapel, however, is aware of no incongruity. To view the scene correctly the reader must hold the illustration overhead and look up.

Such views are abundantly visible in Correggio's crowning achievement, the dome of the Cathedral of Parma, which he painted in 1526–30 (colorplate 81; figs. 609, 610) as part of an extensive series of frescoes covering also the squinches upholding the dome and the

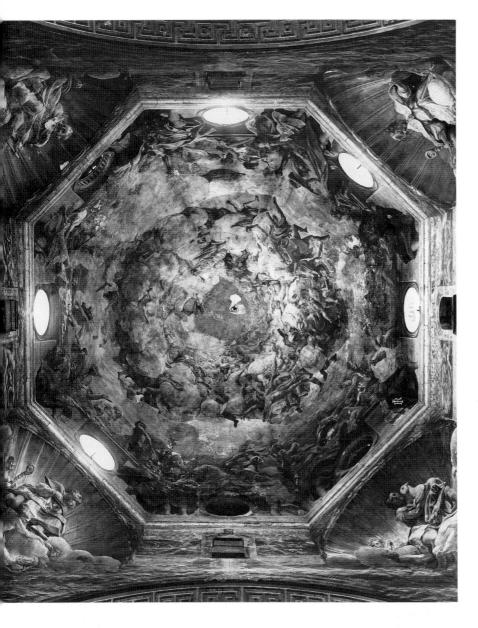

above left: 609. CORREGGIO. Assumption of the Virgin (see also colorplate 81). 1526–30. Fresco in dome. Cathedral, Parma

left: 610. CORREGGIO.
Apostles and Angels, detail of fig. 609

above right: 611.

CORREGGIO.

Jupiter and Io.

Early 1530s.

Canvas, 64½×28".

Kunsthistorisches Museum,

Vienna

conch over the apse. The vast and badly damaged composition, prototype of innumerable Baroque domes, shows the Assumption of the Virgin in the center, surrounded by a vast ring of ascending figures whose active legs and bodies are for the most part nude. As we watch, the entire ring seems to ascend at once, leaving the Apostles on the inside of the drum, painted with such attention to illusionistic effect that their drapery often blows in front of the (painted) oval frames of the windows. Correggio has carefully masked the transition between the octagonal drum and the circular central composition by means of enormous balusters, which, with boy-angels in between, carry the eye effortlessly up the angles until these disappear in the central composition.

In Correggio's dome compositions we are dealing with rapture in the strict etymological sense of the word. The central figure is rapt—torn loose from earthly moorings, carried upward as the spectator is intended to be, vicariously at least. No wonder, therefore, that some of the artist's most alluring compositions deal with classical abduction scenes, especially the series made for Federigo Gonzaga, first duke of Mantua, apparently in the early 1530s, but never delivered. The pictures were designed to satisfy the duke's penchant for such subjects by lining a whole room in the ducal palace with the Loves of Jupiter—a far cry from Mantegna's chaste frescoes nearby (see fig. 410). Jupiter was a mythical ancestor of the Gonzaga family, and in his amorous exploits not unlike Federigo. In one of these scenes Correggio has depicted Jupiter and Ganymede (colorplate 82), a favorite High Renaissance and Mannerist subject, in a thoroughly characteristic and inimitable way. Ganymede, whose pose recalls that of an angel in one of the squinches upholding the dome of the Cathedral of Parma, swings in the grip of Jupiter's fierce eagle, whose wings darken the air; dazzlingly foreshortened, the boy looks back toward the spectator in combined fear and pleasure. Below the floating figure, and below the spectator, mountain pinnacles, chasms, slopes, and valleys gulf away to the remote horizon. The spasm of the boy's final leavetaking from earth is dramatized by the last vain leap of his beautiful white dog, desperate at his master's disappearance.

No such picture had ever been painted in earlier Italian art, nor had anything like the equally daring Jupiter and Io (fig. 611) been seen before. The jealousy of hawkeyed Juno constrained her erring husband to appear to Io, a mortal maiden, in the form of a cloud. Io sits in a pose familiar to us from Raphael's frescoes in the Farnesina (see figs. 558, 564) and, her head thrown back, accepts willingly the embrace of one huge, cloudy paw, as the face of Jupiter dimly emerges from the cloud and plants a kiss upon her lips. The contrast between the soft, trembling warmth of Io's flesh and the mystery of the attack from the cold yet divine cloud increases the startling intensity of what is clearly a representation of sexual climax—one of the most vivid ever painted, and

612. PARMIGIANINO. Self-Portrait in a Convex Mirror. 1524. Panel, diameter 91/2". Kunsthistorisches Museum, Vienna

yet so frank, so open, so direct, so real, that it cannot conceivably be classed as pornography. In an astonishing conflation of Christian and pagan traditions, Correggio has painted at lower right the head of a stag drinking from the water, an accepted symbol of the human soul, drawn from Psalm 42: "As the hart panteth after the water brooks, so panteth my soul after thee, O God." Whatever peace Correggio made with his Christian guilt complex no one can say, but at his untimely death he stood alone, save for his contemporary Titian, in the completeness of his acceptance of the erotic life of man as a subject for art, on a level with and interchangeable with religion. We can only regret that such an attitude in art, past or present, is as rare as it is pure.

PARMIGIANINO

Correggio's slightly younger contemporary in Parma, Francesco Mazzola, called Parmigianino (1503–40), stands in the strongest contrast to Correggio's High Renaissance, even proto-Baroque style. Parmigianino is unmistakably a Mannerist, and introduces himself to us as such in what is perhaps the most startling painting of the entire critical phase of Mannerism, his Self-Portrait in a Convex Mirror (fig. 612). Vasari, who knew the picture well when it belonged to the great letter writer and lampooner Pietro Aretino, tells us that Parmigianino painted it just before his departure for Rome in 1524, when he was twenty-one, to show his skill in "the subtleties of art." Fascinated by his own reflection in a barber's convex mirror, he decided to reproduce it exactly. He had a carpenter turn a wooden sphere on a lathe and

Colorplate 81. CORREGGIO. Assumption of the Virgin. 1526–30. Fresco in dome (portion). Cathedral, Parma

Colorplate 82. CORREGGIO. Jupiter and Ganymede. Early 1530s. Canvas, 64½×28″. Kunsthistorisches Museum, Vienna

Colorplate 83. Parmigianino. Madonna with the Long Neck. 1534–40. Panel, 85 × 52". Uffizi Gallery, Florence

Colorplate 84. GIULIO ROMANO. Wedding Feast of Cupid and Psyche (portion). 1527–30. Wall fresco. Sala di Psiche, Palazzo del Te, Mantua

Colorplate 85. Giorgione. *Tempest.* 1505–10. Canvas, $30\frac{1}{4} \times 28\frac{3}{4}$ ". Accademia, Venice

Colorplate 86. GIORGIONE. Fête Champêtre. c. 1510. Canvas, $43\% \times 54\%$ ". The Louvre, Paris

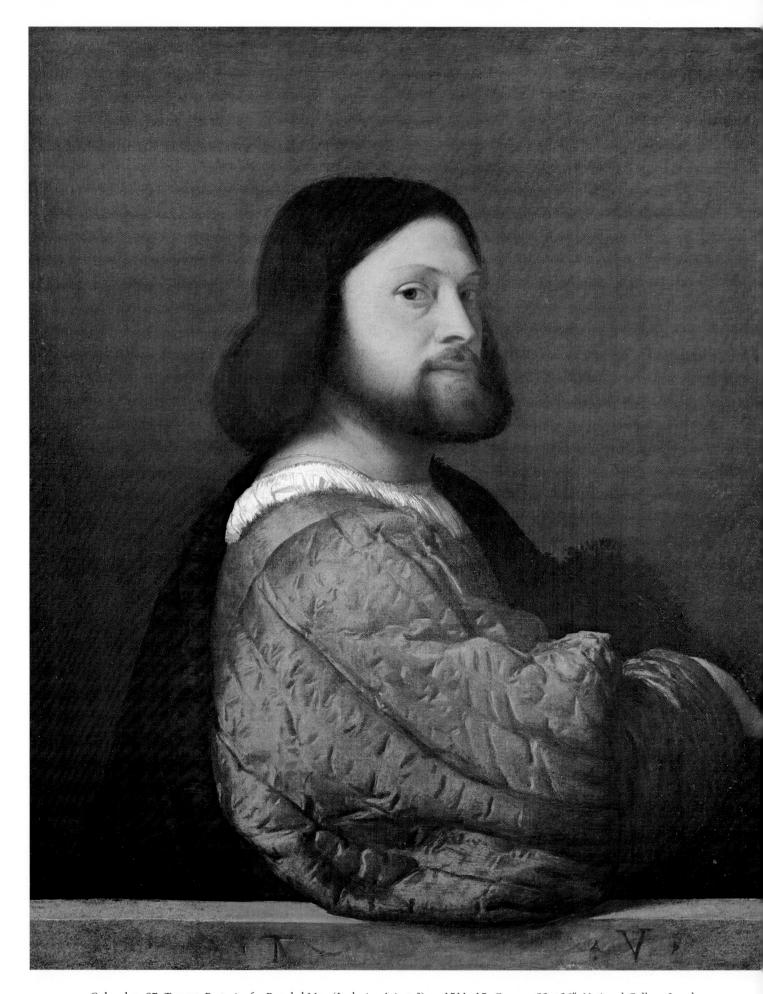

 $Colorplate~87.~TITIAN.~\textit{Portrait~of~a~Bearded~Man~(Ludovico~Ariosto?)}.~c.~1511-15.~Canvas,~32\times26''.~National~Gallery,~London~Colorplate~87.~TITIAN.~Portrait~of~a~Bearded~Man~(Ludovico~Ariosto?).$

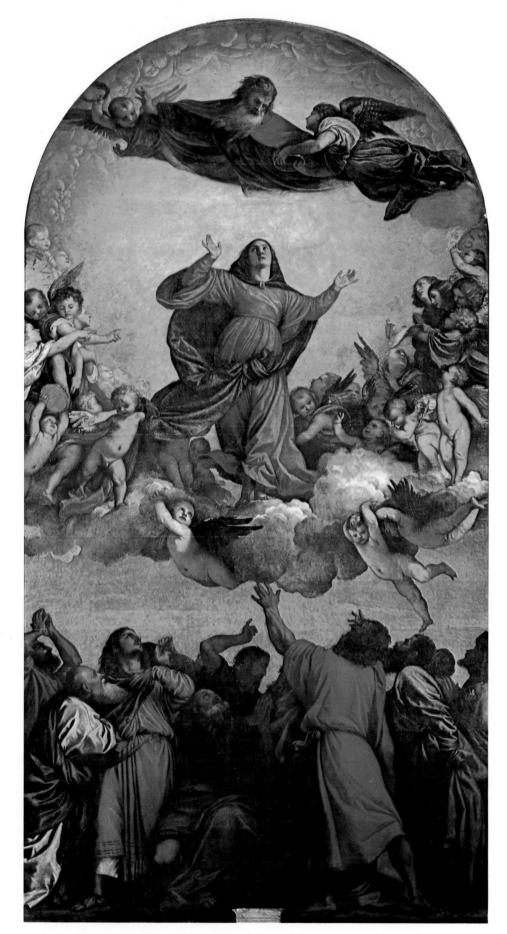

Colorplate 88. TITIAN.
sumption of the Virgin. 1516–18.
Panel, 22'6"×11'10".
Sta. Maria Gloriosa dei Frari,
Venice

Colorplate 89. Titlan. Sacred and Profane Love. c. 1515. Canvas, 3'11"×9'2". Borghese Gallery, Rome

then saw off one section as the base for his painting. On this lens-shaped surface he painted himself looking outward with an air of utter detachment, "so beautiful," Vasari says, "that he seemed an angel rather than a man." His face is far enough back from the surface not to suffer distortion, but his hand (his right in the picture, therefore his left in reality) and its sleeve are enormously enlarged, and the leaded, sloping skylight of his studio as well as the opposite wall are sharply curved. In the High Renaissance, self-portraits are rare, and these generally appear in lieu of signatures, looking out from a lower corner. In the period of the Mannerist crisis they become much more numerous, and generally they are revealing and disturbing. Leonardo had called the mirror the master of painters, whose minds should resemble it insofar as it "transforms itself into the color of that which it has as object, and is filled with as many likenesses as there are things before it." But not a curved mirror, which he compares to the distortion of moving water upon objects seen through it. Parmigianino has delighted in these very distortions, and sits in his Looking-Glass Land, serenely master of all its absurdities. The curved surface, which to Jan van Eyck and to Raphael was a fascinating distortion fit only for a small position in the background, and which it was the artist's duty to correct by the proper visual balance of all objects and persons in the rest of the picture, now becomes the whole image. Truly, this is seeing in a glass darkly, and two generations will pass in Central Italy before an artist will again see himself face to face.

Parmigianino's bravura piece, the Vision of St. Jerome (fig. 613), was painted in 1527 for the chapel of the Bufalini family in San Salvatore in Lauro in Rome, abandoned by the artist after the Sack of Rome, and later taken by the Bufalini to their palace in Città di Castello. It is as exquisitely tormented as Correggio's Holy Night is peaceful, as distorted spatially as the Holy Night is convincing. In a sharply foreshortened pose, at an unexplained depth in the picture, St. Jerome lies sleeping fitfully. The entire painting, foreground and background (if we can call them that), is his dream. It may be for this reason that the Baptist and the Virgin and Child are at least twice St. Jerome's size. The visionary figures towering before us form the vertical axis of the sharply constricted painting, and the real figure is reduced to an afterthought. And we are still in Looking-Glass Land, this time not even a real one since the reflection it recalls to us is of the vertically distorting sideshow variety, unknown to the sixteenth century. St. John's right arm, pointing into the picture in Albertian style, seems tremendously enlarged in contrast to his foreshortened and partially enshadowed right leg. The Virgin and Child are attenuated in a manner not seen since Lorenzo Monaco (see colorplate 19), and have the sloping shoulders and long arms of Botticelli's figures (see fig. 351). Not one figure looks at the observer or at another; even the chill

613. PARMIGIANINO. Vision of St. Jerome. 1527. Panel, 11'6"×5'. National Gallery, London

gaze of the Child glides just past us. In the opaque darkness that veils every possibility of establishing the spatial relationships between the figures, or indeed any spatial construction for the painting, the rays of light flash from the Madonna's head and shoulders like shards of ice.

Every surface is as cold as the unsmiling figures, porcelain-hard, at times almost glassy. Seldom does Parmigianino let his brushwork show. The picture has all the preternatural clarity of a dream, but in contrast to the healthy eroticism of Correggio, this dream is lascivious and perverse. In spite of the obvious Michelangelism of the Child's first steps (see fig. 475), Parmigianino has sharply emphasized the genitals, just as he has with unprecedented daring shown the Virgin's nipples erect through the tight, sheer fabric of her tunic.

The climax of Parmigianino's artistic achievements is doubtless the Madonna dal Collo Lungo (Madonna with the Long Neck), commissioned in 1534 for the Church of the Servi in Bologna but never delivered (colorplate 83). In this work the elongated proportions, sloping shoulders, preciosity of surface, and chill eroticism that we have seen in the Vision of St. Jerome are refined to produce shapes of startling ornamental beauty. The Christ Child lies asleep across the Virgin's lap, in a pose instantly suggestive of death, his left arm hanging as in Michelangelo's Rome Pietà (see fig. 472). Five exquisitely graceful and sexually ambiguous figures appear at the left in varying stages of undress, one holding a huge urn and looking up at the Virgin, another, possibly a selfportrait, gazing out and past us with hard, polished eyes. The Virgin, her body and neck impossibly attenuated, looks down at the Christ Child from sharp-edged eyelids below a marmoreal forehead around which cluster her glossy curls with their ropes of pearls and an enormous ruby. Even more astonishing than her long neck, perhaps, is the fantastic length of her fingers, an obvious Byzantinism absent from Italian painting since Duccio.

Whether or not the Child's head was to remain bald is uncertain. It might be recalled that Joseph was shaved while in prison and that a tradition insists that Christ was also. But even more disturbing than any of the figural representations is the towering column, smooth and polished but without a capital, that stands in nightmarish incompleteness in the background, seeming by its upward thrust to pull the figures up with it. A glance at its base will show that the artist originally intended to represent a complete temple portico, and preserved drawings show that it was to be Corinthian. Why did he never finish it? Possibly because he realized that the row of capitals, the entablature, and the pediment would detract fatally from the soaring unreality of the Madonna. Thus, unsatisfied with the picture (so Vasari tells us), he limited himself to caressing with Brancusi-like tenderness the infinitely subtle entasis of the column, leaving it perfect in its very truncation against the unfinished surface of the panel. But if Parmigianino had painted himself into a corner with the column, he had nonetheless created one of the most brilliant pictures of the Cinquecento, whose mood of despair beneath its jeweled surface is epitomized in the tiny distant figure with a scroll. Is it Isaiah prophesying the Passion?

About contemporary with the Madonna dal Collo Lungo is an even more surprising picture ordered by a private patron, the Cupid Carving His Bow (fig. 614), whose calculated psychological effect is the very antithesis of Correggio's romping sensuality. The epicene youth turns his naked back to us yet twists his head about for one arch glance at our discomfiture, while with one foot braced on two books, apparently symbolic of love's triumph over knowledge, he carves his bow from a freshly cut cherry sapling. Between Cupid's legs appear

two putti; one screams in fear and pain while the other mischievously twists his chubby arm, trying to force his already burned hand back against the hot leg of Cupid. The figure, drawn with fantastic linear precision in the contours, shimmering with reflected lights, is painted with a compactness of mother-of-pearl surface that dazzled the young Peter Paul Rubens, who made a copy of this picture. Although parallel to the picture plane, Cupid is pushed so far forward and his flesh so minutely observed in every facet that he is propelled toward us with a force like that of Mantegna's Dead Christ (see fig. 409), but with what a difference! For all the brilliance of his technical and psychological achievement, Parmigianino's Cupid represents the epitome of the secret sensuality of the mid-sixteenth century, to be gloated over by aristocrats and princes.

PORDENONE

A shocking contrast to the refined sensuality of the two great painters of Parma is furnished by Giovanni Antonio de Sacchis (1483/4–1539), called Pordenone from

614. PARMIGIANINO. *Cupid Carving His Bow.* 1535. Panel, 53 × 25¾". Kunsthistorisches Museum, Vienna

615. PORDENONE. Nailing of Christ to the Cross. 1521–22. Fresco. Cathedral, Cremona

the little town of his birth in the flat portion of Friuli, a sub-Alpine region to the northeast of Venice. Among all the painters of North Italy during the early Cinquecento, Pordenone is surely the most startling. In his life, as well as in his art, he seems to have been a man of unbridled energy and ambition and of few scruples. He shuttled back and forth throughout much of North Italy, from his native Friuli to any Lombard or Emilian center that would give him a commission, and even to far-off Genoa, turning out altarpieces, organ panels, and especially frescoes, at dangerous velocity. In 1516 he journeyed as far as Umbria for some fresco commissions, and must have visited Rome, although no visit is documented. He ran through three wives and, according to charges made in court, hired a band of cutthroats to murder his brother Baldassare so that he could lay hands on the entire paternal inheritance. Brought up under diluted Venetian influence in his remote provincial environment, he lost no time in absorbing the latest in Rome, without benefit of the anatomical training that made the Roman High Renaissance possible, and brought back to the North vivid and simplified memories, and perhaps sketches, of the mighty achievements of Michelangelo and Raphael. Pordenone never fully detached himself from Friuli, though from 1528 on he was active in Venice and its environs, where he was particularly esteemed for his frescoes on the outer walls of palaces and cloisters, exposed to the weather and thus foredoomed to ruin, and for his numerous works in the Doges' Palace, all destroyed in the fires that swept that structure in 1574 and 1577. It is difficult to assess the possible effect of these lost works on Titian (see Chapter 19) and, more probably, on Tintoretto, of whose dramatic style Pordenone was an astonishing precursor. We must judge him now mostly by his surviving fresco cycles in Emilia, Lombardy, and the Veneto, painted with speed, vigor, and deliberate coarseness of expression and execution—intended to shock.

The most powerful of these series is the group of four scenes that culminate the narration of the Passion over the nave arcade and on the entrance wall of the great Romanesque Cathedral of Cremona, in whose immense interior they operate with devastating effect. The Life of Christ had been begun by local Cremonese painters, notably the serene Boccaccio Boccaccino, and continued by the more celebrated Romanino of Brescia, whom Pordenone apparently contrived to have dismissed so that he could complete the series himself. Characteristically, it is Pordenone's frescoes that one remembers. A typical example is the Nailing of Christ to the Cross (fig. 615). All three episodes in the nave arcade are seen from below in Mantegnesque illusionistic style, but they exploit as never before the actual space in which the observer stands. Demonic faces glower from the dimness at the left, above a soldier who has felled one of his own comrades and

holds him by the hair so that he may terminate their private quarrel with a thrust from his short sword. Scrabbling helplessly for a handhold in the painted architecture outside the scene, the victim is about to lurch over the edge onto our defenseless heads. The pose and the muscular back suggest several in the work of Michelangelo (see figs. 524, upper left; 528, 574), as does the dense concentration of foreshortened contrapposto figures throughout the scene. Center stage is occupied by a bald Lanzknecht (lancer) whose bestiality is underscored by his beer belly, his loosely tied breeches, and his pendulous codpiece. On the extreme right the foreshortened Cross is being shoved into the scene from outside the painted frame, which it overlaps, by one of the prophets who points with his other hand to the place where the footrest is to be nailed on. Crowned with thorns, his eyes closed, his legs so sharply bent that the

thighs disappear from view, Christ writhes as the claw hammer drives the spike into his right hand, gushing blood, while a wildly foreshortened and twisted executioner parts his legs to reveal the other claw hammer ready for its dread purpose. The tumult of figures surging into the scene and spilling out of it is delineated by strokes of unprecedented coarseness, and a violence never to be repeated in Italian art—or indeed elsewhere until the late work of Goya. In spite of his brilliance and daring, violence to Pordenone is its own message; he has nothing to say of a spiritual nature, in sad contrast to his sublime successor Tintoretto (see pages 619–26)

Up to this point it has been possible to avoid a "definition" of Mannerism. Now that we have seen the style in operation in the work of six gifted painters, we are in a position to make a few generalizations. At the risk of oversimplification we might put it this way:

HIGH RENAISSANCE

Normal, supernormal, or ideal: appeals

to universal

Narrative: Direct, compact, comprehensible

Space: Controlled, measured, harmonious,

ideal

Composition: Harmonious, integrated, often

centralized

Proportions: Normative, idealized

Figure: Easily posed, with possibility of motion

to new position

Color: Balanced, controlled, harmonious

Substance: Natural

MANNERISM

Abnormal or anormal; exploits

strangeness of subject, uncontrolled

emotion, or withdrawal

Elaborate, involved, abstruse

Disjointed, spasmodic, often limited to

foreground plane or spilling out of it

Conflicting, acentral, seeks frame or

violates it

Uncanonical, usually attenuated

Tensely posed; overextended or confined; excessive contrapposto

frequent

Contrasting, surprising

Artificial

Leonardo, Fra Bartolommeo, Raphael, and to a great extent the mature Michelangelo belong in the first category, as do Andrea del Sarto, Correggio, and their immediate followers. Pontormo, Rosso, Perino del Vaga, Beccafumi, Parmigianino, Pordenone, and again to a great extent the Michelangelo of the Medici Chapel belong in the second. The two categories, or schools, overlap chronologically, so they cannot be considered separate periods. Nonetheless, Mannerism is a precipitate of a crisis that can be localized at about 1517–20, to which Andrea del Sarto, through his stolidity, and Correggio, through his innocence, were immune. So, apparently, were many of their patrons, and we must think of the period from about 1517 to the early 1530s as one

sharply divided between opposing tendencies. During the 1530s Mannerism takes over almost entirely in Central Italy, but in a new form, to be discussed in Chapter 20.

ANTONIO DA SANGALLO THE ELDER

Many of these categories are just as applicable to architecture, and some are abundantly visible in Michelangelo's buildings. He had, nonetheless, architectural rivals in Florence who maintained a surprising independence from his ideas and theories. One of these was Antonio da Sangallo the Elder (1455–1534), younger brother of Giuliano. During his youth Antonio was known chiefly as a military architect and designed religious and civil

left: 616. Antonio da Sangallo the Elder. Madonna di S. Biagio, Montepulciano. 1518–34

above: 617. Antonio da Sangallo the Elder. Plan of Madonna di S. Biagio

below: 618. Antonio da Sangallo the Elder. Interior, Madonna di S. Biagio

structures only for minor centers. He was engaged to complete the Church of Santa Maria del Calcinaio at Cortona, left unfinished at the death of Francesco di Giorgio (see fig. 375). When Giuliano passed from the scene in 1516, Antonio was left in a position of prominence and, two years later, accepted one of the major architectural commissions of the period, the pilgrimage church of the Madonna di San Biagio at Montepulciano (figs. 616, 617), not many miles from Cortona, diagonally across the wide Chiana Valley, on the top of a commanding peak. The Church of the Madonna di San Biagio was built to commemorate a miracle that took place on one of the slopes of this hill, and thus Antonio was given an enviable site, in the midst of a magnificent landscape unencumbered by preexisting constructions.

The structure, on which he worked from 1518 until his death in 1534, was the most ambitious church building of the period save only St. Peter's in Rome, whose construction was dormant after the death of Bramante in spite of designs submitted by Raphael, Peruzzi, and others. It was also Antonio's masterpiece. He chose a simple, Greek-cross plan crowned with a dome, similar to that of his brother Giuliano's Santa Maria delle Carceri at Prato, an unfinished commission he had also inherited (see figs. 313–315). Antonio eschewed entirely the typical Florentine marble incrustation, however, and constructed his church inside and out, except for the barrel vaults, of blocks of porous travertine, which conferred upon the building a cliff-like massiveness, surprising after the ele-

gance of the Florentine tradition. The main façade was to be flanked, and the reentrant angles of the transept filled, by two lofty, freestanding towers, flush with all three façades and higher than the dome, completing, therefore, the appearance of a colossal cube on the first two stories. While these towers may have been suggested by those Bramante designed for St. Peter's, it should be recalled that such towers reappear constantly in Leonardo's architectural fantasies (see fig. 449).

Antonio set up the three cubic stories of the towers in

619. ANTONIO DA SANGALLO THE ELDER. Palazzo Tarugi, Montepulciano. c. 1515

a canonical succession of Doric, Ionic, and Corinthian orders. Oddly enough, the columns on the second and third stories have no molded bases, only simple plinths. The octagonal fourth story was added by Giuliano di Baccio d'Agnolo only in 1564, and it may or may not follow the plans of Sangallo. It is a matter for intense regret that only the east tower was completed (the principal facade faces north); the west tower was never carried above the level of the shafts of the ground-story columns. Much of the effect Antonio intended is thus dissipated; but if we complete the tower mentally, it is not hard to imagine the tension that would have existed between these massive verticals, with which the inert façade would have been unable to compete. The façades, in fact, continue only the Doric order of the first story, in pilaster form. The second story is divided into five recessed panels, the center one penetrated by a single window enclosed in a pedimented Doric tabernacle.

In contrast, the towers are richly articulated, with square corner piers enclosing powerful engaged columns, so that the intervening wall spaces are sharply recessed and the entablatures broken. Giuliano had already drawn a Roman Doric order almost exactly similar to this one, including the square corner piers and the ornamented necking band, from the ruins of the Basilica Emilia in Rome, and utilized the motifs in a design for the façade of San Lorenzo in Florence (see fig. 566).

Wherein, then, lies the originality of the younger brother, who merely adapted two years later what was, after all, company property? Perhaps it is in the wholly new sense of drama, never present in Giuliano's work and never absent from that of Antonio. A real fight seems to be going on within these mighty presences between clustered column-and-pier and massive wall. The latter is enlivened not by the gracious windows favored by Giuliano, but only by tabernacles capped on the second story with, *mirabile dictu*, segmental pediments whose

lower cornices are broken, a motif later to be used in profusion in Michelangelo's buildings. The jagged effect of the entablatures is heightened on the third story by corner obelisks. And even the raking cornices of the great pediments of the three façades (the fourth side is a low apse) are broken against the sky. The dome, so impressive a feature of the building seen from behind the apse, carries only a slight effect from the main façade, being outflanked by the real and imagined towers. It is worth noting that Antonio sticks to the traditional Florentine vertical dome with ribs, even though he places it on a round drum divided by pilasters in imitation of a peristyle.

The effect of the interior is overwhelming (fig. 618) not in terms of space, which one would expect in the Brunelleschi-Alberti-Bramante tradition, but of brute mass. The accent is not on the façade walls but on the reentrant angles of the transept, as if these were merely the inner two walls of the ground stories of the towers. The squat Roman Doric order is identical, inside and out, but these strong projections appear bull-like in their pugnacity when moved indoors; the piers carry arches that are just as heavy. The inside walls are travertine throughout, so the supports do not detach themselves from the walls in the traditional Florentine fashion. The barrel vaults, however, are plain white intonaco, with the result that the ground floor seems to sustain a series of independent arches of gigantic force against a white expanse of sky.

Montepulciano, a Cinquecento cultural center of great brilliance in spite of its tiny size, is lined with palaces by major architects, including several by or attributed to Antonio da Sangallo the Elder. The most original of these is the Palazzo Tarugi (fig. 619), which has two façades fronting on the principal piazza opposite the cathedral. Antonio made each façade roughly symmetrical, but he varied the articulation so as to introduce an open corner arcade on the ground floor and on the top floor an open loggia, or altana, now walled in. Convenient and delightful as these corner porches must have been for the inhabitants, they do violence to the symmetry of the façades in spite of the ponderous, multimolded central arch, which seeks to regain its dominance. That is not all. The first story is Ionic, the second Doric, in a reversal of the accepted succession. The altana piers alternate with small columns, placed directly over the arched window caps of the piano nobile, a weird arrangement indeed: columns are supposed to support arches, not vice versa. Finally, the Ionic columns of the ground story, perched on lofty podia, rise to embrace the piano nobile as well, a very early example of the giant order Michelangelo was soon to employ with tremendous effect. No stringcourse separates the two first floors; thus the windows of the piano nobile seem to be floating upward, beating against the balustrade that runs across the second floor.

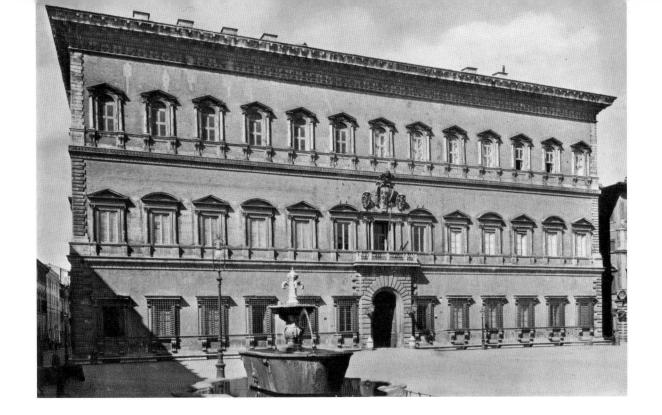

Can we call Antonio da Sangallo the Elder a Mannerist? On the basis of these two buildings, one would be tempted to say yes. Certainly they exhibit many, if not all, of the qualities of tension, asymmetry, disharmony, and conflict so impressive in the works of Antonio's pictorial contemporaries.

ANTONIO DA SANGALLO THE YOUNGER

The last member of the numerous Sangallo tribe to concern us is Antonio da Sangallo the Younger (1485–

1546), nephew of Giuliano and of Antonio the Elder. He was an imaginative yet unequal architect, whose two major undertakings came to grief at the hands of Michelangelo. Originally a carpenter, responsible for the colossal centering of Bramante's four great arches upholding the dome of St. Peter's, Antonio soon became an architect in his own right. His star went into the ascendant in 1517 when the powerful Cardinal Alessandro Farnese acquired a palace in the center of Rome and decided to rebuild it totally from Antonio's designs. The result was

above: 620. Antonio da Sangallo the Younger and Michelangelo. Palazzo Farnese, Rome. 1517–50

below: 621. Antonio da Sangallo the Younger and Michelangelo. Plan of Palazzo Farnese

right: 622. Antonio da Sangallo the Younger. Entrance loggia, Palazzo Farnese, Rome. Begun before 1524

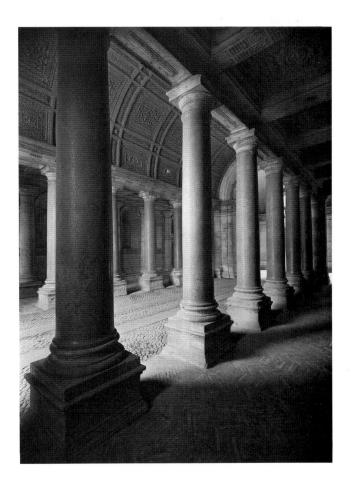

the most majestic and influential of all Roman Renaissance palaces, as much due to Michelangelo's later work on the building (see page 644) as to Antonio's own ideas. Antonio's design was ambitious from the start—an immense rectangle (figs. 620, 621) whose short side faced a piazza created by extensive demolition. The façade is a towering block of masonry recalling the Palazzo Strozzi (see fig. 307), but with rustication restricted to its quoins. Both the screen orders of the Alberti-Laurana tradition and Bramante's engaged colonnade are abandoned in favor of aedicula windows. On the ground floor Antonio adopted the "kneeling window" type (used by Michelangelo in 1517 for the windows with which he filled in the ground-floor arches of the Palazzo Medici in Florence; see fig. 146), seemingly suspended along a stringcourse that is a continuation of their sills. For the second-floor aediculae he used a Corinthian order, supported on postaments resting on a stringcourse and tied in by a smaller second stringcourse in the manner of the ground story. The windows are capped by alternating triangular and arched pediments, save for the central window, which was originally a large arch, repeating the motif of the entrance portal below. The third story is a combination of both lower ones in that the aediculae, while columniated, rest on consoles rather than postaments. Triangular pediments cap all the windows, which are arched in this case, the arches breaking the architraves of the aediculae. All the architectural trim, including the massive quoins at the corners, is in stone set off against the flat surface of the tan brick walls.

The effect is one of richness and restraint, severity and grandeur. But to an overriding extent this depends on a single change made by Michelangelo. Antonio's cornice would probably have been narrow, more or less on the scale of the stringcourses between the stories, giving a rather diffuse general impression. Only the front wing of the palace was carried out before the Sack of Rome in 1527, and only irregularly through the level of the piano nobile. Not until 1539-40 did Alessandro, now Pope Paul III, resume the original design, with some internal changes, under the original architect. But in 1546 the pope, dissatisfied with Antonio's design for the cornice, called in Sebastiano del Piombo, Perino del Vaga, Giorgio Vasari, and Michelangelo to provide competing designs. He accepted the colossal cornice by Michelangelo, even heavier than that of the Palazzo Strozzi, combining elements from various orders; it was so heavy, in fact, that Antonio's walls, set on weak foundations, had in places to be rebuilt. It is Michelangelo's cornice that, by the force of its embrace, imparts unity to the structure. According to Vasari's probably exaggerated account, such was Antonio's displeasure that he died of shock and grief. A second alteration by Michelangelo drew the elements of the building to a central focus: he filled in the tympanum of the second-story arch in the center and flanked it with a Corinthian order moving outward in a cluster of column-pilaster-column. This innovation at once prevented the second story from appearing to split apart, and gave Michelangelo space to insert the Farnese arms on three enormous cartouches.

Antonio's three-aisled entrance loggia (fig. 622) is possibly his finest surviving work. A little basilica in itself, the central aisle is barrel-vaulted, the side aisles flatroofed, and both are supported by a Roman Doric order of polished granite columns with heavy capitals. The low, almost cavernous effect is increased by the narrowing of the architrave and the omission of a frieze, which makes the massive ribs of the richly ornamented, coffered vault seem to rise directly from the columns. These deliberate violations of classical norms and of High Renaissance ideals of harmony would certainly classify this extraordinary entrance as a Mannerist work. It must have been in place before the Sack of Rome, and well under way before Giulio Romano left Rome for Mantua in 1524 because Giulio adapted the idea on a tiny scale in one of the entrances to his Palazzo del Te (see fig. 626). Antonio's courtyard would have been somewhat more conventional—a grand reproduction of the three superimposed orders of the Colosseum (see fig. 697), along the lines of such Quattrocento archaeological courtyards as that of the Palazzo Venezia (see fig. 230)—but, as we shall see, Michelangelo added a third story that transformed this design as well. For Antonio's projects for St. Peter's, we must again turn to the later work of Michelangelo (see pages 645-46).

BALDASSARE PERUZZI

Meanwhile in Rome even the elegant Baldassare Peruzzi (1481–1536), one of the leaders of the High Renaissance (see pages 523-25), succumbed to the new style in an extraordinary building begun in 1532 and now named, on account of its ground-floor columns, the Palazzo Massimo alle Colonne (fig. 623). Of course, the present fantastic view was not obtained until the late nineteenth century, when the originally narrow street was widened. At the time the Massimo family commissioned the building, the irregular curve of the façade would have seemed less illogical because it followed the curve of the street. From no single point of view would the entire façade have been visible, and Peruzzi's design, like that of Vasari a generation later for the Uffizi in Florence (see fig. 722), must have been an experience in time as well as in space. His supports—successively pilasters, single columns, paired columns—and the wide central opening placed just where the bend in the road became most acute and least tolerable would certainly have provided welcome relief to the passerby.

One might imagine, therefore, that Peruzzi would have made every effort to unify the building by vertical motifs. Instead he chose a Tuscan order deprived of even the vertical accents of triglyphs so that the eye is led around the bend with some speed. From street level, the

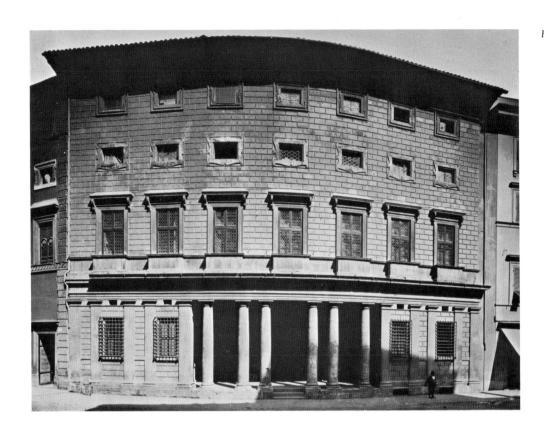

623. BALDASSARE PERUZZI. Palazzo Massimo alle Colonne, Rome. Begun 1532

windows of the *piano nobile*, each on its little podium, must have seemed to move around the bend in a solemn crescendo and decrescendo. There are no other monumental motives. The third and fourth stories are mere mezzanines, afloat in the rustication, with their own horizontal window frames decorated with frivolous combinations of moldings and scrolls.

GIULIO ROMANO

It is fitting to close a chapter on the Mannerist crisis with the most fantastic structure it was ever to beget, the Palazzo del Te in Mantua, which Giulio Romano (c. 1499– 1546), Raphael's pupil and heir, constructed and decorated at great speed from 1527 to 1534 for the insatiable Federigo Gonzaga, then a marquis but made first duke of Mantua while the building was under way. The palace (figs. 624, 625) is known from the region in which it is situated, the Te, a name of unknown origin applied to a peaceful island connecting the fortified city of Mantua, then surrounded entirely by lakes, with the mainland. The meadows of the Te had been the scene of Federigo's horse-breeding ventures, and the first plan, possibly executed in 1526, involved only the addition to the stables of a fine, frescoed banqueting hall. This soon expanded into a little palace, far smaller than its ponderous appearance would lead one to suspect. Two exterior façades fronted on the meadows and the city, but Giulio treated these in quite separate successions of rhythmic groups within the general scheme of a Roman Doric order—also probably derived from the Basilica Emilia-which embraces a ground story and a mezzanine intended for servants and storerooms. The consequent feeling of tension and compression is heightened by the peculiar rustication. Only the second story is serenely rusticated in flat, Albertian blocks like those of Peruzzi's Palazzo Massimo alle Colonne. The windows and arches of the first story are much more heavily rusticated, so violently, in fact, that their quoins and archivolts expand as if to devour the elegant architecture surrounding them, in what has been aptly described as a struggle of formlessness against form.

The courtyard goes to even greater extremes (fig. 626). The pilasters have become engaged columns of great nobility. The stringcourse separating ground floor and mezzanine has now vanished, the Albertian blocks have increased in size and projection, and some are roughened, as if the conflict between form and formlessness in the outer façades had ended in the fusion of both extremes. But the war has entered on a new phase. The windows are capped by massive pediments, whose raking angles do not meet. Yet the rusticated keystones below them have crept upward from the lintels, as if forced out of line. And then the climax: between every pair of columns, and between every two columns, one triglyph suddenly drops out of place leaving a blank hole above it! Nothing like this had ever been seen in Renaissance architecture—perhaps fortunately. Giulio must often have noticed this alarming phenomenon in many a tottering ruin surrounding his house in Rome (he was brought up next door to the Forum of Trajan), especially the Basilica Emilia, but his serious use of it was not an attempt to convert a new monument into an imitation ruin. It is too systematic for that, recurring at regular intervals, and on only two of the four inner façades of the courtyard. The effect on the observer is a fascinated horror at watching the operation of what can only be described, in contemporary aerospace jargon, as a self-destruct device.

The interior, in which Emperor Charles V was royally entertained when he came down to Italy to bring order out of chaos, comprises a series of rooms unmatched in their time for luxury and splendor, now, alas, stripped of all the beautiful furnishings mentioned in old inventories. But the pictorial decoration, which Giulio and his pupils executed at breakneck speed in suites of major and minor rooms and loggie, still survives, in spite of the damage of time. The Sala di Psiche (colorplate 84) tells in great detail the story of Cupid and Psyche, which in the Farnesina had been limited to its airy episodes (see figs. 561–564). Most gorgeous of all is the wedding feast,

which Giulio expanded panoramically to cover two entire walls with gods, nymphs, satyrs, and animals in an endless fabric of fleshy, hot-colored figures against peacock-green foliage—heightened by the silver and gold table service—which, however coarsely executed in spots, was sufficiently alluring to excite the admiration of Ingres in the nineteenth century.

In sharpest contrast to this idyllic—at times orgiastic—scene of sensuous indulgence is the Sala dei Giganti (figs. 627, 628), a room of exactly the same size and shape as the Sala di Psiche but at the opposite corner of the palace. When the door closes upon the observer, he realizes, to his mock terror, that the entire room, doors and all, has been painted in one continuous view, extending right over the vaulted ceiling and down again, representing the destruction by thunderbolts from the

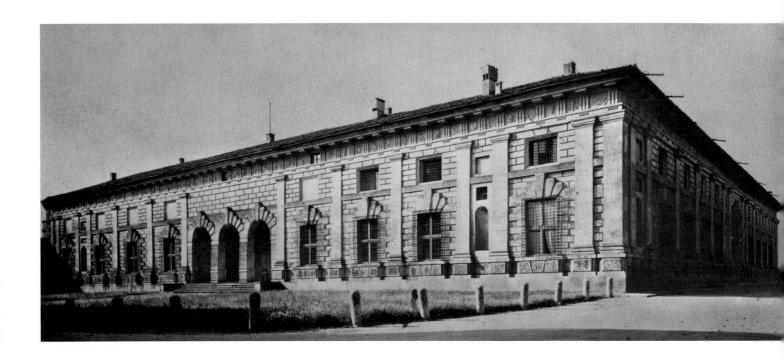

above: 624. GIULIO ROMANO. North façade, Palazzo del Te, Mantua. 1527–34

left: 625. Giulio Romano. Plan of Palazzo del Te

right: 626. Giulio Romano. Courtyard, Palazzo del Te, Mantua. 1527–34

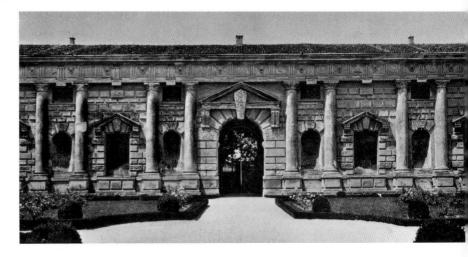

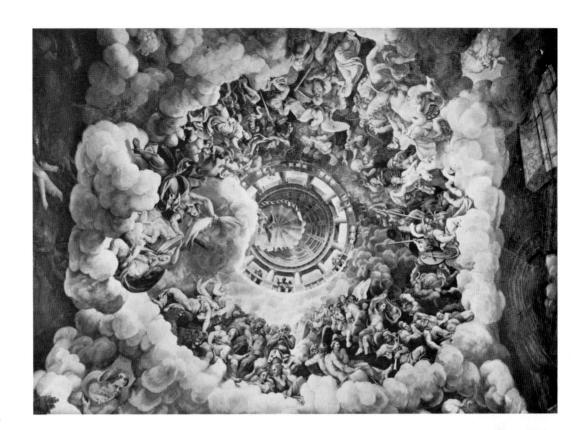

627, 628. GIULIO ROMANO. Ceiling fresco (above) and wall fresco (below). 1530–32. Sala dei Giganti, Palazzo del Te, Mantua

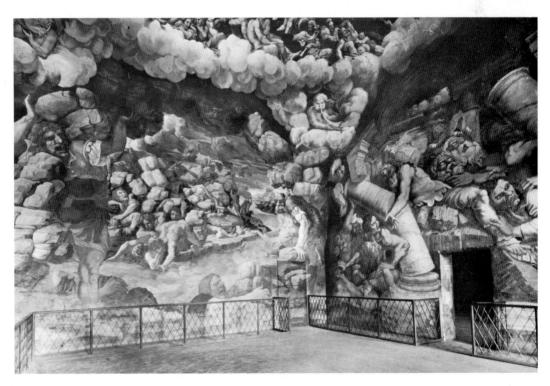

hand of Jupiter of the rebellious giants who had attempted to assault Mount Olympus. The palaces and caves of the giants seem to collapse upon them—and upon us as we watch, as if we were standing in a building struck by a bomb. This paean of destruction and slaughter, painted in a hurry after the emperor's first visit in 1530 so that he could see it completed when he came again two years later, is an eloquent if somewhat coarse expression of

feelings then quite widespread among Italians; after the annihilation of so many values that had seemed permanent until the Sack of Rome and its aftermath, many welcomed the new order of absolutism. And even if the Sala dei Giganti seldom rises above the level of scene painting, it provides images and literary associations that make explicit the conflict we have found in all the arts during the period of the Mannerist crisis.

19

High and Late Renaissance in Venice and on the Mainland

VENICE

t the opening of the sixteenth century, the Venetian school of painting had reached the height of its power and influence, a summit that it maintained until the last years of the century. The passing of the great High Renaissance and Mannerist masters of Central Italy, almost all of whom were either dead or in decline before 1540, eventually left the Venetian painters in a position of absolute supremacy in Europe, disputed only by Michelangelo. As in Quattrocento Florence, the general level of production in Cinquecento Venice was so high that the works of many a minor master of the period look at first sight much better than they are, merely because they partake of the quality radiated by the great painters. Several of these survived from the Quattrocento: one member of the Vivarini family lingered on; Carpaccio was still painting, although past his most impressive period; and Giovanni Bellini, in spite of extreme old age, continued doing paintings of the greatest depth and beauty up until his death in 1516. Two new geniuses of a high order emerged on this already crowded stage: Giorgione, briefly, and Titian, with a tenacious longevity second only to that of Michelangelo, destined to remain in control until the last quarter of the century. About the middle of the century, two more giants, Tintoretto and Veronese, made their appearance. Lotto carried the Venetian style from Lombardy to the Marches; the School of Ferrara fell under the spell of Venice; and after a great work by Titian arrived in Brescia, a new school arose in that Lombard city under Venetian influence.

It is difficult to convince ourselves at this distance that the Republic of St. Mark, whose artistic productions in the early Cinquecento would indicate a position of the utmost security and splendor, was in fact in a very precarious situation. Only, perhaps, its well-nigh impregnable location in the middle of its lagoons saved the Serenissima from the peril of dynastic rule, which eventually extinguished the liberties and the ambitions of its sister republic, Florence. For Venice had become in-

volved in the warfare between France and the Holy Roman Empire, which devastated so much of Italy and threatened the remainder. Moreover, it had profited from the fall of the Borgia family in 1503 by annexing many papal dominions in the Romagna. Julius II, not satisfied with recapturing these in 1506, organized in 1508 the League of Cambrai, which in the ensuing months stripped from Venice, temporarily at least, almost all its possessions on the Italian mainland. Although most of these were eventually regained, throughout the sixteenth century Venice was compelled to adopt a lesser and essentially defensive position with regard to the European monarchies, especially the Empire, which under Charles V had assumed mastery over much of the known world.

It is a curious fact that, at the moment when the aged Bellini and the young Giorgione were bringing land-scape and the beauties of nature closer to us than ever before in the history of artistic endeavor, Venice itself then possessed little nature to enjoy. It may well be that an important ingredient of interest in landscape is the absence of landscape from daily experience. The Romantic movement in England—nature poetry and nature painting—went hand in hand with the Industrial Revolution, which was rapidly devouring the landscape around major urban centers. The great explosion of landscape painting in France in the middle of the nineteenth century accompanied the triumph of industrialism and the resulting massive expansion of Paris and the industrialization of its suburbs.

GIORGIONE

Be that as it may, the landscapes of the late Bellini and the whole art of Giorgione explore the moods of nature in a new way. Bellini, as we have seen in Chapter 15, may be credited with the invention of the Venetian landscape, which envelops the sacred figures and reaches out toward the observer. Giorgione, traditionally and observably his pupil, is more of a mystery. Giorgio (in Venetian dialect, Zorzi) was born in Castelfranco, a small town on the Venetian mainland, probably about 1475—

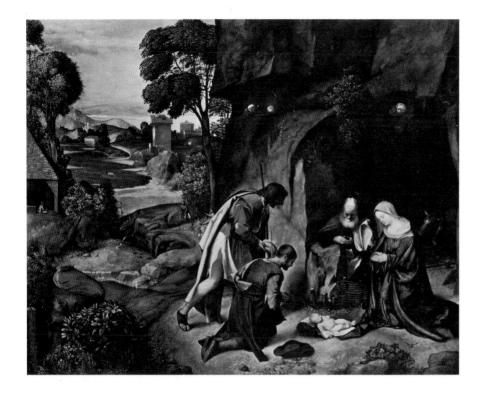

629. GIORGIONE.

Adoration of the Shepherds
(Allendale Nativity).
c. 1505 (?). Panel,
35¾ × 43½".

National Gallery of Art,
Washington, D.C.
(Kress Collection)

77, and came to Venice at an early age. A few documents record his activities in 1507–8, and in 1510 he died, still young, of the plague. According to a tradition picked up and retold by Vasari, Giorgione ("one" is the Italian suffix for "big") was given to worldly delights, good company at parties on account of his agreeable conversation, and a great lover. He enjoyed nature, he loved life, he sang beautifully and accompanied himself on the lute. It is an engaging portrait.

About the works of no other Italian painter save Giotto is there so little general agreement. Expansionist scholars give Giorgione credit for dozens of paintings of the widest variety of styles and even periods; contractionists reduce the list to a bare half-dozen. Whatever the truth may eventually prove to be, all but the first of the five paintings here discussed as works of Giorgione are by now universally accepted. Even that one, the *Adoration of the Shepherds* (fig. 629), often known as the *Allendale Nativity*, by rights ought to be accepted, save for a few figures, disproportionately tiny, with which a later hand has attempted to enliven the landscape at the left. (Significantly enough, these figures are absent from a contemporary replica of the picture, now in Vienna.)

In spite of these not-too-irritating disfigurements, the painting is a thrilling work, luminous and rich in its combination of red, blue, and yellow draperies with the sonorous depth of the landscape's greens and tans. The natural elements dominate the figures to such a degree that we seem almost to be looking at a Landscape with Nativity rather than the reverse. And at first sight it is a convincing landscape—wild, rocky, and completely unsentimental as compared with the transfigured nature of Bellini. A moment's analysis, however, produces some surprising results. First, in the proportion established

between rocks and distant space, in the configuration of the group, and especially in the shape of the cave and its surrounding rocks, Giorgione has relied on Mantegna's familiar *Adoration of the Magi* (see fig. 407). Also in his observation of rocks, Giorgione has pushed naturalism no further than did Mantegna some forty years earlier. Nor has he studied vegetation with the scientific care bestowed upon it by Leonardo: he stands his branches on edge; his leaves are not arranged as in nature. They grow in bunches, with a distinct reminiscence of the schematic trees of Giotto across the intervening two centuries, and they are lighted in Trecento fashion, with the leaves nearest to the observer in the strongest light and those most distant in shadow.

It is the artist's love of wildness for wildness' sake that gives Giorgione's studio landscapes their special quality. The rocks are gloomy and frightening, the cave suitably dark. No royal road winds through the landscape; the shepherds clearly had to scramble for it, over ledges and across streams. And the few and distant works of man are in danger of being reabsorbed into the generally hostile—or at least not friendly—world Giorgione imagines. Fatalism, not religion, is the motivating force in his art. But for his humans he entertains the warmest emotions and can communicate them by means of an illumination derived, in the last analysis, from the late work of Giovanni Bellini. Each head, simplified to spherical or cubic essentials, exists and turns in a radiant envelope of light and shadow with which the forms themselves seem at every point imbued. Probably the work is to be dated after 1505 and, significantly enough, it shows no slightest hint that the artist knew or cared about the Florentine High Renaissance.

Two or three years later, perhaps, the young painter

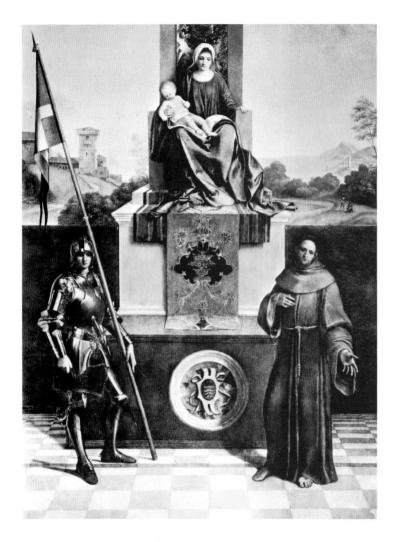

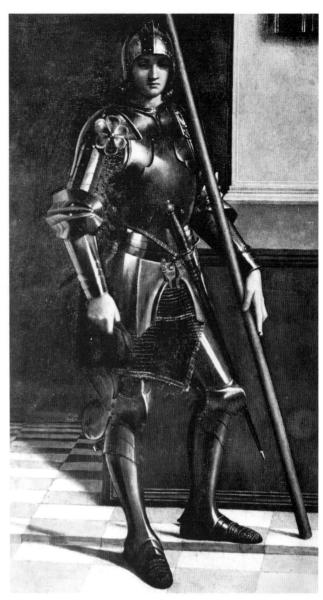

above left: 630. GIORGIONE. Enthroned Madonna with St. Liberalis and St. Francis. c. 1500-5. Panel, $78^{3/4} \times 60''$. Cathedral, Castelfranco

above right: 631. St. Liberalis, detail of fig. 630

right: 632. Giorgione (finished by TITIAN). Sleeping Venus. c. 1510. Canvas, $42^{3/4} \times 69''$. Gemäldegalerie, Dresden

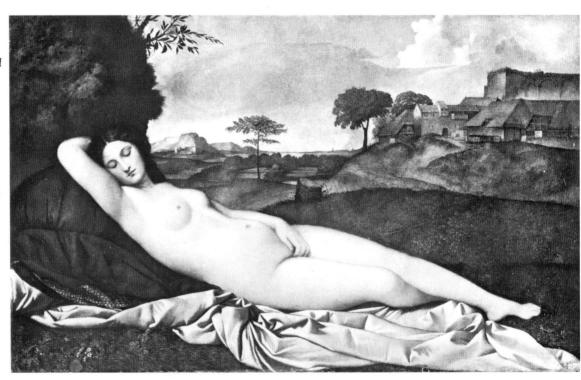

produced his one surviving formal altarpiece, the noble and gracious Enthroned Madonna with St. Liberalis and St. Francis (fig. 630), still in the Cathedral of Castelfranco, for which he painted it. Even this symmetrical composition is not without its surprises. One would hardly expect Giorgione to follow exactly any traditional type, nor does he. Ordinarily, a Renaissance artist provides some means of access to the Virgin, no matter how regally she is installed. We can always climb Bellini's few steps to reach his Madonnas, for example. But Giorgione's heavenly Queen is, for all her gentle beauty, as remote as Cimabue's, seated on a throne of alternating colored and white marble blocks of great size, rising beyond the limits of the frame and so completely without visible steps that we can only assume she came there through the air or, miraculously, just is there.

St. Liberalis (fig. 631), patron of the Cathedral of Castelfranco, stands on the Virgin's right, in shining armor, wearing his helmet and carrying his lance with its cross banner. On the Virgin's left St. Francis addresses the worshiper, in a gesture that at once displays his wounded hands and points to his wounded side. Behind Mary's throne and over a draped wall, our gaze moves out freely over land and sea. Immediately, we recognize Mary's familiar port scene (seldom visible in the background of non-Marian pictures) above St. Francis; above St. Liberalis a mountain village is protected by an enormous tower. While the two landscapes are compositionally united by the broad movement of trees behind the throne, we see them separately and as opposites. It is noteworthy that both show signs of warfare. Two menat-arms, one standing, one seated, have stopped by a bend in the road at the right, and at the left the wooden parapet and roof of the guard tower are shattered as if by artillery.

These explicit allusions, coupled with the melancholy mood of the picture, permit us to interpret the lofty placing of the Virgin as an appeal for her intercession, in the manner of the Florentine Madonnas of the Land (see pages 473–74), for similar reasons and under similar circumstances of military occupation. The high point of view, just at the Virgin's knee, not to speak of the strict pyramidal composition, now suggests a familiarity with the Florentine High Renaissance, which Giorgione could have acquired through the visit of Fra Bartolommeo to Venice in 1508. This may well be the date of the altarpiece. But within the imported pyramid Giorgione plays with characteristically Venetian diagonals: the slanting spear and the parallel motion of the drapery over the Virgin's right knee are answered subtly by a whole fabric of counterdiagonals in the smaller folds of her mantle.

Giorgione's best-known work is the tiny *Tempest* (colorplate 85), which used to be the subject of endless scholarly controversy. Who is the nude woman? Why is she nursing her child outdoors under these unconventional circumstances? Why is the soldier standing near-

by and watching? Many determined and fruitless efforts were made to find in ancient literature and in the Bible a credible subject for the painting. It has been suggested that the picture simply has no literary subject. In 1530, twenty years after Giorgione's death, the Venetian Marcantonio Michiel saw it in the house of Gabriel Vendramin and referred to it in his journal: "The little landscape on canvas with the tempest, with the gypsy and the soldier, was from the hand of Zorzi da Castelfranco." Furthermore, an X ray has shown that where the soldier now stands Giorgione originally painted another nude woman bathing. A change in the dramatis personae, from nude woman to clothed soldier, spells disaster for any story one can possibly imagine. Apparently, the picture is a caprice on Giorgione's part—an antisubject. He has given us the spare parts of a story, so to speak, which we can utilize as we wish.

Again, he shows us an unfriendly nature. The woman seems trapped in the unkempt, weedy natural world that has grown up around her. The trees are unpruned (Piero di Cosimo would have loved them), the bushes shaggy, the columns ruined, the bridge precarious, the village disheveled. And the whole scene is threatened by an immense, low storm cloud, which fills the sky and emits a bolt of lightning, casting the shadow of the bridge upon the little river and illuminating the scene with a sudden glare. Lightning we have seen before (Uccello's *Deluge*, for instance; see fig. 260), but never has it been so believable. When the picture hung in the Accademia in a room by itself, with its own light, one could watch it for hours with inexhaustible fascination.

Another unconventional picture ruled by a savage nature, the so-called Fête Champêtre (colorplate 86), has been interpreted as an allegory of Poetry. Two young gentlemen, one fashionably dressed and playing a lute, are seated upon the ground in happy conversation, paying no attention whatever to two young ladies who are, by and large, unclothed. One of these women is about to give voice to a recorder, while the other, in a pose of infinite grace, pours water back into a well from a crystal pitcher. The voluminous proportions of the two women, so different from the slender Botticellian ideal (see colorplate 46), even from Raphael's ample Galatea (see fig. 558), are fairly typical of Venetian preference in these matters and will reappear in triumph in Titian's abundant Venuses. The shining rounded volumes of the women in Giorgione's picture are played off majestically against the cloudy masses of the tree in the middle distance.

The artist takes us into a landscape without clear-cut shapes or edges. Line exists even less than in Giovanni Bellini's later works. Form is drowned in shadow, and there is almost more shadow than light. The face of the young man on the left, for instance, is full of expression, but so deeply shaded that we can see little more than the profile and the position of one eyebrow. Giorgione be-

gins to move his brush around with greater speed and freedom, animating his opulent shadow world with the motion of the hand as well as with the saturation of color.

One of his last paintings, or so we are led to believe because it was finished by Titian, is the Sleeping Venus (fig. 632), the ancestress of a noble line of recumbent Venuses by later masters, starting with Titian. Far removed from Botticelli's Christianized goddess (see colorplate 46), who stands nude for a brief time, Giorgione's Venus has gone to sleep in that condition and is associated with the very curves of the earth, shining in the soft light in the full perfection of female beauty. The face in its present state is suspect, too classically perfect for so unconventional a master; probably it was repainted in Dresden in the early nineteenth century. The landscape was completed in his grandest style by the young man who rapidly supplanted Giorgione as the leading master among the new painters of Venice, and who soon acquired a dominance over his Venetian contemporaries almost equal in authority to that exerted by Michelangelo in Central Italy. As in the backgrounds of so many Madonnas, the sea appears in the distance, appropriately enough since Venus was born from it.

TITIAN

Tiziano Vecellio, known in English as Titian, was not Venetian born. He came to the city of lagoons from the town of Cadore, high in the mountains, at the beginning of the most spectacular ranges of the Dolomites. No one knows when he was born, but he survived in astonishing health until 1576 and attempted to give the impression of immense age. The belief that he lived to the age of ninety-nine, and was therefore born about 1477, is no longer taken seriously. When Vasari visited Titian in 1566, he recorded the great master's age as seventy-six, which would place the date of his birth in 1490. No independent artistic activity on Titian's part is recorded before 1508 when, barely twenty years old according to his friend Ludovico Dolce, he acted as Giorgione's assistant in a series of frescoes painted on the exterior of the Fondaco dei Tedeschi, the German commercial headquarters in Venice. No dated works by him before 1511 survive. Contemporary sources describe him as still young when, in 1516–18, he painted the Assumption of the Virgin (see colorplate 88). The most probable date for his birth would therefore be about 1488.

His documented career still spans sixty-eight years, in a period when life was generally far too short. During this career, in fact toward the beginning of it, Titian is to be credited with one of the crucial discoveries in the history of art. He was the first man in modern times to free the brush from the task of exact description of tactile surfaces, volumes, and details, and to convert it into a vehicle for the direct perception of light through color and for the unimpeded expression of feeling. True, oth-

ers—notably Masaccio, the Van Eycks, Domenico Veneziano, and Giovanni Bellini—had led mankind a long way on this very road, but it was Titian who found and crossed the bridge—as important as the discoveries by Donatello a century before (see pages 165–68). As early as the Assumption of the Virgin, Titian had demonstrated knowledge and full mastery of the new type of brushwork, but he restricted its use to portions relatively remote from the observer. Long before the end of his life he was painting entire pictures by this method, and so were the majority of the other painters in Venice.

Brushwork was, however, only the beginning of Titian's magic. Contemporaries tell how he used to build up his pictures in oil over a reddish ground to communicate warmth to all the colors, turn the pictures face to the wall for months, and look at them anew as if they were his worst enemies. New layers might then be applied, especially the interminable glazes (the Italian word velatura, or "veiling," is very expressive) to tone down colors that might stare too much and to communicate a depth and richness of tone in which many colors, shadows, and lights seem miraculously suspended. "Trenta, quaranta velature!" ("Thirty, forty glazes!") he is said to have cried, and possibly there are that many, except where overzealous modern restorers have cleaned them off, stripping Titian's paintings to the brilliant colors he was at such pains to tone down and to unite.

Ludovico Dolce, whose Dialogue on Painting was published when Titian still had nineteen years to live, and who knew the great master well, tells us that Titian arrived in Venice at the age of eight (presumably just before 1500) with his older brother Francesco and was at first set to work with the mosaicist Zuccato. Dissatisfied. he was taken on by the aged Gentile Bellini, whose manner he doubtless found old-fashioned, and then by Giovanni Bellini. Even in this authoritative shop he did not stay long, but moved on to study with Giorgione. By 1510 he seems to have become independent. The young mountaineer, whose exuberant strength fills a majestic series of canvases with form, light, and color, was also a shrewd businessman, and invested his earnings in lumber in Cadore. By 1531 he was able to buy a palatial residence in Venice, looking out across the lagoons to Murano and, on clear days, to the summits of his Alpine homeland. In 1533 the painter, already wealthy and famous, was summoned to Bologna to meet Emperor Charles V, who made him a count and his children hereditary nobles. In 1545 and 1546 he stayed in Rome, where he was awarded Roman citizenship on the Capitoline Hill. Twice the emperor called him to Augsburg as court painter. There is even a tale to the effect that one day, when Charles V visited his studio, Titian chanced to drop his brush, and the emperor of most of the known world stooped to pick it up. Leonardo da Vinci, who had striven so hard to see that painters received the honors and material rewards he considered due them above all

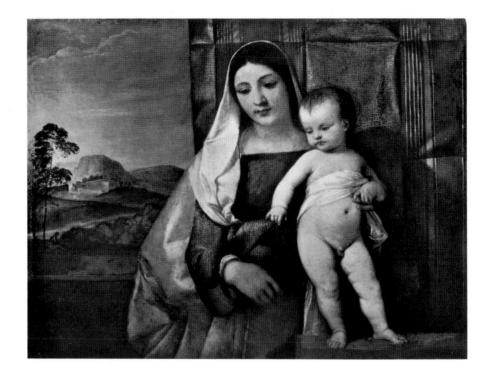

633. TITIAN. *Gypsy Madonna*. c. 1510–15 (?). Panel, 26 × 32½". Kunsthistorisches Museum, Vienna

other artists, would have been pleased indeed at the princely state this painter was able to maintain.

From the very start of his discernible career, Titian showed a sovereign impatience with the cliché. Every motive, every convention had to be seen afresh. In his beautiful early Madonna and Child, nicknamed the Gypsy Madonna (fig. 633), he takes the theme of the parapet, standing Child, and hanging cloth of honor, familiar to us from Giovanni Bellini, and pushes all the elements off center. The Virgin stands slightly to the right of center, but she overlaps only one edge of the cloth of honor, which has been moved so sharply right as to leave only a single landscape view instead of the customary two. The parapet itself runs less than halfway across the lower edge of the picture, and the diagonal rising relationship between the parapet and the cloth of honor corresponds to the direction our glance must follow in its motion over a second parapet and off to the hills of the middle distance and the mountains of the horizon. The diagonals are carried off with such authority and consistency, even in minor relationships within any area of the picture, that the off-center composition is still perfectly balanced.

Throughout Titian's career, diagonal placings and diagonal views will be used in increasing intensity to break up the symmetry of High Renaissance pictures, particularly altarpieces. But another of Titian's lifelong compositional principles is already visible at this stage—the Virgin forms an exact equilateral triangle—and the two principles are therefore related. The triangle is for Titian's art what the spiral is for Raphael and the block for Michelangelo.

It would be discourteous to leave the *Gypsy Madonna* without commenting on her beauty. The sweetness of Bellini's pensive Madonnas is replaced by a peasant healthiness and buoyancy. The sun shines full on her

round face with its large, wide-set eyes, and on her soft neck a half-shadow lingers. Her cheeks and lips glow in the light. Her quiet grace of bearing replaces the linear harmonies of Quattrocento female figures. She is splendid, opulent, warm, and fertile, and her Child, whose classical pose shows a knowledge of Mantegna (see fig. 412), is a sturdy boy of whom she may be justly proud. Although Titian's ideal of womanhood reaches full emotional expression only in his later works, it is present here already, in this quiet early phase.

Among his many early half-length portraits and figures, one of the most striking is certainly the Portrait of a Bearded Man, whom some have identified as the poet Ludovico Ariosto (colorplate 87), painted probably a year or so later than the Gypsy Madonna and even more vividly original. Titian has placed his sitter behind a parapet, in the manner introduced in Jan van Eyck's portraits. But with his usual ease, he rests the man's right elbow full on the parapet, so that the puffs of the sleeve somewhat overlap its edge. Although the body is turned almost at right angles to the picture plane, the head moves slightly in our direction and the eyes look calmly toward us. The broad, spiral motion in depth of the arm and head looks as if Titian already knew, at a distance and perhaps from Fra Bartolommeo, something about what was going on in contemporary Florence. But he handled the motif entirely in his own way. Surprising, un-Florentine, and very beautiful is the way the hand suddenly turns out of our sight, into the shadow. The high side light illuminates the near side of the young man's face, picking out the cheek and forehead and the strong, fine line of his straight nose against the dark of the beard and the shadow. It is a face of the utmost composure and dignity, fully capable of holding its own against the blinding beauty of the sleeve, one of the most alluring fabrics ever painted. An indefinable blue with a

strong violet component catches and holds our eye, against the softer tones of the stone and the gray background. A lesser master would have allowed this wonderful color to eclipse the sitter; in Titian's painting it seems only a proud emanation of his inner nature.

Titian's only venture into the realm of the colossal is the Assumption of the Virgin (colorplate 88; fig. 634), an altarpiece well over twenty feet high. The composition looks larger than it actually is because of Titian's powerful handling of the figures, who are heroic not only in their proportions but also in their deportment. So grand is the picture that it competes successfully with the vast Gothic interior of the Church of Santa Maria Gloriosa dei Frari, on whose high altar it still stands. There may or may not be some relation to the Sistine Madonna of Raphael (see fig. 543), probably painted in 1513, three years before Titian began the Assumption. But we must remember that Titian did not visit Florence and Rome until 1545. A notion of the grandeur and scale of the Central Italian High Renaissance could have been brought to him by Fra Bartolommeo and others, and possibly by visual evidence in the form of drawings and prints. Most likely, Titian was inspired by such sources to create his own thoroughly Venetian version of the High Renaissance style.

He has imagined the moment of the Assumption—the physical ascent into heaven of the Virgin's body miraculously reunited with her soul after burial—as a scene of cosmic jubilation. Nature, so fascinating to Giorgione, has vanished. The foreground is filled with healthy, sturdy mountaineer Apostles, excited and gesticulating wildly. One is seated on what may be the traditional sarcophagus, or perhaps just a stone. Their movements converge to form a typical Titian triangle from whose apex, in an inverted triangle, "Santa Maria Gloriosa" ascends on a curving cloud populated by countless putti (fig. 634). These, by the way, are not the chubby, sometimes cute, sometimes impish babies of Quattrocento tradition, but splendid, robust children, who sail happily upward with Mary into the golden light, which warms their legs and torsos and flashes from their curly hair. In the midst of the ascending throng, Mary sways in the winds of heaven and her mantle billows about her, creating more diagonals and more triangles. Even the Lord floats diagonally toward us in space.

Activated by an irresistible upward drive, the triangles form a kind of escalator through which mankind in the flesh conquers heaven in the completely physical person of Titian's Mary, her entire being yearning for this final realization, like Michelangelo's Adam. It is not without significance for the understanding of Titian as compared with Michelangelo (or, for that matter, Venice as compared with Florence) that the latter found the perfect expression of ideal humanity in male heroes, the former in warmly beautiful women. Certainly, Titian's rapt Virgin, in the fullness of her physical and emotional powers

and the triumph of her youth (why has no one carped that she does not look fifty?), has as beautiful a face as one can imagine, but significantly enough it does not differ essentially from the face of Titian's nude goddesses or allegorical figures. Like Correggio, but on a higher level, he places no barrier between the physical and the spiritual.

And finally there is the color, unforgettable to anyone who has once seen the masterpiece in the Frari. The necessity for broad effects that would be visible from a distance apparently persuaded Titian to restrict himself to a few dominant hues—brilliant reds, blues, yellows, and greens in the garments of the Apostles and the traditional blue and rose for Mary's mantle and tunic, set off against the pale blue of the sky in the lower half and the gold tone of heaven above. The result is a composition of grand simplicity, within which the blood-warmed flesh tones and splendid hair operate freely, a symphonic structure in massive chords reaching the observer immediately and directly.

Probably a year or so earlier than the Assumption, and possibly using the model who later posed for Mary, Titian painted the so-called Sacred and Profane Love (colorplate 89), about whose interpretation so much has been written. The universal appeal of this picture is so strong—due to the harmony of its composition, the splendor of the contrast between glowing stuffs and glowing flesh, and the beauty of the two women—that the simplest explanation is probably the nearest to the

truth. The following combines elements drawn from several not necessarily conflicting interpretations, together with one or two new observations. Two women, so similar in form and coloring that they look like sisters, sit at either end of a fountain in the light of late afternoon. One is clothed, girdled with a locked belt, gloved, and holds a closed jar; she is seen against a fortified hill town to which a huntsman returns, while in the countryside two rabbits, symbols of love, converse in peace; as she looks past us intently, seeming to be listening, she toys with a cut rose, one of several on her side of the fountain. The other figure is nude (fig. 635), save only for a white scarf across her lap and the rose-colored cloak thrown over her left arm, lifted to hold a small urn from which a flame rises. Behind her stretches a more open and luminous landscape in which, before a lake, huntsmen catch up with a rabbit, shepherds tend their flocks, and a church steeple rises above the horizon. The fountain has the shape of a sarcophagus, and its lid is thrust aside so that Cupid may stir its waters. A golden bowl half-filled with clear water rests upon the edge. On the sarcophagus-fountain are carved the arms of Niccolò Aurelio, vice-chancellor of the Venetian Republic; to the left, in emulation rather than imitation of ancient

opposite: 634. TITIAN. Angels, detail of Assumption of the Virgin (see colorplate 88). 1516–18. Panel. Sta. Maria Gloriosa dei Frari, Venice

above: 635. TITIAN. Nude Woman, detail of Sacred and Profane Love (see colorplate 89). c. 1515. Canvas. Borghese Gallery, Rome

right: 636. TITIAN. Festival of Venus. 1518–19. Canvas, 68×68". Prado, Madrid

637. TITIAN.

Bacchanal of the

Andrians. c. 1522–23.

Canvas, 69×76".

Prado, Madrid

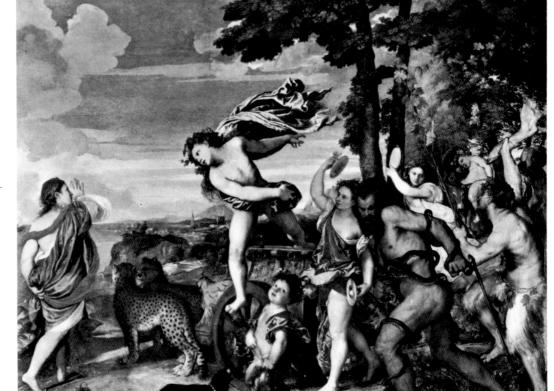

638. TITIAN.

Bacchus and Ariadne.
1522–23. Canvas,
69×75".

National Gallery,
London

sculpture, a proud horse is led by its mane by one groom while others flee, and to the right a man is beaten and a woman is led by her hair.

That the nude woman in the picture is exhorting her listening "sister" is evident to all. What, then, is the nature of that exhortation? Through an analogy with Carpaccio's Meditation on the Passion (see fig. 430), also an allegorical arrangement of figures and carved stone with an upland scene on the left and a peaceful lowland on the right, a mystical transition between two states of being appears to be indicated, and this takes place through suffering and death. The image of the horse on the sarcophagus, it has been suggested, is derived from a Platonic metaphor for the control of the lower senses, and those of torment from ancient initiations into the rites of love. Through the water in the tomb and the familiar cup, a parallel can be drawn to Christian baptism, according to St. Paul a death to the old life and a rebirth in the new; and this baptism into the mysteries of love, requiring control and purification, is what the silent nude is recommending with her earnest gaze and every line of her warm body. The fortress must be abandoned, the garments shed, the roses dropped, the jar opened, the quarry caught. But that the new life of love is truly sacred after purification from mere lust is indicated by the ritual lamp held up to heaven and by the church steeple rising against the sky.

No more satisfying apotheosis of human well-being was left us by the Renaissance. Titian has composed it in terms of his characteristic triangles in a simple harmony based on whites and silver-grays, blues and roses, and deep greens, already showing the warmth and depth of his magical glazes. Setting this picture against Raphael's Galatea (see fig. 558), the palm for the painting of feminine beauty probably goes to Titian, but the two pictures stand together as symbols of an ennobled humanity whose triumph, in Central Italy at least, was (as we have seen in the preceding chapter) tragically short-lived. Sacred and Profane Love, which should, as has often been noted, be renamed something such as the Persuasion to Love or the Baptism in Love, would have been quite as much at home in Agostino Chigi's villa as in Niccolò Aurelio's house.

A more orgiastic aspect of Renaissance paganism can be seen in three dazzling pictures that Titian painted for Alfonso d'Este, duke of Ferrara, the implacable foe of Julius II. Alfonso was in search of pictures to adorn an alabaster pleasure chamber (let us recall the efforts made by his aunt Isabella d'Este and his cousin Federigo Gonzaga to assemble similar painted rooms; see figs. 413, 611, colorplate 82). Two were painted from literary descriptions by Philostratus, the third-century Roman author, of ancient pictures he claimed to have seen in a villa near Naples. First is the *Festival of Venus* (fig. 636), datable in 1518–19, representing a charge of voracious Cupids before an indulgent statue of Venus; they romp

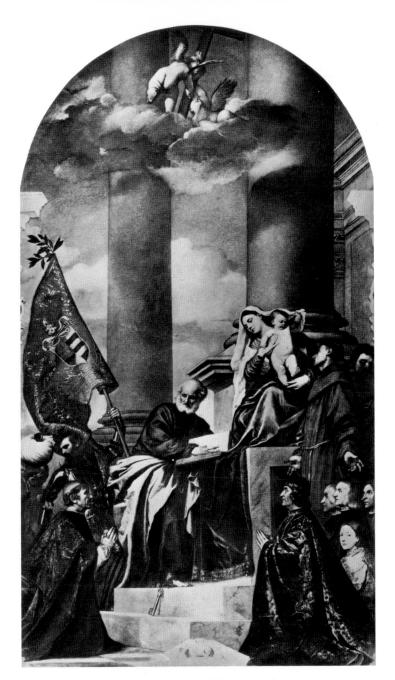

639. TITIAN. *Madonna of the House of Pesaro*. 1519–26. Canvas, 16'×8'10". Sta. Maria Gloriosa dei Frari, Venice

through a meadow devouring baskets of her golden apples, and even fly into the trees to pick still more fruit, while a happy maenad holds a mirror to the goddess. In the second, the Bacchanal of the Andrians (fig. 637), painted about 1522-23, the inhabitants of the island of Andros, where a river of wine gushes profusely from the very ground, are shown in various stages of abandon as a result of the wine they pour and drink from amphorae, vases, pitchers, and cups. Inflamed with wine and love, the Andrians dance, gather in couples, or sleep, like the nude Ariadne, below right, who lies, her breasts uptilted, in a pose to be imitated by Poussin and Goya. One little boy unashamedly lifts his shirt to spout excess liquid, while at the top of the hill the god of the river of wine, caught in a sudden shaft of sun against the cumulus clouds, lies in a vinous torpor. The final and perhaps the

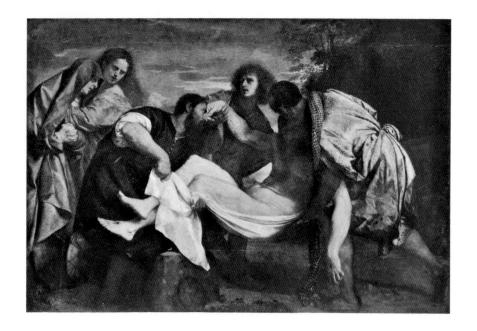

left: 640. TITIAN. *Entombment*. Mid-1520s. Canvas, 58 × 81". The Louvre, Paris

below: 641. TITIAN. Man with the Glove. 1527 (?). Canvas, 39% × 35". The Louvre,

opposite above: 642. TITIAN. Presentation of the Virgin. 1534–38. Canvas, 11'4" × 25'5". Accademia, Venice

opposite below: 643. Women, detail of fig. 642

loveliest painting of the series, *Bacchus and Ariadne*, whose subject is drawn from a variety of classical sources, shows Bacchus leaping from his chariot to rescue Ariadne, abandoned on the island of Naxos by the faithless Theseus (fig. 638). The god is attended by a rout of drunken maenads clashing cymbals and by satyrs brandishing sticks and even the hindquarter of a goat they have torn apart for their feast.

In these three unbridled paintings Titian reaches a new freedom of figural composition and brilliance of coloristic expression. The richness of the flesh tones, now brown, now pale, and the sparkle of the characteristic blues and roses were clearly destined for a captivating effect of high saturation against the alabaster architecture. But the eloquence of color in the shadows is almost more surprising than its beauty in the light. Such effects as the dull red of the wine that no light touches, and the soft sheen of its crystal pitcher against cloud, are as unexpected as the deep glow of the spotted gold coats of Bacchus' leopards within the shadow he suddenly casts upon them as he leaps. If the Mannerist crisis, so acute in contemporary Tuscan centers, had any effect in Venice one certainly cannot find it in these happy affirmations.

Meanwhile, in his religious works Titian was exploiting all the implications for monumental composition of his favorite diagonal-triangular principle. A closely calculated example is the *Madonna of the House of Pesaro* (fig. 639), commissioned in 1519 for a lateral altar in the Church of Santa Maria Gloriosa dei Frari but completed only in 1526. Like Correggio's contemporary *Madonna and Child with Sts. Jerome and Mary Magdalen* (see fig. 605), the scene is laid outdoors in full sunlight. But Titian has chosen as his setting a portico of the Virgin's heavenly palace on whose steps stands St. Peter, to whom an armored warrior, holding an olive-crowned flag with the arms of the Pesaro family, presents as a trophy a captured Turk, in reference to the battle of Santa Maura won in 1502 by Jacopo Pesaro, bishop of Pa-

phos and commander of the papal galleys. Jacopo himself kneels at the left, and at the right kneel five male members of his family, young and old.

An artist in the conservative Venetian tradition would have given us a purely symmetrical composition. Titian has deployed his diagonals and triangles in depth and in height. First, he has turned the palace at a sharp angle to the picture plane, then set the Virgin so far to one side that her head forms one corner of an equilateral triangle, whose other two points are provided by the kneeling chiefs of the Pesaro clan. Similar triangles in smaller scale reappear constantly throughout the picture in figures and in drapery patterns. The columns soar beyond the arched frame, and at the top of the arch a cloud floats in, full of lights and shadows, bearing two putti holding a cross. Titian, just as dissatisfied with High Renaissance regularity as were his Mannerist contemporaries in Flor-

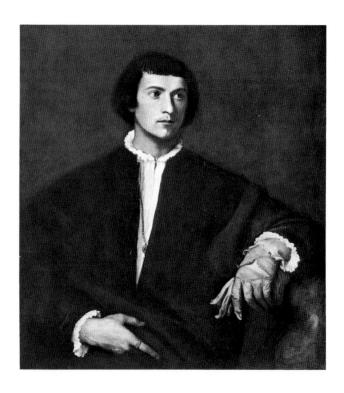

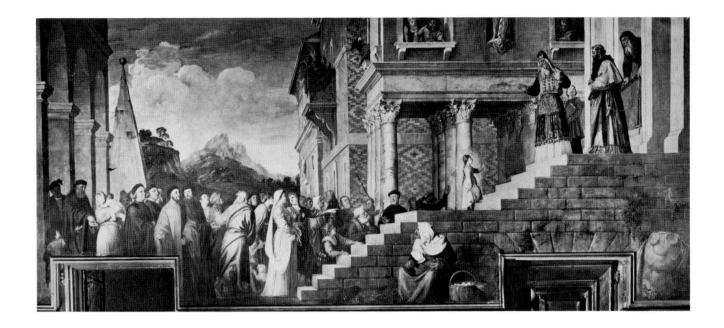

ence, effected his own revolution by rational means and without recourse to caprice. The result is noble, dramatic, and stirring. His pictures of the 1520s have all the harmony of the High Renaissance, but they contain a new power, of shapes rather than muscular action or expressive wildness. The portraits in this altarpiece are deliberately reticent, and the Madonna and Child owe their great beauty more to the reciprocal balance of cone, cylinder, triangle, and sphere in the construction of their heads and bodies than to any such sweetness as we found in the Virgin of the Assumption. Even Titian's color has quieted down; the Pesaro Madonna is darker and richer than the work of the preceding decade, doubtless softened by multiple glazes.

When, at some time in the mid-1520s, Titian took up the subject of the *Entombment* (fig. 640), probably in response to the inner necessities recognized and exalted by

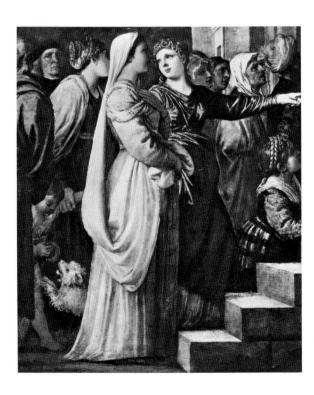

the Oratory of Divine Love and its successor, the Theatine Order (see page 522), he does so in a more measured and controlled fashion than Pontormo or even Andrea del Sarto. The pose of Christ is borrowed from that of the dead Meleager carried from the Calydonian boar hunt, in a well-known series of Roman sarcophagus reliefs. Titian has fitted his central group—Christ, Nicodemus, Joseph of Arimathea, and John-into an isosceles triangle this time, but the diagonals of Christ's thighs form one side of another isosceles triangle with its apex at the head of the Virgin and two sides corresponding to the left lower corner of the frame. These intersecting triangles, of course, are enriched by numerous curving shapes, such as the back of Nicodemus or the arms of Christ. Within the compact composition the heads, simplified to their geometrical essentials as in the Pesaro Madonna, shoot glances of tragic intensity.

Titian's portraiture in the 1520s enters a similar phase of dignity and reserve. The famous *Man with the Glove* (fig. 641) may be the portrait of one Gerolamo Adorno (d. 1523), which Titian delivered to Federigo Gonzaga in 1527. The young man, with his incipient beard, is rendered in a style unexpectedly hard and smooth, no expression crosses his face, and the triangular relationship of hands and face function within a color scheme restricted to black, white, and flesh tones. Yet the effect of the painting is intense. One cannot escape the solemnity of the distant gaze, and not even black-and-white reproduction can kill the richness of Titian's color, which lives in the overlay of glazes.

In the 1530s a strongly conservative phase of Titian's work begins, epitomized by the stately *Presentation of the Virgin* (figs. 642, 643) painted in 1534–38 as a mural for the Scuola della Carità in Venice (now incorporated into the rambling mass of buildings that make up the Accademia). Here Titian had to cope with two preexisting doors, and did so by reviving the traditional motif of a great staircase rising to the Temple—another triangle of

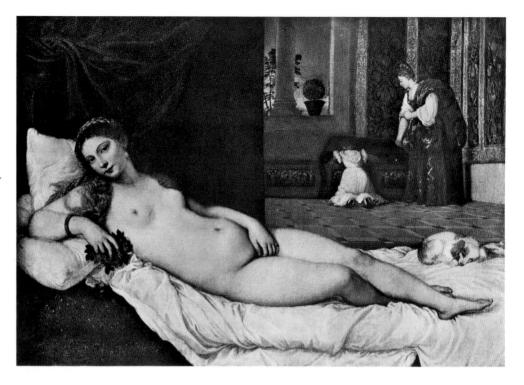

644. TITIAN. Venus of Urbino. Finished in 1538. 47×65 ". Uffizi Gallery, Florence

course, or rather a triangular group of triangles. One door he incorporated into the painted masonry of the staircase by painting archivolts for it; the other he gave up on as a total loss. Into the architecture of the background he also tried to reflect and rationalize a number of inequalities of proportion and spacing in the wooden paneling below and the carved and gilded wooden ceiling above, producing a setting that has at the same time the inevitable accidentality of a city street and a perfect harmony among its component parts and with the random organization of the room.

There is a strange suggestion of the Trecento about all this. Titian may well have looked with interest on the subtle organization of architectural space and crowds of standing figures in the murals of Jacopo Avanzo (see fig. 129) and Altichiero (see fig. 130) in Padua (where, in fact, he had painted a major fresco series as a young man), and adapted their ideas to large-scale narrative composition, which had not previously been his main interest. The details of the architecture are resolutely Renaissance, save for the pink-and-white lozenge patterns in the marble wall, borrowed from the Doges' Palace. On the left appears Titian's idea of the aspect of the Pyramid of Gaius Cestius in Rome and in the distance—a nostalgic touch—the summits of the Marmarole, mountains that tower above Cadore. In this tapestrylike mural, depending for its effect more on areas of bright costumes and rich marbles than on form or movement (see fig. 643), Titian has returned to the web principle that always seems to underlie Venetian painting (see page 138). Later this picture was to provide an example for the greatest Venetian decorator of the century, Paolo Veronese. The details are impressive in sheer richness of color, but the figures are remarkably withdrawn in expression and austere in form. The three-year-old Virgin, center of a soft radiance of light, is a touching figure as she pauses on the first step of the second flight, and the high priest is very grand, dressed with some attention to the biblical description of his vestments, including the jeweled breastplate. The old market woman seated below the stairs to direct our gaze inward along with hers, is a direct tribute to Carpaccio's charming rendering of St. Ursula's nurse (see colorplate 64) in a similar position.

> 645. TITIAN. Cain Killing Abel. 1542. Canvas, 9'2" square. Sacristy, Sta. Maria della Salute, Venice

In this same vein of quiet luxury and emotional reserve, Titian painted his Venus of Urbino (fig. 644), finished in 1538 for Guidobaldo della Rovere, then duke of Camerino. In this, the earliest of the long series of recumbent Venuses with which Titian was to occupy his imagination in later years, he returned with such fidelity to the pose of Giorgione's Sleeping Venus (see fig. 632) that one can only suppose the patron asked him to. Only the head has changed, for the sleeper has awakened, and now looks at us with a calculating stare worthy of Parmigianino. She lies upon a couch, her little dog asleep at her feet; her lowered right hand holds idly a nosegay of flowers: her rich, silky, delicately waved golden-brown hair floods over one white shoulder in a contrast of textures and colors that Titian used and reused from his youth to old age. Instead of Giorgione's natural setting, Titian has divided his background into two roughly equal parts, the left occupied by the curtains and wall of the cubicle in which the nude reclines, while on the right we look into an adjoining chamber, paved with marble squares, hung with rich brocades, and lighted by a columned window opening on treetops. In this palatial environment stands a splendidly dressed lady looking on while a girl in white, presumably a servant, searches for something in one of a pair of handsome carved and gilded cassoni, the chests in which clothes were kept in the Renaissance.

Is this Venus at all? Guidobaldo's correspondence, which betrays great anxiety to obtain this picture, refers to the lady simply as a nude woman. Only her connection with Giorgione's earlier and Titian's later Venuses

646. TITIAN. Sacrifice of Isaac. 1542. Canvas, 10'6" × 9'2". Sacristy, Sta. Maria della Salute, Venice

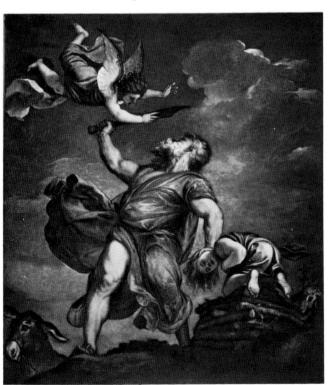

indicates otherwise. If this really is Venus, then Titian has been to considerable pains to demythologize her, to reduce her, in fact, to the position of a prince's mistress who basks like an odalisque in the warmth of her own abundant flesh, while her lady-in-waiting and maidservant find a garment splendid enough to clothe her. Titian's fascination with the reticulated surfaces of marble and brocade in the background—regularly subdivided areas of rich and various texture, uniformly maintained—is indicative of his own attitude toward painting at that time. The closest he ever comes to Central Italian Mannerism is the ornamentalism of this picture, concerned with flat areas, gratifying textures, delicate patterns, and subdued colors rather than freedom of form and space, color and light, action and expression.

The great master had only banked his fires. They burst out again with renewed and surprising heat in an uninterrupted series of passionate works, from the early 1540s until the aged painter was stopped by death. History holds few other examples of such a rejuvenation. In 1542 Titian accepted a commission, offered originally to Giorgio Vasari at the time of his visit to Venice the preceding year, for three scenes of violent action; these paintings, intended for the ceiling of the Church of Santo Spirito in Isola in Venice, are now removed to a similar position in the Sacristy of Santa Maria della Salute (figs. 645-647). For the first time Titian, who had not yet visited Rome, showed a sustained interest in the heroic poses and powerful musculature of the Roman High Renaissance. It would be easy to attribute this to the "influence of Michelangelo," but since the Venetian

647. TITIAN. *David and Goliath*. 1542. Canvas, 9'2" square. Sacristy of Sta. Maria della Salute, Venice

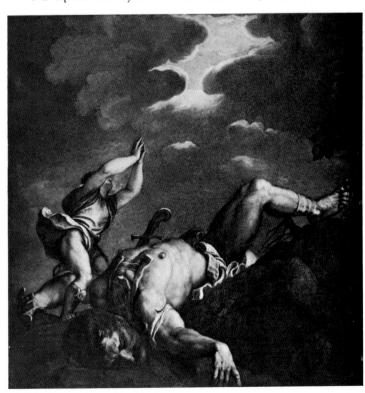

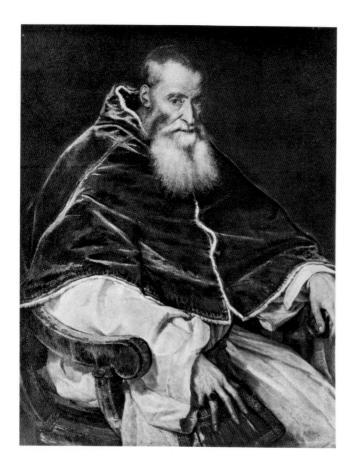

painter seems to have been fairly well informed already about the innovations of his Florentine rival before 1520, the question arises why he resisted direct influence from him for so long.

Titian's first contact with the Roman artistic vocabulary was at second hand, through the person of Giulio Romano, still working in Mantua; and, if we are to be-

lieve Pietro Aretino, Titian even desired Giulio to come to stay in Venice after the death of Federigo Gonzaga in 1540. In the huge, heavily muscled figures who battle and tumble through—and out of—Titian's Cain Killing Abel, Sacrifice of Isaac, and David and Goliath, there is more than an echo of Giulio's giants, intended as ceiling paintings (see figs. 627, 628). Confronted with Giulio's muscular dioramas, Titian must have thought how much better he could do the same thing. There is no way of closing the great gulf fixed between Giulio's wild caprices and Titian's visionary primeval world of tragedy and terror. The poses may be, and sometimes are, derived from Giulio, and so is the startling viewpoint from below. But Titian's figures, like the clouds that tower in the background, are interpenetrated by light and color, and they too weave, twist, turn, and dissolve. The emotional stasis of the 1530s is shattered, and from their shadows the half-seen faces launch glances of a surprising depth of passion.

Among the earliest in a series of portraits in the new, emotionally charged style is the dramatic *Pope Paul III* (fig. 648), which Titian painted at the time of the pope's visit to Bologna in 1543. The unwilling supporter of the Counter-Reformation, at heart a Renaissance prince, is shown in a characteristically restless pose, twisted in his velvet chair, one hand on his purse, his head jutting forward, and his gaze glittering in our direction. Not even the brilliant characterization of the shrewd old face or the powerful drawing of the features, the hands, the hair, and the beard, painted with the relatively fine brushes traditionally in use in Venice, is as important a factor in the total effect of the painting as the electrifying display of rich reds, catching flashes of light on the velvet moz-

above: 648. TITIAN. Pope Paul III. 1543. Canvas, 45 × 35". Museo di Capodimonte, Naples

right: 649. TITIAN. *Danaë*. 1554. Canvas, 501/4×70". Prado, Madrid

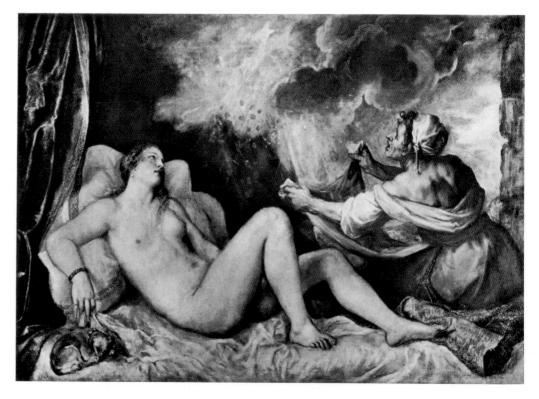

etta. In a contrasting technique that distantly recalls the gold striations of Byzantine painting (see fig. 128), Titian beat these strokes rapidly on the canvas with a broad and heavy brush. His lights crackle from the picture with a new freedom, living a life of their own to such an extent that they dominate the entire composition.

In the last quarter-century of intensive activity in which Titian's lifework culminates, the new freedom of light and brushwork increases, often at the expense of solid form. Tactile reality is softened, dissolved, or even shattered by bursts of brushwork recording luminary visions that lead us beyond the Renaissance. Generally, these are connected with one or the other of the inseparable twins of Late Renaissance emotional life-erotic imagery and religious experience. Three times Titian repeated, for various patrons, his composition showing how the mortal Danaë received the love of Jupiter, who descended upon her as a shower of golden coins. In the pose of the figure he utilized in reverse a motif derived by Michelangelo from an ancient Roman relief for his nowlost picture of Leda, another human loved by Jupiter, in the form of a swan, and echoed also in the famous Night (see fig. 572) of the Medici Chapel. In Titian's first version, now in Naples, he balanced the recumbent Danaë on her bed with a standing Eros at the right, but in the dazzling picture in Madrid (fig. 649), painted in 1554 for Philip II, he substituted a greedy maidservant stretching out her apron to try to catch some of the coins. Her gnarled ugliness and her avarice contrast with the beauty and the rapture of Danaë; one woman looks for material gain, the other lies waiting for a love that, for all the fullness of its physical expression, is divine in origin and expressed in light. The type of Danaë resembles the nude figure in the *Sacred and Profane Love*, painted some forty years earlier, and the glance that of the yearning Mary in the *Assumption of the Virgin*. The broken brushwork of Titian's late style releases the warm, glowing body of Danaë from any trace of Michelangelesque muscular tension, shatters the drapery folds into luminary reflections, and culminates in a burst of glory in the rays of indefinable golden, copper, silver, and turquoise tones that flood from the cloud.

Titian's rejuvenation is expressed in a series of recumbent nude Venuses, less coy than the Venus of Urbino, but recalling her pose. One of the finest is the Venus and the Lute Player (fig. 650), undated but probably painted in the late 1550s, in which the goddess, about to be crowned by Cupid, reclines on a couch before a parapet, while a curly-headed youth in Cinquecento costume plays music for her. In broad, asymmetrical diagonals a curtain parts to reveal a shimmering landscape—painted with speed and authority in Titian's freest style—of water, castled hills, distant crags, and at the center a glade where nymphs dance to a shepherd's pipe. The reader should attempt mentally to detach the power of this brushwork from the unworthy handling of a few details, such as the face and ornaments of Venus. It has been sensibly suggested that this work was among many that were left unfinished at Titian's death and completed in crucial details by lesser men to make them readily salable. But these details do not detract from the breezy freshness of the landscape, one of the richest of the Renaissance and a source of inspiration for later painters, from Rubens to Turner.

In the same rhapsodic style is the Rape of Europa (colorplate 90), begun in 1559 and shipped to Spain

650. TITIAN.

Venus and the Lute Player.

Probably late 1550s.

Canvas, 65 × 82½".

The Metropolitan Museum of Art, New York (Purchase, Munsey Fund, 1936)

in 1562. The nymph Europa, who had been playing on the seashore with her fair companions, fell victim to the blandishments of Jupiter—that amorous hero of Cinquecento imagination—in the relatively innocuous shape of a beautiful white bull, for whom she had been weaving garlands of flowers. He suddenly swept off with her across the waters, leaving her companions to cry out in desperation on the beach. In a twisting, partially foreshortened pose of great force and beauty, Europa clings to one of the bull's horns and tries to maintain her balance on his back. The sea wind and the speed of his motion lift her garment to display her legs, and carry her rose-colored mantle in a great spiral into the blue (fig. 651). The picture's direction from left to right is accelerated by three cupids, one riding behind the bull on a reluctant fish, the other two, with bows and arrows, swooping in varied poses in the air above. As Correggio does in his Jupiter and Ganymede (see colorplate 82), Titian expresses departure from earth in terms of spatial separation between the foreground figures, with whom we identify ourselves, and a distant landscape. But unlike Correggio, Titian abandons any reasonable relationship of scale or spatial connection between foreground and background. The mountains and the shining figures reflected in the sea have suddenly diminished to tiny proportions. But the landscape, which in the Venus and

651. TITIAN. Europa and the Bull, detail of *Rape of Europe* (see colorplate 90). 1559–62. Canvas. Isabella Stewart Gardner Museum, Boston

652. TITIAN. *Jacopo Strada*. 1567–68. Canvas, 49×37½". Kunsthistorisches Museum, Vienna

the Lute Player is like a sudden burst of orchestral music, is here treated with sustained symphonic breadth. The flashing brushwork of the mountain ranges is carried to a point where mountains, sea, clouds, and sky blend into no longer distinguishable fluctuations of blue and silver. Chords of deeper blue and silver play through the transparent water, and the flashing foam around the bull's swimming forelegs parts for a moment to reveal a spiny, surfacing fish. Blue and silver lights also fluctuate through the bull's shaggy coat and the filmy garments of Europa.

In the last decades of Titian's life a new type of action portrait appears, of which a striking example is the picture showing the Mantuan painter and art dealer Jacopo Strada (fig. 652), painted in 1567–68, behind a table on which lie ancient coins, a fragmentary torso, and a bronze figurine, while he holds in his hands a marble statuette of a nude Venus. Strada's success in his profession is shown by his own rich costume, fur cape, and massive gold chain, his gentlemanly status by the sword at his left side and the dagger at his right, and his scholarship by the books on the cornice over his head. The dealer exhibits his treasures in a manner intended to arouse our acquisitive interest. The lurching diagonals of the arms, the marble statuette, and the sidelong glance communicate to the customary sixteenth-century portrait-

with-attributes all the excitement of a moment of high drama. This apotheosis of antiquarian commerce could almost be mistaken for an arresting detail from a larger narrative picture. Finished as far as the aged Titian ever finished anything, *Jacopo Strada* shows a controlled version of his rich brushwork and luminous glazes.

At the very close of Titian's long life, his thoughts, like those of Michelangelo at a similar age (see Chapter 20), turned with increasing intensity toward religious subjects, especially the Passion of Christ. Contemplating the inevitable approach of his own final agony and death, he meditated on that of Christ in pictures for which no patron is known. The Crowning with Thorns, a composition he had treated once before in the early 1540s in a massive style similar to that of the Salute ceiling (see figs. 645-647), he took up again about 1570 (fig. 653) in a more personal and, if anything, even more violent manner, in a picture found in his studio after his death and acquired by Domenico Tintoretto, son of the painter. But this is a new kind of violence, communicated by color and brushwork, not by form. The blows strike the wounded head from staves wielded by weightless figures. The drama of shadows and lights acquires its ferocity through the vibrancy of the brushwork and the slow burn of the coloring. Thick impasti rain upon the canvas. The blues, reds, and yellows of Titian's early style are still there, operating through a nocturnal depth of glazes. The compositional triangles clash and interlock to increase the storm of pain that surrounds the suffering Christ.

The frequent motives of torment and chaos that recur in Titian's last years are resolved in one of the greatest paintings of Italian art, the Pietà (fig. 654), which used to hang opposite an arched entrance in the Accademia in Venice so that one could see it from a distance and be drawn irresistibly into its depths as if called by Magdalen rushing toward us, her hair streaming, her right arm outstretched, her mouth open in a cry of grief. In a niche whose huge embracing rustication recalls the threatening motives Titian had seen in the Palazzo del Te—a kind of architectural mask of death, and X rays show that Titian originally painted a mask in the shell of the apse—Mary holds the dead Christ. On bases formed by snarling lions' heads, symbols of devouring death, stand statues of Moses, carrying the Tables of the Law and the rod with which he struck water from the rock, prefiguring the stream from the side of the Crucified, and of the Hellespontine sibyl, carrying the Cross. St. Jerome, clad only in a cloak, kneels before Christ, holds one hand of the Savior in his own, and looks upward into the dead face. The motive of the rushing Magdalen is repeated, diagonally, at the upper right by a putto soaring out of the niche, carrying an immense wax torch. Below the statue of Moses another putto holds the Magdalen's jar of ointment; below that of the Hellespontine sibyl a little votive picture leans against the

653. TITIAN. Crowning with Thorns. c. 1570. Canvas, $9'2'' \times 5'11\frac{1}{2}''$. Alte Pinakothek, Munich

pedestal, showing Titian and his son Orazio in prayer before the Virgin for delivery from the plague of 1561. The author notes, for the first time, that the drama of human redemption through Christ's sacrifice is summarized in the niche. Above it appear the fig leaves of the Fall of Man. On the raking cornices burn six of the seven lamps, the Seven Spirits of God (Revelation 4:5). The seventh is perched on a bracket emerging from the central block of the triple keystone, which is Christ, the second person of the Trinity. Within the niche and above the shining, sacrificed Christ is the golden apse mosaic of a pelican striking her breast, traditional symbol of Christ's blood shed for mankind.

The *Pietà* was painted by Titian for his own tomb in the Cappella del Crocifisso in Santa Maria Gloriosa dei Frari, the church that already contained two of his masterpieces (see colorplate 88, fig. 639). He did not survive to complete it, for both he and Orazio died in the plague of 1576. He represented himself as in other paintings, in the features of the kneeling St. Jerome (fig. 655), with whose self-inflicted torments in the desert he seems to have felt some form of mystical identification. After Titian's death, the picture was finished, in a manner of speaking, by his assistant Palma Giovane, but it is by no means easy to discover just what he did to it. Certainly, he spared it the tight bits of detailed painting that

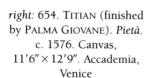

below: 655. St. Jerome, detail of fig. 654

were added ignorantly to many of the master's other unfinished works. In general, the broken brushwork moving over the canvas seems to be Titian's own, and it contains glorious passages, especially in the green tunic of the Magdalen and in her rich masses of light-brown hair. Formless echoes of form resound about the faces of Christ and the Virgin. Light breaks from the thorncrowned head. The closed eyes are barely indicated. Patches of tone clash, merge, and coalesce. But all the tremulous disorder of the surface is locked into the massive triangles of the composition, crossing in depth as they emanate from or converge upon the Savior and the mother. The hypotenuse of Titian's last triangle, by his own careful design, is formed by his own body and by the direction of his gaze as, in his semblance of St. Jerome, he concentrates all his being on that of Christ.

LORENZO LOTTO

A strikingly original and almost equally long-lived contemporary of Titian was the somewhat older Lorenzo Lotto (1480-1556), who, like Crivelli, but—let us hope—for different reasons, spent most of his active years far from the city of the lagoons. Most of Lotto's works were produced for centers on the Venetian mainland and in what is now Lombardy, and he was active in one town after another in the hilly regions of the

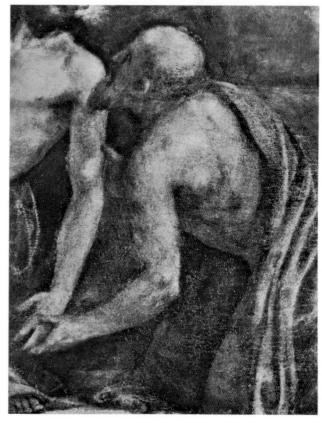

Marches, near the Adriatic coast. Only relatively late in his life did he settle in Venice, and even then he did not break his ties with the mainland. Nor did he ever fully accept the stylistic premises or the freedom of chromatic change that made Titian such a colossus. Throughout his career Lotto retained his own individuality, and he could ring a surprising number of changes on his personal inventions, running from extreme naturalism, through attempts at the bizarre that reflect an interest in the Manneristic movements of Central Italy, to an exultant lyricism of mood and color.

In the little Marchigian city of Recanati is still to be seen an Annunciation (fig. 656) that shows many of Lotto's delightful qualities. Datable somewhere in the 1520s, the picture is hard to take quite seriously. We are in Mary's chamber, represented with a Carpaccio-like fidelity to detail yet lighted in surprising ways, often from below. Mary has been reading or praying at a prie-dieu. God the Father, enveloped below the waist in almost Trecentesque clouds, pops through the loggia outside the arched door, stretching forth his hands as if sending down the dove of the Holy Spirit, but no dove is seen. Perhaps we are intended to believe that the Holy Spirit descended invisibly upon Mary. The angel has just run in through the door, bearing a huge and beautifully painted lily. He drops suddenly to one knee, leaving the other bare, foreshortened, and brilliantly lighted, and raises a smooth white arm in a theatrical gesture, staring

656. LORENZO LOTTO. Annunciation. 1520s. Canvas. Church of Sta. Maria sopra Mercanti, Recanati

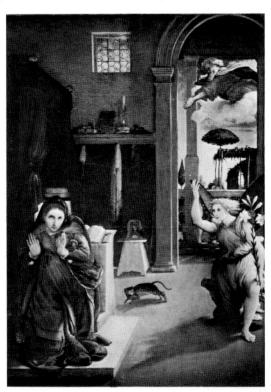

with wide-open eyes under floating yellow locks of hair. Mary turns toward us, away from her book, and opens her hands in wonder, yet seems to shrink into herself, her eyes staring in a curious expression, half simpleminded awe, half incipient trance. Between the two figures a cat, its back arched, scurries away in terror, casting a shadow on the floor like that of the rushing angel. The very oddness of the scene and its peculiar lighting suggest a familiarity with such Mannerists as Parmigianino and Beccafumi, and the dense, often marblelike surfaces have little to do with the coloristic dissolution of Titian. The upstage properties include, in addition to the prie-dieu and the bed, a shelf with books, a candle, and an inkstand, a towel hanging from a nail, and, strangest of all, an hourglass with the sands half run out, partly covered with a cloth and placed on a stool like the chalice and the paten on an altar.

Worlds apart from the riddles and magic of this disturbing painting is Lotto's probably almost contemporary Sacra Conversazione (colorplate 91), a work intensely lyrical not only in the mood of the beautiful figures but also in the singing blue of Mary's tunic and mantle, which fills the whole picture as if with the distilled quintessence of the sky and the distant hills. Any affinities are with Giorgione or with Correggio, rather than the Mannerists, but the ideas and the accents are Lotto's own, and exquisitely personal. The picture is a hymn to youth, health, and beauty, yet the figures are self-contained. They do not reach to each other emotionally and physically as Correggio's do; rather they peacefully coexist. No lovelier face remains to us from the Venetian Renaissance than the partly shadowed countenance of Lotto's tender yet unsentimental Virgin, Praxitelean in the breadth, harmony, and calm of her soft features. Lotto's brushwork, rich yet restrained, recalls that of Correggio rather than the free strokes of Titian, which Lotto never emulated. No other painter of the Renaissance could achieve as much with broad surfaces of glowing color.

PARIS BORDONE

A somewhat more prosaic painter than Lotto, but a master at his own interpretation of Venetian material splendor, was Paris Bordone (1500–1571), from Treviso on the Venetian mainland. At an early age he studied with Titian, who by Bordone's account treated him very badly. On his own, he developed a special sort of vision, as if his whole world of rich foliage, grand architecture, glowing flesh, and sparkling silks and steel were seen in a glass darkly. Never did he emulate the free brushwork of his unloved master, but neither did he experience the passion that demanded it. His unmistakable personal style, well drawn and meticulously painted, floats an entrancing shimmer of light over resonant and highly saturated coloristic depths, which can only be suggested in black-and-white reproductions. One aspect of Titian's

657. PARIS BORDONE. A Fisherman Delivering the Ring. c. 1534–35. Canvas, 12′1¾" × 9′10½". Accademia, Venice

art that Bordone really did absorb was his glazing technique, which he adopted enthusiastically and adapted brilliantly to his own scenographic purposes. One always feels that a Paris Bordone has been staged, seldom that it was felt. He can be credited with the invention of a new type of architectural painting, and this is probably his major contribution in spite of the alluring loveliness of his mythologies and the glow of his portraits.

A real milestone is his huge painting of A Fisherman Delivering the Ring (fig. 657), which shows the loyal citizen bringing back to the doge the ring with which Venice annually wed the sea in a splendid ceremony at the Lido. The portrait figures (doubtless all recognizable) are easily grouped, in the tradition of Carpaccio but with a touch more grandiloquence, in and before a magnificent High Renaissance architectural setting of open loggie and galleries of white and richly colored marble, sometimes embellished with mosaic panels. If the accepted dating of 1534 or 1535 is correct, the painting is remarkably prophetic, for at this moment no such structures existed in Venice. Bordone must have made the acquaintance of Jacopo Sansovino, who had arrived in the city of the lagoons in 1527, but as yet was known chiefly as a sculptor. The noble architectural setting, therefore, may reflect Jacopo's dreams for the civic center of Venice, to be realized in the construction of the Library of San Marco (see colorplate 100), the Zecca (see fig. 679), and other public buildings. It may even have enjoyed the benefit of his specific ideas and his draftsmanly expertise in the projection of these splendid perspectives. The new type of ideal setting proclaimed here, a sharp departure from Titian's somewhat homier background in the *Presentation of the Virgin*, for example (see fig. 642), was in the second half of the century to provide a convenient instrument for Veronese to exploit with meticulous care, and for Tintoretto to dash off without a second thought.

THE MAINLAND

During the first two decades of the Cinquecento, as we have seen, the plain of the Po, with its crown of wealthy and beautiful cities, was the victim of prolonged and severe dynastic strife, between the Venetian Republic, the Sforza dukes, the French kings, the Habsburg emperors, who were also kings of Spain, and the papacy. Louis XII of France, who had dethroned and imprisoned Ludovico Sforza in 1500, was himself ejected by Swiss troops in the service of Julius II in 1512. Nonetheless King Francis I of France returned to the duchy of Milan in 1515, only to lose it for good to Charles V in 1521. From then on Milan, once a brilliant creative center, was a Spanish province, ill-governed and economically depressed. Parma, under the papacy, and Mantua and Ferrara, independent duchies, fared much better. So did the flourishing cities of Bergamo, Brescia, Verona, and Vicenza, all enjoying the enlightened government of the Serenissima, which required little time to recover its political and economic fortunes. Artistically, the heritage of Mantegna remained a force to be reckoned with in Milan, although less powerful than the physical presence, activity, and teaching of Leonardo da Vinci. Parma, as we have seen, had strong ties to Rome. Ferrara had its own artistic tradition, but Brescia and Cremona did not. All three were inevitably submerged in the tide of colorism flowing from Venice.

BRAMANTINO

At the turn of the century the Milanese scene was dominated by direct clones of Leonardo, sometimes so close to the master that attribution problems plague specialists to this day. Often these imitators are delightful; never are they original. One of the few holdouts was Bartolommeo Suardi (c. 1465-1530), known as Bramantino because he studied painting with Bramante. Great as the latter was in architecture, his pupil surpassed him in painting, and soon became the finest and most original member of the small Milanese School. The Adoration of the Magi (colorplate 92), a work of the artist's maturity, shows the characteristic style from which he never wavered despite a sojourn in Rome just before the arrival of Raphael. If one has to look for influences one might find them in the spatial construction of Mantegna and the coloring of Giovanni Bellini, but both have been thoroughly assimilated into Bramantino's personal vision. The painting, whose small size and symmetrical

Colorplate 90. Titian. Rape of Europa. 1559–62. Canvas, $73\times81''$. Isabella Stewart Gardner Museum, Boston

Colorplate 91. LORENZO LOTTO. Sacra Conversazione. c. 1520s. Canvas, $44\frac{3}{4} \times 60^{\prime\prime}$. Kunsthistorisches Museum, Vienna

Colorplate 92. Bramantino. Adoration of the Magi. c. 1500. Panel, $22\% \times 21\%$ ". National Gallery, London

Colorplate 93. Dosso Dossi. *Melissa*. 1520s. Canvas, $69\frac{1}{4} \times 68\frac{1}{2}$ ". Borghese Gallery, Rome

Colorplate 94. GIROLAMO SAVOLDO. *Tobias and the Angel.* Early 1530s. Canvas, $37\frac{3}{4} \times 49\frac{1}{2}$ ". Borghese Gallery, Rome

Colorplate 95. SOFONISBA ANGUISSOLA. *Portrait of the Artist's Three Sisters with Their Governess.* 1555. Narodowe Museum, Poznan

Colorplate 96. TINTORETTO. St. Mark Freeing a Christian Slave. 1548. Canvas, $13'8'' \times 11'7''$. Accademia, Venice

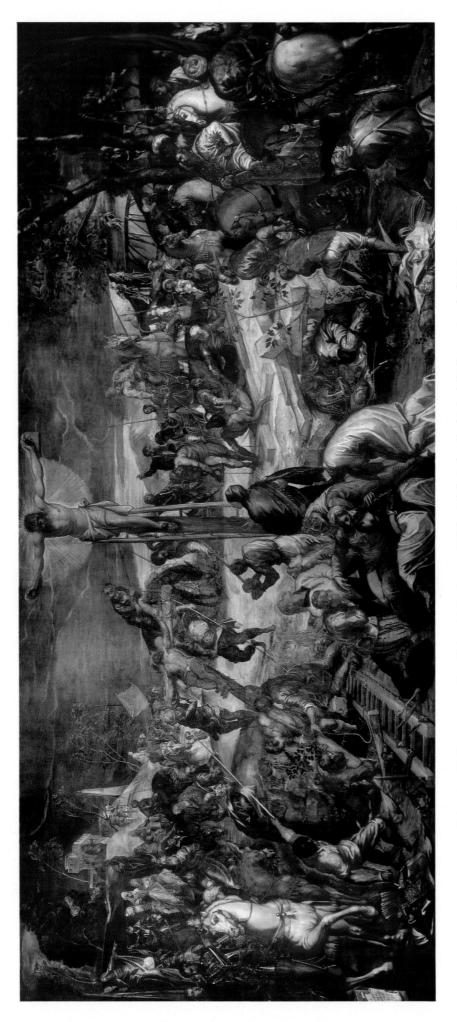

Colorplate 97. TINTORETTO. Crucifixion. 1565. Canvas, 17'7" × 40'2". End wall of Sala dell'Albergo, Scuola di S. Rocco, Venice

disposition indicate that it was made for the devotions of a private patron, breathes the serenity, clarity, and calm typical of this magical artist. Seated on a block of stone in a ruined classical building, whose symbolic nature we can surmise from other such representations (see pages 324, 328), the Virgin is flanked by two enshadowed figures, who have been identified as Isaiah, on her right, and Daniel, shown as a wayfarer, dissheveled in appearance and carrying a staff, pointing toward the Christ Child and looking out to the spectator. On either side in the foreground and in bright light stand two bareheaded Magi, the older carrying what looks like an ancient gold vase, the younger a bowl of rose quartz. The third Magus is barely visible behind the youngest, and Joseph is relegated to the extreme left. The identification of the figure to Mary's left as Daniel is reinforced by the discovery through X rays of an enormous castle that previously topped the crags in the distance, painted out by Bramantino himself to resemble the "stone cut out without hands" of Daniel's prophecy in Quattrocento backgrounds (see, for example, page 218). The intricate linear construction of Mantegna is transformed into a broad handling of masses, disposed, however, with exquisite asymmetrical balances between the circular turban, the circular basin, the rectangular basins, and the two pedestals below the architecture, perfect until suddenly shattered. The broad handling of anatomical forms and drapery is as typical of Bramantino as is the harmony of the colors, dominated by his own special brand of sonorous blue in the Virgin's mantle, the rose of her tunic, the red lining of the left-hand Magus' cloak, and the unexpected and magnificent olive-green of the cloak of the youngest Magus. In spite of the Leonardo followers, apparently, Bramantino was able to achieve his personal version of the High Renaissance style and maintain it to the end in the face of the increasing authority of Rome and Florence. In Milan he was a voice crying in the wilderness but, fortunately for us, a clear voice that can still be heard.

DOSSO DOSSI

The occasional elements derived from Giorgione in Lotto's style become so prevalent in certain North Italian centers as to constitute a real Giorgionism, depending for its effect on a free combination of figures at ease in a Romantic landscape. There were scores of practitioners of the Giorgionesque manner—more of them on the mainland, to be sure, than in Venice—and many achieved a high level of poetic charm within the limits of an idea that, after all, was not their invention. The prolific School of Ferrara fell under the Giorgionesque spell. The Dossi brothers, especially Dosso Dossi (really Giovanni de Lutero, c. 1490–1542), who came originally from Trent, dominated the school, now completely freed from the strange tensions of the Quattrocento Ferrarese masters (see pages 427–30) but not from their artificial-

ity. By common consent Dosso's masterpiece is the lovely enchantress now convincingly identified as Melissa (colorplate 93), a benign personage who, in Ariosto's Orlando Furioso, frees humans whom the black arts of the wicked sorceress Alcina have turned into animals and plants. We are privileged to watch Melissa burn Alcina's seals, erase her spells, and look upward to free two men who are about to emerge from the trunks of trees. Menat-arms, presumably just liberated, relax in the background, while a very convincing dog (in whom surely lurks a person) gazes longingly at a suit of armor he will soon be allowed to resume. Dosso, of course, tames the hostile nature of Giorgione. His trees are a beautiful array of standardized, artificially lighted landscape elements, providing a perfect setting for the magical scene from Ariosto. There is a distinct echo of the early Titian in Melissa's facial type and proportions, and the basically rather wooden drawing characteristic of the Ferrarese painters is enriched by Titianesque glazes. The deep, inner glow of the crimson-and-gold brocade of Melissa's fringed robe is particularly alluring against the gold-andgreen sparkle of the distant trees and meadows.

SAVOLDO AND MORETTO

In Venetian territory since 1426, the Lombard city of Brescia had been subject to mixed influences from Leonardesque Milan to the west and Bellinesque Venice to the east. Nonetheless its painters generally maintained their own tradition of sober everyday realism, often considered characteristic of Lombardy as a whole. The most gifted painter of the Brescian School, Girolamo Savoldo (c. 1480-after 1548), was working in Florence in 1508, where he absorbed something from the Florentine anatomical and draftsmanly tradition, but in 1520 he settled down in Venice, and indeed is often included among the Venetian School. Of the same generation as Giorgione and Lotto, Savoldo generally uses figure and landscape arrangements of the Giorgionesque tradition. His deep coloristic resonance emanates from glazes similar to those of the considerably younger Paris Bordone, but his poetry is deeper and more intense, possibly because it is so firmly based in fact. The two figures in Tobias and the Angel (colorplate 94) were clearly painted from models posed, not necessarily at the same time, in a strong crosslight. It is not hard to imagine Savoldo picking up wings for the Archangel Raphael at the poultry market, and the fish—the oil from whose liver is to restore the sight of Tobias's father—looks very fresh. The colors—gray, rose, dark green—are lovely, but the suedelike texture of the angel's garments becomes standardized in Savoldo's work. Despite the disparaging sound of all this, the picture is haunting-irresistible, in fact, though it is hard to say why. The Leonardesque beauty of the angel's face by no means accounts for the charm of the entire composition. Perhaps one ingredient in the special poetry of Savoldo's art is our pleasure at seeing miracles

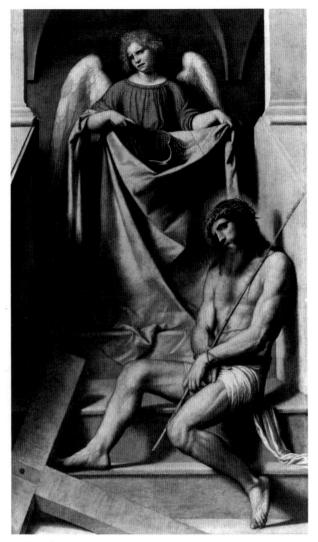

658. MORETTO. Ecce Homo with Angel. c. 1550–54. Canvas, $84\frac{1}{4} \times 49\frac{1}{4}$ ". Pinacoteca Tosio Martinengo, Brescia

achieved in our presence by friendly supernatural figures who seem to want to come and live with us. We can only wish they would stay.

A good deal less glamorous is Alessandro Bonvicino, called Moretto (1498-1544). This sturdy realist grew to maturity in Brescia during Savoldo's absence and stayed put, dominating the scene with an endless series of competently painted works. Although he, like Savoldo, began under the spell of Giorgione, Moretto's dogged devotion to fact soon took over, even in the realization of religious visions. His figural repertory and facial types derived from Venice, but Moretto's native sobriety inclined him to a dry, carefully modeled, often grayish surface in broad and uniform light rather than the full range of Venetian colorism, chiaroscuro, and brushwork. Probably the finest—certainly the most deeply felt achievement of Moretto's religious realism is, paradoxically, a symbolic image rather than an illustration of an actual event. Ecce Homo with Angel (fig. 658), painted about 1550-54, is not the customary representation of the tormented Jesus in his mock royal robe, crowned with thorns, sceptered with a reed, and displayed by Pilate to the people of Jerusalem. Deriving from the relief sculptures on the doors of Venetian tabernacles used for the reservation of the consecrated Host, the painting, doubtless an altarpiece, shows the same Jesus presented to us by a grieving angel who upholds the seamless garment woven by Mary and perpetuated in the chasuble worn by the celebrant at Mass. Modeled with a combination of Michelangelesque grandeur and earthy literalism, Christ, a burly carpenter with hairy legs and chest, sits across a step in a narrow staircase leading to a transverse corridor beyond which we cannot see, above the heavy and carefully morticed, pegged, and planed Cross as if it were his own handiwork (according to Christian doctrine it was, in the sense that Christ's sacrifice was foreordained). We are thus reminded, with all the forcefulness and reliance on fact recommended by the Spiritual Exercises of St. Ignatius Loyola, a close contemporary of Moretto, of the precise circumstances of Christ's physical torture and mental humiliation. Through the position of Christ across the steps, the stairway to Pilate's palace becomes the stairway to Heaven ("No man cometh unto the Father, but by me"; John 14:6) as in Michelangelo's Madonna of the Stairs (see fig. 467). By such means could the worshiper be instructed in the meaning of Communion. And thus the scrupulous literalism of Moretto's art is raised to the level of spirituality. In contemplating such works as this, the appearance of Caravaggio toward the end of the century, scarcely thirty miles from Brescia, seems somewhat less of a miracle.

SOFONISBA ANGUISSOLA

During the Middle Ages women played a considerable role in the important art of manuscript illumination, much of which was done in convents. Lists of women illuminators are preserved, although no single Italian manuscript can be connected with a female artist. However, from the very beginning of panel and fresco painting in Italy, the secular bottega was a man's world, as were all crafts, professions, and political positions. The growing necessity of study from the nude only reinforced the exclusion of women. But with the transformation of painting from a Mechanical to a Liberal Art in the course of the Cinquecento, women artists began to emerge. At first they were considered something between a freak and a miracle, but soon their considerable success won them respect in their own right. Some were their father's assistants; in fact, the only successful woman painter not trained at home was Sofonisba Anguissola (1528-1625). She was born to a learned gentleman in Cremona called Amilcare, who named his only son Asdrubale. (Hamilcar and Hasdrubal were brothers of Hannibal, leader of the Carthaginians against Rome.) The ancient Sophonisba was queen of Tyre, and three of the painter's five sisters were called Minerva, Europa, and Elena (after Helen of Troy). Amilcare brought two of these historically named young ladies to study the art of painting with Bernardino Campi, youngest of a dynasty of competent Mannerist painters who controlled artistic life in Cremona, then part of the Spanish-ruled duchy of Milan. Since Amilcare never traveled, it is unlikely that the young women had any other artistic contacts. Under such circumstances the inventiveness and originality of Sofonisba are the more impressive. The sisters were also taught musical performance, languages, and literature, but Amilcare's concern with their painting may not have been limited to its cachet as a cultural pursuit. He complained to Michelangelo of the difficulty of supporting six daughters in their appropriate station in life. In Sofonisba's dated career of only sixteen years she is known to have painted just three nonportraits—two virtually identical Holy Families and a Pietà. For the most part her considerable number of portraits appear to have been commissioned, and they must have provided a welcome addition to the family income. Today's critical opinion of their quality is divided, but even the diehards admit that they are the finest ever painted in Cremona. They also deserve a high rank in the history of Italian portraiture for their directness, penetration of character, and pictorial skill.

The Campi are today studied mainly by specialists, but Anguissola has become, quite justly, the heroine of those who seek a reappraisal of the historic role of women in art. Amilcare's first letter to Michelangelo, in 1557, was an attempt to establish Sofonisba's professional position on the highest authority. He even offered to have her "color in oil" a drawing by the master, if he would so favor her. Judging from the next letter, Michelangelo complied. (Let us note that in his last years he made a practice of giving drawings to others to paint from.) Neither the drawing, the painting, nor Michelangelo's reply is preserved, but the latter must have been complimentary, as Amilcare thanked him profusely.

Anguissola is acknowledged to have invented a new type of group portraiture in which the sitters are not merely aligned, as was customary, often accompanied by conventional props, but shown in lively activity. A brilliant example is the Portrait of the Artist's Three Sisters with Their Governess, signed and dated 1555 (colorplate 95). Acutely sensitive to the interplay of intimacy and rivalry in a largely female household, Sofonisba has concentrated on a single moment during a game of chess. An older sister has made her move, and turns for admiration to the artist and to us. The next oldest, planning a coup, searches her sister's unsuspecting face, and raises her right hand for the devastating move. The irresistible youngest sister sees what is coming and laughs, while the gentle governess looks on. All this takes place without breaking the format of a half-length group portrait. Apparently Bernardino Campi was able to substitute for the forbidden life drawing some other form of anatomical study, probably from the typical mid-sixteenthcentury anatomical drawings and engravings, for the volumes of the figures are convincing and correct, and everything that propriety allows to emerge from the armor plate of sixteenth-century Spanish costume is exquisitely constructed. Anguissola's delicate brushwork delineates every nuance of the faces and every detail of the fabrics. Her typically subdued coloring is relieved by the soft rose of the older sister's sleeve and by the blue and silver of the standard North Italian landscape of distant lake and castle and still more distant mountain ranges.

The same woman who at twenty-eight signed herself as "Sophonisba Anguissola Virgo" two years later, in 1558, went on a voyage to Sicily, in the course of which the captain fell in love with her, and subsequently married her. The next year she was appointed lady-in-waiting to the queen of Spain, to whose territories both Cremona and Sicily belonged. Judging from the single dated work thereafter, and the absence of Spanish sitters from her portraits and of her works from Spanish collections, Anguissola seems to have painted little for the next sixty years or so. Perhaps in conservative Spain painting was not yet considered an appropriate activity for a gentlewoman. She eventually returned to Sicily, and in Palermo in 1623 this Renaissance painter sat for a portrait to the great Baroque master Anthony van Dyck, no small achievement in an age of relatively short-lived artists. Van Dyck recorded that she insisted on a lighting that would not show her wrinkles. Sofonisba Anguissola died in Palermo in 1625 at the age of ninety-seven, the second oldest Italian artist on record, and the first internationally recognized woman artist of whom we have any certain knowledge.

TINTORETTO

Two diametrically opposed geniuses, Tintoretto and Veronese, in the middle and late Cinquecento disputed the leadership of the Venetian School with the aged and imperious Titian. The older, more dramatic of these younger artists is Jacopo Robusti (1518-94), called Tintoretto after his father's trade as a dyer. Tintoretto's long life takes us, in a sense, beyond the Renaissance, yet not indeed to the Baroque, whose earliest masters preferred to emulate others. Fruitless attempts have been made to identify Tintoretto's teacher, a matter perhaps of slight importance considering the extraordinary originality of his style from the beginning of his artistic career to its end. But Carlo Ridolfi, who wrote about Tintoretto in the seventeenth century and had access to local traditions about him, records that he worked briefly in the studio of Titian until the great man saw one of the boy's drawings, inquired who did it, and promptly ejected him from his house, never to return. To the end of his days Tintoretto had, nonetheless, an unrequited admiration for the colossal master, whom he considered his true teacher. Titian's contrary opinion of Tintoretto may have arisen partly from fear, for, as we shall see, this daring young man offered formidable competition to all artists desiring public commissions. But more likely his distaste is attributable to a fundamental incompatibility of personality, stylistic aims, and methods. The careful craftsman, with his endless succession of glazes and his distrust of his own unfinished paintings, must have been offended by Tintoretto's impetuosity.

We are told that in 1564, when the artists competing for the commission of a ceiling painting in the Scuola di San Rocco in Venice arrived with their scale models, according to instructions, they were outraged to find that during the night Tintoretto had installed his full-sized painting on the ceiling. This and other infractions of union rules aroused great hostility, not only from the artists but also on the part of certain conservative elements of the Venetian citizenry as well; but Tintoretto's strategy worked, and he obtained innumerable commissions that he executed at hitherto unimagined speed. This speed also made enemies for him, but it is an essential aspect of Tintoretto's style, and he would not have been the same artist if he had forced himself to conform to Titian's deliberate methods. His art is one of rapid action and passionate emotion, and it required great velocity in execution.

This was attainable first by shorthand drawing methods. A story is told about two Flemish masters, the scru-

659. TINTORETTO. Study for a Bowman in the Capture of Zara. Before 1585. Black chalk, 141/8×81/8".

Gabinetto dei Disegni e Stampe, Uffizi, Florence

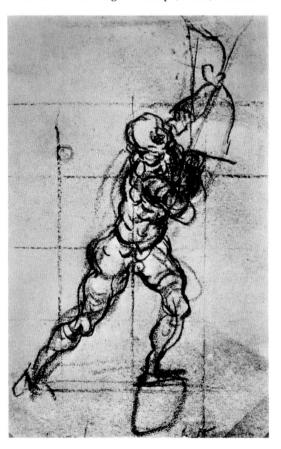

pulous realism of whose detailed and polished drawings astonished the Venetian public. Tintoretto's response was to pick up a piece of unsharpened charcoal and in a matter of minutes, with a few rough, hooklike strokes, knock an action figure into abundant and astonishing life, whereupon he commented, "We poor Venetians can only draw like this." Tintoretto's preserved drawings (fig. 659) are almost exclusively in this hasty style, yet he considered them accurate enough to serve for his pictorial compositions. Although, according to Ridolfi, an inscription on the wall of Tintoretto's studio proudly proclaimed "the Color of Titian and the Drawing of Michelangelo," we never encounter detailed Tintoretto life studies in Michelangelo's manner.

Tintoretto had no patience with the long-drawn-out methods of Titian. He must have felt an overpowering urge to cover vast areas of canvas with great rapidity. (Financial rewards had little to do with this desire, as he often underbid his competitors and is reported to have painted certain works for the cost of the materials alone.) In order to speed up his production, Tintoretto primed his canvases with flat, dark tones—gray-green, brown, or slate-gray—sometimes dividing the canvas into more than one color area, corresponding to the basic tonal divisions intended for the finished painting. The figures from the summary sketches were then rapidly outlined on the dark priming, which served as the basic tone for the shadows. Once the lights were painted in with bright colors, in the manner of drawing on a blackboard with colored chalks, the picture was virtually complete, and needed only a few tonal refinements in crucial areas. As a result, the underlying darks always dominate in Tintoretto's pictures, which often look as if the action were taking place in the middle of a thunderstorm, illuminated by sudden flashes of lightning. Unfortunately, in many of Tintoretto's canvases the dark underpainting has begun to show through and seriously dim the overlying colors. A further increase in the speed of his execution was afforded by his use of the wide, square-ended brush introduced by Titian in such passages as the drapery in his portrait of Pope Paul III (see fig. 648), so wide, in fact, that John Ruskin accused Tintoretto of painting with a broom. Today the passionate vigor of Tintoretto's brushwork is a source of great enjoyment, but there is evidence to show that in the late 1540s, when he introduced his new style at full intensity, his contemporaries considered his technique a sign of deplorably hasty execution.

In order to increase the impact of these tempestuous pictures on the observer, and also in order to enable himself to draw and paint not only with rapidity but with conviction, Tintoretto prearranged his compositions by posing little wax figures in wooden box-stages, sometimes even hanging them from the stage ceiling on wires, turning them at angles to the foreground plane to permit the striking foreshortenings that play so important a role

in his dramatic technique, and moving little lamps about to get vivid chiaroscuro contrasts. By means of a grid across the stage, like the veil Alberti invented (which was used as a standard device in sixteenth-century "drawing machines"), Tintoretto could record an entire composition on squared paper in relatively short time, and, using another proportionate grid, his pupils could enlarge it on the dark-primed canvas in a matter of hours, all ready for the master to go to work painting in the lighted areas. A high rank in the brigade of pupils was occupied by the painter's daughter. Although no certain pictures by her are known, it is wholly possible that many square yards of her father's canvases, including important figures, were actually painted by Marietta Robusti.

Few twentieth-century observers can resist being caught up in the whirlwind of Tintoretto's pictorial dramas, and it is worth mentioning, therefore, that his own life, insofar as we can reconstruct it from the meager documentary evidence, was extremely quiet. He left Venice just once, to supervise the installation of a cycle of canvases in Mantua, and then only on condition that his wife accompany him. He lived in the glittering capital the simple existence of a successful craftsman, prosperous enough, but deprived of the aristocratic and literary acquaintance that enlivened the household of the princely Titian. As a pious, even mystical, Christian, Tintoretto led a life of the spirit. He lived not only for, but also in, his paintings, their fiery brushwork, rushing movement, hurtling bodies, and beautiful, expressive faces providing a personal witness to the pilgrimage of a great poetic soul.

If Tintoretto had died at an early age, like Masaccio, he would have remained a charming art-historical curiosity. His first undoubted masterpiece and first manifesto, in fact his first serious threat to the Titianesque establishment, was his St. Mark Freeing a Christian Slave, painted in 1548 for the Scuola Grande di San Marco (colorplate 96). According to legend, the slave of a knight of Provence took French leave to go to Alexandria and venerate the relics of St. Mark. On his return his master decided to punish him by having his eyes gouged out and his legs broken with hammers. St. Mark himself came down from heaven to end the torment and liberate the slave. At the right we see the knight about to fall off his throne with surprise; on the ground the brilliantly foreshortened (and richly modeled) figure of the slave, surrounded by broken ropes and smashed hardware; on either side a wave of astonished servants, executioners, and bystanders, at once moving away and looking backward and down; and at the top St. Mark, zooming downward and into the picture. With the turbaned servant lifting a broken hammer, St. Mark forms a kind of swastika or pinwheel composition, in depth; this twisted, turning vortex appears in many of Tintoretto's paintings as the basic inner form of his cyclonic compositions.

The full brilliance of the coloring of the St. Mark Freeing a Christian Slave has been appreciated only since its recent cleaning. Now the colors fairly blaze against the underlying dark, and the brushwork of the drapery, glittering armor, sparkling curls, and faces throbbing with emotion is again as fresh as Tintoretto once meant it to be. The restoration has, moreover, revealed an important aspect of the composition that could not be seen when the corners were covered by repaint; it was originally intended as a ceiling painting in a roughly octagonal shape, and the artist arranged diagonal figures to run parallel with, or at right angles to, the corners cut off by the frame.

When the picture was unveiled in 1548, the adverse criticism, emanating largely from the studio of Titian (in spite of the support given Tintoretto by Pietro Aretino), caused the artist to take his picture back, and for several years he kept it in his studio. Eventually, however, he returned the painting to the scuola, and in 1562 the wealthy guardian of the scuola, Tommaso Rangone of Ravenna (to whom we should be eternally grateful), offered to pay for three more pictures to continue the narration of the Legend of St. Mark. In one of the three, according to Raffaele Borghini, the late sixteenth-century Florentine writer, is seen the Transport of the Body of St. Mark (fig. 660). Captured by the pagans, the saint was dragged for two days through the streets of Alexandria by a halter around his neck until he died. Then, as the pagans were about to burn his body, a great storm opened upon them, the pagans fled, and the Christians were able to carry the body reverently to burial.

Tintoretto has set the scene in a long paved square, not unlike the Piazza San Marco in Venice. The orthogonals formed by the squared pattern of the paving stones and the arcades of the enclosing architecture recede rapidly into the distance, while the little group of devoted Christians, about to load the body onto a camel, emerge toward us at the right. The resultant tension in depth, appearing here for the first time in Tintoretto's art, became a standard compositional device in his mature and late works, as frequent as the pinwheel and often combined with it. The perspective is accurate enough as far as the orthogonals go, but the arches, possibly painted by pupils, are out of drawing. This is the kind of detail that Tintoretto allowed to pass and that must have infuriated artists in the craftsmanly tradition. But his foreshortening of the figures, the rapidity of their action, and the rush of the pagans for shelter under the arcade show all the power of Tintoretto's hand. Such effects could not have been attained by conventional methods: in fact, if Tintoretto had tried to paint them slowly, he would have stifled the volcanic activity that is the wellspring of his art. And if the lightning is a trifle stagy (Giorgione did it better), the rush of water across the stones of the piazza is a sight all too familiar to contemporary as well as Cinquecento Venetians and very convincing. Rangone, in

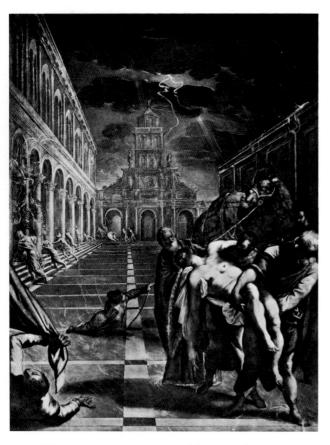

660. TINTORETTO. Transport of the Body of St. Mark. 1562–66. Canvas, $13'10'' \times 10'$. Accademia, Venice

661. TINTORETTO. *Discovery of the Body of St. Mark.* 1562–66. Canvas, 13'1½" square. Brera Gallery, Milan

the gown of a Venetian patrician, is shown gently supporting the head of the saint on his bosom, while Tintoretto has painted his own bearded features just to the right of the camel's hairy neck.

The third canvas from the series (fig. 661) is equally dramatic. Centuries have passed, and a group of Venetians has come to captured Alexandria to rescue the body of St. Mark from the Saracens. As they work in the crypt of the cathedral, taking bodies down from their sarcophagi and opening up a trap door in the floor (with a wonderful light effect), St. Mark himself emerges, shows them his true body, and puts a stop to the despoiling of the tombs. Again the power of the composition is achieved by the tension between the succession of arches moving rapidly inward in perspective (correct, this time), and the figures moving out at the right. An added element is the placing of the hand of the saint over the vanishing point of the perspective, bringing its motion to a sudden halt, as he arrests also the well-meaning sacrilege of the Venetians. As is generally the case with Tintoretto, the architecture is very thinly painted, so that large areas of dark priming are not even covered, while the occasional passages of careful modeling are reserved for the most important figures. Again Rangone appears just to the left of center, kneeling in reverence as he contemplates the true body of Venice's patron saint.

The crowning achievement of Tintoretto's life is the cycle of paintings—fifty-odd pictures, large and small—

for the Scuola di San Rocco and its neighboring church, which convert the benevolent institution into one of the most exalted manifestations of Italian genius. The three principal rooms of the scuola are literally lined with paintings by Tintoretto, carried out in several stages: the Sala dell'Albergo in 1564-67, the ceiling of the Sala Grande in 1575-77 and the walls in 1577-81, and the wall paintings in the ground-floor room in 1583-87. Despite the odd conditions under which the ceiling painting of the Sala dell'Albergo had been smuggled into place in 1564, the Crucifixion (colorplate 97) painted below it in the following year reaches a peak of religious feeling previously inaccessible to any Venetian artist. Approximately forty feet in length, the painting presents a panorama of Golgotha, populated by an immense crowd of rushing soldiers, struggling executioners, prancing horsemen, grieving Apostles. The scene is divided by the Cross, whose bar almost reaches the frame, so that the top is cut off and the titulus is barely visible, and the shadowed head of Christ leans down as if from heaven. At the left the cross of the penitent thief is being partly lifted, partly tugged into place by ropes; at the right the impenitent thief is about to be tied to his cross. A soldier on a ladder behind Christ takes from another on the ground the reed with the sponge soaked in vinegar.

At the left the diagonals of the ropes continue the direction of the rays emanating from the glory of light around the head of Christ. The axis of the ladder on the

ground is prolonged in the upward glance of St. John the Evangelist and in the direction of the reed reaching straight to Christ's feet. On the other side, occupied by the impenitent thief, these lines are absent, but their function is fulfilled by the gaze of the bearded figure on horseback (probably not the Roman centurion, who must be the rider in armor at the extreme left). The radial principles of the composition correspond strikingly to Christ's prophecy of his death, repeated to this day in the more recent service of the Stations of the Cross (John 12:32–33): "And I, if I be lifted up from the earth, will draw all men to me. This he said, signifying what death he should die." The tumult of the crowd, the grief of the Apostles, and the yearning of the penitent thief are brought to a focus in the head of the Crucified, who draws to himself all men who will listen.

Although Tintoretto's figures, due to his light-on-dark technique, always have a tendency to look a bit ghostly, especially in marginal areas and backgrounds, the foreground figures in the Crucifixion (fig. 662), grouped in a massive pyramid at the base of the Cross, are modeled with remarkable plastic force in bold planes of light and dark, and defined in contours of great vigor. Here, as throughout his work, Tintoretto's expressive sensitivity and depth are abundantly visible, and nowhere more strongly than in the head of the aged Joseph of Arimathea, who, holding his hands crossed on his breast, looks downward with intense sympathy at the Virgin swooning under the Cross. The little group, huddled as if for protection against the massive hostility of the surrounding crowds, forms the base of a composition whose sublimity of conception is matched by the artist's care in working out the correspondence of every detail within the embracing system.

Tintoretto's theological advisers developed for the Sala Grande on the upper story of the scuola—the long room through which one walks to the Sala dell'Albergo—an inclusive scheme relating Old and New Tes-

662. TINTORETTO. Virgin, St. Joseph of Arimathea, and others, detail of *Crucifixion* (see colorplate 97). 1565.

Canvas. Scuola di S. Rocco, Venice

663. TINTORETTO. Moses Striking Water from the Rock. 1575–77. Canvas, 18'2½" × 17'2¾". Ceiling of Sala Grande, Scuola di S. Rocco, Venice

tament subjects to each other and to the charitable purposes of the scuola, for which they provide images of divine justification. Although the individual scenes, like those of Michelangelo on the Sistine Ceiling, are at their best when viewed as component elements in a vast iconographic and formal structure, they function very well as individual images. The most successful of the ceiling paintings is the Moses Striking Water from the Rock (fig. 663); the reproduction ought to be held overhead in order to appreciate Tintoretto's purpose and method. One looks up along the diagonals of the square, past a series of drastically foreshortened, rapidly moving figures holding bowls and jars, to the miracle on which all the figures converge—water pouring in three clear arcs of light, graduated in their curvature, at the firm touch of Moses' rod. The illusion is so strong that it appears as if the water would fall on our heads were it not for the intervening receptacles. At the upper right the Lord, reclining foreshortened on a mass of clouds, floats into the picture, partly enclosed in a circle of light intended to symbolize the circles of heaven. The composition is largely built on the opposition of the arcs, the heavenly circle, and the smaller circles of the bowls to the tumultuous movement of the active figures.

In all the scenes of the Sala Grande, the light-on-dark technique of Tintoretto is clearly evident, imparting to the figures a shadowy and diaphanous appearance, even when the artist devoted some modeling to an occasional important face or limb. The light areas surrounding silhouetted dark heads often seem more solid than the heads themselves. Generally, the principal figures are lifted to an upper level. In the *Nativity* (fig. 664) the adoring shepherds, a woman, the sleeping ox (why does the ass not appear?), a cock, and a peacock appear on the lower floor, while the Holy Family and two more women, one praying, one holding a bowl and a spoon, huddle in the hayloft, illuminated by the sharp light coming down between the rafters and through the ruined roof, above which one can just discern the heads of three seraphim and the circles of heaven. Here, as in all the San Rocco compositions, figural diagonals are made to complement and continue those established for the space as a whole by the perspective orthogonals.

In the *Temptation of Christ* (fig. 665) Christ has taken refuge in a ruined shed perched on a rocky eminence and surrounded by wild vegetation, while a beautiful and persuasive Satan reaches up to him two stones he is asked to change into bread. In the *Last Supper* (fig. 666), which is transformed from the announcement of the Betrayal as we saw it in Leonardo (see colorplate 67) into the older Byzantine subject of the Institution of the Eucharist, the same two-level arrangement continues. Two

664, 665, 666. TINTORETTO. *Nativity* (above), *Temptation of Christ* (below left), *Last Supper* (below right). 1577–81. Canvas, height of each 17'9". Walls of Sala Grande, Scuola di S. Rocco, Venice

667. TINTORETTO. Last Supper. 1592-94. Canvas, 12' × 18'8". Chancel, S. Giorgio Maggiore, Venice

servants recline or crouch below a step, which a dog tries to climb, and above them we look along the orthogonals of the checkerboard floor deep into the room, where Christ is seen giving the wafer of the Eucharist to St. Peter. Only eleven Apostles can be counted, probably because Judas has already left. As in several of Tintoretto's numerous paintings of the Last Supper, the chief figures are represented remote from the picture plane, deep in the receding perspective construction. At the top of a short flight of steps, we look into the kitchen of the inn, where food is being prepared and dishes arrayed—a deliberate contrast, as in Pietro Lorenzetti (see fig. 103), of spiritual and material food.

With a painter as prolific as Tintoretto—responsible for several hundred surviving works, as well as a considerable number that, with paintings by Giovanni Bellini, Titian, and others, perished in the fire that gutted the Doges' Palace in Venice in 1577—it is impossible to give more than a summary of his style and a suggestion of his vast artistic activity. In his last years material substance and worldly concerns, always of minor importance to Tintoretto, dissolve before our eyes, and in the darkness of his paintings shines a transcendent light. One of his last works, finished in fact in 1594, the year of the artist's death, is the mystical *Last Supper* in San Giorgio Maggiore (fig. 667), where its otherworldliness contrasts strangely with the sumptuous architectural setting by Palladio (see fig. 684). The long table, set on a

diagonal in depth, serves to divide the material from the spiritual. To the right of the diagonal, powerfully modeled servants gather up the remains of the feast and stack the dishes in a basket, where they attract the interest of a marauding cat (a dog crunches a bone at the foot of the table). Another servant (distinguished as such by his clothing and his cap, although he has been mistaken for Judas) sits on the floor with his elbow on the table, trying to understand what he sees. But behind the table the only solid reality is the light of the spirit. Starting from the heads of the eleven Apostles like the corona in a solar eclipse, it bursts in rays from the head of the gentle Christ, who stands to give Communion with both hands to a waiting Apostle, streams from the flames of the hanging lamp, and floats in disembodied wisps that assume the shapes of angels—heavenly ministers, contrasting with the worldly servants. At the end of his life, Tintoretto's light-on-dark technique, invented to lend speed to his brush, becomes a vehicle for revelation.

We cannot leave Tintoretto without a word about his portraits, of which more than 150 are known. Even if we could imagine this impetuous artist capable of buckling down to a minute transcription of his sitters' features, costumes, and background settings in the Lombard manner, numbers alone would preclude such treatment. Painted in light on dark as we would expect, Tintoretto's portraits supply only the most important sitters with such props as columns, curtains, or appropriate battle

668. TINTORETTO. *Portrait of a Woman in Mourning*. Canvas, 41 × 341/4". Gemäldegalerie, Dresden

scenes. Generally there is no accompaniment. Features and costumes alike are broadly painted without concern for nuances of character and expression or details of attire. Yet Tintoretto's pictorial shorthand depicts the sitters as if capable of deep emotion and decisive action. Perhaps it was this reservoir of latent feeling, often enhanced by the rich coloring of the costumes as a foil for the brilliant faces that made such instant portraiture attractive to the Venetian patriciate from which came Tintoretto's clientele.

In *Portrait of a Woman in Mourning* (fig. 668) he had only deep black to rely on for the costume. Still Tintoretto played the pale face of the beautiful, thirtyish sitter and her blond hair and white scarf against the black with resounding effect, heightened by the dramatic pose and powerful side lighting. In consequence, this portrait takes on some of the emotional depth of the master's great religious narratives. One feels that the artist had some personal connection with the woman. Certainly he has succeeded in making the viewer share her grief and admire her nobility in this, one of the great portraits of the Renaissance.

Is Tintoretto, as some like to say, a Mannerist? If Pontormo, Rosso, Perino del Vaga, Beccafumi, Parmigianino, and Pordenone are Mannerists, then he is not. Tintoretto's style, no matter how feverish, is completely devoid of the conflicts of Central Italian Mannerists of the 1520s and 1530s. His studies of Central Italian art—and he worked long and lovingly to assimilate Michelangelo's style to his own needs from drawings and especial-

669. TINTORETTO. Study of Nude after a Statuette.
Black and white chalk on blue paper.
Gabinetto dei Disegni e Stampe, Uffizi, Florence

ly from small models of Michelangelo's figures (fig. 669)—were intended to liberate him from the stereotypes of his youth. The elements he paints are firmly based on visual reality. Insubstantial though his compositions may appear, they are based on a rigorous and consistent logic. The very violence of their activity is disciplined and ordered to produce a clear, often mathematically formulated expression of channeled velocity. His personages, however violently they throb with emotion, are not tormented but deeply, freely expressive. While their bodies move at angles to the picture plane and sometimes in alarming trajectories through space, their limbs convey without impediment the forces of the composition as a whole. Often surprising, Tintoretto is never bizarre. He speaks in parables, but not in riddles. He is no more a Mannerist than Fra Angelico is Gothic. His aim is toward harmony, of physical and spiritual reality, and in that he is a child of the Renaissance, perhaps its last.

PAOLO VERONESE

The second of the aged Titian's competitors, and the third of the Renaissance giants in Venice, was Paolo Caliari (1528–88), called Paolo Veronese on account of his birth and training in the handsome mainland city of Verona. Paolo came to Venice in 1553 thoroughly equipped and experienced as a painter in a tradition going back beyond Mantegna to Altichiero, and for the next thirty-five years he delighted the Venetians with his unusual pictorial gifts, which would appear to set him at

the antipodes from Tintoretto. Veronese, too, painted biblical suppers, but his concern was only with material food, and with the material splendor of the setting and the sumptuous costumes of the actors. In his extended canvases, Venice of the Late Renaissance passes before our eyes in a parade of marble palaces and healthy people, dressed in massive velvets, satins, and brocades, eating, drinking, and making love with a stolid conviction that this was all they were meant to do in this world. Every now and then, to be sure, he painted a scene from the Passion, but with rare exceptions these are drenched in syrupy color and unconvincing in expression. It is in his festivals and pageants that Veronese's real grandeur as an artist resides, for here he was able to spread his canvas like a giant tablecloth with an overpowering banquet of delicious hues-almost always high and clear, dominated by the pale tones of marble columns and by lemon-yellows, light blues, silvery whites, bright orange and delicate salmon colors—neither subdued with glazes down to Titian's smoldering embers nor shadowed like the nocturnal visions of Tintoretto. Among sixteenth-century composers, Tintoretto's rhythms, darkness, and religious intensity may recall the Masses and motets of Palestrina; Veronese makes us think of the bright brass music of Giovanni Gabrieli.

Looking a little more deeply into Veronese, however, one encounters two surprises. First, as Carlo Ridolfi tells us, writing only sixty years after the great colorist's death, he was a model of rectitude and piety, brought up his sons according to severe religious and moral principles, and though he "wore expensive clothes and velvet shoes," he lived "far from luxury: was parsimonious in his expenses, whereby he had the money to acquire many farms and to accumulate riches and furnishings." Second—and this is seldom noted—Veronese was just as impatient as Tintoretto with Titian's time-consuming methods and, like Tintoretto, invented a shorthand for his pictorial statements.

The principal purpose of Veronese's art was to achieve a kind of intoxication with intense color, not unlike that with which Lotto earlier experimented. But Veronese went far beyond Lotto in the subtlety of his adjustment of color areas to one another. Having established the basic masses of his architectural settings, he subdivided his remaining fields into areas, much as had the tempera painters of the Trecento. Each circumscribed area would be covered with a layer of bright underpaint, as flat as house paint, giving the artist his ground color and allowing him to see exactly its relationship to the adjoining hue. On that layer, once it dried, Paolo could rapidly paint in his system of simplified and precalculated lights, either in a slightly modified version of the same hue or in a contrasting hue, giving a hint of iridescence not unknown to the Trecento-and very few shadows. This method enabled Veronese to paint drapery and architecture at great speed, with a seeming accuracy of detail that is derived entirely from the precision of his placing of the lights, but which vanishes at close range. He maintains, as it were, a high threshold of visual observation, which also keeps the observer standing, by necessity, a certain distance from his canvases, and subject always, therefore, to the total decorative effect. By these means, Veronese was able to cover an acreage of canvas not inferior to that painted by Tintoretto, yet without any appearance of haste.

Two years after his arrival in Venice, the twenty-seven-year-old but fully mature Veronese began the splendid series of frescoed murals as well as the altarpiece, ceiling paintings, and organ shutters in oil that render the little Church of San Sebastiano a monument to his genius. In the central ceiling oval he painted in 1556 the *Triumph of Mordecai* (fig. 670), envisioning the biblical scene of Esther (8:15) as if it were happening in a Renaissance city: "And Mordecai went out from the presence of the king in royal apparel of blue and white, and with a great crown of gold, and with a garment of fine linen and purple: and the city of Shushan rejoiced and was glad." Veronese must already have visited Mantua, where Giulio Romano had actually *built* for Duke Feder-

670. VERONESE. *Triumph of Mordecai*. 1556. Canvas, 24×18′. Ceiling, S. Sebastiano, Venice

671. VERONESE. *Abundance, Fortitude, and Envy.* c. 1561. Fresco. Ceiling, Villa Barbaro, Maser

igo Gonzaga—and on a colossal scale—spiral columns on the model of those supposedly from Solomon's Temple, which Raphael had painted in the tapestry cartoon of the Healing of the Lame Man for the Sistine Chapel (see fig. 547). In the same year as Veronese's ceiling, Giulio's colonnade was being extended on three sides so as to become a courtyard for exhibiting the duke's special breed of horses, of which the Gonzaga family was inordinately proud. Thus Veronese's ceiling painting of mighty steeds with clashing hooves, below spiral columns and balconies with lords and ladies shown against the blue, was not only a daring bit of d'al di sotto in sù ("from below looking up") illusionism, but also a timely reference to a project in the very latest style. Like Mantegna (see fig. 411), whose murals in Mantua he must have studied in exhaustive detail, Veronese plays little tricks on the spectator: we instinctively duck from the threatening hooves. (Why the crowned Mordecai and his attendants should have arrived full tilt at the crumbling brickwork on the edge of an abyss, no one seems to have thought it necessary to ask.)

Veronese went to Rome in 1560. It is instructive with regard to his character and to his art how little that trip changed the fundamental nature of his style. He was a Veronese and an adopted Venetian before he went, and he returned not one whit Romanized. But he must have made some drawings, and he did adopt an occasional

motive that pleased him. It is not hard to imagine the already brilliant artist walking critically through the Farnesina (see figs. 554-564), which may have impressed him as a bit old-fashioned. But in his own utterly different frescoes, which line the walls and vaults in several rooms of the enchanting Villa Barbaro at Maser, near Treviso, Veronese not only accommodated his illusionistic designs to the architecture of Palladio in a wholly new way, but also paid tribute to Raphael's Cupid Pointing out Psyche to the Three Graces (see fig. 564) in his ceiling fresco of Abundance, Fortitude, and Envy (fig. 671) by adopting the figure seen from the rear, and adapting it to a d'al di sotto in sù view. Fortitude, with her lion, steadies the cornucopia in the hand of Abundance, and nobody pays any attention to Envy with her ugly knife. The high, silvery clouds recall those of the early

The largest of all Veronese's scenes of feasting (more than thirty-two feet long) is the Marriage at Cana (fig. 672), which many observers find overcrowded. The huge canvas was painted in 1563 for the Sacristy of San Giorgio Maggiore in Venice, and perhaps Tintoretto's spiritualized Last Supper (see fig. 667), painted for the chancel of the same church a generation later, contains an element of revulsion for the excessive material splendor of Veronese. The horseshoe table is laid on an open terrace, with Roman Doric colonnades on two sides and a higher terrace at the back, set off by a powerful balustrade beyond which one looks past Corinthian porticoes to Composite porticoes and finally to a campanile and cumulus clouds against the blue. Christ can be found, if one looks, and so can Mary, but one hardly notices them in the midst of so much architecture, so many brocaded costumes, and all the good things to eat and drink with which the table is loaded. The guests are very well fed gentlemen and ladies, who, by the expressions in their eyes (and at times the lack of expression), have reached a state of postprandial saturation. No one is eating any more; one somnolent lady is picking her teeth (fig. 673); some gentlemen are interested in the newly created wine, others in the ladies. The master of the feast directs operations at the left; a little black boy hands a glass of wine to a guest; a cat at the right rolls over to scratch the mask on an amphora; and in the center plays a group of musicians, including a string quartet (fig. 674)—recognizable portraits of the painter Jacopo Bassano with a viol, Veronese with a viola da braccio, and Titian with a bass viol. If anybody is concerned about the miracle that has just taken place, the spectator would never know it.

Ten years later a similar but much more tastefully arranged performance, painted for the refectory of the convent of Santi Giovanni e Paolo, got Veronese into serious trouble (colorplate 98). He was, in fact, brought before the Inquisition and asked at length to account for the presence of "buffoons, drunkards, dwarfs, Germans, and similar vulgarities," in a trial whose fascinating record is

672. VERONESE. Marriage at Cana. 1563. Canvas, 21'10" × 32'6". The Louvre, Paris

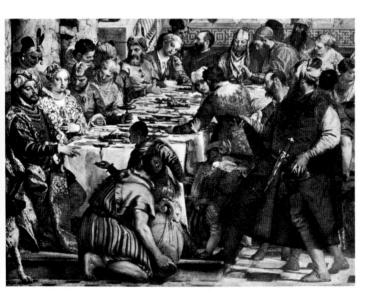

673. Guests, detail of fig. 672

still preserved. With transparent naïveté, Veronese replied to their excellencies that there is a kind of license observed by poets, painters, and madmen, and to this he appealed. Doubtless, he knew perfectly well that all

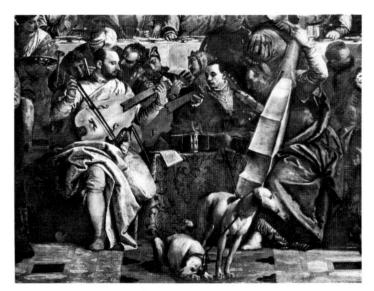

674. Musicians, detail of fig. 672

these goings-on should not have been represented at a Last Supper, which the Holy Office thought it was looking at. There is no telling what the subject was originally to have been, but it was changed to the *Feast in the House*

of Levi, which gave the artist a greater freedom to leave in the offending figures, including a soldier getting drunk on the stairs at the right. To leave his audience in no doubt, Paolo inscribed "LUCAE CAP. V" on the balustrade, indicating the passage (Luke 5:29–31):

And Levi made him a great feast in his own house: and there was a great company of publicans and of others that sat down with them.

But their scribes and Pharisees murmured against his disciples, saying, Why do ye eat and drink with publicans and sinners?

And Jesus answering said unto them, They that are whole need not a physician; but they that are sick.

Christ sits in the center, chatting with the publicans and their attendants, who combine to weave a changing fabric of rose, yellow, blue, green, and silver against the pale stone and the blue of the sky with its sultry clouds.

This time Veronese has utilized an architectural setting strongly reminiscent of the opulent version of classical architecture developed by Jacopo Sansovino in Venice (see colorplate 100) a generation or so earlier, supplying veined marble for the Corinthian columns of the smaller order and gilding the sculptured Victories that fill the spandrels of the three great arches of his imaginary loggia. The background architecture is somewhat more restrained, allowing the principal role to be played by the columns and arches of the loggia, which far outweigh the figures at the table. Aside from the usual classical buildings, we are surprised to see a window with Gothic tracery at the right, as if Paolo were trying to introduce a note of historical distance into his ideal classical setting. Nonetheless, it will be noted that he is no more willing to paint slum dwellings than to admit their inhabitants to his wealthy gatherings.

Veronese's instinct for compositional organization of figures and architecture was as sure as that of Mantegna. the festival aspects of whose art he re-created using Cinquecento pictorial methods and inflated to Cinquecento scale. His Mystical Marriage of St. Catherine (colorplate 99), probably dating from the 1570s, is such a festival picture, and there is little mysticism about it. The Virgin is seated at the top of three steps, between massive Composite columns seen diagonally somewhat in the manner of those Titian introduced into his Madonna of the House of Pesaro (see fig. 639) a half-century earlier. The sun warms the columns and the splendid fabrics, as well as the angel heads and the two swooping putti (recalling those in Titian's Rape of Europa; see colorplate 90), who hold above the group the Virgin's crown and the saint's palm. St. Catherine was, after all, a princess, and Veronese has represented her crowned with a jeweled coronet and regally dressed in a stiff blue-and-white damask. Veronese's inspired juxtaposition of hues, on which the total effect of his pictures depends, is at its best in the

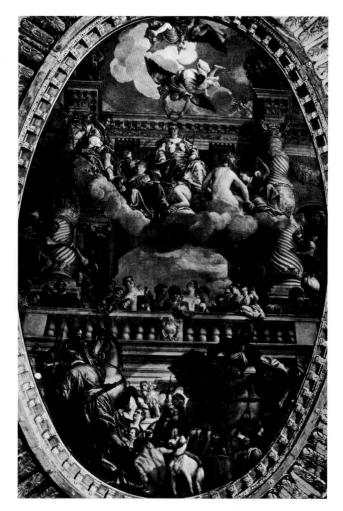

675. VERONESE and PUPILS. *Triumph of Venice*. Probably 1585. Canvas. Ceiling of Hall of the Great Council, Doges' Palace, Venice

pair of angels seated at the lower left-hand corner. Instead of paying attention to the divine favor bestowed on St. Catherine, they are disputing over a piece of music and are not quite ready for the festival. Few color passages in Venetian painting are more seductive than the white-and-gold brocade, green silk, and heavy orange taffeta of their garments.

Probably in 1585 Veronese, together with his pupils, painted the *Triumph of Venice* (fig. 675), on the ceiling of the Hall of the Great Council in the Doges' Palace. The picture contains many elements seen in his earlier works, such as the prancing steeds and the Solomonic columns (borrowed from Giulio Romano) that he had introduced at San Sebastiano thirty years earlier; the seated nude from the Farnesina, which had had used at Maser and repeated again and again; and two winged figures lifted from Giulio Romano's ceiling frescoes in the cathedral of Paolo's native Verona, one holding a crown over the head of Venice, the other—clearly Fame—brandishing a trumpet.

Yet the idea of the picture is essentially new. The massive architecture recedes upward into the sky with the solemnity of organ music, and clouds carry with it the

sceptered Venice, flanked by allegorical figures and enthroned between the towers of the Arsenal, from which the Venetian galleys sailed forth to dominate the seas. Our eye moves upward with the architecture, past the horses, past the terrace thronged with jubilant Venetian patricians, into another realm, beyond that of rational reality and beyond the Renaissance. Tintoretto's late *Last Supper* (see fig. 667) takes us into a world of personal mysticism that offers no exit for the forces of history; Veronese's glorious composition leads straight to the Baroque, and specifically to the ceiling decorators of the seventeenth century, who studied its principles and experimented with all the implications of its daring flight.

JACOPO BASSANO

No one familiar only with the provincial ineptitude of Bassano's youthful work, at best a dull reflection of the style of Bonifazio de' Pitati, a Veronese master who influenced him at the start, could possibly have foreseen the brilliant sophistication of Bassano's art by the middle and toward the end of his long and productive career. Jacopo dal Ponte, called Bassano (c. 1517/18-92), belonged to the second generation of a dynasty of painters culminating in his four sons, two of whom, Francesco and Leandro, shared some of their father's gifts. Or were they truly gifts? Much of the high quality of Jacopo's best work was achieved by close observation and careful study. After escaping from the limited possibilities of the picturesque little city of Bassano, on the banks of the Brenta and in the shadow of lofty Monte Grappa, he seems to have fallen under the influence of the Florentine Francesco Salviati (see pages 663-64, fig. 720, and colorplate 103), who visited Venice in 1536 and must have acquainted Jacopo with some of the inventions of the Central Italian Maniera.

Although of unequal quality, Bassano's work at his

best places him only just behind his towering contemporaries, Titian, Tintoretto, and Veronese. He could be dazzling in his unexpected combination of rustic naturalism with a daring freshness of invention and color. His style is exemplified at its most brilliant in the Adoration of the Magi, made about 1563-64 (fig. 676), whose beautifully painted and astonishingly alive dogs, horses, and donkey smell of the farmyard, but whose elegantly attenuated Virgin and Magi radiate the princely splendor of the Venetian society Bassano painted for, as well as still something of the artificiality of the Central Italian Maniera (see page 639). Coloristically, the picture is dominated by the resonant green of the kneeling Magus' mantle, a note resumed in that of the youngest Magus, and by the unexpected and sharply dissonant pink of the Virgin's tunic, repeated in that of the black and turbaned second Magus. Compositionally, the long lines of the torsos and their silky drapery form a web of shuttling shapes, escaping to a release only in the blue North Italian hills of the background. Unfortunately, the formal and compositional inventions of Jacopo Bassano became quickly standardized not only in the work of his sons but also even in his own.

MICHELE SANMICHELI

Bramante had left behind him a rich, classical tradition, continued throughout the cities of North Italy by a host of talented architects. But the Roman version of the High Renaissance style was imported to the North only by those masters who had had a chance to experience the new grand manner in full operation in the Rome of Julius II and Leo X. One of these was Michele Sanmicheli (1484–1559), an architect from Verona who had actually practiced at the Cathedral of Orvieto from 1509 to 1521, and who in 1526 had collaborated with Antonio da Sangallo the Younger in a survey of papal fortifications. On his return to Verona, after the debacle of 1527, Sanmicheli began a program of construction of fortifications, ornamented with splendid Renaissance gates, and Renaissance places and churches, destined to transform this lovely Gothic city into one of the richest centers of Renaissance architecture in North Italy, to be ranked only just after Venice itself (where Sanmicheli was later to build two noble palazzi on the Grand Canal) and the Vicenza of Palladio (see pages 634–38). While based on the general principles of Bramante's Palazzo Caprini (see fig. 509), with a rusticated lower story and a columned piano nobile, Sanmicheli's palaces are strikingly original in aspect and feeling, often reflecting aspects of the unusual Roman monuments that still stand in Verona. One of his handsomest structures in his native city, and possibly his earliest, is the Palazzo Bevilacqua, probably designed about 1532-33 (fig. 677).

As in the Roman palaces by Giulio Romano and other followers of Raphael, buildings that Sanmicheli surely studied, the Tuscan pilasters of the ground floor are rus-

677. MICHELE SANMICHELI. Palazzo Bevilacqua, Verona. c. 1532–33

ticated, but in this instance so encased in their heavy blocks that only the capitals can escape. The fantastic second story contains elements that can hardly be characterized as other than Mannerist. The three huge, arched windows of the piano nobile alternate with a complex arrangement of smaller arched windows, surmounted by arched pediments, and those by long, rectangular attic windows, all seemingly interlocked and contrasting with heavily sculptured heads and garlands. Even more surprising, four of the eight stately Corinthian columns are fluted normally, while the other four are adorned with spiral fluting (a device derived from Late Roman architecture, but unusual in the Renaissance), two running clockwise, two counterclockwise, and so arranged that every pair of columns, whichever way one reads, is made up of two incompatible members. Coupled with the rich ornamentation of the frieze, the effect is one of extreme and disturbing complexity.

JACOPO SANSOVINO

It is a curious and perhaps significant fact that, although the Grand Canal in Venice can advance a formidable claim to the rank of the most beautiful thoroughfare in the world, by virtue of its incomparable succession of palaces, not one of those constructed during the Renaissance was built by an architect born in Venice itself. Stranger yet, remarkably few of those remaining from the Early Renaissance, largely by Lombard architects, such as the Lombardo family and Mauro Codussi (see pages 423-24), can survive comparison with the achievements of contemporary Florentine and Sienese builders. Not until well into the Cinquecento did the great masterpieces of Venetian palace architecture begin to appear, and their style, definitive for the entire subsequent history of Venetian architecture, was the independent invention of a Florentine, Jacopo Tatti (1486-1570), called Sansovino after his master, Andrea Sansovino, and known chiefly as a sculptor before he came to Venice. If he had remained one, it is doubtful that Jacopo would have commanded our attention, in spite of the charm of such works as the bronze *Venus Anadyomene* (fig. 678), which stands a good chance of being identified with the *Venus* that Duke Federigo Gonzaga ordered for the Sala di Psiche in the Palazzo del Te at Mantua. Of this statue Pietro Aretino wrote to Federigo in 1527 that it was "so true and so live that it fills with desire everyone who beholds it." As is the case with much Cinquecento sculpture, the softness of Sansovino's full and voluptuous forms and his serpentine contours suffer in comparison with Michelangelo's hardness and clarity.

Jacopo's architecture, however, places him immediately in the front rank of Renaissance creators. The magnificence and authority of his classical style render him, in a sense, the architectural equivalent of Titian, and it was not long before he had established himself as the one great original architectural thinker in Venice. He influenced, as we have seen (see colorplate 98), the architectural backgrounds of the works of the greatest Venetian painters and laid down the principles on which Venetian architecture was to proceed for the next two centuries.

Sansovino's arrival in Venice in 1527, after the Sack of

678.

JACOPO SANSOVINO.

Venus Anadyomene.

Before 1527 (?).

Bronze, height 66".

National

Gallery of Art,

Washington, D.C.

(Mellon Collection)

Rome, must have been a real liberation for him, trained as he was in the High Renaissance environment of Bramante, Raphael, and Peruzzi. Florence, with its narrow streets and its tradition of fortress-palaces, could offer only very limited opportunities to an architect brought up on Roman columns, arches, and balconies; Venice, on the other hand, suffered from no such physical restrictions. The lagoons protected the city and its public and private buildings, and these could therefore exploit to the full the advantages of light and air. Venetian palaces, from the Romanesque-Byzantine through the Gothic period and the Early Renaissance, present to the Grand Canal a series of superimposed open arcades and wide windows built of the white Istrian limestone whose luminosity imparts a special brilliance to the Venetian scene. Sansovino's Roman architectural heritage could therefore be allowed almost ideal freedom of expression and development.

His undoubted masterpiece, and surely one of the most satisfying structures in Italian architectural history, is the magnificent Library of San Marco (colorplate 100), which Sansovino commenced in 1537 to shelter the treasury of manuscripts left to the Republic of St. Mark by Cardinal Bessarion, the Greek humanist and Patriarch of Constantinople turned Latin prelate. As was so often the case with Renaissance architectural works, the architect was never privileged to see his finest building completed. In 1554 its construction was interrupted at the sixteenth bay, counting from the right; it was resumed only after the master's death in 1570 by his pupil Vincenzo Scamozzi and completed in 1588. Nonetheless, the work was continued with such fidelity to Jacopo's designs that no break is visible, and the library stands as a completely unified monument.

An ancient prototype has been adduced—Hadrian's marble library, with columns and gilded ceiling described by Pausanias—and it has been suggested that Vitruvius, universally known in Fra Giocondo's Venetian edition of 1511, might have influenced the decision to situate the reading room so as to face the morning light. It was to be placed in a commanding position, safe from high tides, on the upper story. Sansovino designed a two-story structure with three bays facing on the Canale San Marco and twenty-one on the Piazzetta, the opposite side of which is formed by the Gothic Doges' Palace. The ground-story arcade is in the Roman Doric order, based on that of the Colosseum, with keystones carved into alternating masks and lions' heads and with recumbent figures in the spandrels. The second story, not only higher but much richer, is Ionic, and provided with an elaborate decoration in high relief by a group of Venetian sculptors. It is in this second story that Sansovino shows his real originality. The engaged columns standing on postaments, like the second-story columns of Bramante's Palazzo Caprini (see fig. 509), support an entablature whose rich frieze of putti and garlands en-

679. JACOPO SANSOVINO. Zecca (Mint), Venice. 1535–45. Third story added in 1558

closes a half-story of mezzanine windows treated as part of the ornamentation. Between these large, smooth columns, the arches are flanked by fluted freestanding columns of the same order, two-thirds the height of the larger columns. The small columns appear to stand on the Raphaelesque balustraded balconies and, surprisingly, are paired in *depth* rather than in the plane of the façade, so that the windows appear to be part of a continuous loggia, moving inward and outward with each bay. The effect, of extraordinary plastic richness, is increased by the sculptured figures in the spandrels and the friezes.

The verticals are accented at the corners of both stories by piers articulated by pilasters of the appropriate order, and the rich balustrade crowning the entire building is divided at each bay by high postaments holding statues in Istrian stone and, at the corners, lofty obelisks. All traditional boundaries of the building block are thus dissolved. No walls appear on either story, only clusters of columns, large and small, and the piers to which they are engaged or around which they are deployed. The upper contour of the structure, until this moment in Renaissance architectural history invariably marked by a straight and unbroken cornice, dissolves against the sky. All verticals are prolonged from the ground to the heads of the statues, with an effect comparable to that of the pinnacles marking the bay divisions of Gothic buildings. The mass of the building itself includes the shadows of the ground-story portico and of the upper-story windows; the balustrade and statues bring in the sky. The structure, whose columns, piers, arches, balustrades, and statues in white Istrian stone cast dark shadows and glitter against the blue heavens, partakes of the ordered insubstantiality of a painting by Titian. Palladio called the building "probably the richest ever built from the days of the ancients up to now," and Pietro Aretino pronounced it "superior to envy." It is hard to dispute their judgment.

Next to the library, along the quayside facing the Canale San Marco, Sansovino built between 1535 and 1545

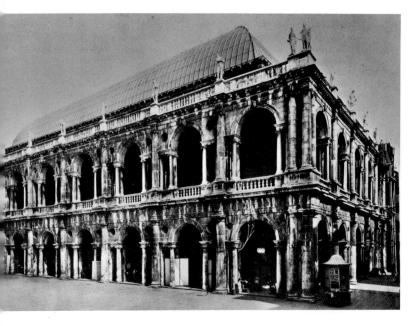

680. PALLADIO. Basilica (Palazzo della Ragione), Vicenza. Begun 1549; completed 1614

the Zecca, or Mint (fig. 679), for which he invented a new order of columns interrupted by rusticated bands so as to look frowning and impregnable. This idea was derived from the Porta Maggiore in Rome, one of the ancient city gates. The building was originally erected as a two-story structure, but the intense heat of the foundries within necessitated a protective third Ionic story, added in 1558 to the original Doric order of the second story. The effect is very imposing, and although some of the horizontals are maintained at levels that also exist in the neighboring Library of San Marco, the proportions of the severe Zecca are deliberately kept separate from the library's luxurious beauty.

ANDREA PALLADIO

The supreme architect of North Italy, regardless of period, and in fact the only North Italian builder to achieve the universal stature of the great Tuscans, Brunelleschi, Alberti, and Michelangelo, was Andrea di Pietro (1508–

80), known to posterity by the classical name Palladio (derived from Pallas, goddess of wisdom), bestowed upon the young man by his first patron, the learned humanist Giangiorgio Trissino of Vicenza. While Palladio's birthplace (Padua or Vicenza) is still a matter of controversy, there is no doubt that he was brought up in Vicenza, which he and his pupils turned into one of the most beautiful cities in Italy by means of their numerous public and private buildings designed in a new and more strongly archaeological version of the Renaissance style. Trissino took Palladio to Rome with him, and on that and subsequent trips the young architect studied in detail not only the works of the High Renaissance architects but also the ruins of antiquity. He was also a theorist of a high order, mastered the writings of Vitruvius and of Alberti, and made some extremely influential literary contributions of his own, including L'antichità di Roma, printed in 1554, and I quattro libri dell'architettura, which appeared in 1570 and in which the virtus (manliness) of Roman architecture, so important a principle to Alberti, is developed in terms of its application to the architectural problems—domestic, public, and religious—of Palladio's own day.

In 1549 Palladio commenced one of his most celebrated buildings, not to be completed until 1614, long after his death. This was a two-story structure of open loggie wrapped around the fourteenth-century Palazzo della Ragione (fig. 680), a typical example of the great public halls built in a number of North Italian cities at the close of the Middle Ages. Palladio himself called it his Basilica, justifying the term by the comparison of its use as a lawcourt with the original function of Roman basilicas. He did "not doubt that this building may be compared with the ancient edifices, and ranked among the most noble and most beautiful fabrics that have been made since the ancient times, not only for its grandeur and its ornaments, but also for the materials." As in his judgment on Sansovino, who are we to say him nay? The building is glorious.

681. PALLADIO. Palazzo Chiericati, Vicenza. Begun 1551

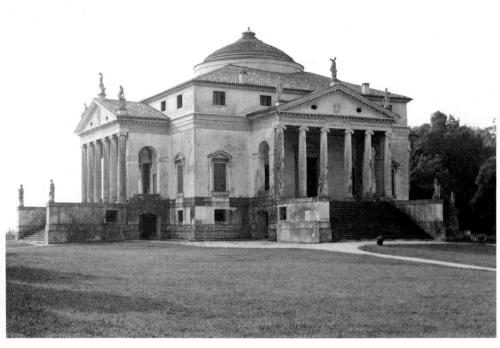

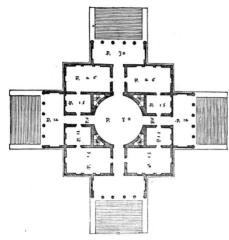

left: 682. PALLADIO. Villa Rotonda (Villa Capra), Vicenza. Begun 1550. Finished by VINCENZO SCAMOZZI

above: 683. PALLADIO. Plan of Villa Rotonda (Villa Capra), Vicenza

Derived quite obviously from Sansovino's Library of San Marco (see colorplate 100), Palladio's Basilica is more severely architectonic, less reliant on sculpture, and at the same time more flexible. What we know today as the "Palladio motive"—an arched opening supported by small columns that define a narrower compartment on either side, the whole embraced by a giant order supporting an entablature—is anticipated in Sansovino's second story, and had probably originated in the circle of Bramante in Rome. Palladio uses it for both stories of the Basilica and shows, for the first time on a grand scale, how the motive made possible a variation of the fixed proportions of bays. It will be noted that the corner bays of the Basilica are narrower than the others because the intervals between the small and the embracing orders are perceptibly less, while the arches maintain, as they should, the same radius throughout the building.

There are some curious aberrations. On both stories the spandrels are pierced by unmolded oculi, but those of the corner bays remain unbroken. The columns of the embracing order are doubled on the outside of each corner bay. When seen from the corner, therefore, this motive appears as a bundle of three columns. Sansovino's device of coupling in depth the columns of the smaller order is used by Palladio for the Doric order of the ground story as well as the Ionic of the upper, but in neither story do the shafts rest on conventional bases. Palladio has substituted unmolded cylinders, apparently so as not to detract from the bases of the giant order. The building is given an entirely different physiognomy by the high medieval convex roof, but Palladio has deployed his arcades in such a manner that the medieval walls are invisible, and the roof seems moored to his building in the manner of a tent.

The most original of all of Palladio's private residences in Vicenza is undoubtedly the Palazzo Chiericati (fig.

681), commenced in 1551, continued until 1557, but not completed until late in the seventeenth century, from Palladio's designs. In his other urban dwellings the great architect was restricted by the narrow streets, which he had to confront with classical façades in many variations of the Bramante tradition. Here his loggie looked out on a spacious piazza, and he was able to give free rein to his architectural imagination. The ground story is a Bramantesque loggia reminiscent of the Tempietto (see fig. 498), the second story a much loftier Ionic loggia; but the architect's unexpected coup lies in the interpenetration of this horizontal division into two stories by a vertical division into three. The central section of the building advances somewhat, its corner columns are doubled, and the outermost of these columns fuses in a peculiar Siamese-twin relationship with its neighbor in the slightly recessed wings. Then, the second story, quite unexpectedly, is filled in by a wall fenestrated as a storyand-a-half, with the result that this solid block of masonry appears suspended among all the columns. The effect has been compared to the architecture on stilts developed in the twentieth century by Le Corbusier. Palladio manages it with the utmost severity, as if this caprice were the most natural thing in the world, never relaxing the clarity and dignity of his classical style. On the profile of the building, the internal divisions are maintained in a delightful alternation of clustered statues with fantastic balusters.

Palladio's most influential building for the history of domestic architecture in Anglo-Saxon countries is his Villa Capra, better known by its nickname of Villa Rotonda (fig. 682), started in 1550 and finished only after Palladio's death by Vincenzo Scamozzi, who also completed Sansovino's Library of San Marco. The villa stands on an eminence that projects from the flank of a ridge overlooking the city of Vicenza from the south.

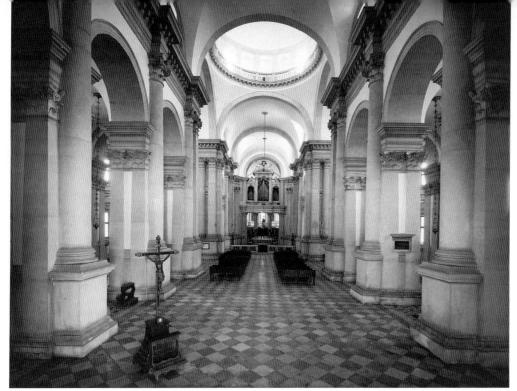

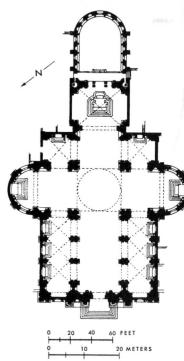

above: 684. PALLADIO. Interior, S. Giorgio Maggiore, Venice. Begun 1566

above right: 685. PALLADIO. Plan of S. Giorgio Maggiore, Venice

right: 686. PALLADIO. S. Giorgio Maggiore, Venice. Façade completed by VINCENZO SCAMOZZI, 1610

Like most of the numerous villas designed by Palladio for wealthy citizens of Vicenza and of Venice, the building is organized around the idea of a classical temple portico, but the Villa Rotonda is unique in having four porticoes, one for each cardinal point of the compass, radiating outward from a central dome (fig. 683). Each portico, therefore, not only commands a different view of mountains, hills, valleys, city, and suburbs, but also enjoys different atmospheric qualities and is appropriate to varying times of the day. Within each portico there are further refinements, for each is protected on the sides by a diaphragm wall to ward off the sun, and each wall is pierced by an arch to admit ventilation. The inhabitants thus could profit by an almost endless variety of sun and shade, breeze and shelter, according to their own desires and the changing atmospheric moments. No wonder that Palladio's ideas were adopted with especial enthusiasm in the architecture of plantation mansions in the American South, where it is natural to live in large measure out-of-doors for much of the year, and yet protection against the sun is essential.

Each portico is reached by a lofty flight of steps flanked by projecting walls that complete the sides of a spatial cube, of which the stairs form a diagonal. On the outer corner of each wall and on all three corners of each pediment, statues—twenty in all—prolong the major vertical axes of the villa into the surrounding air. Yet,

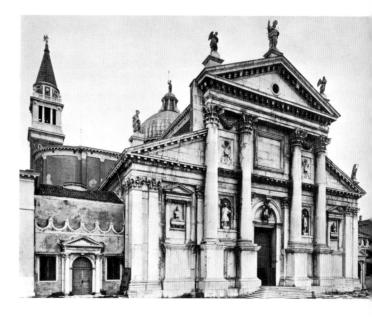

despite the atmospheric principles inherent in the very nature of the structure, the villa is austerely simple in its flat walls, severe Ionic columns, and undecorated frieze, as compared with the richness of Sansovino's architecture. It has been demonstrated in exhaustive detail that Palladio calculated the proportional relationships between the rooms in his villas, between the length and breadth of any room, and between the height and width of any wall according to numerical ratios related to the harmonic relationships within the Greek musical scales, still known in theory in the Renaissance. Palladio's ratios are more elaborate than those utilized by Brunelleschi or even those used and discussed by Alberti. Although these ratios are visualized only through measurement, and are therefore not consciously discerned by the observer, they are doubtless responsible for the feeling of perfect harmony and balance of propor-

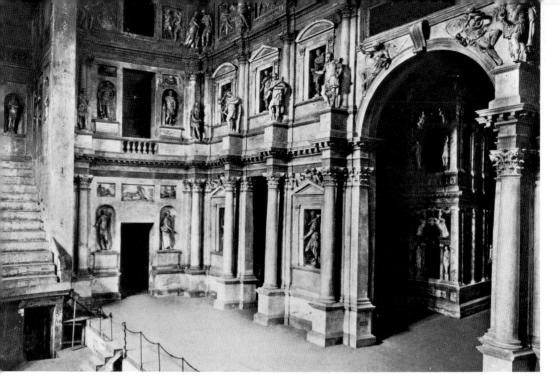

left: 687.
PALLADIO.
Interior, Olympian Theater,
Vicenza. 1580–84.
Executed by
VINCENZO SCAMOZZI

below: 688.
PALLADIO.
View of stage,
Olympian Theater,
Vicenza. 1580–84.
Executed by
VINCENZO SCAMOZZI

tion so abundantly evident in our experience of any of Palladio's buildings.

His few churches also set out some milestones in architectural history. His grandest interior is that of San Giorgio Maggiore (figs. 684, 685), on its island facing Venice across the Canale San Marco. The design is Albertian in the sense that it is conceived in terms of a single giant order (Corinthian in this case) flanking arches supported by a smaller order, but unlike Alberti's plan of Sant'Andrea in Mantua (see figs. 228, 229), San Giorgio Maggiore retains the traditional side aisles of a basilica. The remarkably sculptural quality of the interior is based on a sustained opposition between engaged columns and pilasters. The inner order consists of smaller pilasters, coupled in depth like the paired columns of Sansovino's inner order in the window embrasures of the Library of San Marco (see colorplate 100); the giant order consists of single engaged columns, and at the corners of the crossing the columns are paired with giant pilasters. The entire effect of the interior is predicated on such combinations of flat and rounded form, and decoration is almost totally eliminated. The frieze, for example, is convex but devoid of ornament; the columns and pilasters are unfluted; and even the acanthus leaves lack the customary indentations, looking more like petals than thistles.

San Giorgio Maggiore was commenced in 1566, but Palladio never lived to see the façade erected from his designs by Scamozzi (fig. 686). In this and other church façades, Palladio presented a perfect solution to the ageold dilemma of the architect confronted with devising a façade for the fundamentally unsatisfactory shape of the cross section of a Christian basilica. At Santa Maria Novella (see fig. 226), Alberti had solved it by bridging the gap between the side-aisle roofs and the central temple shape by means of giant consoles, but this was a mere screen. At Sant'Andrea in Mantua (see fig. 227), he ap-

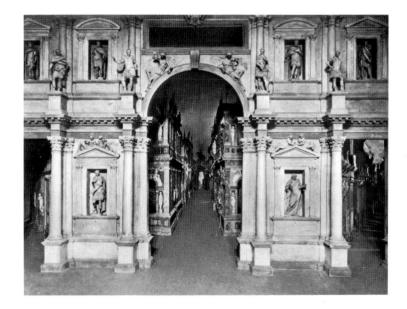

plied to a much larger church a smaller façade, facing the piazza and hidden partly by its campanile, partly by houses—and it was not a basilica anyway. Palladio simply adopted Alberti's notion of the two interpenetrating orders of the Sant'Andrea façade, and amplified it into two intersecting temples, one low and broad to accommodate the side-aisle roofs, and articulated by pilasters, one tall and slender to embrace the lofty nave, and divided by engaged columns. The solution was ingenious, harmonious, and definitive, and it was never used again. Why? Perhaps because any further use of this principle could only appear to be an imitation. The major architects of the seventeenth century, influenced as they were by Palladio's ideas, had their own special problems and devised their own solutions. But Palladio's interlocking temples have a dense and perfect beauty of their own, and are unforgettable.

Like all the leading architects of the Renaissance, Palladio was destined never to see his major designs completed. Perhaps the most delightful of the structures executed by Scamozzi after Palladio's death was the Olympian Theater at Vicenza (figs. 687, 688), one of several learned Cinquecento attempts to re-create, usually in temporary materials such as wood and stucco, the shape and appearance of a Roman theater. The building is, of course, typical of the classicistic ideals of the elegant society for which Palladio built and in which he moved, and was intended for the production of classical drama. The stage is provided with fixed scenery, on the principle of the ancient Roman scenae frons, of which a number of examples, especially that at Orange in southern France, were known to the Renaissance, but the arrangement of columns, postaments, statues, tabernacles, and reliefs, on two stories and an attic, follows no exact model. What connects Palladio most closely with the painters of his day, notably Tintoretto and Veronese, is the entirely unclassical way in which the three central openings lead into radiating streets that seemingly terminate only at a vast distance from the stage. The illusion of perspective is, however, given entirely by a rising pavement and by the diminishing height of the buildings that line these avenues. The visitor, therefore, who penetrates as far as the stage is disconcerted to discover that these attractive Renaissance palaces are only a few feet in depth, and that as he walks up the street, the street comes up to meet him and the rooftops descend. He has, of course, violated the basic principle of Renaissance perspective by retaining his own proper height when according to its unalterable laws he ought to have shrunk.

ALESSANDRO VITTORIA

Like the architects, all the sculptors of any consequence working in Venice in the Cinquecento came from elsewhere (so did three of the four greatest purely Cinquecento painters, as we have seen). Skillful, sometimes even brilliant though these sculptors often are, however, none of them can compare in quality and originality with their great contemporaries in painting and in architecture. With its predominantly pictorial interests, Venice does not seem to have encouraged great sculpture, and the undeniable fact is that every one of the truly great Italian Renaissance sculptors came from Tuscany, and all but two of them were Florentines, native or adopted.

Nonetheless, sculpture was needed, for tombs, for altars, for exterior decoration, and the best of it managed to partake of the pictorial quality of the architecture into which it fitted or the paintings that surrounded it.

Alessandro Vittoria (1525-1608), who came from Trent, in the gloomy cleft of the Adige Valley north of the plain of the Po, and astride the direct route to Austria, is clearly related to the great innovators in painting. He was probably the most gifted of the Cinquecento sculp-

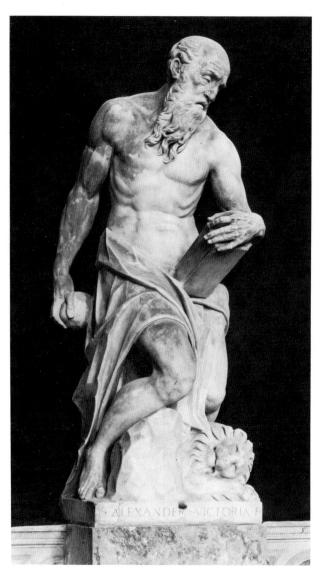

689. ALESSANDRO VITTORIA. St. Jerome. 1576 (?). Marble, height 661/2". Campo SS. Giovanni e Paolo, Venice

tors in Venice, and his St. Jerome (fig. 689), originally done for the Scuola di San Fantin, seems to be the statue on which the artist was at work in 1576. All the lessons of Central Italian anatomy have been learned, but the figure is now fully caught up in the current of Counter-Reformation religiosity that flows from the intensely mystical works of the late Titian and Tintoretto. The work is in itself more pictorial than sculptural. The penitent saint, withdrawn from the world in a state of selflacerating catatonia, seems almost to be floating over his rock rather than kneeling on it. His lion is reduced to a mere symbol; the sculptor has concentrated with deadly accuracy on the play of swollen veins in arms and hands and, above all, on the shuddering muscles and the look of terror at the emptiness within.

20 Michelangelo and the Maniera

he final paradox in the history of Italian Renaissance art is the coexistence, during the same decades of the middle and late Cinquecento, of the late style of Michelangelo and of the culminating phase of Mannerism, more accurately termed the Maniera. Michelangelo was an artist of the utmost individuality, sincerity, and directness; yet the artists of the Maniera, although they placed Michelangelo at the summit of greatness in their writings and regularly borrowed figures, groups, and compositional ideas from his works, systematically devoted themselves to principles of standardization, artificiality, and elaboration, which they proceeded to institutionalize by founding the Florentine Academy in 1563. The explanation is probably to be sought not only in the disparity in quality between Michelangelo and his Mannerist contemporaries; in the enormous age gap (the prime movers of the Maniera were all about thirty-five years younger than he); or in the fact that Michelangelo had been one of the founders of High Renaissance style—for, as we have seen, this had not prevented him from devising inventions of a strikingly different sort in Florence between 1516 and 1534. It should be kept in mind that Michelangelo never relaxed his republican principles, although briefly toward the end of his life he did entertain the possibility of returning to Florence to work for Duke Cosimo I. He kept aloof from dynastic patrons save when they promised the liberation of Florence, and worked for the Churchat times without pay—and for himself. The leaders of the Maniera, to a man, were court artists, and their art, in linear and formal complexities that matched the elaborate allegorical conceits of its content, was chiefly intended to glorify dynastic rule, court society, and a highly formalized version of religion. It is not surprising, therefore, that scholars have detected a trace of similarity between the Maniera of the sixteenth century and the International Gothic style of the early fifteenth, which, as we have noted, was in essence an emanation of the princely courts. Despite the almost universal veneration

in which Michelangelo was held (the opposition of the followers of Antonio da Sangallo the Younger is a note-worthy exception), in his old age he was both an anachronism in Central Italy and, in architecture at least, a prophet of the Baroque.

MICHELANGELO AFTER 1534

The central monument of mid-Cinquecento painting in Rome is Michelangelo's Last Judgment (colorplate 101), painted in 1536-41, that is, between the artist's sixtyfirst and sixty-sixth years. When Pope Clement VII first discussed with Michelangelo early in 1534 the fresco he wished for the end wall of the Sistine Chapel, to replace the Assumption of the Virgin by Perugino, the subject was to be the Resurrection, to which the Medici Chapel in Florence had been dedicated. But when, after Clement's death that same year, the commission was given to Michelangelo by the new pope, Paul III (see Titian's portrait, fig. 648), the Last Judgment must have seemed far more appropriate to the situation of Rome and the papacy in the 1530s. Images of justice and of punishment, sacred and secular, had already appeared on a grand scale in many portions of Italy (Beccafumi's Fall of the Rebel Angels, fig. 604, and Giulio Romano's and Perino del Vaga's frescoes of the Fall of the Giants, fig. 602 and figs. 627, 628, are only three of the numerous examples). The new subject was to fill the entire wall, from the level of the altar to the edge of the vaulting. Certainly, the idea captured the imagination of the aging master, who devoted a remarkable series of studies to the development of the huge composition with its torrents of figures and to the careful definition of the figures themselves. Possibly he had little compunction in tearing down two more frescoes by Perugino, the Nativity and the Finding of Moses, both essential to the narrative program of the fifteenth-century cycles lining the side walls of the chapel (see Chapters 13 and 14), and he may have sacrificed quite cheerfully the end windows and their flanking figures of popes. But it is difficult to imagine his feelings on ordering the destruction of his own lunettes over the windows, representing the first seven generations of the ancestry of Christ. In his construction of the new composition, he did at least retain the autonomy of the two lunettes, separated from the rest of the wall by the edges of the floating clouds in which they are enveloped. He also preserved the axes of the spandrels above (the cross on which Haman is crucified, and the columnar staff of Moses around which the Brazen Serpent is wrapped; see fig. 528) in the diagonals of the Cross and of the column carried by angels in the left and right lunettes in the wall below.

For the rest of the gigantic fresco, Michelangelo dissolved the end wall of the Chapel as if it had fallen away in an earthquake. Medieval Last Judgments (generally inside the entrance wall of churches) are solid hierarchical structures in which all figures, including sometimes even the resurrected dead, are customarily dressed according to their social position, and Christ, the Virgin, and the Apostles are suitably enthroned in heaven; instead, Michelangelo has represented a unified scene without any break, without thrones, without insignia of rank, generally even without clothes. In a vast space stretching from just above the altar and the doors at either side up to the clouds of the lunettes, and in a huge clockwise motion that has been compared to a wheel of fortune, figures rise from their graves, gather round the central Christ, and sink downward toward Hell.

What gives the fresco its special character is the vision of the Second Coming in Matthew 24:30–31:

And then shall appear the sign of the Son of man in heaven: and then shall all the tribes of the earth mourn, and they shall see the Son of man coming in the clouds of heaven with power and great glory.

And he shall send his angels with a great sound of a trumpet, and they shall gather together his elect from the four winds, from one end of heaven to the other.

The airy background of the fresco, of course, should not be construed as infinity; the notion of infinite space had occurred to nobody in the 1530s. It is simply the fulfillment of Christ's words a few verses later: "Heaven and earth shall pass away." In fact, only enough of the earth is shown to contain graves from which the dead can crawl. Some corpses are well preserved, some skeletons, in conformity with a tradition appearing in monumental form in Signorelli's Orvieto frescoes (see fig. 489). The dead show no joy in resurrection or in the recognition of those they knew in life, only dread of the Dies irae taking place around and above them. Some are still dazed, others hopeless; some look upward in awe and wonder. Some soar as if drawn upward by magnetic attraction; others are fought over by angels who lift them, or by demons who drag them down (fig. 690).

The nudity of most of the figures, so shocking to the prudery of the Counter-Reformation that Michelangelo's pupil Daniele da Volterra was later commissioned to paint little pieces of drapery over the offending portions, is perfectly in harmony with Michelangelo's lifelong concern with the human being in its most elemental aspect. Thus not only the dead rising from their graves but also all the elect in Heaven are shown naked before Christ. In the organization of the scene the artist has adopted an arbitrary scale involving striking increases in size as the figures ascend, too sudden and great to be explained by the desire to counteract perspective diminution. The figures are much broader and fuller than those of the Sistine Ceiling, the proportions heavier, the

690. MICHELANGELO. Damned Soul Descending to Hell, detail of *Last Judgment* (see colorplate 101). Fresco. Sistine Chapel, Vatican, Rome

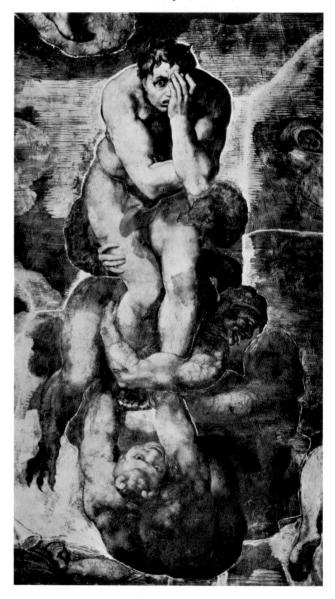

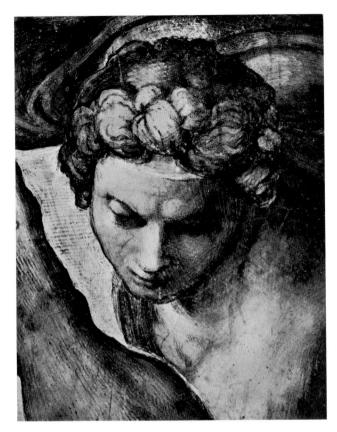

691. MICHELANGELO. Angel, detail of *Last Judgment* (see colorplate 101). Fresco.
Sistine Chapel, Vatican, Rome

heads smaller. As the resurrected dead float upward the women always clothed, the men generally nudecompassionate angels help them into heaven. Wings, like haloes, Michelangelo generally omits as hindrances to the expression of bodily perfection. Only their greater power and their often startling facial beauty (fig. 691) distinguish the angels from ordinary mortals. But the grace of all the figures derives from their motion, which communicates to surfaces and contours a fluid pulsation that is completely new. Throughout the Last Judgment, the dominant color is that of human flesh against the slaty blue sky, with only a few touches of brilliant drapery to echo faintly the splendors of the Sistine Ceiling. The dead rising from their graves still preserve the colors of the earth—dun, ocher, drab. A few patches of red appear in the angels' cloaks. The whole section, moreover, has darkened from the smoke of the candles at the altar.

Around the awesome Judge, the elect are gathered in ranks that run back into the clouds until only the heads can be numbered. Christ is placed in the zone best lighted by the windows on either side, and given a scale still greater than that of the gigantic Apostles who surround him and the Virgin, who appears to shrink into his side. Although his attention is largely occupied with the gesture of damnation—his right hand held on high—his left is extended very gently, as if to summon the blessed up toward him, according to the medieval formula. Instead of the traditional mandorla, a soft radiance extends

from the mighty figure. In spite of some repaint, Michelangelo's beardless and almost nude Christ still shows much of what must have been the artist's original heroic intention, a summation of the more massive canon of proportion on which all the male figures of the fresco are constructed. Among the Apostles before the Judge, St. Bartholomew, who was flayed alive, holds his empty skin; the face is an anguished self-portrait of Michelangelo (fig. 692), revealing as do his letters and his poems the intensity of his sense of guilt and inadequacy:

I live for sin, dying to myself I live; It is no longer my life, but that of sin: My good by heaven, my evil by myself was given me.

By my free will, of which I am deprived.

As the damned descend to their inevitable fate, a few have the temerity to struggle against the angels who drive them from heaven; some rage, but most resign themselves to the overpowering force of divine will. As a child, Michelangelo must have contemplated again and again the torments of Hell as depicted in detail in colossal works in Florence: the mosaic of the *Last Judgment* (see colorplate 3) in the Baptistery, attributed to Coppo di Marcovaldo; Orcagna's frescoes (long since largely destroyed; see page 131) in Santa Croce, Michelangelo's

692. MICHELANGELO. St. Bartholomew, detail of *Last Judgment* (see colorplate 101). Fresco. Sistine Chapel, Vatican, Rome

own parish church; and the Hell by Nardo di Cione in Santa Maria Novella (see fig. 116). He read Dante's Inferno (which Nardo illustrated), and he must have known Giotto's Last Judgment in Padua (see colorplate 9). It is surprising how little these universally known works of literature and art affected him. His interests moved in a realm far beyond that of physical torment, indeed physical experience of any sort. Charon drives the damned from his boat with an oar as Dante says he should, but the oar never touches a body. The only torments shown are spiritual, and only a glimmer of fire appears on the horizon. But Hell Mouth opens up directly above the altar, as a reminder that the celebrant, who might be the pope himself, is in the same mortal danger as all mankind. Leo Steinberg has suggested that for a number of reasons, including the surprisingly gentle expression of Christ and the presence of a broad expanse of water separating the shore from the actual mouth of Hell, Michelangelo and the religious group to which he belonged may not have believed that punishment for sin was necessarily irrevocable. Although seemingly heretical, this view may have been tolerated before the Council of Trent.

Still hounded by the heirs of Julius II on account of the tomb (the reduced version was not dedicated until 1545; fig. 693), then not yet finished, the sixty-seven-year-old artist took up his brushes once again in 1542 and climbed still another scaffold to paint the two principal

693. MICHELANGELO. Tomb of Julius II. Completed 1545. Marble. S. Pietro in Vincoli, Rome

frescoes in the chapel newly constructed by Pope Paul III off the Sala Regia in the Vatican, just outside the main entrance to the Sistine Chapel. Interrupted by illness and other commissions, he worked spasmodically on the two frescoes, representing the Crucifixion of St. Peter and the Conversion of St. Paul (figs. 694, 695). The Pauline Chapel, as it has been named, was not completed until the spring of 1550, several months after Pope Paul's death. The chapel is not easy to visit, and its frescoes are therefore unfamiliar to most students. Yet in spite of passages now in poor condition, the Pauline paintings are among Michelangelo's most powerful works. True, a kind of rigidity has set in, disturbing after the freedom of the Sistine Ceiling or even the Last Judgment, but the artist's powers of expression and of drawing have in no way diminished, and the movement of color shows a freedom and release completely unexpected, in view of the meticulous delicacy of the tones on the Sistine Ceiling or the largely monochromatic quality of the Last Judgment.

Against barren landscapes whose buttes and ridges recall the desolation of the mountains around Caprese, where Michelangelo was born, the terrible events are staged with cataclysmic violence. The fierce Saul, struck down by a ray from the heavenly apparition, falls from his horse on the road to Damascus, whither he was bound for further persecutions of the Christians (Acts 9:3–4):

And suddenly there shined round about him a light from heaven: And he fell to the earth, and heard a voice saying unto him, Saul, Saul, why persecutest thou me?

The vision is here fully corporeal. A sharply foreshortened Christ, shorn of the luminary display customary in representations of this subject, appears in the sky among five angelic platoons whose figures, reminiscent of many in the Last Judgment, have been compressed into blocks, their curves flattened into planes. As Christ moves downward and outward, the equally foreshortened horse leaps upward and inward, splitting Saul's attendants also into blocks of figures. In the foreground the blinded Saul (fig. 696), shortly to become the Apostle Paul—one of Michelangelo's most beautiful figures, yet clearly suggested by Raphael's blinded Heliodorus (see colorplate 74)—falls forward as if struck by some power emanating from the floating Christ. His face reflects the blindness of Homer in ancient busts and the agony of the Laocoön group, on whose restoration Michelangelo had worked. Unexpectedly old (St. Paul was a young man at the time of his conversion), the face with its long, snowy, two-tailed beard was probably intended to suggest that of Pope Paul III (see Titian's contemporary portrait, fig.

The difficult subject of the *Crucifixion of St. Peter* (compare Masaccio's treatment, fig. 204) Michelangelo

left: 694. MICHELANGELO. Crucifixion of St. Peter. 1545–50. Fresco, 20'4"×22'. Pauline Chapel, Vatican, Rome

below left: 695. MICHELANGELO. Conversion of St. Paul. 1542–45. Fresco, 20'4" × 22'. Pauline Chapel, Vatican, Rome

below right: 696. Saul, detail of fig. 695

handled as an elevation of St. Peter's cross. The configuration becomes a hollow square, tilted up with the rising movement of the landscape and traversed by the powerful diagonal of the cross. Yet for all the massiveness of the figures, they are strangely weightless, floating, phantasmal. In spite of the emphasis on block shapes, the foreground figures now stand on the ground, now rise from nowhere, cut off at the waist or knee by the frame.

Renaissance perspective, always uninteresting for an artist so much more responsive to tangible than to optical effects, is abandoned, and with an archaistic disregard of real space, what is behind is represented as above. The strange composition, with its ranks of figures floating upward, generally facing the observer, culminates in an awestruck group silhouetted against the distant promontories. They look down, or at each other, with the

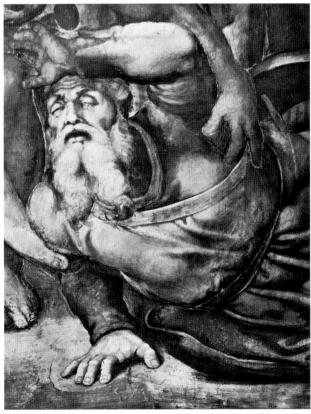

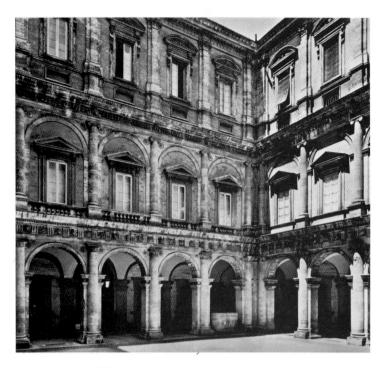

697. ANTONIO DA SANGALLO THE YOUNGER and MICHELANGELO. Courtyard, Palazzo Farnese, Rome. 1517–50

same expressions of trancelike wonder, and these are shared even by the soldiers and executioners. Few figures are shown in action. Contrapposto has disappeared almost entirely. So have hatred, anger, and all emotions save awe and fear. As in a Passion play, in which the actors are all townsfolk, there is little distinction between executioner and martyr, pagan and Christian. The universal becomes strangely intimate and personal, the drama a ritual.

When he finished the Pauline frescoes in 1550, Michelangelo was seventy-five. His failing eyesight and his general ill health prevented his undertaking any further monumental pictorial commissions, but he could still carve stone and design buildings. As his control of the immediate circumstances of practical existence and visual reality faded, his architectural forms became always

grander and more richly articulated, as if the sense of mass, which in his earlier art had arisen from the human figure, had now outgrown it and could function on its own in the abstract shapes of architecture. Aside from his continued long-distance supervision of the details of the Laurentian Library (see figs. 578, 579), which he never again revisited, two of Michelangelo's three most important late architectural projects had been commenced by Antonio da Sangallo the Younger (see pages 583–84).

We have seen the effect Michelangelo's central window and colossal cornice had on Antonio's façade of the Palazzo Farnese (see fig. 620). But it was in Antonio's classic courtyard that Michelangelo intervened with revolutionary results (fig. 697). He carried out Antonio's second, Ionic story with only minor changes. But in the third story he demonstrated his sovereign originality by abandoning the notion of engaged columns, substituting pilasters on lofty postaments (whose height was governed by that of a little mezzanine story inserted for servants' quarters); each pilaster is flanked by a half-pilaster on either side and each postament by a half-postament. These clustered pilasters, the architectural counterpart of the clustered and vibrating figures of Michelangelo's pictorial and sculptural compositions, introduce a new organic richness and near-human vibrancy to the static, almost inert quality of the architectural elements designed by Antonio. It was this new vitality that architects of the seventeenth century especially admired in Michelangelo, and in a sense he was sowing the seeds of Baroque architecture at this moment. He communicated the same quality of tension and inner life to the superb windows he designed for the third story, related to the Medici Chapel tabernacles (see fig. 568) but somewhat more restrained. Broken sills with pendant moldings at the corners, fantastic consoles, lions' heads, broken moldings inside the arched pediments are all related to the bold, dramatic effects Michelangelo also obtained in his brilliantly original articulation of the exterior of St. Peter's.

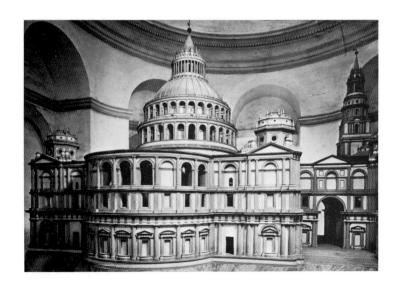

left: 698. ANTONIO DA SANGALLO THE YOUNGER. Model for St. Peter's, Vatican, Rome. 1539–46. Wood. Museo Petriano, Vatican, Rome

right: 699. MICHELANGELO. Plan of St. Peter's, Vatican, Rome. 1546–64

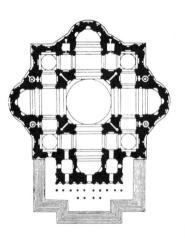

Here Michelangelo took over totally. Antonio the Younger had continued the construction of Bramante's basic project; in fact, the four great piers and four great arches to uphold the dome had been built and could not have been changed in any essential respect (see fig. 503). Vasari's fresco (see fig. 721) shows the state of affairs at that time, with Paul III directing it all. The Albertian coupled pilasters are already built according to Bramante's designs; the barrel vaults of the transept still have their wooden centering; Bramante's colossal temporary Doric construction around the apse appears at the left of the building, and at the right a portion of the nave of the old Constantinian Basilica of St. Peter's still stands. But in the center, masons are laying the stones of the feature Michelangelo particularly disliked, the ambulatory set by Antonio outside the apsidal terminations of Bramante's transept and chancel—as can be seen on the plan that allegorical figures are presenting to the pope—part of a system of galleries and loggie designed to inflate the total bulk of the church to almost double its already gigantic size. The model (fig. 698) shows that the Doric order of the ambulatory would have supported a high mezzanine and a higher Ionic second story, whose largely open arches had no other purpose than show. The space covered by the nave of Old St. Peter's would have been incorporated into the new church by means of an open gallery, connecting the main building with an almost independent façade, culminating in two campanili as lofty as the dome.

Admittedly, Antonio's design is fantastic. At no point can the eye select a single dominant feature; always it has to choose between two of apparently equal importance.

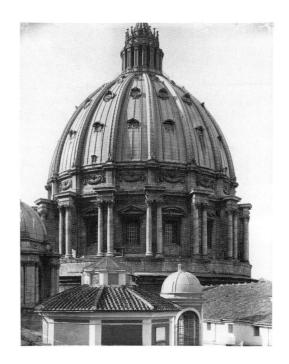

Even the dome has two superimposed peristyles, and the ribbed shell (instead of Bramante's hemisphere) is crushed between the peristyles and the outsize lantern. At the four corners Bramante's towers are converted into strange octagonal structures lighted by oculi, and these excrescences—including the peristyles, the lantern, and the campanili—bristle with obelisks. If there is such a thing as Mannerism in architecture, surely this is it.

Michelangelo wrote a devastating letter criticizing the design as Germanic, pointing out that it would take an army of guards to clear the open loggie at nightfall, that they would provide shelter for all kinds of crime, and (worst of all) that in order to construct the ambulatories whole sections of the Vatican, including the Sistine Chapel and the Pauline Chapel, would have to be demol-

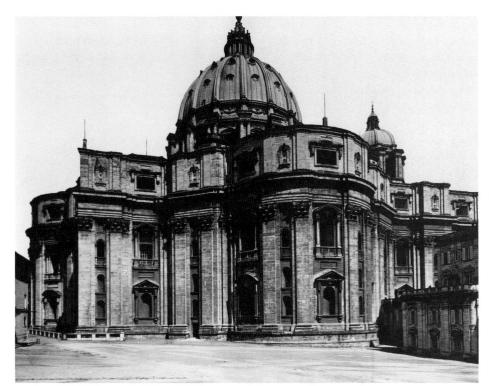

left and above: 700.

MICHELANGELO. St. Peter's,
Vatican, Rome. General view from southwest, and aerial view of dome. 1546–64

ished. Whoever departed from Bramante, Michelangelo said, departed from the truth. He accepted the commission without pay, for the salvation of his soul, and proceeded to substitute a new and mighty order for the wild (and exceedingly expensive) schemes of Antonio da Sangallo the Younger. First went the ambulatories, then the façade with its towers. The Greek-cross plan of Bramante was reinstated (fig. 699; see also fig. 502), along with the idea of a single colossal order on the exterior. In the interests of the stability of the dome, however, Michelangelo also suppressed Bramante's smaller Greek crosses in the reentrant angles, substituting simpler domed spaces (two exterior domes, built later, probably reflect Michelangelo's designs) and increasing the bulk of the piers. The façade was to have been a temple shape of freestanding columns, entirely subordinate to the crowning effect of the dome.

In order to unify the entire exterior of the building (fig. 700), as if it were a sculptural group, Michelangelo adopted a single embracing theme, the idea of the coupled Corinthian order, using pilasters in the main mass of the church enclosing two stories of windows, and columns in the peristyle and lantern of the dome. He retained the Florentine ribbed dome in preference to Bramante's hemisphere, but divided it by twice the number of ribs, and even these and the ribs of the culminating cone of the lantern are paired (fig. 701). Thus the entire church, from the ground to the sphere poised on the lantern, gives the impression of a colossal monolith. To increase its unity and density, Michelangelo cut off the reentrant angles of the transept with diagonal masses,

again articulated by coupled pilasters, and even intended to fill the sharp angles of the entablatures projecting from the peristyle of the dome by consoles curling upward from the pedestals of statues. Unfortunately, these were never carried out. At his death, in fact, the drum and the peristyle of the dome were still under construction. The shell as finally built was lengthened somewhat from Michelangelo's original design, which was lower and closer to a hemisphere, but by and large the effect of the building, seen from the sides or back, follows his intentions. The dome, of course, is lost from the façade view because the nave was prolonged in the early seventeenth century.

The grand unity of the structure embraces immense complexities, in the forms of the windows and in the half-pilasters within the mass of the building, like figures emerging from a block. But in the warfare between wall and column, which had reached a deadlock in the Medici Chapel and the Laurentian Library, the column has at last won. Nonetheless, the struggle continues in many details of the interior. The extraordinary apse windows, for example, are capped by broken pediments that seem crushed by the concave entablatures above them (fig. 702). The glass areas, astonishingly enough, remain flat inside their concave frames. While the basic forms and spaces of the interior were decided by Bramante (save for the floor level, sharply raised by Antonio and thereby shortening Bramante's giant pilasters), Michelangelo was able to alter the apse vaults, which he turned into neo-Gothic ribbed vaults instead of the semidomes Bramante would have desired. Since Michelangelo was

701. MICHELANGELO. Model for dome of St. Peter's, Vatican, Rome. 1558–61. Wood. Museo Petriano, Vatican, Rome

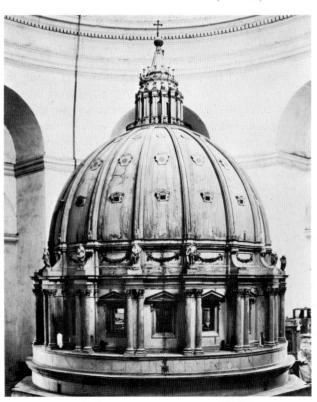

702. MICHELANGELO. Window in north transept, St. Peter's, Vatican, Rome. 1546–64

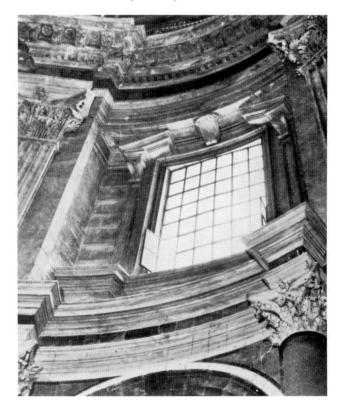

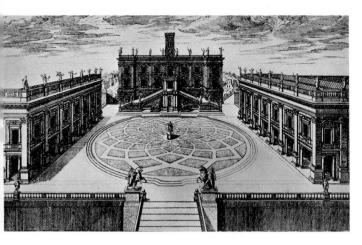

703. MICHELANGELO. Campidoglio, Rome. 1538–64. Engraving by ÉTIENNE DUPÉRAC, 1569

Michelangelo's single but enormously influential contribution to civic design was the project for the remodeling of the partly ruined structures that crowned the Capitoline Hill (fig. 703). Much against his will, he was constrained in 1538 to move the Roman bronze equestrian statue of Marcus Aurelius, then still considered a portrait of Constantine, from its original position near the Basilica of St. John Lateran to the center of the Campidoglio; at that time he provided the statue with its present partly ovoid base, and designed an intricate double flight of steps leading to the Palazzo Senatorio. Although there is still controversy on the subject, the weight of evidence is on the side of those who claim that Michelangelo made no further designs for the Capitoline before 1561, when real work on the project began—the Palazzo dei Conservatori, in fact, was not started until 1563, the year before his death. Certainly, he was responsible for the general idea of the project, whose two facing palaces, the Palazzo dei Conservatori and the Palazzo Nuovo, had to run at a slight angle to each other on account of the configuration of the terrain and of the preexisting structures that had to be incorporated into the new buildings. The beautiful design of the pavement, with its pattern of radiating, interlocking petals in travertine (its significance as symbolizing the placing of Roman rule at the umbilicus of the world has been analyzed in great detail), is his. He never saw the completion of the Palazzo dei Conservatori (fig. 704), which was built from drawings in his latest style, under the supervision of Tommaso Cavalieri (see page 548). The central window is a misunderstood version by his follower Giacomo della Porta of Michelangelo's own window in the second story of the Palazzo Farnese (see fig. 620). Nonetheless, the revolutionary design of the building is Michelange-

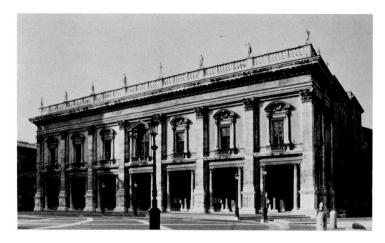

704. MICHELANGELO. Palazzo dei Conservatori, Campidoglio, Rome. Begun 1563

lo's. The structure is, like St. Peter's, embraced and clamped tight by a single colossal Corinthian order, within which a stunted Ionic order for the portico maintains an imprisoned existence. The flat roof of the portico and its straight entablature, in preference to an arcade, are typical Michelangelisms.

In the aged artist's last letters and poems, death is always near. But he no longer dreams of the mighty Creator, nor even of the awesome Judge, but rather of the self-immolating Victim, the merciful Redeemer. His visionary drawings of the crucified Christ are dedicated to

That Love divine Which opened to embrace us His arms upon the Cross.

Sometimes the sacred figures are unable to bridge the gap that separates them from God, and cry soundlessly in the void below the Cross; sometimes (fig. 705) the same last shudder that pierces the Crucified unites them with him, as they embrace him, pressing themselves against and into him, merging their being in his. Michelangelo's eyesight is no longer clear, his hand shakes, and the contours tremble, but vague though the shapes are, their volume is still overwhelming and the mighty forms and tensions of his last architectural masses group the misty figures into shapes of a grand simplicity.

Two unfinished and broken *Pietàs* remain as sculptural witnesses of Michelangelo's inner life in his last years. One, carved before 1555 (fig. 706), was meant for his own tomb. In a fit of desperation (he claimed the stone was too hard and would not obey him, but doubtless there were psychological reasons besides) he started to destroy the work. He had already carefully removed the left leg, apparently to replace it, but he smashed the rest of the group in several places before his pupils stopped him. They were able to piece together the breaks fairly well but the leg has entirely disappeared. In spite of this mutilation, and an ill-advised attempt by one of the pupils to finish the figure of the Magdalen, the effect of the group is irresistible. The theme is the relentless power of death, drawing Christ himself downward into the tomb

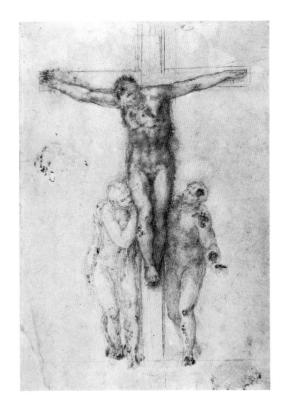

above: 705. MICHELANGELO. Crucifixion. 1550–60 (?). Black chalk, 163/8×11". British Museum, London

below left: 706. MICHELANGELO. Pietà. Before 1555. Marble, height 92". Cathedral, Florence

below right: 707. Joseph of Arimathea, detail of fig. 706

with a force that the human figures are powerless to prevent; and the Madgalen, the Virgin, and Joseph of Arimathea sink with him. It should be remembered that Joseph of Arimathea was the rich man who turned over to Christ his own freshly cut tomb. In the features of this compassionate, quiet, bearded man Michelangelo has represented his own (fig. 707); like Joseph, he welcomes Christ to his own tomb and presses the sacrificed head into his bosom, merging his identity with that of divinity, in whose ultimate being he knew his own must soon be dissolved. The difference between this gentle, controlled self-image and the agonized one in the face of the empty skin hanging in the air below the damning Christ of the Last Judgment (see fig. 692) gives us a new insight into the final transformations of Michelangelo's life and art. Rough though the unfinished surfaces may be, the emotional and spiritual relationships, the power and beauty of the forms and the composition need no analysis.

Only a few days before his death in February 1564, Michelangelo took another *Pietà* that he had started to carve ten years or so earlier and began work on it again (fig. 708). It went through at least two different stages. The original group, which was probably very nearly finished, consisted of the Virgin holding the slender dead Christ in her arms as if lifting him up before us in the spirit of the *Sistine Madonna* with her Infant Son (see fig. 543) or of Michelangelo's own designs for the Virgin on

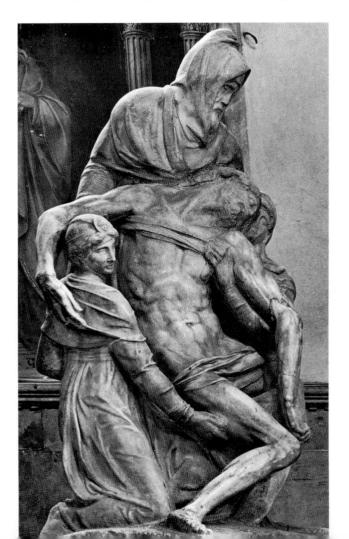

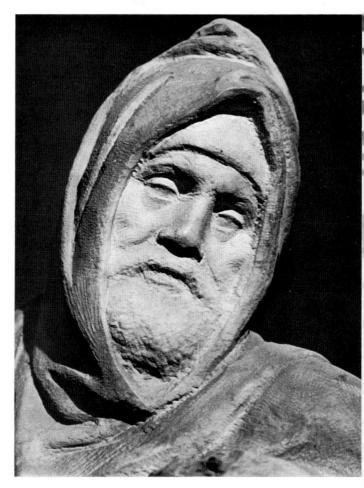

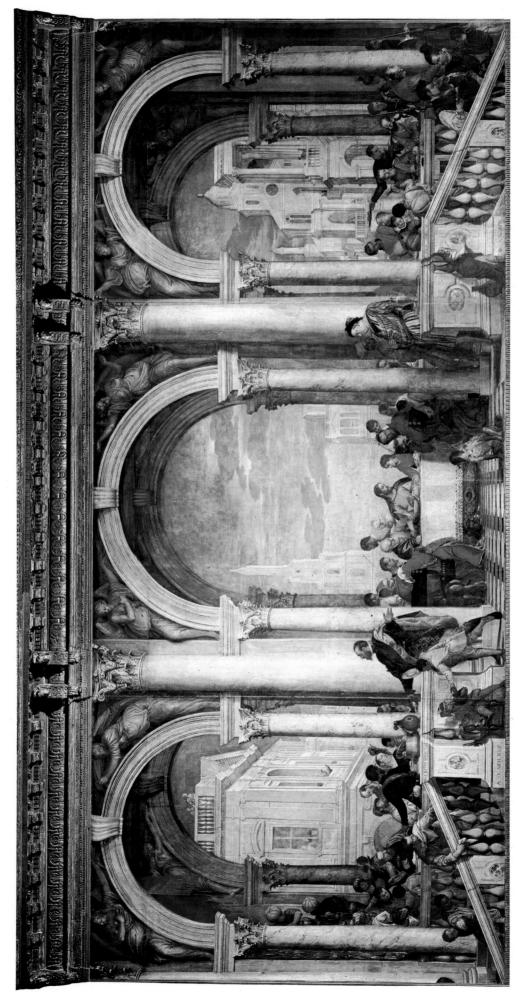

Colorplate 98. VERONESE. Feast in the House of Levi. 1573. Canvas, 18'3" × 42'. Accademia, Venice

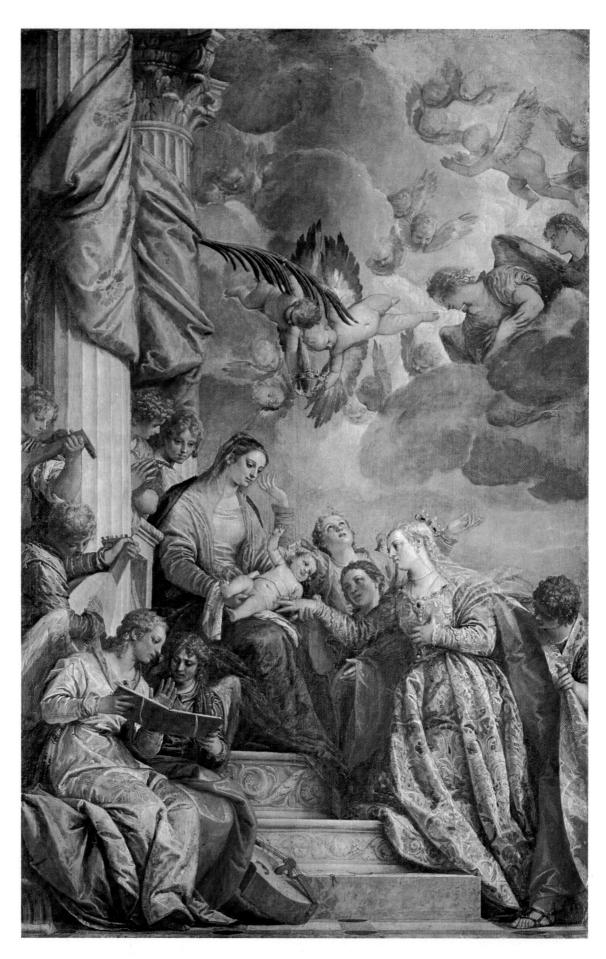

Colorplate 99. Veronese. Mystical Marriage of St. Catherine. Probably 1570s. Canvas, $12'5'' \times 7'11''$. Accademia, Venice

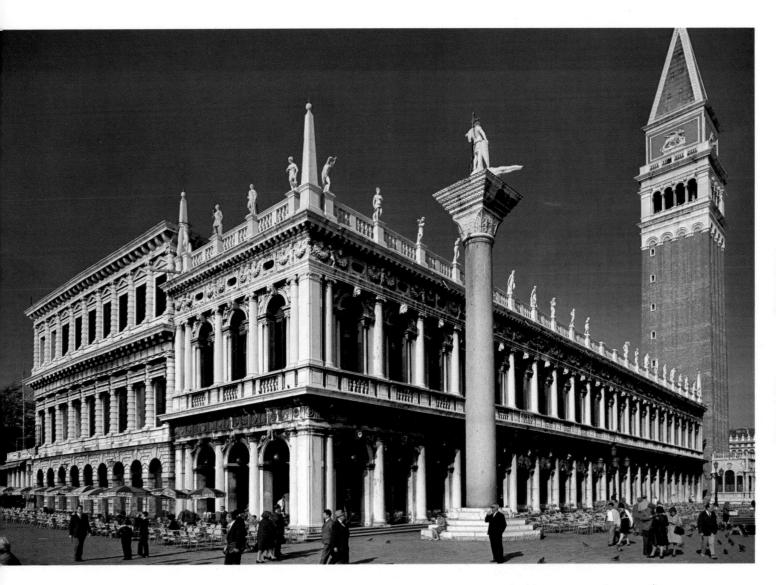

Colorplate 100. JACOPO SANSOVINO. Library of S. Marco, Venice. Begun 1537. (Finished by VINCENZO SCAMOZZI)

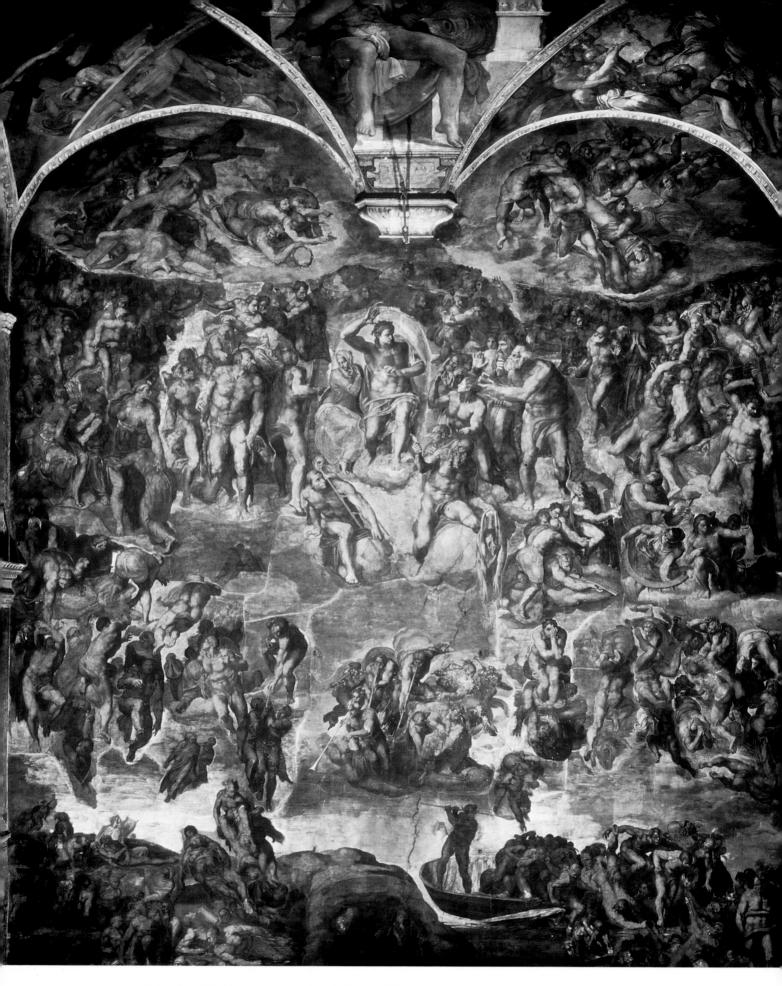

Colorplate 101. MICHELANGELO. Last Judgment. 1536–41. Fresco, 48 × 44'. Sistine Chapel, Vatican, Rome

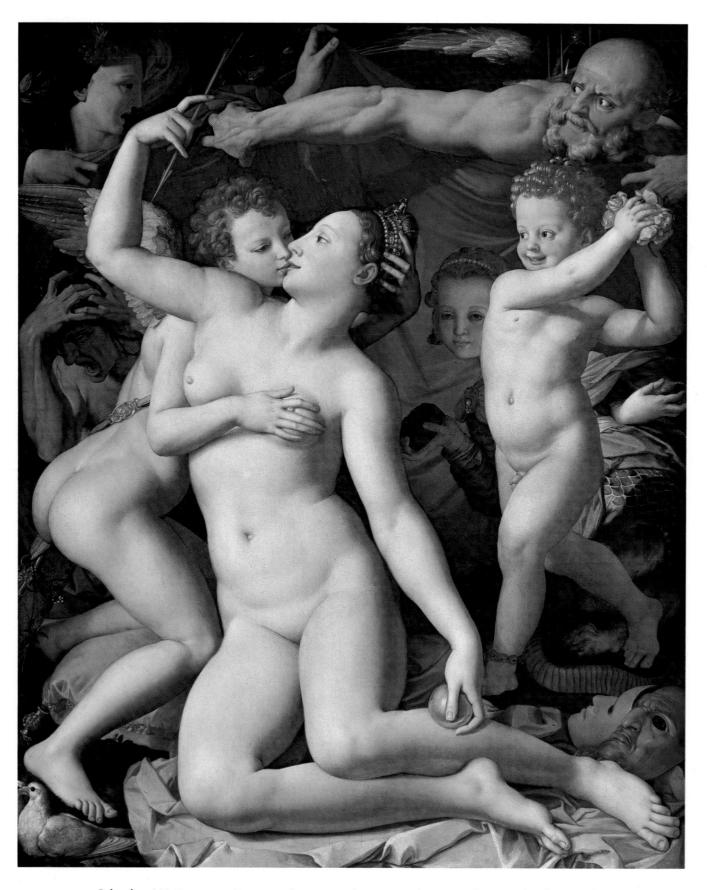

Colorplate 102. Bronzino. *Exposure of Luxury*. Mid-1540s. Panel, $61 \times 56 \%$. National Gallery, London

Colorplate 103. Francesco Salviati. Fresco decoration. c. 1553. Salone, Palazzo Sacchetti, Rome

Colorplate 104. Giorgio Vasari. Perseus and Andromeda. 1570–72. Oil on slate, $451/2 \times 34''$. Studiolo, Palazzo Vecchio, Florence

Colorplate 105. Federico Barocci. *Madonna del Popolo*. 1575–79. Panel, $11'9\%" \times 8'31/4"$. Uffizi Gallery, Florence

the Tomb of Julius II. But in a last feverish burst of activity he cut away the head and shoulders of the Christ, leaving the right arm still hanging, and began to fashion a rough, new head for Christ out of the Virgin's shoulder and bosom. In the beginnings of a third stage he cut into the new heads, drawing them even closer together in an intensification of the process of merging we have seen in all his late work. One gets the feeling, not that they are sinking into the grave, but that the Virgin is standing at its brink and that Christ floats weightlessly in her arms, as if this were less the Entombment than the Resurrection. Through the successive ghostly stages of shattered marble, the chisel, a love of which the artist drank in with his foster-mother's milk, seeks the final riddle of identity between Son and mother and gives Michelangelo's own features to the sacrificed Christ. Six days before his death, at nearly eighty-nine, he was still working on the group. He fell ill after exposure to the rain, at first refused his pupils' counsel to go to bed, and eventually succumbed, probably to pneumonia. In his dictated will he consigned his soul to God, his body to the earth, his belongings to his nearest relatives, and asked the friends around him, including Cavalieri, to remember in his death the death of Christ.

THE MANIERA

After such disclosures one turns with difficulty to the

708. MICHELANGELO. Pietà. 1554-64. Marble, height 633/8". Castello Sforzesco, Milan

artists of the Maniera. Often charming in their own right, they are vastly inferior to the level reached not only by Michelangelo but also by the other co-founders of the High Renaissance, and all of them, with the shining exception of Bronzino, are inferior even to the disordered and poetic spirits of the Mannerist crisis of 1520. These new men believed that they stood, with Michelangelo, at the summit achieved by art since antiquity; Vasari, in his own writings, seems persuaded that he and his contemporaries had discovered the perfect formula for grace of body and feature and for beauty of composition. Of course, their contemporaries in Venice, where the Renaissance still flourished, were by no means convinced. The Venetian Ludovico Dolce uses the word maniera derogatorily to refer to the artists in whose paintings the faces and figures had a tendency to look too much alike: to Vasari, this was a distinct advantage in that it speeded up production time. In the last analysis one's estimate of the Maniera is a matter of personal taste and judgment, but it is hardly open to question that by the middle of the Cinquecento in Central Italy the Renaissance, in its etymological sense of "rebirth," was over. Snatches of Michelangelesque and Raphaelesque, even Leonardesque, melodies linger on, whole motives are sometimes borrowed, but the world has changed: the artist no longer experiences the excitement of discovery, and Nature, the ultimate deity for Masaccio, Alberti, Antonio del Pollaiuolo, and Leonardo, has taken second place, as compared with the primary role assigned to the refined inventions of the cultivated artist. What follows, therefore, is in a sense an epilogue.

THE MICHELANGELESQUE RELIEF

Michelangelo is known to have planned a number of sculptural reliefs for inclusion in the Tomb of Julius II and other undertakings, and the author has attempted to connect a number of his drawings with these reliefs. We are still in a quandary as to what their style might have been, since the only reliefs we possess by his hand are the Battle of Lapiths and Centaurs and the three Florentine Madonnas (see figs. 468, 467, 476, 511). Would the marble panels have been carved in low or high relief? And what would have been the appearance of those in bronze? We have a remarkable insight in a large marble low-relief panel representing Cosimo I as Patron of Pisa (fig. 709) by Pierino da Vinci (probably 1521-54), a young Florentine Maniera sculptor deeply influenced by the great master, whom he had met in Rome. The relief, dated in 1549, shows the duke of Florence uplifting with his left hand a transparently garbed, Venus-like figure representing Pisa holding her coat of arms, while with a general's baton in his right he drives away her enemies, unspecified but laden with plunder. Behind him reclines the bearded River Arno, water gushing from his enormous jar, doubtless deriving from one of Michelangelo's river gods for the Medici Chapel—a reference to Cosi-

709. PIERINO DA VINCI. Cosimo I as Patron of Pisa. 1549. Marble, 287/8 × 63". Museo Vaticano, Rome

mo's plans to deepen the Arno, rebuild the port of Pisa, and connect it with a canal to the newly built port at Livorno. Among the other allegorical figures, the University of Pisa, which Cosimo reorganized and reestablished, is visible holding a great book. The relief is carved in an exquisite emulation of Michelangelo's Madonna of the Stairs (see fig. 467), defining with linear perfection the polished Michelangelesque figures in low and still lower relief. In the background at the left a galley can be seen, and the sculpture would, if finished, doubtless have shown other vessels. The fact that Pierino's groups in the round are almost slavishly dependent on the Victory for Julius' tomb (see fig. 582) lends authority to the belief that Michelangelo's marble reliefs might have looked like this. But there is another possibility for those in bronze, suggested by the work of another Michelangelo imitator, Vincenzo Danti from Perugia (1530-76), who also produced groups based on the Victory. His large relief depicting Moses and the Brazen Serpent (fig. 710), probably of the 1560s, suggests the hazy, sketchy style of Michelangelo's composition drawings, translated directly into bronze, with a wide variety of projections and free handling of detail utilized to produce, as the light moves over the glossy surface of the bronze, an equivalent of the chiaroscuro effects and floating contours of rapid drawing in charcoal or chalk (see fig. 574). The composition is obviously based on Michelangelo's spandrel for the Sistine Ceiling (see fig. 528) in which, however, Moses is relegated to the background. Danti, instead, has placed the tall, bony figure of the lawgiver so that his right hand and the staff around which the Brazen Serpent is entwined are exactly centered. Around and behind him in indescribable tumult are heaped the writhing figures of the Children of Israel, the men mostly nude, their poses often borrowed from the Last Judgment, to display Danti's prowess as an anatomist in the best Michelangelo tradition. The effect of distance, into which the figures recede in countless numbers, is achieved by the spontaneity of hand and tool in modeling the original clay or wax—probably the latter—from which a mold was taken for the cast in bronze. Even in the figures and the drapery all these accidental effects are preserved. As a result, Danti is able to communicate the effect not so much of a historical event as of a marvelous vision, both of healing and of salvation, revealed in a thunderclap.

BENVENUTO CELLINI

Among the host of sculptors who found work in Florence under the Medici rulers of the middle and later Cinquecento, the most familiar figure is Benvenuto Cellini (1500–1571), partly because his highly entertaining Autobiography is so widely read. After many years of activity as a goldsmith in Rome, including hair-raising adventures during the Sack of 1527, and after a prolonged stay in France, Cellini settled in Florence, where he attracted the attention of Duke Cosimo I. In 1545, Cosimo asked him to do the Perseus and Medusa (fig. 711); owing to the difficulty of casting a figure of this size in bronze by means of a novel experimental technique, it occupied him until 1554. Although the proportions of this celebrated work are considerably heavier than those of Cellini's preserved earlier models for it, the statue is one of the most successful sculptural creations of the Maniera.

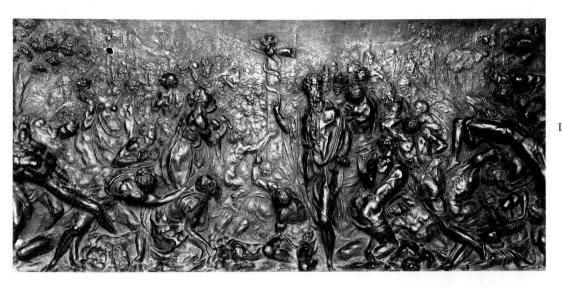

710. VINCENZO

DANTI. Moses and the

Brazen Serpent.

Probably 1560s.

Bronze. Bargello,

Florence

The destination of the work for the Loggia dei Lanzi, where Donatello's Judith and Holofernes (see fig. 292) was then installed, probably caused Cellini to devise a rough parallelism between the triumphant male and female figures, the defeated enemies, and even the cushions used for the bases—iconographically justifiable in the case of the Judith, but hard to understand for Perseus. The modeling of the nude figure shows the most careful study of anatomy, the play of light on corporeal surfaces, and the infinity of possible profiles, in the tradition of Michelangelo's marble nudes. But it remains remarkably inert, as if incapable of motion. There is no attempt, as in Donatello, to evoke horror by the moment of brutality; the very perfection of workmanship, born of Cellini's training as a goldsmith, congeals the possibility of drama. The rich locks of Perseus' hair, the writhing serpents, even the torrents of blood gushing from the severed head and the truncated neck are transformed into ornamental shapes similar to those that animate the decoration of the marble pedestal. Like Michelangelo in the Pietà in St. Peter's, Cellini placed his signature in large letters on a strap crossing Perseus' breast, motivated probably by reasons similar to those that prompted Donatello to sign the Judith "OPVS • DONATELLI • FLO[RENTINVS]" after his return from work in another

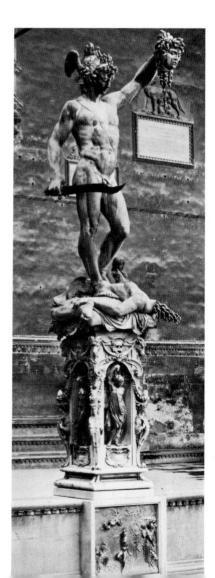

BARTOLOMMEO AMMANATI

A sculptor much closer to Michelangelo, in fact protected and often supervised by him, was Bartolommeo Ammanati (1511-92). A Sea Nymph (fig. 712), probably executed by an assistant using Ammanati's model, from the Fountain of Neptune, which occupied Ammanati and his shop from 1560 to 1575, is instructive with regard to the relation of the Maniera artists to Michelangelo-in its obvious derivation from the Dawn in the Medici Chapel (see fig. 572), and its equally obvious differences. Where Michelangelo is tense, Ammanati is relaxed; where Michelangelo is tragic, Ammanati is serene. Michelangelo's devices, including even the famous pose "slipping off" the support, have been ornamentalized. The motive is Michelangelesque, but the drama is gone. This is true of much of Ammanati's sculpture, as it will be found true of many of the paintings by Vasari and by Alessandro Allori.

Characteristic of the grandiosity of late Cinquecento architecture is the courtyard of the Palazzo Pitti (fig. 713), which Ammanati added in 1558-70 to the original Quattrocento structure, purchased by Cosimo I in 1549 for his duchess, Eleonora da Toledo. For a while Ammanati had worked in Venice under Jacopo Sansovino. Doubtless he had the Zecca (see fig. 679) in mind when

left: 711. BENVENUTO CELLINI. Perseus and Medusa. 1545– 54. Bronze, height 18'. Loggia dei Lanzi, Florence

below: 712. BARTOLOMMEO AMMANATI. Sea Nymph, on the Fountain of Neptune. 1560-75. Bronze, over life-sized. Piazza della Signoria, Florence

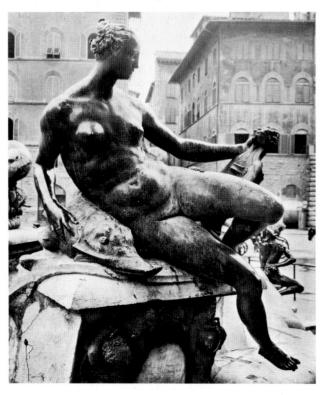

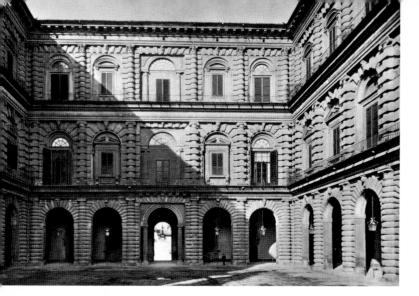

713. BARTOLOMMEO AMMANATI. Courtyard, Palazzo Pitti, Florence. 1558–70

designing the Pitti courtyard, but he carried the rustication even further to embrace not only three stories of columns but also walls, arches, and lintels as well. Only capitals, bases, entablatures, and ornamental window frames escape. Although the rusticated blocks are rough in contrast to Sansovino's smooth ones, they have none of the rude, formless quality so effective and disturbing in the architecture of Giulio Romano (see fig. 626). Their character is consistently maintained throughout each level, but on the ground story (Tuscan) the blocks are rounded and contiguous, on the second (Ionic) square and separated, on the third (Corinthian) rounded and separated. For all its colossal scale, the effect of the courtyard is ornamental and, looked at closely, even weak. The window tabernacles of the second story bear to Michelangelo's originals in the vestibule of the Laurentian Library (see fig. 578) a relation analogous to that between Ammanati's Sea Nymph and Michelangelo's

Ammanati's finest architectural achievement, the Ponte a Santa Trinita (fig. 714), blown up by the Germans in 1944 and rebuilt after World War II, owes its high quality to the fact that in 1564 Ammanati took his designs to Michelangelo shortly before the latter's death, and the great artist criticized and corrected them. Although construction of the bridge was not commenced until 1566, the clarity of statement in the flight of the roadway above the river, the unusual tension and power of the flattened arches, and the fierce simplicity of the wedge-shaped pylons may be understood as emanations of Michelangelo's genius, even if the execution of details is perhaps a bit softened by Ammanati.

GIOVANNI BOLOGNA

The swan song of Late Renaissance sculpture in Florence is performed by a foreigner, in fact a non-Italian, Jean Boulogne (1529–1608), born in Douai (in Flanders) but generally known by the Italianized version of his name, Giovanni Bologna or even Giambologna, because for more than half a century he was active in Italy. Although

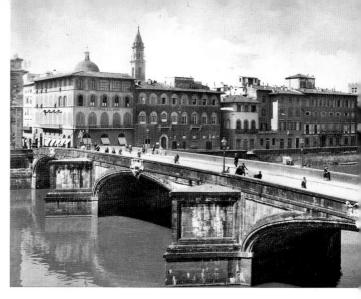

714. BARTOLOMMEO AMMANATI. Ponte a Santa Trinita, Florence. Begun 1566 (rebuilt after 1945)

he rapidly absorbed much from the widest variety of Italian sources, including not only Michelangelo and the innumerable sculptors of the Maniera, but also Donatello, Ghiberti, and Verrocchio, whose works he studied avidly, it must be admitted that in freedom of invention and quality of execution he surpassed any of his native Italian contemporaries save only Michelangelo himself. Is Giambologna an Italian or a Fleming? Is he a Renaissance artist at all? His brilliant relief compositions lead us in the direction of the paintings of the Northerners Rubens and Poussin, his new pictorial treatment of pulsating human flesh, flashing eyes, and silky hair directly to Gianlorenzo Bernini.

If there is a real transition from the Italian Late Renaissance to the universal European Baroque, it is in the sculpture of Giovanni Bologna that we can find it, and thus in essence he does not belong in this book. But in the stiffened intellectual climate of the Maniera and the Academy, his vitality appears as a refreshing antidote. And although he was as much of an anachronism as Leonardo in Lombardy forty years before, he was physically present in late Cinquecento Tuscany. In fact, he added his own contributions to the increasing statuary population of the Piazza della Signoria, including the splendid Rape of the Sabine Woman (figs. 715, 716), placed in 1583 by Grand Duke Francesco I under the Loggia dei Lanzi, in the spot originally occupied by Donatello's Judith and Holofernes. The identification of the subject mattered so little to Giambologna that he proposed earlier versions of the group as Paris and Helen, Pluto and Proserpina, and Phineus and Andromeda. His chief interest lay in the energy of the spiral movement and the splendid vitality of the male and female figures, and he succeeded so well in their rendition that Baroque sculptors, particularly Bernini, never forgot this group.

BRONZINO

After the decline of Pontormo's genius and popularity set in, the leading painter in Tuscany was Pontormo's favorite pupil, Agnolo Tori, called Bronzino (1503–72),

who is the small boy in a cloak seated on the steps in Pontormo's Joseph in Egypt (see fig. 594). Although Bronzino absorbed much from his master, there was something about his character that could not respond to Pontormo's special poetry and wild imagination. Cold and hard are the adjectives that come immediately to mind as we attempt to characterize Bronzino's style; metal, marble, porcelain are the substances his pictures suggest. His early style, during or soon after the period when he was Pontormo's assistant in the decorations of the Capponi Chapel, is represented by the beautiful Pietà (fig. 717), formerly attributed to Pontormo but given back to Bronzino by recent scholarship. Instead of the soaring fountain of figures in Pontormo's Capponi Entombment (see colorplate 78), Bronzino reverts to a closed composition of sculptural masses recalling rather the Luco Lamentation (see fig. 592) by Andrea del Sarto. Yet Pontormo's polished surfaces persist—if anything they are congealed by his pupil's emotional reserve. Linear contours, sometimes precisely drawn in Quattrocento style, isolate the features, anatomical details, and drapery folds. Even the distant landscape—a rare feature in Bronzino's essentially humanistic art—looks Quattrocentesque in the stylization of its trees and hills. Calvary at the left, with its three empty crosses, and a small wood at the right serve as anchors for the arc of the horizon, locking it securely to the upper corners of the

frame; in the lower corners the body of Christ, its bent limbs stiffened in rigor mortis, fits into the left, and the figure of the Magdalen into the right. Yet for all Bronzino's chill, it would be a mistake to suppose that he is an unemotional artist. Within the rigidity of compositional arrangements and metallic surfaces lives the possibility of intense feeling. The cross-light reveals this as it plays on the distraught eyes and open mouth of the Magdalen and illuminates the dead features of Christ from below.

Bronzino was the perfect artist for the newly established regime of Cosimo I, who was installed as second duke of Florence after the murder of the infamous Alessandro de' Medici in 1537 and eventually, in 1569, became grand duke of Tuscany. Again and again, Bronzino and his pupils portrayed the new monarch, his family, and his court in images of incomparable elegance and smoothness, which nonetheless clearly betray the terror of Cosimo's absolutism. The melancholy and defeated stare of Bronzino's portrait of Bartolommeo Panciatichi (fig. 718) issues from a frozen mask, substituted for the customary expression of affability and understanding. Every surface and detail of face and costume are drawn with pitiless accuracy. The hawk-nosed, long-bearded, haughty young man stands with his left elbow propped on a pedestal, against a background of utter unreality. Fragments of buildings, incommensurable in character, style, and scale, deprived of bases, entrances, or connect-

715, 716. GIOVANNI BOLOGNA. Rape of the Sabine Woman. Before 1583. Marble, height 13'6". Loggia dei Lanzi, Florence

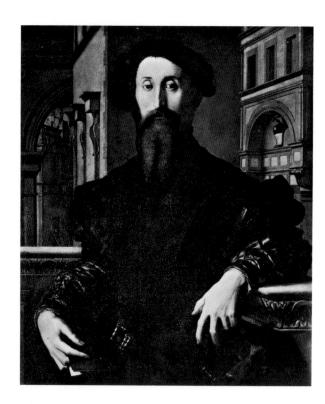

ing streets, and arranged at baffling angles in depth, are drawn with inhuman hardness—a world of carved stone without a living being or a plant and almost without sky. The disorder, even the torment, of the Mannerist crisis continue unresolved in this portrait, whatever appearance of order has been imposed upon it by the implacable consistency of Bronzino's style.

An astounding picture, probably painted in the mid-1540s, is Bronzino's allegory, whose intricate symbolism provoked much scholarly controversy until Panofsky showed that it represents the Exposure of Luxury (colorplate 102). Ordered by Cosimo in person and given by him as a splendid present to King Francis I of France, the picture sums up in brilliant imagery not only the stylistic tendencies but also the moral dilemmas of the age. Bald, winged Father Time at the upper right, assisted by angry Truth at the opposite corner, draws back a curtain to unveil a scene of playful incipient incest. An already older-than-childish Cupid rubs himself against his mother, Venus, kisses her on the mouth, and fondles her breast, while a putto pelts the shameless pair with roses. At the lower left, Venus' doves bill and coo, and at the left edge the haggish Envy tears her hair. The evil of the scene is made explicit by Fraud, a monster with the face of a girl but the tail of a serpent and the hind legs and claws of a lion. She wears a green dress and carries a honeycomb in her left hand, which grows from her right arm, and a serpentlike animal in her right hand, which grows from her left arm.

The sin of Luxury, prime target of the authors of the Counter-Reformation and their predecessors, such as St. Antonine and Savonarola, is at once moralistically condemned and thoroughly enjoyed by both artist and patron. The artist's extreme ability at draftsmanship of cold

and fanatical perfection projects and models in crystalline light the graceful and alluring figure of Venus, the variety of anatomies—male, female, young, and old the pearls and the shining locks of hair, the glittering masks belonging to Fraud, and it sets them all, densely painted, against silks of piercing green, blue, and violet. The deliberate and skillful lasciviousness of this picture should be compared with the freedom and purity of Michelangelo's nudes, who come to us unclothed as from the mind of God. It is characteristic of the period that the same society that accepted such dubious pictures as this also enforced bits of drapery on Michelangelo's Last Judgment, and that Michelangelo was condemned as salacious by Pietro Aretino, who was one of the most scandalous figures of the age. In one variation or another, the Venus and Cupid theme was repeated again and again in the mid-Cinquecento, including several times by Bronzino. It seems to have had some special significance for the day.

Bronzino could also handle large-scale figure compositions with consummate skill, not only in huge altarpieces but also in frescoes. He decorated the walls and ceiling of the chapel erected for Cosimo's duchess Eleonora da Toledo, in the Palazzo Vecchio, with a superb cycle of frescoes, which, according to recent discoveries, was painted between 1540 and 1543. Bronzino must have utilized a technique far more time-consuming than the traditional one. Damaged portions seem to indicate that the underpainting was in true fresco and the finished layer, on which Bronzino lavished all his skill at drawing and modeling, added in tempera. The *Crossing of the Red Sea* (fig. 719) immediately recalls Michelangelo's *Deluge* (see fig. 514) and was so intended. This was the kind of quotation that lent authority to the learned

opposite left: 717. BRONZINO. Pietà. c. 1530. Panel, 41¼×39½". Uffizi Gallery, Florence

opposite right: 718.
BRONZINO.
Bartolommeo
Panciatichi. c.
1540. Panel,
413/8 × 331/2". Uffizi
Gallery, Florence

right: 719.
BRONZINO.
Crossing of the Red
Sea. c. 1540.
Fresco. Chapel of
Eleonora da
Toledo, Palazzo
Vecchio, Florence

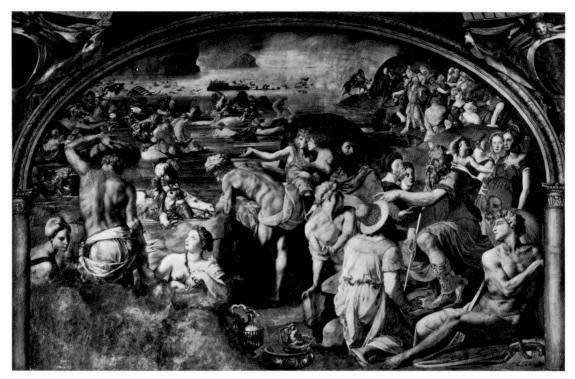

Maniera style. On the other hand, none of Michelangelo's poses are exactly, or even approximately, repeated. Bronzino shows that he can vary the vocabulary and improvise on a Michelangelesque theme. He tosses figures about with some abandon in the rising sea, along with the floating baggage of the pharaoh's army, which he piles impressively along the foreground plane. The well-preserved portions show muscular anatomies that, although devoid of Michelangelo's tremendous energy, are rendered with all the uncanny delicacy of Bronzino's panel paintings and glow with the same cold, pearly light.

FRANCESCO SALVIATI

Approximately contemporary with Bronzino's frescoes in the chapel of Eleonora da Toledo are those by Francesco Salviati (1510-63) in the Sala dell'Udienza, in another part of the Palazzo Vecchio. Salviati, a boyhood companion and lifelong friend of Giorgio Vasari, retained his own striking and often delightful individuality in decorative frescoes in Rome and Florence, and in a series of portraits often mistaken for Bronzino's but more sensitive and intimate. The Triumph of Camillus (fig. 720) in the Sala dell'Udienza is a gorgeous sight, less in its relatively restrained color range of green, gray, tan, and orange than in the free display of combined erudition and virtuosity. Salviati had been analyzing ancient Roman historical reliefs, and the general on his triumphal car, the barbarian captives, the trophies and standards, the lictors bearing fasces, even the altar to Juno with its smoking lamps, all come from the best sources. These sources are allowed to substitute for direct observation of nature, as in the case of the four ornamentalized and archaistic horses imitated from Imperial Roman reliefs. The procession is sharply compressed into the foreground plane in the manner of Salviati's ancient prototypes, yet he has allowed himself considerable imaginative freedom in the mountain landscape and the low and luminous clouds, as well as in the rich movement of line and surface vibrating throughout the painting. Out of the profusion of archaeological elements, an occasional contemporary portrait stands out with surprising freshness and clarity.

The point of no return in full Maniera perversity is exemplified by the astonishing frescoes with which, apparently about 1553, Salviati decorated the salone of the Palazzo Sacchetti in Rome (colorplate 103). Probably representing the havoc wrought by the Ark of the Lord when carried off by the Philistines (I Samuel:5, 6), the frescoes simulate wall paintings of different rectangular proportions, deliberately not harmonizing with the shapes of the upper row of windows, scattered about the wall in emulation of the paintings-within-paintings in Pompeiian murals (which Salviati could not have seen, although he may have known similar examples in Rome or elsewhere, now lost). All are enclosed in fantastic painted frames, all different, intertwined with a proto-Surrealist jumble of garlands and sculptured figures. Out of the darkness under the empty jar and limp vegetables that dangle from one of the frames emerges Father Time, whose hands, holding a balance, overlap the simulated marble frame of the lower row of windows as he steps from his marble pedestal down into the very space of the room. Above the lower window frames, nudes like Michelangelo nudes in a drugged torpor—languish in poses of abandoned sensuality, one seen from the back, the other from the front, on cloths so stretched as almost to cover the tops of the window frames and to slip

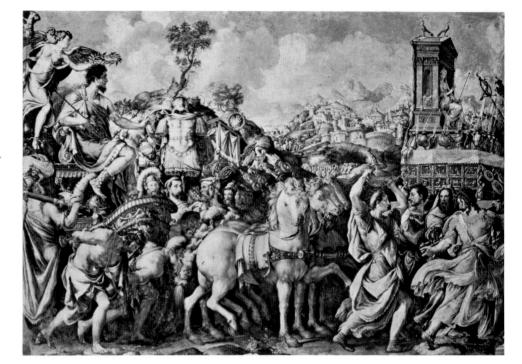

720.
FRANCESCO SALVIATI.
Triumph of Camillus.
Mid-1540s. Fresco.
Sala dell'Udienza,
Palazzo Vecchio,
Florence

into the windows. Nothing more disorderly or contrary to every principle of Renaissance harmony and purposiveness could be imagined, yet all is done with the most exquisite refinement of colorism and draftsmanly skill.

GIORGIO VASARI

The prince of the Florentine Maniera was Giorgio Vasari (1511-74), into whose immense literary reservoir of knowledge, tradition, opinion, theory, and legend, the Lives of the Most Eminent Painters, Sculptors, and Architects, we have dipped from time to time, as all historians of Italian art must. So successful was Vasari's formula for inventing figures and compositions, so slight his necessity for further study from nature, so well disciplined his army of assistants, that with their aid Vasari was able to cover many an acre of Florentine and Roman walls and ceilings with frescoes and oil paintings, which, always unreal and often pompous, seldom lack decorative effect or historical interest. Enormous altarpieces from his crowded studio line the side aisles of Santa Croce, Santa Maria Novella, and other Florentine churches; vast battle scenes and smaller decorative works fill the halls and smaller chambers of the Palazzo Vecchio. The fresco of Paul III Directing the Continuance of St. Peter's (fig. 721), painted in 1544, before Michelangelo took over as architect, is fairly typical of the qualities of his style. It forms a part of the decorations lining the great hall of the Cancelleria in Rome (see fig. 231), a building begun in the late Quattrocento as a cardinal's palace and converted in the Cinquecento into offices for the pontifical government. Vasari and his pupils painted the extensive series of frescoes in just one hundred working days, and when he boasted of this fact to Michelangelo, the latter replied tersely, "Si vede bene" ("So one sees").

A Roman Doric portico at either side encloses a flight of concave, semicircular steps, based on Bramante's design for the fountain of the Vatican Belvedere. On one side of the portico can be distinguished a statue labeled Magnificentia, on the other the figure of Sinceritas opens a door in the right side of her body (and why not the left?) to display her heart. The pope is followed by Renaissance architects, including the recognizable portrait of Bramante, but the pontiff's attendants are allegorical figures in classical costume. He lifts one Michelangelesque hand to point to the unfinished structure of St. Peter's (see page 645), while with the other he approves the plan of Antonio da Sangallo the Younger, held up to him by four more allegorical figures characterized as the Arts of Design and Construction by the drawing and stonecutting tools that they hold or that lie on the steps before them. At the right Father Tiber, his left elbow and left foot propped on books, reclines on the steps, embracing the papal tiara and holding an umbrella sheltering the crossed keys, while putti crown him in succession with wreaths and coronets. The style is standard linear, elaborate, and learned. Many of the figures are borrowed from Michelangelo and Raphael, and the composition is skillful in its interweaving of linear elements. But the artistic result? One's judgment of such rhetorical paintings depends on personal preferences, perhaps, but what is certain, and also odd, is that Vasari's own taste is not that of the Renaissance, about which he knew more than did any of his contemporaries.

The supreme example of Vasari's architecture is the Uffizi in Florence (fig. 722), an enormous structure commissioned by Cosimo I in 1560 (and finished only in 1580, after Vasari's death, by his pupils Bernardo Buontalenti and Alfonso Parigi) to house the governmental

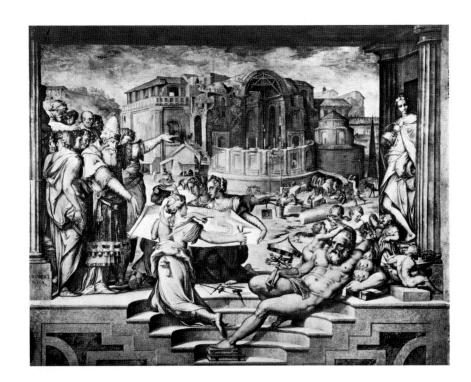

721. GIORGIO VASARI. Paul III Directing the Continuance of St. Peter's. 1544. Fresco. Great hall, Palazzo della Cancelleria, Rome

functions and records of the duchy of Florence, later the grand duchy of Tuscany. The building, with four lofty stories, lines a relatively narrow piazza on three sides and therefore avoids any centrality, deriving its cumulative effect from the severe monotony of the endless repetition of identical sets of elements: two Tuscan columns and one pier on the ground story; then a triplet of mezzanine windows above, alternating with Michelangelesque consoles; then another triad of balustraded windows capped by pediments, two gabled ones flanking an arched opening; and finally an open loggia (now unfortunately glazed) reflecting the Tuscan columns of the

ground story. The only break in the uniformity of the structure comes at the end, where a central arch with a Palladio motive above it (see page 635) opens the vista in the direction of the Arno River. Typically enough for the Maniera and the social forces that produced it, Vasari's governmental structure incorporated existing buildings, including private houses and the entire Church of San Piero Scheraggio. The imposing façades of the Uffizi, whose *pietra serena* trim outweighs the few remaining *intonaco* wall surfaces, mask the wide disparity of old and added buildings, painfully visible when one looks up from the back streets at either side. The huge com-

722.
GIORGIO VASARI.
Uffizi,
Florence.
1560–80.
Finished by
BERNARDO
BUONTALENTI and
ALFONSO PARIGI

plex, so rapidly remodeled, strung together, and refaced, contained such an extensive system of openings and reached such a height that Vasari was constrained to use steel girders to reinforce it, one of the earliest known instances of metal architecture.

THE STUDIOLO

It is fitting that our consideration of Florentine art should draw toward a close with one of the strangest and most characteristic inventions of the Maniera, the Studiolo of Francesco I de' Medici, son and short-lived successor of Cosimo I. This tiny chamber within the mass of the second story of the Palazzo Vecchio (see fig. 54) was dedicated to the geological and mineralogical studies and above all to the alchemistic interests of this selfcentered and ineffective ruler. Its walls are lined with paintings in two tiers, acting as doors for cupboards containing Francesco's scientific books, specimens, and instruments. Two doors, not distinguished in any way from the cupboard doors, cover the only windows: when Francesco was there, he worked by candlelight. This room (1570–72) is also the most attractive achievement of Vasari and his pupils, possibly because its small dimensions gave them a chance to develop in close intimacy their imaginative abilities, their great technical skill, and their jewellike delicacy of color without the necessity of composing on the colossal scale that frequently renders their huge wall decorations and altarpieces a bit tedious. Eight sculptors contributed bronze statues, and the paintings were done by no fewer than twenty-four masters.

Vasari's own contributions are charming, especially the *Perseus and Andromeda* (colorplate 104), which meant for Grand Duke Francesco, of course, the discovery of coral. For when Perseus held up the head of Medusa and plunged his sword into the dragon about to attack Andromeda, the dragon was turned to stone and its blood, streaming through the water, was turned to coral. In the foreground the voluptuous Andromeda is chained to the rock; on either side equally attractive mermaids sport about in—or even *on*—the green sea and delightedly retrieve fantastic branches of red coral. In the background, stylized promontories that recall the real ones of the mountainous seacoast north of Pisa sparkle with classical buildings, and on the beach workmen draw the dragon into land with a huge winch.

Just as toylike in its total unreality is the *Pearl Fishers* (fig. 723) by Bronzino's follower Alessandro Allori (1535–1607), whose style is obviously imitated from the cool, smooth manner developed by his master. Male and female nudes, human and mythological, exquisitely drawn and painted, play about on rocks, dive off boats, and bring up shells overflowing with sea water and with beautiful pearls. Over and over the figures quote Michelangelo (the central nude seen from the back comes straight out of the *Battle of Cascina*; see fig. 479), but in

the most playful way. The solemn echoes of the *Deluge* on the Sistine Ceiling are effectively canceled by the predominantly pink and blue coloring of Allori's picture, as dainty as the tonalities of the French Rococo.

The imaginative artists who contributed to the Studiolo, including even a Netherlander, rang a surprising variety of changes on the Maniera formula. Three among them, nonetheless, seem to have harbored the ideal of a reform—Santi di Tito (the most influential but a bit boring), and two delightful painters hardly known outside the Studiolo, Mirabello Cavalori (before 1520-72) and Girolamo Macchietti (1535/41–92), a younger companion. Their styles, indeed their outlook on the nature and purpose of painting, are strikingly similar, but due to the age gap between them Cavalori must be credited as the innovator. But any argument about him is difficult to sustain, because his production if not his style is the most impenetrable enigma of the Late Renaissance. Only four pictures by him are known, two of them in the Studiolo, and all four were painted in the last four years of his life. The question inevitably arises as to what happened to all the others. In the absence of some lucky find all we can do is rejoice in the remaining jewels, and treat Mirabello as a deus ex machina. After the extreme artificiality of the Maniera paintings in the Studiolo, his pictures and those of Macchietti are like windows into the Cinquecento. Neither artist was able to transfer his naturalism to hieratic themes, as Caravaggio was to do only twenty years later, but here, luckily, they were assigned

723. ALESSANDRO ALLORI. *Pearl Fishers*. 1570–72. Oil on slate, 45½×34". Studiolo, Palazzo Vecchio, Florence

724. MIRABELLO CAVALORI. Wool Factory. 1570–72. Oil on slate. Studiolo, Palazzo Vecchio, Florence

725. GIROLAMO MACCHIETTI. Baths at Pozzuoli. 1570–72. Oil on slate. Studiolo, Palazzo Vecchio, Florence

subjects from daily life, to which their only possible addition appears to be the architectural setting, a severe Tuscan order remarkably similar in both, and also utilized in some of the Maniera pictures in the Studiolo. The extreme devotion to reality in Cavalori's Wool Factory (fig. 724) cannot be paralleled even in Lombardy. It is hard to imagine that the figures were really unposed, but the artist has done his utmost to make them look as if they were. Probably he made sketches in an actual wool factory, of which there were many dotted throughout the less ancient portions of Florence. (One drying yard, or tiratoio, for woolen cloth still survives on the south bank of the Arno.) Models, one would imagine the workmen themselves, could have been posed later in Cavalori's studio. The only remaining device from the Maniera bag of tricks is the placing of two figures in the extreme foreground, cut off at the waist by the frame, but even that is utilized as a repoussoir, to lead the eye directly into the picture. People are doing what they are doing because they have to, not because they look nice—quite a shock after Cinquecento classicism. Also, figures are not nude to display the beauty of their anatomy; they have taken off their outer garments because they are hot, displaying far from ideal bodies wearing typical Cinquecento undershorts. In fact, the only "nudes" are those four who are carrying firewood, stuffing it into the flames, or churning the masses of wool in the boiling caldron. Next behind them a wringer is being twisted, and at the top of the steps the wool, wound on a huge spindle, is being laboriously carded. Mirabello seems to

have taken especial pleasure in the crumpled felt hats and the simple peaked caps worn by the workmen. No abstract scheme, either imposed upon the figures or derived from them, unites their activities, only a strong side light giving deep shadows, a uniformly smooth brushwork conveying actual textures and densities, and a hectic sense of hard labor under pressure. One can see, feel, hear, even smell the factory; endowed with hindsight, we may think of Degas or George Bellows. Yet there is the architectural setting, and in spite of everything an indefinable Renaissance nobility. Whether or not Grand Duke Francesco liked such proletarian pictures as oddities, especially since the wealth of his dominion still depended largely on wool, the Wool Factory was not the kind calculated to gain Mirabello many lucrative public commissions, and he did not get them.

Girolamo Macchietti's *Baths of Pozzuoli* (fig. 725) is strikingly similar to the *Wool Factory* in its naturalistic concept and smooth pictorial style. One can hardly expect that these hot-spring baths, not far from Naples, were set in architecture of such grandeur, and most likely Macchietti had never seen them. He could, however, as did Leonardo and Michelangelo, have studied and sketched in the Florentine public baths. The resemblance between the youth reclining on the steps and the seated figure having his right leg toweled in Macchietti's picture and their counterparts in Michelangelo's *Battle of Cascina* (see fig. 479) are due not to imitation on Girolamo's part, for the figures are in no sense imitations, but, most probably, to the fact that such poses were to be seen

every day in the Stufa. A statue of Aesculapius, god of health, presides over the scene from the left, but so unobtrusively that one reads him in with the bathers. Here, too, one feels the temperature; the three characteristic half-figures in the foreground are cut off by the edge of the marble baths, and one almost envies them standing happily in the warm, medicinal water. Mavericks such as Cavalori and Macchietti may seem were ahead of their time indeed, though Vasari had thought highly enough of them in 1564 to include them among the painters selected to provide pictures for the monumental catafalque to solemnize Michelangelo's funeral in San Lorenzo. Their Studiolo pictures point the way so firmly out of the Maniera that one wonders whether the young Caravaggio could not have gained admittance to this arcane chamber on his way to Rome.

We have come full circle. From the moment of its construction the Palazzo Vecchio had been the home of the Florentine Republic, and its simplicity and power had symbolized for the Florentines and for the world those qualities of individual character that the Republic exalted. Through two and a half centuries these qualities, in crisis and in triumph, in failure and in success, had inspired and directed one of the great periods in the history of human artistic imagination. Now that the Republic was over, it is symbolic that the massive building, deprived of its meaning and its life, should provide the scene for an absolutist ruler to divine secret mysteries by artificial light. The spiritual fortress from which the Florentines of the Renaissance had issued to conquer reality has become the refuge for the most extreme Mannerist flight from reality, and, just as unexpectedly, a womb for the germination of a new vision of reality.

POSTLUDE

For the absolutist elegance of grand-ducal Florence, the Maniera was an appropriate vehicle. But even Counter-Reformation Rome was populated by Maniera artists of intense productivity, great authority, high position, and very limited talent, or even taste. Among them the last paintings, sculpture, and architecture of Michelangelo shone beyond any competition, and even beyond the superficial imitations proliferated by the most industrious practitioners of the doomed Maniera. Nonetheless, the richly dramatic architectural style created by Michelangelo in his last Roman works seems in retrospect to point the way toward the architectural triumphs of the Roman Baroque, and in a sense it really did, because some of his pupils were instrumental in laying the groundwork of early Baroque architecture.

The only strong countercurrents to Maniera artificiality in Central Italy were led by two outsiders to Rome, the architect Vignola and the painter Barocci, neither of whom owes much if anything to Michelangelo. Whether either of them belongs in a book on Renaissance art is as debatable as whether they should appear in the Baroque,

but even if they elude all classification these two masters are too great to omit from a period in which, chronologically at least, they appear.

GIACOMO DA VIGNOLA

Jacopo Barozzi (1507-73) shares nothing except the similarity of his family name with that of the painter who occupies with him these final pages. Born in the little town of Vignola, near Bologna, he started out as a painter, under the tutelage of Sebastiano Serlio, architect and perspective painter, best known for his treatise in several volumes entitled Regole generali di architettura (see Bibliography) and for the part he played in transporting the Renaissance to France. Serlio had studied under Peruzzi in Rome, and thus Vignola was brought into contact with High Renaissance tradition before actually arriving in Rome in 1530. He worked directly with Peruzzi and Antonio da Sangallo the Younger in the Vatican and was employed in finishing many parts of the Palazzo Farnese and, after 1564, St. Peter's itself. Clearly, he desired to revive and codify the Bramantesque tradition, an ambition not unusual for this era of treatises and standardization, in spite of Mannerist and Maniera caprices. Instead of inventing their own capitals, as had so many Quattrocento architects and indeed Michelangelo himself, Maniera architects generally contented themselves with exact copies of those designed by Bramante for St. Peter's. But Vignola settled the course of classical architecture for the next three and a half centuries with his Regola delli cinque ordini di architettura (see Bibliography), first published in 1562 and reprinted in innumerable editions, which came to an end only when the Renaissance tradition of classical architectural training died out in the second quarter of the present century. In this work thirty-two large-scale and elaborate plates accompanied by precise instructions laid down exact principles for the design, proportions, and employment of each of the five orders then recognized—Tuscan, Doric, Ionic, Corinthian, and Composite—including shafts, capitals, bases, and entablatures. All examples were based on those ancient Roman models considered most beautiful, thus imposing Bramantesque taste on posterity and eliminating from consideration those fantasies of Roman architecture that so delight twentieth-century students.

Neither experience in completing Michelangelo's buildings nor collaboration with the Florentine Maniera architects Vasari and Ammanati seems to have had any effect on Vignola other than to reinforce his own determined classicism. He is universally known today for the interior (whose vault was completely transformed in the seventeenth century), of the Gesù, the mother church of the Jesuit Order. Often considered the earliest Baroque church, the Gesù, like the nave and transept of St. Peter's, was derived from Alberti's Sant'Andrea in Mantua (see figs. 227–229).

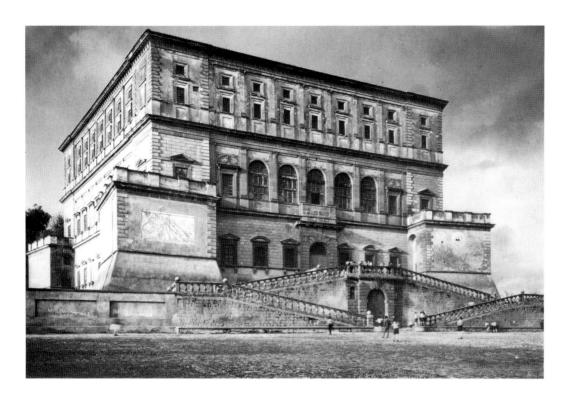

left: 726. GIACOMO DA VIGNOLA. Villa Farnese, Caprarola. Begun 1559. Original fortress and villa façade

below left: 727. GIACOMO DA VIGNOLA. Courtyard, Villa Farnese, Caprarola

below right: 728. GIACOMO DA VIGNOLA. Spiral staircase, Villa Farnese, Caprarola

Out of Vignola's voluminous production the most original work is the Villa Farnese at Caprarola, which is also perhaps the most overwhelming secular building of the Renaissance in absolute dimensions (about 150 feet on each side), in its situation on a hilltop, and in the simple grandeur of its proportions. Vignola was faced with an unusual problem; in 1559 Pope Paul III commissioned him to erect a palace for his son, Pierluigi Farnese, whom he had made duke of Castro and Nepi, on top of a pentagonal fortress the pope himself had built while a cardinal (fig. 726). As Michel de Montaigne put it in 1581, shortly after the completion of the edifice, it is

"pentagonal in form, but looks like a pure rectangle. Inside it is perfectly round." The tension maintained between the five sides of the fortress pedestal and our disappointed expectation of four for the villa is the source of much of our pleasure in the entire design. This sublimated Mannerist conflict, so to speak, is analogous to those we have seen in the work of Vignola's great North Italian contemporary, Palladio. Vignola reinforced the angles of the fortress with quoins, crowned it with a sharp cornice and a parapet, and provided it with two superimposed, rusticated, and arched entrances, connected by balustraded ramps, finished only after his

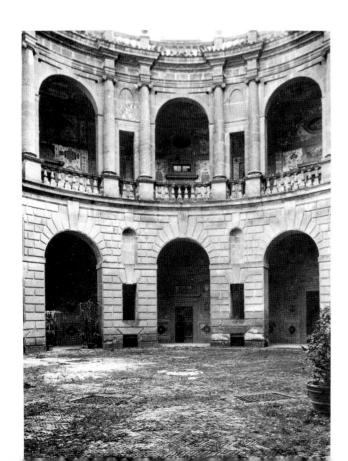

death, and flanked by pedimented windows. The motive of the corner bastions is continued, still with quoins, in the upper stories. Between these towering corners a seven-bay order is stretched like a curtain on each of the five façades, Ionic on the second story, Corinthian on the third. The pilaster sequence of the second story embraces a loggia (formerly open, now glazed) of five arches, affording an immense view over the hills and valleys of northern Latium. Windows fill these bays on the other four sides. The final story is subdivided into a row of oblong windows below a mezzanine of square ones, embraced by the same giant order.

Seen from the pavement, the spectacular courtyard consists of a rusticated circle of arches upholding a majestic *piano nobile* of paired Ionic engaged columns flanking arches that culminate in a balustrade with urns against the sky (fig. 727), which effectively conceals the setback third story. The courtyard thus appears as a triumphant revival in circular form of the two-story scheme announced in Bramante's Palazzo Caprini (see fig. 509). Perhaps the most thrilling aspect of the entire villa is the great spiral staircase (fig. 728), a brilliant invention composed of lofty Tuscan columns, paired on single pedestals, recalling Bramante's spiral ramp for the Vatican Belvedere.

FEDERICO BAROCCI

Ironically enough, the Emilian architect Barozzi (Vignola) based his style on that of Bramante of Urbino, while the Urbinate painter Federico Barocci (1526– 1612) dedicated much of his life to an imaginative revival of the inventions of the Emilian Correggio. And as Barozzi was the most powerful architect in Central Italy during the 1550s and 1560s except for Michelangelo, so Barocci was the most gifted painter in that region between the death of Michelangelo and the arrival in Rome of the Carracci and Caravaggio in the 1590s. He was delightful throughout his long career, which overlapped the beginnings of the Baroque style, and indeed appears to have had considerable effect on Baroque painting, especially on Rubens. Although Barocci was profoundly influenced by the work of Correggio, he experienced it elsewhere than in Parma, in which there is no record of his presence. Nor, for that matter, does he seem to have been anywhere else in North Italy, in spite of the considerable Venetian influence in his work. He did make two trips to Rome, where he studied particularly the work of Raphael and was protected by Federico Zuccari, the accomplished but monotonous leader of the Roman Maniera. He worked in the enchanting little casino (garden house) built by the Mannerist architect Pirro Ligorio for Pope Pius IV in the Vatican Gardens. He left Rome in 1563, in poor health and with the suspicion that he had been poisoned, presumably by a jealous rival. Thereafter, he seldom left his mountain home at Urbino, where the classicism of his illustrious forebears, Piero della Francesca, Bramante, and Raphael, seems to have held little meaning for him.

In an era that sought rules and standards, Barocci acknowledged none save his own exquisite sensibility. In a period of stasis he was as enthralled by the mysteries of motion as was his Venetian contemporary Tintoretto (whom there is no possibility of his ever having met). But Correggio is uppermost in his mature work, especially his most celebrated painting, the huge Madonna del Popolo (colorplate 105), painted for the Confraternity of the Misericordia in Arezzo. The work was done in Urbino over a period of four years, and it was brought to Arezzo by the artist in 1579. The vagueness and inaccuracy of the view of the piazza in front of the triple portal of the Misericordia in the background suggest that Barocci had never seen the city before his actual arrival with the picture. In Piero's altarpiece for a similar confraternity in Sansepolcro more than a century before (see figs. 277–279), the decisive principle had been the relation of the group of mortals to the eternal verities of redemption through Christ and protection by the Virgin. For Barocci the essential was the dramatic instant of the Virgin's intercession for her people before a loving Christ.

The whole scene is caught up in a bewitching fusion of everyday experience with otherworldly rapture. Below surges a crowd worthy of Tintoretto, yet free of his urgency and violence. At the left an elegantly dressed young mother has difficulty directing toward the heavenly apparition the interest of her smiling children, more attracted by the (brilliantly foreshortened) beggar in the foreground and by the player of the vielle—a fourstringed popular instrument operated by a crank—who in turn resists the beggar's request for charity. At the extreme lower right a brown-and-white puppy appeals to the spectator. With no gap between earthly byplay and heavenly apparition, one ascends over the heads of mothers with baskets and babies to cuddly child-angels, seen from fore and aft, who support a sensuously lovely Virgin, her hands spread gracefully in appeal. From a nearby heaven of golden light a youthful Christ blesses the crowd, over whose heads soars the dove of the Holy Spirit. Despite the powerfully modeled anatomy of the male figures, nothing has much weight or substance. Light plays over figures, faces, and bright garments as if through colored mists, as lightly as the Correggiesque smiles that move across the perennially youthful faces. Barocci's paintings, including this one, were prepared for by unprecedented color drawings, made with pastels (sticks of dry color) or with colored chalks glowing in opalescent tones on paper generally tinted a rich robin'segg blue. In the dissolving colors and in the smiling charm of the subjects, we seem to have left the solemnity and tensions of the late Cinquecento far behind—in fact almost to have arrived at the carefree world of early eighteenth-century France.

Glossary

Cross-references are indicated by the use of SMALL CAPITALS.

ABACUS (pl. ABACI). The slab that forms the uppermost member of a CAPITAL.

ABBREVIATORE. A papal brief-writer.

ACANTHUS. A plant having large toothed and scalloped leaves whose forms were imitated on CAPITALS, and used to ornament moldings, brackets, and FRIEZES.

ALTANA. Italian word for a covered and colonnaded or arcaded roof terrace. See also LOGGIA.

ALTARPIECE. A painted or sculptured work of art that stands as a religious image upon and at the back of an altar, either representing in visual symbols the underlying doctrine of the MASS, or depicting the saint to whom a particular church or altar is dedicated, together with scenes from his life. In certain periods it often includes decorated gables and PINNACLES, as well as a PREDELLA. See also MAESTÀ.

AMPHORA (pl. AMPHORAE). A storage jar used in ancient Greece having an egg-shaped body and two handles, each attached at the neck and

shoulder of the jar.

ANCESTRY OF CHRIST. As listed in the GOSPEL of St. Matthew (1:1–16), it includes forty generations, beginning with Abraham, Isaac, and Jacob through Jesse, David, and Solomon down to Joseph, the spouse of Mary. A second, and generally quite different, genealogy, beginning with Joseph and running backward all the way to Adam, is given in Luke 3:23–38.

ANNUNCIATION. The announcement by the angel Gabriel to the Virgin Mary of the Incarnation of Jesus Christ (Luke 1:26–38). In many representations of this scene a dove appears, to indicate that the Virgin has conceived by the Holy Spirit and will bear the Son of God. The annunciation to the shepherds is the scene that represents shepherds watching their flocks by night and being visited by angels who tell them of Christ's birth (Luke 2:8–14).

ANTICHRIST. A mighty antagonist to Christ whose appearance on earth, it is thought, will precede the Second Coming of Christ (I John

2:18, 22; 4:3)

ANTIPOPE. Any pope elected in opposition to another held to be canonically chosen. In general, it refers to the popes elected at Avignon in opposition to those at Rome during the Great Schism (1378–1417), to a third series elected at Pisa, including John XXIII (Baldassare Cossa, deposed in 1415; d. 1419), as well as to still another series elected at Basel, including Felix V (1383–1451).

APOCALYPSE. The Book of Revelation, the last book of the New Testament, in which are narrated the visions experienced by St. John on

the island of Patmos.

APOCRYPHA. A group of books variously included at one time in authorized Christian versions of the Bible, but now generally omitted from Protestant versions.

APSE. A large semicircular or polygonal niche, especially at the end of the choir, or the chapels or transepts, of a church.

ARCADE. A series of ARCHES and their supports.

ARCH. An architectural construction, often semicircular, built of wedge-shaped blocks to span an opening. It requires support from

walls, PIERS, or COLUMNS, and BUTTRESSING at the sides.

ARCHITRAVE. The main horizontal beam, and the lowest part of an ENTABLATURE; i.e., a series of LINTELS, each spanning the space from the top of one support to the next.

ARRICCIO, ARRICCIATO. The rough coat of coarse plaster that is the first layer to be spread on a wall in the making of a FRESCO.

ARTE (pl. ARTI). See GUILDS.

ARTS. See LIBERAL ARTS.

ASCENSION. The ascent of Christ into Heaven as witnessed by his disciples forty days after the RESURRECTION (Luke 24:51 and Acts of the Apostles 1:9–11).

A SECCO. See FRESCO.

ASSUMPTION. The ascent of the Virgin Mary to Heaven after her death and burial when, according to Roman Catholic belief, her soul was reunited with her body.

ASSUNTA. See ASSUMPTION.

BARREL VAULT. A semicylindrical VAULT.

BASE. The lowest element of a COLUMN, wall, or DOME, occasionally of a statue.

BASILICA. A general term applied to any church that, like Early Christian basilicas, whose plan was derived from that of Roman law-courts, has a longitudinal NAVE that is terminated by an APSE and flanked by SIDE AISLES. In the modern Roman Catholic Church, a canonical title bestowed upon certain churches that confers special liturgical privileges.

BAY. A compartment into which a building may be subdivided, usually formed by the space bounded by consecutive architectural supports.

BEAD-AND-REEL. A convex molding having the form of elongated beads alternating with disks placed on edge.

BEATITUDES. Eight declarations of special blessedness in Christ's Sermon on the Mount (Matthew 5:3–11).

BEATO (fem., BEATA). Italian word meaning blessed. Specifically, beatification is a papal decree that declares a deceased person to be in the enjoyment of heavenly bliss (*beatus*) and grants a form of veneration to him. It is usually a step toward canonization.

BENEDICTINE ORDER. Founded by St. Benedict of Nursia (c. 480–c. 543) at Subiaco near Rome, the Benedictine rule spread to England and much of Western Europe in the next two centuries. Less austere than other early Orders, the Benedictines divided their hours among religious worship, reading, and work, generally either educational or agricultural.

BIBLIA PAUPERUM. A fourteenth-century compendium of imagery connecting the Old and the New Testaments.

BIRETTA. The square cap worn by ecclesiastics, that of priests being black, of bishops purple, and of cardinals red.

BLESSED. See BEATO.

BOTTEGA. Italian word for shop, used to describe both the group of assistants who worked with an artist and the place where they worked.

BRACCIO (pl. BRACCIA). Italian word for arm. A linear measurement in use in many Italian centers, but varying from place to place; in

Florence approximately 1.913 feet.

BREVIARY. A book containing the daily prayers for the canonical hours. BUTTRESS. A masonry support that counteracts the lateral pressure exerted by an ARCH or VAULT. See also FLYING BUTTRESS.

CADUCEUS. The staff carried by a Greek or Roman herald, and an attribute of the god Mercury. Mercury's is conventionally represented with two serpents twined about it and two wings at the top.

CALVARY, See GOLGOTHA.

CAMALDOLITE ORDER. An independent branch of the BENEDICTINE ORDER; founded by St. Romuald to establish the Eastern eremitic form of monasticism in the West. St. Romuald was born in Ravenna about 950 and died in 1027.

CAMPANILE. From the Italian word *campana* (bell). A bell tower, either attached to a church or freestanding nearby.

CAMPO. Italian word for field; used in Siena, Venice, and other cities to denote certain public squares. See also PIAZZA.

CANTORIA. Italian word for choir gallery.

CAPITAL. The crowning member of a COLUMN, PIER, or PILASTER, on which rests the lowest element of the ENTABLATURE. See also ORDER. CAPPUCCIO. Italian word for hood. See also MAZZOCCHIO.

CARDINAL VIRTUES. See VIRTUES.

CARMELITE ORDER. Begun in the mid-twelfth century by a crusader named Berthold and his followers, who settled in caves on Mt. Carmel and led lives of silence, seclusion, and abstinence. About 1240 they migrated to Western Europe, where the rule was altered, the austerities mitigated, and the ORDER changed to a mendicant one, analogous to the DOMINICAN and FRANCISCAN ORDERS.

CARTHUSIAN ORDER. Founded by St. Bruno (c. 1030–1101) at Chartreuse near Grenoble in 1084. An eremitic order, the life was, and

still is, one of prayer, silence, and extreme austerity.

CARTOON. Full-scale preparatory drawing on sheets of heavy paper or light cardboard pasted together (*cartone* in Italian means cardboard).

CARYATID. A figure, generally female, used as a COLUMN.

CASINO. A garden house.

CASTING. A method of reproducing a three-dimensional object or RE-LIEF by pouring a hardening liquid or molten metal into a mold bearing its impression.

CATASTO. A graduated tax on property and income instituted in Florence in 1427 to finance the city's defense.

CATHEDRAL. The church in which the bishop of a diocese has his permanent *cathedra*, or episcopal throne.

CENACOLO. Italian word for supper room or REFECTORY. Also used to designate representations of the Last Supper, or of the room where it was held.

CERTOSA. Italian word for Carthusian monastery. From Chartreuse, where St. Bruno founded his monastery in 1084. See also CARTHUSIAN ORDER.

CHALICE. Generally, a drinking cup, but specifically the cup used to hold the consecrated wine of the EUCHARIST.

CHANCEL. In a church, the space reserved for the clergy and choir, set off from the NAVE by steps and occasionally by a screen.

CHASING. The ornamenting of metal by engraving or embossing.

CHASUBLE. A long, oval, sleeveless mantle with an opening for the head, worn over all other vestments by a priest when celebrating MASS.

CHERUB (pl. CHERUBIM). One of an order of angelic beings ranking second to the SERAPHIM in the celestial hierarchy.

CHIAROSCURO. Light and shade, from the Italian chiaro (light) and oscuro (dark).

CHRISTUS MORTUUS. Latin phrase for dead Christ.

CHRISTUS PATIENS. Latin phrase for suffering Christ. A cross with a representation of the dead Christ, which in general superseded representations of the CHRISTUS TRIUMPHANS type.

CHRISTUS TRIUMPHANS. Latin phrase for triumphant Christ. A cross with a representation of a living Christ, eyes open and triumphant over death. Scenes of the PASSION are usually depicted at the side of the cross, below the crossarms.

CINQUECENTO. Italian word for five hundred. Means sixteenth century, the one thousand five hundreds.

CIOMPI. Florentine term for wool carders.

CISTERCIAN ORDER. A reform movement in the BENEDICTINE ORDER, it was started in France in 1098 by St. Robert of Molesme for the purpose of reasserting the original BENEDICTINE ideals of field work and a life of severe simplicity.

CLAUSURA. Latin word for closure, used to signify the restriction of certain classes of monks and nuns to sections of their convents, and

their prohibition from speaking to lay persons.

CLERESTORY. A row of windows in a wall that rises above an adjoining roof. Frequently used in churches having NAVE walls higher than the SIDE-AISLE roofs.

CLOSED DOOR. Ezekiel's vision of the door (PORTA CLAUSA) of the sanctuary in the temple that was closed because only the Lord could enter it (Ezekiel 44:1–4). Interpreted as a prophecy and used as a symbol of Mary's virginity.

CLOSED GARDEN. "A garden inclosed is my sister, my spouse; a spring shut up, a fountain sealed" (Song of Solomon 4:12). As HORTUS CONCLUSUS, used (like the preceding phrase PORTA CLAUSA) as a symbol of Mary's virginity.

COFFER. A casket or box; in architecture, a recessed panel in a ceiling. COLONNADE. A series of COLUMNS spanned by LINTELS.

COLONNETTE. A small COLUMN.

COLUMN. A vertical architectural support, usually consisting of a BASE, a rounded Shaft, and a Capital. See also order.

COMPANY (Italian: compagnia). In Renaissance terms, a fraternal organization under ecclesiastical auspices dedicated to good works. In Venice it was usually called a scuola (school), though it had no educational function, and in Tuscany it was sometimes called a confraternity.

CONDOTTIERE. Italian term for mercenary military leader.

CONFRATERNITY. See COMPANY.

CONSOLE. A bracket, usually formed of VOLUTE scrolls, projecting from a wall to support a LINTEL or other member.

CONTADO. Countryside or rural area around a city.

CONTRAPPOSTO. Italian word for set against. A method derived from ancient art that gives freedom to the representation of the human figure by setting the parts of the body in opposition to each other around a central vertical axis.

COPE. A semicircular cloak or cape worn by ecclesiastics in processions and on other solemn ceremonial occasions.

CORBEL. An overlapping arrangement of stones used to construct a VAULT or ARCH, or as a support projecting from the face of a wall.

CORNICE. The crowning, projecting architectural feature, especially

the uppermost part of an ENTABLATURE.

CORPUS CHRISTI. Latin phrase for body of Christ. The Feast of Corpus Christi in the Roman Catholic Church is held on the Thursday after Trinity Sunday in honor of the Real Presence of Christ in the EUCHARIST. Its most prominent feature is the Procession of the HOST.

CORPUS DOMINI. Latin phrase for body of God. See also CORPUS CHRISTI. CRUCIFIX. From the Latin word *crucifixus*. A representation of a cross with the figure of Christ crucified on it. See also CHRISTUS PATIENS and CHRISTUS TRIUMPHANS.

CUPOLA. A rounded, convex roof or vaulted ceiling, usually hemispherical on a circular BASE and requiring BUTTRESSING.

DALMATIC. An ecclesiastical vestment with wide sleeves and a skirt slit at the sides, worn in the Western church by deacons at High Mass. A similar garment was also worn by kings at coronation.

D'AL DI SOTTO IN SÙ. Italian phrase for from below looking up. A type of illusionism in painting, achieved by means of sharp foreshortening, in which the depicted scene seems to be located high above the spectator.

DENTILS. A series of small, projecting, teethlike blocks found on Ionic and Corinthian cornices.

DESÍO. Italian word for desire, longing, or yearning. Used to describe a doctrine formulated in Lorenzo de' Medici's PLATONIC ACADEMY by which the soul, in its earthly exile, could traverse mystically the gulf separating it from its true home in God.

DIES IRAE. Latin phrase for day of wrath. A thirteenth-century poem written probably by Tommaso da Celano, the friend, disciple, and biographer of St. Francis of Assisi, and early incorporated into the MASS for the Dead.

DIPTYCH. ALTARPIECE or devotional picture consisting of two wooden

panels joined together.

DOGE. Italian dialect word for the elected head of the state, in Venice

DOLCE STIL NUOVO. Italian phrase for beautiful new style. Used to characterize the revolutionary use of the Tuscan language by the poet Guido Cavalcanti in the thirteenth century.

DOME. A large CUPOLA supported by a circular wall or DRUM, or, over a noncircular space, by corner structures (see also PENDENTIVE, SOUINCH).

DOMINICAN ORDER. Founded as a preaching ORDER at Toulouse in 1216 by St. Dominic. The Dominicans lived austerely and believed in having no possessions, surviving by charity and begging. They became, after the FRANCISCANS, the second great mendicant order.

DONOR. The patron of a picture, often represented in the picture. DRUM. One of several sections composing the SHAFT of a COLUMN. Also, a cylindrical wall supporting a DOME.

DUGENTO. Italian word for two hundred. Means thirteenth century, the one thousand two hundreds.

DUOMO. Italian word for CATHEDRAL.

EGG-AND-DART. A decorative molding, consisting of alternating oval and pointed forms.

ENTABLATURE. The upper part of an architectural ORDER.

ENTASIS. The gently swelling convex curvature along the line of taper of a classical COLUMN.

EPISTLE. In Christian usage, one of the apostolic letters that constitute twenty-one books of the New Testament. See also MASS.

EUCHARIST. From the Greek word for thanksgiving. The sacrament of the Lord's Supper; the consecrated bread and wine used in the rite of Communion, or the rite itself.

EX-VOTO. Latin phrase meaning "from a vow." Thus, an offering made in pursuance of a vow, frequently a painting presented to a church in gratitude for divine help.

FATHERS OF THE CHURCH. The four Latin Fathers of the Church are St. Jerome, St. Ambrose, St. Augustine, and St. Gregory. They were early teachers and defenders of Christianity and as such were frequently represented.

FLYING BUTTRESS. An ARCH that springs from the upper part of the PIER BUTTRESS of a Gothic church, spans the aisle roof, and abuts the upper NAVE wall to receive the thrust from the nave VAULTS; it transmits this thrust to the solid pier buttresses.

FRANCISCAN ORDER. Founded by St. Francis of Assisi (Giovanni di Bernardone, 1181/82–1226) for the purpose of ministering to the spiritual needs of the poor and imitating as closely as possible the life of Christ, especially in its poverty. The first great mendicant ORDER.

FRESCO. Italian word for fresh. A painting made on wet plaster with pigments suspended in water so that the plaster absorbs the colors and the painting becomes part of the wall. FRESCO A SECCO, or painting on dry plaster (secco is Italian for dry), was also used, but it is a much less durable technique and the paint tends to flake off with time.

FRIEZE. The architectural element that rests upon the ARCHITRAVE and immediately below the CORNICE; also, any horizontal band decorated with moldings, RELIEF sculpture, or painting.

GARDEN. See CLOSED GARDEN.

GENIUS (pl. GENII). In Roman and Renaissance art, usually the guardian spirit of a person, place, or thing, though it may be purely decorative. Genii are represented in human form, frequently seminude and winged.

GESSO. A mixture of finely ground plaster and glue used to prepare wooden panels for TEMPERA painting.

GHIBELLINE. Originally the name of a German party formed in the twelfth century, but adopted in Italy soon afterward to designate the party composed of the feudal nobility and their supporters who were attached to the Holy Roman Emperor. See also GUELPH.

GILDING. Coating with gold, gold leaf, or some gold-colored substance. Techniques were devised in Italy for gilding on painting, sculpture, and architectural ornament.

GIUDECCA. The suburban islands across the Grand Canal from Venice, partly facing the PIAZZA San Marco.

GLAZE. In oil painting, a transparent film of the vehicle, customarily linseed oil mixed with turpentine, in which a small amount of pig-

ment is dissolved, so as to alter the colors of the lower layers of paint.

GLORY. The circle of light represented surrounding the head or figure of the Savior, the Virgin Mary, or a saint. When it surrounds the head only, it is called a halo. See also MANDORLA.

GOLDEN LEGEND. A collection of the legendary lives of the major saints written in the thirteenth century by Jacopo da Varagine, archbishop of Genoa.

GOLGOTHA. From the Aramaic word for skull; thus, "the Place of the Skull." The name of the place outside Jerusalem where Christ was crucified (Matthew 27:33). "Calvary" is from *calvaria*—skull (Luke 23:33), the Latin translation of the same Aramaic word.

GONFALONIERE. Italian word for standard-bearer.

GOSPEL. In Christian usage, the story of Christ's life and teachings as related in the first four books of the New Testament, traditionally ascribed to the Evangelists Matthew, Mark, Luke, and John. See also MASS.

GRAFFITO (pl. GRAFFITI). Scratched and tinted designs common on Florentine house façades. Also any drawings or writings scratched on a wall.

GRISAILLE. Monochromatic painting in shades of gray.

GROIN. The sharp edge formed by two intersecting VAULTS.

GROIN VAULT. A VAULT formed by the intersection at right angles of two BARREL VAULTS of equal height and diameter, so that the GROINS form a diagonal cross.

GROTTESCHI. A Renaissance decorative scheme using mostly motifs that had been discovered in what seemed to be a grotto and were thus so named. These motifs were interwoven into a variety of patterns to cover walls or PILASTERS.

GUELPH. Originally the name of a German party formed in the twelfth century, but adopted in Italy soon afterward to designate the party composed mostly of artisans, merchants, and guild members who favored the pope. See also GHIBELLINE.

GUILDS. Arti (sing. Arte) in Italian. Independent associations of bankers and of artisan-manufacturers.

The seven major guilds in Florence were:

Arte di Calimala—refiners of imported wool

Arte del Cambio—bankers and money changers

Arte dei Giudici e Notai—judges and notaries

Arte della Lana-wool merchants who manufactured their own cloth

Arte dei Medici e Speziali—doctors and pharmacists, to which guild the painters belonged

Arte della Seta—silk weavers, to which guild the sculptors in metal belonged

Arte dei Vaiai e Pellicciai-furriers

Some other guilds mentioned are:

Arte dei Corazzai e Spadai—armorers and swordmakers Arte dei Linaioli e Rigattieri—linen drapers and peddlers Arte di Pietra e Legname—workers in stone and wood See also MERCANZIA, MERCATANZIA.

GUILLOCHE. An ornamental and curvilinear motif of interlaced lines. HALO. See GLORY.

HARPY (pl. HARPIES). From the Greek word for snatcher. A female monster who carries souls to Hell; represented with a woman's head and body, and a bird's wings, legs, claws, and tail. It occasionally appears as a more benign spirit who carries souls to another world.

HERM. The torso of a male figure emerging from a pedestal; sometimes used as a PILASTER.

HORTUS CONCLUSUS. Latin phrase for CLOSED GARDEN.

HOST. From Latin hostia (sacrificial victim). In the Roman Catholic, Anglican, and Lutheran churches it is used to designate the bread or wafer consecrated in the EUCHARIST and regarded as the body of Christ.

HUMERAL VEIL. An oblong vestment worn by a priest around his shoulders and used for enveloping the hands when holding sacred vessels.

ICON. Literally, any image or likeness, but commonly used to designate a panel painting representing Christ, the Virgin Mary, or a saint, and venerated by Orthodox (East Christian) Catholics.

IMPASTO (pl. IMPASTI). Patches of pigment applied very thickly.

INNOCENTI. Italian word for Innocents, referring in biblical usage to the children under the age of two who were slain by King Herod's order so that the Infant Jesus would surely be destroyed. The scene is frequently represented with the title *Massacre of the Innocents*. In Italian usage, as in Ospedale degli Innocenti, the term also designates foundlings or orphans.

INTARSIA. Inlaid cabinetwork composed of several varieties of differ-

ently colored woods.

INTONACO. The coat of smooth plaster on which a FRESCO is painted. ISTORIA. Italian term for history, story, narrative. See also STORIA. LAMENTATION. See PIETÀ.

LIBERAL ARTS, SEVEN. Derived from the standard medieval prephilosophical education, they consisted of Grammar, Rhetoric, Logic, Arithmetic, Music, Geometry, and Astronomy. They were frequently represented allegorically during the Middle Ages and the Renaissance.

LINTEL. A horizontal beam that spans an opening.

LITANY. A form of group prayer consisting of a series of supplications by the clergy with responses from the congregation.

LITURGY. A collection of prescribed prayers and ceremonies for public worship; specifically, in the Roman Catholic, Orthodox, and Anglican Churches, the collection used in the celebration of the MASS.

LOGGIA (pl. LOGGIE). A gallery or ARCADE open to the air on at least one side.

MACHICOLATIONS. The openings in a projecting wall or parapet through which pitch or molten lead might be cast upon the enemy beneath.

MADONNA OF MERCY. A representation of the Virgin Mary as a large standing figure protecting a group of smaller worshipers with her mantle. In Italian, Madonna della Misericordia.

MAESTÀ. Italian word for Virgin in Majesty. A large altarpiece with a central panel representing the Virgin enthroned, adored by a number of saints and angels.

MAGUS (pl. MAGI). The priestly caste in ancient Media and Persia traditionally reputed to have practiced supernatural arts. In Christian art, applied to the three wise men who came from the East to do homage to the Infant Jesus.

MANDORIA. From the Italian word for almond. A large oval surrounding the figure of God, Christ, the Virgin Mary, or occasionally a saint; it is used to indicate divinity or holiness.

MARZOCCO. A Florentine sculptured or painted representation of the Lion of Florence, a traditional symbol of the city.

MASS. The celebration of the EUCHARIST to perpetuate the sacrifice of Christ upon the Cross, plus readings from one of the GOSPELS and an EPISTLE; also the form of LITURGY used in this celebration.

MAZZOCCHIO. A wire or wicker frame around which a hood or CAPPUC-CIO was wrapped to form a headdress commonly worn by fifteenthcentury Florentine men.

MERCANZIA, MERCATANZIA. The merchants' GUILD.

MINORITES. A name once used for the Franciscan Friars Minor, the largest of the three branches of the FRANCISCAN ORDER.

MITRE. A tall cap terminating in two peaks; the distinctive headdress of bishops and abbots of the Western Church, including the pope. See also TIARA.

 $\begin{tabular}{ll} {\tt MONSTRANCE.} & {\tt An open or transparent receptacle of gold or silver in } \\ {\tt which the consecrated HOST is exposed for adoration.} \\ \end{tabular}$

MOZZETTA. A cape with a small hood worn by the pope and other dignitaries of the Church.

MULLION. A vertical member dividing a window into a number of lights.

NAVE. The central aisle of a BASILICA, as distinguished from the SIDE AISLES; the part of a church between the main entrance and the CHANCEL.

NEOPLATONISM. A school of late Greek philosophy that grew up mainly in Alexandria in the third century A.D., and was revived by Italian humanists in the fifteenth century. These scholars translated the works of Plato and Plotinus and tried to construct an all-inclusive system that would reconcile Christian beliefs with Neoplatonic mystical thought. See also PLATONIC ACADEMY.

OCULUS (pl. OCULI). A circular opening in a wall or at the apex of a DOME.

OIL PAINT. Pigments mixed with oil and usually applied to a panel covered with GESSO, as in TEMPERA painting, or to a stretched canvas prepared with a mixture of glue and white pigment.

OPERA DEL DUOMO. Board of Works of a CATHEDRAL. Also used to denote the Museum of the Board of Works, as an abbreviation for Museo

dell'Opera del Duomo.

ORATORY OF DIVINE LOVE. A confraternity, founded in Rome, which had the grudging approval of Pope Leo X by 1517. Its goal was the reform of the Church from within, and it was pledged to the cultivation of the spiritual life of its members by prayer and frequent Communion, and to the performance of charitable works. Dissolved in 1524. Its members expanded their original work into the newly founded THEATINE ORDER. See also ST. CAJETAN.

ORDER (architectural). An architectural system based on the COLUMN (including BASE, SHAFT, and CAPITAL) and its ENTABLATURE (including ARCHITRAVE, FRIEZE, and CORNICE). The five classical orders are the Doric, Ionic, Corinthian, Tuscan, and Composite.

ORDER (monastic). A religious society or fraternity living under a rule. See Benedictine, camaldolite, carmelite, carthusian, cistercian, dominican, franciscan, sylvestrine, and theatine.

ORTHOGONALS. Lines running at right angles to the plane of the picture surface but, in a representation using one-point perspective, converging toward a common vanishing point in the distance.

PALAZZO (pl. PALAZZI). Italian word for a large town house; used freely to refer to large civic or religious buildings as well as to relatively modest town houses.

PANTOCRATOR. A representation of Christ as the "Almighty Ruler of the Universe." It is a frequent image in the dome mosaics of Byzantine churches.

PARTE GUELFA. See GUELPH.

PASSION. Used specifically in the Church to describe the sufferings of Christ during his last week of earthly life; or the representation of his sufferings in narrative or pictorial form.

PATEN. The shallow dish, usually circular and of silver, on which the HOST is laid at the celebration of the EUCHARIST.

PENDENTIVE. An architectural feature having the shape of a spherical triangle; pendentives are used as a transition from a square ground plan to a circular plan that will support a DOME. The dome may rest directly on the pendentives, or on an intermediate DRUM.

PERISTYLE. A COLONNADE or ARCADE around a building or open court. PIANO NOBILE. Italian phrase for noble floor. It refers to the second story of a building (or first story, European style), intended for the owner and family.

PIAZZA (pl. PIAZZE). Italian word for public square. See also CAMPO. PIER. A vertical architectural element, usually rectangular in section; if used with an ORDER, it often has a BASE and CAPITAL of the same

PIER BUTTRESS. An exterior PIER in Romanesque and Gothic architecture, buttressing the thrust of the VAULTS within.

PIETÀ. Italian word meaning both pity and piety. Used to designate a representation of the dead Christ generally but not always mourned by the Virgin, with or without saints and angels. When the representation is intended to show a specific event prior to Christ's burial, it is usually called a Lamentation.

PIETRA FORTE. The traditional tan stone employed by Florentine builders.

PIETRA SERENA. A clear gray Tuscan limestone used in Florence.

PILASTER. A flat vertical element having a CAPITAL and BASE, engaged in a wall from which it projects. It has a decorative rather than a structural purpose.

PINACOTECA. Italian word for picture gallery.

PINNACLE. A small ornamental turret placed on top of BUTTRESSES, PIERS, or elsewhere. It is mainly decorative.

PINXIT. Latin word for "[he] painted."

PLACE OF THE SKULL. See GOLGOTHA.

PLATONIC ACADEMY. Instituted in Florence by Cosimo de' Medici in the mid-fifteenth century for the study of rediscovered Greek writings of Plato. Cosimo appointed as head of the Academy the young humanist Marsilio Ficino, who translated both Plato and Plotinus into Latin. The Academy and its studies had a great influence on European thought during the Reformation. See also NEOPLATONISM.

POLYPTYCH. ALTARPIECE or devotional picture consisting of more than three wooden panels joined together.

PORPHYRY. A very hard stone having a dark, purplish-red base.

PORTA CLAUSA. Latin phrase for CLOSED DOOR.

POUNCING. Method of transferring a CARTOON to a plaster surface. Small holes are pricked along the outlines of the drawing and dusted with powdered charcoal so that the chief lines of the composition appear on the plaster beneath.

POVERELLO. Italian word meaning little poor man. Refers to St. Francis of Assisi, whose followers were sometimes called *poverelli*.

PREDELLA. Pedestal of an ALTARPIECE, usually decorated with small narrative scenes visible only at close range.

PRIE-DIEU. French phrase literally meaning "pray God." A prayer desk or a small desk having a footpiece on which to kneel and a support to hold a book.

PRIMAVERA. Italian word for spring.

PRIMUM MOBILE. Latin phrase literally meaning the first moving thing. In Aristotelian philosophy, the Prime Mover is the first cause of all movement in the universe, and itself does not move; it is also called the Unmoved Mover.

PRIORI. Italian word for priors, the council or principal governing body of a town.

PROCESSION OF THE HOST. See CORPUS CHRISTI.

PSYCHOMACHIA. From the Greek word meaning conflict of the soul. Refers to Prudentius' poem by the same name in which the VIRTUES and VICES confront each other.

PUTTO (pl. PUTTI). Small nude boys, often winged, frequently used in Renaissance painting, sculpture, and architectural decoration. Sometimes they personify Love and are called "cupids" or "amoretti"; sometimes they are intended to represent angels, and are called "angeletti." Often they are purely decorative. This use of *putto* is of modern application; documents sometimes refer to these figures as "spiritelli."

QUATTROCENTO. Italian word for four hundred. Means fifteenth century, the one thousand four hundreds.

RAISING OF LAZARUS, OF TABITHA, OF THE SON OF THEOPHILUS. See RESURRECTION.

REDENTORE. Italian word for Redeemer, a title frequently given to

Christ.
REFECTORY. The dining hall of a monastery. See also CENACOLO.

RELIEF. Sculpture that is not freestanding but projects from the background of which it is a part. It is called high relief or low relief depending on the amount of projection. See also RILIEVO SCHIACCIATO.

RESURRECTION. The rising again of Christ on the third day after his death and burial, a scene mentioned in the GOSPELS but not directly described. RESURRECTION OF THE DEAD. The rising again of all men at the Last Judgment. Usually RESURRECTION is used only for these two events, the word "raising" being preferred for the miracles of Lazarus, Tabitha, the son of Theophilus, etc.

RIBBED VAULT. A compound masonry VAULT, the GROINS of which are marked by projecting stone ribs.

RILIEVO SCHIACCIATO. Italian term for flattened RELIEF. It refers to the kind of sculpture initiated by Donatello in which distance and perspective are achieved by optical suggestion rather than by sculptural projection.

ROSARY. A string of beads ending in a crucifix. The form in present use was invented by the DOMINICAN ORDER as an aid to memory in the recitation of groups of ten Hail Marys, preceded always by an Our Father; the Hail Marys are represented by small beads, the Our Fathers by large ones. The string ends with a crucifix, on which is recited a Glory Be to the Father. During recitation the worshiper is expected to meditate on the five Joyful, five Sorrowful, or five Glorious Mysteries of the Virgin. In the fifteenth and sixteenth centuries the Dominican rosary competed with many other forms, some even in open strings, each corresponding to a different cycle of prayers, and not all ending in a crucifix; all were known as rosaries.

RUSTICATION. Masonry having indented joinings, and frequently a roughened surface.

SACRA CONVERSAZIONE. Italian term for sacred conversation. A Madonna and Child accompanied by four or more saints either conversing or silently communing.

SAGRA. Italian word for consecration.

ST. ANTONINE OF FLORENCE. Antonino Pierozzi (1389–1459) entered the DOMINICAN ORDER at the age of sixteen, and was consecrated archbishop of Florence in 1446. Much beloved for his activities during the plague and earthquake of 1448 and 1453, he was canonized by Pope Adrian VI in 1523.

ST. CAJETAN (Gaetano da Thiene). Born in Vicenza in 1480, he was an important figure in laying the foundations of sixteenth-century Catholic reform in Italy. In 1516 he joined the ORATORY OF DIVINE LOVE in Rome; when that was dissolved in 1524, he helped to found the THEATINE ORDER in whose affairs he was active until his death in 1547. He was canonized in 1691 by Pope Innocent XII.

ST. ROMUALD. See CAMALDOLITE ORDER.

SALA. Italian word for room or hall.

SALVATOR MUNDI. Latin phrase for Savior of the World. A bust-length representation of Christ holding the orb and the Cross in one hand and blessing with the other.

SAVONAROLA, GIROLAMO. Born in Ferrara in 1452, he became a DOMINICAN monk and in 1489 went to Florence, where he was appointed prior of San Marco. His eloquence as a preacher, his fervor for reform in Florence, and his political adroitness enabled him to become for a short time the virtual dictator of the Republic. However, political and religious intrigues against him led to his downfall. In 1498 he and two companions were hanged in front of the Palazzo Vecchio and their bodies burned on the gallows.

SCUOLA (pl. SCUOLE). See COMPANY.

SELLA GESTATORIA. The portable throne on which the pope is carried on certain ceremonial occasions.

SERAPH (pl. SERAPHIM). A celestial being or angel of the highest order. See also CHERUB.

SFUMATO. Italian word for smoky. The method developed by Leonardo da Vinci to model figures by subtle gradations of light and dark.

SHAFT. A cylindrical form; in architecture, the part of a COLUMN or PIER intervening between the BASE and the CAPITAL.

SHOP. See BOTTEGA.

SIBYLS. Greek and Roman prophetesses believed to have foretold the coming of Christ.

SIDE AISLE. One of the corridors parallel to the NAVE of a church, separated from it by an ARCADE or COLONNADE.

SIGNORIA. Italian word for lordship, but used to refer to the governing bodies of Florence.

SILVERPOINT. A drawing made with a slender silver rod on paper coated with a pigment that causes the silver to oxidize.

SINOPIA. Preliminary brush drawing in red earth mixed with water for a painting in FRESCO; usually done on the ARRICCIO of the wall. An Italian term taken from Sinope, the name of a city in Asia Minor famous for its red earth.

SINS, SEVEN DEADLY. See VICES.

SLIP. Potters' term for a very thin paste of water and clay.

SPANDREL. An area between the exterior curves of two adjoining arches; or enclosed by the exterior curve of an ARCH, a perpendicular from its springing, and a horizontal through its apex.

SPOLVERO. Full-scale preparatory drawing for a TEMPERA painting. The lines are pricked and then tapped with a sponge or bag full of charcoal dust so that the design will appear on the prepared surface of the wooden panel.

SQUINCH. A construction using a small ARCH or one or more LINTELS, built across the corner of a room to support a superimposed mass.

STABAT MATER DOLOROSA. Latin for "there stood the grieving mother," the first words of a famous thirteenth-century poem written by Jacopone da Todi, which describes the sorrows of the Virgin Mary as she watched the Crucifixion of her Son.

STANZA (pl. STANZE). Italian word for room.

STAR OF THE SEA AND PORT OF THE SHIPWRECKED. Among Mary's titles in St. Bernard's LITANY *of the Virgin*, based on titles appearing frequently throughout theological writings.

STATIONS OF THE CROSS. A series of fourteen scenes from the PASSION of Christ ranged around a church and before which devotions are performed. Also the devotional exercises used for this purpose.

STELE. From the Greek word meaning standing block. An upright slab bearing sculptured designs or inscriptions.

- STIGMATA. Marks corresponding to the wounds in the hands, feet, and side of the crucified Christ, sometimes appearing on the corresponding portions of religious persons after prolonged meditation, and believed to be a token of divine favor. In the case of St. Francis, the example most frequently represented, this occurred in 1224 on La Verna.
- STORIA. Italian term for figure composition. Also means history, story, narrative, or episode.
- STYLOBATE. The top step on which COLUMNS rest.
- SYLVESTRINE ORDER. A monastic ORDER founded in 1231 at Montefano by St. Sylvester Gozzolini. Although the order was under the BENE-DICTINE rule, its practice was much stricter in regard to poverty and abstinence.
- TEMPERA. Ground colors mixed with yolk of egg as a vehicle, instead of the oil of more recent tradition. It was widely used for Italian panel painting before the sixteenth century.
- TERRA-COTTA. Italian word for baked earth. A hard glazed or unglazed earthenware used for sculpture and pottery or as a building material. The word can also mean something made of this material or the color of it, a dull brownish-red.
- TERRA VERDE. Italian words for green earth, the color used for the underpaint of flesh tones in TEMPERA painting.
- THEATINE ORDER. The order, also called the Society of Clerks Regular, was founded jointly in 1524 by St. Cajetan and Giovanni Carafa (later Pope Paul IV). It presented a new model of deportment marked by an extreme austerity, a devotion to pastoral work, and a strong emphasis on prayer and EUCHARISTIC devotion.
- THEOLOGICAL VIRTUES. See VIRTUES.
- TIARA (papal). The pope's triple crown, surmounted by the orb and cross. It is the emblem of sovereign power, but has no sacred character and is therefore never worn during celebrations of the MASS, at which time the pope always wears a MITRE.
- TIE-ROD. An iron rod used as a structural element to keep the lower ends of a roof or ARCH from spreading.
- TITULUS. Latin term for inscription. It refers to the label often represented as placed above the head of the crucified Christ and bearing the letters INRI, the abbreviation of "Jesus Nazarenus Rex Judaeorum," which Pilate placed on the Cross (John 19:19–20).
- TONDO. Italian term for circular painting.
- TRANSEPT. In a BASILICAN church, the crossarm inserted at right angles with the NAVE, usually separating the latter from the CHANCEL, or the APSE.

- TRANSVERSALS. Horizontal lines running parallel to the picture plane or base and intersecting the ORTHOGONALS.
- TRAVERTINE. A white or light-colored limestone used in Italy for building. The surface is characterized by alternating smooth and porous passages.
- TRECENTO. Italian for three hundred. Means fourteenth century, the one thousand three hundreds.
- TRIPTYCH. ALTARPIECE or devotional picture consisting of three wooden panels joined together.
- ULTRAMARINE. An expensive pigment of an intense blue color made from pulverized lapis lazuli, a semiprecious stone found in the Near East. It was used especially for painting the Virgin's mantle.
- VAULT. An arched roof or covering, made of brick, stone, or concrete.

 See BARREL VAULT, GROIN VAULT, RIBBED VAULT.
- VENUS ANADYOMENE. Venus rising from the sea. She is usually represented as standing on a scallop shell. VENUS PUDICA. Latin term for modest Venus. She hides her nakedness with her hands in a pose favored by Greek and Roman sculptors and adopted by Renaissance masters.
- VICES. Coming from the same tradition as the VIRTUES, and frequently paired with them, they are more variable but usually include Pride, Avarice, Wrath, Gluttony, and Unchastity. Others such as Folly, Inconstancy, Injustice, etc., are selected to make a total of seven.
- VIRGO LACTANS. Latin phrase for nursing Virgin. She suckles the Christ Child on her lap or in her arms.
- VIRTUES. Divided into the three Theological Virtues of Faith, Hope, and Charity, and the four Cardinal Virtues of Prudence, Justice, Fortitude, and Temperance. As with the VICES, the allegorical representation of the Virtues in the Renaissance derives from a long medieval tradition in manuscripts and sculpture, and from such literary sources as the PSYCHOMACHIA of Prudentius and writings of St. Augustine, with their commentaries.
- VOLGARE. Italian word for vulgar, of the people; used to denote the Italian language as distinct from Latin.
- VOLUTE. Ornament resembling a rolled scroll. Especially prominent on CAPITALS of the Ionic and Composite ORDERS.
- VULGATE. The Latin version of the Bible that St. Jerome prepared at the end of the fourth century A.D.
- wash. Used especially in watercolor and brush drawing to describe a broad thin layer of diluted pigment or ink. Also refers to a drawing made in this technique.
- ZECCA. Italian word for a mint, where money is coined.

Bibliography/Books for Further Reading

Preference has been given in this bibliography to the most important recent books and to books in English. Most contain ample bibliographies. Titles marked with an asterisk are available in paperback editions. Periodical articles on the artists—omitted here for lack of space—are listed at the end of each entry in *Encyclopedia of World Art* (see III. GENERAL, below). Articles published since the *Encyclopedia* was completed (in 1983) are listed in *Art Index*, a biennial with quarterly supplements, which can be found in all art libraries.

I. SOCIAL AND HISTORICAL BACKGROUND OF ITALIAN ART

- ANTAL, FREDERICK, Florentine Painting and Its Social Background, Kegan Paul, London, 1948
- *BARON, HANS, The Crisis of the Early Italian Renaissance, rev. ed., 2 vols., Princeton University Press, Princeton, N.J., 1966
- BAXANDALL, MICHAEL, Giotto and the Orators, Clarendon Press, Oxford, 1971
- *______, Painting and Experience in Fifteenth Century Italy, Oxford University Press, New York, 1974
- *Burckhardt, Jakob C., *The Civilization of the Renaissance in Italy*, (trans. S. G. Middlemore), Phaidon, Oxford, 1965
- CHASTEL, ANDRÉ, The Age of Humanism: Europe 1480–1530 (trans. K. M. Delavenay and E. M. Gwyer), McGraw-Hill, New York, 1964
- ——, The Crisis of the Renaissance, 1520–1600 (trans. P. Price), Skira, Geneva, 1968
- HARTT, FREDERICK, "Art and Freedom in Quattrocento Florence," *Marsyas: Studies in the History of Art*, Suppl. I, Essays in Memory of Karl Lehmann, Institute of Fine Arts, New York University, New York, 1964, pp. 114–31
- ———, "Power and the Individual in Mannerist Art," Studies in Western Art: Acts of the 20th International Congress of the History of Art, vol. 2, The Renaissance and Mannerism, Princeton University Press, Princeton, N.J., 1963, pp. 222–38
- *HAUSER, ARNOLD, *The Social History of Art* (trans. S. Goodman, in collaboration with the author), Knopf, New York, 1951
- Kristeller, Paul O., Renaissance Thought and Its Sources, Columbia University Press, New York, 1979
- *SEZNEC, JEAN, The Survival of the Pagan Gods: The Mythological Tradition and Its Place in Renaissance Humanism and Art (trans. B. Sessions), Princeton University Press, Princeton, N.J., 1953
- *WIND, EDGAR, Pagan Mysteries in the Renaissance, Yale University Press, New Haven, Conn., 1958

II. SOURCES

1. Anthologies

- *GILBERT, CREIGHTON E., Italian Art, 1400–1500: Sources and Documents in the History of Art, Prentice-Hall, Englewood Cliffs, N.J., 1980
- *HOLT, ELIZABETH, ed., Literary Sources of Art History, Princeton Uni-

- versity Press, Princeton, N.J., 1947 (paperback edition entitled *A Documentary History of Art*)
- *KLEIN, ROBERT, and ZERNER, HENRI, Italian Art, 1500–1600: Sources and Documents in the History of Art, Prentice-Hall, Englewood Cliffs, N.J., 1966

2. Writings by Individuals

- ALBERTI, LEONBATTISTA, On Painting and on Sculpture, the Latin Texts of De Pictura and De Statua (ed. with translations, intro., and notes by Cecil Grayson), Phaidon, London, 1972
- ——, Ten Books on Architecture (ed. J. Rykwert, trans. J. Leoni), Tiranti, London, 1955
- Antonine of Florence, Saint, *Lettere*, Florence, 1736; reprinted Tipografica Barbèra, Bianchi e c, Florence, 1859
- Opera a benvivere, Venice, 1578; reprinted Libreria editrice fiorentina, Florence, 1923
- Opus chronicorum, Venice, [1480?]; Lyons, 1587
- ——, *Summa theologica*, Venice, 1480; reprinted Verona, 1740; reprinted Akademische Druck und Verlagsanstalt, Graz, 1959
- BAROCCHI, PAOLA, Trattati d'arte del Cinquecento fra Manierismo e Controriforma, 3 vols., Laterza, Bari, 1960–62
- *CASTIGLIONE, BALDASSARE, The Book of the Courtier (trans. L. E. Opdycke), Scribner's, New York, 1903
- *Cellini, Benvenuto, Autobiography (ed. J. Pope-Hennessy), Phaidon, London, 1960
- *CENNINI, CENNINO, The Craftsman's Handbook (Il libro dell'arte) (trans. D. V. Thompson, Jr.), Dover, New York, 1954
- *CONDIVI, ASCANIO, The Life of Michelangelo (ed. Hellmut Wohl, trans. Alice Sedgwick Wohl), Louisiana State University Press, Baton Rouge, 1976
- FILARETE (ANTONIO AVERLINO), *Treatise on Architecture* (trans. with intro. and notes by J. R. Spencer), 2 vols., Yale University Press, New Haven, Conn., 1965
- LEONARDO DA VINCI, Leonardo da Vinci on Painting: A Lost Book (Libro A) (ed. C. Pedretti), University of California Press, Berkeley, 1964
 - _____, The Literary Works of Leonardo da Vinci (ed. J. P. Richter), 2d ed., 2 vols., Oxford University Press, London and New York, 1939
- *_____, The Notebooks of Leonardo da Vinci (ed. E. MacCurdy), Braziller, New York, 1955
- ——, Treatise on Painting (trans. and annotated by A. P. McMahon), 2 vols., Princeton University Press, Princeton, N.J., 1956
- MANETTI, ANTONIO DI TUCCIO, The Life of Brunelleschi by Antonio di Tuccio Manetti (ed. Howard Saalman), Pennsylvania State University Press, University Park and London, 1970
- MARTINI, FRANCESCO DI GIORGIO, Trattati di architettura, ingegneria e arte militare (ed. C. Maltese), 2 vols., Milan, 1967
- MICHELANGELO, Complete Poems and Selected Letters of Michelangelo (ed. R. N. Linscott, trans. C. Gilbert), 2d ed., Random House, New York. 1965
- _____, The Letters of Michelangelo (ed. and trans. E. H. Ramsden), Stanford University Press, Palo Alto, Calif., 1963

- Palladio, Andrea, *I quattro libri dell'architettura*, Venice, 1570; reprinted in facsimile by Hoepli, Milan, 1951
- SERLIO, SEBASTIANO, Regole generali di architettura sopra le cinque maniere degli edifici, Venice, 1537 and 1551. Books 1–5 and Libro straordinario, Venice, 1566 and 1584. Book 6 (ed. M. Rosci), Milan, 1967
- *VASARI, GIORGIO, Lives of the Most Eminent Painters, Sculptors and Architects (trans. G. du C. De Vere), 10 vols., Medici Society, London, 1912–15
- *——, Vasari on Technique (ed. G. B. Brown, trans. L. S. Maclehose), Dover, New York, 1960
- VIGNOLA, GIACOMO BAROZZI DA, Regola delli cinque ordini di architettura, Rome, 1562

III. GENERAL

- Berenson, Bernard, *The Study and Criticism of Italian Art*, 3d series, Bell, London, 1901–16
- CHASTEL, ANDRÉ, Studios and Styles of the Italian Renaissance (trans. Jonathan Griffin), Odyssey Press, New York, 1966
- COLE, BRUCE, The Renaissance Artist at Work, from Pisano to Titian, Harper and Row, New York, 1983
- Encyclopedia of World Art, 16 vols., McGraw-Hill, New York, vols. 1–15, 1959–68; vol. 16 (suppl.), 1983. Authoritative articles by leading specialists are to be found under "Italian Art" and "Renaissance," as well as under the names of all the artists mentioned in this volume, save only Beccafumi. Useful bibliographies of books and periodical literature appear at the end of each article.
- *GOMBRICH, ERNST H., Norm and Form: Studies in the Art of the Renaissance, Phaidon, London, 1966
- *PANOFSKY, ERWIN, Renaissance and Renascences in Western Art, 2 vols., Almqvist and Wiksell, Stockholm, 1960 (1-vol. ed., 1965)
- POPE-HENNESSY, JOHN, *The Portrait in the Renaissance*, Bollingen Foundation, New York, 1966
- *SHEARMAN, JOHN, *Mannerism*, Penguin Books, Harmondsworth and Baltimore, 1967
- SMYTH, CRAIG H., Mannerism and Maniera, Augustin, Locust Valley, N.Y., 1961
- Studies in Western Art: Acts of the 20th International Congress of the History of Art, vol. 2, The Renaissance and Mannerism, Princeton University Press, Princeton, N.J., 1963
- VENTURI, ADOLFO, Storia dell'arte italiana, 11 vols. in 25, Hoepli, Milan, 1901-40
- WHITE, JOHN, Art and Architecture in Italy, 1250–1400, Pelican History of Art, Penguin Books, Baltimore, 1966
- ———, Studies in Late Medieval Italian Art, Pindar Press, London, 1984
- *Wölfflin, Heinrich, Classic Art, 2d ed., Phaidon, London, 1953

IV. THEORY

- *BLUNT, ANTHONY, Artistic Theory in Italy, 1450–1600, Clarendon Press, Oxford, 1966
- *EDGERTON, SAMUEL Y., The Renaissance Rediscovery of Linear Perspective, Basic Books, New York, 1975
- *PANOFSKY, ERWIN, Meaning in the Visual Arts, Doubleday, Garden City, N.Y., 1957
- *_____, Studies in Iconology: Humanistic Themes in the Art of the Renaissance, Oxford University Press, Oxford, 1939
- *SUMMERS, DAVID, Michelangelo and the Language of Art, Princeton University Press, Princeton, N.J., 1981
- See also II, 2: Writings by Individuals

V. ARCHITECTURE

- FREY, DAGOBERT, Architecture of the Renaissance from Brunelleschi to Michelangelo, Naeff, The Hague, 1925
- FROMMEL, CHRISTOPH LUITPOLD, Der römische Palastbau der Hochrenaissance, 3 vols., Ernst Wasmuth, Tübingen, 1973

- HEYDENREICH, LUDWIG H., and LOTZ, WOLFGANG, Architecture in Italy, 1400 to 1600, Penguin Books, Harmondsworth and Baltimore, 1974.
- Krautheimer, Richard, Studies in Early Christian, Medieval, and Renaissance Art, New York University Press, New York, 1969
- LIEBERMAN, RALPH, Renaissance Architecture in Venice, 1450–1540, Abbeville Press, New York, 1982
- LOWRY, BATES, Renaissance Architecture, Braziller, New York, 1962
- *Murray, Peter, The Architecture of the Italian Renaissance, Schocken Books, New York, 1963
- ——, Renaissance Architecture, Harry N. Abrams, New York, 1971 *PEVSNER, NIKOLAUS, An Outline of European Architecture, 6th (Jubilee) ed., Penguin Books, Harmondsworth and Baltimore, 1960
- RICCI, CORRADO, Architecture and Decorative Sculpture of the High and Late Renaissance in Italy, Brentano's, New York, 1923
- STEGMANN, CARL M., and von GEYMULLER, HEINRICH, Architecture of the Renaissance in Tuscany, 2 vols., Architectural Publishing, New York, 1924
- *WITTKOWER, RUDOLF, Architectural Principles in the Age of Humanism, 3d ed., rev., Tiranti, London, 1962

VI. PAINTING

- BECHERUCCI, LUISA, *I manieristi toscani*, Arti grafiche, Bergamo, 1944 BERENSON, BERNARD, *Italian Painters of the Renaissance*, rev. ed., Phaidon, London, 1967
- ——, Italian Pictures of the Renaissance, 7 vols., Phaidon, London, 1957–68
- BOLOGNA, FERDINANDO, Early Italian Painting: Romanesque and Early Medieval, Van Nostrand, Princeton, N.J., 1964
- BORSOOK, EVE, The Mural Painters of Tuscany from Cimabue to Andrea del Sarto, 2d ed., rev. and enlarged, Clarendon Press and Oxford University Press, Oxford, 1980
- BUSCAROLI, REZIO, La pittura romagnola del Quattrocento, Fratelli Lega, Faenza, 1931
- CARLI, ENZO, Italian Primitives, Harry N. Abrams, New York, 1965
- ——, Sienese Painting, New York Graphic, Greenwich, Conn., 1956 COLE, BRUCE, Sienese Painting, from Its Origin to the Fifteenth Century, Harper and Row, New York, 1980
- ——, Sienese Painting in the Age of the Renaissance, Indiana University Press, Bloomington, 1985
- COLETTI, LUIGI, Pittura veneta del Quattrocento, Istituto geografico de'Agostini, Novara, 1953
- CROWE, JOSEPH A., and CAVALCASELLE, GIOVANNI B., A History of Painting in Italy, 2d ed. (ed. L. Douglas), 6 vols., John Murray, London, 1903–14
- ——, A History of Painting in North Italy (ed. T. Borenius), 3 vols., Scribner's, New York, 1912
- *DEWALD, ERNEST T., *Italian Painting*, 1200–1600, Holt, Rinehart and Winston, New York, 1961
- EDGELL, GEORGE H., A History of Sienese Painting, MacVeagh, Dial Press, New York, 1932
- *Freedberg, Sydney J., *Painting in Italy, 1500–1600*, rev. ed., Pelican History of Art, Penguin Books, Harmondsworth and Baltimore, 1975
- ——, Painting of the High Renaissance in Rome and Florence, 2 vols., Harvard University Press, Cambridge, Mass., 1961
- FREMANTLE, RICHARD, Florentine Gothic Painters from Giotto to Masaccio, Martin Secker and Warburg, London, 1975
- *FRIEDLAENDER, WALTER F., Mannerism and Anti-Mannerism in Italian Painting, Columbia University Press, New York, 1957
- GARRISON, EDWARD, B., Early Italian Painting: Selected Studies, Pindar Press, London, 1984
- ——, Italian Romanesque Panel Painting: An Illustrated Index, Olschki, Florence, 1949; reprinted Hacker Art Books, New York, 1976
- GNOLI, UMBERTO, *Pittori e miniatori nell'Umbria*, Argentieri, Spoleto, 1923; reprinted Ediclio, Foligno, 1980
- GOULD, CECIL, An Introduction to Italian Renaissance Painting, Phaidon, London, 1957

- LONGHI, ROBERTO, Officina ferrarese (1934) seguita degli ampliamenti (1940) e dai nuovi ampliamenti (1940–55), Sansoni, Florence, 1956
- Viatico per cinque secoli di pittura veneziana, Sansoni, Florence, 1946
- MARCHINI, GIUSEPPE, Italian Stained Glass Windows, Harry N. Abrams, New York, 1956
- MARLE, RAIMOND VAN, The Development of the Italian Schools of Painting, 19 vols., Nijhoff, The Hague, 1923-38
- MARTINEAU, JEAN, and HOPE, CHARLES, eds., The Genius of Venice 1500-1600, Royal Academy of Arts, London, 1983
- MEISS, MILLARD, The Great Age of Fresco: Discoveries, Recoveries and Revivals, Braziller, New York, 1970
- -, Painting in Florence and Siena after the Black Death, Princeton University Press, Princeton, N.J., 1951
- NICOLSON, BENEDICT, The Painters of Ferrara: Cosmè Tura, Francesco del Cossa, Ercole de' Roberti and Others, Elek, London, 1950
- OFFNER, RICHARD A., A Critical and Historical Corpus of Florentine Painting, Section III (8 vols.), Section IV (4 vols.), New York University Press, New York, 1930-67
- Studies in Florentine Painting: The 14th Century, Sherman, New York, 1927; reprinted Junius Press, New York, 1972
- Ottino della Chiesa, Angela, Pittura lombarda del Quattrocento, Arti grafiche, Bergamo, 1959
- POPE-HENNESSY, JOHN, Sienese Quattrocento Painting, Phaidon, Oxford and London, 1947
- PROCACCI, UGO, Sinopie e affreschi, Electa Editrice, Milan, 1961
- RICCI, CORRADO, North Italian Painting of the Cinquecento: Piedmont, Liguria, Lombardy, Emilia, Harcourt, Brace, New York, 1929
- SALMI, MARIO, Italian Miniatures, Harry N. Abrams, New York, 1954 SCHMECKEBIER, LAURENCE E., A New Handbook of Italian Renaissance Painting, 2d ed., rev., Hacker Art Books, New York, 1981
- SINIBALDI, GIULIA, and BRUNETTI, GIULIA, Pittura italiana del duecento e trecento; catalogo della Mostra Giottesca di Firenze del 1937, Sansoni, Florence, 1943
- SMART, ALISTAIR, The Dawn of Italian Painting, c. 1250-1400, Cornell University Press, Ithaca, N.Y., 1978
- TOESCA, PIETRO, Florentine Painting of the Trecento, Harcourt, Brace, New York, 1929
- VALVALÀ, EVELYN SANDBERG, La pittura veronese del Trecento e del primo Quattrocento, "La Tipografica veronese," Verona, 1926
- Uffizi Studies: The Development of the Florentine School of Painting, Olschki, Florence, 1948
- WEIGELT, CURT H., Sienese Painting of the Trecento, Harcourt, Brace, New York, 1930; reprinted Hacker Art Books, New York, 1974
- WILDE, JOHANNES, Venetian Art from Bellini to Titian, Oxford University Press, New York, 1974
- ZAMPETTI, PIETRO, La pittura marchigiana da Gentile a Raffaello, Electa Editrice, Venice, [1971?]

VII. SCULPTURE

- BODE, WILHELM VON, Florentine Sculpture of the Renaissance, Methuen, London [1908?]
- Italian Bronze Statuettes of the Renaissance, 3 vols., Methuen, London, 1908-12
- *POPE-HENNESSY, JOHN, Italian Gothic Sculpture, Phaidon, London, 1955
- , Italian High Renaissance and Baroque Sculpture, 3 vols., Phaidon, London, 1963
- -, Italian Renaissance Sculpture, Phaidon, London, 1958
- SEYMOUR, CHARLES, Sculpture in Italy, 1400-1500, Pelican History of Art, Penguin Books, Harmondsworth and Baltimore, 1966
- WILES, BERTHA H., The Fountains of Florentine Sculptors and Their Followers from Donatello to Bernini, Harvard University Press, Cambridge, Mass., 1933

VIII. DRAWINGS

1. Comprehensive Studies

*AMES-LEWIS, FRANCIS, Drawing in the Italian Renaissance Workshop, Victoria and Albert Press, London, 1983

- BERENSON, BERNARD, The Drawing of the Florentine Painters, 3 vols., University of Chicago Press, 1938
- DEGENHART, BERNHARD, and SCHMITT, ANNEGRIT, Corpus der italienischen Zeichnungen, 1300–1450, Gebrüber Mann Verlag, Berlin, 1968-
- Italian Drawings in the Department of Prints and Drawings in the British Museum, 4 vols., British Museum, London:
 - Vol. I. POPHAM, ARTHUR E., and POUNCEY, PHILIP, The 14th and 15th Centuries, 2 vols., 1950
 - Vol. II: WILDE, JOHANNES, Michelangelo and His Studio, 1953
 - Vol. III: POUNCEY, PHILIP, and GERE, JOHN A., Raphael and His Circle, 2 vols., 1962
 - Vol. IV: POPHAM, ARTHUR E., Artists Working in Parma in the 16th Century, 2 vols., 1967
- POPHAM, ARTHUR E., The Italian Drawings of the XV and XVI Centuries in the Collection of His Majesty the King at Windsor Castle, Phaidon,
- TIETZE, HANS, and TIETZE-CONRAT, ERICA, The Drawings of the Venetian Painters in the 15th and 16th Centuries, Augustin, Locust Valley, N.Y., 1944

2. Single Artists

- MOSCHINI, VITTORIO, Disegni di Jacopo Bellini, Arti grafiche, Bergamo,
- CLARK, KENNETH, The Drawings of Sandro Botticelli for Dante's Divina Commedia, Harper and Row, New York, 1976
- SMYTH, CRAIG HUGH, Bronzino as a Draughtsman: An Introduction, Augustin, Locust Valley, N.Y., 1931
- POPHAM, ARTHUR E., Correggio's Drawings, Oxford University Press, London, 1957
- The Drawings of Leonardo da Vinci, Reynal and Hitchcock, New York, 1945
- CLARK, KENNETH, The Drawings of Leonardo da Vinci in the Collection of Her Majesty the Queen at Windsor Castle, 2d ed., 3 vols., rev. with the assistance of Carlo Pedretti, Phaidon, London, 1968
- HARTT, FREDERICK, Michelangelo Drawings, Harry N. Abrams, New York, 1971
- POPHAM, ARTHUR E., The Drawings of Parmigianino, Beechhurst Press, New York, 1953
- DAVIDSON, BERNICE F., ed., Mostra di disegni di Perino del Vaga (trans. F. P. Chiarini), Olschki, Florence, 1966
- HILL, GEORGE F., Drawings by Pisanello, Van Ouest, Paris and Brussels, 1929
- REARICK, JANET C., The Drawings of Pontormo, 2 vols., Harvard University Press, Cambridge, Mass., 1964
- JOHANNIDES, PAUL, The Drawings of Raphael with a Complete Catalog, University of California Press, Berkeley, 1983
- KNAB, ECKHART; MITSCH, ERWIN; and OBERHUBER, KONRAD, Raphael: Die Zeichnungen, Urachhaus, Stuttgart, 1983
- CARROLL, EUGENE A., The Drawings of Rosso Fiorentino, Garland, New York, 1976
- HADELN, DETLEV VON, Titian's Drawings, Macmillan, London, 1927
- OBERHUBER, KONRAD, Disegni di Tiziano e della sua cerchia, Pozza, Venice, 1976
- COCKE, RICHARD, Veronese's Drawings, Cornell University Press, Ithaca, N.Y., 1984

IX. STUDIES OF MAJOR PROJECTS AND INDIVIDUAL WORKS OF ART

- ACKERMAN, JAMES S., The Cortile del Belvedere, Biblioteca apostolica vaticana, Vatican City, 1954
- BALDINI, UMBERTO, Primavera: The Restoration of Botticelli's Masterpiece, Harry N. Abrams, New York, 1986
- and NARDINI, BRUNO, San Lorenzo: la basilica, le sacrestie, le cappelle, la biblioteca, Nardini, Centro internazionale del libro, Florence, 1984
- BECK, JAMES H., Jacopo della Quercia e il portale di S. Petronio a Bologna, ALFA, Bologna, 1970

Brandi, Cesare, Il Tempio Malatestiano, Edizioni Radio Italiana, Turin. 1956

Brunetti, Giulia, and Becherucci, Luisa, eds., Il Museo dell'Opera del Duomo a Firenze, Electa Editrice, Florence, 1969

CARLI, ENZO, Il pulpito di Siena, Arti grafiche, Bergamo, Milan, and Rome, 1943

, Luca Signorelli, gli affreschi nel Duomo di Orvieto, Arti grafiche, Bergamo, 1946

Sculture del Duomo di Siena, Einaudi, Turin, 1941 Vetrata duccesca, Electa Editrice, Florence, 1946

CARRA, CARLO, Giotto: La Capella degli Scrovegni, Pizzi, Milan, 1945

D'ANCONA, PAOLO, The Farnesina Frescoes at Rome, Edizioni del Milione, Milan, 1955

DELOGU, GIUSEPPE, Veronese: The Supper in the House of Levi, Pizzi, Milan, 1948

ETTLINGER, L. D., The Sistine Chapel Before Michelangelo, Clarendon Press, Oxford, 1965

FIOCCO, GIUSEPPE, The Frescoes of Mantegna in the Eremitani Church, Padua, 2d ed., Phaidon, Oxford, 1978

GHIDIGLIA QUINTAVALLE, AUGUSTA, Correggio: The Frescoes in San Giovanni Evangelista in Parma (trans. Olga Ragusa), Harry N. Abrams, New York, 1964

HANSON, ANNE C., Jacopo della Quercia's Fonte Gaia, Clarendon Press, Oxford, 1965

HARTT, FREDERICK; CORTI, GINO; and KENNEDY, CLARENCE, The Chapel of the Cardinal of Portugal, 1434-1459, at San Miniato in Florence, University of Pennsylvania Press, Philadelphia, 1964

HARTT, FREDERICK, and FINN, DAVID, Michelangelo's Three Pietàs, Harry N. Abrams, New York, 1976

JOHNSON, EUGENE J., S. Andrea in Mantua: The Building History, Pennsylvania State University Press, University Park, 1975

MARCHINI, GIUSEPPE, Il Duomo di Prato, Milan, 1957

MEISS, MILLARD, Giotto and Assisi, New York University Press, New York, 1960

MELLINI, GIAN LORENZO, Il pulpito di Giovanni Pisano a Pistoia, Electa Editrice, Milan, 1968

PIETRANGELI, CARLO et al., The Sistine Chapel, a New Light on Michelangelo: The Art, the History, and the Restoration, Harmony Books, New

POPE-HENNESSY, JOHN, Paolo Uccello: The Rout of San Romano in the National Gallery, London, Lund, Humphries, London, 1944

RICCI, CORRADO, Il Tempio Malatestiano, Milan, 1925

RICCOMINI, EUGENIO, La più bella di tutte: la cupola del Correggio nel Duomo di Parma, Silvana, Milan, 1983

ROTONDI, PASQUALE, The Ducal Palace of Urbino, Tiranti, London, 1969

SEIDEL, MAX, La scultura lignea di Giovanni Pisano, Edam, Florence, 1971

SEYMOUR, CHARLES, JR., ed., Michelangelo: The Sistine Chapel Ceiling, Norton, New York, 1972

SHEARMAN, JOHN, Raphael's Cartoons in the Collection of Her Majesty the Queen and the Tapestries for the Sistine Chapel, Phaidon, London,

SMART, ALISTAIR, The Assisi Problem and the Art of Giotto, Oxford University Press, London and New York, 1971

SMITH, GRAHAM, The Casino of Pius IV, Princeton University Press, Princeton, N.J., 1977

STEINBERG, LEO, Michelangelo's Last Paintings: The Conversion of St. Paul and the Crucifixion of St. Peter, Oxford University Press, New

STUBBLEBINE, JAMES H., Assisi and the Rise of Vernacular Art, Harper and Row, New York and Cambridge, 1985

ed., Giotto: The Arena Chapel Frescoes, Norton, New York, 1969

TINTORI, LEONETTO, and BORSOOK, EVE, Giotto: The Peruzzi Chapel, Harry N. Abrams, New York, 1965

TINTORI, LEONETTO, and MEISS, MILLARD, The Painting of the Life of St. Francis in Assisi, with Notes on the Arena Chapel, New York University Press, New York, 1962

TRACHTENBERG, MARVIN L., The Campanile of Florence Cathedral-Giotto's Tower, New York University Press, New York, 1971

VERHEYEN, EGON, The Paintings in the Studiolo of Isabella d'Este at Mantua, New York University Press, New York, 1971

, The Palazzo del Te, Johns Hopkins University Press, Baltimore, 1977

WALKER, JOHN, Bellini and Titian at Ferrara: A Study of Styles and Taste. Phaidon London 1957

WESTFALL, CARROLL WILLIAM, In This Most Perfect Paradise: Alberti, Nicholas V, and the Invention of Conscious Urban Planning in Rome, 1447-55, Pennsylvania State University Press, University Park,

WIND, EDGAR, Bellini's Feast of the Gods: A Study in Venetian Humanism, Harvard University Press, Cambridge, Mass., 1948

X. ARTISTS

Alberti

BORSI, FRANCO, Leon Battista Alberti, Electa Editrice, Milan, 1975 GADOL, JOAN, Leon Battista Alberti, Universal Man of the Renaissance, University of Chicago Press, 1969

RICCI, CORRADO, Leon Battista Alberti architetto, Celanza, Turin,

Schlosser, Julius, Ritter von, Ein Künstlerproblem der Renaissance: Leon Battista Alberti, Hölder-Pichler-Tempsky, Vienna, 1929

Altichiero and Avanzo MELLINI, GIAN LORENZO, Altichiero and Jacopo Avanzo, Communità,

Milan, 1965 Ammanati

> FOSSI, MAZZINO, Bartolommeo Ammanati, architetto, Morano, Florence, [1968?]

Fra Angelico

BERTI, LUCIANO; BELLARDONI, BIANCA; and BATTISTI, EUGENIO, Angelico a San Marco, Curcio, Rome, 1965

HERTZ, ANSELM, Fra Angelico, Herder, Freiburg-Basel, 1981 ORLANDI, STEFANO, O.P., Beato Angelico, Olschki, Florence, 1964 POPE-HENNESSY, JOHN, Fra Angelico, Phaidon, New York, 1952; 2d ed., Cornell University Press, Ithaca, N.Y., 1974

Anguissola

BONETTI, C., Sofonisba Anguissola, Cremona, 1932

HOLMES, C.J., "Sofonisba Anguissola and Philip II," Burlington Magazine, XXVI, 1915, pp. 181-87

Antonello da Messina

BOTTARI, STEFANO, Antonello da Messina (trans. G. Scaglia), New York Graphic, Greenwich, Conn., 1955

VIGNI, GIORGIO, All the Paintings of Antonello da Messina (trans. A. F. O'Sullivan), Hawthorn, New York, 1963

Arnolfo di Cambio

ROMANINI, ANGIOLA MARIA, Arnolfo di Cambio e lo stil nuovo del gotico italiano, Ceschina, Milan, 1969

Baldovinetti

KENNEDY, RUTH W., Alesso Baldovinetti: A Critical and Historical Study, Yale University Press, New Haven, 1938

EMILIANI, ANDREA, Federico Barocci (Urbino 1535-1612), 2 vols., Nuova Alfa, Bologna, 1985

OLSEN, HARALD, Federico Barocci, Almqvist and Wiksell, Stockholm, 1955

Fra Bartolommeo

VON DER GABELENTZ, HANS, Fra Bartolommeo und die florentiner Renaissance, Hiersemann, Leipzig, 1922

Beccafumi

CIARANFI, ANNA FRANCINI, Domenico Beccafumi, Sadea/Sansoni, Florence, 1966

SANMINIATELLI, DONATO, Domenico Beccafumi, Bramante, Milan, 1967

Giovanni Bellini

DUSSLER, LUITPOLD, Giovanni Bellini, Schroll, Vienna, 1949 HEINEMANN, FRITZ, Giovanni Bellini e i Belliniani, 2 vols., Pozza, Venice, 1962

HENDY, PHILIP, and GOLDSCHEIDER, LUDWIG, Giovanni Bellini, Oxford University Press, New York, 1945

ROBERTSON, GILES, Giovanni Bellini, Clarendon Press, Oxford, 1968

Benedetto da Majano

DUSSLER, LUITPOLD, Benedetto da Majano, ein florentiner Bildhauer des späten Quattrocento, Schmidt, Munich, 1924

Botticelli

ARGAN, GIULIO C., Botticelli: Biographical and Critical Study (trans. I. Emmons), Skira, New York, 1957

BODE, WILHELM VON, Sandro Botticelli (trans. F. Renfield and F.L.R. Brown), Scribner's, New York, 1925

CHASTEL, ANDRÉ, Botticelli, New York Graphic, Greenwich, Conn.,

ETTLINGER, LEOPOLD DAVID, and ETTLINGER, HELEN S., Botticelli, Thames and Hudson, London, 1976

HORNE, HERBERT P., Alessandro Filipepi, Commonly Called Sandro Botticelli, Painter of Florence, Bell, London, 1908

LIGHTBOWN, RONALD, Botticelli, 2 vols., University of California Press, Berkeley, 1978

YASHIRO, YUKIO, Sandro Botticelli and the Florentine Renaissance, rev. ed., Medici Society, London, 1929

Bramante

BARONI, COSTANTINO, Bramante, Arti grafiche, Bergamo, [1944?] BRUSCHI, ARNALDO, Bramante architetto, Edizione Laterza, Bari,

SUIDA, WILHELM E., Bramante pittore e Il Bramantino, Ceschina, Milan, 1953

Bronzino

EMILIANI, ANDREA, Il Bronzino, Bramante, Milan, 1960

McComb, Arthur K., Agnolo Bronzino, His Life and Works, Harvard University Press, Cambridge, Mass., 1928

McCorquodale, Charles, Bronzino, Harper and Row, New York,

Brunelleschi

ARGAN, GIULIO CARLO, Brunelleschi, Mondadori, Milan, 1955 KLOTZ, HEINRICH, Die Frühwerke Brunelleschis und die mittelälterliche Tradition, Gebrüder Mann Verlag, Berlin, 1970

LUPORINI, EUGENIO, Brunelleschi, Edizioni di Communità, Milan, 1964

PRAGER, FRANK D., and SCAGLIA, GIUSTINA, Brunelleschi: Studies of His Technology and Inventions, MIT Press, Cambridge, Mass., 1970 SANPAOLESI, PIERO, Brunelleschi, Il Club del Libro, Milan, 1962

Carpaccio

LAUTS, JAN, Carpaccio: Paintings and Drawings, Phaidon, London and New York, 1962

LUDWIG, GUSTAV, and MOLMENTI, POMPEO G., The Life and Works of Vittore Carpaccio (trans. R.H.H. Cust), John Murray, London, 1907 PIGNATTI, TERISIO, Carpaccio: Biographical and Critical Study (trans. J. Emmons), Skira, New York, 1958

Andrea del Castagno

HORSTER, MARITA, Andrea del Castagno: Complete Edition with a Critical Catalogue, Phaidon, Oxford, 1980

RICHTER, GEORGE M., Andrea del Castagno, University of Chicago Press, 1943

SALMI, MARIO, Andrea del Castagno, Istituto geografico de'Agostini, Novara, 1961

Cavallini

HETHERINGTON, PAUL, Pietro Cavallini: A Study in the Art of Late Medieval Rome, Sagittarius Press, London, 1979

LAVAGNINO, EMILIO, Pietro Cavallini, Palombi, Rome, [1953]

MATTHIAE, GUGLIELMO, Pietro Cavallini, De Luca, Rome, 1972 Cellini

POPE-HENNESSY, JOHN, Cellini, Abbeville Press, New York, 1985 Cimabue

BATTISTI, EUGENIO, Cimabue (trans. R. Enggass and C. Enggass), Pennsylvania State University Press, University Park, 1966

NICHOLSON, ALFRED, Cimabue: A Critical Study, Princeton University Press, Princeton, N.J., 1932

SINDONA, ENIO, L'opera completa di Cimabue: e il momento figurativo pregiottesco, Rizzoli, Milan, 1975

Correggio

BROWN, DAVID ALAN, The Young Correggio and His Leonardesque Sources, Garland, New York, 1981

ERCOLI, GIULIANO, Arte e fortuna del Correggio, Artioli, Modena,

GOULD, CECIL, The Paintings of Correggio, Faber, London, 1977 TOSCANI, GIUSEPPE M., Nuovi studi sul Correggio, Libreria Aurea, Parma, [1974?]

Cossa

NEPPI, ALBERTO, Francesco del Cossa, Silvana, Milan, 1958 RUHMER, EBERHARD, Francesco del Cossa, Munich, 1959

DREY, FRANZ, Carlo Crivelli, Bruckmann, Munich, 1927 ZAMPETTI, PIETRO, Carlo Crivelli nelle Marche, Urbino, 1952

OFFNER, RICHARD, A Critical and Historical Corpus of Florentine Painting, Section III, vols. III and IV, New York University Press, New York, 1930 and 1934

, The Works of Bernardo Daddi, New York, 1930

Vincenzo Danti

SUMMERS, DAVID, The Sculpture of Vincenzo Danti: A Study in the Influence of Michelangelo and the Ideals of the Maniera, Garland, New York, 1979

Desiderio da Settignano

PLANISCIG, LEO, Desiderio da Settignano, Schroll, Vienna, 1942

Domenico Veneziano

SALMI, MARIO, Paolo Uccello, Andrea del Castagno, Domenico Veneziano, Valori Plastici, Rome, 1936; Gallimard, Paris, 1937

WOHL, HELLMUT, The Paintings of Domenico Veneziano: A Study in Florentine Art of the Early Renaissance, New York University Press, New York, 1980

Donatello

BENNETT, BONNIE A., and WILKINS, DAVID G., Donatello, Phaidon, Oxford, 1984

GOLDSCHEIDER, LUDWIG, Donatello, Phaidon ed., Oxford University Press, New York, 1941

HARTT, FREDERICK, Donatello, Prophet of Modern Vision, Harry N. Abrams, New York, 1973

JANSON, H. W., The Sculpture of Donatello, 2 vols., Princeton University Press, Princeton, N.J., 1957 (1-vol. ed., 1963)

Dosso Dossi

GIBBONS, FELTON, Dosso and Battista Dossi, Court Painters at Ferrara, Princeton University Press, Princeton, N.J., 1968 MEZZETTI, AMALIA, Il Dosso e Battista Dossi, Silvana, Milan, 1965

Duccio

Brandi, Cesare, Duccio, Vallecchi, Florence, 1951

CARLI, ENZO, Duccio, Electa Editrice, Milan, 1952

STUBBLEBINE, JAMES H., Duccio di Buoninsegna and His School, 2 vols., Princeton University Press, Princeton, N.J., 1979

Francesco di Giorgio

BRINTON, SELWYN J. C., Francesco di Giorgio Martini of Siena: Painter, Sculptor, Engineer, Civil and Military Architect (1439–1502), vol. 1, Besant & Co., London, 1934

WELLER, ALLEN S., Francesco di Giorgio, 1439-1501, University of Chicago Press, 1943

Agnolo Gaddi

COLE, BRUCE, Agnolo Gaddi, Clarendon Press, Oxford, 1977 SALVINI, ROBERTO, L'arte di Agnolo Gaddi, Sansoni, Florence, 1936 Taddeo Gaddi

DONATI, PIER PAOLO, Taddeo Gaddi, Sansoni, Florence, 1966 LADIS, ANDREW, Taddeo Gaddi: Critical Reappraisal and Catalogue Raisonné, University of Missouri Press, Columbia, 1982

Gentile da Fabriano

CHRISTIANSEN, KEITH, Gentile da Fabriano, Cornell University Press, Ithaca, N.Y., 1982

GRASSI, LUIGI, Gentile da Fabriano, Rizzoli, Milan, 1953

MOLAIOLI, BRUNO, Gentile da Fabriano, Edizioni "Gentile," Fabriano, 1927; 1934

Ghiberti

GOLDSCHEIDER, LUDWIG, Ghiberti, Phaidon, London, 1949

KRAUTHEIMER, RICHARD, and KRAUTHEIMER-HESS, TRUDE, Lorenzo Ghiberti, Princeton University Press, Princeton, N.J., 1956; 2d ed.,

Ghirlandaio

DAVIES, GERALD S., Ghirlandaio, Scribner's, New York, 1909 LAUTS, J., Ghirlandaio, Vienna, 1943

Giorgione

BALDASS, LUDWIG VON, Giorgione (trans. J. M. Brownjohn), Harry N. Abrams, New York, 1965

CONWAY, W. MARTIN, Giorgione: A New Study of His Art as a Landscape Painter, Benn, London, 1929

DELLA PERGOLA, PAOLO, Giorgione, Martello, Milan, 1955

PHILLIPS, DUNCAN, The Leadership of Giorgione, American Federation of Arts, Washington, D.C., 1937

PIGNATTI, TERISIO, Giorgione (trans. Clovis Whitfield), Phaidon, London, 1971

RICHTER, GEORGE M., Giorgio da Castelfranco, Called Giorgione, University of Chicago Press, 1937

BACCHESCHI, EDI, and MARTINDALE, ANDREW, The Complete Paintings of Giotto, Harry N. Abrams, New York, 1966

COLE, BRUCE, Giotto and Florentine Painting, 1280–1375, Harper and Row, New York, 1976

GNUDI, CESARE, Giotto, Martello, Milan, 1959

PREVITALI, GIOVANNI, Giotto e la sua bottega, Fabbri, Milan, 1967 SALVINI, ROBERTO, Giotto: Bibliografia, Palombi, Rome, 1938 SIRÉN, OSVALD, Giotto and Some of His Followers (trans. F. Schenck), 2 vols., Harvard University Press, Cambridge, Mass., 1917

Giovanni da Milano

MARABOTTINI, ALESSANDRO, Giovanni da Milano, Sansoni, Florence, 1950

Giovanni di Paolo

POPE-HENNESSY, JOHN, Giovanni di Paolo, 1403-1483, Chatto & Windus, London, and Oxford University Press, New York, 1937 Giulio Romano

HARTT, FREDERICK, Giulio Romano, 2 vols., Yale University Press, New Haven, Conn., 1958

Guido da Siena

STUBBLEBINE, JAMES H., Guido da Siena, Princeton University Press, Princeton, N.J., 1964

Francesco Laurana

ROLFS, WILHELM, Franz Laurana, Bong, Berlin, [1907?]

Leonardo da Vinci

CLARK, KENNETH, Leonardo da Vinci: An Account of His Development as an Artist, rev. ed., Penguin Books, Baltimore and Harmondsworth, 1967

GOLDSCHEIDER, LUDWIG, Leonardo da Vinci, 6th ed., Phaidon, London, 1959

HEYDENREICH, LUDWIG H., Leonardo da Vinci, 2 vols., Macmillan, New York, 1954

KEMP, MARTIN, Leonardo da Vinci: The Marvellous Works of Nature and Man, Harvard University Press, Cambridge, Mass., 1981

Leonardo da Vinci, rev. ed., Reynal, New York, 1967

O'MALLEY, C. D., ed., Leonardo's Legacy: An International Symposium, University of California Press, Berkeley, 1969

WASSERMAN, JACK, Leonardo da Vinci, Harry N. Abrams, New York,

ZUBOV, VASILII P., Leonardo da Vinci (trans. D. H. Kraus), Harvard University Press, Cambridge, Mass., 1968

Filippino Lippi

BERTI, LUCIANO, Filippino Lippi, Arnaud, Florence, 1957

NEILSON, KATHERINE B., Filippino Lippi, Harvard University Press, Cambridge, Mass., 1938

SCHARF, ALFRED, Filippino Lippi, Schroll, Vienna, 1935 and 1950 Fra Filippo Lippi

MARCHINI, GIUSEPPE, Fra Filippo Lippi, Electa Editrice, Milan, 1975 OERTEL, ROBERT, Fra Filippo Lippi, Schroll, Vienna, 1942 PITTALUGA, MARY, Filippo Lippi, Del Turco, Florence, 1949

Ambrogio Lorenzetti BORSOOK, EVE, Ambrogio Lorenzetti, Florence, 1966

ROWLEY, GEORGE, Ambrogio Lorenzetti, 2 vols., Princeton University Press, Princeton, N.J., 1958

Pietro Lorenzetti

Brandi, Cesare, Pietro Lorenzetti, Edizioni Mediterranee, Rome, 1958

Pietro Lorenzetti: affreschi nella Basilica Inferiore di Assisi, Pirelli, Rome and Milan, 1957

CARLI, ENZO, Pietro Lorenzetti, Milan, 1956

CECCHI, EMILIO, Pietro Lorenzetti, Fratelli Treves, Milan, 1930 DEWALD, ERNEST T., Pietro Lorenzetti, Harvard University Press, Cambridge, Mass., 1930

BANTI, ANNA, and BOSCHETTO, ANTONIO, Lorenzo Lotto, Sansoni, Florence, [1953?]

BERENSON, BERNARD, Lorenzo Lotto, Phaidon, London, 1956 BIANCONI, PIERO, All the Paintings of Lorenzo Lotto (trans. P. Colacicchi), 2 vols., Hawthorn, New York, 1963

COLETTI, LUIGI, Lorenzo Lotto, Arti grafiche, Bergamo, 1953 PIGNATTI, TERISIO, Lotto, Mondadori, Verona, 1953

Mantegna

CAMESASCA, ETTORE, Mantegna, Il Club del Libro, Milan, 1964 CIPRIANI, RENATA, All the Paintings of Mantegna (trans. P. Colacicchi), 2 vols., Hawthorn, New York, 1964

FIOCCO, GIUSEPPE, Paintings by Mantegna, Harry N. Abrams, New York, 1963

KRISTELLER, PAUL, Andrea Mantegna (trans. S. A. Strong), Longmans, Green, London and New York, 1901

MEISS, MILLARD, Andrea Mantegna as Illuminator: An Episode in Renaissance Art, Humanism, and Diplomacy, Columbia University Press, New York, 1957

TIETZE-CONRAT, ERICA, Mantegna: Paintings, Drawings, Engravings, Phaidon, New York, 1955

WILENSKI, REGINALD H., Mantegna (1431-1506) and the Paduan School, Faber, London, 1947

Simone Martini

DE RINALDIS, ALDO, Simone Martini, Palombi, Rome, 1938 MICHELI, MARIO DE, Simone Martini, Turin, 1931

PACCAGNINI, GIOVANNI, Simone Martini, Martello, Milan, 1957 VALVALÀ, EVELYN SANDBERG, Simone Martini, Florence, 1951

BERTI, LUCIANO, Masaccio, Pennsylvania State University Press, University Park, 1967

COLE, BRUCE, Masaccio and the Art of Early Renaissance Florence, Indiana University Press, Bloomington, 1980

HENDY, PHILIP, Masaccio: Frescoes in Florence, New York Graphic Society, Greenwich, Conn., 1956

MESNIL, JACQUES, Masaccio et les débuts de la Renaissance, Nijhoff, The Hague, 1927

PROCACCI, UGO, All the Paintings of Masaccio, Hawthorn, New York, 1962

Masolino

LINDBERG, HENRIK, To the Problems of Masolino and Masaccio, 2 vols., Kungl. boktrykeriet, Norstedt & Söner, Stockholm, 1931 MICHELETTI, EMMA, Masolino da Panicale, Istituto editoriale italiano, Milan, 1959

TOESCA, PIETRO, Masolino da Panicale, Arti grafiche, Bergamo, 1908 Matteo di Giovanni

HARTLAUB, GUSTAV FRIEDRICH, Matteo da Siena und seine Zeit, Heitz, Strassburg, 1910

Melozzo da Forlì

BUSCAROLI, REZIO, Melozzo da Forlì, nei documenti, nelle testimonianze dei contemporanei e nella bibliografia, Reale Accademia d'Italia, Rome, 1938

Michelangelo

ACKERMAN, JAMES S., The Architecture of Michelangelo, 2 vols., Viking, New York, 1961-64; 2d ed., 1 vol., Penguin Books, Harmondsworth and Baltimore, 1971

CAMESASCA, ETTORE, The Complete Paintings of Michelangelo (intro. L. D. Ettlinger), Harry N. Abrams, New York, 1969

CLEMENTS, ROBERT J., Michelangelo's Theory of Art, New York Uni-

versity Press, New York, 1961

DE TOLNAY, CHARLES, ed., The Art and Thought of Michelangelo (trans. N. Buranelli), Pantheon, New York, 1964

, The Complete Works of Michelangelo, Reynal, New York, 1965

, Michelangelo, 5 vols., Princeton University Press, Princeton, N.J., 1943-60

GOLDSCHEIDER, LUDWIG, Michelangelo: Paintings, Sculpture, and Architecture, 5th ed., Phaidon, New York, 1962

HARTT, FREDERICK, Michelangelo, Harry N. Abrams, New York, 1965 , Michelangelo, the Complete Sculpture, Harry N. Abrams, New York, 1969

*Hibbard, Howard, Michelangelo, 2d ed., Harper and Row, New York, 1985

MORGAN, CHARLES H., The Life of Michelangelo, Reynal, New York, 1960

SALMI, MARIO, ed., The Complete Work of Michelangelo, 2 vols., Macdonald, London, 1966

Symonds, John A., The Life of Michelangelo Buonarroti, 3d ed., 2 vols., Scribner's, New York, 1899

VENTURI, ADOLFO, Michelangelo (trans. J. Redfern), Warner, London. 1928

WEINBERGER, MARTIN, Michelangelo the Sculptor, 2 vols., Columbia University Press, New York, 1967

Michelozzo di Bartolommeo

CAPLOW, HARRIET MCNEAL, Michelozzo, 2 vols., Garland, New York, 1977

MORISANI, OTTAVIANO, Michelozzo, architetto, Einaudi, Turin, 1951 Moretto

BOSELLI, C., Il Moretto, Brescia, 1964

GOMBOSI, G., Moretto da Brescia, Basel, 1943

VACCARINO, PAOLO, Nanni, Sansoni, Florence, 1950

WUNDRAM, MANFRED, Donatello und Nanni di Banco, de Gruyter, Berlin, 1969

Nardo di Cione

OFFNER, RICHARD, A Critical and Historical Corpus of Florentine Painting, Section IV, vol. II, New York University Press, New York,

Orcagna

OFFNER, RICHARD, A Critical and Historical Corpus of Florentine Painting, Section IV, vol. II, New York University Press, New York, 1962

Palladio

*ACKERMAN, JAMES S., Palladio, rev. ed., Penguin, New York, 1978 CHIERICI, GINO, Palladio, Electa Editrice, Florence, 1949

Dalla Pozza, Antonio, Palladio, Pelicano, Vicenza, 1953

PANE, ROBERTO, Andrea Palladio, Einaudi, Turin, 1948; 2d ed., 1961

Paolo Veneziano

MURARO, MICHELANGELO, Paolo da Venezia, Istituto editoriale italiano, Milan, 1969

Parmigianino

FREEDBERG, SYDNEY J., Parmigianino, His Works in Painting, Harvard University Press, Cambridge, Mass., 1950

QUINTAVALLE, ARMANDO OTTAVIANO, Il Parmigianino, Istituto editoriale italiano, Milan, 1948

Perugino

CAMESCA, ETTORE, Tutta la pittura del Perugino, Rizzoli, Milan, 1959 CANUTI, FIORENZO, Il Perugino, 2 vols., Editrice d'arte "La Diana,"

SCARPELLINI, PIETRO, Perugino, Electa Editrice, Milan, 1984 VENTURI, LIONELLO et al., Il Perugino, Edizioni Radio Italiana, Turin,

1955

Peruzzi FROMMEL, CHRISTOPH LUITPOLD, Baldassare Peruzzi als Maler und Zeichner, Schroll, Vienna, 1968

Piero della Francesca

BATTISTI, EUGENIO, Piero della Francesca, Pennsylvania State University Press, University Park, 1972

CLARK, KENNETH, Piero della Francesca, Phaidon, New York, 1951 GILBERT, CREIGHTON, Change in Piero della Francesca, Augustin, Locust Valley, N.Y., 1968

LONGHI, ROBERTO, Piero della Francesca, Hoepli, Milan, 1946

Piero di Cosimo

BACCI, MINA, Piero di Cosimo, Bramante, Milan, 1966 DOUGLAS, R. LANGTON, Piero di Cosimo, University of Chicago Press, 1946

Pintoricchio

CARLI, ENZO, Il Pintoricchio, Electa Editrice, Milan, 1960 RICCI, CORRADO, Pintoricchio (trans. F. Simmonds), Lippincott, Philadelphia, 1902

Pisanello

HILL, GEORGE F., Pisanello, Duckworth, London, 1905 PACCAGNINI, GIOVANNI, Pisanello (trans. Jane Carroll), Phaidon, London, 1973

Pisanello alla corte dei Gonzaga, Electa Editrice, Milan, 1972

Pisanello e il ciclo cavalleresco di Mantova, Electa Editrice, Milan, [1972?]

SINDONA, ENIO, Pisanello (trans. J. Ross), Harry N. Abrams, New York, 1961

Andrea Pisano

FALK, ILSE, Studien zu Andrea Pisano, Niemann und Moschinski, Hamburg, 1940

KREYTENBERG, GERT, Andrea Pisano und die toskanische Skulptur des 14. Jahrhunderts, Bruckmann, Munich, 1984

TOESCA, ILARIA, Andrea e Nino Pisano, Sansoni, Florence, 1950

Giovanni Pisano

AYRTON, MICHAEL, Giovanni Pisano, Thames and Hudson, London, 1969

CARLI, ENZO, Giovanni Pisano, Pacini, Pisa, 1977

Nicola Pisano

CRICHTON, GEORGE H., and CRICHTON, ELSIE R., Nicola Pisano and the Revival of Sculpture in Italy, Cambridge University Press, Cambridge, 1938

NICCO FASOLA, GIUSTA, Nicola Pisano, Palombi, Rome, 1941 SWARZENSKI, GEORG, Nicola Pisano, Iris-verlag, Frankfurt-am-Main, 1926

Antonio and Piero del Pollaiuolo

ETTLINGER, LEOPOLD D., Antonio and Piero Pollaiuolo: Complete Edition with Critical Catalogue, Phaidon, New York, 1978 SABATINI, ATTILIO, Antonio e Piero del Pollaiuolo, Sansoni, Florence, 1944

Pontormo

BERTI, LUCIANO, Pontormo, Fiorino, Florence, 1966

CLAPP, FREDERICK M., Jacopo Carucci da Pontormo, His Life and Work, Yale University Press, New Haven, Conn., 1916

Jacopo della Quercia

SEYMOUR, CHARLES, Jacopo della Quercia, Yale University Press, New Haven, Conn., 1973

Raphael

BECK, JAMES, Raphael, Harry N. Abrams, New York, 1976 FISCHEL, OSKAR, Raphael (trans. B. Rackham), 2 vols., Kegan Paul,

London, 1948 JONES, ROGER, and PENNY, NICHOLAS, Raphael, Yale University Press,

New Haven, Conn., 1983 SALMI, MARIO et al., The Complete Works of Raphael, Reynal, New York, 1969

Luca della Robbia

MARQUAND, ALLEN, Luca della Robbia, Princeton University Press, Princeton, N.J., 1914

POPE-HENNESSY, JOHN, Luca della Robbia, Cornell University Press, Ithaca, N.Y., 1980

Antonio and Bernardo Rossellino

PLANISCIG, LEO, Rossellino, Vienna, 1942

SCHULZ, ANNE MARKHAM, The Sculpture of Bernardo Rossellino and His Workshop, Princeton University Press, Princeton, N.J., 1977 Rosso Fiorentino

BAROCCHI, PAOLA, Rosso Fiorentino, Rome, 1950

The Sangallo Family

GIOVANNONI, GUSTAVO, Antonio da Sangallo il giovane, Tipografia Regionale, Rome, 1959

LOUKOMSKI, G. K., Les Sangallo, leur vie, leur oeuvre, Vincent, Freal, Paris, 1934

MARCHINI, GIUSEPPE, Giuliano da Sangallo, Florence, 1943

Jacopo Sansovino

HOWARD, DEBORAH, Jacopo Sansovino: Architecture and Patronage in Renaissance Venice, Yale University Press, New Haven, Conn., 1975 LORENZETTI, GIULIO, Jacopo Sansovino, scultore, Nuovo Archivo Veneto, Venice, 1910

Andrea del Sarto

FREEDBERG, SYDNEY J., Andrea del Sarto, 2 vols., Harvard University Press, Cambridge, Mass., 1963

SHEARMAN, JOHN, Andrea del Sarto, 2 vols., Clarendon Press, Oxford, 1965

Sassetta

BERENSON, BERNARD, Sassetta, un pittore senese della leggenda francescana, Electa Editrice, Florence, 1946

CARLI, ENZO, Sassetta e il maestro dell'Osservanza, Martello, Milan, 1957

POPE-HENNESSY, JOHN, Sassetta, Chatto & Windus, London, 1939 Savoldo

BOSCHETTO, ANTONIO, Gian Gerolamo Savoldo, Bramante, Milan, 1963

Sebastiano del Piombo

Dussler, Luitpold, Sebastiano del Piombo, Holbein, Basel, 1942 Hirst, Michael, Sebastiano del Piombo, Oxford University Press, New York, 1981

Signorelli

Dussler, Luitpold, Signorelli: des Meisters Gemälde, Deutsche Verlags-Anstalt, Stuttgart, 1927

KURY, GLORIA, The Early Work of Luca Signorelli, 1465–1490, Garland, New York, 1978

SALMI, MARIO, Signorelli, Istituto geografico de'Agostini, Novara, 1953

Sodoma

HAYUM, ANDRÉE, Giovanni Antonio Bazzi—"Il Sodoma," Garland, New York, 1976

Tintoretto

NEWTON, ERIC, *Tintoretto*, Longmans Green, London, 1952 PALLUCCHINI, RODOLFO, and ROSSI, PAOLA, *Tintoretto: Le Opere sacre e profane*, 2 vols., Alfieri, Milan, 1982

RIDOLFI, CARLO, The Life of Tintoretto and of His Children Domenico

and Marietta (trans. and intro. Catherine Enggass and Robert Enggass), Pennsylvania State University Press, University Park, 1984 TIETZE, HANS, *Tintoretto: The Paintings and Drawings*, Phaidon, New York, 1948

Titian

PALLUCCHINI, RODOLFO, Tiziano, Sansoni, Florence, 1969

PANOFSKY, ERWIN, Problems in Titian, Mostly Iconographic, New York University Press, New York, 1969

ROSAND, DAVID, Painting in Cinquecento Venice: Titian, Veronese, Tintoretto, Yale University Press, New Haven, Conn., 1982

—, Titian, Harry N. Abrams, New York, 1978

TIETZE, HANS, *Titian: Paintings and Drawings*, 2d ed., rev., Phaidon, London, and Oxford University Press, New York, 1950

WETHEY, HAROLD E., The Paintings of Titian, 3 vols., Phaidon, London, 1969–75

Tura

RUHMER, EBERHARD, Tura: Paintings and Drawings, Phaidon, London, 1958

SALMI, MARIO, Cosmè Tura, Electa Editrice, Milan, 1957

Uccello

Carli, Enzo, All the Paintings of Paolo Uccello (trans. M. Fitzallan), Hawthorn, New York, 1963

PARRONCHI, ALESSANDRO, *Paolo Uccello*, Massimiliano Boni, Bologna, 1974

POPE-HENNESSY, JOHN, The Complete Work of Paolo Uccello, Phaidon, London, 1950; 2d ed., 1959

Vasari

BAROCCHI, PAOLA, Giorgio Vasari, Florence, 1963–64 Veronese

PALLUCCHINI, RODOLFO, *La mostra di Paolo Veronese*, 2d ed., Libreria

Serenissima, Venice, 1939 PIGNATTI, TERISIO, Veronese, 2 vols., Alfieri, Milan, 1976

PIOVENE, GUIDO, and MARINI, REMIGIO, L'opera completa del Veronese, Rizzoli, Milan, 1968

ZAVA BOCCAZZI, FRANCA, Veronese, Fabbri, Milan, 1964

Verrocchio

PASSAVANT, GUNTER, Verrocchio: Sculptures, Paintings, and Drawings (trans. Katherine Watson), Phaidon, London and New York, 1969 SEYMOUR, CHARLES, The Sculpture of Verrocchio, Studio Vista, London, 1971

Vignola

ACKERMAN, JAMES S., and LOTZ, WOLFGANG, Vignoliana, Augustin, Locust Valley, N.Y., 1965

WALCHER CASOTTI, F., Vignola, 2 vols., Trieste, 1960

Index

Page numbers are in roman type. Figure numbers of black-and-white illustrations are in *italic* type. Colorplates are specifically designated. Names of artists and architects whose works are illustrated are indicated with Capitals. Titles of works are in *italics*.

A

absolutism, 545, 558, 661

Abundance, Fortitude, and Envy (Veronese), 628; 671

Acts of the Apostles tapestries (Raphael), 518–21, 628; 547, 548; colorplate 75

Adoration of the Child: (Bellini, Giovanni), 411–12; 423; (Perino del Vaga), 561–62; 601

Adoration of the Magi: (Bassano), 631; 676; (Botticelli; Florence), 324–25, 327, 328, 329, 439; 340, 341; colorplate 44; (Botticelli; Washington), 327–29, 439, 449; 346; (Bramantino), 608, 617; colorplate 92; (Domenico Veneziano), 257, 259, 273, 380; 265; (Gentile da Fabriano), 178, 179, 180–81, 183, 203, 206, 257, 274, 299, 380; 184; colorplate 22; (Leonardo da Vinci), 329, 359, 439, 449, 450, 451, 456, 458, 562; 455, 456; (Mantegna), 391–92, 537, 589; 407; (Masaccio), 203, 257, 274; 203; (Nicola Pisano), 53; 38

Adoration of the Shepherds: (Correggio), 86, 565–66, 577; 606; (Ghirlandaio), 344, 346, 438; colorplate 48; (Giorgione), 589; 629; (Goes), 293, 340, 346; 357

Adorno, Gerolamo, 599

Adrian VI (pope), 539, 541

Agony in the Garden: (Bellini, Giovanni), 410–11; 421; (Mantegna), 390–91, 411; 405

Agostino di Duccio, 222

Alberti, Circle of: Palazzo Venezia, Rome, 228, 584; 230

ALBERTI, LEONBATTISTA, 155, 221–31, 244, 260, 284, 297, 304, 333, 376, 486, 490, 621, 634, 636, 657; influence of, 221, 222, 227–28, 231, 234, 242, 245, 248, 263, 269, 275, 276, 299, 359, 371, 382, 383–84, 385, 423, 425, 427, 436; Malatesta Temple (S. Francesco), Rimini, 222–23, 275, 423, 483; 222–224; Palazzo Rucellai, Florence, façade, 223–25, 228, 243, 294, 375, 489; 225; perspective theories of, 152, 174, 209, 211, 216, 229–30, 234, 242, 245, 257, 280, 323, 336; 235;

Sant'Andrea, Mantua, 226–27, 229, 358, 483, 489, 510, 637, 668; 227–229; SS. Annunziata (with Michelozzo), 266, 454; Sta. Maria Novella, Florence, façade, 225–26, 637; 226; writings of, 19, 141, 152, 174, 209–10, 221, 223, 229–31, 234, 235, 332, 336, 377, 431, 436, 634

Albertini, Francesco, 486 Albizzi, Rinaldo degli, 457

Alexander VI (pope), 336, 370, 432, 464, 482, 484, 523

Allegory of Good Government: Commune of Siena (Lorenzetti, A.), 24, 116–17, 126; 107

Allegory of Good Government: Effects of Good Government in the City and the Country (Lorenzetti, A.), 24, 117, 119, 126, 138, 180; 108, 109; colorplate 16

Allendale Nativity (Adoration of the Shepherds) (Giorgione), 589; 629

Allori, Alessandro, 659, 666; *Pearl Fishers*, 666; 723

Altichiero, 138, 626; Martyrdom of St. George, Oratory, S. Giorgio, Padua, 138, 600; 130 Amadeo, Giovanni Antonio, 427; Certosa, Pavia, façade, 425, 427; 439

Amalfi, 29

Ambrose (saint), 91

Amiens: Cathedral of Notre Dame, central portal, 70; 64

Ammanati, Bartolommeo, 659–60, 668; Fountain of Neptune, Sea Nymph from, 659, 660; 712; Palazzo Pitti, Florence, 228, 659–60; 713; Ponte a Sta. Trinita, Florence, 344, 660; 714

Andrea da Firenze (Andrea Bonaiuti), 126, 135, 187; *Triumph of the Church*, Spanish Chapel, Sta. Maria Novella, Florence, 24, 84, 124, 126, 135; colorplate 18

Andrea di Cione, see Orcagna, Andrea Andrea Pisano, 88, 122, 124; Art of Architecture (designed by Giotto?), 16, 27, 88; 17; Art of Painting (designed by Giotto?), 16, 18, 21, 88; 7; Art of Sculpture (designed by Giotto?), 16, 25, 53, 88, 237; 16; Baptistery, Florence, South Doors, 88, 134, 158, 161, 231; 85, 86; Campanile, Florence, 135; 77; relief sculpture (designed by Giotto?), 16, 18, 21, 25, 27, 88, 313; 7, 16, 17, 84; Creation of Man (designed by Giotto?), 16, 71, 88; 84; Salome before Herodias, 88, 134; 86

Angelico, Fra (Giovanni da Fiesole; Guido di

PIETRO), 157, 178, 205-14, 216, 219, 233, 244, 284, 285, 298, 303, 358, 371, 477, 478; Annunciation, S. Domenico, Cortona, 207-8, 211, 231, 259; 206; Annunciation, S. Marco, Florence (staircase), 157, 211-12, 231, 259, 474; 210; Annunciation, S. Marco, Florence (monk's cell), 212; 211; Beheading of Sts. Cosmas and Damian, 210; 209; Chapel of Nicholas V, Vatican, frescoes, 213-14; 214; Coronation of the Virgin, 212; 212; Descent from the Cross, 206-7, 210, 233, 257, 270, 275; 205; colorplate 27; influenced by, 206, 208, 211, 221, 231; influence of, 209, 214, 257, 269, 275, 279, 290, 299, 351, 474, 477; Madonna and Saints (Cortona), 21-22; 11, 12; Madonna and Saints (Florence), 208-10, 231, 327-28, 333, 477; 207; Miracle of the Deacon Justinian, 124, 210; 208; St. Lawrence Distributing the Treasures of the Church, 214, 279, 298; 214; S. Marco, Florence: altarpiece, 208-10, 231, 233, 477, 510; 207-209; frescoes, 210-12, 213, 327-28, 510; 210-213; Transfiguration, 212, 521; 213; Visitation, 208, 270; colorplate 28

Angelo Doni (Raphael), 369, 466, 475–76; 484 Anguissola, Sofonisba, 618–19; Portrait of the Artist's Three Sisters with Their Governess, 619; colorplate 95

Anna Dandolo (queen of Serbia), 51 Annunciation: (Angelico, Fra; Cortona), 207-8, 211, 231, 259; 206; (Angelico, Fra; Florence), 157, 211-12, 231, 259, 474; 210, 211; (Baldovinetti; S. Miniato, Florence), 303; 319, 320; (Baldovinetti; Uffizi, Florence), 201, 300-301, 303, 332, 334; 317; (Botticelli), 334; 352; (Domenico Veneziano), 259; 266; (Donatello), 216, 236, 277, 301, 303, 334; 245, 246; (Ghiberti), 161, 164; 154; (Giotto), 67-68, 99, 135, 212, 237; 59, 60; (Leonardo da Vinci), 339, 438-39, 449; 453; (Lippi, Fra Filippo), 216-17, 334; colorplate 29; (Lorenzetti, P.), 101, 270; 101; (Lorenzo Monaco), 477; (Lotto), 607; 656; (Martini), 93, 98-99, 101, 116, 123; colorplate 14; (Piero della Francesca), 237, 277-78, 279, 303; 285; (Sarto), 552-53; 589

Annunciation, Nativity, and Annunciation to the Shepherds (Nicola Pisano), 52–53, 93–94; 37

Annunciation to the Shepherds (Gaddi, T.), 86, 278; 82

Ansuino da Forlì, 371, 385 Antichità di Roma, L' (Palladio), 634 ANTONELLO DA MESSINA, 398-400, 409, 411, 413, 414, 415-16, 427; Crucifixion, 400; 419; Portrait of a Man, 400; 418; St. Jerome in His Study, 399; colorplate 59; St. Sebastian, 400, 409, 414; colorplate 60; Virgin Annunciate, 399-400; 417 Antonine (saint), 186, 187, 202, 206, 208, 210, 212, 217-18, 219, 220, 231, 233, 234, 238, 266-67, 277, 284, 285, 287, 290, 299, 303, 335, 340, 450, 452, 560, 662 Antonio di Banco, 169 Apollo and Daphne (Pollaiuolo), 317; 327 April (Cossa), 430; 442 Aquarius (Peruzzi), 525; 556 Aragazzi family, 242 Architectural Perspective and Background Figures, for the Adoration of the Magi (Leonardo da Vinci), 359, 439, 449; 456 Arena Chapel, see Padua Aretino, Pietro, 568, 602, 621, 632, 633, Arezzo: Confraternity of the Misericordia, painting (Barocci), 670; colorplate 105; Pieve di Sta. Maria, altarpiece (Lorenzetti, P.), 101, 270; 101; S. Francesco, frescoes (Piero della Francesca), 132, 273-79, 280, 349, 375; 282-286; colorplate 36 Ariosto, Ludovico, 593, 617; conjectural portrait of (Titian), 593; colorplate 87 Arnolfini Wedding (Eyck), 518 ARNOLFO DI CAMBIO, 55, 60-61, 79; Cathedral, Florence, 60, 61, 135, 143; 126, 127; Palazzo Vecchio, Florence, 61, 157; 54; Sta. Croce, Florence, 59, 60-61, 79, 150; 52, 53 Arrival of Cardinal Francesco Gonzaga (Mantegna), 226, 394; colorplate 58 Arrival of the Ambassadors of Britain at the Court of Brittany (Carpaccio), 418-19, 423, 600; colorplate 64 Art of Architecture (Andrea Pisano, and Giotto?), 16, 27, 88; 17 Art of Painting (Andrea Pisano, and Giotto?), 16, 18, 88; 7 Art of Sculpture (Andrea Pisano, and Giotto?), 16, 25, 53, 88, 237; 16 Ascension (Mantegna), 391, 392; 408 Assassination of St. Peter Martyr (Gentile da Fabriano), 179-80; 183 Assisi, 12; S. Francesco, Lower Church of, frescoes: (Lorenzetti, P.), 103-4; 102, 103; (Martini), 98, 99; 96, 97; S. Francesco, Upper Church of, frescoes: (Cimabue), 47, 48, 58; 32; (Giotto), 78, 79, 80-81; (Isaac Master), 48-49; 34; (Master of St. Cecilia), 82, 88-90; 87, 88; (Master of the St. Francis Cycle), 82-83; 78; colorplate 11; (Torriti), 48 Assumption (Lorenzetti, P.), 101, 270; 101 Assumption of the Virgin: (Correggio), 566, 568; 609, 610; colorplate 81; (Nanni di Banco), 170-71, 261, 262; 169; (Perugino), 639; (Rosso Fiorentino), 559; 598; (Sarto), 554; colorplate 77; (Titian), 592, 594, 599, 603; 634; colorplate 88 Atti, Isotta degli, 222 Augustine (saint), 339, 501 Aurelio, Niccolò, 595, 597

·Autobiography (Cellini), 658

AVANZO, JACOPO, 138; Liberation of the Compan-

245, 380, 600; 129 Avignon, France, 47, 63, 83, 101, 178 Azor and Sadoc (Michelangelo), 505; colorplate Bacchanal of the Andrians (Titian), 597-98; 637 Bacchus (Michelangelo), 464, 477; 471 Bacchus and Ariadne (Titian), 598; 638 Baccio d'Agnolo, Giuliano di, 145, 582 Baccio da Montelupo, 553 Baglioni family, 358 Baldassare Castiglione (Raphael), 473, 516; 545 BALDOVINETTI, ALESSO, 281, 293, 299-303, 314, 316; Annunciation (S. Miniato, Florence), 303; 319, 320; Annunciation (Uffizi, Florence), 201, 300-301, 303, 332, 334; 317; Madonna and Child, 281, 301, 303; colorplate 42; Nativity, SS. Annunziata, Florence, 301-3, 412, 451, 455, 551, 555; 318; Portrait of a Young Woman, 303; 321 Baptism of Christ: (Masolino), 186, 204, 257; colorplate 26; (Piero della Francesca), 270-71, 273, 283; 280; (Verrocchio and Leonardo da Vinci), 319-20, 321, 438, 457; Baptism of Hermogenes (Mantegna), 385; 397 Baptistery, see Castiglione Olona; Florence; Barbadori altarpiece (Lippi, Fra Filippo), 215-16, 257, 388; 216 Barbadori family, 215 Bardi Chapel, see Florence, Sta. Croce Bardi di Vernio Chapel, see Florence, Sta. Croce Bardi family, 122, 164 BARNA DA SIENA, 24, 128, 131; Betrayal, 128-29; 120; Collegiate Church, San Gimignano, frescoes, 128-29; 119, 120; Pact of Judas, 128: 119 BAROCCI, FEDERICO, 668, 670; Madonna del Popolo, 670; colorplate 105 Baroncelli Chapel, see Florence, Sta. Croce Bartolini, Leonardo, 218 BARTOLOMMEO, FRA (BACCIO DELLA PORTA), 416, 454, 455, 476-77, 551, 580, 591, 593, 594; Vision of St. Bernard, 476-77, 505, 515, 552; Bartolommeo Panciatichi (Bronzino), 661-62; Basadonne family, 561, 562 Basilica (Palazzo della Ragione), see Vicenza BASSANO, JACOPO (JACOPO DAL PONTE), 628, 631; Adoration of the Magi, 631; 676 Baths at Pozzuoli (Macchietti), 666, 667-68; 725 Battista Sforza (Laurana, F.), 281, 375; 385; (Piero della Francesca), 281-82, 301, 313, 351, 375, 459; 289; colorplate 38 Battle of Anghiari (Leonardo da Vinci), 457-59, 470, 473, 513, 515, 549; copy of (Rubens), 464 Battle of Cascina (Michelangelo), 457, 463,

470-71, 478, 490, 491, 495-96, 549, 666,

667; copy of (Sangallo, Aristotile da), 479

Battle of Constantine and Maxentius (Piero della

Battle of Heraclius and Chosroes (Piero della

Francesca), 276; colorplate 36

Francesca), 276-77, 451; 284

ions of St. James, Sant'Antonio, Padua, 138,

Battle of Lapiths and Centaurs (Michelangelo), 462-63, 464, 470, 478, 481, 657; 468, 469 Battle of San Romano: (Uccello; Florence), 138, 157, 246-48, 276, 351, 352, 449; colorplate 31; (Uccello; London), 246-48, 267, 276, 332, 351, 392; 263 Battle of the Ten Nudes (Pollaiuolo), 315, 463; "Bearded" Captive (Michelangelo), 548, 549, 550-51: 586 "Beardless" Captive (Michelangelo), 548, 549, 550-51: 585 BECCAFUMI, DOMENICO, 562-64, 580, 607, 626; Communion of St. Catherine, 564; 603; Fall of the Rebel Angels, 562, 564, 639; 604; St. Catherine altarpiece, Monte Oliveto, 563-64; 603; colorplate 80; Stigmatization of St. Catherine, 563-64; colorplate 80 Beheading of Sts. Cosmas and Damian (Angelico, Fra), 210; 209 Bellini, Gentile, 378, 380, 381, 382, 397-98. 414, 416, 417, 592; Portrait of a Turkish Boy, 398; 416; Procession of the Relic of the True Cross, 397; 414; Sultan Mahomet II, 397-98; BELLINI, GIOVANNI, 12, 323, 381, 382, 397, 409-16, 417, 419, 420, 427, 455, 467, 516, 565, 588, 589, 591, 592, 593, 608, 625; Adoration of the Child, 411-12; 423; Agony in the Garden, 410-11; 421; Coronation of the Virgin, 411; 422; Enthroned Madonna and Child, Frari altarpiece, 412-14; 424; Enthroned Madonna and Child, S. Giobbe altarpiece, 414, 416, 420; 425; Enthroned Madonna with Saints, S. Zaccaria altarpiece, 281, 416; colorplate 63; Madonna and Child, 409-10; 420; Pesaro altarpiece, 411-12, 413; 422, 423; Pietà, 411, 430; colorplate 61; St. Francis in Ecstasy, 415-16; 426; Transfiguration of Christ, 414-15, 521; colorplate 62; Virgin and Child between St. John the Baptist and St. Catherine, 416; 427 BELLINI, JACOPO, 381-84, 385, 390, 391, 392, 411, 412, 427; Crucifixion, 384, 385, 389, 424; 396; Flagellation, 383-84; 395; Madonna and Child, 381-82; 393; Madonna and Child with Donor, 382, 383, 411, 424; colorplate 56; Nativity, 382-83; 394 Belvedere, see Vatican BENEDETTO DA MAIANO, 293, 294; Bust of Pietro Mellini, 293; 305; Palazzo Strozzi, Florence (finished by Il Cronaca), 294-95, 341, 375, 424, 584; 307-309 Benedictine Order, 134 Bergamo, 378, 608 Berlinghieri family, 43; see also BERLINGHIERO BERLINGHIERI; BONAVENTURA BERLINGHIERI BERLINGHIERO BERLINGHIERI, 31, 32; Cross, 31; Bernard (saint), 29, 285, 339 Bernini, Gianlorenzo, 290, 292, 451, 520, 565, Berruguete, Alonso, 472 Bertoldo di Giovanni, 356, 461 Bessarion, Johannes (cardinal), 633 Betrayal: (Barna da Siena), 128-29; 120; (Giotto), 71-72; 65 Bibbiena, Bernardo (cardinal), 518 Bicci di Lorenzo, 273 Bigallo triptych (Daddi), 85; 80

Bird's-eye View of Chiana Valley, Showing Arezzo, Cortona, Perugia, and Siena (Leonardo da Vinci), 208, 434–35; 446

Birth of the Virgin: (Cavallini), 48, 49, 50, 124; 35; (Ghirlandaio), 346–47, 461, 462, 553; 363; (Lorenzetti, P.), 93, 113–15, 116, 388; 105; (Orcagna), 124; 114; (Sarto), 553, 559; 590

Birth of Venus (Botticelli), 333–34, 337, 396, 477, 526, 591, 592; 349; colorplate 46 Black Death, 13, 122, 123, 129, 130, 131, 135, 219, 284

Blessed Agostino Novello and Four of His Miracles, The (Martini), 101; 98, 99
"Blockhead" Captive (Michelangelo), 548, 549,

550–51; 587
Boccaccino, Boccaccio, 579
Boccaccio, Giovanni, 62, 130, 265
Bologna, Giovanni, see Giovanni Bologna
Bologna, S. Petronio: altarpiece (Cossa), 429;

Bologna, S. Petronio: altarpiece (Cossa), 429; 441; relief sculpture (Quercia), 176–77, 464; 177–180

Bonaventura (saint), 78, 79, 81, 87, 96, 494 Bonaventura Berlinghieri, 32, 45; *St. Francis*, 32, 41, 75, 78, 81, 101; 24

BONINO DA CAMPIONE, 139; Monument to Bernabò Visconti, 139–40, 239; 131

Bono da Ferrara, 385

Book of Art, The (Il Libro dell'arte) (Cennini), 18–19, 20–21, 22, 24, 230; see also Cennini BORDONE, PARIS, 607–8, 617; Fisherman Delivering the Ring, A, 608; 657

Borgherini, Pierfrancesco, 556

Borghini, Raffaele, 621

Borgia, Cesare, 338, 432, 435, 454, 455, 457, 468, 523

Borgia, Roderigo, 482; see also Alexander VI (pope)

Borgia family, 464, 588

Borgo San Sepolcro (now Sansepolcro), 268, 269; see also Sansepolcro

Bosch, Hieronymus, 129, 342

BOTTICELLI, SANDRO (ALESSANDRO DI MARIANO FILIPEPI), 31, 176, 304, 323-38, 340, 342, 343, 353, 420, 431, 469, 538; Adoration of the Magi (Florence), 324-25, 327, 328, 329, 439; 340, 341; colorplate 44; Adoration of the Magi (Washington), 327-29, 439, 449; 346; Annunciation, 334; 352; Birth of Venus, 333-34, 337, 396, 477, 526, 591, 592; 349; colorplate 46; Calumny of Apelles, 336-37, 342; 353; Enthroned Madonna with Saints, 334, 466, 577; 351; influenced by, 171, 218, 231, 324, 329, 330, 464; influence of, 338, 339, 436, 463, 472, 477; Mystical Nativity, 337-38; 355; mythology in the work of, 329-33; Pallas and the Centaur, 330-31, 332, 333; 347; perspective and, 323, 324, 327, 336, 342; Pietà, 337; 354; Primavera, 218, 327, 332-33; colorplate 45; Punishment of Korah, Dathan, and Abiram, 323, 327; 344, 345; Sistine Chapel, Vatican, frescoes, 323, 326-27, 343, 501, 504, 518; 342-345; Venus and Mars, 331-32; 348; Young Man with a Medal, 334, 456; 350; Youth of Moses, 323, 327, 337, 501, 504; 342, 343

Boulogne, Jean, see Giovanni Bologna Bramante, Donato (Donato di Pascuccio), 228, 357, 376, 377, 424, 425, 473, 482, 483– 90, 511, 514, 518, 520, 540, 563, 608, 631, 635, 664; Belvedere, Vatican, 488–90, 670; 507, 508; Palazzo Caprini (House of Raphael), Rome, 490, 631, 633, 670; 509; Sta. Maria delle Grazie, Milan, 483–84; 495–497; Sta. Maria presso S. Satiro, Milan, 483, 486; 493, 494; St. Peter's, Vatican, 26, 227, 483, 486–88, 489, 490, 491, 510, 520, 540, 583, 645, 646, 668; 501–505; Tempietto (S. Pietro in Montorio), Rome, 377, 473, 484–86, 635; 498–500

Bramantino (Bartolommeo Suardi), 608, 617; Adoration of the Magi, 608, 617; colorplate

Brancacci, Felice, 186

Brancacci Chapel, see Florence, Sta. Maria del Carmine

Brancacci family, 186

Brancusi, Constantin, 375

Braque, Georges, 274

Brazen Serpent (Michelangelo), 503-4, 561, 566, 580, 640, 658; 528

Brescia, 136, 378, 588, 608, 617

Bridget (saint), 134, 181, 565

Bronzino, Agnolo (Agnolo Tori), 557, 657, 660–63, 666; Bartolommeo Panciatichi, 661–62; 718; Crossing of the Red Sea, Chapel of Eleonora da Toledo, Palazzo Vecchio, Florence, 662–63; 719; Exposure of Luxury, 662; colorplate 102; Pietà, 661; 717

Bruges, 13

Bruges Madonna (Michelangelo), 467–68, 491, 497, 507, 577; 475

Brunelleschi, Filippo, 142-55, 157, 164, 204, 207, 216, 223, 228, 229, 260, 284, 290, 469, 634, 636; Alberti on, 141, 235; Baptistery, Florence, competition for bronze doors, 158, 159; 150; biography of, 146, 154, 158, 173; Cathedral, Florence: dome, 141, 142-46, 152, 171, 209, 223, 359, 436; 132, 135; lantern (finished by Michelozzo), 144, 145; 134; tribunes, 144-45; 133; influence of, 276, 296, 375, 542; Ospedale degli Innocenti, Florence, 146-48, 149, 150, 152, 161, 201; 136; as painter, 173-74; Pazzi Chapel, Florence (with Giuliano da Maiano?), 148, 153-55, 293, 294, 297; 144, 145; colorplate 21; perspective theories of, 152, 173-74, 204, 230; Sacrifice of Isaac, 158, 159; 150; S Lorenzo, Florence, 60, 149-53, 161, 539; 137, 140 (Old Sacristy, 148, 149, 152, 153, 154, 155, 275, 297, 373, 541; 137-139); Sta. Maria degli Angeli, Florence, 153; 143; Sto. Spirito, Florence, 60, 149-53, 207, 290, 436; 141, 142; as sculptor, 142, 148, 158, 159 Brunellesco, Ser, 142

Bruni, Lionardo, 231, 243; tomb of (Rossellino, B.), 201, 243, 262, 288, 289, 292; 256, 257 Bufalini family, 577

Bulgarini, Bartolommeo, 93

Buonarroti, Lodovico di Simone, 460
BUONTALENTI, BERNARDO, 344, 425, 664: LIffi:

BUONTALENTI, BERNARDO, 344, 425, 664; Uffizi, Florence (with Vasari and Parigi), 664–66; 722

Busketus, 51

Bust of a Young Woman (Verrocchio), 321; 335 Bust of Matteo Palmieri (Rossellino, A.), 293; 304

Bust of Pietro Mellini (Benedetto da Maiano), 293; 305

Buti, Lucrezia, 214, 220

Byzantine art, 28–29, 30, 31, 41, 43, 47, 48, 51, 67; *see also* Italo-Byzantine art

C

Cain Killing Abel (Titian), 601, 602; 645
Cajetan (saint), 522, 558, 564, 565
Calling of Sts. Peter and Andrew (Ghirlandaio), 343; 360

Calumny of Apelles (Botticelli), 336–37, 342; 353

Camaldolite Order, 133, 134, 153, 220 Camera degli Sposi, *see* Mantua, Palazzo Ducale

Campi, Bernardino, 619 Campidoglio, see Rome

Cantoria: (Donatello), 235, 236; 243, 244; (Robbia), 235–36, 245, 270, 282; 241, 242

Capponi, Niccolò, 549

Capponi Chapel, see Florence, Sta. Felicita Capponi family, 558

Caprarola: Villa Farnese (Vignola), 669–70; 726–728

CARADOSSO, 486; medal of Bramante's St. Peter's, 501

Carafa, Giovanni (Paul IV), 522

Caravaggio, 264, 522, 618, 666, 668, 670 Cardinal of Portugal, 290; tomb of (Rossellino, A.), 290–93, 303, 314; 300–303; see also Florence, S. Miniato al Monte

Carducci family, 264.

Care of the Sick (Domenico di Bartolo), 353; 370

CARPACCIO, VITTORE (SCARPAZA; CARPATHIUS), 417–20, 588, 607, 608; Arrival of the Ambassadors of Britain at the Court of Brittany, 418–19, 423, 600; colorplate 64; Departure of the Prince from Britain, His Arrival in Brittany, and Departure of the Betrothed Couple for Rome, 417–18, 423; 428; Dream of St. Ursula, 419; 429; Meditation on the Passion, 419–20, 597; 430

Carracci family, 670

Caryatid (Giovanni Pisano), 58; 48 Cascia di Reggello: S. Giovenale, altarpiece (Masaccio), 182–83, 186; 187

CASTAGNO, ANDREA DEL, 17, 178, 244, 259-68, 269, 270, 273, 285, 288, 302, 319, 353, 373, 378, 455; Crucifixion, 23, 262, 264; 14, 269; Crucifixion with Four Saints, Sta. Maria degli Angeli, Florence, 261, 270; 268; Cumaean Sibyl, 264, 265; 272; David, 140, 265, 267, 276, 313; 273; Death of the Virgin, Mascoli Chapel, S. Marco, Venice, 260-61, 262, 424; 267; Entombment, 262, 264; 269; Famous Men and Women series, Villa Carducci, Legnaia, 264-65; 271, 272; influenced by, 169-70, 221, 243, 259–60, 261, 263, 265, 267, 270, 284, 293; influence of, 261, 300, 313, 343, 392, 424; Last Supper, 201, 261-64, 265, 266, 343, 452, 553; 269, 270; colorplate 34; Niccolò da Tolentino, 267-68; 276; Pippo Spano, 264, 265, 336; 271; relationship with Domenico Veneziano, 259-60, 267, 284; Resurrection, 262, 264; 269; SS. Annunziata, Florence, frescoes, 266-67, 392, 455; 274, 275; colorplate 35; Sant'Apollonia, Florence, frescoes, 261-64, 343; 269, 270; colorplate 34; St. Julian, 266, 267, 316, 520; 274; Vision of St. Jerome, 266-67, 285, 316, 392; 275; colorplate 35

Castelfranco: Cathedral, altarpiece (Giorgione), 591; 630, 631

Castiglione, Baldassare, 457, 473, 516; portrait of (Raphael), 473, 516; 545

Castiglione Olona: Baptistery, frescoes: (Masolino), 204, 257; colorplate 26; (Vecchietta), 354

Castle of St. George, see Mantua

Castracane, Castruccio, 76

Cavalcanti, Guido, 62

Cavalieri, Tommaso, 548, 647, 657

Cavallini, Giovanni, 49

Cavallini, Pietro (Pietro de' Cerroni), 49–51, 55, 63, 65, 66, 82, 83, 84, 124; Birth of the Virgin, 48, 49, 50, 124; 35; Last Judgment, 50–51, 74, 84; colorplate 5

CAVALORI, MIRABELLO, 666–67, 668; Wool Factory, Studiolo, Palazzo Vecchio, Florence, 666–67; 724

Cefalù, Sicily: Cathedral, mosaic, 28; 18 CELLINI, BENVENUTO, 658–59; *Perseus and Medusa*, 658–59; 711

Cennini, Cennino, 18–19, 20–21, 22, 24, 47, 53, 62, 65, 66, 71, 82, 83, 84, 85, 93, 126, 132, 230

Certosa, see Pavia

Cézanne, Paul, 268, 269, 342, 416

Chapel of Eleonora da Toledo, see Florence, Palazzo Vecchio

Chapel of Innocent VIII, see Vatican

Chapel of Nicholas V, see Vatican

Chapel of the Cardinal of Portugal, see Florence, S. Miniato al Monte

Charles I (king of England), 518

Charles IV (Holy Roman emperor), 126

Charles V (Holy Roman emperor), 541, 542, 562, 586, 588, 592, 608

Charles VIII (king of France), 336

Chigi, Agostino, 523, 524, 525, 537, 597

Chiostro Verde, see Florence, Sta. Maria Novella

Christian Decachord (Vigerio), 492, 501 Christ in Glory (Melozzo da Forlì), 373; colorplate 53

Christ Pantocrator, Cathedral, Cefalù, 28, 123;

Christ Treading on the Lion and the Basilisk ("Beau Dieu"), Cathedral, Amiens, 70; 64

Christus, Petrus, 340, 399

Christ Walking on the Waters (Navicella/Little Ship) (Giotto), 79, 123

Chronicle (Villani), 62

Church of the Trinity, see Sopočani

Ciaccheri, Antonio Manetti, 143, 146

CIMABUE (CENNI DI PEPI), 28, 45–47, 53, 62, 63, 70, 83, 85, 91, 323, 591; *Crucifixion*, S. Francesco, Upper Church of, Assisi, 47, 48, 58, 72, 95; 32; *Enthroned Madonna and Child*, 45–47, 75, 76, 91; colorplate 4

Ciompi, 15, 142

Cione, Andrea di, see Orcagna, Andrea Cione, Jacopo di, see Jacopo di Cione

CIONE, NARDO DI, see NARDO DI CIONE

Circumcision (Mantegna), 391, 392; 406

Cistercian Order, 59

Clement VII (pope), 517, 521, 539, 541, 542, 547, 549, 639; *see also* Medici, Giulio de' CODUSSI, MAURO (or CODUCCI), 416, 423–24,

632; Palazzo Vendramin-Calergi, Venice,

façade, 423–24; 434; S. Zaccaria, Venice, façade, 423; 433

COLA DA CAPRAROLA, 488; Sta. Maria della Consolazione, Todi, 226, 488; 506

Colantonio, 399

Collegiate Church, see San Gimignano

Colleoni, Bartolommeo, 323; equestrian monument of (Verrocchio and Leopardi), 139, 323; 337–339

Columbus, Christopher, 282

Commentaries (Ghiberti), 160, 161

Communion of St. Catherine (Beccafumi), 564; 603

Compagnia della Misericordia, see Sansepolcro Condivi, Ascanio, 508

Confraternity of the Misericordia, see Arezzo Constantine (Roman emperor), 83, 239, 276 Constantinople, 28, 29, 47, 136, 284

Conversion of St. Paul (Michelangelo), 642; 695, 696

COPPO DI MARCOVALDO, 43–45, 46, 53, 70, 91; Crucifix, 43, 44, 72; 27–29; Last Judgment, Baptistery, Florence, 44–45, 47, 74, 641; colorplate 3; Madonna and Child, 43–44, 85, 91; 30

Corboli, Girolamo dei, 267

Coronation of the Virgin: (Angelico, Fra), 212; 212; (Bellini, Giovanni), 411; 422; (Francesco di Giorgio), 355–56; 373; (Gentile da Fabriano), 178–79; 181; (Lorenzo Monaco), 133–35, 159, 178, 261, 577; 125; colorplate 19; (Paolo Veneziano), 137–38; 128; (Torriti), 47–48; 33; (Vivarini and Giovanni d'Alemagna), 381; 392

Corpus Domini, Church of, see Urbino Correggio (Antonio Allegri), 373, 564–68, 578, 580, 594, 607, 670; Adoration of the Shepherds (Holy Night), 86, 565–66, 577; 606; Assumption of the Virgin, Cathedral, Parma, 566, 568; 609, 610; colorplate 81; Jupiter and Ganymede, 568, 597, 604; colorplate 82; Jupiter and Io, 568, 597; 611; Madonna and Child with Sts. Jerome and Mary Magdalen, Sant'Antonio, Parma, 565, 598; 605; Vision of St. John the Evangelist, S. Giovanni Evangelista, Parma, 566; 607, 608

Corsignano, see Pienza

Cortona: Sant'Antonio dei Servi, altarpiece (Sarto), 554; colorplate 77; S. Domenico, altarpiece (Angelico, Fra), 207–8, 211; 206; colorplate 28; Sta. Maria del Calcinaio (Francesco di Giorgio), 226, 357–58, 581; 375–377; (Sangallo, A., the Elder), 581

Cosimo I as Patron of Pisa (Pierino da Vinci), 657-58; 709

COSSA, FRANCESCO DEL, 429–30; April, Palazzo Schifanoia, Ferrara, 430; 442; St. John the Baptist, Griffoni altarpiece, S. Petronio, Bologna, 429, 430; 441

Council of Constance, 178

Council of Ferrara, 209, 273

Council of Trent, 565, 642

Counter-Reformation, 602, 638, 640, 662, 668

Crashaw, Richard, 566

Creation, The (Ghiberti), 176, 231, 233; 237

Creation, The (Gliotto), 717, 231, 233, 237 Creation of Adam: (Giotto), 71; (Michelangelo), 176, 499–501, 503; 522, 523; (Quercia; Bologna), 176, 189; 178; (Quercia; Siena), 174 Creation of Eve (Michelangelo), 497, 499; 521 Creation of Man (Andrea Pisano, and Giotto?), 16, 71, 88; 84

Creation of Sun, Moon, and Plants (Michelangelo), 501, 504, 506, 580; 524

Creation of the Birds and Fishes (Maitani), 121;

Cremona, 378, 608, 619; Cathedral, frescoes: (Boccaccino), 579; (Pordenone), 579–80; 615; (Romanino), 579

CRIVELLI, CARLO, 420–21, 423, 427, 606; Madonna della Candelletta, 421, 423; 432; Pietà, 421; 431

Cronaca, Il (Simone del Pollaiuolo), 294, 457; Palazzo Strozzi, Florence, cornice (begun by Benedetto da Maiano), 294, 341, 375, 424, 584; 307, 309

Cross: (Berlinghiero Berlinghieri), 31; 23; (School of Florence), 41, 43, 71; 25, 26

"Crossed-Leg" Captive (Michelangelo), 548, 549, 550–51; 584

Crossing of the Red Sea (Bronzino), 662–63;

Cross No. 15 (School of Pisa), 29-30; 20

Cross No. 20 (School of Pisa), 18, 30–31, 43, 72; 21; colorplate 2

Crowning with Thorns (Titian), 605; 653

Crucifix: (Coppo di Marcovaldo), 43, 44, 72; 27–29; (Donatello), 240–41; 251, 252; (Michelangelo), 463, 464; 470

Crucifixion: (Altichiero), 138; (Antonello da Messina), 400; 419; (Bellini, J.), 384, 385, 389, 424; 396; (Castagno), 23, 262, 264; 14, 269; (Cimabue), 47, 48, 72, 95; 32; (Daphni, Monastery Church), 29, 30; 19; (Duccio), 95–96; 93; (Foppa), 424; 435; (Ghiberti), 162–63, 400; 157; (Giotto), 72, 95, 203, 204; 66; (Lorenzetti, P.), 82; (Mantegna), 388, 389, 400; 404; (Masaccio), 202–3, 204, 270; colorplate 24; (Michelangelo), 647; 705; (Piero della Francesca), 270; 279; (Tintoretto), 622–23; 662; colorplate 97

Crucifixion of St. Peter: (Masaccio), 203, 642; 204; (Michelangelo), 642–44; 694

Crucifixion with Four Saints (Castagno), 261, 270; 268

Crucifixion with Saints (Perugino), 360, 369; 379

Crusaders (Crusades), 28, 116, 136, 280 *Cumaean Sibyl*: (Castagno), 264, 265; 272; (Michelangelo), 497, 506; 519, 520

Cupid Carving His Bow (Parmigianino), 578; 614

Cupid Pointing Out Psyche to the Three Graces (Raphael and Romano), 537, 628; 564

D

Daddi, Bernardo, 85, 87, 122, 124, 126; Bigallo triptych, 85; 80; Madonna and Child Enthroned with Angels, 85, 122, 123; 81, 113

Damned Consigned to Hell (Signorelli), 478, 480, 502; 490

Danaë (Titian), 603; 649

Dance of the Nudes (Pollaiuolo), 315-16; 326

Daniel (Nicola Pisano), 53, 55; 39

Daniele da Volterra, 640

Dante Alighieri, 62, 63, 66, 73, 125, 263, 265, 334, 356, 466, 490, 642

Danti, Vincenzo, 356, 658; Moses and the Brazen Serpent, 658; 710

Daphni, Greece: Monastery Church, mosaic, 29, 30; 19 Daumier, Honoré, 504 David, Jacques-Louis, 518 David: (Castagno), 140, 265, 267, 276, 313; 273; (Donatello; bronze), 140, 237-38, 239, 265, 323, 332; 247, 248; (Donatello; marble), 140, 164-65, 166, 167, 237, 265, 469, 549; 161; (Michelangelo), 164, 338, 343, 466, 468-70, 501, 506, 507, 545; 477, 478; (Verrocchio), 140, 323, 332, 470; 336 David and Goliath (Titian), 601, 602; 646 Dawn (Michelangelo), 543, 544, 545, 546, 659, 660; 576, 577 Day (Michelangelo), 462, 543, 544, 545; 573 Dead Christ (Mantegna), 392-93, 578; 409 De architectura (Vitruvius), 221 Death of the Virgin: (Castagno), 392; (Castagno and Giambono), 260-61, 262, 424; 267 Decameron (Boccaccio), 62, 130 Déguilleville, Guillaume de, 73 Delacroix, Eugène, 457 Della pittura (On Painting) (Alberti), 141, 174, 209-10, 221, 230, 231, 235 Deluge: (Leonardo da Vinci), 432, 459-60; 466; (Michelangelo), 495-96, 662-63, 666; 514, 515; (Uccello), 189, 245-46, 247, 248, 591; 260-262 Departure of Aeneas Silvius Piccolomini for Basel (Pintoricchio), 352, 370-71; colorplate 52 Departure of the Prince from Britain, His Arrival in Brittany, and Departure of the Betrothed Couple for Rome (Carpaccio), 417-18, 423; De pictura (On Painting) (Alberti), 221, 230, 234, 336 De prospectiva pingendi (On Painting in Perspective) (Piero della Francesca), 283 De quinque corporibus regolaribus (On the Five Regular Bodies) (Piero della Francesca), De re aedificatoria libri X (Ten Books on Architecture) (Alberti), 221, 229, 234 Descent from the Cross: (Angelico, Fra, and Lorenzo Monaco), 206-7, 210, 233, 257, 270, 275; 205; colorplate 27; (Lorenzetti, P.), 103, 337; 102; (Rosso Fiorentino), 288, 559-60; 599; colorplate 79 DESIDERIO DA SETTIGNANO, 288-90, 292, 293, 460; Head of a Child, 290; 299; Madonna and Child, 289, 290; 298; Tomb of Carlo Marsuppini, Sta. Croce, Florence, 201, 288-89, 290, 292; 296, 297 De statua (On the Statue) (Alberti), 221 Dialogue on Painting (Dolce), 592 Diamante, Fra, 218 Discovery of the Body of St. Mark (Tintoretto), 622: 661 Discovery of the Wood of the True Cross (Piero della Francesca), 257, 274; 282 Disputa (Disputation over the Sacrament) (Raphael), 478, 508-9, 510; 534, 535 Distribution of the Goods of the Church (Masaccio), 186, 192; 200 Divine Comedy (Dante), 62, 73 Doges' Palace, see Venice Dolce, Ludovico, 592, 657 Domenichino, 518 Domenico da Pescia, Fra, 338

DOMENICO DI BARTOLO, 352-53; Care of the Sick,

370; Madonna of Humility, 352; 369 DOMENICO VENEZIANO, 85, 138, 205, 208, 215, 244, 257-59, 260, 269, 358, 378, 592; Adoration of the Magi, 257, 259, 273, 380; 265; Annunciation, 259; 266; influenced by, 221, 257, 259; influence of, 257, 269, 273, 290, 300, 301; Madonna and Child with Saints, 257, 259, 270, 300, 388; colorplate 32; relationship with Castagno, 259-60, 267, 284; Sant'Egidio, Florence, frescoes, 257, 269, 293, 300, 340; St. John the Baptist in the Desert, 259; colorplate 33; St. Lucy altarpiece, Sta. Lucia dei Magnoli, Florence, 257, 259, 270, 300; 266; colorplates 32, 33 Dominican Order, 59, 126, 206, 208, 335 Dominici, Giovanni, 220 DONATELLO (DONATO DI NICCOLÒ BARDI), 121, 122, 155, 164-69, 171-74, 182, 191, 205, 236-42, 267, 284, 285-88, 292, 356, 378, 469, 549; Alberti on, 235; Annunciation, Sta. Croce, Florence, 216, 236, 277, 301, 303, 334; 245, 246; artistic methods of, 165-66, 169, 285, 290, 321, 460; Campanile, Florence, sculpture, 171-73; 170-172; Cathedral, Florence, sculpture: Cantoria, 235, 236; 243, 244; Porta della Mandorla, 171; compared to: Ghiberti, 165, 166, 167-68, 241; Lorenzo Monaco, 133; Masaccio, 186; Quercia, 174, 176; Crucifix, 240-41; 251, 252; David (bronze), 140, 237-38, 239, 265, 323, 332; 247, 248; David (marble), 140, 164-65, 166, 167, 237, 265, 469, 549; 161; Equestrian Monument of Gattamelata, 139, 238-40, 244-45, 323, 451; 249, 250; Feast of Herod, Cathedral, Siena, 173, 174, 348, 452; 173; God the Father, 169; 167; influenced by, 222, 231, 244; influence of, 174, 186, 187, 238, 242, 259, 265, 351, 354, 355, 356, 385, 425, 461, 592, 660; Jeremiah, 172, 173; 172; Judith and Holofernes, 166, 285, 287, 659, 660; 292, 293; Lamentation, 287-88; 294; late style of, 285-88, 319, 337, 356; Martyrdom of St. Lawrence, 288; 295; Mary Magdalen, Baptistery, Florence, 285, 287, 288; 291; colorplate 40; Miracle of the Believing Donkey, 242; 253; Miracle of the Irascible Son, 242; 254; optical concerns of, 164, 165, 166, 168, 170, 173; Orsanmichele, Florence: niche (with Michelozzo), 320; 333; sculpture, 164, 165-69, 186, 260; 162-167; perspective and, 166, 168, 173, 174, 187, 202; psychological aspect to the work of, 165, 172, 212, 285, 288; Sant'Antonio, Padua, high altar, 240-42, 385, 388; 251-254; St. George, 164, 166-67, 169, 186, 549, 550; 164, 165; St. George and the Dragon, 167-69, 183, 186, 202, 231, 454, 461; 166; S. Lorenzo, Florence: Epistle pulpit, 288; 295; Gospel pulpit, 287-88; 294; Old Sacristy, 148, 241, 260; St. Mark, 165-66, 167, 212, 260, 287, 385; 162, 163; Zuccone, 172-73, 212; 170, 171 Donati, Lucrezia, 321 Doni, Angelo, 466, 467, 475; portrait of (Raphael), 369, 466, 475-76; 484 Doni, Maddalena Strozzi, 466, 467, 475; portrait of (Raphael), 369, 466, 475-76; 485 Doni Madonna (Michelangelo), 202, 293, 466-67, 468, 474, 475, 502, 505; 474; colorplate 69

Sta. Maria della Scala, Siena, 352-53, 371;

Donna Velata (Veiled Woman) (Raphael), 516; 544 Doria family, 562 Dormition of the Virgin, Church of the Trinity, Sopočani, 51: 36 Dossi, Dosso (Giovanni de Lutero), 617; Melissa, 617; colorplate 93 Doubting of Thomas (Verrocchio), 320-21, 340; 333, 334 Dream of Innocent III (Master of the St. Francis Cycle), 17, 80, 82; colorplate 11 Dream of St. Ursula (Carpaccio), 419; 429 Duccio, Agostino di, 469 DUCCIO DI BUONINSEGNA, 45, 55, 91-96, 98, 116, 129, 350, 351, 578; Cathedral, Siena, altarpiece, 92-96; 90-93; colorplates 12, 13; Crucifixion, 95-96; 93; Entry into Jerusalem, 94-95, 116; colorplate 13; Maestà altarpiece, 92-96, 103, 116, 350, 356; 90-93; colorplates 12, 13; Nativity, 93-94; 91; Prophets Isaiah and Ezekiel, 93; 91; Rucellai Madonna, Sta. Maria Novella, Florence, 45, 91-92, 93; 89; Temptation of Christ, 94, 350; 92 Duomo, see Florence, Cathedral; Siena, Cathedral Dürer, Albrecht, 315, 397, 409, 553, 557, 561 Dyck, Anthony van, 619 Dying Slave (Michelangelo), 463, 491, 506-7, 508, 511, 548; 532 Ecce Homo with Angel (Moretto), 618; 658 Edward III (king of England), 122 Eleazar and Matthan (Michelangelo), 505; colorplate 72 Eleonora da Toledo, 659, 662 Enthroned Christ with Madonna and Saints (Orcagna), 123, 124, 125, 126, 133, 180; colorplate 17 Enthroned Madonna: (Giotto; Ognissanti Madonna), 75-76, 85; 72; (Guido da Siena; repainted by Duccio), 45; 31; (Lorenzetti, P.), 104, 113; 104 Enthroned Madonna and Child: (Bellini, Giovanni; Frari altarpiece), 412-14; 424; (Bellini, Giovanni; S. Giobbe altarpiece), 414, 416, 420; 425; (Cimabue), 45-47, 75, 76, 91; colorplate 4; (Mantegna), 281, 388; 403; (Masaccio), 201-2, 218; 202; (Sassetta), 349 Enthroned Madonna and Child with Angels (Tura), 428; colorplate 65 Enthroned Madonna and Child with Saints (Mantegna), 388, 413; colorplate 57 Enthroned Madonna with St. Liberalis and St. Francis (Giorgione), 591; 630, 631 Enthroned Madonna with Saints: (Bellini, Giovanni), 281, 416; colorplate 63; (Botticelli), 334, 466, 577; 351 Enthroned St. Cecilia and Scenes from Her Life (Master of St. Cecilia), 88, 90; 87 Entombment: (Castagno), 262, 264; 269; (Pontormo), 558, 661; 596; colorplate 78; (Titian), 599; 640 Entry into Jerusalem (Duccio), 94-95, 116; colorplate 13 Equestrian Monument of Bartolommeo Colleoni (Verrocchio and Leopardi), 139, 323, 451;

Equestrian Monument of Gattamelata (Dona-

tello), 139, 238-40, 244-45, 323, 451; 249, 250 Erasmo da Narni, see Gattamelata Erasmus, 508 Eremitani Church, see Padua Este, Alfonso d', 597 Este, Borso d', 430 Este, Isabella d', 395-96, 455, 597 Este, Lionello d', 382, 427 Este, Niccolò III d', 239, 427 Este family, 221, 279, 378, 396, 427, 566 Eugenius IV (pope), 153, 208, 213, 371, 425 Exorcism of the Demon in the Temple of Mars (Lippi, Filippino), 341-42; 358 Exposure of Luxury (Bronzino), 662; colorplate Expulsion: (Masaccio), 177, 190-91, 208, 496, 497; 197; (Quercia; Bologna), 177, 497; 180; (Quercia; Siena), 174, 176, 177, 191; 176 Expulsion from the Garden (Mantegazza), 425; Expulsion of Attila (Raphael), 514-15; 542 Expulsion of Heliodorus (Raphael), 513, 642; 540; colorplate 74 Eyck, Jan van, 101, 187, 207, 210, 217, 282, 290, 340, 399, 433, 518, 577, 592, 593 Fabriano: Valle Romita altarpiece (Gentile da Fabriano), 178-80; 181-183 Faith (Michelozzo), 242-43; 255 Fall of Icarus (Sebastiano del Piombo), 525; 557 Fall of Man (Michelangelo), 496-97, 503, 504-5: 518 Fall of the Giants (Perino del Vaga), 562, 639; 602 Fall of the Rebel Angels (Beccafumi), 562, 564, 639; 604 Famous Men and Women series (Castagno), 264-65; 271, 272 FANCELLI, LUCA, 229; Palazzo Pitti, Florence, 228-29; 234 Farnese, Alessandro (cardinal), 583, 584; see also Paul III (pope) Farnese, Pierluigi, 669 Farnese family, 523 Feast in the House of Levi (Veronese), 628-30, 632; colorplate 98 Feast of Herod: (Donatello), 173, 174, 348, 452; 173; (Lippi, Fra Filippo), 218; 220 Federico da Montefeltro (duke of Urbino), 279, 280, 281, 356, 371, 375, 376, 377; portraits of (Piero della Francesca), 281-82, 301, 313, 351, 459, 511; 287, 288; colorplate Federico da Montefeltro (Piero della Francesca), 281-82, 301, 313, 351, 459; 288; colorplate Ferdinand (king of Spain), 484 Ferdinand of Aragon, 375 Ferdinand II (king of Naples), 421 Ferrara, 136, 378, 427, 588, 608, 617; Cathedral, 239; Palazzo Schifanoia, Sala dei Mesi, frescoes: (Cossa), 430; 442; (Roberti), 430; 443; S. Giorgio Fuori, altarpiece (Tura), 428-29; 440; colorplate 65 Festival of Venus (Titian), 597; 636 Fête Champêtre (Giorgione), 591-92; color-

plate 86

Fiesole, 12 608; 657 348. 378 337

Ficino, Marsilio, 330, 331, 332, 333 ci-Riccardi Fighting Men (Raphael), 511, 513; 537 Ognissanti, Refectory, fresco (Ghirlan-Figiovanni, Giovanni, 542 daio), 343; 359 FILARETE, ANTONIO (ANTONIO AVERLINO), 225, Orsanmichele, 15, 85, 553; 6; niche 425; Sforzinda, plan of, 27, 229, 425; 436 Finding of Moses (Perugino), 639 FIORENTINO, ROSSO, see ROSSO FIORENTINO Fioretti (Little Flowers), 78, 79 FIRENZE, ANDREA DA. see ANDREA DA FIRENZE 163-64, 165, 169, 183; 158-160; Fisherman Delivering the Ring, A (Bordone), Five Heads (Gaddi, A.), 20, 133; 10 Flagellation: (Bellini, J.), 383-84; 395; 133; 113, 114 (Francesco di Giorgio), 356-57, 358; 374; (Ghiberti), 20, 161-62, 168, 189, 259; 155, 156; (Sebastiano del Piombo), 537: 565 Flagellation of Christ (Piero della Francesca), del Turco), paintings: (Pontormo), 279-80, 356; colorplate 37 556-57; 594; (Sarto), 556 Flight into Egypt: (Gentile da Fabriano), 180, Palazzo Gondi (Sangallo, G.), 294 182, 187; 186; (Giotto), 70; 62 Florence, 11, 15, 41, 52, 424; 2, 3 (Michelangelo), 155, 584; (Micheartistic role of, 141, 205, 284, 285, 304, lozzo), 152, 155-57, 224, 247, 294, Baptistery, 116, 146, 281; bronze doors: competition for, 158; (Brunelleschi), 158, 159; 150; (Ghiberti), 142, 158-61, 204, 233; 151, 152; (Quercia), 174, 348; East Doors, Gates of Paradise (Ghiberti), 88, 209, 231-35, 241, 242, 259, 356, 359, 439; 85, 236-240; North 157 Doors (Ghiberti), 142, 161-63, 164, Palazzo Pazzi-Quaratesi (Giuliano da 182, 185, 231, 233, 234, 400; 153-155, Maiano), 293, 294; 306 157; South Doors (Andrea Pisano), 88, Palazzo Pitti (Fancelli?), 228-29; 234; 134, 158, 161, 231, 359; 85, 86; mosaics: (Cimabue), 47; (Coppo di Marco-713 valdo), 44-45, 47; colorplate 3; sculpture (Donatello), 285; 291; colorplate 40; tomb sculpture (Donatello and Mi-228: 225 chelozzo), 242 Campanile: (Andrea Pisano), 135; 77; (Arnolfo di Cambio), 79; (Giotto), 20, 79-80, 124, 135; 76, 77; (Talenti), 135; 77; 584; 307-309 sculpture: (Andrea Pisano, and Giotto?), 16, 18, 21, 25, 27, 53, 88; 7, 16, 17, (Arnolfo di Cambio), 61, 157; 54; 84; (Donatello), 171-73; 170-172 Cathedral (Duomo; Sta. Maria del Fiore), 26, 126, 131, 135-36, 143, 285, 335, 425; (Arnolfo di Cambio), 60, 61, 135, 143; 126, 127; (Brunelleschi), 141, 142-46, 152, 171, 209, 223, 359, 436; 132-135; (Ciaccheri), 143; (Orcagna), 124; (Talenti), 135; 126; frescoes: (Cas-666; 723; (Cavalori), 666-67; 724; tagno), 267-68; 276; (Uccello), 244-45, 267; 259; lantern (Brunelleschi and (Macchietti), 666, 667-68; 725; (Vasari), 664, 666; colorplate 104 Michelozzo), 144, 145; 134; sculpture: 163, 260; (Donatello), 164, 171, 235, Pazzi Chapel, Sta. Croce (Brunelleschi), 236, 469; 161, 243, 244; (Michelange-148, 153-55, 293, 294, 297; 144, 145; lo), 468-69; (Nanni di Banco), 169, colorplate 21; façade (Giuliano da 170-71, 261; 169; (Robbia), 235-36, Maiano), 293-94; 144; sculpture (Rob-245; 241, 242; window (Castagno), bia), 148; colorplate 21 plan of, 13, 15; 2 effect of plague on, 122, 218-19, 284 political and economic development of, 12, 15, 28, 45, 61, 63, 76, 122, 131, Fountain of Neptune (Ammanati), 659, 136, 138, 140, 141-42, 155, 187, 205, 660; 712 guild system in, 15, 63, 141-42, 158, 163 284-85, 304, 348, 454, 539, 542 Laurentian Library, see Florence, S. Ponte a Sta. Trinita (Ammanati), 344, 660; 714 Loggia dei Lanzi, 285, 469, 470, 659, 660 SS. Annunziata (Michelozzo and Alberti), Medici Chapel, see Florence, S. Lorenzo 266, 455; altarpiece (Pollaiuolo), 316-

Medici Palace, see Florence, Palazzo Medi-(Donatello and Michelozzo), 320; 333; painting (Daddi), 85, 122, 123; 81, 113; sculpture, 172, 260; (Donatello), 164, 165-69, 186, 260; 162-167; (Ghiberti), (Nanni di Banco), 164, 169-70, 186, 187; 168; (Verrocchio), 320-21; 333, 334; Tabernacle (Orcagna), 85, 123-24, Ospedale degli Innocenti (Brunelleschi), 146-48, 149, 150, 152, 161, 201; 136 Palazzo Borgherini (now Palazzo Rosselli Palazzo Medici-Riccardi, 285, 336, 461; 295, 375; 146-148; Chapel, frescoes (Gozzoli), 298-99; colorplate 41; paintings: (Domenico Veneziano), 257; 265; (Lippi, Fra Filippo), 219-20, 299; 221; (Pollaiuolo), 313; (Uccello), 246-48; 263; colorplate 31; sculpture: (Donatello), 285, 287; 292, 293; (Robbia, L.), courtyard (Ammanati), 228, 659-60; Palazzo Rucellai: façade (Alberti), 223-25, 228, 243, 294, 375, 489; 225; remodeling (Rossellino, B.), 224, 225, Palazzo Strozzi (Benedetto da Maiano and Il Cronaca), 294-95, 341, 375, 424, Palazzo Vecchio, 285, 336, 457, 470, 668; Chapel of Eleonora da Toledo, frescoes (Bronzino), 662-63; 719; Sala del Cinquecento (Il Cronaca), 457; frescoes in: (Leonardo da Vinci), 457-59; 464; (Michelangelo), 470-71; 479; Sala dell'Udienza, frescoes (Salviati), 663; 720; sculpture: (Donatello), 164; 161; Studiolo, 666-68; paintings in: (Allori),

17, 455; colorplate 43; frescoes: (Baldovinetti), 301–3, 451, 555; 318; (Castagno), 266–67, 392, 455; 274, 275; colorplate 35; (Pontormo), 555–56; 593; (Rosso Fiorentino), 559; 598; (Sarto), 551–52, 553, 555, 559; 580, 590

Sant'Apollonia, Cenacolo, frescoes (Castagno), 261–64, 343; 269, 270; colorplate 34

Santi Apostoli, 150

S. Barnaba, altarpiece (Botticelli), 334; 351

Sta. Croce, 320; (Arnolfo di Cambio), 59, 60-61, 79, 150; 52, 53; altarpiece (Vasari), 664; Bardi Chapel, frescoes (Giotto), 76, 77-79, 83; 73-75; colorplate 10; Bardi di Vernio Chapel, frescoes (Maso di Banco), 83, 84; 79; Baroncelli Chapel, frescoes (Gaddi, T.), 86, 87; 82; Chapter House, see Florence, Pazzi Chapel; frescoes: (Gaddi, A.), 73, 132-33, 273; 124; (Gaddi, T.), 86-87; 82, 83; (Giotto), 24, 61, 76, 77-79, 83, 88, 132; 73-75; colorplate 10; (Giovanni da Milano), 127; 117; (Maso di Banco), 83, 84; 79; (Orcagna), 131, 641; Peruzzi Chapel, frescoes (Giotto), 76-77, 83; Refectory, fresco (Gaddi, T.), 86-87; 83; Rinuccini Chapel, frescoes (Giovanni da Milano), 127; 117; sculpture: (Donatello), 216, 236; 245, 246; Tomb of Carlo Marsuppini (Desiderio da Settignano), 201, 288-89, 290, 292; 296, 297; Tomb of Lionardo Bruni (Rossellino, B.), 201, 243, 288, 289, 292; 256,

Sant'Egidio: altarpiece (Goes), 340; 357; frescoes (Domenico Veneziano; assisted by Baldovinetti, Castagno, and Piero della Francesca), 257, 269, 293, 300, 340

S. Felice, 216

Sta. Felicita, Capponi Chapel, altarpiece (Pontormo), 558, 661; 596; colorplate

S. Giorgio alla Costa, painting (Baldovinetti), 300–301, 303; 317

S. Lorenzo: (Brunelleschi), 60, 149-53, 161, 297, 539; 137, 140; (Michelozzo), 153; Epistle pulpit (Donatello), 287, 288; 295; façade (Michelangelo), 27, 153, 540; 567; façade design (Sangallo, G.), 26, 539-40, 582; 566; frescoes (Pontormo), 558; Gospel pulpit (Donatello), 287-88; 294; Laurentian Library (Michelangelo), 358, 546-48, 644, 646, 660; 578-580; Medici Chapel/New Sacristy (Michelangelo), 148, 540-41, 542-46, 547, 550, 557, 644, 646; 568-573, 575-577; painting (Lippi, Fra Filippo), 216-17; colorplate 29; Old Sacristy (Brunelleschi), 148, 149, 152, 153, 154, 155, 275, 373, 541; 137-139; Old Sacristy, relief sculpture (Donatello), 148, 241, 260

Sta. Lucia dei Magnoli, altarpiece (Domenico Veneziano), 257, 259; colorplate 32

S. Marco, 206, 208, 213, 285; altarpiece

(Angelico, Fra), 208–10, 231, 233, 477, 510; 207–209; frescoes (Angelico, Fra), 210–12, 213, 327–28; 210–213; library (Michelozzo), 157, 208; 149

Sta. Maria degli Angeli (Brunelleschi), 153; 143; altarpiece (Lorenzo Monaco), 133–35; 125; colorplate 19; fresco (Castagno), 261, 270; 268

Sta. Maria del Carmine, 216; Brancacci Chapel, frescoes: (Masaccio and Masolino), 186–92, 201, 203, 204, 208, 338, 496, 519; 192–201; colorplate 23; (Lippi, Filippino), 191–92, 338

Sta. Maria Maddalena dei Pazzi, altarpiece (Botticelli), 334; 352

Sta. Maria Novella, 59-60, 61, 225; 50, 51; altarpieces: (Botticelli), 324, 439; 340, 341; colorplate 44; (Duccio), 45, 91-92, 93; 89; (Orcagna), 123, 124, 125, 126, 133, 346; colorplate 17; (Vasari), 664: Chiostro Verde, frescoes (Uccello), 189, 245-46; 260-262; façade (Alberti), 225-26, 637; 226; frescoes: (Andrea da Firenze), 24, 84, 124, 126; colorplate 18; (Ghirlandaio), 346-47, 353, 354, 461; 363, 364; (Lippi, Filippino), 340-42; 358; (Masaccio), 203-4; colorplate 25; (Nardo di Cione), 24, 124-26, 642; 115, 116; (Uccello), 189, 245-46; 260-262; Spanish Chapel, frescoes (Andrea da Firenze), 24, 84, 124, 126; colorplate 18; Strozzi Chapel: altarpiece (Orcagna), 123, 124, 125, 126, 133, 346; colorplate 17; Strozzi Chapel, frescoes: (Lippi, Filippino), 340-42; 358; (Nardo di Cione), 24, 124-26, 642; 115, 116

S. Michele Visdomini, altarpiece (Pontormo), 342

S. Miniato al Monte, 146, 225; Chapel of the Cardinal of Portugal, 290, 327; (Manetti), 290, 292; altarpiece (Pollaiuolo), 317; fresco and panel (Baldovinetti), 303; 319, 320; Tomb of the Cardinal of Portugal (Rossellino, A.), 290–93, 303; 300–303

S. Paolino, painting (Botticelli), 337; 354

S. Procolo, altarpiece (Lorenzetti, A.), 115

S. Salvi, altarpiece (Verrocchio and Leonardo da Vinci), 319–20; 332

Sto. Spirito (Brunelleschi), 60, 149–53, 207, 290, 436; 141, 142; Barbadori altarpiece (Lippi, Fra Filippo), 215–16, 388; 216; sculpture (Michelangelo), 463; 470

Sta. Trinita: altarpieces: (Cimabue), 45–47, 75, 91; colorplate 4; sacristy (Angelico, Fra; begun by Lorenzo Monaco), 206–7; 205; colorplate 27; Sassetti Chapel (Ghirlandaio), 344, 346, 467; colorplate 48; Strozzi Chapel (Gentile da Fabriano), 178, 179, 180–82, 183, 187, 201–2, 299; 184–186; colorplate 22; frescoes: Sassetti Chapel (Ghirlandaio), 343–44; 361, 362

Uffizi (Vasari, Buontalenti, and Parigi), 584, 664–66; 722

Villa La Gallina, fresco (Pollaiuolo), 315–16; 326

Fondaco dei Tedeschi, see Venice

Fonte Gaia, see Siena FOPPA, VINCENZO, 424–25; Crucifixion, 424;

435 Forlì: S. Biagio, ceiling fresco (Melozzo da Forlì), 374

Founding of Santa Maria Maggiore (Masolino), 184, 185; 190

Fountain of Neptune, Sea Nymph from (Ammanati), 659, 660; 712

Fouquet, Jean, 520

Four Crowned Martyrs (Nanni di Banco), 164, 169–70, 176, 186, 187, 237, 284; 168 Francesco delle Opere (Perugino), 369, 456, 476: 380

Francesco di Giorgio, 355–58, 375; Coronation of the Virgin, 355–56; 373; Flagellation, 356–57, 358; 374; Sta. Maria del Calcinaio, Cortona, 226, 357–58, 581; 375–377

Francis I (king of France), 459, 608, 662 Franciscan Order, 59, 82, 87 Francis of Assisi (saint), 30, 32, 47, 78

Frari altarpiece (Bellini, Giovanni), 412–14; 424

Frederick II (Holy Roman emperor), 51 Frederick III (Holy Roman emperor), 348 Freiburg in Breisgau, Germany: Cathedral, 79 Freud, Sigmund, 457

Funeral of St. Francis: (Ghirlandaio), 344; 362; (Giotto), 77–78; 74; colorplate 10 Funeral of St. Martin (Martini), 98; 97

G

GADDI, AGNOLO, 18, 62, 85, 132–33, 342; *Five Heads*, 20, 133; 10; Legend of the True Cross, Sta. Croce, Florence, 73, 132–33, 273; 124; *Triumph of Heraclius over Chosroes*, 132, 133; 124

GADDI, TADDEO, 18, 62, 85–87, 122, 132, 135, 262; Annunciation to the Shepherds, Baroncelli Chapel, Sta. Croce, Florence, 86, 278; 82; Tree of Life, Refectory, Sta. Croce, Florence, 86–87, 494; 83

Gaetano da Thiene (St. Cajetan), 522; see also Cajetan

Galatea (Raphael), 525–26, 537, 553, 591, 597; 558

Galli, Jacopo, 464

Gates of Paradise (Ghiberti), 209, 231–35, 241, 242, 259, 284, 356, 439, 483; 236–240

Gattamelata (Erasmo da Narni), 238; equestrian statue of (Donatello), 139, 238–40, 323; 249, 250

Genoa, 12, 29, 136, 142, 454; Palazzo del Principe, frescoes (Perino del Vaga), 562; 602; Sta. Maria della Consolazione, altarpiece (Perino del Vaga), 561–62; 601

GENTILE DA FABRIANO, 133, 138, 140, 178–82, 183, 187, 201, 257, 274, 348, 371, 378, 382, 398; Adoration of the Magi, 178, 179, 180–81, 183, 203, 206, 257, 274, 299, 380; 184; colorplate 22; Assassination of St. Peter Martyr, 179–80; 183; Coronation of the Virgin, 178–79; 181; Flight into Egypt, 180, 182, 187; 186; Nativity, 86, 104, 135, 180, 181–82, 202, 278, 565; 185; St. John the Baptist in the Desert, 179; 182; Strozzi altarpiece, Sta. Trinita, Florence, 178, 179, 180–82, 183, 187, 201–2; 184–186; colorplate 22; Valle Romita altarpiece, Fabriano, 178–80; 181–183

Géricault, Théodore, 173 Ghent, 13 Gherardini, Lisa di Antonio Maria, 456; portrait of (Leonardo da Vinci), 456; 463 Ghibelline party, 63, 76 GHIBERTI, LORENZO, 17, 121, 122, 143, 155, 158-64, 172, 205, 231-35, 242, 284, 460; Annunciation, 161, 164; 154; Baptistery, Florence, bronze doors: competition for, 142, 158-61, 204, 233; 151, 152; East Doors (Gates of Paradise), 88, 209, 231-35, 241, 242, 259, 356, 359, 439, 483; 85, 236-240; North Doors, 142, 161-63, 164, 182, 185, 231, 233, 234, 400; 153-155, 157; Cathedral, Siena, baptismal font, 173, 348; compared to: Angelico, Fra, 233; Donatello, 165, 166, 167-68, 241; Masaccio, 189; Masolino, 183; Quercia, 174, 176; Creation, The, 176, 231, 233; 237; Crucifixion, 162-63, 400; 157; Flagellation, 20, 161-62, 168, 189, 259; 155, 156; influenced by, 49-50, 222, 231, 234, 242; influence of, 133, 209, 259, 269, 290, 299, 351, 354, 355, 356, 660; Jacob and Esau, 234-35, 439, 552; 239; colorplate 30; Orsanmichele, Florence, sculpture, 163-64, 165, 169, 183; 158-160; perspective and, 162, 168, 234; Sacrifice of Isaac, 142, 158-61, 162, 204, 259, 556; 151, 152; St. John the Baptist, 163-64, 165, 183; 158, 159; St. Matthew, 164; 160; Self-Portrait, 235; 240; Story of Abraham, 233-34; 238; writings of, 81-82, 88, 160, 161, 182, 431 Ghirlandaio, Davide del, 342, 343, 371 GHIRLANDAIO, DOMENICO DEL (DOMENICO BI-GORDI), 132, 304, 342-47, 352-53, 359, 371, 397, 438, 461, 462; Adoration of the Shepherds, 344, 346, 438; colorplate 48; Birth of the Virgin, 346-47, 461, 462, 553; 363; Calling of Sts. Peter and Andrew, 343; 360; Funeral of St. Francis, 344; 362; Last Supper, Ognissanti, Florence, 343, 452; 359; Massacre of the Innocents, 347, 353, 354, 461; 364; Miracle of the Child of the French Notary, 344; 361; Old Man with a Child, 347; colorplate 49; Sta. Maria Novella, Florence, frescoes, 346-47; 363, 364; Sassetti Chapel, Sta. Trinita, Florence, 343-44, 346, 467; 361, 362; colorplate 48; Sistine Chapel, Vatican, frescoes, 326, 327, 343, 518; 360 GIAMBOLOGNA, see GIOVANNI BOLOGNA GIAMBONO, MICHELE, 260; Death of the Virgin (begun by Castagno), S. Marco, Venice, 260; Giocondo, Francesco del, 456, 633 GIORGIONE, 416, 516, 537, 588-92, 594, 607, 617, 618, 621; Adoration of the Shepherds (Allendale Nativity), 589; 629; Enthroned Madonna with St. Liberalis and St. Francis, 591; 630, 631; Fête Champêtre, 591-92; colorplate 86; Sleeping Venus (finished by Titian), 592, 601; 632; Tempest, 591; colorplate 85 Giostra, La (Poliziano), 330, 331, 333 GIOTTO DI BONDONE, 22, 24-25, 61, 62-81, 82, 83, 84, 87, 96, 122, 123, 127, 187, 222, 323, 589; Annunciation, 67-68, 99, 135, 212, 237; 59, 60; Arena Chapel, Padua, frescoes, 63-

75, 76, 77, 81, 88, 137, 173, 262, 642; 55-

71; colorplates 8, 9; assistants and followers

of, 18, 24-25, 62, 83, 85, 129, 138; Betrayal,

71-72; 65; Campanile, Florence, 20, 79-80,

124, 135; 76, 77 (relief sculpture for, executed by Andrea Pisano, 16, 18, 21, 25, 27, 53, 88; 7, 16, 17, 84); Christ Walking on the Waters (Navicella/Little Ship), 79, 123; compared to: Andrea da Firenze, 126; Angelico, Fra, 207; Duccio, 91, 92, 93, 94, 95; Gaddi, A., 133; Orcagna, 124; Creation of Adam, 71; Crucifixion, 72, 95, 203, 204; 66; Enthroned Madonna (Ognissanti Madonna), 75-76, 85; 72; Flight into Egypt, 70; 62; Funeral of St. Francis, 77-78; 74; colorplate 10; Inconstancy, 75, 173; 71; influenced by, 51, 63, 68, 70, 75, 92, 93; influence of, 58, 62, 83, 84, 85, 86, 88, 96, 101, 103, 104, 113, 122, 138, 205, 284, 416, 461; Injustice, 75, 173; 70; Joachim Takes Refuge in the Wilderness, 65, 66, 270; 56; Justice, 75, 173; 69; Lamentation, 72-73, 77; 67; Last Judgment, 24, 64, 73-75, 84, 642; 68; colorplate 9; Last Supper, 71, 262; light and, 24-25, 65-66, 68, 86, 119; Meeting at the Golden Gate, 66-67; 58; Nativity, 68, 70, 72; 61; Raising of Lazarus, 70-71, 134; 63; colorplate 8; Sant'Antonio, Padua, frescoes, 63, 81; Sta. Croce, Florence, frescoes, 24, 61, 132; Bardi Chapel, 76, 77-79, 83; 73-75; colorplate 10; Peruzzi Chapel, 76-77, 83; S. Francesco, Rimini, frescoes, 81; S. Francesco, Upper Church of, Assisi, frescoes, 78, 79, 80-81; St. Francis Undergoing the Test by Fire before the Sultan, 77; 73; Stigmatization of St. Francis, 78-79; 75; Vision of Anna, 66; 57 GIOVANNI BOLOGNA (JEAN BOULOGNE; GIAMBO-LOGNA), 660; Rape of the Sabine Woman, 660; 715, 716 GIOVANNI D'ALEMAGNA, 381, 385; Coronation of the Virgin (with Vivarini), S. Pantaleone, Venice, 381; 392 Giovanni d'Ambrogio, 143 GIOVANNI DA MILANO, 127, 128, 131; Pietà, 127; 118; Resurrection of Lazarus, Sta. Croce, Florence, 127; 117 Giovanni da San Gimignano, 96 GIOVANNI DA UDINE, 521, 542; Villa Madama, Rome, decorations, 521; 549 Giovanni di Francesco, 214 GIOVANNI DI PAOLO, 350-52, 353; Madonna and Child in a Landscape (Madonna of Humility), 351, 382; 367; St. John Entering the Wilderness, 351-52; 368 Giovanni Ghini, 135-36 GIOVANNINO DE' GRASSI, 140; Visconti Hours, 140; colorplate 20 GIOVANNI PISANO, 55-58, 63, 88, 91, 113, 119, 122, 132; Cathedral, Siena, façade, 55–56; 43; colorplate 7; Madonna and Child, Arena Chapel, Padua, 58, 76; 49; Sant'Andrea, Pistoia, pulpit, 56-58, 180; 44, 46-48 Giovio, Paolo, 557 GIULIANO DA MAIANO, 293; Palazzo Pazzi-Quaratesi, Florence, 293, 294; 306; Pazzi Chapel, Florence (with Brunelleschi?), 153, 154; 144; Pazzi Chapel, façade, 293-94; 144 Giuliano di Ser Colino degli Scarsi, 201, 202, 203 Giunta Pisano, 89 Giving of the Keys to St. Peter (Perugino), 358-60, 472, 478; 378; colorplate 51 God the Father (Donatello), 169; 167 GOES, HUGO VAN DER, 340; Adoration of the

Shepherds, Portinari altarpiece, 293, 340, Gogh, Vincent van, 342 Golden Legend (Jacobus de Varagine), 63, 67, 123, 180, 340, 472 Gonzaga, Federigo (duke of Mantua), 392, 394, 568, 585, 597, 599, 602, 627–28, 632; portrait of (Mantegna), 394; colorplate 58 Gonzaga, Francesco (cardinal), 394; portrait of (Mantegna), 394; colorplate 58 Gonzaga, Gianfrancesco, 395, 396 Gonzaga, Ludovico, 221, 226, 391, 393, 394, 395; portraits of (Mantegna), 393, 394; 410; colorplate 58 Gonzaga family, 378, 392, 396, 397 Goya, Francesco de, 580, 597 GOZZOLI, BENOZZO, 12, 24, 298-99, 301, 303, 324, 358, 370, 371; Procession of the Magi, Palazzo Medici-Riccardi, Florence, 298-99; colorplate 41; St. Augustine Given to the Grammar Master, Sant'Agostino, San Gimignano, 299; 316 Greco, El, 212, 334, 398 Griffoni altarpiece (Cossa), 429; 441 Grünewald, Matthias, 43, 129 Guelph party, 15, 63, 142, 187, 320, 348 Guidalotti, Buonamico, 126 Guidantonio da Montefeltro (duke of Urbino). 279, 280 Guidobaldo da Montefeltro, 280, 281 GUIDO DA SIENA, 45; Enthroned Madonna, 45; 31 guilds, 15-17, 27, 63, 141-42 Gypsy Madonna (Titian), 593; 633 Hawkwood, John (Giovanni Acuto), 244; equestrian monument to (Uccello), 238, 244–45, 267, 268; 259 Head of a Child (Desiderio da Settignano), 290; Head of Apostle for Last Supper; Architectural Studies for Sforza Castle (Leonardo da Vinci), 437, 452; 450 Healing of the Cripple and the Raising of Tabitha (Masolino), 186, 189-90, 257; 195 Healing of the Lame Man (Raphael), 518, 520, 628; 547, 548 Hell (Nardo di Cione), 125-26, 315, 642; 116 Henry II (Holy Roman emperor), 123 Henry VII (king of England), 473 Hercules (Donatello and Brunelleschi), 469 Hercules and Antaeus: (Pollaiuolo; bronze), 314-15, 356; 324; (Pollaiuolo; painting), 313-14; 323 Hercules and the Hydra (Pollaiuolo), 313-14; Hohenzollern, Barbara von, 393; portrait of (Mantegna), 393; 410 Holbein, Hans, the Younger, 475 Holy Night (Adoration of the Shepherds) (Correggio), 86, 565-66, 577; 606 Honorius III (pope), 47 Horseman Trampling on Foe (Leonardo da Vinci), 451, 458; 459 Hugh of St. Victor, 119 Hunting Scene (Piero di Cosimo), 481; 492 Hymn in the Nativity (Crashaw), 566

Ignatius Loyola (saint), 618

Imitation of Christ (Thomas à Kempis), 392 Inconstancy (Giotto), 75, 173; 71 Inferno (Dante), 66, 125, 642 Ingres, Jean-Auguste-Dominique, 475, 518, Injustice (Giotto), 75, 173; 70 Innocent II (pope), 29 Innocent III (pope), 12 Innocent VIII (pope), 395, 482; tomb of (Pollaiuolo), 317 Institution of the Eucharist (Justus of Ghent), 248 International Gothic style, 133, 164, 179, 180, 639 Invention of the True Cross (Piero della Francesca), 275-76; 283 Isaac and Esau (Isaac Master), 48-49; 34 ISAAC MASTER, 48-49, 50; Isaac and Esau, S. Francesco, Upper Church of, Assisi, 48; 34 Isabella (queen of Spain), 484 Isenheim altarpiece (Grünewald), 43 Isola, Italy: S. Michele (Codussi), 423 Italo-Byzantine art, 28-29, 45, 51, 52, 53, 58, 91, 92, 137 Italy, 11-12; map of, 1 Jacob and Esau (Ghiberti), 234-35, 439, 552; 239; colorplate 30 JACOBELLO DEL FIORE, 381; Justice with Sts. Michael and Gabriel, 381; 391 Jacobus de Varagine, 63, 340 Jacopo di Cione, 124 Jacopo Strada (Titian), 604-5; 652 Jeremiah (Donatello), 172, 173; 172 Joachim Takes Refuge in the Wilderness (Giotto), 65, 66, 270; 56 John XXIII (antipope; Cardinal Cossa), 242, 292 John Palaeologus (Byzantine emperor), 276, Joseph in Egypt (Pontormo), 556-57, 558, 661; Joshua (Donatello), 469 Judith and Holofernes (Donatello), 166, 285, 287, 659, 660; 292, 293 Julius II (pope), 372, 471, 482-83, 484, 486, 488, 490, 491, 492, 494, 495, 498, 505, 507, 508, 512, 513, 514, 515, 516, 523, 539, 588, 597, 608, 631; tomb of (Michelangelo), 459, 477, 480, 490-91, 492, 505-6, 507-8, 512, 515, 548-51, 642, 657; 510, 530, 531, 581-587, 693 Jupiter and Ganymede (Correggio), 568, 597, 604; colorplate 82 Jupiter and Io (Correggio), 568, 597; 611 Justice: (Giotto), 75, 173; 69; (Raphael), 511 Justice with Sts. Michael and Gabriel (Jacobello del Fiore). 381: 391 Justus of Ghent, 248, 371, 472 Labors of Hercules series (Pollaiuolo), 313

Ladislaus (king of Naples), 142, 164, 167, 169 Lama, Guasparre del, 324 Lamentation: (Donatello), 287-88; 294; (Giotto), 72-73, 77; 67; (St. Pantaleimon, Nerezi), 31, 72; 22; (Sarto), 553-54, 558, 661; Laocoön, 507, 550, 642

Last Judgment: (Cavallini), 50-51, 74, 84; colorplate 5; (Coppo di Marcovaldo), 44-45, 47, 74, 641; colorplate 3; (Giotto), 24, 64, 73-75, 84, 642; 68; colorplate 9; (Maitani), 119, 121; 112; (Michelangelo), 24, 316, 327, 461, 463, 478, 492, 639-42, 648, 662; 690-692; colorplate 101; (Nicola Pisano), 55; 41; (Pontormo), 558; (Traini), 24, 129, 131; 123 Last Supper: (Castagno), 201, 261-64, 265, 266, 343, 452, 553; 269, 270; colorplate 34; (Ghirlandaio), 343, 452; 359; (Giotto), 71, 262; (Leonardo da Vinci), 174, 416, 451-54, 455, 463, 508, 624; 450, 460, 461; colorplate 67; (Lorenzetti, P.), 103-4, 278, 625; 103; (Tintoretto; S. Giorgio Maggiore), 104, 625, 628, 631; 667; (Tintoretto; Scuola di S. Rocco), 624; 666 LAURANA, FRANCESCO, 375, 472; Battista Sforza, 281, 375; 385 Laurana, Luciano, 375, 472; Palazzo Ducale, Urbino, 279, 375-76, 377, 472; colorplate 54; View of an Ideal City (painted by Piero della Francesca), 27, 224, 228, 229, 297, 376-77, 486, 489; 386 Laurentian Library, see Florence, S. Lorenzo League of Cambrai, 378, 588 Le Corbusier, 635 Legenda Maior (St. Bonaventura), 78, 79, 81, Legend of the True Cross: (Gaddi, A.), 73, for 527 132-33, 273, 349, 375; 124; (Piero della Francesca), 73, 132, 273-79, 280, 496; 282-286; colorplate 36 Legnaia: Villa Carducci, frescoes (Castagno), 264-65; 271, 272 Lenzi family, 204 Leo I (pope), 514, 515 Leo X (pope), 155, 285, 459, 461, 508, 515, 516-17, 518, 520, 521, 522, 523, 537, 539, 544, 548, 556, 557, 631; portrait of (Raphael), 517-18; 546 LEONARDO DA VINCI, 265, 304, 316, 323, 356, 431-40, 449-60, 467, 469, 470, 480, 540, 580; Adoration of the Magi, 329, 439, 449, 450, 451, 456, 458, 562; 455; Annunciation, 339, 438-39, 449; 453; Architectural Perspective and Background Figures, for the Adoration of the Magi, 359, 439, 449; 456; Baptism of Christ (with Verrocchio), 319-20, 330, 438, 457; 332; Battle of Anghiari, Palazzo Vecchio, Florence, 457-59, 470, 473, 513, 515, 549; copy of (Rubens), 464; Bird'seye View of Chiana Valley, Showing Arezzo, Cortona, Perugia, and Siena, 208, 434-35; 446; Deluge, 432, 459-60; 466; dissection of corpses by, 314, 435, 463; Head of Apostle for Last Supper; Architectural Studies for Sforza Castle, 437, 452; 450; Horseman Trampling on Foe, 451, 458; 459; influenced by, 174; influence of, 338-39, 355, 416, 424, 431, 457, 466, 473, 476, 483, 486, 513, 515, 551, 555, 563, 564, 608, 617; Last Supper, Sta. Maria delle Grazie, Milan, 174, 416, 451-54, 455, 463, 508, 624; 461; colorplate 67; Madonna and St. Anne, 455-56, 457, 466, 473, 486; 462; colorplate 68; Madonna of the Rocks,

449-50, 457; 457; colorplate 66; Male Nude,

435, 466; 447; in Milan, 140, 449, 451, 454;

Mona Lisa, 438, 455, 456-57, 476; 463; na-

ture and, 380, 432, 433-34, 457, 657; Plans

London, 13

Loredan family, 423

LORENZETTI, AMBROGIO, 101, 115-19, 122, 129,

and Perspective Views of Domed Churches, 26, 436-37, 473, 483, 581; 449; relationship with Botticelli, 324, 329; with Verrocchio, 319, 321, 324, 329, 369, 438; Star-of-Bethlehem and Other Plants, 433; 445; Storm Breaking over a Valley, 432, 434; frontispiece, 444; Studies of a Left Leg, Showing Bones and Tendons, 435; 448; Studies of Water, 437; 452; Studies of Water Movements, 437; 451; Study of Composition of Last Supper, 452; 460; Study of Drapery, 438; 454; Study of the Head of the Angel, for Madonna of the Rocks, 450; 458; Two Sheets of Battle Studies, 459; 465; views on painting, 16, 434, 592-93; writings of, 329, 431-32, 433-34, 435, 438, 455, 459, 577 LEOPARDI, ALESSANDRO, 323; Equestrian Monument of Bartolommeo Colleoni (with Verrocchio), 139, 323; 337-339 Liberation of St. Peter from Prison (Raphael), 507, 513-14, 515; 541 Liberation of the Companions of St. James (Avanzo), 138, 245, 380, 600; 129 Library of S. Marco, see Venice Libro del cortegiano, Il (The Book of the Courtier) (Castiglione), 457, 473, 516 Libro dell'arte, Il (The Book of Art) (Cennini), 18-19, 20-21, 22, 24, 230; see also Cennini Libyan Sibyl (Michelangelo), 502; 526; study Life of Christ (Ludolph of Saxony), 262 Ligorio, Pirro, 670 Limbourg brothers, 140, 182, 257 LIPPI, FILIPPINO, 214, 304, 324, 338-42, 343, 346, 371, 420, 431, 449, 467, 469, 562; Brancacci Chapel, Sta. Maria del Carmine, Florence, frescoes (begun by Masaccio), 191, 192, 201, 338; 201; Exorcism of the Demon in the Temple of Mars, 341-42; 358; Raising of the Son of Theophilus (begun by Masaccio), 192, 201, 338; 201; Strozzi Chapel, Sta. Maria Novella, Florence, frescoes, 340–42; 358; Virgin and Child with Angels, 338-40, 438; 356; Vision of St. Bernard, 340, 476, 477, 481; colorplate 47 Lippi, Fra Filippo, 205, 206, 209, 214-20, 221, 231, 244, 257, 260, 281, 284, 321, 324, 378; Annunciation, 216-17, 334; colorplate 29; Feast of Herod, Cathedral, Prato, 218; 220; Madonna Adoring Her Child, 219-20, 299; 221; Madonna and Child (Palazzo Pitti), 218, 257, 274; 218; Madonna and Child (Uffizi), 217-18, 235, 274, 281, 301; 217; Madonna and Child (Tarquinia Madonna), 215, 216, 218, 352; 215; Madonna and Child with Saints and Angels, Barbadori altarpiece, 215-16, 257, 352, 388; 216; St. John the Baptist Bids Farewell to His Family, Cathedral, Prato, 218; 219 LIPPO MEMMI, 99; standing saints, 99; colorplate Lives of the Most Eminent Painters, Sculptors, and Architects (Vasari), 92, 371, 508, 664; see also Vasari Livorno, 425 Lodi, 378 Lombardo family, 423, 632

180, 187, 350, 351; Allegory of Good Government: Commune of Siena, 24, 116–17, 126; 107; Allegory of Good Government: Effects of Good Government in the City and the Country, 24, 117, 119, 126, 138, 180; 108, 109; colorplate 16; Madonna and Child with Saints, 115–16; 106; Presentation in the Temple, 93, 113, 116; colorplate 15; Sala della Pace, Palazzo Pubblico, Siena, frescoes, 24, 116–17, 119; 107–109; colorplate 16

LORENZETTI, PIETRO, 101-4, 113-15, 116, 122, 129, 350; Annunciation, 101, 270; 101; Assumption, 101, 270; 101; Birth of the Virgin, 93, 113-15, 116, 388; 105; Descent from the Cross, 103, 337; 102; Enthroned Madonna, 104, 113; 104; Last Supper, 103-4, 278, 625; 103; Madonna and Child with Saints, 101, 270; 101; S. Francesco, Lower Church of, Assisi, frescoes, 103-4; 102, 103

LORENZO MONACO (PIERO DI GIOVANNI), 133–35, 142, 161, 163, 169, 178, 180, 181, 183, 261, 284, 351–52, 477; Coronation of the Virgin, 133–34, 159, 178, 261, 577; colorplate 19; Descent from the Cross (finished by Angelico, Fra), 206; colorplate 27; Nativity, 86, 134–35, 181; 125; Six Saints, 19, 134; 9

Loreto: Sta. Casa (Sangallo, G.), 373; Sacristy of St. Mark, dome fresco and painting (Melozzo da Forlì), 373–75; 383, 384

LOTTO, LORENZO, 588, 606–7, 617, 627; Annunciation, 607; 656; Sacra Conversazione, 607; colorplate 91

Louis XII (king of France), 451, 459, 514, 608 Louis XIV (king of France), 451

Lucca, 12, 28, 31, 41, 76

Ludolph of Saxony, 262

Ludovico Gonzaga, His Family, and Court (Mantegna), 226, 393–94; 410

Luke (saint), 15, 102, 371 Luther, Martin, 517, 522

M

MACCHIETTI, GIROLAMO, 666, 667; Baths at Pozzuoli, 666, 667–68; 725

Machiavelli, Niccolò, 454, 541, 545 *Maddalena Strozzi Doni* (Raphael), 369, 466, 475–76; 485

Madonna (Lorenzetti, A.), 115

Madonna Adoring Her Child (Lippi, Fra Filippo), 219–20, 299; 221

Madonna and Child: (Baldovinetti), 281, 301, 303; colorplate 42; (Bellini, Giovanni), 409–10; 420; (Bellini, J.), 381–82; 393; (Coppo di Marcovaldo), 43–44, 85, 91; 30; (Desiderio da Settignano), 289, 290; 298; (Giovanni Pisano), 58, 76; 49; (Lippi, Fra Filippo; Palazzo Pitti), 218, 257, 274; 218; (Lippi, Fra Filippo; Uffizi), 217–18, 235, 274, 281, 301; 217; (Masolino), 183–84; 188; (Nicola Pisano), 55; 42

Madonna and Child (Tarquinia Madonna) (Lippi, Fra Filippo), 215, 216, 218, 352; 215 Madonna and Child Enthroned with Angels

(Daddi), 85, 122, 123; 81, 113

Madonna and Child in a Landscape (Madonna of Humility) (Giovanni di Paolo), 351, 382; 367

Madonna and Child with Donor (Bellini, J.), 382, 383, 411, 424; colorplate 56
Madonna and Child with Saints: (Domenico

Veneziano), 257, 259, 270, 300, 388; colorplate 32; (Lorenzetti, A.), 115–16; 106; (Lorenzetti, P.), 101, 270; 101; (Masaccio), 182–83, 186, 202, 218; 187; (Nardo di Cione), 22, 126; colorplate 1; (Piero della Francesca), 280–81, 388, 414; 287

Madonna and Child with Saints and Angels (Lippi, Fra Filippo), 215–16, 257, 352, 388; 216
Madonna and Child with Sts. Jerome and Mary
Magdalen (Correggio), 565, 598; 605

Madonna and St. Anne (Leonardo da Vinci), 455–56, 457, 466, 473, 486; 462; colorplate

Madonna and Saints (Angelico, Fra): (Cortona), 21–22; 11, 12; (Florence), 208–10, 231, 327–28, 333, 477; 207

Madonna della Candelletta (Crivelli), 421, 423; 432

Madonna del Popolo (Barocci), 670; colorplate

Madonna di S. Biagio, *see* Montepulciano Madonna Enthroned in a Church (Antonello da Messina), 414

Madonna of Humility (Domenico di Bartolo), 352; 369

Madonna of Mercy (Piero della Francesca), 270, 273; 278

Madonna of the Harpies (Sarto), 553; 591 Madonna of the House of Pesaro (Titian), 598– 99, 630; 639

Madonna of the Meadows (Raphael), 473-74; 482

Madonna of the Rocks (Leonardo da Vinci), 449–50, 457; 457; colorplate 66

Madonna of the Stairs (Michelangelo), 461–62, 463, 544, 618, 657, 658; 467

Madonna of the Victory (Mantegna), 395, 421, 593; 412

Madonna with the Long Neck (Parmigianino), 578; colorplate 83

Maestà: (Duccio), 92–96, 103, 116, 350, 356; 90–93; colorplates 12, 13; (Martini), 96–97, 103; 94

Mahomet II (sultan), 279, 397, 398; portrait of (Bellini, Gentile), 397–98; 415

Maiano, Italy, 293, 450

Mainardi, Bastiano, 342

MAITAINI, LORENZO, 119–21; Cathedral, Orvieto, sculpture, 119, 121; 110–112; Creation of the Birds and Fishes, 121; 111; Last Judgment, 119, 121; 112; Scenes from Genesis, 119, 121; 110, 111

Malatesta, Pandolfo, 178

Malatesta, Sigismondo, 221, 222, 223, 275, 279

Malatesta Temple, see Rimini

Male Nude (Leonardo da Vinci), 435, 466; 447 Manetti, Antonio di Tuccio, 146, 290

Manetti, Giannozzo, 155, 204, 285

Mantegazza, Cristoforo, 425, 427; Expulsion from the Garden, Certosa, Pavia, 425; 438

Mantegna, Andrea, 242, 260, 371, 381, 382, 384–97, 400, 409, 410, 427, 428, 454, 593, 608, 617, 626, 628, 630; Adoration of the Magi, 391–92, 537, 589; 407; Agony in the Garden, 390–91, 411; 405; Arrival of Cardinal Francesco Gonzaga, 226, 394; colorplate 58; Ascension, 391, 392; 408; Baptism of Hermogenes, 385; 397; Camera degli Sposi, Palazzo Ducale, Mantua, frescoes, 393–94, 566, 568; 410, 411; colorplate 58; Circumci-

sion, 391, 392; 406; Crucifixion, 388, 389, 400; 404; Dead Christ, 392-93, 578; 409; Enthroned Madonna and Child, 281, 388; 403; Enthroned Madonna and Child with Saints, 388, 413; colorplate 57; Ludovico Gonzaga, His Family, and Court, 226, 393-94; 410; Madonna of the Victory, 395, 421, 593; 412; Martyrdom of St. James, 387-88, 389; 402; Ovetari Chapel, Eremitani Church, Padua, frescoes, 385-88, 394; 397-401; Parnassus, 396, 597; 413; perspective and foreshortening and, 385, 386, 390, 391, 394, 527; St. James before Herod Agrippa, 385; 398, 399; St. James Led to Execution, 386-87, 409; 400, 401; S. Zeno altarpiece, Verona, 388-89, 390, 394, 411, 424; 403, 404; colorplate 57 Mantua, 136, 378, 608; Castle of St. George,

Mantua, 136, 378, 608; Castle of St. George, 395 (Grotta, 395–96; paintings by Mantegna, 396; 413); Palazzo del Te, 632; (Romano), 584, 585, 605, 627–28; 624–626; frescoes (Romano): Sala dei Giganti, 562, 586–87, 602, 639; 627, 628; Sala di Psiche, 586; colorplate 84; Palazzo Ducale, Camera degli Sposi, frescoes (Mantegna), 393–94, 566, 568; 410, 411; colorplate 58; Sant'Andrea, 394; (Alberti), 226–27, 229, 358, 483, 489, 510, 637, 668; 227–229; S. Sebastiano (Alberti), 297

Man with the Glove (Titian), 599; 641 Marcus Aurelius (Roman statue), 239, 647 Marignolle: Le Campora, altarpiece (Lippi, Filippino), 340; colorplate 47

Marriage at Cana (Veronese), 628; 672–674 Marriage of Alexander and Roxana (Sodoma), 526–27; 559

Marriage of St. Francis to Lady Poverty (Sassetta), 350; 365

Marriage of the Virgin (Raphael), 472-73, 508; colorplate 70

Marsuppini, Carlo, 288; tomb of (Desiderio da Settignano), 201, 288–89, 290, 292; 296, 297

Martin V (pope), 134, 178, 180, 184, 185, 186,

Martini, Simone, 96–101, 116, 123, 128, 129, 350, 351, 352; Annunciation, 93, 98–99, 101, 116, 123; colorplate 14; Blessed Agostino Novello and Four of His Miracles, The, 101; 98, 99; Funeral of St. Martin, 98; 97; Maestà, Palazzo Pubblico, Siena, 96–97, 103; 94; S. Francesco, Lower Church of, Assisi, frescoes, 98, 99; 96, 97; St. Louis of Toulouse Crowning Robert of Anjou, King of Naples, 97–98, 101; 95; Vision of St. Martin, 98, 99, 124; 96; Way to Calvary, 101; 100

Martyrdom of St. George (Altichiero), 138, 600; 130

Martyrdom of St. James (Mantegna), 387–88, 389: 402

Martyrdom of St. Lawrence (Donatello), 288; 295

Mary Magdalen (Donatello), 285, 287, 288; 291; colorplate 40

Mary, Sister of Moses (Giovanni Pisano), 56; 43
MASACCIO (MASO DI SER GIOVANNI DI MONE CASSAI), 17, 119, 122, 133, 182–92, 201–4, 205,
284, 323, 342, 369, 371, 592, 621, 657; Adoration of the Magi, 203, 257, 274; 203; Alberti
on, 231, 235; Brancacci Chapel, Sta. Maria
del Carmine, Florence, frescoes, 186–89,

190-92, 201, 203, 204, 338, 496, 519; 192-194, 197-201; colorplate 23; collaborations with Masolino, 184, 187, 189, 190, 204; Crucifixion, 202-3, 204, 270; colorplate 24; Crucifixion of St. Peter, 203, 642; 204; Distribution of the Goods of the Church, 186, 192; 200; Enthroned Madonna and Child, 201-2, 218; 202; Expulsion, 177, 190-91, 208, 496, 497; 197; influenced by, 169, 183, 186, 187, 190-91; influence of, 177, 181, 186, 205, 206, 214, 215, 216, 218, 257, 259, 269, 270, 274, 324, 343, 352, 359, 461, 519, 520; Madonna and Child with Saints, S. Giovenale, Cascia di Regello, 182-83, 186, 202, 218; 187; perspective and, 174, 187, 189, 191, 202, 204, 206; Pisa polyptych, Sta. Maria del Carmine, Pisa, 191, 201-3, 204; 202-204; colorplate 24; Raising of the Son of Theophilus (finished by Lippi, Filippino), 192, 201, 520; 201; St. Peter Baptizing the Neophytes, 189, 520; 193, 194; St. Peter Healing with His Shadow, 186, 191-92; 198, 199; St. Jerome and St. John the Baptist, 184-85, 186, 202; 189; Tribute Money, 186, 187, 189, 190, 191, 201, 343, 520; 192; colorplate 23; Trinity, Sta. Maria Novella, Florence, 186, 203-4, 260, 386; colorplate 25

Maser: Villa Barbaro, frescoes (Veronese), 628; 671

MASO DI BANCO, 83–85, 138; Bardi di Vernio Chapel, Sta. Croce, Florence, frescoes, 83, 84; 79; Sts. Paul and Julian, 25, 83–85; 15; St. Sylvester Resuscitating Two Deceased Romans, 83; 79

MASOLINO (MASO DI CRISTOFANO), 182, 183–90, 191, 204, 265, 371; Baptism of Christ, Baptistery, Castiglione Olona, 186, 204, 257; colorplate 26; Brancacci Chapel, Sta. Maria del Carmine, Florence, frescoes, 186–87, 189–90, 496; 195, 196; Founding of Santa Maria Maggiore, 184, 185; 190; Healing of the Cripple and the Raising of Tabitha, 186, 189–90, 257; 195; Madonna and Child, 183–84; 188; St. John the Evangelist and St. Martin of Tours, 184, 185; 191; Temptation, 190, 496; 196

Massacre of the Innocents: (Ghirlandaio), 347, 353, 354, 461; 364; (Giovanni Pisano), 57; 46; (Matteo di Giovanni), 353–54, 356; 371; (Nicola Pisano), 57; 45

Mass of Bolsena (Raphael), 512–13; 539 Master of Flémalle, 101, 257

MASTER OF ST. CECILIA, 83, 88–90; Enthroned St. Cecilia and Scenes from Her Life, 88, 90; 87; S. Francesco, Upper Church of, Assisi, frescoes, 82, 88–90; 88; St. Francis and the Madman, 89–90; 88

MASTER OF THE ST. FRANCIS CYCLE: Dream of Innocent III, 17, 80, 82; colorplate 11; S. Francesco, Upper Church of, Assisi, 82–83; 78; colorplate 11; St. Francis Giving His Cloak to the Beggar, 82; 78; St. Francis Praying before the Crucifix at San Damiano, 17, 80, 82; colorplate 11; St. Francis Renouncing His Worldly Goods, 17, 80, 82; colorplate 11

Matilda (countess of Tuscany), 28 Matteo di Giovanni, 353–54; Massacre of the Innocents, Sant'Agostino, Siena, 353–54, 356; 371

Medici, Alessandro de' (Duke of Florence), 542, 661 Medici, Carlo de', 218

Medici, Cosimo de' (Cosimo Vecchio), 153, 155, 157, 205, 208, 213, 214, 215, 221, 238, 257, 285, 299, 333, 334, 340

Medici, Cosimo I de' (duke of Florence), 155, 457, 639, 657–58, 659, 661, 662, 664, 666; portrait sculpture of (Pierino da Vinci), 657–58: 709

Medici, Ferdinand I de', 425

Medici, Francesco I de', 660, 666, 667

Medici, Giovanni de' (son of Cosimo Vecchio), 157, 285, 325

Medici, Giovanni de' (son of Lorenzo the Magnificent), 285, 461, 515, 516, 539; see also Leo X (pope)

Medici, Giovanni di Bicci de', 148

Medici, Giuliano de' (duke of Nemours; son of Lorenzo the Magnificent), 285, 539, 540, 542–43; tomb of (Michelangelo), 540, 541, 542, 543–46; 569, 572, 573, 575

Medici, Giuliano de' (son of Piero the Gouty), 285, 325, 330, 331, 461, 517

Medici, Giulio de' (cardinal), 517, 518, 521, 539, 540, 546–47, 557; portrait of (Raphael), 517–18; 546; see also Clement VII (pope)

Medici, Lorenzo de' (duke of Urbino), 539, 540, 541, 542–43, 545, 557; tomb of (Michelangelo), 540, 541, 542, 543–46, 557; 570, 576, 577

Medici, Lorenzo de' (Lorenzo the Magnificent), 157, 246, 285, 294, 296, 299, 304, 317, 321, 323, 325, 329, 330, 331, 332, 342, 461, 463, 477, 516, 540, 543, 557; tomb of (Michelangelo), 540, 541, 543

Medici, Lorenzo de Pierfrancesco de', 317, 330, 332, 333, 334, 342, 480

Medici, Piero de' (Piero the Gouty), 24, 205, 219, 257, 285, 298, 299, 325

Medici, Piero de' (Piero the Unlucky), 285, 336, 461, 463

Medici Chapel, see Florence, S. Lorenzo Medici family, 148, 149, 155, 157, 205, 217, 228, 237, 238, 285, 287, 299, 324, 326, 330, 332, 467, 468, 470, 539, 542

Medici Madonna (Michelangelo), 462, 463, 541, 543, 544, 546; 571

Medici Palace, see Florence, Palazzo Medici-Riccardi

Medici Villa, see Poggio a Caiano, Villa Medici Meditation on the Passion (Carpaccio), 419–20, 597; 430

Meditations on the Life of Christ (Giovanni da San Gimignano), 95–96

Meeting at the Golden Gate (Giotto), 66–67; 58 Meeting of Solomon and the Queen of Sheba (Piero della Francesca), 257, 274, 275; 282 Melissa (Dossi), 617; colorplate 93

Mellini, Pietro: bust of (Benedetto da Maiano), 293; 305

Melozzo da Forlì, 371–75, 454, 472, 527; Christ in Glory, Santi Apostoli, Rome, 371, 373; colorplate 53; Sta. Casa, Loreto, dome fresco and panel, 373–75; 383, 384; Sixtus IV Appointing Platina, Library, Vatican, 228, 371–73, 393, 515; 382

Melzi, Francesco, 434 Memlinc, Hans, 360, 369, 399, 417 Memmi, Lippo, *see* Lippo Memmi Michelangelo Buonarroti, 17, 27, 145, 231, 265, 288, 431, 460–71, 476, 482, 490–508, 516, 524, 537, 539-51, 556, 580, 594, 619, 634, 639-48, 657, 664, 668; Azor and Sadoc, 505; colorplate 73; Bacchus, 464, 477; 471; Battle of Cascina, Palazzo Vecchio, Florence, 457, 463, 470-71, 478, 490, 491, 495-96, 549, 666, 667; copy of (Sangallo, Aristotile da), 479; Battle of Lapiths and Centaurs, 462-63, 464, 470, 478, 481, 657; 468, 469; "Bearded" Captive, 548, 549, 550-51; 586; "Beardless" Captive, 548, 549, 550-51; 585; "Blockhead" Captive, 548, 549, 550-51; 587; Brazen Serpent, 503-4, 561, 566, 580, 640, 658; 528; Bruges Madonna, 467-68, 491, 497, 507, 577; 475; Campidoglio, Rome, 647; 703, 704; Conversion of St. Paul, 642; 695, 696; Creation of Adam, 176, 499-501, 503; 522, 523; Creation of Eve, 497, 499; 521; Creation of Sun, Moon, and Plants, 501, 504, 506, 580; 524; "Crossed-Leg" Captive, 548, 549, 550-51; 584; Crucifix, 463, 464; 470; Crucifixion, 647; 705; Crucifixion of St. Peter, 642-44; 694; Cumaean Sibyl, 497, 506; 519, 520; David, 164, 338, 343, 466, 468-70, 501, 506, 507, 545; 477, 478; Dawn, 543, 544, 545, 546, 659, 660; 576, 577; Day, 462, 543, 544, 545; 573; Deluge, 495–96, 662–63, 666; 514, 515; dissection of corpses by, 314, 463; Doni Madonna, 202, 293, 466-67, 468, 474, 475, 502, 505; 474; colorplate 69; Dying Slave, 463, 491, 506-7, 508, 511, 548; 532; Eleazar and Matthan, 505; colorplate 72; Fall of Man, 496-97, 503, 504-5; 518; financial success of, 16; foreshortening and, 270; influenced by, 121, 176, 186, 292, 316, 346, 347, 357, 373, 454, 455, 461, 464, 466, 582, 642; influence of, 344, 477, 481, 506, 507, 511, 513, 525, 537, 538, 540, 553, 556, 561, 566, 577, 579, 580, 588, 592, 601-2, 620, 626, 644, 657, 658, 659, 660, 664, 670; Last Judgment, 24, 316, 327, 461, 463, 478, 492, 639–42, 648, 662; 690–692; colorplate 101; Laurentian Library, S. Lorenzo, Florence, 358, 546-48, 644, 646, 660; 578-580; Libyan Sibyl, 502; 526; study for, 527; Madonna of the Stairs, 461-62, 463, 544, 618, 657, 658; 467; Medici Chapel (New Sacristy), S. Lorenzo, Florence, 148, 540-41, 542-46, 547, 550, 557, 644, 646; 568-573, 575-577; Medici Madonna, 462, 463, 541, 543, 544, 546; 571; Moses, 327, 491, 497, 506, 511, 548; 531; Night, 543, 544, 545-46, 603; 572; painting style of, 339; Palazzo dei Conservatori, Rome, 647; 704; Palazzo Farnese, Rome (and Sangallo, A., the Younger), 583, 584, 644, 647; 620, 621, 697; Palazzo Medici-Riccardi, Florence, 155, 584; Palazzo Nuovo, Rome, 547; Pauline Chapel, Vatican, frescoes, 642-44; 694-696; Pietà (Florence), 121, 647; 706, 707; Pietà (Milan), 648, 657; 708; Pietà (Vatican), 464-66, 468, 470, 578; 472, 473; Pitti Madonna, 491-92, 657; 511; Plan for Triangular Rare-Book Room of the Laurentian Library, 548; 580; Prophet Isaiah, 496, 505; 516, 517; Rebellious Slave, 491, 506, 507, 508, 548; 533; religious passion in the work of, 288, 605; Resurrection, 544, 580; 574; Ruth, Obed, and Boaz, 504; 529; S. Lorenzo, Florence, façade, 27, 153, 540; model for, 567 (see also Michelangelo, Lau-

sculptural techniques and innovations of, 25, 171, 172; Separation of Light from Darkness, 501-2, 503, 566; 525; Sistine Chapel, Vatican: ceiling frescoes, 57, 270, 293, 316, 326, 459, 461, 463, 464, 466, 467, 471, 491, 492–505, 509, 518, 543, 545, 640; 512–520, 528, 529; colorplates 72, 73; wall fresco, 24, 327, 461, 463, 478, 492, 639-42, 648; 690-692; colorplate 101; Study for Libyan Sibyl, 502; 527; Study for Sistine Ceiling, 494; 513; Taddei Madonna, 468, 491, 507, 657; 476; Tomb of Giuliano de' Medici, Medici Chapel, Florence, 540, 541, 542, 543-46; 569, 572, 573, 575; Tomb of Julius II, S. Pietro in Vincoli, Rome, 459, 477, 480, 490-91, 492, 505-6, 507-8, 512, 515, 548-51, 642, 657; 510, 530, 531, 581-587, 693; Tomb of Lorenzo de' Medici, Medici Chapel, Florence, 540, 541, 542, 543-46, 557; 570, 576, 577; Tomb of Lorenzo the Magnificent, Medici Chapel, Florence, 540, 541, 543; Twilight, 543, 544, 545; Victory, 548, 549-50, 658; 582, 583 MICHELOZZO DI BARTOLOMMEO, 153, 155-57, 208, 211, 242-43, 266, 292, 455; Cathedral, Florence, lantern (designed by Brunelleschi), 145; 134; Faith, 242-43; 255; Orsanmichele, Florence, niche (with Donatello), 320; 333; Palazzo Medici-Riccardi, Florence, 152, 155-57, 224, 294, 295, 375; 146-148; S. Marco, Florence, library, 157, 208; 149 Michiel, Marcantonio, 591 Milan, 136, 138-39, 142, 152, 163, 187, 378, 424, 608, 617; Cathedral, 140, 425; Ospedale Maggiore (Filarete), 425; S. Francesco Grande, altarpiece (Leonardo da Vinci), 449; colorplate 66; S. Giovanni in Conca, tomb (Bonino da Campione), 139-40; 131; Sta. Maria delle Grazie: (Bramante), 483-84; 495-497; (Solari, Guiniforte), 483; fresco (Leonardo da Vinci), 451-54; 461; colorplate 67; Sta. Maria presso S. Satiro (Bramante), 483, 486; 493, 494; Vigevano (Bramante), 425 Milton, John, 545, 564 Miracle of the Believing Donkey (Donatello), 242: 253 Miracle of the Child of the French Notary (Ghirlandaio), 344; 361 Miracle of the Deacon Justinian (Angelico, Fra), 124, 210; 208 Miracle of the Host (Uccello), 248, 257; 264 Miracle of the Irascible Son (Donatello), 242; 254 Misericordia altarpiece (Piero della Francesca), 269-70, 273, 277, 349, 670; 277-279 MONACO, LORENZO, see LORENZO MONACO Mona Lisa (Leonardo da Vinci), 438, 455, 456-57, 476; 463 Mondrian, Piet, 224 Monet, Claude, 416 Montaigne, Michel de, 669 Montefeltro, Federigo da, see Federigo da Montefeltro Monte Oliveto Maggiore, see Siena Monte Oliveto, Monastery: altarpiece (Beccafumi), 563-64; 603; colorplate 80; painting (Leonardo da Vinci), 438; 453 Montepulciano: Cathedral, tomb sculpture

rentian Library; Medici Chapel); St. Peter's.

Vatican, 227, 486, 488, 644-47; 699-702;

(Michelozzo), 242-43; 255; Madonna di S. Biagio (Sangallo, A., the Elder), 226, 540, 581-82; 616-618; Palazzo Tarugi (Sangallo, A., the Elder), 582; 619 Monument to Bernabò Visconti (Bonino da Campione), 139-40, 239; 131 MORETTO (ALESSANDRO BONVICINO), 618; Ecce Homo with Angel, 618; 658 Moses (Michelangelo), 327, 491, 497, 506, 511, 548: 531 Moses and Jethro's Daughters (Rosso Fiorentino), 561: 600 Moses and the Brazen Serpent (Danti), 658; 710 Moses Striking Water from the Rock (Tintoretto), 623; 663 Mystical Marriage of St. Catherine (Veronese), 630; colorplate 99 Mystical Nativity (Botticelli), 337-38; 355 Mythological Scene (Piero di Cosimo), 481; colorplate 71 Nailing of Christ to the Cross (Pordenone), 579-80; 615 NANNI DI BANCO, 133, 169-71, 176, 177, 186, 187, 205, 261, 284; Assumption of the Virgin, 170-71, 261, 262; 169; Four Crowned Martyrs, Orsanmichele, Florence, 164, 169-70, 176, 186, 187, 237, 284; 168; Porta della Mandorla, Cathedral, Florence, sculpture, 169, 170-71, 261; 169 Naples, 12, 63, 139, 142, 163 NARDO DI CIONE, 124-26, 131, 642; Hell, 125-26, 315, 642; 116; Madonna and Child with Saints, 22, 126; colorplate 1; Paradise, 125; 115; Strozzi Chapel, Sta. Maria Novella, Florence, frescoes, 24, 124-26, 642; 115, Nativity: (Baldovinetti), 301-3, 412, 451, 455, 551, 555; 318; (Bellini, J.), 382-83; 394; (Duccio), 93-94; 91; (Gentile da Fabriano), 86, 104, 135, 180, 181-82, 202, 278, 565; 185; (Giotto), 68, 70, 72; 61; (Lorenzo Monaco), 86, 134-35, 181; 125; (Perugino), 639; (Piero della Francesca), 282-83; 290; (Tintoretto), 624; 664 Navicella (Giotto), 123 Neoplatonism, 304, 330, 461, 508, 543, 544 Nerezi, Yugoslavia: St. Pantaleimon, fresco, 31, 72; 22 Neri di Fioravante, 135 Niccolò da Tolentino, 248, 267; equestrian portrait of (Castagno), 267-68; 276 Niccolò da Tolentino (Castagno), 267-68; 276 Niccolò da Uzzano, 167 Nicholas IV (pope), 47 Nicholas V (pope), 213, 214, 221, 222, 227, 228, 279, 284, 477, 486 NICOLA PISANO (NICOLA D'APULIA), 51-55, 56, 57, 58, 60, 63, 88, 91, 113, 119, 122, 132, 139, 358; Adoration of the Magi, 53; 38; Annunciation, Nativity, and Annunciation to the Shepherds, 52-53, 93-94; 37; Daniel, 53, 55; 39; Last Judgment, 55; 41; Madonna and Child, 55; 42; Massacre of the Innocents, 57; 45; pulpit, Baptistery, Pisa, 51-53, 55, 56, 57, 93-94, 202; 37-39; colorplate 6; pulpit, Cathedral, Siena, 55, 57, 91; 40-42, 45 Night (Michelangelo), 543, 544, 545-46, 603; 572

Novellara, Pietro da, 455 Oddantonio da Montefeltro (duke of Urbino), 279, 280 Oderisi da Gubbio, 62 Ognissanti, see Florence Ognissanti Madonna (Enthroned Madonna) (Giotto), 75-76, 85; 72 Old Man with a Child (Ghirlandaio), 347; colorplate 49 Old St. Peter's, see Vatican Olympian Theater, see Vicenza On Painting (Della pittura) (Alberti), 141, 174, 209-10, 221, 230, 231, 235 On Painting (De pictura) (Alberti), 221, 230, 234, 336 On Painting in Perspective (De prospectiva pingendi) (Piero della Francesca), 283 On the Dignity and Excellency of Man (Manetti), On the Five Regular Bodies (De quinque corporibus regolaribus) (Piero della Francesca), 283 On the Statue (De statua) (Alberti), 221 Oratory of Divine Love, 522, 554, 599 ORCAGNA, ANDREA (ANDREA DI CIONE), 123, 126, 131, 135, 641; Enthroned Christ with Madonna and Saints, Strozzi Chapel, Sta. Maria Novella, Florence, 123, 124, 125, 126, 133, 180, 346; colorplate 17; Tabernacle, Orsanmichele, Florence, 85, 123-24, 133; 113, 114 Orlando Furioso (Ariosto), 617 Orsanmichele, see Florence Orvieto: Cathedral, 119, 512; (Maitani), 119, 121; 110-112; (Sanmicheli), 631; Cathedral, S. Brixio Chapel, frescoes: (Angelico, Fra), 477; (Signorelli), 477-80, 481, 509, 640; 488-490; Servi, Church of the, painting (Coppo di Marcovaldo), 43-44; 30 Ospedale degli Innocenti, see Florence Ospedale Maggiore, see Milan Ovetari Chapel, see Padua, Eremitani Church Ovetari family, 385 Ovid, 463, 526 Pacioli, Fra Luca, 323, 342 Pact of Judas (Barna da Siena), 128; 119 Pact with the Wolf of Gubbio (Sassetta), 350; 366

Nolde, Emil, 342

Padua, 63, 136, 138, 378, 424; Arena Chapel: altar sculpture (Giovanni Pisano), 58, 76; 49; frescoes (Giotto), 63-75, 76, 77, 81, 88, 137, 173, 262, 642; 55-71; colorplates 8, 9; Eremitani Church, Ovetari Chapel, frescoes (Mantegna), 385–88, 394; 397–401; Sant'Antonio: Chapel of St. James (now Chapel of St. Felix), frescoes: (Altichiero), 138; 130; (Avanzo), 138, 245; 129; equestrian statue at (Donatello), 238-40; 249, 250; frescoes (Giotto), 63, 81; high altar (Donatello), 240-42, 385, 388; 251-254; S. Giorgio, Oratory, frescoes (Altichiero), 138; 130 Palaeologan dynasty, 51 Palazzo: Bevilacqua, see Verona; Borgherini (now Palazzo Rosselli del Turco), see

Florence; della Cancelleria, see Rome; Ca-

prini, see Rome; Chiericati, see Vicenza; dei

Conservatori, see Rome; Ducale, see Mantua; Urbino; Farnese, see Rome; Massimo alle Colonne, see Rome; Medici-Riccardi, see Florence; Pazzi-Quaratesi, see Florence; Pitti, see Florence; del Principe, see Genoa; Pubblico, see Siena; della Ragione, see Vicenza, Basilica; Rucellai, see Florence; Sacchetti, see Rome; Schifanoia, see Ferrara; Strozzi, see Florence; Tarugi, see Montepulciano; del Te, see Mantua; Vecchio, see Florence; Vendramin-Calergi, see Venice; Venezia, see Rome

Palladio, Andrea (Andrea di Pietro), 538, 628, 631, 633, 634–38, 665, 669; Basilica (Palazzo della Ragione), Vicenza, 634–35; 680; Olympian Theater, Vicenza (executed by Scamozzi), 638; 687, 688; Palazzo Chiericati, Vicenza, 635; 681; S. Giorgio Maggiore, Venice (façade finished by Scamozzi), 625, 637; 684–686; Villa Rotonda (Villa Capra), Vicenza (finished by Scamozzi), 635–37; 682, 683

Pallas and the Centaur (Botticelli), 330–31, 332, 333; 347

Palma Giovane, 605; *Pietà* (begun by Titian), 605–6; 654, 655

Palmieri, Matteo, 293; bust of (Rossellino, A.), 293; 304

PAOLO VENEZIANO, 137–38; Coronation of the Virgin, 137–38; 128

Paradise (Nardo di Cione), 125; 115

Paradiso (Dante), 334

Parentucelli, Tommaso, 221; see also Nicholas V (pope)

Parigi, Alfonso, 664; Uffizi, Florence (with Vasari and Buontalenti), 664–66; 722 Paris, 13

Parma, 608; Cathedral, dome frescoes (Correggio), 566, 568; 609, 610; colorplate 81; Sant'Antonio, painting (Correggio), 565; 605; S. Giovanni Evangelista, dome fresco (Correggio), 566; 607, 608

Parmigianino (Francesco Mazzola), 564, 568, 577–78, 580, 601, 607, 626; Cupid Carving His Bow, 578; 614; Madonna with the Long Neck, 578; colorplate 83; Self-Portrait in a Convex Mirror, 568, 577; 612; Vision of St. Jerome, 577; 613

Parnassus (Mantegna), 396, 597; 413 Pasti, Matteo de', 222, 223; medal of Malatesta Temple (Alberti), 223; 224

Pater, Walter, 323

Paul III (pope), 584, 639, 642, 645, 669; portrait of (Titian), 602–3; *648*; *see also* Farnese, Alessandro

Paul III Directing the Continuance of St. Peter's (Vasari), 645, 664; 721

Paul IV (pope), 522

Pauline Chapel, see Vatican

Pausanias, 330, 633

Pavia, 139, 142, 378; Certosa, 140, 425; (Solari, Giovanni and Guiniforte), 425; 437; altarpiece (Perugino), 369; 381; façade (Amadeo), 425, 427; 439; façade sculpture (Mantegazza), 425; 438

Pazzi Chapel, see Florence Pazzi family, 153, 285, 293, 325 Peace of Lodi, 205, 284–85 Pearl Fishers (Allori), 666; 723 PERINO DEL VAGA (PIERO BONACCORSI), 518, 561-62, 580, 584, 626; Adoration of the Child, 561-62; 601; Fall of the Giants, Palazzo del Principe, Genoa, 562, 639; 602 Perseus and Andromeda (Vasari), 666; colorplate 104

Perseus and Medusa: (Cellini), 658–59; 711; (Peruzzi), 525; 555

Persian Sibyl (Michelangelo), 500

Perspective Study of a Chalice (Uccello), 244; 258

Perspective Study, with Section and Plan, of St. Peter's (Peruzzi), 503

Perugia, 12, 348, 358, 424

Perugino, Pietro (Pietro Vannucci), 12, 304, 358–60, 369–70, 420, 431, 472, 473, 515, 553, 563; Crucifixion with Saints, 360, 369; 379; Francesco delle Opere, 369, 456, 476; 380; Giving of the Keys to St. Peter, 358–60, 472, 478; 378; colorplate 51; St. Michael, 369; 381; Sistine Chapel, Vatican, frescoes, 326, 327, 358–60, 370, 518, 639; 378; colorplate 51; Tobias with the Archangel Raphael, 369; 381; Virgin Adoring the Child, 369; 381

Peruzzi, Baldassare, 521, 563, 584–85, 668; Aquarius, 525; 556; Palazzo Massimo alle Colonne, Rome, 584–85; 623; Perseus and Medusa, 525; 555; Perspective Study, with Section and Plan, of St. Peter's, 503; Villa Farnesina, Rome, 523–24; 552, 553; frescoes: Sala delle Prospettive, 527; 560; Sala di Galatea, 524–25; 554–556; Villa Madama, Rome, decorations, 521; 549

Peruzzi Chapel, see Florence, Sta. Croce Pesaro, Jacopo, 598

Pesaro: S. Francesco, altarpiece (Bellini, Giovanni), 411–12, 413; 422, 423

Pesaro family, 598

Pescia: S. Francesco, painting (Bonaventura Berlinghieri), 32, 41; 24

Petrucci, Pandolfo, 348

Philip II (king of Spain), 603

Philostratus, 597

Piacenza: S. Sisto, painting (Raphael), 515; 543 Picasso, Pablo, 201, 274, 342

Piccolomini, Aeneas Silvius, 348, 370; see also Pius II (pope)

Piccolomini, Francesco, 370; see also Pius III (pope)

Pienza, 228; Cathedral (Rossellino, B.), 228, 348; 233; Piazza Pio II (Rossellino, B.), 228, 243, 348, 376; 232

PIERINO DA VINCI, 657–58; Cosimo I as Patron of Pisa, 657–58; 709

Piero della Francesca, 244, 248, 268–83, 284, 285, 300, 304, 317, 321, 323, 342, 371, 398, 400, 538; Annunciation, 237, 277-78, 279, 303; 285; Baptism of Christ, 270-71, 273, 283; 280; Battista Sforza, 281-82, 301, 313, 351, 375, 459; 289; colorplate 38; Battle of Constantine and Maxentius, 276; colorplate 36; Battle of Heraclius and Chosroes, 276-77, 451; 284; Crucifixion, 270; 279; Discovery of the Wood of the True Cross, 257, 274; 282; Domenico Veneziano and, 257, 269, 293; Federico da Montefeltro, 281-82, 301, 313, 351, 459; 288; colorplate 39; Flagellation of Christ, 279-80, 356; colorplate 37; foreshortening in the work of, 270, 274, 276; influenced by, 214, 221, 243, 269, 270, 273, 274, 275, 276, 279, 281, 301, 349; influence of, 371, 427, 428, 472, 477; Invention of the True Cross, 275-76; 283; Legend of the True Cross, S. Francesco, Arezzo, 73, 132, 273-79, 280, 349, 375, 496; 282-286; colorplate 36; Madonna and Child with Saints, 280-81, 388, 414; 287; Madonna of Mercy, 270, 273; 278; Meeting of Solomon and the Queen of Sheba, 257, 274, 275; 282; Misericordia altarpiece, Sansepolcro, 269-70, 273, 277, 349, 670; 277-279; Nativity, 282-83; 290; perspective and, 269, 275, 280, 281, 283, 323, 324, 385; Recognition of the True Cross, 276; 283; Resurrection, Town Hall, Sansepolcro, 273, 275, 420, 496; 281; Triumph of Battista Sforza, 281, 282; 289; Triumph of Federico da Montefeltro, 281, 282, 511; 288; View of an Ideal City (designed by Laurana, L.), 27, 224, 228, 229, 297, 376-77; 386; Vision of Constantine, 278-79; 286

Piero di Cosimo, 469, 477, 480–81, 551, 555, 559, 591; Hunting Scene, 481; 492; Mythological Scene, 481; colorplate 71; Simonetta Vespucci, 480–81; 491

Pierozzi, Antonio, 206; see also Antonine (saint)

Pietà: (Bellini, Giovanni; Milan), 411, 430; colorplate 61; (Bellini, Giovanni; Vatican), 411; (Botticelli), 337; 354; (Bronzino), 661; 717; (Crivelli), 421; 431; (Giovanni da Milano), 127; 118; (Michelangelo; Florence), 121, 647; 706, 707; (Michelangelo; Milan), 648, 657; 708; (Michelangelo; Vatican), 464–66, 468, 470, 578; 472, 473; (Titian and Palma Giovane), 605–6; 654, 655; (Tura), 428–29; 440

Pietro da Cortona, 228 Pieve di Sta. Maria, see Arezzo Pilgrimage of Human Life, The (Déguilleville), 73

Pintoricchio (Bernardino di Betto), 327, 370–71, 482; *Departure of Aeneas Silvius Piccolomini for Basel*, Piccolomini Library, Cathedral, Siena, 352, 370–71; colorplate 52 Piombo, Sebastiano del, *see* Sebastiano del

Ріомво

Pippo Spano (Castagno), 264, 265, 336; 271
Pisa, 12, 28, 29, 41, 51, 76, 136; Baptistery, 30; pulpit (Nicola Pisano), 51–53, 55, 56, 57, 93–94, 202; 37–39; colorplate 6; Campo Santo, 131; frescoes (Traini), 24, 129–31; 121–123; Cathedral, 30, 53; (Busketus), 51; Leaning Tower, 30; Sta. Maria del Carmine, altarpiece (Masaccio), 191, 201–3, 204; 202–204; colorplate 24

PISANELLO, ANTONIO, 257, 378–81, 427; St. George and the Princess, S. Anastasia, Verona, 378, 380; 388; Study of Hanged Men, 380; 390; Study of the Head of a Horse, 380; 389; Vision of St. Eustace, 380–81; colorplate 55

Pisano, Andrea, see Andrea Pisano
Pisano, Giovanni, see Giovanni Pisano
Pisano, Giunta, see Giunta Pisano
Pisano, Nicola, see Nicola Pisano
Pisano, Nicola, see Nicola Pisano
Pisa polyptych (Masaccio), 191, 201–3, 204; 202–204; colorplate 24

Pistoia, 28; Sant'Andrea, pulpit (Giovanni Pisano), 56–58, 180; 44, 46–48; S. Francesco, painting (Lorenzetti, P.), 104, 113; 104
Pitati, Bonifazio de', 631

Pitti, Luca, 228

Pitti Madonna (Michelangelo), 491-92, 657;

Pius II (pope), 214, 222, 228, 243, 280, 348, 370 Pius III (pope), 370, 482 Pius IV (pope), 670 Pizzolo, Niccolò, 385 Plan for Triangular Rare-Book Room of the Laurentian Library (Michelangelo), 548; 580 Plans and Perspective Views of Domed Churches (Leonardo da Vinci), 26, 436-37, 473, 483, 581; 449 Platina (Bartolommeo de' Sacchi), 372 Platonic Academy, 329 Poggio a Caiano: Villa Medici (Sangallo, G.), 296-97, 316, 557; 311, 312; fresco (Pontormo), 296, 557-58, 559; 595 Poliziano, Angelo, 330, 331, 333 POLLAIUOLO, ANTONIO DEL, 17, 265, 304, 313-19, 321, 323, 324, 333, 342, 380, 398, 449, 480, 657; Apollo and Daphne, 317; 327; Battle of the Ten Nudes, 315, 463; 325; Dance of the Nudes, Villa La Gallina, Florence, 315-16; 326; Hercules and Antaeus (bronze), 314-15. 356; 324; Hercules and Antaeus (painting), 313-14; 323; Hercules and the Hydra, 313-14; 322; influenced by, 313; influence of, 316, 317, 343, 356, 477; Labors of Hercules, Palazzo Medici-Riccardi, Florence, 313; mythology in the work of, 304, 313, 317, 329; Portrait of a Young Woman, 317; 328; St. Sebastian, 316-17, 409, 437, 455; colorplate 43; Tomb of Pope Sixtus IV, 317-19; 329-Pollaiuolo, Piero del, 313, 316, 319, 324 Polyphemus (Sebastiano del Piombo), 525 Ponte, Francesco dal, 631 Ponte, Leandro dal, 631 Ponte a Sta. Trinita, see Florence PONTORMO, JACOPO CARUCCI DA, 242, 538, 555-59, 561, 562, 580, 599, 626, 660; Entombment, Capponi Chapel, Sta. Felicita, Florence, 558, 661; 596; colorplate 78; Joseph in Egypt, 556-57, 558, 661; 594; Study for Deluge, 558; 597; Vertumnus and Pomona, Villa Medici, Poggio a Caiano, 296, 557-58, 559; 595; Visitation, SS. Annunziata, Florence, 555-56; 593 Pope Leo X with Cardinals Giulio de' Medici and Luigi de' Rossi (Raphael), 517-18; 546 Pope Paul III (Titian), 602-3, 620; 648 Porcari, Stefano, 284 PORDENONE (GIOVANNI ANTONIO DE SACCHIS), 578-80, 626; Nailing of Christ to the Cross, Cathedral, Cremona, 579-80; 615 Porta, Giacomo della, 647 Portinari, Tommaso, 340 Portinari altarpiece (Goes), 293, 340, 346; 357 Portrait of a Bearded Man (Ludovico Ariosto?) (Titian), 593-94; colorplate 87 Portrait of a Man (Antonello da Messina), 400; Portrait of a Turkish Boy (Bellini, Gentile), 398; 416 Portrait of a Woman in Mourning (Tintoretto), 626; 668

Portrait of a Young Woman: (Baldovinetti), 303;

Portrait of the Artist's Three Sisters with Their

321; (Pollaiuolo), 317; 328

Governess (Anguissola), 619; colorplate 95 Poussin, Nicolas, 475, 518, 526, 597, 660 Prato, 28, 539; Cathedral, frescoes (Lippi, Fra Filippo), 218; 219, 220; Sta. Maria delle Carceri (Sangallo, G.), 226, 297-98, 344, 357; Preaching of the Antichrist (Signorelli), 478; 488 Presentation in the Temple: (Gentile da Fabriano), 180; (Lorenzetti, A.), 93, 113, 116; colorplate 15 Presentation of the Virgin (Titian), 599-600, 608; 642, 643 Primavera (Botticelli), 218, 327, 332-33; colorplate 45 Principe, Il (The Prince) (Machiavelli), 545 Procession of the Magi (Gozzoli), 298-99; colorplate 41 Procession of the Relic of the True Cross (Bellini, Gentile), 397; 414 Prophet Isaiah (Michelangelo), 496, 505; 516, Prophets Isaiah and Ezekiel (Duccio), 93; 91 Psyche Received on Olympus (Raphael and assistants), 527-28, 537; 563 Pucci family, 316 Pugliese, Francesco del, 340, 481 Punishment of Korah, Dathan, and Abiram (Botticelli), 323, 327; 344, 345 Punishment of the Gamblers (Sarto), 551-52;

Quattro libri dell'architettura, I (Palladio), 634 QUERCIA, JACOPO DELLA, 158, 172, 173, 174-77. 189, 190-91, 238, 284, 348, 354, 355, 425, 464; Creation of Adam, 176, 189; 178; Expulsion (Bologna), 177, 497; 180; Expulsion (Siena), 174, 176, 177, 191; 176; Fonte Gaia, Piazza del Campo, Siena, 174-76, 177; 174-176; S. Petronio, Bologna, portal sculpture, 176-77, 464; 177-180; Temptation, 176-77; 179; Wisdom, 176; 175

Raimondi, Marcantonio, 513, 527

Raising of Lazarus (Giotto), 70-71, 134; 63;

Raising of the Son of Theophilus (Masaccio and

Lippi, Filippino), 192, 201, 520; 201

colorplate 8

Rangone, Tommaso, 621, 622 Rape of Europa (Titian), 603-4, 630; 651; colorplate 90 Rape of the Sabine Woman (Giovanni Bologna), 660; 715, 716 RAPHAEL (RAFFAELLO SANTI OF SANZIO), 16, 159, 323, 370, 371, 431, 471–76, 480, 482, 490, 508-23, 537, 538, 542, 560, 565, 577, 580; Acts of the Apostles tapestries, Sistine Chapel, Vatican, 518-20, 628; cartoons for, 518-21; 547, 548; colorplate 75; Angelo Doni, 369, 466, 475-76; 484; Baldassare Castiglione, 473, 516; 545; Cupid Pointing Out Psyche to the Three Graces (with Romano), 537, 628; 564; Disputa (Disputation over the Sacrament), 478, 508-9, 510; 534, 535; Donna Velata (Veiled Woman), 516; 544; Expulsion of Attila, 514-15; 542; Expulsion of Heliodorus, 513, 642; 540; colorplate 74; Fighting Men, 511, 513; 537; Galatea, 524, 525-26, 537,

553, 591, 597; 558; Healing of the Lame Man. 518, 520, 628; 547, 548; influenced by, 209, 356, 357, 358, 360, 369, 373, 376, 416, 454, 455, 472, 474, 476, 477, 506, 507, 511, 513, 515, 516, 519, 520; influence of, 472, 515, 521, 522, 526, 551, 553, 561, 562, 564, 579, 585, 631, 664, 670; Liberation of St. Peter from Prison, 507, 513-14, 515; 541; Maddalena Strozzi Doni, 369, 466, 475-76; 485; Madonna of the Meadows, 473-74; 482; Marriage of the Virgin, 472-73, 508; colorplate 70; Mass of Bolsena, 512-13; 539; Pope Leo X with Cardinals Giulio de' Medici and Luigi de' Rossi, 517-18; 546; Psyche Received on Olympus (with assistants), 527-28, 537; 563; St. George and the Dragon, 473, 515; 480; St. Paul Preaching at Athens, 518, 520-21; colorplate 75; School of Athens, 209, 509-11, 513, 526, 553, 563; 536; Sistine Chapel. Vatican, tapestries, 518-20, 628; cartoons for, 518-21; 547, 548; colorplate 75; Sistine Madonna, 477, 515, 516, 564, 594, 648; 543; Small Cowper Madonna, 280, 475; 483; Stanza d'Eliodoro, Vatican, frescoes, 459, 473, 512-15, 526, 528; 539-542; colorplate 74; Stanza della Segnatura, Vatican, frescoes, 459, 473, 508–12, 513, 525, 526; 534–536, 538; Studies of the Madonna and Child, 473; 481; Three Cardinal Virtues: Fortitude, Prudence, and Temperance, 504, 511-12, 526; 538; Transfiguration of Christ, 521-22, 526, 537; 550, 551; colorplate 76; Villa Farnesina, Rome, frescoes: Loggia di Psiche (with assistants), 527-28, 537, 568; 561-564; Sala di Galatea, 524, 525-26, 568; 558; Villa Madama, Rome, 518, 521; 549; Wedding of Cupid and Psyche (with assistants), 527-28, 537: 562 Ravenna, 26; Sant'Apollinare Nuovo, 223 Rebellious Slave (Michelangelo), 491, 506, 507, 508, 548; 533 Recognition of the True Cross (Piero della Francesca), 276; 283 Reformation, 517, 522 Regisole, 239 Regola delli cinque ordini di architettura (Vignola), 668 Regole generali di architettura (Serlio), 668 Reims, France: Cathedral, 52, 55, 56, 79 Rembrandt van Rijn, 212, 516, 554 Resurrection: (Castagno), 262, 264; 269; (Michelangelo), 544, 580; 574; (Piero della Francesca), 273, 275, 420, 496; 281 Resurrection of Lazarus (Giovanni da Milano), 127; 117 Resurrection of the Dead (Signorelli), 478, 502, 640; 489 Riario, Raffaello (cardinal), 228 Riccardi family, 155, 299 Riccobaldo, 81 Ridolfi, Carlo, 619, 620, 627 Rimini, 348; Arch of Augustus, 223; Malatesta

Temple/S. Francesco (Alberti), 222-23, 275, 423, 483; 222-224; (Pasti), 222; frescoes:

(Giotto), 81, 222; (Piero della Francesca),

222, 275; sculpture (Agostino di Duccio),

Rinuccini Chapel, see Florence, Sta. Croce

Risen Christ (Vecchietta), 354-55; 372

Robbia, Andrea della, 235

ROBBIA, LUCA DELLA, 171, 173, 235-36, 243. 269, 270, 304; Cantoria, Cathedral, Florence, 235-36, 245, 270, 282; 241, 242; Pazzi Chapel, Florence, sculpture, 148; colorplate 21; Singing Boys, 236; 242

ROBERTI, ERCOLE DE', 430; St. John the Baptist, Palazzo Schifanoia, Ferrara, 430; 443 Robert of Anjou (king of Naples), 97 Robusti, Marietta, 621 Rodin, Auguste, 290, 315

Roger (king of Sicily), 28 Romanesque art, 29, 30, 43

Romanino, 579

ROMANO, GIULIO, 518, 519, 520, 521, 522, 524, 527, 585-87, 602, 630, 631, 660; Cupid Pointing Out Psyche to the Three Graces (with Raphael), Villa Farnesina, Rome, 524, 537, 586; 564; Palazzo del Te, Mantua, 584, 585-86, 627-28; 624-626; frescoes: Sala dei Giganti, 562, 586-87, 602, 639; 627, 628; Sala di Psiche, 586; colorplate 84; Villa Madama, Rome, decorations, 521; 549; Wedding Feast of Cupid and Psyche, 586; colorplate 84

Rome, 12, 47, 227-28, 375, 424, 482, 608; Ara Pacis, 235; Arch of Constantine, 223, 327, 347; Arch of Septimius Severus, 223; Basilica Emilia, 582, 585; Basilica of Maxentius (Temple of Peace), 242; Baths of Trajan, 341; Campidoglio (Michelangelo), 647; 703, 704; Colosseum, 224, 226, 228, 633; effect of plague on, 218-19, 284; Forum of Augustus, 157; Forum of Trajan, 585; Gesù (Vignola), 668; Golden House of Nero, 341; Old St. Peter's, see Vatican; Palazzo Caprini/House of Raphael (Bramante), 490, 631, 633, 670; 509; Palazzo dei Conservatori (Michelangelo), 547; 704; Palazzo della Cancelleria, 224, 228, 490; 231; frescoes (Vasari), 664; 721; Palazzo Farnese (Sangallo, A., the Younger, and Michelangelo), 523, 583-84, 644, 647, 668; 620-622, 697; Palazzo Massimo alle Colonne (Peruzzi), 584-85; 623; Palazzo Nuovo (Michelangelo), 647; Palazzo Sacchetti, frescoes (Salviati), 663-64; colorplate 103; Palazzo Venezia (Circle of Alberti), 228, 584; 230; Pantheon, 144, 145, 223, 292, 373, 486; political and economic development of, 142, 539, 541-42, 560; Porta Maggiore, 634; SS. Apostoli, frescoes (Melozzo da Forlì), 371, 373; colorplate 53; Sta. Cecilia in Trastevere, frescoes (Cavallini), 49, 50-51; colorplate 5; S. Francesco, frescoes (Cavallini), 49; S. Giovanni in Laterano, 486; frescoes (Gentile da Fabriano), 178; Sta. Maria in Trastevere, apse mosaic (Cavallini), 48, 49-50; 35; Sta. Maria Maggiore, 184, 185; altarpiece (Masaccio and Masolino), 184-86, 202; 189-191; apse mosaic (Torriti), 47-48; 33; Sta. Maria sopra Minerva, 341; altarpiece (Angelico, Fra), 213; S. Paolo fuori le Mura, frescoes (Cavallini), 49, 50; St. Peter's, see Vatican; S. Pietro in Montorio, fresco (Sebastiano del Piombo), 537; 565; S. Pietro in Vincoli, 373, 507, 514; see also Tomb of Julius II (Michelangelo); S. Salvatore in Lauro, painting (Parmigianino), 577, 578; 613; Tempietto (S. Pietro in Montorio), 521; (Bramante), 377, 473, 484-86, 635; 498-500; Temple of Venus and Rome, 226; Theater of Marcellus, 228; Vatican, see

Vatican; Villa Farnesina (Peruzzi), 523-24; 552, 553; frescoes, 628; bedroom fresco (Sodoma), 524, 526-27; 559; Loggia di Psiche (Raphael, Romano, and assistants), 527-28, 537, 568, 586; 561-564; Sala delle Prospettive (Peruzzi), 527; 560; Sala di Galatea: (Peruzzi), 524-25; 554-556; (Raphael), 524, 525-26, 568; 558; (Sebastiano del Piombo), 524, 525; 557; Villa Madama: decorations (Giovanni da Udine), 521: 549: (Peruzzi), 521; 549; (Romano), 521; 549; interior (Raphael), 518, 521; 549 Rosselli, Cosimo, 326, 327

ROSSELLINO, ANTONIO, 243, 290-93; Bust of Matteo Palmieri, 293; 304; Tomb of the Cardinal of Portugal, S. Miniato al Monte, Florence, 290-93, 303, 314; 300-303

ROSSELLINO, BERNARDO, 228, 243, 292, 293, 348, 486; Cathedral, Pienza, 228, 348; 233; Palazzo Rucellai, Florence, remodeling, 224, 225, 228; 225; Piazza Pio II, Pienza, plan of, 228, 243, 348, 376; 232; Tomb of Lionardo Bruni, Sta. Croce, Florence, 201, 243, 262, 288, 289, 292; 256, 257

Rossellino, Giovanni, 290, 292

Rossellino family, 288, 290, 292, 293, 460 Rossi, Luigi de' (cardinal), 517; portrait of (Raphael), 517-18; 546

ROSSO FIORENTINO (GIOVANNI BATTISTA DI JA-COPO), 538, 559-61, 580, 626; Assumption of the Virgin, SS. Annunziata, Florence, 559; 598; Descent from the Cross, 288, 559-60; 599; colorplate 79; Moses and Jethro's Daughters, 561; 600

Rouault, Georges, 342

Rovere, Francesco Maria della (duke of Urbino) 548

Rovere, Girolamo Basso della (cardinal), 373 Rovere, Giuliano della, 372, 373, 482; see also Julius II (pope)

Rovere, Guidobaldo della (duke of Camerino), 601

Rovere, Marco Vigerio della, see Vigerio della Rovere, Marco

Rovere, della, family, 317, 373, 374, 467, 494 Roverella altarpiece (Tura), 428-29; 440; col-

RUBENS, PETER PAUL, 458, 515, 565, 578, 603, 660, 670; Battle of Anghiari, copy after Leonardo da Vinci, 458-59, 470, 473; 464 Rucellai, Giovanni, 157, 221, 223, 225

Rucellai Madonna (Duccio), 45, 91-92, 93; 89

Ruisdael, Jacob van, 350

Ruskin, John, 65, 155, 342, 620

Ruth, Obed, and Boaz (Michelangelo), 504; 529

Sacra Conversazione, 209, 565, 607 Sacra Conversazione (Lotto), 607; colorplate 91 Sacred and Profane Love (Titian), 594-95, 597, 603; 635; colorplate 89

Sacrifice of Isaac: (Brunelleschi), 158, 159; 150; (Ghiberti), 142, 158-61, 162, 204, 259, 556; 151, 152; (Titian), 601, 602; 646

Sagra (Masaccio), 186

Saints include S., Sant', Santi, SS., St., Sta., Sto. Sant'Agostino, see San Gimignano; Siena Sant'Anastasia, see Verona

Sant'Andrea, see Mantua; Pistoia

SS. Annunziata, see Florence

Sant'Antonio, see Padua; Parma Sant'Antonio dei Servi, see Cortona Sant'Apollinare Nuovo, see Ravenna Sant'Apollonia, see Florence Santi Apostoli, see Rome

- St. Augustine Given to the Grammar Master (Gozzoli), 299; 316
- S. Barnaba see Florence
- S. Bernardino, see Urbino
- S. Biagio, see Forlì
- S. Brixio Chapel, see Orvieto, Cathedral

Sta. Casa, see Loreto

St. Catherine altarpiece (Beccafumi), 563-64; 603; colorplate 80

Sta. Cecilia in Trastevere, see Rome

Sta. Croce, see Florence

S. Domenico, see Cortona; Siena

Sant'Egidio, see Florence

S. Felice, see Florence

Sta. Felicita, see Florence

- S. Francesco, see Arezzo; Pesaro; Pescia; Pistoia; Rimini, Malatesta Temple; Rome; Sansepolcro
- S. Francesco, Lower Church of, see Assisi
- S. Francesco, Upper Church of, see Assisi
- S. Francesco Grande, see Milan
- St. Francis (Bonaventura Berlinghieri), 32, 41, 75, 78, 81, 101; 24
- St. Francis and the Madman (Master of St. Cecilia), 89-90; 88
- St. Francis Giving His Cloak to the Beggar (Master of the St. Francis Cycle), 82; 78
- St. Francis in Ecstasy: (Bellini, Giovanni), 415-16; 426; (Sassetta), 349-50; colorplate 50
- St. Francis Praying before the Crucifix at San Damiano (Master of the St. Francis Cycle), 17, 80, 82; colorplate 11
- St. Francis Renouncing His Worldly Goods (Master of the St. Francis Cycle), 17, 80, 82; colorplate 11
- St. Francis Undergoing the Test by Fire before the Sultan (Giotto), 77; 73
- St. George (Donatello), 164, 166-67, 169, 186, 549, 550; 164, 165
- St. George and the Dragon: (Donatello), 167-69, 183, 186, 202, 231, 454, 461; 166; (Raphael), 473, 515; 480
- St. George and the Princess (Pisanello), 378, 380; 388
- San Gimignano: Collegiate Church, frescoes (Barna da Siena), 128-29; 119, 120; Sant' Agostino, frescoes (Gozzoli), 299; 316
- S. Giobbe, Hospital of, see Venice
- S. Giobbe altarpiece (Bellini, Giovanni), 414, 416, 420; 425
- S. Giorgio, Oratory, see Padua
- S. Giorgio alla Costa, see Florence
- S. Giorgio Fuori, see Ferrara
- S. Giorgio Maggiore, see Venice
- S. Giovanni, see Sansepolcro
- Santi Giovanni e Paolo, see Venice
- S. Giovanni Evangelista, see Parma
- S. Giovanni in Conca, see Milan
- S. Giovenale, see Cascia di Reggello St. James before Herod Agrippa (Mantegna), 385; 398, 399
- St. James Led to Execution (Mantegna), 386-87, 409; 400, 401
- St. Jerome: (Eyck and Christus), 340; (Vittoria), 638; 689

- St. Jerome and St. John the Baptist (Masaccio), 184-85, 186, 202; 189
- St. Jerome in His Study (Antonello da Messina), 399; colorplate 59
- St. John Entering the Wilderness (Giovanni di Paolo), 351-52; 368
- St. John the Baptist: (Cossa), 429, 430; 441; (Ghiberti), 163-64, 165, 183; 158, 159; (Leonardo da Vinci), 455; (Roberti), 430;
- St. John the Baptist Bids Farewell to His Family (Lippi, Fra Filippo), 218; 219
- St. John the Baptist in the Desert: (Domenico Veneziano), 259; colorplate 33; (Gentile da Fabriano), 179; 182
- St. John the Evangelist and St. Martin of Tours (Masolino), 184, 185; 191
- St. Julian (Castagno), 266, 267, 316, 520; 274
- St. Lawrence Distributing the Treasures of the Church (Angelico, Fra), 214, 279, 298; 214
- S. Lorenzo, see Florence
- St. Louis of Toulouse Crowning Robert of Anjou, King of Naples (Martini), 97-98, 101; 95
- Sta. Lucia dei Magnoli, see Florence
- St. Lucy altarpiece (Domenico Veneziano), 257, 259, 270, 300, 388; 266; colorplates 32, 33
- S. Marco, see Florence; Venice
- Sta. Maria degli Angeli, see Florence
- Sta. Maria del Calcinaio, see Cortona
- Sta. Maria del Carmine, see Florence; Pisa
- Sta. Maria della Consolazione, see Genoa; Todi
- Sta. Maria della Salute, see Venice
- Sta. Maria della Scala, Hospital of, see Siena
- Sta. Maria delle Carceri, see Prato
- Sta. Maria delle Grazie, see Milan
- Sta. Maria Gloriosa dei Frari, see Venice
- Sta. Maria in Trastevere, see Rome
- Sta. Maria Maddalena dei Pazzi, see Florence
- Sta. Maria Maggiore, see Rome
- Sta. Maria Novella, see Florence
- Sta. Maria presso S. Satiro, see Milan
- Sta. Maria sopra Minerva, see Rome
- St. Mark (Donatello), 165-66, 167, 212, 260, 287, 385; 162, 163
- St. Mark Freeing a Christian Slave (Tintoretto), 621; colorplate 96
- St. Matthew (Ghiberti), 164; 160
- St. Michael (Perugino), 369; 381
- S. Michele Visdomini, see Florence
- S. Miniato al Monte, see Florence
- St. Pantaleimon, see Nerezi
- S. Pantaleone, see Venice
- S. Paolino, see Florence
- S. Paolo fuori le Mura, see Rome
- Sts. Paul and Julian (Maso di Banco), 25, 83-
- St. Paul Preaching at Athens (Raphael), 518, 520-21; colorplate 75
- St. Peter Baptizing the Neophytes (Masaccio), 189, 520; 193, 194
- St. Peter Healing with His Shadow (Masaccio), 186, 191–92; 198, 199
- St. Peter's, see Vatican
- Sta. Petronilla, see Siena
- S. Petronino, see Bologna
- S. Pietro in Montorio, see Rome, Tempietto
- S. Pietro in Vincoli, see Rome
- S. Procolo, see Florence
- S. Prospero, see Reggio Emilia

- S. Salvatore in Lauro, see Rome
- S. Salvi, see Florence
- St. Sebastian: (Antonello da Messina), 400, 409, 414; colorplate 60; (Pollaiuolo), 316-17, 409, 437, 455; colorplate 43
- S. Sebastiano, see Mantua; Venice
- S. Sisto, see Piacenza
- Sto. Spirito, see Florence
- St. Sylvester Resuscitating Two Deceased Romans (Maso di Banco), 83; 79
- Sta. Trinita, see Florence
- S. Zaccaria, see Venice
- S. Zaccaria altarpiece (Bellini, Giovanni), 281, 416; colorplate 63
- S. Zeno, see Verona
- S. Zeno altarpiece (Mantegna), 388-89, 390, 394, 411, 424; 403, 404; colorplate 57
- Salome before Herodias (Andrea Pisano), 88,
- SALVIATI, FRANCESCO, 470, 631, 663-64; Palazzo Sacchetti, Rome, frescoes, 663-64; colorplate 103; Triumph of Camillus, Palazzo Vecchio, Florence, 663; 720
- SANGALLO, ANTONIO DA, THE ELDER, 296, 469. 470, 580-83; Madonna di S. Biagio, Montepulciano, 226, 540, 581-82; 616-618; Palazzo Tarugi, Montepulciano, 582; 619
- SANGALLO, ANTONIO DA, THE YOUNGER, 296, 357, 583–84, 631, 639, 644, 664, 668; Palazzo Farnese, Rome (and Michelangelo), 523, 583-84, 644, 668; 620-622, 697; St. Peter's, Vatican, 645-46; 698
- SANGALLO, ARISTOTILE DA, 471; Battle of Cascina, copy after Michelangelo, 457, 463, 470-71;
- Sangallo, Giuliano da, 294, 296–98, 346, 373, 376, 469, 470, 495, 553, 580, 583; S. Lorenzo, Florence, design for façade, 26, 539-40, 582; 566; Sta. Maria delle Carceri, Prato, 226, 297-98, 344, 357; 313-315; Theater of Marcellus, 26, 228, 296; 310; Villa Medici, Poggio a Caiano, 296-97, 316, 557; 311, 312
- SANMICHELI, MICHELE, 631-32; Palazzo, Bevilacqua, Verona, 631; 677
- Sansepolcro: Compagnia della Misericordia, altarpiece (Piero della Francesca), 269-70, 349; 277-279; S. Francesco, altarpiece (Sassetta), 349-50; 365, 366; colorplate 50; S. Giovanni, altarpiece (Piero della Francesca), 270-71, 273; 280; Town Hall, fresco (Piero della Francesca), 273; 281
- Sansovino, Andrea, 632
- SANSOVINO, JACOPO (JACOPO TATTI), 553, 608, 630, 632-34, 659; Library of S. Marco, Venice, 608, 630, 633, 634, 635, 637; colorplate 100; Venus Anadyomene, 632; 678; Zecca, La (Mint), Venice, 608, 633-34, 659, 660; 679
- Santi, Giovanni, 358, 371, 472
- Santi di Tito, 666
- SARTO, ANDREA DEL, 339, 356, 454, 551-54, 555, 556, 557, 580, 599; Annunciation, 552-53; 589; Assumption of the Virgin, 554; colorplate 77; Birth of the Virgin, 553, 559; 590; Lamentation, 553-54, 558, 661; 592; Madonna of the Harpies, 553; 591; Punishment of the Gamblers, 551-52; 588; SS. Annunziata, Florence, frescoes, 551-52, 553, 555, 559; 588, 590
- SASSETTA (STEFANO DI GIOVANNI), 349-50, 353. 562; Marriage of St. Francis to Lady Poverty,

- 350; 365; Pact with the Wolf of Gubbio, 350; 366; S. Francesco, Sansepolcro, altarpiece, 349-50; 365, 366; colorplate 50; St. Francis in Ecstasy, 349-50; colorplate 50
- Sassetti, Francesco, 343
- Sassetti Chapel, see Florence, Sta. Trinita SAVOLDO, GIROLAMO, 617-18; Tobias and the Angel, 617-18; colorplate 94
- Savonarola, Girolamo, 285, 335-36, 337, 338, 464, 662
- Scala family, 239
- SCAMOZZI, VINCENZO, 633, 635; Olympian Theater, Vicenza (designed by Palladio), 638; 687, 688; S. Giorgio Maggiore, Venice, façade (begun by Palladio), 637; 686; Villa Rotonda (Villa Capra), Vicenza (begun by Palladio), 635-37; 682, 683
- Scenes from Genesis (Maitani), 119, 121; 110,
- Schongauer, Martin, 315
- School of Athens (Raphael), 209, 509-11, 513, 526, 553, 563; 536; study for, 537
- SCHOOL OF FLORENCE: Cross, 41, 43, 71; 25, 26
- School of Pan (Signorelli), 477; 487 SCHOOL OF PISA: Cross No. 15, 29-30; 20; Cross
- No. 20, 18, 30-31, 43, 72; 21; colorplate 2 Scrovegni, Enrico, 63; portrait of (Giotto), 74-
- Scrovegni, Reginaldo, 63
- Scuola della Carità, see Venice
- Scuola di S. Fantin, see Venice
- Scuola di S. Giovanni Evangelista, see Venice
- Scuola di Sant'Orsola, see Venice
- Scuola di S. Rocco, see Venice
- Scuola Grande di S. Marco, see Venice
- SEBASTIANO DEL PIOMBO, 516, 525, 584; Fall of Icarus, Villa Farnesina, Rome, 524, 525; 557; Flagellation, 537; 565
- Segni, Fabio, 336
- Self-Portrait (Ghiberti), 235; 240
- Self-Portrait in a Convex Mirror (Parmigianino), 568, 577; 612
- Separation of Light from Darkness (Michelangelo), 501–2, 503, 566; 525
- Serbia, 29, 30, 51
- SERLIO, SEBASTIANO, 486, 668; architectural drawings of, 499, 500, 504
- Servi, Church of the, see Orvieto Seurat, Georges, 416
- Sforza, Battista (duchess of Urbino), 280, 281; portrait bust of (Laurana, F.), 375; 385; portraits of (Piero della Francesca), 281-82, 301, 313, 351, 375, 459; 289; colorplate 38
- Sforza, Costanzo, 411 Sforza, Francesco (Francesco I), 424, 425, 451
- Sforza, Galeazzo Maria, 399, 424, 425 Sforza, Ludovico, 424, 425, 432, 449, 451, 483,
- Sforza family, 139, 378, 424, 425, 484, 608 Sforzinda, plan of (Filarete), 27, 229, 425; 436 Sibyl (Giovanni Pisano), 57-58; 47
- Siena, 12, 15, 43, 91, 92, 122, 348, 424; aerial view of, 4; Carmine, Church of the, 564; Cathedral, 26, 131; altarpieces: (Duccio), 92-96; 90-93; colorplates 12, 13; (Lorenzetti, A.), 93, 113, 116; colorplate 15; (Lorenzetti, P.), 93, 113–15, 116; 105; (Martini), 93, 98– 99, 101, 116; colorplate 14; baptismal font: (Donatello), 173, 174, 348; 173; (Ghiberti), 173, 348; (Quercia), 173; façade (Giovanni

Pisano), 55-56; 43; colorplate 7; Piccolomini Library, fresco (Pintoricchio), 352, 370-71; colorplate 52; pulpit (Nicola Pisano), 55, 57, 91; 40-42, 45; Fontana Maggiore (Nicola Pisano), 358; Fonte Gaia, Piazza del Campo (Quercia), 174-76, 177; 174-176; Monte Oliveto Maggiore, altarpiece (Francesco di Giorgio), 355-56; 373; Palazzo Pubblico, 174; frescoes: Council Chamber (Martini), 96-97; 94; Sala della Pace (Lorenzetti, A.), 24, 116-17, 119; 107-109; colorplate 16; political and economic development of, 15, 28, 45, 122, 131, 142; Sant'Agostino: altarpiece (Martini), 101; 98, 99; painting (Matteo di Giovanni), 353-54; 371; S. Domenico, painting (Guido da Siena), 45; Sta. Maria della Scala, Hospital of, 92; frescoes: (Domenico di Bartolo), 352-53, 371; 370; (Vecchietta), 354; tomb sculpture (Vecchietta), 354-55; 372; Sta. Petronilla, altarpiece (Lorenzetti, A.), 115-16; 106

Sigismund (Holy Roman emperor), 348
SIGNORELLI, LUCA, 304, 327, 420, 477–80, 518;
Damned Consigned to Hell, 478, 480, 502;
490; Preaching of the Antichrist, 478; 488;
Resurrection of the Dead, 478, 502, 640; 489;
S. Brixio Chapel, Cathedral, Orvieto, frescoes, 477–80, 481, 509, 640; 488–490;
School of Pan, 477; 487

Simeon Metaphrastes, 31

SIMONE MARTINI, *see* MARTINI, SIMONE *Simonetta Vespucci* (Piero di Cosimo), 480–81; 491

Singing Boys (Robbia), 236; 242 Sir John Hawkwood (Uccello), 238, 244–45, 267, 268; 259

Sistine Chapel, see Vatican

Sistine Madonna (Raphael), 477, 515, 516, 564, 594, 648; 543

Six Saints (Lorenzo Monaco), 19, 134; 9
Sixtus IV (pope), 228, 285, 326, 358, 359, 371, 373, 375, 395, 449, 477, 482, 492, 494, 508; portrait of (Melozzo da Forlì), 371, 515; 382; tomb of (Pollaiuolo), 317–19; 329–331

Sixtus IV Appointing Platina (Melozzo da Forlì), 228, 371–73, 393, 515; 382

Sleeping Venus (Giorgione and Titian), 592, 601; 632

Small Cowper Madonna (Raphael), 280, 475; 483

Soderini, Piero, 457, 470, 491, 501, 539 SODOMA (GIOVANNI ANTONIO BAZZI), 508, 511, 526; Marriage of Alexander and Roxana, Villa Farnesina, Rome, 524, 526–27; 559

SOLARI, GIOVANNI, 425; Certosa, Pavia (with Solari, Guiniforte), 425; 437

Solari, Guiniforte, 425, 483; Certosa, Pavia (with Solari, Giovanni), 425; 437

Solari family, 425

Solomon and the Queen of Sheba (Ghiberti), 510 Sophocles, 65 Sopočani, Yugoslavia: Church of the Trinity,

frescoes, 51; 36

Spanish Chapel, see Florence, Sta. Maria Novella

Spano, Pippo (Filippo Scolari), 182, 264, 265; painting of (Castagno), 264, 265, 336; 271 Speculum humanae salvationis, 237 Spiritual Exercises (St. Ignatius Loyola), 618

Squarcione, Francesco, 384–85 Stanza d'Eliodoro, see Vatican Stanza della Segnatura, see Vatican Stanza dell'Incendio, see Vatican Star-of-Bethlehem and Other Plants (Leonardo da Vinci), 433; 445

Stigmatization of St. Catherine (Beccafumi), 563–64; colorplate 80

Stigmatization of St. Francis (Giotto), 78–79; 75

Storm Breaking over a Valley (Leonardo da Vinci), 432, 434; frontispiece, 444
Story of Abraham (Ghiberti), 233–34; 238
Strada, Jacopo, 604; portrait of (Titian), 604–

Strozzi, Filippo, 294, 341

Strozzi, Giovanni, 466

5:652

Strozzi, Maddalena, see Doni, Maddalena Strozzi

Strozzi, Palla, 180, 206, 294

Strozzi, Tommaso di Rossello, 123

Strozzi altarpiece, Sta. Maria Novella, Florence (Orcagna), 123, 124, 125, 126, 133, 180; colorplate 17

Strozzi altarpiece, Sta. Trinita, Florence (Gentile da Fabriano), 178, 179, 180–82, 183, 187, 201–2, 274, 299; 184–186; colorplate 22

Strozzi Chapel, see Florence, Sta. Maria Novella

Strozzi family, 206, 467

Studies of a Left Leg, Showing Bones and Tendons (Leonardo da Vinci), 435; 448

Studies of the Madonna and Child (Raphael), 473; 481

Studies of Water (Leonardo da Vinci), 437; 452 Studies of Water Movements (Leonardo da Vinci), 437; 451

Studiolo, see Florence, Palazzo Vecchio; Urbino, Palazzo Ducale

Study for a Bowman in the Capture of Zara (Tintoretto), 620; 659

Study for Deluge (Pontormo), 558; 597 Study for Libyan Sibyl (Michelangelo), 502; 527 Study for Sistine Ceiling (Michelangelo), 494; 513

Study of Composition of Last Supper (Leonardo da Vinci), 452; 460

Study of Drapery (Leonardo da Vinci), 438; 454 Study of Hanged Men (Pisanello), 380; 390 Study of Nude after a Statuette (Tintoretto), 626: 669

Study of the Head of a Horse (Pisanello), 380;

Study of the Head of the Angel, for Madonna of the Rocks (Leonardo da Vinci), 450; 458 Sultan Mahomet II (Bellini, Gentile), 397–98;

Summa (St. Antonine), 208, 231, 233, 238, 287, 452; see also AntonineSylvestrine Order, 208

T

Tabernacle, Orsanmichele, Florence (Orcagna), 85, 123–24, 133; 113, 114
Taddei, Francesco, 468
Taddei Madonna (Michelangelo), 468, 491, 507, 657; 476

Talenti, Francesco, 124, 135; Campanile, Florence, 135; 77; Cathedral, Florence, 135; 126

Talenti, Jacopo, 135

Talenti, Simone, 135

Tarquinia *Madonna* (Lippi, Fra Filippo), 215, 216, 218; 215

Tempest (Giorgione), 591; colorplate 85

Tempietto, see Rome

Temptation: (Masolino), 190, 496; 196; (Quercia), 176–77; 179

Temptation of Christ: (Duccio), 94, 350; 92; (Tintoretto), 624; 665

Ten Books on Architecture (De re aedificatoria libri X) (Alberti), 221, 229, 234

Theater of Marcellus (Sangallo, G.), 26, 228, 296; 310

Theatine Order, 522, 558, 599

Theresa (saint), 565

Thomas à Kempis, 392

Three Cardinal Virtues: Fortitude, Prudence, and Temperance (Raphael), 504, 511–12, 526; 538

TINTORETTO (JACOPO ROBUSTI), 384, 503, 579. 580, 588, 608, 627, 631, 638, 670; Crucifixion, 622-23; 662; colorplate 97; Discovery of the Body of St. Mark, 622; 661; Last Supper, S. Giorgio Maggiore, Venice, 104, 625, 628, 631; 667; Last Supper, Scuola di S. Rocco, Venice, 624; 666; Moses Striking Water from the Rock, 623; 663; Nativity, 624; 664; Portrait of a Woman in Mourning, 626; 668; St. Mark Freeing a Christian Slave, 621; colorplate 96; Scuola di S. Rocco, Venice, paintings: Sala dell'Albergo, 622-23; 662; colorplate 97; Sala Grande, 622, 623-25; 663-666; Scuola Grande di S. Marco, Venice, paintings, 621-22; 660, 661; colorplate 96; Study for a Bowman in the Capture of Zara, 620; 659; Study of Nude after a Statuette, 626; 669; Temptation of Christ, 624; 665; Transport of the Body of St. Mark, 621-22; 660

TITIAN (TIZIANO VECELLIO), 16, 176, 323, 409, 414, 416, 568, 588, 591, 592-606, 621, 625, 627, 628, 631, 638; Assumption of the Virgin, 592, 594, 599, 603; 634; colorplate 88; Bacchanal of the Andrians, 597-98; 637; Bacchus and Ariadne, 598; 638; Cain Killing Abel, 601, 602; 645; Crowning with Thorns, 605; 653; Danaë, 603; 649; David and Goliath, 601, 602; 646; Entombment, 599; 640; Festival of Venus, 597; 636; Gypsy Madonna, 593; 633; influenced by, 564, 579; influence of, 516, 525, 537, 592, 600, 603, 607-8, 617, 619-20; Jacopo Strada, 604-5; 652; Madonna of the House of Pesaro, 598-99, 630; 639; Man with the Glove, 599; 641; Pietà (finished by Palma Giovane), 605-6; 654, 655; Pope Paul III, 602-3, 620; 648; Portrait of a Bearded Man (Ludovico Ariosto?), 593-94; colorplate 87; Presentation of the Virgin, 599-600, 608; 642, 643; Rape of Europa, 603-4, 630; 651; colorplate 90; Sacred and Profane Love, 594-95, 597, 603; 635; colorplate 89; Sacrifice of Isaac, 601, 602; 646; Sta. Maria della Salute, Venice, Sacristy, ceiling paintings, 601, 602, 605; 645-647; Sleeping Venus (begun by Giorgione), 592, 601; 632; Venus and the Lute Player, 603, 604; 650; Venus of Urbino, 601, 603; 644

Tobias and the Angel (Savoldo), 617–18; colorplate 94

Tobias with the Archangel Raphael (Perugino),

Todi: Sta. Maria della Consolazione (Cola da Caprarola and others), 226, 488; 506

Tomb of Carlo Marsuppini (Desiderio da Settignano), 201, 288-89, 290, 292; 296, 297 Tomb of Giuliano de' Medici (Michelangelo), 540. 541, 542, 543-46; 569, 572, 573, 575

Tomb of Julius II (Michelangelo), 459, 477, 480, 490-91, 492, 505-6, 507-8, 512, 515, 548-51, 642, 657; 693; reconstruction drawings of, 510, 530, 581; sculpture from, 531, 582-587

Tomb of Lionardo Bruni (Rossellino, B.), 201, 243, 262, 288, 289, 292; 256, 257

Tomb of Lorenzo de' Medici (Michelangelo), 540, 541, 542, 543-46, 557; 570, 576, 577 Tomb of Lorenzo the Magnificent (Michelan-

gelo), 540, 541, 543 Tomb of Pope Sixtus IV (Pollaiuolo), 317–19; 329-331

Tomb of the Cardinal of Portugal (Rossellino, A.), 290-93, 303, 314; 300-303

Tommaso of Sarzana, 284; see also Nicholas V

Tornabuoni, Giovanni, 346, 347 Tornabuoni, Lucrezia, 219

Tornabuoni, Ludovica, 347

Torrigiani, Pietro, 461

TORRITI, JACOPO, 47, 48, 50, 83; Coronation of the Virgin, 47-48; 33

Toscanelli, Paolo del Pozzo, 281-82

Traini, Francesco, 129-31; Campo Santo, Pisa, frescoes, 24, 129-31; 121-123; Last Judgment, 24, 129, 131; 123; Triumph of Death, 24, 129-31, 138; 121, 122

Transfiguration (Angelico, Fra), 212, 521;

Transfiguration of Christ: (Bellini, Giovanni), 414-15, 521; colorplate 62; (Raphael), 521-22, 526, 537; 550, 551; colorplate 76

Transport of the Body of St. Mark (Tintoretto), 621-22; 660

Traversari, Ambrogio, 153

Treatise on Painting (Leonardo da Vinci), 434 Tree of Life (Gaddi, T.), 86-87, 494; 83 Treviso, 378

Tribute Money (Masaccio), 186, 187, 189, 190, 191, 201, 343, 520; 192; colorplate 23

Trinity (Masaccio), 186, 203-4, 260, 386; colorplate 25

Trissino, Giangiorgio, 634

Triumph of Battista Sforza (Piero della Francesca), 281, 282; 289

Triumph of Camillus (Salviati), 663; 720 Triumph of Death (Traini), 24, 129-31, 138; 121, 122

Triumph of Federico da Montefeltro (Piero della Francesca), 281, 282, 511; 288

Triumph of Heraclius over Chosroes (Gaddi, A.), 132, 133; 124

Triumph of Mordecai (Veronese), 627–28; 670 Triumph of the Church (Andrea da Firenze), 24, 84, 124, 126, 135; colorplate 18

Triumph of Venus (Veronese and pupils), 630-31; 675

Trivulzio, Giangiacomo, 459

TURA, COSIMO, 428-29, 430; Enthroned Madonna and Child with Angels, 428; colorplate 65; Pietà, 428-29; 440; Roverella altarpiece, S.

Giorgio Fuori, Ferrara, 428-29; 440; colorplate 65

Turner, Joseph Mallord William, 603 Twilight (Michelangelo), 543, 544, 545 Two Sheets of Battle Studies (Leonardo da Vinci), 459; 465

U

Uberti family, 61

UCCELLO, PAOLO (PAOLO DI DONO), 138, 221, 244-48, 257, 260, 278, 304, 342, 351, 378, 380, 390, 472; Battle of San Romano (Florence), 138, 157, 246-48, 276, 351, 352, 449; colorplate 31; Battle of San Romano (London), 246-48, 267, 276, 332, 351, 392; 263; Chiostro Verde, Sta. Maria Novella, Florence, frescoes, 189, 245-46; 260-262; Deluge, 189, 245-46, 247, 248, 591; 260-262; Miracle of the Host, 248, 257; 264; perspective and, 244, 245, 246, 248, 257, 319, 373; Perspective Study of a Chalice, 244; 258; Sir John Hawkwood, Cathedral, Florence, 238, 244-45, 267, 268; 259

Uffizi, see Florence

Urban IV (pope), 119

Urban V (pope), 126

Urbino, 279, 348, 375; Corpus Domini, Church of, altarpiece (Uccello), 248, 257; 264; Palazzo Ducale, 280, 281; (Laurana, L.), 279, 375-76, 377, 472; colorplate 54; Studiolo of Federico da Montefeltro, 279, 377; 387; S. Bernardino, altarpiece (Piero della Francesca), 280-81; 287

Uroš I (king of Serbia), 51

 \mathbf{v}

Valori, Baccio, 542

Varchi, Benedetto, 460, 461, 543

Vasari, Giorgio, 24, 132, 347, 470, 663, 664-66, 668; as artist/architect, 342, 457, 460, 545, 584, 601, 657, 659, 664-66; art historical writings of, 19, 28, 45, 53, 657, 664; on Alberti, 223, 224; on Angelico, Fra, 206; on Botticelli, 327, 332, 333, 338; on Brancacci Chapel frescoes, 186; on Brunelleschi, 142, 143, 155, 173; on Castagno, 259-60, 266; on Domenico Veneziano, 259-60; on Donatello, 236, 238; on Duccio, 92-93; on Filarete, 425; on fresco technique, 24; on Giorgione, 589; on Giotto, 62, 63, 66, 81; on Gozzoli, 371; on Italian festivals, 216; on Leonardo da Vinci, 436, 438, 451, 456; on Lippi, Fra Filippo, 214; on Lorenzetti, P., 82; on Masaccio, 182-83, 204; on Michelangelo, 466, 468, 470, 491, 501, 508, 545; on Parmigianino, 568, 577, 578; on Perugino, 358; on Piero della Francesca, 268, 270, 273, 283; on Pollaiuolo, 316; on Pontormo, 555, 557, 558; on Quercia, 174; on Raphael, 472, 516; on Rosso Fiorentino, 559; on Sangallo, A., the Younger, 584; on Sarto, 553; on sculptural technique, 165-66; on Signorelli, 477; on sketching process, 19; on Titian, 592; on Uccello, 244; Paul III Directing the Continuance of St. Peter's, Palazzo della Cancelleria, Rome, 645, 664; 721; Perseus and Andromeda, Studiolo, Palazzo Vecchio, Florence, 666; colorplate 104; Uffizi, Florence (finished by Buontalenti and Parigi), 584, 664-66; 722

Vatican

Belvedere (Bramante), 488-90, 670; 507,

Chapel of Innocent VIII, frescoes (Mantegna), 395

Chapel of Nicholas V, frescoes: (Angelico, Fra), 213-14, 279, 298; 214; (Gozzoli),

Library, frescoes: (Ghirlandaio, D. and D.), 371; (Melozzo da Forlì), 228, 371-73, 393; 382

Old St. Peter's (Basilica of St. Peter's), 482, 486, 490; bronze and silver doors (Filarete), 425; frescoes (Cavallini, 49, 50; mosaic (Giotto), 79

Pauline Chapel, frescoes (Michelangelo), 642-44; 694-696

St. Peter's, 79, 153; (Bramante), 26, 227, 483, 486–88, 489, 490, 491, 510, 520, 540, 583, 645, 646, 668; 501-505; (Michelangelo), 227, 486, 488, 644-47; 699-702 (sculpture, 464-66; 472, 473); (Raphael), 518, 521; (Rossellino, B.), 228, 486; (Sangallo, A., the Younger), 645-46; 698; (Vignola), 668; frescoes (Angelico, Fra), 213

Sistine Chapel, frescoes: (Botticelli), 323, 326-27, 343, 501, 504, 518; 342-345; (Ghirlandaio), 326, 327, 343, 518; 360; (Michelangelo): ceiling, 57, 270, 293, 316, 326, 459, 461, 463, 464, 466, 467, 471, 491, 492–505, 509, 518, 543, 545, 640; 512-520, 528, 529; colorplates 72, 73; wall, 24, 327, 461, 463, 478, 492, 639-42, 648; 690-692; colorplate 101; (Perugino), 326, 327, 358-60, 370, 518, 639; 378; colorplate 51; (Signorelli), 327, 477, 518

Sistine Chapel, tapestries (Raphael), 518– 20, 628 (cartoons for, 518-21, 628; 547, 548; colorplate 75)

Stanza d'Eliodoro, frescoes (Raphael), 512-15, 526, 528; 539-542; colorplate

Stanza della Segnatura, frescoes: (Raphael), 508–12, 513, 525, 526; 534–536, 538; (Sodoma), 508

Stanza dell'Incendio, frescoes (Raphael),

VECCHIETTA (LORENZO DI PIETRO), 354-55; Risen Christ, Sta. Maria della Scala, Siena, 354-55;

Vecellio, Francesco, 592 Vecellio, Orazio, 605

Velázquez, Diego, 259, 416

Vendramin, Gabriel, 591

VENEZIANO, DOMENICO, see DOMENICO VENEZIANO

VENEZIANO, PAOLO, see PAOLO VENEZIANO Venice, 12, 15, 29, 47, 284, 424, 588, 608, 631

aerial view of, 5

Doges' Palace, 414, 625; altarpiece (Jacobello del Fiore), 381; 391; frescoes: (Gentile da Fabriano), 178, 378; (Pisanello), 378; Hall of the Great Council, ceiling painting (Veronese and pupils), 630-31; 675; paintings (Pordenone), 579; Sala del Gran Consiglio, frescoes (Gentile da Fabriano), 178

Fondaco dei Tedeschi, frescoes (Giorgione and Titian), 592

history and founding of, 136

Library of S. Marco (Sansovino), 608, 630, 633, 634, 635, 637; colorplate 100

Palazzo Vendramin-Calergi, façade (Codussi), 423–24; 434

political and economic development of, 12, 136, 137, 138, 142, 378, 454

S. Giobbe, Hospital of, altarpiece (Bellini, Giovanni), 414, 416; 425

S. Giorgio Maggiore (Palladio and Scamozzi), 625, 637; 684–686; paintings: (Tintoretto), 625; 667; (Veronese), 628; 672–674

Santi Giovanni e Paolo, painting (Veronese), 628–30; colorplate 98

 Marco, 136, 423; mosaics: (Castagno and Giambono), 260–61, 424; 267; (Uccello?), 244

Sta. Maria della Salute, Sacristy, ceiling paintings (Titian), 601, 602, 605; 645–647

Sta. Maria Gloriosa dei Frari: altarpieces (Titian), 594, 598, 605; 634, 639; colorplate 88; Cappella del Crocifisso, tomb of Titian, 605; Sacristy, altarpiece (Bellini, Giovanni), 412–14; 424

S. Pantaleone, altarpiece (Vivarini and Giovanni d'Alemagna), 381; 392

S. Sebastiano, ceiling painting (Veronese), 627–28, 630; 670

Sto. Spirito in Isola, 601

 Zaccaria: altarpiece (Bellini, Giovanni), 281, 416; colorplate 63; façade (Codussi), 423; 433

Scuola della Carità, mural (Titian), 599–600; 642, 643

Scuola di S. Fantin, sculpture (Vittoria), 638; 689

Scuola di S. Giovanni Evangelista, painting (Bellini, Gentile), 397; 414

Scuola di Sant'Orsola, paintings (Carpaccio), 417–19; 428, 429; colorplate 64

Scuola di S. Rocco, paintings (Tintoretto), 620, 622–25; Sala dell'Albergo, 622– 23; 662; colorplate 97; Sala Grande, 622, 623–25; 663–666

Scuola Grande di S. Marco, paintings (Tintoretto), 621–22; 660, 661; colorplate 96

Zecca, La (Sansovino), 608, 633–34, 659, 660; 679

Venus Anadyomene (Sansovino), 632; 678 Venus and Mars (Botticelli), 331–32; 348 Venus and the Lute Player (Titian), 603, 604; 650

Venus of Urbino (Titian), 601, 603; 644 Vergerio, Pier Paolo, 16 Vermeer, Ian. 416

Verona, 378, 608, 631; Palazzo Bevilacqua (Sanmicheli), 631; 677; Sant'Anastasia,

fresco (Pisanello), 378, 380; 388; S. Zeno, altarpiece (Mantegna), 388–89, 390, 394, 411, 424; 403, 404; colorplate 57

VERONESE, PAOLO (PAOLO CALIARI), 323, 384, 418, 588, 600, 608, 619, 626–31, 638; Abundance, Fortitude, and Envy, Villa Barbaro, Maser, 628; 671; Feast in the House of Levi, 628–30, 632; colorplate 98; Marriage at Cana, 628; 672–674; Mystical Marriage of St. Catherine, 630; colorplate 99; Triumph of Mordecai, S. Sebastiano, Venice, 627–28, 630; 670; Triumph of Venus (with pupils), Doges' Palace, Venice, 630–31; 675

Verrocchio, Andrea del, 201, 304, 314, 319–23, 342, 356, 358, 480, 660; Baptism of Christ (with Leonardo da Vinci), 319–20, 321, 330, 438; 332; Bust of a Young Woman, 321; 335; David, 140, 323, 332, 470; 336; Doubting of Thomas, Orsanmichele, Florence, 320–21, 340; 333, 334; Equestrian Monument of Bartolommeo Colleoni (with Leopardi), 139, 323, 451; 337–339; influence of, 319, 324, 329, 330, 343, 359, 369, 438

Vertumnus and Pomona (Pontormo), 296, 557–58, 559; 595

Vespasiano da Bisticci, 240 Vespucci, Amerigo, 324 Vespucci, Simonetta, 331 Vespucci family, 331

Vicenza, 378, 608, 631; Basilica/Palazzo della Ragione (Palladio), 634–35; 680; Olympian Theater (Palladio and Scamozzi), 638; 687, 688; Palazzo Chiericati (Palladio), 635; 681; Villa Rotonda/Villa Capra (Palladio and Scamozzi), 635–37; 682, 683

Victory (Michelangelo), 548, 549–50, 658; 582, 583

View of an Ideal City (Laurana, L., and Piero della Francesca), 27, 224, 228, 229, 297, 376–77, 486, 489; 386

Vigerio della Rovere, Marco, 492, 497, 500, 501

VIGNOLA, GIACOMO DA (JACOPO BAROZZI), 668–70; Villa Farnese, Caprarola, 669–70; 726–728

Villa: Barbaro, see Maser; Capra, see Vicenza, Villa Rotonda; Carducci, see Legnaia; Farnese, see Caprarola; Farnesina, see Rome; La Gallina, see Florence; Madama, see Rome; Medici, see Poggio a Caiano; Rotonda, see Vicenza

Villani, Filippo, 16 Villani, Giovanni, 62

Virgil, 330, 557

Virgin Adoring the Child (Perugino), 369; 381 Virgin and Child between St. John the Baptist and St. Catherine (Bellini, Giovanni), 416; 427

Virgin and Child with Angels (Lippi, Filippino), 338–40, 438; 356

Virgin Annunciate (Antonello da Messina), 399-400; 417

Visconti, Bernabò, 139, 140; tomb monument of (Bonino da Campione), 139–40, 239; 131

Visconti, Federigo, 51

Visconti, Filippo Maria, 142, 187, 238, 424, 457

Visconti, Giangaleazzo (duke of Milan), 136, 140, 142, 158, 201, 348, 425; portrait of (Giovannino de' Grassi), 140; colorplate 20 Visconti family, 139, 142, 378, 425, 451

Visconti Hours (Giovannino de' Grassi), 140; colorplate 20

Vision of Anna (Giotto), 66; 57

Vision of Constantine (Piero della Francesca), 278–79; 286

Vision of St. Bernard: (Bartolommeo, Fra), 476–77, 505, 515, 552; 486; (Lippi, Filippino), 340, 476, 477, 481; colorplate 47

Vision of St. Eustace (Pisanello), 380–81; colorplate 55

Vision of St. Jerome: (Castagno), 266–67, 285, 316, 392; 275; colorplate 35; (Parmigianino), 577, 578; 613

Vision of St. John the Evangelist (Correggio), 566; 607, 608

Vision of St. Martin (Martini), 98, 99, 124; 96 Visitation: (Angelico, Fra), 208, 270; colorplate 28; (Pontormo), 555–56; 593 Vitruvius, 221, 633, 634

Vittoria, Alessandro, 638; St. Jerome, 638; 689

VIVARINI, ANTONIO, 381, 382, 385; Coronation of the Virgin (with Giovanni d'Alemagna), S. Pantaleone, Venice, 381; 392

Vivarini family, 381, 416, 588

Volterra: Cathedral, painting (Rosso Fiorentino), 559–60; 599; colorplate 79

W

Way to Calvary (Martini), 101; 100 Wedding Feast of Cupid and Psyche (Romano), 586; colorplate 84

Wedding of Cupid and Psyche (Raphael and assistants), 527–28, 537; 562

Wenceslas (Holy Roman emperor), 140 Weyden, Rogier van der, 282, 369, 399, 427 Wisdom (Quercia), 176; 175 Wool Factory (Cavalori), 666–67; 724

Y

Young Man with a Medal (Botticelli), 334, 456; 350

Youth of Moses (Botticelli), 323, 327, 337, 501, 504; 342, 343

Z

Zecca, La (Mint), see Venice
Zibaldone (Rucellai), 223
Zuccari, Federico, 670
Zuccato, 592

Zuccone (Donatello), 172-73, 212; 170, 171

Zurbarán, Francisco de, 212

Photograph Credits

The author and publisher wish to thank the libraries, museums, and private collectors for permitting the reproduction of paintings, prints, and drawings in their collections. The frontispiece and figures 444–448, 450–452, 459, and 466 are reproduced with the gracious permission of Her Majesty Queen Elizabeth II. Photographs have been supplied by the owners or custodians of the works of art except for the following, whose courtesy is gratefully acknowledged:

Alinari, including Anderson and Brogi: 4-7, 9, 16-18, 21, 23, 24, 30-32, 38–42, 44–49, 52, 54–63, 65–72, 74–78, 80, 81, 84–86, 88–90. 93-99, 101-103, 106-111, 113-115, 118-127, 129, 130, 132-134, 138-141, 144, 146-148, 150-155, 157-160, 162-186, 192, 195, 196, 200, 201, 204, 205, 209–220, 222, 223, 225, 226, 230, 233, 234, 236-257, 264, 267-272, 282, 287-289, 291-297, 300, 304-307, 309, 312, 313, 315-318, 324, 326, 328-332, 334, 336-341, 343, 345, 347-353, 356, 357, 359, 361, 362, 364, 369-371, 373-375, 378, 380-388, 391-393, 395-404, 406-412, 414, 417, 423, 425, 427-429, 432, 434, 435, 437, 438, 440-442, 453-458, 460-462, 465, 467, 469, 471, 474, 477, 478, 484–486, 488–491, 495, 498, 505, 507, 511, 512, 515-526, 528, 529, 531, 534, 535, 538-544, 546, 550, 552, 555-559, 564, 565, 567, 569-572, 575, 577, 578, 582-584, 586, 587, 590-593, 595, 598, 600, 602-604, 606, 609, 610, 615, 616, 618, 619, 623, 626, 630-632, 634, 636, 639, 641-649, 655, 656, 660-667, 670, 671, 673–675, 677, 679–681, 686–688, 690–698, 701, 706, 707, 711-722. Aragozzini, Milan: 493-497. Archives Photographiques: 508, 672. Raffaeli Armoni & Moretti: colorplate 20; 112. The author: 532, 533. Bertotti-Scamozzi, Idea dell'architettura universale (Avery Library): 683. Bildarchiv Foto Marburg, Marburg/Lahn: 568. Calzolari, Mantua: 229, 627, 628. Cameraphoto, Venice: 424, 654, 657.

Ludovico Canali, Rome: colorplates 6, 7, 9, 11, 12, 25, 93, 94, 97, 103; 549, 689. Eugenio Cassin, Florence: 506, 620. Giancarlo Costa, Milan: 131. De Antonis, Rome: 35. Encyclopedia of World Art: 2, 308, 314, 376, 553, 617. David Finn, New York: 161. O. Foerster, Bramante, p. 91: 494. Fondazione Giorgio Cini, Venice: 72, 684. Foto Grassi, Siena: 43, 372. Fotostudio Rapuzzi, Brescia: 658. Fototeca Unione, Rome: 310, 554, 560, 702, 704. Gabinetto Fotografico Nazionale, Florence: 11, 12, 14, 20, 25–29, 73, 79, 82, 83, 87, 116, 117, 149, 187, 193, 194, 197–199, 206–208, 258–262, 274–279, 283– 286, 319, 320, 333, 335, 363, 377, 468, 470, 503, 507, 573, 580, 585, 589, 596, 597, 599, 710, 723. Gabinetto Fotografico Nazionale, Rome: 34, 475, 703. Giraudon, Paris: 100, 365, 413. Hirmer Verlag, Munich: 64. Istituto Centrale del Restauro, Rome: 105. Letarouilly, Les edifices . . . , vol. II, pl. 116: 621. Bates Lowry, Renaissance Architecture (Braziller), fig. 94: 625. Rollie McKenna, New York: 227. Mansell Collection: London, 281. A. Martinelli, Venice: colorplate 63. MAS, Barcelona: 637. Pepe Merisio, Bergamo: 231, 727, 728. Nippon Television Network Corporation: colorplates 72, 73. E. Peets and W. Hegeman, Civic Art, p. 25: 232. Penguin Press, Baltimore: 51 (John White, Art and Architecture in Italy: 1250-1400, fig. 3), 228 (N. Pevsner, Outline of European Architecture). Eric Pollitzer, New York: 509. Josephine Powell, Rome: 19, 22. Quattrone Mario Fotostudio, Florence: colorplates 15, 34, 40, 69, 104, 105; 724, 725. Gerhard Reinhold, Leipzig-Molkau: colorplate 60. Scala, Florence: colorplates 45, 84. Umberto Sciamanna, Rome: 561-563. Mario Semprucci & C., Pesaro: 422. Service Photographique des Musées Nationaux, Paris: 15, 545. Walter Steinkopf, Berlin: 203, 265, 443. H. Strack, Central in Italien, pl. 11, fig. 19: 496. Dusan Tasic, Belgrade: 36. Marvin Trachtenberg, New York: 50, 136, 229, 311, 433, 682. Vaghi, Parma: 607, 608. Viollet, Paris: 463. Leonard Von Matt, Buochs, Switz.: 622.